Cézanne

Cézanne

Françoise Cachin

Isabelle Cahn

Walter Feilchenfeldt

Henri Loyrette

Joseph J. Rishel

Harry N. Abrams, Inc., Publishers
in association with the
Philadelphia Museum of Art

This volume is published in conjunction with the exhibition *Cézanne*,
held at the Galeries Nationales du Grand Palais, Paris, September 25, 1995, to January 7, 1996,
the Tate Gallery, London, February 8 to April 28, 1996,
and the Philadelphia Museum of Art, May 30 to August 18, 1996.

The exhibition is made possible in Philadelphia by

ADVANTA

Additional support has been provided by grants from The Pew Charitable Trusts
and the National Endowment for the Arts, by
an indemnity from the Federal Council on the Arts and the Humanities,
and by a generous contribution from Gisela and Dennis Alter.
USAir is the official airline for the exhibition.
NBC 10 WCAU is the media sponsor.

This book is dedicated to the memory of John Rewald

Library of Congress Cataloging-in-Publication Data

Cézanne, Paul. 1839-1906.
 [Cézanne. English]
 Cézanne / Françoise Cachin ... [et al.].
 p. cm.
 An exhibition jointly organized by the Philadelphia Museum of Art,
the Réunion des Musées Nationaux/Musée d'Orsay, Paris, and the Tate
Gallery, London.
 Includes bibliographical references and index.
 ISBN 0-87633-100-2 (Philadelphia Museum of Art: paper)
 ISBN 0-87633-101-0 (Philadelphia Museum of Art: cloth)
 ISBN 0-8109-4039-6 (Abrams: cloth)
 1. Cézanne, Paul, 1839-1906--Exhibitions. I. Cachin, Françoise.
II. Philadelphia Museum of Art. III. Title.
ND553.C33A4 1996
759.4--dc20 95-51493

Published in 1996 by Harry N. Abrams, Incorporated, New York
A Times Mirror Company

Printed and bound in France

Produced by the Publications Department of the Philadelphia Museum of Art,
George H. Marcus, Head of Publications

Editor: Jane Watkins, assisted by W. Douglass Paschall

Translator: John Goodman

Coordination of French edition: Céline Julhiet-Charvet, assisted by Aude Joseph
Design: Bruno Pfäffli
Production: Jacques Venelli

This exhibition was jointly organized by the Philadelphia Museum of Art,
the Réunion des Musées Nationaux/Musée d'Orsay, Paris,
and the Tate Gallery, London

Exhibition Organizers

Françoise Cachin
Director, Musées de France

assisted by Isabelle Cahn
Research Associate, Musée d'Orsay

Joseph J. Rishel
Curator of European Painting before 1900, Philadelphia Museum of Art

assisted by Katherine Sachs
Research Coordinator, Philadelphia Museum of Art

Organizing Committee

Irène Bizot
General Administrator, Réunion des Musées Nationaux

Anne d'Harnoncourt
Director, Philadelphia Museum of Art

Henri Loyrette
Director, Musée d'Orsay

Nicholas Serota
Director, Tate Gallery

Lenders to the Exhibition

Corinne Cuéllar (cat. no. 53)
Drue Heinz (cat. no. 63)
Mrs. John Hay Whitney (cat. no. 159)
The Alex Hillman Family Collection (cat. no. 105)
Jan and Marie-Anne Krugier-Poniatowski (cat. nos. 152 and 169)
Yvon Lambert (cat. no. 88)
The Thaw Collection (cat. nos. 165, 183, 194, 198, 207, 211, and pp. 521-522)

Aix-en-Provence
Musée Granet (cat. nos. 1 and 4)
Avignon
Musée Calvet (cat. no. 22)
Baltimore
The Baltimore Museum of Art (cat. no. 175)
Basel
Öffentliche Kunstsammlung Basel (cat. nos. 20, 62, 82, 111, and 143)
Berlin
Staatliche Museen zu Berlin, Nationalgalerie (cat. no. 75)
Bern
Kunstmuseum Bern (cat. no. 66)
Boston
Museum of Fine Arts (cat. nos. 47 and 76)
Bremen
Kunsthalle Bremen, Kupferstich-kabinett (cat. no. 81)
Brooklyn
The Brooklyn Museum (cat. no. 115)
Cambridge
The Fitzwilliam Museum (cat. nos. 2, 12, and 49)
Cambridge, Massachusetts
Fogg Art Museum, Harvard University Art Museums (cat. nos. 52, 96, and 178)
Canberra
National Gallery of Australia (cat. no. 39)
Cardiff
National Museum and Gallery of Wales (cat. nos. 13 and 56)
Chicago
The Art Institute of Chicago (cat. nos. 25, 31, 41, 94, 114, 123, 184, 215, 220, 224, and p. 523)
Cincinnati
Cincinnati Art Museum (cat. no. 3)
Cleveland
The Cleveland Museum of Art (cat. no. 121)
Columbus, Ohio
Columbus Museum of Art (cat. no. 46)
Copenhagen
Ny Carlsberg Glyptotek (cat. no. 139)
Dublin
The National Gallery of Ireland (cat. no. 204)
Essen
Museum Folkwang (cat. no. 149)
Fort Worth, Texas
Kimbell Art Museum (cat. nos. 137 and 145)

Frankfurt
Städelsches Kunstinstitut, Kupferstichkabinett (cat. no. 59)
Glasgow
Glasgow Museums and Art Galleries (cat. no. 69)
Hamburg
Hamburger Kunsthalle, Kupferstich-kabinett (cat. no. 210)
Houston
The Museum of Fine Arts (cat. no. 125)
Indianapolis
Indianapolis Museum of Art (cat. no. 116)
Kansas City, Missouri
The Nelson–Atkins Museum of Art (cat. no. 202)
Liverpool
National Museums and Galleries on Merseyside, Walker Art Gallery (cat. no. 16)
London
The British Museum (cat. nos. 99 and 163)
Courtauld Institute Galleries (cat. nos. 86, 92, 162, and 174)
The National Gallery (cat. nos. 171, 218, and 226)
Tate Gallery (cat. nos. 24 and 206)
Los Angeles
The Armand Hammer Collection, UCLA/Armand Hammer Museum of Art and Cultural Center (cat. no. 131)
Los Angeles County Museum of Art (cat. no. 157)
Malibu, California
The J. Paul Getty Museum (cat. nos. 8, 42, and 197)
Mannheim
Städtische Kunsthalle (cat. no. 136)
Minneapolis
The Minneapolis Institute of Arts (cat. no. 113)
Montreal
Collection of Phyllis Lambert (cat. no. 148)
Moscow
Pushkin State Museum of Fine Arts (cat. no. 205)
Munich
Neue Pinakothek, Bayerische Staatsgemäldesammlungen (cat. no. 77)
Newark
The Newark Museum (cat. no. 192)
New York
The Metropolitan Museum of Art (cat. nos. 7, 37, 68, 89, 155, 158, and 167)
The Museum of Modern Art (cat. nos. 104, 142, 151, and 195)
The Pierpont Morgan Library (cat. no. 135)
The Selch Family (cat. no. 227)
Solomon R. Guggenheim Museum (cat. no. 179)
Norfolk, Virginia
The Chrysler Museum (cat. no. 10)
Northampton, Massachusetts
Smith College Museum of Art (cat. no. 74)

Oslo
Nasjonalgalleriet (cat. no. 187)
Paris
Musée du Louvre, Département des Arts Graphiques (cat. nos. 21, 100, 102, 108, 122, 146, 193, 196, pp. 520-21 and 524-25)
Musée de l'Orangerie (cat. nos. 78 and 85)
Musée d'Orsay (cat. nos. 6, 18, 19, 23, 28, 30, 32, 34, 40, 57, 58, 95, 126, 128, 130, 134, 140, 166, 168, 172, 181, and 190)
Musée du Petit Palais (cat. nos. 60 and 177)
Musée Picasso (cat. nos. 50 and 72)
Philadelphia
Philadelphia Museum of Art (cat. nos. 29, 33, 83, 106, 138, 182, 185, 186, 201, 203, 208, and 219)
Prague
Národní Galerie (cat. no. 173)
Princeton
The Henry and Rose Pearlman Foundation, Inc. (cat. nos. 147, 200, and 217)
Providence
Museum of Art, Rhode Island School of Design (cat. no. 132)
Rochester
Memorial Art Gallery of the University of Rochester (cat. no. 54)
Rotterdam
Museum Boymans–van Beuningen (cat. nos. 61, 73, 79, 84, 87, 90, 98, 112, and 119)
St. Petersburg
The Hermitage Museum (cat. nos. 17, 154, 180, and 188)
São Paulo
Museu de Arte de São Paulo, Chateaubriand Collection (cat. nos. 11, 55, and 153)
Solothurn
Kunstmuseum Solothurn (cat. no. 213)
Stockholm
Nationalmuseum (cat. no. 161)
Tokyo
Bridgestone Museum of Art, Ishibashi Foundation (cat. nos. 141 and 176)
Toledo
The Toledo Museum of Art (cat. no. 118)
Vienna
Graphische Sammlung Albertina (cat. nos. 51 and 91)
Washington, D.C.
National Gallery of Art (cat. nos. 71, 124, and 189)
The Phillips Collection (cat. nos. 36, 93, and 209)
Zurich
Kunsthaus Zurich (cat. nos. 70, 80, 156, and 223)
Fondation Rau pour le Tiers-Monde (cat. no. 44)

Sponsor's Foreword

On behalf of my more than 2,500 colleagues at Advanta and our five million customers around the country, I wish to express how honored we are to be associated with this exceptional exhibition—a retrospective of the works of Paul Cézanne.

The challenge of bringing this exhibition together was driven by the desire to unite the most representative and important of Cézanne's works into a show that would provide an opportunity to reassess the full measure of his genius— his extraordinary eye, his obsession with perfection, and his passion for nature, its color and light. To be a part of that challenge as the sponsor of the only venue for the exhibition in the United States of America is an unprecedented honor for Advanta. We are proud to contribute to this tremendous undertaking in which we all celebrate an artist who not only embodied his own era, but also inspired the century of modern artists who followed.

As John Ruskin said in 1870, "Life without industry is guilt, industry without art is brutality."

Advanta's support of this exhibition is a demonstration of our company's belief that art and culture play an essential role in a successful business climate. We believe that exposure to art awakens the senses and ignites the mind, teaching us more about ourselves, our own potential, and our world. At Advanta, art is much more than a message from the past; it is a gateway to the future.

On behalf of Advanta, I extend our thanks to all those who have worked to bring this retrospective to life. Very special thanks go to the staff of the Philadelphia Museum of Art, with whom we are extremely proud to be partners in this magnificent project. The tireless spirit of discovery that drove Cézanne in his work is the same that motivates all of us at Advanta. We are pleased to be able to play a part in making this exhibition possible here in the United States.

Dennis Alter
Chairman
Advanta Corporation

Acknowledgments

The authors of the catalogue would like to thank Jayne Warman, John Rewald's assistant, for her inexhaustible patience and kindness in fielding our many queries about information in the forthcoming catalogue raisonné of Cézanne's paintings; Alison Goodyear, research assistant at the Philadelphia Museum of Art; as well as Juliette Armand, Richard Brettell, Philip Conisbee, Françoise Dios, Gilles Gratté, Aude Joseph, Céline Julhiet-Charvet, Fatima Morethy-Couto, Sabine Rewald, Elisabeth Salvan, and Richard Shiff. The English edition was admirably supervised by Jane Watkins, assisted by W. Douglass Paschall.

We also wish to thank the following people and all those who have assisted in the preparation of the exhibition and its catalogue: William Acquavella, Noriko Adachi, Candance J. Adelson, Götz Adriani, David Alston, Hortense Anda-Bührle, Robert Anderson, Irina Antonova, Alexander Apsis, Alison Baber, Colin Bailey, Felix Baumann, Knut Berg, Robert Bergman, Claude Bernard, Paula Berry, Annie Billard, Leon Black, Robert Boardingham, Doreen Bolger, Patrick Boulanger, Helen Braham, Claudine Brohon, Christopher Brown, Emily Brown, M. l'abbé Bry, Robert T. Buck, Thérèse Burollet, Sara Campbell, Görel Cavalli-Björkman, Philippe Cézanne, Marie-Anne Chabin, Madeleine Chabrolin, Philippe de Chaisemartin, Conna Clark, Robert Clémentz, Micheline Colin, Anna Corsy, Dr. Frédéric Corsy, Jean Coudane, Denis Coutagne, Arturo and Corinne Cuellar, James Cuno, Magdalena Dabrowski, Françoise Dallenge, Ladislav Daniel, Guy-Patrice Dauberville, Cara D. Denison, Lisa Dennison, Barbara Divver, Michelle Doucet, Marie-Hélène Drolet, Douglas Druick, Françoise Dumont, Dominique Dupuis-Labbe, George A. Embiricos, Giuseppe Eskenazi, Mark Evans, Suzannah Fabing, Everett Fahy, Manfred Fath, Sarah Faunce, Marianne Feilchenfeldt, Anne-Brigitte Fonsmark, Colin Ford, Robert H.

Frankel, Margaretta Frederick, Gerbert Frodl, Françoise Fur, Kate Garmeson, Pierre Georgel, Barbara Gibbs, Danièle Girard, Robert B. Glynn, Caroline Durand-Ruel Godfroy, George Goldner, Peter John Goulandris, Olle Granath, Doris Grunchec, André Guttierez, Stephen Hahn, Bernhard Hahnloser, Donald S. Hall, Mr. and Mrs. Samuel M. V. Hamilton, Vivien Hamilton, Mr. and Mrs. Neison Harris, Chieko Hasegawa, Tokushichi Hasegawa, John and Paul Herring, Johann Georg Prinz von Hohenzollern, Siegmar Holsten, Luiz Hossaka, John House, Ay-Whang Hsia, Kannichiro Ishibashi, Florence Jacquet, David Jaffé, Simon Jervis, Flemming Johansen, R. Jullien, André Kamber, Yasuo Kamon, Raymond Keaveney, Dorothy Kellett, Georg W. Költzsch, Albert G. Kostenevich, Thomas Krens, Elizabeth Kujawski, Phyllis Lambert, Mr. and Mrs. Ronald S. Lauder, Ellen W. Lee, André Lejeune, Christian Lenz, Erika Lindt, Dominique Lobstein, Glenn Lowry, Annie-Claire Lussiez, Neil MacGregor, Nanette Maciejunes, Fabio Magalhaes, Isabelle Malmon, George Marcus, Luis Marques, Peter C. Marzio, Evan M. Maurer, Suzanne McCullagh, Mr. and Mrs. Werner Merzbacher, Nils Messel, Lilah Mittelstaedt, Katsumi Miyazaki, Charles S. Moffett, Miklos Mojzer, J. R. ter Molen, Philippe de Montebello, Olivier Morel, Alain Mothe, Cristina Mur de Viu, John Murdoch, Peter Nathan, Larry Nichols, Monique Nonne, Konrad Oberhuber, Maureen C. O'Brien, Vlasta Odell, Richard Oldenburg, Donald Oresman, Fieke Pabst, Ursula Perucchi, Béatrice Perreaut, Charles Pierce, Edmund P. Pillsbury, Mikhail Piotrovsky, Joachim Pissarro, Earl A. Powell III, Mary Sue Sweeney Price, Pierre Provoyeur, Odyssia Skouras Quandrani, G. Rau, Theodore Reff, Gérard Régnier, Marie-Christine Rémy, Brenda Richardson, Christopher Riopelle, Mr. and Mrs. David Rockefeller, Baronne Élie de Rothschild, Allen Rosenbaum, Pierre Rosenberg, Anne Röver-Kann, Margit Rowell, Samuel Sachs II, Siegfried Salzmann, David E. Scrase, Eckhard Schaar, Mr. and Mrs. Walther Scharf,

Mr. and Mrs. David T. Schiff, Vanessa Schmid, Katharina Schmidt, Patrice Schmidt, Uwe M. Schneede, Peter Klaus Schuster; Nicholas, Jason, Andrea, and Gregory Selch; Véronique Serrano, Jiri Sevcik, George T. M. Shakelford, Innis Howe Shoemaker, Julian Spalding, David Steadman, Marie-Daniella Strouthou, Charles Stuckey, Margaret Stuffmann, Jeanne-Yvette Sudour, S. Martin Summers, Patricia Tang, Irene Taurins, Hans Christoph van Tavel, Bernard Terlay, Lyne Therrien, Gary Tinterow, Julian Treuherz, Mikako Tsukada, Béatrice Tupinier, Evan Turner, Jennifer Vanim, Kirk Varnedoe, Jean-Pierre Vuilleumier, Bret Waller, John Walsh, Mr. and Mrs. John C. Weber, James Weidman, Regina Weinberg, Suzanne F. Wells, Éliane de Wilde, John Wilson, Marc F. Wilson, Élisabeth Wisniewski, James Wood, Jean-Claude Yon, Eric M. Zafran, Marke Zervudachi, and Faith Zieske.

Preface

As the end of the twentieth century approaches, with what seems breakneck speed, it is both thrilling and profoundly daunting to have had the honor of organizing a great retrospective exhibition devoted to the painter who more than any other exemplifies the new adventures in art unleashed by the turn of a century. Paul Cézanne himself rarely appeared to look very far forward. The foundations of his art lay rather in his scrutiny of the past, what he called "the art of the museums," and in the intensity—sometimes serene, often frustrated—with which he contemplated each of his own works in progress. Yet, it would be difficult to overestimate his decisive effect on the art that has followed in the hundred years since Cézanne's first one-man show. The analytical Cubism of Picasso and Braque, the arching trees and ginger pots of Mondrian, the bronze *Backs* of Matisse—all are impossible without Cézanne. And since World War II, in steady succession over the decades, the array of painters whose rich heritage now encompasses both Cézanne and those who came hard on his heels only grows larger and more distinguished.

It has been this project's great good fortune to have had the passionate scholarship of Françoise Cachin and Joseph Rishel at its helm, and they, in turn, have been enormously helped by their colleagues, Henri Loyrette, Director of the Musée d'Orsay, Isabelle Cahn, Research Associate of the Musée d'Orsay, and Katherine Sachs, Research Coordinator at the Philadelphia Museum of Art. Walter Feilchenfeldt, who, with Jayne Warman, undertook, at the late John Rewald's request, the completion of Rewald's magisterial catalogue raisonné of Cézanne's paintings, to be published by Abrams, has made an invaluable contribution with his annotated glossary of collectors in this volume, as well as with thoughtful advice along the way.

It is not possible to express adequate thanks to all those on the staff of the Réunion des Musées Nationaux, the Musée d'Orsay, the Tate Gallery, and the Philadelphia Museum of Art, whose collective efforts created the exhibition and its mighty catalogue. For the latter, we are particularly indebted to the leadership of Anne de Margerie in Paris and George Marcus in Philadelphia, together with their skilled respective editors Céline Julhiet-Charvet and Jane Watkins, and to the Paris-based designer Bruno Pfäffli, who has given such handsome form to a wealth of visual material and scholarship. At the Tate, Ruth Rattenbury, Head of the Exhibitions Department, together with Sionaigh Durrant from the Registrar's Department, and at the Philadelphia Museum of Art, Suzanne F. Wells, Coordinator of Special Exhibitions, together with Irene Taurins, Registrar, have been especially involved in logistical arrangements for the British and American venues. Elsewhere in this volume, Françoise Cachin and Joseph Rishel express their gratitude to other colleagues inside and outside our museums, here most warmly seconded, and we join them in saluting the indefatigable Irène Bizot, General Administrator of the Réunion des Musées Nationaux, *prima mobile* of this as of so many great international exhibition projects, which would never happen without her rare combination of wit, energy, and common sense.

Without the enormous goodwill of so many lenders, public institutions, and private collectors alike, the exhibition could never have come into being, and we join what will surely be well over a million viewers in Paris, London, and Philadelphia in thanking them from the bottom of our hearts. When putting Cézanne "together" again after so many important and scholarly exhibitions that examined aspects of his oeuvre, we counted upon the enthusiasm and generosity of many friends, and have not been disappointed. We are grateful,

too, to the enlightened governments of France, Great Britain, and the United States, whose indemnity policies have sufficiently reduced the necessarily huge costs of insurance so that the exhibition could go forward.

To undertake such a vast international project, our museums have depended not only upon dedicated and insightful scholars, enthusiastic and patient lenders, and our staff who work long hours during years of preparation and months of intense activity to serve the exhibition's huge public, but also corporate sponsors of enterprise and generosity on a splendid scale. We cannot sufficiently express our thanks to Dennis Alter, Chairman of Advanta in Horsham, Pennsylvania, and Nick Land, Senior Partner of Ernst & Young in London, for the close personal interest they have taken in the Cézanne retrospective from the time they heard the first word about it and throughout its development as a project of such great significance for the audiences in Great Britain and the United States. We are infinitely grateful, in turn, to the executives and staff of Advanta and of Ernst & Young, who have involved themselves in the success of the exhibition with enormous energy, good will, and imagination.

Anne d'Harnoncourt
Director
Philadelphia Museum of Art

Nicholas Serota
Director
Tate Gallery

Contents

Note to the Reader

The catalogue entries have been arranged both chrono-
logically (in five divisions by decade, incorporating
paintings, watercolors, and drawings) and in several
thematic groupings within these divisions. The entries
on Cézanne's sketchbooks are discussed in a separate
section at the end of the catalogue.

The Cézanne catalogues raisonnés are referred to
throughout by the following abbreviations:

V. Lionello Venturi, *Cézanne, son art—son oeuvre*, 2 vols.
 (Paris, 1936).
R. John Rewald, *Paul Cézanne: The Watercolors,*
 A Catalogue Raisonné (Boston, 1983).
C. Adrien Chappuis, *The Drawings of Paul Cézanne:*
 A Catalogue Raisonné, 2 vols. (Greenwich,
 Connecticut, 1973).

A new publication, *The Paintings of Paul Cézanne:*
A Catalogue Raisonné, by John Rewald, edited by Jayne
Warman and Walter Feilchenfeldt, is forthcoming
(Harry N. Abrams, Inc., New York). A concordance
of the new Rewald numbers with the above catalogues
raisonnés is given in the back of this book.

Quotations from the artist's own letters (see Cézanne,
1978), Ambroise Vollard's biographical study (Vollard,
1914), and Joachim Gasquet's account of his conversa-
tions with the artist in his last years (Gasquet, 1921)
have been newly translated from the French by John
Goodman. Quotations from Rainer Maria Rilke's series
of letters to his wife in 1907 (see Rilke, 1952) were
translated anew from the German for this book by
Russell Stockman.

For full citations of the exhibition catalogues, books,
and articles cited in abbreviated form in the notes, see
the list of sources and exhibitions at the back of this
volume.

"He is the man who paints"

Even now, to broach the subject of Cézanne is to enter upon holy ground. He is simultaneously a spiritual role model—a saint, a hermit, an artist whose signal achievement was obtained at the considerable cost of solitude and intransigence— and a prophet of modernity. It was not only astute contemporaries who viewed his quest for moral and artistic truth as heroic; he himself did, too. Yet there is probably more than a dash of humor in likening himself to Moses: "I work doggedly, I glimpse the Promised Land. Will I be like the great Hebrew leader or will I be able to penetrate it?"

Is this perception the result of the veneration he inspires? Despite the abundant literature that has successively denigrated, praised, studied, interpreted (and overinterpreted) him over the preceding century, Cézanne remains an infinitely mysterious artist. His art shifts course at several points, but these re-orientations seem to proceed almost by fits and starts; some themes appear briefly and then vanish, while others—configurations of imaginary nudes in a landscape, elaborate still-life compositions—survive every twist and turn in his long career. After all is said and done, the motivations behind these renunciations and obsessions, the real intentions behind Cézanne's Murders, Cardplayers, and Large Bathers, are inaccessible to us.

This exhibition and the accompanying catalogue make no claim to providing new keys, nor do they aim to reveal an unfamiliar Cézanne; they are meant solely to present an oeuvre of genius, whose impact on generations of artists has always been more readily apparent than the intentions behind it, which sometimes have become more comprehensible with the passing of time. While we will be delighted if this event prompts a renewal of Cézanne scholarship, it seems to us that every significant creative achievement perpetually retains something that is enigmatic.

Marking one century after the first exhibition devoted to Cézanne, mounted by Ambroise Vollard in 1895, and almost sixty years after the last important survey, held in Paris in 1936, a comprehensive retrospective of Cézanne's work seemed imperative. He is the only "great" French artist of the nineteenth century who has not been honored with an international retrospective in the postwar years.

There are several reasons for the delay, some of them material. Despite having been the most disinterested of artists, who disdained easy success, he has since become perhaps the most expensive painter in the world. This state of affairs certainly hasn't facilitated the organization of such an exhibition, and thus we are especially grateful to the patrons who have underwritten this project. Furthermore, great collectors tend to be deeply attached to their paintings, and are therefore reluctant to surrender them for a full year, the time required for an exhibition presented in three successive venues. And, of course, certain institutions, such as the Barnes Foundation in Merion, Pennsylvania, are unable to make loans that disperse their collections. As a result, several important paintings are absent from our exhibition; they are reproduced in the first part of this volume in order to accurately reflect the full range of the artist's achievement.

We did not seek so much to mount an exhaustive exhibition as to present a hundred paintings and almost as many drawings and watercolors representative of the painter's development. Bringing them together will doubtless clarify questions of chronology, which have often been blurred. Finally, we are especially pleased to be able to unite for the first time since 1907 two of the three famous *Large Bathers* that have played such an important role in the history of modern painting, namely the versions from London and Philadelphia (the third, now at the Barnes Foundation, was recently exhibited in Paris and Philadelphia).

We have deliberately kept technical and bibliographic information in the catalogue entries to a minimum, citing only selected monographic and group exhibitions, in anticipation of the forthcoming catalogue raisonné of paintings by the late John Rewald, edited by Jayne Warman and Walter Feilchenfeldt. By contrast, we have recounted more fully the provenance of each work after it left the studio. Remarkably, while some became the property of admiring artists and a handful of important collectors very early on, others "navigated" from dealer to dealer before coming to berth in a great public or private collection. For some time, Cézanne was not a truly popular artist and his work was difficult to sell. The provenances reveal that most of the paintings now in museums entered their collections as gifts. At the end of this volume, we publish a chronological inventory of the most important collectors of Cézanne's work, compiled by Walter Feilchenfeldt, as well as an extensive chronology of the artist's life prepared by Isabelle Cahn, using previously unpublished material. Both should prove useful for Cézanne research.

Considerations of a more intellectual order have also played their role in postponing a comprehensive Cézanne retrospective. Recent exhibitions and publications have focused on single aspects of the artist's achievement that paralleled contemporary shifts in sensibility. At the end of the 1970s, the exhibition *Cézanne: The Late Work* (New York, Houston, and Paris) drew from a traditional formalist, modernist perspective to show the artist as a precursor: as the father of Cubism, Constructivism, and abstraction. Ten years later, when postmodernism held sway, it was the narrative and pictorial aspect of his work that was the object of attention; two exhibitions mounted in the 1980s, *Cézanne: The Early Years* (London, Paris, and Washington) and *Paul Cézanne: The Bathers* (Basel), portrayed him as an instinctive being who, through his art, gradually sublimated his violent obsessions.

These shifts of interest figure in the context of larger historical developments. For over a century, Cézanne has served as a beacon for the various modernist movements, Fauvism, Cubism, and early abstraction, then in the 1920s as a flag-bearer of the classical tradition, and in particular as the heir to Poussin, an idea reopened in the exhibition *Cézanne and Poussin*, held in Edinburgh in 1990. In the 1930s the Surrealists stressed the painter's dark side. André Breton was drawn to the paintings "around which hovers a threat that is half tragic, half *guignolesque*," and Picasso—who during his Cubist period had been most attentive to the artist's formal innovations—claimed in 1935 that he was interested above all in "the disquiet of Cézanne, . . . [the] drama of the man." By contrast, the 1950s and 1960s, which saw the triumph of European and American abstract art, were marked by a return to a formalist approach.

Cézanne's worst fear was—in his own words—that people would "get their hooks into him." Yet that is precisely what all his admirers, all those who have taken him up as a pedagogue or as an object of research, have proceeded to do. He complained that Gauguin had stolen "his little sensation" to put it on public display. The Symbolist critics of the 1890s named him as their patron saint, and the Fauves and the Cubists claimed him as their own and expanded upon very specific aspects of his art. The champions of the 1920s "return to order" pressed him into service as the embodiment of the great French tradition, while formalist aestheticians have read his work as the first expressions of pure painting. Iconological historians since Meyer Schapiro have interpreted his imagery along psychoanalytic lines, and the same could be said of those who seek painterly subtexts. Yet, while many grappling "hooks" may indeed have been sunk into the inexhaustible ground that is the art of Cézanne, in the end, both the man and the artist remain singularly enigmatic. Although he was far more shrewd and sophisticated than he generally let on, his eschewal of facile effect, his disdain for pathos and the explicitly emotional (what he termed the "literary"), his often cryptic aphorisms, and his cultivated persona of the peasant smelling of garlic (that failed to hide the hypersensitive being beneath, whose mantra seems to have been, "It's terrifying, this life!") were all factors that helped to protect his art, his individuality, and indirectly, his mystery.

Despite the excellent investigations of Lionello Venturi, John Rewald, Adrien Chappuis, and Theodore Reff, in catalogues as well as articles dealing with questions of sources and chronology, our basic knowledge about Cézanne's works is very limited. The moment of their execution often remains unknown. Cézanne did not date his pictures, leading specialists to hold divergent views even for the chronology of works representing the same motif in different mediums (oil, watercolor, graphite). And except for the landscapes, only rarely can we specify with any degree of certainty where a given painting was executed.

Rather than proposing new interpretations, we, like Judith Wechsler and John Richardson before us, have concerned ourselves with the "critical fortune" of Cézanne, who for a century now has been an inescapable presence in the histories of, successively, French, European, and American painting. In an attempt to facilitate a better understanding of the extent to which writings about him have determined our conception of both the painter and the man, we have decided to publish here texts that reveal essential elements of the Cézanne myth, which have perhaps played as important a role as his work in the evolution of twentieth-century art and taste, and fell into place as early as the 1880s and 1890s. In 1894 the critic for *La Revue blanche*, Thadée Natanson, set the tone: "However unfinished his work might appear, it adduces the idea of an absolute overthrow of the art of painting."

This critical overview renders accessible some of the benchmark texts written by both critics and art historians—each with an intellectual agenda and set of interests—that have shaped our changing perceptions of the painter. A few of the most remarkable, in chronological order, include Rainer Maria Rilke (1907), Joachim Gasquet, Roger Fry, and Élie Faure (1910s), Lionello Venturi, Fritz Novotny, and John Rewald (1930s), Maurice Merleau-Ponty, Clement Greenberg, and Meyer Schapiro (1940-70).

The most influential writings, especially early on, were often by authors who had been prodded by artists to write about Cézanne, such as J.-K. Huysmans by Pissarro, Gustave Geffroy by Monet, and, above all, by critics who were also painters, from Émile Bernard and Maurice Denis (whose 1907 article remains fundamental) to, more recently, Lawrence Gowing.

By way of introduction to this anthology of Cézanne literature, which proceeds from Émile Zola to D. H. Lawrence, from Huysmans to Meyer Schapiro, we include a few of the artist's own remarks about painting. These might not appear notably original in many respects, for they reiterate formulas that had made the rounds of nineteenth-century studios since the days of Constable and Corot. Cézanne's notions about the virginal eye, for example—that it is indispensable to any good artist, who should make a concerted effort to forget how previous artists depicted the motif—and his ideas about the treatment of nature in terms of geometric shapes rendered in perspective had been in circulation since the Renaissance. Even so, these remarks meant a great deal to generations of artists who admired Cézanne; furthermore, they offer moving testimony of his uneasiness, his scruples, his sincerity, his wariness of theory, and of what he dubbed "chatter" about art, and also provide insight into his goals that—while not so simple as they might appear—he knew perfectly well he sometimes attained to a sovereign degree. They are the pronouncements of one who could identify the "vividness" and "strength" of his "feeling for nature," a master speaking from personal exper-ience: "It's necessary to see one's model clearly, to feel on pitch, and still express oneself with distinction and force."

Words are poor things, as Cézanne himself was convinced; no commentary, whether by him or anyone else, can adequately convey his sense of rightness, his distinction, his force. Writing cannot communicate the visual and spiritual emotion that he so miraculously transmitted to canvas and paper, which visitors to the exhibition will undoubtedly sense for themselves. It is impossible to remain indifferent in the face of the vehemence that he gradually mastered, which then resurfaced at the end of his life, and the equilibrium, miraculously reestablished in each work, that manages to articulate the essential by means of the simplest forms.

For it would seem that, in the matter of Cézanne, the unsaid and the unwritten continue to carry the day. Now, as in the past, he is, to a greater extent than

anyone else in the history of art, a painter's painter, an artist for those who particularly love painting. "He is the man who paints," affirmed Maurice Denis, adding: "Renoir said to me one day: 'How on earth does he do it? He cannot put two touches of color on to a canvas without its being already an achievement.'"

It was the painters of his own generation who first made his reputation and all but forced dealers to represent him and critics to write about him. A letter from Pissarro to his son, written at the time of the exhibition at Vollard's gallery in 1895 when Cézanne was fifty-six, characterizes the situation: "You wouldn't believe how much trouble I have convincing certain art-lovers, friends of the impressionists, of all the great and rare qualities in Cézanne. I think centuries will pass before people realize this. Degas and Renoir are enthusiasts of Cézanne's work, Vollard showed me a drawing of some fruit over which they drew straws to determine who would be its happy owner. What do you make of Degas's being so passionate about Cézanne's sketches? Did I see things clearly myself when, in 1861, Oller and I went to see this curious Provençal at the Atelier Suisse, where he made *académies* at which all the school's impotents laughed?" (December 1, 1895).

Since then, over several generations, Cézanne has been a tutelary presence in nearly every modern painting studio. Gauguin and Picasso, Bonnard and Malevich, Matisse and Paul Klee, Braque and Kandinsky, Marcel Duchamp and Jasper Johns: all these artists have had intense relationships with Cézanne's work, and, resources permitting, have acquired an example of his work for their own collections (see cat. nos. 50, 56, 60, 69, 72, 125, 126, and 190). In addition to being "the father of us all" (Picasso), "the supreme master" (Klee), Cézanne has also served as a spiritual model, as "a kind of benevolent god of painting" (Matisse), the author of a "mystical construction" (Franz Marc) that, by its forms, gave painting "back its soul" (Kandinsky).

He incarnates the ideal image of the disinterested artist, neither calculating nor vain, concerned only with his *réalisation*, haunted by painting as a means of expressing nature—as he said over and over—although exactly what he meant by nature is unclear. Surely it was not just landscape, but the real in general, everything in which the eye perceives that elusive element from the spiritual domain that only great artists are able to capture and is most readily discernible to other artists. "I have never heard an admirer of Cézanne give me a clear and precise reason for his admiration; and this is true even among those artists who feel most directly the appeal of Cézanne's art," Maurice Denis observed, and it remains the case today. Of course, Denis could not resist proposing a definition of his own at the moment of Impressionism's triumph: "The art of Cézanne showed the way to substitute reflection for empiricism without sacrificing the essential role of sensibility. . . . He was able to hold the emotion of the moment even while he elaborated almost to excess, in a calculated and intentional effort, his studies after nature."

The contradictory richness of Cézanne's work has made it an essential school for artists. Sometimes it is his doubt, his uneasiness, his mistakes, his eccentricities, and his frustrations that have encouraged artists—for example, Picasso, as William Rubin convincingly demonstrates in his study "Cézannisme and the Origins of Cubism" (New York and Houston, 1977-78). At other moments, by contrast, it is the certainty, the clarity, and the rightness of his painting that appears most striking to painters and writers, many of whom are as interested in his ethical quest as in his work. Two examples will suffice: during the retrospective exhibition of 1907, Rainer Maria Rilke wrote of a presence "that closes over you like a colossal reality. It's as if these colors forever purged you of all uncertainty." And Matisse was to say: "In moments of doubt, when I still felt uncertain of myself, sometimes frightened by my discoveries, I thought: 'If Cézanne was right, then I'm right,' because I know Cézanne did not make mistakes."

Françoise Cachin and Joseph J. Rishel

Cézanne on Art

Except for the observations reported by Émile Bernard in *L'Occident* in 1904 and the fragments published by Charles Morice in the *Mercure de France* in 1905, the following passages from Cézanne's letters (see Cézanne, 1978) are the only reflections about art that can be reliably attributed to him. However, many of the comments reported by the critics and painters close to him are in all likelihood either authentic or close approximations of his views. These have been anthologized in the volume *Conversations avec Cézanne,* edited by P. M. Doran (Paris, 1978).

<div align="right">F. C.</div>

"Chatter about art is almost useless"

"But I'm only a poor painter and without doubt it is rather the brush that heaven has placed in my hands. So it's not my affair to have ideas and develop them."

To Louis Aurenche
Aix-en-Provence, probably October 1901

"I have little to tell you; one talks about painting more, in effect, and perhaps better, by being at the motif than by devising purely speculative theories, which often lead one astray."

To Charles Camoin
Aix, January 28, 1902

"But I always come back to this: the painter should devote himself entirely to the study of nature and endeavor to produce pictures that are an education. Chatter about art is almost useless. . . . One is neither too scrupulous, nor too sincere, nor too submissive to nature; but one is more or less master of one's model, and above all of one's means of expression. To penetrate what's before one, and persevere in expressing oneself as logically as possible."

To Émile Bernard
Aix-en-Provence, May 26, 1904

"Will I reach the goal so long sought after?"

"I work obstinately, I glimpse the Promised Land. Will I be like the great leader of the Hebrews or will I be able to penetrate it? . . . I've made some progress. Why so late and so painfully! Is Art, then, a priesthood demanding pure beings who belong to it completely?"

To Ambroise Vollard
Aix-en-Provence, January 9, 1903

"You speak to me in your letter about my *réalisation* in art. I think I get closer to it every day, although a bit painfully. Because while a strong feeling for nature—and certainly mine is very keen—is the necessary basis of every artistic conception, and on which rest the grandeur and beauty of all future work, knowledge of the means of expressing our emotion is nonetheless essential, and is acquired only through very long experience."

To Louis Aurenche
Aix-en-Provence, January 25, 1904

"My age and my health will never allow me to realize the dream of art I've pursued my whole life. But I will always be grateful to the public of intelligent art-lovers who—through my hesitant efforts—have intuited what I wanted to attempt in order to renew my art. In my opinion one doesn't replace the past, one only adds a new link to it."

To Roger Marx
Aix-en-Provence, January 23, 1905

"The thesis to develop—whatever our temperament or form of power in the presence of nature—is to give the image of what we see, forgetting everything that appears in front of us. Which, I think, should permit the artist to give

all of his personality, large or small. . . . Now, [being] old, nearly seventy years, the color sensations that light gives are in me the cause of abstractions that do not permit me to cover my canvas, nor to pursue the delimitation of objects when the points of contact are tenuous, delicate; with the result that my image or picture is incomplete."

To Émile Bernard
Aix-en-Provence, October 23, 1905

"Finally, I'll tell you that, as a painter, I become more lucid in front of nature, but that realization of my sensations is always very painful. I cannot attain the intensity which unfolds to my senses, I don't have that magnificent richness of coloration which animates nature. Here, by the riverbank, the motifs multiply, the same subject seen from a different angle offers a subject for study of the greatest interest, and so varied that I think I could keep myself busy for months without shifting my position, inclining sometimes more to the right, sometimes more to the left."

To his son, Paul
Aix-en-Provence, September 8, 1906

"Will I reach the goal so long sought after, so long pursued? I hope so, but insofar as it's not attained, a vague state of uneasiness subsists that can disappear only after I've reached port, which is to say realized something which develops better than in the past. . . . You'll forgive me for repeatedly returning to the same point; but I believe in the logical development of what we see and feel through the study of nature, and concern myself with method only later; method being for us but the simple means by which we manage to make the public feel what we ourselves feel and so accept us. The great men we admire must have done just that."

To Émile Bernard
Aix-en-Provence, September 21, 1906

"Art is a harmony parallel to nature"

"Art is a harmony parallel to nature—what are we to think of imbeciles who say the artist is always inferior to nature?"

To Joachim Gasquet
Le Tholonet, September 26, 1897

"I proceed very slowly, the nature that presents itself to me [being] very complex; and there is always progess to be made. It's necessary to see one's model and feel on pitch; and what's more, express oneself with distinction and force. . . . Taste is the best judge. It is rare. Art never addresses itself to more than an extremely small number of individuals."

To Émile Bernard
Aix-en-Provence, May 12, 1904

"The Louvre is the book in which we learn to read. We should not, however, content ourselves with retaining the beautiful formulas of our illustrious predecessors. Let's take leave of them to study beautiful nature, let's undertake to disengage our minds from them, let's seek to express ourselves in accordance with our personal temperaments. Time and reflection, moreover, modify vision little by little, and finally comprehension comes to us."

To Émile Bernard
Aix-en-Provence, 1905

Some Reflections by Cézanne

"Allow me to repeat what I said to you here: treat nature by means of the cylinder, the sphere, the cone, with everything put in perspective so that each side of an object or a plane is directed toward a central point. Lines parallel to the horizon convey breadth, whether of a section of nature, or if you prefer, of the spectacle that the *Pater Omnipotens Aeterne Deus* spreads out before our eyes. Lines perpendicular to this horizon convey depth. Now nature, for us men, is more depth than surface, hence the need to introduce into our vibration of light, represented by reds and yellows, a sufficient amount of blue, to make the air palpable."

To Émile Bernard
Aix-en-Provence, April 15, 1904

"In an orange, an apple, a ball, a head, there's a culminating point; and this point is always—despite the tremendous effect: light and shadow, color sensations—closest to our eye; the edges of objects flee toward a center placed on our horizon. With a small temperament one can be quite a

painter. One can make some fine things without being much of a harmonist or a colorist. It's sufficient to have a feeling for art—and without doubt it's the horror of the bourgeois, this feeling."

To Émile Bernard
Aix-en-Provence, July 25, 1904

"Here's something that can't be disputed, I'm quite sure about this: an optical sensation is produced in our visual organ that makes us classify by light, half tones or quarter tones, the planes represented by color sensations. So light doesn't exist for the painter. As long as we're forced to go from black to white, the first of these abstractions being something like a point of support as much for the eye as for the brain, we flounder, we don't manage to attain mastery, to possess ourselves. During this period of time (I'm a bit repetitive of necessity), we go toward the admirable works the ages have transmitted to us, where we find comfort, support, like the plank gives the swimmer."

To Émile Bernard
Aix-en-Provence, December 23, 1904

Cézanne on Other Painters

"Michelangelo is a constructor, and Raphael an artist who, for all his greatness, is always bridled by the model. When he sets out to become 'reflective,' he falls short of his great rival."

To Charles Camoin
Aix-en-Provence, December 9, 1904

"Since you're in Paris, and the masters in the Louvre attract you, and if it appeals to you, make studies after the great decorative masters, Veronese and Rubens, but as you would after nature."

To Charles Camoin
Aix-en-Provence, February 3, 1902

"The greatest ones, you know who they are better than I: the Venetians and the Spaniards."

To Émile Bernard
Aix-en-Provence, July 25, 1904

"I've already told you, Redon's talent pleases me very much, and I share his feeling and admiration for Delacroix. I don't know if my precarious health will permit me to realize my dream of doing his apotheosis."

To Émile Bernard
Aix-en-Provence, May 12, 1904

"Study modifies our vision to such an extent that the humble and colossal Pissarro finds himself justified in his anarchist theories."

To Émile Bernard
Aix-en-Provence, 1905

"I scorn all living painters, except Monet and Renoir."

To Joachim Gasquet
Aix-en-Provence, July 8, 1902

Some Portraits of Cézanne

In the 1860s

"Those who knew Cézanne only in the last years of his life, when he was stricken by illness, cannot imagine him as he was at age thirty: a tall, solid man perched on rather slender legs. He walked with a rhythmic gait, holding his head upright as if he were looking at the horizon. His noble face, surrounded by a black curly beard, recalled the figures of the Assyrian gods. His large eyes, sparkling brilliantly and extremely mobile, presiding over a fine but slightly bent nose, tended to give his physiognomy an oriental character. He generally had a serious air, but when he spoke, his features grew animated, and he accompanied his words with expressive gestures, speaking in a strong, idiosyncratic voice with a marked Provençal accent adding a special flavor.

"He professed a profound disdain for his toilette; he was in no way preoccupied by his appearance. He was also rather negligent about his wardrobe. On his head he wore a small, soft cap pushed back; his somber clothing seemed never to have been new, and he wore it until it was almost threadbare. When painting, he donned a jacket and overalls of blue canvas like those worn by workers; whatever precautions he may have taken, his clothing was covered with large paint stains.

"In this period, Paul Cézanne enjoyed excellent health. If he was quick to anger, at least he wasn't suffering from the morbid irritability noted by the biographers of his final years.

"Since he was wary of the digressions to which his excitable temperament made him prone, Cézanne was not talkative, even in the small circle of his best friends. He remained silent until the moment when, spurred on by remarks made in his vicinity, unable to contain himself any longer, he launched into a sally or swore an oath to make his feelings known. In any case, when he did feel compelled to speak, he formulated his views with admirable logic and clarity. It goes without saying that it was always a question of art, and of painting above all. Ethics, philosophy, and literature rarely stirred him; he refrained from discussing them. As for politics, he deliberately ignored it and was astonished that it should be of any interest to his friend Zola. Neither the Salon jury's rejections nor the sarcastic remarks heaped upon him by the bourgeoisie could get Cézanne to take up a political cause, as Courbet had done and, to a lesser extent, Manet. It would have been easy for him to follow such a course, however, for he was already considered a revolutionary. In their hostility, the friends of order placed him on the same level as the famous group of "irreconcilables" of which Gambetta was the noisiest orator. It must be said that Cézanne's imprecations

against the jury, against the École and its professors, seemed to justify those who made him out to be a revolutionary when he was no more than an indignant rebel."

Georges Rivière, *Le Maître Paul Cézanne*
(Paris, 1923), pp. 76-78

"His physique is rather more handsome, his hair is long, his face exudes health, and his very dress creates a sensation on the Cours [Mirabeau, Aix-en-Provence]. So you can rest easy on that score. His morale, while always on the boil, allows him some moments of calm, and painting, encouraged by a few serious commissions, promises to reward his efforts, in a word, the 'sky of the future occasionally seems less dark.'"

Antoine Guillemet to Émile Zola,
November 2, 1866 (in Cézanne, 1978, p. 127)

Cézanne the "Impressionist"

"It might amuse you to know that Cézanne showed up not too long ago at the little café on the place Pigalle in one of his outfits from the old days: blue overalls, white toile jacket covered with brushstrokes and smears from other implements, old battered cap. He was a great success! But exhibitions of this kind are dangerous."

Louis-Edmond Duranty to Zola, [1877],
in Auriant, "Duranty et Zola,"
La Nef, no. 20 (July 1946), pp. 50-51

At Giverny, 1894

"The circle has been increased by a celebrity in the person of the first Impressionist, Monsieur Cézanne. . . . He is a friend of the Bohemian [Václav Radimsky], and of Monet. Monsieur Cézanne is from Provence, and is like the man from the Midi whom Daudet describes. When I first saw him I thought he looked like a cutthroat with large red eyeballs standing out from his head in a most ferocious manner, a rather fierce looking pointed beard, quite gray, and an excited way of talking that positively made the dishes rattle. I found later on that I had misjudged his appearance, for far from being fierce or a cutthroat, he has the gentlest nature possible, 'comme un enfant,' as he would say. His manners at first rather startled me, he scrapes his soup plate, then lifts it and pours the remaining

drops into the spoon; he even takes his chop in his fingers and pulls the meat from the bone. He eats with his knife and accompanies every gesture, every movement of his hand with that implement, which he grasps firmly when he commences the meal and never puts down until he leaves the table; yet in spite of the total disregard of the dictionary of manners he shows a politeness towards us which no other man here would have shown. He will not allow Louise to serve him before us in the usual order of succession at the table; he is even deferential to that stupid maid, and he pulls off the old tam-o'-shanter, which he wears to protect his bald head, when he enters the room. I am gradually learning that appearances are not to be relied upon over here."

Matilda Lewis (previously ascribed to Mary Cassatt),
from Giverny, to her family, [November 1894], typescript,
Yale University Art Gallery, New Haven, Connecticut

In Aix-en-Provence, 1897

"Suddenly the door opened. Someone entered with an almost exaggerated air of prudence and discretion. He had the appearance of a petit bourgeois or a well-to-do farmer, but also sly, ceremonious. He was slightly round-shouldered and had a tan complexion with patches of brick-red, a bald forehead with white hair falling in long strands, small piercing and prying eyes, a Bourbon nose, slightly red, a short droopy moustache, and a military goatee. This is the way I saw Paul Cézanne on his first visit, and this is the way I will always see him. I hear his manner of speaking, nasal, slow, meticulous, with something careful and caressing about it. I listen to him holding forth on art and nature, with subtlety, with dignity, with profundity."

Edmond Jaloux, *Fumées dans la campagne*
(in Gasquet, 1921, p. 60)

"He had the type, the accent, the comportment of a Provençal. In Provence as in the Orient, the feeling for castes is not very acute, nor the castes themselves a settled matter. Cézanne simultaneously had about him something of the petit bourgeois and something of the artisan, with a simple decency, dignity, and pride difficult to find in those classes. He combined peasant finesse with exaggeratedly polite manners. . . .

"I have the impression that all the previous portraits of Cézanne tend toward caricature. He always struck me as infinitely less eccentric, less of an 'outlaw,' than he is made out to be today. Or was he distrustful of the excesses of Parisians, and more particularly of dealers? I also think he has been misunderstood because he was, I repeat, essentially Provençal. Many unsophisticated remarks attributed to him should be understood as refined mockery that would have duped the listener. His simplicity was not naïveté. He was quite intelligent, admirably and painfully aware of what he was doing, and extremely cultivated. He

sought style all his life and knew perfectly well where it is to be found. Today there is a tendency to transform him into a savage, a barbarian of genius. He was the most classic, the most deliberate, the most poised of masters. And I always found that this was his own impression of himself.

"His conversation was admirable; he spoke almost exclusively of painting since it was all he thought about; he abounded in large, rich, savory turns of phrase and in technical insights that were unexpected, clever, ingenious.

"I can also hear him exclaiming in the rue Cardinale, between the fountain of the four dolphins and the church of Saint-Jean-de-Malte:

'An artist, you see, neither glory nor ambition counts for him. He should do his work because the Good Father wills it, like an almond-tree makes its flowers (there was a second comparison here that I've forgotten), like a snail makes its slime.'"

Edmond Jaloux, "Souvenirs sur Paul Cézanne," *L'Amour de l'art,*
December 1920, pp. 285-86

Autumn 1900

"I can still see myself ringing his doorbell the first Sunday he had invited me to lunch.

—'Come early,' he'd said to me, 'we'll talk art a bit, and note well the address: 23, rue Boulegon.'

"I arrived too early. The old painter, who was preparing to don his good clothes, was in his night-shirt. . . .

"I waited for him in the dining room, where his housekeeper, Mme Brémond, had already laid two places at the table.

"Ah! Father Cézanne was scarcely partial to knick-knacks; he had never dreamed of affecting the genus 'artist,' of fashioning for himself one of those painter's interiors that were all the rage around 1880. Despite his fortune, he possessed only what was required by a single man his age living alone, who takes a modest meal between two sessions of work and who, after his lunch, doesn't tarry to smoke oriental cigarettes while sipping Turkish coffee. There were a few cane-bottomed chairs, a round table of polished walnut, a buffet decorated with a liter beaker and a plate of fruit.

"He avowed to me at once that he was a weakling, that he never realized anything, that I struck him as very poised, and that I should come often, for I would give him moral support.

"I didn't know what to make of this, and the old man said to me with a dejected air:—'It's terrifying, this life!'

"The chicken with olives and little mushrooms cooked by Mme Brémond was excellent."

Léo Larguier, *En compagnie des vieux peintres* (Paris, 1927),
pp. 158-59

21

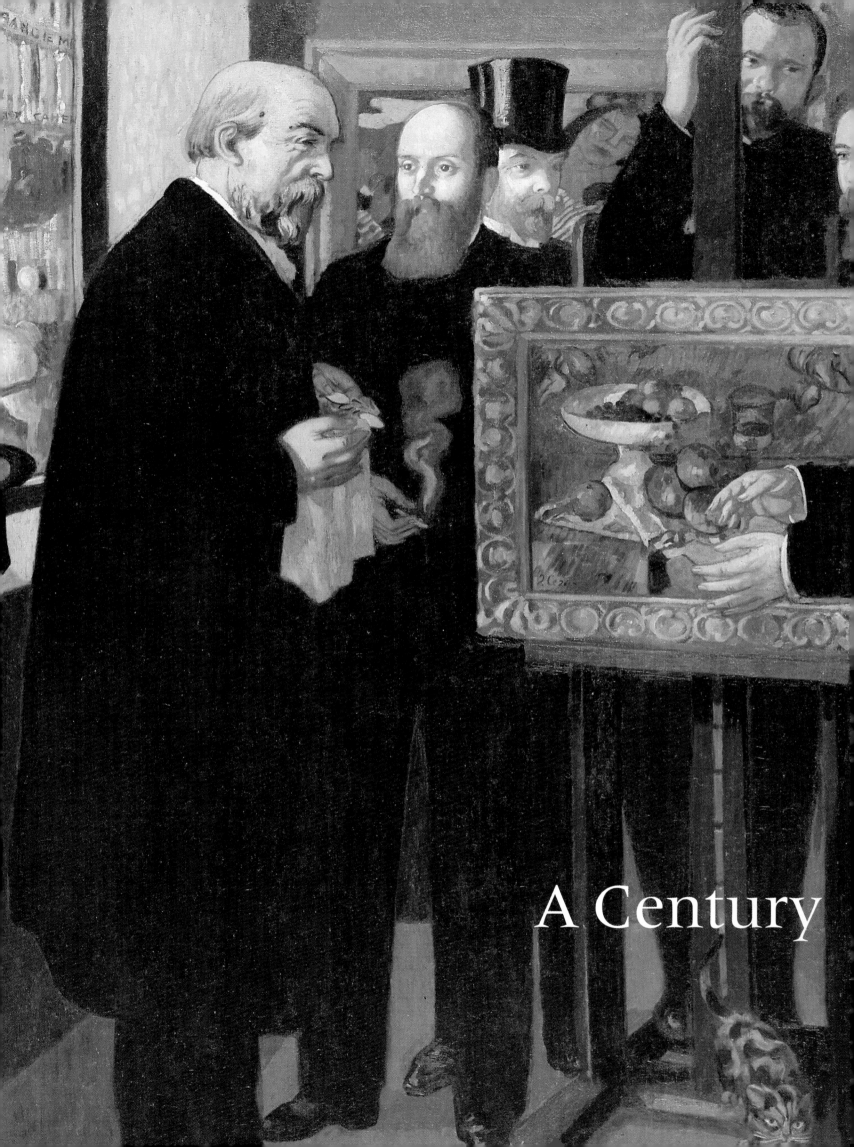

A Century

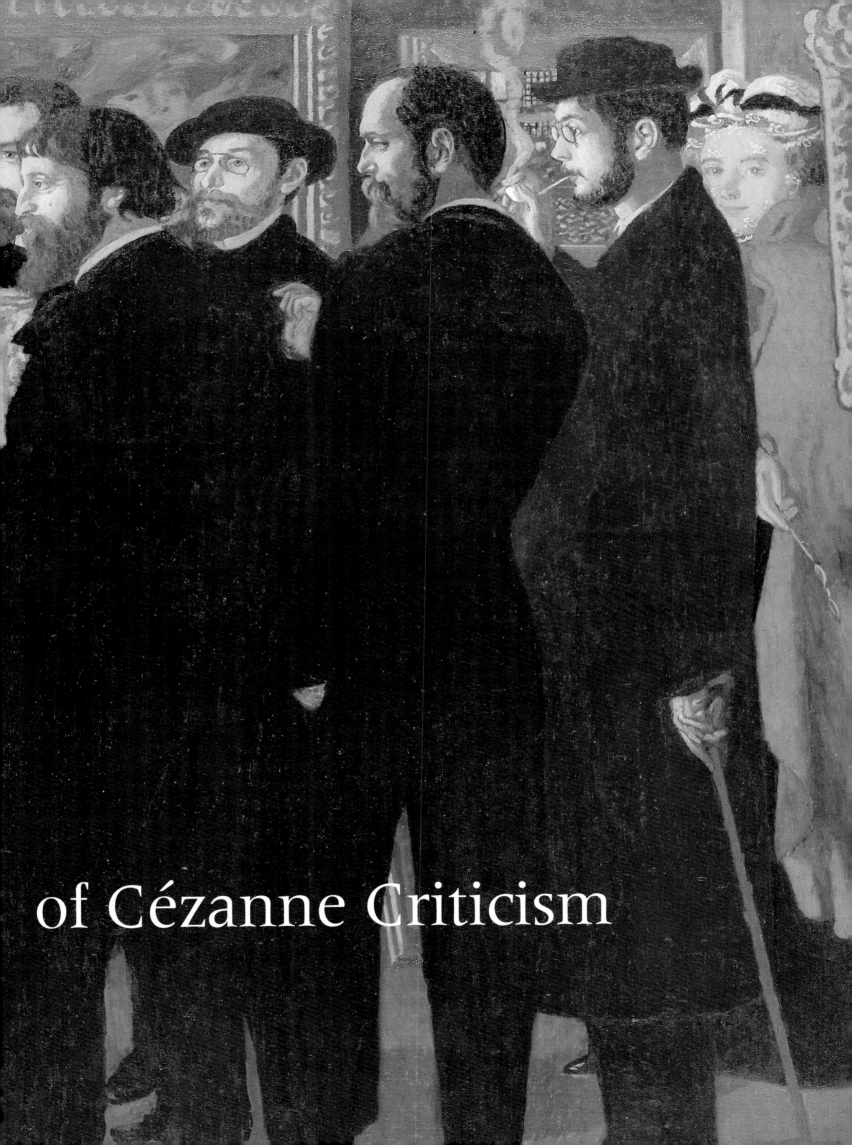

of Cézanne Criticism

A Century of Cézanne Criticism
I: From 1865 to 1906

The 1860s

The First Published References to Cézanne

The intense fraternal bond between the two young men from Aix who "went up to Paris"—Émile Zola in 1858, Paul Cézanne in 1861—has been examined more than once, above all by John Rewald.[1] The documents clearly indicate the durability of their alliance, despite the fact that the writer-critic became famous long before the painter had emerged from obscurity. Zola was generous with encouragement as well as with much-needed financial assistance (notably in 1878), but support from Zola in his guise as an 1860s critical eminence was not forthcoming, and there is reason to believe that he already regarded his friend's art in a way consistent with his novel *L'Oeuvre*, published in 1886, whose protagonist is a failed painter with unmistakable similarities to Cézanne. There is nothing surprising in the subsequent break between them, effected by a brief, formal note from Cézanne thanking him for having sent the book.[2]

In any case, it was Zola who first mentioned Cézanne in print, in his novel *La Confession de Claude*, which bears a dedication at the head of the preface, dated October 15, 1865, that reads: "to my friends P. Cézanne and J.-B. Baille." The juxtaposition of these two names is a clear indication that Zola regarded Cézanne, like Baille,[3] primarily as a childhood friend.

The following year, in the preface to *Mon Salon*,[4] a collection of newspaper articles in which he defended Manet brilliantly while berating academic art, he affectionately addressed not the artist but the fellow-traveler and companion—and, in truth, wrote not so much about his painter friend as about himself:

> I feel a profound joy, my friend, talking intimately with you. You wouldn't believe how much I suffered during the quarrel I've just had with the crowd, with unknowns; I felt so little understood, I sensed such hatred around me that discouragement often led me to let the pen drop from my hand.
>
> Today I can give myself over to the voluptuous intimacy of one of those good conversations we've been having together for ten years. It is for you alone that I write these few pages. I know that you will read them with your heart, and that tomorrow you'll love me with greater affection. . . .

> We have been talking together about art and literature for ten years. We often lived together—Do you remember?—and frequently the dawn caught us still conversing, digging into the past, questioning the present, trying to find the truth and devise a religion for ourselves that was infallible and complete. We worked over frightful heaps of ideas, we examined and rejected all systems, and after such hard labor we agreed that aside from the powerful individual life all is lies and stupidity. . . .
>
> You are the whole of my youth; I find you in all my joy, in all my suffering. . . .
>
> We lived within our own shadows, isolated, unsociable, taking pleasure in our ideas. We were lost in the midst of the complacent fickle crowd. We sought out the man in everything, we wanted to find in each work, painting, or poem a personal accent. We affirmed that the masters, the geniuses, are creatures who, each one, created a world from scratch, and we rejected the disciples, the sterile, those who make it their business to steal here and there a few scraps of originality.
>
> Do you realize we were revolutionaries without knowing it? Only now can I say outright what we've been saying to each other for ten years. . . .
>
> You painters are a much more irritable lot than us writers. I've been frank about mediocre and bad books, and the literary world has accepted my judgments without taking too much offense. But artists are thinner-skinned. I haven't been able to put my finger on them without inducing cries of pain. (Émile Zola, *Mon Salon*, Paris, 1866)[5]

The following year, Zola briefly came to Cézanne's defense in his review of the Salon, characterizing him as "a young painter whose vigorous and personal talent I hold in singular esteem." (Zola, *Le Figaro*, April 12, 1867)

The 1870s and 1880s

There was a seven-year interval between these texts by Zola and the next references to Cézanne in the press, which appeared in the context of the scathing jibes and criticisms directed against the Impressionist exhibition of 1874, the first one, and that of 1877, the third in the series and the last in which Cézanne took part.[6] A selection follows.

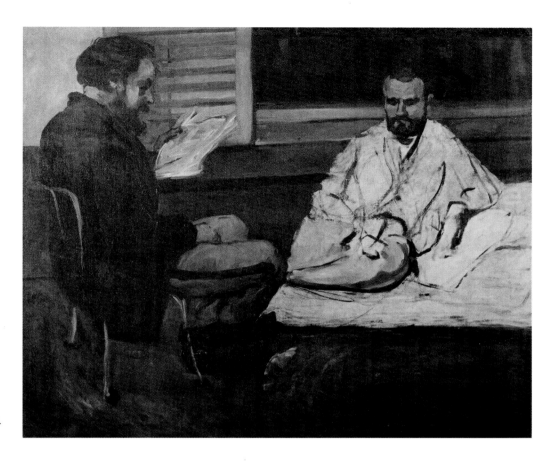

Paul Cézanne,
Paul Alexis Reading to Émile Zola,
c. 1869-70, oil on canvas,
Museu de Arte de São Paulo, Brazil.
Chateaubriand Collection (V. 117).

"Cézanne Is an Ignorant Dauber"

As for others who, neglecting to reflect and learn, would pursue the impression to the bitter end, the example of M. Cézanne *(A Modern Olympia)* is at hand to show what awaits them. [Proceeding] from idealization to idealization, they will end up at this same degree of unbridled romanticism, in which nature is no longer anything but a pretext for reverie, and in which the imagination becomes powerless to formulate anything but personal, subjective fantasies, without echo in the general reason because they are uncontrolled and impossible to verify in reality. (Jules-Antoine Castagnary, "Exposition du boulevard des Capucines, Les Impressionnistes," *Le Siècle,* April 29, 1874)

M. Cézanne exhibits a strange landscape, which demonstrates that he has been violently *impressed [impressionnisé]* by two things: spinach and cobbling.

1. Rewald, 1936; and Rewald, 1939.
2. Cézanne to Zola, April 4, 1886, in Cézanne, 1978, p. 225. See Chronology, April 4, l886.
3. Jean-Baptistin Baille, who had been a friend of Cézanne and Zola at the Collège Bourbon since 1852.
4. See Zola, 1974, pp. 59ff.
5. Reprinted in *Mes Haines* (Paris, 1879).
6. Cézanne exhibited sixteen paintings, Sisley seventeen, Degas twenty-five, and Monet thirty.

Its green makes one shudder, and a clump of trees that's in the foreground seems exactly like a row of boots cringing in horrible pain. We'll also mention a *Head of a Man,* which looks like Billoir [an infamous murderer] made of chocolate. (Anonymous, "L'Exposition des impressionnistes," *L'Événement,* April 6, 1877)

MM. Claude Monet and Cézanne, delighted to take part, have exhibited; the first, thirty canvases, and the second, fourteen. One must see them to imagine what they're like. They provoke laughter yet they're pitiable: they reveal the most profound ignorance of drawing, of composition, of coloring. (Roger Ballu, "L'Exposition des peintres impressionnistes," *La Chronique des arts et de la curiosité,* April 23, 1877)

A real Impressionist, this M. Paul Cézanne. He sent to the rue Le Peletier a series of paintings each more stupefying than the last. We took most notice of a *Head of a Man,* deliberately odd

M. Cézanne, above this portrait, exhibits some *Bathers* the color of soot. It seems this is a preliminary version—of a work the artist would do well not to execute. (Anonymous [G. Lafenestre], "Le Jour et la nuit," *Le Moniteur universel,* April 8, 1877)

One who'll never be corrected, for example, is M. Cézanne. M. Cézanne can brave all his colleagues,

no one's his equal. He has reached the extreme limit of intransigence. Pale tints couldn't go any farther, nor will he. Others love yellow, pink, and violet; M. Cézanne has a taste for blue and green. He sees green, he sees blue, and he doesn't depart from them. . . . But one simply has to look at two watercolors (nos. 30 and 31), entitled *Impressions after Nature*, to grasp just how far one can go in the direction of artistic insanity. (Charles Bigot, "Causerie artistique, L'Exposition des 'Impressionnistes,'" *La Revue politique et littéraire*, April 28, 1877)

First Signs of Interest

Nevertheless, the singular Cézanne "legend" was beginning to emerge, along with a few defenders. In 1874 he was hailed solely as a martyr of the Salon jury:

> Shall we speak of M. Cézanne, who, moreover, has his own legend? Of all known juries, none has ever, even in its wildest dreams, considered the possibility of accepting a picture by this painter, who presented himself at the Salon carrying his canvases on his back like Jesus Christ his cross. Up to the present, an overly exclusive love of yellow has compromised the future of M. Cézanne. Nonetheless, the jury has been wrong, being the jury. (Jean Prouvaire, "L'Exposition du boulevard des Capucines," *Le Rappel*, April 20, 1874)

Three years later Georges Rivière, a peripheral member of the Impressionist circle (writing in a magazine published by his patron, Georges Charpentier, and edited by Renoir's brother), penned the first, somewhat clumsy attempt to defend him:

> Others laughed in front of the *Bathers* and the portrait of a man by M. Cézanne. Let them question a few painters and they'll regret their laughter. (Georges Rivière, "À M. le Rédacteur du *Figaro*," *L'Impressionniste*, April 6, 1877)

> The artist most attacked and maligned by press and public alike over the last fifteen years is M. Cézanne. . . .
>
> M. Cézanne is a painter and a great painter. Those who've never held a brush or a pencil have said he doesn't know how to draw, and they've reproached him for *imperfections* that are nothing other than refinements procured through immense skill.
>
> I know well that, despite everything, M. Cézanne cannot have success like that obtained by fashionable painters. Between the *Bathers* and the little soldiers in cheap Épinal prints, there's no choice, it's the little soldiers that people go for. . . .
>
> However, M. Cézanne's painting has the inexpressible charm of biblical and Greek antiquity, the movements of the figures are simple and grand like

those of ancient sculpture, the landscapes have an imposing majesty, and his still lifes, so beautiful, so precise in their tonal relations, have a certain solemnity in their truth. All the artist's pictures are moving because he himself experiences a violent emotion before nature that skill transfers to the canvas.

One of my friends writes me:[7] "It is truly remarkable that the same society that looks without laughing at the pretentious efforts of a puerile archaeology, that duly admires both mutilated masterpieces from the Louvre to the Campana museum and the first tentative steps of an art in its infancy, that bids fantastic sums for the efforts of minor Renaissance potters, that this society, I say, comes to laugh at a living person before it knows whether this living person is a man of genius. . . ."

"I don't know," added the same friend about the *Bathers*, "I don't know what qualities might be added to this picture to render it more moving, more passionate, and I seek in vain the faults for which it is reproached. The painter of the *Bathers* belongs to a race of giants. Since he is without compare, it is deemed convenient to repudiate him; but he should be likened to some of the respected names of art, and if the present fails to do him justice, the future will class him among his peers beside the demigods of art." (Georges Rivière, "L'Exposition des impressionnistes," *L'Impressionniste*, April 14, 1877)

"They Are All Precursors"

In 1880, when Cézanne was absent from both the Salon and the Impressionist exhibition, Zola wrote a few lines in a Marseille newspaper, for his Southern compatriots, in which serious reservations and praise were co-mingled. Even though Zola, commenting on the Impressionists generally, evoked his friend in equivocal terms, the artist thanked him, for he was rarely mentioned in the press.[8]

> M. Paul Cézanne, a great painter's temperament still floundering in a search for the right facture, remains closer to Courbet and Delacroix. . . .
>
> The truly unfortunate thing is that not one artist in this group has powerfully, definitively realized the formula that they all adduce in their works. The formula is there, infinitely divided; but nowhere, not in any of them, does one find it applied by a master. They are all precursors, the man of genius has not yet been born. (Émile Zola, "Le Naturalisme au Salon," *Le Voltaire*, June 18, 1880)

7. Pissarro could be the friend in question, but an even more likely candidate is Renoir, who was close to the author.
8. Cézanne to Zola, June 19, 1880, in Cézanne 1978, p. 192.
9. Republished in *Certains* (Paris, 1889), and again in *La Plume*, September 1, 1891.

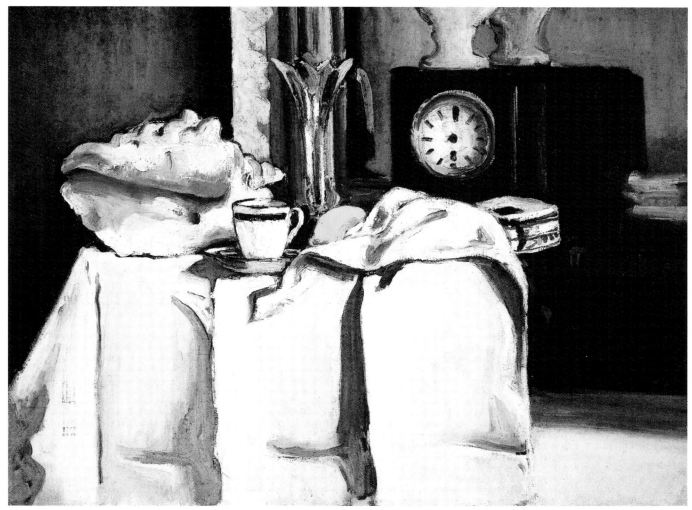

Paul Cézanne, *The Black Clock*,
c. 1870, oil on canvas,
private collection (V. 69).

"The Premonitory Symptoms of a New Art"

The first truly notable article about Cézanne—who was, remarkably, already considered "forgotten" in 1888—is by Joris-Karl Huysmans. Cézanne was forty-nine when it appeared.

> In bright light, in porcelain compotiers or on white napkins, pears and apples that are brutal, rugged, built up with a trowel, abruptly rubbed with the thumb. Nearby, a furious pugging of vermilion and yellow, of green and blue somewhat apart, ripe fruit intended for the windows of Chevet's, fruit that's plethoric and savory, enviable.
>
> And hitherto-bypassed truths become discernible, tones that are strange yet real, blots of a singular authenticity, nuances of linen, vassal-like shadows strewn along the turning edges of the fruit and scattered with possible, charming bluish tones that make these canvases works of initiation, when one compares them to customary still lifes set off by bitumen, against unintelligible backgrounds.

> Then some oil sketches of *plein-air* landscapes, efforts still in limbo, attempts at freshness spoiled by retouching, and, finally, baffling imbalances: houses tilted to one side as if drunk, skewed fruit in besotted pottery, nude bathers defined by lines that are demented but throbbing—to the greater glory of the eye—with the ardor of a Delacroix without refinement and without delicacy of touch, whipped into a fever of botched colors, shrieking in relief, on canvas so loaded it sags!
>
> In short, a revelatory colorist who contributed more than the late Manet to the Impressionist movement, an artist with diseased retinas who, in his exasperated visual perceptions, discovered the premonitory symptoms of a new art, so might we sum up this too-neglected painter, Cézanne.
>
> He has not exhibited since the year 1877, when, in the rue Le Peletier, he showed sixteen canvases whose perfect artistic probity long kept the crowd amused. (Joris-Karl Huysmans, "Trois peintres," *La Cravache*, August 4, 1888)[9]

A Painter's Painter

As it happens, Huysmans had been prompted to write about Cézanne by Degas and Pissarro. As early as 1883, after the publication of his volume of art criticism, *L'Art moderne*, he had been reproved by the latter, who was possessed of a remarkable eye that led him to appreciate the genius of Cézanne, Gauguin, and Seurat before all other painters.

> How is it you say not a word about Cézanne, whom not one among us would fail to acknowledge as one of the most astounding and curious temperaments of our time and who has had a very great influence on modern art? (Pissarro to Huysmans, May 15, 1883, in Pissarro, 1980-91, vol. 1, no. 149, p. 208)

The phrase "not one among us" is revealing. Cézanne was a painter's painter, and to a considerable extent he was to remain one.

Antoine Guillemet, a friend of Manet's (he appears in *The Balcony*) whose work had been accepted by the Salon jury, was among the first to try to win Cézanne access to it. The landscapist Daubigny did likewise. As for Manet, we know that he became interested in his work as early as 1866, and that "this gave Cézanne great joy." Antony Valabrègue, Cézanne's childhood friend who reported this information in a letter of April 1866, added that the two artists were "parallel temperaments, they will surely understand one another."[10] To our eyes the differences between them seem more obvious, but in any case they both held back a bit from full commitment to the Impressionist cause: Manet never exhibited at any of the group's exhibitions, Cézanne ceased doing so after participating in the first and the third, and both of them regularly submitted work to "Bouguereau's Salon," as Cézanne dubbed the official exhibitions.

But it was Pissarro who was Cézanne's most consistent supporter from 1861 onward: "Pissarro was a father to me. He was a wise counselor and something like God Almighty," Cézanne asserted.[11] They worked together quite closely from 1872 to 1874 in Pontoise and in 1877 in Pontoise and Auvers. As soon as it became feasible, Pissarro bought paintings by him, as he had previously advised several collectors to do, Comte Doria among them.

Renoir, whose art is so different from Cézanne's, was on very close terms with him; the two painters worked together at L'Estaque, and Renoir was a faithful supporter. It was he who, beginning in 1875, encouraged Victor Chocquet to acquire three of his paintings, and who also encouraged the young dealer to take up Cézanne (despite Vollard's claims of having "discovered" him), a decision that resulted in the artist's first one-man exhibition in 1895. Jean Renoir reported that his father once remarked that the "artistic value" of Cézanne's work was "unequaled since the end of Roman art."[12]

Monet and Cézanne always greatly admired each other's work, and Monet constantly sought to assist him (see cat. no. 172). He was also one of the most important of Cézanne's artist-collectors during the artist's life, acquir-

ing before 1906 twelve paintings of various kinds, including *The Negro Scipion* (cat. no. 11), a landscape of L'Estaque, and a still life with apples.[13] It is noteworthy that even before Cézanne's death, artists were important collectors of his work. By 1906 Pissarro owned fourteen paintings, Matisse four, Renoir three, Denis two, and Ker-Xavier Roussel, Félix Vallotton, Paul Signac, and Max Liebermann each owned one. As for Degas, he acquired no fewer than seven paintings by Cézanne, whose work had always greatly interested him: during the third Impressionist exhibition he sketched his *Bathers at Rest*, a painting bequeathed by Gustave Caillebotte to the French State but refused by it and now in the Barnes Foundation, Merion, Pennsylvania (p. 279, fig. 1). The generous Caillebotte owned many Cézannes, four of which figured in his original bequest list (see Chronology, February 21, 1894). Odilon Redon was also an admirer of Cézanne (see cat. no. 187).

The generation immediately following that of the Impressionists was genuinely devoted to Cézanne—especially Gauguin, whose enthusiasm from the 1880s was probably spurred by his "master," Pissarro. In July 1883, when he was a small-scale investor-collector and only an amateur painter, Gauguin bought two canvases that he never wanted to surrender, even in moments of serious financial difficulty. "It's the apple of my eye, and except in case of dire necessity, I'll keep it until my last shirt's gone."[14] He proclaimed his admiration by introducing another painting by Cézanne into one of his own.[15] For him, as for all young avant-garde painters of the 1880s and 1890s, Cézanne was both an exemplary artistic modernist, a figure who pointed beyond Impressionism, and a personification of the independence and wisdom it was proper for a great artist to possess.

> Behold Cézanne the misunderstood, the essentially mystical nature of the Orient (his face resembles an old man from the Levant), he cherishes in forms a mystery and a heavy tranquillity like a man reclining to dream, his color is grave like the character of Orientals; a man of the Midi, he spends entire days on mountaintops reading Virgil and looking at the sky, also his horizons are high his blues very intense and the red he uses has an astonishing vibration. Like Virgil who has several meanings and can be interpreted at will, the literature of his paintings has a parabolic meaning with two aims; his foundations are as imaginative as they are real. To sum up, when one sees a painting by him one cries out to oneself, Strange but it's madness—Separate mystic

10. Passage in a letter from Valabrègue cited in another letter from Marion to Morstatt, April 12, 1866, in Barr, 1938, no. 5, p. 223. See Chronology, April 1866.
11. Cézanne, interview with Jules Borély, July 1902, in Borély, "Cézanne à Aix," *L'Art Vivant*, no. 2 (1926). Reprinted in Doran, 1978, p. 21.
12. See Renoir, 1981, pp. 336-39.
13. See Vauxcelles, December 1905; for additional works acquired after 1906, see "Cézanne's Collectors: From Zola to Annenberg."
14. Gauguin to Émile Schuffenecker, early June 1888, in Gauguin, 1984, vol. 1, no. 47, p. 182.
15. *Portrait of a Woman, with Still Life by Cézanne*, 1890, The Art Institute of Chicago.

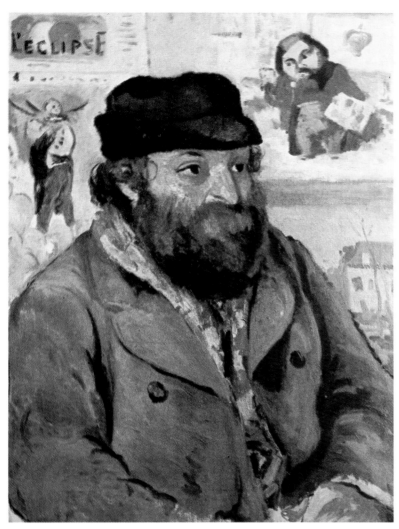

Camille Pissarro, *Portrait of Cézanne*,
c. 1874, oil on canvas,
private collection.

writing, *drawing* of same. (Gauguin to Émile
Schuffenecker, January 14, 1885, in Gauguin, 1984,
no. 65, p. 88)

Among the future Neo-Impressionists, Seurat does not
seem to have been particularly drawn to the work of the
hermit from Aix. Signac, in contrast, acquired his first
painting from père Tanguy at age twenty-one, in November
1884 (see cat. no. 67).

"The Place We Went to See the Cézannes"

A mere three years later, other young artists in Gauguin's
circle were visibly fascinated by Cézanne, as Émile Bernard
made clear in his account of the 1880s:

> In 1887 we were perfecting cloisonnisme under the
> influence of Paul Cézanne, we had encountered real
> painting. Anquetin harked back to the great mas-
> ters. I remained faithful to Cézanne. . . .
> The place we went to see the Cézannes was on
> the rue Clauzel (the so-called Pont-Aven school

would be better called the rue Clauzel school), it
was run by an old Breton paint merchant; he called
himself Julien Tanguy, or more familiarly père Tan-
guy (his goodness toward the young was indeed pa-
ternal). This modest shop had considerable
influence on the present generation.
> Summoned to help out the old Armorican, I
> painted his shop a pure blue to distinguish it from
> his neighbors. It was in his dark den that, over a
> twenty-year period, the Cézannes burned with a
> contained fire, and all the artists and art-lovers in
> Paris went to see them. To draw up the list of his
> visitors would be to write the history of current art.
> It is there that I became acquainted with Van Gogh,
> who had asked to meet me, and with Maurice
> Denis. (Émile Bernard, "Notes sur l'École de Pont-
> Aven," *Mercure de France*, November 1903)

The Years 1890 to 1895

"Painting for Its Own Sake"

It was, in fact, Émile Bernard who, in 1891, wrote the first
long text devoted to Cézanne, although it was largely in-
spired by Gauguin's observations and ideas:

> In Provence. A romantic youth with poetry, high-
> flown walks with Zola, his high-school friend; Hugo
> and Musset declaimed to the foliage along the banks
> of the Arc; arrival in Paris full of enthusiasm, noc-
> turnal conversations at the feet of the great city—
> which they dreamed of conquering—beneath the
> stars. Then a bit of poverty due to a prosperous but
> disapproving family; marriage; failure with both
> public and impotent artists, a paroxysm of theories
> (his most inspired period), and finally seclusion and
> the absolute
> The friends: Pissarro, Guillaumin, Monet, Zola,
> Bail [*sic*] went their ways, have had their share of
> glory, known the joy of just rewards. He, unknown,
> or rather misunderstood, loved art to the point of
> renouncing notoriety gained through friendships
> and coteries. Not contemptuous but obstinate, he
> refused to be forthcoming about his efforts. . . .
> How astonishing for us then, last year, his submis-
> sions to Les XX in Brussels: he was no better under-
> stood than twenty years ago; not even honored
> with a discussion! He was mentioned, nothing
> more.
> Yet what pages: these female nudes in a strange
> blurry decor, their elegance more suggestive of six-
> teenth-century Dianas than anything else, these
> southern landscapes with a new kind of solidity.
> Style. Tone. — Painter above all and yet a
> thinker, grave as well, he opens that surprising door
> for art: painting for its own sake. . . .

There are three distinct manners: the arrival in Paris, the light period, the solemn period.

The last manner is scarcely more than a return to the first one, but through nascent color theory and unexpected, deeply personal insights about style. In no way, however, are the first works of lesser interest than the last. They grab hold through a precocious power; they grab hold despite frequent reminders of Delacroix, Manet, Courbet, Corot, Daumier.

The light period was his most unfortunate; what's more, he was in difficult straits. He had met Monet, who dreamed only of sun and light, and he succumbed in his turn to the charms of a light palette, but little by little he recovered his composure and ponderation, and he returned to his point of departure more complete and more skillful.

With solid surfaces treated in strokes lightly applied from right to left, the works in the last manner vouchsafe an art that is new, strange, unknown. Pondered lighting slips mysteriously into half-lights that are *transparent solids*; an architectural gravity presides over the disposition of lines, sometimes the thick handling is reminiscent of sculpture. . . .

Uniquely pictorial, at first encounter this canvas [*The Temptation of Saint Anthony*] could easily be mistaken for what is commonly called a "crude daub," for it really seems nothing more than a thick sludge of paint; thus it would appear, at least, to inexperienced eyes (exoteric ones). But if we tarry to reckon its qualities—the tone, the grace, and the *undefinable something* that suggests the brain of an artist more than a fantastic representation brushed in or described in the usual way—we avow that there's a power of originality here, of ever-striving technique, seldom encountered in works shown us by the generation that's currently known. And that makes me think of the view Paul Gauguin expressed one day in my presence: Nothing resembles a *daub* as much as a masterpiece. A view that, for my part, I find cruelly truthful here.

Paul Cézanne was born in Aix-en-Provence. He is fifty years old. (Émile Bernard, "Paul Cézanne," *Les Hommes d'aujourd'hui*, 1891)

"Precursor of Another Art"

In the 1890s, before being widely recognized and celebrated, the unknown Cézanne was already regarded in avant-garde circles as a forefather, as a crucial point of reference. The Brussels critic reviewing the exhibition of modern painting mounted by Les XX (Les Vingt) saw Cézanne as "the rough painter whose art seems to occupy an intermediary position between Courbet and the Impressionists."[16]

Such a view made it possible for every modernist tendency to claim him as its godfather. We have seen how Bernard endorsed the "Gauguin view" by denigrating Cézanne's most Impressionist period, the 1870s, in favor of

earlier and much later canvases. Georges Lecomte, a friend of the Neo-Impressionists, took exception to the fact that the new school that was centered around Gauguin—what might be termed the Pont-Aven or Symbolist school—saw Cézanne exclusively as a tutelary figure, as a protector of their own views. Lecomte considered this a fundamental misunderstanding, an "appropriation" benefiting only one strain of what would later be known as Post-Impressionism: Bernard insisted on style and the "undefinable," while the Neo-Impressionists emphasized technical innovation and experiments with color.

> It is above all M. Cézanne who was one of the first annunciators of the new tendencies and whose effort exercised a notable influence on the Impressionist evolution; his sober craft, his syntheses, and his color simplifications, so surprising in a period particularly smitten with reality and analysis, his oft-reproached values, very soft, whose skilled play creates subtle and impeccable harmonies, contain and reveal the entire contemporary movement; they were a valuable education for all. (Georges Lecomte, "L'Art contemporain," *La Revue indépendante*, April 1892)

A year later, the well-known critic Gustave Geffroy published a long article on Impressionism in *La Revue encyclopédique* that was the first to place Cézanne in historical perspective. After examining all the painters in the group one by one, he noted:

> To be absolutely complete, these six studies[17] must be complemented by some words about Cézanne, who was a sort of precursor of another art. (Gustave Geffroy, "L'Impressionnisme," *La Revue encyclopédique*, December 15, 1893)

A few years later, Paul Signac, in his defense of the Seurat school, went even further:

> Cézanne, by juxtaposing in squared and distinct strokes, without concern for either imitation or resolution [*adresse*], the various elements of decomposed tints, was closer to the methodical *division* of the Neo-Impressionists. (Paul Signac, "Les Techniques impressionniste et néo-impressionniste," *La Revue blanche*, May 15, 1898)

"The Demon of Art"

Geffroy, a friend of both Monet and Rodin, then wrote an article (subsequently published in a book) treating both the man and the painter in which he made an honest but rather uninspired attempt to analyze the essence of Cézanne's art. Cézanne, touched by this, expressed his

16. Anonymous, January 27, 1890.
17. Geffroy's other subjects were Monet, Pissarro, Renoir, Manet, Degas, and Raffaëlli.

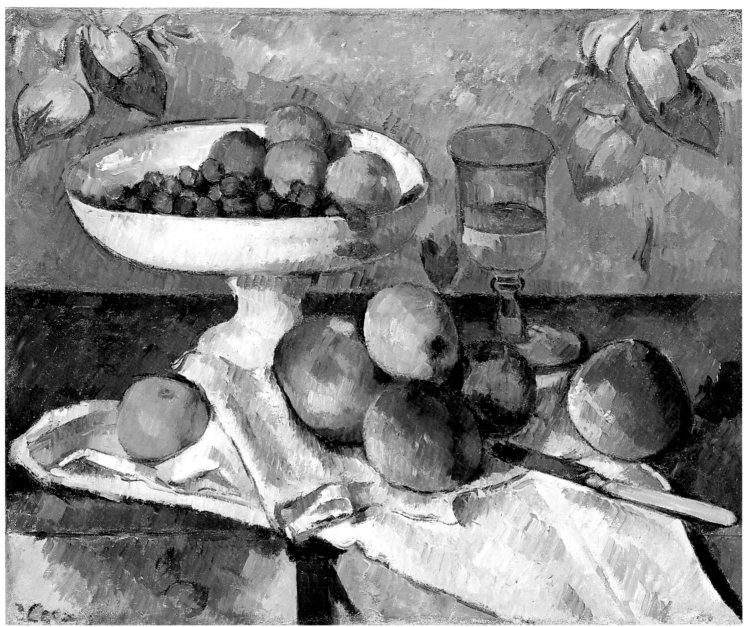

Paul Cézanne, *Compotier, Glass, and Apples (Still Life with Compotier)*,
1880, oil on canvas, private collection (V. 341).
This painting belonged to Paul Gauguin and was used as the central motif by
Maurice Denis in his *Homage to Cézanne* (repro. pp. 22-23).

thanks, became acquainted with him, and painted his portrait (see cat. no. 172).

> For some time now Paul Cézanne has had a singular artistic destiny. . . . From the paucity of information about his biography, the quasi-secrecy of his production, and the scarcity of his canvases, which seemed resistant to all accepted laws of publicity, there resulted a bizarre kind of renown, distant before the fact; his person and his œuvre were enveloped in mystery. Those in quest of the unfamiliar, who love to discover things not previously seen, spoke of Cézanne's canvases with knowing airs, furnished information as though they were trading passwords. . . . What did his canvases look like? Where could one see them? The reply came: there's a portrait at Zola's, two trees at Théodore Duret's, four apples at Paul Alexis's, and then the week before a canvas had been seen at père Tanguy's, the paint merchant on the rue Clauzel, but one had to hurry, for with Cézannes there were always collectors ready to pounce on these prizes so few and far between. . . .
>
> Since then, Cézanne's reputation has gained strength, has visibly gained stature in artistic circles. The Symbolists have claimed Cézanne as a kind of precursor, and it is quite certain that there's a direct link, a clearly established connection, between

Cézanne's painting and that of Gauguin, Émile Bernard, etc. Likewise the art of Vincent van Gogh. From this perspective alone, the name Paul Cézanne deserves the place accorded it. . . .

Then there are the accounts, so clear-cut, of those who were Cézanne's comrades, his painter friends, those who were in the fields with him, Renoir, Monet, Pissarro, witnesses to his labor, those who saw him, like themselves, intent on the search for truth, on its realization in art. . . . That's what he liked, and that's all he liked. He forgot everything but that, staying for hours and hours, days and days in front of the same spectacle, intent on penetrating it, expressing it, obstinate, striving, tenacious, like the shepherds who, in the solitude of the fields, found the beginnings of art, of astronomy, of poetry. . . .

Any canvas by Cézanne, however simple and serene of aspect, is the result of intense struggle, of feverish work and six months' patience. It was an unforgettable spectacle, Renoir told me: Cézanne positioned at his easel, painting, looking at the countryside—truly alone in the world, ardent, concentrated, attentive, respectful. He returned the next day, and every day, accumulated his efforts, and sometimes also went off in despair, returning without his canvas, having left it behind on a rock or in the grass, exposed to the wind, rain, and sun, absorbed by the ground, its painted landscape reclaimed by the nature surrounding it.

One wouldn't know what Cézanne's works say out loud, the tension toward the real affirmed by them, this patience, this temporal protraction, this upright artist's nature, this conscience so difficult to satisfy. It is perfectly obvious that the painter is often incomplete, that he hasn't managed to overcome difficulties, that the obstacles to realization are there for all to see. It's rather, and without method, the touching research of the Primitives. . . .

But these remarks do not apply to all of Cézanne's canvases. He has laid out and given material form to some infinitely expressive pages. He sometimes deploys beautiful, animated skies, white and blue, in a limpid ether he draws up the peak of his beloved Sainte-Victoire, the upright trees that surround his Provençal residence, the Jas de Bouffan, hillocks [un mamelonnement] of colored and gilded foliage in the environs of Aix, the heavy coastal inlet of a rocky bay where the landscape is crushed beneath the hot atmosphere.

One no longer notices the arbitrary distributions of light and shade, formerly so surprising. One is in the presence of an integrated painting that seems a single whole and that was executed slowly, in thin coats, that finally has become compact, dense, velvety. The earth is solid, the carpet of grass thick with that green shot through with blues so typical of Cézanne, which he distributes in apt patches through masses of foliage, spread out in large grassy stretches along the ground, blended into soft moss on tree trunks and rocks. His painting then takes on the muted beauty of tapestry, arrays itself in a strong harmonious weave. Or, as in the *Bathers*, coagulated and luminous, it takes on the brilliant, bluish white aspect of richly decorated faïence.

. . . And finally there are the famous apples the painter so loved to paint and painted so well. Sometimes the backgrounds come forward, but how supple the tablecloths and napkins, how nuanced their whites, and how naively beautiful the fruit. . . .

Whatever subject he treated, there is genuine sincerity in Cézanne, the mark—sometimes charming, sometimes painful—of a resolve that will find satisfaction or miscarry. Also, quite often, of a guileless grandeur. . . .

That Cézanne did not realize with all the desired force the dream that invaded him before the splendor of nature, so much is certain; such is the story of his life and that of many others. But it is also certain that his thought revealed itself, and that bringing his paintings together would reveal a profound sensibility, a rare existential unity. Surely this man has lived and lives a beautiful interior novel, for the demon of art lives in him. (Gustave Geffroy, "Paul Cézanne," *Le Journal*, March 25, 1894)[18]

"An Absolute Overthrow of the Art of Painting"

Thadée Natanson, the critic of *La Revue blanche*, a friend of the young Nabis—Bonnard, Denis, Roussel, and Vuillard—as well as of Toulouse-Lautrec, brilliantly summed up the view current in Parisian avant-garde circles of the 1890s.

> As for Cézanne—however limited his presence here in physical terms—his novelty retains all its tartness and savor. Despite imitation and even diminishment, he remains the only theoretician, almost without disciples, the only already venerable creator of a formula that no [other] painter has yet applied in the pursuit of glory. For however unfinished his work might appear, it adduces the idea of an absolute overthrow of the art of painting. (Thadée Natanson, "Exposition, Théodore Duret," *La Revue blanche*, April 1894)

"Unfinished But Truly Extraordinary"

Shortly after the appearance of Geffroy's article, the initial long piece about Cézanne to appear in a prestigious art magazine, the artist was finally taken up by a professional dealer, Ambroise Vollard (see cat. no. 177), who organized the earliest one-man exhibition devoted to the artist, in late November 1895. At age fifty-six, Cézanne had finally achieved recognition. This development had an immediate impact on the amount of press coverage he received (see Chronology, November 13, 1895). Not everyone was convinced—far from it—but everyone was talking about him.

Cézanne had become something of a celebrity, if a misunderstood one. As always, Pissarro, among the first visitors to the exhibition, was admiring:

> There's a very complete Cézanne exhibition at Vollard's. Still lifes of astonishing finish, things unfinished but truly extraordinary in their savagery and idiosyncrasy. I think it will be little understood. (Camille Pissarro to Esther Pissarro, November 13, 1895, in Pissarro, 1980-91, vol. 4, no. 1169, p. 113)

> Leaving Portier's [a paint merchant and picture-dealer] the other day, I thought to myself: How rare it is to find true paintings that manage to establish harmony between two tones. . . . I thought of Hayet, who looks for noon at two o'clock, of Gauguin, who at least has an eye, of Signac, who also had something, all more or less paralyzed by theory. I also thought about the Cézanne exhibition, where there are exquisite things, *Still lifes* of irreproachable finish, *others very worked up* and yet left flat, still more beautiful than the others, landscapes, nudes, and heads that are incomplete yet truly grandiose and so painterly, so supple. . . . Why? The sensation's in them! (Pissarro to Lucien Pissarro, November 21, 1895, in Pissarro, 1980-91, vol. 4, no. 1174, p. 119)

But many, Arsène Alexandre among them, continued to focus less on the painter than on the personage, the childhood friend of Zola, "who conquered Paris all on his own; as for Cézanne, his name never reached the large public. By contrast, he became a legendary, mysterious personage who was discussed almost constantly in the studios, while his painting was seen only rarely and his person almost never." Alexandre concluded with a few words about his influence, characterized as that of the "discoverer who doesn't profit from what he discovers. In short, an artist without issue but not without utility."[19]

A year later, in *Le Figaro*, Émile Zola lashed out against his childhood friend in the following terms:

> Yes, thirty years have passed [since *Mon Salon* of 1866] and my interest in painting has waned somewhat. I grew up virtually in the same cradle as my friend, my brother Paul Cézanne, in whom the touches of genius of a great [but] aborted painter are only now beginning to be discovered. I mingled with a whole group of young artists, Fantin, Degas, Renoir, Guillemet, and still others that life has dispersed, has scattered with various degrees of success. And I, likewise, have continued on my way, avoiding friends' studios, carrying my passion elsewhere. (Émile Zola, "Peinture," *Le Figaro*, May 2, 1896)

18. A revised and expanded version of this text appears in volume 3 of Geffroy, *La Vie artistique* (Paris, 1894), pp. 249-60.
19. Alexandre, December 9, 1895.

"An Oeuvre That's Nothing But Painting"

But the real homage—at last unreserved—was that written by Thadée Natanson and published in *La Revue blanche*. This was the most determined defense of the pivotal exhibition mounted by Vollard in 1895 (commemorated by the present exhibition):

> Of M. Paul Cézanne, a contemporary of Degas, Renoir, Monet, and Manet, very little has previously been known, almost nothing in fact.
>
> It is not in the museums that one must seek out documents concerning a painter honored by some masters as a precursor, an initiator. But it has been some time now since museums lost the public's gratitude—if they ever enjoyed it. Incapable of instructing or guiding it, they also lack the virtue of assembling for its edification capital works that, since no one's yet buying them, are extremely difficult to see. But where would they learn about impartiality? From the politicians? An artist outside the official hierarchy must conquer the entire world as well as America to force the door of the Luxembourg.
>
> It would seem that M. Cézanne never even dreamed of sending anything to the Salon. Since the landscape "Wide Sandy Road in a Wood," which represented him at the now-famous exhibition of 1874, nothing has been shown publicly, except some landscapes still in the Duret collection. Prior, that is, to the recent exhibition we should be grateful to M. Vollard for having organized.
>
> This reserve that M. Cézanne has finally been convinced to surrender—after how many efforts!—is known to have been deliberate. Was it prompted by timidity, fear of the inevitable sarcasm, by modesty, pride, or indifference? No matter. The biographer should be interested in but a single view, the one holding that the artist, a tenacious worker, a passionate painter, was never interested in anything but pursuing a particular [line of] study and concerned himself with absolutely nothing else. Witness the number of stretchers that are barely covered, mere sketches, the obsession with certain motifs, and the piles of his canvases in deplorable condition that must be salvaged from attics. And then one is reminded of the tranquil life of the Provençal landowner in his Aix retreat, the debt to his father for the fortune permitting him to live in comfort, painting in his own way without concern for the world, which lets obstinate types die from hunger.
>
> But, in addition to the image of him as already old, swathed in winter clothing and an otter-fur cap, absorbed and sad, the most fortunate were acquainted with singular landscapes glimpsed at rare intervals, heavy fresh apples in some studio or other, and strange figures including a monumental portrait, more landscapes, some still lifes seen in the

tiny shop of the unforgettable père Tanguy, which the good fellow gloried in showing off.

He is known to have had famous friends, to be respected by masters, yet even his most ardent partisans never completed a panegyric without expressing reservations. There was virtual consensus about the applicability of the word "unfinished" [incomplet].

Whatever paintings one managed to glimpse exercised an elusive attraction akin to a mysterious summons from the future, the source of qualities from which issued the talent of many artists who came after him. Contemporaries contemplated him gravely, took the time to ponder him, and the youngest revered him; some of them avowed they were unable to see even the least of his canvases without being influenced by them, while others left them to the spectator's discretion.

Nonetheless, his imperfections continued to be stressed, as if to excuse and render acceptable praise that might otherwise have seemed excessive. Once more he was reproached for not being *finished* . . . a hypocritical epithet synonymous with *advantageous* for eager dealers and greedy collector-speculators anxious to have the greatest possible [value] for their money.

The fifty or so exhibited canvases are divided in about equal measure among figures or figure compositions, still lifes, and landscapes. Provisionally, we must make do with this survey of the whole oeuvre. . . .

But so far there's nothing to distinguish these still lifes from the desserts that stimulate the appetite of gourmands every year at the Salon, or from the ordinary run of wooded landscapes, or from standard-issue bathing pictures.

That's because these lines lack the essential, impenetrable, and most precious part of these objects, *the residue that is nothing but painting.*

Due to the boldness and emphatic solidity of such forms as quarries, clouds rolling across blue skies, the roofs of houses, greenery, fruit outlined in ways accentuating their curves and corners, set muscles, falls of cloth, ornamental fabric, and stiff drapes, all the represented objects take on the quality of embellishment, of festoons or arabesques in this enamel-like painting.

Nonetheless, it is inexpressible, this grace and delicacy the artist distributes everywhere and that's consummated by relations between pure tones which at first seemed brutal but are merely out of the ordinary. There's a boldness about these images that the uninitiated would be tempted to qualify as brutal, yet how pretty they are, in the most positive sense of the word! How savory these never-before-dared relations, these audacious values whose crudity is so surprising. . . .

After this, how impoverished appear the words red, green, and blue. It is easy to comprehend an impulse to prohibit them when one thinks about these mute violets, these sumptuous greens, these strident reds, these dazzling oranges, this brutal, acidic blue, and the pungency of their relations. Such reflections arise whenever what's at issue are painting's true qualities, which here present themselves at every juncture in an oeuvre that's nothing but painting and in which only souls amorous of painting can take delight. . . .

But, before looking any further, there's a certain insouciance concerning everything not within his strict purview, a contempt for [easy] pleasure, that already augurs a master. Aside from the unalloyed purity of his art, which abjures cheap seduction, there's another essential quality associated with precursors that attests to his mastery: he dares to be rough, almost savage, and, disdaining all else, he gives himself over to a preoccupation typical of initiators: the creation of a few new signs.

There's no need to issue predictions about his influence: it is [already] manifest, revealing itself not only among a few who have put it into practice but already, indirectly, in others, younger ones, who perhaps have never seen [his work]. This *incomplete* artist, the creator of an oeuvre resembling nothing previously seen, only things unmistakably issuing from it, has, like some of his illustrious contemporaries, encountered pillagers and plagiarists and had a notable influence on his period. But perhaps he alone, or at least he more than anyone else among [the Impressionists], can glory in having formed students and generated a school, in the most positive and deepest sense of the word.

Paul Cézanne can lay claim to more than the title of precursor.

He deserves yet another.

He can already lay claim to being the French school's new master of still life.

Given the love with which he paints them and imbues them with all his gifts, he is and remains a painter of apples—apples that are smooth, round, fresh, ponderous, dazzling, of shifting color, not the ones you'd like to eat, the ones whose illusionism stops gourmands in their tracks, but rather of forms that ravish. . . .

He has made apples his own. Through his magisterial grasp they now belong to him. They are his just as much as any object belongs to its creator.

Some, finding this a mean achievement, will simply smile.

Is there, then, a hierarchy of subjects, just as there's a hierarchy of qualities? Does the fact that grandeur prevails over delicacy and grace yields to majesty, despite our being unable to justify this in rational terms, necessitate the creation of such a ranking, [entail] the precedence of a painter who has produced only portraits of generals over one whose models come from the ranks, and the latter's lording it in turn over another painter who has treated only the shapes of gourds?

One can say further of Paul Cézanne that he

loved painting passionately, that he placed limits on his painting out of love of a few forms that his gifts enabled him to establish.

But because he painted with love and would have done so from pure inclination, would have followed his penchant regardless of personal advantage or anything else, some very young people to whom he doubtless never gave a moment's thought pause respectfully in front of his despised canvases, seeking [to derive] strength from the traces of his audacity. And his contemporaries, old like himself, are moved on seeing his efforts gathered together and respectfully bow down before his oeuvre. (Thadée Natanson, "Paul Cézanne," *La Revue blanche*, December 1, 1895)

The Final Decade, 1895 to 1906

Maurice Denis's *Homage to Cézanne*

In the nine-year interval between 1895, date of the first Cézanne exhibition at Vollard's gallery, and 1904, when a key article by Émile Bernard appeared in July, followed in October by numerous reviews of the retrospective at the Salon d'Automne, little of importance was written about the artist. Cézanne was becoming increasingly reclusive in Aix; more often than not he dealt with Vollard through his son Paul, who lived in Paris. He was distrustful of visitors in general and of journalists in particular, but he was happy to receive young poets and painters.

Of course, throughout this period he was consistently supported by a small group of writers in "advanced" periodicals: Thadée Natanson and Félicien Fagus in *La Revue blanche*, Tristan Klingsor in *La Plume*, André Fontainas in the *Mercure de France*. His usual treatment in the press, however, is typified by the following cursory remarks penned by André Mellerio in response to three paintings shown in the Exposition Centennale de l'Art Français at the Exposition Universelle of 1900:

> Cézanne, an original but unevenly realized temperament. A whole painter whose painting is pure and solidly grounded. Some landscapes, then some characteristic still lifes, especially apples. (André Mellerio, *L'Exposition de 1900 et l'impressionnisme*, Paris, 1900)

This period saw several new developments in biographical writing about the painter. Joachim Gasquet, the young Félibrige poet from Aix (see cat. no. 173), praised Cézanne as a regionalist Provençal artist, as the Frédéric Mistral of painting, while in Germany his work was discovered by dealers, collectors, and museum directors (see

Chronology, October 25, 1897), as well as by several critics, including Julius Meier-Graefe, beginning in 1898, and shortly thereafter Hans Rosenhagen.

But in 1901 the aging hermit of Aix—at sixty and already ill, he now cut the figure of an old man—became a prime focus of attention in the artistic world, thanks to Maurice Denis's large, celebrated painting *Homage to Cézanne*, in which the artists Odilon Redon, Édouard Vuillard, Ker-Xavier Roussel, Denis himself, Paul Sérusier, Paul Ranson, and Pierre Bonnard, as well as his dealer Vollard, his wife, Marthe Denis, and André Mellerio, are arrayed on each side of an easel bearing a Cézanne still life.[20] It was much commented upon in the press, both in Brussels, where in March it was shown at the Libre Esthétique, and in Paris, where in April it was included in the Société Nationale des Beaux-Arts exhibition.

Cézanne subsequently wrote to Denis expressing "intense gratitude" both to him and to "the painters grouped around" him, and Denis responded:

> I am deeply touched by the letter you were so kind as to write me. Nothing could be more agreeable to me than to know that, in the depths of your solitude, you are aware of the commotion that's been made over *Homage to Cézanne*. Perhaps you will now have some idea of the place you occupy in the painting of our time, of the admiration you inspire, and of the enlightened enthusiasm of a few young people, myself included, who can rightly call themselves your students, because it is to you they are indebted for whatever they have understood about painting; and we will never be able to thank you enough for it. (Maurice Denis to Cézanne, June 13, 1901, in Cézanne, 1978, p. 275)

"Painting in Blocks"

A new generation smitten with Cézanne entered the record in 1902, when Tristan Klingsor first cited the names of René Seyssaud, Albert Marquet, Jean Puy, and Matisse, the future "Fauves."[21] In the same periodical, *La Plume*, Mecislas Golberg, reviewing the Salon d'Automne of 1903 and its posthumous retrospective of paintings by Gauguin, described the new tendencies that were to characterize advanced painting of the century's early years. On this occasion, Cézanne was viewed through the lens of Gauguin, but it was the former's work that was deemed the decisive influence on the new painting—a distinction some found dubious:

> Despite the absence of the leaders of Impressionism and Pointillism, there's a sufficient sampling of these two tendencies at the Salon d'Automne. However, what dominates the exhibition and gives it its character is the method of Cézanne and Gauguin.
>
> Here and there one sees something else, but the soul of this Salon is painting in blocks *[peinture par masse]*, with which the workers of painting seem intent on replacing the excesses of Pointillism and the

20. The still life in *Homage to Cézanne* (repro. pp. 22-23) is the one that belonged first to Gauguin. It is currently in a private collection (repro. p. 31).
21. Klingsor, May 1, 1902.

exquisite nervousness of Impressionism. Instead of nuances multiplied to infinity, bold analyses, and color, there appears a heavy pictorial vision [composed of] blots that are uniform, distinct, without transition. It's as though the painters, looking through sculptors's eyes, saw things [solely] in terms of surface. The envelope, the atmosphere, the sky, in short everything constituting the analytic elements of painting gives way to a simplistic vision dominated by contours and surfaces, to studio backdrops, to broad areas of color arrayed in plaques. . . .

The attempt is interesting in itself as a reaction against analytic excess. While representing an advance, however, it is [also] a negative development, due to the distortions that this art deems indispensable. It has a flaw, that of having left the domain of special research only to present itself as a definitive fact, as a genuine gain. . . .

Producing blots and nothing but blots, giving their contours arbitrary shapes, breaking down equilibrium and destroying a painting's construction, this seems to me excessive, seeing how contours, equilibrium, and construction are the primordial elements of a work of art. . . . My work's cut out for me! From a distance, the heads of Cézanne's cardplayers give me the impression of billiard balls suspended in mid-air.

Why, after the excesses of Monet, relapse into opposite excesses? (Mecislas Golberg, "Les Peintres du Salon d'Automne, suite," *La Plume*, December 15, 1903)

"A Love of Ugliness"

Cézanne no longer followed the press. In fact, he asked his son to stop sending him clippings after reading an article by Henri Rochefort titled "L'Amour du laid" (A Love of Ugliness), occasioned by the Zola estate sale, that was imbued with the author's passionate anti-Dreyfusard sentiments. Nine early Cézannes were listed in the sale catalogue, and Rochefort, venting his anti-Semitism, described the artist as an "ultra-Impressionist," an epithet intended to taint him through association with the despised author of *J'accuse*. The text is pure delirium, but given the history of its author—a former republican pamphleteer and, twenty-five years earlier, the hero of the escape from the New Caledonia prison famously pictured by Manet—it has a certain curiosity value that makes it worth quoting:

There are some ten works signed by an ultra-Impressionist named Cézanne, landscapes and portraits, that would induce mirth in [Henri] Brisson himself. . . .[22]

Pissarro, Claude Monet, and the most eccentric of the *plein air* and Pointillist painters—the ones who've been dubbed the "confetti painters"—are academics, almost members of the Institut, beside this strange Cézanne whose productions Zola gathered together. . . .

We have often affirmed that there were Dreyfusards long before the Dreyfus affair. All the sick brains, inside-out souls, squinty-eyed types, and cripples were ripe for the coming of the Messiah of Treason. (Henri Rochefort, "L'Amour du laid," *L'Intransigeant*, March 9, 1903)

A Modern Saint

The efforts of painters, seconded by Vollard, to win Cézanne recognition were having their effect, and, in 1904, two years before his death, the painter attained genuine celebrity, both in Paris and outside France, especially in Germany. Julius Meier-Graefe devoted a long passage to him in his famous work on modern art, *Die Entwicklungsgeschichte der modernen Kunst*, in which he, along with Van Gogh, figures as a hero of contemporary painting.[23] And a long review by Hans Rosenhagen of the Berlin exhibition mounted by Cassirer in 1904 concludes as follows:

Despite his culture, he appears a pure, uncorrupted man issued directly from the hand of the creator. In everything, his taste and the way he wields the brush, one senses "nature" in Goethe's sense of the word, even in the least of his works, which is the best proof of his greatness. And the time when recognition of the latter is no longer restricted to a small circle is surely closer than is generally believed at present. (Hans Rosenhagen, "Von Ausstellungen und Sammlungen," *Die Kunst für Alle*, June 1, 1904, p. 403)

Gothic, Modern, French, Mystical

In July 1904, Cézanne was again described as an artist touched by the divine in an article in the Parisian journal *L'Occident* that was the longest yet devoted to him. Its author was the artist Émile Bernard, and he made Cézanne out to be a saint, a redeemer. The tone changed considerably since Bernard's first article of 1891: formerly quirky and uncouth, Cézanne now becomes something like a preacher. This must have irritated more than one reader, but the remarks attributed to Cézanne and quoted from his letters quickly made the rounds of the studio and café circuit; indeed, they are often repeated even today and remain the painter's most celebrated formulations. Incorporated in the article were a number of observations drawn from Cézanne's correspondence, and consequently of certifiable authenticity. It is well known that the young generation of the century's early years was drawn to these aphorisms. Matisse and the Fauves would have been attracted to the *opinions* numbered 6, 7, 9, 11, and 12 (see below). Picasso, Braque, and the Cubists were particularly attracted to the celebrated 10th aphorism, which reappears in somewhat different form in other comments attributed to Cézanne. This article marked the first appearance in print of *pensées* by the most reclusive, the least worldly, and

the least forthcoming of painters. "It is true that with Bernard one can develop theories to infinity, for he has the temperament of a reasoner," Cézanne wrote to his son, doubtless with a dash of irony.[24] But Bernard got him to talk, reproduced his comments with relative accuracy,[25] and offered the first conceptual analysis of Cézanne's art and method.

> Soon it will be twenty years since young painters who are now the focus of attention in Paris made pious pilgrimages to a small dark shop on the rue Clauzel. Having arrived, they asked the old Armorican with a Socratic visage [for] paintings by Paul Cézanne. . . . They studied religiously these pages of a book spelling out nature and a contemporary aesthetics like so many sheets of a dogma, one whose revealer, while unknown to them, was clearly infallible. . . .
>
> Paul Cézanne was not the first to follow this road [Impressionism], he delights in acknowledging his indebtedness to Monet and Pissarro for having extricated him from the over-preponderant influence of the museums, for his having placed himself under that of Nature. . . . Before long it was not Pissarro who was advising him but he who was affecting the latter's pictorial evolution. He did not adopt the working methods of Monet and Pissarro; he remained what he was, which is to say a *painter* with an eye that sees with ever greater clarity, that educates itself, that exalts itself in front of sky and mountains, in front of things and beings. To use his own expression, he made himself a new optics, for his own had been obliterated, swept away by a boundless passion for too many images, prints, paintings. He wanted to see too much; his insatiable desire for beauty made him examine the multiform tome of Art too much; henceforth, he comes to feel that he must exercise restraint, must restrict himself to a conception and an aesthetic ideal; if he now goes to the Louvre, if he contemplates Veronese for extended periods, it is in view of stripping down appearances, of scrutinizing its laws; there he learns about contrast and tonal opposition, there he distills his taste, ennobles it, elevates it. If he takes another look at Delacroix, it is to observe in him a blossoming of the effect of colored sensation; for, he asserts, "Delacroix was an imaginative fellow sensitive to color," a powerful gift but one of great rarity; in effect, some artists have a brain but no eye, others have an eye but no brain. Cézanne immediately cites Monet as an example: [he has] the nature of a painter, the intelligence of an artist, but is only a mediocre colorist.
>
> It was to Auvers, close to Pissarro, after having painted some large powerful canvases under Courbet's dominion, that Cézanne withdrew to wean himself of all influences under Nature's tutelage; and it was in Auvers that he began the stupefying creation of the sincere, naively skillful art that he has since shown us. . . .

> Such is his method of working: first, complete submission to the model; careful establishment of the armature, a quest for curves and proportional relations. Then, in intensely meditative sessions, an exaltation of color sensations, an elevation of form toward a decorative conception, of color toward the most harmonious pitch. Thus, the more the artist works, the more removed is the result from his objective, the more he distances himself from the opacity of the model serving as his point of departure, the more he enters into a painting without adornment whose sole aim is itself. The more he abstracts his painting, the more he gives it a simplified amplitude, after having first begotten it as something constricted, compliant, tentative. . . .
>
> Here are some of the opinions of Paul Cézanne:
> [1] Ingres is a noxious classic, like all those who, denying nature or copying it prejudicially, pursue style by imitating the Greeks and Romans.
> [2] Gothic art is essentially invigorating, it is of our race.
> [3] Let us read nature, let us realize our sensations in an aesthetic that's at once personal and traditional. The strongest will be he who has seen deepest and realizes most completely, like the great Venetians.
> [4] Painting after nature is not copying the objective, it's realizing our sensations.
> [5] In painting there are two things: the eye and the brain. They should mutually aid one another, one must work to develop them in tandem with one another, the eye through looking at nature, the brain through the logic of organized sensations, which provides the means of expression.
> [6] To read nature is to see it beneath the veil of interpretation, as colored patches succeeding one another according to a law of harmony. Thus these colors are analyzed by modulations. To paint is to register these color sensations.
> [7] There are no lines, there is no modeling, there are only contrasts. These contrasts are produced not by black and white but by color sensations. Modeling results from precise relations between tones. When they are juxtaposed harmoniously and are all present, the picture, by itself, takes on modeling.
> [8] One shouldn't speak of modeling but rather of modulation.
> [9] Shadow is a color like light, but it is less brilliant; light and shadow are nothing other than a relation between two tones.
> [10] Everything in nature is modeled according to the sphere, the cone, and the cylinder. It is neces-

22. Henri Brisson, the prime minister of France elected in May 1898, whose restraint was proverbial, was responsible for overturning the initial condemnation of Dreyfus.
23. Meier-Graefe, 1904, vol. 1.
24. Cézanne to his son, September 22, 1906, in Cézanne, 1978, p. 327.
25. Save for a few nuances introduced by Cézanne in two letters to Bernard, before and after having read the article. See Cézanne, 1978, pp. 302, 304.

sary to learn to paint from these simple figures, afterward one can do whatever one likes.

[11] Drawing and color are not distinct; when one paints one also draws; the more the colors harmonize, the more precise the drawing. When color is at its richest, form is at its fullest. Contrasts and tonal relations, these are the secrets of drawing and modeling.

[12] The effect is what constitutes the picture, unifying and concentrating it; it's against the existence of a dominant patch that it must be established.

[13] One must be a worker in one's art. Grasp early on its method of realization. Be a painter by means of qualities proper to painting. Make use of coarse materials.

[14] One must become classic again through nature, which is to say by means of sensation.

[15] Everything comes down to this: having sensations and reading nature.

[16] In our period there are no longer any real painters. Monet gave us his vision. Renoir did the women of Paris. Pissarro was very close to nature. What came after doesn't count, consisting only of practical jokers who feel nothing, who perform acrobatics. . . . Delacroix, Courbet, and Manet made pictures.

[17] To work without worrying about anyone else and [so] grow strong, such is the aim of the artist; the rest is not even worth *le mot de Cambronne*.[26]

[18] The artist should have contempt for opinions not based on intelligent observation of character. He should beware of the literary cast of mind, which so often makes the painter stray from the true path—the concrete study of nature—and waste too much time on intangible speculations.

[19] The painter should devote himself entirely to the study of nature and endeavor to produce paintings that are an education. Chatter about art is almost useless. The work that leads to progress in one's craft is sufficient compensation for the incomprehension of imbeciles. The literary man expresses himself in abstractions while the painter renders concrete, by means of drawing and color, his sensations, his perceptions.

[20] One is neither too scrupulous, nor too sincere, nor too subject to nature; but one is more or less master of one's model, and above all one's means of expression. To penetrate what's before one, and persevere in expressing oneself as logically as possible.

. . . In sum, Cézanne, through the cogency of his works, has proven himself the only master onto which the art of the future might graft its fruition. Yet how little appreciated were his discoveries! Mistakenly held by some to be explorations without issue because of their unfinished state; by others to be inconsequential oddities produced by the unique fantasy of a sickly artist; by himself, before whom there arises an ideal of the absolute, to be bad rather than good, doubtless from vexation at seeing [his

intentions] betrayed in them as they are (he destroyed a great many of them and showed none), they nonetheless constitute the most beautiful attempt at a pictorial and coloristic rebirth to be seen in France since Delacroix. (Émile Bernard, "Paul Cézanne," *L'Occident*, July 1904)

"His Purely Abstract and Aesthetic Vision of Things"

I am not afraid to assert that Cézanne is a painter of mystical temperament, and that it is only by mistake that he has always been ranked in the deplorable school inaugurated by M. Zola, who, despite his blasphemies against nature, hyperbolically dubbed himself a "naturalist." I say that Cézanne is a painter of mystical temperament on the basis of his purely abstract and aesthetic vision of things. . . .

He worked from the first people of good will to be found in his vicinity, his wife, his son, or more often common folk, ditchdiggers and milkmaids, in preference to dandies and socially polished types, whose corrupt taste and worldly insincerity he loathed.

Here, of course, it is no longer a question of seeking beauty outside the means proper to painting: line, value, color, handling, style, presentation, character. We are far indeed from a conventional or material beauty, and the work will be beautiful to us only to the extent we possess an exceedingly elevated sensibility capable of making us lose sight of the thing represented and so derive a purely artistic pleasure. "It's necessary to see one's model and feel on pitch; and what's more, express oneself with distinction and force. Taste is the best judge. It is rare. Art never addresses itself to more than an extremely small number of individuals. . . ."[27]

This great artist is a humble man, he has understood the ignorance and obstruction that are the reserve of his contemporaries; accordingly, he has closed his door to plunge into the absolute. Possessed to a singular degree by the love of painting, to whose tyrannical but beneficent tenacity he has submitted his life, he holds that the pleasure afforded by his work is sufficient unto itself, rendering superfluous any desire for approbation and praise. He detests the literary cast of mind that has made so many unhealthy intrusions into painting and has distorted the most direct comprehension of it. . . .

[Cézanne's oeuvre] dominates all contemporary production, it imposes itself by dint of the value and originality of its vision, the beauty of its materials, the richness of its color, its serious and durable char-

26. A reference to the French general Pierre Cambronne, who, when asked to surrender at Waterloo, responded, "Merde."
27. Excerpted from a letter written by Cézanne to Bernard, May 12, 1904, in Cézanne, 1978, p. 301.

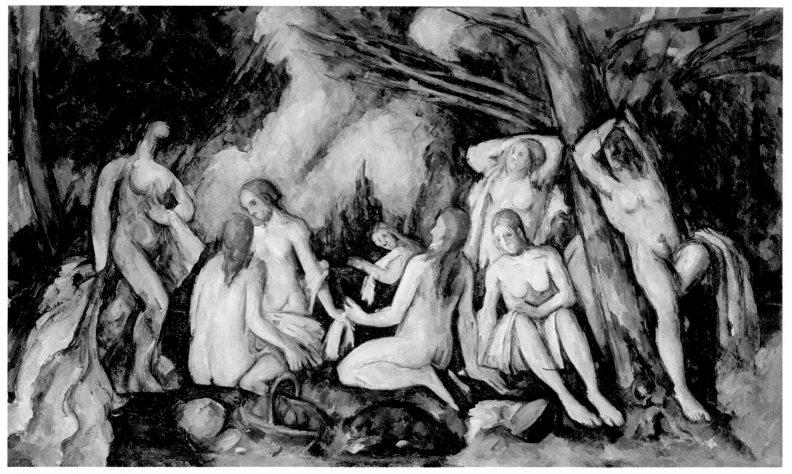

Paul Cézanne, *The Large Bathers*,
1900-1905, oil on canvas,
The Barnes Foundation, Merion, Pennsylvania (V. 720).

acter, its decorative amplitude. It attracts us by its conviction and its healthy doctrine, it persuades us by means of the manifest truth it proclaims, and, amid the current degeneracy, presents itself to us as a wholesome oasis. Having a refined sensibility that links it to Gothic art, it is modern, it is new, it is French, it is possessed of genius. . . .

A life that's simple, regular, organized around the daylight hours needed to work, an eye ceaselessly on the watch, a mind always in contemplation, such is Paul Cézanne. His frank, naive, honest, precise painting proclaims his artistic genius; removed from vanities and vainglory, his existence proclaims his goodness and humility as a man. It is his hope to prove through his work that he is sincere and that he labors to better his art. Many famed contemporaries, arrogant and stupid, will fall when science is acknowledged; then, as a Christian and an artist, he will witness the realization of these words from the Magnificat: "The great shall be cast down and the humble exalted." (Émile Bernard, "Paul Cézanne," *L'Occident*, July 1904)

"Cézanne Is Fashionable"

The next Salon d'Automne, which opened on October 15, 1904, featured a Cézanne retrospective consisting of thirty-one paintings. This was an event. For the first time the entire press took notice, from the Parisian dailies to the international magazines (see Chronology, October 15-November 15, 1904), although in many instances not without registering a certain irritation, as exemplified by the following passage:

> I said a moment ago that there weren't any snobs there. Sorry. There are some, and they're all in the Cézanne room. They understand nothing about it, basically they don't like it. This art by a primitive who painted in ignorance of the discoveries of his predecessors shocks and suffocates them, but one must keep pace. Cézanne, the mournful Claude Lantier of [Zola's novel] *L'Oeuvre*, is fashionable. If he didn't live far away from us, in his villa in Aix-en-Provence, he'd be all the rage this winter in Paris. (Louis Vauxcelles, "Salon d'Automne, le vernissage," *Gil Blas*, October 15, 1904)

Criticism in French newspapers—familiar through the sampling included by Ambroise Vollard in his book on

Cézanne (1914)—was generally ironic and hostile, not to say repetitive. The words that most often recur are *gaucherie, sincérité, maladresse, raté, doué, infirme, malgache, incomplet, impuissant* (awkwardness, sincerity, clumsiness, failed, gifted, crippled, Madagascan, incomplete, impotent).

We will single out Camille Mauclair, who, while supportive of Carrière and Rodin, was to become well known for his peevishness toward the Fauves and the Cubists:

> And what to say about the group by M. Cézanne? The general impression made by his color is quite strong: intense blues, agreeable red notes. An accurate perception of the Provençal atmosphere. But what hideous handling, and on this packing-canvas! What false values, often, and what discordant tones! Signs for fairground stalls, seen in the sun, can be diverting, but placed within frames they're unspeakable—and here I'm thinking of several small paintings of nudes that seem to have been made out of hatred for flesh, grace, light, and love by some ferocious baroque image-maker. These jerky strokes that stand in for greenery, these bowls of fruit of whose edges are horizontal even though everything else is on an incline, these dubious napkins on which roll apples, the famous apples of M. Cézanne, these ignoble tavern wallpapers he uses as backgrounds for his still lifes and whose designs he copies with utmost seriousness, what surprising evidence of an unconscious taste for the ugly and the coarse! Never was the epithet "common" more applicable than to this painting for workers' housing. The most curious thing about this painter's still lifes is the virulence of their tones in the total absence of light. (Camille Mauclair, "La Peinture et la sculpture au Salon d'Automne," *L'Art décoratif*, December 1904)

Between Courbet and Matisse

Cézanne was already being held responsible for all the "errors of modernity":

> But Cézanne? Ah! Cézanne! Happy are the poor in spirit, for they shall inherit the artistic heavens! If it doesn't revert to complete barbarism as a result of progress, the future will take melancholy amusement in our dithyrambic eulogies of the pseudo-primitive trinity Cézanne–Gauguin–Van Gogh. Cézanne is its father—one whom, despite his grandfather beard, I dare not think eternal. . . . The fanatics exclaim: The sole route to salvation leads through Cézanne. They declare him to be at once *Poussinesque* and *Chardinesque*, for the saint cultivates simultaneously portraiture, landscape, and still life, disposing apples on bar cloths and setting purplish tulips in bandy-legged stoneware vessels. Like César Franck, Gustave Moreau was, unbeknownst to himself, the most dangerous of professors. . . . It wasn't so much Moreau as Cézanne who

bred disorder in his studio. And how are we to explain this bizarre alliance? By the liberality of this professor so generously open to all novelty. Many and various at the Salon d'Automne, his faithful followers set a striking example, while Redon, Lautrec, and Cézanne have spurred on their aspirations. Look at Georges Devallières, that loyal adherent of the pure line of French portraiture! How he divides himself between a calm beauty and the outrageous! Look at Georges Rouault, that poet of lesser exercises in style, who inebriates himself with shadow. A painter and a sculptor, Henri Matisse is more Cézannean than Cézanne. (Raymond Bouyer, "Le Procès de l'art moderne au Salon d'Automne," *La Revue bleue*, November 5, 1904)

The construction of Cézanne as a primordial but negative figure in modernist painting of the first quarter of the century was already underway.

The most serene review of the famous 1904 Salon d'Automne was that of Roger Marx, the enlightened official critic who had selected the modern art shown at the Exposition Universelle of 1900. He situated the artist between his sources and his progeny, between Courbet and Matisse. In other words, in 1904 Cézanne made his entrance into history.

> Of all the founders of Impressionism, it is M. Paul Cézanne who has remained the most faithful to Courbet; like M. Degas, he remains odd man out in the group; his painting has none of the characteristic traits shared by his companions-in-arms M. Monet and Sisley, Renoir and Berthe Morisot, Pissarro and Seurat; he has only slight aspirations to lighten his palette, is little concerned with luminous irisation, and doesn't break down his tones, which, on the contrary, he prefers bold, applied freely and flatly. Not long ago, visitors to the French Primitives likened him to the author of the *Avignon Pietà*, so guileless is his craftsmanship; there can be no doubt about his cult for Poussin, and he also loves Daumier, if we can judge from the line in his *académies* and the deliberately exaggerated character of his contours. Whether figures or portraits, they will be modeled with bold handling in a pure-toned light; in the landscapes, the amplitude so characteristic of Courbet is accompanied by nuancing that is sometimes dark, sometimes delicate, and that is reminiscent of early Corots from the Italian period; more than anything else, it is the excellent still lifes that give the measure of M. Paul Cézanne; he confers on fruit, flowers, and everyday objects a verisimilitude, a reality, a relief that are extraordinary; here his gifts as a colorist reach an intensity of expression and manifest the human genius's power of animation to a greater degree, perhaps, than has hitherto been seen in painting.
>
> It is M. Cézanne who initiated the penchant, now so widespread, for giving full expression to the beauty and life of physical material. . . . Here, a new

synthesis reconciles the use of simple tones and broad flat handling with the principle of clear and vibrant color. It is [an approach] familiar to a group of former students of Gustave Moreau—MM. Marquet, Matisse, Camoin, Bréal, and Manguin—who all tend toward this style. . . . What more is there to say, unless it be that a revolutionary has produced a classic oeuvre? At a moment in which analysis of the atmosphere, perhaps over-subtle, fostered complicated [technical] procedures, he sanctioned a simplicity dear to the masters of the past; he forcefully steered us back to a love of beautiful material and to the virile boldness of a practice that's robust and healthy. (Roger Marx, "Le Salon d'Automne," *Gazette des Beaux-Arts*, December 1904, pp. 462-64)

The Watercolors

A new aspect of Cézanne's work was winning public appreciation and even becoming the object of a veritable cult among the artist's admirers: his watercolors.

The watercolors of Cézanne are revealed to us at a time propitious for [both] the artist's glory and our pleasure. Works that are precious, gracious. The master amuses himself. But his diversions are wondrous marvels and beautifully instructive. They make play with bold blues, pure whites, clear yellows—still lifes, flowers, landscapes, and they sometimes give the illusion of painted porcelain, of delicate iridescent opals. Others, with only a few touches of color, are admirable drawings marked with that novel primitive character discerned everywhere by eyes that are, one might say, forever newborn. (André Fontainas, *Mercure de France*, July 1, 1905)

Recently we saw from him, at Vollard's, a collection of watercolors solidly based on vivid contrasts against backgrounds washed with Prussian blue; the definitive tone of these sketches, as composed and constructed as paintings, was already quite developed, powerful, and admirably resonant. One would have said they were old faience. Some landscapes in the same series showed clearly delineated trees and buildings over which played a white light rendered more intense by violet and deep yellow shadows, nuanced and shimmering. (Maurice Denis, "La Peinture," *L'Ermitage*, November 15, 1905)[28]

The Prophet of Decadence

Until Cézanne's death in the fall of 1906, his fame continued to develop along lines laid down over the preceding years. He remained a scapegoat for some critics, among them Camille Mauclair, his most virulent castigator, who opposed him not only to conventional painters in the

Beaux-Arts tradition but also to his Impressionist comrades.

Renoir's awkwardness is a virtue because it precludes neither skill nor beauty . . . but in Cézanne's case it's a matter of impotence. . . . In the one it's French grace, in the other, it's barbarism. (Camille Mauclair, "La Peinture et la sculpture au Salon d'Automne," *L'Art décoratif*, December 1905)

His name will remain associated with the most memorable artistic joke of the last fifteen years. To use a phrase of Ruskin's, only "Cockney impudence" could have invented the "genius" of this honest old man who painted in the provinces for his own pleasure and produced works that are heavy, badly put together, conscientiously mediocre, still lifes with rather beautiful handling but whose color is somewhat crude, leaden landscapes, figures that a journalist recently described as "Michelangelesque" but that are, quite frankly, the shapeless efforts of a man whose good will proved no substitute for skill. (Mauclair, "La Jeune Peinture française et ses critiques," *La Revue*, December 15, 1905)

This fierce vindictiveness was rooted in a perception of Cézanne's determinant influence on the development of contemporary art. He was held partly responsible for the prevailing "modern decadence," for having legitimized a quest for "salvation" through ignorance and primitivism. Cézanne, along with Gauguin and Redon, was one of the principals answerable for what had already emerged as Fauvism and what would soon take shape as Cubism, the fruits of this

refined generation excessively drawn to critical consciousness, inclined to ratiocination, nervous, anxious to understand all directions but unable to settle on any, enemy of the École [des Beaux-Arts], enemy of virtuosity and technical tricks—in a word, blasé. . . . To place oneself ahead of nature, to forget everything that's been done, everything that's taught, to make a good-faith effort to attain the state of mind of a caveman carving a reindeer bone, to succeed in doing so, what a regeneration! Such is the genuine desire of the decadents! . . . Under the names Primitivism, Synthetism, Symbolism, etc., this demented hope has seized the [present] generation. And how to attain quickly a sanctified, salubrious ignorance? How to regain rapidly a state of virginity vis à vis sensation? First and foremost, by being deliberately contrary to everything that one sees being done in painting; by proclaiming admirable those who know nothing and don't want to learn anything, eleutheromaniacs who stop their ears for fear the discourse of one of their brothers

28. Reprinted under the title "De Gauguin, de Whistler et de l'excès des théories," in Denis, 1912.

might prejudice their free will; by following the example of those who do not follow. The mentality of the eleventh-century illuminator, of the savage carving a fetish, surpasses that of the artist who has worked for twenty years taking into account the museums, the heritage of the races. . . . Gauguin went to Tahiti not so much to find beautiful luminous motifs as to forget Europe and remake his life and soul in Tahitian terms; Redon plunged into bizarre extravagance to rid himself of memories of the human figure that he cannot draw and that fetter him; Cézanne turns out motley works as naive as Épinal prints, as though he had never seen a painting in his life. Nothing more is needed to make these men seem like the pure prophets of a return to nature. (Mauclair, "La Jeune Peinture française et ses critiques," *La Revue*, December 15, 1905)

Such views had a wide currency, and these citations convey something of Cézanne's importance in the century's early years as a model for the young generation of painters in Paris, whose members admired his spiritual force—his isolation and independence—as well as his technical innovations.

The responses to a questionnaire regarding "current tendencies in the plastic arts," put to a group of artists and published by Charles Morice in the *Mercure de France* in 1905,[29] provide even more direct evidence of Cézanne's powerful effect on a great many painters:

> — Cézanne's color enchants me in his own canvases but repels me in those of others. (Jacques-Émile Blanche)
> — By contrast [with literary painters], Cézanne takes pleasure in affirming quite forcefully the prerogatives of technique. (Raoul Dufy)
> — By dint of sincerity as well as the intensity of his emotion, Cézanne has felt the beauty that is given off by form. . . . (Pierre-Paul Girieud)
> — Cézanne has managed to strip pictorial art of all the mildew that it had accumulated over time. (Paul Sérusier)
> — A still life by Cézanne, a cigar-box top by Seurat, these paintings are as beautiful as the *Mona Lisa* or the 200 square meters of Tintoretto's *Paradise*. (Paul Signac)
> — Cézanne is the most beautiful painter of his period. But how many moths are consumed by this flame! (Kees van Dongen)

But the most telling response was that of a young Fauve painter from Marseille, a fellow southerner: Charles Camoin, one of a small group that had recently visited Aix and whom Cézanne had taken into his confidence. He incorporated passages from letters the painter had recently addressed to him, the first direct evidence of the thought of the "master," as he was henceforth known:

> Cézanne is a genius through the novelty and importance of his contribution. He is one of those who

shapes an evolution. He is the Primitive of the open air. He is profoundly classic, and he often repeats that he has tried to "enliven Poussin after nature." He does not see objectively and in patches like the Impressionists; he deciphers nature slowly, through light and shadow, which he expresses as color sensations. However, he has no goal other than to "make images" *[faire l'image]*.

But I think it interesting to cite some of the thoughts and advice I've received from him:

"Since you're in Paris and the masters in the Louvre attract you, make studies after the great decorative masters, Veronese and Rubens, as you would after nature, something I've only managed to do inadequately. But you would do well to study nature above all. Go to the Louvre, but after having seen the masters who repose there, you must hasten out to rejuvenate, through contact with nature, the instincts, the sensations of art that reside in us. One talks better about painting at the motif than by devising purely speculative theories, which often lead one astray.

"You see that a new era in art prepares itself, you have a presentiment of this. Continue to study without faltering, God will do the rest.

"Everything, especially in art, is theory developed and applied in contact with nature. When I see you, I'll talk to you more accurately about painting than anyone else. I have nothing to hide in art. Nothing but the initial force, that is to say, temperament, can bring a person to the goal he ought to attain.

"Whoever your favorite master might be, he should only be an orientation for you. The advice, the method of another should not make you change your own way of feeling.

"Drawing is nothing but the configuration of what you see.

"Michelangelo is a constructor, and Raphael an artist who, for all his greatness, is always bridled by the model. When he sets out to become 'reflective,' he falls short of his great rival."

I ought to say, since Cézanne wants it known, that he has the greatest admiration for Monet. (Charles Camoin)

It is worth adding another response to this bouquet, that of Félix Vallotton: "Cézanne, I have the highest opinion of him. I keep him at a respectful distance."[30] Two years later, however, Vallotton wrote an interesting article about him on the occasion of the great retrospective of the 1907 Salon d'Automne, discussing the "Cézanne case" both as a critic and as a fellow artist:

29. Morice, August 1 and 15, and September 1, 1905. All these texts are republished with commentary in Dagen, 1986.
30. Morice, August 1 and 15, and September 1, 1905.
31. Denis, September 1907.

A painting by Cézanne is a headstrong, isolated object that's sufficient unto itself and finds its highest expression within the very limits of its frame; the handling is generally laborious and stubborn, the effect attained at the cost of countless fresh starts. No facility: for Cézanne everything is a problem, and the never-settled question is posed anew with each stroke. Layer by layer, his brush lays on pondered colors; the consistently bold tones are added, joined, linked, superimposed on one another without ever blending, constructing a block of harmonies that are powerful yet incomparably delicate. Each canvas represents an effort to begin again, from scratch. Cézanne is perpetually moving mountains, for he has no "manner" and no one has ever "fabricated" less than this relentless worker. Such a method generates an impression of great power, but also a tension that sometimes exhausts the spectator. (Félix Vallotton, "Le Salon d'Automne," *La Grande Revue*, October 25, 1907)

The author of the 1905 questionnaire, Charles Morice—since forgotten but at the time an admired Symbolist poet and critic for the *Mercure de France* (the most important literary and artistic periodical of the day) and well known in avant-garde circles as a defender of Gauguin— felt that Cézanne was insufficiently idealist:

> The paintings of Paul Cézanne frighten the public and delight artists—the public as a whole, not all artists. I don't think there's impassioned discourse between him and poets. A painter. A complete painter? If so, there would be passionate dialogue between poets and himself. A painter, period, admirable but uneven. He sometimes closes himself off in the cryptography of a difficult technique, and sometimes he expresses himself with the simplicity of an ingenuous child touched with genius. He is anxious, but only about knowing whether his values are exact, and his paintings have only as much human value as their [tonal] values. (Charles Morice, "Le Salon d'Automne," *Mercure de France*, December 1, 1905)

At this point, halfway between the hatred of some and the veneration of others, a transition from criticism to art

history was being effected. Take the example of Manet's old friend Théodore Duret, who included a chapter on Cézanne—insipid but informative—in his *Histoire des peintres impressionnistes*, published shortly before the painter's death; its most personal note is struck when the author expresses amazement at something that would prompt André Breton and the Surrealists to despise Cézanne:

> We can conclude, then, by saying that, if several features of Cézanne's work and life are singular enough to be worth pointing out, the most singular is the astonishing contrast between the considered opinion of his character and his real way of life. This man whose art has seemed to resemble that of a Communard or an anarchist, whose work has been shielded from the eyes of emperors and has instilled terror in directors of the [École des] Beaux-Arts, is a rich, conservative, Catholic bourgeois who never suspected he might be seen as an insurgent, who has given all his time over to work, leading a life that, in fact, could not be more regular or more worthy of esteem. (Théodore Duret, *Histoire des peintres impressionnistes*, Paris, 1906, p. 195)

Cézanne's death on October 23, 1906, occasioned the customary obituaries, none of which contained views other than those in circulation for at least a decade: "unfinished and powerful" (Paul Jamot, *Gazette des Beaux-Arts*, December); "sincere but unfinished" (Anonymous, *Bulletin de l'art ancien et moderne*, November 3); "imperfect" (René-Marc Ferry, *L'Éclair*, October 25); "a mad Chardin," "an absolute inability to stay the course to the end" (Arsène Alexandre, *Le Figaro*, October 25); whereas others characterized him as "classical" (J.-F.-S., *Chroniques des arts et de la curiosité*, November 3), as the inventor of an "art that is pondered, concentrated, probative, contained, classical, unliterary" (Louis Vauxcelles, *Gil Blas*, October 25).

But it is in the remarkable article by Maurice Denis, in preparation at the time although published only the following year,[31] that we find the subtlest and perhaps the most accurate assessment of a man then in the process of becoming, simultaneously, the sacred cow of pictorial modernity and the model for a renovation of the great French tradition. Two complementary and, on balance, equally accurate images of his artistic personality.

Françoise Cachin

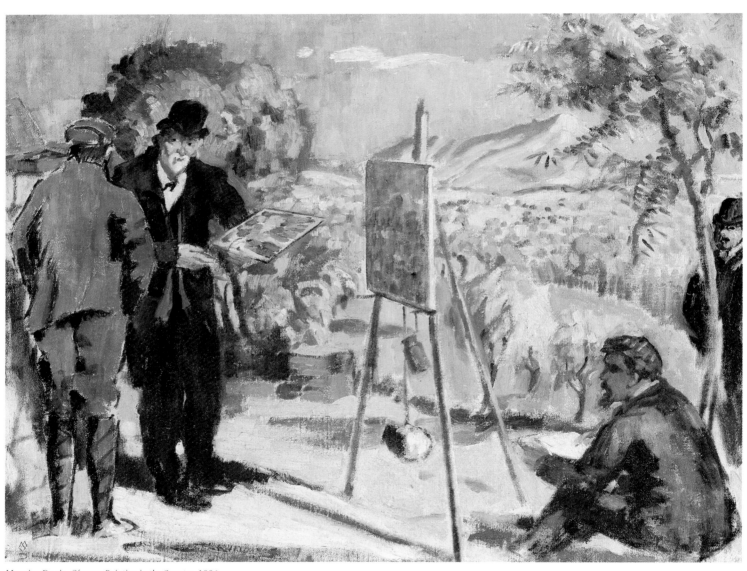

Maurice Denis, *Cézanne Painting in the Country*, 1906,
oil on canvas, private collection.

A Century of Cézanne Criticism
II: From 1907 to the Present

Reactions to the Salon d'Automne (1907)

The two rooms devoted to Cézanne at the Salon d'Automne in 1907, one year after his death, marked a full coming-of-age for his reputation. According to Charles Morice, critic for the *Mercure de France*, the painter already belonged to history:

> A number of artists and critics, even in this great Paris where people think they know everything, will [be surprised to] learn of the death of he who was and remains Paul Cézanne. As assiduously as so many seek it out, but with singular *adresse*, he avoided glory. He very nearly succeeded in eluding it his whole life. All his strength, every moment was consecrated solely, exclusively, jealously to the study of nature, to artistic research. One hesitates even to say that Cézanne lived: he painted. And in order to paint better, to paint as well as he could in complete freedom and total security, he fled [other] painters and the big city [as well as] exhibitions, newspapers, and commotion, inventing himself in the depths of France, in his old native town, in a solitude without echo, full of deep and secret joys, full of endeavor. (Charles Morice, "Paul Cézanne," *Mercure de France*, February 15, 1907, p. 577)

Together with the large exhibition of watercolors held at Bernheim-Jeune that same year,[1] the Salon d'Automne was a watershed in the reception of Cézanne's art. It was on this occasion that the myth and the critical definition of his oeuvre began to take on a complexity that has continued to accrue to the present day.

Perhaps the most moving accounts of the 1907 exhibition are those given by Rainer Maria Rilke (1875-1926) in letters to his wife, in Bremen at the time. With remarkable candor, they trace the evolution of his views as he visited and revisited the Grand Palais. The earlier letters reveal the degree to which the influence of Émile Bernard (1868-1941) was rapid and pervasive,[2] for they are dominated by his construction of Cézanne as a troubled figure forever on the verge of failure.

> As regards his work, he has claimed that up until his fortieth year he lived as a bohemian. Only then, under the influence of Pissarro, did he develop a taste for work. But then so strongly that he did nothing *but* work the following thirty years of his life. Without real pleasure, it appears, in a continuous frenzy, wrestling with each of his paintings, convinced that none of them attained what he felt was truly essential. He called that the *réalisation*,

something he had found in the Venetians he had seen early on in the Louvre, and had gone back to see and wholly endorsed. It seemed to him that his most crucial task was to be convincing, to give life to objects, by his own perception of them to imbue them with a reality so intense as to be indestructible; old, unwell, spent to the point of exhaustion each night by the same struggle day after day. . . . (Rilke to his wife, October 9, 1907, in Rilke, 1952, p. 21)

> In the process (if one is to give credence to the person who has reported all these facts, a not altogether likable painter who consorted with all of them for a time), he made his work more difficult out of sheer stubbornness. . . . It is my feeling that in him the two processes, namely making accurate observations and registering them and actually taking possession of what he had perceived and using it for his own purposes, were—perhaps owing to his awareness of them—in opposition, that they both started hounding him at once, so to speak, constantly interrupting each other, ceaselessly quarreling. (Rilke to his wife, October 9, 1907, in Rilke, 1952, p. 21)

But when Rilke began to focus on his own experience instead of paraphrasing Bernard's views, a new vitality took over. After another visit to the Salon, he wrote:

> But one needs a long, long time for all of this. When I recall my astonishment and perplexity on seeing his first pieces, hanging there along with his unfamiliar name. And then for a long time nothing, and now suddenly I have the proper eyes. . . . (Rilke to his wife, October 10, 1907, in Rilke, 1952, p. 24)

With each encounter he found himself more absorbed, his response to Cézanne more positive. Of a visit in the company of the painter Mathilde Vollmoeller he wrote:

> More and more do I realize what an event this is. Just imagine my amazement when Fräulein V., seeing him strictly through the eyes of a trained

1. Paris, 1907 (a). In Paris the exhibition included seventy-nine watercolors; the following September-October, sixty-nine of them traveled to Berlin, where they were shown under the auspices of Paul Cassirer. These works made up about half of the cache that Ambroise Vollard and the brothers Josse and Gaston Bernheim-Jeune had purchased from Paul Cézanne *fils* earlier that year.
2. See Rilke, 1985, p. 35.

painter, remarked: "He sat there in front of this like a dog, simply looking, in no hurry and with no preconceptions." [. . .] "What a clear conscience he must have had," I said. "O indeed: he was content, deep down inside somewhere. . . ." And then we compared arty things that he probably did in Paris under the influence of others with his most personal ones, with reference to color. In the former, color was a thing of its own; later he treats it as his somehow, in a way no one has treated color before, using it solely for the creation of objects. The color is wholly used up in becoming things; nothing is left over. And absolutely to the point, Fräulein V. commented: "It's as though placed on a scale: here the object, and there the color; never more and never less than is required for equilibrium. It may be a lot or a little, it depends, but it is precisely what corresponds to the object." This last would not have occurred to me; but it is eminently correct and helps one understand the pictures. Also it occurred to me yesterday how unaffectedly varied they are, how untroubled with originality, confident that they will lose nothing of themselves in approaching nature's infinity of forms but rather, in the face of that external abundance, patiently explore their own inner inexhaustibility. All of this is quite beautiful. (Rilke to his wife, October 12, 1907, in Rilke, 1952, pp. 25-26)

And on October 13, 1907:

Today I went to see his pictures again. It is remarkable what an ambience they create. Without looking at any particular one, standing there between the two galleries, you feel their presences joining together into a single, colossal reality. As if these colors were stripping you of your indecisiveness once and for all. The innocence, the simple truthfulness of these reds, these blues, is instructive; and if you put yourself beneath them and open yourself up to them as much as you can it's as if they do something for you. You also notice, each time more clearly than the last, how essential it was to get beyond love as well; of course it is only natural that you love each of these objects as you're painting them: but if you show that, you don't paint them as well; you *judge* them instead of *expressing* them. You stop being impartial; and the best part, the love, stays outside the work, does not enter into it, remains something else, untransmuted: that's how people used to produce mood paintings (which are in no way better than factual ones). You painted: "I love this thing," instead of painting: "Here it is." When anybody can see perfectly well for himself whether I loved it. You absolutely don't show that, and many will even claim that it has nothing to do with love. That's how completely it's consumed in the act of painting. It may be that no one has ever been so successful at using up his love in anonymous labor, creating such purified works, as this old man; his

inner nature, increasingly mistrustful and surly, helped to make it possible for him. He would certainly not have revealed his love to any person if he felt it; but with such a disposition, fully evolved in his lonely eccentricity, he now applied himself to nature and knew how to stifle his love for each individual apple and invest it in the painted apple for all time. Can you picture what that's like and how he lets you see it? (Rilke to his wife, October 13, 1907, in Rilke, 1952, pp. 27-28)

Later, after reflection, he described Cézanne's labor in terms of awe:

This way of working, which no longer had any preconceptions, any preferences, and made no choices out of mere habit, whose tiniest step was weighed on the scales of an infinitely adaptable conscience, and which was so incorruptible in its reduction of each aspect of being to its essential colors that it entered into a new existence beyond color, with no memory of before. (Rilke to his wife, October 18, 1907, in Rilke, 1952, p. 33)

And on October 21, 1907, he wrote:

All discourse is misunderstanding. The only insight is in the work itself. I'm certain of it. It's raining, raining, . . . and tomorrow they're closing the Salon, where I've virtually been living of late. (Rilke to his wife, October 21, 1907, in Rilke, 1952, p. 38)

In his following letter, of October 23, after writing about the unrelenting honesty and absence of pretension in the self-portrait owned by Auguste Pellerin (cat. no. 35), he concluded: "Today is the anniversary of his death."[3]
Finally, on October 24, 1907, he wrote:

I wish I could search the picture for it once again. But the Salon is no more; in a few days it is to be followed by an exhibition of automobiles, which will stand there, long and dumb, each with its own *idée fixe* of speed. (Rilke to his wife, October 24, 1907, in Rilke, 1952, p. 43)

This exhibition also served as an occasion for the painters Émile Bernard and Maurice Denis to consolidate their ideas about Cézanne. Émile Bernard's 1904 essay was widely disseminated in 1907 under the title "Souvenirs sur Paul Cézanne et lettres inédites" in the *Mercure de France*.[4]
These reflections on Cézanne, written by the only person (with Renoir) to paint in the master's proximity since the early 1870s, the days of Pissarro and Armand Guillaumin, were among the first to appear in print, and their influence was considerable. Bernard worked with Cézanne at Les Lauves for a month in 1904 (although Cézanne insisted that Bernard remain below while he himself painted in the large second-floor studio). Hence he could claim firsthand knowledge of both Cézanne's technical procedures and his ideas, but his account of them is deeply col-

ored by his own profoundly reactionary notions about art and the role of the artist. Furthermore, the many contradictions in the more theoretical pages of his writings make it clear how ill prepared he was to fully grasp many of the ideas Cézanne broached with him in the course of their discussions or attempted to explain to him in his letters— which, together with Bernard's accompanying glosses, became the bedrock of subsequent critical writing about Cézanne.[5] To make matters worse, Bernard's initially equivocal ideas about Cézanne eventually gave way to a reading that was categorical: "It would interest me very much to show how, despite this murderous error on Cézanne's part, . . ."[6]

It seems clear that Bernard was unable to break free of Zola's Cézanne, or rather of the figure of Claude Lantier, the failed painter in the novel *L'Oeuvre* whose gifts fell fatally short of his ambitions. Bernard consistently pictured Cézanne as an artist bordering on failure, although in pursuit of the highest goal. This is especially evident in Bernard's description of the master's conception of resolution and finish, his *réalisation*. It should be borne in mind that, while imagination and creativity took precedence over observation in the views of the Pont Aven group, of which Bernard had been a member, by 1907 his style had reverted to a kind of academic literalism, which never completely corresponds with his theories.

Bernard continued to write about Cézanne over the next two decades.[7] His conservatism grew increasingly dogmatic, making it tempting to dismiss his criticism after 1907 (along with his contemporaneous artistic production). But the fact remains that he continued to worry over a paradox that was to preoccupy virtually everyone who subsequently wrote about the artist in a theoretical vein, namely the opposition between the real and the ideal, between observation and imagination, which all too easily extrapolates to that between content and form. However extremist and eccentric his language, Bernard usefully articulated a central question that would be reiterated by Richard Shiff in 1984: "Was Cézanne's art essentially a matter of spontaneous finding or of controlled making?"[8]

For Maurice Denis (1870-1943), also writing in 1907, Cézanne both exceeded Impressionism and restored classicism.

> I have never heard an admirer of Cézanne give me a clear and precise reason for his admiration; and this is true even among those artists who feel most directly the appeal of Cézanne's art. I have heard the words—quality, flavour, importance, interest, classicism, beauty, style. . . . Now of Delacroix or Monet one could briefly formulate a reasoned appreciation which would be clearly intelligible. But how hard it is to be precise about Cézanne! (Maurice Denis, "Cézanne," trans. Roger Fry, *The Burlington Magazine*, January-February 1910, p. 208)[9]
> In constant reaction against the art of his time, his powerful individuality drew from it none the less the material and pretext for his researches in style;

he drew from it the sustaining elements of his work. At a period when the artist's sensibility was considered almost universally to be the sole motive of a work of art, and when improvisation—"the spiritual excitement provoked by exaltation of the senses"—tended to destroy at one blow both the superannuated conventions of the academies and the necessity for method, it happened that the art of Cézanne showed the way to substitute reflexion for empiricism without sacrificing the essential *rôle* of sensibility. Thus, for instance, instead of the chronometric notation of appearances, he was able to hold the emotion of the moment even while he elaborated almost to excess, in a calculated and intentional effort, his studies after nature. (Ibid., pp. 213-14)

When Maurice Denis painted his *Homage to Cézanne* in 1900 (repro. pp. 22-23), he had not yet met the painter; indeed, the prospect of an encounter between this Symbolist and an artist who had so little in common with Denis and his circle seemed singularly unpromising. Nonetheless, Denis and Ker-Xavier Roussel, perhaps encouraged by the welcome extended to Bernard, paid a brief visit to Aix in 1906, and the pair was cordially received. Denis published his impressions of the meeting, along with some reflections about Cézanne, at the time of the Salon d'Automne memorial exhibition of October 1907. While his Cézanne is no less paradoxical than the one evoked by Bernard the same year, the oscillation that Denis observed "perpetually between invention and imitation"[10] is less rigidly dichotomized and more organically creative: he describes the artist as a great genius who, in the end, he sees as remarkably complete and free of contradictions:

> It is a touching spectacle that a canvas of Cézanne presents; generally unfinished, scraped with a palette-knife, scored over with *pentimenti* in turpentine, many times repainted, with an *impasto* that approaches actual relief. In all this evidence of labour,

3. Rilke to his wife, October 23, 1907, in Rilke, 1952, p. 41.
4. Bernard, "Paul Cézanne," *L'Occident*, vol. 6 (July 1904), pp. 17-30; Bernard, *Mercure de France*, no. 247 (October 1, 1907), pp. 385-404, and no. 248 (October 15, 1907), pp. 606-27. The rapid diffusion of this essay is demonstrated by its publication in German the following year (*Kunst und Kunstler*, vol. 6 [1908], pp. 421 ff.). The original French version was republished in Paris in 1912, 1921, and 1925, making it by far the most accessible of all Bernard's writings on Cézanne.
5. Cézanne was fond of Bernard, but in a letter from the older artist to his son dated September 13, 1906, he wrote about him: "He draws only rubbish that smacks of his artistic dreams suggested not by the emotion of nature but by what he's been able to see in the museums, and even more by a philosophical cast of mind that comes from his over-familiarity with the masters he admires." (Cézanne, 1978, p. 325).
6. Bernard, "Réflexions à propos du Salon d'Automne," *La Rénovation esthétique*, vol. 6 (December 1907). Reprint, 1971, p. 62.
7. Bernard, October 1 and October 15, 1907; Bernard, December 16, 1908, pp. 600-616; Bernard, 1912; Bernard, 1917; Bernard, March 1, 1920; Bernard, December 1920, pp. 271-78; Bernard, 1921; Bernard, June 1, 1921, pp. 372-97; Bernard, February 1924, pp. 32-36; Bernard, 1925; Bernard, 1926; Bernard, May 1, 1926, pp. 513-28.
8. Shiff, 1984, p. 132.
9. Originally published in French in Denis, September 1907, and reprinted in Denis, 1912. Reissued in Doran, 1978.
10. Denis, January-February 1910, p. 214.

one catches sight of the artist in his struggle for style and his passion for nature; of his acquiescence in certain classic formulae and the revolt of an original sensibility; one sees reason at odds with inexperience, the need for harmony conflicting with the fever of original expression. Never does he subordinate his efforts to his technical means; "for the desires of the flesh," says St. Paul, "are contrary to those of the spirit, and those of the spirit are contrary to those of the flesh, they are opposed one to another in such wise that ye do not that which ye would." It is the eternal struggle of reason with sensibility which makes the saint and the genius. (Ibid., p. 275)

Denis calls for a synthesis of these opposites that could be achieved only by someone who was simultaneously a saint and a genius:

> Painting oscillates perpetually between invention and imitation: sometimes it copies and sometimes it imagines. These are its variations. But whether it reproduces objective nature or translates more specifically the artist's emotion, it is bound to be an art of concrete beauty, and our senses must discover in the work of art itself—abstraction made of the subject represented—an immediate satisfaction, a pure aesthetic pleasure. The painting of Cézanne is literally the essential art, the definition of which is so refractory to criticism, the realization of which seems impossible. It imitates objects without any exactitude and without any accessory interest of sentiment or thought. . . .
>
> He is the man who paints. Renoir said to me one day: "How on earth does he do it? He cannot put two touches of colour on to a canvas without its being already an achievement." (Ibid., p. 214)

Denis quotes André Suarès:

> In times of decadence everyone is an anarchist, both those who are and those who boast that they are not. For each finds his law within himself. . . . We love order passionately, but it is the order we desire to make, not the order we receive. (Ibid., p. 275)

The image of Cézanne created by Denis is powerful and poetic but, while he manages to liberate the artist of his associations with Symbolism, in the end Denis, like Bernard, cannot see Cézanne as a guide to the future: "modernism" has no place in his reading of the master. In an essay he wrote in 1920 for *L'Amour de l'art* entitled "L'Influence de Cézanne,"[11] Denis reverted to his old analogies, picturing a Cézanne very much at home in the distant past, among the Spanish masters and Italian artists of the baroque. André Derain and Émile-Othon Friesz are mentioned in passing, Cubism not at all.

The First Biographers

Julius Meier-Graefe (1867-1935) was the first influential non-French critic of Cézanne, and of progressive French painting in general; the impact of his copious writings, in Germany as well as in England and the United States (they were rapidly translated into English), would be difficult to overestimate.[12] Like Roger Fry, who was influenced by him, Meier-Graefe was an instinctive popularist, a synthesizer whose work as a successful novelist and playwright was never far removed from his art criticism. The flamboyance of his prose, which can still be quite engaging (and, when dealing with specific works, very revealing), may have prevented him from gaining much of a reputation in France, despite his having lived there for extended periods. The only one of his books to appear in a French-language edition is the volume on Van Gogh.

It is likely that Meier-Graefe, who settled in Paris in 1895, saw the retrospective at Ambroise Vollard's that year. Thereafter, he followed the dealer's activities closely, as he did those of Paul Cassirer in his native Berlin after the turn of the century.[13]

Meier-Graefe's first, if somewhat naive, text on the artist is a brief chapter in *Die Entwicklungsgeschichte der modernen Kunst: Ein Beitrag zur modernen Ästhetik*, published in 1904.[14] His sole source of information appears to have been Doctor Gachet, and he even wrote about Cézanne in the past tense: "He was a very reserved person; of the younger generation none ever saw him; artists who owe him everything never exchanged a word with him. His very existence has been doubted." But Meier-Graefe already had seen enough work by the artist to become convinced of his importance—"except van Gogh, no one in modern art has made stronger demands on aesthetic receptivity than Cézanne"[15]—and to lay out a perceptive general account of the evolution from his early style of the 1860s, influenced by Delacroix, Manet, and Courbet, into a more Impressionist mode.

> He followed Pissarro in that development to high tones, which Monet enjoined. It is obvious that Cézanne never troubled himself so much about a revolution in technique as the other Impressionists. Without Pissarro he would probably have gone on quietly painting his blacks, and it is possible that his artistic importance would hardly have suffered. Like Manet, he breathed his own individuality into every technique, and made it significant. By this means he retained the originality which evaporated

11. Denis, December 1920.
12. The best introduction is Moffett, 1973, which contains a full bibliography.
13. On Meier-Graefe's early purchases from Vollard of works by Van Gogh but not Cézanne, see Rewald, 1989, p. 44. Rilke, in a letter to his wife on October 7, 1907, referred to a conversation he and Meier-Graefe had about the artist in the 1907 retrospective at the Grand Palais (Rilke, 1985, p. 28).
14. Meier-Graefe, 1904. Numerous revised editions of the three-volume set, as well as of individual volumes, appeared between 1914 and 1927. A paperback was issued in 1966. An English-language edition, translated by Florence Simmonds and George W. Chrystal, was published in 1908.
15. Meier-Graefe, 1908, pp. 266-67.

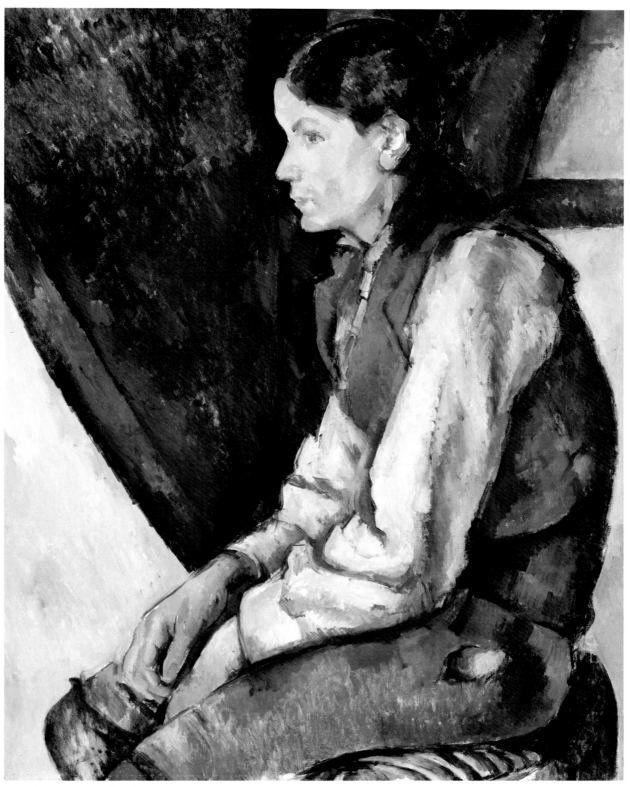

Paul Cézanne, *The Boy in the Red Vest*,
1890-95, oil on canvas,
private collection (V. 680).

somewhat with Monet and Pissarro in successive technical evolutions. (Julius Meier-Graefe, *Modern Art: Being a Contribution to a New System of Aesthetics*, London and New York, 1908, p. 269)

His 1910 monograph, entitled simply *Paul Cézanne*, was the first book on the artist to appear in any language. It enjoyed a wide readership, and its illustrations, revised and expanded in many subsequent editions, provided an early repertory of visual references that was remarkably balanced in evoking all aspects of the artist's career.[16] In 1918 Meier-Graefe developed his ideas in a larger book, *Cézanne und sein Kreis*, which was translated into English in 1927.[17] Like its predecessor, it is a wild paean to the artist, applauding at once his classic sensuality, characteristic of artists of the Midi—"he was saturated no less than Renoir and Maillol, Poussin and Claude, with the blessings of Arcady"— and his northern "Gothic nature," manifest in his "ruthless subjection of the material of his spirit, the aspiration to infinity."[18] The early works, still described in vividly passionate prose, are deemed "Baroque."[19] The most significant advance in this book, as opposed to his first volume on Cézanne, is its sophisticated formal language, which at times achieves a stunning clarity that almost makes the pictures palpable.[20] His key interpretive idea, applied to works from all periods, is the artist's power of "ornamentation":

> We are accustomed to ornament in only one dimension, in the surface, and this limitation of its magic is the father of most of our troubles. Cézanne's masses, ragged and tattered as they may be, go back into space uncannily and somehow make secure a third dimension, the volume, which not only the craftsmen of our day, but also modern masters of painting who are rich in tangible vitality, renounce compulsorily to a very far-reaching extent. Cézanne's masses secure this volume without any nonsense, without any petty modelling, without any inhibition of his confession, and they enable this ideated space to be the bearer, if not of men and things which are familiar to us and thus of a ghostly life, but at any rate of extraordinary probable existence. (Julius Meier-Graefe, *Cézanne*, London and New York, 1927, p. 28)

And he continues in this vein, developing florid images at a gradually accelerating pace, writing in a style marked with the extravagant diction associated with German romanticism, which, while seemingly at odds with so sober a figure as Cézanne, exerted immense influence on the critical tradition through the first half of the century.

Meier-Graefe's Cézanne is a man trapped within himself, one for whom the act of painting is a vast struggle, the confession of a true prophet. He "invented for his most personal edification an expression far excelling that of the forms of his time"[21] Which is not to say that he was unaffected by his contemporaries. Meier-Graefe's summary account of Cézanne's development—short on facts, despite their ready availability at the time—traces his evolution

from an early "Baroque" style dependent on Courbet—"a Courbet who, in the darkness, has hit upon Delacroix and Delacroix's predecessors"—to a more Impressionist one at Auvers—a "necessary cure before he could withdraw."[22] The landscapes of the 1870s are said to derive much of their power from the dark paintings preceding them— which, in some sense, continue to live within them. And it is claimed that, with the reemergence in the 1880s of the early period's emotionalism, a new plateau was reached: "Cézanne's nature always remained the home of his emotion which he decorated with the enthusiasm of a lover. . . . We glide through the pictures of men like Monet, Pissarro, Sisley and the late Manet. [But] we remain in his pictures. His nature is a mightily constructed building."[23] Meier-Graefe holds that Cézanne retained this power to the end, even if the late *Bathers* must be deemed qualified failures. And he concludes by observing that the Cubists are false heirs to Cézanne, no more than "skilful adepts."[24]

"Professor Meier-Graefe considers the critic's task to be itself a kind of artistic creation. His aim has been to use language not so much for analysis, for precise discrimination of values, and for exposition as for the evocation by means of words of a feeling as nearly as possible corresponding to that produced by the artist's work."[25] So wrote Roger Fry in his review of Meier-Graefe's *Cézanne* in *The Burlington Magazine*.

Fry was still warmer to Ambroise Vollard (1867-1939), whose biographical memoir of Cézanne was published in 1914.[26] "M. Vollard has played Vasari to Cézanne and done so with the same directness and simplicity, the same narrative ease, the same insatiable delight in the oddities and idiosyncrasies of his subject."[27]

Charmingly discursive, transparently self-serving, and occasionally contradictory, these memoirs, which probably reached a broader public than any other Cézanne publication prior to World War II, are widely regarded with suspicion. Yet, of the few first-hand accounts by those who actually knew Cézanne, Vollard's is the most reliable with regard to both points of fact and to Cézanne's artistic theories and world view. Their accuracy is especially striking when they are compared with the more influential reminiscences by Bernard, Denis, and Gasquet.

Vollard's Cézanne is a naive, bluntly spoken, deeply conservative man possessed of enormous self-assurance and profoundly devoted to his native Midi. He is wracked by self-doubt but is nonetheless sure of his own greatness, which he knows will be tested eventually in the Louvre, the "only sanctuary worthy of his art."[28]

> Listen, Monsieur Vollard, painting certainly means more to me than anything else in the world. I think my mind becomes clearer when I am in the presence of nature. Unfortunately, the realization of my sensations is always a very painful process with me. I can't seem to express the intensity which beats in upon my senses. I haven't at my command the magnificent richness of color which enlivens Nature. Nevertheless, when I think of my awakening

color sensations, I regret my advanced age. It is distressing not to be able to set down specimens of my ideas and sensations. Look at that cloud; I should like to be able to paint that! Monet could. He has muscle. (Ambroise Vollard, *Cézanne*, New York, 1923, p. 117)

His friends bantered him a great deal about his obstinate determination to get into the official Salons; but we must not forget his conviction that, if ever he could slip into the Salon of Bouguereau with a "well-realized canvas," the scales would fall from the eyes of the public, and they would desert Bouguereau to follow the great artist that he felt himself capable of becoming. (Ibid., p. 140)

While Vollard's Cézanne rages and destroys canvases before the author's eyes—a spectacle that must have been painful for him to witness, given his profession—he can also be eminently sensible and is even capable of genuine wit. He recounts the following remarks made by Cézanne about Émile Zola's thinly disguised depiction of him in his novel *L'Oeuvre* (which occasioned a definitive break between these two old friends), whose protagonist, an artist incapable of fulfilling his promise, commits suicide over a failed painting of a nude:

"You can't ask a man to talk sensibly about the art of painting if he simply doesn't know anything about it. But by God!"—and here Cézanne began to tap on the table like a deaf man—"how can he dare to say that a painter is done for because he has painted one bad picture? When a picture isn't realized, you pitch it in the fire and start another one!" (Ibid., p. 170)

And he recounts an anecdote concerning a local Aix man who had run through his wife's entire dowry. Cézanne was the only one who did not become indignant over his behavior. "'But tell me, can you find a single re-

deeming quality in that man?' asked one of the victim's relatives. 'Yes,' replied Cézanne, 'I believe he knows how to buy olives for the table.'"[29]

Vollard was not only fond of the artist; he was fiercely loyal to him. This is demonstrated by his efforts to embarrass those who failed to appreciate the power of Cézanne's work. He maintains that the 1895 exhibition had been conceived as a direct response to the debacle surrounding the Caillebotte bequest, and that, by way of informal indictment, he placed *Bathers at Rest* (p. 279, fig. 1), the most important of the three works by Cézanne in Caillebotte's bequest rejected by the State, in the window of his shop. Much of his book, written in 1914, is colored by his relish at seeing how the artist's work had prevailed over the philistines who had been so slow to see the light. But his defense of Cézanne is not altogether self-serving. The letters Cézanne wrote to Vollard, who published them in his book, only confirm the portrait of the artist and of their relations sketched elsewhere in its pages:

Aix, January 9, 1903
Dear Monsieur Vollard:

I work obstinately, I glimpse the Promised Land. Will I be like the great leader of the Hebrews or will I be able to penetrate it?

If I'm ready by the end of February, I'll send you my canvas to be framed and dispatched to some welcoming haven.

I had to put aside your flowers, I'm not at all happy with them. I have a large studio in the country. I work there, I'm better off there than in the city. I've made some progress. Why so late and so painfully! Is Art, then, a priesthood demanding pure beings who belong to it completely? I regret the distance that separates us, for more than once I could have used a little moral support from you. . . .
Paul Cézanne (Vollard, 1914, pp. 144-45)

Of the authors whose writings on Cézanne reflect direct contact with the artist—Bernard, Denis, Vollard—it is Joachim Gasquet (1873-1921; see cat. no. 173) whose claims to authenticity are most credible. His reminiscences, based on remembered conversations as well as on letters Cézanne wrote to him, appeared in 1921.[30] Gasquet was an admired poet of the "naturalist" school and a passionate advocate of Provençal literary traditions. He was also a royalist and a devout Catholic. Cast in a rhapsodic style, his portrait of Cézanne creates a superhuman figure so compelling that the reader is very likely to be seduced by it. Gasquet is often less than scrupulous when it comes to distinguishing his own views from those of his subject, however, and this renders assessment of his text a delicate business. In 1896 Joachim's father, Henri, a successful Aixois baker and a school friend of the painter had introduced the twenty-four-year-old Gasquet to the artist, then fifty-seven. The two men were quite close for a time, but Gasquet had an unfortunate tendency to exaggerate the extent of their intimacy when discussing their relationship. An important *Mont Sainte-Victoire with Large Pine* (cat. no. 92) was to given him by Cézanne, and he owned other

16. When Dr. Albert Barnes was determined to obtain *Woman in a Green Hat*, he referred to it specifically by the plate published in Meier-Graefe, 1910. See Rewald, 1989, p. 268.
17. Meier-Graefe, 1918; reissued in 1920, 1922, 1923, and 1927; English-language edition, *Cézanne*, trans. J. Holroyd-Reece (London and New York, 1927).
18. Meier-Graefe, 1927, pp. 17-18.
19. Ibid., p. 25.
20. According to Moffett, 1973, p. 101, the origins of "formal" art criticism are to be sought in Meier-Graefe as well as in R.A.M. Stevenson and Roger Fry.
21. Meier-Graefe, 1927, p. 33.
22. Ibid., pp. 35-36.
23. Ibid., pp. 42-43.
24. Ibid., p. 66.
25. Fry, February 1928, pp. 98-99.
26. Vollard, *Paul Cézanne* (Paris, 1914); revised and expanded in 1924; English-language edition, *Paul Cézanne: His Life and Art*, trans. Harold L. Van Doren (New York, 1923).
27. Fry, August 1917, p. 53.
28. Vollard, 1923, p. 128.
29. Ibid., pp. 145-46.
30. Gasquet, *Cézanne* (Paris, 1921). Republished in a new edition in 1926; this version was reissued in 1988. An English translation by Christopher Pemberton, published with a preface by John Rewald (extracted from Rewald, 1959) and an introduction by Richard Shiff, appeared in 1991.

works by the artist as well (see cat. nos. 171 and 173). It seems they saw one another often in Aix in the late 1890s. When Cézanne was obliged to sell the Jas de Bouffan in 1899, a wrenching experience for him, he sought consolation in the company of Gasquet, his wife, and their literary friends. Gasquet also claimed to have accompanied the artist on working outings in and around Aix. Although the first section of Gasquet's book is honestly entitled "What I Know or Have Seen of His Life," it continues without any noticeable shift in tone to Cézanne's death in 1906, despite the fact that there is no evidence they saw one another after 1904. The reliability of the book's second section, "What He Told Me," is very much open to question. Clearly Gasquet had read all the previously published reminiscences and citations from Cézanne's correspondence, for he insinuated many passages from them into his text, but the precise boundary between solid fact and interested extrapolation remains elusive. This has presented all subsequent commentators with a quandary, for Gasquet's Cézanne is immensely seductive, both as a man and as a thinker.

To cite one example, Gasquet begins his section on "The Motif" with a remembered conversation between the two of them in the hills east of Aix on a fine summer day:

> Cézanne:
> — The sun is shining and hope laughs in my heart.
> Myself:
> — You're having a good morning?
> Cézanne:
> — I'm getting a grip on my motif. . . . *(He clasped his hands together.)* This is a motif, you see. . . .
> Myself:
> — How do you mean?
> Cézanne:
> — Well then *(He repeated his gesture, holding his hands apart, fingers spread wide, bringing them slowly, very slowly together again, then squeezing and contracting them until they were interlocked.)* That's what must be achieved. . . . If I pass too high or too low, the whole thing is botched. There shouldn't be a single weak link, a single hole through which emotion, light, or truth can escape. I advance my entire canvas at once, as a whole, if you get my meaning. I bring together, in one impulse, with one conviction, everything that's scattered. . . . Everything we look at disperses and disappears, doesn't it? Nature is always the same, but nothing remains of it, of what appears to us. Our art should set out to convey the thrill of its permanence along with the elements, the appearance of all its changes. It should give us a taste of nature's eternity. What's underneath it? Perhaps nothing. Perhaps everything. Everything, you understand? So I join together [nature's] straying hands. . . . From left and right, from here, there, and everywhere, I take its tones, its colors, its nuances, I set them down, I bring them together. . . . They make lines. They become objects, rocks, trees, without my thinking about it. They take on volume. They have value. If these volumes, if these

values correspond on my canvas, in my sensibility, to the planes and patches that are in front of me, that are right before my eyes, well then! my canvas "joins hands." It doesn't waver. It passes neither too high nor too low. It is true, it is dense, it is full. . . . But if I have the slightest distraction, the slightest weakness, above all if I interpret too much one day, if I'm carried away today by a theory that contradicts yesterday's, if I think while I'm painting, if I meddle, then bang!, everything goes to pieces.
> Myself:
> — What do you mean, if you meddle? (Joaquim Gasquet, *Cézanne*, Paris, 1921, pp. 79-80)

It is not easy to convey the problems raised by Gasquet's prose in these poetic dialogues because his own interpolations, which inflect Cézanne's core beliefs and character in ways that can be misleading, have been grafted onto the text with cunning ingenuity. For example, he stages a scene in which Cézanne reads him the now-famous passage about recasting nature in terms of "the cylinder, the sphere, and the cone," taken from a letter Cézanne wrote to Bernard in 1904, thereby giving this essentially simplistic, textbook phrase a much wider circulation than it had enjoyed in Bernard's writings. But he takes the liberty of adding a further exchange—entirely his own invention—in which the artist remarks: "Yes, . . . I do better to paint than to write, don't I?" And then he adds: *"He crumpled the paper into a ball and threw it away. I picked it up. He shrugged his shoulders."*[31]

Finally, a conversation that purportedly took place in the studio while Cézanne was working will stand in for all that is so winning yet so dangerous about Gasquet:

> It's so good and so terrible to settle down before an empty canvas. That one, now, it represents months of work. Of tears, laughter, grinding of teeth. We were talking about portraits. People think a sugar-bowl doesn't have a physiognomy, a soul. But that changes every day, too. You have to know how to catch them, how to win them over, those gentlemen. . . . Objects interpenetrate one another. . . . They never stop living, you understand. . . . They spread themselves about imperceptibly through intimate reflections, just as we do through looks and words. . . . It's Chardin who first glimpsed that, nuanced the atmosphere of things. (Ibid., pp. 121-22)

Joachim Gasquet died in 1921, shortly before the book's publication. Gasquet's widow always claimed that he had written it in 1912-13, doubtless with the intent of lending credibility to his account, but even if this were true the text would date from some eight years after the friendship with Cézanne had come to an end. Comparison of Gasquet's citations from Cézanne's letters with the eighteen manuscript missives that have survived, which were published integrally by John Rewald in 1959, only confirms the poet's penchant for overstatement—and the skill with which he devised a myth that has proved tenacious.[32]

Two years later a more sober biography appeared, one that was less concerned with the theory of art than with basic facts: *Le Maître Paul Cézanne* by Georges Rivière (1855-1943). Its author was a poet, a journalist, an art critic, and, eventually, a successful public servant who rose to be a deputy director in the Ministry of Finance. In his youth he had been an active supporter of the Impressionist group; indeed, his account of the 1877 Impressionist exhibition, the one in which Cézanne figured most prominently, contains some of the most vivid pages in the literature on the group.[33] He was a close friend of Renoir, who painted at least two portraits of him; after 1897 their previously sporadic friendship settled into regular rhythms.[34] In 1921, two years after the death of Renoir, he published a book of reminiscences about the artist and his circle.[35]

After the death of Cézanne, Rivière's daughter Renée married Paul Cézanne *fils*, which gave him access to valuable information about dating and chronology. As John Rewald has noted: "This list, very incomplete and full of errors, is nevertheless the first attempt at a catalog of the oeuvre. The dates given by him, sometimes very unreliable though at other times extremely accurate, were obviously established with the help of the artist's son, whose recollections were usually more reliable for later works the execution of which he had witnessed."[36]

Drawing on his own memories as well as information provided by his son-in-law, Rivière wrote a series of biographical studies of Cézanne. The first version appeared in 1923; a shortened and much revised edition was published in 1933.[37] Despite the fact that there is no evidence of Rivière's having had any direct contact with Cézanne after the late 1870s, he was better situated than most to undertake the first general biography, and his responsiveness to the artist's work was genuine. His book was reissued many times, and it has become a standard reference in the French bibliography. Many of Rivière's observations have been so fully integrated into our understanding of the artist that his role as their initial purveyor has often been overlooked.

In his narration of the artist's childhood, Rivière establishes that, in his role as father, Cézanne senior was "a 'boss,' not a 'bourgeois,'"[38] an insight that was to assume considerable importance in the subsequent literature. He further informs us that the artist's parents never set foot in a museum, that Zola's temperament was "quite different"[39] from Cézanne's, and that the artist's classical education was first-rate:

"He never relinquished [the stories of Homer and Virgil], and they can often be found in his pictures: bathers or rustic scenes, the essence of antique poetry, as in canvases by Poussin. (Georges Rivière, *Le Maître Paul Cézanne*, Paris, 1923, p. 4)

He evokes the artist's early visits to the Louvre and his lifelong devotion to the art of the past:

A general theory of art was elaborated in the young painter's brain, one of impeccable logic and solidly based on study of the old masters. What was then lacking in Paul Cézanne was craft. The craft that all painters of the past possessed to an almost equal degree. But its secret was lost, as the young Paul was made to realize every day through painful experience. (Ibid., pp. 22-23)

His description of the young Cézanne is vivid and convincing:

He generally had a serious air, but when he spoke his features grew animated and he accompanied his words with expressive gestures, speaking in a strong idiosyncratic voice with a marked Provençal accent adding a special flavor. (Ibid., p. 76)

On his relationship to the circle that frequented the Nouvelle-Athènes:

He remained silent until the moment when, spurred on by remarks made in his vicinity, unable to contain himself any longer, he launched into a sally or swore an oath to make his feelings known. In any case, when he did feel compelled to speak, he formulated his views with admirable logic and clarity. It goes without saying that it was always a question of art, and of painting above all. Ethics, philosophy, and literature rarely stirred him, he refrained from discussing them. As for politics, he deliberately ignored it and was astonished that it should be of any interest to his friend Zola. Neither the Salon jury's rejections nor the sarcastic remarks heaped upon him by the bourgeoisie could get Cézanne to take up a political cause, as Courbet had done and, to a lesser extent, Manet. It would have been easy for him to follow such a course, however, for he was already considered a revolutionary. (Ibid., p. 78)

Rivière describes Cézanne's extended withdrawal from public view between 1877 and 1895 with greater accuracy than Vollard, for he notes that, although they went largely unremarked, there were venues in the intervening period where his pictures could be seen aside from père Tanguy's shop, namely in the Salon of 1882, the Exposition Centennale de l'Art Français in 1889, and the Brussels exhibition of 1890. Of the artist's isolation, Rivière says:

He tirelessly pursued his task with the same sincere faith, the same resolve as during the first days of his

31. Gasquet, 1921, p. 89.
32. Rewald, preface to Gasquet, 1991, pp. 7-13; see also Rewald, 1959.
33. Rivière, April 6, 1877; and Rivière, April 6 and 14, 1877. Reprinted in Venturi, 1939, vol. 2, pp. 306-21.
34. See Renoir, 1962, p. 353.
35. Rivière, 1921.
36. Rewald, "Comparative Chronology," in New York and Houston, 1977-78, p. 203.
37. Rivière, 1923. Rivière, 1933, 1936, 1942. Cézanne also figures briefly in Rivière's biography of Renoir (1921) and in Rivière, 1926, where the author devotes a few vivid lines to him.
38. Rivière, 1923, p. 2.
39. Ibid., p. 4.

career. His facture grew lighter and more diverse, his palette became more variegated, and a feeling of calm power was generated by the richness of his tones and the personal accent of his drawing.

Retiring within himself, making art his sole concern, he analyzed, with an acuity unequaled by any of his contemporaries, the impression that nature produced on his sensibility. He introduced order into the tumult of his passionate soul, but he did not try to weaken his artistic emotion through [resort to] reason. On the contrary, he wanted it to pass into his work fresh and intact; he tried to retain its spontaneity. To express this emotion clearly and completely an appropriate technique was necessary, and the painter endeavored to seek it out, without ever being completely satisfied with what he found. By turns, he abandoned and took up again all the means at his disposal: impasto, scumbling, glazes applied with aid of silk or sable brushes or with a palette knife, often employing on the same canvas all the devices known to painters, wielding them in accordance with his inspiration, one might say, if one didn't know that with Cézanne the material execution was always preceded by prolonged reflection.

The applied result of these various approaches, born of logical deliberation, did not always answer to the painter's expectations; more often than not, in fact, it disappointed him. Many times, after having tried to conquer insurmountable difficulties, he abandoned a work that was all but completed. This is why there are so many pictures in what remains to us of Cézanne's oeuvre with areas that are barely covered, otherwise admirable bits of painting from which artists can learn just as much as from completed works by the greatest masters. (Ibid., pp. 94-95)

Rivière differs with Gustave Geffroy about the supposed link between Cézanne and the Symbolists:

The Symbolists mistakenly believed that the art of Cézanne posited a doctrine, whereas [in fact] it was the manifestation of an original temperament. This is a matter of only relative importance, however, for artists with pronounced personalities, such as Maurice Denis, emerged from this Symbolist movement, and, like Cézanne, they turned to a technique based in experience to realize their ideal. (Ibid., p. 110)

But Rivière modifies his position somewhat in the pages that follow, asserting that Cézanne "had the ardent and naive soul of medieval artists,"[40] a view that is more consistent with the writings of Bernard and the Symbolists.

The power of the construction, [which] unifies what many artists would consider awkwardnesses and clumsy drawing; the intensity of the color, obtained by means of assembled tones that are harmonious but not shrill; the emotion that produced

these calm landscapes palpitating with life despite the absence of animating figures; the serenity of the scenes of bathers, which bring to mind Poussin and Virgil, if only by way of analogy: everything about Cézanne's painting induced astonishment in those who studied it, and they sought to learn the master's doctrine, his guiding principles. (Ibid., p. 134)

The messianic character of Cézanne's influence was amplified over time. Along with painters, sculptors attempted to transpose the master's technique, then came the interior decorators, who sought to adapt their contours and colors for use in [household] furnishings, conceiving unexpected but logical forms for furniture in order to achieve what was, in their view, harmony with the new aesthetic. Cézanne's influence also made itself felt in literature. In reality, all forms of art were marked to one degree or another by the lesson of Cézanne in the years immediately following his death. (Ibid., p. 176)

Yet, when it comes to assessing the contemporary impact of Cézanne's legacy, Rivière, like Bernard and Denis before him, draws the line, revealing himself to be a man firmly rooted in the nineteenth century.

I ask myself what Cézanne would have said on seeing works by the Cubists, he who declared without equivocation that Van Gogh painted like a madman. Would he have considered the Cubists to be reasonable people? (Ibid., p. 180)

It fell to another generation—and another language, quite literally—to provide the words that would bring Cézanne completely into the twentieth century.

Formalism and Its Consequences

In 1910 the text of Maurice Denis's 1907 conversation appeared in *The Burlington Magazine*. The translator was the journal's editor, Roger Fry, who more or less singlehandedly transformed Bernard's and Denis's conception of Cézanne's "classicism" into the first formalist, "modernist" construction.

In 1910, at the Grafton Galleries in London, Fry organized an exhibition entitled "Manet and the Post-Impressionists." It contained twenty-one Cézannes—and, not incidentally, introduced the designation "post-impressionist" into the critical lexicon. Fry mounted a second exhibition in 1912 that served as a springboard into the Armory Show in New York, held the following year. Throughout Fry's prolonged campaign to introduce new French painting to England, Cézanne was the object of his most sustained and passionate advocacy; indeed, his conviction of the artist's greatness grew stronger over time.[41]

Fry was also largely responsible, at least in the Anglo-American world, for the separation of Cézanne's early work into a unique category, or "prologue." He wrote quite vividly about its charged emotions and sexual exuberance, but in the end he deemed it "too deliberately expressive," maintaining that Cézanne's "was a genius that could only attain its true development through the complete suppression of his subjective impulses."[42]

> In all these efforts to rival the triumphant constructions of the Baroque, Cézanne was betrayed, even more than by his defective apparatus, by his instinctive, though as yet unconscious, bias towards severe architectural disposition and an almost hieratic austerity of line. (Roger Fry, *Cézanne: A Study of His Development*, London, 1927, p. 26)

Fry was always troubled by the late figurative work, initiating another rift in the critical tradition that would have important consequences for later criticism:

> Those of us who love Cézanne to the point of infatuation find, no doubt, our profit even in these efforts of the aged artist; but good sense must prevent us from trying to impose them on the world at large, as we feel we have the right to do with regard to the masterpieces of portraiture and landscape. (Ibid., p. 82)

To explain this shortcoming, Fry invokes an alleged aversion to the model on Cézanne's part:

> For so many years Cézanne's fear of the model had deprived him of all observation of nature that his power of conjuring up a credible image to his inner eye, never remarkable, has by now become extremely feeble. (Ibid., p. 82)

The ramifications of these views were felt as recently as 1964, when Douglas Cooper objected strongly to the purchase by the National Gallery in London of their late *Bathers*.

Fry's visual analyses are justly famous; not only are they fine literary constructions, they are remarkably successful in providing entry to the pictures:

> One notes how few the forms are. How the sphere is repeated again and again in varied quantities. To this is added the rounded oblong shapes which are repeated in two very distinct quantities in the *Compotier* and the glass. (Ibid., p. 48)

Fry's development of this new mode of writing about Cézanne was to have immense consequences; for one thing, it also effectively elevated the late work into a separate category, designating it as the privileged departure point for modernism.

> But whatever the technique we find in this last phase a tendency to break up the volumes, to arrive almost at a refusal to accept the unity of each object, to allow the planes to move freely in space. We get, in fact, a kind of abstract system of plastic rhythms, from which we can no doubt build up the separate volumes for ourselves, but in which these are not clearly enforced on us. But in contradistinction to the earlier work, where the articulations were heavily emphasized, we are almost invited to articulate the weft of movements for ourselves. (Ibid., p. 78)

When Fry is at his best, describing pictures he loves unreservedly, the results are all but unequaled in the English-language literature on Cézanne. For example, of the *Cardplayers* he writes:

> It is hard to think of any design since those of the great Italian Primitives—one or two of Rembrandt's later pieces might perhaps be cited—which gives us so extraordinary a sense of monumental gravity and resistance—of something that has found its centre and can never be moved, as this does. (Ibid., p. 72)

Another notable English voice was raised in defense of Cézanne in this period, and it, too, exerted an important influence on evolving notions of modernism and formalism: that of Clive Bell (1881-1964). Younger than Fry and lacking his breadth of vision, Bell nonetheless had a somewhat tighter grasp of Cézanne's historical role.

> Cézanne is the full-stop between Impressionism and the contemporary movement. . . . It is true that there is hardly one modern artist of importance to whom Cézanne is not father or grandfather, and that no other influence is comparable with his. (Clive Bell, *Since Cézanne*, London, 1922, p. 11)

> Taking the thing at its roughest and simplest, one may say that the influence of Cézanne during the last seventeen years has manifested itself most obviously in two characteristics—Directness and what is called Distortion. Cézanne was direct because he set himself a task which admitted of no adscititious flourishes—the creation of form which should be entirely self-supporting and intrinsically significant, *la possession de la forme* as his descendants call it now. To this great end all means were good: all that was not a means to this end was superfluous. To achieve it he was prepared to play the oddest tricks with natural forms—to distort. All great artists have distorted; Cézanne was peculiar only in doing so more consciously and thoroughly than most. (Ibid., p. 14)

> To the young painters of 1904, or thereabouts, Cézanne came as the liberator: he it was who had freed painting from a mass of conventions which,

40. Ibid., p. 130.
41. See Twitchell, 1987, p. 53. This is perhaps the best introduction to the question of Fry's influence as a "formalist" advocate of Cézanne's work.
42. Fry, 1927, pp. 30, 74.

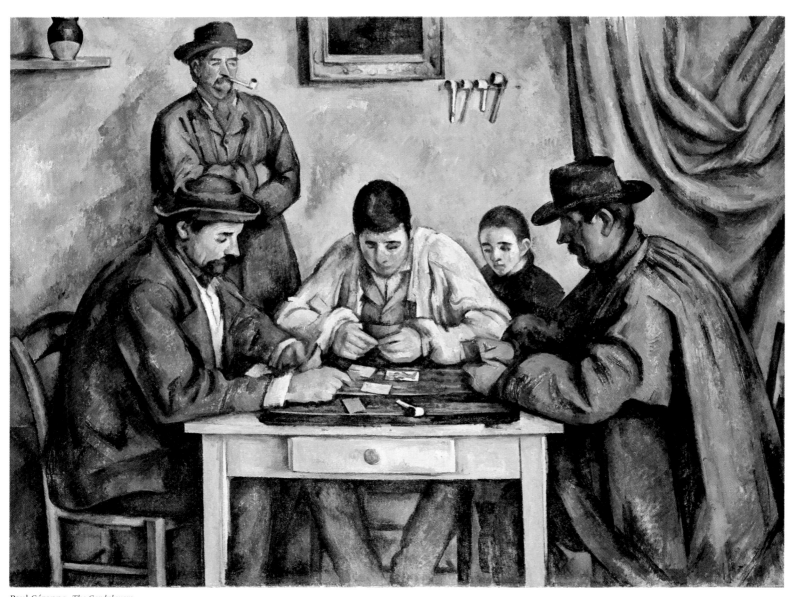

Paul Cézanne, *The Cardplayers*,
1890-92, oil on canvas,
The Barnes Foundation, Merion, Pennsylvania (V. 560).

useful once, had grown old and stiff and were now no more than so many impediments to expression. To most of them his chief importance—as an influence, of course—was that he had removed all unnecessary barriers between what they felt and its realization in form. . . . But to an important minority the distortions and simplifications—the reduction of natural forms to spheres, cylinders, cones, etc.—which Cézanne had used as means were held to be in themselves of consequence because capable of fruitful development. From them it was found possible to deduce a theory of art—a complete aesthetic even. Put on a fresh track by Cézanne's practice, a group of gifted and thoughtful painters began to speculate on the nature of form and its appeal to the aesthetic sense, and not to speculate only, but to materialize their speculations. The greatest of them, Picasso, invented Cubism. (Ibid., pp. 14-15)

Bell's links with English aestheticism of the 1890s are more obvious and restrictive than Fry's; he proceeds from an art-for-art's-sake position to one of modernist formalism with disarming blitheness.

> We all agreed now—by "we" I mean intelligent people under sixty—that a work of art is like a rose. A rose is not beautiful because it is like something else. Neither is a work of art. Roses and works of art are beautiful in themselves. (Ibid., p. 40)

The logical next step in the development of this English-formalist perception of Cézanne is taken in a somewhat improbable place: an introduction by D. H. Lawrence (1885-1930) to a luxury edition of plates illustrating his own paintings and watercolors.[43] Lawrence's Cézanne, "the sublime little grimalkin," is the best there is: "Cézanne's apple rolled the stone from the mouth of the tomb,"[44] but still very wanting. Oddly, given the heavy sensuality and primitivist style of Lawrence's own paintings, the writer finds nothing to admire in either Cézanne's early pictures or his nudes: "If he wanted to paint a woman, his mental consciousness simply overpowered him and wouldn't let him paint the woman of flesh, the first Eve who lived before any of the fig-leaf nonsense. . . . The result is almost ridiculous."[45] He pokes fun at Bell's "Significant Form and Pure Form"—little more than evangelical raving in his view—yet he himself argues that Cézanne undertook to purify representation:

> The actual fact is that in Cézanne modern French art made its first tiny step back to real substance, to objective substance, if we may call it so. Van Gogh's earth was still subjective earth, himself projected into the earth. But Cézanne's apples are a real attempt to let the apple exist in its own separate entity, without transfusing it with personal emotion. Cézanne's great effort was, as it were, to shove the apple away from him, and let it live of itself. It seems a small thing to do: yet it is the first real sign that man has made for several thousands of years that he is willing to admit that matter *actually* exists. Strange as it may seem, for thousands of years, in short, ever since the mythological "Fall," man has been pre-occupied with the constant preoccupation of the denial of the existence of matter, and the proof that matter is only a form of spirit.—And then, the moment it is done, and we realize finally that matter is only a form of energy, whatever that may be, in the same instant matter rises up and hits us over the head and makes us realize that it exists absolutely, since it is compact energy itself. (D. H. Lawrence, *The Paintings of D. H. Lawrence*, London, 1929, p. [17])

> He terribly wanted to paint the real existence of the body, to make it artistically palpable. But he couldn't. He hadn't got there yet. And it was the torture of his life. (Ibid., p. [18])

> After a fight tooth-and-nail for forty years, he did succeed in knowing an apple, fully; and, not quite so fully, a jug or two. That was all he achieved. . . . So that Cézanne's apple hurts. It made people shout with pain. And it was not till his followers had turned him again into an abstraction that he was ever accepted. Then the critics stepped forth and abstracted his good apple into Significant Form, and henceforth Cézanne was saved. . . . Put safely in the tomb again, and the stone rolled back. (Ibid., pp. [19-20])

> When he makes Madame Cézanne most *still*, most appley, he starts making the universe slip uneasily about her. It was part of his desire: to make the human form, the *life* form, come to rest. Not static—on the contrary. Mobile but come to rest. And at the same time he set the unmoving material world into motion. Walls twitch and slide, chairs bend or rear up a little, cloths curl like burning paper. Cézanne did this partly to satisfy his intuitive feeling that nothing is really *statically* at rest—a feeling he seems to have had strongly—as when he watched the lemons shrivel or go mildewed, in his still-life group. (Ibid., pp. [29-30])

> And these two activities of his consciousness occupy his later landscapes. In the best landscapes we are fascinated by the mysterious *shiftiness* of the scene under our eyes; it shifts about as we watch it. And we realise, with a sort of transport, how intuitively *true* this is of landscape. It is *not* still. It has its own weird anima, and to our wide-eyed perception it changes like a living animal under our gaze. This is a quality that Cézanne sometimes got marvellously. (Ibid., p. [30])

43. D.H. Lawrence, *The Paintings of D.H. Lawrence* (London, 1929).
44. Ibid., pp. [13-14, 18].
45. Ibid., p. [18].

Limited in circulation, these views had little of the impact of the critical writings of Fry or Bell, but seem in temper still closer to the aestheticism of English artistic circles embracing the beginnings of modern art.

The 1930s

In 1936 in Paris the eminent Italian art historian Lionello Venturi (1885-1961) published *Cézanne, son art—son oeuvre*, his catalogue raisonné of Cézanne's work. It was the first reliable source to treat all the artist's paintings (as well as many of his watercolors and drawings), and it proposed the first lucidly argued chronology of the artist's development. Proceeding in much the same way as in his previous catalogues of Giorgione, Leonardo da Vinci, and Caravaggio, if on a less ambitious scale, he brought established art-historical methodology and stylistic analysis to bear on Cézanne's works. The tone of the book is severe and emphatically rational, for it was his conscious intention to wipe the slate clean of confused speculation and dogmatic, theoretical constructs:

> Much has been written about Cézanne, almost all of it with polemical intent: to praise him or condemn him, or even, when the author was an artist, to justify his own painting. There is no denying that, given the public's general incomprehension, it was necessary to demonstrate Cézanne's importance in the history of taste by establishing connections between his art and the art that came after. But the time has come for us to break free of these prejudices, to adopt a stance of indifference toward the "modernity" and "contemporary character" of the master's art, to distinguish his theory and his taste from his art, and the individual man from his personality as an artist, so that we may concern ourselves exclusively with the ways in which his manner of feeling was realized in painting. We should speak of him as we do of Giotto, or Titian, or Rembrandt. We do not question whether or not they were artists; we seek to understand how they were artists. This is the only way to bring to a close the series of chronicles and histories of an oratorical cast and commence a series of studies of his true history as an artist. (Lionello Venturi, *Cézanne, son art—son oeuvre*, 2 vols., Paris, 1936, vol. 1, p. 13)

According to Venturi, nearly all attempts to interpret Cézanne as a proto-Symbolist (beginning with those of Gauguin, Bernard, and Denis) and, in his own generation, as a necessary bridge to Cubism were misguided and essentially distortive.

> In any case, the most serious critical error is not so much having classed Cézanne as Symbolist, neo-Impressionist, mystical, neoclassical, or Cubist; it is

having proclaimed that he was a precursor of all the tendencies to have appeared in painting after him, a very great precursor, but *only* a precursor. Everyone who made this proclamation reserved for himself the role of Messiah. This is how the original legend of Cézanne's impotence did all its damage; those who derived profit from Cézanne's theories lost view of his absolute value as an artist.

> One need only cite a passage from Baudelaire to reduce these people to silence: "An artist is answerable only to himself. He promises nothing to the centuries to come save his own works; he stands caution only for himself. He dies childless. He has been his own king, his own priest, and his own god." (Ibid., vol. 1, pp. 14-15)

Venturi tartly observes that as early as 1895, Thadée Natanson, in his review of Vollard's great exhibition, had grasped the absolute completeness of Cézanne's pictures as well as their ravishing unity with nature, but no one was listening.

> Thus Cézanne's phrase about the cylinder and the sphere must be read in light of his "sensation" if one wants to avoid a ridiculous falsification of his thought. To M. Bernard, who sought an artistic order outside reality in rhetorical abstraction, to all the Cubists or pseudo-Cubists who thought they were basing their abstractions on the so-called principles of Cézanne, Cézanne himself, in the last year of his life, when he was weighing the sum total of his experience, opposed the teaching of Pissarro, that is to say the Impressionist principle of the natural sensation. The error committed by almost all critics who have concerned themselves with Cézanne dissolves in the light of these last letters, of these effusions about nature, of his contempt for everything in art that's not [the product of] individual, fundamental intuition, free of all preconceived ideas sanctioned by school or science. The truth was easy to grasp from looking at Cézanne's paintings, but an error caused by criticism and by the "interviews" with Cézanne prevented its being seen. The time has come to affirm that the spiritual world of Cézanne, until his life's last hour, was not that of the Symbolists, nor of the Fauves, nor of the Cubists; but that this world was associated with that of Flaubert, Baudelaire, Zola, Manet, Pissarro. Which is to say that Cézanne belongs to the heroic period of art and literature in France that managed to find a new path to the natural truth by going beyond, by realizing, by transforming romanticism into an eternal art. In the character as in the work of Cézanne, there is nothing that's decadent, nothing that's abstract, no art-for-art's sake, only an indomitable natural impulse to create art. (Ibid., vol. 1, p. 45)

Venturi's Cézanne is very much the man who (writing to his son on September 13, 1906), expressed regret about Émile Bernard's inability to grasp "the idea, so sound, so

reassuring, the only right one, of developing one's art in contact with Nature,"[46] a phrase Venturi quoted on two occasions in his introduction to the catalogue raisonné.

Both Venturi's views and his sharply authoritative tone mellowed with the passage of time, partly, no doubt, because he saw that Cézanne was beginning to occupy his rightful place in the history of art. In many of his later writings, including a book on the artist left unfinished at his death in 1961,[47] one has the sense he is retreating from the isolated, messianic figure of his 1936 Baudelaire quotation[48] in favor of another, more conventional Cézanne, squarely situated in history (which for Venturi was almost always the "history of taste"): Cézanne as the father of "modernism."

In a series on Giorgione, Caravaggio, Manet, and Cézanne intended for a popular readership and published by Columbia University in 1956 as *Four Steps Toward Modern Art*, Venturi, surprisingly, begins as follows:

> When we speak of modern art in the sense of the art of today or of the first half of the twentieth century, we must admit that cubism has dominated the whole period. . . . Cubism descends from Paul Cézanne. (Lionello Venturi, *Four Steps Toward Modern Art: Giorgione, Caravaggio, Manet, Cézanne*, New York, 1956, p. 61)

However much he refined his historical and contextual reading of Cézanne, Venturi continued to view him as the personification of "modern moral beauty," as a painter who

> could so abstract his style of form and color from any given experience of nature and yet convey through his abstractions so profound an interpretation of the nature of things, that every artist and also many laymen have in the last forty years seen nature with the eyes of Cézanne himself. (Lionello Venturi, *Painting and Painters: How to Look at a Picture, from Giotto to Chagall*, New York, 1945, p. 179)

The most astute and constructive review of the Venturi catalogue raisonné was by a young German scholar then residing in Paris: John Rewald (1912-1994). As Rewald noted, Venturi's book "inaugurate[d] . . . a new era in Cézanne studies."[49] Rewald had just completed his dissertation at the Sorbonne on the relationship between Cézanne and Zola;[50] he was to become the direct heir of Venturi and one of the principal players in this new era, to which he contributed an invaluable edition of the letters, photographs of sites painted by Cézanne, and many other publications on works by the artist as well as documents relating to him.[51] Extremely skeptical about the utility of art theory and aesthetics, alert to the abuses that follow from adopting an extreme point of view, he focused exclusively on matters that could be securely documented. The result is a body of scholarship that laid the foundation of modern Cézanne studies. Pragmatic, empirical writing like Rewald's does not readily lend itself to excerpted quotation, but the following passage from his article on

Cézanne's art theory will serve to convey something of its practical, down-to-earth tone:

> Realizing that it was too late for him to form pupils, Cézanne decided to leave to posterity what might be called a system of painting. Despite his frequently expressed contempt for theories, he now did not hesitate to formulate some of his own, glad to be sought after and to have his advice esteemed. (John Rewald, "Cézanne's Theories about Art," *Art News*, November 1948, p. 31)

Considering, for example, Cézanne's advice that a better grasp of the model could be obtained by artists' trying to "see in nature the cylinder, the sphere, the cone, putting everything in proper perspective, so that each side of an object or a plane is directed toward a central point," however, Rewald concluded:

> This theory, which preoccupied Cézanne during his last years, is the outcome of his study of planes and volume. In Cézanne's work, however, one finds neither cylinders, cones, nor parallel and perpendicular lines, the line never having existed for Cézanne except as a meeting place for two planes of different color. One might thus be permitted to see in this theory an attempt to express his consciousness of structure beneath the colored surface presented by nature. It was this awareness of form that detached Cézanne from his Impressionist friends. But nowhere in his canvases did Cézanne pursue this abstract concept at the expense of his direct sensations. He always found his forms in nature and never in geometry. (Ibid., pp. 31-32)

Although Meier-Graefe had been the first important critic to make Cézanne known to German readers, he was considered by many a francophile, which posed the risk of alienating nationalist supporters of local artistic traditions. The next generation was served by a sterner, more explicitly dialectical author fully versed in the German philosophical tradition who was to construe Cézanne in terms quite different from those favored by the flamboyant and cosmopolitan Meier-Graefe: this was Fritz Novotny (born 1902).

Novotny's first article on Cézanne dates from 1929,[52] but it was his fifteen-page introduction to the 1937 Phaidon volume of reproductions of works by Cézanne, published simultaneously in Vienna and New York, that first reached a large public.[53] The ideas given there were subse-

46. Venturi, 1936, vol. 1, p. 45.
47. Venturi, 1978. This includes the completed portion of the manuscript as well as a perceptive introduction by Giulio Carlo Argan.
48. Venturi, 1936, vol. 1, p. 15.
49. Rewald, March-April 1937, p. 53.
50. Rewald, 1936 (still the finest biography of the artist). See also Rewald, 1939; Rewald, 1948; Rewald, November 1948, pp. 29-34; Rewald, 1950; Rewald, 1968; Rewald, 1986 (a); and Rewald, 1990.
51. The most complete list of Rewald's publications is in Rewald, 1986 (b), pp. 277-85.
52. Novotny, 1929.

quently expanded into a monumental study that appeared in 1938, *Cézanne und das Ende der wissenschaftlichen Perspektive*.[54]

In his reading, Cézanne is a major genius—the most influential and innovative artist since the Renaissance, one who completely changed the course of painting. Novotny builds his case with great skill, displaying a rhetorical flair that, while sometimes skirting dogmatism, often manages to convert the reader to his own passion for his subject. He makes his position perfectly clear in the first paragraph of the book's foreword:

> This essay discusses two problems in the course of a single investigation. The first part deals with the structuring of space in Cézanne's landscape paintings. In the second part, in what is only a brief and very cursory historical overview, I attempt to compare Cézanne's way of breaking down the conventions of scientific perspective, one that would greatly influence further developments, with analogous practices to be found in earlier periods of "painterly" painting, or since the art of Titian. (Fritz Novotny, *Cézanne und das Ende der wissenschaftlichen Perspektive*, Vienna, 1938, p. vii)

Using the site photographs published by John Rewald and Léo Marschutz just two or three years earlier,[55] Novotny begins by stressing Cézanne's essential realism, his complete lack of invention in the sense of "picturesque Impressionism," and his fidelity to the landscape motifs he chose to depict, no less than 133 of which are inventoried in an appendix. But Novotny maintains that, in the course of rendering these motifs into singularly palpable objects, Cézanne has invented a new kind of painting. His systematic breakdown of the distinction between color and drawing, between hue and outline (and the double role of outline as form), introduced an entirely new kind of aerial perspective. Certain artists who came after him—Novotny seems to have the Cubists in mind—would understand his approach to be one of abstraction, and this interpretation brought new artistic horizons within their view. But the key word in Novotny's own account of this process is "reduction,"[56] by which he means something akin to distillation. According to him, the term "abstraction" is inadequate to describe what Cézanne was about; the artist often sought "representation of the elemental," but this was something quite distinct from and more spiritual than any empirically based formalism.

In Novotny's account, Cézanne's picture-making becomes a rather joyless enterprise in which he remained aloof and strictly objective. He contrasts what he sees as Cézanne's "lack of pleasure in the reproduction of substance, or at least in the direct reproduction of material beauties," with the "sensuality of impressionist rendering."[57] In the artist's landscapes, his method led to a complete elimination of *Stimmung* (mood or atmosphere):

> The element of mood, which is found in some form or other in all European landscape painting from the beginnings until the end of impressionism and which before the appearance of Cézanne seems to be an indispensable part of the interpretation of landscape, is completely excluded from his landscapes. In them there is no mood, whether in the form of expression of temperament or for the purpose of interpreting definite landscape situations or phenomena, and it is lacking because Cézanne's art is the very antithesis of expressive art. . . . [This] marks a turning-point of the highest importance in the history of intellectual development. (Fritz Novotny, *Cézanne*, 2nd ed., New York, 1937, p. 10)

Novotny saw the absence of expressive qualities as having a negative effect on Cézanne's portraits, but its impact on figure subjects was far worse. These compositions were not based on the direct observation of nature but were rather the products of his imagination; as a result, they are often "puppet-like" and empty.[58]

However, Novotny's dialectical method led him to characterize another, "romantic" side of the artist's temperament:

> Certainly it would be quite wrong to assume that elements like the spiritual expression of a human countenance, the "Stimmung" of a landscape, the material charm and the secret life of a "nature morte" are completely banished from Cézanne's art. . . . [But in the end,] all these traits, all these external forms of thematic and temperamental significance, play a very curious part in the ultimate formation of the picture: they are covered up and submerged by those effects of opposite tendency, which are certainly too complicated to be adequately defined by such expressions as aloofness from mankind or from life. (Ibid., pp. 10-11)

Novotny's Cézanne is a maker of something that transcends conventional images:

> One of the leading characteristics of Cézanne's art is the new kind of relationship between the illusion value of the representation and the impression which the picture creates as a structural form. If we compare it with examples of impressionism, a picture by Cézanne is to a much higher degree a structural form. (Ibid., p. 11)

And here Novotny introduced the most clearly articulated and decisive move in his argument, positing that in Cézanne's work the relationship that holds "between pictorial plane and space" is altogether new.

> Cézanne's pictures . . . are not flat in the sense that they have only a limited extension in depth, nor do they give the flat impression of decorative painting. On the contrary space does exist in his pictures, but a form of space which despite its depth and intensity nevertheless makes it difficult for the beholder to enter into the spatial construction. (Ibid., p. 11)

The key to this process is color (as opposed to the dominance of "composition" and "outline drawing" characteristic of earlier art)—specifically, color manipulated in complete union with drawing:

> These individual patches of colour, as small constructional parts of the picture, are the real supports of the pictorial structure in Cézanne's painting. And it should be noticed that this is found for the first time in Cézanne, for the impressionistic technique of streaks and patches was employed in the service of an individualized reproduction, rich in details, of objects and space, and secondly this painteresque molecular structure, which reduced the value of the individual object, had yet a material significance: the atmosphere inundated with light. The structure on the basis of small component parts, as evolved in the painting of Cézanne, first marks the completion of this movement which in the course of the development of European painting led further and further away from that pictorial world composed of independent objects and individual forms. The predominance of formal and especially of chromatic combinations over the individual bodies depicted, whether living beings or inanimate images, now becomes much stronger, because there was no longer any concrete counterpart, such as the atmosphere, to this painteresque conception of the elemental. This gives rise to the often noticed impression that in Cézanne's pictures the objects appear to form themselves before our eyes, to grow out of the surface of the picture and to dissolve themselves in it again. (Ibid., p. 12)

Novotny's most incisive passages about Cézanne's innovations are those that analyze his dissolution of the image, his replacement of individual forms by a unity devised by means of "modulation" (Cézanne's own term). This is what is sometimes described as Cézanne's way of "drawing" with color, and, according to Novotny,

> its intent is not so much to isolate the object it encloses as to form the connecting link between two contiguous colour-values. Hence the hesitation, the continual reappearance and dying away of outlines in Cézanne's painting, the blurring of the contours

which do not everywhere correspond to real reflected or cast shadows. . . .

> The composition, that is to say the arrangement of the larger unities in plane and space, was subject to the most radical alterations: in Cézanne's pictures there is no longer any composition in the ordinary sense of the word, and this is one of the most revolutionary transformations in the history of the development of painting. One might almost believe that with his "consolidation of Impressionism" Cézanne created a new form of monumentality. . . .

> The principal specific characteristics here mentioned as forming part of Cézanne's pictorial method are very well suited to serve as elements for the construction of an abstract painting. And really one way taken by the followers of Cézanne led to the same end. But in the art of the master himself these characteristics have not this function; on the contrary all the effects of the relations of form, all the life of the pictorial organism, which is created out of the wealth of modulations of colour, out of the reciprocal reactions of plane and space, is brought into relation with the world of objects and serves to create objects. (Ibid., pp. 13-14)

With more than a nod to the Kantian *Ding an sich*, or "thing in itself," which can be sensed behind his philosophically inflected prose at every step, Novotny maintained that Cézanne felt no need to look beyond the real, that indeed he abandoned any "assistance of associations," and went about his artistic work "without being brought into relationship to some realm of thought, either generally religious or subjective, transcending reality."[59]

Novotny's Cézanne is an impressive construct, and he continued to honor it in his many subsequent publications on the artist.[60] His reading is unable to contend with the early pictures, but it works well as a guide to the landscapes and, to a lesser degree, the still-lifes. The figurative works prove more resistant to its powerful logic, which is true even in the essay that he contributed in 1977 to the catalogue accompanying the Cézanne exhibition at the Museum of Modern Art, which concludes as follows:

> It is obvious that truth to nature is given up in Cézanne's series of *Bathers*, with their freely invented landscape elements that look like stage sets. Whatever significance these pictures have in the history of painting, they are not the works that represent the consummation of Cézanne's career. For that we must turn to the turbulent, ecstatic last views of Mont Sainte-Victoire in the distance—the stirring climax of Cézanne's art, together with the late forest landscapes of timeless peace and breathless quiet. (Novotny, "The Late Landscape Paintings," in *Cézanne: The Late Work*, New York and Houston, 1977-78, p. 111)

Novotny's formal analyses of the construction of Cézanne's landscapes and the precision of his language are, essentially, unprecedented in modernist criticism.

53. Novotny, *Cézanne* (Vienna and New York, 1937). This publication has had remarkable staying power, appearing in three postwar English-language editions (London, 1947 and 1961, and Oxford, 1978).
54. Novotny, 1938. An excerpt was published in *Beaux-Arts*, December 31, 1937, p. 5. A reprint (Vienna, 1970) attests to the continuing influence of Novotny's work on Cézanne.
55. Rewald and Marschutz, January 1935; and Rewald and Marschutz, August 1936.
56. Novotny, 2nd ed., 1937, p. 7.
57. Ibid., p. 9.
58. Ibid., p. 8.
59. Ibid., pp. 14-15.
60. See Novotny, "The Artist's Approach," in Vienna, 1961, pp. 11-16; and Novotny, "The Late Landscape Paintings," trans. Ellyn Childs Allison, in New York and Houston, 1977-78, pp. 107-11.

Content, in the conventional sense—and therefore all subjective and associative elements—is the victim: "In Cézanne's painting content and approach are extremely closely interrelated. . . . The apple and the plate, the house and the copse, are each somehow subordinated to a superior element."[61]

It would be unfair to hold Novotny responsible for what was to follow him, but it is worth examining the comments of Hans Sedlmayr (1896-1984) in his book *Verlust der Mitte (Art in Crisis: The Lost Centre)*, which in the late 1940s and 1950s won a large readership in both German and English.[62] Sedlmayr, extrapolating selectively from Novotny's ideas in ways consistent with his own dark theories about the collapse of any ordered relationship between art and life in the modern world, noted:

> It has always been felt that Cézanne's painting was something of a key to the understanding of modern painting as a whole, but the real position of his art, which stands apart both from expressionism and impressionism, has only become clear as a result of the most recent research. . . .
>
> The essential aim of Cézanne then is to represent what "pure" vision can discover in the visible world, vision, that is to say, that has been cleansed of all intellectual and emotional adulteration. . . .
>
> The magic that pertains to this way of looking at things is that even the most ordinary scene acquires a strange and original freshness. . . . But precisely because he confines us wholly to the experience of the eye, he also to some extent shuts off from us the very world that the eye beholds, and makes it impossible for us really to feel our way into it. (Hans Sedlmayr, *Art in Crisis: The Lost Centre*, London, 1957, pp. 129-32)

As Novotny had noted previously, this total absorption into the visual "demands a mode of behaviour which in life can only occur under certain very exceptional conditions, *it demands a state of complete dissociation and disinterestedness on the part of the spirit and the soul from the experiences of the eye.*"[63] In other words, it calls for an *"eruption of the extra-human."* And other painters followed in this path:

> Soon after Cézanne, Seurat was to represent man as though he were a wooden doll, a lay figure, or au-

tomaton, and still later, with Matisse, the human form was to have no more significance than a pattern on wallpaper, while with the Cubists man was to be degraded to the level of an engineering model. . . . It is at this point that the behaviour of these allegedly "pure" painters borders on the pathological. . . . It is also at this point that the whole world begins to become unstable, for when things are mere phenomena that have no meaning inherent in them, then they begin to be experienced as things without stability, things fleeting, wavering, bodiless and undetermined. (Ibid., p. 134)

Sedlmayr proposed the following solution:

> As to art, some time, perhaps a very long time, may have to elapse before the empty place in the midst of its world can be filled—and if indeed it is to be filled, we must keep alive the thought that in the lost centre the empty throne awaits the perfect man. (Ibid., pp. 255-56)

These bleak views, linked to Nietzsche and what would follow, have had little influence. By contrast, the scholarly rigor of the young John Rewald and the probing analyses of Novotny did find emulators in postwar Germany. To cite one example, Gertrude Berthold's exhaustive examination of Cézanne's relationship to earlier art has cast considerable light on Cézanne's creative process.[64]

Postwar Reconsiderations

In the tradition of Novotny, Kurt Badt (1890-1973) grappled with Cézanne on a titanic level.[65] He began as a specialist in Milanese Renaissance painting, and the subjects of his publications range from Poussin to Vermeer, from color theory to notions of space and imaginative cognition.[66] In his writings on Cézanne, he drew from the fields of contemporary psychology and philosophy, especially Existentialism and its sources,[67] and advanced his opinions in a style that is often combative and polemical:

> Interpretations of the inner motives which caused him to paint as he did are still very unsatisfactory, and the significance of his aims—which every artist reveals in the works he creates—is still largely obscure. (Kurt Badt, *The Art of Cézanne*, New York, 1985, p. 21)

> Is his work incomprehensible and inherently contradictory when regarded as a whole, significant though each small fragment may be? Is it perhaps as great as it is just because it says everything that can be said about the conflict between art and an era hostile to art? (Ibid., p. 20)

61. Novotny, in Vienna, 1961, pp. 14-15.
62. Sedlmayr, *Verlust der Mitte—Die bildende Kunst des 19. und 20. Jahrhunderts als Symptom und Symbol der Zeit* (Salzburg, 1948); English-language edition, *Art in Crisis: The Lost Centre*, trans. Brian Battershaw (London, 1957). The writing of this book coincided with lectures given by Sedlmayr in 1941 and 1944.
63. Sedlmayr, 1957, p. 134.
64. Berthold, 1958.
65. Badt, *Die Kunst Cézannes* (Munich, 1956); English-language edition, *The Art of Cézanne*, trans. Sheila Ann Ogilvie (London and Berkeley, California, 1965; reprint, New York, 1985).
66. For useful introductions to Badt's writing, see Gosebruch, 1961; and Gosebruch and Dittmann, 1970.
67. Notably, the thought of Karl Jaspers, as demonstrated in Wechsler, 1972, pp. 72-76.

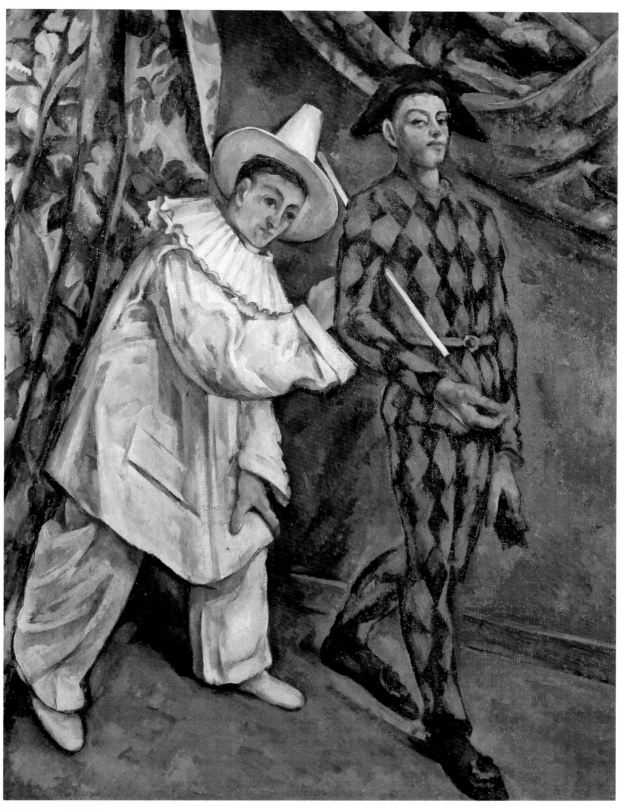

Paul Cézanne, *Mardi Gras*,
1888, oil on canvas,
Pushkin Museum, Moscow, former Shchukin Collection (V. 552).

The biography of Cézanne is presented as a Via Dolorosa:

> This road started out from a revolt, and then a genuine "conversion" took place. . . . The metaphysical presence of God was always real to Cézanne when he was painting, though for that very reason he seldom mentioned it. (Ibid., p. 31)

> Cézanne himself has given sufficient indication that a number of his pictures can be understood as symbolical representations of some of the events of his own life to induce me to interpret them thus and to feel justified in doing so. . . . Loneliness played a great and significant rôle in his art. (Ibid., p. 131)

> About the middle of the nineteenth century a radical and general transformation took place which plunged the artist's whole existence into a still deeper, hitherto unknown degree of isolation. The classical school was dying and romantic painting had proved incapable of forming a school, with the result that the artist's last conceivable anchorage was crumbling away. (Ibid., p. 136)

For Cézanne, liberation from this emphatically modern condition required a radical act:

> It meant a true renunciation of his former ego, a release from hate and rage. . . . [It was] an event brought about by faith. . . . Yet this element of sacrifice in Cézanne's conversion is precisely what entitles him to be regarded as one of the great minds of his century—one of those who . . . accepted a state of loneliness as being the real and true condition of man, and who then set out from this "lost stronghold" to seek a way to reunite man with the transcendental. (Ibid., pp. 142-43, 147)

> The humility which he took upon himself, the passive self-abandonment to creative work, the complete exclusion of his own feelings, of his own vanity (in contrast, as it were, to Manet and Delacroix), of his personal will (in contrast to Van Gogh and all the later artists)—all these are qualities which have been extolled by those who have had mystical experiences, as ways leading to the understanding of the truth. (Ibid., p. 148)

> In the deep night of loneliness in which everything disintegrates he became convinced that there was a divine value and significance in the very fact of being in existence, and that the essence of the reality of things lay in this "existing." (Ibid., p. 149)

This explains the profound "distance" of the portraits (they have no secrets) and the complete unity and permanence of the *Bathers*.[68]

The spiritual content of Cézanne's art was something which was in effect if not in subject religious; it was a belief in the eternity of "being," an eternity which he once *believed* was "in God," which he then later *observed* in the realness of the world and *portrayed* in his works as a new type of interrelationship between things and as their "existing together." (Ibid., p. 156)

As to Symbolist literature and its purpose, Badt affirms that Cézanne was drawn to its

> spiritualization, his constant worry was to evade the rhetoric, the pathos and the exteriority of the picture of everyday. He looked for the mystery, which leads out of the appearances behind appearances with a mixture of mystery and candour and which makes description impossible, in order to reveal truth through the beauty created by the artist. (Ibid., p. 271)

Badt sees Cézanne as the great synthesis between Rubens and Poussin:

> He unconsciously accomplished the closing of the rift within French painting. That is the reason why Cézanne towers so far above his contemporaries, why his work appears so incomparable. (Ibid., p. 322)

And in this sense, Cézanne closed the past and opened the future for painting.

Criticism in America before 1950

Judging from the large number of translations and new editions, European and English critical writing on Cézanne found a ready audience across the Atlantic, although it could be argued that the showing and acquisition of works by Cézanne was, in the United States, far in advance of any formulation of critical viewpoints.[69] Certainly Cézanne and modernism were linked from the start. One of the pamphlets published to coincide with the Armory Show in 1913 in New York—America's first overview of progressive European art—was a paean to Cézanne written in 1910 by Élie Faure (1873-1937):

> All the young men who love painting, in this generation, have more or less consciously solicited the counsel of this rough and subtle art. Most of them have thought they must submit themselves to the letter of his teaching,—by voluntarily inflicting twists and fractures on the form, by peopling imaginary landscapes with nudes that look like bursted sausages or by installing on the edge of a table a glass of wine and three onions. Some, penetrated by his spirit, have resolutely approached nature with the sole preoccupation of demanding from her—aside from all literary or moral intentions and tendencies—the secret of pure coloration and the essential structure which will permit the men of to-

morrow to bring back her great decorative rhythms. Never since Rubens perhaps has a painter awakened such fervor in the world of artists. (Élie Faure, *Cézanne*, trans. Walter Pach, New York, 1913, pp. 69-70)

The translator of this text was Walter Pach (1883-1958), an artist and critic who had been living in Paris and was aware of the current of many of the new ideas in circulation there. He became one of modernism's foremost advocates in New York and, while the shades of Bernard, Denis, and Fry can be sensed behind his writing, it has a no-nonsense urgency that can generate novel insights:

> [Cézanne] continues to paint from nature until the end of his life; but the slightest sketch of his later years shows his growing preoccupation with the aesthetic qualities of the picture. Herein lies the difference between him and the Impressionists. With the latter, one feels that the limits of the picture, and its subdivisions, were imposed from without, by the aspect of the scene portrayed; the oppositions of the colors were used to produce effects of luminosity, again an external thing: what gives the picture its life is the splendid instinct of the artist who transcends his theory in the excitement of his work. . . . Cézanne's immense authority proceeds precisely from his having rendered comprehensible to the next generation the laws of picture-making which the haste and confusion of the nineteenth century had obscured. Needless to say, these laws are such as can never be written down; they are the principles, perceived by the mind without the intermediation of words, which govern the productions of the masters of all times and races, the principles which differentiate the work of art from everything else in the world. (Walter Pach, *The Masters of Modern Art*, New York, 1929, pp. 41-42)

The same down-to-earth tone pervades Gerstle Mack's biography of Cézanne, first published in New York and London in 1935; a French edition appeared in 1938. For several generations this was the most accessible book on the artist.[70]

Mack (1894-1983) set out to write an "exhaustive" biography, but in retrospect his book seems not very far from a typical product of 1930s America and its romance with tough-guy straightforwardness:

> Numerous inaccuracies and misconceptions have crept into the record, where they have become crystallized in a Cézanne legend . . . while the true (and far more interesting) inner nature of the man has

been lost sight of. (Gerstle Mack, *Paul Cézanne*, New York, 1935, pp. v-vi)

Describing Cézanne, he sided with Zola against Vollard:

> He was not one of those fire-eating rebels who love insurrection and conflict for their own sakes, but a timid, sensitive soul with a profound respect for authority. (Ibid., p. 200)

Further on, he quoted Walter Pach at some length on Cézanne's "revolt against realism":

> Cézanne, superimposing color upon color to get their cumulative effect, watching the reverberation throughout his canvas of each new touch, was performing a mental operation similar to that of the musician, whose material, farther removed from the imitative than is the painter's, arrived much sooner at its purity as an agent of expression. Since form, more than color, renders the thing seen, Cézanne's organizing of the lines and planes of his pictures will stand as an even greater achievement than his work with color. A certain latitude has usually been permitted the colorist in his search for harmony—which has been pretty generally understood as the object of his effort. But drawing, "the probity of art," was another matter. For many hundreds of years, since the decline of Byzantine art, Europe had been working for an ever-greater completeness of representation; and Cézanne himself, when his need for an aesthetic structure forced him to modify, in his painting, the physical structure of objects, was tortured with doubts about his procedure. Yet he went on, always in the same direction, making a constantly more rigorous elimination of the sensations which to him represented only accidents of vision and which were not essential to the new organism he was building up. (Ibid., pp. 309-10)

Mack soon saw the difficulty of this notion and proceeded to a simplistic answer to his own dilemma: "Cézanne's daring conception of the abstract in art was in eternal conflict with his devotion to nature," bringing home his argument with a conclusion that makes Cézanne's achievement appear uneven at best:

> Sometimes he succeeded in balancing the two elements so perfectly that the mental struggle involved is scarcely perceptible, as in the serenely beautiful *Lac d'Annecy* [cat. no. 174], painted in 1896. But more often the effort to bring the *motif* into harmony with the laws of abstract composition is apparent, to some extent, in Cézanne's canvases. (Ibid., p. 311)

From there his arguments fall of their own weight, or rather, his position inevitably entails a complete reassessment of Cézanne's stature, which Mack duly provides:

68. Badt, 1985, p. 153-55.
69. See Rewald, 1989.
70. Mack, 1935. Rewald, 1936 is much closer to its subject, but it acquired a large readership only with the English edition of 1948. For a perceptive comparison of the two books, see the text signed "G. W." [Georges Wildenstein] in the *Gazette des Beaux Arts*, 6th ser., vol. 20 (September 1938), p. 133.

This handicap [Cézanne's dependance on observed nature] was due in part to an inherent lack of a certain kind of imaginative power—a congenital inability to evoke a clear mental image of an object that was not there—and in part to the defects of his early training. If in his youth he had undergone the rigorous discipline administered to the apprentices in an artist's workshop during the Italian Renaissance, for example, it is probable that the disability could have been overcome to a considerable extent. But unfortunately the haphazard, go-as-you-please Académie Suisse offered no such discipline, and Cézanne remained tied to his model until the end of his days. (Ibid., p. 312)

The reticence of this Cézanne who could not function outside a direct reference to his motif inevitably leads to great difficulties with those works, such as the Bathers, which, of necessity, are drawn from memory and imagination.

The second widely read American publication to appear in the 1930s is a book by Dr. Albert Barnes (1872-1951), the most important American collector of Cézanne. He was a man deeply influenced by a rather naive formalism derived from Fry, which he combined with John Dewey's ideas about the psychology of perception and the learning process. The result is an idiosyncratic variation on the formalist tradition that can accommodate both the constructive role of perception and the optimism of "universal values." Barnes maintained that his was a scientific method, that he was recording objectively observable physical phenomena of paintings, but he allowed that the success of any such process depended "upon the endowment and training of the investigator, the sensitiveness of his perceptions, the acuteness of his intelligence, the accuracy of his discrimination between essential and accidental."[71]

> The essential and fundamental effect of Cézanne's form, in its best estate, is the quality of power, rendered in legitimate painting terms. . . . Cézanne, taking the dynamic relation of planes and solid color-volumes in deep space as the principal theme of his paintings, does not duplicate sculpturesque surface-effects or devices, and the intensity of drama in which his power largely resides is practically independent of represented action. Except in the pictures of his apprenticeship, influenced by Tintoretto, the late Venetians, the Spaniards, Delacroix, Daumier, Courbet, and Manet, and painted before he had mastered the traditions and made them his own, the illustrative aspect of his work is relatively negligible. There is in his mature work abundance of movement, but it is plastic activity, that is, the result of the interplay of the essential components of the form, not depicted narrative. (Albert C. Barnes and Violette de Mazia, *The Art of Cézanne*, New York, 1939, p. 3)

"The term which most accurately describes Cézanne's form is architectonic." And in his distillation to essential forms, Cézanne,

> though a very great artist, was also exceedingly circumscribed in the range of his perceptions and of his effects. He was, in addition, limited also in his capacity for growth: he mastered his difficulties slowly and he seldom conquered all of them entirely. He did develop and modify his technique, but neither steadily nor consistently, and he constantly reverted to his earlier immature methods. His natural command of the medium of paint was not great, and in relatively few pictures did he attain to a uniformly high level of craftsmanship. (Ibid., pp. 4-5)

Barnes was capable of considerable emotion on the subject of Cézanne:

> Because of the power in himself, he had an incomparable eye for power in nature, for the qualities which can make the simplest material object seem massive, immovable and immutable. Because of it, he discarded in his work all the aspects of things which are accidental, superficial or fugitive—the play of light as it changes from hour to hour or from season to season, the expression of transient emotion on a human face, as well as all preoccupation with incident or narrative. (Ibid., p. 106)

Barnes was not afraid of celebrating his hero:

> Whatever his difficulties, frustrations and doubts about himself, Cézanne did in essentials bring his romanticism to fruition, make his dreams a part of nature itself. (Ibid., p. 108)

Regarding Cézanne's influence, Barnes thought that Cubism

> would never have existed but for Cézanne. . . . There can be no graver error, however, than to assume that the cubists, in building on what are indubitably basic elements in Cézanne's form, either attain to its esthetic essence or produce pictures of great intrinsic importance. (Ibid., pp. 126-27)

Much of Barnes's writing is optimistically premised on the possibility of developing a universally applicable mode of analysis. A comparable utopianism underlies *Cézanne's Composition: Analysis of His Form with Diagrams and Photographs of His Motifs* by Erle Loran (born 1905), which has been through four editions since it first appeared in 1943. In this volume, Loran analyzed paintings by Cézanne—primarily landscapes and still lifes—with the aid of diagrams, which he sometimes compared with views of the actual sites.

> No doubt this diagrammatic approach may seem coldly analytical to those who like vagueness and

poetry in art criticism. To those who want pleasant reading and rhapsodical flights of the imagination, I can only recommend the essays of Meier-Graefe and Elie Faure. (Erle Loran, *Cézanne's Composition: Analysis of His Form with Diagrams and Photographs of His Motifs*, 2nd ed., Berkeley, 1946, p. 1)

Loran is engagingly frank about the discrepancy between his ideas and those recorded in Cézanne's letters and the published "conversations":

I must confess that I have never been able to correlate Cézanne's statements of aesthetic theory into any pattern that would fit the interpretation I now give to his work. . . . Now, the extraordinary influence that Cézanne has had on Abstract art is markedly bound up with his abandonment of scientific perspective. Cézanne eliminated destructively converging lines, as well as lines that would seem to expand out of the picture plane or beyond the confines of the picture format. (Ibid., p. 8)

And Loran concluded:

Cézanne's historical role has been that of a regenerator. He has brought back into consciousness the basic principles that have given the eternal qualities to the art of his great predecessors. The value of understanding these principles seems obvious. The art of the future cannot fail to be better for learning and accepting them. (Ibid., p. 131)

This strain of American critical thought interacted fruitfully with the contemporary art world in New York during and just after World War II, when the Abstract Expressionists found in Clement Greenberg (1909-1994) one of their most articulate champions. He wrote only one article concerned exclusively with Cézanne,[72] but it can be understood, in one sense, as the culmination of the formalist tradition of Cézanne criticism. According to Greenberg, the artist deliberately excluded "human interest" from his work, but Greenberg's Cézanne is very different from the monumental and static Cézanne of Mack and Loran.[73]

Greenberg argued that Cézanne's mature pictures were shaped by a formal and personal tension resulting from the ultimate incompatibility of his goal of pictorial unity with his Impressionist-derived means (although he criticized Fry for underestimating the degree of formal unity occasionally achieved by the more canonical Impressionists). He made his case in strong language of compelling authority, and his reading of the artist's achievement immediately eclipsed earlier, often ponderous critical attempts to place Cézanne at the threshold to modernism.

Cézanne, as is generally enough recognized, is the most copious source of what we know as modern art, the most abundant generator of ideas and the most enduring in newness. The modernity of his art, its very stylishness—more than a retroactive effect—continues. There remains something indescribably racy and sudden—racier than Dufy, as sudden as Picasso or Matisse—in the way his crisp blue line separates the contour of an apple from its mass. Yet how distrustful he was of bravura, speed—all the attributes that go with stylishness. And how unsure down at bottom about where he was going.

On the verge of middle age Cézanne had the crucial revelation of his artist's mission; yet what he thought was revealed was in good part inconsistent with the means he was already developing under the impact of the revelation. The problematic quality of his art—the source, perhaps, of its unfading modernity—and of which he himself was aware, came from the ultimate necessity of revising his intentions under the pressure of a style that evolved as if in opposition to his conscious aims. He was making the first—and last—pondered effort to save the intrinsic principle of the Western tradition of painting: its concern with an ample and literal rendition of the illusion of the third dimension. He had noted the Impressionists' inadvertent silting up of pictorial depth. And it is because he tried so hard to re-excavate that depth without abandoning Impressionist color, and because his attempt, while vain, was so profoundly conceived, that his work became the discovery and turning point it did. Completing Manet's involuntary break with Renaissance tradition, he fell upon a new principle of painting that carried further into the future. Like Manet and with almost as little appetite as he for the role of revolutionary, he changed the course of art out of the very effort to return it by new paths to its old ways. (Clement Greenberg, "Cézanne and the Unity of Modern Art," *Partisan Review*, May-June 1951, p. 324)

Greenberg characterized Cézanne's relationship to Impressionism in the following terms:

What Cézanne wanted was a different, more emphatic, and supposedly more "permanent" kind of unity, more tangible in its articulation. Committed though he was to the motif in nature in all its givenness, he still felt that it could not of its own accord provide a sufficient basis of pictorial unity; that had to be read into it by a combination of thought and feeling—thought that was not a matter of extra-pictorial rules, but of consistency, and feeling that was not a matter of sentiment, but of sensation.

. . . To accommodate the weightless, flattened shapes produced by the divided tones of Impressionism to such schemes was obviously unfeasible. Cézanne had to fill in his forms more solidly in order

71. Barnes and de Mazia, 1939, p. vii.
72. Greenberg, May-June 1951. Reprinted in Greenberg, *The Collected Essays and Criticism*, vol. 3, *Affirmations and Refusals, 1950-1956*, ed. John O'Brian (Chicago and London, 1993), pp. 82-91. A substantially revised version of this text, retitled "Cézanne," was published in his collection *Art and Culture* (Boston, 1961).
73. Greenberg, May-June 1951, p. 327.

to be plausible in that direction. He set out to convert the Impressionist method of registering purely optical variations of color into a method by which to indicate variations of depth and planar direction *through,* rather than for the sake of, variations of color. Nature still came first, and indispensable to nature was the direct, light-suffused color of Impressionism; gradations of dark and light and the controlled studio illumination of the old masters were unnatural. (Ibid., p. 325)

He summarized the crucial factor in Cézanne's construction of a painting as follows:

> The illusion of depth is constructed with the surface plane more vividly in mind; the surface does not override the illusion but it does control it. The facet-planes jump forward from the images they define, to become more conspicuously elements of the abstract surface pattern. (Ibid., p. 328)

The risk of his analysis is, in retrospect, an oversimplified link to the Abstract Expressionists, whom he so heroically defended. Particularly in the late work, he found that

> monumentality is no longer secured at the price of a dry airlessness. The paint itself becomes more succulent and luminous as it is applied with a larger brush and more oil. The image exists in an atmosphere made intenser because more exclusively pictorial, the result of a heightened tension between the illusion and the independent abstractness of the formal facts. (Ibid., p. 328)

This notion, restrictive in many ways, revitalized and—to use his term—"de-academicized" writing about the artist, opening up a new realm of interpretative possibilities.

Paris After the War

American writing of the 1930s and 1940s sometimes described Cézanne's work in almost mechanistic terms. But the same general approach of exploring formal elements could be employed to quite different ends, as in *Cézanne et l'expression de l'espace* by Liliane Brion-Guerry (born 1916).

> The late *Bathers* canvases . . . represent a culmination of Cézanne's aesthetic and technique. Without the artifice of compromise, in the purity of an irreproachable success, Cézanne attained the synthesis of spatial container and the contained toward which all his efforts had tended since the beginning of his career. He could have accepted the results of his predecessors without discussion, conforming to principles that were tried and tested, integrating the hesitations of his own optic within the reliable structure of classical perspective. [But] this would have been to renounce the uneasiness and joy of individual discovery in favor of the security, and tyr-

anny, of conformity—in other words, to consent to seeing things only through the eyes of others. Despite the aid and facility it initially would have provided, such a compromise was never an option for a seeker so smitten with the absolute as was Cézanne. For him, painting was not a matter of blithely following a path cleared by others but rather one of reconsidering each problem in turn, posing it anew and trying to resolve it as if no one had previously attacked it. Cézanne successfully brought off this *tour de force:* a cultivated painter who frequented the museums, who appreciated the achievements of his predecessors more than most, he obliged himself to forget everything that had been said before him, he looked at nature with new eyes and started painting anew, entirely on his own terms. (Liliane Brion-Guerry, *Cézanne et l'expression de l'espace,* Paris, 1966, pp. 194-95)

In this interpretation, Cézanne's spatial constructions steer clear of fixed schemas and as a result have a "freedom" and a "suppleness" that make them the very antithesis of everything that is mechanical or rigid: they must "forge the laws of [their] own stability."[74]

Brion-Guerry's reading remains true to individual works, and it also manages to convey something of the dynamic process through which Cézanne evolved the intensely interactive method that shaped his mature production. When she wrote about the late works, she described his method in terms that are almost mystical:

> [These works] do not limit themselves to representation of the real. . . . Dream perspectives prolong the approaches to the immediate, and the creator's imaginative deposits discernibly transform the objective givens. (Ibid., p. 197)

She summed up her principle idea as follows:

> In Cézanne, it is not the object that bends to the exigencies of a spatial structure external to it; on the contrary, it engenders this structure itself by means of its own volumetric potency. (Ibid, p. 214)

Brion-Guerry reintroduced a poetic, expressive dimension into discussions about the nature of Cézanne's achievement—a welcome development, given the dry formalist language that had come to prevail.

Much of Brion-Guerry's spirit of grace and expansiveness that led her to see Cézanne as a kind of joyous Mozartian deity was sustained by Maurice Merleau-Ponty (1908-1961) in his justly famous essay "Cézanne's Doubt," first published in 1945 but subsequently included in the 1948 collection *Sens et non-sens* (translated into English in 1964).[75] But there is a crucial difference: he goes one step further in engaging the viewer as a complete participant in the artistic process. As Richard Shiff has noted; "Merleau-Ponty stressed the capacity of one's consciousness *of* an object to become the equivalent of attributing consciousness

to an object, so that a thing might 'think itself' within the perceptual experience."[76]

This "phenomenology of perception" would seem to be an essentially material process, almost a "formal" exercise, with roots in recent developments in science and psychology:

> What we call his work was, for him, only an essay, an approach to painting. . . . His extremely close attention to nature and to color, the inhuman character of his paintings (he said that a face should be painted as an object), his devotion to the visible world: all of these would then only represent a flight from the human world, the alienation of his humanity.
>
> These conjectures nevertheless do not give any idea of the positive side of his work; one cannot thereby conclude that his painting is a phenomenon of decadence and what Nietzsche called "impoverished" life or that it has nothing to say to the educated man. Zola's and Émile Bernard's belief in Cézanne's failure probably arises from their having put too much emphasis on psychology and their personal knowledge of Cézanne. It is quite possible that, on the basis of his nervous weaknesses, Cézanne conceived a form of art which is valid for everyone. Left to himself, he could look at nature as only a human being can. The meaning of his work cannot be determined from his life. (Maurice Merleau-Ponty, "Cézanne's Doubt," in *Sense and Non-Sense*, Evanston, Illinois, 1964, pp. 9-11)

> The use of warm colors and black shows that Cézanne wants to represent the object, to find it again behind the atmosphere. Likewise, he does not break up the tone; rather, he replaces this technique with graduated colors, a progression of chromatic nuances across the object, a modulation of colors which stays close to the object's form and to the light it receives. Doing away with exact contours in certain cases, giving color priority over the outline—these obviously mean different things for Cézanne and for the Impressionists. The object is no longer covered by reflections and lost in its relationships to the atmosphere and to other objects: it seems subtly illuminated from within, light emanates from it, and the result is an impression of solidity and material substance. . . .
>
> . . . His painting was paradoxical: he was pursuing reality without giving up the sensuous surface, with no other guide than the immediate impression of nature, without following the contours, with no outline to enclose the color, with no perspectival or pictorial arrangement. This is what Bernard called Cézanne's suicide: aiming for reality while denying himself the means to attain it. (Ibid., p. 12)

Cézanne did not think he had to choose between feeling and thought, between order and chaos. He did not want to separate the stable things which we see and the shifting way in which they appear; he wanted to depict matter as it takes on form, the birth of order through spontaneous organization. He makes a basic distinction not between "the senses" and "the understanding" but rather between the spontaneous organization of the things we perceive and the human organization of ideas and sciences. (Ibid., p. 13)

On the subject of our assumption that the world exists, "necessarily and unshakeably," he wrote:

> Cézanne's painting suspends these habits of thought and reveals the base of inhuman nature upon which man has installed himself. This is why Cézanne's people are strange, as if viewed by a creature of another species. Nature itself is stripped of the attributes which make it ready for animistic communions: there is no wind in the landscape, no movement on the Lac d'Annecy; the frozen objects hesitate as at the beginning of the world. (Ibid., p. 16)

> Forgetting the viscous, equivocal appearances, we go through them straight to the things they present. The painter recaptures and converts into visible objects what would, without him, remain walled up in the separate life of each consciousness: the vibration of appearances which is the cradle of things. Only one emotion is possible for this painter—the feeling of strangeness—and only one lyricism—that of the continual rebirth of existence. (Ibid., pp. 17-18)

This was Merleau-Ponty's only attempt at sustained aesthetic discussion. When it first appeared in Paris, its lucid phenomenological reading of the artist's work must have had immense force, like a kind of clarion blast. Shortly thereafter, but in New York rather than in Paris, a second thinker published a modest book on Cézanne that had much the same impact, breathing new life and freshness into Cézanne criticism.

74. Brion-Guerry, 1966, p. 196. See also Brion-Guerry, "The Elusive Goal," trans. John Shepley, in New York and Houston, 1977-78, pp. 73-82; and Brion-Guerry, "Arriverai-je au but tant cherché. . . .?" in Paris, 1978, pp. 15-24.
75. Merleau-Ponty, "Le Doute de Cézanne," *Fontaine*, no. 47 (December 1945); reprinted in *Sens et non-sens* (Paris, 1948); English-language edition, *Sense and Non-Sense*, trans. Hubert L. Dreyfus and Patricia Allen Dreyfus (Evanston, Illinois, 1964), pp. 9-25.
76. Shiff, introduction to Gasquet, 1991, p. 23 n. 4.

Cézanne Rediscovered

Starting with a modest introduction and expanded captions to a popular book of illustrations, Meyer Schapiro (born 1904), with great dignity and forbearance, reassembled Cézanne from the essentially fragmenting criticism of the previous twenty years and placed him back on the stage as a whole. Nearly all that was said before is implicitly registered, yet all critical writing is borne lightly. The works of art, lovingly observed and described, carry all the weight. His Cézanne is a product of biography, picture-making, and a range of artistic and intellectual influences; to this Schapiro added a dimension of profound psychological insight, the repercussions of which continue into the present literature. He brought an elevated wisdom, an almost seerlike calm to his subject, writing in stately and beautiful prose of a composite in Cézanne of the objective and the subjective, "the fusion of nature and self."[77] Although this scholar has devoted less than one hundred pages to the artist, these writings, in combination with his lectures at Columbia University, have arguably placed Schapiro at the center of our understanding of Cézanne.

> The mature paintings of Cézanne offer at first sight little of human interest in their subjects. We are led at once to his art as a colorist and composer. He has treated the forms and tones of his mute apples, faces, and trees with the same seriousness that the old masters brought to a grandiose subject in order to dramatize it for the eye. His little touches build up a picture-world in which we feel great forces at play; here stability and movement, opposition and accord are strongly weighted aspects of things. At the same time the best qualities of his own nature speak in Cézanne's works: the conviction and integrity of a sensitive, meditating, robust mind.
>
> It is the art of a man who dwells with his perceptions, steeping himself serenely in this world of the eye, though he is often stirred. Because this art demands of us a long concentrated vision, it is like music as a mode of experience—not as an art of time, however, but as an art of grave attention, an attitude called out only by certain works of the great composers.
>
> Cézanne's art, now so familiar, was a strange novelty in his time. It lies between the old kind of picture, faithful to a striking or beautiful object, and the modern "abstract" kind of painting, a moving harmony of colored touches representing nothing. Photographs of the sites he painted show how firmly he was attached to his subject; whatever liberties he took with details, the broad aspect of any of his landscapes is clearly an image of the place he painted and preserves its undefinable spirit. But the visible world is not simply represented on Cézanne's canvas. It is re-created through strokes of color among which are many that we cannot identify with an object and yet are necessary for the harmony of the whole. If his touch of pigment is a bit

> of nature (a tree, a fruit) and a bit of sensation (green, red), it is also an element of construction which binds sensations or objects. The whole presents itself to us on the one hand as an object-world that is colorful, varied, and harmonious, and on the other hand as the minutely ordered creation of an observant, inventive mind intensely concerned with its own process. The apple looks solid, weighty, and round as it would feel to a blind man; but these properties are realized through tangible touches of color each of which, while rendering a visual sensation, makes us aware of a decision of the mind and an operation of the hand. In this complex process, which in our poor description appears too intellectual, like the effort of a philosopher to grasp both the external and the subjective in our experience of things, the self is always present, poised between sensing and knowing, or between its perceptions and a practical ordering activity, mastering its inner world by mastering something beyond itself. (Meyer Schapiro, *Paul Cézanne*, New York, 1952, pp. 9-10)

There is nothing formulaic or generic here, no "key" to a "problem":

> Cézanne's method was not a foreseen goal which, once reached, permitted him to create masterpieces easily. His art is a model of steadfast searching and growth. He struggled with himself as well as his medium, and if in the most classical works we suspect that Cézanne's detachment is a heroically achieved ideal, an order arising from mastery over chaotic impulses, in other works the conflicts are admitted in the turbulence of lines and colors. (Ibid., p. 10)

Despite its technical diversity and range of subject matter, Cézanne's production is perceived as a whole:

> In his first pictures, painted in the 1860's in his native Aix and in Paris, he is often moody and violent, crude but powerful, and always inventive—to such a degree that in his immaturity he anticipates Expressionist effects of the twentieth century. This early art is permeated by a great restlessness. Impressionism released the young Cézanne from troubling fancies by directing him to nature; it brought him a discipline of representation, together with the joys of light and color which replaced the gloomy tones of his vehement, rebellious phase. Yet his Impressionist pictures, compared to those of his friend, Pissarro, or to Monet's, are generally graver, more troweled, more charged with contrasts. Unlike these men, he was always deeply concerned with composition, for which he showed since his youth an extraordinary gift—he was a born composer, with an affinity to the great masters of the sixteenth and seventeenth centuries in the largeness of his forms, in his delight in balancing and varying the

massive counterposed elements. The order he creates is no cool, habitual calculation; it bears evident signs of spontaneity and the bias imposed by a dominant mood, whether directed towards tranquillity or drama. Some of his last works are as passionate as the romantic pictures of his youth; only they are not images of sensuality or human violence, but of nature in a chaos or solitariness responding to his mood. A great exaltation breaks through at times in his later work and there is an earlier picture with struggling nudes that tells us—more directly than the paintings of skulls and muted faces—of the burden of emotion in this shy and anguished, powerful spirit. Still more, the late works allow us to see the range of his art which transposes in magnificent images so vast a world of feeling. (Ibid., pp. 10-11)

With a freshness of insight, Schapiro offers ideas about the motivations underlying the artist's subject matter:

The choice of landscape sites by Cézanne is a living and personal choice; it is a space in which he can satisfy his need for a detached, contemplative relation to the world. Hence the extraordinary calm in so many of his views—a true suspension of desire. (Ibid., p. 14)

Schapiro agrees with the critics, predominantly German ones, who stress Cézanne's detachment. He describes the Bührle Foundation self-portrait (repro. p. 72): "The suspended palette in his hand is a significant barrier between the observer and the artist-subject."[78]

Yet this has no quality that is "superhuman," in any Nietzschean sense:

The aesthetic as a way of seeing has become a property of the objects he looks at; in most of his pictures, aesthetic contemplation meets nothing that will awaken curiosity or desire. But in this far-reaching restriction, which has become a principle in modern art, Cézanne differs from his successors in the twentieth century in that he is attached to the directly seen world as his sole object for meditation. He believes—as most inventive artists after him cannot do without some difficulty or doubt—that the vision of nature is a necessary ground for art. (Ibid., p. 17)

He allows for the role of projected sentiment in Cézanne's method, and not exclusively in the early work.

But the baroque aspect is only a part of the originality of his late works. What strikes us most of all in the 1890's is the resurgence of intense feeling—it may be related to the new tendencies of the forms

with their greater movement and intricacy. The work of his last years offers effects of ecstasy and pathos which cannot be comprised within the account of Cézanne's art as constructive and serene. The emotionality of his early pictures returns in a new form. . . . The truth is that it had never died out. (Ibid., p. 28)

Discussing Cézanne's process, particularly his method of drawing, Schapiro notes:

Compared with the normal broken line of an interrupted and re-emerging edge, Cézanne's shifting form is more varied and interesting; by multiplying discontinuities and asymmetry, it increases the effect of freedom and randomness in the whole. It is a free-hand construction through which his activity in sensing and shaping the edge of the table is as clear to us as the objective form of the original table. We see the object in the painting as formed by strokes, each of which corresponds to a distinct perception and operation. It is as if there is no independent, closed, pre-existing object, given once and for all to the painter's eye for representation, but only a multiplicity of successively probed sensations—sources and points of reference for a constructed form which possesses in a remarkable way the object-traits of the thing represented: its local color, weight, solidity, and extension. (Ibid., p. 19)

Like others before him, Schapiro ascribes to Cézanne a crucial role in the development of Western painting:

The polarity of styles that had become evident since the seventeenth century in the divergence between the followers of Rubens and Poussin in France and in the nineteenth century between Ingres and Delacroix, was for Cézanne no longer an artistic problem. Both poles were available to him as equally valid conceptions which he discovered within his own experience in looking at nature as well as in the museums. The alternative constructions of depth by parallel or diagonal receding planes were familiar to him very early. As an Impressionist in the 1870's, he painted many views of landscapes with sharply receding houses and roads at the same time that he set up still lifes of a simple formality before a wall parallel to the plane of the canvas. As a youth, he adored Delacroix; but he also painted for the family salon in a linear style a series of panels of the Four Seasons which he signed in mock-heroic spirit with the name of Ingres (perhaps to please the taste of his father whose portrait was in the central field). But unlike those who in admiring both artists supposed that Classic and Romantic were incompatible kinds of art—the art of the colorist and the art of the pure draftsman—Cézanne discovered a standpoint in which important values of both could co-exist within one work. (This was also the goal of the mad Frenhofer, the

77. Schapiro, 1952, p. 10.
78. Ibid., p. 15.

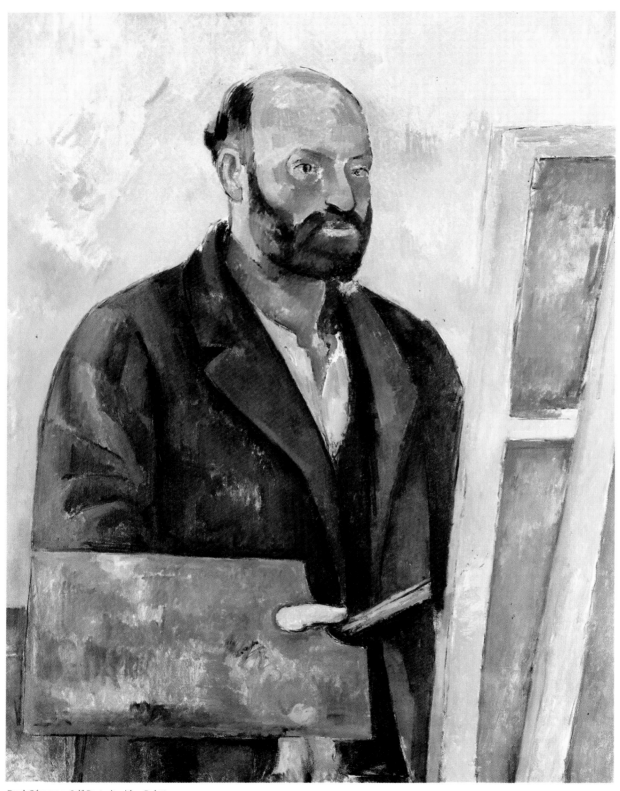

Paul Cézanne, *Self-Portrait with a Palette,*
1885-87, oil on canvas,
E. G. Bührle Foundation, Zurich (V. 516).

tormented hero of Balzac's moving story, *The Un-known Masterpiece*, in whom Cézanne once recognized himself.) The fact that his classic style, stable and clarified as any work of Raphael, was built upon color and the directly given space of nature already freed him from the narrow partisan views. Firmly dedicated though he was to color and to nature, he filled his notebooks in his journeys through the Louvre with drawings after sculptures of the Renaissance and the seventeenth century. In his thought, the essence of style was no longer sufficiently defined by the categories of classic and romantic. These were only modes in which a personal style was realized, more concrete than either. In this new relation to the old historical alternatives, Cézanne anticipates the twentieth century in which the two poles of form have lost their distinctness and necessity. Since then, in Cubism and Abstraction, we have seen linear forms that are open and painterly that are closed, and the simultaneous practice of both by the same artist, Picasso. (Ibid., p. 28)

The book concludes with a gentle call for intellectual tolerance and catholicity that today seems strikingly prophetic:

> Cézanne's accomplishment has a unique importance for our thinking about art. His work is a living proof that a painter can achieve a profound expression by giving form to his perceptions of the world around him without recourse to a guiding religion or myth or any explicit social aims. If there is an ideology in his work, it is hidden within unconscious attitudes and is never directly asserted, as in much of traditional art. In Cézanne's painting, the purely human and personal, fragmentary and limited as they seem beside the grandeur of the old content, are a sufficient matter for the noblest qualities of art. We see through his work that the secular culture of the nineteenth century, without cathedrals and without the grace of the old anonymous craftsmanship, was no less capable of providing a ground for great art than the authoritative cultures of the past. And this was possible, in spite of the artist's solitude, because the conception of a personal art rested upon a more general ideal of individual liberty in the social body and drew from the latter its ultimate confidence that an art of personal expression has a universal sense. (Ibid., p.30)

These beliefs were to develop and deepen in the course of the next decade:

> After fifty years of the most radical change in art from images to free abstraction, Cézanne's painting, which looks old-fashioned today in its attachment to nature, maintains itself fresh and stimulating to young painters of our time. He has produced no school, but he has given an impulse directly or indirectly to almost every new movement since he died.

His power to excite artists of different tendency and temperament is due, I think, to the fact that he realized with equal fullness so many different sides of his art. It has often been true of leading modern painters that they developed a single idea with great force. Some one element or expressive note has been worked out with striking effect. In Cézanne we are struck rather by the comprehensive character of his art, although later artists have built on a particular element of his style. Color, drawing, modelling, structure, touch and expression—if any of these can be isolated from the others—are carried to a new height in his work. He is arresting through his images—more rich in suggestive content than has been supposed—and also through his uninterpreted strokes which make us see that there can be qualities of greatness in little touches of paint. In his pictures single patches of the brush reveal themselves as an uncanny choice, deciding the unity of a whole region of forms. Out of these emerges a moving semblance of a familiar natural world with a deepened harmony that invites meditation. His painting is a balanced art, not in the sense that it is stabilized or moderate in its effects, but that opposed qualities are joined in a scrupulously controlled play. He is inventive and perfect in many different aspects of his art. (Meyer Schapiro, foreword to *Loan Exhibition: Cézanne*, New York, 1959)

In 1968 Schapiro published an article innocuously titled "The Apples of Cézanne: An Essay on the Meaning of Still-life." For better or worse—many of Schapiro's would-be emulators lack his intellectual subtlety—it was to prove the most influential contribution to Cézanne literature since World War II. While retaining the Cézanne of his 1952 book more or less intact, Schapiro is here far more audacious in his use of ideas "suggested by psychoanalytic theory." A new world of interpretation is opened. He proposes that the apples so prevalent in the artist's still lifes carry "a latent erotic sense," that they are "an unconscious symbolizing of a repressed desire":

> In a painting no element exists for one purpose alone but must satisfy a multitude of requirements, certain of which change from work to work. The painting of apples may also be regarded as a deliberately chosen means of emotional detachment and self-control; the fruit provided at the same time an objective field of colors and shapes with an apparent sensuous richness lacking in his earlier passionate art and not realized as fully in the later paintings of nudes. To rest with the explanation of the still-life as a displaced sexual interest is to miss the significance of still-life in general as well as important meanings of the objects on the manifest plane. In the work of art the latter has a weight of its own and the choice of objects is no less bound to the artist's consciously directed life than to an unconscious symbolism; it also has vital roots in social experience. (Meyer Schapiro, "The Apples of Cézanne:

An Essay on the Meaning of Still-Life," *Art News Annual*, 1968, p. 40)[79]

Schapiro attacks head-on the art-for-art's-sake formalism so prevalent in the 1930s. Citing Venturi's observation on the essential "insignificance" of the objects represented in the paintings, Schapiro comments:

> It is surprising that a critic who has been so attentive to Cézanne's probing study of the delicately varied shapes and colors of the apples and has responded to the richness of their image on the canvas should speak of the apples as a "simplified motif," as if they were schematic spheres or circles. But apart from this misapprehension of the "motif," Venturi's answer, which appeared obvious to a generation of painters who believed in "pure art" and prized form as a self-sufficient harmony (while continuing to represent objects), will not satisfy those who see in imagery in modern art and especially in the recurrent themes of a painter a personal choice of what Braque has called "the poetry of painting." (Ibid., p. 42)

But he goes on to qualify this categorical position:

> In Cézanne's painting of landscape, too, and sometimes of the human being, we recognize within the steadfast commitment to the visible that same distinctive distance from action and desire. In his contemplative view he seems to realize a philosopher's concept of esthetic perception as a pure will-less knowing. But is not the style of "knowing," however personal, shaped in part by the character of the objects of attention, their meaning and interest for the responding mind? True, he painted also landscapes, portraits and nudes which are no less personal in conception than the still-lifes, but have quite other qualities that contradict the idea of Cézanne's mature art as always devoid of passion and concern. (Ibid., p. 46)

And he brings his very tightly wrought argument to rest:

> I venture to say the apple was a congenial object, a fruit which in the gamut of qualities in nature's products attracted him through its analogies to what he felt was his own native being. In reading the accounts of Cézanne by his friends, I cannot help thinking that in his preference for the still-life of apples—firm, compact, centered organic objects of a commonplace yet subtle beauty, set on a plain table with the unsmoothed cloth ridged and hollowed like a mountain—there is an acknowledged kinship of the painter and his objects, an avowal of a gifted withdrawn man who is more at home with the peasants and landscape of his province than with its upper class and their sapless culture. This felt affinity, apart from any resemblance to his bald head, explains perhaps the impulse to represent an isolated apple beside a drawing of himself. (Ibid., p. 47)

Through the breadth of his scholarship, his remarkable ability to see issues from all sides, Schapiro revitalized Cézanne studies. Some have embraced his catholicity of approach, while others have preferred to pursue particular lines of investigation more single-mindedly.

Theodore Reff (born 1930) is one critic who draws close to Schapiro's probity and range. His first published work on Cézanne is a 1959 article on the drawings, a subject on which he has become an authority.[80] Reff's essays on the artist are characterized by an exemplary prudence and attentiveness to his specific subject. Like John Rewald, he is most at ease when closest to confirmable facts, but this has not prevented him from reassessing some of the broader issues of Cézanne interpretation, usually in the guise of a scholarly dragonslayer intent on debunking misguided notions than have taken root in the literature. His contributions in this vein include critical essays on subjects as various as the "libidinous content" of Cézanne's figures, the artist's relationship to tradition and earlier art, Cézanne and poetry, and the relation between his theory and his practice. Something of the flavor of Reff's writing is conveyed by the following quotation, which opens an article on Cézanne's treatment of nature in terms of the cylinder, the sphere, and the cone:

> Few great artists' theories are more in need of explication than Cézanne's. Like his paintings, they stand at a major historical intersection, and the heavy mental traffic flowing by, both backward into tradition and forward into modernism, seems increasingly to blur their contours and to dull their colors. To recapture their original meaning, we must try to distinguish the personal significance of the artist's theories from their sources in older pedagogical treatises, on the one hand, and their influence on later esthetic programs, on the other. (Theodore Reff, "Cézanne on Solids and Spaces," *Artforum*, October 1977, p. 34)

Since the 1960s, museum and gallery exhibitions have become the driving force behind much Cézanne criticism. As early as 1954, on the occasion of a Cézanne exhibition

79. This article is republished in Schapiro, *Modern Art: 19th and 20th Centuries* (New York, 1978), pp. 1-38.
80. Reff, May 1959.
81. Edinburgh and London, 1954.
82. Cooper, November-December 1954. See also Gowing, June 1956; and Cooper, December 1956.
83. Newcastle upon Tyne and London, 1973; London, Paris, and Washington, 1988-89; and New York, 1988.
84. Gowing, April 1991; Basel, 1989.
85. New York and Houston, 1977-78.
86. Edinburgh, 1990.
87. Aix-en-Provence, 1990.
88. Tübingen and Zurich, 1982 (English-language edition, 1983); Tübingen, 1993 (English-language edition, 1993). ·
89. Rewald, forthcoming catalogue raisonné of Cézanne's paintings, edited by Jayne Warman and Walter Feilchenfeldt, to be published by Harry N. Abrams, Inc., New York.

in Edinburgh and London, Lawrence Gowing (1918-1991), a painter as well as a critic, proposed new dates for many of the pictures shown[81] (prompting a vigorous rebuttal from Douglas Cooper[82]). Gowing subsequently helped organize three more exhibitions of the artist's work,[83] all of them accompanied by catalogues in which he expounded his views in evocative prose. He always wrote like an artist, not unlike Fry at his best when he focused on specific works, but richer still, more abundant and essentially poetic. In his preface to the watercolor and pencil drawings exhibition organized by Northern Arts and the Arts Council of Great Britain in 1973 he wrote:

> The ordering of colour generated form which in its turn precipitated drawing with a fullness and a force quite foreign to the "right" colour and value of Impressionism. Cézanne, whose head was full of poetry, had a jingle to fix the principle in the memory of his young admirers: "Plus la couleur s'harmonise, plus le dessin se précise." [The more harmonious the colors, the more precise the drawing.] It described his actual technique. As the colour blossomed, successive contours narrowed down the zone of uncertainty round the form in rhythms that made visible the force of the organizing logic. The residual uncertainty that remained, a lateral vibration of edges, was perhaps the irreducible ambiguity of binocular vision. Only a kernel of undoubted tree trunk might be left between the overlapping, quivering alternatives that presented themselves to the two fierce eyes which probed beyond them into space. (Lawrence Gowing, introduction to *Watercolour and Pencil Drawings by Cézanne*, London, 1973, pp. 18-19)

His final work was a review of Mary Louise Krumrine's book on Cézanne's Bather images, which accompanied the Basel exhibition of works on the same theme:[84]

> Sensible post-modernists, Cézanne-lovers to a man, tell one another that the bathers were "not the kind of thing Cézanne was good at." It is still not altogether easy to recognize the artist who, not being good at something he can't do without, is left with no option but to be great at it, and labors until the categories are reversed and all winners are seen to be losers, while an occasional loser is found to have won every trick in the new game. Making his way towards his new kind of picture which was also a new conception of artistic fulfillment, Cézanne must have understood that he was by nature a subject-painter as his contemporaries were not. He painted in succession an unbridled *Temptation of St. Anthony*, a *Déjeuner sur l'Herbe* and, luxuriating in the Venetian inspiration, an idyllic *pastorale* reimagined for the painter and his models (followed later by modernized versions of the *Olympia* subject, in turn somberly brooding and light-headed), in most of which Cézanne himself made a farouche appearance, as if daring to take Manet to task for his imper-

sonality. (Lawrence Gowing, "The True Nature of Cézanne's *Bathers*," *The Journal of Art*, April 1991, p. 58)

The exhibition of Cézanne's late works in 1977 at the Museum of Modern Art provided an occasion for several scholars—particularly its organizer William Rubin—to reassess Cézanne's role in the development of twentieth-century art.[85] More recently, the above-mentioned exhibition in Basel prompted its curator, Mary Louise Krumrine, to write a catalogue focusing on Cézanne's approach to the nude, while Richard Verdi's *Cézanne and Poussin* show in Edinburgh[86] and Denis Coutagne's *Sainte-Victoire—Cézanne 1990* exhibition in Aix-en-Provence[87] occasioned catalogues that blend critical speculation and connoisseurship. Most recently, Götz Adriani, in his work on Cézanne's watercolors and paintings, has merged his insightful scholarship with his talents as an exhibition organizer with very happy results.[88]

Other publications must be mentioned here, for they are indispensable tools for anyone working on Cézanne: Adrien Chappuis's 1973 catalogue raisonné of the drawings and John Rewald's 1983 catalogue raisonné of the watercolors, as well as Rewald's forthcoming catalogue raisonné of paintings.[89]

From Prometheus to Pandora

By and large, Cézanne's eminence has been secure since Vollard's exhibition on the rue Laffitte a century ago. But his precise critical profile has varied considerably over the years, and the question remains: Which Cézanne is the right one? Is he the heroic figure of the late landscapes and still lifes? The deeply erotic and expressive artist of the early and late figurative works? The constructor of a vision for the twentieth century? The destroyer of art as it had been known in the West since the Renaissance? Each generation, and even each national tradition, has devised a vision of Cézanne consistent with its own values and aspirations.

It is tempting to view the evolution of Cézanne criticism as moving in great pendulum swings from the deeply subjective and often poetic approach whose outlines were laid down by those who actually knew him, notably Bernard and Denis, to the more structured one exemplified by the formalist strain of writing on the artist, initiated by Roger Fry. Its subsequent arcs, crucially influenced by American critics, trace a more distant and godlike figure who opened the door to modernism; this bound Prometheus (an image dear to German writers) was liberated into a polyphony of approaches based on sex, history, literature, religion, and even retooled notions of stylistic development and formal values—Meyer Schapiro, of course, having been responsible for turning the key of this pluralist Pandora's box.

Joseph J. Rishel

Catalogue

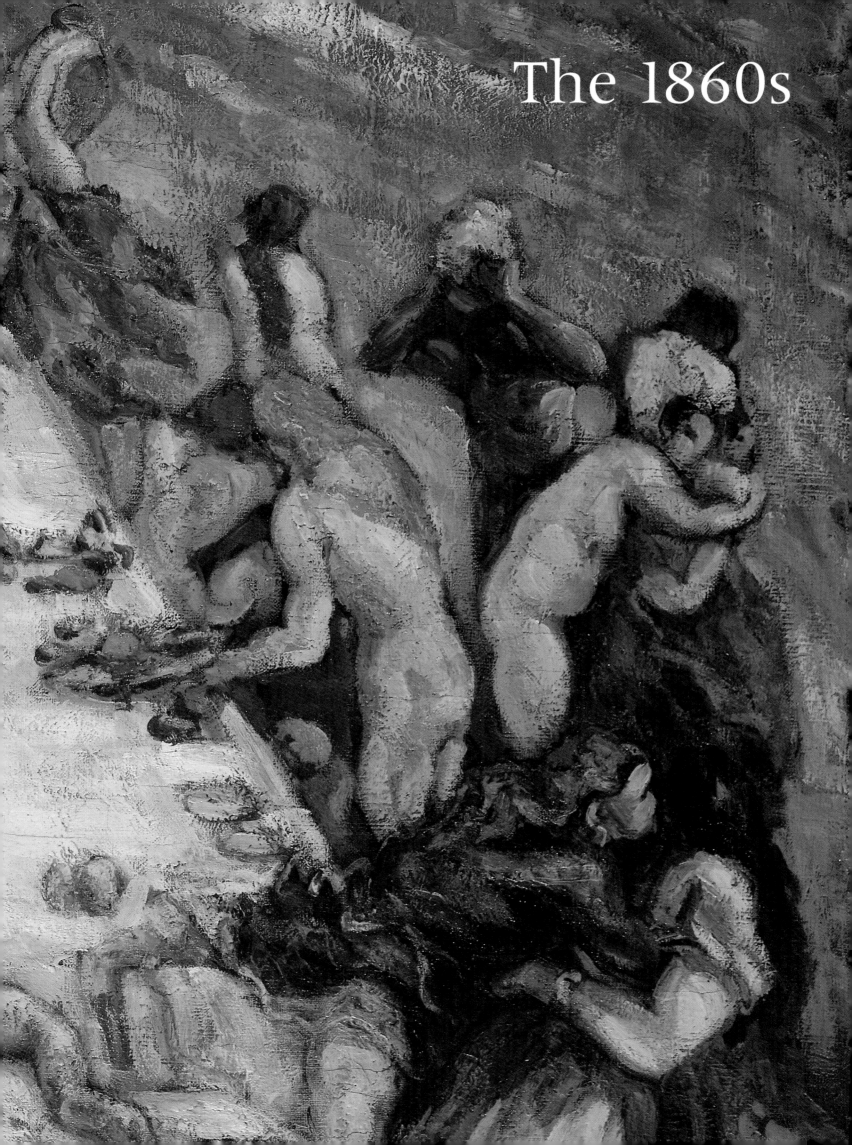

The 1860s

1 | *Academic Nude*

1862
Graphite on paper; 24³/₁₆ × 18¹³/₁₆ inches
(61.5 × 47.8 cm)
Signed and dated on verso: *P. Cézanne—1862*
Musée Granet, Aix-en-Provence
C. 76

PROVENANCE
This drawing passed from the École Gratuite de Dessin in Aix-en-Provence
to the Musée Granet, Aix.

EXHIBITIONS
After 1906: Aix-en-Provence, 1949, no. 4; Newcastle upon Tyne and Lon-
don, 1973, no. 1; Liège and Aix-en-Provence, 1982, no. 36; Aix-en-Pro-
vence, 1984, no. 12; London, Paris, and Washington, 1988-89, no. 68
(exhibited in Paris only).

A few *académies* dating from 1862 survive from Cézanne's
years of apprenticeship at the École Gratuite de Dessin in
Aix-en-Provence.[1] Without their signatures they would be
indistinguishable from run-of-the-mill productions in this
genre; Cézanne's studies of the live model are comparable
and equivalent to those of his fellow students Numa Coste,
Justin Gabet, Philippe Solari, Joseph Huot, and Jules Gi-
bert.[2] But one of them (C. 75) has a curious feature that's
worth noting: although the figure represented is a strap-
ping fellow with a beard, his male organ has been reduced
to a cherub's foreskin.

H. L.

1. C. 75-78, to which should be added the drawings published by Bruno
 Ély (in Aix-en-Provence, 1984, pp. 159, 163).
2. See Ély, in Aix-en-Provence, 1984, p. 160.

2 | *Academic Nude*

c. 1865
Black chalk on paper with white highlights;
19³/₈ × 12¹/₄ inches (49 × 31 cm)
The Syndics of the Fitzwilliam Museum, Cambridge
C. 99

PROVENANCE
This drawing was purchased from Charles Vignier by Louis C. G. Clarke, who bequeathed it to the Fitzwilliam Museum in 1961.

EXHIBITIONS
After 1906: Newcastle upon Tyne and London, 1973, no. 2; London, Paris, and Washington, 1988-89, no. 72 (exhibited in Washington only).

EXHIBITED IN PARIS AND PHILADELPHIA ONLY

This *académie*, which represents a model seen on many other sheets (C. 93, C. 97, C. 98, C. 104-6, C. 108-12), was probably executed around 1865 at the Académie Suisse. It is quite different from the preceding one (cat. no. 1), revealing an original sensibility. Using thick black chalk lines that underscore the contours as well as the oppositions between shadow and light, Cézanne here displays, in the words of Lionello Venturi, "his tendency to accentuate the joints of the limbs, to find art's rationale in the expression of energy and force."[1] The flowing and harmonious bodies of the earlier studies are replaced by one that is foreshortened, thickened, and at odds with academic norms, and whose willful distortions—ample buttocks, protruding musculature, large feet—anticipate the morphological deformations of the *Portrait of Achille Emperaire* (cat. no. 19) and the first painted nudes.

H. L.

1. Venturi, 1936, vol. 1, p. 47.

3 | *Bread and Eggs*

1865
Oil on canvas; 23¼ × 30 inches (59.1 × 76.3 cm)
Signed and dated lower left: *P. Cézanne 1865*
Cincinnati Art Museum. Gift of Mary E. Johnston
V. 59

This still life—one of the very few works signed and dated by Cézanne—was doubtless painted for exhibition at the Salon of 1865, but of course was refused by the jury.[1] It might be one of the canvases about which the painter remarked, in a letter to Pissarro dated March 15, 1865, that they were likely to "make the Institute blush from rage and despair."[2] For, as he was to do so often in the 1860s, Cézanne violated a hallowed norm: this still life against a dark background, in a style seemingly inspired by the Spanish masters, is composed not of the makings of a luxurious repast but of the cheap utensils and the meager fare of a poor artist. Many realist painters before him, notably Théodule Ribot and Antoine Vollon, had made a specialty of such austere canvases. Working in a restricted palette, they used all their skill to render the play of light and shadow, deploying refined points of luminosity to evoke sparkling glass and metal, amply illuminating an object or plunging it into shadow virtually to the point of invisibility. Cézanne, however, placed his similarly illuminated motifs against a uniform black ground—Rainer Maria Rilke would write of Cézanne's still lifes "hoarded by dark-ness"—from which the wood of the table is scarcely distinguishable. Whereas the realist *petits maîtres*, eyeing their Dutch counterparts, painted in a manner that was unctuous and caressing, Cézanne employed broad, variable handling that gives the canvas a certain tartness and makes his predecessors' tranquil compositions seem constricted and dull. The influences of both the Spanish tradition and Chardin, whose work enjoyed a revival in the 1860s,[3] have rightly been discerned in this work; however, as early as December 1865, Marius Roux, a friend of Cézanne's, in one of the very first articles devoted to him, stressed the limited value of such comparisons: "A great admirer of Ribera and Zurbarán, our painter goes his own way."[4] This aggressiveness and strength seduced Manet, despite his different take on the Spanish school; in 1866 he saw several Cézanne still lifes at Antoine Guillemet's home and found them "powerfully treated." Cézanne was pleased with this pronouncement, but he downplayed it, as was his wont; it was recorded by his friend Antony Valabrègue, who predicted the development of an artistic complicity: "Parallel temperaments, they will surely understand one another."[5]

H. L.

1. Most scholars refer only to its submission to the 1866 jury, to which Cézanne also submitted the *Portrait of Antony Valabrègue* (p. 92, fig. 1).
2. Cézanne, 1978, pp. 112-13.
3. On this subject, see the discussion by Gabriel Weisberg in *Chardin and the Still-life Tradition in France* (Cleveland, 1979), pp. 31-47; Henri Loyrette, in Paris and New York, 1994-95, pp. 160-65; and Bettendorf, January 1982.
4. Roux, December 3, 1865.
5. Passage in a letter from Valabrègue cited in another letter from Fortuné Marion to Heinrich Morstatt, April 12, 1866, in Barr, 1938, no. 5, p. 223.

4 | *Sugar Bowl, Pears, and Blue Cup*

c. 1866
Oil on canvas; 11¹³/₁₆ × 16¹/₈ inches (30 × 41 cm)
Musée Granet, Aix-en-Provence. On loan from the Musée d'Orsay (R.F. 1982-44)
V. 62

PROVENANCE
This canvas passed from the collection of Auguste Pellerin to that of his son, the playwright Jean-Victor Pellerin. It entered the French national collections in lieu of estate taxes in 1982, and soon thereafter was lent to the Musée Granet.

EXHIBITIONS
After 1906: Paris, 1953, no. 4; Madrid, 1984, no. 1; London, Paris, and Washington, 1988-89, no. 14.

While *Bread and Eggs* recalls the still lifes exhibited by Manet at Cadart's gallery in 1865, if in a cruder idiom (it shares their Spanish manner and their Chardin-like arrangements), *Sugar Bowl, Pears, and Blue Cup* is conceived along very different lines. The objects are arrayed horizontally and all suggestion of artful *mise-en-scène* is eschewed. The handling, worked with a palette knife, consists of broad irregular strokes that "build up" the fruit and vessels almost like masonry; the colors, previously distributed in large uniform areas of white, brown, and black, are inextricably mixed together. It is not so much the Spanish masters and Manet as the provincial painter Adolphe Monticelli whose example can be sensed here. His work offers the only parallel with this rough-hewn style, briefly adopted by Cézanne for some months in 1866 and dubbed by the artist himself some thirty years later *couillarde*, or "ballsy."[1]

Cézanne turned this small canvas, so unprepossessing yet so novel, into something of a manifesto; as if to drive this home, he placarded it on the wall in the large portrait of his father reading *L'Événement* (fig. 1). Unlike Degas, for example, who in his *Bellelli Family* (Musée d'Orsay, Paris) boldly presented one of his own drawings on the wall as if it were from the hand of an acknowledged master (giving it a wide *marie-louise* mat and a large gilded frame), Cézanne placed his little composition on the wall unframed, squaring its format a bit and moving its constituent elements closer together. Thus this modest composition, partly obscured by the chintz-covered "throne" into which his father settles, becomes an emblem for a "new manner of painting," the one so pointedly defended by Émile Zola in his articles in *L'Événement*, which Cézanne's father is here depicted reading with as much resignation as skepticism.

H. L.

1. This term–a derivative of the French *couilles*, or "testicles"—has entered wide usage as a characterization of Cézanne's most brutal 1860s palette-knife idiom. It first appeared in print in Ambroise Vollard's *Paul Cézanne* (1914, p. 22). In the course of a discussion of the painter's work from the mid-1860s, Vollard wrote: "Cézanne had divided painting into two categories: painting that was 'really ballsy' *[la peinture 'bien couillarde']*, namely his own; and painting that was not 'ballsy,' that of the 'others' *[qui n'était pas 'couillarde,' celle des 'ôttres']*." Presumably Vollard was recalling conversations with him shortly after they first met face-to-face, in Aix, probably in 1896.

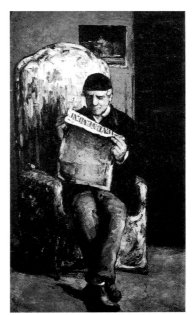

Fig. 1. Paul Cézanne,
Portrait of Louis-Auguste Cézanne Reading "L'Événement," 1866,
oil on canvas,
National Gallery of Art, Washington, D.C.
Collection of Mr. and Mrs. Paul Mellon (V. 91).

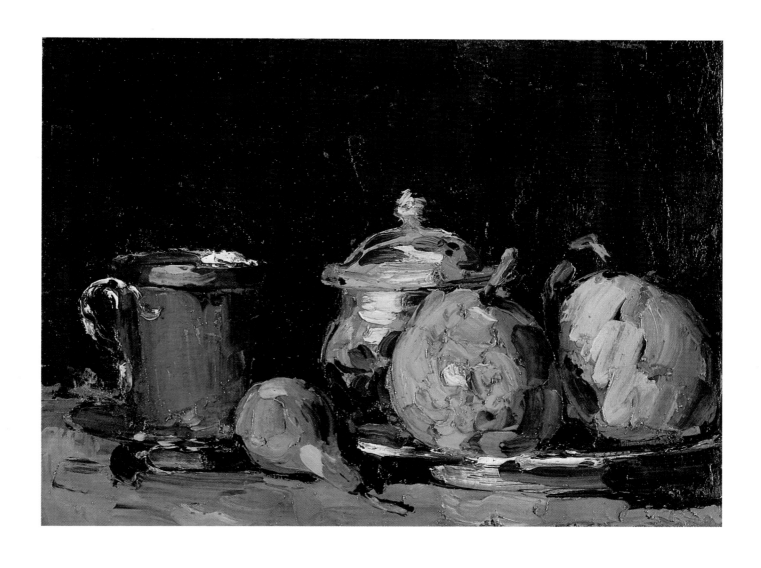

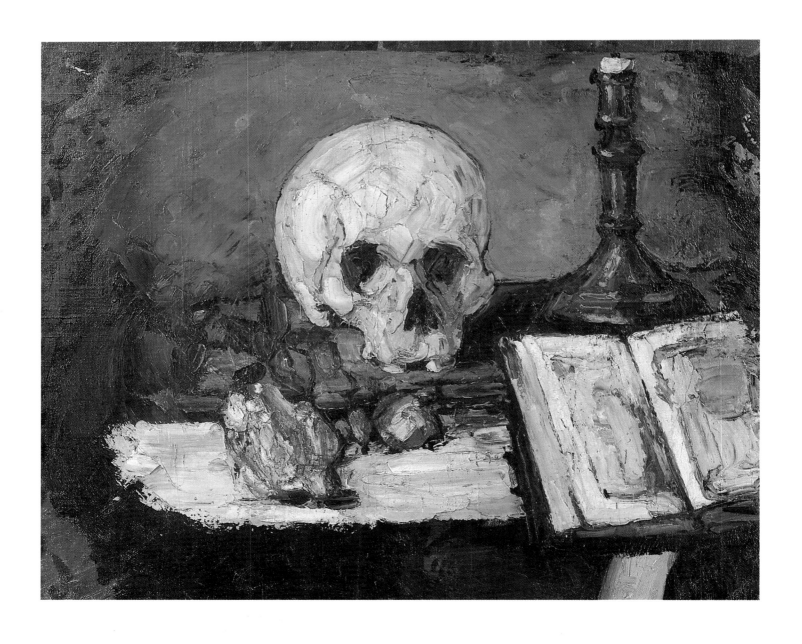

5 | *Skull and Candlestick*

1866
Oil on canvas; 18¹³/₁₆ × 24⁵/₈ inches (47.5 × 62.5 cm)
Private collection, Switzerland
V. 61

PROVENANCE
This canvas was first owned by the German musician Heinrich Morstatt; it may be the "still life by Paul" to which Fortuné Marion refers in a letter to Morstatt dated July 17, 1868, as having just been sent to him.[1] Sold by Morstatt around 1923[2] to Heinrich Thannhauser's Moderne Galerie in Munich, it passed on November 25, 1925, to Thannhauser's Lucerne gallery, where it was purchased on February 2, 1928, by the Zurich collector Bernhard Mayer. It is now in a private Swiss collection.

EXHIBITIONS
After 1906: Berlin, 1927 (a), no. 10; Basel, 1936, no. 3; Paris, 1953, no. 3; The Hague, 1956, no. 1; Zurich, 1956, no. 1; Basel, 1983, no. 3; London, Paris, and Washington, 1988-89, no. 12.

This small still life, painted quickly on a reused canvas (elements of an underlying composition are visible along its perimeter), was apparently given by Cézanne in the summer of 1868 to his friend Heinrich Morstatt (1844-1925); the painter had met him through Fortuné Marion (1846-1900) three years earlier, when the young German was living in Marseille and pursuing a business career. The three young men became fast friends; they were soon joined by Antony Valabrègue (1844-1900), and the resulting group engaged in lengthy discussions about painting, literature, geology, biology, aesthetics, and music. Morstatt, who returned to Stuttgart around 1867, having given up business to teach piano and then establish a music school, was intent on propagating the Wagnerian faith, and the other members of the circle were willing converts (see cat. no. 17).[3] Even if this canvas is indeed the one Cézanne sent to Morstatt in the summer of 1868, it must have been painted two years earlier, in 1866: the use of the palette knife and the resulting impasto, discernible in the rough-hewn pages of the book as well as in the tablecloth, the dried bones, and even the fragile, blooming flowers—roses or peonies, it is difficult to tell which—indicate a date close to that of the portraits of Uncle Dominique (cat. nos. 6 and 7) and *Sugar Bowl, Pears, and Blue Cup* (cat. no. 4). This is Cézanne's first attempt at a *vanitas*;[4] it initiates a strain of imagery he developed a few months later in *Mary Magdalen* (fig. 1) and to which he returned throughout his long life. Later, he would place skulls like jugs on a tablecloth or arrange them prettily in pyramids, like a centerpiece for some macabre repast, and they appear as disquieting motifs in a few still lifes. In 1866, however, Cézanne still resorted to the full gamut of *vanitas* symbolism, including the extinguished candle, the dying flowers, the inexorable book of life, and the death's-head—which here seems anything but dead, fixing the viewer with the intent, ironic gaze of the grim reaper.[5]

H. L.

1. Barr, January 1937, no. 32, p. 42.
2. Ibid., p. 42.
3. On Cézanne's friendship with Marion and Morstatt, see Barr, January 1937, pp. 37, 58; and Barr, 1938.
4. See also V. 68 (private collection), which can be dated around 1868.
5. On the motif of the skull in Cézanne's work, see Reff, October 1983.

Fig. 1. Paul Cézanne,
Mary Magdalen, c. 1867,
oil on canvas (transferred),
Musée d'Orsay, Paris (V. 86).

Uncle Dominique

6 | *Uncle Dominique as a Lawyer*

Fall 1866
Oil on canvas; 24⁷/₁₆ × 20¹/₂ inches (62 × 52 cm)
Musée d'Orsay, Paris (R.F. 1991-21)
V. 74

PROVENANCE
After belonging to Ambroise Vollard, this painting passed, in turn, to Auguste Pellerin, his daughter Mme René Lecomte, and his granddaughter Mme Louis de Chaisemartin. It was acquired by the State in 1991 in lieu of estate taxes.

EXHIBITIONS
After 1906: Paris, 1907 (b), no. 1 *(L'Avocat)*; Paris, 1954, no. 5; London, Paris, and Washington, 1988-89, no. 23; Paris and New York, 1994-95, no. 24 (exhibited in Paris only).

EXHIBITED IN PARIS ONLY

7 | *Uncle Dominique (Man in a Cotton Cap)*

Fall 1866
Oil on canvas; 31³/₈ × 25³/₁₆ inches (79.7 × 64 cm)
The Metropolitan Museum of Art, New York. Wolfe Fund, 1951; acquired
from the Museum of Modern Art, Lillie P. Bliss Collection (53.140.1)
V. 73

PROVENANCE
Purchased from Ambroise Vollard by Alexandre Rosenberg in 1898, this painting was acquired probably in 1899 by Auguste Pellerin, in whose collection it remained until 1916, when it became the property of the dealer Jos Hessel. In 1920 it was sold to the New York dealer Marius de Zayas, who resold it around 1921 to Lillie P. Bliss. She bequeathed it in 1931 to the Museum of Modern Art in New York; in 1951 it was purchased by the Metropolitan Museum of Art.

EXHIBITIONS
After 1906: Paris, 1907 (b), no. 2; New York, 1921, no. 4; New York, 1929, no. 1; New York, Andover, and Indianapolis, 1931-32, no. 1; Chicago and New York, 1952, no. 5; London, Paris, and Washington, 1988-89, no. 22; Paris and New York, 1994-95, no. 25 (exhibited in New York only).

EXHIBITED IN PHILADELPHIA ONLY

It was in 1865-66 that Cézanne became a painter. Hitherto, it must be acknowledged, his art was limited to a few tentative efforts whose laudable intentions were thwarted by technical limitations. Zola was to gloss such a moment in his own evolution with an aphorism that sums up Cézanne's entire history: "One is born a poet, one becomes a worker."[1] In the mid-1860s Cézanne the "poet," with only a few awkward canvases to his credit (fig. 1), set about turning himself into a worker. The flat, tight, painstaking idiom of his first canvases was replaced by the impassioned crudity of the *couillarde* style.[2] The palette knife, which he used consistently and which allowed him to build up his canvases in thick irregular strokes, was the instrument with which he effected this transformation. The subject matter became more diverse and the rate of production increased; during the summer of 1866, in Bennecourt, he dreamed of undertaking pictures of "four to five meters."[3] Zola observed: "Cézanne is working; he grows ever stronger in the original path his nature has urged him to take."[4] And three months later, Guillemet described a

Cézanne who is "more handsome," wholly dedicated to his art, surer of himself, and intent on prevailing.[5]

The portrait played a crucial role in this reorientation. In Aix, where he spent the late summer and fall of 1866, Cézanne painted many portraits of those close to him, using a variety of formats; the resulting works include the full-length depiction of his father reading *L'Événement* (p. 84, fig. 1), the rough oil sketch *Marion and Valabrègue Setting Out for the Motif* (V. 96), and an impressive series of portraits of his maternal uncle, the bailiff Dominique Aubert. Valabrègue, who also had his portrait painted at about this time (see cat. no. 8), wrote Zola in November 1866 that "every afternoon" Cézanne made a new portrait of Uncle Dominique "while Guillemet belabors it with terrible jokes."[6]

Ten canvases from this sustained and productive painting campaign survive, picturing Uncle Dominique in full face, profile, and three-quarter views, in bust and half length, behatted, beturbaned, and becapped. All were executed with a palette knife—also Courbet's favorite paint-

Fig. 1. Paul Cézanne,
The Four Seasons, 1860-62,
oil on canvas (transferred),
Musée du Petit Palais, Paris (V. 4-7).

ing implement at this time—in the broad, impassioned *couillarde* style, and in emphatically contrasted blacks and whites reminiscent of Manet. These are indeed the two artists who must be invoked in connection with this remarkable series, but Cézanne was already outstripping their transgressive lessons. Guillemet sensed this when, in a letter to his friend the Puerto Rican painter Francisco Oller, he praised the revolutionary power of these new works: "Courbet becomes a classic. He's done some superb things, next to Manet he's traditional, and Manet will one day seem so in turn next to Cézanne. . . . Today's gods will not be tomorrow's, to arms, let our febrile hands seize hold of the knife of insurrection, let's tear down and rebuild. . . . Paint with heavy impasto and dance on the belly of the terrified bourgeois."[7]

Cézanne approached the portrait in the same spirit that he did the landscape, focusing as closely on facial asperities as on geographic idiosyncracies, on the particulars of individual features as on the geological strata in the environs of Aix and the Gulf of Marseille. But, just as he did not hesitate to add an elaborate factory complex to an otherwise accurately described site (fig. 2), so, too, did he provide the patient and compliant bailiff with imaginary lives: Domi-

nique Aubert was cast in turn as a cowled monk with a cross around his neck, an artisan in a worker's smock, or a lawyer in toque and collar (cat. no. 6). The larger meaning of these masquerades remains a subject of conjecture: perhaps Cézanne was making a visual pun when he transformed Dominique into a Dominican[8] (he resorted to a similar play of word and image in his portrait of Achille Emperaire; see cat. no. 19), perhaps the lawyer costume was meant to evoke one of his first defenders, perhaps the artisan's smock signaled the new orientation of his art. In any case, Uncle Dominique is a figure comparable to Manet's Victorine Meurent and Degas's Emma Dobigny: models whose pronounced individuality renders them recognizable from one painting to the next despite their many disguises. And these costumes—whether flimsy (the worker's smock sits haphazardly on top of the bailiff's own dark suit) or deliberately inaccurate (the toque and the collar are the same blue-gray color)—are but pretexts for successive metamorphoses: the bailiff, his arms crossed, meditates, or, flattened against a crude white expanse like an icon against its gold ground, blesses rather than pleads with the authority of a Christ Pantocrator.

H. L.

1. Zola to Cézanne, April 16, 1860, in Zola, 1978-, vol. 1, no. 15, p. 146.
2. See cat. no. 4, note 1.
3. Zola to Coste, July 26, 1866, in Zola, 1978-, vol. 1, no. 151, p. 453.
4. Ibid.
5. Guillemet to Zola, November 2 [1866], in Cézanne, 1978, p. 127.
6. See Rewald, 1986 (a), p. 82.
7. Guillemet to Oller, September 12, 1866, in Ponce Art Museum, Puerto Rico, *Francisco Oller: A Realist-Impressionist* (Ponce, 1983), p. 227.
8. See Schapiro, 1952, p. 32.

Fig. 2. Paul Cézanne,
Factories Near Le Cengle, 1869-70,
oil on canvas,
private collection (V. 58).

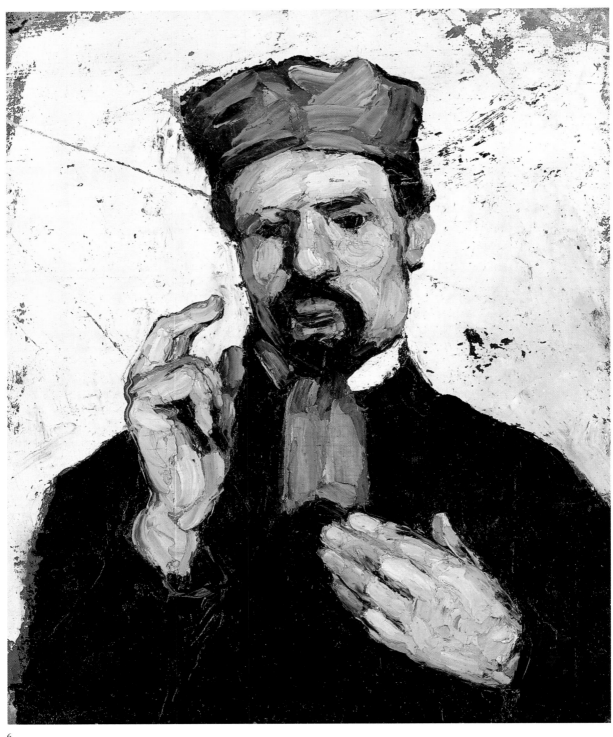

6

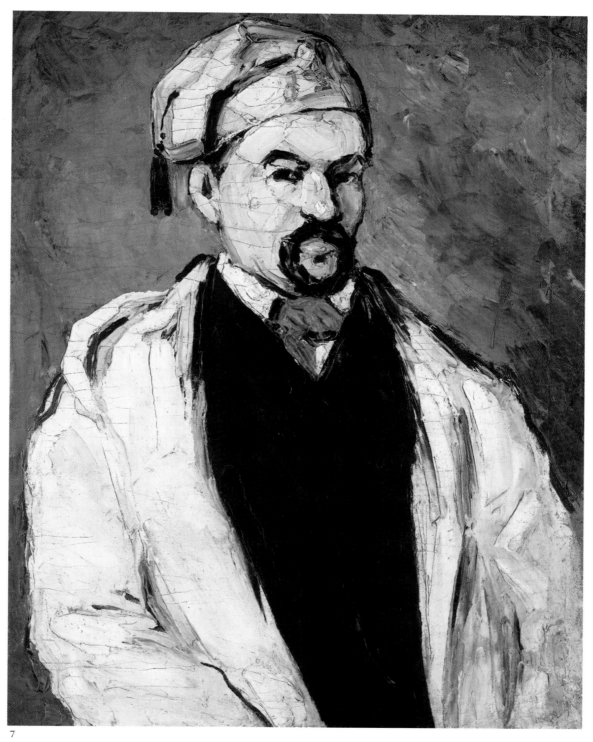

7

8 | *Portrait of a Man*

c. 1866
Oil on canvas; 23⁵/₈ × 19³/₄ inches (60 × 50 cm)
Collection of the J. Paul Getty Museum, Malibu, California
V. 127

PROVENANCE
Ambroise Vollard sold this painting to Comte Armand Doria, who kept it in
the Château d'Orrouy. It subsequently came into the hands of Auguste
Pellerin, who passed it on to his son, Jean-Victor Pellerin. It was pur-
chased from the Wildenstein Galleries by André Meyer (1898-1979), the
French-American banker who underwrote the new wing of the Metropol-
itan Museum of Art in New York devoted to nineteenth-century European
art. The painting figured at the sale of the Meyer collection (Sotheby's,
New York, October 22, 1980, lot 21), where it was purchased by the Ga-
lerie Beyeler in Basel, from whom the J. Paul Getty Museum acquired it in
1985.

EXHIBITIONS
Before 1906: Berlin, 1904.
After 1906: Stuttgart, 1913, no. 330; Brussels, 1935, no. 9; Paris, 1936,
no. 17; London, 1939 (b), no. 9; Basel, 1983, no. 6; London, Paris, and
Washington, 1988-89, no. 56.

When this portrait was exhibited for the first time by Paul
Cassirer in Berlin in 1904, it was thought to represent An-
tony Valabrègue, the Aixois poet and critic who was a
childhood friend of Cézanne's. In 1936 this identification
was questioned: the catalogue of the exhibition at the
Orangerie suggested as likely candidates Valabrègue or the
geologist Fortuné Marion, another of the painter's child-
hood friends. All authors since then—including John Re-
wald, once a bit hesitant himself[1]—have accepted the first
identification. It is difficult, however, to recognize in this
large trapezoidal face the "discreet and delicate visage"[2] of
the Provençal poet painted by Cézanne in the majestic por-
trait of him refused by the jury of the 1866 Salon (fig. 1).[3]
Likewise, it does not bear a strong resemblance to Marion,
whose portrait was also painted by his friend (fig. 2),
stressing his characteristic features: sunburnt complexion,

globular eyes, and squashed nose. Thus, prudence sug-
gests provisionally identifying the sitter as anonymous, al-
though he is doubtless one of the artist's Aixois friends, for
this modest-sized canvas has clear affinities with the afore-
mentioned portraits: the same use of a neutral back-
ground; the same harmony of blacks, whites, and grays;
the same broad, unctuous handling in the background and
clothing, countered by tighter, less regular, more thickly
impastoed strokes in the face. It seems ill advised to assign
this canvas a date considerably later than that of the *Por-
trait of Antony Valabrègue* in Washington, D.C., securely
dated 1866, and, while most scholars tend to place it about
1870-71 (Venturi suggested 1870-71; Gowing, around
1871; Rewald, 1869-71),[4] a more likely date would be
1866, when the artist was intensely preoccupied with por-
traiture (see cat. no. 6). In their dry, telegraphic style, the
brief comments of Lionello Venturi underscore the most
memorable characteristics of this remarkable portrait: "Im-
pasto still thick, but the handling is already free; molten,
sensitive passages of light. Influence of Manet. Impres-
sionism on the ascendant."[5]

H. L.

1. Rewald, 1936, fig. 10, as "Portrait of a Man (A. F. Marion or A.
 Valabrègue)."
2. Émile Blémont, preface to Antony Valabrègue, *L'Amour des bois et des
 champs* (Paris, 1902), p. xii.
3. Cézanne painted another portrait of Valabrègue that is more summary
 and dashed-off (V. 128). The poet's pointy, emaciated profile, with its
 eagle-beak nose, also appears twice on a sheet of drawings now in the
 Kunstmuseum in Basel (C. 154).
4. See Venturi, 1936, vol. 1, no. 127, p. 95; Gowing, in London, Paris,
 and Washington, 1988-89, no. 56, p. 182; and Rewald, forthcoming,
 no. 147.
4. Venturi, 1936, no. 127, p. 95.

Fig. 1. Paul Cézanne,
Portrait of Antony Valabrègue, 1866,
oil on canvas,
National Gallery of Art, Washington, D.C.
Collection of Mr. and Mrs. Paul Mellon (V. 126).

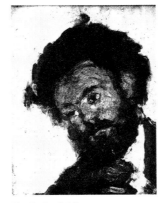

Fig. 2. Paul Cézanne,
Portrait of Fortuné Marion, 1866,
oil on canvas,
Kunstmuseum, Basel (V. 129).

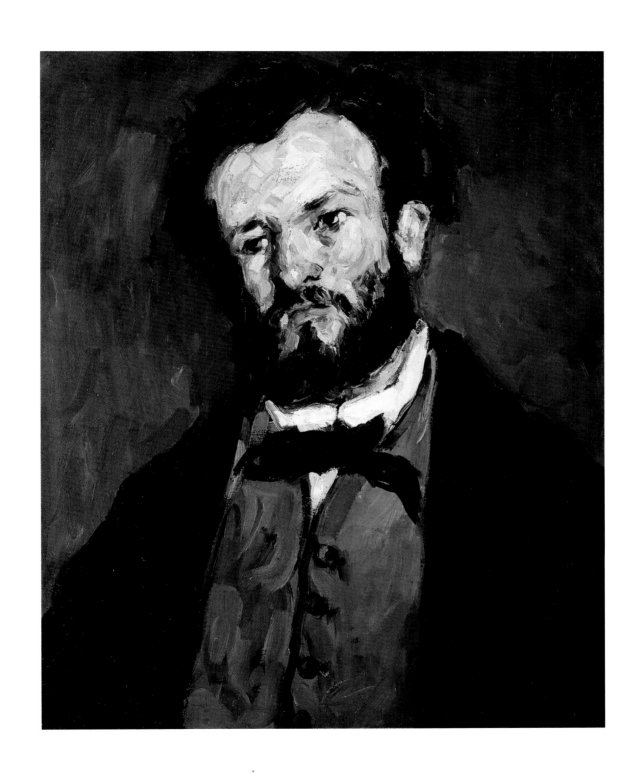

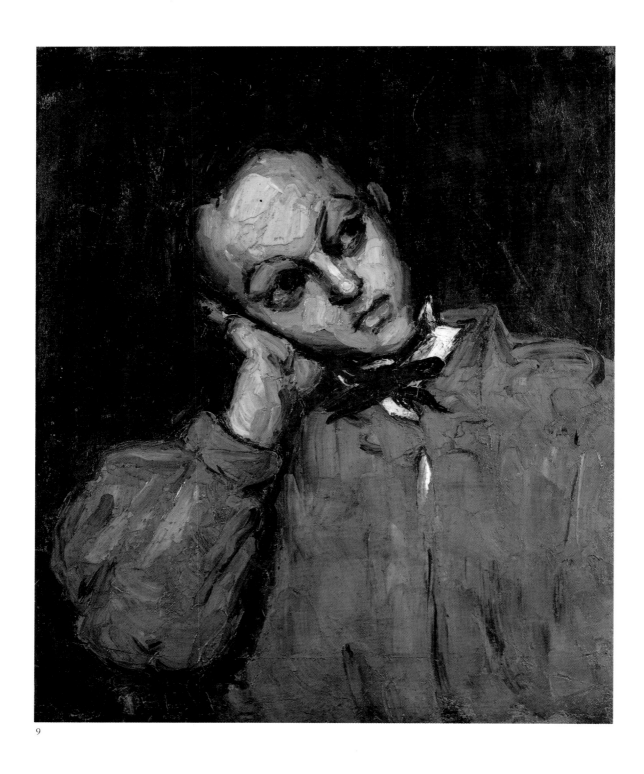

9

9 *Young Man Leaning on His Elbow*

1866
Oil on canvas; 22³/₄ × 19³/₄ inches (58 × 50 cm)
Private collection
V. 109

PROVENANCE
After belonging to Ambroise Vollard, this portrait became the property of Franz Meier-Fierz in Zurich; it then entered the collection of Josef Müller in Solothurn, whose descendants still own it.

EXHIBITIONS
After 1906: Berlin, 1911, no. 6 (?); Paris, 1936, no. 4; Zurich, 1956, no. 6; Basel, 1983, no. 4.

EXHIBITED IN PARIS ONLY

Georges Rivière dated this beautiful portrait, little known and rarely exhibited, to 1874. John Rewald differed, rightly suggesting that it was a work of the 1860s and opting for the dates 1867-68.¹ This he based on a letter from Marion to Morstatt, dated April 27, 1868, in which the geologist described a notable development in the painter's evolution: "He has now attained a degree of science that's truly astonishing. All his excessive ferocity has been tempered."² It is true that this tender depiction of a young schoolboy in the dreamy pose of the so-called self-portrait by Raphael (p. 245, fig. 1) lacks the solemnity of the portraits of Uncle Dominique and seems less "ferocious" than they, but, even so, it is difficult to accept it as contemporary with *The Negro Scipion* (cat. no. 11). The use of a palette knife, the composition, the uniform background, and the limited color scheme all indicate that this is a work of 1866, when Cézanne, having returned to Aix, was turning out portraits on a daily basis.

H. L.

1. See Rewald, forthcoming, no. 135.
2. Barr, January 1937, no. 30, p. 48.

10 *Bather and Rocks*

c. 1867-69 (possibly earlier)
Oil on canvas (transferred from plaster); 66 × 41¹/₂ inches (167.6 × 105.4 cm)
The Chrysler Museum, Norfolk, Virginia. Gift of Walter P. Chrysler, Jr.
V. 83

PROVENANCE
This painting came into the possession of Louis Granel when he purchased the Cézanne family property, the Jas de Bouffan, in 1899. Granel sold this and other works by Cézanne to Jos Hessel in 1907. For a brief period the painting was in the possession of the Parisian dealer Georges Bernheim, who was related to Hessel. Thereafter it passed through the collection of Alphonse Kann, Saint-Germain-en-Laye, to the dealer Paul Rosenberg, from whom it was acquired in 1955 by Walter P. Chrysler, New York. The painting became part of the permanent collection of the Chrysler Museum in 1971.

EXHIBITIONS
After 1906: New York, 1921, no. 3; Chicago and New York, 1952, no. 3.

In 1859 Louis-Auguste Cézanne bought a large eighteenth-century house with extensive grounds on the outskirts of Aix. It was called, in the local Provençal dialect, the Jas de Bouffan and would be Cézanne's primary home in the Midi until the death of his mother in 1899.

On the ground floor, to the left of the door opening onto the allée of chestnut trees bordering an ornamental pool, is a large salon—the largest space in the house—which the elder Cézanne allowed his son to decorate. During the next eight to ten years Paul painted, in oils, directly on the plaster walls, some of the largest and most curious works of his youthful period, including *The Four Seasons* (signed "Ingres 1811"; p. 89, fig. 1), now in the Petit Palais, Paris, and the *Portrait of Louis-Auguste Cézanne, the Artist's Father* (V. 25), now in the National Gallery, London. It has been suggested that they were part of a carefully considered decorative scheme, but this is unlikely: the discrepancies of scale and the diversity of subjects are too great. These murals stayed in place until 1907, when the owner at the time, Louis Granel, had most of them removed from the walls and transferred to canvas.¹

These decorations included two large pastoral landscapes, probably based on popular prints, situated on each side of the alcove containing *The Four Seasons*.² Venturi, followed by Cooper and Rewald, dated these murals to about 1864. At a later date, perhaps shortly after returning from his first extended trip to Paris in 1868, Cézanne introduced a muscular male nude into the landscape to the left of the niche. His stalwart pose and physique bring Atlas or Hercules to mind, and he appears to be engaged in a monumental task of some sort, holding back the immense rock in front of him, as water surges around it.

Venturi's illustration (fig. 1) is the only surviving record of this mural as it appeared intact. After its removal from the wall, the figure was isolated from its surround and the landscape was broken down into three fragments that were acquired by different collectors.

Several scholars have noted that this nude, seen from the back, must relate in some way to the similarly posed female nude in Courbet's famous *Bathers*, which Cézanne could have seen in Paris during his first or second visit (fig. 2; a photograph of Courbet's work still survives in Cézanne's studio at Les Lauves).[3] However, the tense, animated contour, the sensual S-curve of the backbone, and the suavity of the modeling in Cézanne's figure bring Delacroix's nudes more readily to mind.

Despite its fragmentary state, the image has considerable power, the result of its vigorous handling and imposing scale, qualities it shares with the Musée d'Orsay's *Mary Magdalen* (p. 87, fig. 1), which also figured in the Jas de Bouffan decorations. A comparison could be forced between the *Bather and Rocks* and the *Large Bather* (cat. no. 104), if only because they are both large-scale renderings of isolated male nudes (or, in the case of the later picture, an almost nude figure), but the differences between these two works far outweigh their similarities. In any case, *Bather and Rocks* is Cézanne's first ambitious treatment of a bather in a landscape. The heroism, sensuality, and awareness of precedent that will mark all his later treatments of this subject, male and female, are essentially present here.

J. R.

1. The State refused Louis Granel's gift of *The Four Seasons*. See Mack, 1935, pp. 145-47, for a letter dated November 25, 1907, by Léonce Bénédite, curator of the Musée du Luxembourg, which describes all the works in this room and the basis upon which he rejected Granel's offer.
2. See London, Paris, and Washington, 1988-89, p. 6; and Cooper, February 15, 1955.
3. See Reff, November 1960, p. 304.

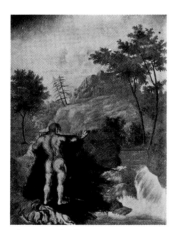

Fig. 1. Paul Cézanne,
Bather and Rocks
(before being cut down),
oil on plaster (V. 83).

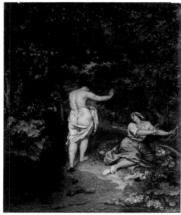

Fig. 2. Gustave Courbet,
The Bathers, 1853,
oil on canvas,
Musée Fabre, Montpellier.

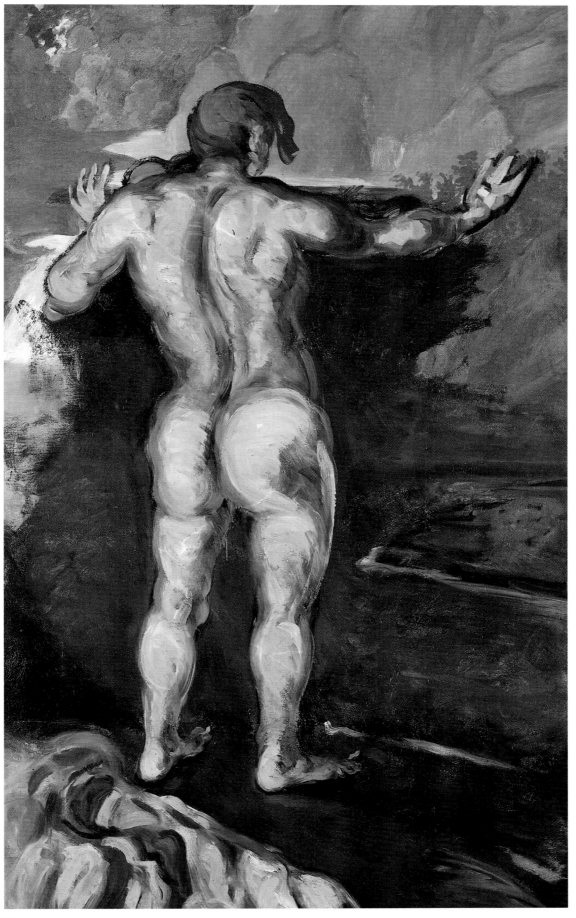

10

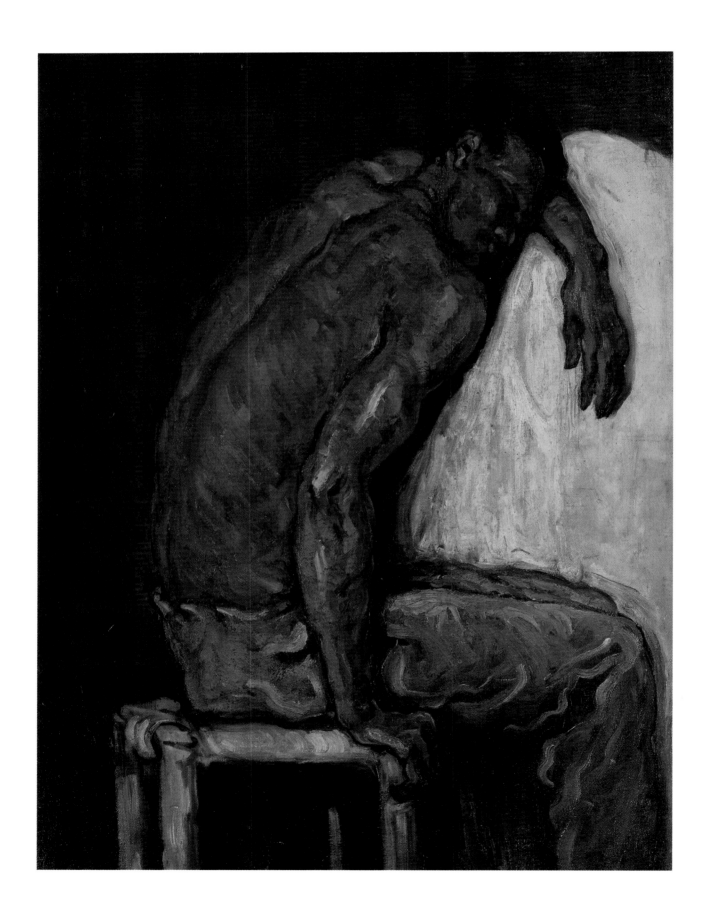

11 | *The Negro Scipion*

1867
Oil on canvas; 42¹/₈ × 32¹¹/₁₆ inches (107 × 83 cm)
Museu de Arte, São Paulo. Chateaubriand Collection
V. 100

PROVENANCE
Claude Monet acquired this canvas from Ambroise Vollard and hung it in
his bedroom at Giverny. It subsequently passed to his son, Michel Monet,
who sold it to the dealer Paul Rosenberg. The Museu de Arte in São Paulo
purchased it from the Wildenstein Galleries in 1950.

EXHIBITIONS
After 1906: Paris, 1931 (b), unnumbered; Basel, 1936, no. 2; Paris, 1939
(a), no. 1; London, 1939 (a), no. 1; Chicago and New York, 1952, no. 4;
Tokyo, Kyoto, and Fukuoka, 1974, no. 3; Madrid, 1984, no. 2; Tokyo,
Kobe, and Nagoya, 1986, no. 3; London, Paris, and Washington, 1988-89,
no. 30.

The walls of Monet's bedroom at Giverny were hung with
canvases cheek by jowl, including paintings by Renoir, a
Pissarro, a Degas, some Morisots, and several Cézannes,
"beautiful pictures by all his friends," as he observed to
René Gimpel.[1] Notable among the Cézannes were a "snow
effect in the woods" (V. 336), "three figures in a land-
scape," and this "Negro," acquired from Vollard for 400
francs—the work of a "beginner," conceded Monet, who
added that his colleague had "since made good his defi-
ciencies."[2] In any case, he confided to Marc Elder that it
was "un morceau de première force."[3]

Monet's chronological mistake—in designating it the
work of a "beginner"—was a reflection of the erroneous
date provided by Ambroise Vollard. Vollard, whose datings
were always approximate, had situated the canvas in 1865,
comparing it with the *Portrait of Antony Valabrègue* (p. 92,
fig. 1) and *Bread and Eggs* (cat. no. 3), which is indeed from
1865. But the handling in *The Negro Scipion*—thick, whirl-
ing strokes applied with a brush instead of a palette knife—
clearly links it with *The Abduction* (cat. no. 12), dated 1867;
thus it can be assigned a similar date, making it one of
three important works Cézanne executed in either Paris or
Aix in that year: *The Negro Scipion, The Abduction,* and the
large decoration that was once on the salon wall in the
Jas de Bouffan and is now divided in two, *Mary Magdalen*
(p. 87, fig. 1) and *Christ in Limbo* (fig. 1).[4]

Reportedly, Scipion was a well-known model at the
Académie Suisse, which Cézanne frequented when he first
went to Paris. Nothing is known about him, except that he
very likely posed for a plaster by Philippe Solari exhibited
at the Salon of 1868 (no. 3843, *Nègre endormi* [Sleeping
Negro]), a fragment of an uncompleted allegory, the "War
of Independence," that was to have represented a "tall
Negro fighting with dogs."[5] It is possible that, like Solari's
work, Cézanne's "portrait" is the only surviving portion of
a larger composition. This would explain, for example, the
curious white mass on which the model leans; perhaps he
is not asleep, as now appears, but overcome with grief.
Bruno Ély has recently published a possible source for
Cézanne's canvas, a large painting (77³/₁₆ by 89⁹/₁₆ inches,
196 by 227.5 cm) by Joseph de Lestang-Parade (1810-
1887), *Le Camoëns Dying in the Hospital in Lisbon* (Salon of
1835), which the artist donated to the Musée Granet.[6] It
might be that the "Negro Scipion," too, is mourning over
an unknown deceased, for the white area could have been
a shrouded recumbent figure: the mass seems to have ex-
tended to the left, where it was subsequently painted over.

Whether a fragment or a study—it is certainly not a
portrait—this is one of the young Cézanne's strongest
works. In the 1920s, when there was little curiosity about
the painter's beginnings, it surprised many visitors to Gi-
verny, among them Elder, Gimpel, and Louis Vauxcelles,
who described it as a "striking masterpiece" and deemed it
"worthy of Delacroix."[7] Zola, too, penned lines that might
be mistaken for an impassioned defense of it: "No seeking
after plastic beauty as this is understood by our most recent
classic [artists]. An interpretation of astonishing breadth, a
disdain for finish that must scandalize many people
The artist didn't render [the subject] gracious, he con-
tented himself with copying nature and marking it with his
personality. That sufficed to make a work." He went on to
praise the "superb" head, "admirable passages in the back
and the arms," and the "feeling for oily and enveloping
flesh."[8] But the work in question here is Solari's *Sleeping
Negro;* about Cézanne's canvas Zola never wrote a word.

H. L.

1. Gimpel, 1963, p. 155; Vauxcelles, December 1905, p. 89.
2. Gimpel, 1963, p. 155. Monet owned fourteen paintings by Cézanne:
 The Negro Scipion (cat. no. 11), *Portrait of a Man* (V. 102), *The Beach at
 L'Estaque* (V. 295), *Melting Snow at Fontainebleau* (V. 336), *Turn in the
 Road* (cat. no.76), *L'Estaque* (V. 492), *Bathers* (V. 581), *Pot of Primroses
 and Fruit on a Table* (V. 599), *Boy in a Red Vest* (V. 680), *Ginger Jar and
 Fruit on a Table* (V. 733), *Still Life* (V. 735), *The Garden Vase* (V. 756),
 Château Noir (V. 794), and *Picnic on a River* (not in Venturi, Yale Univer-
 sity Art Gallery).
3. Elder, 1924, p. 49.
4. See Gowing, June 1956, p. 186.
5. Gasquet, 1921, p. 31.
6. See Ély, in Aix-en-Provence, 1984, pp. 182-83.
7. Vauxcelles, December 1905.
8. Zola, 1991, p. 228.

Fig. 1. Paul Cézanne,
Christ in Limbo, c. 1867,
oil on canvas (transferred),
private collection (V. 84).

The Abduction

1867
Oil on canvas; 35¼ × 45¾ inches (89.5 × 116.2 cm)
Signed and dated lower left: *67 Cézanne*
The Provost and Fellows of King's College, Cambridge.
Keynes Collection. On loan to the Fitzwilliam Museum.
V. 101

PROVENANCE
Given to Zola at an early date, this canvas remained in his possession until his death, when it figured in his estate sale (Hôtel Drouot, Paris, March 9-13, 1903, lot 115 ["'L'Enlèvement,' oeuvre de première jeunesse"]). Vollard acquired it for 4,200 francs, but he quickly sold it, through Durand-Ruel, to the New York collector H. O. Havemeyer, to whom it was sent on May 7, 1903. After Havemeyer's death, it was purchased at public auction (Anderson Galleries, New York, April 10, 1930, lot 80) by the Galerie Étienne Bignou, Paris. At the beginning of the 1930s, it belonged for a short time to an organization in Lucerne known as La Peinture Contemporaine; when this was dissolved, it was sold at the Galerie Charpentier, Paris, June 26, 1934 (lot 4). It was purchased by J. Maynard Keynes, London, in 1935 from Wildenstein Galleries, London.

EXHIBITIONS
After 1906: New York, 1917, unnumbered; Paris, 1935, unnumbered; London, 1935, no. 1; Chicago and New York, 1952, no. 6; Paris, 1953, no. 6; London and Edinburgh, 1954, no. 4; London, Paris, and Washington, 1988-89, no. 31; Basel, 1989, no. 2; Aix-en-Provence, 1990, no. 24.

What little we know about this canvas is quickly stated: it bears the date 1867, and it belonged to Émile Zola, in whose estate sale it was given the somewhat vague title *L'Enlèvement* (The Abduction). Since then, it has passed through the hands of famous collectors and dealers (Vollard, Durand-Ruel, Havemeyer, and others); it has been widely exhibited and frequently reproduced, and has occasioned numerous commentaries, especially in recent years with the rediscovery of the "early" Cézanne. Georges Rivière deemed it a transitional work in a style that is still romantic, but more controlled, moderate, and supple than that of earlier efforts.[1] For Venturi, it was an "imposing picture with a certain outrageous quality," characterized by "agitation rather than drama."[2] For Théodore Duret, it was a "composition of the purest romanticism," painted under the influence of Delacroix before the realist revelation of Courbet's work.[3] Meier-Graefe, clearly disturbed by it, saw it similarly in 1918, stressing Cézanne's youthful aberrations: "In the foreground of a romantic landscape, like a stage set, darker than the darkest Courbet, stands a nude fellow with a naked woman in his arms—the fellow, with muscles exaggerated in the style of Daumier; the woman, a spongy white, with monstrous extremities, a package of arms and legs. In the background, a pair of smaller nudes, crumbling pieces of flesh. Nothing at all for the youngsters of the time. Not a trace of naturalism—rather the opposite—nothing of Manet. In the disintegrating nudes of the background there is a childish baroque quality, like something that could have fallen from the table of Delacroix, tiny balls of bread kneaded with thick fingers."[4] The German critic's negative reading implies a question that many would pose without being able to provide an answer: given the work's apparent incompatibility with the writer's naturalist convictions, why did Cézanne give it to Zola—and

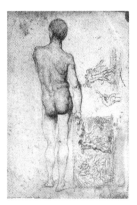

Fig. 1. Paul Cézanne,
*Standing Man Seen from the Back
and Two Studies for "The Abduction,"* 1866-67,
graphite on paper, private collection (C. 200).

Fig. 2. Paul Cézanne,
The Abduction, c. 1867,
pen, india ink, and watercolor on paper,
Collection of Patricia and
Donald Oresman (R. 30).

Fig. 3. Eugène Delacroix,
The Abduction of Rebecca, 1846,
oil on canvas,
The Metropolitan Museum of Art,
New York. Purchase 1903,
The Wolfe Fund (03.30).

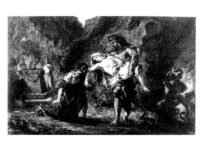

Fig. 4. Eugène Delacroix,
Hercules Rescuing Alcestis, 1862,
oil on canvas,
The Phillips Collection, Washington, D.C.

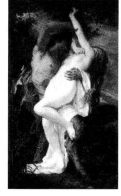

Fig. 5. Alexandre Cabanel,
Nymph Abducted by a Faun, 1860,
oil on canvas,
Musée des Beaux-Arts, Lille.

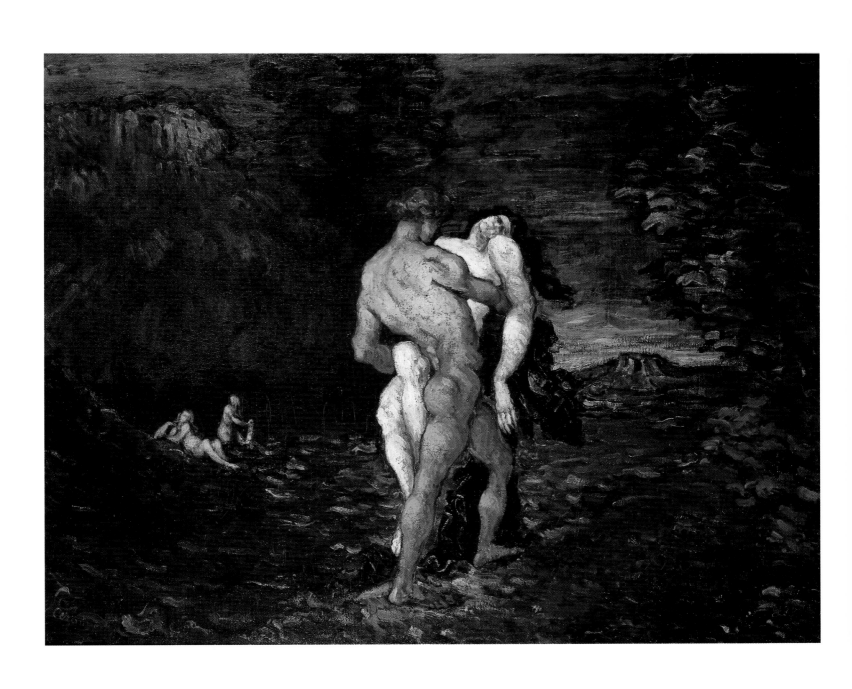

even, according to Georges Rivière (who provided no source for the assertion), paint it for him?[5] Mary Louise Krumrine saw in the landscape an evocation of Mont Sainte-Victoire and the Arc River running at its feet; she observed that it was "the scene of happy days of fishing and swimming that Cézanne and Zola had once shared,"[6] intimating that this holds the key to the mystery. Sidney Geist proposed a psychoanalytic interpretation: *The Abduction* would show Cézanne being "carried off" by Zola—for what reason, to what destination?—within the setting, darkened but identifiable, of their youthful idylls.[7] In truth, there is nothing in this generic landscape to support such a positive identification: not the bare mountaintop, perhaps volcanic, on the horizon; not the splashing dark water of indeterminate extent that could be a lake, a pond, or a river; not the thick, blurry vegetation, already faded and autumnal, which lacks any discernible southern accent. We are in a mythological nature whose luxuriant woods and deep waters provide an apt setting for amorous intrigues.

The canvas was preceded by four rapid sketches for the reclining nymph (C. 199), a watercolor of the central male figure (R. 28), and two compositional studies (figs. 1 and 2). Mary Tompkins Lewis has suggested that Cézanne painted the celebrated episode of Pluto abducting Proserpina described in Ovid's *Metamorphoses*;[8] more convincingly, Geist and Peter Kropmanns have identified the subject as Hercules rescuing Alcestis from the Underworld.[9] All scholars posit the young artist's having turned to one visual source or another: Niccolo dell'Abbate's *Abduction of Proserpina* (c. 1560) in the Louvre, Piazzetta's *Abduction of Helen* in the Musée Granet, and various canvases and decorative schemes by Delacroix (figs. 3 and 4).[10] A more surprising candidate should be added to the list: Cabanel's *Nymph Abducted by a Faun* (fig. 5), one of the great successes at the Salon of 1861, where Cézanne saw it and was probably struck by the violence of the scene as well as by the brutal contrast between the two figures' complexions, between "the nymph white as milk" and "the ravisher's swarthy arms."[11]

For, whatever the mythological pretext, the picture figures importantly in Cézanne's painful but determined struggle to master the painted female nude; this was a point of discipline for him, even an obsession, and, if we can believe those in his circle, a challenge that always remained daunting for him. From the start he belonged to the "family of makers of flesh" (to use a phrase coined by Zola in connection with Courbet),[12] a flesh that was abundant but firm, all curves and rotundities, partly covered by long hair, more hospitable than comely, but that, even so, made him "dizzy" when he approached it.[13] Sometimes the women tranquilly offer up their charms, giving new life to Eve the temptress (see cat. nos. 27 and 29); often they are pursued, abducted, tortured, strangled, stabbed (see cat. no. 16). They are capable only of seduction and submission, of leading one astray and accepting well-deserved punishment. In *The Abduction*, the woman is merely a bundle of white flesh lugged about by a tawny Hercules before nymphs who observe the event with indifference.

Though not qualifying as one of the "four to five meter canvases" the artist dreamed about in the summer of 1866,[14] it is nevertheless an ambitious work. Painted in small comma-like touches of the brush instead of the broad, flat strokes produced by the palette knife, it is stylistically close to *The Negro Scipion* (cat. no. 11), which should be assigned a similar date.

H. L.

1. See Rivière, 1923, pp. 46-47.
2. Venturi, 1936, vol. 1, no. 101, p. 88.
3. Duret, 1906, pp. 170-71.
4. Meier-Graefe, 1918, pp. 9-10.
5. Rivière (1923, p. 46) maintained that "during one of his Parisian sojourns, Cézanne executed a painting for Zola: *The Abduction*"; somewhat later, Rewald (1936, p. 70) added that the canvas was painted "on the rue La Condamine, in the rooms of Zola, to whom Cézanne gave it." However, from May 1866 to April 1867, Zola resided at 10, rue de Vaugirard, and from April 1867 to April 1868 at 1, rue Moncey (now rue Dautancourt) in the Batignolles quarter; see Zola, 1978-, vol. 1, pp. 432, 468.
6. Krumrine, 1989, p. 45.
7. Geist, 1988, pp. 225-29.
8. See Tompkins Lewis, 1989, pp. 156-62.
9. See Geist, 1988, pp. 227-28; and Kropmanns, 1993.
10. See Tompkins Lewis, 1989, p. 161; Ély, in Aix-en-Provence, 1984, p. 183; and Kropmanns, 1993.
11. Callias, 1861, p. 244; Henri Loyrette, in Paris and New York, 1994-95, p. 122 n. 72.
12. Zola, 1991, p. 128.
13. Gasquet, 1921, p. 34.
14. Zola to Coste, July 26, 1866, in Zola, 1978-, vol. 1, no. 151, p. 453.

13 | *Woman Diving into the Water*

1867-70
Graphite, watercolor, and gouache on paper; $6^{1}/_{8} \times 6^{3}/_{4}$ inches (15.6 × 16.2 cm)
National Museum and Gallery of Wales, Cardiff
R. 29

PROVENANCE
This watercolor originally belonged to Ambroise Vollard, and was one of four watercolors he sold to Nicolas Hazard, Orrouy, in February 1896.[1] It was auctioned at the Hazard sale on December 1-3, 1919 (lot 257), at the Galerie Georges Petit, Paris, and bought on December 4, 1919, by the Galerie Bernheim-Jeune, Paris. On March 12, 1920, it was purchased (along with two other watercolors and an oil) by Gwendoline E. Davies. She bequeathed her Cézannes to the National Museum of Wales in 1952.

EXHIBITIONS
Before 1906: Paris, 1895, unnumbered.
After 1906: London, 1925, no. 1; Newcastle upon Tyne and London, 1973, no. 9; Tübingen and Zurich, 1982, no. 108; London, Paris, and Washington, 1988-89, no. 66 (exhibited in Paris only).

Cézanne's early watercolors have much of the dark, brooding quality of his oil paintings from the same period. Often the surfaces of the paper look like they were roughed up, the texture abraded to be more absorbent to the pigments washed over them. Almost always, as here, they are worked to the edges of the sheet, with very little paper left blank. The themes of these watercolors parallel those of the paintings: they tend to picture fantastic or sexual narratives drawn deep from the artist's imagination, their meaning not easy to grasp.

Venturi called this small and intense sheet "The Fall of Icarus";[2] it was given its present title by Félix Fénéon in 1919.[3] Chappuis compared this drawing to another of two male figures diving (C. 96).[4] It must be acknowledged, however, that the figure has much in common with the male aggressor in the still more fraught watercolor called *The Abduction* (p. 100, fig. 2).

J. R.

1. See Rewald, 1983, no. 29, pp. 89-90.
2. See Venturi, 1936, vol. 1, no. 818, p. 239.
3. This history is reviewed in Rewald, 1983, no. 29, pp. 89-90.
4. Chappuis, 1973, vol. 1, no. 96, p. 71.

The Feast

14 | *The Feast*

c. 1867-72
Oil on canvas; 50³/₄ × 31¹/₂ inches (129 × 80 cm)
Private collection
V. 92

PROVENANCE
This canvas was acquired from Ambroise Vollard by Auguste Pellerin; until recently, it remained in the possession of his descendants.

EXHIBITIONS
Before 1906: Paris, 1895, unnumbered.
After 1906: Paris, 1926, no. 21; Paris, 1954, no. 2; London, Paris, and Washington, 1988-89, no. 39; Paris and New York, 1994-95, no. 33.

15 | *The Feast*

c. 1867
Gouache, watercolor, pastel, and crayon on cardboard,
with an additional piece of paper attached (2⁷/₈ × 3¹/₂ inches [7.3 × 8.9 cm]);
12³/₄ × 9¹/₈ inches (32.4 × 23.1 cm)
Private collection, Stuttgart
R. 23

PROVENANCE
Once the property of Charles Guérin (1875-1939), painter and engraver, co-founder of the Salon d'Automne, and a great admirer of Cézanne, this work was subsequently acquired by the Galerie Bernheim-Jeune, Paris, after which it passed to two French collectors in succession, Raymond Selles of Neuilly-sur-Seine and Jean Mazel of Paris. The latter sold it to its present owner.

EXHIBITIONS
After 1906: Basel, 1921, no. 46; Tübingen, 1978, no. 7a; Tübingen and Zurich, 1982, no. 1; London, Paris, and Washington, 1988-89, no. 65.

The canvas (cat. no. 14) was exhibited at the Galerie Vollard, rue Laffitte, in 1895 with the title *Le Festin* (The Feast); since then it has often been called *L'Orgie* (The Orgy), a more colorful appellation but one that Cézanne, who was bashful to the point of prudishness, might not have appreciated. It was placed at the rear of the gallery, where it was remarked upon by Gustave Geffroy, who, struck by the "luxury of the colors" and the "unprecedented sparkling light," made it out to be "a capital point of departure in the artistic stock here on exhibit. It speaks succinctly, brutally, in a fiercely affirmative voice, of the enthusiasms and loves of Cézanne's youth, of his comprehensive admiration for Veronese, Rubens, and Delacroix. This is not a servile admiration, it is a profession of faith, the declaration of a new artist swearing his allegiance to painting, to opulence, to energy. It is respectful of past masters, but how ardently it wants to speak in its own turn! Its ambition is betrayed by the violence it expresses, by the couple of lovers, so tightly knotted together, by the rhythmic disorder of the orgy, by the haughty figure pre-siding over this melee of instincts, by the other figure, so robust, placed at the summit, leaning over the balustrade from which draperies joyously unfurl with an air of freedom."[1]

Geffroy's views were repeated in similar terms throughout the twentieth century: a consensus emerged early on that *The Feast* exemplifies the romantic aspect of the artist's youthful production, that it is singularly instructive about his relations with the old masters, and that it was acceptable and exhibitable, whereas so many other works from this period were only obscure documents in which the traces of a Cézanne-before-Cézanne were difficult to discern. Like Geffroy, many authors have enumerated the painter's visual sources. Emphasis has rightly been placed on the influence of Veronese, a "unique phenomenon" about whom Cézanne thought constantly, and whose talent for devising the large, complex pictures dubbed by the French *grandes machines* was so admired by him. The oft-contemplated *Wedding at Cana*—"Now that's painting. The details, the ensemble, the volumes, the val-

ues, the composition, the blending together, everything's there"— exemplified what he was trying to achieve in *The Feast*, "a grand colored undulation, . . . an irisation, . . . a harmonious warmth, an abyss into which the eye plunges, a mute germination."[2] Then there was Rubens, whose works he copied at the Louvre (see cat. no. 110) and whose hearty pictorial health he envied, a "maker of flesh" whose only genuine rival was Courbet, the master of flesh that is abundant, sensual, sprightly, colored, and hence the opposite of Manet's,[3] which is gray, dry, and cerebral. Finally, there was Delacroix, the worthy heir of this Venetian and Flemish heritage from whose work he cited openly, borrowing from *The Death of Sardanapalus* the accumulation of nudes, the profusion of sumptuous accessories, and the connivance of death and debauch, or more literally, from *The Entry of the Crusaders into Constantinople*, the entwined woman with cascading blond hair on the left. But Cézanne did not resort repeatedly to such citations to camouflage a lack of imagination or an inability to bring ideas to fruition; on the contrary, he saw himself as the heir of a well-established line dating back to the Venetian Renaissance, one widely held to have migrated a century later to Flanders and thence to Delacroix, a "blackguard of a great painter" with "the most beautiful of French palettes."[4]

In recent years, there also has been much speculation about a literary source for this *Feast*. Theodore Reff discerned one in a poem written by Cézanne in 1858, *The Dream of Hannibal*:

Departing a feast, the hero of Carthage,
Who had too frequently resorted to
Rum and cognac, stumbled, staggered.[5]

According to Mary Louise Krumrine, Cézanne "transcribed images drawn from Virgil and Flaubert," particularly the descriptions of Dido's banquet in Book I of the *Aeneid*, of the "great feast" given by Hamilcar's soldiers at the beginning of *Salammbô*, and of Nebuchadnezzar's banquet in *The Temptation of Saint Anthony*.[6] Mary Tompkins Lewis pointed to Cézanne's familiarity with de Musset, Hugo, and Gautier,[7] but in the end—noting that Cézanne was a faithful reader of *L'Artiste*,[8] where an early version of the *Temptation* was published in installments between December 1856 and February 1957—she insisted on the crucial role of Flaubert's text, which has striking affinities with Cézanne's image: "Then appears, beneath a black sky, a vast hall illuminated by golden candelabra. Plinths of porphyry, supporting columns that are half lost in shadow, so high are they, form long lines. . . . Slaves run about with dishes, women pass round the tables and pour out for the guests to drink."[9] But both Krumrine and Tompkins Lewis used the second version of the text, citing only a portion of the tempting vision and omitting everything that does not correspond with the canvas: Nebuchadnezzar, "in the extreme rear—higher—alone, wearing the tiara," the camel, "loaded down with tapped leather bottles," the lions led by keepers, the dancers, and the black jugglers.[10]

Little attention has been paid to a remark made by Cézanne and reported by Gasquet that, in *The Feast*, he seems to have set out "to present something like a pendant to the orgy in [Balzac's] *La Peau de chagrin*."[11] The painter had always been interested in the collection of short works by Balzac entitled *Études philosophiques*, and especially in *Le Chef-d'oeuvre inconnu*; but if Cézanne was the story's protagonist, Frenhofer—an artist who long slaved over a canvas that struck visitors as no more than "confused heaps of color contained within a multitude of bizarre lines"[12]—he was also Raphael in *La Peau de chagrin*, a poor student haunted by dreams of luxury. This character, "stripped of everything and lodged in an artist's garret," suddenly sees himself, like Saint Anthony, "surrounded by ravishing mistresses." His first wish when he gains possession of the talisman, a magical animal skin that grants its owner's every desire, is for "a dinner of royal splendor, something like a bacchanale."[13] It is granted, but the day after this orgy, which briefly enables him to play Nebuchadnezzar but also shortens his life, he is overwhelmed by disgust at his recent elation and is overcome by melancholy of the flesh and bitterness in the face of quotidian reality. There is a striking contrast in Cézanne's oeuvre between the outrageousness of certain canvases—notably *The Feast*—and the temperate humility characteristic of others; a similar claim could be made about *La Peau de chagrin*, in which there is a calculated opposition between the hypertrophy of the initial scenes—the antiquities shop, the orgy—and the narrative's subsequent linear development. If Cézanne's women are often severely punished, this is because they arouse desire and lead one astray; in Cézanne's particular case, they also distract him from blessed hours in the studio.

In truth, Cézanne had taken up an image that was common in the literature and painting of his time, that of the orgy or bacchanale.[14] Many contemporary artists, usually basing their work on ancient texts, resorted to it as a means of criticizing contemporary mores or of expressing nostalgia for a lost world of luxury and indulgence, one still innocent of Christian proscriptions and driven to scorn death by perpetually pursuing pleasure. As in treatments by Delacroix and Couture, Cézanne's composition features a lewd profusion of nude flesh, black bodies, golden vessels, and sumptuous fabrics. Like the bacchanales in the roughly contemporary operas by Wagner *(Tannhäuser)* and Gounod *(Faust)*, it could be said to have orchestral richness, striking harmonies, and languid rhythms that occasionally take a frenetic turn.

Both the many preparatory drawings (C. 135-37, C. 139, C. 156, C. 194 *bis*) and the visibly reworked final canvas attest to a difficult process of elaboration. Doubtless the work evolved over a period of several years. A compositional study (cat. no. 15), in which crayon, gouache, pastel, and watercolor in somber tones completely cover the thin cardboard ground, was probably executed around 1867; the guests, fused into indistinct couples, encompass the banquet table, onto which the exhausted revelers have collapsed. The room is dark and hemmed in by large pil-

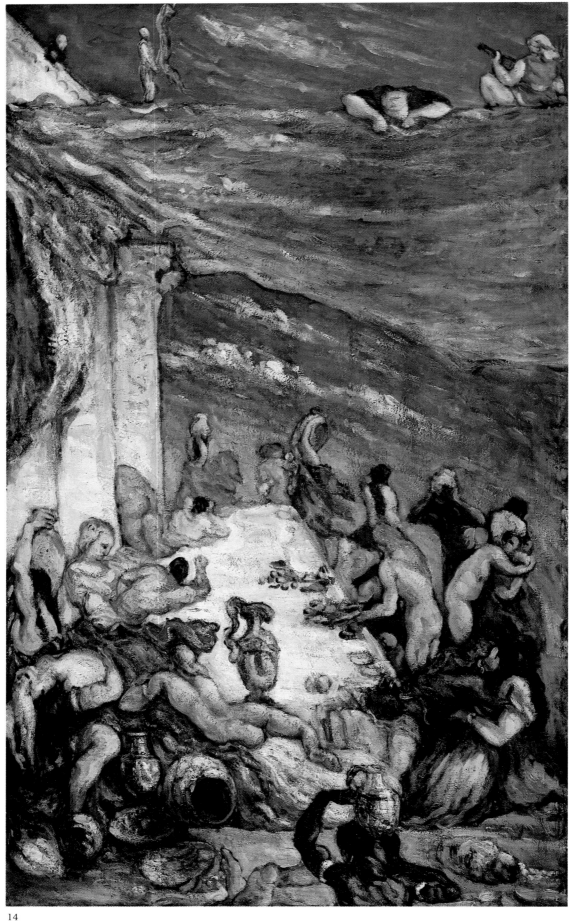

14

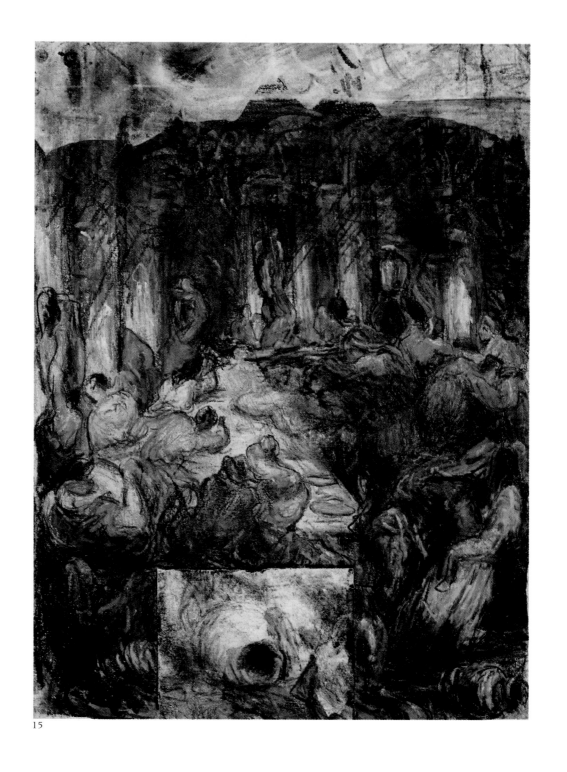

15

lars; overturned vessels in the foreground transform the scene into a pagan wedding at Cana at which all the guests have become intoxicated. In the canvas—perhaps begun about 1867 and taken up again around 1870-72[15]—the columns, whose forms are still discernible to the naked eye, were covered by a blue sky streaked with white clouds and interrupted by a long, fluttering piece of fabric. Cézanne painted a vision whose sprightly rhythms and coloristic brilliance convey unmistakably that it was conceived as a delicious fantasy rather than an impious "temptation." The couples interlock; the servants move about bearing amphoras on their heads as fearlessly as the companions of Rebecca; two youngsters, the descendants of Renaissance cherubim, intently contemplate the scene below, while a musician, his back to the viewer, plays the lute or the guitar from his perch in the heavens.

H. L.

1. Geffroy, 1900, pp. 215-16.
2. Gasquet, 1921, p. 101.
3. Ibid., p. 110.
4. Ibid., p. 109. Delacroix was very much on Cézanne's mind during the execution of *The Feast*; a sheet bearing a study for this composition also carries a bust-length portrait of Delacroix (C. 156).
5. "Au sortir d'un festin, le héros de Carthage,/ Dans lequel on avait fait trop fréquent usage/ Du rhum et du cognac, trébuchait, chancelait." Cézanne to Zola, November 23, 1858, in Cézanne, 1978, pp. 37-38; and Reff, June 1963, p. 152.
6. Krumrine, 1989, pp. 48-50.
7. See Tompkins Lewis, in London, Paris, and Washington, 1988-89, pp. 34-36.
8. See Ballas, December 1981, p. 224.
9. Gustave Flaubert, *La Tentation de saint Antoine*, excerpt published in *L'Artiste*, December 21, 1856, pp. 19-20.
10. Ibid.
11. Gasquet, 1921, p. 46.
12. Honoré de Balzac, *Le Chef-d'oeuvre inconnu*, in *La Comédie humaine* (Paris, 1979), vol. 10, p. 436.
13. Balzac, *La Peau de chagrin*, ibid., pp. 139, 205-7.
14. See Tompkins Lewis, in London, Paris, and Washington, 1988-89, pp. 32-34; and Albert Boime, *Thomas Couture and the Eclectic Vision* (New Haven, 1980), pp. 143-52, 165-68.
15. Rewald indicated "circa 1867, perhaps later"; Gowing, "c. 1870" (London, Paris, and Washington, 1988-89, no. 39, p. 148); Chappuis dated some of the preparatory drawings (C. 135-39, C. 156) between 1864 and 1868; Robert Ratcliffe (1960) proposed, on the basis of modifications visible to the naked eye, that it is an early painting reworked around 1872.

16 | *The Murder*

c. 1868
Oil on canvas; 25³/₄ × 31³/₄ inches (65.5 × 80.7 cm)
Walker Art Gallery, Liverpool. Board of Trustees of the National Museums and Galleries on Merseyside
V. 121

PROVENANCE
On October 16, 1916, this canvas was purchased from Ambroise Vollard by Paul Cassirer; acquired by Sally Falk, of Mannheim, it was repurchased by Paul Cassirer in April 1918. On May 3 of that year it was sold to Julius Elias (1861-1927). Purchased by the Wildenstein Gallery from Elias's widow, the canvas was acquired, with support provided by the National Art Collections Fund, by the Walker Art Gallery in 1964.

EXHIBITIONS
After 1906: Cologne, 1913, no. 8; Berlin, 1913, no. 24a; Berlin, 1921, no. 1; Basel, 1936, no. 6; Chicago and New York, 1952, no. 2; Aix-en-Provence, Nice, and Grenoble, 1953, no. 2 (exhibited in Aix and Nice only); Zurich, 1956, no. 5; Munich, 1956, no. 2; Vienna, 1961, no. 4; Tokyo, Kyoto, and Fukuoka, 1974, no. 7; Liège and Aix-en-Provence, 1982, no. 2; Madrid, 1984, no. 6; London, Paris, and Washington, 1988-89, no. 34; Tübingen, 1993, no. 2.

Fig. 1. Paul Cézanne, *The Strangled Woman*, 1870-72, oil on canvas, Musée d'Orsay, Paris, gift of Max and Rosy Kaganovitch (V. 123).

In the 1860s and 1870s, Cézanne was intensely preoccupied by the female body, whether a tremulous creature abducted by a muscular hero (see cat. no. 12) or a courtesan brutally strangled in an alcove (fig. 1). Provided with abundant unbound hair and pronounced bosoms, the painter's women were duly punished by him; it seems he could tolerate the opposite sex only in the guise of a tightly corseted young girl with her hair in a chignon, insipid and timid, darning or playing the piano (see cat. no. 17). In *The Abduction* (cat. no. 12), the nude bodies evoke the remote world of mythology. Things are very different in *The Murder*, which has an unmistakably contemporary feel: the time is the present, the place indeterminate but desolate,

Fig. 2. Paul Cézanne, *The Murder*, 1874-75, graphite, watercolor, and gouache on paper, private collection (R. 39).

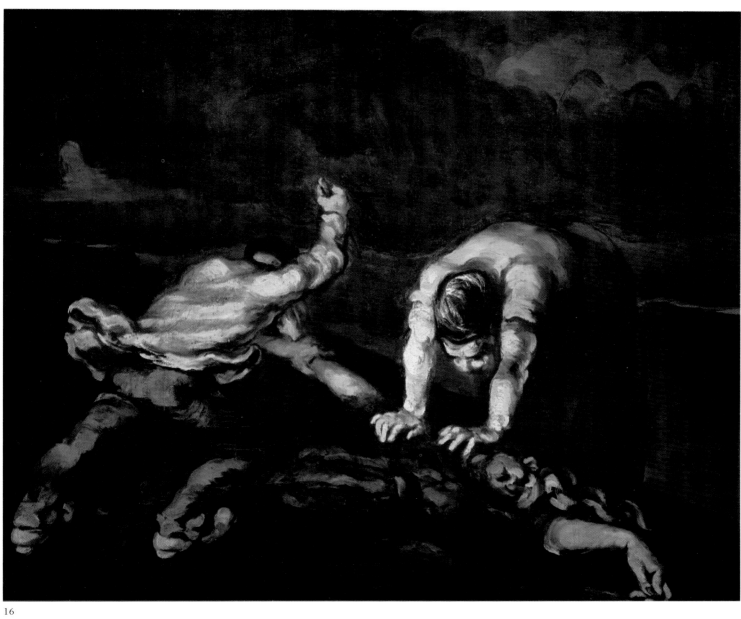

16

the hour ambiguous. Everything here conspires to evoke a terrible *fait divers*, or unsavory news item: the isolation, the darkness, the dead surface of the river (which takes on an exaggerated breadth, the better to swallow the body that will soon be rolled into it), and the three figures set against a dark landscape, committing a murder whose circumstances remain mysterious. There's the faceless man who stabs the victim, nothing more than an avenging arm brandishing a knife. There's the prostrate woman—his woman, for she is linked with him visually: her dress is the color of his pants, his flesh, his shirt. And then there's the bent-over creature whose gender is conveyed solely by her broad skirt,[1] who holds down the victim with all her strength and weight. The violence of the image is inflected more by this heavy, placid, inexorable body than by the theatrical gesture of the true assassin.

The Murder has been interpreted as a realist picture and related to the frightening machinations of the protagonist in Zola's contemporary novel, *Thérèse Raquin*. It is much closer in spirit, however, to illustrations in the popular press—surely a visual source for the composition[2]—and the strain of Romantic imagery epitomized by Géricault's drawings of the horrific Fualdès incident.[3] For Cézanne eschewed everything that might be deemed picturesque; aligning the somber tones of the landscape with the dark tenor of the action, eliminating all superfluous detail, he painted a modern allegory of the ordinary crime, vicious but of uncertain motivation. Some years after this canvas, he repeated the figure group in a watercolor (fig. 2). The basic configuration remains the same, but the man's face is no longer hidden and the victim lifts her arm in supplication. We are now in a particular place, perhaps L'Estaque, but, in any event, a tranquil landscape where "land stands out against a blue sea,"[4] where pines cling to steep rocks and lift high their wispy green tufts against blue sky and clear water.

H. L.

1. Roger Fry (1927, p. 13) identified the figure as a man.
2. On this subject, see Simon, May 1991, pp. 125-30, 134-35.
3. In 1817 Antoine-Bernardin Fualdès, who had been a magistrate under the Empire, was assassinated under mysterious circumstances. The case soon became a *cause célèbre* and Géricault made many drawings.
4. Julie Manet, diary entry, November 29, 1895, in Manet, 1979, p. 74.

17 | *Young Girl at the Piano—Overture to Tannhäuser*

c. 1869
Oil on canvas; 22³/₄ × 36³/₈ inches (57.8 × 92.5 cm)
The Hermitage Museum, St. Petersburg
V. 90

PROVENANCE
Cézanne probably gave this canvas to his sister Rose (she may have posed for it), who married Maxime Conil in 1881. It long remained on the Conil property, Montbriant, near the Jas de Bouffan, but around 1904 it was sold to Ambroise Vollard. In 1908 he sold it for 20,000 francs to the Russian collector Ivan Morosov; in 1918 it was confiscated by the Soviet State along with the rest of his collection. It was exhibited in Moscow, at the Museum of Modern Western Art from 1918 to 1948, when it was sent to the Hermitage.

EXHIBITIONS
After 1906: Moscow, 1926, no. 2; Paris, 1936, no. 8; Leningrad, 1956, no. 2; London, Paris, and Washington, 1988-89, no. 44; Paris and New York, 1994-95, no. 28 (exhibited in New York only).

Exceptional for a work from the 1860s, the genesis of the Hermitage canvas was established as early as 1937 by Alfred Barr.[1] It can be traced in the regular correspondence between Fortuné Marion, a childhood friend of Cézanne's, and Heinrich Morstatt, a young German musician then pursuing a business career in Marseille. During the summer of 1866 the painter settled on a first version of the subject: "In a single morning," Marion wrote on August 28, "he has half built a superb picture, you'll see. It will be called the *Overture to Tanauhser [sic]*—it belongs to the future just as much as Wagner's music. Here it is: a young girl at the piano; some white against some blue; everything in the foreground. The piano superlatively and broadly treated, an old father in an armchair in profile;—a young child with an idiotic air, listening in the background. The mass very wild and overwhelmingly powerful; one has to look quite a long time."[2] A year later, in June or July 1867, Marion informed his correspondent that Cézanne, dissatisfied with the first version, had undertaken a second: "He already has several large canvases underway and he's going to treat again, in altogether different tonalities, with lighter notes, the *Overture to Tannhäuser* that you saw in a first canvas."[3] And on September 6, he specified: "I'd like you to see the canvas he's working on right now. He's again taken up the subject already known to you, the *Overture to Tannhäuser*, but in very different tonalities and very clear colors, with all the figures very finished. There's a young blond girl's head that's astonishingly powerful and pretty, and my profile is a very good likeness, yet at the same time very resolved, without the harsh colors that were so annoying and the ferocity that was so off-putting. The piano is still very beautiful, as in the other canvas, and the draperies, as usual, of an astonishing truth. Very likely it will be refused for the exhibition, but it will be exhibited somewhere, a canvas like this is sufficient to establish a reputation."[4]

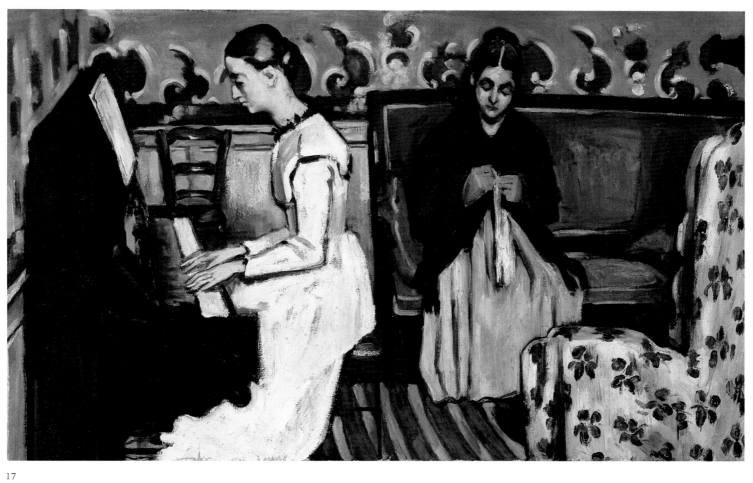

17

Clearly the Hermitage canvas is a later version of the composition, its elaboration having extended over several years (roughly 1866 to 1869). It was intended for the Salon and seems to have caused the artist some trouble. Already in November 1866, Cézanne made the following admission about the first version, noted in a postscript to a letter from Antoine Guillemet to Zola: "Having attempted a family *soirée*, it didn't come out at all, but I'll persevere and perhaps with another stab it will come."[5] It indeed "came," but only after significant changes were introduced: tones that were lighter and less "harsh" than the original ones; "very finished figures," less sketchily and vehemently executed than in the initial version, where they were probably in the *couillarde* style; and finally a new cast of characters. The "old father" and the "young child with an idiotic air" from the earlier version as well as the "profile" of Marion from the second have disappeared, giving way to an entirely feminine cast: a young girl at the piano—the only survivor from the two previous campaigns—and an older woman, sitting farther back, who embroiders or darns.

In general conception, Cézanne's depiction of an intimate, bourgeois musicale is not unlike those by Whistler (*At the Piano*, The Taft Museum, Cincinnati), Fantin-Latour (*The Two Sisters*, The Saint Louis Art Museum), Degas (*Portrait of M. and Mme Édouard Manet*, Kitakyushu Municipal Museum of Art), and Manet (*Madame Manet at the Piano*, Musée d'Orsay, Paris). But the title he assigned this subject gives it quite another resonance. Cézanne's painting is not "Wagnerian" in any programmatic sense, like Fantin-Latour's *Tannhäuser on the Venusberg* (fig. 1), a visual fantasy inspired by the bacchanale in the first act of the opera. Rather than attempting to illustrate the sonic richness and theatrical extravagance of Wagner with any specific episode, he set out to paint a scene of quiet, provincial life, steady and fairly boring.

Even so, Cézanne's canvas is subtly responsive to the Wagnerian ethos. The painter had certainly discovered this composer in the early 1860s, when he was the subject of heated conversation in artistic circles in Paris; later, Mor-

statt strengthened his Wagnerian faith. During the 1865 Christmas season, Cézanne went so far as to "beg" Morstatt to come from Marseille to play some Wagner for him;[6] in May 1868 he wrote him of his "happiness" on having heard "the overtures to *Tannhäuser, Lohengrin*, and *The Flying Dutchman*."[7] Cézanne doubtless knew Baudelaire's article "Richard Wagner et *Tannhäuser* à Paris," written in the wake of the work's resounding failure at the Opéra and first published in the *Revue européenne* in 1861 (also issued that year in pamphlet form). When, in the same letter from 1865, the artist implored Morstatt to visit him and cause "our acoustic nerves to vibrate to the noble accents of Richard Wagner,"[8] he was using language unmistakably reminiscent of the poet's evocation of the music's "titillating" aspect: "From the first measures, the nerves vibrate in unison with the melody; all flesh that remembers is set trembling."[9]

The Overture to Tannhäuser was conceived as a pictorial correspondence to the Wagnerian drama; in effect, Cézanne the *refusé* answered the "music of the future" so reviled in Paris with his own "painting of the future." But the canvas also subtly invokes the conflict at the core of the opera: "*Tannhäuser*," wrote Baudelaire, "represents a struggle between two principles that have chosen the human heart as their principal field of battle, namely flesh and spirit, hell and heaven, Satan and God. And this duality is established at the outset, and with incomparable skill, by the overture."[10] Cézanne—himself engaged in perpetual struggle with these two "principles," as his work from the 1860s and 1870s makes clear—shows us one woman darning and another making music, one woman seemingly devoted to a domestic existence and another who dreams about the artistic life. Elizabeth and Venus—or alternatively, Martha and Mary, but with Cézanne we are left in the dark as to who has chosen the "good part"—each in her own world, so close yet so distant from one another, nurture their respective talents within the stuffy surroundings of a bourgeois interior. But for the time being, the "music of the future," laboriously approximated on a small upright piano, resonates in a void, stirring up only the flowers on the chintz slipcover and the arabesques on the wallpaper.

H. L.

Fig. 1. Henri Fantin-Latour,
Tannhäuser on the Venusberg, 1864,
oil on canvas,
The Los Angeles County Museum of Art,
gift of Mr. and Mrs. Charles Boyer (59.62).

1. Barr, January 1937, pp. 52-57.
2. Marion to Morstatt, August 28, 1866, in Barr, January 1937, no. 7, p. 54.
3. Marion to Morstatt, June or July 1867, ibid., no. 20, p. 54.
4. Marion to Morstatt, September 6, 1867, ibid., no. 23 [not 20], pp. 54-55.
5. Baligand, 1978, p. 180.
6. Postscript by Cézanne to a letter from Marion to Morstatt, December 23, 1865, in Barr, January 1937, no. 3, p. 53.
7. Postscript by Cézanne to a letter from Marion to Morstatt, May 24, 1868, ibid., no. 31, p. 53.
8. Postscript by Cézanne to a letter from Marion to Morstatt, December 23, 1865, ibid., no. 3, p. 53.
9. Reprinted in Baudelaire, 1975-76, vol. 2, p. 795.
10. Ibid., p. 794.

18 | *Still Life with Green Pot and Pewter Jug*

c. 1869-70
Oil on canvas; 25³/₁₆ × 31⁷/₈ inches (64 × 81 cm)
Musée d'Orsay, Paris (R.F. 1964-37)
V. 70

PROVENANCE
At the end of the nineteenth century this canvas belonged to the Russian collector Sergei Ivanovich Shchukin (or perhaps his brother Ivan?), who had assembled in his Parisian residence an admirable collection of French paintings (Monet, Degas, Cézanne, Gauguin), now divided between the Pushkin Museum in Moscow and the Hermitage in St. Petersburg; he probably acquired it from Ambroise Vollard. The painting was sold at the Hôtel Drouot, Paris, on March 24, 1900 (lot 3). It was purchased from Gaston Bernheim de Villers by the Musées Nationaux in 1963, with funds provided by an anonymous Canadian benefactor and additional support from the heirs of Gaston Bernheim de Villers and the Société des Amis du Louvre.

EXHIBITIONS
Before 1906: London, 1906, no. 199.
After 1906: Paris, 1912 (a), unnumbered; Zurich, 1917, no. 33; Paris, 1926, no. 49; Paris, 1936, no. 14; Chicago and New York, 1952, no. 12; Paris, 1960, no. 28; Paris, 1974, no. 3; London, Paris, and Washington, 1988-89, no. 53 (exhibited in Paris only).

EXHIBITED IN PARIS ONLY

Like *The Black Clock* (repro. p. 27), usually assigned a similar date,[1] *Still Life with Green Pot and Pewter Jug* has been considered something of a watershed in Cézanne's career, a work in which the painter, finally hitting upon his true path, renounced the "baroque" and "romantic" extravagance of the *couillarde* style and brought together for the first time all the features of the masterpieces to come: humility before the motif, classical *mise en place*, and assured handling. It was still life—which, as he subsequently observed, necessitated "grappling directly with objects"[2]—that prompted the development of this new manner.[3] It should be noted, however, that in this period and for several years subsequently, Cézanne was both a painter of re-ality and an artist devoted to imaginative subject matter. An evolution paralleling the one in his still lifes can be observed in his portraiture; one of the principal reasons for this development was the recent ascendancy of Manet in Cézanne's artistic sights. The influence of his glorious senior is especially evident in *Still Life with Green Pot and Pewter Jug*. The geography of *The Black Clock*, for example, is peculiarly Cézannean: a rugged patch of nature in which the artist depicts a *rocaille* shell and the severe, almost monumental façade of a clock perched atop a white tablecloth disposed in striking, cliff-like configurations. This picture, by contrast, recalls the tranquil still-life landscapes of Manet (fig. 1)—broad and dark, punctuated by the spires of bottles and glasses, juxtaposing the dome of a melon with a mound of fruit—which Cézanne could have seen in the artist's 1867 retrospective. He adopted their overall disposition but recast them in coarser terms: their Gothic spires and Renaissance domes give way to Romanesque towers. His table lacks the bourgeois elegance and profusion of Manet's; there is no brioche or salmon or basket of fruit here, only the modest art student's fare of apple, eggs, and onions. But he is more directly indebted to Manet for the emphatically contrasted blacks and whites (customarily associated with the Spanish masters), the thick, creamy handling, the black edging used to define objects, and the intense white tablecloth, which brings to mind the melancholy observation made by Cézanne at the end of his life—paraphrasing Balzac—that he'd always wanted to paint "a tablecloth of new-fallen snow."[4]

Fig. 1. Édouard Manet,
Still Life with Melon and Peaches, 1866 (?),
oil on canvas,
National Gallery of Art, Washington, D. C.,
gift of Eugene and Agnes Meyer, 1960.

In addition to Manet, the example of Chardin must be invoked. The author of the *Olympia* looked to him quite often in the 1860s, going so far as to imitate his *Brioche*, which entered the Louvre in 1869 with the La Caze bequest, rather closely in his own painting of the same title (1870, The Metropolitan Museum of Art, New York). Cézanne, who made no secret of his admiration for this "cunning fellow" and the way he enveloped objects in a "dust of emotion,"[5] followed suit. Distancing himself from the still lifes of his contemporaries Charles Monginot and Blaise-Alexandre Desgoffe, whose modest gift for shop-window-like tableaux resulted in resonant but hollow compositions, Cézanne—to cite the Goncourt brothers on Chardin—used his "beautiful buttery touch" and dipped "his brush right in the batter."[6] As Rilke remarked: "His still lifes are so amazingly self-absorbed. The frequently used white cloth, first of all, which mysteriously soaks up the dominant local color, and the objects placed on it, which proceed, each for all it is worth, to speak up and express opinions about it."[7] Like Chardin before him, he discovered the manifold possibilities available to the painter in simple arrangements of a few inanimate motifs: a pot, a tablecloth, an apple, some onions—next to nothing.

After 1870 his colleagues at the Nouvelle-Athènes began to move away from the genre: Manet gave up "composed" still life in favor of small canvases isolating a piece of fruit, a vegetable, or a few flowers, while Pissarro and Sisley turned their attention exclusively to landscape. Only Renoir and Monet continued to paint inanimate objects, on an occasional basis. By contrast, still life became Cézanne's genre of choice; it allowed him to exercise his penchant for order and stability. In old age he explained this deep attachment as follows: "A sugar bowl teaches us as much about ourselves and about our art as a Chardin or a Monticelli. It has more color. It's our pictures that become *natures mortes* [literally, 'dead nature']."[8] Painting gives only a pale reflection of the world; it is pure vanity and deceit, and only the foolish birds who pecked at Zeuxis's grapes are taken in by it. Still life is a metaphorical embodiment of painting itself, for everything that falls from the artist's hand irremediably tends toward it; in a very real sense, then, the genre represents art's last word. "Our pictures, they're like the prowling night, the groping night. . . . The museums are like Plato's caves. I'd have engraved on their doors: 'Painters not admitted. Sunlight available outside.'"[9]

H. L.

1. John Rewald concluded that *Still Life with Green Pot and Pewter Jug* was probably painted in 1869, in La Roche-Guyon, and rejected any later date for it (see Paris, 1974, no. 3, p. 28). Lawrence Gowing proposed "c. 1870" (Paris, London, and Washington, 1988-89, no. 53, p. 176). Most scholars consider that *The Black Clock* was painted in 1870 in Zola's apartment on the rue La Condamine (see the discussion by Gary Tinterow in Paris and New York, 1994-95, no. 31, p. 351).
2. Gasquet, 1921, p. 124.
3. See notably the judicious remarks by Dorival, 1948 (b), pp. 28-29.
4. Gasquet, 1921, p. 123.
5. Ibid., p. 122; Cézanne to Émile Bernard, June 27, 1904, in Cézanne, 1978, p. 304. On the Cézanne-Chardin parallel, see Sterling, 1959, pp. 96-99. On the rediscovery of Chardin in the 1860s and his influence on Impressionist artists, see Henri Loyrette, in Paris and New York, 1994-95, pp. 160-65.
6. Goncourt, December 1, 1863, p. 520.
7. Rilke to his wife, October 24, 1907, in Rilke, 1952, p. 42.
8. Gasquet, 1921, p. 124.
9. Ibid.

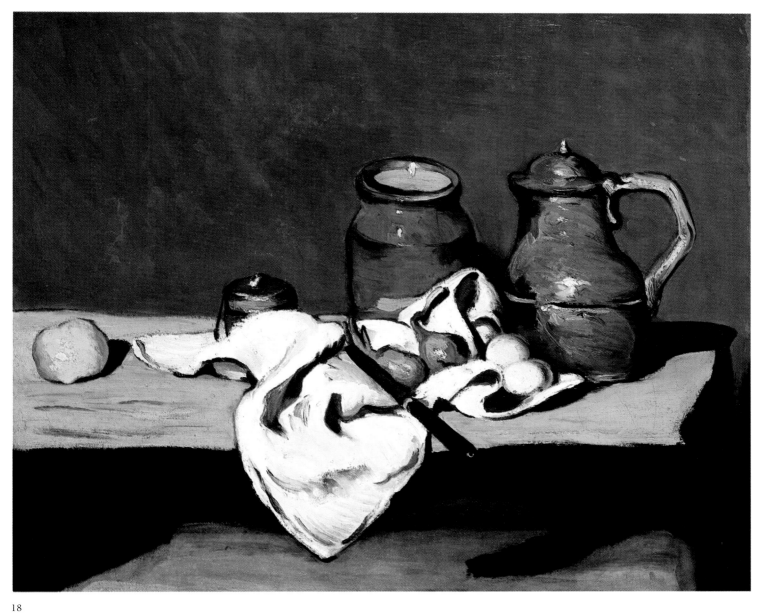

18

Portraits of Achille Emperaire

19 | *Portrait of Achille Emperaire*

1869-70
Oil on canvas; 78³/₄ × 47¹/₄ inches (200 × 120 cm)
Signed lower right: *P. Cézanne*
Inscribed at top: *ACHILLE EMPERAIRE PEINTRE*
Musée d'Orsay, Paris. Gift of Mme René Lecomte and Mme Louis de Chaisemartin (R.F. 1964-38)
V. 88

PROVENANCE
Around 1890, Émile Bernard "discovered" this portrait in père Tanguy's shop, hidden "under a pile of other canvases that were quite mediocre." According to Tanguy, "Cézanne, who often came to see him, . . . had resolved to destroy it."[1] At the urging of Émile Bernard, it was acquired early in 1892, for 800 francs, by Eugène Boch, "the Belgian artist who specialized in mining sites";[2] he kept it on his Monthyon property, near Meaux, until about 1908, when he turned it over to the Galerie Bernheim-Jeune in Paris. After difficult negotiations—Boch wanted 50,000 francs for the portrait while Bernheim estimated it could bring at most 30,000—the work was acquired on January 28, 1910, by Auguste Pellerin for 45,000 francs; in 1964, his daughter, Mme René Lecomte, and his granddaughter, Mme Louis de Chaisemartin, gave it to the Jeu de Paume, Paris.[3]

EXHIBITIONS
Before 1906: refused for the Salon of 1870.
After 1906: Paris, 1907 (b), no. 45; Paris, 1953, no. 10; Paris, 1954, no. 13; Paris, 1974, no. 4; London, Paris, and Washington, 1988-89, no. 46.

20 | *Portrait of Achille Emperaire*

1869-70
Charcoal on paper; 17 × 12⁹/₁₆ inches (43.2 × 31.9 cm)
Kunstmuseum, Basel
C. 229

PROVENANCE
This drawing passed from the hands of Paul Cézanne *fils* to the collection of Lukas Lichtenhan (1898-1964), director of the Basel Kunsthalle. The Kunstmuseum in acquired it from him in 1951.

EXHIBITIONS
After 1906: Paris, 1936, no. 149; Tübingen, 1978, no. 31; New York, 1988, unnumbered; London, Paris, and Washington, 1988-89, no. 79 (exhibited in Paris and Washington only).

21 | *Portrait of Achille Emperaire*

c. 1869-70
Charcoal and graphite on paper; 19 × 12¹/₈ inches (48.2 × 30.8 cm)
Musée du Louvre, Paris. Département des Arts Graphiques. Musée d'Orsay
C. 230

PROVENANCE
This drawing passed from the hands of Paul Cézanne *fils* to the Galerie Renou et Colle, Paris, which sold it to Adrien Chappuis, the author of the catalogue raisonné of Cézanne drawings. He donated it to the Cabinet des Dessins of the Louvre in 1967.

EXHIBITIONS
After 1906: Paris, 1936, no. 141; Basel, 1936, no. 99; San Francisco, 1937, no. 54; London, 1939 (b), no. 75; Tübingen, 1978, no. 32; London, Paris, and Washington, 1988-89, no. 80 (exhibited in Paris only).

EXHIBITED IN PHILADELPHIA ONLY

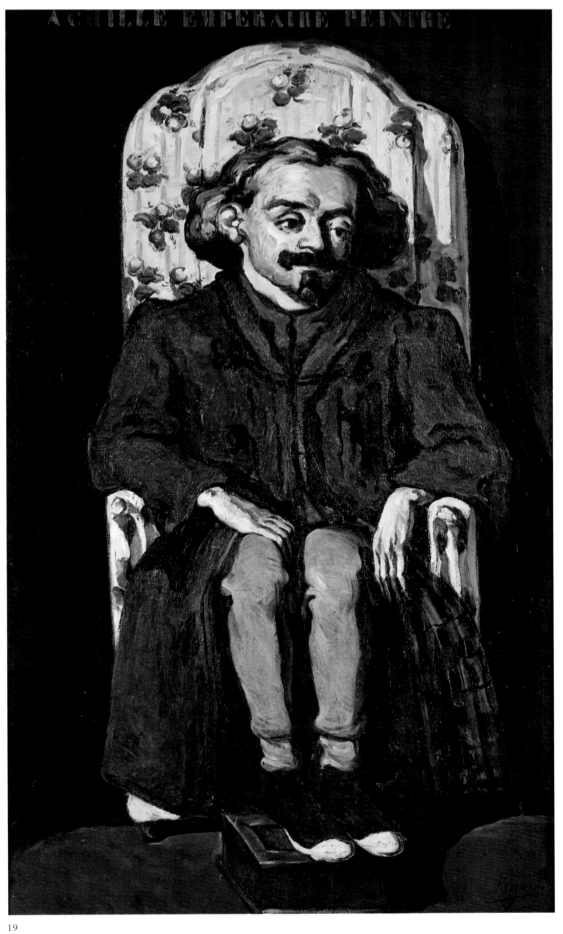

19

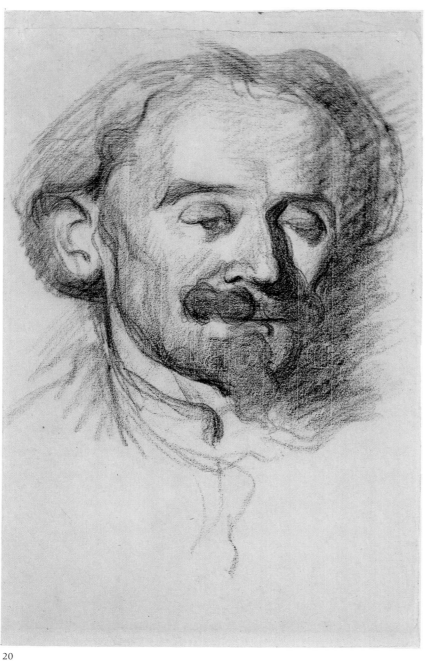

20

Achille Emperaire (1829-1898) was a dwarf, a large head atop a shortened body with long, bony extremities; he was also Aixois, ten years older than Cézanne, and, like him, a painter.[4] They met in the early 1860s at the Académie Suisse[5] and were to be extremely close for at least a decade. Later, Cézanne remembered his youthful companion with emotion, speaking of "a burning soul, nerves of steel, an iron pride in a misshapen body, a flame of genius in a crooked hearth, a mixture of Don Quixote and Prometheus."[6] They shared endless conversations about art, an obstinate and unquenched love for painting, and parallel dreams of glory. Emperaire was for Cézanne what Evariste de Valernes was for Degas: a rather pitiful but obliging double who embodied what his friend might have become if he had lacked genius. Both great artists cherished their less successful colleagues throughout their lives; Degas made pilgrimages to the miserable Valernes in Carpentras, while Cézanne developed a strong attachment to some red-chalk drawings and still lifes by his friend that hung in a cheap restaurant because, in a sense, they were a summation of "all their youth."

Emperaire had "a magnificent cavalier's head *à la* Van Dyck,"[7] a high, domed forehead, a musketeer's longish hair, and a Louis XIII goatee; his stunted body was compensated by his beautiful, ardent head and eloquent, long hands, which offered Cézanne wonderful opportunities. It was the face that first captured his attention, as demonstrated by two magnificent charcoal drawings in Basel (cat. no. 20) and the Louvre (cat. no. 21); in the first he is pensive and calm, his eyes half closed, while in the second he seems visited by an inspiration whose force has impelled him toward the upper limit of the sheet. These were pre-

paratory studies for the large portrait submitted to the Salon of 1870. The date of this impressive picture—in the words of Venturi, "one of the culminating points of Cézanne's romanticism"[8]—has not been firmly established. Perhaps it was begun in mid-1867, when the painter, having returned to Aix, embarked upon "some truly beautiful portraits; no longer [executed] with the palette knife, but just as vigorous."[9] Despite apparent similarities in both their dimensions and their compositional schemes, there are striking differences between this picture and the masterpiece in the *couillarde* style painted in the fall of 1866, the *Portrait of Louis-Auguste Cézanne Reading "L'Événement"* (p. 84, fig. 1). The broad but flat handling of the Musée d'Orsay painting represents a total departure from the thickly impastoed, almost frenzied strokes in the palette-knife works of 1866. Cézanne had certainly contem-

plated the example of Manet during his Parisian sojourn in the winter and spring of 1867, for the *Portrait of Achille Emperaire* shares with the older artist's works—the *Fifer*, for example—a limited tonal range, a uniform background, a simplification of form that Zola claimed was derived from Épinal prints, and large areas of unmodulated color surrounded by black edging that outlines the figure like the leading in a stained-glass window.

He also took from Manet the general approach to his subject. The *Portrait of Achille Emperaire* (cat. no. 19) is not, as Valabrègue thought, a *portrait-charge*, or caricature-portrait, intended to avenge "some hidden injury" perpetrated by the model;[10] it should be compared with the large figures painted by Manet in the 1860s, which ingeniously depict marginal, low-life characters in a vertical format associated with archetypal images of authority. In the

21

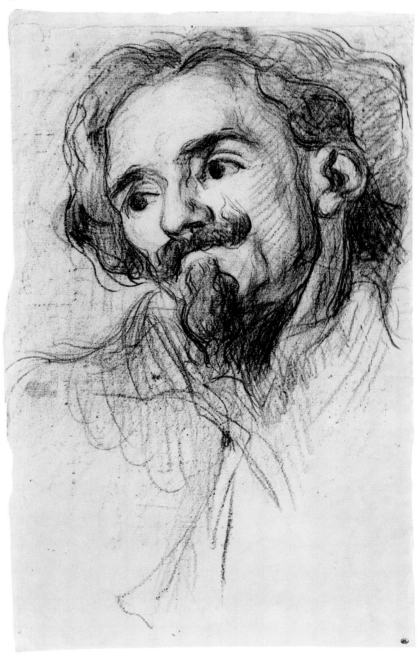

Street Singer (Museum of Fine Arts, Boston), Manet represented a young woman leaving a sleazy cabaret and nibbling cherries; by depicting his regimental fifer life-size, he transformed that popular subject into a "latter-day icon."[11] Cézanne proceeded along similar lines. In an earlier painting he had made his father, whom Zola described as "mocking, republican, bourgeois, cold, meticulous, stingy,"[12] resemble "a pope on his throne."[13] A year later he plunked down his misshapen friend in the same armchair, propped up his short legs on a foot warmer, the footstool of this mock throne, dressed him, by way of "coronation" regalia, in a bathrobe that falls open to reveal woollen leggings, and capped the whole thing off with an inscription at the top in block lettering: *Achille Emperaire peintre*.

Nina Athanassoglou-Kallmyer has demonstrated how Cézanne, invoking Ingres's commanding image of Napoleon I (fig.1) in light of the similarity between the words *empereur* and *Emperaire*, painted what is in effect a "Napoleon the Small" that subverts its prestigious model.[14] This does not explain the work's rejection by the jury of the 1870 Salon, however, for it shared this fate with a large nude, now lost but known to us through a caricature in the *Album Stock* (fig. 2): a "modern Olympia" in the form of a bony courtesan reclining on a white sheet. The cartoon's caption explained the reasons for the academic establishment's repeated rejections of Cézanne's submissions: they outdid the realist lessons of Manet, "going beyond" anything that could have been imagined by "Courbet, Manet, Monet, and all you painters who use palette knives, paintbrushes, and brooms." But Cézanne had made it not to provoke nor to win notoriety but simply because he saw it that way: "Yes, my dear Monsieur Stock," he told the journalist (and one can just hear his voice), "I paint as I see, as I feel—and I have very strong sensations. They also feel and see like me but they don't dare. . . . They make Salon painting. . . . Myself, I dare, Monsieur Stock, I dare. . . . I have the courage of my convictions, and he who laughs last laughs best."[15] Such serene self-assurance, offered without braggadocio, is very much at odds with the image of a tentative Cézanne propagated by Zola at about the same time: "I cannot give you the address of the painter you speak to me about," he wrote Théodore Duret, who wanted to meet this "eccentric." "He keeps very much to himself, he is in a period of groping, and in my view he is right not to let anyone penetrate his studio. Wait until he's found himself."[16] Perhaps Cézanne had been momentarily crushed by this latest rejection by the Salon jury; perhaps Zola, for reasons unknown, was disinclined to further a meeting that might have had important consequences for his painter-colleague. In any case, he was singularly blind to have seen in Cézanne's recent production only ramblings and "gropings" toward something not yet found. Almost twenty years later—between 1886 and 1888—the canvas was "discovered" by Émile Bernard in the jumble of Tanguy's shop, where Cézanne, "wanting never to see it again, had abandoned it." The young disciple saw in it a Cézanne that was altogether new to him: "This was a manner of Cézanne that was completely unknown, that in no way resembled the little pictures that Tanguy generally showed; it was the Cézanne of earlier days, proceeding, broadly and with heavy impasto, in thick layers comparable to bas-relief and with a violent chiaroscuro like that of the Spaniards. The exaggeration of the forms, their emphatic quality, made one think of Daumier, but without there being any question of his influence."[17]

H. L.

1. Bernard, 1925, p. 43.
2. Ibid.
3. Rewald, forthcoming, no. 139.
4. The most complete source of information about Achille Emperaire is Rewald's article of May 3, 1938.
5. Gasquet, 1921, p. 26.
6. Ibid.
7. Ibid.
8. Venturi, 1936, vol. 1, no. 88, p. 85.
9. Marion to Morstatt, June or July 1867, in Barr, January 1937, no. 20, p. 41; see Chronology, early June 1867. See also the remarks by Gowing, who proposed a dating of 1868 (June 1956, p. 186).
10. Rewald, 1986 (a), p. 82.
11. Cachin, in Paris and New York, 1983, p. 246.
12. Rewald, 1936, p. 73.
13. Guillemet to Zola, November 2, 1866, in Rewald, 1971-72, p. 47.
14. Athanassoglou-Kallmyer, September 1990, pp. 488-90.
15. Rewald, July 21-27, 1954, p. 8.
16. Zola to Théodore Duret, May 30, 1870, in Zola, 1978-, vol. 2, no. 89, p. 219.
17. Bernard, December 16, 1908, p. 609.

Fig. 1. Jean-Auguste-Dominique Ingres, *Napoleon I on His Imperial Throne*, 1806, oil on canvas, Musée de l'Armée, Paris.

Fig. 2. Stock, Caricature of Paul Cézanne with two paintings refused by the 1870 Salon jury

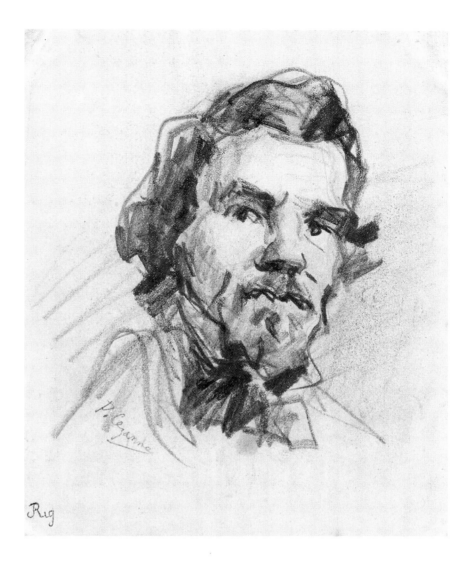

22 | *Portrait of Eugène Delacroix*

c. 1870-71
Soft crayon and graphite on paper; 5¹/₂ × 5¹/₈ inches (14 × 13 cm)
Signed lower left (in a hand other than the artist's): *P. Cézanne*
Musée Calvet, Avignon
C. 155

PROVENANCE
This page from a notebook in the collection of Joseph Rignault in Avignon
was given to the Musée Calvet in 1947.

EXHIBITIONS
Tübingen, 1978, no. 25.

In the early 1860s Cézanne developed a passion for Delacroix that never flagged.[1] He invoked him frequently in conversation, he copied[2] and derived inspiration from his work (see cat. no. 12), he tacked up reproductions of his paintings in the studio, and he undertook an *Apotheosis of Delacroix* that, conceived in a spirit quite different from Fantin-Latour's heavy-handed homage, shows angels wafting him toward the paradise of great painters while a group of his faithful admirers watch from below (V. 245). He depicted him three times: once, about 1882-85, working from the *Self-Portrait* in the Louvre (C. 619), and, nearly fifteen years earlier, working from two photographs by Eugène Durieu.[3] But he considerably softened and enlivened the remote, embittered visage captured by the camera; using a soft crayon, repeating its strokes in every direction, he transformed the cold, implacable photograph into a romantic portrait.

H. L.

1. See Cachin, 1964; and Lichtenstein, March 1964.
2. See Lichtenstein, February 1975.
3. See Lichtenstein, 1966, pp. 39-41. To the Musée Calvet drawing
 should be added a sheet in the Kunstmuseum in Basel (C. 156). It is
 difficult to accept Chappuis's assertion that the Avignon drawing was
 executed around 1864-66; it more likely dates from about 1870-71, a
 view shared by Theodore Reff (verbal communication).

23 | *Pastoral (Idyll)*

1870
Oil on canvas; 25⅝ × 31⅞ inches (65 × 81 cm)
Dated lower right, on the boat: *1870*
Musée d'Orsay, Paris (R.F. 1982-48)
V. 104

PROVENANCE
This canvas was owned, from around 1872, by Doctor Gachet, Auvers-sur-Oise. On December 24, 1910, it was sold by Ambroise Vollard to the Galerie Bernheim-Jeune in Paris; three days later, on December 27, it was ceded to Auguste Pellerin in exchange for three watercolors and a supplementary fee. It was then inherited by his son, Jean-Victor Pellerin. It entered the French national collections in lieu of estate taxes in 1982.[1]

EXHIBITIONS
Before 1906: Paris, 1899 (b), no. 23 *(Fête au bord de la mer)*.
After 1906: Paris, 1936, no. 12; Paris, 1953, no. 11; Aix-en-Provence, 1956, no. 3; Paris, 1985-86 no. 128; Brooklyn and Dallas, 1986, no. 2; London, Paris, and Washington, 1988-89, no. 52; Basel, 1989, no. 5; Paris and New York, 1994-95, no. 34.

Before acquiring the neutral title *Pastoral*, this work was referred to in various ways—*Picnic at the Seaside*, from 1899,[2] then *Plein-Air Scene*,[3] *Don Quixote on the Barbary Shore*,[4] and *Idyll*[5]—which underscores the perplexity of its would-be interpreters.[6] On one point, however, there has been universal agreement: its ties to Manet and *Le Déjeuner sur l'herbe*. In 1870, seven years after Manet's picture had created such a scandal at the Salon des Refusés, Cézanne revisited it, just as he was to do with Manet's notorious courtesan of the 1865 Salon in his two versions of *A Modern Olympia* (cat. nos. 27 and 28). Both paintings pair clothed men with nude women and combine old references with contemporary ones; even so, while Cézanne's reworkings avow their debt to Manet, they stress their differences with equal emphasis. The scenes conceived by the younger artist are profuse and copious, while their prototypes are economical and might even seem dry. Manet's mediocre copsewood with its improbable, shallow pool has been replaced in the Cézanne by a "primordial" nature redolent of Arcadia or the Venusberg, with large trees, slippery ground, and a deep lake. Manet's suburban foursome has given way to an embarkation for Cythera, his pointed commentary on contemporary social mores to autobiographical revery. For Cézanne has inserted himself into the scene: it is he whom we see reclining in a meditative pose in the center of this "supernatural eclogue."[7] He shows himself in the guise of a merciful and disabused Sardanapalus,[8] who remains reflective and resolutely indifferent to the tempting female bathers, while his commonplace companions drink, crouch in the grass, or puff on their pipes.

The eagerness of recent scholars to identify Cézanne's sources has led to Baudelairean and Wagnerian readings of the picture. As early as 1936, Michel Florisoone connected this "canvas of somber irony"[9] to the poetic universe of the *Fleurs du mal*, where Cythera figures as an "island sad and black . . . the banal El Dorado of worn-out roués"[10] where "damned women," "like pensive cattle lying on the sand, . . . scan the far horizon of the ocean."[11] More recently, Lawrence Gowing and Mary Tompkins Lewis have seen in it a variation on the bacchanale from *Tannhäuser*, like Fantin-Latour's painting for the Salon of 1864 (p. 112, fig. 1).[12] Baudelaire and Wagner were much discussed in artistic circles at this time, and they may well have played a role in the genesis of this canvas, although, if so, they were not as crucial to its inception as Manet. But, like *The Murder* (cat. no. 16) and *The Feast* (cat. no. 14), *Pastoral* is above all a Cézannean phantasm. The nude women, immense and corpulent—who, unlike Manet's courtesan, have not just shed their contemporary clothing—seem to have issued forth from the imagination of the man in black as though it were for his benefit that they strike the timeworn poses of nymphs, Venus, and Antiope, and as a result, come across more as beautiful objects for the painter's brush than as compliant confederates in some rustic escapade. Like them, the nature evoked here is turbid and slow, the large trees reduced to cottony tufts reflected in the still water. There's not the slightest breeze, no hint of sound, and it is difficult to say how the solitary navigator will get to his Cythera, for the sail of his skiff is a sadly dangling affair. We are no longer in the sheer, realist world of *Le Déjeuner sur l'herbe* but rather in one that looks forward to the paintings of Bathers to come, in which, to paraphrase Degas, the air that circulates is no longer the same air we breathe.

H. L.

1. Rewald, forthcoming, no. 166.
2. "Fête au bord de la mer." Fagus, December 15, 1899, pp. 627-28.
3. "Scène de plein air." Vollard, 1914, p. 34 n. 1, and pl. 7.
4. "Don Quichotte sur les rives de Barbarie." Paris, 1936, no. 12.
5. "Idylle." Ibid.
6. On the critical response to this painting, see Gache-Patin, 1984, pp. 131-32.
7. Gasquet, 1921, p. 105. Gasquet's Cézanne used this phrase to describe Giorgione's *Concert champêtre*.
8. Theodore Reff (March 1966, p. 40) was the first to propose the parallel with Delacroix's "hero."
9. Florisoone, August 10, 1936, pp. 201-2.
10. Charles Baudelaire, "Un Voyage à Cythère," in Baudelaire, 1857, p. 208.
11. Baudelaire, "Femmes damnées," ibid., p. 196.
12. London, Paris, and Washington, 1988-89, pp. 36-39, 174.

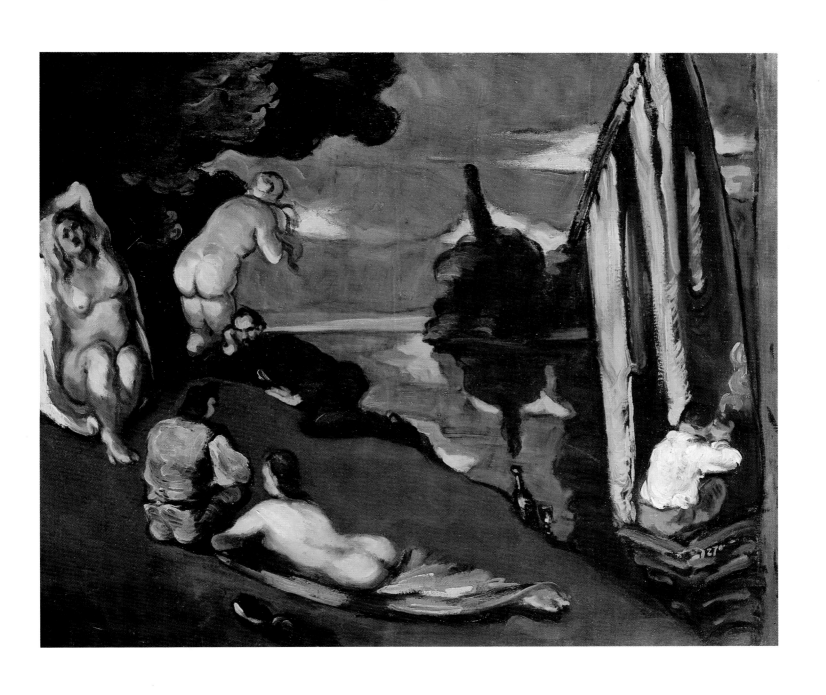

The 1870s

| *The Allée of Chestnut Trees at the Jas de Bouffan*

c. 1871
Oil on canvas; 15 × 18¹/₈ inches (38.1 × 46 cm)
The Tate Gallery, London. Bequeathed by the Honourable Mrs. A. E. Pleydell-Bouverie through the
Friends of the Tate Gallery, 1968
V. 47

PROVENANCE
This work was acquired from the artist's family by Georges Bernheim; he subsequently consigned it to the Galerie Bernheim-Jeune in Paris (January 1920). It was successively in the collections of M. Wanamaker (January 1924), Walter Berry in Paris, the American novelist Edith Wharton in Saint-Brice-sous-Forêt (1936), and James Bomford in Aldbourne (Wiltshire). Jointly purchased in 1934 by the Reid and Lefevre Gallery and the Matthiesen Gallery, both in London, it was acquired in November 1943 by the Honourable Mrs. A. E. Pleydell-Bouverie, who bequeathed it to the Tate Gallery in 1968.

EXHIBITIONS
After 1906: Paris, 1920 (a), no. 1; Paris, 1920 (b), no. 18 *(L'Allée);* Paris, 1936, no. 24; Edinburgh and London, 1954, no. 8; London, Paris, and Washington, 1988-89, no. 60; Edinburgh, 1990, no. 10.

The Jas de Bouffan, the country house that Louis-Auguste Cézanne purchased in 1859, a large blocky structure, rather severe, with a red-tile roof and stone walls covered with yellow stucco, is situated near Aix on a fifteen-hectare plot encompassing tenant farms and vineyards as well as a modest pleasure garden with an oblong pool and an allée of old chestnut trees. It was not long before Cézanne made the latter one of his favorite motifs. In 1865-66 he made some dark, vigorous palette-knife paintings of the allée that bring to mind similar tree-lined avenues favored by the Barbizon painters (V. 38–40). Struck with wonder, like Coriolis in the Goncourt brothers' *Manette Salomon,* at these trees "magnificent and severe, as old as the gods, as solemn as monuments,"[1] he always cropped their crowns, thereby giving his images a force out of all proportion with their diminutive formats.

Despite its comparable size and point of view, the Tate Gallery picture must be somewhat later than these early landscapes, for it eschews their asperity and violent contrasts. The greens are quite nuanced, ranging from almost black to quite light with an admixture of yellow, revealing a Cézanne more attentive to the play of light and shadow, a colorist above all. Departing from the Barbizon model, he seems indifferent to the anatomy of the trees, which are reduced to smooth trunks embellished with tufts of green. The work has been assigned various dates, from 1867-69 (Venturi) to 1875-80 (Paul Cézanne *fils).*[2] Doubtless it makes most sense to place it somewhere toward the middle of this range, about 1871, following Lawrence Gowing, who thought it was painted during Cézanne's sojourn in Aix in the summer of 1871.[3] The turbid, slippery nature depicted in *The Allée of Chestnut Trees* is comparable to that in *Pastoral (Idyll)* (cat. no. 23) and *Le Déjeuner sur l'herbe* (V. 107), while the handling brings to mind *The Wine Depot, Seen from the Rue de Jussieu* (cat. no. 26). Here we are certainly prior to Auvers (see cat. no. 30) and the artist's absorption of the lessons of Impressionism.

H. L.

1. Edmond and Jules de Goncourt, *Manette Salomon* (1867; reprint, Paris, 1979), p. 239.
2. See Venturi, 1936, vol. 1, no. 47, p. 76; and the photograph annotated by Cézanne's son: "Jas de Bouffan, 1875-1880," in the Vollard Archives, Musée d'Orsay, Paris, no. 337.
3. See London, Paris, and Washington, 1988-89, no. 60, p. 190. But Gowing reached this conclusion quite late; in 1956 he still placed the Tate canvas in 1874, which is close to Douglas Cooper's preferred dating of around 1875. See Cooper, November-December 1954, p. 349; and Gowing, June 1956, p. 187.

25 | *Landscape at L'Estaque*

1870 or 1871
Graphite on paper; $9^1/_2 \times 12^7/_{16}$ inches (24.2 × 31.6 cm)
The Art Institute of Chicago. Gift of Justin K. Thannhauser
C. 121

PROVENANCE
This drawing passed from a private collection in Berlin to the Ottinger collection in New York. On December 16, 1938, it was sold at Christie's, London (lot 56), to Hugo Perls, who sold it to James Lord. It was subsequently acquired by Justin K. Thannhauser, who donated it to the Art Institute of Chicago in 1964.

EXHIBITIONS
After 1906: Tübingen, 1978, no. 73; Marseille, 1994, no. 6.

EXHIBITED IN PHILADELPHIA ONLY

It was probably in August 1864 that Cézanne first went to L'Estaque, a village by the sea close to Marseille, dominated by suburban residences and light industry.[1] He returned for a lengthy stay in 1870-71, during the Franco-Prussian War, profiting from his isolation to ponder the lessons of the "tenacious" Pissarro and assess the previous decade, finding himself suddenly seized by "a passion for work."[2] Apparently, the only paintings that survive from this productive period are two landscapes (V. 111 and V. 112) bearing a stylistic resemblance to *The Wine Depot, Seen from the Rue de Jussieu* (cat. no. 26). The Chicago drawing, executed on the spot, shares with these canvases its high horizon line and a shift in emphasis from the randomly scattered cubic houses to the sparse but dark vegetation.[3] In this beautifully elliptical drawing, thick strokes trace the wavy edges of roofs and walls, stress the compact mass of greenery in the center as well as the jagged outline of the distant islands, and detail the branches of an isolated tree, which takes on the grace and elegance of a Japanese fan.

H. L.

1. See Véronique Serrano, in Marseille, 1994, p. 217. On L'Estaque, see Claude Jasmin, in Marseille, 1994, pp. 138-45.
2. Gasquet, 1921, p. 115.
3. Contrary to Chappuis (1973, vol. 1, no. 121, p. 76), this cannot be a study for a much later landscape (V. 407).

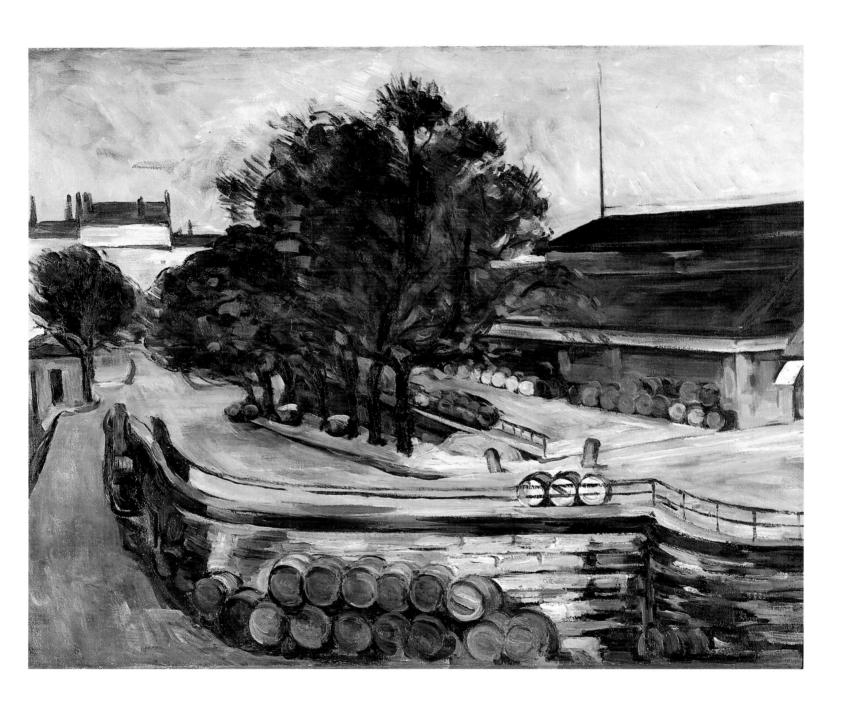

26 | *The Wine Depot, Seen from the Rue de Jussieu*

Winter 1872
Oil on canvas; 28³/₄ × 36¹/₄ inches (73 × 92 cm)
Private collection
V. 56

PROVENANCE
Cézanne probably gave this canvas to Pissarro, who is known to have had it in his possession in the summer of 1872.[1] It was subsequently acquired by Auguste Pellerin, and remained in the possession of his descendants until recently.

EXHIBITIONS
After 1906: Paris, 1936, no. 22; Paris, 1954, no. 22; London, Paris, and Washington, 1988-89, no. 62.

This canvas is generally known as *The Quai de Bercy* (based on Venturi's title), but, as Rewald noted as early as 1937, it, in fact, represents a wine depot that was on the left bank of the Seine, just downstream from the Jardin des Plantes.[2] This marketplace, which centralized "the collection of duties on wines and *eaux-de-vie*," occupied a large rectangular area defined by the quai Saint-Bernard, the rue des Fossés-Saint-Bernard, the rue de Jussieu and the rue Cuvier, on which, since 1819, "five large building complexes separated by avenues and divided into storerooms" (now the site of the Jussieu faculty) had been built.[3] Over a few months in the winter of 1872, Cézanne lived in a modest apartment on the second floor of 45, rue de Jussieu "opposite the wine stronghold,"[4] in a section also known until 1869 as the rue Saint-Victor, right on the corner of the rue des Fossés-Saint-Bernard. It was there that, on January 4, 1872, Hortense Fiquet, then the artist's mistress, gave birth to his son, Paul, and it was there that, in February and March, Cézanne's fellow painter Achille Emperaire briefly stayed with him (see cat. no. 19). According to Emperaire, Cézanne was not only "badly set up" but also "abandoned by everyone." "He no longer has a single intelligent or affectionate friend.—The Zolas, the Solaris, and others . . . are no longer mentioned.—He's the oddest sort one could imagine."[5] Cézanne's lack of money, his new paternal obligations, the disconcertingly close quarters, the persistent doubts about his talent as a painter, and yet another refusal by the Salon jury contributed to the artist's morose state of mind, which lasted until the summer, when he moved to Auvers.

This view, painted from a window in his apartment in the winter of 1872—one of the few works from this period that can be securely dated—has a palette altogether consistent with his despair: it is uniformly gray and brown, heightened very selectively with muted blues and reds in some of the wine kegs. It is dominated by the central row of dull trees, a sinister Parisian variation on the beautiful allée at the Jas de Bouffan (see cat. no. 24). There is no sign here of noise or human presence (the distant buildings along the quai de Béthune are quite windowless), although the neighborhood was in reality so animated that the sensitive Emperaire wrote of "a hubbub that would wake the dead."[6] The impression created is one of abandonment beneath a "low and heavy" sky that "presses down like a lid."[7]

We are very far removed from the Parisian views of Monet and Renoir, so seductive and so teeming with life, that picture the city's historical center; we are rather closer to Jongkind, who had been painting the tortuous, ill-paved streets and ramshackle structures in the more eccentric neighborhoods of Paris for some time. But Jongkind, like Guillemet and, a bit later, Stanislas Lépine, always made a few concessions to the picturesque sensibility. There are no such concessions in Cézanne's canvas, which is unique in his oeuvre, and which Pissarro, its first owner, impressed by its modest subject matter and the simplicity of its handling, praised for its "vigor" and its "remarkable force."[8]

H. L.

1. See Rewald, forthcoming, no. 179.
2. See Rewald, March-April 1937, p. 54.
3. Adolphe Joanne, *Le Guide parisien* (Paris, 1863), p. 406.
4. Cézanne to Emperaire, January 26, 1872, in Cézanne, 1978, p. 140.
5. Emperaire to friends in Aix, March 17 and 27, 1872, in Cézanne, 1978, pp. 141-42.
6. Emperaire to friends in Aix, March 17, 1872, in Cézanne, 1978, p. 141.
7. Charles Baudelaire, "Spleen," in Baudelaire, 1857, p. 144.
8. Pissarro to Guillemet, September 3, 1872, in Pissarro, 1980-91, vol. 1, no. 18, p. 77.

27 | *A Modern Olympia*

c. 1869-70
Oil on canvas; 22⁷/₁₆ × 21⁵/₈ inches (57 × 55 cm)
Private collection
V. 106

PROVENANCE
This canvas was acquired from Paul Cézanne *fils* by Ambroise Vollard and the Galerie Bernheim-Jeune on February 12, 1907. Bernheim-Jeune bought Vollard's share of the painting on May 19, 1908, and sold it on November 14, 1908, to Auguste Pellerin,[1] who subsequently bequeathed it to his daughter, Mme René Lecomte. It recently entered a private collection.

EXHIBITIONS
After 1906: Paris, 1936, no. 16; Paris, 1954, no. 19; London, Paris, and Washington, 1988-89, no. 40; Basel, 1989, no. 4; Paris and New York, 1994-95, no. 32.

EXHIBITED IN LONDON AND PHILADELPHIA ONLY

28 | *A Modern Olympia*

1873
Oil on canvas; 18¹/₈ × 21¹¹/₁₆ inches (46 × 55 cm)
Musée d'Orsay, Paris. Gift of Paul Gachet (R.F. 1951-31)
V. 225

PROVENANCE
Soon after its completion, this canvas was acquired by Doctor Gachet, Auvers-sur-Oise (or was given to him by Cézanne); it subsequently came into the hands of his son, Paul Gachet, who donated it to the State in 1951.

EXHIBITIONS
Before 1906: Paris, 1874, no. 43.
After 1906: Paris, 1936, no. 28; Paris, 1939 (b), no. 7; Paris, 1953, no. 13; Paris, 1954, no. 25; Aix-en-Provence, 1956, no. 11; Paris, 1974, no. 6.

EXHIBITED IN PARIS ONLY

According to the memoirs of Paul Gachet, Doctor Gachet's son, the Musée d'Orsay canvas (cat. no. 28) was executed in Auvers in 1873 after a conversation about Manet between the painter and the collector-doctor. There was some discussion of *Le Bon Bock* (1873, Philadelphia Museum of Art), the picture by the older artist that had met with success at that year's Salon, and then "we reverted to the *Olympia*." "Gachet's frank admiration [for it] stung the self-regard of Cézanne, who responded quite vigorously that the invention of an Olympia, even a recast one, was for him a mere bagatelle. He resolved to prove it. And, on a '10' canvas, there appeared almost immediately *A Modern Olympia*, exceptionally dashed-off, dazzlingly fresh despite [coming from] a usually dark period, in short a 'marvelous sketch' on which Gachet subsequently placed an embargo, fearing that Cézanne would wreck it by setting out to 'take it further.'" The rest of the narrative is less clear: Gachet suggested that Cézanne make a copy of the newly completed picture, and even provided him with the canvas for it, but the painter, for unspecified reasons, did not comply.[2]

In Paul Gachet's account, the genesis of *A Modern Olympia* has all the earmarks of fable. In point of fact, however, the canvas, despite its *fa'presto* handling, was not executed as spontaneously as he would have us believe, for it was preceded by a first version (cat. no. 27), doubtless painted around 1869-70, which was itself preceded by two drawings (C. 271 and C. 274).

"A Modern Olympia. Sketch. Property of M. le Dr Gachet" was exhibited at the first Impressionist exhibition in 1874, along with *The House of the Hanged Man, in Auvers-sur-Oise* (cat. no. 30) and *Study: Landscape in Auvers* (probably V. 157, Philadelphia Museum of Art). It did not pass completely unnoticed, occasioning a few remarks from the critics—in a sarcastic vein, of course. Louis Leroy, who first coined the term "Impressionism," wrote that the homonymous canvas by Manet was "a masterpiece of drawing, accuracy, and finish compared with that of M. Cézanne."[3] Castagnary, the champion of realism, showing himself to be more obtuse than usual, held it up as an example for those who, "neglecting to reflect and learn, would pursue

the impression to the bitter end." He wrote: "[Proceeding] from idealization to idealization, they will end up at this same degree of unbridled romanticism, in which nature is no longer anything but a pretext for reverie, and in which the imagination becomes powerless to formulate anything but personal, subjective fantasies, without echo in the general reason because they are uncontrolled and impossible to verify in reality."[4] Kinder but less perspicacious, Marie-Émilie Chartroule, who praised the worthy talents of Alexandre Cabanel and Ernest Hébert in reviews signed Marc de Montifaud, pronounced the work nothing more than a "voluptuous vision," a "corner of an artificial paradise" sustained by hashish, but found it infinitely preferable to the two landscapes.[5]

On the walls of Nadar's rooms on the boulevard des Capucines, the contrast between the two solid views of Vexin, near Auvers-sur-Oise, and this brilliantly colored "vision"—which might have reminded discriminating viewers of French eighteenth-century painting, notably Boucher and Fragonard—was too pointed not to have been deliberate. In his first exhibition since the Salon des Refusés, Cézanne sought to prove that, like Ingres, he had "several brushes" at his command. The reference in the title to Manet—the great absence from the show—was meant both as an homage to his great predecessor and as an implicit criticism. The use of the word "modern" hinted that, in his view, the scandalous picture of the 1865 Salon was now "old." Without denying his considerable debt to Manet, whose influence on his work was pervasive from 1866 to 1870, Cézanne was moving on. The *Olympia* became something like an incunabulum of Impressionism: "One must always have this before one's eyes. . . . It's a new order of painting. Our Renaissance dates from it,"[6] he always proclaimed—exhibiting the initial enthusiasm as well as the awkwardness and native tartness that was for Cézanne the mark of all the primitives.

The differences between Cézanne's two canvases of this subject underscore the progressive distancing of his work from Manet. In the first (cat. no. 27), the opposition of whites and blacks—the latter used, as in Manet, to edge both figures and objects—and the thick, unctuous paint laid on in broad, flat strokes come right out of the *Fifer*. This *Olympia* is also consistent with Zola's view of the picture: "Olympia, reclining on white sheets, makes a large pale stain on the dark background."[7] By contrast, the truly "modern" version—despite its servant, burgeoning bouquet, and parodistic little pooch—has very little to do with the great painting of ten years previous. The dark, compact image of Cézanne's first canvas has given way to a nimble, brilliantly colored vision marked by sarcastic wit rather than Baudelairean spleen. Placed on a cloud-like sheet, the courtesan is "revealed"—there are hints of religious parody here—by the Negress/brothel-keeper, who in the first canvas resembles a painted-wood *torchère*. Nothing has been retained from Manet's *Olympia* except its subject. The painter—for the dark foreground figure is unmistakably the artist himself—examines the woman, who assumes something like a fetal position and is made to seem simultaneously fearful and alluring, as if she were bewildered to find herself in this lavish rococo decor. He calmly assesses her pink form against the white sheet as if she were fruit arrayed on a tablecloth. She is both model and subject, and he duly pays her homage: the homage (which Manet conveyed with his bouquet of flowers) of a client to his preferred paramour; that is to say, the homage of an artist to his own world, to everything that he has chosen to represent—in short, the homage of a painter to painting.

<div align="right">H. L.</div>

1. See Rewald, forthcoming, no. 171.
2. Gachet, 1956, pp. 57-58.
3. Leroy, April 25, 1874.
4. Castagnary, April 29, 1874.
5. Montifaud, May 1874, pp. 310-11.
6. Gasquet, 1921, p. 31.
7. Zola, 1991, p. 160. On the differences between the two versions, see Dorival, 1948 (b), pp. 41-42.

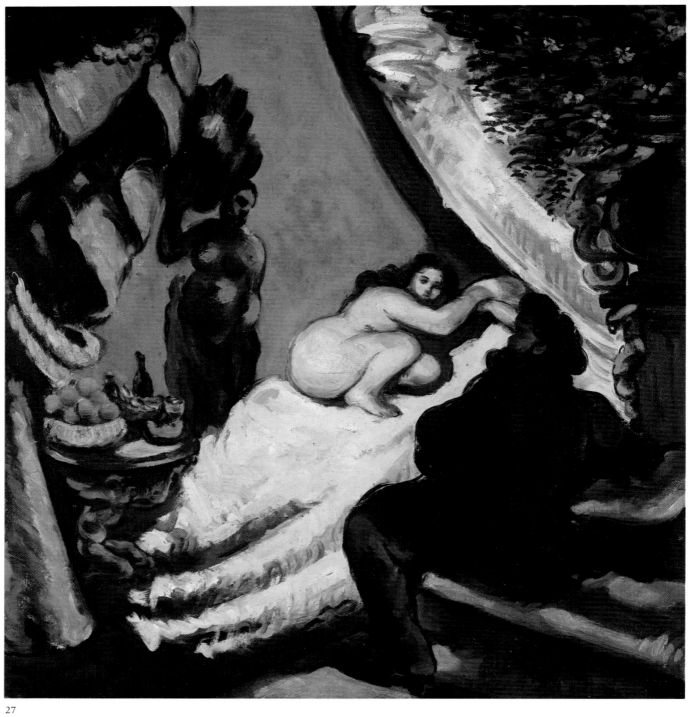

27

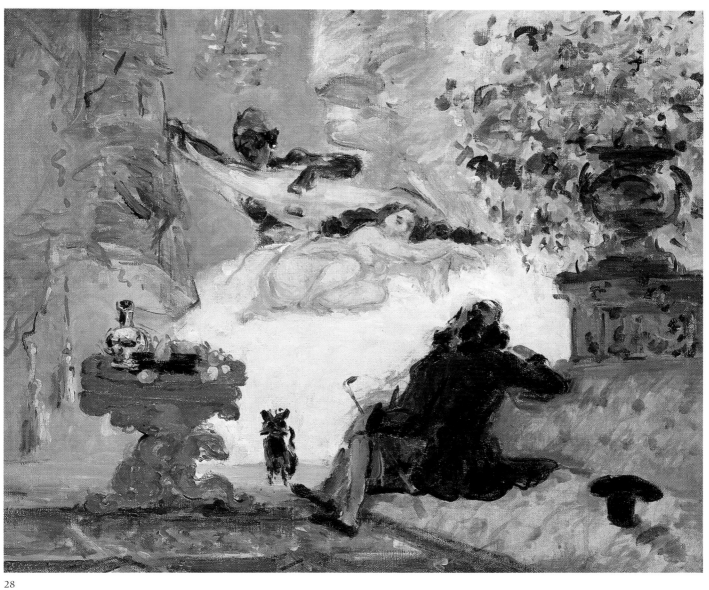

28

Olympia

c. 1875
Graphite and watercolor on paper; 9³/₄ × 11¹/₄ inches (24.8 × 28.6 cm)
Philadelphia Museum of Art. The Louis E. Stern Collection, 1963-181-123
R. 135

PROVENANCE
About 1935, this watercolor was sold by Paul Cézanne *fils* to the Galerie
Renou et Colle, Paris, from whom it was acquired by Fine Arts Associates,
New York. In 1950 it was purchased by Louis E. Stern (1886-1962), and
entered the Philadelphia Museum of Art in 1963 as part of his bequest.

EXHIBITIONS
After 1906: Paris, 1935, unnumbered; New York, 1937, no. 17; New York,
1959 (a), no. 60; New York, 1963 (a), no. 3; Philadelphia, 1983, no. 24.

EXHIBITED IN PARIS AND LONDON ONLY

Cézanne produced several variations on the *Olympia* theme
in the 1870s (including cat. nos. 27 and 28). He worked
several essential elements from Manet's composition into
his own: certainly the female nude, although usually in
full bloom, with loose hair, accessible, lacking the angular-
ity that he had reproached in his predecessor's figure; the
servant, who is sometimes a black slave or an obliging
brothel-keeper; occasionally the cat, who gambols at the
foot of the bed, more amenable than Manet's hostile feline;
and even the hanging or the bouquet. Often he introduced
a man dressed in black, who seems untroubled by the crea-
ture exhibited to him—the artist amusing himself by actu-
ally representing the client that Manet had implied was to
be found afoot among the visitors to the Salon. In *A Mod-
ern Olympia* (cat. nos. 27 and 28), Cézanne staged a tableau,
perching the woman atop a mountain of white fabric as if
she were a singing goddess floating on cardboard clouds in
an operatic vision conceived by Lully or Rameau. In the
Philadelphia watercolor, she reclines directly on the floor,
entirely nude, contemplated or mourned—it's hard to say
which—by a man and a woman who are motionless and
reserved. The scene is ambiguous: elements that in other
compositions by the artist seem redolent of anticipated
sensual pleasure here take on a somber cast more sugges-
tive of a funeral wake.

H. L.

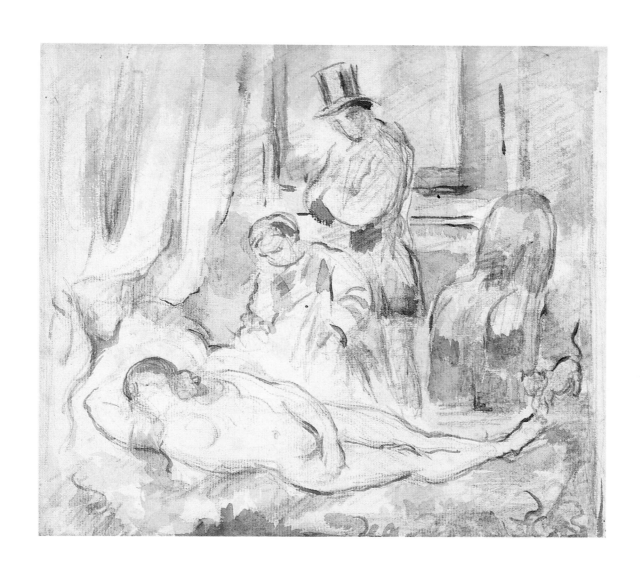

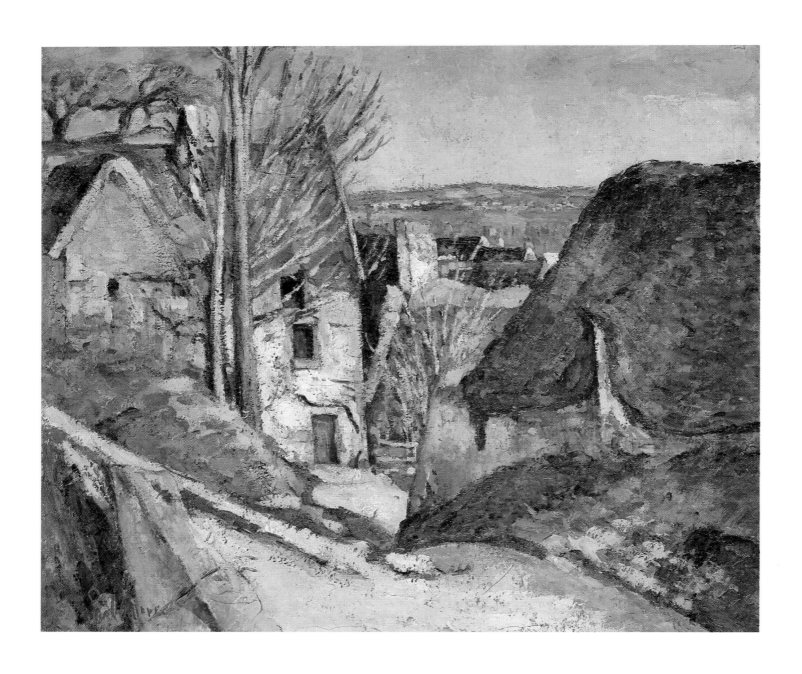

1873
Oil on canvas; 21⁵/₈ × 26 inches (55 × 66 cm)
Signed lower left: *P. Cézanne*
Musée d'Orsay, Paris. Bequest of Comte Isaac de Camondo (R.F. 1970)
V. 133

PROVENANCE
Comte Armand Doria acquired this canvas for 100 or 200 francs in 1874;[1] in 1889 he ceded it to Victor Chocquet in exchange for *Melting Snow at Fontainebleau* (V. 336). At Madame Chocquet's estate sale (Galerie Georges Petit, Paris, July 1-4, 1899, lot 106), it was acquired for 6,510 francs by Comte Isaac de Camondo on the recommendation of Claude Monet;[2] it was included in the 1911 Camondo bequest to the Louvre, entering the collection in 1914.

EXHIBITIONS
Before 1906: Paris, 1874, no. 42; Paris, 1889, no. 124; Brussels, 1890, no. 2.
After 1906: Paris, 1936, no. 26; Paris, 1953, no. 14; Paris, 1954, no. 28; Paris, 1974, no. 11; Paris and New York, 1974, no. 6.

Probably painted early in 1873, *The House of the Hanged Man, in Auvers-sur-Oise*—the full title from the catalogue of the first Impressionist exhibition in 1874[3]—is a key work in Cézanne's career. It is the first picture he sold to a collector, Comte Doria, a wealthy landowner deeply enamored of painting;[4] and it subsequently passed through two prestigious collections, that of Victor Chocquet, then that of Comte Isaac de Camondo. It also was regularly exhibited during the artist's lifetime at his express request, indicating that Cézanne, rarely satisfied with his works, was pleased with this one. In 1874 it figured, along with *A Modern Olympia* (cat. no. 28) and *Study: Landscape in Auvers* (probably V. 157, Philadelphia Museum of Art), at the first Impressionist exhibition. In 1889 it was included in the prestigious Exposition Centennale de l'Art Français, and the following year it was sent to the exhibition of Les XX in Brussels at the request of Octave Maus.

The House of the Hanged Man, which represents a picturesque cottage situated in Auvers above the rue de Four[5] (no hanged man is ever known to have set foot there), has been widely regarded as the masterpiece of Cézanne's Impressionist period. Taking the advice of his friend Pissarro, the painter abandoned the rough, dark manner of his first works and, painting at the motif, became a convert to the light, fleet, vibratory touch of Impressionism. To be sure, the *House of the Hanged Man* has nothing in common with the fluid landscapes of Monet, and all it shares with those of Pissarro is its compositional configuration. Later, Venturi cited a judicious remark made by a peasant who had watched the two painters working together in the open air: "When working, Pissarro pricked *[piquait]* . . . while Cézanne laid in *[plaquait]*."[6] In effect, Cézanne first painted a summary composition and then reworked it, applying successive coats that sculpted the canvas and emphasized the volumes, as can be seen in a photograph of the painting in raking light (fig. 1).[7] The two frail trees, the chimneys, and the edges of the roof protrude slightly from the dense and granular surface. The resulting technique has no parallel in Pissarro's work and anticipates Monet's paintings of Rouen Cathedral.[8]

Cézanne's vision in this picture is no less singular than the method he used to paint it. Monet tended to combine landscape with scenes from modern life and Pissarro set out to make himself a chronicler of works and days, but *The House of the Hanged Man* depicts a landscape devoid of human presence. Its eponymous subject is the ancestor of all those abandoned habitations with cracked walls (V. 659 and V. 657), isolated and blind, that André Breton judged to be suitable sites for crime.[9] Like the neighboring cottage on the right, it resembles an accident of the terrain, and, surging forth as if from some immemorial telluric dust, makes the red and black roofs of the village beyond seem like a beacon of civilization.

H. L.

Fig. 1. *The House of the Hanged Man, in Auvers-sur-Oise*, photographed in raking light by the conservation laboratory of the Musées de France.

1. See Rewald, forthcoming, no. 202.
2. Monet to Camondo [June 1899], in Wildenstein, 1974-85, vol. 4, no. 1467, p. 338 (this letter is now lost).
3. Cézanne subsequently hinted that the title *La Maison du Pendu, à Auvers-sur-Oise* was not his. In a letter to Comte Doria dated June 30, 1889, he wrote: "You have kindly promised M. Chocquet to exhibit *The House of the Hanged Man*. That's the title that's been given to a landscape I made in Auvers" (Cézanne, 1978, p. 228). On December 21, 1889, he referred to it as "A Cottage in Auvers-sur-Oise" (ibid., p. 231).
4. On Comte Doria, see Distel, 1989, pp. 170-73.
5. See Gachet, 1956, p. 51.
6. Venturi, 1936, vol. 1, p. 31, citing Coquiot, 1919, p. 186.
7. Kindly provided by Anne Roquebert.
8. See also Callen, 1983, pp. 72-74.
9. See André Breton, *L'Amour fou* (Paris, 1937), pp. 155-57.

31 | *View of Auvers-sur-Oise*

c. 1873
Oil on canvas; 25¹¹/₁₆ × 32 inches (65.2 × 81.3 cm)
The Art Institute of Chicago. Mr. and Mrs. Lewis Coburn Collection
V. 150

PROVENANCE
The canvas may have belonged to Doctor Gachet in Auvers-sur-Oise.¹ Its first documented owner was Ambroise Vollard; according to Venturi, it subsequently figured in the collection of the dentist Dr. Georges Viau. Acquired by Alfred Strolin, it was sold along with the rest of his collection (Hôtel Drouot, Paris, July 7, 1921, lot 7), passing through Hector Brame, Paris, to the Galerie Durand-Ruel, which sold it to Mrs. Lewis L. Coburn, Chicago. It entered the Art Institute of Chicago in 1933 as part of her bequest.

EXHIBITIONS
After 1906: Paris, 1912 (a), no. 15; Philadelphia, 1934, no. 4; Chicago and New York, 1952, no. 15; Los Angeles and Chicago, 1984-85, no. 69; Paris, 1985, no. 35.

Lionello Venturi rightly considered this canvas to be "one of the first works by the master in which a panoramic view is transformed into a pictorial motif."² Cézanne adopted— doubtless for the first time, for this was probably in the spring or summer of 1873—a formula favored by Pissarro in the 1860s: a high-vantage view of cubic houses with planar roofs randomly scattered amid encompassing greenery.

Later, on the occasion of the 1895 Cézanne exhibition organized by Vollard, the "humble and colossal Pissarro"³ emphasized the "kinship" between "certain of the Auvers landscapes" and others by himself, although he went on to note that "each [artist] kept the only thing that counts, 'his sensation.'"⁴ But where Pissarro pursued the "infinite variety of contrasts between lights and darks"⁵ and employed a limited range of color harmonies, Cézanne scattered attenuated but sonorous notes of vermilion among his varied hues of green. Where Pissarro accentuated the perspective effect by placing a tree or a receding path in the foreground (a tactic borrowed from Corot and Courbet), Cézanne cropped the banal motif more or less at random, indiscriminately juxtaposing trees, meadows, and a motley collection of houses.⁶

He pitched his easel at the edge of a narrow path, known as the *sente de Pontoise*, that gave the villagers access to their fields on the plateau above.⁷ In front of him lay a view of the Four and Vessenots quarters, "in which the isolated house, the highest one on the left, shows the west side of the Gachet house, with a single window."⁸ He did not finish the canvas, which is so thinly and smoothly painted that some scholars have questioned the attribution.⁹ Given the manner in which Cézanne worked in Auvers, however, it seems viable to see this work as a sketch for a landscape that, elaborated in successive applications of paint and "sculpted" to emphasize the structural armature, would have been as densely handled as *The House of the Hanged Man, in Auvers-sur-Oise* (cat. no. 30).

H. L.

1. The only evidence is a brief mention by Vincent van Gogh in a letter to his brother Théo, [May 21, 1890], in Van Gogh, 1959, vol. 3, no. 635, p. 273.
2. Venturi, 1936, vol. 1, no. 150, p. 100.
3. Cézanne to Émile Bernard, [1905], in Cézanne, 1978, p. 314.
4. Pissarro to his son Lucien, November 22, 1895, in Pissarro, 1980-91, vol. 4, no. 1175, p. 121.
5. Venturi, 1936, vol. 1, p. 33.
6. On this subject, see the remarks by Schapiro (1952, p. 44) and Shiff (1984, pp. 112-15).
7. See Brettell, in Los Angeles and Chicago, 1984-85, no. 69, p. 190.
8. Gachet, 1956, p. 54.
9. See note 7.

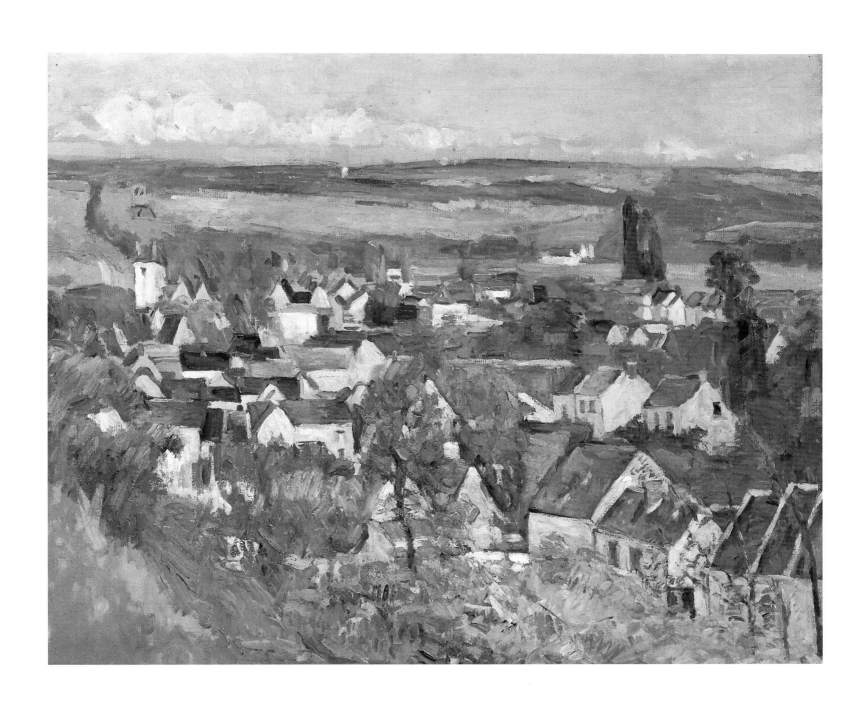

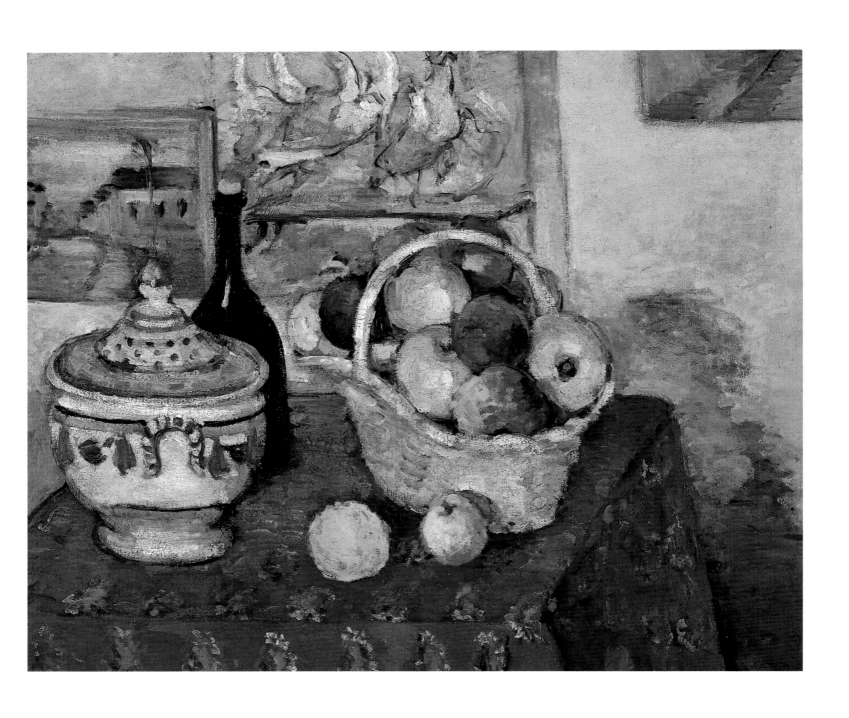

32 | *Still Life with Soup Tureen*

c. 1873-74
Oil on canvas; 25⁹/₁₆ × 32¹/₁₆ inches (65 × 81.5 cm)
Musée d'Orsay, Paris. Bequest of Auguste Pellerin (R.F. 2818)
V. 494

PROVENANCE
The first owner of this canvas was Pissarro; it was subsequently acquired by Auguste Pellerin thanks to "the intervention of Octave Mirbeau, one of the first 'Cézanneans.'"[1] Pellerin bequeathed it to the Louvre in 1929.

EXHIBITIONS
After 1906: Paris, 1912 (b), unnumbered; Basel, 1936, no. 34; Paris, 1954, no. 50; Paris, 1974, no. 21.

This still life raises interesting but difficult problems of dating. Venturi placed it around 1883-85, but Rewald rightly situated it in the 1870s, proposing, as early as 1937, the more convincing date of 1877. He based his argument on two points: Lucien Pissarro's recollection that "this painting was executed in Pontoise at the home of his parents," and the likelihood that Cézanne sojourned in Pontoise in 1877.[2] This was the year Cézanne painted *The Path to the Ravine, Seen from the Hermitage, Pontoise* (V. 170, The Hermitage Museum, St. Petersburg), which resembles a landscape of the same site by Pissarro dated 1877 (Musée d'Orsay, Paris).[3] Later, after Lucien Pissarro's death, Rewald elaborated on these recollections, claiming that his interlocutor had explicitly stated that the canvas was painted in 1877—something Rewald refrained from doing while Lucien was alive—and that the flowered tablecloth was a shawl Cézanne had borrowed from Madame Pissarro. In 1956 Lawrence Gowing offered stylistic corroboration of Rewald's position, maintaining that *Still Life with Soup Tureen* was one of the first works in which Cézanne abandoned the "atmospheric tones of impressionism" in favor of "the intensity of local colour." Gowing further asserted that it was in 1877 that color "gained a kind of autonomy, and form, as if to serve it, became progressively simpler and more block-like."[4] Douglas Cooper proposed a slightly earlier date; he compared this canvas with the portraits of Victor Chocquet (see cat. nos. 45 and 46) and, in light of what he termed the "impressionistic character" of these works, placed them around 1875-76.[5] Reff, accepting the assertion made by Ludovic Rodo Pissarro and Venturi that the landscape pictured on the wall at the left is a canvas by Pissarro, *The Gisors Road, the House of Père Galien*,[6] dated 1873, a work that also appears in the *Portrait of Paul*

Cézanne by Pissarro,[7] found these works comparable and proposed a date of about 1877 for the still life.[8]

We do not hesitate to place it still earlier, around 1873-74, during Cézanne's extended sojourn in Auvers, when, prior to his return to Paris early in 1874, he saw his beloved Pissarro almost daily. It is difficult to maintain that *Still Life with Soup Tureen*, which is solidly painted in broad continuous strokes, is contemporary with *Compotier and Plate of Biscuits* (cat. no. 48), executed in the halting, quasi-"constructive" strokes that appeared only in the second half of the 1870s, or with the works commissioned by Chocquet (cat. nos. 44–46). It is comparable, however, with other canvases executed in Auvers, above all *The House of the Hanged Man, in Auvers-sur-Oise* (cat. no. 30); the side of the tureen and the weave of the basket have the firm, thick, rough-hewn texture of the massive cottages in that picture. A final comparison can be made with *Still Life: Pots, Bottle, Cup, and Fruit* (V. 71) in the Nationalgalerie in Berlin, currently dated 1871-72. The two canvases share similar formats and handling, as well as the same opaque bottle with a protruding cork. They are probably contemporary, the one being nocturnal and overtly theatrical, illuminated by artificial light that casts black shadows, doubling the objects, the other of a diurnal brightness, depicting the makings of a rustic meal, plain but, like the painting itself, solid and amiable: soup kept piping hot in the thick faience, table wine produced by the peasants down the road, and ripe red and yellow apples overflowing their small basket. One can just hear the remarks they would have occasioned to Madame Pissarro: "This year we'll be drowning in apples."

H. L.

1. Rey, December 1929, p. 274.
2. See Venturi, 1936, vol. 1, no. 494, p. 171; and Rewald, March-April 1937, p. 54.
3. Pissarro and Venturi, 1939, no. 387.
4. Gowing, June 1956, p. 188.
5. Cooper, November-December 1954, p. 346.
6. Pissarro and Venturi, 1939, no. 206.
7. Ibid., no. 293.
8. See Reff, June 1979, p. 95.

33 | *Peasant Girl Wearing a Fichu*

c. 1873
Graphite on paper; 6¹/₈ × 8⁵/₈ inches (15.6 × 21.9 cm)
Philadelphia Museum of Art. The Henry P. McIlhenny Collection
in memory of Frances P. McIlhenny, 1986-26-2
C. 273

PROVENANCE
According to Venturi, this drawing's first owner was probably Doctor Ga-
chet. It remained in his family, passing to his son, Paul. In 1962 it was in
the possession of the Galerie Daber, Paris, from whom Henry P. McIlhenny
(1910-1986) acquired it later that year. The drawing was bequeathed to
the Philadelphia Museum of Art in 1986.

EXHIBITIONS
After 1906: Paris, 1936, no. 145; Philadelphia, 1983, no. 30.

EXHIBITED IN PARIS AND LONDON ONLY

In a discussion of Cézanne's drawings, Sir Kenneth Clark
wrote of the artist's "mysterious conspiracy with the white
paper,"[1] an observation well illustrated in this sketch. The
artist not only created a head and shoulders of gentle but
profound three-dimensionality but also suggested their
spatial context with the lightly hatched band on the right.
There is a firm yet gentle decisiveness to the drawing, with
the expanse of the right cheek given over entirely to the
white of the laid paper. Chappuis has proposed that this
drawing is related to one of the few etchings produced by

Cézanne in Auvers in 1873, when Doctor Gachet con-
vinced him to try his hand at that medium (V. 1160);[2] he
noted that this drawing once belonged to Doctor Gachet.
Reff and Clark, however, have argued for a later date.[3]

This quietly haunting visage is unusual in Cézanne's
oeuvre, for the subjects of his portraits were almost always
close friends or members of his household, who could be
persuaded to sit for him. This sheet is the only surviving
work by the artist in which this lovely yet melancholy face
appears.[4]

J. R.

1. Clark, July 1974, p. 80.
2. Chappuis, 1973, vol. 1, no. 273, p. 108.
3. See Reff, July 1975, p. 490; and Clark, July 1974, pp. 79-80.
4. See Rishel, in Philadelphia, 1983, no. 30, p. 65.

Self-Portraits from the 1870s

34 | *Self-Portrait*

c. 1875
Oil on canvas; 25³/₁₆ × 20⁷/₈ inches (64 × 53 cm)
Musée d'Orsay, Paris. Gift of Jacques Laroche (R.F. 1947-29)
V. 288

PROVENANCE
This canvas was acquired from Ambroise Vollard by Cornelis Hoogendijk, Amsterdam; it was sold to the Parisian dealer Paul Rosenberg in 1920. He, in turn, sold it to the industrialist Jean Laroche, a friend of Vuillard; it was bequeathed to the Louvre, with retention of life interest (surrendered in 1969), by his son Jacques Laroche (1904-1976).

EXHIBITIONS
Before 1906: The Hague, 1901, no. 23.
After 1906: Amsterdam, 1911, no. 1; Paris, 1929, no. 31; Paris, 1939 (a), no. 4; London, 1939 (a), no. 3; Paris, 1953, no. 19; Edinburgh and London, 1954, no. 11; Paris, 1974, no. 17; Madrid, 1984, no. 10; London, Paris, and Washington, 1988-89, no. 63.

35 | *Self-Portrait (Portrait of the Artist with a Rose Background)*

c. 1875
Oil on canvas; 26 × 21⁵/₈ inches (66 × 55 cm)
Private collection, Paris
V. 286

PROVENANCE
This canvas belonged to Auguste Pellerin and then to his daughter Mme René Lecomte; it subsequently entered a private Swiss collection. Its present owner acquired it from the Galerie Beyeler in Basel in 1982.

EXHIBITIONS
After 1906: Paris, 1907 (b), no. 22; Paris, 1936, no. 47; Paris, 1954, no. 33; Basel, 1983, no. 8; Basel, 1989, no. 17; Tübingen, 1993, no. 13.

36 | *Self-Portrait*

c. 1877
Oil on canvas; 23³/₄ × 18¹/₂ inches (60.3 × 46.9 cm)
The Phillips Collection, Washington, D.C.
V. 290

PROVENANCE
This canvas was acquired from Ambroise Vollard by the Berlin dealer Paul Cassirer; it then passed successively through two important German collections: in 1912, that of Theodor Behrens (1857-1921)—from whom the Hamburger Kunsthalle obtained Manet's *Nana*—and then, about 1920, that of Baron Leo von Koenig, in Berlin-Schlachtensee. Duncan Phillips purchased it from the Parisian dealer Paul Rosenberg in 1928; it is now in the Phillips Collection.

EXHIBITIONS
Before 1906: Paris, 1904 (b), no. 6.
After 1906: Berlin, 1921, no. 16; New York, 1929, no. 3; Philadelphia, 1934, no. 8; Chicago and New York, 1952, no. 38; Aix-en-Provence, 1956, no. 15; Washington, Chicago, and Boston, 1971, no. 8; Madrid, 1984, no. 20.

At regular intervals in the 1870s Paul Cézanne painted his self-portrait, an exercise in which he had scarcely demonstrated an interest prior to that time: only a single, rather odd example survives from the previous decade (fig. 1). Executed around 1861-62 and based on a photograph, it is an awkward and disturbing image with a hallucinatory quality: against a black ground, set within folds of ashen flesh, there emerge two piercing, bloodshot eyes. The artist's presence, however, had not been entirely absent from his work in the meantime: it is he who strikes a meditative pose among the unclothed women in *Pastoral (Idyll)* (cat. no. 23); it is he who, properly attired in dark clothing, contemplates *A Modern Olympia* (cat. no. 27); he is encountered yet again painting the uproar prompted by *The Eter-*

nal Feminine (cat. no. 42). The artist's new interest in self-portraiture may indicate a greater self-confidence or perhaps a resigned acceptance of his own image. For Cézanne was scarcely enamored of himself, knowing full well that he came across as churlish and uncouth in comparison with Manet and Degas, for example, who cut figures of exemplary elegance.

The chronology of these self-portraits is difficult to establish, but the earliest is probably the one in the Musée d'Orsay (cat. no. 34). In all likelihood it was executed around 1875 in the Paris studio of Armand Guillaumin, at 13, quai d'Anjou on the Île Saint-Louis.[1] A portion of Guillaumin's painting *The Seine at Paris* (1871, The Museum of Fine Arts, Houston) is visible behind Cézanne's head, testimony to the close friendship of the two artists at the time.[2]

The self-portrait with a rose background (cat. no. 35) is probably similar in date;[3] here the pigment is applied in long, thick, irregular and overlapping strokes like those in the Musée d'Orsay canvas, but the cut of the hair and the length of the beard suggest that a few weeks or months have elapsed between the two pictures. By contrast, the *Self-Portrait* in the Phillips Collection (cat. no. 36) is painted very differently. The face is modeled with short strokes; the handling is freer in the clothing, which is barely sketched in; and the beard and hair are painted in the parallel applications that hint at the "constructive" stroke, which the artist developed over the second half of the 1870s. By representing himself on canvases of the same format and in similar compositional schemes, Cézanne was taking stock of the effects of passing time; he was also using this special genre to explore technical innovations first adumbrated in landscapes and still lifes, creating in the process a record of both his physical appearance and his artistic evolution.

For the time being, he did not depict himself as a painter—it was not until the 1880s that an incongruous cap (see cat. no. 77) or an easel and palette (repro. p. 72) were introduced to so identify him—but rather as a cross between a bourgeois and a peasant, decked out in a black or brown jacket. He is seen in three-quarter profile and bust-length, as he looked in a mirror, his hands out of view because he was using them to paint. Only the backgrounds, not the poses, vary. In the Musée d'Orsay *Self-Portrait*, the hirsute head is profiled against a fragment of an urban landscape by Guillaumin—given a "Cézannean" inflection, it lacks the original's artlessness and dry handling—that bears witness not only to a friendship but also to Cézanne's having lived for a time in the pictured Maubert and Jussieu quarters. Later, the background is set off by pink wallpaper decorated with large white arabesques that suggest clouds or wisps of smoke,[4] giving rise to sinuous forms that anticipate the volutes of the Nabis. The background of the *Self-Portrait* in the Phillips Collection is simpler still, a harmony of browns, greens, and yellows with red accents that reprise the hues of the clothing and the slightly blotched flesh of the face.

As a number of critics have pointed out, these images also record the evolution of Cézanne's mien and state of mind. The uncouth wild man in the Musée d'Orsay *Self-Portrait* was to grow milder with the passing years, becoming more civilized, first trading outright hostility for mere grumbling discontent and finally adopting a philosophical posture that still left room for mischief. These canvases have always been viewed as a moral portrait of the artist; their consistency with the legends that had crystallized around him made it easy to accept them as relatively straightforward depictions, especially given the paucity of biographical information. In 1904, when the *Self-Portrait* in the Phillips Collection was exhibited at the Salon d'Automne, one critic wrote that it conveyed "a rough and aggressive sincerity,"[5] while another saw it as the depiction of a "hoary, bald, sympathetic, earnest old man."[6] Even so, no allowances were made for the obvious limitations of his art: "M. Cézannes [*sic*] sends his portrait! A worthy man! He's a worker given to dreaming. Why doesn't he just stick to still life, since he knows nothing about the rest?"[7] The perspicacity of a Venturi was required to discern in this blunt image of a *brave homme* a sincerity, a penetration, and a "disinterestedness" worthy of Rembrandt.[8] But as early as 1907, Rainer Maria Rilke, after one of his visits to the Salon d'Automne, penned the following penetrating analysis of the *Portrait of the Artist with a Rose Background*: "It is a man gazing at us, twisted a quarter turn from right profile. His thick, dark hair is bunched together at the back of his head and stops above the ears in such a way that the whole line of his cranium is exposed; it is drawn with eminent assurance, hard and yet rounded, from the temple downward in a single stroke, and its strength is apparent even in those spots where, broken up into shapes and planes, it becomes only the outermost of a thousand contours. The powerful structure of this skull, formed as though by hammering from within, is again apparent in the ridges of the brows; from there down, however, the face sags, thrust forward toward the bottom, the densely bearded chin projecting like the toe of a shoe—sags as if, in startling progression, each feature were separately suspended, and at the same time producing that expression of gaping wonder that, to put it in the most primitive terms, children and peasants can assume—only the dull stupor of their

Fig. 1. Paul Cézanne,
Self-Portrait, c. 1861-62,
oil on canvas,
private collection (V. 18).

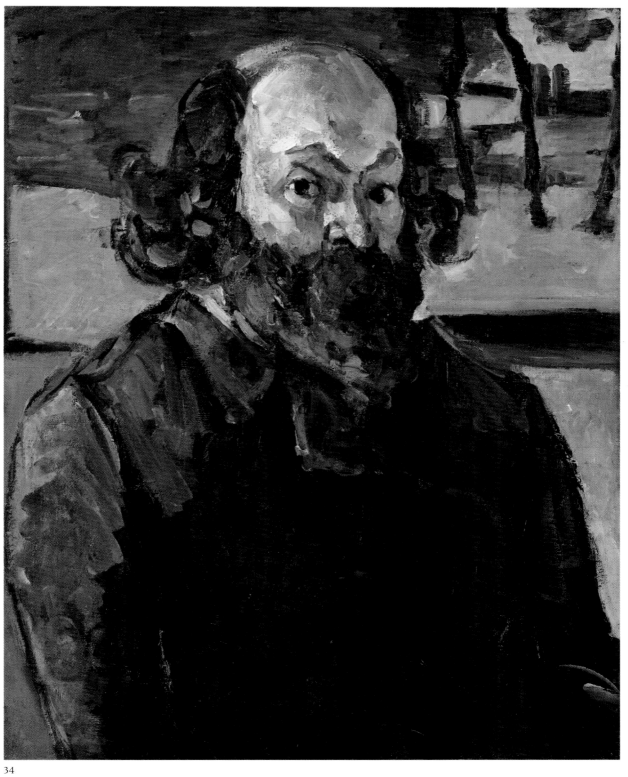

34

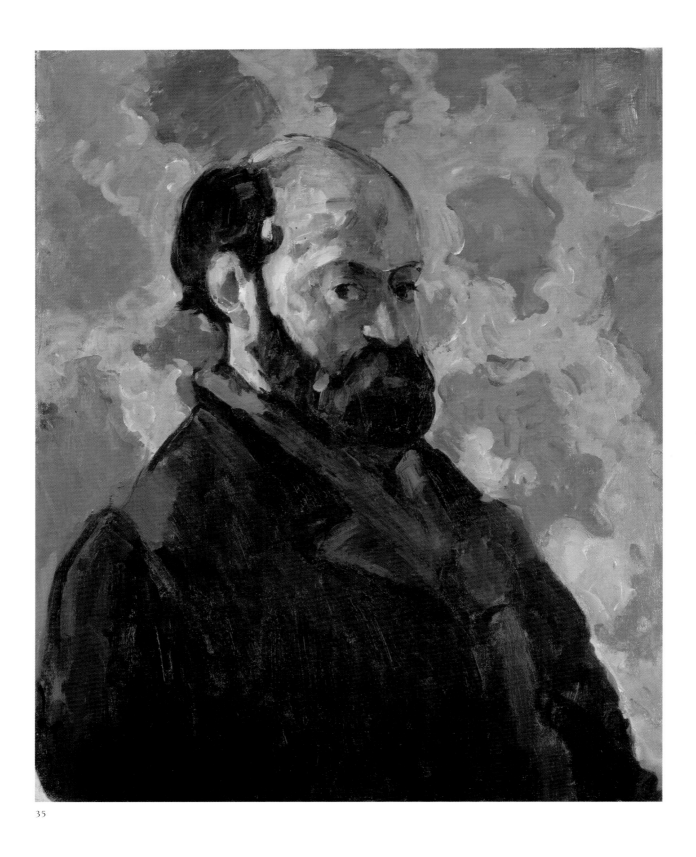

35

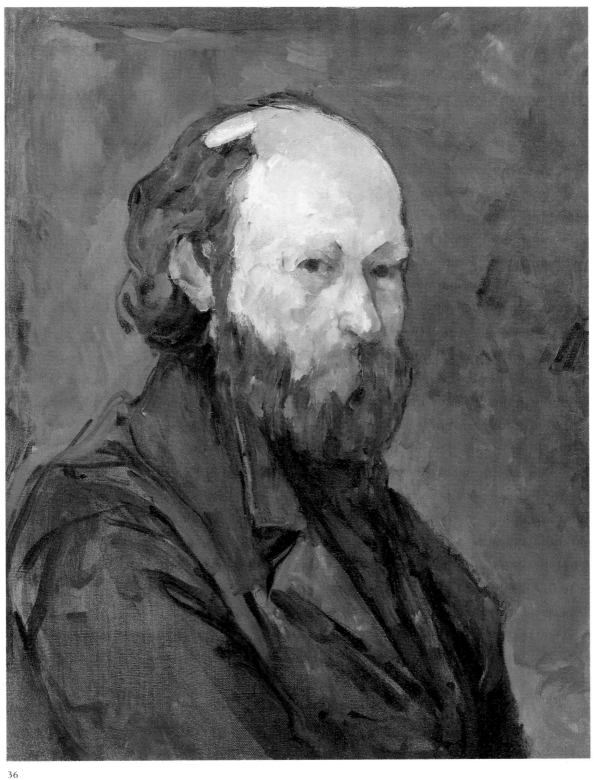

36

abandon has been replaced with an animal alertness that maintains in the eyes, unencumbered by lids, a patient, detached wakefulness. And it is almost touching to see him confirm how intense and incorruptible he could be in his observation by portraying himself with such selfless objectivity, without remotely apologizing for his looks or condescending to them, with the good faith and concern for the simple facts exhibited by a dog who sees himself in the mirror and thinks: there's another dog."[9]

H. L.

1. See Christopher Gray, *Armand Guillaumin* (n.p., 1972), pp. 15-16.
2. See Reff, June 1979, p. 92. On the relations between Cézanne and Guillaumin, see Rewald, 1985, pp. 103-19. Theodore Reff kindly shared his views about the dating of these self-portraits.
3. Only Rewald has previously stressed this proximity.
4. See Brion-Guerry, 1966, pp. 84-86.
5. Fourquier, October 14, 1904.
6. Ponsonailhe, October 15, 1904.
7. Péladan, October 28, 1905, p. 465.
8. Venturi, 1936, vol. 1, p. 36.
9. Rilke to his wife, October 23, 1907, in Rilke, 1952, pp. 40-41.

37 | *Bathers*

1874-75
Oil on canvas; 15 × 18^1/$_8$ inches (38.1 × 46 cm)
The Metropolitan Museum of Art, New York. Bequest of Joan Whitney Payson, 1975
V. 265

PROVENANCE
In the late 1890s this painting was acquired from Ambroise Vollard by the American Charles A. Loeser, Fiesole. After passing through the dealer Hector Brame, Paris, it was purchased in 1963 by Mrs. Joan Whitney Payson, New York, and was bequeathed by her to the Metropolitan Museum of Art in 1975.

EXHIBITIONS
After 1906: Venice, 1920, no. 26; Edinburgh and London, 1954, no. 14; Basel, 1989, no. 15.

This picture is strikingly close in color and handling to the *Bathers at Rest* (p. 279, fig. 1) shown at the third Impressionist exhibition in 1877; despite the considerable discrepancy in their dimensions, this can be regarded as its female equivalent or even a pendant of a kind. The brilliant palette of these two images (especially the sharp chartreuse yellow of the foliage), their richly worked surfaces, and the stately balance of the figures to the landscape make them pivotal works in Cézanne's treatment of the Bather theme. They also share a nude figure seen from the back and lifting one elbow directly above his or her head; this erotic posture is particularly haunting in the present picture, where it is echoed by another, frontal nude striking much

the same pose, her copious red hair billowing in the breeze like the equally sinuous black hair of her almost mirror-reversal companion.

As Rewald and Shiff have observed, this picture's bracing freshness is shared by the landscapes Cézanne made in Auvers in the mid-1870s, when, encouraged by Pissarro, he painted out-of-doors directly before the motif.[1] In this *Bathers*, Cézanne was coming to grips with a problem that, in one form or another, would preoccupy him throughout his career: the production of a resolved composition in which imaginary subjects—he rarely depicted nudes directly from life—are introduced into an observed setting. Both realms—imagination and nature—exerted considerable power over him; his ability to fuse them successfully at this early point in his career anticipates the later, more fully integrated attempts to resolve this dilemma.

J. R.

1. See Rewald, 1989, p. 53; and Shiff, 1984, p. 114.

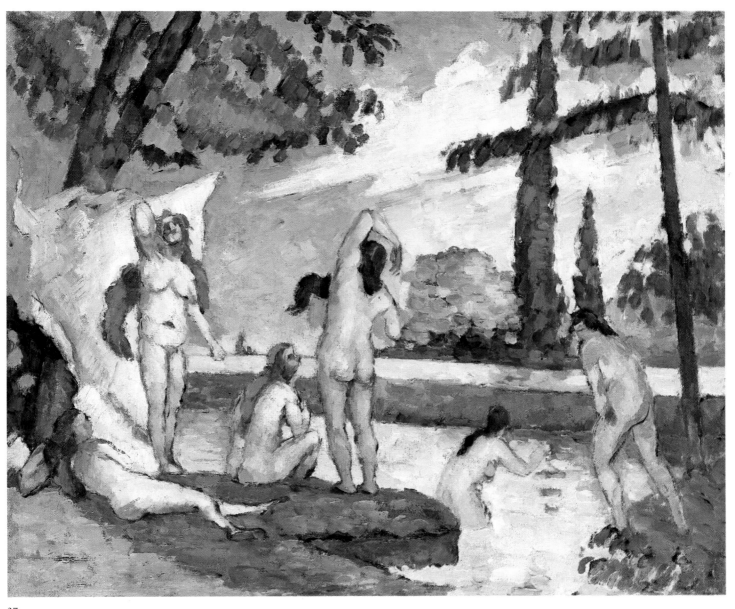

37

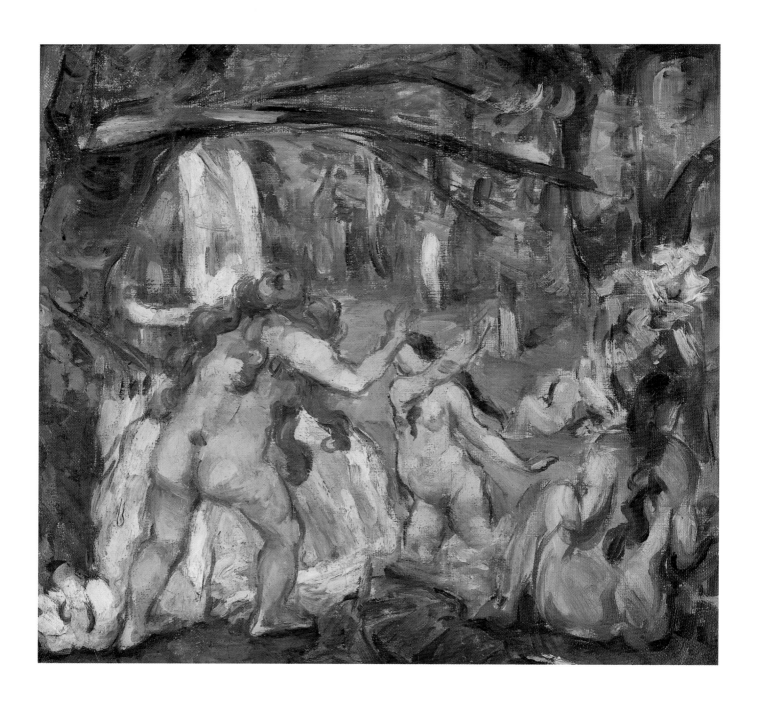

38 | *Three Bathers*

c. 1875
Oil on canvas; 11⁵/₁₆ × 12⁵/₁₆ inches (28.8 × 31.2 cm)
Private collection
V. 267

PROVENANCE
This picture originally belonged to Ambroise Vollard. In 1951 it came into the possession of the dealer Paul Rosenberg, Paris, and by 1958 it was in the collection of the Galerie des Arts Anciens et Modernes, Paris. It was subsequently acquired by Marlborough Fine Art, London. By 1962 it was in the collection of the sculptor Henry Moore and passed from his estate into a private collection.

EXHIBITIONS
After 1906: Chicago and New York, 1952, no. 28; Tokyo, Kobe, and Nagoya, 1986, no. 10; Basel, 1989, no. 23.

It has often been noted that Cézanne's life took an important turn in the early 1870s: in 1872 his beloved son was born, and the following year he settled in the small village of Auvers, where he worked daily with the serene and steady Pissarro. The vehemence of his earlier palette-knife pictures gave way to a more reflective approach to his craft sustained by his increasing delight in painting directly from nature. The flights of imagination characteristic of his early imagery were not completely abandoned, however, as is demonstrated by this wonderfully vital and even comic picture of four young women disporting around a gushing waterfall, two of them engaged in a splashing fight.

This work belonged for several years to the British sculptor Henry Moore. He made a set of little sculptures after its three principal figures, first as independent pieces that could be shifted into different relationships (fig. 1) and then combined on a single base, and he executed drawings after them that capture both the playful quality and the essential monumentality of this little canvas.[1]

In an interview, Moore related: "Well, it's the only picture I ever wanted to own. It's . . . the joy of my life. I saw it about a year ago in an exhibition and was stunned by it. I didn't sleep for two or three nights trying to decide whether to To me it's marvellous. Monumental. It's only about a foot square, but for me it has all the monumentality of the bigger ones of Cézanne. . . .

". . . It's not perfect, it's a sketch. But then I don't like absolute perfection. I believe one should make a struggle towards something one can't do rather than do the thing that comes easily.

"Perhaps another reason why I fell for it is that the type of woman he portrays is the same kind as I like. Each of the figures I could turn into a piece of sculpture, very simply. . . .

"Not young girls but that wide, broad, mature woman. Matronly. Look at the back view of the figure on the left. What a strength . . . almost like the back of a gorilla, that kind of flatness. But it has also this, this romantic idea of women. Four lots of long tresses, and the hair he has given them."[2]

J. R.

1. See Erich Steingräber, "Henry Moore Maquetten: Zum Wandel des Arbeitsprozesses in seinem Werk," *Pantheon*, vol. 36, no. 3 (July/August/September 1978), p. 251; and Philip James, ed. *Henry Moore on Sculpture* (London, 1966).
2. James, ed. *Henry Moore on Sculpture*, pp. 190, 193.

Fig. 1. Henry Moore,
Three Bathers, after Cézanne, 1978,
plaster, The Henry Moore Foundation,
Hertfordshire, England.

39 | *Afternoon in Naples*

c. 1875-77
Oil on canvas; 14⁹/₁₆ × 17¹¹/₁₆ inches (37 × 45 cm)
National Gallery of Australia, Canberra
V. 224

PROVENANCE
After having been, successively, in the hands of Ambroise Vollard and the Galerie Bernheim-Jeune, Paris, this picture was acquired by Auguste Pellerin from whom it passed to his son, Jean-Victor Pellerin. He sold it to the Wildenstein Galleries, from which it was acquired by the National Gallery of Australia in 1985.

EXHIBITIONS
After 1906: London, Paris, and Washington, 1988-89, no. 27 (exhibited in Washington only); Basel, 1989, no. 27; Tübingen, 1993, no. 11.

This enigmatic composition has been variously dated: 1872-75 by Venturi and 1876-77 by Rewald—with whom we agree—but 1866-77 by Gowing. Ambroise Vollard provided an anecdote about a canvas painted by Cézanne around 1867: "The model who posed for this *académie* was a hearty old scavenger, whose wife kept a little creamery where she served a beef soup much appreciated by her clientele of young art students. Cézanne, who had gained the scavenger's confidence, asked him to pose one day. The other reminded him about his 'job.' 'But you work at night, you don't do anything during the day.' The scavenger pointed out that he slept during the day. 'Well then, I'll paint you in bed!' At first the good fellow got under the covers, wearing a fine night cap on his head in the painter's honor; but since there was no point bothering with the proprieties 'between friends,' he first removed the night cap and then threw back the covers, in the end posing quite nude; his wife appeared in the picture handing her husband a bowl of warm wine. . . . For the study of the scavenger, his friend Guillemet came to his rescue by devising the title *An Afternoon in Naples*, or *The Wine Grog*."[1] But the scene described by Vollard bears no resemblance to the small Canberra canvas. Furthermore, in a letter written in April 1867 to Francis Magnard, who worked for *Le Figaro* and *L'Événement*, Émile Zola referred to two works by his friend, *The Wine Grog* and *Drunkenness*, that had been refused by that year's Salon jury. They had been mocked by the journalist Arnold Mortier, who evoked them in summary terms: "These compositions are entitled *The Wine Grog* and represent, the one, a nude man to whom an elaborately dressed woman brings a wine grog, the other, a nude woman and a man dressed like a lazzarone. Here the grog has been overturned."[2] Even bearing in mind Zola's assertion that "the descriptions given by M. Arnold Mortier are inaccurate,"[3] it is difficult to maintain that the present painting is one of those ridiculed by the hostile critic.

Besides, despite the fact that certain details—the poses of the nude figures, the gilded ewer—bring to mind *The Feast* (cat. no. 14), stylistic considerations preclude a date in the 1860s, for here the painter used a controlled mode of handling that intimates the "constructive stroke" (see cat. no. 42), which was introduced only in the second half of the 1870s. The touch in this canvas is very different from the rapid, fluent, impetuous one he employed in *A Modern Olympia* (cat. no. 28) and, to an even greater extent, from the thick, sinuous strokes of *The Negro Scipion* (cat. no. 11). In this connection, comparison of the two black backs is especially telling.

The Afternoon in Naples—we retain the usual but erroneous title to avoid confusion—is one of the many erotic fantasy pictures produced by Cézanne in the 1860s and 1870s.[4] Here he deployed all the customary paraphernalia of these images: a mirror, precious objects, lifted drapes, and a black slave—male or female, it is hard to say— drenched in perfume." The sex of the reclining figures is indeterminate: it has always been assumed that they are a man and a woman, but they could be two women with contrasting hair and skin color—one blond, the other brunette, as in Courbet's *Sleep* (Petit Palais, Paris). The influence of Delacroix's *Women of Algiers* has rightly been noted in connection with this painting; the drapery framing the composition, the posture of the black slave, and the diffuse light falling from a window on the left all have parallels in the earlier canvas.[5] It is possible, too, that Cézanne, haunted by Manet's *Olympia*, set out to amuse himself by imagining the playful occupations of its courtesan on a torpid afternoon.[6]

H. L.

1. Vollard, 1914, pp. 21-22.
2. Mortier, cited in Zola, 1978-, vol. 1, p. 492 n. 3.
3. Zola to Magnard, [around April 8, 1867], in Zola, 1978-, vol. 1, no. 172, p. 491.
4. On these scenes, see Krumrine, 1989, pp. 100-103; and Adriani, 1993 (b), pp. 68-71.
5. See Lichtenstein, March 1964, p. 59. An early study for this composition (C. 180) is on the same sheet as a partial copy of Delacroix's ceiling in the Galerie d'Apollon in the Louvre.
6. A preparatory drawing (fig. 1) provides support for this view, for it shows, at the foot of the bed, a little cat with its tail in the air that inescapably brings to mind the feline in Manet's *Olympia*.

Fig. 1. Paul Cézanne, *Afternoon in Naples*, c. 1872, graphite, watercolor, and gouache on paper, Galerie Krugier and Geofroy, Geneva (R. 35).

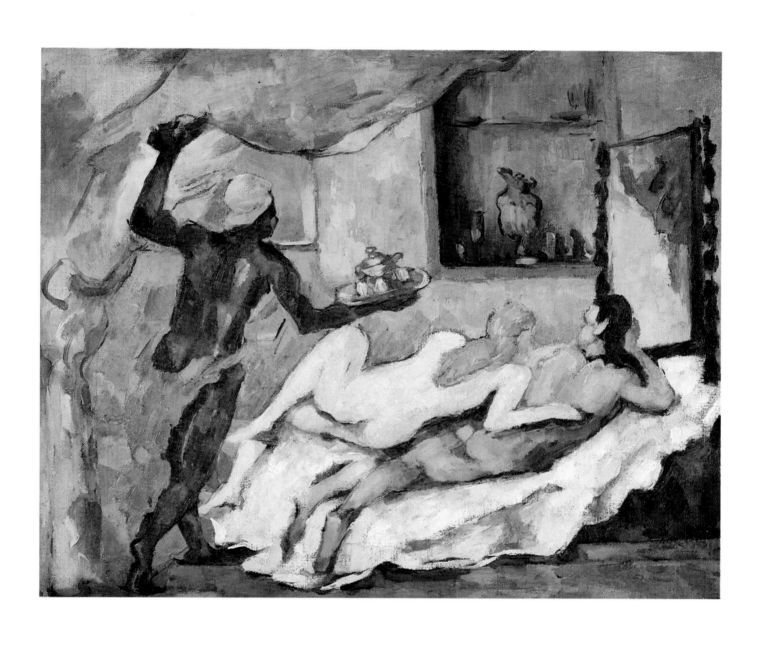

The Temptation of Saint Anthony

c. 1875-77
Oil on canvas; 18¹/₂ × 22¹/₁₆ inches (47 × 56 cm)
Musée d'Orsay, Paris (R.F. 1982-46)
V. 241

PROVENANCE
After belonging to the *pâtissier* Eugène Murer (Eugène Meunier, known as Murer, 1841-1906), this canvas was owned by the art critic Arsène Alexandre (1859-1937). It was sold in 1903 (Galerie Georges Petit, Paris, May 18-19, 1903, lot 8) with the rest of his collection. It was owned for a time by the dealer Eugène Blot; then it was acquired by Auguste Pellerin, who left it to his son, Jean-Victor Pellerin. It entered the French national collections in lieu of estate taxes in 1982.

EXHIBITIONS
After 1906: Paris, 1907 (b), no. 3; Paris, 1936, no. 33; Madrid, 1984, no. 13; Basel, 1989, no. 10.

In the Cézanne issue of the series *Les Hommes d'aujourd'hui*, published in 1891, Émile Bernard devoted a third of his text to a discussion of this *Temptation of Saint Anthony*, then the property of the *pâtissier* Eugène Murer. Bernard maintained that the work—"typical of a genre pursued by the painter, and one of the most fully achieved examples of it"—was executed after a brief Impressionist, or "clear," period. He argued that Cézanne had succumbed for a time to the influence of Monet and "the charms of pronounced light tones," but that here he renewed his ties to the "precocious potency" of his first productions, delivering a work "romantic in conception" but thoroughly imprinted with the "architectural gravity" that the disciple saw as characteristic of his master. "Here," he continued, "[there are] no positive shadows, a uniform lightness bathes everything and renders it iridescent; one would say it was a very old bas-relief, faded by the years and beautiful with that mysterious indecision with which time stamps art. It is one of [the artist's] most powerfully colored works."[1] Despite the considerable amount of text he devoted to this "uniquely pictorial" painting, however, he wrote not a word about the subject—in contrast to his successors, who were to track down possible sources and reveal the autobiographical nature of this apparent *scène d'imagination*.

The most thorough analysis remains the one published more than thirty years ago by Theodore Reff,[2] who was the first to examine closely the relation between this *Temptation of Saint Anthony* and Flaubert's book of the same title. Such a linkage is indeed seductive, especially given the dates of the two works—the definitive text of Flaubert appeared in 1874, while Cézanne's canvas is now dated c. 1875-77[3]—and it is also supported by the painter's established interest in the novelist (see cat. no. 14).[4] As with *The Feast*, however, there are also notable differences between Flaubert's vision and Cézanne's: one will seek in vain on this small canvas—which, excluding the escort of *putti*, is limited to three figures placed in a setting more suggestive of rocky Provence than of the vast panorama of the Thebaid—the grandiose apparatus conceived by the writer. Cézanne reduced the queen's numberless cortege to a flutter of plump cupids; furthermore, he depicted neither the many gifts nor the promised riches, and he blatantly exhibited an unclothed female body, whereas the writer merely evoked a "train of fire" that conjured in the hermit's mind the nudity of the creature adorned in brocades and beset with jewels.

In addition to the literary source, numerous visual antecedents have been proposed, from Romanesque sculpture to Dominique Papety and Eugène Isabey.[5] But none of them is convincing, for Cézanne deliberately avoided traditional iconography. When he painted a first version of the *Temptation* around 1870 (fig. 1), he relegated the monk to a corner of the composition, devoting the foreground to three nude women who are indifferent to the tactics of the brazen seductress in the background. In the Musée d'Orsay canvas, Saint Anthony, paired with a horned comic-opera devil, is cast into the shadows by the temptress, who not only occupies the center of the composition, but shines with a particular brilliance. A preparatory watercolor (fig. 2),[6] quite different from the definitive picture, bears an annotation in Cézanne's hand that specifies his intentions: the disrobing woman is made to say, "See my body's dazzling complexion / Anthony, and do not resist seduction."[7] The painted temptress is, in effect, a luminous

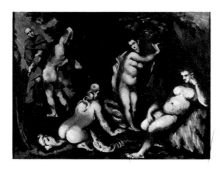

Fig. 1. Paul Cézanne, *The Temptation of Saint Anthony*, c. 1870, oil on canvas, E. G. Bührle Foundation, Zurich (V. 103).

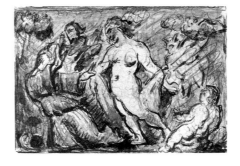

Fig. 2. Paul Cézanne, *The Temptation of Saint Anthony*, c. 1875, graphite, watercolor, india ink, and gouache on paper, private collection (R. 40).

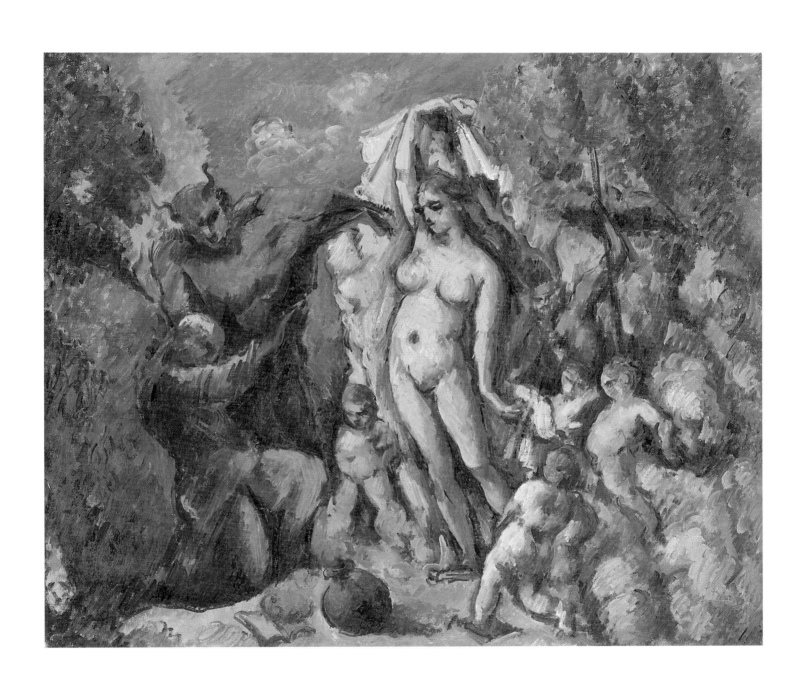

apparition in a mandorla of radiant white, more like a madonna with cherubim come to succor exhausted penitents than a lascivious creature populating an erotic dream. Cézanne constructed a pagan vision on the template of a religious one. He did this with "stylish excesses" (as Flaubert said concerning his own *Temptation*) that he would later avoid, when his provocative women become tranquil bathers splashing about in shallow water. Perhaps for the last time, Cézanne/Saint Anthony here painted his obsession with woman; he is depicted as though exhausted from consecutive assaults and, like the anchorite in the popular mystery play that made such an impression on the young Flaubert, he entreats: "Messieurs les démons, let me be!"[8] This could well serve as an exergue for all Cézanne's work from the 1860s and 1870s.

H. L.

1. Bernard, 1891, n.p.
2. See Reff, June 1962. See also two recent discussions: Gache-Patin, 1984, pp. 134-35; and Krumrine, 1989, pp. 50-56.
3. Reff (June 1962, p. 119) dated it to around 1875; John Rewald (forthcoming, no. 300) to 1877.
4. According to Joachim Gasquet, "the poet Gilbert de Voisins suggested to the old master of Aix that he illustrate, to suit his fancy, the *Temptation of Saint Anthony* by Gustave Flaubert," occasioning "a week of enthusiasm" (Gasquet, 1921, p. 19). But Gilbert de Voisins was born in 1877, which means that any such project would have to be situated around the turn of the century.
5. On the iconography of *The Temptation of Saint Anthony*, see Roger-Marx, March-April 1936, pp. 3-48; and Seznec, March 1947. On the visual sources of Cézanne's canvas, see Reff, June 1962, pp. 114-24; and Ballas, 1975, p. 197.
6. This watercolor (fig. 2)—along with a rapid graphite sketch (C. 448)—is usually placed a few years earlier than the Musée d'Orsay canvas; Rewald (1983, no. 40, p. 93) dated it 1873-75, but we prefer a later date closer to that of the painting, around 1875.
7. "De mon corps éclatant vois la carnation / Antoine, et ne résiste à la séduction."
8. See René Dumesnil, introduction to Flaubert, *La Tentation de saint Antoine* (1874; reprint, Paris, 1962), vol. 1, p. 43.

41 | *Young Man Beset by Rats*

c. 1875-77
Graphite on paper; $8^{9}/_{16} \times 4^{7}/_{8}$ inches
(21.7 × 12.4 cm)
The Art Institute of Chicago. Arthur Heun Fund
C. 453

PROVENANCE
The sketchbook to which this drawing belongs was initially in the possession of Paul Cézanne *fils*. On consignment to Renou and Poyet, Paris, it was sold to Sam Salz, New York, who in turn sold it to the Art Institute of Chicago in 1951.

EXHIBITED IN PHILADELPHIA ONLY

In the mid-1870s, while he was working on *The Temptation of Saint Anthony* (cat. no. 40), Cézanne made several studies of Satan leaning over the kneeling anchorite and extending his arm toward the seductive vision (C. 445, C. 447, C. 449, and C. 450). The posture of the young man in the present drawing resembles the devil's on those sheets, and the face faintly sketched above him here is that of a horned demon. This page is from a sketchbook in the Art Institute of Chicago (page XXIX verso). Reff has placed this page among the many variations executed by Cézanne between 1875 and 1885 on the theme of a male bather with outstretched arms (see cat. no. 103).[1] The presence of the rats suggests a possible relationship with the man holding his nose in *The Plague of Ashdod* by Poussin (Musée du Louvre, Paris).[2] But it may be that Cézanne, struck after the fact by a resemblance he had not intended, added the filthy, leaping, and plunging creatures, which are more aggressive than those in Poussin's picture and which—despite the summary delineation, stressing their interminable tails—give this drawing a disturbing, even frightening cast.

H. L.

1. Reff, March 1962, pp. 185-86.
2. Reff, 1963, pp. 306-7, 310.

41

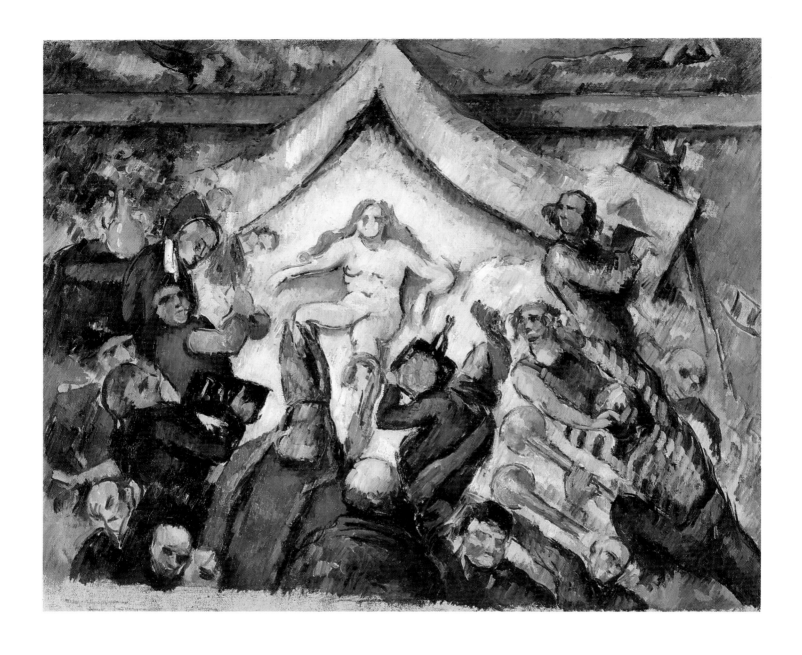

c. 1877
Oil on canvas; 16⅝ × 21 inches (42.2 × 53.3 cm)
Collection of the J. Paul Getty Museum, Malibu, California
V. 247

PROVENANCE
This canvas was acquired from Ambroise Vollard by Auguste Pellerin; it passed from the collection of his son, Jean-Victor Pellerin, to the Wildenstein Galleries, New York, which sold it to Stavros S. Niarchos in 1954. He subsequently sold it back to the Wildenstein Galleries, from which it was purchased by Harold Hecht, Beverly Hills, California, by 1959. By 1970 it was in a private collection in New York and by 1973 it was again with Wildenstein, who sold it to Mrs. John Goulandris, New York, from whom it was consigned to the Galerie Beyeler, Basel, and acquired by the J. Paul Getty Museum in 1987.

EXHIBITIONS
Before 1906: Paris, 1899, no. 6.
After 1906: Paris, 1907 (b), no. 5; Brussels, 1935, no. 10; Paris, 1936, no. 37; London, 1939 (b), no. 16; New York, 1947, no. 13; Chicago and New York, 1952, no. 23; New York, 1959 (b), no. 11; Basel, 1989, no. 29; Tübingen, 1993, no. 12.

On a small canvas about twenty men assemble in a half-circle around a nude woman posed on a white sheet. She presides over them, brazenly nude and immobile, her body fleshy and pink, her abundant coppery hair echoing the gold of the crosier and the metallic hue of the trumpets. The men are noisy and agitated, as excited as she is indifferent. They are drawn from all social stations, for one can make out, with some difficulty, an artist at his easel, two wrestlers wearing striped jerseys, a figure who might be a conductor keeping time, two trumpeters, a troubadour in a feathered hat, a row of men dressed in black behind a bishop with a miter and crosier, a man holding a small box on which can just be deciphered the letters BAN(?), a soldier in a red jacket with gold epaulets, a man in a red vest shaking what may be a money bag, and four more men bowing slightly toward the feminine object they adore. The decor is just as difficult to read, beginning with the bed or sofa on which the woman is seated; it is surmounted by a triangular curtain. On the left, a bouquet in a vase sits on a table covered by a blue cloth; above is a wide gold bar, doubtless part of a frame around a fragment of a landscape. This last identification is confirmed by a preparatory watercolor (fig. 1), in which a framed landscape is clearly visible

Fig. 1. Paul Cézanne, *The Eternal Feminine*, c. 1877, graphite, watercolor, and gouache on paper, private collection (R. 57).

in the upper left corner. It would seem that we are in the studio of the painter himself, who is shown working on a small canvas like the present one, transcribing what he has before his eyes.

The juxtaposition in this studio of an artist at his easel, a central nude, and figures from all walks of life has prompted comparisons with Courbet's *The Studio* (Musée d'Orsay, Paris), but Cézanne's rapidly dashed-off little picture has nothing to do with that immense, realist *machine*, and the two compositions have profoundly different meanings. While Courbet's "real allegory" is a "moral and physical history of [his] studio"—"It is my way of looking at society high, low, and in-between. It is the world come to me to be painted"[1]—Cézanne's ironic allegory treats the hackneyed subject of the woman-idol controlling the world despite herself, the beautiful but lifeless and soul-less object who incites desire in men of every stripe: men of power, prelates, soldiers, and financiers on the left and artists and circus performers on the right. Nor does it have anything to do with *The Toast!*, the "homage to truth" exhibited by Fantin-Latour at the Salon of 1865, which depicts a few serious and intent artists attired in black assembled around a nude woman perched on a table or podium.[2] Fantin's men, all impeccably dressed, converse amiably around a "statue" of female flesh, while those of Cézanne make a wild commotion to the fanfare of shrieking trumpets. Once again we are in the world of *The Feast* (cat. no. 14)—which can be viewed as a latter-day incarnation of Delacroix's grand compositions[3]—but probably for the last time (the chronology of these works remains uncertain). Rather than exhibiting one of his fantasies of a woman tortured or assassinated, he here proposed a statement—laced with a distancing irony—about the irrepressible feminine power of which he, like so many others, had been a victim. Note, however, that, while all the other men offer gifts to seduce the static idol, Cézanne has opted to paint her; the woman becomes, as in *A Modern Olympia* (cat. no. 28), both an allegory of painting and a preferred motif, like two other elements in this improbable studio: the still life on the table and the landscape on the rear wall.

For this farewell to the "baroque" and "romantic" works of his early career, Cézanne resorted to a new technique; the rhythm and structure of the composition are shaped in large part by tight, parallel brushstrokes that, applied consistently on the diagonal, underscore the unanimous and irresistible convergence toward the central nude. *The Eternal Feminine* is thus one of the first canvases in which, around 1877, he employed the constructive

stroke that was to become prevalent in his works of the 1880s and was soon to be taken up by the younger generation of Gauguin and Paul Signac.[4] Devised to replace the looser handling favored by Monet and Renoir, which Cézanne deemed overly subjective and haphazard, it was intended to facilitate his transformation of Impressionism into "something solid and durable like the art of the museums."[5] Thus *The Eternal Feminine* is a pivotal work.[6] It would seem to have been preceded by more versions of the subject than have come down to us, for Joachim Gasquet, in a tantalizing passage in his *Souvenirs*, described one such painting, detailing as well the older Cézanne's contempt for it: "In the attic of the Jas de Bouffan I saw a ripped canvas scratched with a palette knife, grimy with dust—how it got there I can't say—that apparently was burned along with about thirty others, and during Cézanne's lifetime, [since] he couldn't be bothered with them. This one, wild, cracked, battered, flaming, revealed to me, when I had wiped away the obscuring layer of dust, a creature with torrential flesh crouching on a cloud shaped like a swan, her belly protruding, her breasts swollen, her face glittering, splendid and hideous under winglike hair simultaneously red and brown, her hands clotted with blood, an enormous gold chain barring access to her thighs, and her torso battered, like Danaë's, by a shower of light and gold

coins. Around her, in dawning light, a circle of men—screaming, twisted, abominable—attired as priests, generals, old men, a child, workmen, and judges, mugs in the style of Daumier but bloated with red smears resembling blood, a riot of bodies corroded by a Dantesque rainbow in baroque hues that coiled around them like a snake, a whirlpool of shrivelled arms—and, under a star, in a dark corner of the sky, a white apparition covering her eyes. 'Eh? Just the thing for [Octave] Mirbeau,' said Cézanne, who caught me contemplating this page from some apocalypse, and with a kick he sent the canvas flying to the rear of the attic."[7]

<div align="right">H. L.</div>

1. Courbet to Champfleury, [Autumn 1854], in Réunion des Musées Nationaux, *Gustave Courbet* (Paris, 1977), p. 246.
2. This comparison was first made by Charles Stuckey, "What's Wrong with This Picture?," *Art in America*, vol. 69, no. 7 (September 1981), p. 103.
3. Françoise Cachin (1964, p. 342) describes *The Eternal Feminine* as "a sarcastic version of the *Sardanapalus*," a comparison that has been much repeated since.
4. On this subject, see the fundamental article by Reff, Autumn 1962.
5. Cézanne, cited in Denis, 1912, p. 242.
6. Some repaintings, added at an unknown date, were removed only recently; on this subject, see Andersen, December 1990.
7. Gasquet, 1921, p. 32.

43	*Life in the Fields*

1876-77
Oil on canvas; $10^{1}/_{4} \times 13^{3}/_{4}$ inches (26 × 35 cm)
Private collection
V. 251

PROVENANCE
Prince Antoine Bibesco probably acquired this painting from Ambroise Vollard. It was auctioned at his sale at the Hôtel Drouot, Paris, on June 17, 1931 (lot 75). By 1934 it was in the possession of the Pierre Matisse Gallery, New York. It was offered for sale at Parke-Bernet, New York, on January 6, 1949 (lot 48). It subsequently passed through Acquavella Galleries, New York, and then entered the collection of Mrs. Elinor Dorrance Ingersoll, Newport, Rhode Island. It was offered for sale at Christie's, New York, on October 18, 1977 (lot 6), and is now in a private collection.

EXHIBITIONS
After 1906: Philadelphia, 1934, no. 7.

EXHIBITED IN PHILADELPHIA ONLY

Cézanne's narrative paintings—even well into the 1870s, after the dark urgencies of the *couillarde* style had begun to lift—always have an autobiographical significance. His picnics and *fêtes galantes*, too, for all their charm, are charged by the artist's fantasies. There are, however, several watercolors and loosely worked oil paintings, usually dated to the mid-1870s, that manifest a completely different approach to anecdotal painting.[1] Modest in scale, they

are perhaps best described as rural genre images (fig. 1). They have the timeless quality of visual fables; Cézanne never produced anything like them again.

Here, a woman in black with her hand raised to her face and a white-bearded man with a bright yellow hat have just sauntered into view on the left. Immediately in front of this couple sits a man wearing a white shirt and a broad blue hat and holding a stick; beyond, a sway-backed white horse nuzzles a feed pail. On the far right, a man identifiable from other paintings and a watercolor drawing (fig. 2) as a reaper pushes against some object. Anchoring the center of the composition is a statuesque woman with an unlaced bodice who carries water from the river in two vessels, one in her hand and the other on her head. All of these figures seem like characters going about their parts in a rustic operetta, and many elements of the setting—the horizontal band of the river, the barque moored on the far shore, the villa set atop the wooded hill—are redolent of a stage set.

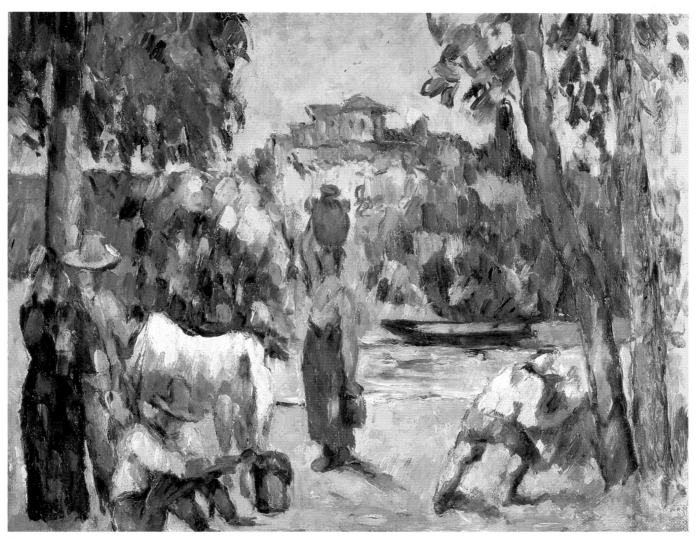

43

Fig. 1. Paul Cézanne,
The Spring, 1872-75,
pen, graphite,
and watercolor on paper,
private collection,
Paris (R. 50).

Fig. 2. Paul Cézanne,
The Harvesters, 1875-78,
graphite and watercolor
on paper,
private collection (R. 53).

The yellows and greens of the landscape are extremely bright—as they must be to vie successfully with the white and blue tones of the figures. The red skirt of the water-bearer provides a strong central accent that keys up the whole composition, in a manner reminiscent of Corot. The paint is loosely and thickly laid on, with brushstrokes going in every direction with great freedom and relish; save for a bare strip of canvas on the right, hardly an inch of the surface is left unanimated.

This is a gay and winning picture, free of sexual forebodings or violent undertones. The pastoral tradition has a long history in French painting; this is one of the rare instances where Cézanne was content to utilize its most innocent and guileless mode.

<div align="right">J. R.</div>

1. V. 248 and V. 249, R. 54 and R. 55, and figs. 1 and 2.

44 | *Landscape, Study after Nature (The Sea at L'Estaque)*

1876
Oil on canvas; $16^1/_2 \times 23^1/_4$ inches (42×59 cm)
Signed lower right: *P. Cézanne*
Fondation Rau pour le Tiers-Monde, Zurich
V. 168

PROVENANCE
The picture was painted for Victor Chocquet and was sold with the rest of his collection in 1899 (Galerie Georges Petit, Paris, July 1-4, 1899, lot 2, *La Méditerranée*). Purchased by the Galerie Bernheim-Jeune for 1,500 francs, it passed to Sam Salz, New York, after 1936, and entered the collection of Mrs. Richard J. Bernhard, New York, where it remained until 1973. In 1975, a European collector acquired it at the Wildenstein Galleries, New York; it was put up for sale at Sotheby's in London on June 30, 1981 (lot 8), when it was purchased by the present owner for £640,000.

EXHIBITIONS
Before 1906: Paris, 1877, under nos. 22 to 25 ("Paysage; étude d'après nature").
After 1906: Paris, 1914, no. 19; Paris, 1926, no. 57; Paris, 1936, no. 35; Washington and San Francisco, 1986, no. 43; Tübingen, 1993, no. 19.

In June and July of 1876, Cézanne returned to L'Estaque. A famous letter to Pissarro, dated July 2, informs us about his sojourn and the poor weather—"It rains here every week two days out of seven. This is flabbergasting in the Midi. It's never been seen before."—and above all about the many projects inspired by places he seems to be discovering for the first time, despite his having studied them a few years earlier (see cat. no. 25). "I have begun," he wrote Pissarro, "two small motifs with the sea, for Monsieur Chocquet, who had spoken to me about it. —It's like a playing card. Red roofs against the blue sea. If the weather turns favorable I might be able to finish them off. Given the circumstances, I haven't done anything yet. —But motifs are to be found that would require three or four months of work, for the vegetation doesn't change here. It's olive trees and pines, which always keep their leaves. The sun here is so frightful that it seems to me the objects are silhouetted not only in white or black, but in blue, red, brown, violet. I could be wrong, but it seems to me that this is the opposite of modeling." And by way of conclusion, after suggesting that the "gentle landscape painters from Auvers" join him, he announced that, on a future sojourn to be arranged as soon as possible, he would undertake "canvases of two meters at least."[1]

These few lines—comparable to Degas's 1873 letters detailing his discovery of Louisiana—are quite remarkable: Cézanne has experienced the revelation of the Midi, of everything that this region, which he thought he knew so intimately, had to offer his painting if only he could manage to transcribe its violent light, its brutal contrasts, its exacerbated colors. The appeal he addressed to his colleagues in Auvers, to Pissarro and Guillemet above all, amounts to an implicit condemnation of an impressionism devoted to coloristic subtlety, to handling that was splintered and vibratory. The landscape of L'Estaque prompted him to summarize what was before his eyes, reclaiming the simplicity and the absence of modeling found on playing-card images, and the resulting paintings paved the way for the "synthetic" Cézanne of the 1880s.

This picture does not yet fully manifest all the intimated innovations: Liliane Brion-Guerry has rightly emphasized the opposition between the foreground, "analyzed with scrupulous realism" in short, parallel brushstrokes, for the most part applied diagonally, and the background, "occupied by the uniform mass of the sea against which the Frioul islands stand out," which is "treated in a broadly synthetic way."[2] When shown in 1877 at the third Impressionist exhibition, along with the portrait of Victor Chocquet (see cat. no. 45), who had commissioned it, this *Landscape, Study after Nature*—a title Cézanne gave to four of the exhibited works—was scarcely noticed, perhaps because it was poorly hung, "above a door, in the second

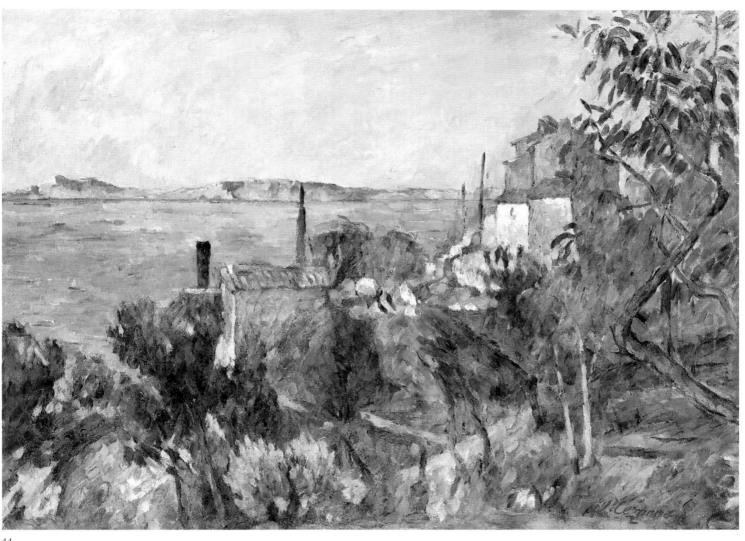

44

room."[3] But this neglect was more likely due to its relative awkwardness in comparison with the surrounding Impressionist landscapes. It was described as "strange" by the reviewer for *L'Événement*, who took delight in ridiculing it: "M. Cézanne exhibits a strange landscape which demonstrates that he has been violently *impressed [impressionnisé]* by two things: spinach and cobbling. Its green makes one shudder, and a clump of trees in the foreground seems exactly like a row of boots cringing in horrible pain."[4]

Georges Rivière, an ardent defender of Cézanne in whom he saw "a Greek of the best period," also stressed the eccentricity of this landscape in the context of the more Impressionist productions: "It has an astonishing grandeur and an unprecedented calm; it's as if this scene were transpiring in the memory of someone reviewing his life."[5] He thus transformed it into a *souvenir de L'Estaque* in the manner of Corot, whereas for Cézanne it was a "study after nature," seized at the motif during that uncertain summer of 1876, the sky having momentarily cleared, the agitated sea punctuated by a solitary sailboat, the trees frail and twisted by the wind.

H. L.

1. Cézanne, 1978, pp. 152-53.
2. Brion-Guerry, 1966, p. 106.
3. Rivière, April 14, 1877, p. 2.
4. Anonymous, April 6, 1877.
5. Rivière, April 14, 1877, p. 2.

Portraits of Victor Chocquet

45 | *Portrait of Victor Chocquet*

c. 1876-77
Oil on canvas; 18 × 14¹/₂ inches (45.7 × 36.8 cm)
Signed toward the lower left: *P. Cézanne*
Private collection
V. 283

PROVENANCE
Initially owned by Victor Chocquet, and then by his wife, née Caroline Buisson, this canvas was sold at the Chocquet sale (Galerie Georges Petit, Paris, July 1-4, 1899, not in catalogue). After being acquired from Bernheim-Jeune by Lord Rothschild (1878-1957), it passed to the Marlborough Galleries in London (which co-owned it with Reid and Lefevre), and then to its present owner.

EXHIBITIONS
Before 1906: Paris, 1877, no. 29 ("Tête d'homme; étude").
After 1906: Paris, 1910, no. 44; Paris, 1926, no. 54; London, 1939 (a), no. 4; Chicago and New York, 1952, no. 37; Edinburgh and London, 1954, no. 15; Philadelphia, 1983, unnumbered; Washington and San Francisco, 1986, no. 44.

46 | *Portrait of Victor Chocquet*

1877
Oil on canvas; 18 × 15 inches (45.7 × 38.1 cm)
Signed lower right: *P. Cézanne*
Columbus Museum of Art, Ohio. Museum purchase, Howald Fund
V. 373

PROVENANCE
Initially owned by Victor Chocquet, and then by his wife, née Caroline Buisson, this canvas was sold at the Chocquet sale (Paris, Galerie Georges Petit, July 1-4, 1899, not in catalogue). On January 2, 1929, it was purchased from the Durand-Ruel Gallery, New York, by Lillie P. Bliss, who in 1931 bequeathed it to the Museum of Modern Art, New York. Deaccessioned on June 17, 1941, to the Paul Rosenberg Gallery, New York, as part of an exchange agreement, it was purchased by Marius de Zayas of Greenwich, Connecticut. The Paul Rosenberg Gallery repurchased the painting on December 29, 1947, and sold it in April 1950 to the Columbus Museum of Art.

EXHIBITIONS
Before 1906: Berlin, 1900, no. 8; Vienna, 1903, no. 59; Paris, 1904 (b), no. 23; London, 1905, no. 42.
After 1906: Paris, 1920 (b), no. 7; Paris, 1924, unnumbered; New York, 1929, no. 9; New York, Andover, and Indianapolis, 1931-32, no. 6; Edinburgh and London, 1954, no. 18; Paris, 1955, no. 1; The Hague, 1956, no. 23; Aix-en-Provence, 1956, no. 17; Zurich, 1956, no. 41; Munich, 1956, no. 29; Cologne, 1956-57, no. 11; Vienna, 1961, no. 15; Aix-en-Provence, 1961, no. 6; Washington, Chicago, and Boston, 1971, no. 6; Tokyo, Kyoto, and Fukuoka, 1974, no. 16; Tübingen, 1993, no. 15.

Victor Chocquet (1821-1891), born into a comfortable family of Lille textile entrepreneurs, was a low-level employee at the Ministry of Finance in Paris.[1] Married to a woman with "expectations" (as the French say, *des espérances*)—she inherited a small fortune after her mother's death in 1882—this customs official began to collect very early on, first acquiring works by his hero, Delacroix, then others by Renoir, whom he regarded as the master's most legitimate artistic heir. Chocquet was present at the calamitous Impressionist sale of 1875, and, while he bought nothing on that occasion, it introduced him to the work of artists—ridiculed by those in attendance—he had not known before. He immediately commissioned Renoir to paint a portrait of his wife (1875, Staatsgalerie, Stuttgart), who posed in a light-colored dress in their apartment on the rue de Rivoli, sitting in front of an oil sketch by Delacroix. It was through Renoir that he met Cézanne: "As soon as I met Monsieur Chocquet, I thought about having him buy a Cézanne! I took him to père Tanguy's, where he bought a small 'Study of Nudes.' He was delighted with his acquisition, and, while we were returning to his home, [remarked]: 'How well that will go between a Delacroix and a Courbet!'"[2]

Neither Chocquet's boldness—he was the first real collector of Cézanne, acquiring no fewer than thirty-three canvases by him—nor his perspicacity—he immediately sensed the painter's affinities with Delacroix and Courbet—ever flagged. In July 1876, Cézanne was working on "two small motifs with the sea, for Monsieur Chocquet."[3] By this time he had perhaps already begun the first portrait of his benefactor (he was to paint six in all, and several drawings as well), which depicts him in three-quarter view, bust-length, wearing a blue jacket over a white shirt with an open collar (cat. no. 45). Unlike Renoir, in whose portrait (fig. 1) we see the collector's head nimbed by the gold frame of an oil sketch by Delacroix, his mien amiable but thoughtful, his gaze gentle but serious, Cézanne consistently infused Chocquet with a hallucinatory quality that seems to vindicate Degas's quip, uttered when the canvas, now in Columbus (cat. no. 46), slipped away from him at auction, that it was "the portrait of a madman by a madman."[4] The critical reaction to the *Head of a Man; Study* (cat. no. 45), as it was called when shown at the third Im-

pressionist exhibition in 1877, could have been predicted. Cézanne contributed sixteen oils and watercolors, primarily landscapes and still lifes, but it was this canvas that attracted the lion's share of mockery.[5] Less hostile writers confessed to being puzzled by this "deliberately odd" portrait: "It's a worker in a blue smock whose face—long, long, as if passed through a wringer, and yellow, yellow, like that of a dyer who specialized in ocher—is framed by blue hair bristling from the top of his head."[6] Others jeered at what they deemed an example of "artistic insanity,"[7] likening it to "a Billoir made of chocolate"[8] (Billoir was an infamous murderer) and claiming it was of "so strange an aspect" that the mere glimpse of it might so "impress" a pregnant woman that she would "give yellow fever to her fruit before it came into the world."[9] But such facile jibes, of course, pass over the boldness of this portrait, built up with small touches such that the flesh, beard, and hair, the greens, yellows, and reds are judiciously intermingled, with brushstrokes, some broad, others more cursory, that are applied in all directions, giving the face an astonishing mobility and incandescence.

After painting this informal likeness of a "maniacal collector" reminiscent of Géricault's madmen, Cézanne doubtless resolved to depict Chocquet in the more conventional guise of an *amateur*, surrounded by the objects he so cherished. The Columbus canvas (cat. no. 46), which, according to Georges Rivière, was painted in the dining room of the rue de Rivoli apartment in 1877,[10] and is perhaps a sketch for a larger picture, adheres to a well-established pattern: relaxing in a Louis XVI armchair (and taking on some of its dryness and angularity), Chocquet poses in front of three pictures in his collection, unidentifiable but with wide gold frames typical of works from a previous generation. We could be in a decor designed for Chauchard, the wealthy collector of Barbizon paintings, with its thick carpet woven in a geometric pattern and its inevitable roll-top desk. But Cézanne, using a distinctive, robust yet crisp mode of handling, unsettles this familiar image even as he invokes it: Chocquet, tie-less and in slippers, rests his large frame—which, unfolded, would shatter the confines of the canvas—in an armchair whose legs are eccentrically abbreviated; as Meyer Schapiro has noted, "everything is cut somewhere and in a unique way,"[11] a visual tactic that disturbs the formal serenity of this bourgeois interior.

H. L.

Fig. 1. Pierre-Auguste Renoir,
Portrait of Victor Chocquet,
1875-76,
oil on canvas,
Fogg Art Museum,
Harvard University Art Museums,
Cambridge, Massachusetts.

1. See Rewald, July-August 1969.
2. Vollard, 1920, p. 84.
3. Cézanne to Pissarro, July 2, 1876, in Cézanne, 1978, p. 152.
4. Julie Manet, diary entry, July 1, 1899, in Manet, 1988, p. 174.
5. See Rivière, April 6, 1877, p. 2.
6. Anonymous, April 9, 1877.
7. Bigot, April 28, 1877, p. 1047.
8. Anonymous, April 6, 1877.
9. Leroy, April 11, 1877.
10. Georges Rivière met Cézanne in 1877, and there is no reason to doubt his dating; see Rivière, 1923, p. 204.
11. Schapiro, 1952, p. 50.

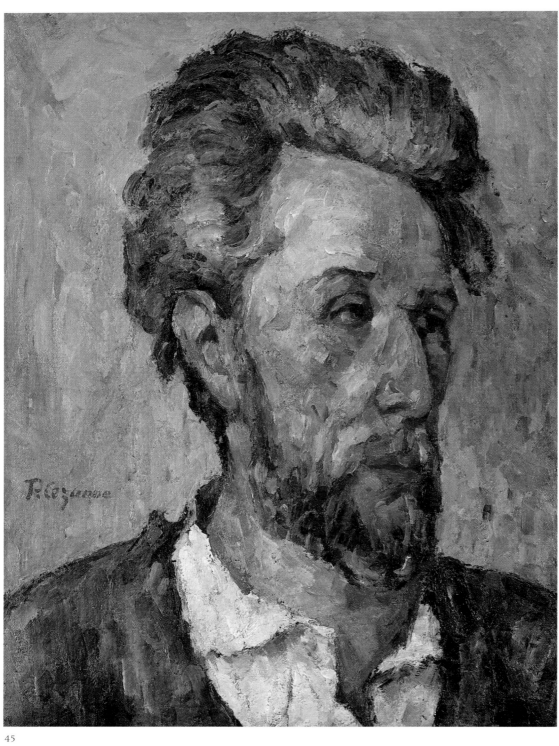

45

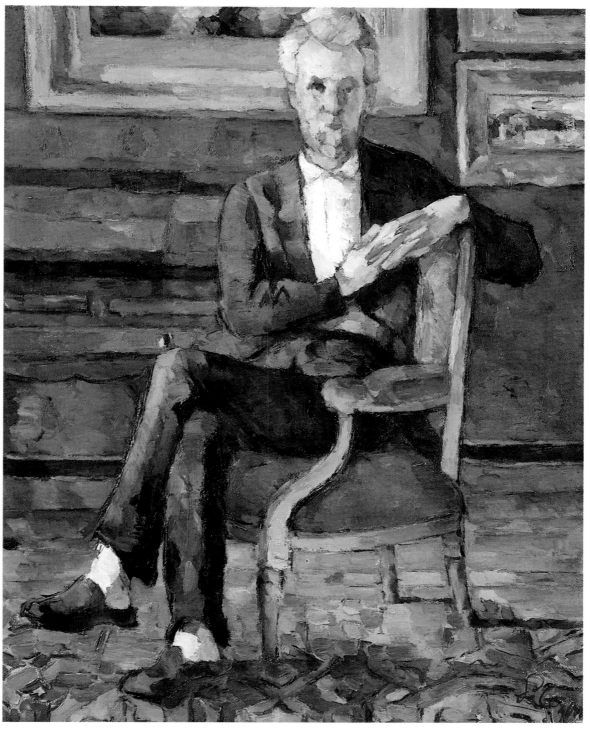

46

Madame Cézanne in a Red Armchair

1877
Oil on canvas; 28⁹/₁₆ × 22¹/₁₆ inches (72.5 × 56 cm)
Museum of Fine Arts, Boston. Bequest of Robert Treat Paine II
V. 292

PROVENANCE
Egisto Fabbri acquired this painting from Ambroise Vollard (Fabbri is known to have owned sixteen works by Cézanne as early as 1899).[1] Subsequently passing through the collection of Samuel Courtauld, London, it came into the possession of Robert Treat Paine II, who bequeathed it to the Museum of Fine Arts, Boston.

EXHIBITIONS
After 1906: Paris, 1907 (b), no. 53 (*La Femme au fauteuil rouge*); Paris, 1910, no. 18; Venice, 1920, no. 7; Philadelphia, 1934, no. 14; Paris, 1936, no. 46; Washington, Chicago, and Boston, 1971, no. 5; Tübingen, 1993, no. 14.

Hortense Fiquet (1850-1922)—who was not to marry Cézanne until 1886—was the artist's companion from 1869; their son, Paul, was born in January 1872. She was the artist's most frequent model, posing for at least twenty-four painted portraits, the latest of which dates from the early 1890s (see cat. nos. 138 and 167). From that time on, she lived with their son, usually in Paris, far from Cézanne. This portrait dates from a period when they were living together—in straitened circumstances, for Cézanne did not dare reveal the liaison to his dreaded father (though his mother was aware of it), and the family had to survive on the modest allowance provided for Cézanne alone. In these years, he often appealed to the generosity of Zola, whose growing fame had brought him considerable financial success.[2]

The picture was apparently painted in Cézanne's Paris apartment at 67, rue de l'Ouest, identifiable by the yellow-green wallpaper with blue medallions that recurs in a series of still lifes,[3] as well as in another, smaller portrait of Hortense sewing, in the same striking red armchair (fig. 1).

In each of these paintings, however, Cézanne introduced slight changes in the design and color of this wallpaper. For the still lifes, he reproduced the light diagonals between the blue floral ornaments, adding considerably to the force of their compositions (see cat. no. 48). But here their insistent regularity would have vitiated the round, abundant, protective form of the red, tasseled armchair; Cézanne therefore retained only the blue patches that made the background wall resonate, as in *Madame Cézanne Sewing*.

The whole is an astonishing harmony of blues, greens, and blue-greens—note especially the baseboard at the lower left—placed around and within the vibrant red mass of the armchair. The latter sets off the discreet but up-to-date elegance of the young Hortense,[4] something that Cézanne, perhaps half-charmed and half-bemused, always carefully rendered in his portraits of her (see cat. nos. 126 and 167).

The face is calm and cool, and its presence has "a natural human grace, reserved and fastidious."[5] Even so, the picture's essence is to be sought in its handling and formal organization; remarkable breakthroughs are achieved in both areas, particularly in the judiciously gauged contrasting colors that make the canvas sing. This becomes most clear when the painting is compared with a slightly earlier self-portrait (cat. no. 36). There, the features are modeled in the traditional manner, through the use of darker colors for the part of the face in shadow. Here, as in the portrait of Victor Chocquet (cat. no. 46), which is very similar in style, shadows and volume are indicated by flat patches of unmodulated color—greens "shading" the right sides of both the face and the clothing—a procedure adopted systematically by Cézanne only in this period. The formal construction is equally striking: all the colors are contained within clearly delineated areas, interlocking in a way that anticipates portraits by Gauguin and Matisse.

The picture attracted much attention at the retrospective at the 1907 Salon d'Automne. It positively enthralled the young poet Rainer Maria Rilke, who paid it homage in one of the most brilliant and penetrating analyses of a painting by Cézanne ever written: "The Salon closes today. And already, as I was coming home from it for the last time, I wished I could go back once more and study a violet, a green, or certain shades of blue that I feel I should have looked at more intently, more indelibly. Already, even though I stood there in front of it so often, transfixed and unflinching, I find that the splendid color cohesion of the woman in the red armchair is fading from memory beyond recall, as hopelessly as some long string of numbers. And yet I fixed it in my mind. Digit by digit. The knowledge that it exists has become a boost to my spirits that I feel even in my sleep; my very blood keeps describing it, but talking somehow passes it by and can't be called back. . . . A low, red, overstuffed chair has been pushed up against

Fig. 1. Paul Cézanne,
Madame Cézanne Sewing, c. 1877,
oil on canvas,
Nationalmuseum, Stockholm
(V. 291).

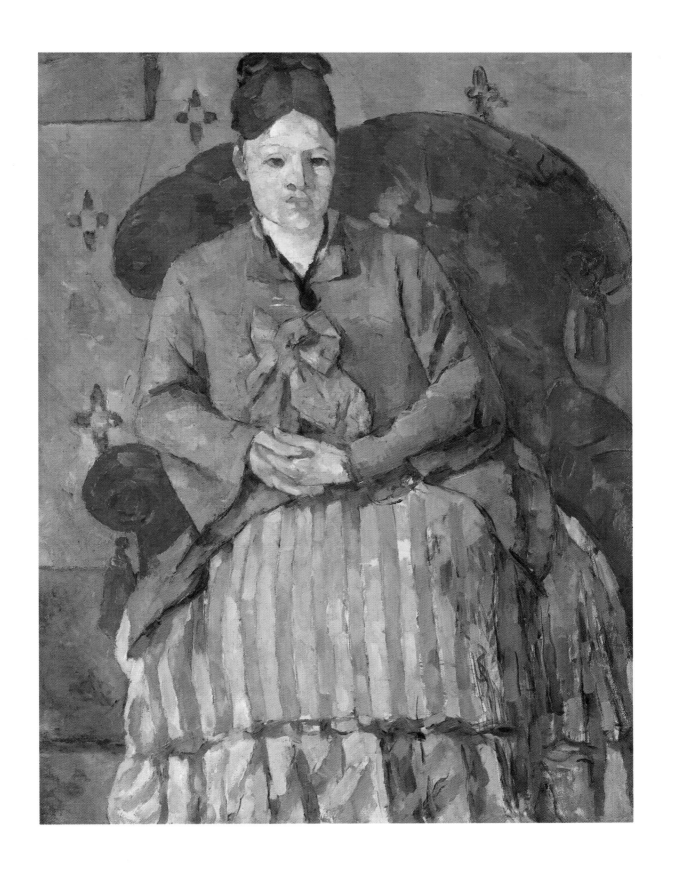

an earthen-green wall on which there are occasional re-peats of a cobalt-blue pattern (a cross with the center left out: +); the puffy round back curves forward and down into armrests (closed like the sleeve of a man who has lost an arm). The armrest on the left and the tassel drenched with cinnabar hanging down from it no longer have the wall behind them, but rather a wide strip of baseboard in a greenish blue, against which they contrast loudly. Seated in this armchair, a personality in itself, is a woman who rests her hands in the lap of her dress of wide vertical stripes, which is simply rendered in discrete little patches of greenish yellow and yellowish green up to the edge of her blue-green jacket, which is closed in front by a blue silk tie shot with green reflections. In the brightness of her face the proximity of all these colors is exploited for the most elementary modeling; even the brown of her hair curving down over her temples and the flat brown in her eyes has to assert itself against its surroundings. *It is as if each spot had a knowledge of every other.* That is how carefully it plays its part; that is how clearly it expresses accommodation and self-denial; that is how intently each concerns itself in its own way with equilibrium, and helps create it: how the whole picture, finally, holds its own against reality. For if one identifies this as a red armchair (and it is the first and most quintessential red armchair in all of painting), it is so only because it incorporates a sum of color experience that, however this is possible, bolsters its redness and confirms it. . . . Everything has become a matter of the colors among themselves; one draws itself back in the presence of an-other, intrudes itself, falls into self-contemplation. . . . The essence of the picture hovers in this back and forth of re-ciprocal and varied influences, rises and falls back into it-self without coming to rest. . . . You see how difficult it becomes if one wants to get quite close to the realities."[6]

F. C.

1. Fabbri to Cézanne, May 28, 1899, in Cézanne, 1978, p. 269 n. 2.
2. See the Chronology: 1869; May 1871; January 4, 1872; March 23, 1878, to September 14, 1878; and April 28, 1886.
3. Cat. no. 48, V. 210, V. 212–14, V. 291, V. 356, V. 358, V. 363–65.
4. See Van Buren, 1966, pp. 115ff.
5. Venturi, 1936, vol. 1, p. 36.
6. Rilke to his wife, October 22, 1907, in Rilke, 1952, pp. 38-40.

48 | *Compotier and Plate of Biscuits*

c. 1877
Oil on canvas; $21^{3}/_{8} \times 25^{3}/_{16}$ inches (54.3 × 64 cm)
Private collection, Japan
V. 209

PROVENANCE
This painting belonged to Victor Vignon (1847-1909), a landscapist who frequented the Impressionists, knew Doctor Gachet and Paul Alexis, and was a protegé of Comte Armand Doria. Acquired by Ambroise Vollard, it was sold via Alexandre Rosenberg to Josse and Gaston Bernheim-Jeune. They sold it to Wildenstein Galleries, New York, where it was purchased by Edwin C. Vogel, New York. It passed through Acquavella Galleries and Sam Salz, New York; Georges S. Livanos, Saint-Moritz, Switzerland; Acquavella Galleries, New York; and the Nichido Gallery, Tokyo.[1]

EXHIBITIONS
After 1906: London, 1935, no. 4; Paris, 1936, no. 34; Chicago and New York, 1952, no. 26; New York, 1959, no. 14.

Two elements make it possible to date this canvas with rel-ative precision. First, the wallpaper, whose "yellow-olive"[2] ground is decorated with a network of open lozenges punctuated with blue crosslike motifs, is probably what adorned the walls of an apartment that Cézanne occupied intermittently from 1877 to 1879 at 67, rue de l'Ouest; it appears in a small group of canvases (see cat. no. 47) that can be assigned similar dates.[3] Second, the technique, as Gowing has noted, resembles that of the *Portrait of Victor Chocquet* (cat. no. 46).[4] Both pictures feature an early ver-sion of the constructive stroke henceforth to be used with increasing rigor; compact, precise, methodical, it judi-ciously distributes notes of color that resonate with one an-other across the entire canvas—here impregnating the tu-multuous tablecloth (which no longer has the striking, unmodulated whiteness of earlier works) with the "domi-nant local color,"[5] the blue-violet and yellow of the wall-paper. The latter delineates a geometric constellation, a stylized starry sky, against which stand out the fruity dome of a compotier and a ziggurat of biscuits. These are situated on a large piece of material—restless, turbulent—that agi-tates the whole composition. This work was to serve as a prototype for many still lifes yet to come: fruit and dishes would be caught up in roiling folds in later canvases, and unsettled tables and chairs would wreak havoc even with their backgrounds.

H. L.

1. See Rewald, forthcoming, no. 325.
2. Venturi, 1936, vol. 1, no. 209, p. 111.
3. V. 210, V. 212–14, V. 291, V. 356, V. 358, V. 363–65, and cat. no. 47.
4. See Gowing, June 1956, p. 188; Andersen, June 1967, pp. 138-39.
5. Rilke to his wife, October 24, 1907, in Rilke, 1952, p. 42.

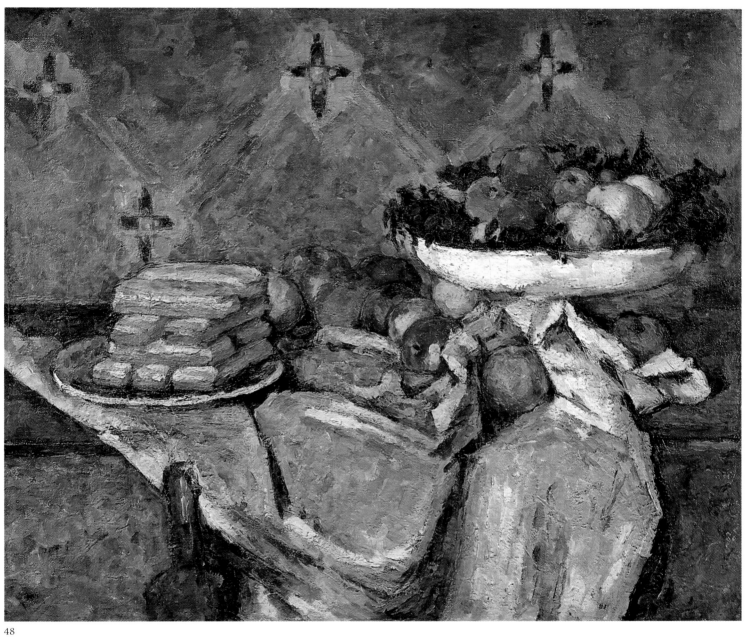

48

49 | *Apples*

c. 1877-78
Oil on canvas; 7¹/₂ × 10¹/₄ inches (19 × 26 cm)
The Provost and Fellows of King's College (Keynes Collection),
on loan to the Fitzwilliam Museum, Cambridge
V. 190

PROVENANCE
In January 1896 Degas acquired this canvas from Ambroise Vollard for 200 francs (see note 5). It was sold with the rest of his collection (Galerie Georges Petit, Paris, March 26-27, 1918, lot 10). Purchased by Knoedler Galleries, it subsequently entered the collection of John Maynard Keynes; his widow, Lady Keynes, bequeathed it in 1968.

EXHIBITIONS
Before 1906: Paris, 1895, unnumbered.
After 1906: London, 1922, no. 36; London, 1937, no. 7; Edinburgh and London, 1954, no. 20.

The apples of Cézanne, which, like his Bathers and Mont Sainte-Victoires, have come to function as a kind of iconographic moniker comparable to Fantin-Latour's bouquets and Degas's dancers, first appeared in his work in the 1870s. Absent from the still lifes of the previous decade, they suddenly began to proliferate, piling up in compotiers, judiciously distributed over tablecloths, or captured as if by chance on the corner of a table. But, in addition to the more "symphonic" of these works, in which the painter-demiurge depicted complex domestic geographies of his own devising, he produced a few canvases representing only isolated fruit. These can be viewed as studies for more ambitious pictures in which the artist examined his subject from every angle, thoroughly perusing their globular forms, seemingly simple, in reality quite complex: in short, as visual exercises in which he practiced his tonal scales, carefully gauging the effect produced by juxtapositions of greens, yellows, and reds.[1] Alternatively, they can be regarded as self-sufficient little pictures that, like Manet's *Asparagus*, deliberately reject the contrivances visible in the larger works to showcase motifs so simple as to border on abstraction.

The "painter of apples" saluted by Thadée Natanson[2] was a discovery of the 1890s; in 1891 Joris-Karl Huysmans, in his inimitable voice, praised these "apples that are brutal, rugged, built up with a trowel, abruptly subdued with the thumb," and that when viewed up close—perhaps he had the Cambridge still life in mind—are "a furious pugging of vermilion and yellow, of green and blue."[3] These apples were to win over a surprising admirer at the Vollard exhibition of 1895: none other than Degas, who, according to Pissarro (apparently startled by this development), was seduced by "the charm of this refined savage nature."[4] Two months later, Degas expressed his enthusiasm in another way, acquiring several works by the artist in January 1896—including this little canvas, entitled by him "Apples, green, yellow, red"—for the museum he was planning to establish.[5]

H. L.

1. See especially V. 191, V. 202, and V. 203.
2. Natanson, December 1, 1895, p. 500.
3. Huysmans, September 1, 1891, p. 301.
4. Pissarro to his son Lucien, November 21, 1895, in Pissarro, 1980-91, vol. 4, no. 1174, p. 119.
5. In the same transaction with Vollard, Degas purchased a "Still life. Green and red apples/napkin, green with leaves on it" for 400 francs, as well as "3 pears in a dish/watercolor" for 100 francs; unpublished notes, private collection.

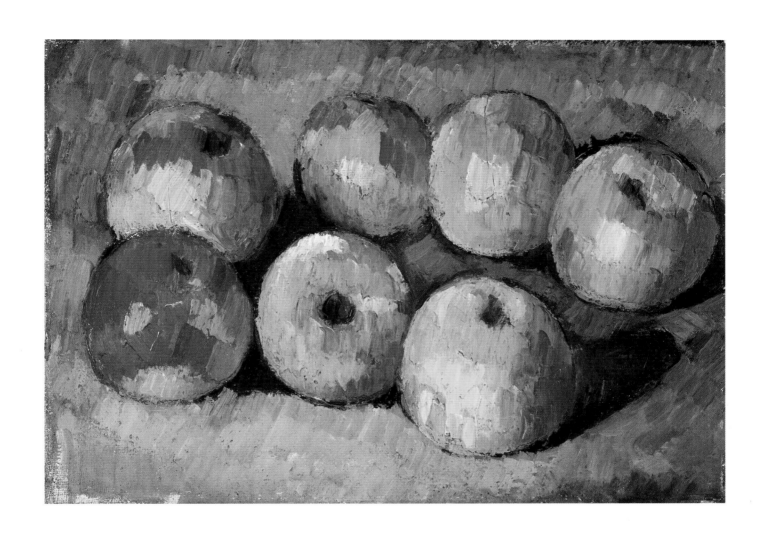

Five Bathers

1877-78
Oil on canvas; $18^{1}/_{16} \times 21^{15}/_{16}$ inches (45.8 × 55.7 cm)
Musée Picasso, Paris
V. 385

PROVENANCE
This painting was in the collection of Auguste Pellerin. Following his death in 1929, it remained in the family until it was sold at the Galerie Charpentier, Paris, in 1956. By 1957 it was in the possession of the Marlborough Galleries, London. It was acquired by Pablo Picasso shortly thereafter.[1]

EXHIBITIONS
After 1906: Lyon, 1939, no. 27; Paris, 1954, no. 44; Basel, 1989, no. 38.

EXHIBITED IN PARIS ONLY

In the late 1870s and early 1880s Cézanne painted several small canvases of female bathers and two of male bathers in an almost square format. These works are all executed in the densely packed, parallel diagonal strokes—the so-called constructive strokes—with which he was experimenting at this point in his career. The figures have a sense of compression that, although far from unique in his work, gives them a quality Lawrence Gowing once referred to as "solid state." As a group, they had considerable influence on subsequent artists: three Bather paintings in the present exhibition belonged, respectively, to Henri Matisse (cat. no. 60), Henry Moore (cat. no. 38), and Pablo Picasso (cat. no. 50).[2]

Some of these works, such as the painting owned by Matisse, can seem oddly mute and inexpressive, as though the process of making them had squeezed all the narrative juice from the subject matter. The figures—sometimes three, sometimes five—are arranged in a carefully worked-out formula predetermining their placement and each gesture. This sense of artificial constraint is especially noticeable in this canvas, with its high horizon line that contains the bathers within an almost claustrophobic glade, and with its dull green foliage and artificial poses reinforcing the studied effect.

J. R.

1. John Richardson (1991, p. 469 n. 19) has indicated that Picasso purchased the painting in 1956, but in June-July 1957 it was listed in the catalogue of an exhibition at the Marlborough Galleries as still belonging to the Pellerin family.
2. On the influence of Cézanne's Bather images on Picasso, see William Rubin, in New York and Houston, 1977-78, pp. 151-202; also see Richardson, 1991. Note, however, that Picasso did not acquire this work until 1956 or 1957, although he certainly knew, and perhaps envied, Matisse's, which that artist had purchased in 1899.

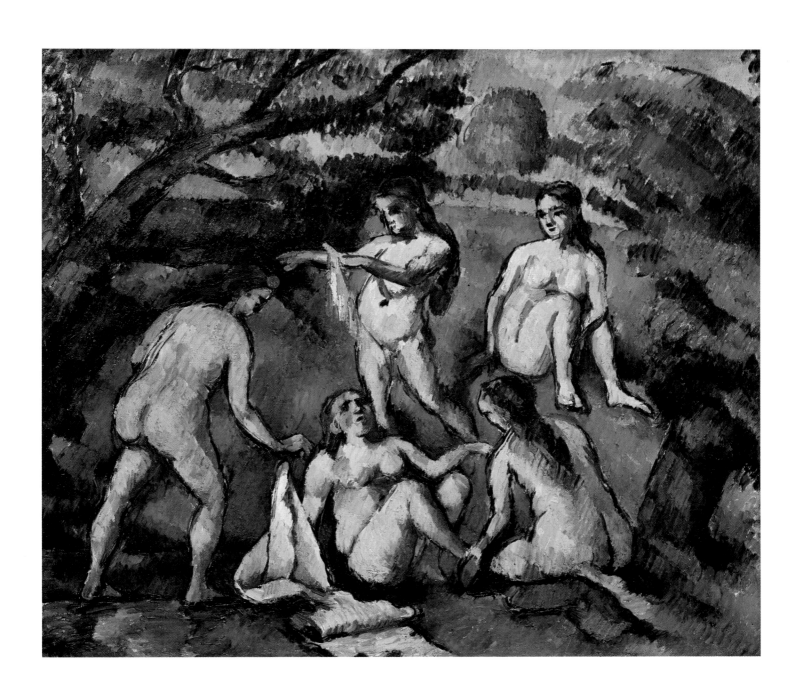

Studies and Portraits of the Artist's Son

c. 1878
Graphite, with ink blot, on paper; 12^{13}/$_{16}$ × 11^{13}/$_{16}$ inches (32.5 × 30 cm)
Graphische Sammlung Albertina, Vienna
C. 713

PROVENANCE
This drawing was originally owned by Ambroise Vollard. It subsequently entered the collections of the Albertina, Vienna.

EXHIBITIONS
After 1906: Basel, 1936, no. 124; San Francisco, 1937, no. 61; Vienna, 1961, no. 90.

EXHIBITED IN LONDON ONLY

The drawing of little Paul on the lower left of this sheet, holding his mouth closed in a smile with his head slightly cocked, was used by Vollard as an independent image to illustrate the 1914 edition of his biography of Cézanne;[1] Meier-Graefe did the same in 1920.[2] Of the hundreds of records Cézanne made of Paul *fils* over the years, few are as disarming and as wonderfully revealing of the father's pleasure in his son. By 1936 the image had become so well known that Venturi was unaware that it figured on a sheet with other drawings, and hence accorded it an independent illustration and inventory number.

In fact, the boy shares the page with another image of himself, looking a bit more dour and apprehensive. The quickly sketched female figure on the sheet is based on an ornamental mantel clock in the style of Charles X, which Cézanne drew several times.[3] The fluted water glass often appears in Cézanne's paintings and drawings. In the upper left corner, Cézanne drew a small but quite finished version of the *Bather with Outstretched Arms* (cat. no. 103), contained within a rectangle of landscape, as if he were quoting a preexisting work, perhaps one of the small oil sketches that seem to have preceded the large painting.

This random collection of images falls casually but gracefully on the page. Indeed, there are those who would claim it is not random at all, for some recent commentators maintain there are no simple moments even in Cézanne's more casual productions. Reff, for example, has argued persuasively that this juxtaposition of an empty glass and a male nude in an eccentric pose is revelatory of Cézanne's sexual anxieties.[4] To make matters still more complicated, the sheet has been dated to about 1878 on the basis of the age of the child, here no older than six, a hypothesis that implies a surprising chronological dislocation between the *Bather with Outstretched Arms* and *The Large Bather* of about 1885 in the Museum of Modern Art (cat. no. 104). Such quandaries abound when dealing with the sketchbook drawings, whose variety of graphic notation and odd juxtapositions tend to raise questions that are difficult to answer. But this only increases their charm and mystery.

J. R.

1. See Vollard, 1914, p. 37.
2. See Meier-Graefe, 1920, p. 26.
3. See Chappuis, 1973, vol. 1, nos. 457-59, pp. 140-41.
4. See Reff, March 1962, p. 186.

| *Corner of a Studio*

1877-81
Graphite on cream paper; 8⁹/₁₆ × 4⁷/₈ inches (21.8 × 12.4 cm)
Fogg Art Museum, Harvard University Art Museums, Cambridge, Massachusetts.
Bequest of Marian H. Phinney
C. 536

PROVENANCE
This drawing was originally part of a sketchbook in the possession of Paul Cézanne *fils*. It subsequently entered the collection of Adrien Chappuis, Tresserve. It then passed through the hands of the dealer Walter Feilchenfeldt, Zurich, to Otto Gerson of Fine Arts Associates, New York, who in late 1955 sold it to Mrs. Charles W. (Marian) Phinney; she bequeathed it to the Fogg Art Museum in 1962.

EXHIBITIONS
After 1906: Tübingen, 1978, no. 114.

The great majority of Cézanne's drawings—and more of the watercolors than is generally acknowledged—were originally pages in sketchbooks. These books, whether still intact or in dispersed pages, afford intimate glimpses of the artist's daily rhythms and practice.[1] Sketchbooks survive from virtually every period of Cézanne's career, and evidence indicates that the artist, unconcerned with chronological continuity, used individual books interchangeably over considerable spans of time. Only rarely does their subject matter relate to his paintings; most often they record objects and people that momentarily captured his attention. There are portraits of family and friends (including many sleeping figures observed unawares), drawings after older works of art (which tell us much about Cézanne's sensibilities), the occasional landscape, and close-ups of his domestic surroundings: an unmade bed, a chair back, a lamp, or, as here, a corner of his studio.

The casual subjects of these still-life drawings can be deceiving, however. The present sheet, for example, may lack the pondered calculation of the painted compositions, but an acute formal sense is nonetheless at work in the framing and positioning of the objects. Conventional patterns of observation have been avoided, but in a way that combines classical organization with that more elusive order found only in the accidental.

A pile of stretched canvases is stacked in a corner against a wainscoted wall, along with what Chappuis termed a "large roller" but is more likely a loosely rolled canvas.[2] The foreground canvas is seen from behind and bears a round mark of some kind; this is in fact a stain on the paper, but it could almost have been applied deliberately, for it evokes Cézanne's notoriously casual treatment of his canvases, something that greatly distressed Vollard when he first visited the artist.[3] A drop cloth, or perhaps a large canvas removed from its stretcher and abandoned, is heaped on the right. Everything is noted with great assurance with pencil marks that are sometimes dense and sometimes sparse, making this sheet one of the most subtly modulated of all Cézanne's still-life drawings. Chappuis observed that this work "has been hailed as one of the forerunners of Cubism,"[4] and there is no denying its special appeal to twentieth-century sensibilities.

J. R.

1. For a summary of the literature on the sketchbooks, see the essays by Theodore Reff and Innis Howe Shoemaker in Philadelphia, 1989, pp. 8-26. See also Sketchbooks, pp. 518-25 below.
2. Chappuis, 1973, vol. 1, no. 536, p. 156.
3. See Vollard, 1914, p. 74.
4. Chappuis, 1973, vol. 1, no. 536, p. 156.

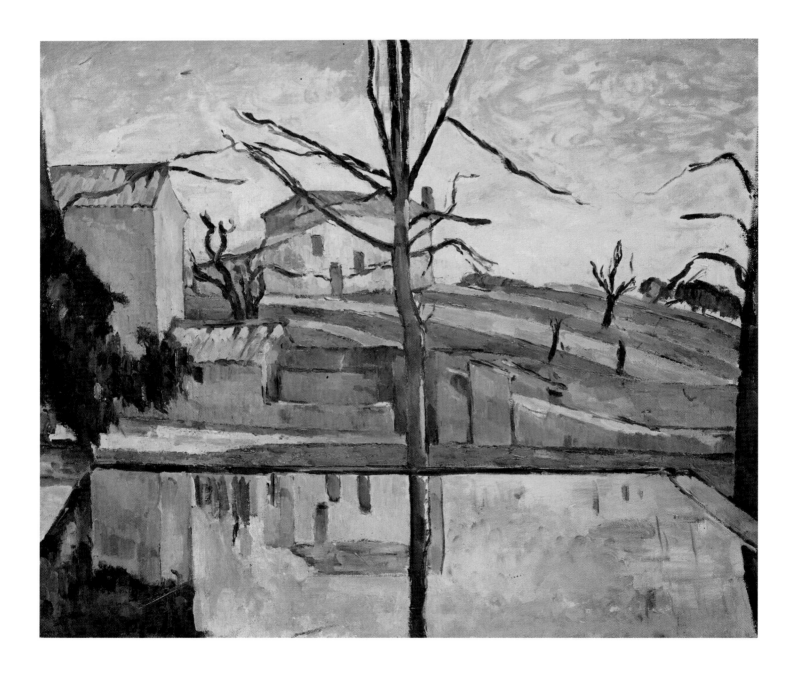

The Pool at the Jas de Bouffan

1878
Oil on canvas; 18½ × 22⅛ inches (47 × 56.2 cm)
Signed lower left: *Cézanne*
Collection of Corinne Cuéllar
V. 164

PROVENANCE
This picture changed hands several times between 1905 and 1909. It was acquired by Ambroise Vollard, belonging jointly in 1905-6 to Vollard and the Galerie Bernheim-Jeune, whose interest in it was repurchased by Vollard on April 20, 1906. Baron Denys Cochin, Paris, owned it next. He sold it to Galerie Bernheim-Jeune on March 18, 1909, and Auguste Pellerin acquired it the next day.[1] It remained in the Pellerin family for more than eighty years, until it was sold on November 30, 1992—along with six other pictures from the collection—at Christie's, London (lot 11), where it was acquired by its present owner.

EXHIBITIONS
Before 1906: London, 1906, no. 205.
After 1906: Chicago and New York, 1952, no. 36; Paris, 1954, no. 40.

In his Impressionist period, from the 1870s to the early 1880s, Cézanne organized many of his landscapes of motifs in Aix and the Île-de-France around central voids—a turning road, an allée, a glade, or the prospect of a distant village (see cat. nos. 30, 72, and 76)—framed by foreground trees. Here, he opted for a very different strategy: the compositional scheme effects a systematic reversal of the Île-de-France landscapes.

In this depiction of the pool in front of the family manor house, the Jas de Bouffan (see cat. nos. 24 and 59), the opulent greens of the earlier landscapes are replaced by a spare rigor. It was probably one or two years before, in the spring or early summer of 1876, when the artist painted two canvases representing the other side of the pool, with its waterspouts and ornamental sculptures of a lion and a dolphin: *The Pool*, now in the Sheffield City Art Galleries (V. 160), and the picture formerly in the Krebs collection and now in the Hermitage Museum, St. Petersburg (fig. 1),[2] both of which feature Impressionist compositions and handling.

On returning to Aix early in 1878, Cézanne reverted to his natural penchant for austerity, indulging his delight in simplified structures. In this composition, voids are relegated to the four corners, while the center is dominated by a focal tree that, with its reflection in the pool and the

latter's horizontal edge, defines four rectangles, thereby baffling spatial recession. The reductive intention becomes clearer when the painting is compared with its preparatory watercolor (fig. 2).[3] In the passage from paper to canvas, Cézanne "purified" the image, simplifying it, stripping it to essentials. He insisted on the frail rigidity of the leafless tree, recentering its trunk and extending it downward in the aligned reflection. He pruned many of its smaller branches, deeming them superfluous. He positioned himself a bit farther to the right, maneuvering the second tree trunk on the left out of view and creating an emphatic compositional armature configured like an inverted cross. In addition, he accentuated the oblique bands of the green fields, alternating them with strips of bare earth, and he opened the format, extending the sky upward and the pool downward, allowing the composition to breathe.

The date of this picture has been a point of contention. Both Rewald and Gowing placed it during Cézanne's sojourn in the Midi in 1878, when he was dividing his time between his parents' house in Aix and his lodgings in L'Estaque and Marseille, where Hortense and Paul *fils* were living. According to this theory, the canvas would have been painted at the beginning of the stay, with the color of the sky and the green shoots signs of impending spring. But Cézanne's son later inscribed a date of 1880 on the back of a photograph of the canvas in the Vollard archives, and Douglas Cooper maintained that it was painted during the winter of 1881-82,[4] which is consistent with the date assigned the watercolor by Rewald, who also described the season as winter. In any event, the dates of the winter and spring sojourns in Provence during the specified years seem to confirm a dating of early 1878 for both the painting and the watercolor.

The man who was to become Cézanne's first great defender in England, Roger Fry, discovered his work in 1906, partly as a result of this canvas: "We confess to having been

Fig. 1. Paul Cézanne,
The Pool at the Jas de Bouffan,
1876,
oil on canvas,
The Hermitage Museum,
St. Petersburg (V. 167).

Fig. 2. Paul Cézanne,
*The Pool at the Jas de Bouffan
with Leafless Trees*, 1878,
graphite and watercolor
on paper,
Oskar Reinhart Collection,
Winterthur (R. 155).

hitherto sceptical about Cézanne's genius, but these two pieces [the other one was *Still Life with Green Pot and Pewter Jug*, cat. no. 18] reveal a power which is entirely distinct and personal, and though the artist's appeal is limited, and touches none of the finer issues of the imaginative life, it is none the less complete."[5] Almost twenty years later, Fry's enthusiasm was unstinting: "The bleak nakedness of a wintry landscape is forcibly expressed. Here the rectilinear structure and the preponderance of right angles is almost disconcerting at first, but we feel that Cézanne has accepted this bleakness of the scene with a sort of austere voluptuousness. The exaltation of the artist's mood, his passionate emotion, translate themselves everywhere in the rich elaboration of the pigment. These bare surfaces of grey wall give evidence of obstinate and patient research into all their variations of surface and colour. Again, it is by the accumulation of innumerable slight variations that he is able to construct for the imagination this immensity of space filled with light and vibrating with life."[6] Albert Châtelet responded to the picture in similar terms: "Rarely has Cézanne been more assertive in his stripping-down of forms," he wrote, "but it is this very dryness, tempered by the suppleness of his touch, that here gives birth to the poetry of the vision."[7]

F. C.

1. See Rewald, forthcoming, no. 350.
2. See Albert Kostenevich, *Hidden Treasures Revealed* (New York and St. Petersburg, 1995), pp. 176-81.
3. Rewald (1983, no. 155, p. 123) dated this watercolor to 1881-83.
4. See Cooper, November-December 1954, p. 379.
5. Fry, "The New Gallery," *Athenaeum*, January 13, 1906; cited in Virginia Woolf, *Roger Fry: A Biography* (New York, 1940), p. 112.
6. Fry, 1927, pp. 62-63.
7. Châtelet, in Paris, 1954, no. 40, p. 16.

54 | *The Bay of L'Estaque from the East*

c. 1878-82
Oil on canvas; 21¼ × 25⅝ inches (54 × 65.1 cm)
Memorial Art Gallery of the University of Rochester, New York.
Anonymous gift in tribute to Edward Harris and in memory of H. R. Stirlin, Switzerland
V. 408

PROVENANCE
Egisto Fabbri probably purchased this painting from Ambroise Vollard. It was bought from Fabbri by the dealer Paul Rosenberg, Paris, and then acquired by the Swiss collector H. R. Stirlin in 1936. It remained in his collection through 1957. Passing in 1969 to a private collection in Rochester, New York, it was given by an anonymous donor to the Memorial Art Gallery of the University of Rochester.

EXHIBITIONS
After 1906: Venice, 1920, no. 17; Basel, 1936, no. 32; Paris, 1939 (a), no. 15; Lyon, 1939, no. 28; Zurich, 1956, no. 45; Munich, 1956, no. 33; Tokyo, Kyoto, and Fukuoka, 1974, no. 21; Liège and Aix-en-Provence, 1982, no. 11.

The village of L'Estaque, located some five miles northwest of Marseille and eighteen miles southwest of Aix, is squeezed, with the neighboring hamlet of Saint-Henri, between the mountains and the sea. The 1914 Baedeker guide describes it as "a favorite sea-bathing resort," although in Cézanne's time there were already several tile and brick factories, harbingers of the industrialization of this end of the bay that would eventually consume L'Estaque as an independent town.

Cézanne's mother rented a house in the village, and it was there that he weathered the Franco-Prussian War in 1870 with his mistress, Hortense Fiquet, sometimes joined by Émile Zola. Cézanne often returned to L'Estaque between 1876 and 1885, either renting a house in the small town or coming out for the day from Marseille. It was clearly a place he held dear. It was also at a convenient distance from Aix, permitting him to keep company with Hortense and his son Paul while making regular visits alone to his parents (Cézanne was determined to hide the existence of his mistress and son from his father, necessitating such an arrangement). It seems the artist never returned to the area after 1886, the year of both his marriage to Hortense and the death of his father.

There are some dozen paintings of the town, looking across or down the bay of Marseille and beyond. They differ greatly from one another, but, like the square-formatted Bathers series of the same period, they allow us to trace the remarkable transformation of Cézanne's art during this crucial decade.

All of Cézanne's representations of L'Estaque are taken from a high vantage point. The artist placed himself in the pine woods above the village to assure the privacy he sought while painting, and also to obtain the best views. As he wrote to Zola in 1883:

"I've rented a little house with a garden in L'Estaque, just above the train station and at the foot of the hill, where behind me rise the rocks and the pines.

"I keep myself busy painting. I have some beautiful

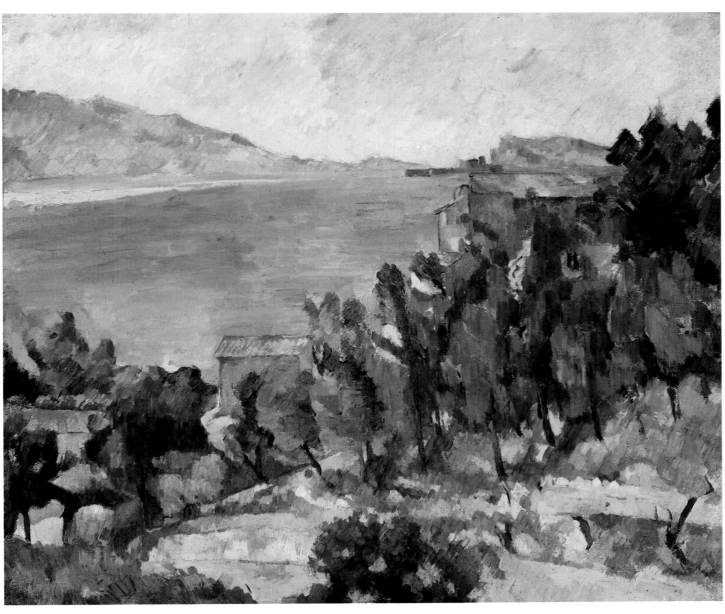

54

viewpoints here, but that doesn't always make a motif.—
Nevertheless, climbing on the heights when the sun is set-
ting, one has a glorious view of Marseille in the distance
and the islands, the whole giving a very decorative effect in
the evening light."[1]

Such a picturesque description could hardly be applied
here. Rarely—even at this juncture, when Cézanne was
most concerned about containment and compression—
has a panoramic vista been so radically circumscribed. The
descending shelf of rock on the left (the massive peninsula
just south of Marseille called the Marseilleveyre) visually
connects—at a point just above the orange house on the
right—with one of the distant islands in the bay, com-
pletely enclosing the body of water, which in reality opens
expansively into the Mediterranean Sea. Furthermore, for
all the intensity of color, a leaden quality binds the sky,
sea, and land into an oppressive mass allowing no escape
into atmospheric space. Liliane Brion-Guerry discerned

this quality in several views of L'Estaque: "The constituent elements of the landscape are quite various: rocks, *châteaux forts*, little rounded hills scattered with orange trees that bring Lorenzetti to mind, trees with twisted forms through which gleam Cézanne's houses in all their sunny disorder. Despite a simplification of the formal contours through a process of abstraction, however, as the spatial content becomes more heterogenous the atmospheric content grows denser and more oppressive, as though this static mass of air were locking the composition into place with its weight, preventing it from coming apart."[2]

J. R.

1. Cézanne to Zola, May 24, 1883, in Cézanne, 1978, p. 211.
2. Brion-Guerry, 1966, p. 110.

55 | *Rocks at L'Estaque*

1879-82
Oil on canvas; $28^3/4 \times 35^{13}/16$ inches (73×91 cm)
Museu de Arte de São Paulo, Brazil. Chateaubriand Collection.
V. 404

PROVENANCE
This painting was first owned by Georges Dumesnil, one of the few people in Aix-en-Provence who possessed a work by Cézanne. In 1910, it was sold by the Galerie Bernheim-Jeune to Harry Graf Kessler, who sold it to Robert von Hirsch in Frankfurt. Paul Cassirer purchased it from him, and it was then sold to Baron Kojiro Matsukata, Kobe and Paris. After passing through the Wildenstein Galleries, of Paris, London, and New York, it entered the collection of the Museu de Arte, São Paulo, prior to 1953.

EXHIBITIONS
After 1906: Paris, 1910, no. 15; Tokyo, Kobe, and Nagoya, 1986, no. 20; Tübingen, 1993, no. 22; Marseille, 1994, no. 13.

It is tempting to date this dramatic picture to the early months of 1882, when Cézanne, living in L'Estaque, was visited by Renoir, whose stay was prolonged when he fell ill in February and was nursed back to health by his friend.

Renoir's presence seems to have encouraged Cézanne to penetrate deeper than usual into the mountainous wilderness behind the village, which provided Cézanne with landscape motifs for more than a decade. Four paintings by Renoir showing boulders strewn in barren ravines date from this trip south (see fig. 1). Only two works by Cézanne seem to survive from this campaign, a vertical canvas of a steep, rocky slope (fig. 2) and the present picture, for which he set up his easel at the head of a dry ravine at a point shallow enough to afford him a restricted view of the sea and the islands dominating the bay. From this site, he also made two drawings, both in the Chicago sketchbook (figs. 3 and 4). All these works convey the harshness of cold winter light flooding a rugged landscape,

Fig. 1. Pierre-Auguste Renoir, *Rocks at l'Estaque*, 1882, oil on canvas, The Museum of Fine Arts, Boston, Juliana Cheney Edwards Collection.

Fig. 2. Paul Cézanne, *Bottom of the Ravine*, c. 1879, oil on canvas, The Museum of Fine Arts, Houston, The John A. and Audrey Jones Beck Collection (V. 400).

Fig. 3. Paul Cézanne, *The Coast Near l'Estaque*, 1881-84, graphite on paper, page X verso of sketchbook, The Art Institute of Chicago, Arthur Heun Fund (C. 809).

Fig. 4. Paul Cézanne, *Rocky Coast Near l'Estaque*, 1881-84, graphite on paper, page XVII verso of sketchbook, The Art Institute of Chicago, Arthur Heun Fund (C. 810).

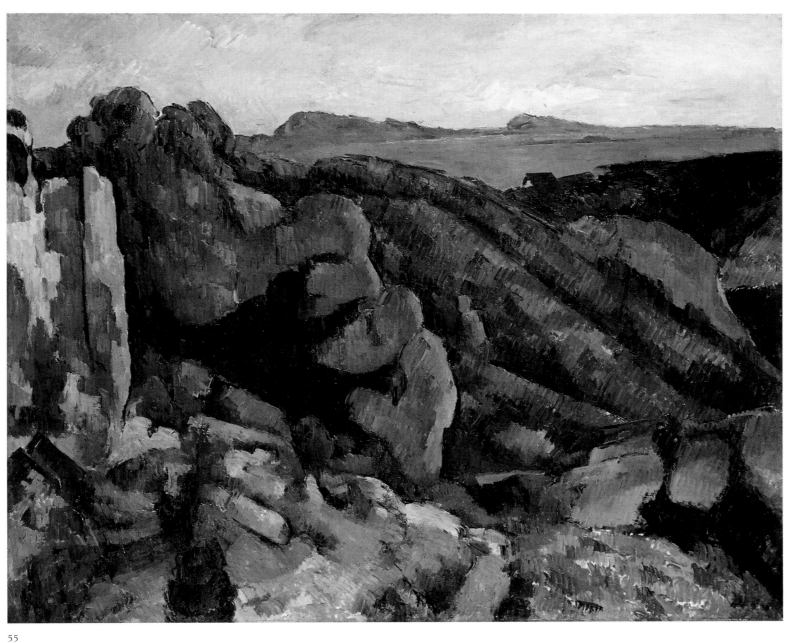

55

whose seasonal dearth of greenery thrusts the stark forms of the rocks and the orange patches of earth into greater prominence.

A photograph from the same vantage, published by Xavier Prati in 1994 (fig. 5), drives home just how far Cézanne had ventured from the town and the bay to choose a site not yet overwhelmed by industrial development. Recording the three rocky outcroppings that abut the side of this shallow ravine, which opens into a wider gorge emptying into the sea, the photograph also documents Cézanne's fidelity to the physical facts of the motif. The sheer cliffs on the far left stand in bleak contrast to the tumble of stone, whose foremost edge marks the center of the picture, while another, less eccentrically shaped extrusion of gray rock forms a silhouetted slope on the far right. The two islands—here, as in the photograph, visually fusing into a single mass—almost completely contain a small sliver of sea. All that's lacking in Prati's image is the lone house whose roof appears just above the cliffs toward the right.

But the correlation should not be taken too far. Prati's image reveals an isolated, windswept, and grandly expansive site overlooking the sea; the effect produced by Cézanne's canvas is very different. The artist compressed all the landscape elements into a tight, carefully wrought unit. The parallel brushstrokes he was using at the time make the painting resemble a roughly chiseled sculptural relief. Every facet of rock, every patch of dry grass or exposed earth is rendered by these aligned units of color to create a subtle field of interlocking planes that loosens and releases incrementally as the ravine opens to the right. The sea, island, and sky are more freely handled, but the pigment is as densely applied in these passages as in the foreground, precluding escape from the contained world Cézanne has defined.

In the end, the effect is more brooding than heroic. Despite the dramatic interplay of light and dark colors—one rock face turns pale orange in the raking afternoon light, while another behind it is blue with deep green shadows— the prevailing mood is ponderous and introspective. The work reminded Adriani of the "pathos-laden landscapes of Courbet"[1]—an apt comparison, for, despite the unique splendor of their construction, many of Cézanne's works from this period are indeed reminiscent of the dark, compacted late landscapes by Courbet (fig. 6).

<div align="right">J. R.</div>

1. Adriani, 1993 (b), p. 102.

Fig. 5. *Rocks at l'Estaque*, photograph, Musée Cantini, Marseille.

Fig. 6. Gustave Courbet, *The Fringe of the Forest*, c. 1856, oil on canvas, Philadelphia Museum of Art, The Louis E. Stern Collection, 1963-181-19.

c. 1879
Oil on paper mounted on canvas; 21⁵/₁₆ × 29³/₁₆ inches (54.2 × 74.2 cm)
National Museum and Gallery of Wales, Cardiff. Bequest of Gwendoline E. Davies
V. 490

PROVENANCE
This painting was bought by Paul Gauguin from père Tanguy in the early 1880s. After Gauguin left Copenhagen in 1885, his wife, Mette Gauguin, sold it to Edvard Brandès. Gauguin tried to get the picture back from Brandès in 1894, but was unsuccessful. By 1913 it was in the possession of Baron Denys Cochin, who sold it shortly thereafter to Bernheim-Jeune, Paris. It was exhibited at the Galerie Bernheim-Jeune in 1914 and sold by them in 1918 to Gwendoline E. Davies.

EXHIBITIONS
Before 1906: Copenhagen, 1889, unnumbered.
After 1906: Paris, 1914, no. 4 (?); New York, 1916, no. 4 *(The François Zola Dam)*; Zurich, 1917, no. 5; London, 1922, no. 40; Paris, 1936, no. 42; Edinburgh and London, 1954, no. 32; Edinburgh, 1990, no. 34.

EXHIBITED IN PHILADELPHIA ONLY

This picture, along with a still life by Cézanne (V. 734) also belonging to Gwendoline Davies, was rejected as a loan to the Tate Gallery in 1921 just as that institution was opening its galleries to "non-British art." The refusal prompted the editor of *The Burlington Magazine* to note: "Although, of course, the opinion of such enthusiasts varies greatly regarding the relative merits of the painters of modern France, all have come to an agreement about Cézanne, who was born as long ago as 1839, is universally recognised as the father of the whole movement, and is now given a place in great public collections throughout the world. A Gallery of Modern Foreign Art without Cézanne is like a gallery of Florentine art without Giotto."[1] Roger Fry, the author of this unsigned editorial, had also chosen this landscape for particular praise when he reviewed an exhibition of French art at the Burlington Fine Arts Club: "It seems to me one of the greatest of all Cézanne's landscapes, and I dare hardly say how high a place that gives it for me in all known examples of landscape art."[2] Richard Verdi has observed that Samuel Courtauld acquired the first of his Cézannes the very next year, suggesting that it was Gwendoline Davies's example that had prompted him

to do so and that she had set the standard for progressive collecting in Britain at a remarkably high level.[3]

This picture had first belonged to Gauguin, and it was among his most treasured possessions. In the summer of 1883 Gauguin informed Pissarro that he had obtained it from père Tanguy at a "good price." He described the work as "a view of the Midi that's unfinished but very advanced—blue-green and orange. I think it quite simply a marvel."[4] He used it as the basis for a fan design dated 1885 (fig. 1), and desperately tried to buy the painting back from his brother-in-law after his wife was forced to sell it, probably in the wake of Gauguin's first departure for Tahiti, in 1891.[5]

There is an American chapter to the life of this picture. It was shown in New York at the Montross Gallery in 1916 with a group of Cézanne's works on loan from the Galerie Bernheim-Jeune in Paris. Titled *The François Zola Dam*, it was singled out for special praise by at least one astute critic, Willard Huntington Wright: "It possesses that quality of linear depth which gives it synthetic movement. Cézanne, when sitting before nature, tried to penetrate to the motivating rhythm of his subject, irrespective of preconceived ideas as to what the rhythm should be."[6]

Wright's analysis seems particularly apt since this landscape has a direct, unpremeditated quality—rare in Cézanne's paintings of the early 1880s. Much of this is simply due to the way the picture is composed of blunt, saturated strokes of paint applied over the entire surface with very little build-up in "constructed" planes, the white of the support left exposed in many areas. There is also a naive simplicity to the composition, most apparent in the crescent of evenly spaced trees following the curve of the sandy road in the foreground or in the disarmingly obvious centrality of the gabled building with a red-tile roof two-thirds of the way up.

Fig. 1. Paul Gauguin,
Study for a Fan (after Cézanne), 1885,
gouache on canvas,
Ny Carlsberg Glyptothek, Copenhagen.

This is not to say that the work lacks complexity. The serpentine path of the road through the foreground, the trapezoidal shed acting as a fulcrum, the single black tree trunk on the left standing almost coyly against a patch of green, and the low peak of the red-tiled building that echoes the form of the mountain beyond all suggest that the work was pondered as deeply as any from this period. In this case, however, the pictorial elements are presented in a particularly spontaneous way determined in part by their unusual material. The support is a piece of commercially prepared paper that Cézanne pinned to a board, very much as he would do with large watercolor sheets; only later was it fixed to a stretched canvas.[7] This surface, smoother and less resistant to the movement of the brush than the primed canvases Cézanne normally used, seems to have encouraged a mode of handling remarkable for its dash and spontaneity; it proved especially apt for this lyrical sweep of radiant Provençal landscape.

The precise location has never been firmly established beyond the "Midi" mentioned in Gauguin's letter to Pissarro. Venturi speculated that it was perhaps near L'Estaque,[8] and many have accepted that identification. The strip of intense blue to the left of the central house, however, is rather puzzling. It resembles water, but the only body of water of any consequence in the arid region between the hills behind L'Estaque and the valley beyond Le Tholonet—the perimeter of Cézanne's working area in Provence—is the reservoir engineered by Émile Zola's father in the 1860s on the slope of Mont Sainte-Victoire. Perhaps the 1916 description is indeed correct.[9] If so, the work would be Cézanne's only depiction of the site, but, since everything else about this delightful work sets it somewhat apart, perhaps a provisional retention of the Montross Gallery title is justifiable.

J. R.

1. Fry, May 1921, p. 209.
2. Fry, May 27, 1922, p. 210.
3. Verdi, 1990, no. 34, p. 131.
4. Gauguin to Pissarro, [between July 25 and 29, 1883], in Gauguin, 1984, no. 38, pp. 50-51. See also Bodelsen, June 1968, p. 335.
5. See Bodelsen, May 1962, pp. 207-8.
6. Wright, February 1916, p. cxxx.
7. See Verdi, 1990, no. 34, p. 131; and Kendall, 1989, pp. 38-41.
8. See Venturi, 1936, vol. 1, no. 490, p. 170.
9. This notion was rejected by Rewald, who knew the region well.

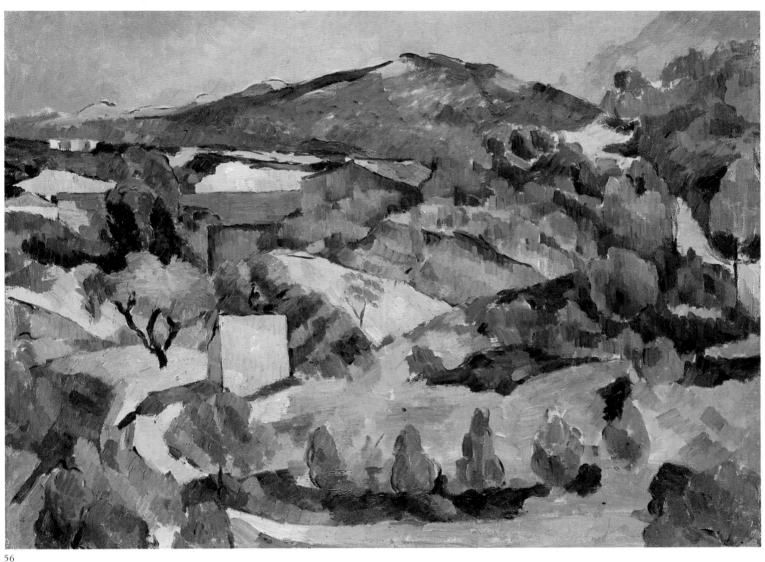

56

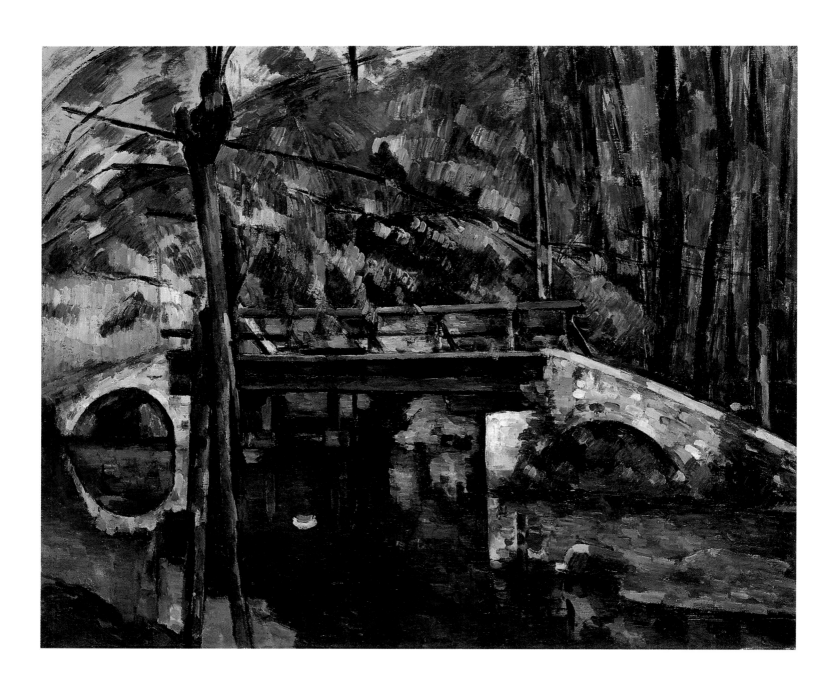

57 | *The Pont de Maincy*

1879-80
Oil on canvas; 23 × 28⁹/₁₆ inches (58.5 × 72.5 cm)
Musée d'Orsay, Paris (R.F. 1955-20)
V. 396

It is symptomatic of the difficulties endemic to the study of Cézanne's development that scholars have assigned this major painting dates spanning nearly twenty years. Venturi dated it to the early or mid-1880s; Rivière thought it must be as late as 1898.[4] The confusion that long prevailed with regard to the chronology of Cézanne's whereabouts did not help matters. In 1958, however, a photograph was published in *Les Lettres françaises* documenting the bridge, then still partly standing, which spanned the little river Almont at Maincy, near Melun.[5] As it happens, we know that Cézanne stayed in Melun from the spring of 1879 to the spring of 1880.

Perhaps it is not so surprising that an important painting from the middle of Cézanne's constructive phase should have been postdated in this way. As has often been remarked, in the years around 1880 Cézanne developed ways of looking and painting—especially in his landscapes—that he was to spend the rest of his life refining. The key to this breakthrough was a novel approach to facture, the way pigment was applied to canvas. In this new technique, pictorial space is constructed through repeated parallel brushstrokes that produce a patterned, woven effect. The effect produced is extremely sensuous and very subtle.

Sir Kenneth Clark has noted: "In such a picture as the *Wooden Bridge* [cat. no. 57] even the foliage is reduced to straight lines. But these straight lines, for example in the trunks of the trees, are frequently interrupted. It is as if Cézanne put them up as scaffolding, but then feared that they would arrest the movement of the picture and lead to too great insistence on contours. He recognised that an uninterrupted line implies a point of focus on the edge of the object and so makes impossible any movement in space forward or backward; and even in his first pencil notes he will always interrupt an outline and start it again a fraction further in or out."[6]

There are few Cézannes that so gently convey the particulars of a specific site—the way light moves through it, the way hovering dampness controls our sense of it. The ordered reflections on the water here are very different from the dancing strokes Monet used in rendering such scenes, but their building-block solidity does not preclude a strong sense of place.

J. R.

1. See Sterling, December 1955, p. 195.
2. See Rewald, forthcoming, no. 436.
3. See Paris, 1939 (a), no. 11.
4. See Venturi, 1936, vol. 1, no. 396, p. 151; and Rivière, 1923, p. 222.
5. See Lhander, September 25–October 1, 1958.
6. Clark, 1949, pp. 124-25.

| *Poplars*

1879-80
Oil on canvas; 25⁹/₁₆ × 31⁷/₈ inches (65 × 81 cm)
Musée d'Orsay, Paris (R.F. 2324)
V. 335

PROVENANCE
Ambroise Vollard sold this painting in early 1900 to the playwright Georges
Feydeau. It was auctioned at the Hôtel Drouot, Paris, on February 11,
1901 (lot 42). At an unknown date it came into the possession of Joseph
Reinach, Paris, who bequeathed it to the Louvre in 1921. It is now in the
Musée d'Orsay.

EXHIBITIONS
Before 1906: Paris, 1899, no. 13.
After 1906: Basel, 1936, no. 26; Paris, 1954, no. 42; The Hague, 1956,
no. 21; Vienna, 1961, no. 13; Aix-en-Provence, 1961, no. 5; Paris, 1974,
no. 26; Los Angeles and Chicago, 1984-85, no. 71; Paris, 1985, no. 37.

The sumptuous verdancy of this picture immediately brings to mind *The Pont de Maincy* (cat. no. 57), with which, happily, it has shared the same room for some years now. There is general consensus that these two works date from about the same time, a moment when Cézanne had just developed a structured mode of parallel brushstrokes that could result in pictures that are either tightly controlled (see cat. no. 69) or, as here and in *The Pont de Maincy*, remarkably open and exhilarating.

The site has been identified as a place "just outside the park of the Château des Marcouvilles in the hamlet of Les Patis,"[1] north of the Seine just beyond Pontoise, where Cézanne had been living on and off for almost ten years. He may have been drawn to this locale in part because his friend and mentor, Pissarro, had also painted there some five years earlier.[2] In any case, the configuration of the site would have reminded him of Pissarro; the S-curve of the path on the far left was one of the latter's favorite devices.

Even so, this canvas could not be mistaken for the work of Pissarro, whose gentle resolutions are here replaced by a tensile energy. The surface is covered with patches of parallel strokes applied in all directions over white priming that shows through nearly everywhere, adding a luminous glow to the restricted palette of blues, greens, and spare touches of yellow. The curving path following the edge of the trees to a wall—or perhaps a river—strikes a romantic note, as do the emphatically vertical tree trunks, one of which leans to the right, marking a picturesque hiatus in their stately processional rhythm. The tangle of bushes amid the poplars suggests that this was once a garden that had long since been left unkempt.

J. R.

1. Brettell, in Los Angeles and Chicago, 1984-85, no. 71, p. 194.
2. Ibid.

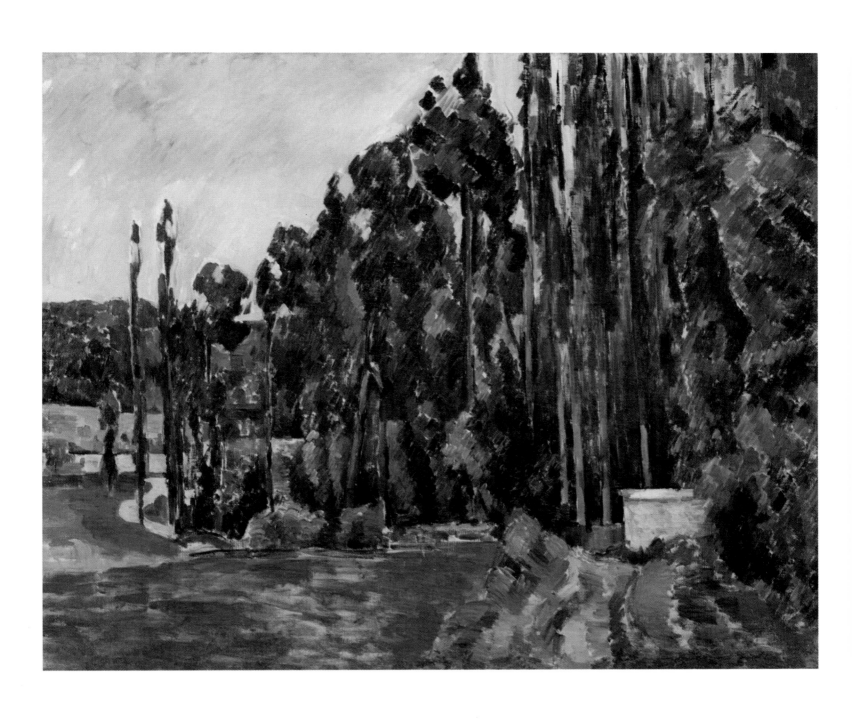

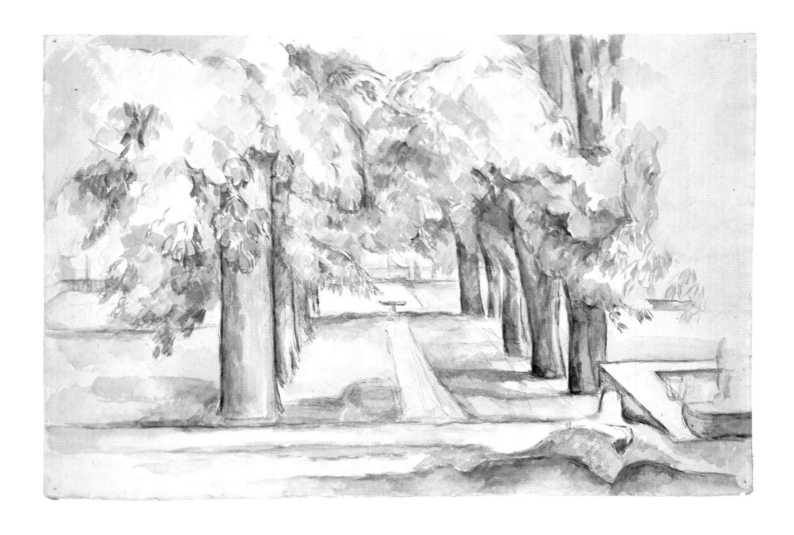

Pool and Allée of Chestnut Trees at the Jas de Bouffan

1878-80
Graphite and watercolor on white paper; $11^{13}/_{16} \times 18^{1}/_{2}$ inches (30 × 47 cm)
Städelsches Kunstinstitut, Frankfurt-am-Main. Kupferstichkabinett
R. 113

PROVENANCE
Originally in the collection of the artist's son, Paul, this watercolor passed through the collections of Maurice Renou, Paris, and Walter Feilchenfeldt, Zurich. It is now in the Städelsches Kunstinstitut, Frankfurt-am-Main.

EXHIBITIONS
After 1906: New York, 1933 (b), no. 11; Paris, 1935, unnumbered; Paris, 1936, no. 119; New York, 1937, no. 4; London, Leicester, and Sheffield, 1946, no. 11.

EXHIBITED IN PARIS AND PHILADELPHIA ONLY

Behind the Jas de Bouffan, there was—and happily still is—a long allée of chestnut trees thought to date back to the original owner of the property, the Marquis de Villars. The grounds and farmland around the Jas de Bouffan provided some of Cézanne's favorite landscape motifs in the 1870s and 1880s (see cat. nos. 24, 53, 97, and 113). This view, almost directly down the allée, is from the east terrace of the house. The end of the large ornamental pool is just visible on the right; the sculpture of a crouching lion at one of its corners is cropped by the edge of the paper.

Of this work, Georges Rivière poetically remarked: "The majesty of these centenarian chestnut trees, the noble lines of their trunks, the soft light that falls from their verdant canopy, everything capable of moving the viewer is noted by the painter with, simultaneously, such intensity and such discretion that one seeks to discover by what spell he was able to give such a powerful impression of reality."[1]

Theodore Reff used this watercolor as the principal illustration in a discussion of Cézanne's art theory, recalling a phrase first written by Cézanne in a letter to Émile Bernard in 1904: "treat nature by means of the cylinder, the sphere, the cone, with everything put in perspective so that each side of an object or a plane is directed toward a central point."[2] This phrase, so often invoked to link Cézanne with Cubism and later twentieth-century developments, seems to be perfectly confirmed here in Cézanne's actual practice. However, Cézanne followed up this rather simplistic and didactic piece of advice—in fact, taken from basic drawing manuals—with an observation that is both more personal and more profound: "Lines parallel to the horizon convey the extent of a section of nature, or if you prefer, of the spectacle that the *Pater Omnipotens Aeterne Deus* spreads out before our eyes. Lines perpendicular to this horizon convey depth. Now nature, for us men, is more depth than surface, hence the need to introduce into our vibrations of light, represented by reds and yellows, a sufficient amount of blue, to make the air palpable."[3] This understanding of how geometry and color can be brought together to show space in a fundamentally new way is the subject of Fritz Novotny's book on Cézanne and "the end of scientific perspective."[4] And it is what Lionello Venturi meant when he wrote of this seemingly modest watercolor: "It relies on a perspective different from the geometric one, which emphasizes the volume of objects in space instead of space containing volumes; and also on the chopping off of the trees at the top which further increases their magnitude."[5]

J. R.

1. Rivière, 1923, pp. 122-23.
2. Reff, October 1977 (a); the letter of April 15, 1904, can be found in Cézanne, 1978, p. 300.
3. Cézanne to Bernard, April 15, 1904, in Cézanne, 1978, p. 300.
4. Novotny, 1938.
5. Venturi, 1943, p. 37.

1879-82
Oil on canvas; 20$^{1}/_{2}$ × 21$^{5}/_{8}$ inches (52 × 55 cm)
Musée du Petit Palais de la Ville de Paris
V. 381

PROVENANCE
Henri Matisse acquired this painting from Ambroise Vollard for 1,200 francs in 1899; it remained in his collection until 1936, when he and his wife donated it to the Petit Palais.

EXHIBITIONS
Before 1906: Paris, 1904.
After 1906: Paris, 1910, no. 27; Paris, 1924, unnumbered; Aix-en-Provence, 1956, no. 18; Zurich, 1956, no. 42; Munich, 1956, no. 30; Cologne, 1956-57, no. 7; Tokyo, Kyoto, and Fukuoka, 1974, no. 13; Madrid, 1984, no. 22; Tokyo, Kobe, and Nagoya, 1986, no. 10; Basel, 1989, no. 35.

This remarkable picture has had to bear more critical weight than nearly any other Bather scene by Cézanne. Because it belonged to Matisse for more than three decades, it has been widely regarded as a major signpost in the history of twentieth-century art. Matisse wrote the following letter to the curator of the Musée de la Ville de Paris, Raymond Escholier, when he donated the work to the Petit Palais:

"Yesterday I entrusted the Cézanne *Bathers* to your shipper. I saw that the picture was carefully packed, and it should depart this very evening for the Petit Palais.

"Permit me to say that this picture is of the first importance in Cézanne's oeuvre, for it is the very dense and very complete realization of a composition much studied by him in several canvases which, although in important collections, are only the studies that led up to this work.

"I have owned it for thirty-seven years, I know this canvas rather well, although I hope not completely; it has provided me with moral support in critical moments in my adventure as an artist; I have drawn from it my faith and my perseverance. Permit me, on this basis, to request that you give it the place it demands so that it might give of itself in all its possibilities. For this it requires light and reviewing distance. Its color and handling are delectable, and from a certain distance it reveals the powerful élan of its lines and the exceptional sobriety of its relationships.

"I know it is not my place to *tell* you this, but I think nonetheless that it is incumbent upon me to do so; I ask that you accept *it* as the excusable testimony of my admiration *for* this work, which has not ceased to grow since I have owned it.

"Permit me to thank you for the care you will bestow upon it, for I consign it to you with complete confidence. . . . Henri Matisse"[1]

As many eminent Matisse scholars have noted,[2] the sentiments expressed here are by no means exaggerated. Echoes of this canvas are discernible in many works by Matisse, most obviously in his depictions of similar female figures in both painting and sculpture (he seems to have been especially enamored of the standing woman seen from behind with her hair falling straight down her back). And it was shortly after Matisse acquired the work from Vollard in 1899 that he began to work with explosions of "unnatural" color applied with rapid strokes.

Cézanne's paintings of the late 1870s and early 1880s have an oddly compressed quality, as if produced under controlled but formidable pressure. This is particularly evident in the small, square Bather subjects. Their handling retains much of the quickness and energy of his earlier treatments of the theme (see cat. no. 38), but the effect they produce is neither heroically elevated nor conventionally lyrical. They seem introspective and full of themselves in a very intense, charged way.

J. R.

1. Henri Matisse, "Un geste noble de Henri Matisse," *Beaux-Arts* (Brussels), May 28, 1937, p. 2.
2. See Alfred H. Barr, Jr., "Matisse, Picasso and the Crisis of 1907," *Magazine of Art*, vol. 44, no. 5 (May 1951), pp. 163-70; Barr, *Matisse, His Art and His Public* (New York, 1951), pp. 38-40; Jack Flam, *Matisse on Art* (London, 1973), pp. 24-25; and Flam, *Matisse: The Man and His Art 1869-1918* (London and Ithaca, New York, 1986), pp. 66-73.

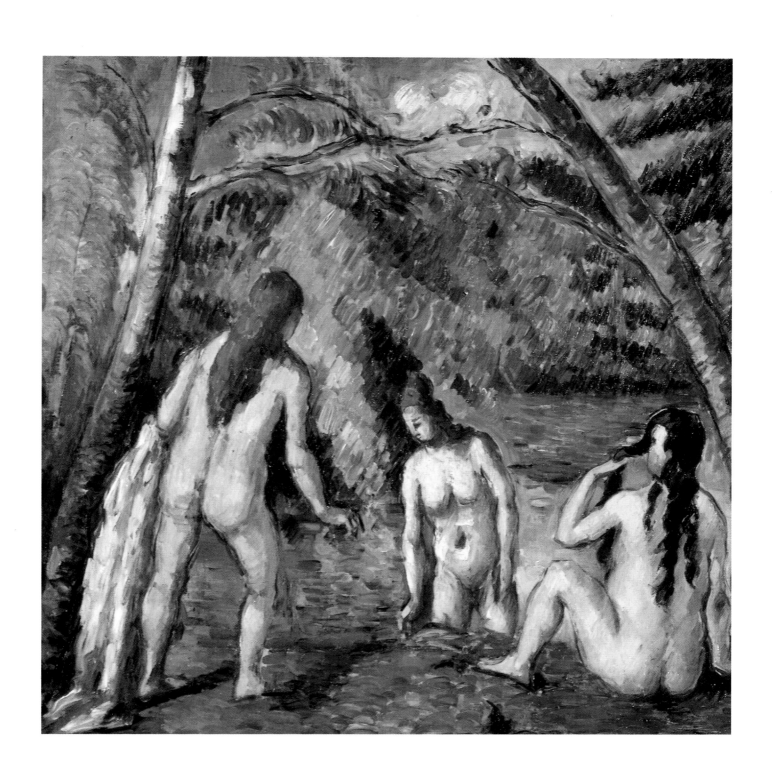

61 | *Four Bathers*

1879-82
Graphite and black chalk on paper; 8 × 8³/₄ inches (20.3 × 22.3 cm)
Museum Boymans–van Beuningen, Rotterdam
C. 514

PROVENANCE
This drawing originally belonged to Ambroise Vollard. It subsequently
passed through the collection of Harry Graf Kessler, Weimar, to the dealer
Paul Cassirer, Berlin. Franz Koenigs, a Haarlem-based banker who began
to collect drawings in 1921, acquired this drawing from Cassirer in 1930.[1]
In 1940 he sold his entire collection to D. G. van Beuningen, who donated
a portion of it to the Boymans Museum.

EXHIBITIONS
Before 1906: Paris, 1898, unnumbered.
After 1906: Rotterdam, 1933-34, no. 2; Basel, 1935, no. 177; Basel, 1936,
no. 125; Amsterdam, 1946, no. 11; The Hague, 1956, no. 112; Zurich,
1956, no. 171; Munich, 1956, no. 131; Hamburg, 1963, no. 26; Tübingen,
1978, no. 137; Basel, 1989, no. 118.

Ambroise Vollard used this drawing to illustrate the invita-
tion to his 1898 Cézanne exhibition, and again as the cover
illustration for the first edition of his book on Cézanne.[2] It
has been famous ever since—understandably, for it is
characterized by a combination of freedom and formal res-
olution not found elsewhere in the series of square compo-
sitions of female bathers dating from the late 1870s and
early 1880s.

In composition it is very close to a slightly larger canvas
now in the Barnes Foundation (fig. 1); however, this sheet
conveys a much more relaxed air. Even so, of some twenty
drawings that share the female Bather theme and the gen-
eral composition, it is in this one that Cézanne most closely
approximated his attempts in oil to resolve the lessons of
Impressionism, especially the depiction of light.[3] He
achieved this result through the vigor of his pencil strokes
and their judicious interplay with the white paper.

J. R.

Fig. 1. Paul Cézanne,
Four Bathers, 1879-82, oil on canvas,
The Barnes Foundation, Merion, Pennsylvania (V. 386).

1. Walter Feilchenfeldt (1894-1953) joined the Berlin firm of Paul Cas-
sirer in 1919. Following Cassirer's death in 1926, he became managing
director and co-owner of the firm, which played a major role in the
formation of Koenigs's drawings collection. Koenigs purchased many
Cézanne watercolors (cat. nos. 73, 119) and drawings (cat. nos. 79, 84,
87, 90, 98, 112) from him.
2. See Venturi, 1936, vol. 1, no. 1264, p. 303; and Vollard, 1914.
3. See Waldfogel, 1961, p. 153.

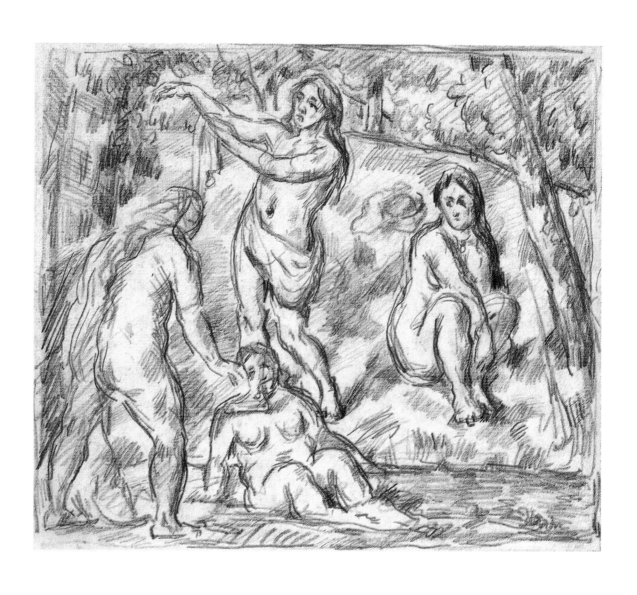

62 | *Five Bathers*

1885-87
Oil on canvas; $25^{13}/_{16} \times 25^{13}/_{16}$ inches
(65.5 × 65.5 cm)
Öffentliche Kunstsammlung Basel
V. 542

PROVENANCE
Egisto Fabbri acquired this painting from Ambroise Vollard. In 1928 it was in the possession of the dealer Paul Rosenberg, Paris. In 1936 Venturi listed it as being in the collection of Alphonse Kann, from whom it was re-acquired by Paul Rosenberg. The Kunstmuseum in Basel purchased it in 1960.

EXHIBITIONS
After 1906: Paris, 1910, no. 23; Venice, 1920, no. 24; Basel, 1936, no. 42; Paris, 1939 (a), no. 18; London, 1939 (a), no. 12; Basel, 1989, no. 49.

This painting is widely regarded as the culmination of the series of nearly square images of four or five female bathers that preoccupied Cézanne from the late 1870s through the mid-1880s.[1] In this, like the preceding works, several figures are positioned near a water source in a rudimentary landscape. But if one traces the evolution from the version owned by Henry Moore (cat. no. 38) to this one by way of the small canvas that belonged to Matisse (cat. no. 60), it becomes clear that a considerable distance has been covered in terms of both handling and spatial amplitude. This sequence of works provides a signal illustration of Cézanne's gradual distancing from Pissarro's example in favor of a new, more reasoned method of applying paint to canvas, rendering pictorial space, and placing figures within it. The work also differs from its predecessors in pointing to the powerful treatments of the Bather theme that were to come ten or fifteen years later.

Oblique parallel brushstrokes are still used rather systematically, and, as in most works in the series, the figures are pressed forward and held in place by the landscape. But these bathers have an easy amplitude, a full-blown grandeur, that distinguishes them from their earlier cousins. What's more, for the first time one senses the possibility of genuine communication between the figures. These developments suggest that Cézanne was trying to reintroduce narrative into his work. As Krumrine has noted, the most unmistakable evidence of this intent is provided by the pointing gestures of the nudes on each side of the composition. If what is at issue is a new type of pictorial language, we are here witnesses to its birth pangs, its most primitive articulations. But, in a peculiarly Cézannean way, the brusqueness of the forms only adds to their monumentality.[2]

63 | *Five Bathers*

1885-87
Graphite on paper; $5^{1}/_{4} \times 5^{1}/_{4}$ inches
(13.3 × 13.3 cm)
Collection of Drue Heinz
C. 517

PROVENANCE
This drawing belonged at an early date to Ambroise Vollard. It was subsequently acquired by Richard S. Davis, director of the Minneapolis Institute of Art. It then came into the possession of Eugene V. Thaw, New York. It is currently owned by Drue Heinz.

EXHIBITIONS
After 1906: Basel, 1989, no. 121.

Of this picture, Roger Fry wrote: "The composition is based on a regular pyramid placed in the centre of the canvas. . . . This, by the by, is one of his happiest efforts in such inventions. The aggressive symmetry is broken by the figure to the right, and the forms are disposed in happily varied and harmonious sequences, the quantities of the volumes are adjusted to the space and beautifully coordinated. If it is lacking of completeness as a pictorial design, it would at least make a remarkable sculptural relief. . . . There have been indeed very few artists who have created so many entirely original and rigidly compact compositions as Cézanne. He scarcely ever lapses into what is casual or accidental or fails to bring every part of the canvas into organic relation with the central theme."[3]

The extent of Cézanne's investment in this picture is suggested by the compositional drawing for it, which, unique among those that survive, has been carefully scored with a grid of horizontal and vertical lines to allow him to transfer the composition precisely onto the large canvas. Such careful preparation only confirms what is indicated by the painting itself—namely, that Cézanne gave the most careful consideration to its every aspect. The word *perfection* often appears in writings about the artist; he himself preferred to describe his work in terms of a perpetual striving for *réalisation*. It has never been altogether clear what that word meant for him, or what Cézannean perfection might be, but in the case of the Basel *Five Bathers*, we can be a little more certain.

J. R.

1. See Krumrine, May 1980, p. 123 n. 66; and Krumrine, 1989, p. 137.
2. See Krumrine, 1989, p. 137.
3. Fry, 1927, p. 85.

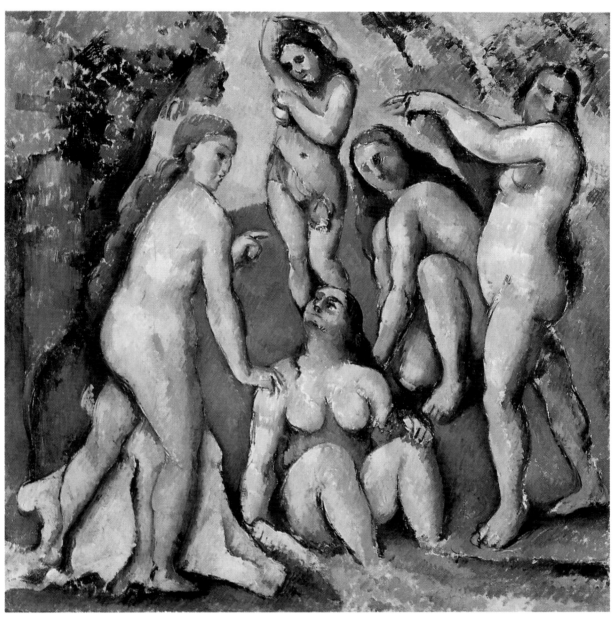

62

63

64 | *The Battle of Love, I*

c. 1880
Oil on canvas; 17⁵/₁₆ × 22 inches (44 × 56 cm)
Private collection
V. 379

PROVENANCE
This painting's first owner was Pissarro. In 1910 it was in the collection of the Galerie Bernheim-Jeune, Paris. It was subsequently acquired by Auguste Pellerin and is now in a private collection.

EXHIBITIONS
After 1906: Paris, 1936, no. 66; Paris, 1954, no. 37; Basel, 1989, no. 40.

65 | *The Battle of Love*

1875-76
Graphite, watercolor, and gouache on buff paper;
7¹/₂ × 9⁵/₈ inches (19 × 24.5 cm)
Private collection
R. 60

PROVENANCE
This watercolor was first in the collection of the writer Octave Mirbeau. It was sold at his estate sale at the Galerie Durand-Ruel, Paris, on February 24, 1919 (lot 12). Thereafter it passed through the collections of Jos Hessel, Paris, Gottlieb Friedrich Reber, Lausanne, and Walter Feilchenfeldt, Zurich. It is currently in a private collection.

EXHIBITIONS
After 1906: Berlin, 1927 (b), no. 1; Lyon, 1939, no. 41; Vienna, 1961, no. 46; Aix-en-Provence, 1961, no. 20; New York, 1963 (a), no. 2; Newcastle upon Tyne and London, 1973, no. 26; Tübingen and Zurich, 1982, no. 10; Basel, 1989, no. 79.

This painting exists in three quite similar versions: the present canvas (cat. no. 64), which belonged to Pissarro; another (fig. 1) that Cézanne may have given to Renoir; and a watercolor (cat. no. 65) that was formerly in the collection of the critic Octave Mirbeau.

The subject is Ovidian: a priapic bacchanal with couples sporting by the sea on a sun-drenched day.[1] In a general sense, Cézanne's composition can be said to be in the same tradition as Titian's *The Andrians* (fig. 2), but there is some question as to just how much play is afoot here and how much trouble. For Schapiro, the subject is "a theme out of Venetian art, perhaps by way of a Poussinist artist, but . . . conceived in another mood. The Renaissance bacchanals are scenes that combine love-play, drinking, and dancing; they are images of gayety and joyous release. Cézanne's painting is of a struggle, the violence of love, even rape. Four men attack four women; a leaping dog adds another note of animality. These are not pagan idyllic nudes from Greek mythology, but a modern fantasy like Cézanne's solemn picnic of clothed and nude figures. The multiplication of figures increases the violence, but also makes it more

Fig. 1. Paul Cézanne,
The Battle of Love, c. 1880,
oil on canvas,
National Gallery of Art, Washington, D.C.,
Gift of the W. Averell Harriman Foundation
in memory of Marie N. Harriman (V. 380).

natural, an action of all men and not a solitary crime."[2] This reading was endorsed by Krumrine, who saw these pictures as a continuation of the violent, sex-obsessed paintings of the 1860s, noting that it was "probably Cézanne's last scene of overt sexual aggression."[3]

The extension of the dark paintings of sexual encounter done by Cézanne in the 1860s supports the notion that the artist was deeply troubled by women and wished harm upon the opposite sex. This reading has gained currency since the 1960s. But one could also argue that this composition's playful tone aligns it closely with an iconographic tradition in which the battle of the sexes is construed more positively, one in which death and guilt cast no long shadows: namely, the many Renaissance and Baroque paintings that set out to celebrate love. Sadly, a work of signal importance in the transformation of Cézanne's erotic imagery at this time disappeared from the collection of Josse Bernheim-Jeune during World War II: *The Amorous Shepherd*, which figures prominently in Schapiro's influential essay of 1968 (fig. 3).[4] Judging from reproductions, it produced a stagy, sensual effect akin to that of *The Battle of Love*, and its benign atmosphere—linked by Schapiro to the Latin poet Propertius—suggests that the less fraught reading of *The Battle of Love* might be closer to the mark. As it happens, there are other works from the years around 1880 in which Cézanne recast classical themes in a lighthearted, slightly mocking way. It is, for example, difficult to be grave about the fate of the female nude in the Barnes Collection's *Leda and the Swan* (V. 550); in a related drawing (C. 483), Leda holds up a champagne flute, apparently toasting her unseen avian suitor. In the early 1870s, Cézanne parodied Manet's *Olympia* in much the same deflationary spirit (see cat. no. 27), revealing a light touch that would have been outside his expressive range ten years earlier.

In short, the works in this group have a theatricality that is closer to the Offenbach of *La Belle Hélène* than to Grand Guignol.

J. R.

Fig. 2. Titian,
The Andrians, c. 1525,
oil on canvas,
Museo del Prado, Madrid.

Fig. 3. Paul Cézanne,
The Amorous Shepherd, 1883-85,
oil on canvas, lost during World War II (V. 537).

1. See Krumrine, 1989, pp. 58-63.
2. Schapiro, 1952, p. 48.
3. Krumrine, 1989, p. 56.
4. See Schapiro, 1968, esp. pp. 35-39. This painting was known as *The Judgment of Paris* until Schapiro demonstrated convincingly that a more correct title would be *The Amorous Shepherd.*

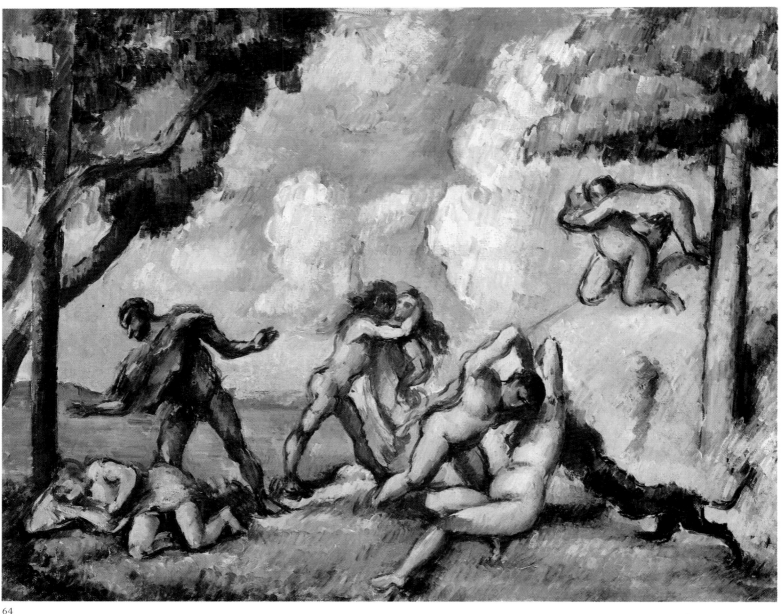

64

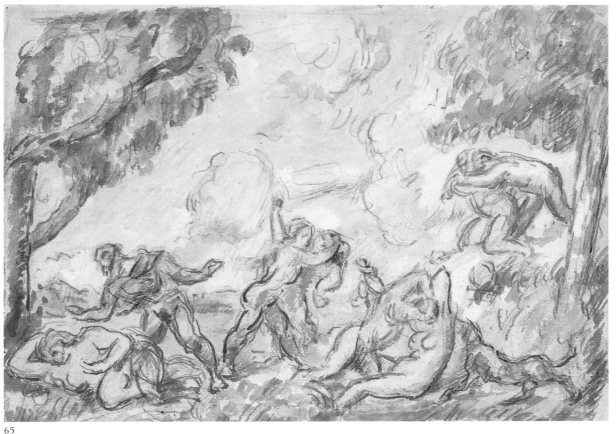

65

The 1880s

66 | *Self-Portrait*

1879-82
Oil on canvas; $25^5/_8 \times 20$ inches (65×51 cm)
Kunstmuseum Bern
V. 366

PROVENANCE
This painting stayed with the artist until his death. It was then owned jointly by Ambroise Vollard and Galerie Bernheim-Jeune. By 1917 it was in the possession of Alphonse Kann. It subsequently figured in the collections of Marcel Kapferer in Paris, Lord Ivor Spencer Churchill in London (by 1929), and the dealer Georges F. Keller in New York (by 1948), and shortly thereafter entered the Kunstmuseum Bern.

EXHIBITIONS
Before 1906: Paris, 1904, no. 5.
After 1906: Paris, 1936, no. 41; San Francisco, 1937, no. 12; Chicago and New York, 1952, no. 43; Edinburgh and London, 1954, no. 23; Zurich, 1956, no. 40; Munich, 1956, no. 28; Vienna, 1961, no. 14; Madrid, 1984, no. 23; Basel, 1989, no. 30.

EXHIBITED IN LONDON AND PHILADELPHIA ONLY

There are, all told, forty-six self-portraits by Cézanne, twenty-six in oil and twenty on paper—this from a man who seems never to have concerned himself with his physical being, dressing conservatively and modestly (at least from the mid-1870s) while resolutely avoiding any sign of vanity or interest in attentions to him. These disarmingly direct appraisals of himself—consistent in their neutrality, enlivened only by a general tone of brutality—are among the most perplexing works in his oeuvre. Some have argued that he turned to himself as a subject because of his shyness and discomfort with models. Yet the pictures are too unlike any of his other portraits—too consistent as a group and too regularly produced throughout his career— not to suggest that he was, with an objectivity unprecedented in this genre in the history of art, taking inventory.

The Bern self-portrait, particularly well known because of its distinguished provenance (Alphonse Kann, Lord Ivor Spencer Churchill) and its exhibition history, may be the most baffling of the lot. Dr. Albert Barnes, whose collection of sixty-six works by Cézanne did not include a self-portrait, regarded it as a signal failure: "This portrait offers evidence of Cézanne's lack of mastery of his medium, and of his partial reversion to devices of his immature form. The modeling, for instance, has advanced little beyond the tricky contrast of light and dark patches. . . . The figure, likewise, with its strongly highlighted and patterned face, is spatially set off by overaccentuated contrast from the background which is dull and almost uniform in color, without internal illumination; and an additional means of differentiation, the broad band of color with multiple parallel brushstrokes, is no less specious."[1] It is true that the abrupt angularity of the figure in black, placed against the right angles of the door and wall panel, makes for an exceedingly relentless and severe composition. The addition of the felt hat—from his father's first successful business venture in Aix?—and the sharply cropped beard result in an image that is positively rabbinical in the sternness with which the subject's gaze confronts the viewer. This can all be turned to the positive, however; if one is inclined to view the "regressive" handling that Barnes found "specious" as the result of Cézanne's authenticity to self, the Bern portrait can be seen as something of a watershed in the series.

Brion-Guerry understood the pictorial problems raised by the portrait quite clearly: "The expression of the eyes seems just as wary and uneasy as in the Munich self-portrait [V. 284], and the cheeks seem agitated by an irrepressible quiver suggested by the divisionism of the handling, which is fragmented into tiny dabs that vibrate like the tesserae of a mosaic. Despite this analytic excavation, the volumes do not break down. The despotic presence of a glazed door made of reddish wood functions, in effect, like a chemical catalyst that manages to hold together molecules about to fly apart."[2]

J. R.

1. Barnes and de Mazia, 1939, pp. 338-39.
2. Brion-Guerry, 1966, p. 84.

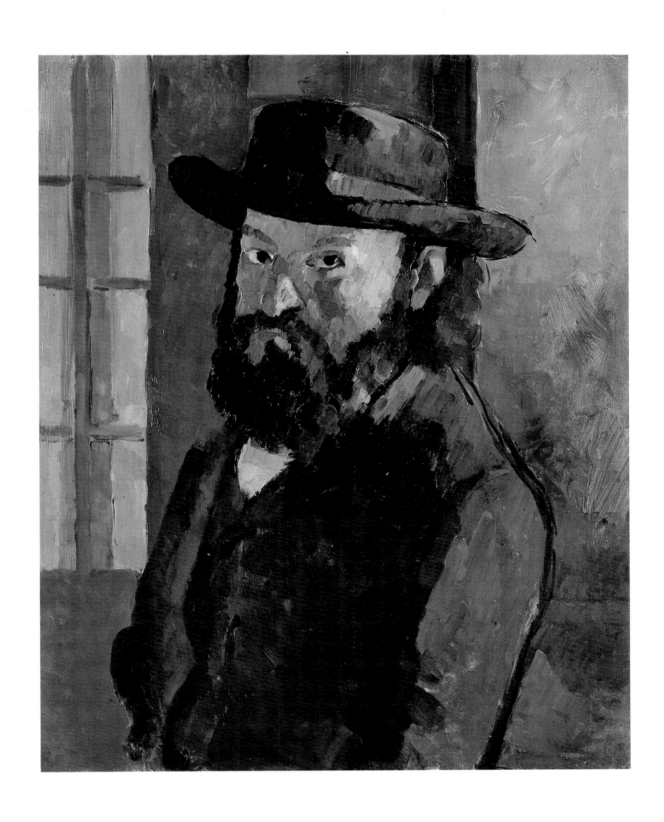

67 | *The Oise Valley*

c. 1880
Oil on canvas; 28³/₈ × 35¹³/₁₆ inches (72 × 91 cm)
Private collection
V. 311

PROVENANCE
In 1886 Paul Signac persuaded his mother Héloise to buy this painting from père Tanguy,[1] "who had the keys of Cézanne's Paris studio with instructions to sell the large pictures for a hundred francs and the small ones for forty."[2] It has remained in the family.

EXHIBITIONS
Before 1906: Paris, 1902, no. 323.
After 1906: Paris, 1910, no. 39; Paris, 1920 (b), no. 27; Paris, 1939 (b), no. 10.

At several points in his career, Cézanne set himself the tricky problem of depicting nature through a screen of trees (see cat. no. 113); he was probably introduced to the device by Pissarro when the two artists were working closely together in Pontoise in the mid-1870s. By the end of that decade, however, Cézanne began to set higher stakes for himself, developing a mode of handling—more systematic than the Impressionist *tache*—dominated by short, parallel brushstrokes. The resulting facture, suggestive of woven rugs or tapestries, draws attention to the surface in a way that runs counter to the illusionistic landscape tradition of the previous three centuries. When Cézanne used such handling to render a composition with a foreground screen of objects, as here, he was furthering an experimental project that was to preoccupy him for the rest of his life, and change the very nature of painting: the development of what is now generally termed his constructive style, which entered a new phase in the years around 1880.

The dilemma, or rather the delight, is that such a critical moment in history—which has occasioned more than its fair share of ponderous analyses—saw the production of straightforwardly lyrical pictures such as this view, which seems completely natural, down a hill and across a rural valley. Virtually all the brushstrokes align vertically, but this has in no way diminished their power to describe clouds, farm buildings, grasses, or young saplings. A new pictorial tension is apparent, produced by the competing claims of spatial recession and surface patterning, but the animated brushstrokes carry such conviction that, paradoxically, the viewer is convinced of the picture's fidelity to the motif. Everything—with a sense of brushes and colors constantly maneuvering, each gesture fulfilling several purposes—seems in constant play, and the result, however fraught with implications for the history of art, comes across as completely fresh and unpretentious.

This canvas was among the first pictures by the artist to be sold. In 1886 Paul Signac returned from père Tanguy's shop with three Cézanne landscapes to show to his mother. She opted to buy only one of them; it sustained him throughout his artistic life, much as the *Three Bathers* (cat. no. 60) nourished its owner, Henri Matisse.

J. R.

1. Françoise Cachin, *Paul Signac* (Greenwich, Connecticut, 1971), p. 15.
2. R. H. Wilenski, *Modern French Painters* (New York, 1939), p. 87.

68

1878-80
Graphite, gouache, and watercolor on paper; $12^3/_4 \times 19^{11}/_{16}$ inches (32.4 × 50 cm)
The Metropolitan Museum of Art, New York. Bequest of Mary Cushing Fosburgh, 1978
R. 88

PROVENANCE
This watercolor was owned by H. von Simolin, Berlin, from whom it passed to Paul Cassirer, Amsterdam, and the Knoedler Galleries, New York. Mrs. Vincent Astor, who married James Fosburgh of New York, bequeathed it to the Metropolitan Museum of Art in 1978.

EXHIBITIONS
After 1906: London, Leicester, and Sheffield, 1946, no. 53; New York, 1963 (a), no. 13.

A comparison between this watercolor and the related painting (cat. no. 67) reveals much about Cézanne's attempt, in the years around 1880, to move beyond Impressionist technique toward a more overtly structured one that was still capable of conveying a sense of place. Both works represent the Oise valley seen through a screen of young saplings in early spring, before they were in full leaf. Even the relationship of the tree that closes the view on the left and the slope of land to the right is maintained. If anything, the opening to the sky through the trees and beyond the end of the valley seems even more expansive in the watercolor than the oil.

The watercolor seems much less labored and constructed than the painting. This is largely a function of the difference of medium. Watercolor dries quickly on the page, and the white of the paper provides a constant brightness throughout. As Martha Schrader observed, this sheet "retains to a greater degree the freshness and spontaneity of a first impression"[1] than does the canvas. But even so, there is, in the watercolor, a great deliberation in the placement of the green and blue strokes, which sit densely and independently on the sheet and hold their own with the opaque gouache used for the clouds in the sky. One experiences the same sense of the watercolor as the painting: the artist looking very hard at his subject and considering with intense care every move he makes.

J. R.

1. Schrader, in New York, 1963 (a), no. 13, p. 28.

The Château de Médan

c. 1880
Oil on canvas; $23^1/_4 \times 28^1/_2$ inches (59 × 72 cm)
Glasgow Museums. The Burrell Collection.
V. 325

PROVENANCE
This painting was deposited by the artist in the shop of père Tanguy. By 1885 it was owned by Paul Gauguin. Around 1893 it passed into the collection of Edvard Brandès, a prominent Copenhagen writer and politician who acquired several works from Gauguin's collection through the artist's wife. Before 1930 Brandès sold the painting through Dr. Alfred Gold, a dealer in Berlin.[1] It was subsequently owned by D. Pagenstecher, Wiesbaden, and then by Tietze, Cologne and Amsterdam. It then passed to Étienne Bignou and Reid and Lefevre, London, who sold it to Sir William Burrell, Glasgow. In 1944 Burrell bequeathed his collection to the Glasgow City Art Gallery.

EXHIBITIONS
Before 1906: Copenhagen, 1889.
After 1906: New York, 1936, no. 12; London, 1937, no. 12; Edinburgh and London, 1954, no. 22; Edinburgh, 1990, no. 29.

EXHIBITED IN LONDON ONLY

1879-81
Graphite, watercolor, and gouache on paper; $12^5/_{16} \times 18^9/_{16}$ inches (31.3×47.2 cm)
Kunsthaus Zurich
R. 89

PROVENANCE
This watercolor originally belonged to Jules Straus, Paris. It entered the private collection of Paul Cassirer, Berlin, and passed on his death to his daughter Suse Paret-Cassirer, Berlin. In 1935 she consigned a group of watercolors,[2] including this one, to the firm of Paul Cassirer, Amsterdam, who sold it in the same year to the Kunsthaus in Zurich.

EXHIBITIONS
After 1906: Lyon, 1939, no. 44; The Hague, 1956, no. 57; Zurich, 1956, no. 94; Munich, 1956, no. 71; Vienna, 1961, no. 49; Newcastle upon Tyne and London, 1973, no. 37; Tübingen and Zurich, 1982, no. 20; Edinburgh, 1990, no. 31.

EXHIBITED IN PARIS ONLY

In 1878 Émile Zola used the earnings from his early successes as a novelist to buy a house on the banks of the Seine northwest of Paris, in the town of Médan. He asked his childhood friend Cézanne to visit him there, which the artist first did in June 1879, apparently for a short time only. The following year, when Cézanne was living in Paris, he wanted to come for a longer stay, writing Zola on June 19: "I can't say for sure whether there will be really hot weather, but as soon as I won't be a bother, write to me, I'll gladly come to Médan. And if you're not alarmed by the long time I might stay there, I'll permit myself to bring along a small canvas and do up a motif there, if you don't see any inconvenience in this."[3] Zola, who was becoming a very busy literary figure, was slow to reply. Cézanne wrote again, on July 4: "On June 19th last I answered the letter you wrote me on the 16th. I asked if I could come to visit you there, to paint, it's true.—But it goes without saying that I don't want to be any trouble. I still haven't heard from you, and since it's been about two weeks now, I take the liberty of asking you for a few words to let me know what's happening. If you want me to come wish you good day, I will come; if you tell me otherwise then I won't come yet."[4] Matters were finally settled, and it was on August 22 that Zola wrote to Guillemet from Médan: "Paul is still with me. He's working hard, and he's still counting on you to do your share" (referring to Cézanne's admission to the Salon).[5] Cézanne made visits to Médan again later, but nearly everyone who has deliberated over the picture's date has endorsed Rewald's conclusion that the little canvas Cézanne proposed in his first letter is probably this one.

The tone of these letters implies the increasing delicacy of the relations between the two men. One year apart in age, they had been passionate friends as youths, dreaming of eventual success in Paris, success that Zola was rapidly achieving. Cézanne, gaining only marginal recognition despite his vigorous efforts through official channels as well as not-so-official ones, came to embody for Zola a type of failed artistic genius, tormented by ideas he was incapable of realizing on canvas. Borrowing directly from Balzac's *Chef-d'oeuvre inconnu*, Zola portrayed such a figure in Claude Lantier, the protagonist of his 1886 novel *L'Oeuvre*. Whether Cézanne took that fictitious painter to be a por-

trait of himself, and to what extent he thought the novel revealed Zola's actual views of him, remains unclear. By this time Cézanne had probably sensed Zola's limited grasp of the visual arts (and his literary bias), and in particular of his own attempts to invent a new kind of painting. It is also possible by then—and perhaps starting with the awkward, twice-proposed, self-invitation to Médan in 1880—that Cézanne had realized his friend's worldly ambitions were prompting him to distance himself from his provincial roots. Whatever the psychological undertones in this complicated and tragic friendship, Cézanne did visit Zola on this occasion, borrowing his skiff called *Nana*—Zola had sent him a copy of the novel the previous year—and setting up his easel on the little island in the Seine called Platias, which afforded him a view of the village.

These circumstances would have suited Cézanne perfectly. He always preferred to work in isolation, and this vantage allowed him to examine the town nestling in the trees at complete leisure, without human interruption. Two drawings (figs. 1 and 2), a watercolor (cat. no. 70), and an exceptionally studied and resolved canvas (cat. no. 69) testify to the concentration he brought to his subject on those summer days. Many regard this painting as the landscape masterpiece of his middle years, a picture of rare perfection.

Zola's house and garden are actually out of sight, beyond the Château de Médan, whose slate roof and yellow walls appear on the right. As so often in later works, Cézanne positioned himself so that nearly all the architectural elements are seen head-on, visually in plane with the hill and the riverbank.[6] To accentuate the rigor of this carefully aligned composition, he applied color with great regularity: horizontal strokes for the band of water at the bottom, diagonal strokes for the bank of the river, vertical strokes for the buildings themselves, and diagonal ones again—in the same direction as the bank—for the sky. The patiently wrought pictorial organization is a tour de force of Cézanne's constructive style. In contrast to other landscapes from this remarkable moment in his career, such as *The Pont de Maincy* (cat. no. 57) or the *Poplars* (cat. no. 58), here the artist distanced himself from the motif and subjected it to almost formulaic logic, an operation that, in lesser hands, would have led to dryness and sche-

matism. As Seurat was to do some five years later, Cézanne developed a technique that liberated him from Impressionism. It allowed him to render landscape with remarkable sensuality and specificity, but, unlike the ambitious plein-air paintings of his contemporaries, it transmuted the transient into something classical, structured, and serene, in keeping with his desire to transform Impressionism into "something solid and durable like the art of the museums."[7]

It may have been this sense of freedom through discipline that attracted Gauguin, who owned this picture as well as the equally famous still life incorporated by Maurice Denis into his painting *Homage to Cézanne* (repro. pp. 22-23). Gauguin had left both paintings in Copenhagen when he went to Paris. Fearful that his wife might sell them, he wrote to her: "I am concerned about my two Cézannes. They are rare in this genre, for he's made few that are finished and one day they'll be very valuable."[8]

Only rarely do Cézanne's more finished watercolors directly parallel his oils. The exhibited sheet (cat. no. 70) is clearly related to the Glasgow painting and is often cited as a preparatory study, but there are fundamental differences between the two works. The motif is much the same, but the château and its two adjoining towers, more clearly visible through the trees, have been shifted to the left, presumably to permit a glimpse of Zola's house rising above the high wall on the right. The broad horizontal format accommodates an ampler development of the compelling sidelong rhythm of the buildings and trees along the riverbank. The hill rising behind them, by contrast, receives less emphasis here than in the oil, where its saturated green merges with the foliage of the tree to push the whole composition forward, heightening the effect of containment generated by the tighter framing and constructive handling. There are extensive preliminary pencil marks on the sheet, indicating that Cézanne considered the placement of its various elements with great care, but the watercolor is washed on in a way that has all the freshness of vision and sense of transience so linked with Impressionism, the very style Cézanne was seeking to supersede in oil painting.

J. R.

1. Bodelsen, May 1962, p. 208; and Bodelsen, September 1970, p. 606.
2. The group of watercolors also included cat. nos. 80, 156, and 223.
3. Cézanne, 1978, p. 193.
4. Ibid., pp. 193-94.
5. Ibid., p. 194 n. 7; and Zola, 1978-, vol. 4, no. 15, p. 94.
6. John Rewald's photograph of the site in the 1930s shows the riverbank parallel to the buildings much as it appears in Cézanne's painting. See Rewald, 1936, fig. 44.
7. Cézanne, cited in Denis, 1912, p. 242.
8. Gauguin to his wife, [first half of December 1885], in Gauguin, 1984, no. 90, p. 118.

Fig. 1. Paul Cézanne, *Landscape in Médan*, 1879-80, graphite on paper, location unknown (C. 786).

Fig. 2. Paul Cézanne, *Landscape in Médan*, 1879-80, graphite on paper, Öffentliche Kunstsammlung Basel, Kupferstichkabinett (C. 787).

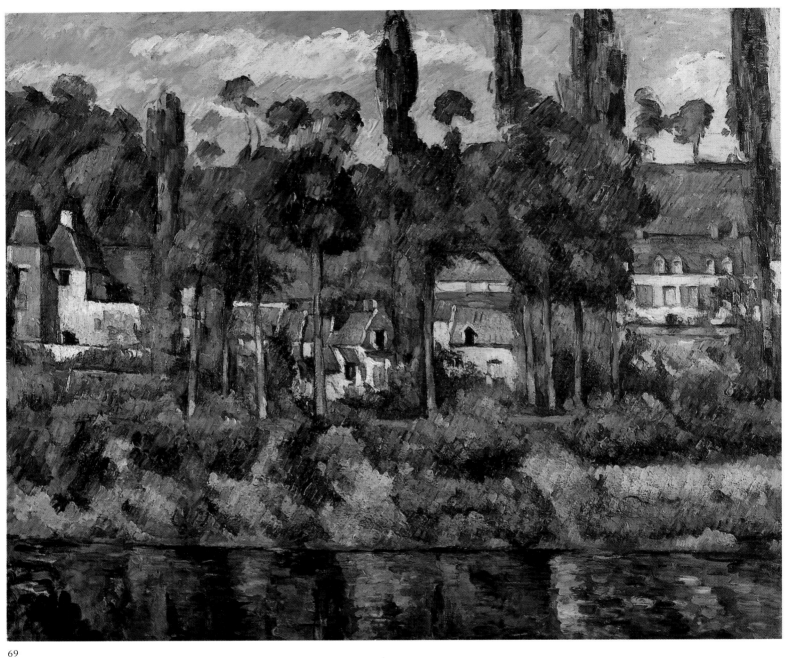

69

70

Houses in Provence–The Riaux Valley Near L'Estaque

1879-82
Oil on canvas; 25⁵/₈ × 32 inches (65 × 81.3 cm)
National Gallery of Art, Washington, D.C. Collection of Mr. and Mrs. Paul Mellon (1973.68.1)
V. 397

PROVENANCE
Egisto Fabbri probably purchased this canvas from Ambroise Vollard, although no record of the sale survives. Paul Rosenberg and the Wildenstein Galleries acquired it jointly from Fabbri in 1928-29. It was subsequently purchased by Virginia Harrison, the wife of Marius de Zayas. On October 14, 1965, Mrs. Harrison sold it at Parke-Bernet, New York (lot 92),[1] where it was purchased by Mr. and Mrs. Paul Mellon, Upperville, Virginia, for the record price of $800,000. In 1973 it was given by them to the National Gallery of Art, Washington, D.C.[2]

EXHIBITIONS
After 1906: Paris, 1910, no. 17; Venice, 1920, no. 11; Basel, 1921, no. 13 (?); Chicago and New York, 1952, no. 55; Washington, 1986, unnumbered; Edinburgh, 1990, no. 33.

It was only in 1990 that John Rewald and Lawrence Gowing identified and published the precise location of this site: a house in the Riaux valley behind L'Estaque. In Cézanne's time the house was identified as the birthplace of the seventeenth-century sculptor Pierre Puget, whom Cézanne revered as an early artistic hero of the Midi; indeed, Cézanne reported that when he felt homesick he went to the Puget galleries in the Louvre, where he could almost feel the mistral.[3] To what extent this association dictated Cézanne's choice of the isolated locale is far from known; in any case, the motif occasioned one of his most provocatively bold and forward-looking paintings.

In the 1920s, when the paintings of Cézanne's constructive style were the subject of intense critical interest, this work was held up as evidence of the Cubist's debt to the artist. Roger Fry gave it one of his most eloquent appraisals: "We may describe the process by which such a picture is arrived at in some such way as this:—the actual objects presented to the artist's vision are first deprived of all those specific characters by which we ordinarily apprehend their concrete existence—they are reduced to pure elements of space and volume. In this abstract world these elements are perfectly co-ordinated and organized by the artist's sensual intelligence, they attain logical consistency. These abstractions are then brought back into the concrete world of real things, not by giving them back their specific peculiarities, but by expressing them in an incessantly varying and shifting texture. They retain their abstract intelligibility, their amenity to the human mind, and regain that reality of actual things which is absent from all abstractions."[4]

The picture has been admired ever since: "*Houses in Provence—The Riaux Valley Near L'Estaque* perfectly exemplifies the results obtained by Cézanne with his technique of tight strokes applied diagonally on the canvas, which produce color rhythms that simultaneously express the light, space, and volume of the landscape. Only the houses are not handled in this way, ensuring the monumentality of these modest structures. To provide more room on their geometric surfaces for the play of varied nuances, Cézanne reduced the scale of their doors and windows. The houses in his pictures generally have few openings, maximizing the surface available for tinted reflections of light and giving them an emphatic density. The rooflines of the houses do not have a common vanishing point. As in so many still lifes, the artist here juxtaposes different points of view, blending imaginary space with natural space in a way that creates an impression of volumetric complexity, rendering the buildings larger and more interesting than [they are] in nature. He thus confers upon them a dramatic dynamism that is an expressive conquest for painting and preserves their geometrization, urging it toward abstraction. Not without a gentle irony, Cézanne commented on this refined skill to É[mile] Bernard as follows: 'I confess to you that I'm afraid of too much science and prefer naïveté to it.' Rarely has there been a 'naïveté' more calculating or a 'primitive' sensibility—'I am the primitive of a new art,' he said—more intelligent. The colors, too, are knowingly chosen; the dominant scale of harsh greens and pink ochres honoring [restituant] what Van Gogh, commenting on Cézanne's art to his brother in 1888, called 'the harsh side of Provence.'"[5]

Other critics, while acknowledging these singular formal qualities, have seen the picture as something of a rarity in Cézanne's work, one of the very few occasions in which he allowed shadows—and, at that, the blue-toned ones so dear to the Impressionists—to manipulate the spatial relationship of objects. They are used here in combination with chiseled brushstrokes, and the result is one of the artist's most unrelentingly monumental landscapes.

J. R.

1. See Rewald, 1986 (c), pp. 308-10, for detailed information on the picture's provenance.
2. See Washington, 1986, n.p.
3. See Gowing and Rewald, September 1990, pp. 638-39.
4. Fry, 1927, pp. 58-59.
5. Arrouye, 1982, pp. 84-85.

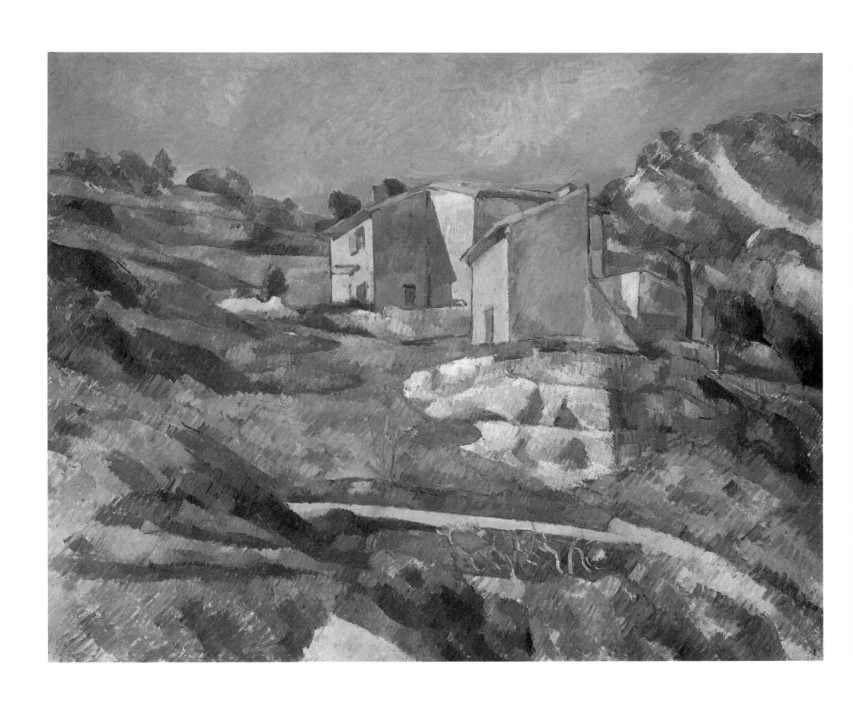

The Sea at L'Estaque

1878-79
Oil on canvas; 28³/₄ × 36¹/₄ inches (73 × 92 cm)
Musée Picasso, Paris
V. 425

PROVENANCE
This painting was originally owned by Paul Cézanne *fils*, Paris. From him it passed through the Galerie E. Bignou, New York and Paris, to Pablo Picasso, who acquired it in the 1940s (it is one of four Cézannes that he owned).

EXHIBITIONS
After 1906: New York, 1936, no. 13; London, 1937, no. 14; Lyon, 1939, no. 29; Paris, 1939 (b), no. 11; Edinburgh, 1990, no. 36; Tübingen, 1993, no. 23; Marseille, 1994, no. 11.

Much has been made—usually with some justification—of Cézanne's implicit move toward abstraction, or at least toward geometric construction and experimentation with degrees of flatness, beginning in the late 1870s and early 1880s. This development is often linked to a famous letter he wrote to Pissarro from L'Estaque on July 2, 1876: "I fancy the country where I am would suit you marvelously well. . . . It's like a playing card. Red roofs against the blue sea. . . . It's olive trees and pines, which always keep their leaves. The sun here is so frightful that it seems to me the objects are silhouetted not only in white or black, but in blue, red, brown, violet. I could be wrong, but it seems to me that this is the opposite of modeling."[1]

Of the twenty-some surviving canvases of the village just northwest of Marseille on the bay of L'Estaque, none corresponds more closely with this description than the present canvas showing L'Estaque from about halfway up the hill above the train station. It has been variously dated, from the late 1870s[2] up to 1883-86.[3] Cézanne apparently set up his easel on a ledge—a path, a road (or a formal device of his own invention)—that stretches like a band across the foreground. Two smaller paintings (V. 426 and fig. 1) were painted from nearly the same vantage point overlooking the tile works with its smokestack and an ad-

joining cluster of buildings ascending to the right, almost toylike in their schematic geometry. In the painting now in a private collection (fig. 1), Cézanne used a similar screen of two intertwining trees to enframe the plunging vista into the town and toward the expanse of sea beyond. The presence of the proscenium-like ledge—almost entirely absent in the other, smaller, swiftly executed view (fig. 1)—mitigates the decorative effect of these branches, which twist through the foreground of this picture with a robust three-dimensionality.

The surface is evenly worked with quick, short strokes. Constructive parallelism is present only in select passages, such as the tufts of greenery. Contrasting colors are played off one another, literally stroke by stroke, but the overall effect is muted and unified, with no single hue or geometric element visually dominating. Like the playing card mentioned in the 1876 letter, this painting is a pattern of bright color patches woven into a loose but solid network, with little distinction made between the various landscape elements. One of the most beguiling passages within this gently billowing interplay of forms and colors occurs in the upper left, where the horizon line, crisply delineated on the right, is so obscured by limbs that we can only guess where the sea ends and the sky begins.

It is remarkable, even in Cézanne's work from this period, to find a surface in which all the elements so constantly reaffirm their harmonious interaction. Nothing is forced or overly declarative. The space is ample but contained. The contrast between the sensual tree limbs and the geometric architecture is grounded in a spirit of play that prevents pomposity.

J. R.

1. Cézanne, 1978, p. 152.
2. See Rewald, forthcoming, no. 395.
3. See Venturi, 1936, vol. 1, no. 425, p. 156.

Fig. 1. Paul Cézanne,
L'Estaque Seen Through Trees, 1878-79,
oil on canvas,
private collection, New York (V. 427).

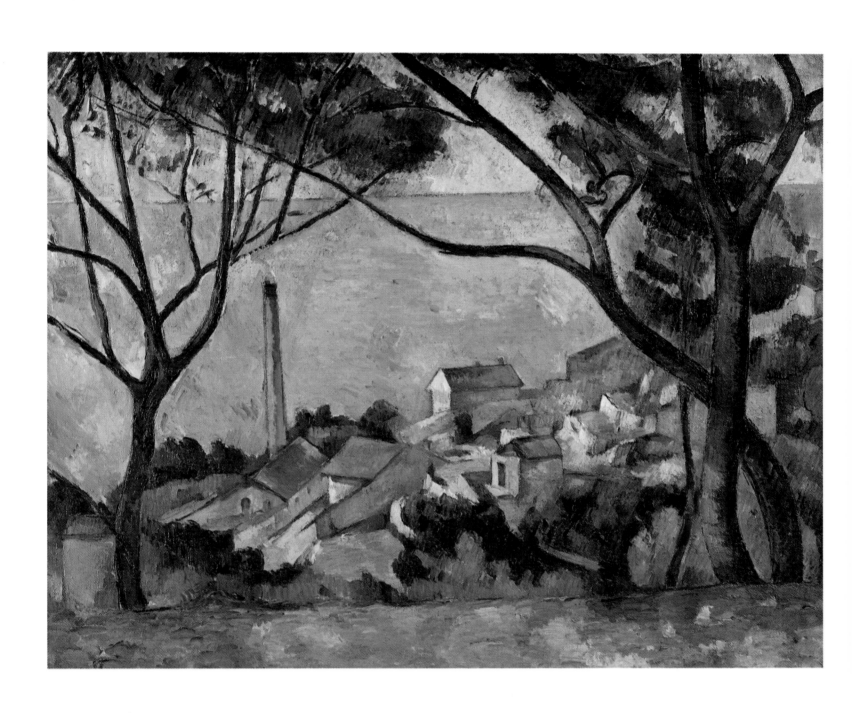

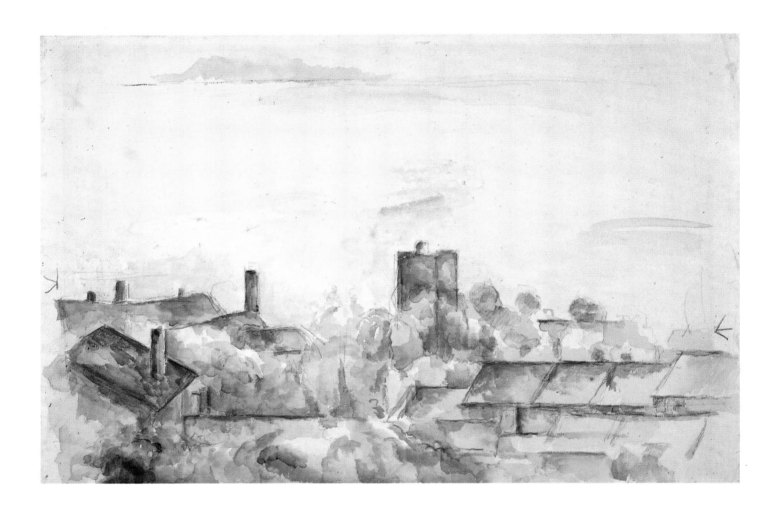

73 | *Roofs in L'Estaque*

1878-82
Graphite and watercolor on slightly yellowed paper; 12³/₁₆ × 18¹¹/₁₆ inches (31 × 47.5 cm)
Museum Boymans–van Beuningen, Rotterdam
R. 116

PROVENANCE
This drawing may have belonged to Charles Vignier, Paris. It subsequently passed to J. W. Böhler, Lucerne, and then to Paul Cassirer, Amsterdam. It was purchased from Cassirer by Franz Koenigs, Haarlem. In 1940 Koenigs sold his entire collection to D. G. van Beuningen, who donated a portion of it to the Museum Boymans.

EXHIBITIONS
After 1906: Rotterdam, 1933-34, no. 13; Basel, 1935, no. 177; Basel, 1936, no. 69; London, Leicester, and Sheffield, 1946, no. 10; The Hague, 1956, no. 61; Zurich, 1956, no. 98; New York, 1963 (a), no. 15; Washington, Chicago, and Boston, 1971, no. 39; Tübingen and Zurich, 1982, no. 22.

EXHIBITED IN PARIS AND PHILADELPHIA ONLY

This delicate and beautifully keyed watercolor shows a view over the rooftops of L'Estaque and across the bay to the range of mountains that extends south of Marseille. The prominent square tower (the Tour Sommati?), the cluster of closely interlocking gables, and the distinctive arrangement of stubby smokestacks appear in an almost identical configuration in the right foreground of the more panoramic painting of L'Estaque in the Metropolitan Museum of Art (fig. 1). Two other paintings (V. 405 and V. 493) as well as three sketchbook drawings (C. 814–16) seem to have been done from approximately the same spot.

Despite its close relationship to similar works in other mediums, it seems unlikely that this watercolor was undertaken as a preparatory study for a painting. Its delicate chromatics and translucent crystalline configurations set it very much apart from the New York picture, which is washed by a harsher light and seems altogether more robust. The top two-thirds of the sheet is toned with a thin blue wash, over which the mountains float like a mirage. The effect is vivid and fresh, convincing us that this is a faithful record of a particular place as it appeared at a particular moment in time. Such spontaneous response to a specific time and place is rarely credited to Cézanne; this occurs mostly in the watercolors, but always in a formal resolution beyond momentary observation.

J. R.

Fig. 1. Paul Cézanne,
The Gulf of Marseille Seen from L'Estaque, 1884,
oil on canvas,
The Metropolitan Museum of Art, New York,
H. O. Havemeyer Collection, bequest of
Mrs. H. O. Havemeyer, 1929 (V. 429).

74 | *Cottages*

1880-85
Graphite, watercolor, and gouache on brownish paper; 12⁷/₈ × 19⁵/₈ inches (32.7 × 49.9 cm)
Smith College Museum of Art, Northampton, Massachusetts
R. 159

PROVENANCE
This watercolor was in the possession of the artist's son, Paul, in Paris. It
then passed through the Valentine (Dudensing) Gallery, New York, where
it was purchased from the 1937 exhibition of the artist's work by Charles
C. Cunningham, then on the staff of the Museum of Fine Arts, Boston.
Subsequently director of the Wadsworth Athenaeum, Hartford, and the
Art Institute of Chicago, he gave it in 1980 to the Smith College Museum
of Art in honor of his first wife, Eleanor Lamont Cunningham, a Smith
alumna.

EXHIBITIONS
After 1906: Paris, 1907 (a), no. 2; Paris, 1936, no. 121; New York, 1937,
no. 9; San Francisco, 1937, no. 39; Chicago and New York, 1952, no. 32;
New York, 1963 (a), no. 12; Tübingen and Zurich, 1982, no. 21.

EXHIBITED IN PHILADELPHIA ONLY

Cézanne was rarely drawn to subjects so resolutely geo-
metrical as this cluster of small houses. An oil sketch of the
rooftops of Paris (fig. 1), the upright views of the hill town
of Gardanne (V. 432), the church of Saint-Pierre in Avon
(cat. no. 148)—one could almost count on one hand the
works in which he concentrated on a motif so thoroughly
man-made, so unrelieved by natural forms, so devoid of
curves.

Rewald, who pursued Cézanne's motifs with dogged
determination, did not hazard so much as a guess about
the location of this one. These tightly clustered structures
could have been situated in Auvers, Pontoise, or anywhere
Cézanne worked around Paris. On the other hand, the
projecting eaves of the central house, the red—possibly
tile—roofs, and especially the deep, cast shadows suggest
the architecture and light of the Midi.

The watercolor washes consistently follow the pencil
drawing, the linear pattern having been established before
color was added. This is rare in Cézanne's work, in which
color and line are usually in constant interplay.

J. R.

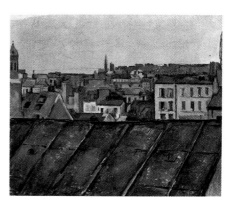

Fig. 1. Paul Cézanne,
Paris Rooftops, c. 1882,
oil on canvas,
private collection (V. 175).

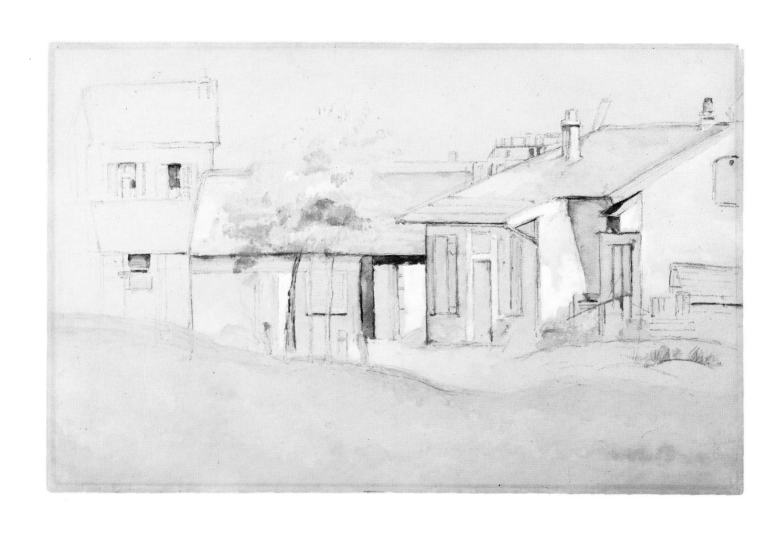

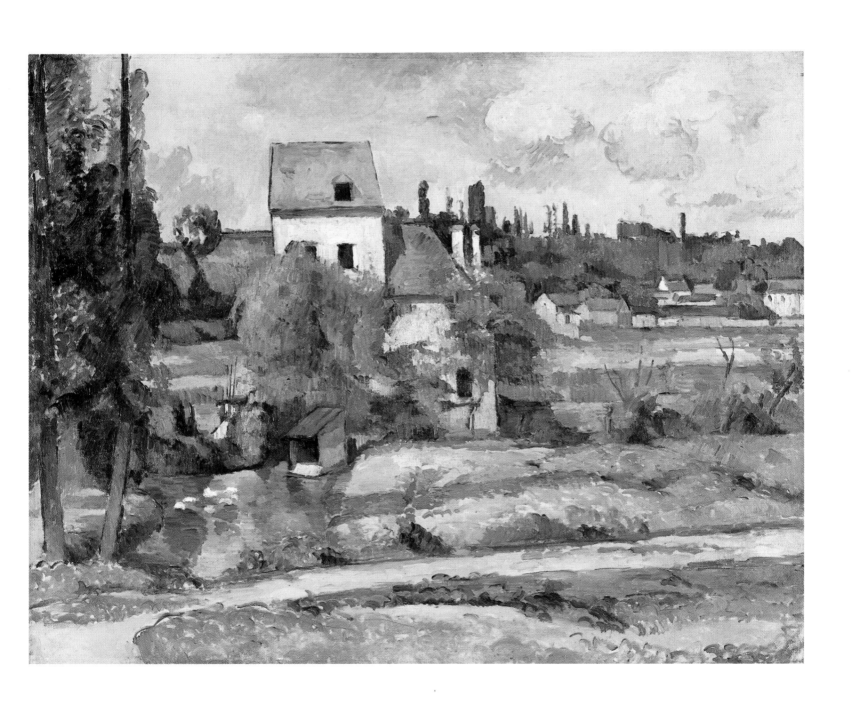

75 | *Mill on the Couleuvre at Pontoise*

1881
Oil on canvas; 29 × 36 inches (73.5 × 91.5 cm)
Staatliche Museen zu Berlin, Nationalgalerie, Berlin
V. 324

PROVENANCE
This painting was sold by père Tanguy to Robert de Bonnières, Paris. In 1897 the museum director Hugo von Tschudi negotiated for the acquisition of the painting, through Paul Durand-Ruel, for the Nationalgalerie, Berlin. It was purchased with funds provided by Wilhelm Staudt. This was a benchmark event, for it marked the first purchase of a Cézanne by a museum.

EXHIBITIONS
Before 1906: Brussels, 1890, no. 1; Bremen, 1906, no. 34.
After 1906: Paris, 1936, no. 50; Basel, 1936, no 30; Vienna, 1961, no. 19; Aix-en-Provence, 1961, no. 7; Tübingen, 1993, no. 25.

EXHIBITED IN PARIS AND LONDON ONLY

In August 1872, several months after the birth of his son, Cézanne left Paris for the village of Pontoise, about an hour west of the city. The principal attraction of this place was Pissarro, who had lived and worked there since 1863. At the end of the year Cézanne moved with his family to the nearby town of Auvers-sur-Oise. This short move did not interrupt the close working relationship he had developed with the older artist. Pissarro is justly credited with having transformed Cézanne's style and, to some degree, his temperament, by encouraging him to interact more fully with nature and by initiating him into a more deliberate, less subjective approach to his craft. The mutual influence that ensued between these two artists over the next ten years is one of the great chapters in the history of nineteenth-century painting. At its beginning, the sage Pissarro endeavored to calm the ferocious young Cézanne, but, as time passed, the pupil progressively found himself in the lead, encouraging the older artist to follow his example in testing the limits of Impressionist landscape painting.

From May to October 1881, Cézanne rented a house at 31, quai du Pothuis in Pontoise, within easy walking distance of Pissarro. It was to be his last stay in this region, a place where he painted some of his most beautiful pictures and, it is often maintained, reached artistic maturity.

The motif depicted in this painting, a mill on the Couleuvre river, was photographed by Rewald in the 1930s.[1] Rewald later came across a turn-of-the-century postcard showing the site in a state even closer to that of Cézanne's time, providing still more evidence of the degree to which the artist remained faithful to the visual facts before him.[2]

We are very far in this picture from the influence of Impressionism and Pissarro's work of the early 1870s. The geometric relationship of the buildings and the banded landscape give the whole a solidity and structure that the older artist had himself begun to emulate by this time. Even so, the handling, with its "comma" strokes of pigment thinly applied over the white priming, much of which was allowed to show through, produces an effect of lightness and spontaneity that sets this painting apart from *The Château de Médan* (cat. no. 69), probably painted in the previous summer. The present canvas is a somewhat more relaxed product of this happy moment in Cézanne's career, which saw him achieve a rare balance between the conflicting imperatives of observation and pictorial values, of Impressionist and constructive approaches to painting.

In much of the formalist literature on Cézanne, there is a tendency to downplay the intensity of his response to his subjects, which he seems to have selected to reflect his mood or temper at a given moment. This picturesque motif clearly attracted and even delighted him, and for reasons that were not exclusively formal. The signal that not every picture from this time in his career is a grave and serious exploration into deeper truths is the presence of the ducks or geese on the surface of the millpond. Cézanne usually banished both human beings and animals from his landscapes, yet these birds are dashed in with summary white brushstrokes that make them pictorial events as much as representational signs. Even so, they retain their ability to charm, like the rustic motif as a whole.

J. R.

1. See Rewald, 1936, fig. 40.
2. See Rewald, February 15-29, 1944, p. 9; and Adriani, 1993 (b), p. 111.

Turn in the Road

c. 1881
Oil on canvas; 23¹³/₁₆ × 28¹⁵/₁₆ inches (60.5 × 73.5 cm)
Museum of Fine Arts, Boston. Bequest of John T. Spaulding (48.525)
V. 329

PROVENANCE
This picture may originally have been in the shop of père Tanguy. Entering the collection of Theodore Duret, it was purchased at the Duret sale (Galerie Georges Petit, Paris, March 19, 1894, lot 3)[1] by the painter Paul-César Helleu, Paris, for 800 francs. It was later acquired by Claude Monet, passing to his son Michel Monet. It subsequently belonged to Paul Rosenberg, Paris, and the Wildenstein Galleries, New York, from whom it was acquired, in 1928 at the latest, by John T. Spaulding, Boston.[2] Spaulding, a corporate lawyer and trustee of the Museum of Fine Arts, Boston, bequeathed it to the museum in 1948.

EXHIBITIONS
After 1906: New York, 1928, no. 14; Chicago and New York, 1952, no. 42; Edinburgh and London, 1954, no. 26; New York, 1959 (b), no. 19; Washington, Chicago, and Boston, 1971, no. 11; Tokyo, Kyoto, and Fukuoka, 1974, no. 29; Los Angeles and Chicago, 1984-85, no. 72; Paris, 1985, no. 38; Tübingen, 1993, no. 27.

EXHIBITED IN PHILADELPHIA ONLY

There is something deeply eccentric and original about this painting. Its curving principal form and its artfully contrived decorative composition mark it as the kind of Cézanne that was most to influence Gauguin. Much of it is painted in a faceted and complex way, using short, parallel strokes that Cézanne was developing in these years: are these the *petits sensations* that Cézanne feared the young Gauguin would steal from him? Everything seems caught up in abrupt visual rhythms that sit uneasily on the picture plane and undercut perspectival recession. Key forms and colors—the white house, the red roof, the yellow road—contend for visual dominance against an armature of barriers: the screen of trees in the foreground, the curved wall, and the flattened upper band of the picture, where the interplay of greens, purples, and blues unites the hill with the sky. The result is a tour de force of contained energy. It has an oddly disturbing effect on the viewer, and one cannot help wondering what Monet, who owned it for many years, made of it. Monet, more than most of his contemporaries, would have recognized the discipline and probing intelligence that lay behind such a singular achievement as well as its particularly charged quality.

Richard Brettell has suggested that the cluster of houses is the little village of Valhermay, along the Oise between Auvers and Pontoise. This site would have been well known to Cézanne, who had lived and worked intermittently in the area, often at Pissarro's side, for ten years. Pissarro painted many landscapes there and the neighboring village of Chaponval during the same years, and "the picturesque assembly of traditional rural dwellings along a naturally curved, unpaved path appealed to the sensibilities of both artists."[3] But the comparison must stop there: while Pissarro's landscapes are full of people and life, in Cézanne's "one never sees an inhabitant; smoke never comes from a chimney; animals never rustle in the barnyards. One thinks of the earlier deserted villages painted by Daubigny and Sisley. *Bend in the Road*, like so many of Cézanne's landscapes, at first entices the viewer into its cool depths and then denies him access to the landscape. The road swoops generously into the painting, but bends behind a tree and seemingly disappears. The houses have virtually no windows or doors, and those openings that are present are—as always—closed, featureless rectangles. The viewer stands outside the village, which refuses him admission, and he can imagine no intercourse with its inhabitants. Indeed, the social—and psychological—detachment of this landscape is its most important characteristic—and its greatest paradox."[4]

J. R.

1. See Andersen, June 1967, p. 139 n. 22.
2. See New York, 1928, no. 14.
3. Brettell, in Los Angeles and Chicago, 1984-85, no. 72, p. 194.
4. Ibid., p. 200.

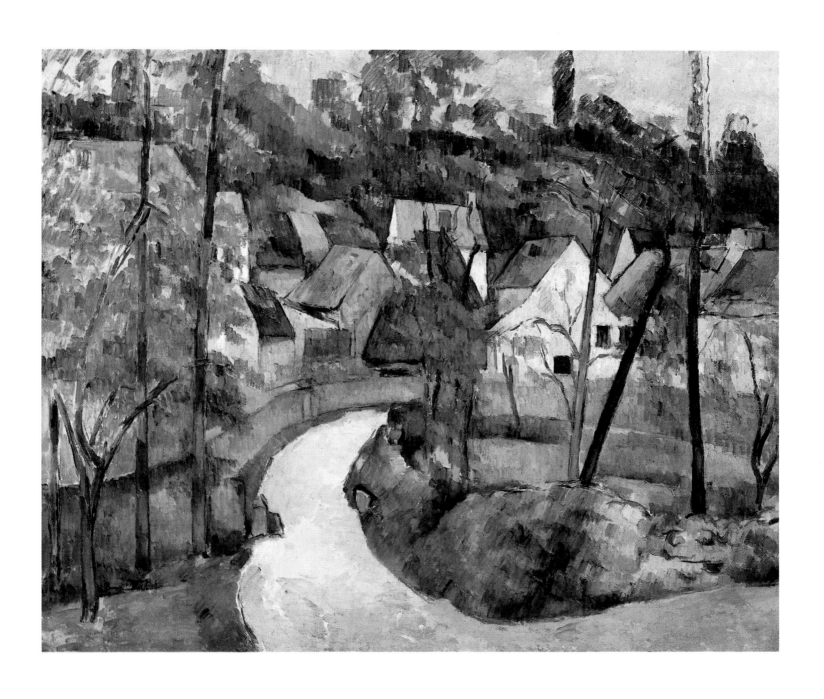

Self-Portrait in a White Cap

1881-82
Oil on canvas; 21⁷/₈ × 18¹/₈ inches (55.5 × 46 cm)
Bayerische Staatsgemäldesammlungen, Munich
V. 284

PROVENANCE
The Galerie E. Druet, Paris, sold this painting to Hugo von Tschudi on January 10, 1908, for 10,000 francs. Tschudi bought the painting for the Nationalgalerie, Berlin, of which he was the director. In 1909, however, he was removed from this post, before the painting could be accessioned. Tschudi took it with him when he accepted his next position, the directorship of the Königliche Pinakotheken, Munich, where it entered the collection in 1912 as the gift of Eduard Arnhold and Robert von Mendelssohn.[1]

EXHIBITIONS
After 1906: Berlin, 1908, no. 38a; The Hague, 1956, no. 16; Aix-en-Provence, 1956, no. 23; Zurich, 1956, no. 29; Munich, 1956, no. 20; Cologne, 1956-57, no. 14; Vienna, 1961, no. 12; Basel, 1989, no. 42.

Cézanne had attained a level of assurance by the early 1880s, and his new frame of mind is reflected in this self-portrait, which has an equilibrium and a solidity that set it very much apart from the one in Bern (cat. no. 66), in which the artist seems almost introspective. He was in his early forties and had just completed a series of paintings that had given him greater confidence in his own gifts. Doubt, worry, anger, satisfaction—any and all sentiment—seem superficial and irrelevant to the way he has chosen to present himself here.

The figure is built up with richly layered short strokes, mostly in a palette of browns, ochers, and crimsons. Great care was taken with the face and the ear. The brushwork is looser, and the pigment less dense, in the folds of the suit and in the background, but the contrast between the two modes of handling is so subtle that the final image, for all its textural and coloristic variety, seems remarkably unified. It is the reconciliation of surface animation with a settled psychological aura that most distinguishes this self-portrait from others by Cézanne. His gaze seems profoundly neutral, neither approving nor disapproving, giving the image its powerful presence.

Much has been written about the constructed quality of Cézanne's pictures of the late 1870s and early 1880s. Cézanne's pleasure in his craft is evident in this painting, in which formal and technical problems have been resolved in a manner entirely his own, never too refined, too tight, or too complicated.

So convincing, in fact, is the sense of the picture's inevitability that the beholder can easily overlook the sitter's eccentric headgear, which is unique to this self-portrait. It appears to be a plasterer's hat made from a napkin or a small towel. Cézanne was quite bald from his early thir-

ties, and this impromptu cap would have protected his bare head. Yet, it seems too specifically chosen—especially for a self-portrait—not to mean something more. Perhaps Cézanne wished to represent himself as an artisan, a no-nonsense craftsman going about his business in a conservative wool suit of a particularly dull color. But one could take this further. In a letter to Émile Bernard in 1904, he wrote of his admiration for a pastel self-portrait by Chardin (fig. 1): "Do you remember the beautiful pastel of Chardin, equipped with a pair of spectacles, a visor forming a hood? He's a cunning fellow *[un roublard]*, this painter."[2] In this portrait Chardin looks at himself in a mirror with an attitude of steady but uncomplicated candor; his white headgear is not so very different from what Cézanne wears in the Munich self-portrait. And we know from drawings Cézanne made after Chardin's works how much this eighteenth-century artist meant to him.

J. R.

1. See Barbara Paul, *Hugo von Tschudi und die moderne französische Kunst im Deutschen Kaiserreich* (Mainz, 1993), pp. 204, 301, 385, no. 141.
2. Cézanne to Bernard, June 27, 1904, in Cézanne, 1978, p. 304.

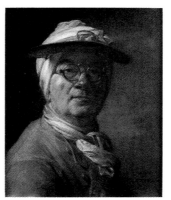

Fig. 1. Jean-Baptiste-Siméon Chardin,
Self-Portrait, 1775, pastel,
Musée du Louvre, Paris,
Département des Arts Graphiques.

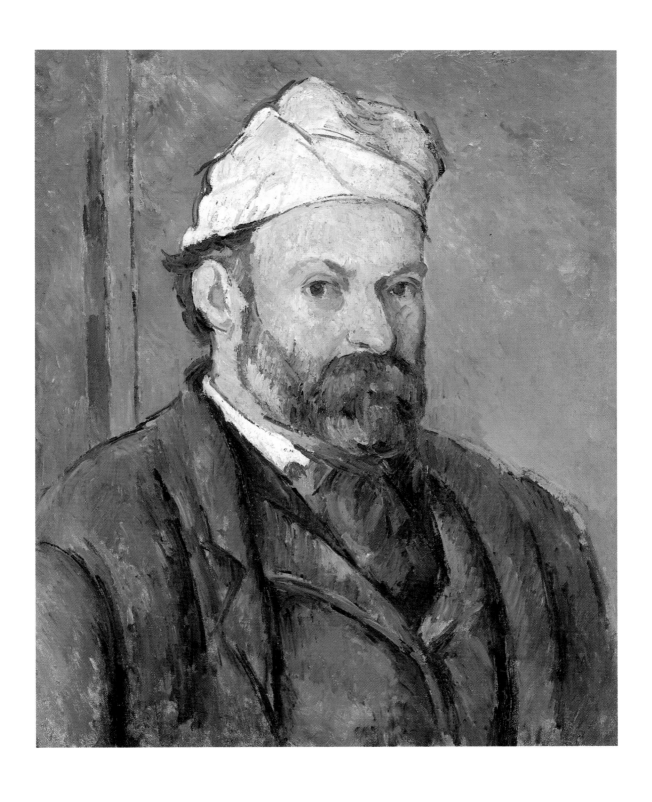

c. 1880
Oil on canvas; 18¹/₈ × 21⁵/₈ inches (46 × 55 cm)
Musée National de l'Orangerie, Paris. Jean Walter and Paul Guillaume Collection (R.F. 1960-11)
V. 343

PROVENANCE
This picture belonged to Alphonse Kann, Saint-Germain-en-Laye, and then to Marczell de Nêmes, Budapest; at the latter's sale (Galerie Manzi-Joyant, Paris, June 18, 1913, lot 87) it was acquired by Baron Maurice de Herzog, also of Budapest. It passed through Paul Rosenberg, Paris, and then Durand-Ruel, Paris and New York, and by 1936, was in the collection of Gabriel Cognacq,[1] owner of the Samaritaine department store. At his sale (Galerie Charpentier, Paris, May 14, 1952, lot 28), it was purchased by Mme Jean Walter, the widow of Paul Guillaume, for 33 million francs.[2] "In 1957, negotiations began that resulted in two successive agreements, in 1959 and 1963. The collection was ceded to the Musées Nationaux on exceptionally generous terms with assistance provided by the Amis du Louvre, on the condition that it be displayed, after the donor's death, in an autonomous museum in the Orangerie des Tuileries."[3]

EXHIBITIONS
After 1906: Paris, 1936, no. 54; Paris, 1939 (a), no. 7; London, 1939 (b), no. 23; Paris, 1966, no. 5; Paris, 1974, no. 30.

EXHIBITED IN PARIS AND PHILADELPHIA ONLY

In 1952, when this still life was sold from the estate of Gabriel Cognacq to Mme Jean Walter, it fetched a sensational price. It is for many, with its banded simplicity and luminous sparseness, the quintessential Cézanne still life. As Michael Hoog has written: "This still life is among the purest of Cézanne's maturity, one of those that best sums up the essential characteristics of his art in his most serene period. A plate and a few apples arranged on a chest sufficed for him to create a composition of perfect coherence. The delicacy of the colors (pink and pale blue on the right), whose nuances suggest watercolor, and the deceptive simplicity of the arrangement, which subtly exploits the voids surrounding a few modest objects, can scarcely be found elsewhere save in Baugin or Zurbarán, whose still lifes Cézanne is unlikely to have seen."[4]

It is one of seven still lifes of apples and other simple objects placed on a long wooden surface—a simple storage chest—in front of a wall covered with blue-gray wallpaper decorated with a delicate floral pattern (see fig. 1). Of this group of still lifes, all of which are characterized by great dignity and restraint, this picture is the simplest. The three principal compositional zones—the front of the chest, its top, and the wall behind—form bands of roughly equal width that extend across the full breadth of the picture. The placement of the apples, their shapes, and their colors have a resolution in their formal interaction that could be called Aristotelian. Only one red apple extends above the "horizon" of the chest top. This errant fruit, the abrupt cropping of a dish of biscuits, the slight tilt of the whole

composition, and, especially, the rudely assertive iron latch animate what otherwise would be a nearly static construction of absolute perfection.

The similar wallpaper in this group of paintings led Venturi, followed by several other scholars, to conclude that they all must have been produced in one place, perhaps Melun, where Cézanne rented a house in 1879-80, or Paris, where he lived in two "campaigns" in 1880-82, at 32, rue de l'Ouest.[5] Given the appearance of a very similar motif in the background of the portrait of the boy Louis Guillaume—said to be the son of a shoemaker who was Cézanne's neighbor in Paris (fig. 2)—the latter date seems more likely.

J. R.

1. See Venturi, 1936, vol. 1, no. 343, p. 140.
2. See Cabanne, 1963, p. 119.
3. Hoog, 1984, p. 10.
4. Ibid., p. 22.
5. See Venturi, 1936, vol. 1, no. 337, p. 138.

Fig. 1. Paul Cézanne,
Plate and Compotier, 1879-82,
oil on canvas,
Ny Carlsberg Glyptotek, Copenhagen (V. 342).

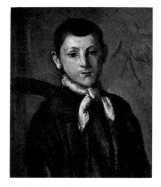

Fig. 2. Paul Cézanne,
Portrait of Louis Guillaume,
c. 1882, oil on canvas,
National Gallery of Art,
Washington, D.C.,
Chester Dale Collection (V. 374).

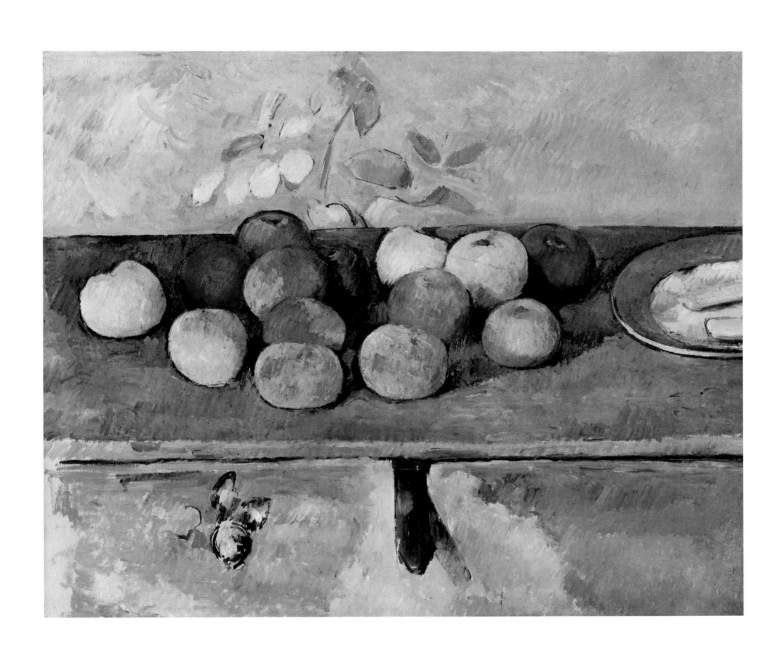

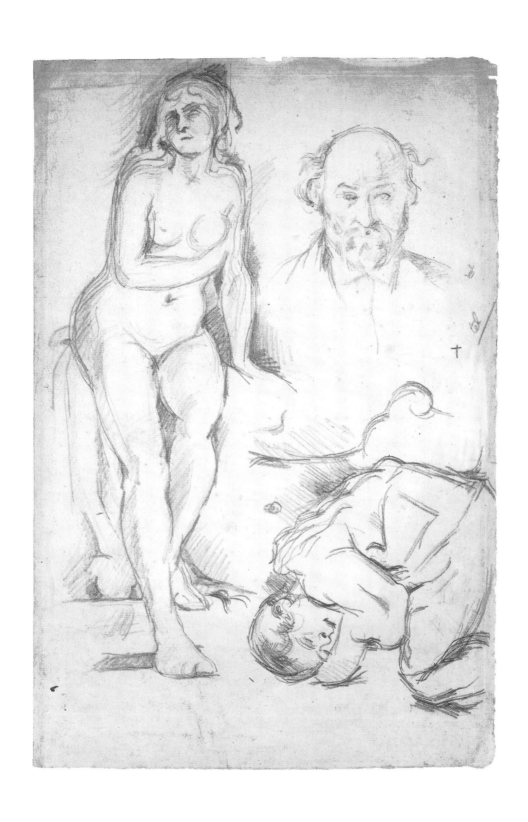

79 | *Page of Studies*

c. 1876, c. 1883, and c. 1885
Graphite on paper; $19^5/_8 \times 12^{11}/_{16}$ inches (49.8 × 32.2 cm)
Museum Boymans–van Beuningen, Rotterdam
C. 363

PROVENANCE
This drawing was first in the collection of Franz Koenigs, Haarlem. In 1940 he sold his entire collection of drawings to D. G. van Beuningen, who donated a portion of it to the Museum Boymans.

EXHIBITIONS
After 1906: Rotterdam, 1933-34, no. 1; Basel, 1935, no. 176; Basel, 1936, no. 126; The Hague, 1956, no. 113; Zurich, 1956, no. 173; Munich, 1956, no. 133.

Venturi was the first to recognize, in 1936, that the nude lifting herself heavily from a cloth-draped bench was drawn after the life-size marble *Psyche Abandoned* by Augustin Pajou (1730-1809) in the Louvre (fig. 1). It is difficult to say whether Cézanne would have been more drawn to the controlled anguish expressed by Pajou's *Psyche* as she slowly realizes the bleakness of her fate or to the beautiful way in which the sculptor has shown the shifting of her weight—from her still-seated torso, to her left foot, to her right—in a cascading rhythm of great discretion. In any event, this sketch—one of very few drawings by Cézanne after a statue of a female nude—effectively captures the restrained sensuality of her smooth form, slowly turning in space.

Psyche shares the large sheet—in a way that decidedly invites psychological speculation—with a self-portrait and a charming view of Paul *fils* asleep in an overstuffed arm-chair. Working with a harder pencil (and therefore fainter lines), Cézanne drew himself full-face, with his lips pursed, two wisps of hair escaping from his balding head like Chinese eaves. It is hard to imagine that his intent in this spectral self-image, floating behind the statue, is not comic. The depiction of Paul *fils* is so frankly affectionate—the artist's feelings so exposed—that one almost has to look away.

Chappuis thought this sheet was drawn at three different times: the nude about 1876, the self-portrait about 1883, and the boy about 1885.[1] The last date, based on estimating the boy's age, is perhaps subject to doubt (he looks younger than twelve or thirteen), but Chappuis's grasp of the evolution of Cézanne's draftsmanship was extremely refined. In all likelihood the composition of this sheet—so visually satisfying despite its improbable juxtapositions—was indeed produced over several years but rests happily together on one page.

J. R.

1. See Chappuis, 1973, vol. 1, no. 363, p. 124.

Fig. 1. Augustin Pajou,
Psyche Abandoned, 1791, marble,
Musée du Louvre, Paris.

Medea (after Delacroix)

1880-85
Graphite, watercolor, and gouache on paper; 15⁹/₁₆ × 10¹/₄ inches (39.5 × 26.1 cm)
Kunsthaus Zurich
R. 145

PROVENANCE
This watercolor was auctioned at the estate sale of Cornelis Hoogendijk in Amsterdam, on May 22, 1912 (lot 101). It was purchased by Paul Cassirer, Berlin, for his private collection, and passed on his death to his daughter Suse Paret-Cassirer, Berlin. In 1935 she consigned it to the firm of Paul Cassirer, Amsterdam, who sold it in the same year to the Kunsthaus in Zurich.

EXHIBITIONS
After 1906: Berlin, 1921, no. 51; Paris, 1936, no. 120; Paris, 1939 (b), no. 53 (revised cat. no. 27); London, 1939 (b), no. 50; Lyon, 1939, no. 45; Chicago and New York, 1952, no. 35; Paris, 1953, no. 22; The Hague, 1956, no. 59; Zurich, 1956, no. 96; Munich, 1956, no. 72; Vienna, 1961, no. 50; Newcastle upon Tyne and London, 1973, no. 43; Tübingen and Zurich, 1982, no. 106; Tokyo, Kobe, and Nagoya, 1986, no. 45.

EXHIBITED IN PARIS ONLY

Of the artists from the generation that immediately preceded him, Cézanne was most attracted to Manet and Courbet, whose influences can be traced over the first two decades of his career. But one artist of his own century was to sustain him throughout his life: Eugène Delacroix. Cézanne's friendship with Victor Chocquet, his first patron, was furthered by their shared admiration for Delacroix. One of the few original works of art that Cézanne owned was a large watercolor of flowers by Delacroix, a gift from Vollard, who acquired it at the Chocquet sale in 1899. And one of Cézanne's most ambitious projects, never pursued beyond an oil sketch, was an *Apotheosis of Delacroix*.[1]

The present watercolor is a copy after one of Delacroix's most celebrated compositions, a depiction of the horrific moment when the Greek queen Medea, rejected by Jason, takes her revenge by killing their two sons. There are several versions of Delacroix's composition, one of which—of the same dimensions as the Cézanne watercolor—actually belonged to Chocquet. However, Cézanne's watercolor follows more closely the large picture of 1838 now in Lille (which he almost certainly never saw). On the basis of a lithograph after the Lille picture (fig. 1), Rewald convincingly suggested that "Cézanne may have used it for this copy, selecting the colors with the help of his recollections of the version belonging to Chocquet."[2] This scenario merits attention, for it reveals something about the nature of Cézanne's relationship to Delacroix, and particularly about this watercolor, which is no passive copy. Rather (and here the idea that Cézanne had before him a black-and-white print is particularly interesting), Cézanne was nourishing something very deep within himself through what are essentially recreations of things past. The compositions of the two works are much the same, but the way that he summarizes and distills Delacroix's image marks it unmistakably as his own independent work.

Venturi has analyzed the effect produced by this watercolor: "Cézanne concentrated on the dramatic effect of the contrast of light and shade; he placed spots of light in the group as well as in the background and fused figures and background. His dramatic effect is less determined and associated with reality than Delacroix's but both rocks and figures participate in the drama. Thus he gives greater breadth to the drama. The slightest element of illustration disappears. The integration is complete. The water colour expresses its own drama by its own means, more poetically and freer, detached from life, because it has its own life. Light and shade follow the rhythm with an inspiring lightness and freshness, which show no fear of departing from conventional ideas about the form of bodies. A detail particularly reveals Cézanne's creative imagination. When Delacroix represented the left hand of Medea holding the dagger, he knew the natural way for a hand to hold it, but he distorted the right hand and the relation between it and the natural left hand is unpleasant. Cézanne felt this; he did not change the distortion of the right hand, but he also distorted the left, making the holding of the dagger appear absurd and finding a happy rhythm in the opposition of the two hands."[3]

On stylistic grounds, both Venturi and Rewald placed this work in the early 1880s, by which time Cézanne's figure paintings do not seem to reflect the passion and violence seen here. But to liken this watercolor to "a last farewell to the dark thoughts of the early period"[4] is to radically underestimate the complexity of Cézanne's mind and emotions. This Medea made a lasting impression on his memory, for a similar figure appears in the *Large Bathers* now in the Barnes Foundation (repro. p. 39).

J. R.

Fig. 1. *La Médée furieuse*, lithograph after Eugène Delacroix, *Medea* (1838, Musée des Beaux-Arts, Lille), published in *L'Artiste*, 1883.

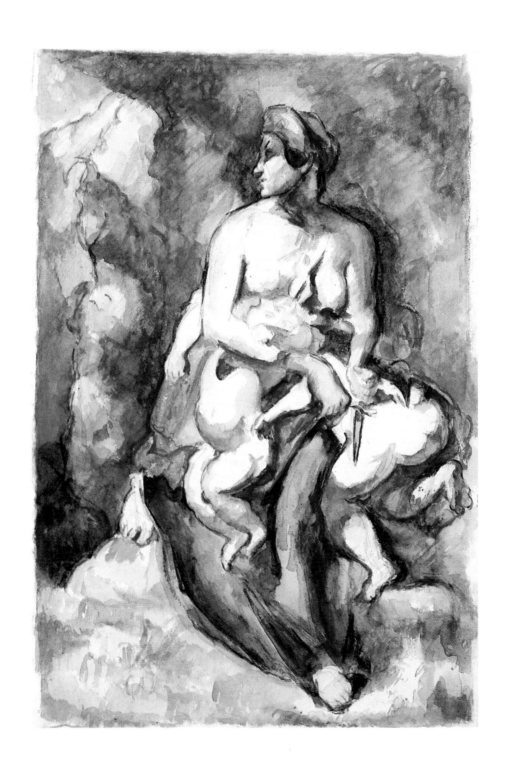

1. See Venturi, 1936, vol. 1, nos. 245 and 891, pp. 119, 249-50. See also Lichtenstein, March 1964.
2. Rewald, 1983, no. 145, p. 120. Rewald was made aware of the lithograph by Guila Ballas.
3. Venturi, 1943, p. 16.
4. Schmidt, 1953, p. 25.

81 | *Milo of Crotona (after Puget)*

1880-83
Graphite on paper; $8^{1}/_{2} \times 5^{3}/_{16}$ inches (21.6 × 13.2 cm)
Kunsthalle Bremen. Kupferstichkabinett
C. 504

PROVENANCE
Originally part of a sketchbook belonging to the artist's son, Paul, this drawing was acquired by the dealer Paul Guillaume, Paris. It was purchased in 1934 from the Guillaume estate by Werner Feuz,[1] Bern, and on June 13, 1968, it appeared in a Kornfeld and Klipstein sale in Bern (lot 138), at which time it was acquired by the Kunsthalle Bremen.

EXHIBITIONS
After 1906: Tübingen, 1978, no. 171.

Pierre Puget (1620-1694) was one of the most celebrated and controversial of all French sculptors. He was also a man of the South. Cézanne, deeply loyal to Provence, reportedly told Gasquet that when he felt homesick in Paris he would go to see the Pugets in the Louvre, which were "cleansed" by the mistral.[2] One of Cézanne's finest landscapes of the early 1880s pictures a house between Aix-en-Provence and L'Estaque that was believed to have been Puget's birthplace (cat. no. 71).[3] All the same, it is far from clear what he made of the campaign to celebrate the culture of his native region that was so enthusiastically embraced by his young biographer, Joachim Gasquet.

A plaster reproduction of a *Cupid* formerly attributed to Puget is still in Cézanne's Chemin des Lauves studio (see cat. nos. 161-65), and of the artist's sketchbook drawings after sculpture, those related to Puget probably outnumber all others. The *Milo of Crotona* was one of three monumental marbles commissioned from Puget for the gardens of Versailles. The subject is a cautionary tale about the dangers of pride: Milo, famed for his strength, becomes unable to free himself from a fissure in the trunk of a tree he thought he could fell with his bare hands, and was then killed by a lion. There are seven surviving Cézanne drawings of the statue, nearly all from the same point of view as this sheet. The artist seems most interested in the strained twist of the torso and the converging angles of the leg, the trunk, and the attacking lion. In the present drawing, the rapidly executed curves and countercurves make the figure appear to rotate in space, producing a graphic equivalent of the marble.

J. R.

1. See Dieter Koepplin, in New York, 1988, p. 8.
2. Gasquet, 1921, pp. 115-16.
3. See Gowing and Rewald, September 1990, p. 639.

81

| *Pietro Mellini (after Benedetto da Maiano)*

1881-84
Graphite on paper; 8¹/₈ × 4¹³/₁₆ inches (20.6 × 12.2 cm)
Öffentliche Kunstsammlung Basel. Kupferstichkabinett
C. 555

PROVENANCE
Originally in a sketchbook owned by the artist's son, Paul, this drawing came into the possession of Paul Guillaume, Paris. It was subsequently acquired by Werner Feuz, Bern. In 1935 it entered the collection of the Kunstmuseum, Basel.

EXHIBITIONS
After 1906: Basel, 1935, no. 198; Vienna, 1961, no. 95.

For much of the nineteenth century, the bust of Pietro Mellini (fig. 1) by Benedetto da Maiano (1442-1497) was viewed as one of the greatest masterpieces of the Florentine Renaissance. The original marble, remarkable for its deeply lined, expressive face, has been in the Bargello in Florence since Cézanne's lifetime, but casts could be found in museums and art schools throughout Europe. Cézanne made this drawing after a plaster in the Musée de Sculpture Comparée at the Trocadéro.

Cézanne was clearly drawn to this bust, as he was to Renaissance portrait sculpture in general. The sketchbooks contain several studies after heads by Francesco Laurana, Antonio Pollaiuolo, and Mino da Fiesole, as well as Benedetto.[1] Their frequency should make us wary of claims that individual characterization was of little or no interest to Cézanne.

J. R.

1. C. 556-60, C. 601, C. 671, and others.

Fig. 1. Benedetto da Maiano,
Bust of Pietro Mellini,
1474, marble,
Bargello, Florence.

83 | *Filippo Strozzi (after Benedetto da Maiano)*

1881-84
Graphite on paper; $8^{1}/_{2} \times 5$ inches (21.6 × 12.7 cm)
Philadelphia Museum of Art. Gift of Mr. and Mrs. Walter H. Annenberg, 1987-53-58b
C. 556

PROVENANCE
This drawing comes from a sketchbook that belonged to the artist's son, Paul. Among several sketchbooks placed on consignment with Renou and Poyet, Paris, this and four more Cézanne sketchbooks were purchased by the New York dealer Sam Salz, who sold two of the sketchbooks to Mrs. Enid Annenberg Haupt, New York. At this point, the pages were removed and mounted separately. In 1983 Mrs. Haupt sold them to her brother, Walter Annenberg, and his wife Leonore, who donated the two sketchbooks to the Philadelphia Museum of Art in the winter of 1987.[1]

EXHIBITIONS
After 1906: Philadelphia, 1989, unnumbered.

EXHIBITED IN PARIS AND LONDON ONLY

Unlike his drawing of Benedetto da Maiano's bust of Pietro Mellini (cat no. 82), there was no need for Cézanne to resort to a plaster copy when executing his sketchbook drawing of da Maiano's portrait of Filippo Strozzi, for the marble bust of this Florentine banker and builder had entered the Louvre in 1878 (fig. 1). Nevertheless, caution is in order when dealing with Cézanne's drawings after famous works of art, for many of these works, even those accessible to him in the Louvre, were done after book illustrations or photographs. The sketchbooks contain three other drawings of the same portrait, two of which may also show the feet of Michelangelo's *Slaves* (see cat. no. 185), which were installed in the same room as the Strozzi bust in the years when Cézanne was regularly visiting the Louvre.[2]

The stern and regal head is depicted from below. The right profile is worked nervously, with repeated pencil strokes hovering on the outline proper, a technique enlivening many of Cézanne's drawings. It is a completely natural gesture, intrinsic to his intense observation of and reflection on three-dimensional objects. Balthus and Giacometti were to learn much from this way of seeing.

J. R.

1. See Shoemaker, in Philadelphia, 1989, p. 15.
2. See Berthold, 1958, p. 87.

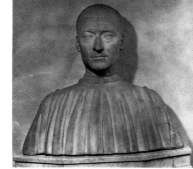

Fig. 1. Benedetto da Maiano,
Bust of Filippo Strozzi,
1491, marble,
Musée du Louvre, Paris.

Landscape at the Jas de Bouffan and Portrait of a Young Man

1882-85

Graphite on paper; 5 × 8⁹/16 inches (12.6 × 21.7 cm)

Museum Boymans–van Beuningen, Rotterdam

C. 608

PROVENANCE

This drawing belonged to the artist's son, Paul. It passed through the hands of Paul Cassirer, Amsterdam, before being acquired, in 1930, by Franz Koenigs. In 1940 Koenigs sold his entire collection to D. G. van Beuningen, who donated a portion of it to the Museum Boymans.

This informal page of studies, torn from a sketchbook, is the smaller of two sheets among Franz Koenigs's remarkable cache of Cézanne drawings, now in Rotterdam, to depict the great open space with the allée of chestnut trees behind the Jas de Bouffan (see cat. no. 98).[1] In comparison with the other, larger sheet, here Cézanne situated himself a few steps farther from his subject, but cropped the view and compressed the space between the trees and the farm buildings, whose sharper perspective is reinforced by the informal repoussoir of the leaning chestnuts. Cézanne clearly seems to have enjoyed contrasting the substance of his spatial creation, drawn in a few blunt strokes, with the relaxed, almost whimsical, lines of the trees' bare limbs.

The boy leaning his head on his hand is after an engraving of a work that was believed in Cézanne's day to be an oil portrait by Raphael (fig. 1).[2] The boy's relaxed posture and dreamy demeanor are reminiscent of Cézanne's drawings of his son, Paul.

The verso of this page is a sumptuous watercolor of a kneeling figure (fig. 2) who also appears in other Cézanne drawings (C. 625-26). The figure was identified in Koenigs's inventory as a statue of a Chinese deity (his robe is bright yellow shot with red), and Venturi described it as a funerary monument.[3] Rewald, citing Chappuis, has suggested that it was an object that may have been in Zola's collection.[4]

J. R.

1. See H. R. Hoetink, *Franse Tekeningen uit de 19e Eeuw* (Rotterdam, 1968).
2. See Chappuis, 1973, vol. 1, no. 608, p. 172. The painting is now attributed to Bacchiacca.
3. See Venturi, 1936, vol. 1, no. 870, p. 246.
4. See Rewald, 1983, no. 64, p. 100. He was presumably working from Chappuis's unpublished notes.

Fig. 1. Engraving after Bacchiacca, *Young Man* (Musée du Louvre, Paris), published in *Le Magasin pittoresque*, 1845, p. 9.

Fig. 2. Paul Cézanne, *Study after a Monument*, 1878-80, watercolor on paper, Museum Boymans–van Beuningen, Rotterdam (R. 64).

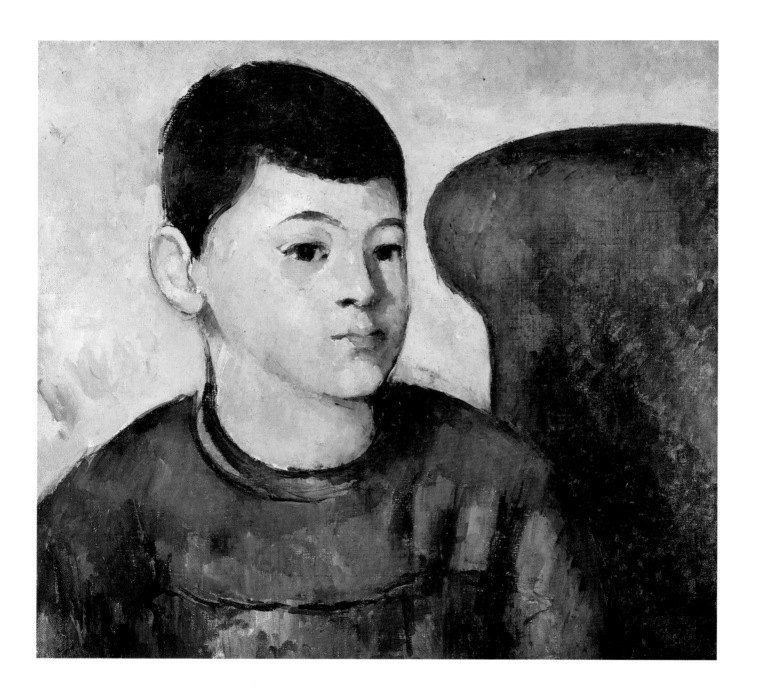

85 | *Portrait of Paul Cézanne, the Artist's Son*

1883-85
Oil on canvas; 13³/₄ × 15 inches (35 × 38 cm)
Musée National de l'Orangerie, Paris. Jean Walter and Paul Guillaume Collection (R. F. 1963-59)
V. 535

PROVENANCE
This painting was purchased from Ambroise Vollard by Paul Guillaume.
His widow, who later married Jean Walter, ceded the work to the Musées
Nationaux in 1963.

EXHIBITIONS
After 1906: Paris, 1966, no. 7; Tokyo, Kyoto, and Fukuoka, 1974, no. 30;
Paris, 1974, no. 32.

EXHIBITED IN PARIS AND LONDON ONLY

Those who knew Paul Cézanne *fils* as a grown man reported that he was rather vague and lethargic, and that, like his mother, seemed never to have fully grasped the importance of his father's achievement, despite the considerable profit he reaped from it. Cézanne, however, had complete confidence in his son, and all evidence suggests the relationship between father and son was exceptionally untroubled. Shortly before his death in 1906, Cézanne wrote from Aix to Paul in Paris, and, after requesting a few favors and reporting the large and small events of his day (as he regularly did), signed off: "My dear Paul, to conclude I'll tell you that I have utter confidence in your instincts, which impress upon your reason the orientation best suited to the management of our interests, which is to say that I have the greatest confidence in your management of our affairs."[1]

Young Paul, his father's namesake, was born out of wedlock in 1872 and was the apple of his father's eye. Vollard reported—doubtless with discomfort—the number of holes the child punched in drawings and canvases. Cézanne proudly testified to his son's intelligence: "The son opened the windows and the chimneys; he saw perfectly well, the little fellow, that it was a house."[2] The sketchbooks are peppered with young Paul's juvenile scrawls, often directly over his father's drawings (see p. 519), as well as with the artist's images of him at all ages, more often than not showing him asleep (see cat. no. 51).

Here, young Paul appears to be sitting on the arm of an overstuffed chair in a close-up composition—rarely used by Cézanne (see fig. 1)—that is extremely effective, concentrating the viewer's attention on the sitter rather like a daguerreotype portrait. The outlines of the chair and the boy are sharply drawn, and it is only gradually that the delicate modeling of the boy's head emerges from the drama of the overall image.

J. R.

Fig. 1. Paul Cézanne,
Portrait of Madame Cézanne, 1872-77,
oil on canvas,
private collection, Switzerland (V. 228).

1. Cézanne to his son, September 8, 1906, in Cézanne, 1978, p. 324.
2. Vollard, 1914, p. 74.

86 | *Farm in Normandy, Summer (Hattenville)*

1882
Oil on canvas; 19¹/₂ × 25⁷/₈ inches (49.5 × 65.7 cm)
Private collection, on extended loan to the Courtauld Institute Galleries, London
V. 443

PROVENANCE
This painting, originally in the collection of Victor Chocquet, was auctioned at the Chocquet sale, held at the Galerie Georges Petit, Paris, on July 1-4, 1899 (lot 11); it was acquired by Alexandre Rosenberg, Paris. Sold on January 13, 1900, to Bernheim-Jeune, it entered the collection of Auguste Pellerin two days later.[1] Thereafter it passed through the hands of Ambroise Vollard, Galerie E. Bignou, Paris, and Reid and Lefevre, London. It was acquired by Samuel Courtauld in July 1937 for £2,500. In 1948 it was in the possession of his daughter, Christabel Lady Aberconway, London. It is now in a private collection, London, on extended loan to the Courtauld Institute Galleries.

EXHIBITIONS
After 1906: New York, 1933 (a), no. 7; London, 1948, no. 6; Edinburgh and London, 1954, no. 30; London, 1994, no. 5.

In March 1882 Victor Chocquet's mother-in-law died. Chocquet's wife, Augustine Marie Caroline Buisson Chocquet, being the sole heir, inherited a substantial fortune as well as her mother's farm in Normandy, near the village of Hattenville. With this turn of events, Chocquet, a customs official of modest salary who had been a staunch supporter and collector of the young painter—and a particularly good friend to Renoir as well—was able to give up his job and retire to the country. In 1923 Georges Rivière noted—probably on the basis of information provided by Paul Cézanne *fils*, who had become his own son-in-law—that this canvas "was painted, we think, on the property of M. Chocquet, in Hattenville."[2] Venturi followed suit, titling it simply *Ferme Normande: Le Clos*,[3] a generic designation he also gave to two similar landscapes (V. 445 and V. 447). Rewald added a fourth to the group (V. 442) and demonstrated that they had all belonged to Chocquet, speculating

that Cézanne, who went north in the summer of 1882, painted these views of an enclosed orchard during a visit to his newly prosperous patron in Normandy.[4]

The dense, green abundance of the foliage, which is consistent with Rewald's summer dating, immediately recalls *The Pont de Maincy* (cat. no. 57) and *Poplars* (cat. no. 58), painted two or three years before, but the open hatching of distinct colors that enlivens those landscapes has here begun to blend. In various passages, particularly in the grass in the foreground and at the edges, individual brushstrokes are difficult to discern, the overall effect being one of soft golden light filtering through the leaves and limbs of the young saplings, with everything slightly out of focus. John House rightly raised the question of finish, noting how Cézanne made little effort to disguise the various changes he introduced, particularly in the placement of the tree trunks on the right.[5] These alterations only add to the mesmerizing quality of the picture, which is, finally, like a contented dream about a summer's day.

J. R.

1. See Rewald, forthcoming, no. 508.
2. Rivière, 1923, p. 214.
3. See Venturi, 1936, vol. 1, no. 443, p. 160.
4. See Rewald, July-August 1969, pp. 61, 83. Cézanne may have brought his family with him, for Hortense Fiquet and Mme Chocquet seem to have gotten along.
5. See House, in London, 1994, no. 5, p. 66.

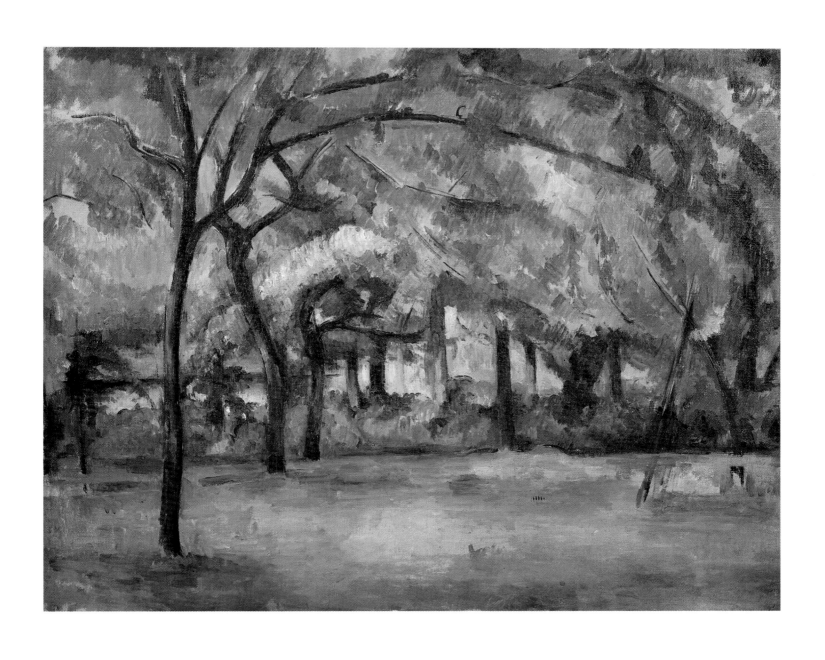

87 | *Trees and Roof*

1882-83
Graphite on paper; 12^{13}/$_{16}$ × 13^{9}/$_{16}$ inches (32.6 × 34.5 cm)
Museum Boymans–van Beuningen, Rotterdam
C. 878

PROVENANCE
This drawing was acquired by Franz Koenigs in 1925. In 1940 Koenigs sold his entire collection of drawings to D. G. van Beuningen, who donated a portion of it to the Museum Boymans.

EXHIBITIONS
After 1906: The Hague, 1956, no. 116; Zurich, 1956, no. 177; Munich, 1956, no. 134; Newcastle upon Tyne and London, 1973, no. 45; Tübingen, 1978, no. 84.

Many Cézanne drawings and watercolors have generic titles of necessity; over time such vague designations come to seem completely natural. Nevertheless, Cézanne's works are always about something. They have a physical subject, a specific place or tree or apple, observed and recorded under specific circumstances, even if we cannot yet identify it. Frustration sets in when we have no clues.

It appears to have been winter when Cézanne drew this sheet, for the larger trees are leafless. The soft-roofed cottages resemble those in Auvers or Pontoise, near Paris. Yet, Chappuis placed this sheet in 1882-83, but Cézanne did not go north that winter; either the drawing depicts a southern site, or it comes from another time. To complicate matters further, the reverse of this sheet shows a young tree in first leaf.

In an interview in 1925 Henri Matisse observed: "There were so many possibilities in Cézanne that, more than anyone else, he had to organize his brain."[1] Even in the simplest sketchbook sheets, the options do seem endless, the resolutions irrefutable. Three bare trees rise from rugged terrain; behind a wall, two others in full leaf stand in the distance. A dormered cottage abuts the wall. Low shrubs dot the foreground in isolated clumps. These are observations of a rather barren site—in Provence?—in which the artist explored essential formal and expressive questions of open versus closed forms, staccato strokes versus deliberate ones, thick marks versus thin ones.

As so often with Cézanne's pencil drawings, one tends, when looking at this sheet, to forget that it is not in color.

J. R.

1. Jacques Guenne, "Entretien avec Henri Matisse," *L'Art Vivant*, no. 18 (September 15, 1925), pp. 1-6; quoted in Jack Flam, *Matisse on Art* (London, 1973), p. 55.

88 | *In a Forest*

1880-83
Graphite on paper; 18$^1/_2$ × 12$^3/_{16}$ inches (47 × 31 cm)
Collection of Yvon Lambert, Paris
C. 792

PROVENANCE
This drawing was first owned by the Galerie Druet, Paris. It then passed in succession from Hugo Perls, Berlin, to Otto Wertheimer, Paris, and to Matthew H. Futter, New York, before coming onto the art market once more. It is now in the collection of Yvon Lambert, Paris.

EXHIBITIONS
After 1906: Berlin, 1927 (b), no. 48.

This drawing appears to depict the shelf of rocks above the Tholonet road, east of Aix and near the Château Noir (cat. no. 119). There are numerous paintings and watercolors of this dry and isolated spot, a contained environment where Cézanne could be protected from the Provençal sun and work without human interruption. Nearly all the works he made in this place stress its dense enclosure, the net of trees here pierced in the center with a release into open space up the hill beyond. The shallow soil and aridity of the region prevented many of the trees from surviving very long, and those that did were twisted and gnarled from the struggle. The trees grow so thickly between the boulders that even dead trunks do not fall to the ground.

There seems to be a primordial battle taking place between trees and rocks. It provided the artist with a motif of great linear complexity, the billowing outlines of the rocks forming a base from which the tight twist of trunks and branches rise up like flames. In this particularly fine drawing, remarkable for the deceptive economy of its draftsmanship, all the trees in the foreground appear to be dead, or at least very late in budding. Only the vertical ones glimpsed through the central opening are in leaf.

Rilke would have had no difficulty finding, in a sheet such as this, the essential drama of struggle and release, death and redemption. Perhaps, like us, he might have marveled at the patient, deliberative way Cézanne wove together each element on the page, left to right, front to back, in a completely resolved whole. And it is where the artist did not make a mark—where the white of the laid paper contains the view at the perimeter of the sheet and yet suggests a way out of the enclosure through the small gateway of light in the center distance—that Cézanne's great powers as a draftsman are revealed.

J. R.

First Series of Mont Sainte-Victoire

89 | ## *Mont Sainte-Victoire Seen from Bellevue*

1882-85
Oil on canvas; 25³/₄ × 32¹/₈ inches (65.4 × 81.6 cm)
The Metropolitan Museum of Art, New York.
H. O. Havemeyer Collection, bequest of Mrs. H. O. Havemeyer, 1929
V. 452

PROVENANCE
Mr. and Mrs. H. O. Havemeyer, New York, bought this canvas around 1901
from Ambroise Vollard for 15,000 francs, probably on the advice of Mary
Cassatt.[1] In 1929 it was bequeathed, along with the rest of Mrs.
Havemeyer's collection, to the Metropolitan Museum of Art.

EXHIBITIONS
After 1906: New York, 1930, no. 6; Chicago and New York, 1952, no. 53;
Aix-en-Provence, Nice, and Grenoble, 1953, no. 14; Liège and Aix-en-
Provence, 1982, no. 4; Edinburgh, 1990, no. 38.

90 | ## *Pine Tree and Mont Sainte-Victoire*

1883-86
Graphite on paper; 12³/₁₆ × 19 inches (31 × 48.2 cm)
Museum Boymans–van Beuningen, Rotterdam
C. 896

PROVENANCE
Originally owned by the Galerie Bernheim-Jeune, this drawing passed to
Paul Cassirer, Berlin. By 1926 it was in the possession of Franz Koenigs,
Haarlem. In 1940 Koenigs sold his entire collection of drawings to D. G.
van Beuningen, who donated a portion of it to the Museum Boymans.

EXHIBITIONS
After 1906: Basel, 1936, no. 143; Edinburgh, 1990, no. 39.

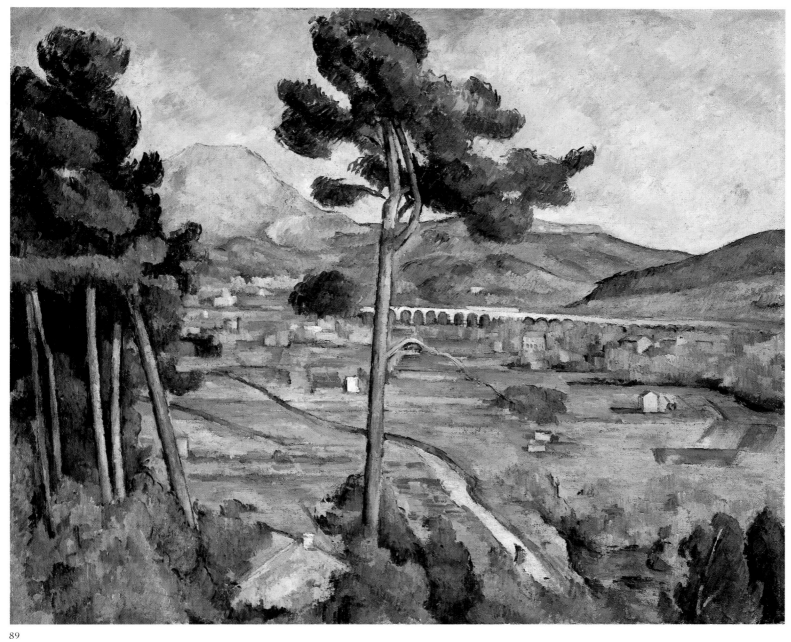

89

91 | *Pine Tree in the Arc Valley*

1883-85
Graphite and watercolor on buff paper; $11^5/_8 \times 8^1/_2$ inches (29.6 × 47 cm)
Graphische Sammlung Albertina, Vienna
R. 239

PROVENANCE
This watercolor entered the collection of the Albertina, Vienna, in 1925.

EXHIBITIONS
After 1906: Basel, 1936, no. 71; San Francisco, 1937, no. 41; Munich,
1956, no. 75; Cologne, 1956-57, no. 35; Vienna, 1961, no. 54.

EXHIBITED IN LONDON ONLY

92 | *Mont Sainte-Victoire with Large Pine*

c. 1887
Oil on canvas; $26^5/_{16} \times 36^5/_{16}$ inches (66.8 × 92.3 cm)
Signed lower right: *P. Cézanne*
Courtauld Institute Galleries, London. Courtauld Gift
V. 454

PROVENANCE
Cézanne gave this painting to Joachim Gasquet in 1896.[2] Gasquet sold it
to Bernheim-Jeune in 1908. It then passed through the collection of Percy
Moore Turner, London, and in 1925 came into the possession of Samuel
Courtauld, who donated it to the Courtauld Institute in 1934.[3]

EXHIBITIONS
After 1906: London, 1948, no. 10; Chicago and New York, 1952, no. 52;
Edinburgh and London, 1954, no. 39; London, 1994, no. 8.

EXHIBITED IN PARIS AND LONDON ONLY

93 | *Mont Sainte-Victoire with Large Pine*

1886-87
Oil on canvas; $23^1/_2 \times 28^1/_2$ inches (59.6 × 72.3 cm)
The Phillips Collection, Washington, D.C.
V. 455

PROVENANCE
Ambroise Vollard sold this canvas in 1913 to Gottlieb Friedrich Reber.
Thereafter it passed to Paul Rosenberg, Paris, and, with the intermediation
of the Wildenstein Galleries, New York, was acquired by Duncan Phillips in
1925.

EXHIBITIONS
After 1906: Darmstadt, 1913, no. 17; Washington, Chicago, and Boston,
1971, no. 131; Los Angeles and Chicago, 1984-85, no. 131; Paris, 1985,
no. 131; Edinburgh, 1990, no. 41.

94 | *The Arc Valley*

c. 1885
Graphite, watercolor, and gouache on buff paper; $13^{15}/_{16} \times 21^{1}/_{8}$ inches (35.4 × 53.7 cm)
The Art Institute of Chicago. Gift of Marshall Field
R. 241

PROVENANCE
This watercolor belonged, until 1939, to the artist's son, Paul, in Paris. Thereafter it passed through the collection of Otto Wertheimer, Paris, to the Knoedler Galleries, New York, where it was acquired by Henry T. Mudd, Los Angeles, before again coming into the possession of the Knoedler Galleries. It next appeared in the collection of Marshall Field, Chicago, who gave it to the Art Institute of Chicago in 1964.

EXHIBITIONS
After 1906: Paris, 1907 (b), no. 33; Paris, 1935, no. 122; Paris, 1936, no. 122; Basel, 1936, no. 72; Paris, 1939 (b), no. 33; Lyon, 1939, no. 49; London, Leicester, and Sheffield, 1946, no. 18; Washington, Chicago, and Boston, 1971, no. 41; Tübingen and Zurich, 1982, no. 28.

EXHIBITED IN PHILADELPHIA ONLY

95 | *Mont Sainte-Victoire*

c. 1890
Oil on canvas; $24^{3}/_{8} \times 36^{1}/_{4}$ inches (62 × 92 cm)
Musée d'Orsay, Paris. Anticipated gift with retained life interest
V. 488

PROVENANCE
This painting was first in the collection of Auguste Pellerin. It passed by inheritance to René Lecomte and his wife, née Pellerin, Paris. It is now in the Musée d'Orsay, Paris, as an anticipated gift with retained life interest.

EXHIBITIONS
After 1906: Paris, 1936, no. 91; Paris, 1954, no. 52; Paris, 1974, no. 37; Aix-en-Provence, 1990, no. 37.

EXHIBITED IN PARIS ONLY

The period from what may be called Cézanne's "apprenticeship" with Pissarro in the 1870s (see cat. nos. 30 and 31) through the constructive phase of the years around 1880 (see cat. nos. 67-70, 75, and 76) has often been characterized as a coming-of-age for the artist, a ponderous and grand passage from his romantic explorations in the spirit of Courbet and Delacroix to his experimentation with Impressionist techniques and attitudes and, finally, to his arrival at a style and a manner of painting that were purely his own. According to this reading, whose essential plot lines were established by his earliest biographers, Cézanne, in the early 1880s, entered a period of stylistic (and by implication, psychological) growth summarized as classical, when his work might well be compared to the mature paintings of Raphael or Poussin. The degree to which this is true and is not an imposition of later sentiments and theories on what was, in fact, a very natural, organic evolution of a strong-willed artist, is far from clear.[4] What is certain is that there is a new quality of tranquillity and grandeur in the landscapes done in the second half of the 1880s, a quality best revealed in his views of the landscape around his father's house and the vast terrain to its east.

As John Rewald has noted: "The fruit of Cézanne's Parisian experiences, both visual and technical, appears in the pictures he painted on his return to the Jas de Bouffan; they constitute a virtual rediscovery of Provence. He sees it now in terms of colored planes organized in a firm, almost architectural construction, irreconcilable with the doctrines of Impressionism.

"Wherever Cézanne went in the serenely beautiful countryside around Aix, he could be sure of finding grandiose vistas, brilliant colors, and picturesque forms. From a hilltop, for example, he could look over an immense valley to the conical summit of Mount Sainte-Victoire. In

90

91

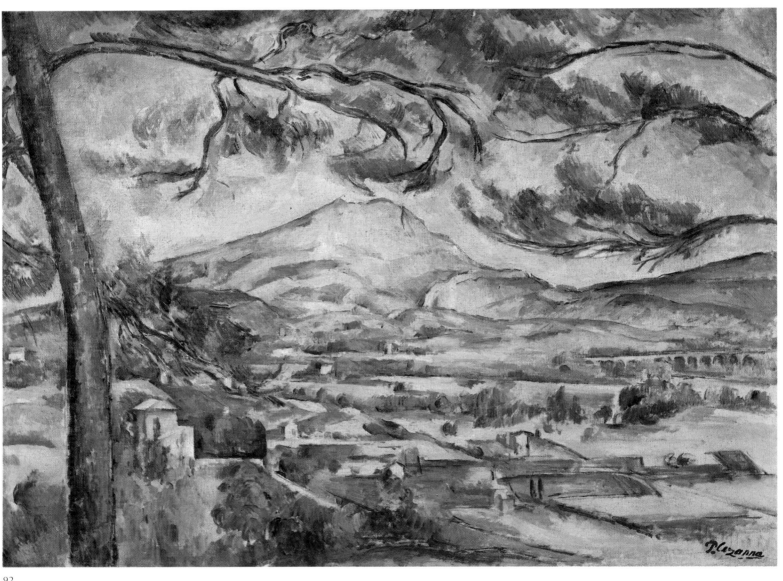

92

such a landscape, the dominant forms are so massive that the details are reduced to insignificance, and the large planes and clearly-traced line—such as those of a viaduct with open arches—lent themselves admirably to the fulfillment of Cézanne's purpose, which was 'to paint like Poussin, but from nature.' These unobstructed yet enclosed panoramas were not to be found in the North, but in Provence he had a rich and harmonious landscape always ready to hand."[5]

Rewald was referring specifically to a group of paintings, drawings, and watercolors Cézanne made at several sites near a farm called Bellevue, owned by his sister Rose and her husband, Maxime Conil, from the 1880s.[6] Located southwest of Aix-en-Provence, it was farther out from the town than the Jas de Bouffan but within walking distance for Cézanne, who often covered long distances on foot.

The prospect from this vantage has become one of the best known panoramas in the history of art. It encompasses a world familiar to Cézanne from his childhood outings with Zola and Baille in the valley of the Arc River. Mont Sainte-Victoire dominates the region, looming like a Fuji or Sinai, still and ever present. The mountain's name allegedly honors the victory of Marius over the barbarians in the first century A.D., when the river skirting the southern slopes ran red with the blood of the slain.

In the first view (cat. no. 89), the bed of a railroad carves a diagonal path across the fields; the arched viaduct that serves as its trestle across the Arc spans the middle ground on the right, backed by the long ridge called Le Cengle. Ocher-stuccoed houses and farm buildings with red-tile roofs are scattered over the valley and foothills. It is perhaps not surprising, given the sense of permanence and certitude Cézanne found in this vista, that many of its features assume the weight of its history: the train trestle transforming into an ancient aqueduct, the straight cut of the railway bed, a Roman road.[7]

Of about twenty surviving works that depict the vista from Bellevue, seven are included in this exhibition. Their vantage points differ, but all show the view from a rise of ground, looking east toward the mountain, often from a pine forest. The views of the mountain discussed here range in date from 1882 to 1890; Cézanne would undertake another campaign to depict the mountain, from 1901 until his death in 1906 (see cat. nos. 200-206).

When H. O. Havemeyer first saw the painting now in the Metropolitan Museum of Art (cat. no. 89), he is reported to have said: "I wonder what there is in it that reminds one of so many things."[8] So much of what had gone before—Cézanne's feelings about Provence, the painting techniques he had evolved—is abundantly revealed in this one picture. Of the sequence of works looking down and out from this wooded ridge, the Havemeyer painting is the most completely worked and specifically detailed. The brushwork is very evenly paced, with short directional strokes animating the entire canvas. The effect of this densely yet quickly worked surface unifies the composi-

tion, so that the background elements have the weight and monumentality of those in the foreground (given this work's prominent position in New York, this formal feature has been seen as influential for developments in abstract painting some sixty years later). Richard Shiff, for example, has eloquently described the way in which the delicate lower branch of the central pine tree "appears not so much in front of and above the valley, but embedded in it. This visual effect has a material cause: some of the paint strokes articulating the branch have been overlaid by those defining the fields, so that 'foreground' and 'background' appear to, and in a very physical way quite nearly do, occupy one and the same position."[9]

While this particularly nimble brushwork tends to flatten the image into the picture plane, it also creates a very stately sense of the vast panorama, pacing each move through and into the space in a tranquil, unhurried rhythm. Meyer Schapiro, too, has described the effect of this masterful unity of technique and composition: "With so many diagonals, there are none that converge in depth in the usual perspective foreshortening. On the ground plane of the landscape, Cézanne selects diagonals that diverge from the spectator towards the sides of the canvas and thus overcomes the tension of a vanishing point, with its strong solicitation of the eye. In the roof in the foreground, he has run together the gable and ridge as a single slope, parallel to the diagonal paths, in defiance of perspective rules. The depth is built up by the overlapping of things and through broad horizontal bands set one above the other and crossed by the vertical tree and the long diagonals."[10]

The mountain itself is farther off center than in any of the other works in this group. Its distant form, half-hidden by the dense screen of trees on the left, rises from the undulating foothills like a great boulder from the sea; then it, too, encounters and must react to the single pine in the center, whose green crown is thrown into relief by the delicate lavenders, pinks, and off-whites of the sky.

A large drawing in Rotterdam (cat. no. 90) also treats the relationship of the single pine to the viaduct, the ridge of Le Cengle, and Mont Sainte-Victoire. It is a beautifully composed sheet; and is closely related to both the Havemeyer painting and another canvas in a private collection (V. 453). A comparison of the views reveals that Cézanne climbed up and down the steep incline above the pine tree, testing the different vantages and the compositions they offered. From this elevation, the boughs appeared in profile, and the artist clearly enjoyed the lyrical interplay of their forms against the swelling lines of the mountains beyond.

To compare the drawing to the Havemeyer painting is to introduce an unanswerable question of the relationships between Cézanne's works in different mediums. The similarity of this drawing to the Havemeyer canvas might suggest it to be a preparatory study, a literal record to be adapted and refined into a more ambitious work in color.

More telling, however, are the differences between the two works, for while the relationship of the tree boughs to the profile of the mountain on the left in the drawing mirrors that of the painting, the right half in no way matches. In the drawing the lower right branch of the tree is aligned with the viaduct, while in the oil this same gently arching bough appears well below it. Each work, in the end, is a product of direct observation from a carefully chosen spot on the hillside; neither retreats from the effectiveness of conveying the vivid nature of this magical place.

It is tempting, yet fraught with difficulties, to trace Cézanne's physical movements up and down the hills in his search for a slightly different perspective for his landscape motifs. A richly colored watercolor formerly in one of the sketchbooks and now in the Albertina, Vienna (cat. no. 91), seems to show the same lone pine. The bend of the limbs and their turning in space indicate that Cézanne's vantage point is much higher and to the right (the south), a placement confirmed by the new relationship of the foliage to the viaduct and Le Cengle beyond. However, Mont Sainte-Victoire is excluded from view to the left, allowing the pine and the viaduct to become the primary subjects. In this sense, the Vienna watercolor connects most directly with those heroic paintings in which the pine tree itself becomes the primary feature and not the noble accomplice to the mountain (see cat. nos. 153 and 154).

The canvas in the Courtauld Institute (cat. no. 92) was painted about a quarter of a mile north of the vantage for the Havemeyer picture. The trees on this slope are sparser and the mountain takes center stage. This shift in viewpoint yields a broader vista, stretching out with an amplitude and horizontal ease very unlike the Havemeyer picture. The larger scale and wider proportions of this painting bring to mind a view of L'Estaque in the Art Institute of Chicago (cat. no. 114); each commands a full-voiced, broadly read gesture. The handling is both more summary and more transparent than that of the Havemeyer painting. Elements picked out in the landscape waver forward and back amid the fields of alternating greens and ochers. The viaduct and its arches have become less assertive than in other depictions; the rolling rhythm of the ridge to the right sets up a pattern of easily spaced curves across the distance, and the shift from the green of the valley to the gray blue of the mountainside develops in a very understated and gradual manner. With vigorous, albeit relaxed brushstrokes the artist has evoked the somnolent atmosphere of a warm summer day in the Midi.

Eccentrically, in terms of Cézanne's earlier compositional devices, but completely in accord with his intentions here, he has introduced a great sweep of pine boughs across the top of the picture and the vertical column of an unanchored tree trunk on the left. This proscenium places the viewer just beyond the footlights in Cézanne's stagecraft, overlooking the floor of the valley, but far enough back that the grand sweep of the valley is at its full effect.

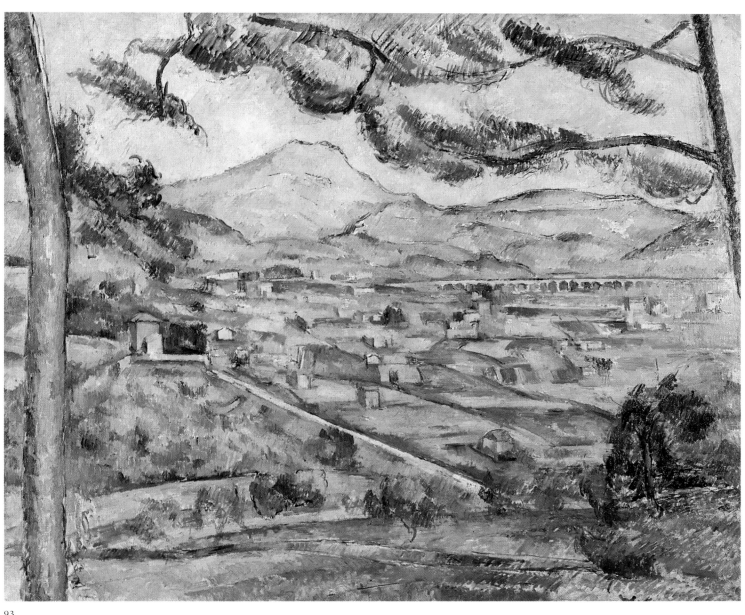

93

94

Many have sensed that the device of the repoussoir of the playfully interlocked boughs is somehow Japanese in its origins, but as Rewald has noted, Cézanne, of all his colleagues, probably had the least contact with Oriental art.[11] It seems more likely that the use of tree branches as a theatrical scrim developed directly from his early spatial experiments in the company of Pissarro; the technique is found in many Corot landscapes, where a view into deep space is introduced and controlled through foliage seen close in. In a similar manner, the loosely brushed boughs and sensuous branches in the Courtauld canvas establish a lyrical note at the threshold of the picture that reverberates through the entire landscape and up the side of the mountain. The dark brown of the trunk and intense green of the needles set up a very effective contrast to the luminous, nearly silver radiance of the mountain and the adjacent sky. The final effect is one of a tranquil release into a dazzling panorama.

Exceptional for a Cézanne of this period, the painting is signed. One explanation for this is provided by his early biographer Joachim Gasquet. In 1895 Cézanne submitted two paintings to a modest exhibition in Aix. The young Gasquet, introducing himself, enraged the artist by overly admiring this work and, finally, on convincing him of his sincerity, was amazed when Cézanne not only gave him the landscape but signed it as well.[12] The accuracy of this account may be subject to question (Gasquet, as close as he was to Cézanne, had a propensity for embellishing the truth), but the work is signed and its eventual sale by Gasquet is documented. Lending further credibility to his story of this first and very emotional encounter with Cézanne over the picture is Gasquet's very sympathetic and insightful record (itself perhaps also a fiction drawn from true experience) of the genesis of this painting:

"This is the landscape Cézanne was painting. He was at his brother-in-law's. He had planted his easel in the shade of a clump of pines. He had worked there for two months, one canvas in the morning, one in the afternoon. The work was 'going well.' He was cheerful. The session was almost over.

"The canvas slowly became saturated with equilibrium. The preconceived and pondered image, linear in its rationale, and which he must have sketched out in charcoal with rapid strokes, as was his custom, already stood out from the colored patches that everywhere surrounded it. The landscape seemed to shimmer, for Cézanne had slowly circumscribed each object, sampling, so to speak, each tone."[13]

From almost the same vantage point, Cézanne painted the view from Bellevue in the Phillips Collection (cat. no. 93) with very different results. The proscenium of pine boughs and the strong vertical trunk in the left foreground are clearly the same as in the Courtauld painting, but the frame is shifted downward, the horizon raised, inducing the sense that one is looking up at the profile of Mont Sainte-Victoire. The compositional rigor of the strong horizontal line of the viaduct and the diagonal strip of the roadbed are reminiscent of the Havemeyer picture, as is the sharp articulation of each building and field within the valley. But Cézanne's palette is lighter here, and the paint is applied with spare, quick strokes that allow much of the white priming to show through. The result of these fine adjustments is a sense of luminescence emerging from every element in the landscape. This quality held particular appeal for one owner of this painting, Duncan Phillips, himself a painter, who wrote: "The 'Mt. St. Victoire' is as ordered and pondered a construction as a Greek temple. . . . Every stroke was laid on with thought and the canvas was left uncovered here and there with intention. The constructive function of color and its organization of design could best be revealed in such a laying bare of process."[14]

It is perhaps this work's rare luminosity that has prompted many authors to write about it in unusually exalted terms, bordering on the mystical. Lionello Venturi noted of this work: "The new trend of Cézanne was towards abstraction, but his order was essentially different from everything that had been done before, because he did not impose his order on his sensations but tried to find order in his sensations. In other words, he did not close his colors and lights within a preconceived form, but extracted a new form from his masses of colors, thus letting order and sensation coincide."[15]

A large watercolor (cat. no. 94), now in Chicago, is related to the Phillips and Courtauld paintings; the correlation is so close, in fact, that Rewald maintained that Cézanne probably "executed this watercolor before tackling the oils of the same subject."[16] All the essential elements of the larger compositions are here, albeit in rather skeletal form. The tonal balance of the watercolor is established with thin washes of green, ocher, and blue. Highlights of Chinese white on the mountain suggest the opalescent quality it would have in the oils, particularly the one in the Phillips Collection. The composition was established and the essential features were set on the page with loose and rather playful pencil lines before the application of color. The addition of a whitewash allowed the

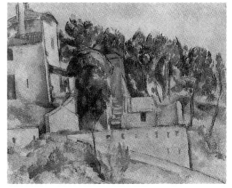

Fig. 1. Paul Cézanne,
The House at Bellevue, c. 1890,
oil on canvas,
Musée d'Art et d'Histoire
de la Ville, Geneva (V. 655).

exposed paper (now slightly discolored to a yellow tan) to take on a luminosity that moves evenly from land to sky.

A sense of miniaturization, at once charming and a little perplexing, suffuses the sheet, as if the huge vistas familiar to us through the paintings are here seen through the wrong end of a telescope.

Quite distinct from the Havemeyer, Courtauld, and Phillips paintings is another whose vantage point may well be one of the terraces of Cézanne's brother-in-law's house (see fig. 1). The Musée d'Orsay canvas (cat. no. 95) shows a very similar view that includes the viaduct, but the diagonal roadbed is obscured by foliage in the foreground. There is, both optically and psychologically, a reorientation of the landscape features, particularly the flank of the mountain, into a more frontal plane. This is reinforced by the familiar repoussoir of pines and the horizontal accent of the retaining wall (part of the terrace?) across much of the foreground. The tonality and handling of the landscape, too, differs markedly from the three other paintings, which are thought to have preceded this picture by as much as five or six years. Cézanne's primary landscape colors—green, ocher, and blue—have been blended and undercut by shades of lavender and a sharp chartreuse yellow that brightens the center of the painting and draws the viewer's gaze through the foreground barrier of wall and trees. The handling is less crisp than in the earlier oils; the pigments are smoothly applied and rubbed into one another, affording a suave and polished quality.

At the risk of attributing to this painting an observation relevant to his work of some ten years earlier, there is something autumnal about this work. Its elements are infused with golden and feeble light. The grandeur and tranquillity of the vista that held his interest for so long has here, perhaps, found its final moment of articulation from this vantage. When he would return to the mountain as his primary subject (see cat. nos. 200-206 and fig. 2) toward the end of his life it would be with a tonal range much closer to this painting than to those that came before.

J. R.

1. See Weitzenhoffer, 1986, pp. 142-43.
2. See Rewald, 1959, p. 20.
3. See John House, in London, 1994, no. 8, p. 72.
4. The relation of Cézanne and his work to motions of classicism has been much explored. See especially Reff, 1960; and Shiff, in Kendall, 1993, pp. 51-68.
5. Rewald, 1958.
6. The dates of the purchase of these properties remains uncertain; see Rewald, 1986 (a), pp. 158-59, 269.
7. See Phillips, 1931, p. 124.
8. Vollard, 1936, p. 142.
9. Shiff, in Kendall, 1993, p. 58.
10. Schapiro, 1952, p. 66.
11. See Rewald, 1983, no. 241, p. 142.
12. See Gasquet, 1921, p. 54.
13. Ibid., p. 79.
14. Phillips, 1931, p. 94.
15. Kimball and Venturi, 1948, p. 194.
16. Rewald, 1983, no. 241, p. 142.

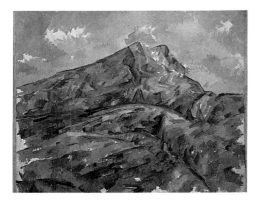

Fig. 2. Paul Cézanne,
*Mont Sainte-Victoire Seen from
the Château Noir,* c. 1904,
oil on canvas,
Edsel & Eleanor Ford House,
Grosse Pointe Shores, Michigan (V. 665).

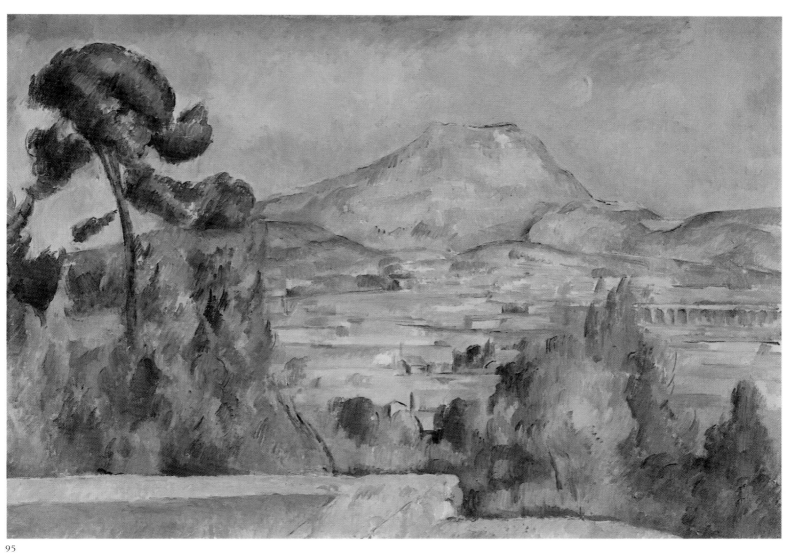

95

Mont Sainte-Victoire

1885-87
Graphite and watercolor on buff paper; $12^{1}/_{4} \times 18^{1}/_{2}$ inches (30.9 × 46.7 cm)
Fogg Art Museum, Harvard University Art Museums, Cambridge, Massachusetts.
Gift of Mr. and Mrs. Joseph Pulitzer, Jr., in honor of Agnes Mongan
R. 281

PROVENANCE
This watercolor first belonged to Eugène Blot; it was sold at the Hôtel Drouot, Paris, on June 2, 1933 (lot 3). By 1936, it was in the possession of the dealer Alfred Daber, Paris,[1] from whom it passed to Paul Cassirer, Amsterdam. Thereafter it passed through the collections of Erich Maria Remarque, Ascona (through 1956), and Walter Feilchenfeldt, Zurich. It was subsequently acquired by E. V. Thaw and Co., New York. On January 12, 1968, it was purchased by Mr. and Mrs. Joseph Pulitzer, Jr., St. Louis.[2] In 1977 it was given to the Fogg Art Museum by Mr. and Mrs. Pulitzer in honor of Agnes Mongan, curator of drawings and director of the museum.

EXHIBITIONS
After 1906: Copenhagen, 1914, no. 233; New York, 1943, no. 30 or 32; Chicago and New York, 1952, no. 101; The Hague, 1956, no. 71; Zurich, 1956, no. 111; Munich, 1956, no. 86; Tübingen and Zurich, 1982, no. 32.

EXHIBITED IN PHILADELPHIA ONLY

Cézanne's movements in search of landscape motifs in northern France are relatively well documented. He is known to have worked for varying lengths of time at various points along the Seine, on the Marne, and in villages and forests north and south of Paris. By contrast, in the South he resided for the most part only at three addresses in the course of his life, yet he explored the landscape around Aix with great persistence, searching for a new angle or an effect of light that would satisfy him as a subject. This is most apparent in his views of Mont Sainte-Victoire. Most of his depictions of the mountain fall into three geographic groups: those probably made in the vicinity of his brother-in-law's property at Bellevue (see cat. nos. 89-95), those made at sites near the Tholonet road (see cat. nos. 175-76), and the final heroic profile views painted in the hills above his studio on the Chemin des Lauves (see cat. nos. 200-206).

A fourth and smaller group of works presents a view from yet another vantage, one that has proved more difficult to locate but was clearly situated in the valley, much nearer to the mountain. In the present watercolor, as well as in two others (R. 279-80), the summit looms powerfully, with the ridge of Le Cengle rising on the right to a greater height as a result of the closer, lower viewpoint. The foothills create a saddle from which the peak itself rises. A bare pistachio tree and a summarily indicated house mark stages into depth, which—given the composition's spare color and the absence of topographic detail—is quite convincing and lucid.

Cézanne first drew a few pencil lines to establish the forms over which he applied the watercolor with even, fluid strokes. The spacing of his brushwork on the white of the paper is less regularized than in his earlier watercolors, establishing an ample, almost languorous rhythm that suits the breadth and uncluttered comfort of his vista.

J. R.

1. See Venturi, 1936, vol. 1, no. 1021, p. 267.
2. See Charles Scott Chetham et al., *Modern Painting, Drawing, and Sculpture Collected by Louise and Joseph Pulitzer, Jr.* (Cambridge, Massachusetts, 1971), no. 154.

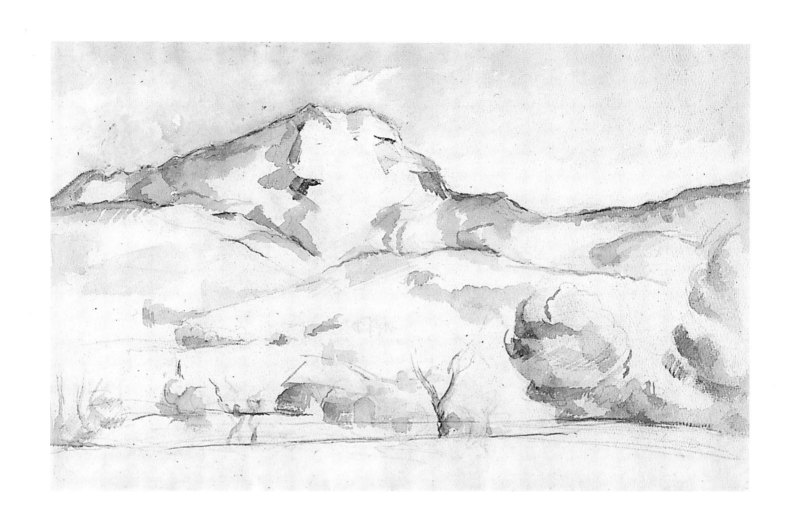

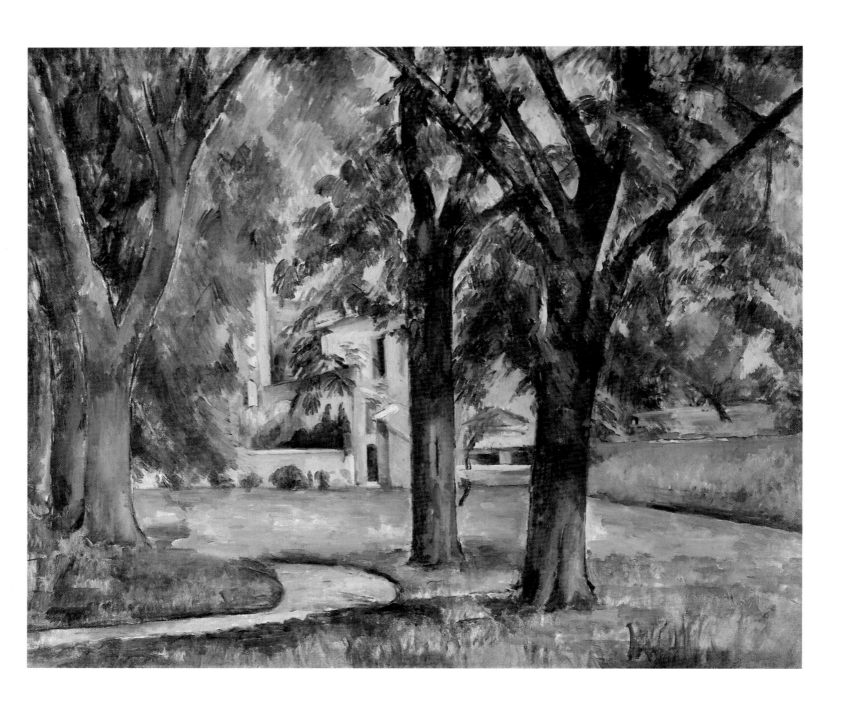

97 | *Chestnut Trees and Farm at the Jas de Bouffan*

c. 1885
Oil on canvas; 25⁹/₁₆ × 31⁷/₈ inches (65 × 81 cm)
Private collection
V. 467

PROVENANCE
Gustave Geffroy may have purchased this painting from Ambroise Vollard in April 1896.[1] It then entered the collection of Henri Bernstein, Paris. Vollard reacquired it at the Bernstein sale at the Hôtel Drouot, Paris, on June 8, 1911 (lot 6). It then passed through the hands of, in turn, Hans Wendland, Berlin, Paul Cassirer, Berlin, and finally Mme Henry P. Newman, née von Duering, Hamburg. It then entered a private collection. In 1968 it was acquired through the Wildenstein Galleries by another private collector.

EXHIBITIONS
After 1906: Paris, 1910, no. 8; Berlin, 1921, no. 26; Washington, Chicago, and Boston, 1971, no. 12.

EXHIBITED IN PHILADELPHIA ONLY

The walk down the allée of trees behind the Jas de Bouffan ends in a circular promenade bordered by chestnut trees. For this painting Cézanne planted his easel beneath them, in a spot that afforded him a glimpse of the main house—one of its blue shutters is just visible on the left—as well as a fuller view of the adjoining farm buildings. The wall to the right marked the eastern boundary of the inner compound of the Cézanne property, setting it apart from the vineyards and fields beyond.

These spaces, which had been familiar to Cézanne since his early twenties, provided a tremendous attraction for him in the mid-1880s. They offered him motifs for some of his most ambitious landscapes of that decade, when Cézanne was achieving an artistic maturity that would enable him to instill them with a new breadth and complexity. The geometry of the buildings, the screen of trees, and the enclosing wall were explored in several mediums over a range of seasons to a great variety of formal and expressive ends.[2]

The present composition is the most firmly contained of the paintings Cézanne made from the chestnut allée; it is also the most dramatic. It harbors intimations of anxiety and thwarted release that bring to mind some of the landscapes produced earlier in the decade in northern France,

such as *Turn in the Road* (cat. no. 76). As in that work, walls and paths strike strong directions only to have their trajectories countered by others—tree trunks or corners of buildings—intersecting at right angles, a compositional device that frustrates conventional perspectival resolution. Nothing is seen whole, especially the farm buildings, which in a less ambitious and idiosyncratic picture would have been the unambiguous subject. The overall shape of these structures must be pieced together from visual fragments.

We are not in the Île-de-France but in Provence, whose intense sunlight made it possible for Cézanne to imagine spatial effects of remarkable and sometimes unnerving clarity, achieved primarily through the manipulation of color. The abrupt transition from the shadowed arbor supported by nearly black tree trunks to the brilliantly lit yellow-green lawn beyond is one of the most dramatic that he would attempt in the 1880s, and recalls in many ways the nearly reckless work he did in the same garden some fifteen years earlier (see cat. no. 24). The rapid application of thin pigment, brushed on in directional waves of little discernible order, brings to mind the bravura and haste of those early southern landscapes. But even in a work with a pitch and a drama as high as this one, there is a sense of competence and confident control of his means that allowed him to manipulate color in a more heroic and resolved manner than in anything he had undertaken earlier.

J. R.

1. See Rewald, forthcoming, no. 538.
2. See Barskaya, 1975. See also V. 38, V. 47, V. 160, V. 162, V. 460–61, V. 463–67, V. 471, V. 480, V. 648, R. 111–13, and cat. nos. 59 and 113.

The Allée and Houses at the Jas de Bouffan

1884-87
Graphite on paper; 12^{1}/$_{6}$ × 18^{13}/$_{16}$ inches (30.7 × 47.8 cm)
Museum Boymans–van Beuningen, Rotterdam
C. 916

PROVENANCE
This drawing was first in the collection of Franz Koenigs, Haarlem. In 1940 he sold his entire collection of drawings to D. G. van Beuningen, who donated a portion of it to the Museum Boymans.

EXHIBITIONS
After 1906: Berlin, 1927 (b), no. 58; Rotterdam, 1933-34, no. 9; Amsterdam, 1946, no. 15; Washington, Chicago, and Boston, 1971, no. 73; Liège and Aix-en-Provence, 1982, no. 40.

This large drawing, beautiful in its complexity, was made from nearly the same vantage as the sketchbook page from a few years earlier (cat. no. 84). In the previous decade, Cézanne had depicted the same allée of chestnut trees behind his father's house, but from the other end (cat. no. 59); the abundant foliage on the trees in that watercolor makes clear that it was done in another season. Here, the artist has placed himself in the circular terminus of the allée and immediately in front of the little fountain that marked its center. He was looking back toward what Fritz Novotny identified as a garden tower (it no longer stands),[1] or, more likely, toward the ornamental gates that marked the northern boundary of the walled property surrounding the house and opened, in Cézanne's time, to vineyards on the far side of the road. Through the trees on the right can be seen the facade and terrace of the main house, adjoined by farm buildings. The ornamental pool, which played a dominant role in other depictions of this contained landscape (see cat. no. 53), is only suggested to the left.

As opposed to the earlier watercolor (cat. no. 59), which shows a view shifted slightly to the left of center, allowing a charming syncopation of formal rhythm that plays out on a bias, tree to tree, this drawing is nearly a bull's-eye view to a vanishing point, and its rush into depth is reinforced by the orthogonal borders of the gravel path. But the schematism of this perspective is relieved by the natural irregularity in the placement of the trees, and its plunging effect is mitigated by two long shadows and the line of the terrace in front of the main house that traverse the vista horizontally.

The trunks and larger limbs of the trees are turned in space with a precision and an assurance of draftsmanship that Cézanne, at this point in the mid-1880s, had brought under full command: a cursory band of pencil strokes for a shadow across and around a trunk, five or six hatched lines to darken a juncture. Yet as the eye takes in the vista, the density of the drawing abates, resolving into a delicately

99

woven network of lines that brings several of the branches nearly to the top of the sheet. For Venturi this is Cézanne's *Winter's Tale:* "It was only in 1885 that he managed to express in this motif the plastic force of emptiness, . . . the power of trees in their struggle against the wind, and their grandeur, which is even touched by sadness when the winter has stripped them bare."[2]

<div align="right">J. R.</div>

1. See Novotny, 1938, p. 200.
2. Venturi, 1978, p. 92.

99 | *Landscape*

1884-87
Graphite on yellowish gray paper;
$13^9/_{16} \times 20^5/_8$ inches (34.5 × 52.4)
Trustees of the British Museum, London
C. 917

and watercolours that the son of Paul Cézanne had brought in for sale. We just had time to go through them, selected fifty, many of them familiar from reproduction in Vollard's book, gave him a cheque for £250 and dashed to the station with our portfolio."[1] In April of 1952 this drawing was presented to the British Museum through the National Art Collections Fund.

The uncultivated and random patterns of these trees discourage any identification with the formal chestnut allée in the park of the Jas de Bouffan. Indeed, comparison of this sheet with another drawing of that site (see cat. no. 98) reveals just how wild and romantic is the present motif. A faintly indicated form on the left could be a boulder or a clump of thick bushes, while the leafless branches of the trees have an agitated, flame-like quality. The suggestion of a high ridge in the distance gives the composition a hemmed-in feeling, adding to the disquieting atmosphere. The one note of civilization, a cottage visible between the trees in the center, seems remote and isolated, especially given the empty expanse in the foreground.

<div align="right">J. R.</div>

1. Sir Kenneth Clark, *Another Part of the Wood: A Self-Portrait* (New York, 1975), p. 240.

c. 1885
Graphite, gouache, and watercolor on beige yellowed paper;
9¼ × 12¹/₁₆ inches (23.5 × 30.7 cm)
Musée du Louvre, Paris. Département des Arts Graphiques. Musée d'Orsay,
bequest of Comte Isaac de Camondo
R. 194

PROVENANCE
This watercolor, which belonged to Victor Chocquet, was sold with the rest of his collection on July 1-4, 1899, at the Galerie Georges Petit, Paris (not in catalogue). It may have been purchased at this sale by Comte Isaac de Camondo, who bequeathed it to the Louvre in 1911.[1]

EXHIBITIONS
After 1906: Paris, 1933, unnumbered; Aix-en-Provence, Nice, and Grenoble, 1953, no. 35; Paris, 1954, no. 69; Paris, 1974, no. 56.

EXHIBITED IN PHILADELPHIA ONLY

A small greenhouse once stood in the park of the Jas de Bouffan, near the back entrance to the house and adjacent to the ornamental pool. It was a secluded place in which Cézanne could work undisturbed when the weather was harsh during those winters he spent in Provence in the 1880s. Several watercolors and at least two paintings were produced there around 1885 (fig. 1 below, and p. 329, fig. 1).[2] It may also be the "conservatory" in which Madame Cézanne sat in the early 1890s for her unfinished portrait now in the Metropolitan Museum of Art (fig. 2).

In contrast to Cézanne's complex and heroic still lifes of fruit and household objects, his paintings of flowers assume a distinct and different role in his oeuvre. While their lighting effects and compositions are carefully judged, they have a casual air very much at odds with his more formal still lifes, a quality that links them to the flower paintings produced by his Impressionist colleagues in the 1870s. It is for this reason, perhaps, that this watercolor has struck several writers as a retrogressive production, one that looks back to the decorative highlights and reflective shadows of

Impressionism in general and Cézanne's own work of a decade earlier in particular.[3] But this sheet has qualities that are more studied than many of his more relaxed representations of potted plants, and that evoke some of his more ambitious later paintings.

Ten terracotta pots of various sizes are aligned on a narrow shelf. They contain a motley grouping of geraniums which, judging from the sparseness of their leaves and the legginess of their stalks, are near the end of their winter dormant cycle. Pale sunlight filters through glass from the upper left, losing intensity as it traverses the sheet. The brightness of the left side, rendered by the bare paper and the transparency of intermittent strokes of color, is countered on the right by progressively heavy build-ups of thin washes, notably a dense blue used to suggest shadows across the wall, onto the pots, and into the space under the shelf. The layering of mediums and colors is evident, yet each stage is completely legible, unfolding over time. It is, in one sense, a remarkably understated depiction of light effects—and the introspective mood they engender—on a winter afternoon in the South. But if this work is consistent with the Impressionist program to capture transient effects, it also carries poetic evocations that lift it above such specificity.

The branches of the plants reaffirm the two-dimensional plane of the wall, all their leaves turned in the same direction in search of the winter sun. The bracket beneath the shelf—the picture's fulcrum point—is just right of center, and the wooden shelf buckles slightly to its left, as if in

Fig. 1. Paul Cézanne,
Potted Geraniums, c. 1885,
graphite and watercolor on paper,
collection of Mr. and Mrs. Paul Mellon,
Upperville, Virginia (R. 213).

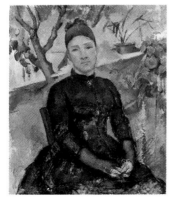

Fig. 2. Paul Cézanne,
Madame Cézanne in the Conservatory, 1891-92,
oil on canvas,
The Metropolitan Museum of Art, New York,
Stephen C. Clark Collection (V. 569).

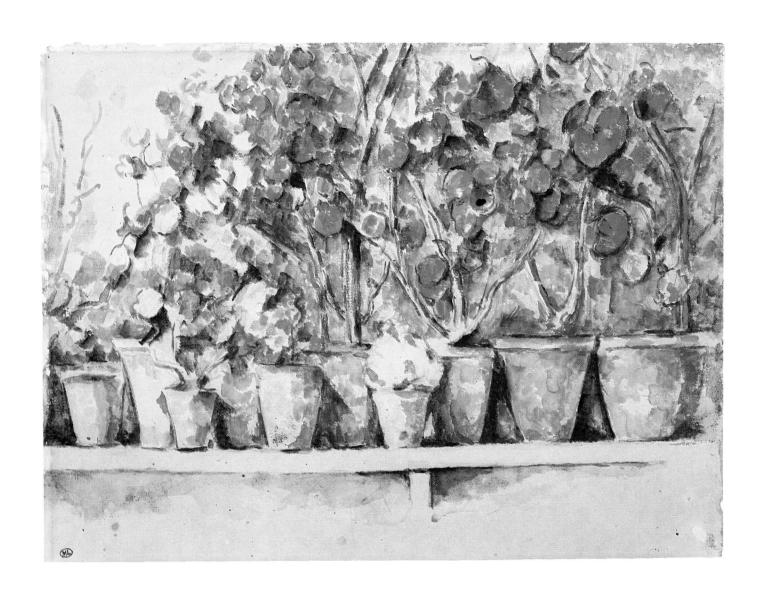

response to the light descending from above. There is not enough room for the pots to align comfortably on their shallow perch; the smaller ones nestle precariously beneath the larger ones, threatening to tumble to the ground. In other words, this is not only a study of lyrical light effects but also an image of nature confounding human attempts to domesticate it.

<div align="right">J. R.</div>

1. See Musée National du Louvre, Paris, *Catalogue de la Collection Isaac de Camondo* (Paris, 1922), p. v.
2. Other works include R. 211-12, R. 214, R. 216-21, and V. 198.
3. See Albert Chatelet, in Paris, 1954, no. 69, p. 28.

101 | *Madame Cézanne (Hortense Fiquet) with Hortensias*

c. 1885
Graphite and watercolor on paper; 12 × 18¹/₈ inches (30.5 × 46 cm)
Private collection
R. 209

PROVENANCE
Originally owned by Cézanne's son, Paul, this watercolor passed through the dealer Bernheim-Jeune and into the collections of Charles Vignier, Paris, and Charles Gillet, Lyon. It was in the possession of Heinz Berggruen, and is now in a private collection.

EXHIBITIONS
After 1906: New York, 1911, no. 19; New York, 1916, no. 17; Tokyo, Kyoto, and Fukuoka, 1974, no. 68; Tübingen, 1978, no. 51; Tübingen and Zurich, 1982, no. 85.

EXHIBITED IN LONDON ONLY

When this sheet was drawn, Hortense Fiquet had been with Cézanne for some fifteen years. She was his most patient and frequent model (see cat. nos. 47, 112, 125, 126, 138, and 167). More often than not, his drawings of her were taken unawares when she was either asleep or just waking, as here. John Rewald was sparing in his praise of the expressive qualities of Cézanne's art, but of this sheet he wrote: "While [the hydrangea] is a statement of remarkable delicacy, the true miracle is the exquisite tenderness revealed by the head of Hortense Cézanne, a tenderness found in very few likenesses of Cézanne's most constant model."[1] The flower is no less delicately rendered, the addition of light washes of watercolor making, in the mind's eye, a subtle transition to the study of Hortense, where the pencil drawing is of such refinement and the modeling so gentle that it, too, seems about to take on color.

Hydrangeas were especially popular in the late nineteenth century, and they flourished in the Midi. The French word for this plant is *hortensia*, which occasioned the charming verbal-visual pun that makes this page so winning, giving it something of the quality of a valentine. The affection underlying the gesture is clear, and it tells one much about a playful side to his relationship with Hortense, which is often pushed aside in an attempt to make him into the troubled, isolated titan.

This work disconcerted early critics of Cézanne: it was not "difficult" in the way his productions were supposed to be. In juxtaposing a lovely, sleepy-eyed woman and a blooming flower on a single sheet, he clearly seemed to be regressing to a sentimentality linked to a rejected age.[2] But, in fact, such moments of tender regard are often to be found in Cézanne's works, especially in his drawings. This work more than most is completely captivating in the magical way the two images happily share the same page while retaining a precise independence.

<div align="right">J. R.</div>

1. Rewald, 1983, no. 209, p. 135.
2. Ibid.

101

c. 1885
Graphite, watercolor, and gouache on paper; 19 × 12 inches (49 × 30.7 cm)
Musée du Louvre, Paris. Département des Arts Graphiques.
Musée d'Orsay, bequest of Comte Isaac de Camondo
R. 193

PROVENANCE
Ambroise Vollard sold this watercolor to Comte Isaac de Camondo, who bequeathed it to the Louvre in 1911 with the rest of his collection.

EXHIBITIONS
Before 1906: Paris, 1895, unnumbered.
After 1906: Paris, 1933, unnumbered; Paris, 1954, no. 70; The Hague, 1956, no. 63; Zurich, 1956, no. 100; Munich, 1956, no. 78; Tokyo, Kyoto, and Fukuoka, 1974, no. 70; Paris, 1974, no. 58.

EXHIBITED IN PARIS ONLY

Flat decorative patterns play an important role in Cézanne's art. Rococo-revival screens and furniture, floral wallpapers, and stenciled decorations enliven the backgrounds of his still lifes and portraits, introducing new and often subtle elements into his compositions. As he grew older, he became increasingly fascinated by the challenge of depicting patterned fabrics illusionistically in complex folds while retaining the sense of the essential flatness of their designs. It was partly for this reason that large pieces of woven cloth, carpets, or tapestry fragments were introduced into his repertory of still-life objects (see cat. nos. 180, 181, and 216) to enrich and aggrandize what otherwise would be an arrangement of mundane objects. The same fabrics reappear in some of the portraits, theatrically draped behind the sitters or even in their laps (see cat. nos. 167, 187, and 188). Some of these props survive in his studio at Les Lauves. Scholars have attempted to use the identification of such fabrics as a basis for dating the works in which they appear, but with little success.

The watercolor from the Camondo collection depicts a heavy woven fabric—apparently North African or Near Eastern—drawn back by tasseled cords to reveal a wall and a closed door a short distance beyond. The image is enigmatic, for, despite the calculated effect of improvised stage trappings, nothing has been staged within them. The drape itself is the subject, observed in the spirit of recording that Cézanne usually reserved for his sketchbooks. To

add to the mystery, no more ambitious picture for which this sheet could have been a direct preliminary study has come to light. This is an image that is going nowhere, one we are quite content to observe with the same neutrality Cézanne exercised when he sat down to depict it. The point is made clearer, perhaps, by comparison with another, later watercolor of a different drape (fig. 1). This sumptuous image, which he would repeat as an oil painting as well (fig. 2), is clearly arranged as a formal prop, probably for *Mardi Gras* (repro. p. 63). Despite obvious discrepancies in the fabric and the pattern of the folds in our watercolor, this draped passage could be the same location where Paul *fils* and his young friend, dressed in *commedia dell'arte* costumes, posed for *Mardi Gras*. Perhaps this draped door was indeed in the furnished apartment on the quai d'Anjou, Paris, which Cézanne rented from 1888 to 1890, for nothing this heavy or bourgeois is typical of his residences in Aix.

J. R.

Fig. 1. Paul Cézanne,
Study of a Curtain, 1888-90,
graphite and watercolor on paper,
private collection (R. 296).

Fig. 2. Paul Cézanne,
The Curtain, 1888-90, oil on canvas,
Abegg Foundation,
Riggisberg, Switzerland (V. 747).

103 | *Bather with Outstretched Arms*

1877-78
Oil on canvas; $28^{3}/_{4} \times 23^{5}/_{8}$ inches (73×60 cm)
Private collection
V. 549

PROVENANCE
Ambroise Vollard sold this painting to the Galerie Bernheim-Jeune, which sold it to Auguste Pellerin. It passed by inheritance to M. and Mme René Lecomte (née Pellerin), Paris, and is now in a private collection.

EXHIBITIONS
Before 1906: Paris, 1895, unnumbered.
After 1906: Paris, 1954, no. 54; Basel, 1989, no. 48.

Fig. 1. Paul Cézanne,
Bathers at Rest, 1875-76,
oil on canvas,
The Barnes Foundation, Merion,
Pennsylvania (V. 276).

This picture and its larger companion now in the Museum of Modern Art (cat. no. 104) are among the most discussed yet least explained of all Cézanne's works. Both clearly derive from the central figure, posed in bathing trunks, in the *Bathers at Rest* in the Barnes Foundation (fig. 1). There is also a group of related works—at least four small oil sketches (see fig. 2) and several drawings—that allow us to observe Cézanne modifying the figure and handling the theme with variations. Views on their respective dates differ, but it seems reasonable to affirm that the subject held the artist's interest for the better part of a decade.

Despite all the visual evidence, the key to unlock the mystery of these images remains elusive. As Reff noted in the introduction to his probing article on the *Bather with Outstretched Arms*, when it comes to "the study of the personal content of Cézanne's art, few pictures are more difficult to interpret yet ultimately more revealing than the series representing a solitary male bather with arms extended stiffly from the body. . . . He seems less a bather than a sleepwalker absorbed in his dream. . . . Yet the whole is carefully constructed, the curving contours of the distant shore echoing those of the legs, and the arms fitting precisely into the rectangle of sky. The figure itself is like a colossal statue in its massive compact shapes, built up through many finely graded tones applied in tiny parallel strokes. Thus it claims our attention equally as a powerful construction and as an enigmatic image, elemental in its nudity and stark isolation."[1] Reff speculated further that the figure might be "a projection of Cézanne himself, an image of his own solitary condition,"[2] suggesting that it was "possible to link it with a specific theme in his own fantasy life,"[3] namely his sexual anxiety, fueled by unresolved conflicts with his authoritarian father, from whom he kept his liaison with Hortense Fiquet a secret as long as possible. The theme is essentially a projection of the artist onto his youth as a means of sexually liberating himself from the oppression of his father and his own marital conflicts.

Many others have attempted to make sense of this compelling image, and the curious disposition of the figure's arms. Few have taken their argument as far as Reff's thoughtful and personal approach, but a consensus

Fig. 2. Paul Cézanne,
Bather with Outstretched Arms, 1883,
oil on canvas,
collection of Jasper Johns,
New York (V. 544).

has emerged that the picture's dominant theme is the longing for individual release, a breaking away, an act of liberation that would literally come to rest with the lowering of the arms and the squaring of the figure's shoulders, as in the New York *Large Bather* (cat. no. 104).

The *Large Bather* has consistently been dated later than the present canvas and its related sketches; indeed, this is the one point of unanimity about the chronology of these works. In the words of Jerome Klein, "it was thus not by accident . . . that Cézanne was impelled to cross the standing figure of the 1876 *Bathers* [fig. 1] with the most mature version of the striding bather, in order to produce the definitive version of the *Bather* in the Bliss Collection [at the Museum of Modern Art]."[4] In Klein's view, the *Bather with Outstretched Arms* must date from the late 1870s or early 1880s, when Cézanne was freeing himself from his "dark idylls."

The danger in placing this picture in a crucially pivotal moment in Cézanne's career is that such an approach can lead all too easily to its being dismissed as a preliminary effort on the way to the larger and more famous painting in the Museum of Modern Art, which has played so conspicuous a role in the artistic life of New York. They are, in fact, about two distinctly different things: animation versus stability, fast versus slow (in their respective modes of handling); exposure versus closure (in the poses); and, finally, openness versus containment (in the relative depth of their backgrounds).

Like nearly all of Cézanne's figures, this boy with raised arms has a ghost predecessor in earlier art. Reff noted a beautifully free drawing after the *Dancing Satyr*,[5] a Hellenistic marble in the Louvre, which shares the basic position of Cézanne's bather (figs. 3 and 4).[6] However, what makes sense in the pose of the satyr—he is about to clang his cymbals—is abandoned in all versions of Cézanne's figure, who seems to be engaged in no activity other than holding

a pose. Professional models, such as those Cézanne would have encountered in his youth at the Académie Suisse, were obliged to maintain poses established in the academic routine. To prevent fatigue over long sessions, they often held onto ropes or poles, which were rarely represented in the final drawing (see fig. 5).

This work has been variously dated, placed as early as 1875 and as late as 1885. Both Reff and Gowing assume that the head of the figure is that of Cézanne's son, Paul, who was born in 1872.[7] Reff's comparison to a sketchbook drawing means that Paul *fils* must have been an adolescent, about thirteen or fourteen, when the picture was painted, thus arriving at a date of 1885-86.[8] This dating is consistent with the view of the water and cliffs behind the figure, which resemble the view of the Marseilleveyre from L'Estaque, where we know Cézanne was living with his family in 1885. However, such reasoning does not account for the painting's brushwork of an early constructive style, a handling that suggests the picture was painted some years before the New York *Large Bather*, where the pigment was applied much more freely. Such fundamental questions about the work persist.

J. R.

1. Reff, March 1962, p. 173.
2. Ibid., p. 174.
3. Ibid., p. 179.
4. Klein in The Museum of Modern Art, *The Lillie P. Bliss Collection, 1934* (New York, 1934), p. 28.
5. See Reff, March 1962, p. 174.
6. See Losch, 1990, pp. 41-43.
7. See Reff, March 1962, p. 182; Gowing, June 1956, p. 190 n. 11.
8. See Reff, March 1962, pp. 179, 181, fig. 9.

Fig. 3. Paul Cézanne,
Dancing Satyr (after the Antique),
graphite on paper,
Musée du Louvre, Paris,
Département des Arts Graphiques,
Musée d'Orsay (C. 1108).

Fig. 4. *Satyr with Cymbals*,
3rd century B.C.E., marble,
Musée du Louvre, Paris.

Fig. 5. Pompeo Batoni,
Male Nude, Leaning on a Ladder,
black chalk on blue prepared paper,
Philadelphia Museum of Art,
Bequest of Anthony Morris Clark, 1978-70-170.

| *The Large Bather*

c. 1885
Oil on canvas; 50 × 38⅛ inches (127 × 96.8 cm)
The Museum of Modern Art, New York. Lillie P. Bliss Collection, 1934
V. 548

PROVENANCE
Ambroise Vollard sold this canvas to the Parisian dealer Paul Rosenberg, who sold it in turn to Marius de Zayas, New York. Lillie P. Bliss acquired it from him in 1916. On her death in 1931, the canvas was bequeathed to the Museum of Modern Art, where it was accessioned in 1934.

EXHIBITIONS
After 1906: Paris, 1910, no. 1; New York, 1921, no. 10; New York, 1929, no. 11; New York, Andover, and Indianapolis, 1931-32, no. 8; Philadelphia, 1934, no. 35; Chicago and New York, 1952, no. 66; Basel, 1989, no. 47.

The depiction of the male nude was central to academic training in the nineteenth century, and while Cézanne's education in this conventional method was limited, his early *académies* (see cat. nos. 1 and 2, and figs. 1 and 2) provided a foundation for works like the present canvas and the other male nudes he painted in the 1880s. But perhaps more important for the artist than drawing after the live studio model (which he seems to have abandoned quite early in his career), was the equally essential pedagogical exercise of drawing after sculpture. He pursued this exercise throughout his life, taking as his subjects antique statuary as well as male nudes by Michelangelo, Pierre Puget, and Jean-Baptiste Pigalle (see cat. nos. 81, 142, and 185). The great question, of course, is what led him to develop these conventions into a series of intensely isolated and introspective images, unencumbered by historical trappings assumed by academic tradition, yet conspicuously lacking the general references to modern life of a kind favored by his own circle (one thinks immediately of the male nudes by Bazille). The resulting group of works must be numbered among his very greatest achievements.

The origin of this figure is found in the pose of the central figure in Cézanne's first ambitious painting of bathers in a landscape, the *Bathers at Rest* in the Barnes Foundation (p. 279, fig. 1). There, the central figure stands with his hands on his hips, looking down at the edge of the water that he tests with his foot. In the ten or so years that separate the two works, a considerable metamorphosis of the figure's chunky physique has ensued; he has become thinner and more graceful. Some years ago, a studio photograph of a male model in exactly the same pose was discovered glued to the back of a Cézanne drawing (it is now in the Museum of Modern Art).[1] It offers little clue to the transformation this image would undergo other than to suggest the temporal and contemplative distance the photograph allowed.

In the Museum of Modern Art's picture there is a quality of heroic proportion and classical equilibrium that places the figure in quite another, more elevated realm. In

Fig. 1. Paul Cézanne,
Seated Nude Model, Seen from the Back, 1862-64,
soft pencil on gray paper,
current location unknown (C. 79).

Fig. 2. Paul Cézanne, *Male Nude*, c. 1867-69,
charcoal on light brown paper,
The Art Institute of Chicago,
gift of Tiffany and Margaret Blake, 1947.36 (C. 110).

the words of Alfred Barr, Cézanne's standing bather rises before the beholder "like a colossus who has just bestrode mountains and rivers."[2]

Comparison with the earlier *Bather with Outstretched Arms* (cat. no. 103), which is similar in conception, proves instructive. The figure that towers over the sea in that picture has a quality of contained animation and freedom, whereas the New York painting is markedly more static, as if beyond time. Here, as a result of deliberate effects of handling that anticipate the artist's late work, the figure is bonded in unity with the surrounding water, sky, and landscape. The salmon-peach tone of the beach is exactly the same as that of the boy's skin; the denim blue of the sky is the same pigment used in the shadows of his torso and thighs; strident jabs of emerald green and cobalt blue enliven the sky, the earth, and the figure's flesh.

The picture's total surface unity, its apparent flatness and overall surface cohesion, has led to its being defined in completely formal and abstract terms, a point of view embraced by several generations of artists in New York, where it was readily accessible from 1934. But as Meyer Schapiro cautioned, it should not be viewed primarily as an exercise in pure form or abstract construction: "There is in this monumental bather a complex quality of feeling, not easy to describe."[3] Perhaps this is largely a function of the absence of conventional resolution, as in the vigorous yet tentative prodding of the strokes animating the sky, or the rough reworking of the figure's outline. And yet one senses that the artist was working toward resolution of another sort, at once monumental, gentle, final. This has always been the essential enigma of this picture, at once so heroic but approachable. Early on, Lionello Venturi suggested something similar about the picture's character, asserting that it was "made in view of affirming abstract method, but humanized by the sensitivity of the tonal variations."[4]

J. R.

1. See Barr, 1954, p. 22.
2. Ibid.
3. Schapiro, 1952, p. 68.
4. Venturi, 1936, vol. 1, no. 548, p. 182.

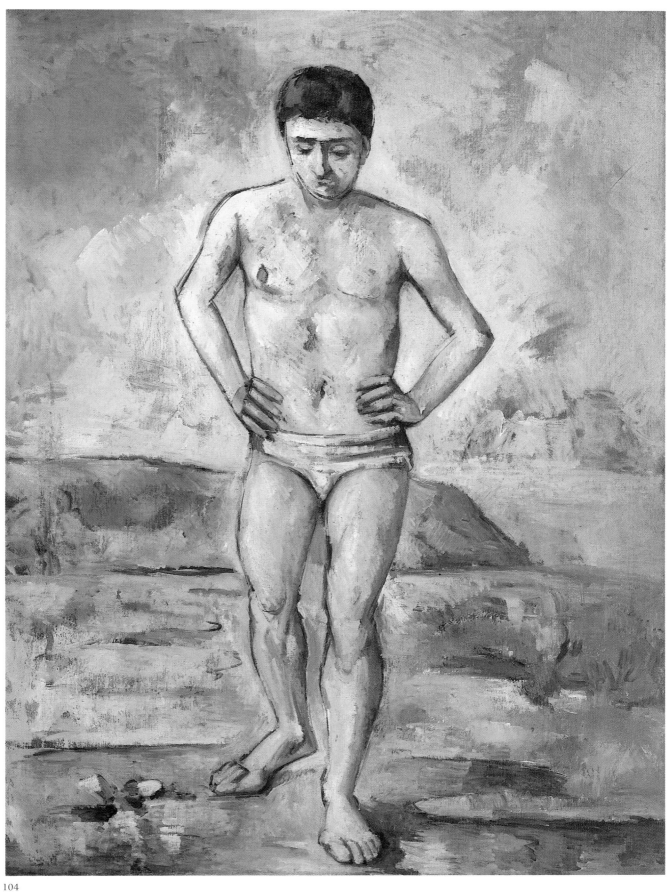

104

The Artist's Son

c. 1885
Graphite on paper; 19³/₄ × 12¹/₂ inches (50.2 × 31.7 cm)
The Alex L. Hillman Family Collection, New York
C. 850

PROVENANCE
Originally owned by Cézanne's son, Paul, the drawing subsequently be-
longed to César de Haucke, Paris, who sold it to Richard S. Davis, Minnea-
polis. In 1954 the Buchholz Gallery (Curt Valentin), New York, sold it to
Mr. and Mrs. Alex L. Hillman, New York.[1]

EXHIBITIONS
After 1906: The Hague, 1956, no. 117; Aix-en-Provence, 1956, no. 90; Zu-
rich, 1956, no. 178; Vienna, 1961, no. 98; Washington, Chicago, and Bos-
ton, 1971, no. 75; Newcastle upon Tyne and London, 1973, no. 51; Tokyo,
Kyoto, and Fukuoka, 1974, no. 108; Tübingen, 1978, no. 55; Liège and
Aix-en-Provence, 1982, no. 39 (not exhibited in Liège); Madrid, 1984, no.
71.

EXHIBITED IN PARIS AND PHILADELPHIA ONLY

The artist's son poses in a formal and self-conscious man-
ner, his left foot extended, his right hand on his hip, his
weight shifted onto his right leg, adopting the classic con-
trapposto of antique sculpture, in a pose that studio mod-
els were requested to hold for traditional drawing classes.
But this pose—graceful and manly—suits him especially
well, and he seems to hold it proudly, mustering all the
confidence that his adolescent years will allow. The draw-
ing has usually been dated on stylistic grounds to about
1885, when Paul would have been thirteen.

He stands before a wall with a high baseboard below
floral wallpaper. Attempts to identify this setting have
proved futile, but the bare ankles, soft strapped shoes, and
loose trousers all point toward a southern venue, where
the family is known to have spent most of the mid-1880s.

Many scholars have sensed an affinity between this
sheet—a study of the physique and psychology of an ado-
lescent boy—and the watercolors and paintings of the
hired model Michelangelo di Rosa (see cat. no. 127),
which are known to date from the time when the family
was living in Paris, 1888 to 1890. The similarities may,
however, be the result of long-term thematic preoccupa-
tions, rather than of any chronological proximity. The ex-
istence of a similar drawing (fig. 1) suggests that Cézanne
was quite taken with the image of his son in this relaxed
yet formal pose and was perhaps beginning to think in
terms of a future project, the most ambitious composition
he would undertake of his family: the Moscow *Mardi Gras*
(repro. p. 63), in which a slightly older Paul displays a sly
self-confidence that is pointedly lacking here.

J. R.

Fig. 1. Paul Cézanne,
The Artist's Son, Full-Length Study, c. 1885,
graphite on gray brown paper,
private collection (C. 849).

1. See Emily Braun et al., *Manet to Matisse: The Hillman Family Collection*
(Seattle, 1994), p. 43.

106 | *Derby Hat and Garment*

1884-87
Graphite on paper; 5 × 8½ inches (12.7 × 21.6 cm)
Philadelphia Museum of Art. Gift of Mr. and Mrs. Walter H. Annenberg, 1987-53-67b
C. 951

PROVENANCE
The sketchbook from which this drawing came belonged to the artist's son, Paul. On consignment to Renou and Poyet, Paris, it was purchased by the New York dealer Sam Salz along with four more sketchbooks. Shortly thereafter, two of these sketchbooks—including the one from which this drawing comes—were acquired by Mrs. Enid Annenberg Haupt, New York. At this point the pages were removed and mounted separately. Mrs. Haupt sold them to her brother, Walter Annenberg, and his wife, Leonore, who gave both sketchbooks to the Philadelphia Museum of Art in the winter of 1987.[1]

EXHIBITIONS
After 1906: Philadelphia, 1989, unnumbered.

EXHIBITED IN PARIS AND LONDON ONLY

Like Chardin, Cézanne had the power to enhance a subject immeasurably through simplification. This sheet is from a sketchbook, and, like many similar pages (see cat. no. 52), records incidental arrangements that caught Cézanne's eye, in this case a derby hat with a coat tossed nearby. It is the steady and seemingly easy labor of an economical and skilled draftsman who, with calm concentration, makes everyday domestic encounters into remarkable works of art. The very magnitude of their simplicity tends to invite

interpretation. As often seen in the sketchbooks, the objects pictured nearly always have a strong associative reference, for the artist's beloved son owned a similar hat about this time (see fig. 1).

J. R.

1. See Shoemaker, in Philadelphia, 1989, p. 15.

Fig. 1. Paul Cézanne,
Portrait of the Artist's Son, Paul, 1888-90,
oil on canvas,
National Gallery of Art,
Washington, D.C.,
Chester Dale Collection (V. 519).

Ginger Jar and Fruit on a Table

1888-90
Graphite and watercolor on paper; $9^7/_{16} \times 14^3/_{16}$ inches (24 × 36 cm)
Private collection, Canada
R. 289

PROVENANCE
This watercolor originally belonged to the artist's son, Paul. It passed from him to Josse Bernheim-Jeune, Paris, and then to Jean Dauberville, Paris. It subsequently came into the possession of the Lefevre Gallery, London, and is now in a private collection.

EXHIBITIONS
After 1906: Paris, 1914, no. 28.

This lively page shows a group of apples and a large pear arrayed on a simple kitchen table with a napkin and the familiar blue ginger jar wrapped in willow strands (see cat. nos. 128 and 160). A set of flat planes seems to fold in and out in the background. The leaf pattern on the right plane, which has been identified as part of the decorative screen Cézanne made for his father in his youth,[1] is cleverly juxtaposed with the large pear just in front of it. One can easily imagine that Cézanne took great pleasure not only in painting but also in arranging his still-life elements, in calculating the spatial and coloristic effects they would produce when rendered on canvas or paper.

Another, slightly larger watercolor depicts the same elements arranged somewhat differently and augmented by the addition of a plate (fig. 1); two oil paintings with completely different backgrounds clearly belong to the same series (V. 595 and fig. 2). In the work of Degas, Picasso, or a host of other artists, such groups would suggest hierarchical or chronological sequences, with a "minor" work on paper most likely anticipating a "major" painting. But in the case of Cézanne it is difficult to discern any such order of priority or hierarchy. Each of these four works, for example, focuses on a different set of compositional problems, reconfiguring the fruit, the ginger jar, the table, and the background in different ways, with varied coloristic weights establishing a fresh pictorial economy in each case. The resulting images have quite independent temperaments. It is possible that this page, the smallest and least ambitious of the group in terms of color, was the last to be executed, since (if one argues a progression from simplicity to complexity) the planes in the background are more subtly and densely compacted than in the three related compositions.

J. R.

1. See Reff, June 1979, pp. 95-97.

Fig. 1. Paul Cézanne,
Ginger Jar with Fruit and Tablecloth, 1888-90,
graphite and watercolor on paper,
private collection (R. 290).

Fig. 2. Paul Cézanne,
Ginger Jar with Fruit on a Table, 1888-90,
oil on canvas,
The Phillips Collection, Washington, D.C.,
gift of Gifford Phillips in memory of his father,
James Laughlin Phillips, 1939 (V. 733).

| *The Green Jug*

1885-87
Graphite and watercolor on paper; $8^{11}/_{16} \times 9^{3}/_{4}$ inches (22 × 24.7 cm)
Musée du Louvre, Paris. Département des Arts Graphiques. Musée d'Orsay,
bequest of Comte Isaac de Camondo
R. 192

PROVENANCE
Ambroise Vollard sold this watercolor to Comte Isaac de Camondo, who
bequeathed it to the Louvre in 1911.

EXHIBITIONS
Before 1906: Paris, 1895, unnumbered.
After 1906: Paris, 1954, no. 71; The Hague, 1956, no. 68; Zurich, 1956,
no. 107; Munich, 1956, no. 83; Vienna, 1961, no. 60; Aix-en-Provence,
1961, no. 30; Newcastle upon Tyne and London, 1973, no. 56; Paris, 1974,
no. 57.

EXHIBITED IN PHILADELPHIA ONLY

This famous watercolor was shown in Vollard's 1895 Cézanne exhibition. Since 1914, when it was shown at the Louvre as part of the Camondo collection, it has been widely regarded as a quintessential work that, for all its direct simplicity, continues many of the essential ideas Cézanne expressed about modeling forms in space. In the words of Paul Jamot, "Here Cézanne draws with color. One catches him unawares in his search for a colored geometry, going about that exercise which he called 'modulations'; and one remembers M. Renoir's remark [to Maurice Denis]: 'How does he do it? He can't put two brushstrokes on canvas without its being very good.'"[1]

This is the equivalent of the "stovepipe"[2] that Cézanne instructed young painters to draw in order to understand the difference between modeling and modulation, and thus a perfect illustration for the artist's advice to Émile Bernard: "To make progress there's only nature, and the eye is trained through contact with her. It becomes concentric through looking and working. I mean to say that in an orange, an apple, a ball, a head, there's a culminating point; and this point is always—despite the tremendous effect: light and shadow, color sensations—closest to our eye; the edges of objects flee toward a center placed on our horizon."[3]

Lawrence Gowing gives a wonderfully vivid analysis of this sheet: "By 1890 the colours in a watercolour like *Le cruchon vert* had a logic of their own. At the culminating point of the form (which was always, as Cézanne explained later, the point nearest to the eye) the paper was left blank. This white patch was not the highlight (as it may appear if we are still thinking of Impressionism); that must have been higher and to the right, perhaps near one of the triangular spaces between washes. The white marked a summit, as if on a map, and from it the surface was carved back by a series of hues arranged in natural order and stated in transparent patches which remained clear where they overlapped; first blue, then emerald green, strengthened in successive washes to identify the material colour of the pot, then yellow ochre. When the zones along the contours were reached and the tone at last darkened, they were connected with the background by colours, blue on the left and brown on the right, which originated as much in imagined affinities as in reflections. Low in the shape a grey-blue segment that creased its fullness was seen to foretell the swelling contour, which reappeared beyond, distended further, in the boundary of a grey-blue cast shadow, so that the bulge itself was incorporated in a sequence of echoing correspondences."[4]

Gowing's observations are apt, but he was well aware of the problems inherent in such theorizing and its unavoidable temptation toward abstraction. Later in the same text, he confesses: "It is still almost possible to see the colours of *Le cruchon vert* as existing on an actual pot."[5] In the end, this watercolor is remarkable in transmuting an irrefutable physical presence into a powerful work of art.

One always returns to the comforts of the specific, the object observed. Cézanne was partial to pieces of low-fired pottery whose green glazes had been allowed to flow freely; the olive jars and jugs of his late still lifes are always of this color. Perhaps what most attracted him was the way their luxurious saturated green, underscored by blue, took the light and tossed shadows in a particularly pleasing and complex way. The form of the object, a swelling cylinder with a handle, here turned to the right, also appealed to him. Michel Hoog has noted that Cézanne singled out a similar vessel when making drawings in the Louvre after *The Ray* by Chardin (V. 1385).[6]

And then we are presented here with more than a jug sitting in space. Venturi was the first to observe that, in all likelihood, the vessel is resting on a table against which leans a stretched canvas, above which, in turn, can be glimpsed what is presumably a reddish strip of wall. These elements add a spatial and interpretive dimension to this "simple" work well beyond the formal point of entry.

J. R.

1. Jamot, July 1914, p. 61.
2. See Rewald, 1986 (a), p. 228.
3. Cézanne to Bernard, July 25, 1904, in Cézanne, 1978, pp. 304-5.
4. Gowing, in Newcastle upon Tyne and London, 1973, p. 14.
5. Ibid.
6. See Hoog, in Paris, 1974, no. 57, p. 141.

Still Life: "Pain sans mie"

1887-90
Graphite on paper; 12¹/₂ × 19³/₈ inches (31.8 × 49.2 cm)
Private collection
C. 957

PROVENANCE
Originally owned by the artist's son, Paul, this drawing was subsequently acquired by Sir Kenneth Clark, London, and is now in a private collection.

EXHIBITIONS
After 1906: Washington, Chicago, and Boston, 1971, no. 78.

From the vantage of the late twentieth century, certain works by Cézanne seem almost too good to be true, so consistent are they with prevailing notions about the artist's role in the development of modern art. This charming yet complex drawing of common kitchen items takes its name from the label on the box of crackers to the right, which translates literally as "crumbless bread." The use of commercial typography as a formal element in collages and paintings, later appearing in the work of Picasso, Braque, Léger, and Duchamp, might be seen to have begun here.

The box with the label is set about two-thirds of the way back on a tabletop, on which are arrayed eight other objects: a small pitcher, a shallow bowl, a half-filled glass carafe, a portable copper burner for a chafing dish, a small bottle which might have a wick extruding from its top, a deeper bowl (partly visible on the left), and, on the very back edge, an empty wine bottle and another, smaller bottle. The wall beyond is covered with an animated and sinuous decorative pattern. Cézanne often recorded domestic objects in his drawings, as if catching them unawares.[1] Here, as in most of his late still lifes in oil and watercolor, he has arranged the elements with great care. The compositional theme is established by the elliptical shape of the trademark on the box, which is repeated, at slightly different angles, throughout the drawing: in the bowls, the surface of the wine in the carafe, the rim of the burner, and even the sweeping semicircular perimeter of the front edge of the composition. Sections of both bowls fade out to accommodate this curved perimeter, as does the tip of the copper burner's handle. The result brings to mind the apron of a stage. All the objects are turned for maximum legibility, and their ties to one another are affirmed by their shared affinity with the "billboard" cracker box, and to a certain extent with the wall pattern beyond.

Like the works by Picasso that were to follow, Cézanne's still-life drawings can sometimes be quite witty. There is something formal and sober about this sheet, however, bearing its complexity without gravity, but holding itself very correct and upright at the same time.

J. R.

1. See, for example, C. 533-54 and C. 951-60.

110 | *Bellona (after Rubens)*

1879-82
Graphite on paper; 18^7/$_8$ × 11^{13}/$_{16}$ inches (48 × 30 cm)
Private collection
C. 489

PROVENANCE
This drawing originally belonged to the Galerie Bernheim-Jeune, Paris. In 1936 Venturi indicated it was in the possession of Robert von Hirsch, Basel. It was included in the sale of his extensive collection at Sotheby Parke Bernet, London, on June 20-27, 1978 (lot 834). It is now in a private collection.

EXHIBITIONS
After 1906: Basel, 1936, no. 171; Zurich, 1956, no. 214a; Tübingen, 1978, no. 163.

EXHIBITED IN LONDON AND PHILADELPHIA ONLY

Cézanne was strongly attracted to the paintings of Rubens, and especially to his female nudes, as is evidenced by his drawing after the *Three Naiads* (C. 455). Like that group, this heroic figure also comes from the Marie de Médicis cycle painted for the Luxembourg Palace in Paris, in this case from *The Apotheosis of Henri IV*. She is Bellona, the victorious goddess of war, who appears in the center of Rubens's vast composition, beating back Calumny and Injustice as the queen regent restores peace (fig. 1). Cézanne's interest in the figure is documented by two sketchbook drawings (C. 489 *bis* and C. 490) as well as by this large and vigorously worked sheet.[1]

Bellona's strained posture—one elbow lifted high and cradling the head—recalls the posture Cézanne used for the standing bather removing his shirt in the *Bathers at Rest* (p. 279, fig. 1). It is a gesture that will continue to interest him, and one that he will apply in various ways for figures in related poses, and of both genders, that reappear throughout his work (see cat. nos. 37, 40, 62, and 220),[2] the grandest instance being the bather leaning against a tree on the right in the Barnes Foundation's *Large Bathers* (repro. p. 39).

<div align="right">J. R.</div>

1. See Berthold, 1958, pp. 18, 50, 114.
2. See Krumrine, 1989, pp. 243-53.

Fig. 1. Peter Paul Rubens,
The Apotheosis of Henri IV and the Proclamation of the Regency of Marie de Médicis, May 14, 1610,
c. 1622, oil on canvas,
Musée du Louvre, Paris.

111 | *Écorché and Interior with a Chair*

1887-90
Graphite on gray paper; 12⁵/₁₆ × 18³/₄ inches (31.2 × 47.7 cm)
Öffentliche Kunstsammlung Basel. Kupferstichkabinett
C. 980

PROVENANCE
This drawing originally belonged to the artist's son, Paul, and was acquired from him by Werner Feuz, Bern. In 1934 it entered the collection of the Kunstmuseum, Basel.[1]

EXHIBITIONS
After 1906: Tokyo, Kyoto, and Fukuoka, 1974, no. 112; Tübingen, 1978, no. 180; New York, 1988, no. 103.

A plaster cast of a flayed man, after a work attributed in Cézanne's time to Michelangelo, still exists, though sadly broken, in the artist's studio at Les Lauves. In Cézanne's drawings it always seems monumental, as though on a scale with Michelangelo's *Dying Slave* in the Louvre (see cat. no. 185). In reality, it is about seven inches high.[2]

The practice of drawing after plaster casts was a standard method of instruction in art schools in the nineteenth century.[3] Figurines like this one were used to teach both anatomy and expression. In all likelihood, the earliest appearance in Cézanne's oeuvre of this *écorché*, or figure stripped of its skin to expose the underlying musculature, is on a sketchbook page dated by Chappuis as early as 1866-70. It reoccurs some seventeen times thereafter, the last being five drawings from about 1893-96.[4] In the Chicago sketchbook alone there are nine different pages showing it at different angles and in different lights.

The upper portion of the contorted pose, especially its bent and uplifted arm, is related to an array of temptress and bather figures spanning the artist's career, for example, the brazen seductresses in the two versions of *The Temptation of Saint Anthony* (see cat. no. 40), the standing male bather on the left in the Barnes Foundation's *Bathers at Rest* (p. 279, fig. 1), and similar figures in other compositions (cat. nos. 37, 62, 218, and 220).[5] This similarity was surely a factor in his continuing interest in the piece, as was its considerable plastic interest, which encouraged him to explore a host of technical problems.

In this rendering, as in many of his sketches after sculpture, Cézanne addresses the problem of the edge: the means by which one can show the turning of a three-dimensional object in space without inscribing it with a line. He uses his pencil to describe conventional cast shadows on the table; this same pencil then works up the back of the figure in negative space, throwing what is before it into positive relief. By showing the figure's chest in a frontal way, he is also exploring the distortions that preoccupied him in his depictions of nudes: the remarkable breadth a figure can assume as the shape of the chest ex-

pands and extends under an uplifted arm. Like the cast of Hercules by Puget, this model presented a series of planes turned obliquely in space that he used as puzzles to stimulate his visual apprehension, as in his drawings of *écorchés*.

In the upper-right corner, we see a chair pulled to a table over which hangs a mirror or a framed picture. Against the drama of the *écorché*, nothing else could be so banal or comfortable.

<div align="right">J. R.</div>

1. See Dieter Koepplin, in New York, 1988, pp. 8-10.
2. See the photograph reproduced by Rewald, in New York and Houston, 1977-78, p. 103.
3. Chappuis (1973, no. 74, p. 67) published a "scrupulously" finished drawing after a cast of an antique female torso as well as a drawing after a cast of the antique bust of an ancient divinity (C. 73), both of which were probably executed while Cézanne was at the École Gratuite de Dessin in Aix.
4. In addition to the present drawing, see C. 185, C. 232, C. 565-74, and C. 1086-89.
5. For a schematic overview of such figures, see Krumrine, 1989, pp. 243-53.

112

112 | *Portrait of Madame Cézanne*

1887-90
Graphite on paper; 19¹/₈ × 13¹/₁₆ inches
(48.5 × 33.2 cm)
Museum Boymans–van Beuningen, Rotterdam
C. 1065

PROVENANCE
This drawing was originally in the possession of Ambroise Vollard. Thereafter it passed in turn to Dr. S. Meller, Budapest, and Paul Cassirer, Amsterdam. It was purchased from Cassirer by Franz Koenigs, Haarlem. In 1940 Koenigs sold his entire collection of drawings to D. G. van Beuningen, who donated a portion of it to the Museum Boymans.

EXHIBITIONS
After 1906: Rotterdam, 1933-34, no. 6; Basel, 1935, no. 179; Basel, 1936, no. 136; Amsterdam, 1946, no. 14; Chicago and New York, 1952, no. 45; Washington, Chicago, and Boston, 1971, no. 77; Tübingen, 1978, no. 59; Liège and Aix-en-Provence, 1982, no. 41; Madrid, 1984, no. 72.

Cézanne seems to have been completely lacking in personal vanity, paying little or no attention to his clothing and toilette. This habit may have exacerbated the tensions with his wife. From what little we know about her, Hortense Fiquet had an excessive interest in and appetite for fashion.

Richard Verdi has wisely observed of the artist's many portraits of Hortense: "In drawings of her, Cézanne continues to explore a wide range of poses and moods, some of which reveal a careworn, if soulful figure of ineffable sadness. The more formal and prolonged sittings required for his paintings, however, generally elicited a more detached response from the artist."[1]

Here, Hortense appears to be wearing the same richly brocaded jacket with a high, stiff collar that she wears in another portrait now in Philadelphia (fig. 1). It is a rather matronly outfit to which she has added a hat divided into two segments, bearing a central ornament of some kind. She seems dressed for a special occasion, and it is tempting to speculate that the unhappy expression on her face was prompted by her husband's having prevailed upon her— yet again—to pose when it was less than entirely convenient.

<div align="right">J. R.</div>

1. Verdi, 1992, p. 132.

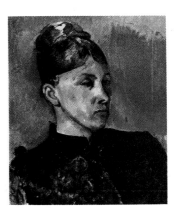

Fig. 1. Paul Cézanne,
Portrait of Madame Cézanne,
1886-87,
oil on canvas,
Philadelphia Museum of Art,
The Samuel S. White 3rd
and Vera White Collection,
1967-30-17 (V. 521).

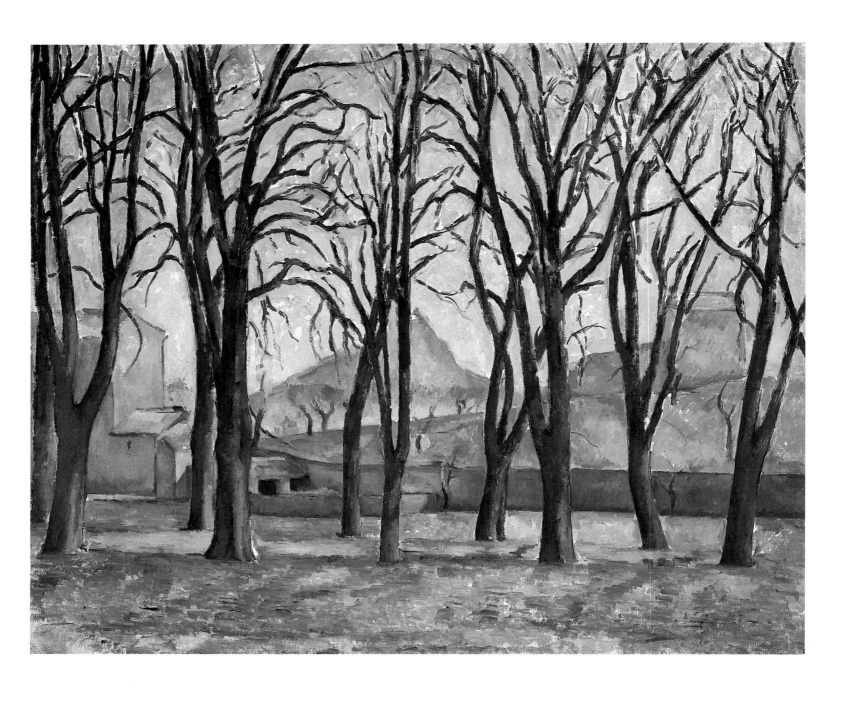

113 | *Chestnut Trees at the Jas de Bouffan*

1885-86
Oil on canvas; 29 × 36½ inches (73.7 × 92.7 cm)
The Minneapolis Institute of Arts. The William Hood Dunwoody Fund
V. 476

PROVENANCE
Ambroise Vollard sold this painting to Egisto Fabbri, with whom it re-
mained until 1924. It then passed to the dealer Paul Rosenberg, Paris. In
1936 it was at the Wildenstein Galleries, Paris and New York, and sold to
the Frick Collection in New York. It was that museum's first purchase of a
Post-Impressionist canvas, overturning their previous policies for acquisi-
tions. The Frick Collection then sold the canvas, with two other nine-
teenth-century works, back to the Wildenstein Galleries in late 1949. It
was immediately purchased by the Minneapolis Institute of Arts.

EXHIBITIONS
After 1906: Paris, 1910, no. 21; Venice, 1920, no. 20; New York, 1929, no.
19; Chicago and New York, 1952, no. 62; Edinburgh and London, 1954,
no. 36; The Hague, 1956, no. 34; Zurich, 1956, no. 59; Munich, 1956,
no. 42; Madrid, 1984, no. 31.

If one stands today on the spot where this picture was painted—in the garden of the Jas de Bouffan, south of the ornamental pool and to the side of the chestnut allée—the essential elements of the composition remain in place. But the distant view toward the east, with its great silhouette of Mont Sainte-Victoire, is now obscured by the buildings of suburban Aix-en-Provence.[1] Of Cézanne's many paintings of the family park from the 1880s, this is the only one with a dominant reference beyond its confines.

The picture is made up of a series of horizontal bands across the canvas: the strip of lawn in the foreground, the buff promenade between the trees, another strip of lawn, the gray wall, and the green hillside in the middle distance. The mountain rises above them as a vaguely modeled sil-houette of lavender (an effect that is true to optical experi-ence in the limpid winter air of Provence). The principal barrier to any swift movement to the distant summit is the enchantingly drawn screen of trees, which connect the foreground to the top of the canvas across the painting's entire width. As if to underscore their ability to contain the viewer within the space of the compound, the two cen-tral tree trunks intersect at the mountain's peak, thereby muting its profile.

Cézanne was partial to landscape compositions of this kind, in which a steadily plotted gradation into space is countered by a screen of trees (see cat. nos. 67, 68, and 72),

but this is among the most considered and dramatic of such works in the artist's oeuvre. He was encouraged by Pissarro's example to experiment with such devices in the 1870s, and both artists would have been familiar with it from the work of Corot, who often filtered his landscapes through scrims of trees and foliage.[2] The effect in Corot's work is almost always one of a gentle exploration into space through easy stages, as if the viewer were emerging from the woods into a clearing or village. In Pissarro's work such devices were more circumspect, as if the ob-server might as easily opt to remain sheltered behind the screen as proceed. In the present painting, by contrast, the network of intertwining branches is perhaps too beauti-fully intricate (and the goal beyond too vague) to en-courage any urgent movement to escape this tranquil containment.

As Schapiro noted, "Cézanne has re-discovered here a principle of Moslem art: complicated ornamental lines, lacy and elusive, set above sparser, stable forms. In the late Gothic, too, the spreading ribs of the vaults often rise from simple piers. Cézanne, however, has chosen a viewpoint with a minimum of perspective play and hence little ten-sion in depth. . . . The upward striving force of the vertical lines is gradually dissipated in the all-over network of thin-ner, lighter branches which are finally lost in the vaporous sky. These graceful branching forms are beautifully de-signed, without a dull repeat. They arise imperceptibly from the heavier limbs and merge with the drawn outlines of the buildings and smaller trees. Their diagonal move-ments also parallel the sloping edges of the muted moun-tain peak."[3]

J. R.

1. Douglas Cooper (February 15, 1955, p. 15) suspected that this might have been the case even in Cézanne's day.
2. See Isaacson, September 1994, pp. 437-45.
3. Schapiro, 1952, p. 72.

The Gulf of Marseille Seen from L'Estaque

c. 1886
Oil on canvas; 31^9/$_{16}$ × 39^5/$_8$ inches (80.2 × 100.6 cm)
The Art Institute of Chicago. Mr. and Mrs. M. A. Ryerson Collection
V. 493

PROVENANCE
Ambroise Vollard sold this painting to Cornelis Hoogendijk. Hoogendijk's Cézannes were sold in 1920 to the dealer Paul Rosenberg, Paris. It was purchased, probably in June 1920, by M. A. Ryerson, Chicago. He began collecting art around 1890, when he became a trustee of the Art Institute of Chicago. In 1933 the painting was bequeathed by Mr. and Mrs. Reyerson to the Art Institute of Chicago.

EXHIBITIONS
After 1906: New York, 1929, no. 18; Philadelphia, 1934, no. 26; Chicago and New York, 1952, no. 50; Washington, Chicago, and Boston, 1971, no. 21; Los Angeles and Chicago, 1984-85, no. 129; Paris, 1985, no. 129; Edinburgh, 1990, no. 45.

This is by far the largest canvas representing the Bay of Marseille seen from above the village of L'Estaque (see cat. nos. 44, 54, and 72); it may also be the most satisfying. It is a work in which all elements coalesce, where formal and expressive values—picture-making and illusion—come into play with an ease and equilibrium that are truly transfiguring. As Schapiro observed, "a marvelous peace and strength emanate from this work—the true feeling of the Mediterranean, the joy of an ancient nature which man has known how to sustain through the simplicity of his own constructions."[1]

The view is toward the east, with the distant city of Marseille identifiable only by the towers of Nôtre-Dame du Gard on the hill protecting the old port. All the elements—houses, water, mountains—seem inclined to turn themselves nearly broadside to the picture plane. The sky, loosely scumbled, plays over the geometric forms, which present themselves with a clarity and simplicity that are nothing less than magical. As if in a children's game, the smoke rising from a chimney drifts out to greet a distant jetty projecting into the sea.

J. R.

1. Schapiro, 1952, p. 62.

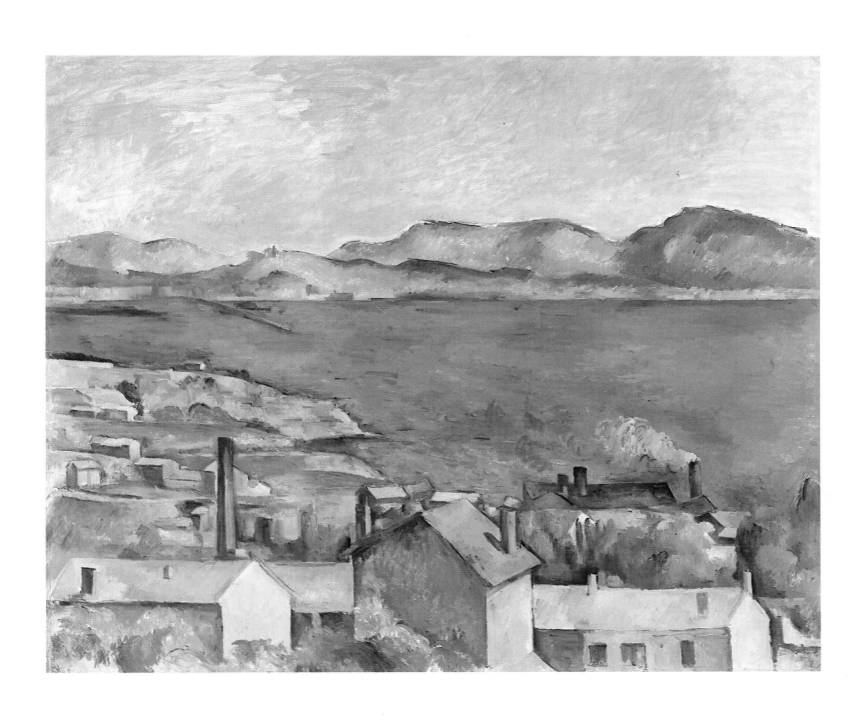

115 | *Gardanne*

1885-86
Oil on canvas; 36¹/₄ × 29⁵/₁₆ inches (92 × 74.5 cm)
The Brooklyn Museum. Ella C. Woodward and A. T. White Memorial Funds
V. 431

PROVENANCE
This canvas was first mentioned in the catalogue of the Wendland sale at the Hôtel Drouot, Paris, February 23-24, 1922 (lot 209). It was purchased by Durand-Ruel, Paris and New York, who brought it to New York and sold it to the Brooklyn Museum in January 1923.

EXHIBITIONS
After 1906: Philadelphia, 1934, no. 15; New York, 1947, no. 31; Vienna, 1961, no. 24; Aix-en-Provence, 1961, no. 10; Tübingen, 1993, no. 31.

EXHIBITED IN PHILADELPHIA ONLY

Gardanne is located some seven miles southeast of Aix. Cézanne lived there with Hortense Fiquet and their young son, Paul, from the autumn of 1885 until the spring of 1886, and he often walked to Aix to spend the night at the Jas de Bouffan. Like L'Estaque, Gardanne seems to have been a refuge for his family, who were still not acknowledged by Cézanne's father. This town, at a discreet distance from Aix, was close enough to allow the artist to maintain contact with his parents and sisters. This double life finally came to an end in April 1886, when Hortense and Cézanne married and moved to Aix with their son.

Gardanne is situated on a slope beyond which rises a still higher range of hills, the height of which is exaggerated to some degree in the views Cézanne painted. The town is dominated by a square bell tower that is surrounded by red-roofed houses. It is a picturesque effect somewhat retained today, despite the town's having become an important center for bauxite and cement production.

Cézanne depicted the village in three oil paintings. A horizontal canvas in the Barnes Foundation is one of his more resolved and cerebral works (fig. 1). Two vertical canvases remain unfinished: this one and another that is now in the Metropolitan Museum of Art (V. 432). A small drawing (C. 902) is the only other record of the artist's activity in Gardanne that winter and spring. As a group, these works document a 180-degree circuit around the village through the green fields and copses on its outskirts. It

is as though Cézanne were carefully rotating the motif about in his head. He recorded the geometric variations in the alignment of the buildings seen from different angles. As in some of the views he had made of L'Estaque (see cat. nos. 54 and 72), but from a vantage looking up, the artist circumscribed a compressed motif rather than containing a broad panorama.

The Brooklyn painting is the least analytical and most open of the three. It is built around a sequence of rhythmic and expressive dualities. The emphatic, architectural geometry, the primary focus of the other two views, is here dispersed amid the undulating organic forms of the distant hills and of the trees that nearly consume the lower section of the canvas. The walls and rooftops are carefully defined in flat, sedentary strokes of ocher and red pigment; the foliage and landscape ridges are rendered with commas and swirls of green, lavender, and pale blue. This *pas de deux* is made all the more engaging by the exposed passages throughout, especially in the lower right, where the outlines of tree trunks and branches ascend in playful spirals and splaying lines.

As ever with Cézanne's works that show a fair proportion of exposed canvas, the question arises: Why did he stop there? Perhaps the remarkable balance of ease and alertness that we witness here was impossible to sustain, rather like a moment of grace. There are more heroically resolved landscapes than this, just as there are more sweetly pastoral ones. But it is the perfect harmony of mind and emotion, analysis and spontaneity, that sets aside the Brooklyn *Gardanne* as unique in Cézanne's oeuvre.

J. R.

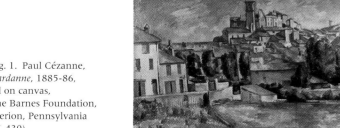

Fig. 1. Paul Cézanne, *Gardanne*, 1885-86, oil on canvas, The Barnes Foundation, Merion, Pennsylvania (V. 430).

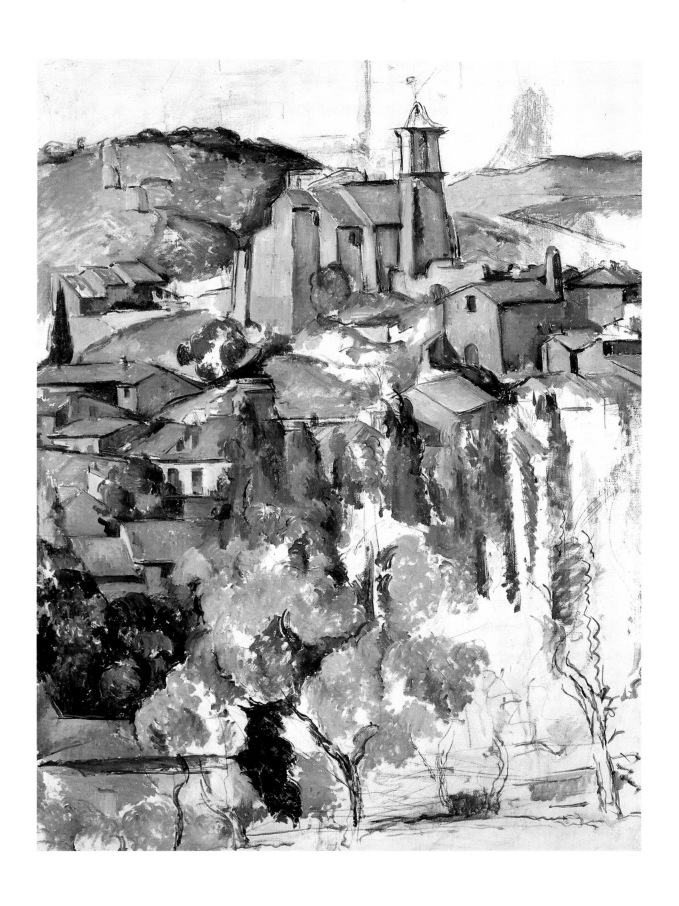

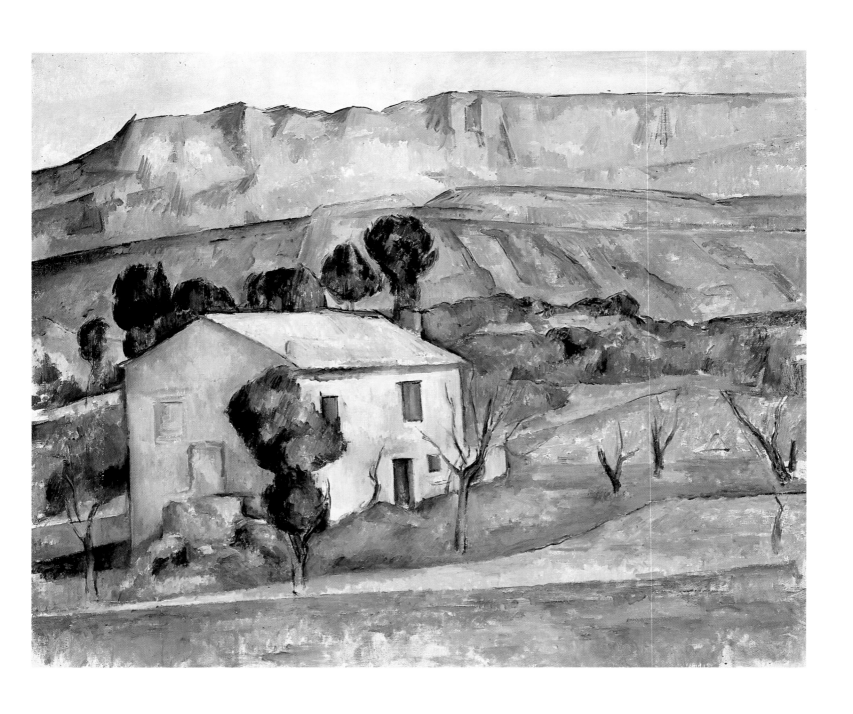

116 | *House in Provence, Near Gardanne*

1886-90
Oil on canvas; 25$^{1}/_{2}$ × 32 inches (64.8 × 81.3 cm)
Indianapolis Museum of Art. Gift of Mrs. James W. Fesler
in memory of Daniel W. and Elizabeth C. Marmon
V. 433

PROVENANCE
This painting was auctioned with the Henry Bernstein collection at the Hôtel Drouot, Paris, on June 8, 1911 (lot 9), where it was acquired by Ambroise Vollard. It was purchased from Vollard by Auguste Pellerin, Paris, and then came into the possession of Paul Cassirer, Berlin. By 1920 it was in the collection of Gottlieb Friedrich Reber. The Marie Harriman Gallery, New York, owned it from 1936 until it was sold in 1945 to the John Herron Art Institute (which in 1967 became the Indianapolis Museum of Art), as a gift of Mrs. James W. Fesler, in memory of Daniel W. and Elizabeth C. Marmon.

EXHIBITIONS
After 1906: Paris, 1910, no. 7; San Francisco, 1937, no. 19.

EXHIBITED IN PHILADELPHIA ONLY

In a letter Cézanne wrote in Gardanne to Victor Chocquet on May 11, 1886, the artist reassured his young friend that he was persisting in the pursuit of his goals: "I will tell you that I always keep myself busy painting and that there are treasures to be taken away from this country, which has not yet found an interpreter up to the riches it offers."[1] Eloquent testimony to Cézanne's diligence, there are at least five paintings from about this time showing buildings in the vast landscape around Aix (see fig. 1).[2]

Cézanne chose as his subject isolated farmhouses, half-protected by clusters of trees and crumbling walls. These buildings often seem abandoned or reduced to seasonal use only. During the last quarter of the nineteenth century, the rural population of France was rapidly declining. In Provence, the traditional rules of inheritance fostered even distribution of property among the male offspring, a practice that often resulted in the separation of houses from the natural springs that were their indispensable sources of water.

It is difficult to imagine anyone living in these desolate houses. Their shuttered windows and low doors look like empty eyes. They stand as precise geometric objects, independent, but in a profound harmony within the landscape, reflecting the long and pervasive habitation by which the things of man and nature have come into balance.

It is relatively easy to identify the landscape pictured here, with its withered remnants of an orchard. The erosion marks on the distant cliffs—the long ridge that declines from the south side of Mont Sainte-Victoire—indicate that we are on the plain east of Aix at a point quite close to the village of Gardanne, where Cézanne lived with his family from 1885 to 1886. In the 1930s Rewald photographed a site similar to this one near the hamlet of Beaurecueil, which Venturi associated with this picture.

In Schapiro's view, "this is one of the exemplary Cézannes—an original poetic harmony of the artificial and the natural. . . . The placing of the windows and door—oddly, yet in harmony with nearby forms—is an example of Cézanne's great scruple and delicacy in the design of details. See how the tree masks one window, and how the door and the other window form a slightly sloping line with the chimney and the tree above it; imagine the dullness of the first window complete and the stiffness of the other openings in a normal alignment and you will admire Cézanne more for his arbitrariness and discretion."[3]

J. R.

1. Cézanne, 1978, p. 227.
2. V. 433-37.
3. Schapiro, 1952, p. 70.

Fig. 1. Paul Cézanne,
Mont Sainte-Victoire, Near Gardanne, 1885-86,
oil on canvas,
The White House Historical Association,
Washington, D.C. (V. 435).

House with Red Roof

1887-90
Oil on canvas; 28³/₄ × 36¹/₄ inches (73 × 92 cm)
Private collection
V. 468

PROVENANCE
Ambroise Vollard sold this canvas to Paul Cassirer, Berlin. It subsequently passed through the collections of Margarete Oppenheim, Berlin (from about 1920 to 1936) and Mrs. Georg Hirschland, New York (from about 1952 to 1959). It is now in a private collection.

EXHIBITIONS
After 1906: Berlin, 1921, no. 14; Chicago and New York, 1952, no. 57; Tübingen, 1993, no. 48.

EXHIBITED IN PARIS ONLY

It is tempting to identify this site as the park and manor house at the Jas de Bouffan.[1] The blue shutters and attic windows beneath the eaves correspond to the familiar features of the manor's southern facade, and the row of trees on the left aligns with the building at an angle not entirely unlike that of the famous chestnut allée. But these resemblances are misleading. The way the terrain falls away on the right and the presence of only five window bays—the Jas de Bouffan has six—is unlike any other view Cézanne made of the Jas de Bouffan. Also lacking are the farm buildings and adjacent wall on the right. Venturi and Rewald resisted the temptation and identified the work simply as a house with a red roof.

In most salient respects, this picture is conceived quite differently from the artist's depictions of the Jas de Bouffan and its park. The abrupt handling of the foliage—parallel strokes in local alignments—is not unrelated to the constructive style that Cézanne had developed in the years around 1880. Here the strokes are grouped into explosive patches that rustle against one another, producing a blurry effect quite unlike earlier, carefully hewn works. Forms—the facade, the path crossed by shadows, the trees—are very closely gathered into a textural unity that recalls the landscapes of early 1870s. While those denser works, such as the Tate view of the chestnut allée (cat. no. 24), have a sense of airlessness and vague oppression, here the chalky denseness of the forms and the high note of the light flashing through them give the sense of a familiar and worn object. This is one of the instances in which the essential objectiveness of a painting by Cézanne is so appealing in its palpability that it is difficult to see the work also as the illusion—the representation of something—he intended.

J. R.

1. Most recently, see Adriani, 1993 (b), no. 48, pp. 161-62.

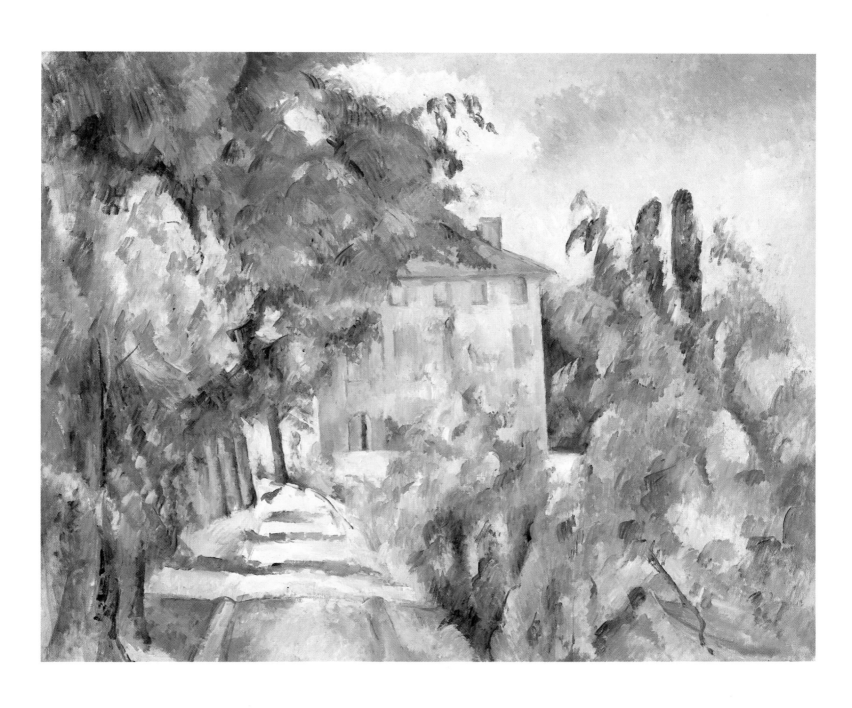

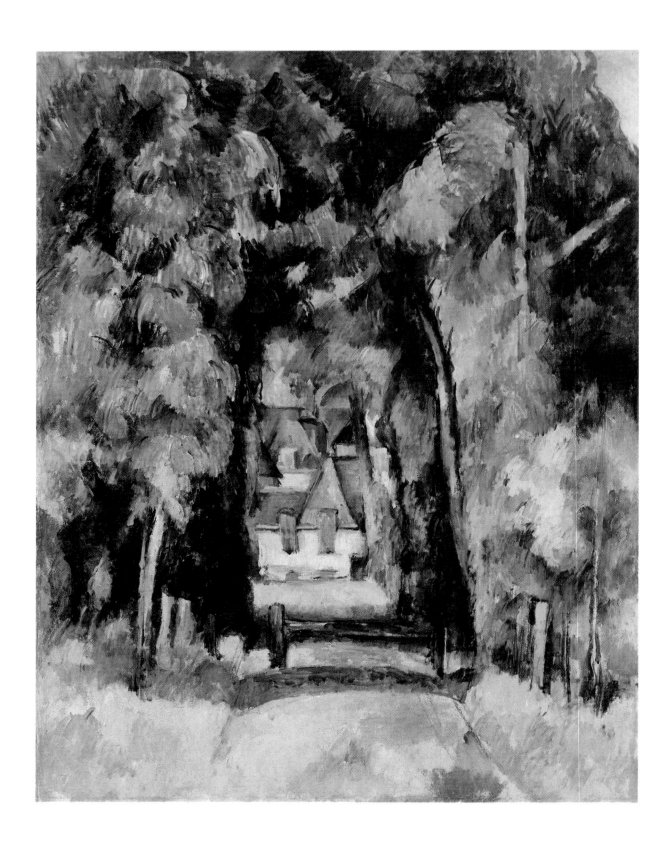

1888
Oil on canvas; 32 × 25½ inches (81.3 × 64.8 cm)
The Toledo Museum of Art. Gift of Mr. and Mrs. William E. Levis
V. 627

PROVENANCE
This painting was sold by the artist to Ambroise Vollard in 1899. In April 1907 it passed through Paul Cassirer, Berlin, to Hugo Cassirer, and then to Lotte Cassirer-Fürstenberg, Berlin.¹ Subsequently it may have been in the possession of Justin K. Thannhauser, New York. Between 1949 and 1953 it was in the collection of Mr. and Mrs. William A. M. Burden, New York. In 1953 it was sold by the Knoedler Gallery, New York, to Mr. and Mrs. William E. Levis of Perrysburg, Ohio. In 1959 it was given by Mr. and Mrs. Levis to the Toledo Museum of Art.

EXHIBITIONS
After 1906: Cologne, 1912, no. 136; Edinburgh, 1990, no. 44.

According to the artist's son, Cézanne spent five months in 1888 at Chantilly, staying at the Hôtel Delacourt. Five, or perhaps six, works have been associated with that sojourn. All represent views down the tunnel-like roads that cut at regular intervals through the forest surrounding the town and the château.² The painting now in Toledo is the largest and most complex of the group.

Each time he visited the Île-de-France, Cézanne must have been struck anew by the lushness of full summer foliage in the moisture-filtered atmosphere. The works he made there are very different in character from the epic landscapes he had just completed in the harsh, sun-baked countryside of Provence. These verdant images consolidate lessons learned under Pissarro's guidance in Pontoise and Auvers in the early 1870s, with those of the heroic constructive landscapes done at Médan and Maincy earlier in the 1880s. In the midst of one of the densest forests in France, Cézanne's old qualities of tough experimentation and rigorous analysis lifted. The resulting pictures are blurred yet dramatic images, awash in golden light. Their unity of handling and the pleasure of moving through space with color have an august ease and maturity.

Fig. 1. Paul Cézanne,
The Chestnut Allée at the Jas de Bouffan,
1888, oil on canvas,
The Barnes Foundation, Merion,
Pennsylvania (V. 649).

One senses in the Chantilly paintings the presence of Corot, whom Pissarro venerated as his master and whose importance for Cézanne has been underestimated. They are worked all over with gentle but firm brushstrokes that shift the scene's depths with contrasts of color, such as the patch of blue to the middle left: though applied over the leaves it describes a surprising opening toward the sky beyond. Yet, the resolutely symmetrical composition is very unlike those of Corot or Pissarro, who preferred to use planar configurations or trees lined along prominent obliques to convey a sense of space. Here, Cézanne chose single-point perspective, one of the simplest and oldest spatial devices, dating from the Renaissance.

Cézanne essentially reinvented the convention. Orthogonals—the borders of the road—are short, not so much indicated as evoked, for they consist solely of a dry scrub of black on the right and a spare ocher shadow on the left. Their advance into depth is impeded by a green wooden barrier and a very broad ink-blue shadow. They culminate in the facade of the château, whose tawny stone walls, hidden beneath a rise of ground, are visible only from the third story up. The vanishing point coincides with the marvelous geometry of the blue slate roof, whose color, repeating that of the glimpse of sky above it, has the optical effect of bringing the entire structure forward. This effect is heightened by the similarly pitched brightness of the distant walls and the grass in the foreground. The result is a gentle tug-of-war between illusionistic depth and beautifully keyed colors blended together on the surface that is as sophisticated as it is revealing of the artist's delight in his motif.

The two other paintings of forest roads in Chantilly (V. 626 and V. 628), both now in the National Gallery in London, lack a building at the end of the vista. To compensate for this, and doubtless in response to the actual views, Cézanne stressed the paths' horizontal elements—long shadows cast by trees and irregular pools of light—by handling them in lean, sometimes schematic, patches of thinly applied pigment. This technique, used frequently by Cézanne at this time, gives the pictures he made along the Marne during the same summer (V. 629-32) their slightly eerie polish, reminiscent of paintings on vellum. It also appears in paintings done in the South, such as a view down the chestnut allée at the Jas de Bouffan of about the same date (fig. 1), but there the grid of horizontals and verticals is much more starkly apparent. This contrast within a group of paintings that share superficial similarities derives, as always for Cézanne, from the circumstances in which

the motif presented itself to him: the way the intense light of Aix falls through an allée of trees is completely different from the way light suffuses Chantilly—thus two distinct artistic moods were provoked.

J. R.

1. It was still listed as being in the Fürstenberg collection in The Art Institute of Chicago, *Masterpieces of French Art Lent by the Museums and Collectors of France*, April 10-May 20, 1941, no. 13.
2. V. 626-28, R. 308, R. 309, and perhaps R. 310.

119 | *The Château Noir*

1887-90
Graphite and watercolor on paper; $14^3/_{16} \times 20^{11}/_{16}$ inches (36 × 52.6 cm)
Museum Boymans–van Beuningen, Rotterdam
R. 313

PROVENANCE
According to Rewald, this and three other watercolors by Cézanne were listed in the catalogue of a 1927 exhibition at the Galerie Flechtheim, Berlin, as belonging to a "private collection, Paris, formerly Moscow."[1] All four sheets were acquired at this time by Paul Cassirer. The present watercolor and two others were sold by Cassirer to Franz Koenigs, Haarlem.[2] In 1940 he sold his entire collection of drawings to D. G. van Beuningen, who donated a portion of it to the Museum Boymans.

EXHIBITIONS
After 1906: London, Leicester, and Sheffield, 1946, no. 20; The Hague, 1956, no. 75; Zurich, 1956, no. 122; New York, 1963 (a), no. 44; Newcastle upon Tyne and London, 1973, no. 62; Tübingen and Zurich, 1982, no. 40.

EXHIBITED IN PARIS AND PHILADELPHIA ONLY

About three miles east of Aix-en-Provence, just north of the road leading to the village and château of Le Tholonet, stands an eccentric structure called the Château Noir. Thanks to Cézanne, who made it the subject of four dramatic oil paintings and several watercolors, it is one of the most famous houses in the history of art.[3]

It was built—or rather begun, for it was never completed—by a coal magnate in the middle of the nineteenth century. He is said to have dabbled in the occult, which prompted some of the locals to call the house the Château du Diable. It consists of two completely detached buildings. The taller and more conventional one overlooks the valley of the Arc River to the south. The other one, less finished than the first, faces west; its main facade features a large barn door, painted bright red in Cézanne's time, as

well as four crudely detailed ogive windows that strike a pseudo-gothic note. In the right angle between the two buildings, an old well head dominates a small courtyard. The incline of the land up from the Tholonet road is quite steep, and to the east, the land declines into a valley before rising to the barren, rocky slopes of Mont Sainte-Victoire. It is an altogether odd place, the structures ill-proportioned and vaguely sinister.

From 1887 to 1902 Cézanne rented space in a small structure just off the courtyard, where he could store his painting materials. In the wake of his father's death in 1886, he seems to have turned away from the landscape west of Aix, preferring to explore the harsher and more brutal region along the Tholonet road, where the Château Noir served as his base. When, in 1899, following the death of his mother, the Jas de Bouffan was sold—at his sister's insistence and despite his protests—the artist sought, unsuccessfully, to purchase the Château Noir property.

Of all Cézanne's views of the château, it is the Rotterdam watercolor that gives the clearest idea of the shapes of the buildings and their relation to the site. Cézanne placed himself on the steep path leading up from the Tholonet road, choosing a view that records the buttressed terrace (now gone) and the disposition of the buildings. He drew the principal forms in pencil, which he set down with economical dashes. This he followed with brighter dabs of watercolor for the sweeping shapes of the trees and rocks, barely touching the shadows cast by doors and eaves with

119

color, as if to emphasize the creations of nature rather than man.

There is something succinct and direct about this sheet. It is really only a drawing touched in with color. The artist was content to restrict himself to objective observation, restraining the expressive force with which he endowed other views of the site (see cat. nos. 189 and 191). For this reason Rewald dated it shortly after Cézanne first started to work at the Château Noir,[4] a moment in his career when his work has a particularly lucid and straightforward authority.

J. R.

1. Rewald, 1983, no. 441, p. 196.
2. Ibid.
3. John Rewald lived in the house for two summers in the 1930s, at which time he photographed it and the surrounding landscape. See Rewald, in New York and Houston, 1977-78, pp. 83-106.
4. See Rewald, 1983, no. 313, p. 161.

120 | *Trees and Bridge*

1888-90
Graphite and watercolor on paper;
19³/₁₆ × 14 inches (48.8 × 35.5 cm)
Private collection
R. 325

PROVENANCE
Originally owned by Georges Aubry, Paris, this watercolor then passed through the collection of Pierre Landry, Neuilly-sur-Seine. It is now in a private collection.

EXHIBITIONS
After 1906: Tokyo, Kyoto, and Fukuoka, 1974, no. 77.

From 1888 to 1890 Cézanne rented an apartment on the third floor of 15, quai d'Anjou, on the north side of the Île Saint-Louis in Paris. These were years of intense activity during which he painted *Mardi Gras* (repro. p. 63), the four versions of *Boy in a Red Vest* (see cat. no. 127 and p. 49), and some of his most ambitious portraits of Madame Cézanne (see cat. no. 125). It has long been assumed, presumably on the basis of information provided by Paul *fils*, that the view shown here was made from a vantage point near the doorstep of that building, looking north and east across the Seine, with one arch of the Pont de Sully just upstream appearing in the center. Cézanne must have placed himself on the river side of the street close to the wall overlooking the lower embankment, which cuts off the trunks of the trees.

This is a particularly pure and controlled work, a refined drawing to which the palest washes have been added with great discretion, the brush completely taking its cue from the pencil. The effect is extremely suave and elegant.

J. R.

120

The Pigeon Tower at Bellevue

1889-90
Oil on canvas; 25^{13}/$_{16}$ × 32^{1}/$_{16}$ inches (65.6 × 81.5 cm)
The Cleveland Museum of Art. The James W. Corrigan Memorial
V. 650

PROVENANCE
This canvas was first in the collection of the artist's brother-in-law, Maxime Conil, who sold it to Ambroise Vollard on December 18, 1899, according to Vollard's stock books. Vollard sold it on January 25, 1922, to Ralph M. Coe, Cleveland, and it was purchased in early 1936 by the Cleveland Museum of Art.

EXHIBITIONS
After 1906: New York, 1928, no. 15; New York, 1929, no. 23; San Francisco, 1937, no. 26; Aix-en-Provence, 1956, no. 41; Edinburgh, 1990, no. 46.

The Bellevue farm owned by Cézanne's brother-in-law, Maxime Conil, in the countryside southwest of Aix, provided safe harbor for the artist through much of the 1880s. From there he explored the surrounding terrain, particularly the vistas it offered of the Arc valley and Mont Sainte-Victoire (see cat. nos. 89-95). However, it was only toward the end of the decade that he turned his attention to the buildings on the estate, a jumbled aggregate of structures hugging a small knoll sheltered by cypress, pine, and olive trees (see figs. 1 and 2). The most distinctive architectural feature of the complex was a freestanding pigeon tower at the property's highest point. Renoir made a painting of it when Cézanne arranged for him to rent the house from the Conils in 1889 (fig. 3). Cézanne himself included the tower in at least three of his landscapes, and it is tempting to speculate that he painted the version now in Cleveland in the company of his old Parisian colleague, for the two works show views from a similar vantage.

However, any comparison must stop there. In Renoir's painting the buildings merge with the landscape in a web of color, while Cézanne's tower stands alone and isolated. This is one of Cézanne's most geometric paintings; the outlining of the architecture extends to much of the foliage and the horizontal bands of earth. There is little texture to the paint, which is laid on thinly, and the tonal modulations shift smoothly from one feature to the next. The brilliant highlights on the tile and pale stucco of the tower could only occur in the sunlight of the South, but there is no sense here of atmosphere or even of the light's passage through air. As Richard Verdi has observed, "This picture is as close as Cézanne ever came to imbuing a landscape subject with the purity and finality of one of his still-life compositions."[1]

J. R.

1. Verdi, 1992, p. 147.

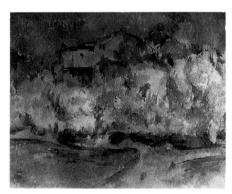

Fig. 1. Paul Cézanne,
Houses and Pigeon Tower at Bellevue,
1888-92, oil on canvas,
Folkwang Museum, Essen (V. 651).

Fig. 2. Pigeon tower at Bellevue,
photograph by John Rewald, c. 1935,
collection of Sabine Rewald.

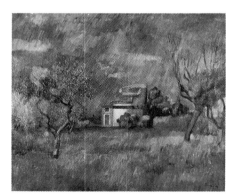

Fig. 3. Pierre-Auguste Renoir,
Pigeon Tower at Bellevue, 1889,
oil on canvas,
The Barnes Foundation, Merion,
Pennsylvania.

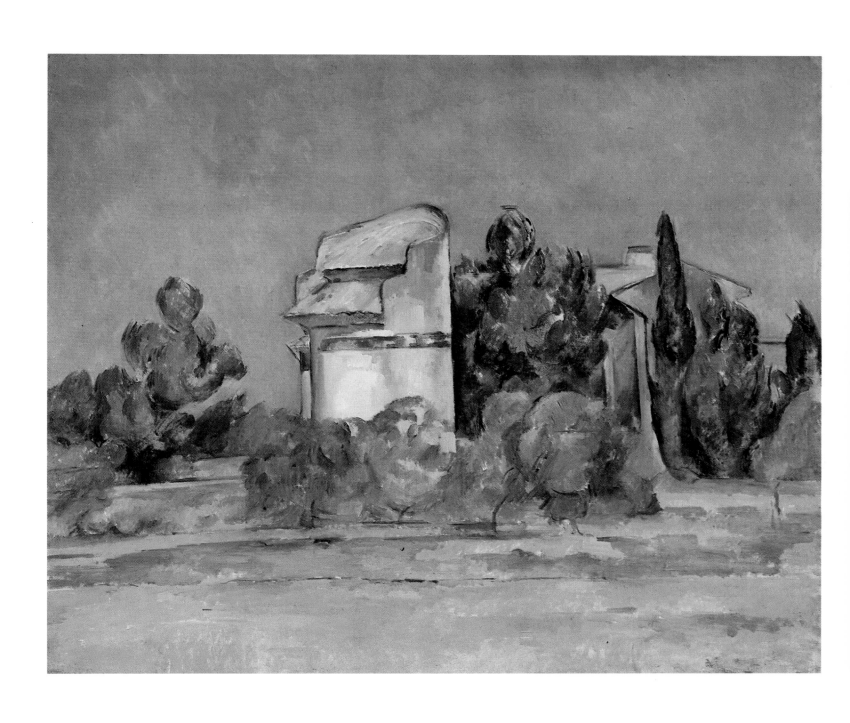

Works Related to *Mardi Gras*

122 | *Studies for "Mardi Gras"*

c. 1888
Graphite on paper with white highlights; 9⅝ × 12 1/16 inches (24.5 × 30.6 cm)
Musée du Louvre, Paris. Département des Arts Graphiques. Musée d'Orsay, Personnaz Bequest
C. 938

PROVENANCE
By 1936, this drawing was in the collection of Antonin Personnaz, Bayonne,[1] who gave it to the Louvre in 1937.

EXHIBITIONS
After 1906: Paris, 1974, no. 60.

EXHIBITED IN PARIS ONLY

123 | *Harlequin*

c. 1888
Graphite on paper; 18⅝ × 12 3/16 inches (47.3 × 30.9 cm)
The Art Institute of Chicago. Margaret Day Blake Collection
C. 941

PROVENANCE
This drawing originally belonged to the artist's son, Paul. Thereafter, it passed to Walther Halvorsen, Oslo. By 1936, it was owned by the Galerie Thannhauser, Lucerne. In 1944 the drawing was purchased from the Justin K. Thannhauser Gallery, New York, and given by Tiffany and Margaret Blake to the Art Institute of Chicago, where it is now part of the Margaret Day Blake Collection.

EXHIBITIONS
After 1906: Berlin, 1927 (a), no. 36; Basel, 1935, no. 109; Basel, 1936, no. 137; Paris, 1939 (a), not in catalogue; Lyon, 1939, no. 70; Chicago and New York, 1952, no. 72; Washington, Chicago, and Boston, 1971, no. 80.

EXHIBITED IN PHILADELPHIA ONLY

124 | *Harlequin*

1888-90
Oil on canvas; 39 13/16 × 25⅞ inches (101.1 × 65.7 cm)
National Gallery of Art, Washington, D.C. Collection of Mr. and Mrs. Paul Mellon, 1985. 64.7
V. 554

PROVENANCE
It is possible that this canvas was purchased directly from Ambroise Vollard by Émile Schuffenecker, Paris.[2] It subsequently passed into the collection of Auguste Pellerin and then to that of his son, Jean-Victor Pellerin, Paris. In 1967 Mr. and Mrs. Paul Mellon, Upperville, Virginia, purchased it from Pellerin, and gave it to the National Gallery of Art in 1985.[3]

EXHIBITIONS
Before 1906: Paris, 1899, no. 5 (?).
After 1906: Paris, 1936, no. 73; Paris, 1939 (a), no. 24; Washington, 1986, unnumbered.

EXHIBITED IN PARIS AND PHILADELPHIA ONLY

Cézanne's son told Lionello Venturi that he had posed for the figure on the right in *Mardi Gras* (Pushkin State Museum of Fine Arts, Moscow; too fragile to travel, repro. p. 63) in the studio his father had rented on the rue Val-de-Grâce in Paris. The other young man in the picture, dressed in white, is young Paul's longtime friend Louis Guillaume, a cobbler's son who had sat for a portrait by Cézanne some six years earlier (see p. 234, fig. 2). When this picture was painted in 1888, Paul was sixteen years old, and to judge from the image here, full of poise and self-confidence.

The two boys wear costumes of the *commedia dell'arte*, the boisterous street theater that was imported from Italy to France in the sixteenth century and whose stock characters and standard plots provided imagery for French painters from Watteau to Daumier and Picasso. Paul is in the diamond-patterned suit of the lithe and ingenious scamp known as Harlequin, while Louis wears the loose white tunic and ruff collar of Pierrot, who was always thwarted in love. They have just emerged from the curtain behind them, as from the wing of a steeply sloped stage. Pierrot is occupied in an antic of some sort, perhaps pinning a lewd placard onto the back of Harlequin, as Rivière speculated,[4] or attempting to steal his white baton. Both figures seem stiff, even frozen, despite their implied forward strides, but, as Venturi noted, there is "a certain humor in the monumental fixedness of their forms."[5]

In the late 1880s Cézanne, having concentrated on still lifes, landscapes, and imaginary Bather subjects for almost two decades, once again turned his attention to making figure paintings after the live model. At his studio on the rue Val-de-Grâce, he asked Paul and his friend to pose at about the same time he was depicting another youth in costume—a hired Italian model wearing a red waistcoat (see cat. no. 127)—in the family apartment on the quai d'Anjou. One explanation for Cézanne's renewed interest in figure painting is simply that having momentarily traded the isolation of Aix, L'Estaque, or Bellevue for Paris, he found himself caught up in urban rhythms and daily contact with a wide range of people. His improved financial circumstances in the wake of his father's death in 1886 may have been a factor as well, making it possible for him to afford paid models and a studio in a respectable Parisian neighborhood. Whatever the cause, in these years he embarked on a series of multifigure compositions—genre paintings, in fact—that were to climax in the early 1890s, after his return to Aix, in the several versions of *Cardplayers* (see cat. nos. 132-35).

In a sense, *Mardi Gras* is their urban predecessor. It has sometimes been described as a paradox: a scene of amateur theatrical high jinks featuring gaily costumed actors but completely lacking in expression. According to Rewald, the figures are "untouched by any emotions."[6] In Gowing's view, "the action of the picture is seemingly automatic, as if the figures were attached to a pendulum swinging back and forward from the top edge."[7] But this quality is not the result of an incapacity to infuse *commedia dell'arte* subject matter with dramatic interest. Three quite vigorous "carnival" drawings (C. 935, C. 936, and fig. 1) date from about the same time as *Mardi Gras*. They show four or five figures—one roughly embraces a female figure, and another collapses beside Pierrot's conical hat or grasps a female figure—drawn directly from a performance or extrapolated from one the artist had seen. Yet none of the agitation that characterizes these sketches, so reminiscent of his early work, is present in the painting.

The unrelenting neutrality of the two figures in the Moscow painting has prompted at least two highly developed biographical readings. Is this Cézanne's confession of a melancholic nostalgia for his own youth, which he was reliving through his son's sexual coming of age and could express only with a certain joylessness?[8] Is it an emblematic depiction of his shattered friendship with Zola, in which he cast himself as the brave and persevering Harlequin upon whom Zola, the treacherous Pierrot, advances sneakily from behind?[9] Neither of these interpretations seems entirely consistent with our experience of the picture, and Cézanne's profound aversion to everything that was "literary" in painting. On balance, it seems more likely that he was simply doing what he did in the *Cardplayers* and the late Bather subjects: redefining the nature of expression in narrative painting once and for all by bringing it to a new pictorial level.

Mardi Gras was prepared with unusual care. The heavy, draped curtain through which the boys have just passed is also the subject of a highly finished watercolor and an oil painting (see p. 276, figs. 1 and 2), and Cézanne drew several studies of both boys' faces; indeed, more meticulous studies for the Harlequin are preserved than for any other figure in his oeuvre.[10] The Louvre drawing (cat. no. 122) is one of the few showing the artist's son as a man, or as a youth trying to grow his first mustache. In drawings of some three years earlier the son seems tentative and psychologically undefined (see cat. no. 105), but his unflinching gaze here indicates considerable cocky self-possession. The juxtaposition of the two portraits allows us to observe almost cinematically the way Paul changed his expression with the slightest tightening of his mouth, as if rethinking his character's role in the play. We also see Cézanne's responsiveness to such subtleties in the shifted scale and

Fig. 1. Paul Cézanne,
Carnival Scene, Study, 1885-88,
graphite on paper,
Öffentliche Kunstsammlung Basel
(C. 937).

weight of his renderings. Perhaps this lad of sixteen is a bit callow, but his late-adolescent vanity and self-assurance clearly delighted his father.

Most of this vivacity disappeared when the head was transferred to the painting. However playful the dramatic pretext, the full-dress version comes across as a serious and even public statement. Cézanne here set out to make his players seem to inhabit another, more permanent level of existence, one outside of time. Transient emotions or flashes of characterization would have been inappropriate in this formalized world, which has a schematic quality suggestive of Egyptian relief or Greek vase painting. The one thing Cézanne retained was the intensity and confidence of the boy's gaze, at once distant and familiar.

It is hard to think of an image that held Cézanne's interest so firmly as the Harlequin he invented for *Mardi Gras*. The artist represented him in three oil paintings (cat. no. 124, V. 553, V. 555), a highly finished watercolor (R. 295), and one of his most complex figure drawings (cat. no. 123). The precise relation of these works to the Moscow canvas is unclear. We know that the latter painting was completed by 1890, when Victor Chocquet purchased it. Most scholars have dated the single Harlequins to 1888-90, and have given the Moscow picture chronological precedence. The two kinds of images could not be more different. *Mardi Gras* is one of the artist's most austere creations. The contrast of the figure's costumes, the decisiveness of their poses, and the sharp incline of the setting initiate a narrative of human interaction that is imminent but never consummated. That tension provides the painting's mystery and power. The single Harlequins, by contrast, are neutral, the figures stable and self-controlled.

Compared with its counterpart in *Mardi Gras*, the Harlequin in the Chicago drawing (cat. no. 123) is a stylized invention: more elegant in physique, more artificial in pose, more mannered in proportion. The mask-like face prompted Chappuis to speculate that this was drawn after an artist's dummy wrapped in the same costume worn by Paul.[11] It is a complex tour de force of draftsmanship as the lozenge pattern on the figure turns in space. The contrast of the diamonds is here rendered in black and white. The shading and blurring of the pattern to convey the contours of the legs suggest that the image is about to acquire color in some magical fashion, as it literally would in the slightly elongated and tightened watercolor version (R. 295).

There, the medium's inherent coloristic effects are indeed given free rein: pencil marks are minimized and the brush describes both line and color.

The Washington canvas (cat. no. 124) is the largest of the three oil versions of Harlequins. It is tempting to think of the third, the smallest and most freely handled variant (now in Japan), as a transition point between the watercolor and the larger picture, but such sequences are difficult to establish with certainty.

In each of the three canvases the face has been reduced to near featurelessness. The effect, heightened by the white crescent of the hat, is almost spectral. The pose is almost exactly that of Paul in *Mardi Gras*, but here the figure is a much more aggressive presence—his right foot placed forward and turned more toward the picture plane. The cropping of the right foot literally cuts short his advance. The palette is very different from that of the Moscow picture. The color scheme of the costume has been retained, but the muted grays and browns of the background in *Mardi Gras* have been replaced by sharp pinks and greens, while the ocher of the drapery has been given yellow highlights. These changes provide a disquieting quality to the Washington painting, which is keyed up even further by the electric whiteness of the baton slicing through the composition with unnerving clarity and precision.

Rewald wrote of the Washington version: "*Harlequin* strikes a peculiar note which Cézanne did not produce—or even attempt to produce—anywhere else. It is bold and delicate at the same time, tightly knit and yet vibrant."[12]

J. R.

1. For more information on the Personnaz collection, see Vergnet Ruiz, "Musée du Louvre, peintures et dessins: La Collection Personnaz," *Bulletin des Musées de France*, vol. 9, no. 7 (July 1937), pp. 98-101.
2. See Rewald, 1986 (c), p. 316.
3. See Washington, 1986, n.p.
4. See Rivière, 1933, p. 140.
5. Venturi, 1936, vol. 1, no. 552, p. 184.
6. Rewald, 1986 (c), p. 316.
7. Gowing, in New York, 1988, pp. 32-33.
8. See Lindsay, 1969, p. 220.
9. See Badt, 1985, pp. 108-9.
10. See Rewald, 1986 (c), p. 315.
11. See Chappuis, 1973, vol. 1, no. 941, p. 221.
12. Rewald, 1986 (c), p. 316.

122

123

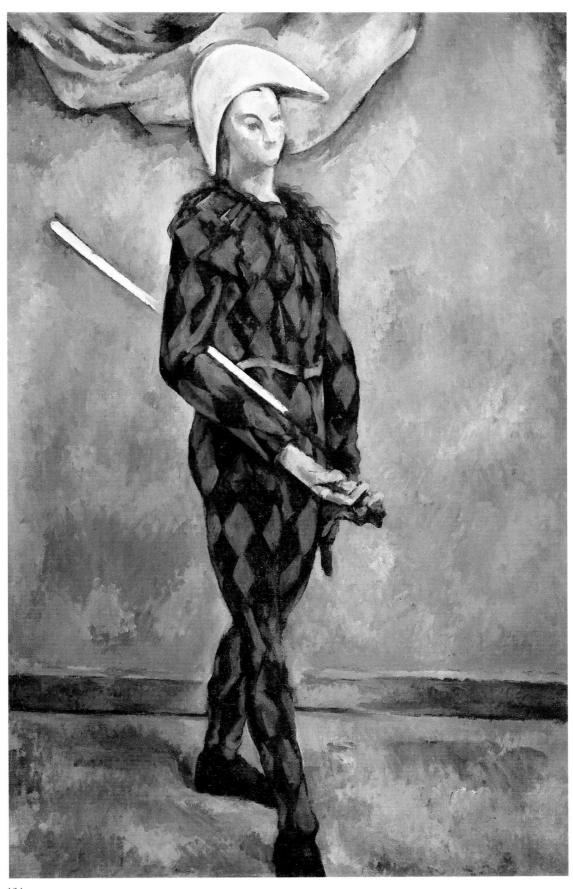

124

Portrait of Madame Cézanne

1888-90
Oil on canvas; 29³/₁₆ × 24 inches (74.1 × 61 cm)
The Museum of Fine Arts, Houston. The Robert Lee Blaffer Memorial Collection,
gift of Sarah Campbell Blaffer
V. 529

PROVENANCE
From Ambroise Vollard this canvas passed to Walther Halvorsen, Oslo, and
then to the Galerie Thannhauser, Lucerne, and to Étienne Bignou, Paris,
before arriving in 1930 at the Knoedler Galleries in New York. In Febru-
ary 1948 it was purchased by Mrs. Robert Lee Blaffer, Houston, who in the
same year gave it to the Houston Museum of Fine Arts, where it became
the first piece in the Robert Lee Blaffer Memorial Collection.[1]

EXHIBITIONS
After 1906: London, 1925, no. 14; Berlin, 1927 (a), no. 23; San Francisco,
1937, no. 23; Paris, 1939 (b), no. 14; Lyon, 1939, no. 31; Chicago and New
York, 1952, no. 67; Liège and Aix-en-Provence, 1982, no. 18; Tübingen,
1993, no. 38.

Cézanne looked at Hortense Fiquet longer and more in-
tensely than anyone else in his life. In more conventional
circumstances she would have been his muse, for she was
his constant subject. But no one, not even the most sym-
pathetic biographer, has cast her in this role. The forty-
four paintings and numerous drawings of her are pervaded
by a sense of neutralizing observation that is too sober to
suggest such a characterization.

A tall and handsome woman with brown hair, large
black eyes, and a sallow complexion, Hortense Fiquet met
Cézanne in Paris in 1869, when she was a nineteen-year-
old artist's model. Cézanne must have felt deeply drawn to
her, even though he was desperately shy of women and
seems to have suffered from an almost hysterical fear of
physical contact. Perhaps her docile and calm tempera-
ment encouraged him, for she became his mistress that
same year. Their only child was born in 1872. It is often
said that their relationship disintegrated thereafter. Cer-
tainly the dull, restrictive life of Aix bored Hortense.
Cézanne's household continued to be run by his mother
(until 1889) and his maiden sister, Marie, and Hortense
spent as much time in Paris as he would allow her. Yet
they married in 1886, and nearly every letter Cézanne
wrote to Paul includes a warm greeting to her. The notion
that she, like all the artist's portrait subjects, was turned
into a still-life object by him is one of the earliest and sad-
dest misconceptions to enter the Cézanne mythology. The
pictures themselves tell another story. Whatever he
thought of Hortense at any given time, every image of her
is permeated with deep and ponderous emotions.

Here she appears remarkably plain, an impression rein-
forced by her severely parted hair. The set of her head,
cocked almost imperceptibly to the left, and her slight tilt
to the same side loosen what otherwise would be a static
confrontation. There is no passivity in the steadiness of her
gaze, and she holds her head and shoulders with consider-
able dignity. The flesh tones of her head and neck are ex-
tremely refined; the transition of their contours from the
soft modeling of the jaw to the line drawn around the chin
and ear truly has a lyrical quality.

Only gradually does one realize that Hortense's head is
actually an island of stability and stillness within a tremen-
dously complex and animated construct. The collar of her
blouse projects over the outer garment (presumably a kind
of housecoat), introducing a scalloped rhythm that tum-
bles down her chest in a rippling cascade. These feminine
shapes are contrasted with the sharp folds of the outer col-
lar, which seems more of a piece with the garment's crisply
tailored shoulders. The vigorously brushed dress is a rich
dialogue of blues and greens. The door beyond, painted a
lighter tone of the same blue, rests easily in its plane, even
where the outlines of its moldings are interrupted by the
thick strokes of her shadow. The exaggerated scrollwork of
a large piece of furniture, tightly cropped on the left, ob-
scures all but a small field of a teardrop-patterned wall-
paper. The opposition of the two sides of the canvas—the
exotic shapes on the left contrasting the spare regularity of
the background of the right—is further accentuated by the
tonal contrast of browns and pale blues. As Madame
Cézanne sits on a chair in front of this onslaught of idio-
syncratic shapes, she seems to hold them in check through
the calmly determined rectitude of her straight-backed
posture.

J. R.

1. See *The Bulletin of the Museum of Fine Arts of Houston, Texas,* vol. 10, no. 2
(Spring 1948), n.p.

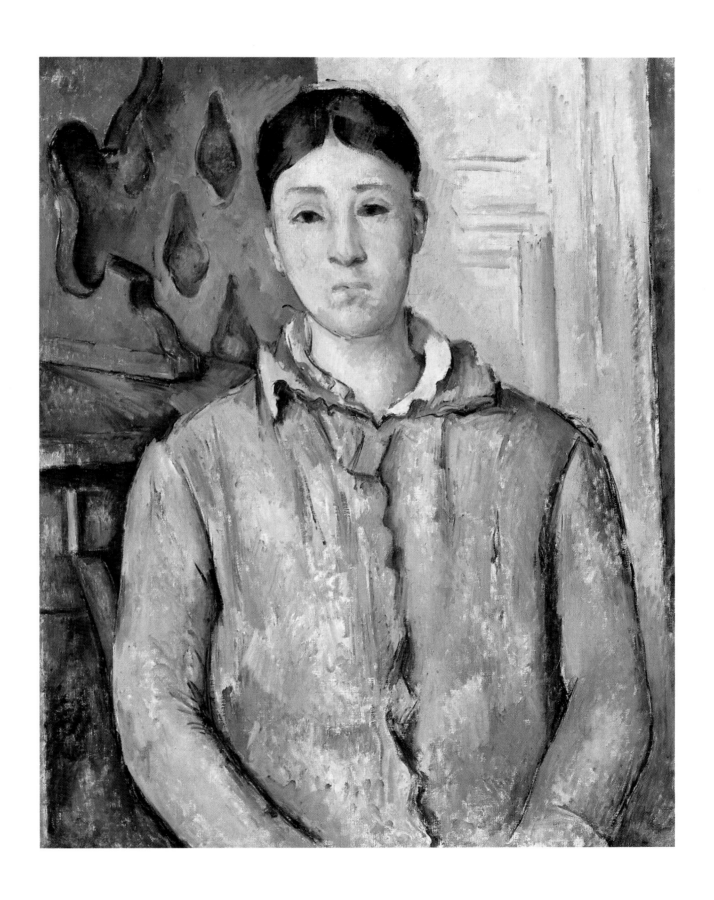

126 | *Portrait of Madame Cézanne*

1888-90
Oil on canvas; 18⁵⁄₁₆ × 15¹⁄₈ inches (46.5 × 38.4 cm)
Musée d'Orsay, Paris (R.F. 1991-22)
V. 530

PROVENANCE
This painting first belonged to Madame Cézanne. It then passed through the hands of the dealer Paul Rosenberg, Paris, who sold it to Henri Matisse. It remained in the Matisse estate until 1991, when it entered the collection of the Musée d'Orsay.

EXHIBITIONS
After 1906: Paris, 1924, unnumbered; Paris, 1939 (a), no. 17; London, 1939 (a), no. 11.

Madame Cézanne wears the same powder-blue dress—here modulated with touches of green—she wore for the previous portrait (cat. no. 125), but she has removed the prim blouse with the scalloped collar.

This is simpler fare all around than the Houston painting, to which it is clearly related. While there is little suggestion of setting in this less ambitious composition, the background is similarly divided into two areas of brownish green and pale blue. An ear projects emphatically from the left side of the head, but on the opposite side nothing interrupts the lyrical curve that rises from the chin to the top of the head.

It is particularly difficult to keep Cézanne's simpler and less embellished works in their historical context. The next step beyond the reduced and elegant understatement of this portrait would logically seem to be a Brancusi. But perhaps it was this quality of polished abstraction that attracted Henri Matisse, from whose estate the work entered the Musée d'Orsay. The subtle coloristic manipulations, the comfortable way the sitter fills out the visual space, and the serenity conveyed thereby must also have pleased an artist whose professed aim in his own work was the projection of luxurious calm.

 J. R.

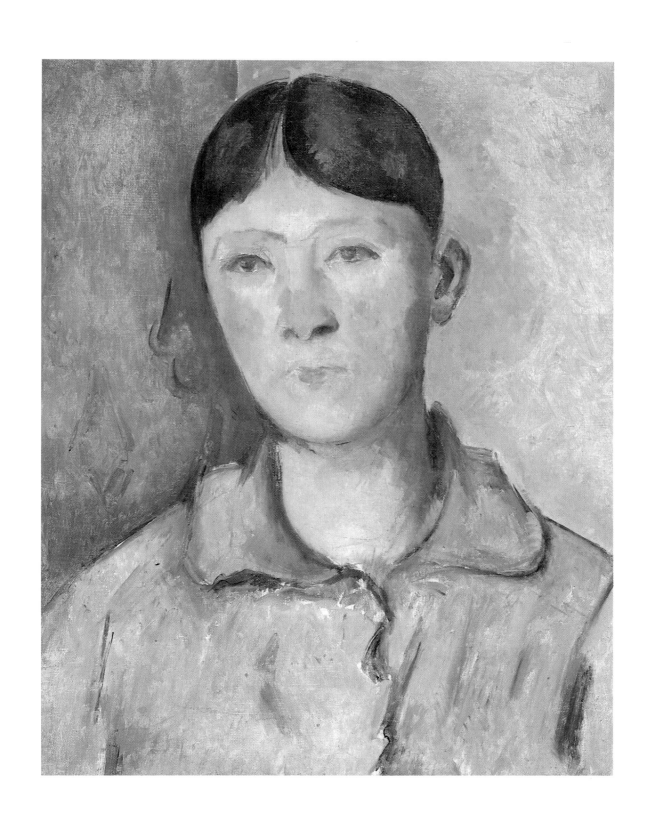

The Boy in the Red Vest, I

1889-90
Graphite and watercolor on paper; 18¹/₈ × 12³/₁₆ inches (46 × 31 cm)
Private collection
R. 375

PROVENANCE
This watercolor was first owned by Ambroise Vollard. In 1938 it was acquired by Walter Feilchenfeldt, of Amsterdam and Zurich.[1] It is now in a private collection.

EXHIBITIONS
After 1906: New York, 1943, no. 35; New York, 1947, no. 78; Chicago and New York, 1952, no. 74; The Hague, 1956, no. 70; Aix-en-Provence, 1956, no. 74; Zurich, 1956, no. 110; Munich, 1956, no. 85; New York, 1963 (a), no. 33; Hamburg, 1963, no. 17; Washington, Chicago, and Boston, 1971, no. 47; Tübingen and Zurich, 1982, no. 99.

From 1888 to 1890 Cézanne and his family lived in Paris in an apartment at 15, quai d'Anjou on the Île Saint-Louis. The room that served as his studio in that apartment had several distinctive features—notably a wainscot or molding accompanied by a narrow wine-red band—that have made it possible to date several pictures to this period. Among these are four oil paintings (figs. 1, 2; repro. p. 49; and V. 682) of a long-haired young man shown three-quarter length and wearing a red vest. The paintings depict the sitter in a remarkably varied set of poses and moods and are among the artist's greatest achievements. Writing of one of the pictures (recently donated by Paul Mellon to the National Gallery of Art in Washington, D.C.), Gustave Geffroy noted that it could "stand in comparison with the most beautiful figures in painting."[2]

The young man in question was a paid model named Michelangelo di Rosa. The use of a professional sitter was a departure for the artist, who usually prevailed upon family and friends to sit for him—no small burden, given the long sessions he required. It may be that Cézanne, having come into his inheritance on the death of his father in 1886, felt he could finally afford such an expense. This episode did not set a precedent, however, for he soon resumed using those who surrounded him daily as his sitters.

The four paintings for which di Rosa sat attest to the rich possibilities inherent in portraiture. The three larger oils evoke a number of artistic precedents, ranging from the elegance of Pontormo, to the introspection of Holbein, to the romantic pensiveness of Delacroix. In each the young man seems tremendously handsome and vital. The smallest portrait (fig. 1) shows him as a vulnerable and rather simple adolescent.

There are also two watercolors depicting di Rosa in the same basic pose, seated and leaning slightly forward. These are not studies for the oils but autonomous works of art. One of these (R. 376) was executed solely with the brush and without any underdrawing and has a casual flavor unlike the oils. The version shown here is the more complex of the two, an image of rare graphic richness: the essential forms were lightly sketched in pencil, then watercolor was added in some passages, reinforcing the pencil lines in some areas and in others taking on independent life.

In this sheet, the young di Rosa straddles the leg of a low stool, his red vest blousing open; he has removed the blue cravat that binds his collar in all the oils. The effect is very different from the paintings, striking an entirely new mood. The strokes of pencil and watercolor have a fluency and ease in keeping with the attitude of the model, who, presented in this modest state of dishabille, seems rather dashing. Even so, the awkwardness of the adolescent body—the large hands, the uneasy pose—is more apparent here than in the oils, and the subject's blurred expression can be read as petulant and dimly wary. These varied studies after a single model reveal a profound sympathy for the psychological vicissitudes of youth.

J. R.

1. See Rewald, 1983, no. 375, pp. 174-75. During World War II, according to Rewald, Dr. and Mrs. Walter Feilchenfeldt entrusted this and other Cézanne watercolors in their possession to a friend, novelist Erich Maria Remarque, for safekeeping in the United States. This explains why these works were exhibited in New York at the Knoedler Galleries in 1943 and at the Wildenstein Galleries in 1947 among works from the Remarque collection. After the war he returned all of them to their owners in Zurich.
2. Geffroy, 1900, p. 218.

 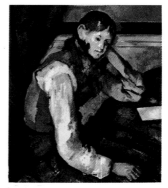

Fig. 1. Paul Cézanne,
The Boy in the Red Vest, 1888-90,
oil on canvas,
The Barnes Foundation,
Merion, Pennsylvania (V. 683).

Fig. 2. Paul Cézanne,
The Boy in the Red Vest, 1888-90,
oil on canvas,
E.G. Bührle Foundation,
Zurich (V. 681).

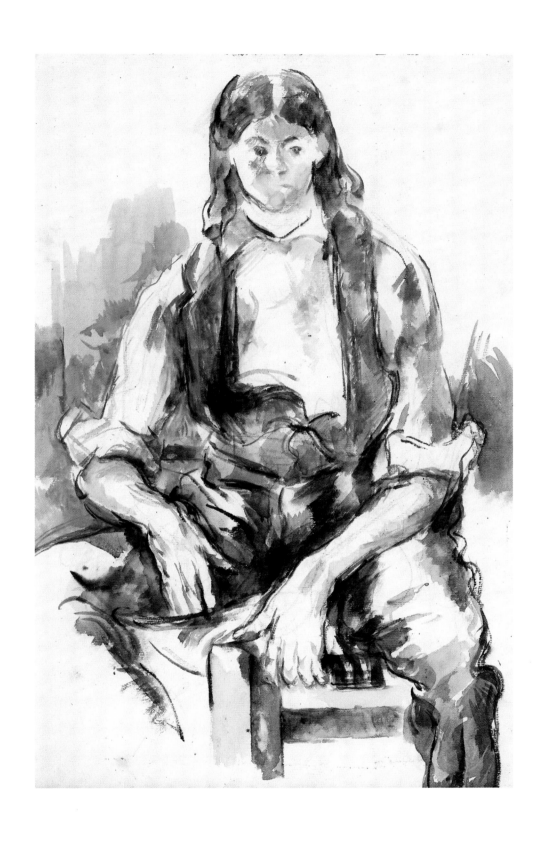

1888-90
Oil on canvas; 25⅝ × 31½ inches (65 × 80 cm)
Signed lower right: *P. Cézanne*
Musée d'Orsay, Paris. Bequest of Auguste Pellerin (R. F. 2819)
V. 594

PROVENANCE
This painting was given in 1891 or 1892 by Cézanne to Émile Zola's close friend Paul Alexis. Thereafter it was acquired through Bernheim-Jeune by Auguste Pellerin. On Pellerin's death in 1929, it was bequeathed to the Musée du Louvre. It is now in the Musée d'Orsay.

EXHIBITIONS
After 1906: Basel, 1936, no. 46; Paris, 1954, no. 36; Paris, 1974, no. 36; Madrid, 1984, no. 38.

Few Cézanne still lifes contain such a variety of elements or involve them in such complicated spatial maneuvers as this one. The end result is as colorful, gay, and amusing as an eighteenth-century canvas—oddly enough, qualities rarely credited to Cézanne—as well as gloriously satisfying in the way it keeps all its parts moving and in tune.

The blue ginger jar was one of the artist's favorite studio props, appearing in nine other painted still lifes as well as two watercolors. It is the "kind of pot, a diapered alcaraza" mentioned by Joachim Gasquet when he described this still life in Cézanne's studio, Gasquet having mistaken the willow strands for decorations in the glaze.[1] It is joined by other familiar objects: the gold-banded white sugar bowl and the small pitcher that, judging from the floral pattern found on both, may be its mate. These vessels nestle within the folds of a carefully arranged white napkin on a rustic wooden table, which also holds small yellow and red pears, yellow and green apples, and huge green pears, perhaps those famously grown in the Durance valley near Cavaillon, northwest of Aix. The arrangement of the various objects at angles that can hardly be random confirms Louis Le Bail's observation about the great care with which Cézanne ordered the elements in his still lifes before setting to work, often propping them up with coins or bits of wood to produce the desired effect.[2] On the far right corner of the table sits a large oval basket lined with another white napkin, into which have been placed, again with great care, seven additional pears. The basket sits perilously over the back edge of the table but gives no sense of disequilibrium, bracketed as it is between the shadow of the ginger jar on the left, the cropped leg of a stool on the right, and the large pears in front. Part of a high, narrow table appears on the left, on which rest a small jar, an empty satchel whose black string tie falls over the front edge, and a flat object with a hole through it that resembles an artist's palette. Behind this table is a wide floral band, identifiable as the border of a folding screen that Cézanne painted with Zola's help in the mid-1850s, and that became part of the furnishings of the Jas de Bouffan (it also appears in other still lifes).[3] The corner of a green portfolio is just visible beyond the second fold of the screen, resting on the floor beside a simple rush-seated chair against the back wall. On the far right the square stool leg intrudes on the scene, bringing the entire composition to oblique resolution.

This must be the deepest space Cézanne ever explored in his still lifes, which usually unfold in more confined settings (see cat. nos. 166, 180, and 181). He needed this much room to accommodate the shifting planes in which the rounded forms interact. The design encourages the viewer's gaze to move through the composition in a zigzag trajectory. Vertical and receding planes unfold from the foreground to the middle ground, where the space drops away, only to rise once again in the pitched floor and wall at the rear. With deferential delicacy, the edge of the floor meeting the wall descends to the right at the subtlest of inclines.

Of all the Cézanne still lifes in this exhibition, this one may best exemplify the famous observation made by Wassily Kandinsky in *On the Spiritual in Art*: "He made a living thing out of a teacup. To be more precise, he realized the existence of a being in this cup. He raised the 'nature morte' to a height where the exteriorly 'dead' object becomes inwardly alive. He treated these things as he would the human being, because he was endowed with the gift of divining inner life in everything. He gives to them a colourful expression, which establishes an artistic, inner note and molds them into the form, which are elevated to abstract sounding notes of harmony radiating mathematical formulae. It is not a man, an apple, or a tree that are represented. All are solely used by Cézanne for the construction of an innermost artistically sound reality which we call a painting."[4]

The painting is signed in blue in the lower right corner, rare for Cézanne at any point in his career, but particularly so in the 1890s. In all likelihood, he added the signature as a special gesture to Paul Alexis when he gave him the work in 1891 or 1892, just as he would do for Gasquet with *Mont Sainte-Victoire with Large Pine* (cat. no. 92).

J. R.

1. Gasquet, 1921, p. 120.
2. See Rewald, 1986 (a), p. 228.
3. See Reff, in New York and Houston, 1977-78, p. 32.
4. Wassily Kandinsky, *On the Spiritual in Art*, ed. and trans. Hilla Rebay (New York, 1946), pp. 31-32.

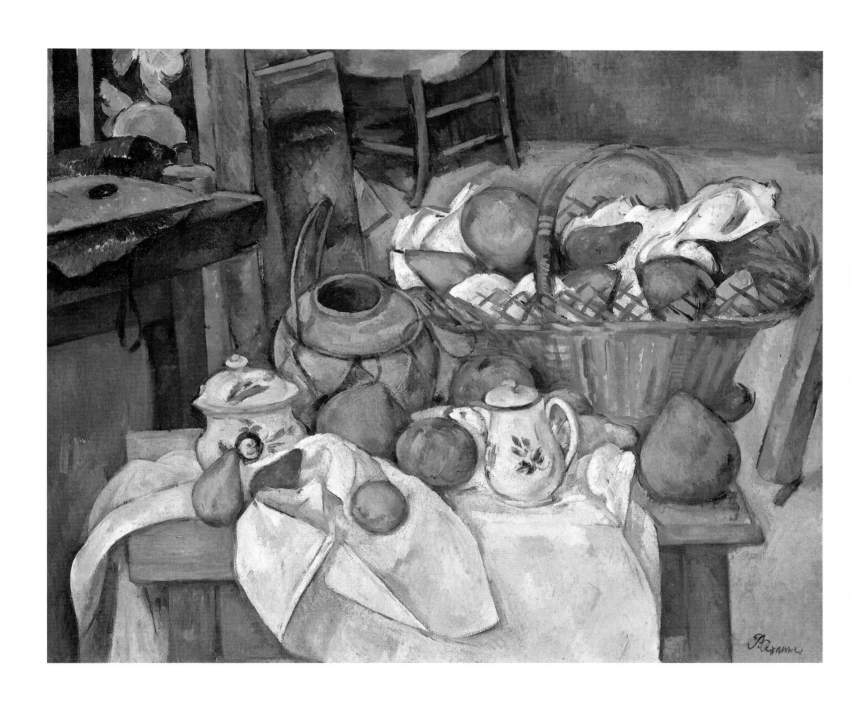

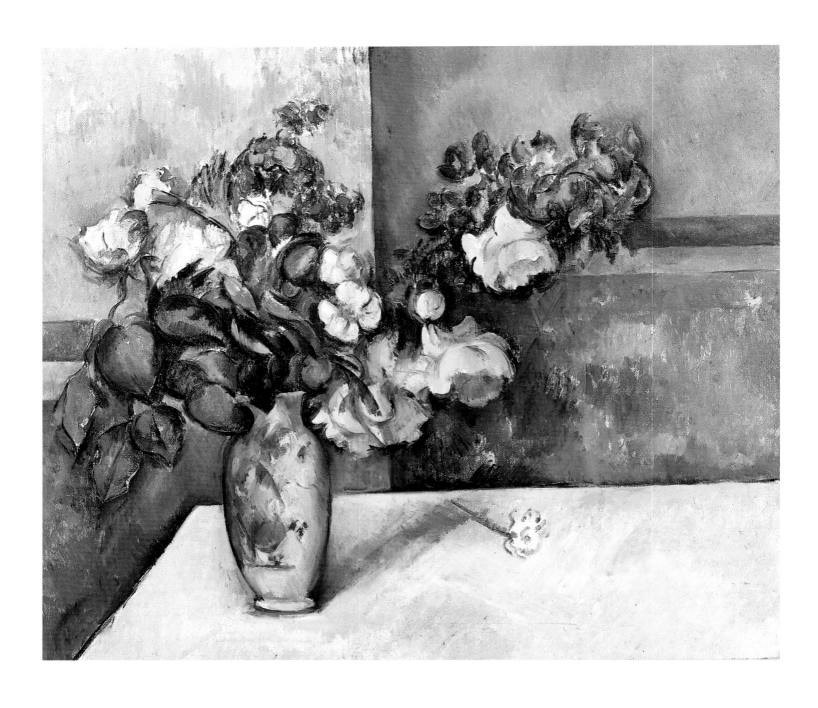

129 | *Flowers in a Vase*

1885-88
Oil on canvas; 18¼ × 21⅞ inches (46.4 × 55.6 cm)
Private collection

PROVENANCE
This painting was sold by Ambroise Vollard to Horace and Louisine Have-meyer, probably in 1906.[1] Upon Mrs. Havemeyer's death in 1929, it was inherited by their son, Henry. When he died in 1956, it passed to his widow, Doris Dick Havemeyer. After her death in 1982, it was included in the sale of her collection at Sotheby's, New York, on May 18, 1983 (lot 10). It is now in a private collection.

EXHIBITIONS
After 1906: New York, 1993, no. 76.

A comparison of this luminous flower piece with the more tautly composed *Blue Vase* from the Musée d'Orsay (cat. no. 130) illustrates the tremendous expressive range Cézanne could find in similar subjects. The construction of the Paris picture is manifestly the result of formal calculations of brilliant complexity, all playing off a center. This former-Havemeyer painting, by contrast, seems uncalculated due to its asymmetrical composition and loose handling. Or so it seems at first encounter. Closer examination reveals a host of subtleties.

A white porcelain vase decorated with blue motifs *à la chinoise* sits well to the left on a cream-colored tabletop. Several branches of flowers, selected with no apparent coloristic or compositional rationale, are placed in it. The stem on the left seems to belong to the five red blooms, one of which (on the far upper left) is a rose. Near the center of the group are four white flowers, another of which has fallen onto the table. Most dramatically, a long single branch of yellow roses (one still in bud) extends far to the right, raising doubts about the stability of the vase. The sprawling blooms at the center, however, have a wonderful abundance, prompting pleasurable associations rarely linked with Cézanne: smells of summer, warm breezes, bountiful well-being.

The table sits slightly forward from the blue wall marked by a red band. At nearly the center of the canvas this wall divides and steps back to another plane, as if through a broad opening. The question, of course, is: Which is the forward plane, and which farther back, the darker blue, or the lighter? Both explanations offer very different spatial readings of the picture, either of which is engaging. This is not a question of ambiguity. For Cézanne it was absolutely one thing or the other, recorded from observed reality. It is simply that we, not knowing the actual space of this room, are left with an enigma, a completely pleasurable one.

The variety of whites is dazzling. The coldest is the one on the vase, which is dragged into blue and green, melding this area into a stable, dense unit. The cream tones of the tabletop are applied more broadly; they are tinged in blues and lavenders, with a few strokes of bright, pure white, interspersed to give a surface of considerable coloristic richness and vitality. The white paint of the blossoms is tinted with red, while the white that shines through the vertical strokes of green and blue on the walls is actually the priming of the canvas showing through, giving it an extraordinary unity and luminosity.

It is this unity that allowed Cézanne to bring off what is the real wonder of this painting: the large void of the table and wall in the right third of the canvas. In a more conventional composition it would read as so much dead space and unspring the whole, but here it allows the composition to breathe. Despite their weight and amplitude, the yellow roses would not have the same effect if they were not surrounded by this generous space. It is a calculated idea of positive and negative forms, of asymmetry, which we have come, in the twentieth century, to better understand, largely as a result of our acquaintance with Eastern art. Yet, for Cézanne it seems a completely natural invention, a formality he arrived at with great ease and seeming inevitability as he played with this enchanting composition.

J. R.

1. Frances Weitzenhoffer (1986, p. 167) has written: "During the summer of 1906, [Mary Cassatt, in a letter to Louisine Havemeyer dated July 27, 1906] informed her friends that Vollard was sending them 'some photos of Cézannes which he says he can get.' The dealer was most likely referring, among other works, to two landscapes—one probably *The Banks of the Marne* [now in the Hermitage Museum, St. Petersburg]—and a floral still life."

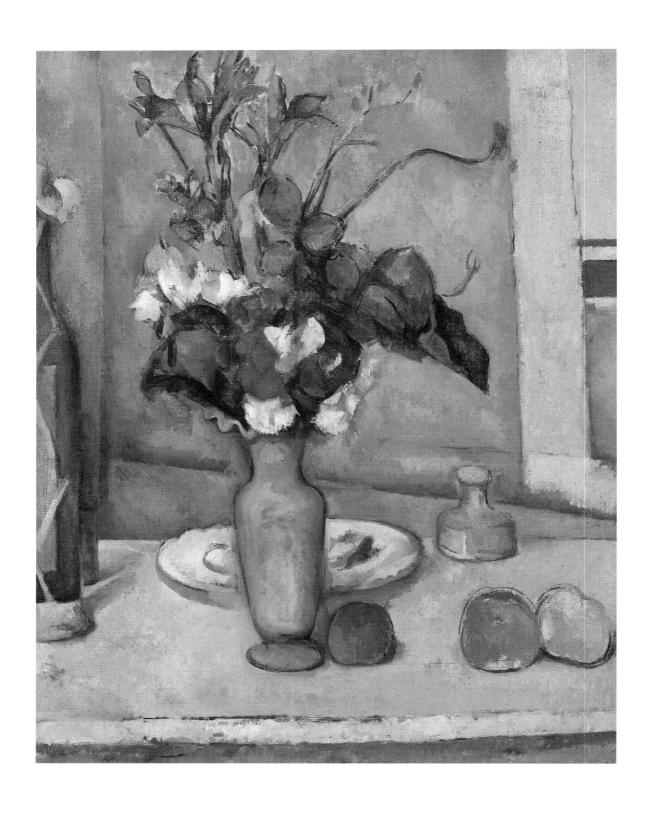

The Blue Vase

1889-90
Oil on canvas; 24 × 19^{11}/₁₆ inches (61 × 50 cm)
Musée d'Orsay, Paris. Bequest of Comte Isaac de Camondo (R. F. 1973)
V. 512

PROVENANCE
This painting was originally in the collection of Eugène Blot. It was included in the Blot sale at the Hôtel Drouot, Paris, May 9-10, 1900 (lot 20), but was bought in. It was again offered at a second Blot sale in May 1906 (lot 16), when it was acquired by Comte Isaac de Camondo, who bequeathed his collection to the Louvre in 1911.[1] It is now in the Musée d'Orsay.

EXHIBITIONS
Before 1906: Paris, 1904 (b), no. 18.
After 1906: Paris, 1936, no. 64; Chicago and New York, 1952, no. 61; Paris, 1954, no. 53; Washington, Chicago, and Boston, 1971, no. 17; Paris, 1974, no. 33.

Of all the artists who belonged to the Impressionist circle at one time or another, Cézanne is the one whose work displays the greatest variety of subject matter. Landscapes, still lifes, portraits, genre, historical, and mythological painting: all were undertaken by him at some point in his career. He demonstrated relatively little interest in flower painting, however, a genre much favored by his colleagues, notably Monet and Renoir. He produced only a dozen such works (see cat. no. 129). *The Blue Vase* is perhaps the best known of them. It is certainly the strangest.

A blue glass vase with a wide scalloped mouth sits just off-center on a marble or painted tabletop. Its base aligns horizontally with three pieces of fruit: one intimately near its foot, and a pair farther to the right. On the left, cropped by the edge of the canvas, is a corked bottle of rum wrapped in straw, which Cézanne also used in the mysterious still life of geraniums in the greenhouse at the Jas de Bouffan (fig. 1). Just behind the vase is a blue-rimmed, white biscuit plate that figures in many of the artist's still lifes from the 1890s. At the back edge is a short glass vessel with a label, which Rivière took to be a perfume bottle. The flowers are difficult to identify: two purple irises, certainly; some small yellow blossoms on stems; a soft, white, downward-turning flower (cyclamen?); and one or two heads of red blooms. Some of the artist's contemporaries maintained that Cézanne preferred artificial flowers because they did not wither away and thus allowed him ample time to paint them, but the variety and natural patterns of these flowers suggest that they were real.

The key to the mysterious spell cast by this picture is the way the blue of the vase seems to emanate like an aura, infusing the walls behind. The harmony between these powder blues and the oranges and yellows of the nearby objects is extremely beautiful and a bit eerie, as is the quality of light, which casts only very small shadows. As a result, the objects have a flatness suggestive of the silhouetted "shadow plays" that Cézanne denigrated in Gauguin's work.[1] It is perhaps this quality that prompted Michel Hoog to note: "Cézanne here defines a pictorial space that is completely autonomous, one whose sole justification is itself, even if certain of the objects carry a symbolic charge."[2]

Works like this make it easier to understand how Émile Bernard and Maurice Denis came to regard Cézanne as a kindred spirit. As for this particular work, it was clearly the point of departure for one of Matisse's greatest still lifes, the splendid *Blue Window* of 1913 (fig. 2).

J. R.

1. See Charles Chassé, *The Nabis and Their Period,* trans. Michael Bullock (New York and Washington, D.C., 1969), p. 41.
2. Hoog, 1989, p. 71.

Fig. 1. Paul Cézanne,
Geraniums, 1888-90,
oil on canvas,
The Barnes Foundation,
Merion, Pennsylvania (V. 602).

Fig. 2. Henri Matisse,
The Blue Window, 1913,
oil on canvas,
The Museum of Modern Art, New York,
Abby Aldrich Rockefeller Fund.

| *Boy Resting*

c. 1890
Oil on canvas; 21¹/₄ × 25¹¹/₁₆ inches (54 × 65.3 cm)
UCLA/Armand Hammer Museum of Art and Cultural Center, Los Angeles.
The Armand Hammer Collection
V. 391

PROVENANCE
This painting originally belonged to Ambroise Vollard, from whom it was acquired in June 1929 by the Galerie Thannhauser, Lucerne. In August of the same year it was purchased by Josef Stransky, former conductor of the New York Philharmonic Orchestra (it was one of five works by Cézanne to enter his collection). As part of the estate of Josef Stransky it was on loan to the Worcester Art Museum (Worcester, Massachusetts) from June 1932 through March 1936. Thereafter it came into the possession of the Wildenstein Galleries, New York (through 1947), whence it passed to the collection of Arnold Kirkeby, a California hotel operator who relocated to New York. It was sold at the Kirkeby collection sale at Parke-Bernet, New York, in 1958.[1] It was acquired for the Armand Hammer Collection, Los Angeles, in 1971.

EXHIBITIONS
After 1906: Paris, 1926, no. 5; New York, 1929, no. 13; San Francisco, 1937, no. 16; London, 1939 (b), no. 30; New York, 1947, no. 19; Aix-en-Provence, Nice, and Grenoble, 1953, no. 12 (not exhibited in Grenoble); Tokyo, Kyoto, and Fukuoka, 1974, no. 41; Liège and Aix-en-Provence, 1982, no. 21.

The figure in a landscape was a central theme for the Impressionists and was much favored by Cézanne, notably in his paintings of bathers. By and large, however, he spun these compositions from his imagination. Only rarely does one have a sense, as here, that the figure actually posed for him out-of-doors.

Ambroise Vollard said that the model for this painting was Cézanne's only child, Paul, which would accord with what we see in the picture. Rewald dated it to about 1890 on stylistic grounds. Paul *fils*, born in January 1872, would have been about eighteen in that year, a plausible age for the figure represented here. Like his mother, Paul often served as a model for his father (see cat. no. 85). Cézanne was notoriously shy, and the two members of his immediate family were among the few people upon whom he could consistently impose for extended modeling sessions. It is tempting to speculate how the images of figures in a

landscape would have evolved had he felt more comfortable with professional models. Note, however, that the integration between figure and landscape in his Bather paintings is neither more nor less successful than that achieved in this canvas.

This youth rests casually and gracefully. So easygoing is the general impression created by the pose, in fact, that one hardly notices the rather awkward positioning of the legs. There is a remarkable similarity between this reclining figure and that of Poussin's *Echo and Narcissus* (fig. 1). No drawings by Cézanne after that work survive, but he haunted the Louvre and could have known the picture, as well as a print in which Poussin's composition appears in reverse.

J. R.

1. The painting may have been bought in at this sale, although it was cited in *Connoisseur*, vol. 142 (January 1959), as having sold for $125,000. The painting was then advertised for sale by Marlborough Fine Art Ltd. in *Apollo*, vol. 69, no. 412 (June 1959), p. 215.

Fig. 1. Nicolas Poussin,
Echo and Narcissus, c. 1627,
oil on canvas,
Musée du Louvre, Paris.

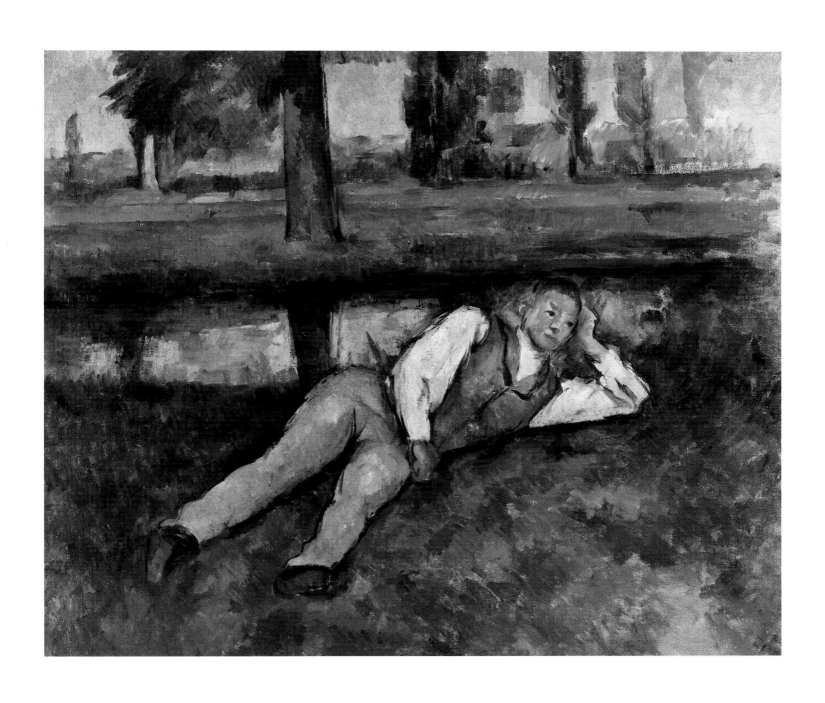

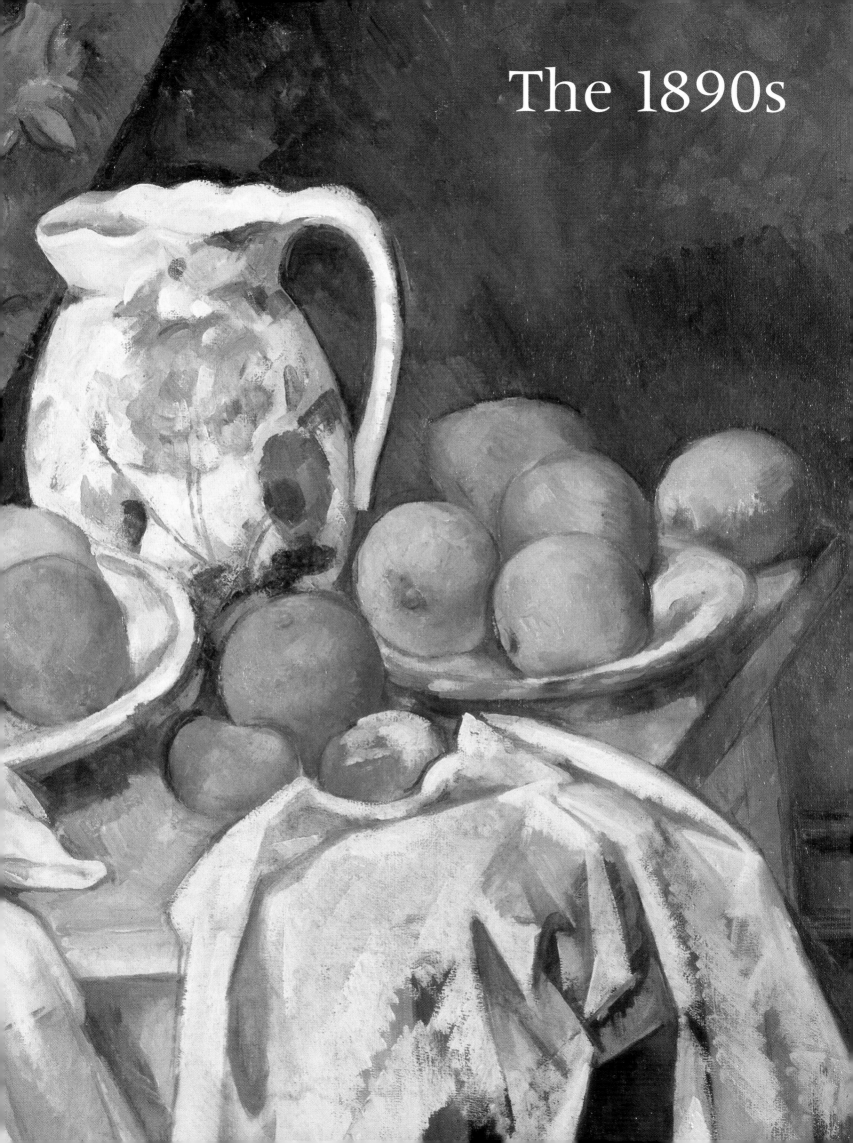

The Cardplayers

132 | *Cardplayer in a Blue Smock*

1890-92
Graphite and watercolor on paper; 20$^{1/4}$ × 14$^{9/16}$ inches (51.4 × 37 cm)
Museum of Art, Rhode Island School of Design, Providence.
Gift of Mrs. Murray S. Danforth (42.211)
R. 379

PROVENANCE
Ambroise Vollard sold this watercolor to the dealer Jacques Seligmann,
Paris and New York. In 1934 it was acquired by Mrs. Murray S. Danforth,
a Providence philanthropist, who bequeathed it to the Museum of Art,
Rhode Island School of Design, in 1942.

EXHIBITIONS
After 1906: New York, 1933 (b), no. 7; Philadelphia, 1934, no. 48; Wash-
ington, Chicago, and Boston, 1971, no. 46.

133 | *Cardplayer*

1890-92
Graphite and watercolor on paper; 14$^{1/4}$ × 19$^{1/8}$ inches (36.2 × 48.5 cm)
Private collection
R. 377

PROVENANCE
This watercolor may originally have been in the possession of Ambroise
Vollard.[1] Later it passed to the dealer Jacques Seligmann, Paris and New
York. By 1934 it was in the collection of the Chicago businessman Chaun-
cey McCormick. It is now in a private collection.

EXHIBITIONS
After 1906: New York, 1933 (b), no. 6; Philadelphia, 1934, no. 47; Chicago
and New York, 1952, no. 78.

134 | *Cardplayers*

1893-96
Oil on canvas; 18$^{11/16}$ × 22$^{7/16}$ inches (47.5 × 57 cm)
Musée d'Orsay, Paris. Bequest of Comte Isaac de Camondo (R.F. 1969)
V. 558

PROVENANCE
Ambroise Vollard probably sold this painting to Baron Denys Cochin, Paris.
Thereafter it passed to Durand-Ruel. It was subsequently acquired by
Comte Isaac de Camondo, who bequeathed his collection to the Louvre in
1911.

EXHIBITIONS
After 1906: Aix-en-Provence, Nice, and Grenoble, 1953, no. 18 (not ex-
hibited in Grenoble); Paris, 1954, no. 55; The Hague, 1956, no. 37; Vienna,
1961, no. 33; Paris, 1974, no. 44; Madrid, 1984, no. 43; Tübingen, 1993,
no. 66.

135 | *Cardplayer*

1892-96
Graphite on paper; 21 × 17 inches (53.3 × 43.1 cm)
The Pierpont Morgan Library, New York. The Thaw Collection, 1974.39
C. 1093

PROVENANCE
This drawing was originally owned by Ambroise Vollard, from whom it passed through F. Matthiesen, Ltd., London, to Paul Rosenberg and Co., New York. It was subsequently purchased through Knoedler Galleries, New York, by Dr. and Mrs. T. Edward Hanley, Bradford, Pennsylvania. Edward Hanley died in 1969, and a large portion of the collection was given by his wife to the M. H. de Young Memorial Museum, San Francisco. This drawing, however, was purchased by Mr. and Mrs. Eugene V. Thaw, who in turn sold it to Norton Simon, Los Angeles. It was reacquired by Mr. and Mrs. Thaw and they gave it to the Pierpont Morgan Library.

EXHIBITIONS
After 1906: Newcastle upon Tyne and London, 1973, no. 67; Tokyo, Kyoto, and Fukuoka, 1974, no. 125; Tübingen, 1978, no. 62; New York, 1994-95, no. 98.

EXHIBITED IN PHILADELPHIA ONLY

In 1955 Robert Ratcliffe interviewed Léontine Paulet, an elderly woman who still lived in her native Aix-en-Provence; she recalled that as a young girl she had posed for Cézanne when he was painting his famous *Cardplayers.* She was paid three francs. Her father, Paulin Paulet (a gardener at the Jas de Bouffan) was paid five francs for the same task.[2] Léontine Paulet was almost certainly modeling for the picture now in the Barnes Foundation (repro. p. 56), the largest and most complex of five paintings showing rustic men gathered around a table, engrossed in a game of cards. Her recollection and a letter from Paul Alexis to Émile Zola dated February 13, 1891, which reports that Cézanne was working at the large house near Aix "where a worker serves him as a model,"[3] form the basis for dating Cézanne's commencement of the Cardplayers series to the autumn of 1890.

The Barnes picture is one of the most ambitious compositions Cézanne would ever attempt. It is usually cited as the first in the group of paintings, all five of which Venturi declared masterpieces.[4] Next followed a canvas now in the Metropolitan Museum of Art in New York (V. 559) that seems to have served as a rethinking of the subject in the form of a replica reduction: it is about a quarter the size of the first and excludes the child and a few still-life elements. Alexis's letter suggests that Cézanne never gathered his subjects together at one time but rather made individual studies that he then incorporated into his carefully calculated interior. The number of preparatory studies of cardplayer figures—including the three exhibited here (cat. nos. 132, 133, and 135)—helps to confirm this speculation on the artist's process.

Cardplayer in a Blue Smock (cat. no. 132), a "remarkably emphatic"[5] drawing with a few discreet touches of blue watercolor to indicate the color of the smock, shows the stout fellow who also appears on the right side of the table in the Barnes and Metropolitan paintings. Even if we knew him only in this drawn form, the numerous comparisons of the men of the Cardplayers series to the ponderous figures of Giotto and the early Renaissance would ring true. A great bell of a form, he leans slightly forward, the better to concentrate on the hand he has been dealt. As Roger Fry noted of the grouped figures in general: "It is hard to think of any design since those of the great Italian Primitives—one or two of Rembrandt's later pieces might perhaps be cited—which gives us so extraordinary a sense of monumental gravity and resistance—of something that has found its centre and can never be moved."[6]

In essential details, this figure seems to relate most closely to the Barnes version of the composition, particularly in the placement of the ham-fisted hands on the table and the pattern of deep folds in the smock. A comparison of the two figures reveals the powerful transformations that occurred when the artist translated his almost monochromatic rendering of a closely observed sitter into the generalized figure of the life-size, full-color painting. Not only does the man become all the more still and patient, but his personal qualities of simplicity and goodness have been elevated to a level of universal humanity. In the drawing the movement of light across the face picks out individual features; in the painting it is concentrated on one area of the cheek and neck, leaving the details of his profile in shadow and throwing his ear into relief to catch the sun like a mountain peak at dawn. The way that Cézanne used the white of the paper to convey the soft light on his cloak is carried through in the painting, where exposed patches of canvas vie with broad strokes of blue pigment to amplify the figure to a level of colossal massiveness. In all likelihood, Cézanne knew his models well, for he had lived at the Jas de Bouffan since he was twenty. Nothing specific or overtly familiar is revealed in his depiction of them, yet his profound sympathy and respect for them are apparent in each work.

While the effect of the Providence drawing depends almost entirely on Cézanne's able draftsmanship, the sheet depicting the contender (cat. no. 133)—who in the painting is seated directly across the table—is an entirely different matter. Here, too, the essential forms were established by a quiet network of lines, but these were then more heavily overlaid with washes of brown and black. The resulting image, while clearly a rendering of a figure in space, has a strong sense of the counterpoint of light and dark, which play back and forth, and nearly, but never quite,

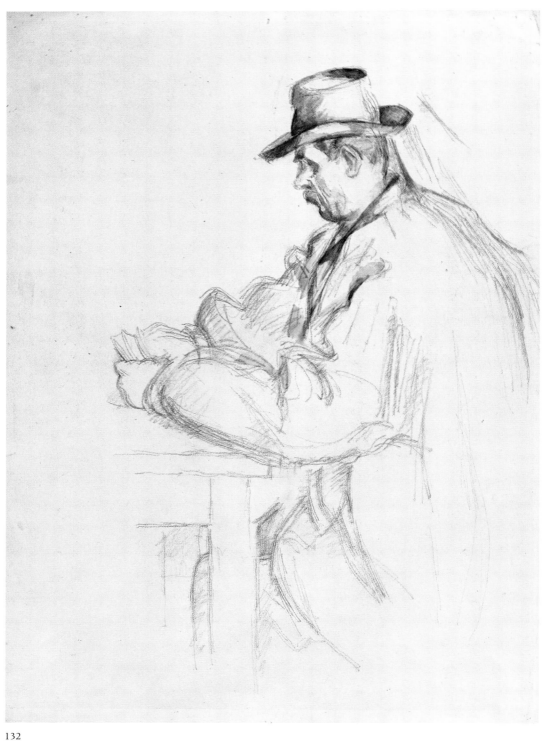

132

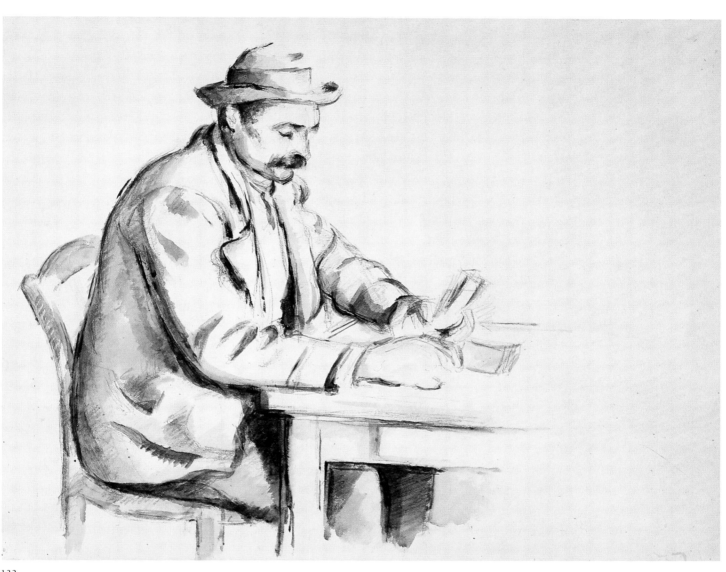

133

Fig. 1. Jean-Baptiste-Siméon Chardin,
The House of Cards, c. 1737,
oil on canvas,
Musée du Louvre, Paris.

Fig. 2. Paul Cézanne,
The Cardplayers, 1893-96,
oil on canvas,
private collection (V. 556).

Fig. 3. Paul Cézanne,
The Cardplayers, 1893-96,
oil on canvas,
Courtauld Institute Galleries,
Courtauld Collection, London (V. 557).

dissolve the illusion. Cézanne's purpose—other than to charge his drawing with vitality—is not entirely clear. Perhaps he was thinking ahead to the very different formal problems that this particular cardplayer would present in full color, the white shirt and cuffs contrasting with the heavy brown suit. It also seems in part a matter of characterization: the same light that throws much of the face of the blue-smocked player into darkness floods this fellow's features, his heavy arms, and his hands.

The entire picture is, of course, a question of weights and counterweights (open/closed; winner/loser?), much in the spirit of the game the figures play so slowly and deliberately. It is remarkable how firmly so many features of the oil painting are already set in the watercolor study.

Theodore Reff has persuasively argued that Cézanne had somewhere in his mind the image of Chardin's *House of Cards* (fig. 1)—hanging then, as now, in the Louvre—when he was creating the figure in this watercolor.[7] The similarity of the poses of lifting the cards, a detail altered in the completed paintings, gives particular weight to Reff's case. Few other artistic antecedents could be so sympathetically compared with Cézanne at this moment in his career. There is something about both artists' sense of pace—the gentle, nearly mute way in which the figures go about their slow and patient business—that suggests they understood the idleness of games and the attention that a hand of cards can draw.

Since 1926, when Georges Rivière first made the suggestion, the Cardplayers with four and five figures have been closely linked as a "series" with three other pictures that show only two men seated at a table, stoically concentrating on their cards. One of these, now in a private collection (fig. 2), is "dominant," by far the largest of the three and probably the first to address the subject in this particular composition. The second is in the Courtauld Institute in London (fig. 3), and the third is exhibited here (cat. no. 134). Their tonality and general expressive quality are completely different from the Barnes and Metropolitan paintings, which probably date from 1890-92. Comparing them with other works by Cézanne, particularly the portrait of Gustave Geffroy (cat. no. 172) documented in the spring of 1895, Cooper and Rewald, agreeing for perhaps the only time and then by chance, placed these pictures with two men as late as 1895-96.[8] The probable order of execution was the one in a private collection, the painting in London, then the one in Paris, with each successive picture decreasing in scale.

The large drawing in the Morgan Library (cat. no. 135) is sufficiently similar to the one of the man in the blue smock (cat. no. 132) to tempt one to think that both were made in preparation for the same painting: the Barnes version of the *Cardplayers,* or its reduced variant in the Metropolitan Museum of Art. However, the Providence sheet clearly corresponds to the man seated on the right in both paintings, whereas it would require a considerable adjustment—reversing the image and altering the model's

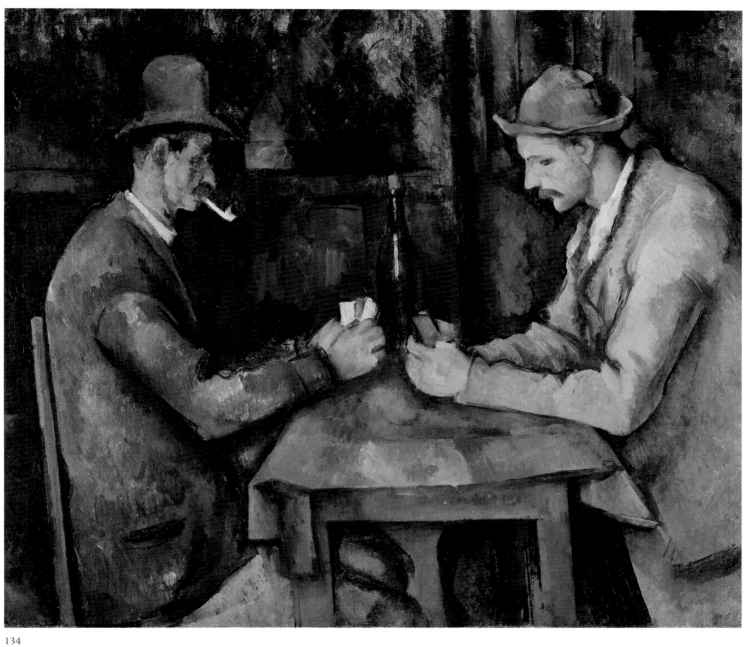

134

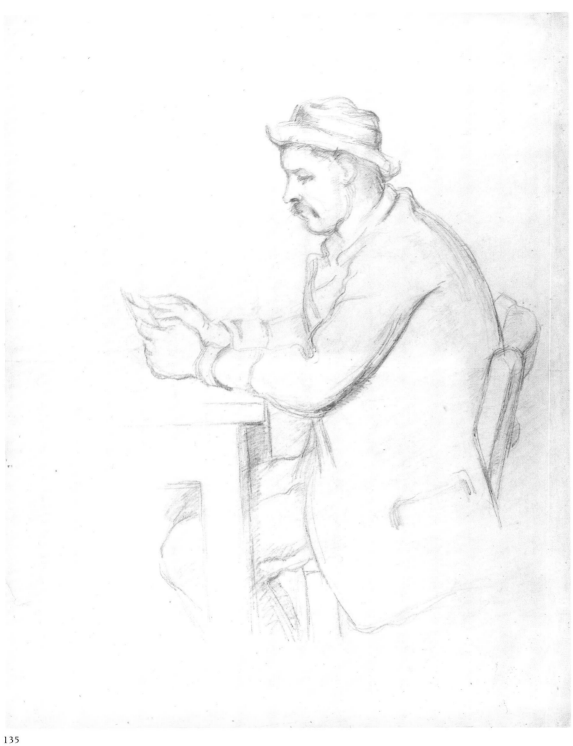

135

Fig. 4. Paul Cézanne,
Man Smoking, 1892-96,
graphite on paper,
Boymans–van Beuningen Museum,
Rotterdam (C. 1094).

of the chin suggest associations with the similarly pitched head in the three paintings, but, after careful scrutiny of the features, it seems that the sitter in the Morgan Library version was not used for any of the thinner figures in the painted versions.

There is something satisfying about our inability to connect this drawing with a specific painted cardplayer, for its degree of finish gives it the spirit of an independent image. In fact, if one thinks of it as an equivalent of the painted depictions of the same field hands and laborers from the Jas de Bouffan (see cat. no. 137), it acquires even greater interest.

J. R.

posture—to equate the figure in the New York drawing with the one on the left in either of those paintings. A case can also be made that the sitter in the New York drawing corresponds to the man in the tan jacket on the right side of the three paintings in the second Cardplayers series (figs. 2, 3, and cat. no. 134). He holds his cards similarly, but seems several pounds heavier. A powerful sheet in Rotterdam (fig. 4) focuses on the head of the same man smoking a cigarette. The forward tilt and slight tucking in

1. Rewald (1983, no. 377, p. 176) suggested that this watercolor may have been owned by Vollard. Venturi (1936, vol. 1, no. 1085, p. 275), however, began his provenance with Seligmann.
2. See Reff, November 1980, p. 105; and Ratcliffe, 1960, pp. 19-20.
3. Reff, November 1980, p. 105; and Rewald, 1939, pp. 237, 336.
4. See Venturi, 1936, vol. 1, p. 59.
5. Rewald, 1983, no. 379, p. 177.
6. Fry, 1927, p. 72.
7. See Reff, November 1980, p. 110.
8. See Gowing, June 1956, p. 191; Rewald, forthcoming, no. 714.

136 | *Smoker*

c. 1891-92
Oil on canvas; 36$^7/_{16}$ × 28$^{15}/_{16}$ inches (92.5 × 73.5 cm)
Signed on the table: *P. Cézanne*
Städtische Kunsthalle Mannheim
V. 684

PROVENANCE
This may be the *Portrait de jardinier (Portrait of a Gardener)* that, according to Paul Signac, was given by Cézanne to Paul Alexis in 1891.[1] Alexis apparently ceded it to Ambroise Vollard, who, on March 5, 1912, sold it to Paul Cassirer in Berlin; the museum in Mannheim acquired it by 1914.

EXHIBITIONS
After 1906: Berlin, 1912, no. 11; New York (no. 219?), Chicago (no. 43?), and Boston (no. 18?), 1913; Brussels, 1935, no. 3; Basel, 1936, no. 53.

EXHIBITED IN LONDON ONLY

Cézanne painted three versions of this same peasant leaning on his elbow and—his head in his right hand, his hat shifted slightly back—smoking a little white clay pipe. One is in the Hermitage Museum, St. Petersburg (fig. 1); another is in the Pushkin State Museum of Fine Arts, Moscow (fig. 2); the third is the present canvas, now in Mannheim.

These three pictures have generally been dated 1895-1900, notably in Venturi's catalogue. Recent publications by Ronald Pickvance,[2] Theodore Reff,[3] and John Rewald (in his forthcoming catalogue raisonné) have linked them, quite rightly, with the series of Cardplayers, dated 1890 to 1896 (see cat. nos. 132-35 and repro. p. 56), in which the same model appears. The most patient of the agricultural laborers who worked for the Cézanne family at the Jas de Bouffan seems to have been père Alexandre—for his name has come down to us; he figures in almost all versions of the Cardplayers in various postures. He is also depicted in two portraits (V. 561 and V. 563).

The two other canvases, quite similar to this one, represent the sitter in Cézanne's studio, for both include glimpses of other paintings by him: in the St. Petersburg version (formerly in the Morosov collection), portions of several canvases are visible, most prominently a very early still life (V. 71); in the Moscow version (formerly in the Shchukin collection), we see the lower left quadrant of a

Fig. 1. Paul Cézanne,
Smoker, 1890-92,
oil on canvas,
The Hermitage Museum,
St. Petersburg (V. 686).

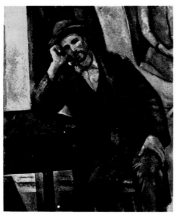

Fig. 2. Paul Cézanne,
Smoker, 1890-92,
oil on canvas,
Pushkin State Museum of Fine
Arts, Moscow (V. 688).

Fig. 3. Paul Cézanne,
Smoker, 1890-91,
graphite and watercolor on paper,
The Barnes Foundation, Merion,
Pennsylvania (R. 381).

portrait of Madame Cézanne (V. 528).[4] The Mannheim picture is the most stripped down of the three, depicting the model with maximum concentration and a minimum of accessories—notably, without "citations" of other paintings. Given Cézanne's tendency toward simplification, this could well be the third version.

The man poses in the kitchen or studio of the Jas de Bouffan, leaning on a table covered with a brown tablecloth with a geometric pattern, possibly the same one to be seen in some of the *Cardplayers* (see cat. no. 134). Behind him is a heater whose vertical flue pipe frames the composition at the left, as if to counter the main thrust of the design, which proceeds from the lower right to the upper left via the oblique lines of the jacket and vest. This diagonal movement is reinforced by the disposition of two of the peasant's powerful fingers as well as by his facial features, which intensify the effect of dynamism through their psychological impact. For the artist here set out to represent a force of nature, "one of those popular personalities, full of energy and power, that inspired sympathy and admiration in Cézanne."[5]

The color modulations are particularly refined, both in the background wall, a subtle harmony of blues and mauves, and in the clothing, a glossy brown that shades into blue to indicate the play of light. The vivid hues of the face are clearly those of a young man who worked in the fields. Louis Vauxcelles once wrote that Cézanne painted "the heads of shifty, obstinate peasants,"[6] but this man, while indeed "serene,"[7] gazes at the artist attentively, even amicably, as if in response to a similar gaze directed at him by Cézanne.

The painting was preceded by a preparatory watercolor, in the Barnes Foundation (fig. 3), now badly faded. This sheet belonged for many years to Gertrude Stein, who received many painters in her Paris apartment on the rue de Fleurus, most notably Matisse and Picasso, and also a number of American expatriate artists, who surely saw it there between about 1905 and the 1920s.

F. C.

1. See Rewald, 1983, no. 381, p. 177.
2. See Pickvance, in Tokyo, Kobe, and Nagoya, 1986, no. 33.
3. See Reff, in New York and Houston, 1977-78, p. 17.
4. Now in the Detroit Institute of Arts. Ibid., pp. 18-20.
5. Venturi, 1936, vol. 1, p. 60.
6. Vauxcelles, March 18, 1905.
7. It appears that the picture was exhibited in the New York Armory Show in 1913, on which occasion the *New York Times* anonymous critic—in fact, Willard Huntington Wright—claimed it was "eloquent of mental idleness," observing more generally that Cézanne's single figure compositions included "a succession of untroubled and untroubling types, sitting for the most part solid and serene" ("Art at Home and Abroad," *New York Times,* July 6, 1913, section 5, p. 15; cited in Rewald,1989, p. 219).

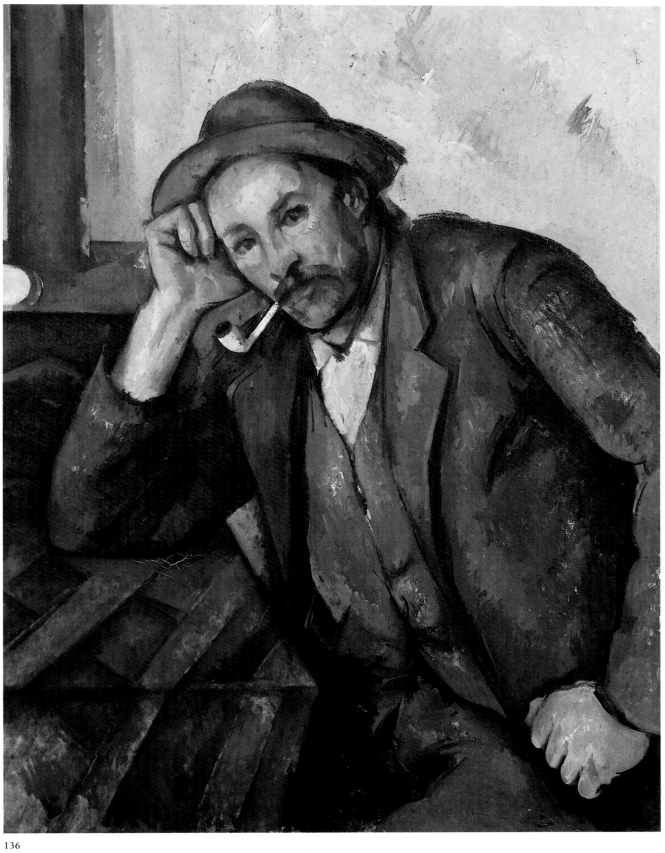

136

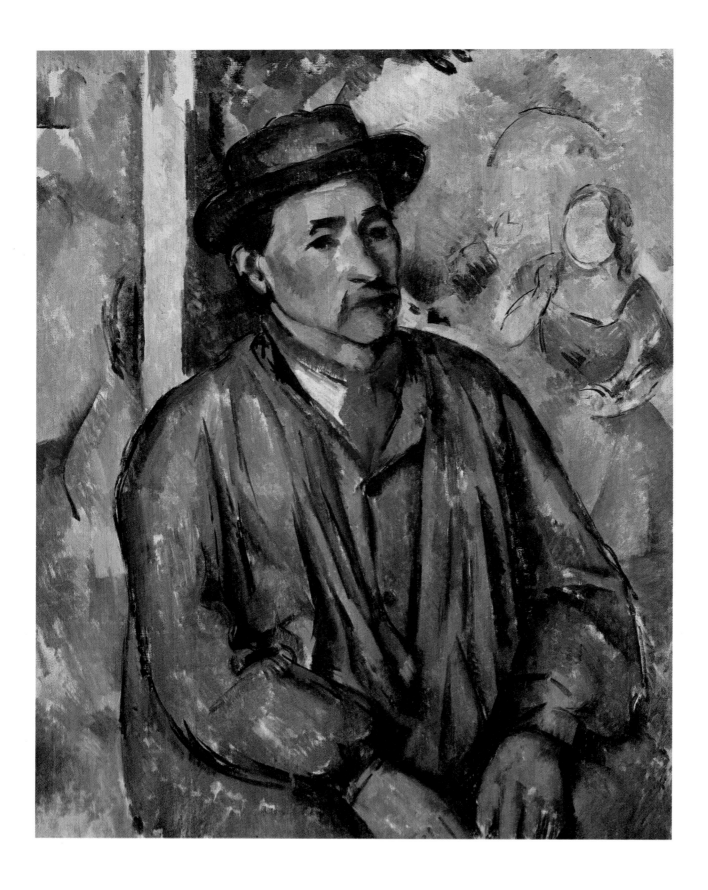

Peasant in a Blue Smock

1892 or 1897
Oil on canvas; $31^7/_8 \times 25^9/_{16}$ inches (81 × 65 cm)
Kimbell Art Museum, Fort Worth, Texas
V. 687

PROVENANCE
Ambroise Vollard sold this picture to Auguste Pellerin; he kept it only a short time, returning it to Vollard in exchange for another Cézanne. In 1911 it was in the possession of Vollard and Bernheim-Jeune, who in 1912 consigned it to Paul Cassirer, in Berlin. From there it passed to the collection of Gottlieb Friedrich Reber in Lausanne. In 1926 it was in the Paul Rosenberg Galleries, London. In 1928 it was in the collection of A. Conger Goodyear in Buffalo, from which it passed, by bequest, to Mrs. Mary G. Kenefick. It then came into the possession of Henry Ford II, Detroit; it figured with other works from his collection at a sale at Christie's, New York, on May 13, 1980 (lot 3), when it was acquired by the Kimbell Art Museum.

EXHIBITIONS
Before 1906: Perhaps Paris, 1898, no. 14 *(Paysan dans un intérieur).*
After 1906: Berlin, 1912, no. 8; Cologne, 1912, no. 146; Darmstadt, 1913, no. 13; New York, 1928, no. 21; Philadelphia, 1934, no. 37; Paris, 1936, no. 88; New York, 1942, no. 20; Paris, 1978, no. 5.

In the 1890s, Cézanne often asked working-class people to pose for him, either in his studio or, as here, in the grand salon of the Jas de Bouffan. Generally, their clothing identifies the nature of their labor. The sitter in this painting wears a blue worker's smock and a neckerchief of Provençal red; his "Sunday-best" hat suggests he has just returned from the market. The contrast between his rustic dignity and the coquettish demeanor of the woman carrying an umbrella and glimpsed over his shoulder is clearly deliberate. The woman appears in the central panel of a large folding screen (V. 3) that Cézanne, with Zola's help, had painted about 1859-60 to decorate the Jas de Bouffan,[1] purchased in 1859 by his father (see cat. no. 24).

An interval of almost forty years separates the two works. The naive pastiche, with the idyllic reveries of a youthful image (the young woman in the panel converses with an elegant suitor here obscured by the peasant), is contrasted with the pictorial mastery of the aging artist and his present model's rough forthrightness.

Cézanne's young friend Joachim Gasquet saw the painting in the studio. In his enthusiasm, he read the artist's work in terms consistent with the ideals of the group of regionalist poets known as Félibrige, which Gasquet had made his own: "In the Jas de Bouffan studio there are some canvases of robust peasants resting from their work, their complexions nourished by the sun, their shoulders powerful, their hands consecrated by the most difficult exertions. One especially, in a blue smock, decked out in a red foulard, his arms dangling, is admirable in his ruggedness, like the materialized thought of a bit of earth that's suddenly been incarnated in this crude and magnificent flesh, cooked by the sun and whipped by the wind. Others, in the room of a farmhouse, play cards and smoke. . . . All [of them] are hale, poised, one senses their sound minds, they are tranquil, their sole concern is to love the earth and cultivate it. . . . It was through them . . . that I learned to understand my race completely. They were a beautiful lesson for me."[2]

Gasquet's passage, however, effects an overhasty assimilation of Cézanne's work to a regionalist literary movement, implying he was the Frédéric Mistral of painting—a visual poet whose work touted, in moralizing terms, a "return to real values," an artist who anticipated the future writings of Gasquet's friends Edmond Jaloux and Charles Mourras.

This canvas is difficult to date. If it is indeed the one described by Gasquet in 1898, it could have been painted in early 1897 or in the course of the following fall and winter. The thin, discontinuous handling would be consistent with such a dating. But it also could have been executed much earlier, concurrent with the *Cardplayers,* for this same mustachioed peasant in a blue smock is seen standing, his arms crossed, smoking a pipe in the versions of the *Cardplayers* in the Barnes Foundation (repro. p. 56) and in the Metropolitan Museum of Art in New York (V. 559), as well as in another portrait in which he appears alone (V. 563). Cézanne's son assigned the present canvas a date of 1891,[3] which is consistent with the second hypothesis. Does it represent the model mentioned by Paul Alexis in a letter to Zola, dated February of that same year, in which he recounted a recent visit to Cézanne? "During the day he paints at the Jas de Bouffan, where a worker serves as his model."[4]

F. C.

1. See Reff, June 1979, pp. 95-98.
2. Gasquet, March-April 1898; cited in Rewald, 1959, p. 34.
3. Paul Cézanne *fils* inscribed the date 1891 on a photograph in the Vollard Archives, Musée d'Orsay, Paris, no. 166, but Rewald doubted this information.
4. Cézanne, 1978, p. 235.

Portrait of Madame Cézanne with Loosened Hair

1890-92
Oil on canvas; 24³/₈ × 20¹/₈ inches (61.9 × 51.1 cm)
Philadelphia Museum of Art. The Henry P. McIlhenny Collection
in memory of Frances P. McIlhenny, 1986-26-1
V. 527

PROVENANCE
Ambroise Vollard sold this picture to Walther Halvorsen, Oslo, and then re-acquired it from him—at an unknown date—before selling it in May 1914 to Gottlieb Friedrich Reber of Barmen. The canvas subsequently came into the possession of Paul Rosenberg, from whom it was purchased in 1929 by Samuel Courtauld. It did not figure among the works given by him to the Courtauld Institute in London, and Paul Rosenberg sold it in the 1950s to the Philadelphia collector Henry P. McIlhenny, who bequeathed it to the Philadelphia Museum of Art in 1986.

EXHIBITIONS
Before 1906: Perhaps Paris, 1898, no. 8, 11, or 15 *(Portrait de Mme Cézanne)*. After 1906: Philadelphia, 1934, no. 13; Paris, 1936, no. 58; Philadelphia, 1983, no. 15; Tübingen, 1993, no. 44.

Cézanne's portraits of his wife almost always show her sitting in a chair, her hands in her lap, looking serenely—or with an air of boredom—at the artist and the viewer. She tends to be meticulously dressed and is often shown wearing a hat, but the resulting aura of respectability does not necessarily preclude coquettishness (see cat. nos. 47 and 167). Rumor has it that, having been recalled from Paris when Cézanne's health took a turn for the worse, in October 1906, she arrived in Aix too late to see her husband alive because an appointment with her dressmaker had caused her to miss the next train.[1]

The dress she wears in this painting appears to be made of blue-black velvet with appliquéd bands of gray satin; once more, we have evidence of her taste—or her husband's—for striped clothing, as in *Madame Cézanne in a Red Armchair* (cat. no. 47) or the *Portrait of Madame Cézanne* in the Meadows collection (V. 229).

Cézanne does not treat her face with his customary ob-jectivity, which sometimes comes across as indifference. The tilt of her head, with its suggestion of internalized suffering, and the casual fall of her hair, so different from the more usual tight chignon worn high up in a way accentuating the almost geometric oval of the face (see cat. no. 126), give her the dolorous air of a penitent saint.[2] Can we follow Schapiro in interpreting the image as a representation of Cézanne's own "repression and shyness," here projected onto a likeness of his wife?[3] However that may be, there is in this portrait a tenderness toward the model, and an attentiveness to her emotional state, that is rare in the artist's depictions of her. This makes itself felt not only in the unusual expressivity of the face but also in the treat-ment of the flesh, which is handled with a rare delicacy, its fresh, animated tones answering subtly to the muted blue grays and greens of the background. It is as though the face were mounted on a dark setting, its wavy edge extending on the left from the hair to the little puff of the sleeve.

Liliane Brion-Guerry has suggested that one of the keys to the expressive power of this portrait is its rendering of space: "The face of Madame Cézanne conveys, even in its transcription, the delicate flutter of human emotion. . . . The air around the forms does not have that icy hardness which freezes expression, impedes gestures, immobilizes volumetric combinations by locking them into place: a dis-agreeable effect characteristic of the later portraits."[4]

The date of this affecting portrait poses difficulties: Venturi placed it 1883-87, Georges Rivière in 1874-75.[5] John Rewald dated it to the early 1890s, primarily for stylistic reasons, but perhaps also because the form of the face—fuller than in the portraits from the 1870s and 1880s, where the chin is finer and more pointed—suggests the subject was in her forties rather than her thirties.

However tempting it might be to criticize Hortense Fiquet-Cézanne—specifically, on the grounds of her frivolity and her extravagance—we should bear in mind that day-to-day existence with the painter cannot have been easy, and that she regularly bowed to his wishes and endured long posing sessions for him. Members of the artist's family considered Paul's marriage to a woman of such modest origins a misalliance, and they generally spoke "very little about the painter's wife"; but even they acknowledged that she "nonetheless is not without qualities; she has an even-tempered disposition and a tireless patience. When Cézanne couldn't sleep, she read to him in the night, sometimes for hours at a time."[6]

F. C.

1. See Perruchot, 1956, p. 488; and Rewald, 1986 (a), pp. 264-65.
2. See Schapiro, 1952, p. 58.
3. Ibid.
4. Brion-Guerry, 1966, p. 130.
5. See Venturi, 1936, vol. 1, no. 527, p. 178; and Rivière, 1923, p. 201.
6. M. C., November 1960, p. 300.

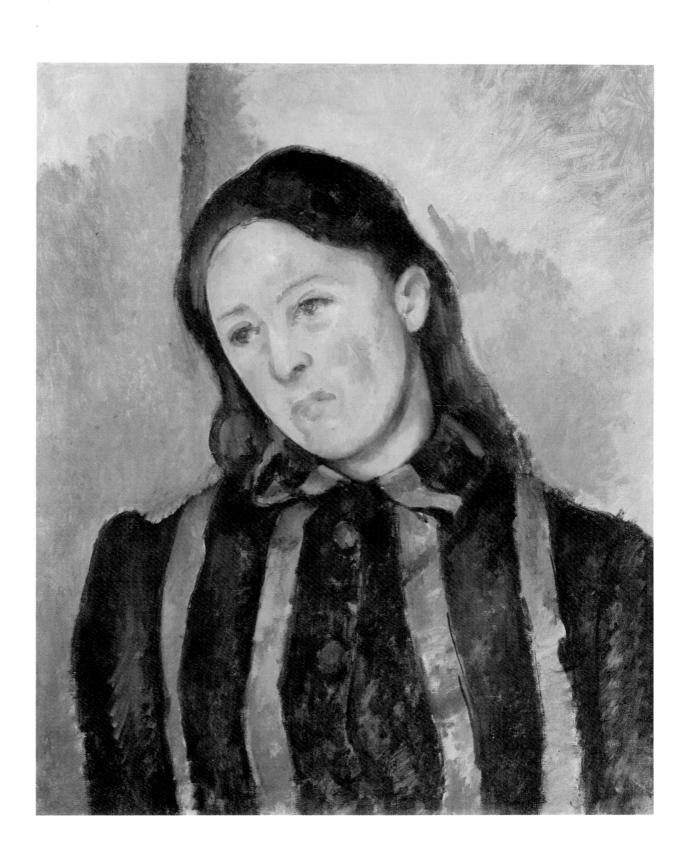

139 | *Four Bathers*

1888-90
Oil on canvas; 28³/₄ × 36¹/₄ inches (73 × 92 cm)
Ny Carlsberg Glyptotek, Copenhagen
V. 726

PROVENANCE
This painting was originally in the possession of Ambroise Vollard. Between 1927 and 1936 it was owned by Alexander Lewin, Guben.[1] It subsequently passed to his daughter, Mrs. Alix Kurz, New York, and then to Walter Feilchenfeldt, Zurich. In June 1956 it was acquired by the Ny Carlsberg Glyptotek.

EXHIBITIONS
Before 1906: Brussels, 1890, unnumbered.

EXHIBITED IN PARIS ONLY

For all their complexity and beauty, none of Cézanne's earlier images of bathers can stake a comparable claim on the adjective "formidable," as this work was described shortly after it was acquired by the Ny Carlsberg Glyptotek.[2] Only three years had passed since the artist used the theme of female bathers in a series of compact paintings and drawings (see cat. nos. 62 and 63), but here he completely reinvented the subject, introducing a new sense of elevation and operatic drama that he would continue to explore into the twentieth century.

Everything is bigger, faster, more heated, more charged. The subtly modulated constructive strokes of the Basel *Bathers* (cat. no. 62) have been replaced by bold dashes reminiscent of the palette-knife pictures of the 1860s. While the figures are still contained in the shallow foreground by a wall of green, Cézanne knocked out a hole of blue at the top, as if to release some of the energy. Most importantly, the rather girlish bathers in the earlier paintings—playful and demure—have here become near-goddesses, overacting and flinging themselves into their roles. The central figure brings to mind the brazen temptress in Cézanne's *Temptation of Saint Anthony* (p. 156, fig. 1).[3] The next step in her evolution would be the woman leaning against a tree in the *Large Bathers* in the Barnes Foundation (repro. p. 39).

This painting also proved a potent source for the next generation of artists. As Carla Gottlieb has noted, the assertively blooming central bather served as a point of departure for both the vine-strewn girl on the left in Matisse's *Joy of Life* (fig. 1) and the central figure in Picasso's *Demoiselles d'Avignon* (fig. 2).[4]

J. R.

1. See Meier-Graefe, 1927, plate LII; and Venturi, 1936, vol. 1, no. 726, p. 222.
2. Vagn Poulsen, *Ny Carlsberg Glyptotek: A Guide to the Collections,* 6th ed. (Copenhagen, 1961), p. 80.
3. See Reff, in New York and Houston, 1977-78, pp. 41-42.
4. See Gottlieb, Winter 1959, p. 110.

Fig. 1. Henri Matisse,
The Joy of Life, 1905-6,
oil on canvas,
The Barnes Foundation,
Merion, Pennsylvania.

Fig. 2. Pablo Picasso,
Les Demoiselles d'Avignon, 1907,
oil on canvas,
The Museum of Modern Art, New York,
acquired through the Lillie P. Bliss Bequest.

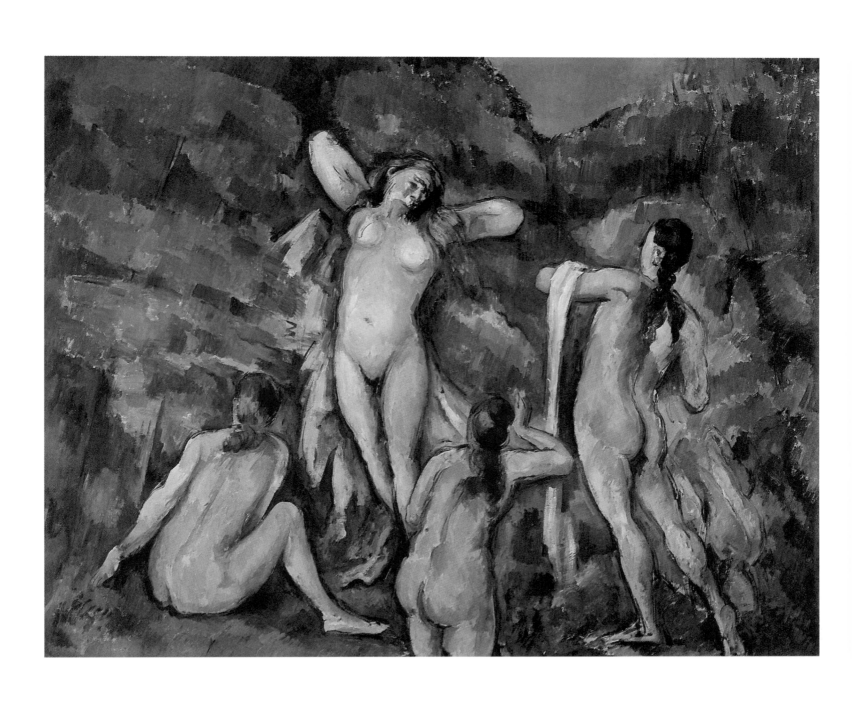

c. 1890
Oil on canvas; 23^{11}/$_{16}$ × 32^{5}/$_{16}$ inches (60 × 82 cm)
Musée d'Orsay, Paris. Gift of Baroness Eva Gebhard-Gourgaud (R. F. 1965-3)
V. 580

PROVENANCE
This painting remained in the collection of Gottlieb Friedrich Reber until 1920.[1] Thereafter it was with Paul Rosenberg, Paris, and by 1936 it had been acquired by Baron Napoléon Gourgaud, Paris.[2] It remained in the family until 1965, when it was given to the Louvre by Baroness Eva Gebhard-Gourgaud.

EXHIBITIONS
Before 1906: Paris, 1904 (b), no. 27.
After 1906: Paris, 1936, no. 80; Chicago and New York, 1952, no. 96; Aix-en-Provence, Nice, and Grenoble, 1953, no. 20 (not exhibited in Grenoble); Tokyo, Kyoto, and Fukuoka, 1974, no. 42; Paris, 1974, no. 38; Basel, 1989, no. 58.

This, the largest canvas of male nudes Cézanne ever executed, is the culmination of his engagement with this theme, to which he would never return with a comparable degree of ambition. Female nudes grouped in a landscape would dominate his imagination, reaching its own climax in the three large paintings that were the principal occupation of his last years (see cat. nos. 218, 219, and repro. p. 39). With the early *Bathers at Rest* in the Barnes Foundation (p. 279, fig. 1) and the *Large Bather* in New York (cat. no. 104), the Musée d'Orsay picture forms a triad of masterworks.

All three of these works are closely related to numerous sketchbook drawings and smaller paintings showing nude young men in a landscape. The artist's interest in the theme may have been rooted in idyllic memories of his youth in Provence, time spent happily in long summer hours swimming and sunning with his friends Émile Zola and Baptistin Baille in the countryside. His letters also record his pleasure, later in life, in watching soldiers swimming in the same Arc River, just south of Aix. These images, which appear even in the early sketchbooks and recur throughout the artist's career, were tempered by and blended with both his academic drawing exercises after live models and sculptures and his fascination with earlier masters' treatments of such subjects, specifically Michelangelo's *Battle of Cascina* cartoon (which shows soldiers surprised while bathing) and the drawings of Luca Signorelli. They probably also respond to the art of his contemporaries, particularly Bazille, whose two ambitious paintings of male bathers would have been well known to Cézanne in the 1860s.

It is tempting to read the artist's alternating focus on male and female bathers over the course of his career as a reflection of his changing temperament. These shifts in his attention from one gender to the other do not necessarily suggest any vacillation or ambiguity in his sexuality,[3] but rather document the way formal and expressive qualities interact within his art. The numerous drawings and oil sketches of female bathers are more inventive than those of their male counterparts. The women's poses are more varied, the compositions more animated, more charged, and more expressive. The male subjects, by comparison, seem to derive from a formula, the effect being more detached and self-contained. Reviewing all two hundred of Cézanne's bather images, Reff has written that "the design of the male bather pictures remains relatively constant, much more so than that of the female bathers. Already established in the late seventies, it consists of two standing figures, seen largely or entirely from behind, alternating with three seated or bending figures, the central one in the water behind the others. The same design occurs in the eighties, though now the middle figure is on the opposite shore, thus deepening the apparent space. In the early nineties this schema is developed further by the gradual addition of smaller figures in the intervals between the larger ones."[4]

The Musée d'Orsay picture continues in this vein, but with the exception that it features an unprecedented number of figures, ten in all. Their disposition in earlier Bather compositions is often friezelike, but here it brings to mind a tympanum, arching toward the center, with a second layer of bathers presented in shallow relief behind.[5] The small-scale figures on the opposite shore echo their correspondents in the foreground. Chappuis proposed that the elegant standing figure in the center foreground—perhaps the most regularly employed image in all of Cézanne's work—is probably modeled after an antique marble in the Louvre known as *The Roman Orator* (fig. 1).[6] Cézanne made at least ten study drawings for this figure (C. 423-30, C. 432), paying special attention to the stance and the relation of the towel to the body. His mirror image across the pool has folded his arms. The poses of the animated young men in the right foreground are also reflected in a distant figure across the water. But what is truly new in this composition and in the theme is the degree to which they are enjoying themselves. There is far more physical exertion and interaction among the figures here than in Cézanne's earlier male bather images. Nothing that came before is even remotely comparable to the fellow on the right making a running dive into the river or the man gesticulating in the distance. In this manifestation, the theme has opened into a kind of easy paradise of health and well-being, comradeship, and harmony.

Cézanne painted another version of this composition, now in St. Louis (fig. 2). Slightly smaller and more loosely worked, it probably preceded the Musée d'Orsay painting.

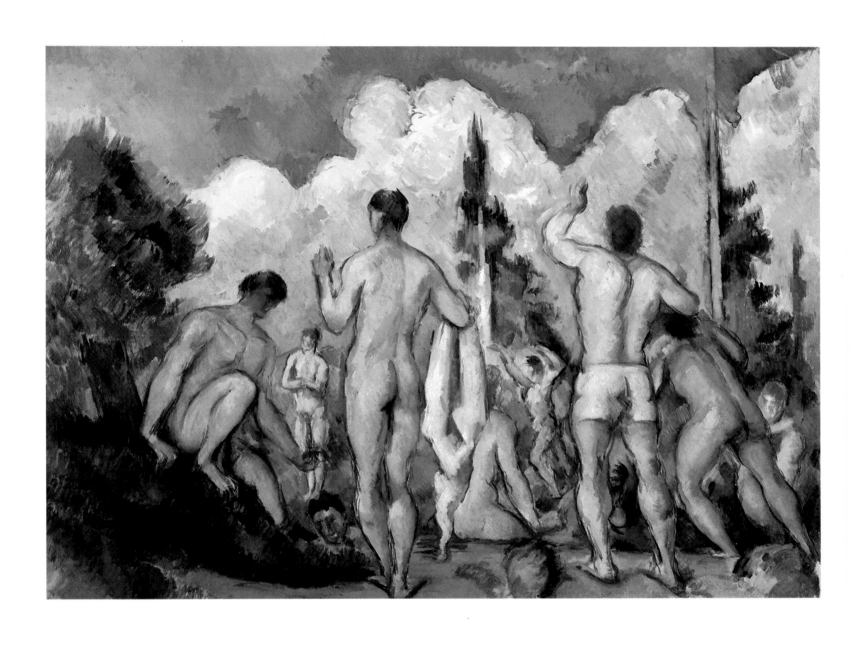

Fig. 1. Cleomenes,
The Roman Orator or *Germanicus* (back view),
40-30 B.C.E., marble,
Musée du Louvre, Paris.

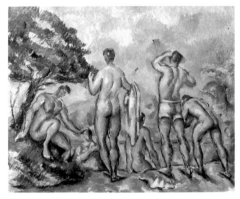

Fig. 2. Paul Cézanne,
Bathers, 1890-92,
oil on canvas,
The Saint Louis Art Museum,
gift of Mrs. Mark C. Steinberg (V. 581).

The number of figures is back to six, of which five correspond in pose and position to their counterparts in the more finished oil. The man submerged to his neck in the Paris picture is here visible from the waist up, lending credence to Krumrine's thoughtful analogy of a baptism, given the gesture of the seated man.[7] But the major difference between the two paintings is their change in locale. The figures in the Saint Louis painting occupy a sandy beach beside a large body of water, with a vague mountain marking the far shore. We are close here to the realm of the single standing bathers (see cat. nos. 103 and 104), who seem to pose near the bay at L'Estaque. The introduction of a deep space behind these figures has a tremendously exhilarating effect. Perhaps this is why Cézanne went to such pains to reintroduce a definite backdrop of pines and densely painted clouds in the Musée d'Orsay picture.

J. R.

1. See Meier-Graefe, 1920, p. 150.
2. See Venturi, 1936, vol. 1, no. 580, p. 190.
3. Speculation concerning Cézanne's sexuality has become something of a subgenre in Cézanne scholarship since the appearance of Meyer Schapiro's important article of 1968. However, little biographical evidence survives to clarify much about this, and the readings so far proposed have only added to the obscurity of the matter.
4. Reff, in New York and Houston, 1977-78, pp. 40-41.
5. See Michel Hoog, in Paris, 1974, no. 38, p. 98.
6. See Chappuis, 1973, vol. 1, nos. 423-30, 432, pp. 135-37.
7. See Krumrine, May 1980, p. 119.

141 | *Bathers*

c. 1890
Graphite and watercolor on paper; 5 × 8³/₁₆ inches (12.6 × 20.8 cm)
The Bridgestone Museum of Art, Tokyo. Ishibashi Foundation
R. 134

PROVENANCE
This watercolor first belonged to Georges Bernheim, Paris. The Galerie Bernheim-Jeune sold it to Kichizaemon Kishimoto, Osaka, in 1919. It subsequently passed to the collection of Shojiro Ishibashi, Tokyo, who in 1952 founded the Bridgestone Museum of Art. It is now in the collection of that museum.

EXHIBITIONS
After 1906: Tübingen and Zurich, 1982, no. 115; Madrid, 1984, no. 60; Tokyo, Kobe, and Nagoya, 1986, no. 58; Basel, 1989, no. 169.

To say that this sheet, torn from a sketchbook, shares with the *Bathers* in the Musée d'Orsay (cat. no. 140) a quality of vigorous activity new to Cézanne's customarily quite formal and static compositions of male bathers would be a bald understatement. The Bridgestone *Bathers* is electric with energy, almost manic in the way the figures interact. The entire surface is alive.

Two layers of nude men frolic within a narrow ledge of space. Every inch of the page is animated by frenzied swirls and short strokes of the pencil, over which Cézanne has dashed color with quick twists of the brush. All the poses are familiar from other male Bather subjects in watercolors or oil sketches,[1] which, in turn, often draw from earlier works of art. But here, as if in a spirit of horror vacui, their bodies are defined by bundled lines that vibrate so vividly around the edges of their forms that any calm and leisure the figures convey in other versions on this theme have been completely abandoned. The effect is similar to that of a late Roman sarcophagus, with light flickering evenly over a shallow, rectangular surface.

Cézanne, who had begun to move away from the classic repose of the Musée d'Orsay *Bathers* (much as he would do a few years later with the female strain of Bather imagery), here nearly pitched it over an expressionistic edge. The exuberant antics of youth—innocent enough as a theme—have taken on a fevered quality that is ultimately disquieting. It is the bacchantic side of the antique. Cézanne would not take this frenzied male theme any further beyond this small scale. The Barnes Foundation's female *Large Bathers* (repro. p. 39) would make public some of the ideas he introduced here, but with a gravity and a sense of august terror that was perhaps only possible for him through a female vehicle.

J. R.

1. A drawing of the two central figures about to wrestle also survives (C. 1218).

| *Mercury Tying His Sandal (after Pigalle)*

c. 1890
Graphite on paper; 14^{15}/$_{16}$ × 10^{15}/$_{16}$ inches (38 × 27.8 cm)
The Museum of Modern Art, New York. The Joan and Lester Avnet Fund
C. 973

PROVENANCE
The painter and art theorist André Lhote purchased this drawing from
Bernheim-Jeune. It then passed through the hands of Reinhold Hohl and
Ernst Beyeler, Basel, as well as Walter Feilchenfeldt, Zurich, before enter-
ing the collection of the Museum of Modern Art.

EXHIBITIONS
After 1906: Basel, 1936, no. 141; Paris, 1939 (b), no. 47.

This drawing belongs to a series of studies after sculpture in
the Louvre or plaster casts in the Musée de Sculpture
Comparée in the Trocadéro (see cat. no. 143). Every after-
noon, notebook in hand, he would sketch these pieces;
their immobility and lack of emotional charge made them
perfectly suited to his needs, for he rather dreaded face-to-
face encounters with living subjects. After completing an
initial drawing in a larger format representing the *Mercury*
from the front (C. 972 *bis*), he made three more studies
(cat. no. 142, C. 974, and C. 975), the present one being
the most fully elaborated. The marble (fig. 1) is viewed
close-up, such that the drapery and the base are cropped
by the side and bottom of the page. The disproportionately
long thigh in the foreground is only summarily indicated,
but the foreshortened leg and the musculature of the torso
are powerfully evoked. The god's face and winged hel-
met—he was the protector of travelers and thieves—are
delicately rendered by a combination of concise lines and
smudged or hatched areas indicating shadows. The supple
strokes produce a convincing equivalent of the marble's
animated Baroque silhouette, successfully conveying the
compressed energy of Mercury's strained pose, as he turns
to buckle his sandal.

I. C.

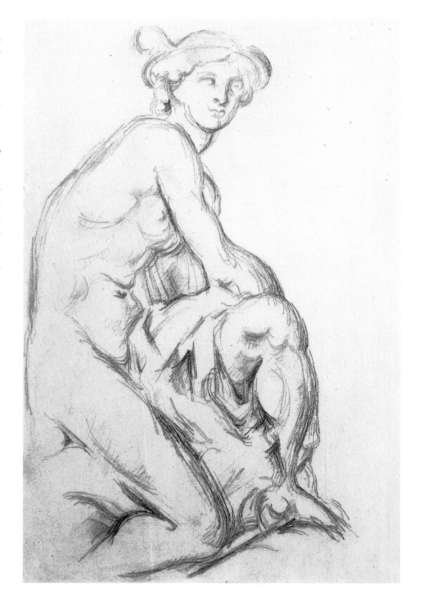

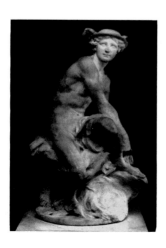

Fig. 1. Jean-Baptiste Pigalle,
Mercury Tying His Sandal,
marble,
Musée du Louvre, Paris.

143 | *Pierre Mignard (after Desjardins)*

1892-95
Graphite on paper; 8¹/₁₆ × 4⁷/₈ inches (20.5 × 12.4 cm)
Öffentliche Kunstsammlung Basel. Kupferstichkabinett
C. 1027

PROVENANCE
In 1934 the Bern painter Werner Feuz (1882-1956) sold sixty-five
Cézanne drawings to the Kunstmuseum in Basel for 15,000 francs; all
were individual sheets (most of them detached from several of the artist's
sketchbooks) that Feuz had acquired from Paul Cézanne *fils*. A year later,
Feuz sold the museum eighty-five more drawings: eighty loose sheets, of
which this is one, from three sketchbooks (formerly owned by Paul Guil-
laume, who had obtained them from Paul Cézanne *fils*), which Feuz had
broken up, and five independent drawings obtained directly from Paul
Cézanne *fils*. This acquisition was made possible by the generous participa-
tion of Robert von Hirsch: he contributed 10,000 francs toward the total
price of 16,000 francs, choosing, by way of return, ten drawings for him-
self, which he bequeathed to the museum in 1977.[1]

EXHIBITIONS
After 1906: New York, 1988, unnumbered.

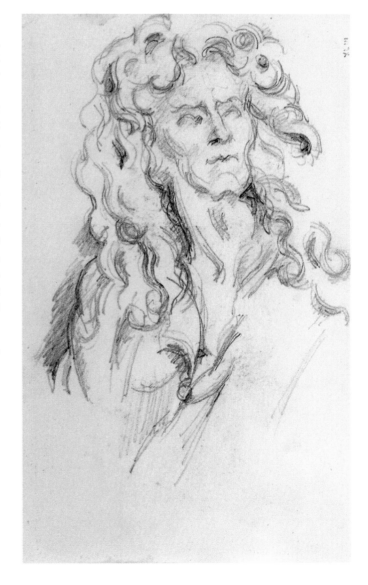

The marble bust of the French painter Pierre Mignard
(1612-1695)—sometimes called "Mignard le Romain"—is
one of three works in the Louvre by the Dutch sculptor
Martin van den Bogaert, known as Desjardins (1640-
1694). Cézanne drew this bust three times; the present
drawing is the most finished of the group.[2] If the artist
complained of the slowness of his *réalisation* in oils, he did
not encounter the same difficulties with pencil and paper.
In this drawing, probably completed in a single session, the
emaciated face and curled wig are quite fully delineated.
Volume is evoked not by means of contour but by interior
modeling. Forms are indicated by redoubled lines of vary-
ing widths, and shadows by cursory hatching. The lines
rarely define an enclosed field, but rather suggest the form,
allowing the eye to complete the drawing. Cézanne often
used this elliptical technique in drawings he made in the
1890s after sculpture in the Louvre and the Musée de
Sculpture Comparée in the Trocadéro (see cat. no. 142).[3]

I. C.

1. See Dieter Koepplin, in New York, 1988, pp. 8-10.
2. C. 1028 *(After Desjardins: Pierre Mignard)*, Musée du Louvre, Paris,
 Département des Arts Graphiques, Musée d'Orsay; and C. 1216 *(After
 Desjardins: The Painter Pierre Mignard)*, Öffentliche Kunstsammlung
 Basel, Kupferstichkabinett.
3. This drawing is on a sketchbook page; another drawing entitled *Young
 Satyr and Satyresque* (C. 687), after an antique marble in the Louvre,
 appears on the verso.

144 | *Jacket on a Chair*

1890-92
Graphite and watercolor on paper; $18^{11}/_{16} \times 12$ inches (47.5×30.5 cm)
Private collection
R. 382

PROVENANCE
Ambroise Vollard undoubtedly sold this watercolor before 1900 to Cornel-is Hoogendijk, Amsterdam, for Roland Dorn has discovered that it figured in Hoogendijk's estate sale (F. Muller, Amsterdam, May 21 and 22, 1912) as a work by Vincent van Gogh (lot 114, *Paletot déposé sur une chaise*). It passed through the Galerie Bernheim-Jeune, Paris and Lausanne, which sold it to Mrs. Chester Beatty, London. It then went to Paul Rosenberg, New York, and is now in a private collection.

EXHIBITIONS
After 1906: London, 1937, no. 28; London, 1939 (b), no. 62; London, Leicester, and Sheffield, 1946, no. 26; Zurich, 1956, no. 119; Vienna, 1961, no. 67; Aix-en-Provence, 1961, no. 29; New York, 1963 (a), no. 35; Tübingen and Zurich, 1982, no. 89.

EXHIBITED IN LONDON ONLY

A jacket of blue-brown wool resting on a small wooden chair in the kitchen of the Jas de Bouffan, perhaps left there by a fieldworker (maybe one of the models for the *Cardplayers*): such is the prosaic subject of this remarkable watercolor.

Venturi saw this as a *Draperie sur une chaise*;[1] Alfred Neumeyer, by contrast, maintained that "a maximum of drama is extracted from the old coat draped over a chair. The body-forms of its wearer seem still contained in it. The rich play of flowing, heavy curves lend a simple majesty to an everyday object."[2] Chappuis associated this piece of ordinary clothing with the boots or the pipe on a chair painted by Van Gogh.[3] Apparently he was not alone in making this connection, for the sheet was attributed to Vincent van Gogh in the 1912 sale of the Hoogendijk collection. There is no justification, however, for resorting to sentimental or pathos-laden readings of the image; Cézanne always scrutinized simple objects isolated from their contexts, imbuing them with intensity and presence through purely formal means. There are many drawings in which he scrupulously recorded wooden chair backs[4]—an element whose presence is only implied here—and simple corners.[5] All his life he was fascinated by the play of folds in fabric, curtains, carpets, and clothing.[6] For him, these objects were also pieces of "nature"; he likened them to other natural forms and vice versa, for in his view they all shared a common structural logic: rocks suggest the animate world (see cat. nos. 150 and 151), folded material resembles mountain ranges, and a crumpled jacket on a chair surges with life and presence.

F. C.

1. See Venturi, 1936, vol. 1, no. 1125, p. 281.
2. Neumeyer, 1958, no. 57, p. 52.
3. See Rewald, 1983, no. 382, p. 178.
4. See, for example, drawings C. 333-40, C. 346, C. 546, C. 1135, and the watercolor R. 188.
5. See cat. no. 52, C. 537, C. 662, C. 662 *bis*, and C. 823.
6. See cat. no. 106, C. 247, C. 341, C. 344, C. 548, C. 549, C. 960, C. 1077, and more rarely, in watercolor, R. 2, R. 189, R. 190, and cat. no. 102.

Houses and Trees in the Environs of Aix

145 | *The Maison Maria*

c. 1895
Oil on canvas; 25⁹/₁₆ × 31⁷/₈ inches (65 × 81 cm)
Kimbell Art Museum, Fort Worth, Texas
V. 761

PROVENANCE
Ambroise Vollard sent this picture to the 1907 exhibition in Budapest of works by Gauguin, Cézanne, and other artists, where it was acquired by the collector Marczell de Nêmes. It figured in the sale of the Nêmes collection, held in Paris at the Galerie Manzi-Joyant on June 18, 1913 (lot 89). It was purchased by Jos Hessel, in all likelihood for Auguste Pellerin, for in 1976 his son, Jean-Victor Pellerin, sold it to Georges Embiricos, of Lausanne. The Kimbell Art Museum acquired it in 1982.

EXHIBITIONS
After 1906: Budapest, 1907, no. 68; Tokyo, Kyoto, and Fukuoka, 1974, no. 48; Madrid, 1984, no. 47; Aix-en-Provence, 1990, no. 31.

EXHIBITED IN PHILADELPHIA ONLY

146 | *The Lime Kiln (The Mill at the Pont des Trois Sautets)*

1890-94
Graphite and watercolor on paper; 16⁹/₁₆ × 20⁷/₈ inches (42 × 53 cm)
Musée du Louvre, Paris. Département des Arts Graphiques. Musée d'Orsay,
Bequest of Comte Isaac de Camondo (R.F. 4031)
R. 392

PROVENANCE
Comte Isaac de Camondo probably acquired this sheet directly from Ambroise Vollard and bequeathed it to the Louvre along with the rest of his collection in 1911.

EXHIBITIONS
After 1906: Paris, 1907 (a), no. 8; Paris, 1954, no. 72; Paris, 1974, no. 61.

EXHIBITED IN PHILADELPHIA ONLY

147 | *House in Provence*

1890-94
Graphite and watercolor on paper; 16⁹/₁₆ × 21 inches (42 × 53.3 cm)
The Henry and Rose Pearlman Foundation, Inc.
R. 389

PROVENANCE
This sheet passed, in turn, through the Galerie Bernheim-Jeune, Paris, the Galerie Hessel, Paris, and the Galerie Rosengart, Lucerne; it then figured successively in the collections of Hans Purmene, Florence, and Justin K. Thannhauser, New York, from whom it was acquired by the collector Henry Pearlman.

EXHIBITIONS
After 1906: Berlin, 1927 (a), no. 30; Basel, 1935, no. 206; Basel, 1936, no. 80; Chicago and New York, 1952, no. 102; Aix-en-Provence, 1956, no. 73; Cambridge, 1959, unnumbered; New York, 1959, no. 32; New York, 1963 (a), no. 30; New York, 1963 (b), unnumbered; Washington, Chicago, and Boston, 1971 (not exhibited in Washington or Chicago; not in catalogue).

145

The Maison Maria (cat. no. 145) was situated beside one of the paths Cézanne took when he went into the countryside outside Aix to work, heading toward Mont Sainte-Victoire along the narrow Tholonet road. The path in question led to the Château Noir property (see cat. nos. 189 and 191), where between 1890 and 1902 Cézanne rented some space for his work, and which he tried but failed to purchase after the sale of the Jas de Bouffan in 1899. It was in the wake of this frustrating episode that he undertook to build the Chemin des Lauves studio.[1] Looking down the path, one sees Mont Sainte-Victoire rising above a section of a wall of the Château Noir; the mountain is barely distinguishable from the same-colored sky. The transparent handling of the blue and green pigment is suggestive of watercolor, and, unlike many Cézanne landscapes, this one has an almost ethereal quality, evoking the pure air and clear morning light of a Mediterranean spring. It is difficult to follow Venturi in perceiving tragic overtones in this canvas: "The first landscape masterpiece of Cézanne's dramatic and synthetic period is of the Maison Maria, a modest structure beside the road leading to the Château Noir. Cézanne depicts it as if it were in torment; the color has a clarity that pierces like a flash of lightning, to drive home the disorder of nature."[2]

In the eyes of the English critic Roger Fry, the *Maison Maria* exemplifies the artist's luminous 1890s landscapes: "Here the 'crystallization' of the forms is complete. The planes interjoin and interpenetrate to build a design where the complexity does not endanger the lucidity of the relations. Not only has Cézanne's notion of plasticity and of the plastic continuity here attained its plenitude, but the artist controls it with perfect freedom. . . . Not only have the forms been reduced to those elements with which we are familiar, but here also the colour has become increasingly systematic. He modulates in the chosen chromatic key almost as a musician does. He accepts from nature, not so much the precise indications as before, but rather suggestions of modulations which he then renders according

146

147

to the progressions of his scale. It must be understood that this is only a difference of degree; what we have here is only a freer and bolder use of the method of his earlier work. It implies that he can by now modulate with such suppleness and with so rich a variety of transitions, that he can give the feeling of living reality by a still more generalized interpretation of the actual vision."[3]

This beautiful formal analysis is remarkable on its own terms, but it tells us nothing about what Cézanne actually represented. The image of a turning road disappearing, often behind rural houses, had fascinated Cézanne ever since he had worked in Pontoise and Auvers, about twenty years earlier (see cat. no. 76).[4] But he rarely used such motifs in his Aix landscapes of the 1880s and 1890s, for these tend to be either open and panoramic or immersed in the primeval substance of quarries and forests. He revisited the subject of his Impressionist period to focus on the scenery of some of his most celebrated landscapes. Here, we are

on the property of the imposing Château Noir, the back of which is visible. Mont Sainte-Victoire is but a fleeting allusion, the majestic goal toward which the turning path is directed.

In his drawings and watercolors of houses among the trees in the countryside around Aix (cat. nos. 146 and 147), Cézanne deliberately contrasted the stiff geometric forms of human constructions with the softer, rounder, less predictable ones of nature, regardless of whether the trees were bare or in full leaf. "The definitive tone of these sketches—as composed and constructed as his paintings—is already advanced, powerful, and admirably resonant. . . . Some landscapes from the same series show the play of pale light over clearly delineated trees and buildings, exalted by violet and deep yellow shadows, nuanced and glistening,"[5] wrote Maurice Denis in 1905 when, during the artist's lifetime, Cézanne's watercolors were first shown in Paris. It is impossible to establish with certainty whether

Denis could have seen either of these two sheets on that occasion, for the wording in the catalogue is vague, but his description corresponds to them perfectly.

The Lime Kiln (cat. no. 146) depicts a large building, painted ocher yellow, that no longer exists.[6] As always, Cézanne selected the precise vantage from which he could obtain the most judicious composition: the high cylindrical smokestack cuts into the space just right of center, its top rising slightly above the distant ridge of Mont Sainte-Victoire, the irregular triangle of which surmounts the whole, echoing the more schematic but analogous outlines of the two roofs below. Another watercolor (R. 391) representing the same building, but from a closer vantage point and a different angle, was given by Cézanne to Josse Bernheim-Jeune, probably when he visited Aix in 1902; apparently he pulled the sheet from a portfolio where it had long been left undisturbed, for stylistically it suggests a date in the first half of the 1890s.

House in Provence (cat. no. 147) has sometimes been mistitled *House of the Artist*. It is easy to see how this came about, for the placement of the trees and the venerable character of the building bring to mind the Jas de Bouffan; but the latter structure has a third story. It was doubtless in the course of his extended forays into the countryside that Cézanne painted this sheet, which enchanted Alfred Neumeyer: "The soft richness of the blue, violet, and green color spots lends to the scene a nearly magic quality, enhanced by the large size of the paper and the symmetrical frontality. The drawing emanates the silent peace of a summer day."[7]

F. C.

1. See Rewald and Marschutz, January 1935. The painter Léo Marschutz, a great admirer of Cézanne and a friend of John Rewald, lived successively in the Château Noir and the Maison Maria after World War II; see Rewald, in New York and Houston, 1977-78, pp. 105-6.
2. Venturi, 1936, vol. 1, p. 64.
3. Fry, 1927, p. 76.
4. See also V. 134, V. 137, V. 140, V. 144, V. 145, V. 147, V. 327, V. 328, V. 330, V. 334, V. 441, and others.
5. Denis, November 15, 1905; reprinted in Denis, 1912, p. 197.
6. Rewald photographed the building about 1934; see Rewald, 1983, p. 181.
7. Neumeyer, 1958, no. 82, p. 59.

148 | ## *The Church of Saint-Pierre in Avon*

1892-94
Graphite and watercolor on paper; 18⁷/₈ × 12³/₈ inches (48 × 31.5 cm)
Collection of Phyllis Lambert, Montreal
R. 327

PROVENANCE
This watercolor was sold by Paul Cézanne *fils* to Eugène Blot; it then came into the possession of Albert Charpentier, Paris, and figured in the sale of the Charpentier collection (Galerie Charpentier, Paris, March 30, 1954, lot 1), on which occasion it was purchased by the publisher and dealer Charles Slatkin. It is now owned by the architectural historian Phyllis Lambert.

EXHIBITIONS
After 1906: Washington, Chicago, and Boston, 1971, no. 36; Tübingen and Zurich, 1982, no. 56.

During the summer of 1892, Cézanne rented a studio in Fontainebleau and lived in nearby Avon; in September 1894, he sojourned in Melun, also not far from Avon and this church.

This little village church was identified and photographed by Pavel Machotka shortly before the publication of John Rewald's catalogue raisonné of the watercolors.[1] A depiction of architecture without adjacent vegetation is rare in Cézanne's oeuvre (see cat. no. 74). The emphatically geometric configuration of the buildings—made up of a succession of diagonal rooflines, running from upper right to lower left, which seem compressed between the two large vertical forms on either side—must have interested him more than the colors of the roofs or the sky, for he has applied watercolor only to clarify volume and depth.

This watercolor was chosen to represent Cézanne at the Canadian Center for Architecture, where it is on deposit.

F. C.

1. See Rewald, 1983, no. 327, pp. 165-66.

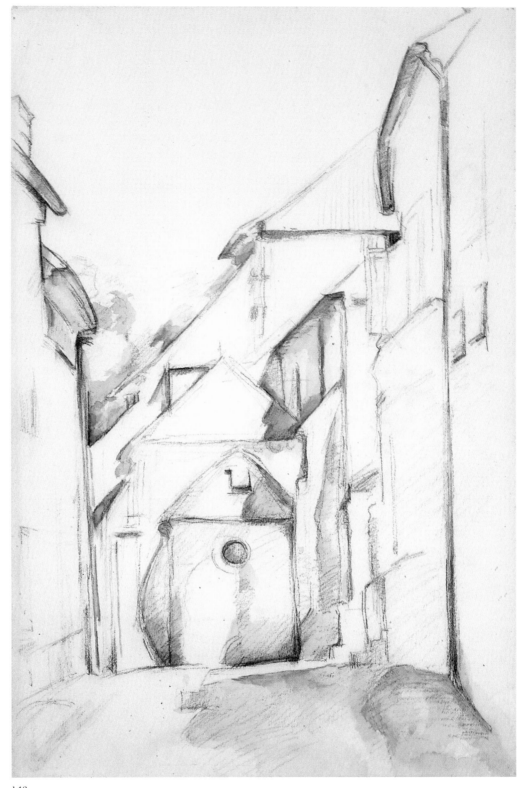

148

149 | *Bibémus Quarry*

c. 1895
Oil on canvas; 25⅝ × 31½ inches (65 × 80 cm)
Museum Folkwang, Essen
V. 767

PROVENANCE
Ambroise Vollard sold this painting to Karl Ernst Osthaus in 1906 on the latter's return from Aix, where he had visited Cézanne.[1] It passed from him to the Museum Folkwang. Later, under the Third Reich, it was "deaccessioned" because "such a bad picture does not deserve to hang in a [German] museum."[2] It subsequently passed into the collection of Siegfried Kramarsky, New York. In 1964 it was repurchased for Essen.

EXHIBITIONS
After 1906: Paris, 1939 (b), unnumbered; Chicago and New York, 1952, no. 107; New York, 1959 (b), no. 50; New York and Houston, 1977-78, no. 11; Paris, 1978, no. 36.

EXHIBITED IN PARIS ONLY

Rugged footpaths lead northwest from the village of Le Tholonet and north from the Château Noir to an area known as Le Prignon. Beyond the shelf of boulders and cliffs that parallel the Tholonet road, one comes upon the barren, windswept western flank of Mont Sainte-Victoire, just above the small valley where Zola's father had built the dam bearing his name. One section of the slowly ascending plateau of rock is irregularly gouged with crevices and fissures that are too geometric to be natural; these are the abandoned quarries called Bibémus that provided much of the pale ocher building stone of Aix. Some of these quarries date to the Roman era and are so eroded that it is difficult to distinguish the effects of man from those of nature. The emptiness of the place and its strangely architectural rock formations attracted Cézanne during the 1890s. In November 1895 he rented a small two-story cabin in the heart of the quarry, where he could store his painting materials and, if need be, spend the night.

Of the numerous paintings and watercolors Cézanne made at Bibémus, this canvas represents one of the most complex rock faces. The quarry was worked by stonecutters in random, unsystematic campaigns over a long period of time. Blocks of stone were removed from the natural crevices in places that either were relatively accessible or had a particularly appealing grain pattern. The workmen then moved on, leaving precise geometric patterns in the living rock, like those visible here in the upper right, that contrast sharply with the softer shapes occasioned by natural undercuts and upheavals. Cézanne depicted all these recesses and curves with brushwork of a particularly masterful and unhurried complexity. The focus is very even throughout the space, with industrious strokes slightly blurring each plane of the rock face just as they do the pine trees and bushes. There is something very neat and correct in the way he has shaped these carefully spaced planes and surfaces with blunt, small strokes of black or deep blue that discreetly define each transition. Small patches of thinly applied color animate the entire canvas, even in those areas that would seem to require less definition, such as the sheer face of rock that acts as a repoussoir element on the right or the similarly unscarred cliff behind the pine tree on the left. It is perhaps this consistency of gesture that keeps the sky so closely in plane with the pines and rocks below; the vibrant air is contained within a low relief that denies any release into deep space. This consistency, too, stands in striking contrast to the execution of the Baltimore *Mont Sainte-Victoire Seen from Bibémus* (cat. no. 175), where the dense, active brushwork in the center of the canvas subsides at the edges, suggesting a quite different formal and expressive approach.

The product of all this calm, concentrated workmanship is an image that, despite its natural grandeur, conveys great serenity. It is as if Cézanne had established for himself a complex mathematical problem whose patient unraveling and resolution have given him great pleasure. For these reasons—the absence of theatricality and perfection of execution—Rewald has dated this picture among the earliest of Cézanne's views of Bibémus,[3] perhaps the first ambitious painting he undertook there.

In April 1906 the German collector Karl Ernst Osthaus and his wife visited Aix with the set purpose of seeing Cézanne. Despite their trepidation, they were very graciously received by the artist both at the apartment on the rue Boulegon and at the studio at Les Lauves, where they saw, among other things, what was probably the Philadelphia version of the *Large Bathers* (cat. no. 219). On his way back to his native city of Hagen, where he would commission Henry van de Velde to build a museum for him, Osthaus stopped in Paris and bought two landscapes from Vollard, of which this is one. This was the first time Cézanne received someone who was not an artist or a critic but rather an amateur who wished to see his work. It would be the only such occasion.

J. R.

1. See Rewald, in New York and Houston, 1977-78, no. 11, p. 390.
2. Ibid.
3. Ibid.

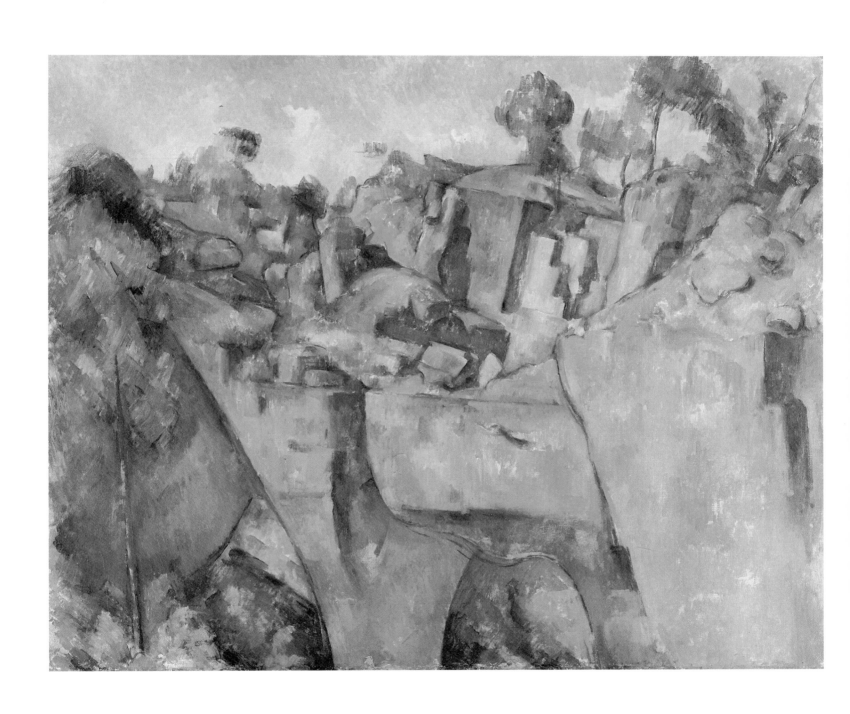

Rocks Near the Château Noir

150 | *Rocks Near the Caves Above the Château Noir*

1895-1900
Watercolor on paper; 19^1/$_{16}$ × 11^7/$_{16}$ inches (48.5 × 29 cm)
Private collection
R. 432

PROVENANCE
After passing from Paul Cézanne *fils* to Bernheim-Jeune, this watercolor was owned by Alphonse Kann, St. Germain-en-Laye. It then passed through Jos Hessel, Paris, and the Galerie Bernheim-Jeune, Paris, and several English collections: those of John Hugh Smith, Oxford, Oswald T. Falk, London, Dr. and Mrs. Alfred Scharf, London, and Ursula Price, London. It was sold at Sotheby's, London, April 1, 1981 (lot 162) to John R. Gaines, Lexington, Kentucky, and is now in a private collection.

EXHIBITIONS
After 1906: New York, 1963 (a), no. 39; Newcastle upon Tyne and London, 1973, no. 82; Tübingen and Zurich, 1982, no. 122.

EXHIBITED IN PARIS AND LONDON ONLY

151 | *Rocks Near the Caves Above the Château Noir*

1895-1900
Graphite and watercolor on paper; 12^1/$_2$ × 18^3/$_4$ inches (31.7 × 47.6 cm)
The Museum of Modern Art, New York. Lillie P. Bliss Collection, 1934
R. 435

PROVENANCE
This watercolor was purchased by the Galerie Bernheim-Jeune, Paris, from Paul Cézanne *fils*. John Quinn acquired it from the Montross Gallery, New York, in 1916; after Quinn's death, it was purchased by Lillie P. Bliss, who bequeathed it to the Museum of Modern Art in 1931. It entered the collection in 1934.

EXHIBITIONS
After 1906: New York, 1916, no. 20; New York, Andover, and Indianapolis, 1931-32, no. 18; New York and Houston, 1977-78, no. 85; Paris, 1978, no. 46.

Just as at the Bibémus quarry (see cat. no. 149), Cézanne was fascinated by the rock formations adjacent to the caves above the Château Noir. To a considerable degree, human intervention had shaped the former, but the cave faces were entirely natural, and this made them all the more remarkable. They inspired several superb watercolors (R. 432-39). Two of these (including cat. no. 150) were executed directly with the brush, without any preparatory drawing.[1] The compositions are structured entirely by color, their greens, mauves, and orange ochers having been applied quickly around the blue passages that define the more crucial masses of rock.

The painter Amédée Ozenfant used the watercolor (cat. no. 150)—which he unwittingly reproduced upside-

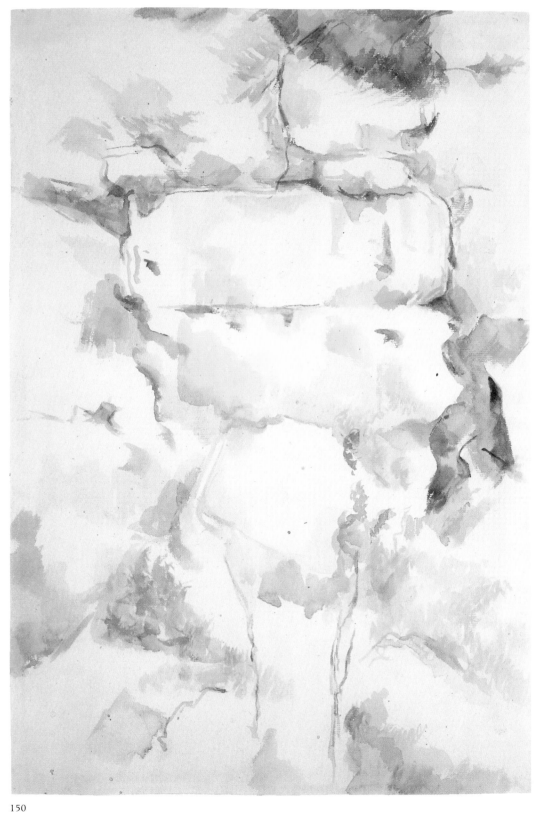

150

down—as an example of the abstract tendencies of Cézanne's art: "It is clear that Cézanne towards the end of his life conceived painting as approximate to an effort of pure creation. His last water-colours witness to an astonishing detachment from objectivity. It was an art of related forms and colours adequate in themselves yet almost without any recognisable links with a subject. But actually, as always, no work of art absolutely attains the ideal sought for."[2] By taking the artist to task for stopping short of total abstraction, Ozenfant revealed that he completely misconstrued the artist's intentions. This sheet indeed exemplifies Cézanne's search for essentials, but only within the larger framework of his longstanding and deeply felt commitment to the accurate transcription of nature.[3]

The watercolor in the Museum of Modern Art (cat. no. 151), of similar dimensions but oriented horizontally, was executed at the same site, but the composition is more complex. Its basic outlines were first laid down in pencil and the color was brushed in later; the forms are rounder, more sculptural, and less open.

If the first watercolor has a fluid, allusive quality that brings to mind Chinese wash drawings, the second, when it was exhibited in New York in 1916, reminded the critic Willard Huntington Wright of another oriental art tradition: "When we stand for a moment before this last picture its seemingly abstract lines and colours take form little by little until finally they appear to possess all the solid and fantastically ordered beauty of an Indian temple."[4] Theodore Reff has more justifiably situated this watercolor in a purely Cézannean context, stressing its baroque aspect, discerning in it the same rolling cadences to be found in drawings executed by the artist in this same period after works by Rubens and Puget: "This compelling rhythm . . . was probably what led him to choose a horizontal format and to introduce the second cliff at the right, an area in which the alternately protruding and hollow surfaces lent themselves to an elaborate, scroll-like pattern of lines. But this area was apparently also a source of more obscure analogies, for we cannot help sensing in its vaguely organic forms, half hidden in shadow, a human body, a female body metamorphosed into the rock."[5]

F. C.

1. The other watercolor, R. 438, of similar dimensions but oriented horizontally, is in the Mattioli collection, Milan.
2. Amédée Ozenfant, *Foundations of Modern Art,* trans. John Rodker (New York, 1931), p. 68.
3. See the photographs taken by Rewald, in New York and Houston, 1977-78, p. 92; and Rewald, 1983, pp. 192-93.
4. Wright, February 1916, p. cxxx.
5. Reff, April 1963, p. 30.

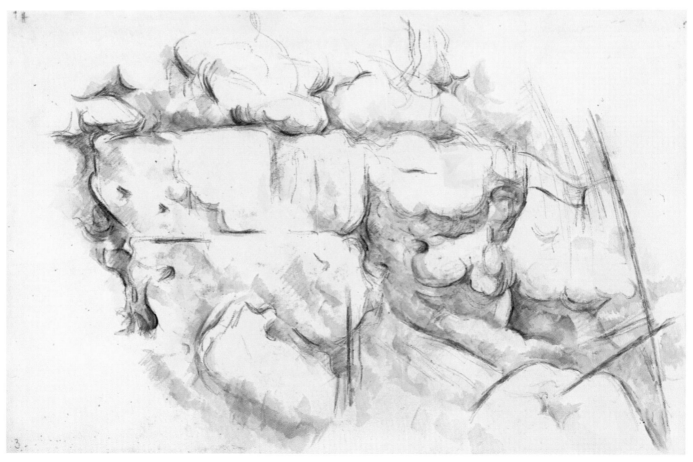

151

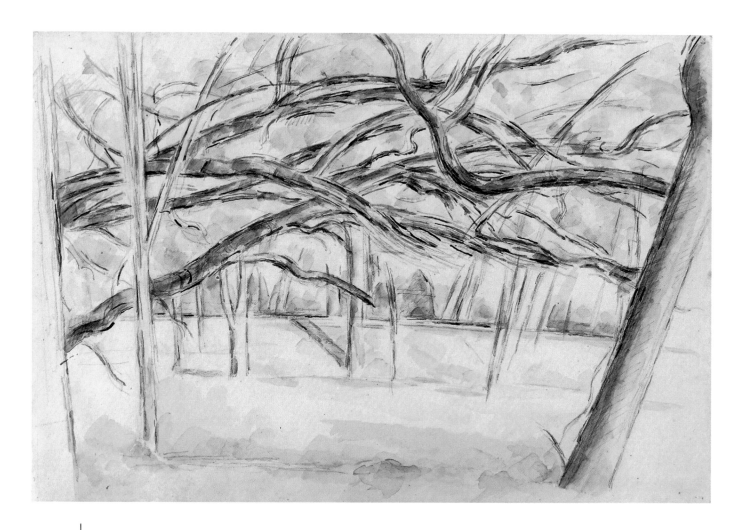

152 | *The Orchard*

c. 1890-95
Graphite and watercolor on paper; 13 × 18¹/₂ inches (33 × 47 cm)
Collection of Jan and Marie-Anne Krugier-Poniatowski
R. 407

Cézanne always liked to paint and draw the complex pat-
terns of tangled branches, which naturally form a powerful
structure where space is organized into irregular compart-
ments. In *Large Pine and Red Earth* (cat. no. 154), they ex-
tend outward from the trunk like a sunburst. In the
present drawing the painter lovingly described with water-
color bare winter branches, making them resemble a low
vault over the schematic verticals of the tree trunks and
the horizontals of the wall in the middle distance.

Venturi dated this superb sheet to 1885-86 on the basis
of its similarity to paintings executed at the house of Victor
Chocquet in Hattenville (see cat. no. 86).[1] Rewald has since
noted, however, that this visit took place in 1882; moreover,
the style of *The Orchard* would place it at least ten years
later. Furthermore, it has been tacitly assumed that if this
sheet pictures an orchard, it must have been painted in
Normandy, a limited argument however. In all likelihood
it was not executed in Aix, for in the course of the 1890s
Cézanne often sojourned in the Île-de-France, Marlotte,
Avon, Fontainebleau, and Giverny. In 1896 he also visited
Talloires in the Haute-Savoie. Any of these sites would
have afforded views of orchards similar to this one.

F. C.

1. See Venturi, 1936, vol. 1, no. 927, p. 255.

Pine Trees

153 | *The Great Pine*

c. 1889
Oil on canvas; 33¹/₁₆ × 36¹/₄ inches (84 × 92 cm)
Museu de Arte de São Paulo, Brazil. Chateaubriand Collection
V. 669

PROVENANCE
The first owner of this canvas was Joachim Gasquet (1873-1921), who was particularly attached to it, for it reminded him of his long walks with the painter through the countryside around Aix. After 1921 it was owned by the dealer Eugène Druet. The picture subsequently figured in the collection of Franz von Mendelssohn-Bartholdy, Berlin; about 1945 it was in New York, in the possession of P. H. Kempner, then, in 1951, it was acquired by the Knoedler Galleries, New York, where it was purchased by the museum

in São Paulo with funds contributed by Joào Chammas, Antonio Adibchammer, and Geremia Lunardelli.

EXHIBITIONS
Before 1906: Paris, 1895, unnumbered.
After 1906: London, 1910-11, no. 20; Berlin, 1921, no. 18; Chicago and New York, 1952, no. 100; Edinburgh and London, 1954, no. 45; Tokyo, Kobe, and Nagoya, 1986, no. 27; Edinburgh, 1990, no. 59.

154 | *Large Pine and Red Earth*

1890-95
Oil on canvas; 28³/₈ × 35¹³/₁₆ inches (72 × 91 cm)
The Hermitage Museum, St. Petersburg
V. 458

PROVENANCE
The Moscow collector Ivan Morosov bought this canvas from Ambroise Vollard in 1908 for 15,000 francs.[1] After the revolution the painting remained in his house, which in 1918 became the Museum of Modern Western Art; it was one of many works in the collection that were transferred in 1948 to the Hermitage in Leningrad.

EXHIBITIONS
After 1906: Moscow, 1926, no. 24; Tübingen, 1993, no. 71.

155 | *Large Pine, Study*

1890-95
Graphite and watercolor on beige paper; 12 × 18¹/₈ inches (30.5 × 46 cm)
The Metropolitan Museum of Art, New York, and Fogg Art Museum, Cambridge, Massachusetts.
Bequest of Theodore Rousseau, 1974
R. 286

PROVENANCE
This watercolor was acquired from Ambroise Vollard by the dealer Étienne Bignou; it then belonged to a curator of the Metropolitan Museum of Art, New York, Theodore Rousseau, who in 1974 bequeathed it to the Fogg Art Museum and the Metropolitan Museum of Art.

EXHIBITED IN PARIS ONLY

156 | *Large Pine, Study*

c. 1890
Watercolor on blue paper; 10⅞ × 17³/₁₆ inches (27.7 × 43.7 cm)
Kunsthaus Zurich
R. 287

PROVENANCE
Paul Cézanne *fils* sold this watercolor to the Galerie Bernheim-Jeune, Paris; it subsequently figured in the collection of the poet Francis Vielé-Griffin, Paris. It then passed through the Galerie Bernheim-Jeune, Paris, and Paul Cassirer, Berlin, who sold it to Sally Falk, Mannheim. It then came into the possession of Paul Cassirer, Berlin, and passed to his daughter, Suse Paret-Cassirer, Berlin. She consigned it in 1935 to Walter Feilchenfeldt, who sold it the same year to the Kunsthaus in Zurich.

EXHIBITIONS
After 1906: Zurich, 1956, no. 104; Munich, 1956, no. 81; Tübingen and Zurich, 1982, no. 37.

EXHIBITED IN PHILADELPHIA ONLY

As much as the particular majesty of these paintings of isolated pine trees depends upon their plastic and formal qualities, the image of the tree itself is not unimportant. Cézanne associated pine trees with his most cherished childhood memories: "Do you remember the pine tree planted on the banks of the Arc, with its hirsute head projecting above the abyss at its foot? That pine whose foliage protected our bodies from the intense sun? Ah! May the gods protect it from the woodsman's baleful axe!"[2] he wrote to Émile Zola, then in Paris, in 1858. Five years later, in Paris himself, he sent some lines of verse to his childhood friend Numa Coste, who was still in Aix, in which he waxed nostalgic for

> The days we went to the meadows near la Torse[3]
> To eat a good lunch, and palette in hand,
> Trace on canvas a luxuriant landscape . . .
> [Whereas today]
> The plants along the brook are withered
> And the tree, battered by furious winds,
> Stirs its stripped branches in the air,
> An immense cadaver that the mistral swings.[4]

Clearly, poetry was not Cézanne's strong suit, but his lyrical outburst conveys just how indelibly the artist's youthful memories were imprinted on his mind, and it demonstrates that in 1863 the pine tree was already imbued for him with both tragedy and optimism, just as it would be in his later paintings.

The two canvases (cat. nos. 153 and 154) have an emblematic power that is altogether remarkable. They are not the artist's first treatments of this motif. Pine trees appear in many earlier paintings as one landscape element among many; generally, he placed trees to one side in the foreground or used branches to limn the upper edge of the visual field so as to frame the principal view—of L'Estaque, for instance (see cat. no. 72), or of Mont Sainte-Victoire (see cat. nos. 92 and 93). In so doing, he was proceeding in a way consistent with the classical landscape tradition, and thus with his professed aim to "enliven Poussin after nature."[5]

The vision manifest in the two later works, however, is quite different. Mention should be made here of another painting that marks an intermediary stage between Cézanne's use of the tree in his more classically conceived landscape compositions and in these "portraits" of pine trees: *Large Pine and Red Earth* (fig. 1), in a private collection, in which the tree is given considerable prominence but still frames a significant landscape view of houses and hills in the Arc valley.

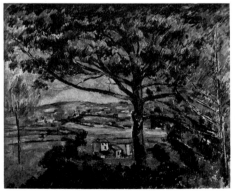

Fig. 1. Paul Cézanne,
Large Pine and Red Earth, c. 1885,
oil on canvas,
private collection, Paris (V. 459).

In these two canvases, Cézanne renounced the approach derived from seventeenth-century landscape painting to focus squarely on a single tree. Such images were not unknown in romantic painting from the first half of the century. Many examples could be cited in the work of Paul Huet, Jules Dupré, Théodore Rousseau, and especially Courbet, whose *Oak at Flagey* (fig. 2), which pictures a kind of tree often associated with the Druids, might be regarded as a Northern archetype of the genre. Cézanne's trees, by contrast, are redolent of ancient idylls.

When working on his first painting of this motif (cat. no. 153), Cézanne could have been thinking of solitary pines at the edge of the sea in paintings by Monet, the only living artist he truly admired, for two pictures by him of this subject (see fig. 3) had been exhibited in 1888 and in 1889.[6] A comparison of the treatments favored by the two artists, however, reveals their profound temperamental differences. Monet's pine trees—sun-loving, celebratory, immediate—seem to dance in the brilliant seaside light. Cézanne, especially in the Hermitage canvas (cat. no. 154), approached them with a concentrated identification, a reverent admiration.

"He loved trees," wrote Gasquet, who, despite his penchant for sentimental elaboration, recounted many stories that have the ring of authenticity: "Toward the end, with his need for sustained solitude, an olive tree became his friend. . . . The tree's wisdom entered his heart. 'It's a living being,' he said to me one day, 'I love it like an old colleague. . . . I'd like to be buried at its feet.'"[7]

The evolution of the São Paulo *Great Pine* (cat. no. 153) is noteworthy. Initially, the upper third of the tree was cropped, with the sky being visible only through the lower branches and on either side. Cézanne then sensed a need to open up the composition and added two bands of canvas to the top. The first one allowed him to include the tree's crown; still dissatisfied, he added another strip to accommodate a bit of blue sky above, thereby enhancing the effect of grandeur. It has become a portrait of a tree more than a mere landscape.

The Hermitage canvas (cat. no. 154) was executed on the Montbriant property of Cézanne's sister and brother-in-law, the Conils, which overlooked the valley and the small village of Bellevue; it represents the same tree he had previously painted there (see fig. 1). This time he viewed the pine frontally and from a closer vantage, making it the centerpiece of a cross-shaped composition and emphasizing the patterns traced by the trunk and the branches emanating from it, whose tentacular forms have a sovereign vitality so powerful as to be almost disturbing.

Cézanne had previously used a compositional scheme centered on a vertical tree in *The Pool at the Jas de Bouffan* (cat. no. 53); there, however, it is thin and scraggly, its primary function being to divide the visual field into four parts. Here the play of forms conveys the formidable energy of nature. The azure sky of the preceding canvas (cat. no. 153), with its majestic yet gracious arboreal subject, has largely disappeared behind the screen of branches, and

Fig. 2. Gustave Courbet,
The Oak at Flagey (also known as
The Oak of Vercingétorix), 1864,
oil on canvas,
Murauchi Art Museum, Tokyo.

Fig. 3. Claude Monet,
Antibes, 1888,
oil on canvas,
Courtauld Institute Galleries, London,
Sir John Atkins Collection.

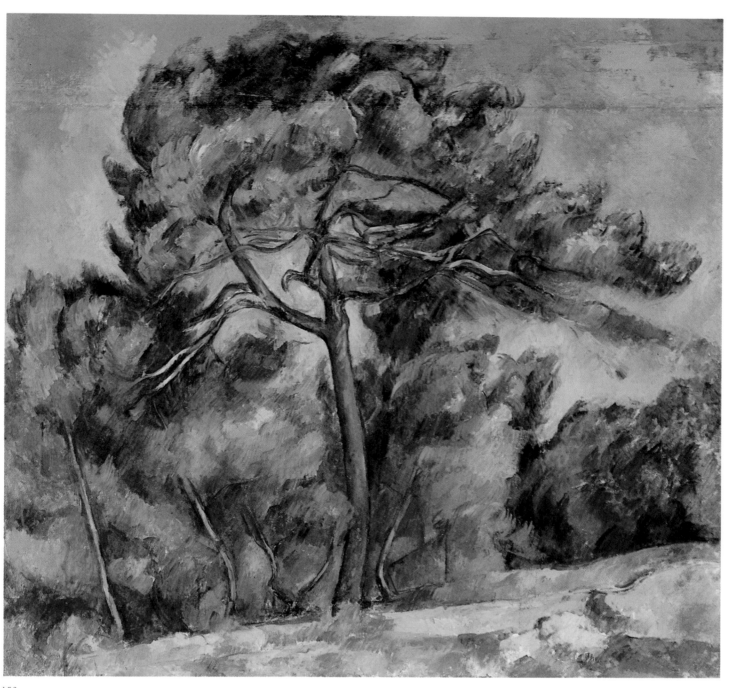

153

the red earth rises higher on the canvas. Buildings can be glimpsed in the valley, but they are very summarily indicated. The touch is lighter and broader, yet at the same time more constructive than in the São Paulo canvas, and the geometry of the composition is more radical. In sum, the Hermitage painting should be dated a few years later than the São Paulo picture, for its style aligns with works from the 1890s.

The very beautiful preparatory drawing with watercolor highlights (cat. no. 155) details the basic configuration of the picture's central elements. The watercolor in Zurich (cat. no. 156) further reveals Cézanne's fascination with this structure of trunk and branches. For the two sheets indeed picture the same pine in two studies, one as much as five or six years later than the other. It is the page placement of the Zurich watercolor that links it most clearly to the first *Large Pine and Red Earth* (fig. 1). But the most idiosyncratic forms—notably the two horizontal branches on the right and the slowly rising one on the left, which is complemented by the oval traced by two more branches breaking away just above it—are found in both paintings. They are more carefully delineated in the St. Petersburg canvas, but they are clearly from the same tree. A third drawing with a few watercolor highlights, now in the Mellon collection (fig. 4), shows the same pine as the two watercolors.

All three sheets display Cézanne's characteristically resourceful use of untouched areas of the paper, which in these compositions serves to focus attention on the pine's structure and color, captured with a fine precision that does not preclude a reduction to essentials.

F. C.

1. An article in the *Journal des débats* of January 29, 1914, signed G. Migeon, recounts a visit to the Morosov house and the superb collection within it, singling out this landscape for special praise. Like the rest of Morosov's collection, it had considerable influence on the young artists of the Russian avant-garde.
2. Cézanne to Zola, April 9, 1858, in Cézanne, 1978, p. 19.
3. A small river between Aix-en-Provence and Le Tholonet.
4. "Ce temps où nous allions sur les prés de la Torse/Faire un bon déjeuner, et la palette en main,/Retracer sur la toile un paysage rupin . . ./Sur le bord du ruisseau les plantes sont flétries/Et l'arbre, secoué par les vents en fureur,/Agite dans les airs comme un cadavre immense/Ses rameaux dépouillés que le mistral balance." Cézanne to Numa Coste, January 5, 1863, in Cézanne, 1978, p. 109.
5. Charles Camoin, paraphrasing Cézanne, in Morice, August 1 and 15, and September 1, 1905, pp. 353-54. This phrase is discussed in Shiff, 1984, pp. 180-83.
6. These two paintings (Wildenstein, 1974-85, nos. 1192, 1193) were shown twice in Paris: in 1888 at the Galerie Boussod et Valadon *(Monet)* and in 1889 at the Galerie Georges Petit *(Monet et Rodin)*. Cézanne spent time in Paris in both years.
7. Gasquet, 1921, pp. 72-73.

Fig. 4. Paul Cézanne,
Large Pine, Study, 1889-90,
graphite and watercolor on paper,
collection of Mr. and Mrs. Paul Mellon,
Upperville, Virginia.

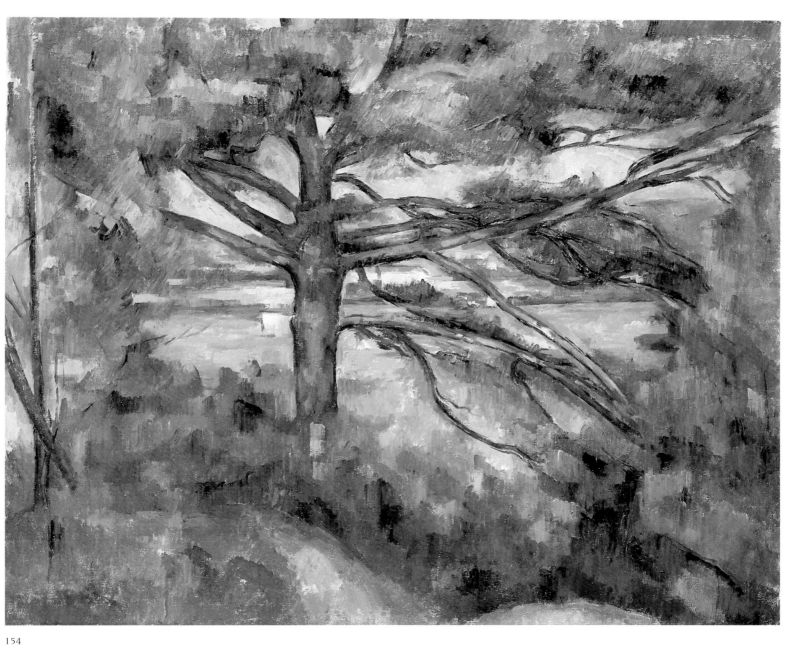

154

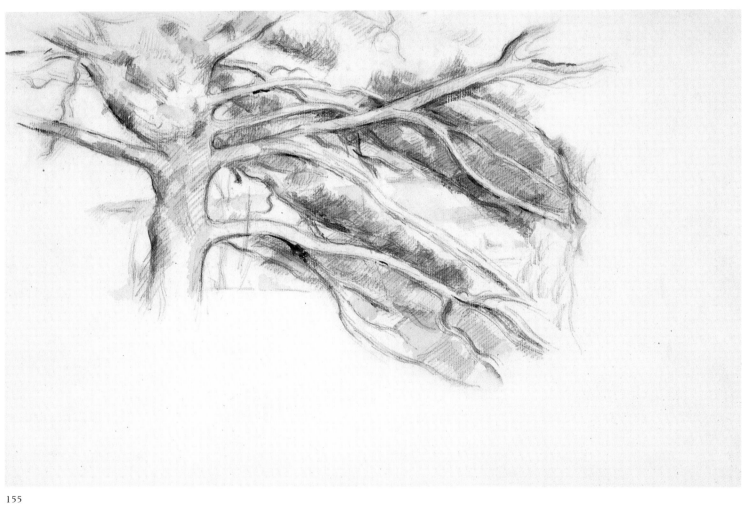

155

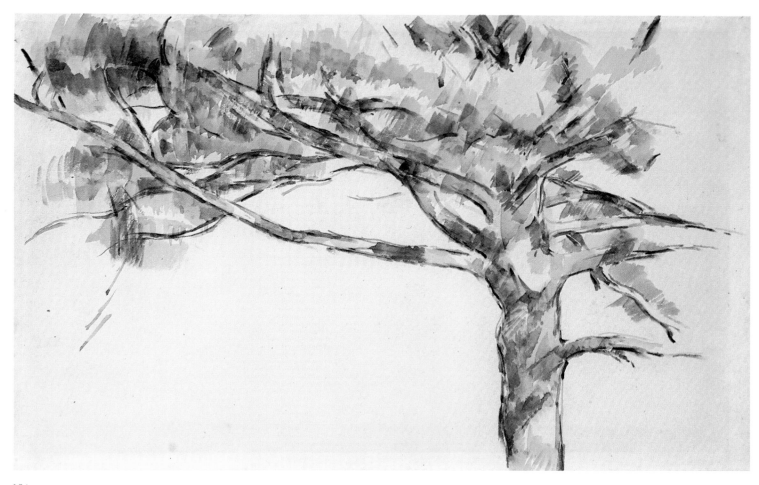

156

Forest

1894
Oil on canvas; 45¹³/₁₆ × 32 inches (116.2 × 81.3 cm)
Los Angeles County Museum of Art. Wallis Foundation, in memory of Hal B. Wallis
V. 419

PROVENANCE
This canvas was acquired directly from Ambroise Vollard in 1928 by Drs. Harry and Ruth Bakwin, New York. It was purchased from their daughter by the Los Angeles County Museum in 1992.

EXHIBITIONS
Before 1906: Paris, 1895, unnumbered.
After 1906: New York, 1942, no. 5; Chicago and New York, 1952, no. 76; The Hague, 1956, no. 27; Aix-en-Provence, 1956, no. 29; Zurich, 1956, no. 46; Munich, 1956, no. 34; Cologne, 1956-57, no. 18; New York, 1959 (b), no. 25; New York, 1963 (b), unnumbered.

The Cézanne biographer Gerstle Mack thought this picture was painted during the artist's visit to Switzerland, about 1890, when his itinerary included a stop in Besançon.[1] However, the red tones of the earth and the disposition of the pine trees evoke a Provençal forest like those on the slopes around Château Noir. The date of 1894 inscribed by Paul Cézanne *fils* on the back of a photograph of the painting in the Vollard Archives supports this hypothesis.[2] Even so, it is easy to understand why Mack would have associated this picture with the countryside around Besançon, for that is Courbet territory: Cézanne's admiration for the master of Ornans is well known, and it was probably paintings by the older artist that had prompted him to take up such wooded subjects.

From the Île-de-France landscapes of the 1870s (fig. 1 and V. 332) to the paintings of the Bibémus quarry and the environs of the Château Noir from the very last years of his life,[3] Cézanne obsessively explored motifs of trees, forests, thickets, screens of foliage, and leafy masses, all viewed from a person's average height, with no trace of sky and no depth of field, images of a nature whose vitality is almost suffocating, whose colors are organized in green patches held in place by the rigorously drawn lines of tree trunks. While his earliest efforts from the 1860s (V. 30–38) still resemble landscapes by Provençal painters and members of the Barbizon school, his admiration for Courbet's idiosyncratic way of structuring landscapes made itself felt as early as the 1870s (see cat. no. 24).

But this taste for woods and underbrush as a principal motif emerged at a key moment of his development, when he was working in Auvers and Pontoise close to the man he would characterize in his old age, with gratitude and deep affection, as "the humble and colossal Pissarro."[4] And Pissarro's influence on Cézanne cannot be overestimated. Many pictures by this patriarch of Impressionism feature similar motifs of trees spread integrally over the canvas. The two artists often painted views side by side, as is evidenced, for example, by paintings of similar compositions—such as *The Côte des Boeufs in Pontoise*—of which one is by Pissarro (National Gallery, London) and the other by

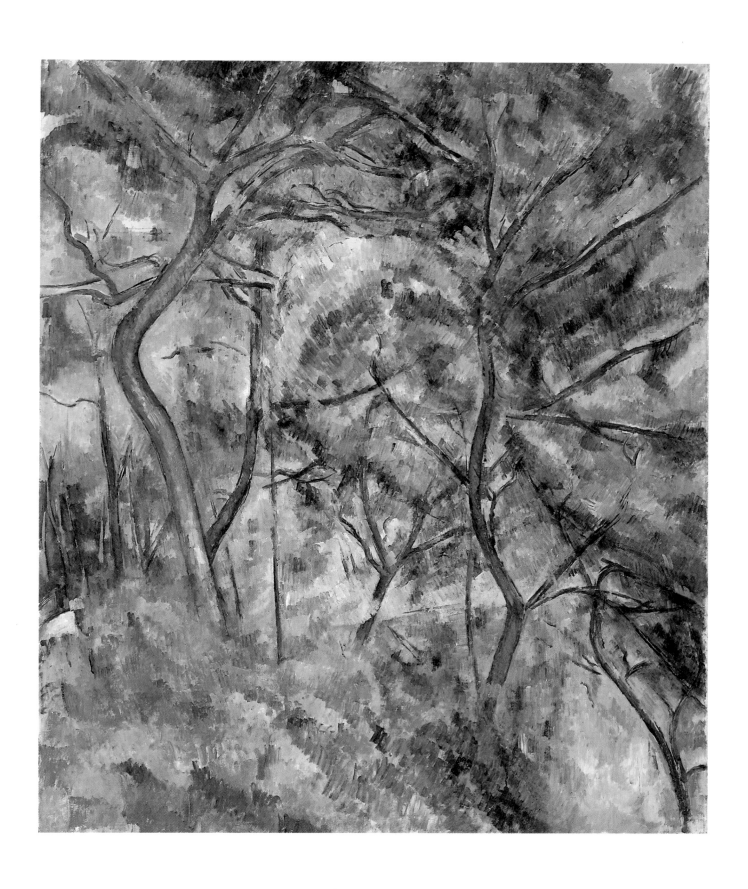

Cézanne (fig. 1). But in Pissarro's work, the trees generally form a screen through which signs of human presence can be discerned: a path, a house, a passerby. Cézanne, in contrast, liked to focus on an invasive, all-powerful nature, selecting views in which nothing is visible beyond the trees but rocks and more plants. One of the Cézannes owned by Pissarro is a painting of a forest from this period; its thick handling is reminiscent of Courbet, whose influence is discernible in the way Cézanne covered the entire canvas with a bent tree (fig. 2), rather like the forked tree on the left in *The Côte des Boeufs in Pontoise* (fig. 1), but on the opposite side.

The Los Angeles picture is a rhythmical, crackling, and almost euphoric treatment of this recurrent motif; the red earth, the prickly light-green foliage, and the touches of blue sky visible through the tangle of branches give this canvas a singular gaiety.

A preparatory sketch (C. 930) established the configuration of overlapping trunks in the upper two-thirds of the composition, but Cézanne ultimately preferred a format that would accommodate the trees' full height, as in a preparatory watercolor picturing the left side of the composition (R. 405).

F. C.

1. See Mack, 1935, p. 325.
2. Another annotation on the photograph of the painting, in the Vollard Archives of the Musée d'Orsay, Paris, indicates that it represents a wood in front of the caves at the Château Noir; see Rewald and Marschutz, January 1935.
3. For example *The Park of the Château Noir* (V. 785, V. 787, and others). About sixty-five watercolors depict woods exclusively, more than survive of Mont Sainte-Victoire (about forty); this does not include representations of trees, allées, and so forth.
4. Cézanne to Émile Bernard, [1905], in Cézanne, 1978, p. 314.

Fig. 1. Paul Cézanne,
The Côte des Boeufs in Pontoise, 1875-77,
oil on canvas,
private collection (V. 173).

Fig. 2. Paul Cézanne,
The Étang des Soeurs, Osny, 1877,
oil on canvas,
Courtauld Institute Galleries, London (V. 174).

c. 1893
Oil on canvas; 28⁷/₈ × 36³/₈ inches (73.3 × 92.4 cm)
The Metropolitan Museum of Art, New York. H. O. Havemeyer Collection,
Bequest of Mrs. H. O. Havemeyer, 1929
V. 673

PROVENANCE
This painting was first owned by Ambroise Vollard from 1899 to 1900. It was sold through Paul Durand-Ruel to Henry O. and Louisine Elder Havemeyer. In 1929 the painting was bequeathed by Mrs. Havemeyer to the Metropolitan Museum of Art.

EXHIBITIONS
After 1906: New York, 1930, no. 8; Philadelphia, 1934, no. 42; San Francisco, 1937, no. 31; New York and Houston, 1977-78, no. 8; Paris, 1978, no. 58; New York, 1993, no. 79.

This dark and foreboding landscape has made a powerful impression on nearly all who have written about it. In the 1930 Metropolitan Museum of Art *Bulletin,* which focused on the newly arrived Havemeyer collection, Harry Wehle wrote of the work's "intentionally harsh forms expressive of a morbid inner conflict, a compelling agony of spirit."[1] That same year Frank Jewett Mather actually found the painting to be a failure: "It has robust passages of drawing in the rocks but the broader relations are ambiguous and the color has not reached that harmony which every fine Cézanne has in so high a degree."[2] Meyer Schapiro saw it as "the vision of a hermit in despair," and accorded it one of his most beautifully written descriptions of a work by the artist:

"In this somber, passionate painting, so saturated by the catastrophic mood, there is a remarkable inner development—a course of feeling moving upward and into depth. The powerful rocks in the lowest part have a strong organic quality—a visceral effect—in their curved and congested forms. We discern a vague human profile in the lower right and physiognomic intimations—a reclining head—in the brighter central rock with scalloped edge. Beyond at the left, the monstrous ground coils and twists into depth. In this tumultuous play of dimmed purple masses, the spectrum of Cézanne's marvellous palette enriches the monochrome surface with a transparent layer of deepened tones. Beneath the common purple is revealed the underground of feeling it has overcast, and out of these changing chords rises the unique orange and yellow lighting of the central rock.

"From this region of crowded, pulsing forms, we pass to a higher barrier of angular rocks, one, especially, impending and architectural in form, sharp-edged like a block of cut stone; it slopes forward and to the left, in opposition to the lower rocks. From their hidden depths rise the tree trunks in tilted lines, parallel to the edges of the rocks; they carry a vaporous foliage, spotted like the rocky surfaces below, and crossed by the nerve-like branches which repeat the contours of the rocks in a disengaged line. The

fourth region—the sky—is an immaterial void, pale, remote, and sunless, with a fantastic, spreading silhouette. The rare line of the horizon, marking the observer's point of view, is soon lost among the trees and rocks."[3]

A bit further on, in a leap of poetic intuition, Schapiro compared the painting to a passage from *L'Éducation sentimentale* by Flaubert, "who, like Cézanne, knew the alternatives of contemplation and despair."[4] In the novel, two lovers have escaped to the country from Paris and the chaos of 1848:

"The path zigzags between the stunted pines under the rocks with angular profiles; this whole corner of the forest is somewhat stifling, a little wild and close. . . . One thinks of hermits. . . . Rosanette stumbled, she was in despair and wanted to cry. . . .

"The light . . . subdued in the foreground planes as if at sundown, cast in the distance violet vapors, a white luminosity. . . .

"The rocks filled the entire landscape, . . . cubic like houses, flat like slabs of cut stone, supporting each other, overhanging in confusion, like the unrecognizable and monstrous ruins of some vanished city. But the fury of their chaos makes one think rather of volcanos, deluges and great forgotten cataclysms. Frédéric said that they were there since the beginning of the world and would be there until the end. Rosanette looked away, saying that it would make her mad."[5]

In 1936 Venturi titled this painting simply *Rocks.*[6] He later came to think, as did Charles Sterling, that the site might be one of the famous extrusions of boulders and low cliffs in the forest at Fontainebleau that had so appealed to Corot and Théodore Rousseau. Rewald endorsed this identification, arguing that both the palette of purples and greens and the nearly watercolor-thin application of paint were in accord with Cézanne's technique in 1892-93, when he is known to have worked in the Fontainebleau forest, having acquired a house in Marlotte in 1892.[7] Cooper felt this date was too early and placed the painting in the late 1890s, noting that the subject could just as well have been the pine trees pushing up through the shelves of rock that border the road between the Maison Maria and the Château Noir east of Aix.

Speculation about the dates of Cézanne's paintings on the sole basis of their color and handling is a tricky business. He seems to have been, above all else, a modal painter, adapting his touch and palette to the formal and expressive nature of the motif before him. In his restless

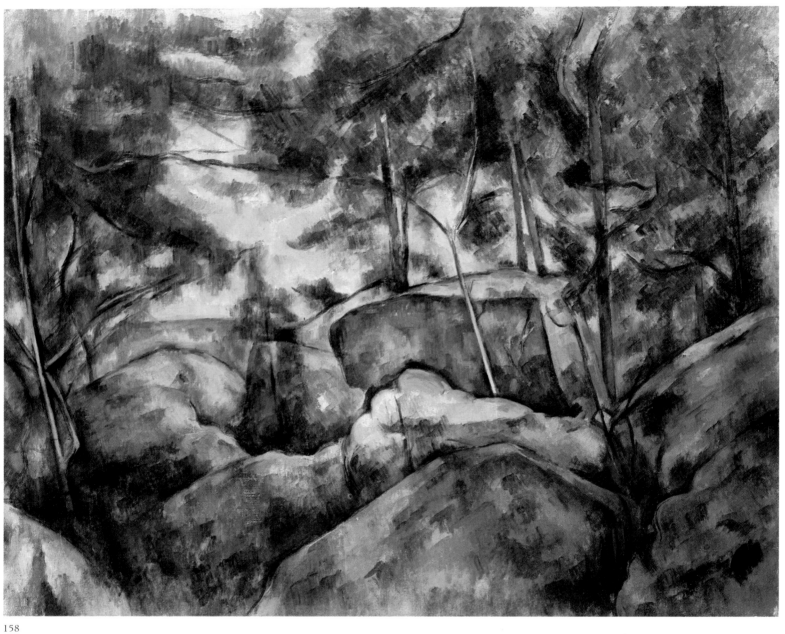

158

moves between the North and the South, as in his far-ranging explorations for subjects in both regions, he actively sought out those places that most suited him and to which he wished to devote his full attention. Deep in the forest of Fontainebleau there is a sense of forlorn melancholy very much in the spirit of this picture. The equal value of the greens and purples against the muted ochers of the rocks, the "immaterial void" of the sky, the sense that direct sunlight has never penetrated this place: all this is more suggestive of Barbizon painting and the forest with which its painters were most closely associated than it is of even the most hidden and overgrown spots of Provence.

J. R.

1. Harry B. Wehle, "The Exhibition of the H. O. Havemeyer Collection," *Bulletin of the Metropolitan Museum of Art*, vol. 25, no. 3 (March 1930), p. 58.
2. Frank Jewett Mather, Jr., "The Havemeyer Pictures," *The Arts*, vol. 16, no. 7 (March 1930), p. 483.
3. Schapiro, 1952, p. 118.
4. Ibid.
5. Ibid.
6. See Venturi, 1936, vol. 1, no. 673, p. 209.
7. See Rewald, 1986 (a), p. 269.

159 | *Curtain, Jug, and Compotier*

1893-94
Oil on canvas; 23$^{1}/_{4}$ × 28$^{1}/_{2}$ inches (59 × 72.4 cm)
Collection of Mrs. John Hay Whitney
V. 601

PROVENANCE
This still life was purchased from Ambroise Vollard by Cornelis Hoogendijk; it was bought in 1920 with the Cézannes of the Hoogendijk collection by Paul Rosenberg, Paris. Dr. Albert C. Barnes acquired it on August 7, 1920. It was resold to the Carroll Carstairs Gallery, New York, and in April 1950 became the property of Mr. and Mrs. John Hay Whitney.

EXHIBITIONS
After 1906: Chicago and New York, 1952, no. 82; Aix-en-Provence, 1956, no. 50; Munich, 1956, no. 53.

The still lifes of Cézanne's maturity elude all attempts at moralizing or symbolic interpretation. They are neither staged glimpses of everyday life—pictures of meals about to be served or just consumed—nor allegories of the senses. The fruit is presented not as food but as objects of contemplation. "With an apple," he once proclaimed, "I want to astonish Paris."[1] There was no need, then, for him to seek out motifs of rare beauty or luxurious aspect; modest tableware and ordinary fruit not liable to spoil quickly would suffice.[2] Here, the painter has placed a white faience compotier, a gray-blue glazed stoneware jug, and a carefully arranged white tablecloth on a simple wooden table that anchors the composition. On the left appears a blue drapery that is also found in several still lifes from the 1880s and 1890s.[3] Vollard recognized it (or perhaps another material familiar to him from the artist's work) in the Aix studio: "Close to the window hung a curtain that had always served as a background for portraits and still lifes."[4] Fruit of various kinds—lemons, apples, pears, oranges—

has been heaped in a pyramid in a compotier, nestled into the folds of the tablecloth, or placed directly on the wooden table, the vibrant colors contrasting starkly with the muted palette of the rest of the painting. A few years earlier Cézanne had worked on similar compositions, using the stoneware vessel with fruit (figs. 1 and 2) that would appear in several more canvases executed in the late 1880s or early 1890s (figs. 3–5).[5] This series culminates in the present picture, which is more resolved compositionally. No preparatory drawings for *Curtain, Jug, and Compotier* are known, but there are two sketches of the stoneware jug that date from 1891-94 (C. 1079 and C. 1080). Cézanne probably composed his canvas directly in front of the motif. He proceeded by juxtaposition and superimposition of forms and colors, placing oranges and green pears side by side. The forms sometimes blend into one another, as do the yellow apple and the lemon in the center of the composition, and the large red and yellow apple that merges visually with the tablecloth beneath the compotier. Their defining outlines remain open. "Cézanne did not seek to represent forms by means of line. Contour existed for him only as the place where one form ended and another form began."[6] Volumes are described by directional brushstrokes that leave a discernible weave on the surface. The uniform back wall is also rendered in a multitude of blended brownish red, brownish green, and violet strokes. This patient evocation of modeling[7] by means of color

enabled Cézanne to imbue the motif with luminosity in the absence of artificial illumination. No shadows are cast on the wall, and each object radiates an individual clarity: "The object is no longer covered by reflections and lost in its relationships to the atmosphere and to other objects: it seems subtly illuminated from within, light emanates from it, and the result is an impression of solidity and material substance."[8] This autonomy gives the painter's still lifes a spiritual force that transcends the subject matter: "For Cézanne, the view of some apples or some pieces of bacon produces a spiritual experience as majestic as was, for Giotto, the tearful contemplation of the Virgin during prayer."[9]

I. C.

1. Cézanne, quoted in Geffroy, 1922, p. 198.
2. Rilke underscored the intentional modesty of Cézanne's motifs: "The apples are all cooking apples, the bottles would not be out of place in old jacket pockets stretched by repeated use." Rilke to his wife, October 7, 1907, in Rilke, 1952, p. 19.
3. See cat. nos. 160 and 161, V. 597, V. 624, V. 625, and figs. 1 and 5.
4. Vollard, 1914, p. 75.
5. To the series of works reproduced here, one might add V. 749, *Still Life with Jug*, 1895-1900, oil on canvas, The Tate Gallery, London.
6. Rivière and Schnerb, December 25, 1907; reprinted in Doran, 1978, p. 87. Merleau-Ponty (1964, pp. 14-15) developed this idea explicitly: "The contour of an object conceived as a line encircling the object belongs not to the visible world but to geometry. If one outlines the shape of an apple with a continuous line, one makes an object of the shape, whereas the contour is rather the ideal limit toward which the sides of the apple recede in depth. Not to indicate any shape would be to deprive the objects of their identity. To trace just a single outline sacrifices depth—that is, the dimension in which the thing is presented not as spread out before us but as an inexhaustible reality full of reserves. That is why Cézanne follows the swelling of the object in modulated colors and indicates *several* outlines in blue. Rebounding among these, one's glance captures a shape that emerges from among them all, just as it does in perception."
7. Denis reported that Cézanne preferred the term *moduler* (modulation) to *modeler* (modeling) (Denis, September 1907; reprinted in Denis, 1912, p. 250).
8. Merleau-Ponty, 1964, p. 12.
9. Fülep, in de Tolnay, 1974, p. 113.

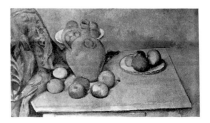

Fig. 1. Paul Cézanne,
Jug and Fruit on a Table,
1885-87 (?),
oil on canvas,
private collection (V. 499).

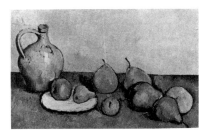

Fig. 2. Paul Cézanne,
Pitcher and Fruit,
1885-87,
oil on canvas,
private collection (V. 500).

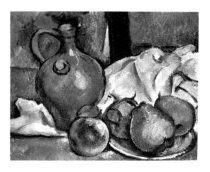

Fig. 3. Paul Cézanne,
Pitcher and Plate of Pears,
1888-90,
oil on canvas,
private collection (V. 609).

Fig. 4. Paul Cézanne,
Fruit and Jug,
1890-94,
oil on canvas,
private collection (V. 612).

Fig. 5. Paul Cézanne,
Stoneware Jug,
1890-94,
oil on canvas,
private collection (V. 622).

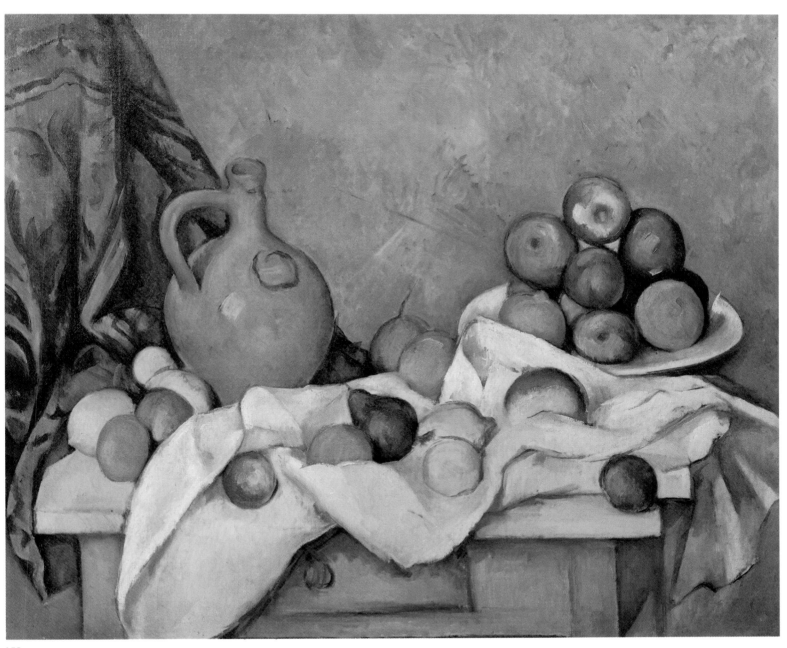

159

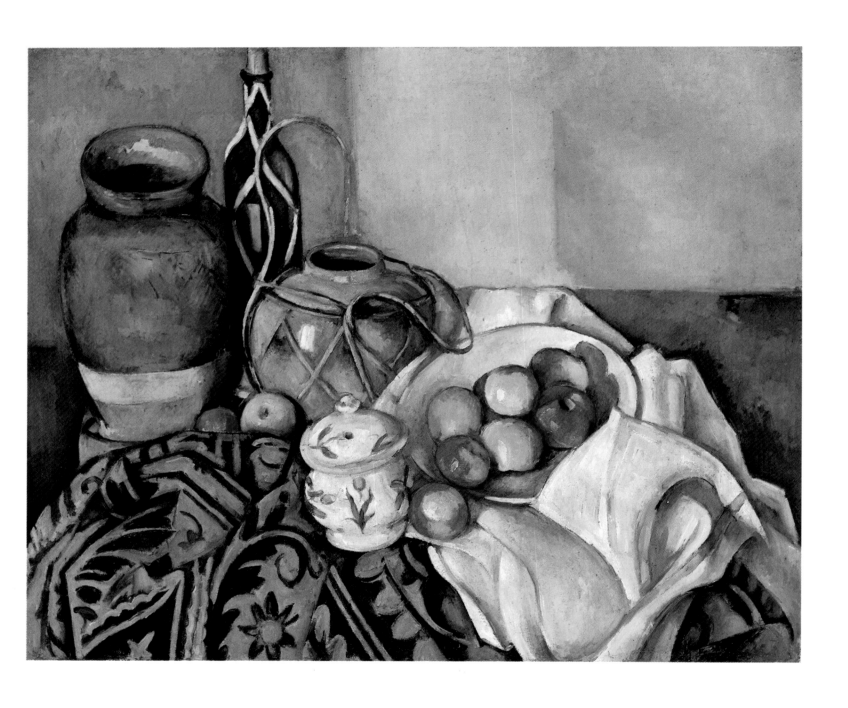

160 *Still Life with Apples*

1893-94
Oil on canvas; $25^{13}/_{16} \times 32^{1}/_{16}$ inches (65.5 × 81.5 cm)
Private collection
V. 598

PROVENANCE
Ambroise Vollard sold this canvas to Paul Cassirer, Berlin. About 1910 it was acquired by Baron Ferenc Hatvany, one of the most important Hungarian collectors in the century's early years.[1] After 1912 it was purchased by Hugo Cassirer, the brother of Paul Cassirer, and passed successively to his widow, Lotte Cassirer-Furstenberg, and to her son, Reinhold Cassirer, Johannesburg. It is now in a private collection.

EXHIBITIONS
After 1906: Prague, 1907, no. 54 or 55; Cologne, 1912, no. 129; Berlin, 1921, no. 32; Tübingen, 1993, no. 58.

After visiting the exhibition of French Impressionist painting in Prague in 1907, at which this work was publicly exhibited for the first time, Rilke was much taken with it, describing it as "a still life with the blue spread; between its bourgeois, cottony blue and the wall, which has been overlaid with a slightly hazy, bluish tint, an exquisite, large, gray-glazed ginger jar, whose right and left sides don't align; an earth-green bottle of yellow Curaçao; and also a ceramic vase, the top two-thirds with a green glaze. On the other side, in the blue spread, are apples, several of them having rolled out of a porcelain plate tinged by the blue. The rolling of their red into the blue appears to be an action determined as much by the color processes of the picture as is the embrace of two Rodin nudes by their physical affinity."[2]

The elements of this composition appear in several other still lifes of the late 1880s and early 1890s:[3] the blue drapery with a leafy pattern, the Marseille pottery,[4] the bottle of rum (mistaken by Rilke for Curaçao), the ginger jar, the faience sugar bowl, and the plate of apples. Cézanne placed them differently in each canvas—with great care, for these arrangements are anything but haphazard—according to relationships among forms, colors, and textures. Objects put side by side form a complex network of curves and countercurves, whose rhythms continue into the decor and the folds of the fabric. Arranged in descending order of size, the objects trace a large diagonal extending across the picture from upper left to lower right. The eye moves inexorably from the high, "shouldery" forms of the bottle and the green pot to the more compact curves of the ginger jar, the sugar bowl, and the apples. The surfaces are meticulously rendered, their differences emphasized by considered juxtapositions. The reflections on the glazed pottery and the shiny apple skins contrast with the mat, muted harmonies of the pottery, the willow netting, and the patterned cloth. Taking liberties with perspective,[5] Cézanne widened the oval mouth of the green vessel and tilted the plate of apples to emphasize the fruit and the precarious situation of the sugar bowl. What's holding it up? one might ask, no support being visible beneath it. The violet and black surface to the right might serve this function, but on examination it seems more like a vertical screen than a horizontal tabletop. Only the green pot appears to be securely grounded on a plane that extends beneath the bottle, the ginger jar, and the two apples in front of them. This solidly planted ensemble counters the instability of the picture's central motifs.

The entire composition is bathed in a bluish atmosphere that evokes the freshness of a cottage in Provence. Simultaneously simple and sumptuous, this still life communicates an intense poetic emotion. It was included in the 1912 Sonderbund exhibition in Cologne, which, along with the series of exhibitions organized by Paul Cassirer and the Berlin Secession exhibition of 1903, introduced Cézanne's work to the artists of the German avant-garde.[6]

I. C.

1. See Gerlötei, May-June 1966, p. 365.
2. Rilke to his wife, November 4, 1907, in Rilke, 1952, p. 45.
3. See cat. no. 128, V. 496, V. 497, V. 597, V. 616, and V. 738.
4. This green pot, or an identical one, appears in Cézanne still lifes dating from 1867 to 1869 (see cat. no. 18). It is used as a vase in still lifes from the 1870s (V. 218) and from the last fifteen years of the artist's life: V. 511, V. 513, V. 617, and V. 618. It is also incorporated, empty, into several more compositions: V. 496, V. 497, V. 498, and V. 597.
5. Merleau-Ponty (1964, p. 14) remarked: "By remaining faithful to the phenomena in his investigations of perspective, Cézanne discovered what recent psychologists have come to formulate: the lived perspective, that which we actually perceive, is not a geometric or photographic one."
6. The beauty and modernity of Cézanne's still lifes were quickly ascertained by both his contemporaries and the more innovative artists of the century's early years. Signac ranked them with the *Mona Lisa* and Tintoretto's *Paradise* (see Morice, August 1 and 15, and September 1, 1905, p. 79). They are widely regarded as having been the formal point of departure for the Cubists: "Cézanne's compotier, previously imbued by him with such force and infused with a Cézannean light, is definitively broken by us, the first Cubists," noted Robert Delaunay ("Les Cahiers de Robert Delaunay," *Du cubisme à l'art abstrait*, ed. Pierre Francastel [Paris, 1957], p. 79).

The Plaster Cupids

161 | *Still Life with Plaster Cupid*

1894-95
Oil on canvas; $24^{13}/_{16} \times 31^{7}/_{8}$ inches (63 × 81 cm)
Nationalmuseum, Stockholm
V. 707

PROVENANCE
Ambroise Vollard acquired this canvas in 1911[1] and sold it at the end of the same year, in November or December, to the Swedish collector Klas Fahraeus. The picture entered the museum's collection in 1926.

EXHIBITIONS
After 1906: Stockholm, 1917, no. 5; The Hague, 1956, no. 41; Zurich, 1956, no. 71.

EXHIBITED IN PARIS AND LONDON ONLY

162 | *Still Life with Plaster Cupid*

c. 1895
Oil on paper mounted on panel; $27^{13}/_{16} \times 22^{9}/_{16}$ inches (70.6 × 57.3 cm)
Courtauld Institute Galleries, London. Courtauld Bequest
V. 706

PROVENANCE
Baron Denys Cochin, the French deputy and collector who met Cézanne in 1898, acquired this still life from Ambroise Vollard.[2] On November 11, 1912, he sold it to Bernheim-Jeune. The gallery sold it a month later to Herbert Kullmann, Manchester, but repurchased it from him on December 31, 1913.[3] The picture then passed through the hands of several dealers and collectors—Jebson, 1916; Paul Rosenberg, Paris, and Alexander Reid, Glasgow—before being acquired in 1923, on the occasion of an exhibition at the Agnew Gallery, London, by Samuel Courtauld, who donated it to the institute established by him in London in 1931.

EXHIBITIONS
After 1906: Copenhagen, 1914, no. 20; New York, 1916, no. 2; London, 1925, no. 10; London, 1939 (a), no. 19; London, 1948, no. 15; Edinburgh and London, 1954, no. 50; New York and Houston, 1977-78, no. 23; Paris, 1978, no. 17; London, 1994, no. 12.

163 | *Plaster Cupid*

c. 1890
Graphite on paper; $19^{9}/_{16} \times 12^{11}/_{16}$ inches (49.7 × 32.2 cm)
Trustees of the British Museum, London
C. 988

PROVENANCE
The British Museum acquired this drawing in 1935 from the London dealers Reid and Lefevre.

EXHIBITIONS
After 1906: Tübingen, 1978, no. 179.

Plaster Cupid

1900-1904
Graphite and watercolor on paper; 18⁷/₈ × 8⁷/₈ inches (48 × 22.5 cm)
Private collection
R. 560

Plaster Cupid

1900-1904
Graphite and watercolor on paper; 18¹/₂ × 8¹¹/₁₆ inches (47 × 22 cm)
The Pierpont Morgan Library, New York. The Thaw Collection
R. 558

There is no way to determine with any degree of certainty where these two still lifes were painted. Vollard reported having seen reproductions of several works of art, including this Cupid, on the walls of the artist's studio in Aix.⁶ But this is of little help; photographs are readily transportable, like the small plaster, and could also have been in the Paris studio.⁷ Nor is it known when the artist purchased the cast (fig. 1). The piece is not listed in the catalogues of plasters available at the time from the Louvre,⁸ the École des Beaux-Arts, or the Palais du Trocadéro; in all likelihood it was acquired from a private caster. The original marble, which has disappeared, was in Cézanne's day attributed to Pierre Puget (1620-1694). More recently François Duquesnoy (1594-1643) and Nicolas Coustou (1658-1733) have each been proposed as its creator,⁹ but neither of these attributions is wholly convincing.¹⁰ The cast had been in Cézanne's possession for several years by the time he embarked on these canvases, as is evidenced by the many drawings he made of it from as early as the mid-1870s. Clearly he was fascinated by its gracious rotundities and animated silhouette, for he depicted them over and over again until about 1904.¹¹

The two paintings, both of which feature the plaster as well as a plate of fruit and a drapery, were painted in the mid-1890s.¹² In the Stockholm canvas (cat. no. 161), probably the earlier of the two pictures, the space is reduced to two levels of depth: a foreground containing a table with a still life, and a background wall with a fireplace on the right and some shapes on the left that are difficult to decipher. The blue drapery joins the two areas.¹³ The plaster figure is the only dynamic element in the composition: facing outward from the canvas, it seems to stride toward the viewer. This effect is intensified by the slightly plunging perspective.¹⁴

It was Joachim Gasquet who first discovered this still life in Cézanne's studio in Aix: "He went over to the pile of canvases, looking for something. . . . He brought out three still lifes and leaned them against the wall on the floor. Warm, profound, alive, they burst forth like magic wall panels yet were deeply rooted in everyday reality. . . . And the third [canvas]—elegant, tangy, lucid—was a work altogether French in character, decorative but pointed,— half breaking away from some rich material in a muted floral pattern and draped in ample folds, a plaster Cupid, its arms broken, to its right a plate of pears, to its left a pile of plums. In the background—unexpected, bourgeois, but so richly painted, so stunningly wrought—a Prussian fireplace like the ones still used in cottages in Provence."¹⁵ As Gasquet's description implies, this picture may well have been painted in the Midi.

The "thick, velvety blue"¹⁶ that dominates the composition evokes the legacy of Chardin. "For Cézanne's highly

characteristic blue is of this lineage, it originated in the eighteenth-century blue that Chardin stripped of pretentiousness and now, in Cézanne, no longer carries with it any such connotation."[17] The pigment is applied in light touches that leave much of the priming visible, a mode of handling suggestive of watercolor. The ample breathing space between brushstrokes, especially in the drapery, the fruit, and the Cupid's face, makes the composition seem more like an oil sketch than a finished painting. As such it provides access to Cézanne's working method. Toward the end of his life, he recommended to Émile Bernard, "begin lightly, and with tones that are almost neutral. Then it's necessary to proceed by intensifying the [color] range and tightening the chromatics."[18] He further advised Bernard not to confine his motifs within rigid linear contours. Indeed, it was in front of this very painting that Gasquet heard Cézanne reflect on the nature of his technique as follows: "He indicated the plaster Cupid in his still life. 'Here, look. This hair, this cheek, they're drawn, that's easy; there, these eyes, this nose, they're painted . . . and in a good picture, like the ones I dream about, there's a unity. The drawing and the color are no longer distinct; as one paints, one draws; the more the colors harmonize among themselves, the more precise the drawing becomes. That's what I've learned from experience. When color is at its richest, form is at its fullest. Tonal contrast and affinity, that's the secret of drawing and modeling. . . . All the rest is poetry.'"[19]

In the Courtauld picture (cat. no. 162), Cézanne chose to showcase the putto in a vertical format, rare in his still lifes. The statuette is placed in the center of the picture and viewed from slightly above, its prominence belying its small scale; the painted version is slightly larger than the cast.[20] The figure easily dominates the elements around it. Although none of the drawings depicts a three-quarter frontal view of the plaster,[21] the approach to modeling here parallels that in the drawings: the forms are powerfully evoked by directional brushstrokes, their volumes given relief by gray shadows and black edging applied discontinuously.

The onions and apples at the Cupid's feet echo its sensual convexities. Their bright colors—red, yellow, orange, and green—contrast with the bluish white of the plaster. The objects lose much of their symbolic charge in this incongruous juxtaposition, which was determined by purely formal considerations.[22] As he often did in his 1890s still lifes, Cézanne depicted a corner of his studio in the background.[23] The propped-up canvases form an array of geometric panels that sets off the Cupid's silhouette, and a sense of recession is created by the canted rectangle in the center. The floor effects a transition between the two levels of depth, but it seems to tilt forward illogically, and its surface handling, which consists of freely applied patches of color, intensifies the spatial ambiguity. An oversize green apple on the floor toward the rear appears visually suspended and thus flattens the space still further, even as it threatens to roll the length of an emphatic diagonal. An-

other diagonal cuts across the canvas, too, extending from the lower right to the upper left, emphasized by the top left corner of the stretcher behind the statuette. These two axes cross one another in the center of the canvas, very close to the figure's groin.

Cézanne eschewed unitary perspective in several still lifes of the 1890s, but here it is undermined with exceptional subtlety. Initially the viewer's gaze is directed along a plunging trajectory toward the still life in the foreground, only to be prompted upward a moment later, from the floor of the studio to the canvas that closes the composition at the upper right.[24] These spatial ploys and eccentric framing strategies produce visual traps predicated on the reduplicative play of various levels of reality.[25] The Cupid statuette in the foreground is echoed in the background by the painting of another cast owned by Cézanne, an écorché figure formerly attributed to Michelangelo (see cat. no. 111).[26] The conceit initiated by this sculpture[27] is taken to another level in the dialogue between the painted still life to the left and the one at the Cupid's feet. Both are composed of fruit and drapery, and the eye moves back and forth between them virtually unimpeded: their respective factures are virtually indistinguishable,[28] and the transition between the large onion and its green stem is made to coincide with the bottom of the depicted canvas, effecting visual fusion. In effect, this gesture proposes a modernist gloss on the fable of Parrhasius and Zeuxis,[29] suggesting a critique of the traditional conception of still life as trompe-l'oeil, as an exaltation of reality intended to deceive the senses. Cézanne does not make do with representing on the canvas the objects observed by him; he extrapolates from his own perceptual experience to comment on the relation between things and space. In the words of Rilke: "It seemed to him that his most crucial task was to be convincing, to give life to objects, by his own perception of them to imbue them with a reality so intense as to be indestructible."[30] Naturalist, symbolic, and moralizing notions of still life give way to a purely pictorial conception in which forms and colors answer one another, generating visual tension that establishes a powerful equilibrium on the canvas.

Fig. 1. Plaster cast of a Cupid that belonged to Cézanne and is still in the artist's Les Lauves studio, Aix-en-Provence.

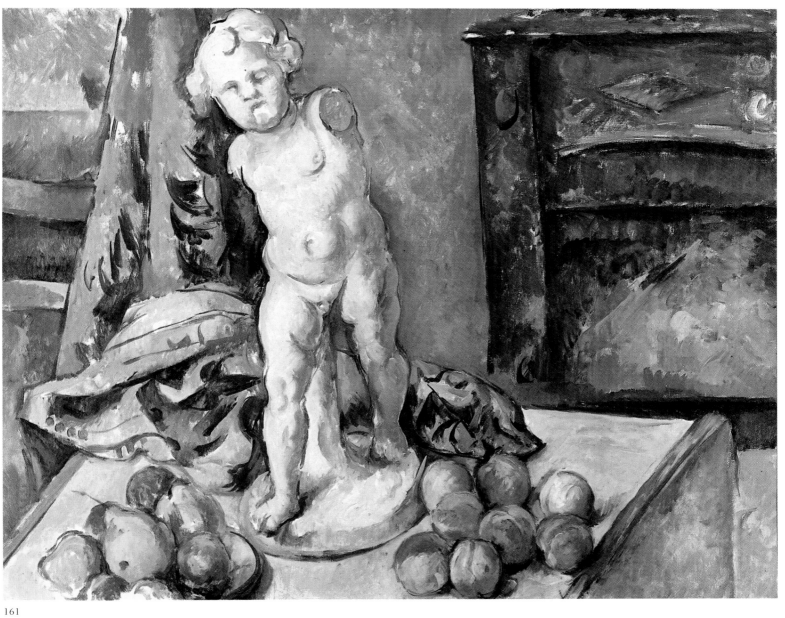

161

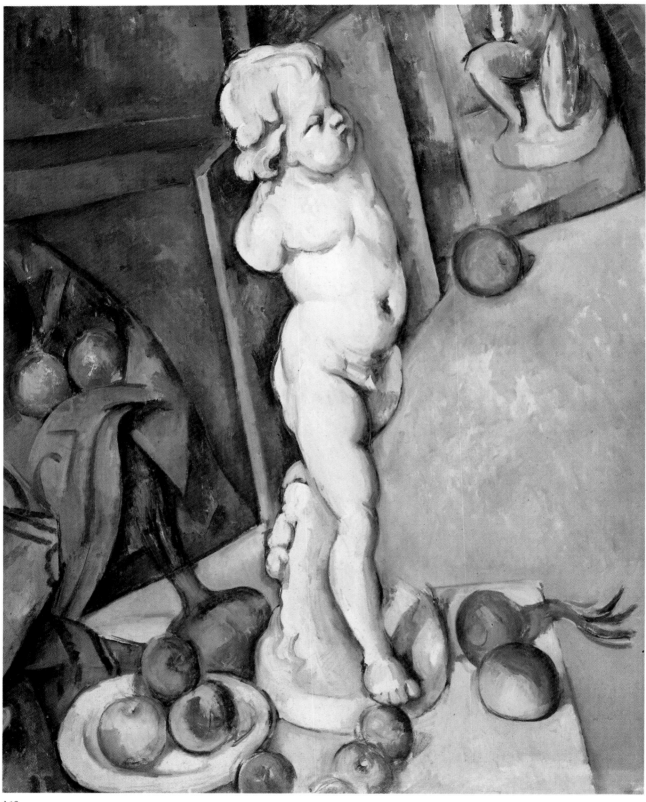

162

In the series of drawings of the putto initiated by Cézanne in the mid-1870s,[31] the sheet dating to about 1890 and now in the British Museum is one of the least finished (cat. no. 163). It is not a preparatory study for a specific painting. Cézanne liked to depict familiar objects from different angles, like so many variations on a given theme. The particulars of its execution—all parts of the body are carefully articulated except the right leg, which is evoked solely by the inner contour of the thigh—suggest that the artist deliberately left it in this state, having found it satisfying. Such *non finito*, or selective incompletion, has a long history in Western draftsmanship (see fig. 2). The abbreviated Cupid, lacking its right leg as well as its arms, stretches diagonally like a strung bow across the white paper, which is left completely blank on the left. Cézanne used hatched shadows to convey volume, whereas in later watercolors he modeled the putto's anatomy exclusively by means of contour. The statuette is illuminated from the left, all shadows being concentrated on its right, with those cast by the figure itself serving to define its silhouette. Part of the putto's face disappears into half-light, but all its features—the fleshy, somewhat pouty mouth, the round chin modeled by a luminous spiral, the blind gaze—are meticulously rendered. This unfinished representation gives the figure an aerial lightness and élan suggestive of eighteenth-century depictions of the victorious Cupid. Of all the drawings, this is the one that most closely resembles the putto in the Stockholm painting (cat. no. 161).

Cézanne produced two watercolors (cat. no. 164 and R. 556)—as well as a few drawings—picturing the statuette more directly from the rear. In both, it is contained within a narrow vertical format; presumably the paper was cropped. The artist began by delineating the motif in pencil and then added touches of thin wash. In one of the two sheets (cat. no. 164), he seems to have been especially pre-occupied by the figure's right leg, for he drew and redrew its defining marks. They are not properly described as re-workings, however, for the bundled lines work together to define a vibrant, nervous contour. The background elements, which might be a doorframe or canvases leaning against the wall, were lightly brushed in without any preparatory drawing. He used broader strokes, sometimes doubled, from a more heavily charged brush to articulate the silhouette. A patch of wash emphasizes the stub of the arm.

The New York watercolor (cat. no. 165) shows the figure in a three-quarter rear view, placed on a table of light wood. The background is more developed and the cast's contours more assertive than in the other versions. The brushstrokes underscore the chubby forms, being applied over the multiple pencil marks delineating the contours. This reiterative, fragmented drawing technique makes it possible to model the volumes without the use of shadows to evoke light and dark. Cézanne used this same approach for his drawings of sculptures in the Louvre, delineating their forms with bundled but open strokes. The statuette's feet and base, left incomplete (as in the three other watercolors of this subject), blend into the white paper; paradoxically, this visual device serves to ground the figure quite firmly. Unlike the drawings realized in the late 1870s and early 1880s representing the Cupid from the rear, this sheet accords considerable prominence to the stabilizing support that rises between the figure's two legs.[32]

The milky-blue atmosphere that pervades this composition is redolent of old porcelain. Maurice Denis rightly compared the faded Prussian blues of Cézanne's watercolors with "old faience."[33] The association is perfectly in keeping with the eighteenth-century charm of this appealing statuette.

I. C.

Fig. 2. Michelangelo,
Study of a Nude,
pen and ink and black chalk,
Casa Buonarroti, Florence.

163

164

165

1. "Enfant de plâtre sans bras sur une table au milieu de deux natures mortes de pommes sur un tapis bleu 65 × 80 [cm]" (Plaster child without arms on a table in between two still lifes of apples on a blue cloth 65 × 80 [cm]). Vollard record-book, no. 3678 [A], Vollard Archives, Musée du Louvre, Bibliothèque Centrale et Archives des Musées Nationaux, Paris.

2. "Enfant en plâtre sans bras sur une table entre deux natures mortes; à gauche une draperie bleue; à droite un haut fragment de sculpture 71 × 58 [cm]" (Plaster child without arms on a table between two still lifes; to the left some blue drapery; to the right a tall fragment of sculpture 71 × 58 [cm]). Vollard record-book, no. 3686 [A], Vollard Archives, Musée du Louvre, Bibliothèque Centrale et Archives des Musées Nationaux, Paris.

3. Vollard record-book, no. 20135, Vollard Archives, Musée du Louvre, Bibliothèque Centrale et Archives des Musées Nationaux, Paris.

4. Bernheim-Jeune Archives, Paris, stock no. 15.871.

5. Ibid.

6. See Vollard, 1914, p. 75.

7. Rewald refrained from opting for either of the two possibilities; see New York and Houston, 1977-78, no. 23, pp. 392-93.

8. Information kindly provided by Florence Rionnet, the author of *L'Historique de l'atelier de moulage du musée du Louvre, 1794-1928* (Paris, 1994).

9. Theodore Reff has cited Duquesnoy; see New York and Houston, 1977-78, p. 30. Herding (1970, no. 125, p. 214) noted that an inscription on the plinth of the cast reads: "FA . . . N. COU," but François Souchal does not attribute the work to Nicolas Coustou; see *French Sculptors of the 17th and 18th Centuries: The Reign of Louis XIV,* trans. Elsie and George Hill (Oxford, 1977), vol. 1, pp. 152-76. Robert Ratcliffe, citing Émile Lombard, attributed it to Christophe Veyrier (1637-1689); see Newcastle upon Tyne and London, 1973, no. 59, p. 163.

10. Mme Geneviève Bresc, curator in the sculpture department of the Louvre, provided information regarding the statuette, as well as on the *écorché* reproduced in cat. no. 111.

11. See cat. nos. 164 and 165, V. 711, R. 556 and R. 557, C. 980 *bis* to C. 990.

12. A photograph (no. 532) in the Vollard Archives, Musée d'Orsay, Paris, bears the annotation "around 1895"; cited in Rewald, forthcoming, no. 782.

13. For other works with the blue fabric, see cat. no. 159, note 3.

14. See Brion-Guerry, 1966, p. 125.

15. Gasquet, 1921, pp. 120-21.

16. Rilke to his wife, October 7, 1907, in Rilke, 1952, p. 19.

17. Rilke to his wife, October 8, 1907, in ibid., p. 20.

18. Bernard, 1925, p. 51.

19. Gasquet, 1921, p. 123. Cézanne is using "poetry" generically, to designate the literary as opposed to the specifically pictorial.

20. The height of the actual cast is 18 inches (46 cm); the height of the painted version is 24 inches (61 cm).

21. See note 11.

22. Schapiro (1968, p. 39) has discerned in the juxtaposition of apples and onions a suggestion of "the polarity of the sexes."

23. See also V. 595, V. 622, and V. 623.

24. See Brion-Guerry, 1966, pp. 125-26. Cézanne was already devising such double trajectories for the viewer's gaze in the late 1880s (cat. no. 114, V. 489, and V. 492).

25. Schapiro (1952, p. 98) has discussed the various levels of reality operative in this composition with great subtlety, analyzing the studied juxtaposition of the natural fruit, the plaster cast (as depicted here, a copy of a copy of a sculpture), and the *écorché* figure in the upper right, which, represented as a two-dimensional rendering of another cast, "is a fourth step away from nature and is already remote and curtailed."

26. See Edinburgh and London, 1954, nos. 49, 50. A smaller painting of the *écorché* survives (V. 709). Cézanne executed many drawings after this cast, which was often found in nineteenth-century artists' studios: cat. no. 111, C. 185, C. 232, C. 418, C. 559, C. 565-74, C. 1086-89. Its silhouette also appears in V. 68. "Until his last day, he drew or painted Michelangelo's *écorché* for an hour every morning, [depicting it] from every angle, like a priest reading his breviary" (Gasquet, 1921, p. 21). This *écorché*, about 10 inches high (25 cm), appears in other paintings listed by Theodore Reff (June 1979, pp. 99, 104 n. 58): *The Draughts Players* by Courbet (1844, private collection, Caracas), *The Plaster Statuette, Young Man Kneeling* by Van Gogh (1887, Rijksmuseum Vincent van Gogh, Amsterdam), and *Still Life with Aubergines* by Matisse (1911, private collection, New York).

27. Schapiro (1952, p. 98) has observed that the Cupid and the *écorché* figure "represent the erotic and the suffering in a transposed form."

28. See Reff, June 1979, pp. 98-100.

29. The two Greek painters competed with one another to determine who was the most skillful at imitating reality. Zeuxis painted grapes sufficiently naturalistic to fool even birds, which tried to pick them. Parrhasius then painted a curtain "over" his own composition that fooled Zeuxis, who tried to open it. Pliny, *Natural History,* XXXV, 65. See Pierre Georgel, *La Peinture dans la peinture* (Dijon, 1982), p. 57.

30. Rilke to his wife, October 9, 1907, in Rilke, 1952, p. 21.

31. There are no less than four watercolors and eleven drawings of this subject (cat. nos. 164 and 165, R. 556 and R. 557, C. 980 *bis* to C. 990, including cat. no. 163).

32. See also R. 556 and R. 557.

33. Denis, November 15, 1905; reprinted in Denis, 1912, p. 197.

1896-98
Oil on canvas; 26 × 32⁵/₁₆ inches (66 × 82 cm)
Musée d'Orsay, Paris. Bequest of Auguste Pellerin (R.F. 2817)
V. 730

PROVENANCE
After the artist's death this canvas was in the possession of his son. It was sold by the dealer Jos Hessel to Auguste Pellerin, who bequeathed it to the Louvre in 1929 along with other works from his collection.

EXHIBITIONS
After 1906: Paris, 1907 (b), no. 28 (*Oignons*); Paris, 1936, no. 98; Basel, 1936, no. 47; London, 1939 (b), no. 37; Lyon, 1939, no. 35; Paris, 1954, no. 61; Paris, 1974, no. 41; New York and Houston, 1977-78, no. 25; Paris, 1978, no. 21.

The onions, this picture's principal motif, give it a rustic character that is accentuated by the simple decor and the presence of a bottle of ordinary table wine, also appearing in a still life from the 1870s, *Still Life with Pot and Bottle* (V. 71), as well as in two compositions from the 1890s, *The Smoker* (V. 686) and *Cardplayers* (cat. no. 134). Unlike the Flemish and Italian still-life masters of the seventeenth and eighteenth centuries, Cézanne did not introduce luxurious objects into his compositions, eschewing the silverware and crystal that had occasioned countless illusionistic passages in earlier paintings. Here he played on the basic opposition between transparent and opaque materials. The drinking glass is rendered with patches of blue that blend into the tints of the rear wall. Through this thin screen, an onion and the refracted image of its stem are visible. The immateriality of the glass is accentuated by the interruption of the line tracing the oval of its mouth. Another glass can be distinguished within the body of the bottle, but this may only be a reflection of the first, for the line defining its edge seems to belong to the bottle. The transparency and verticality of these objects contrast sharply with the full volumes of the pink and russet onions, with their disorderly long stems rendered by lively strokes of the brush.

The composition of this still life evokes Chardin's modest table arrangements, especially those in his smaller works. The overall sobriety of the motifs is countered, however, by the decorative, feather-like flourishes of the green stems. All these elements are arrayed on a wooden table with a scalloped apron, usually designated a kitchen table (see fig. 1).[1] Shifted to the side such that its left end is cropped and only its right front leg is visible, this rudimentary support sets off the principal motifs, as does the large blank wall to the rear. Liliane Brion-Guerry has associated this play of solids and voids, also discernible in the landscapes of the final years, with the aesthetic of Chinese painting.[2] To mitigate the pronounced horizontality of the design, the painter resorted to traditional devices: a knife placed diagonally at the table's edge, indicating spatial recession, and a rumpled white tablecloth falling in ample folds.[3] He also took some liberties with the table: its right edge has been reoriented in a way that makes the tablecloth seem to float unsupported. A pervasive simplicity gives this painting an unusually intimate and personal quality, even a certain melancholy, keyed to its predominantly cool color scheme: "To the sharp, almost painful rhythm of lines corresponds a color scheme of pale blues and pinks, seemingly numb with cold, a harmony of sadness and disenchantment."[4] This impression is tempered by the subtle chromaticism, not without warmth, of the fruit and onions resting on the table. The lustrous quality of their skins is rendered with a range of colors that extends from white to deep russet. A few pieces of yellow fruit, difficult to identify, add an acidic note to this harmony of browns and pinks. The artist's delight in model-

Fig. 1. Table and objects owned by Cézanne
and depicted by him in his still lifes,
Les Lauves studio, Aix-en-Provence.

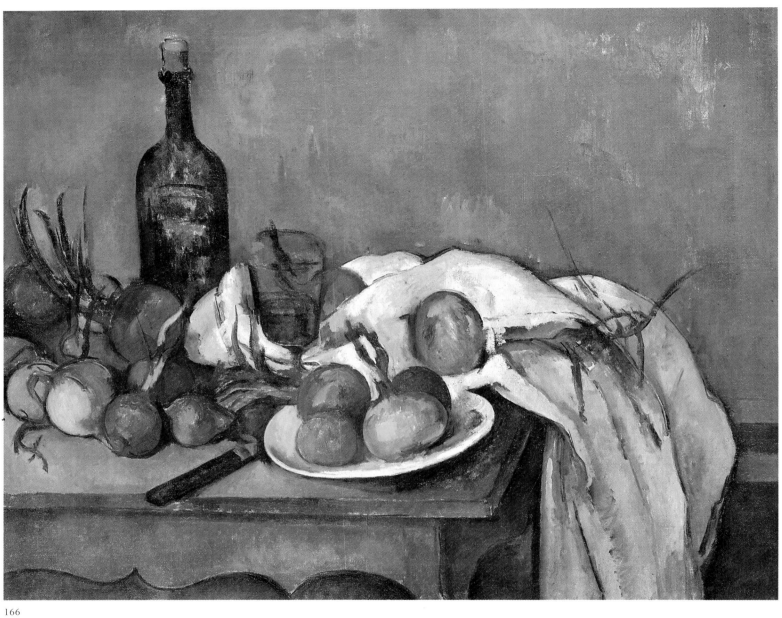

166

ing the ample natural forms with color is immediately apparent. Light outlines tracing the contours stress their globular profiles, and the exuberant plumes bursting from the onions are described with summary but authoritative brushstrokes. The curves and countercurves of these motifs provide an animated counterpoint to the static glassware and table, and to the somewhat frosty aspect of the back wall. The pigment is applied thinly, except on the bottle, which initially may have been taller and placed farther to the right, closer to the glass. The objects and the background are built up, touch by touch, by a multitude of color nuances that enliven the surface of the canvas, the light priming of which is visible in places. The painter here displays complete technical mastery. "Contrasts and tonal relations, these are the secrets of drawing and modeling."[5]

Cézanne's still lifes sparked immediate interest, rapidly attracting the attention of his more discerning contemporaries. On the occasion of the 1907 Salon d'Automne, where this composition was exhibited for the first time, the critic André Pératé spoke for many of the artist's admirers: "The conscientiousness of his craftsmanship is everywhere apparent in the still lifes, where it seems the sense of sight has been transformed for us into that of touch. This fruit on

a plate, these beautiful apples in sparkling reds, greens, and yellows, these acid grapes, these red onions, a plate, a faience compotier, a glazed stoneware pot, a black marble clock, here are things that exist and that endure."[6]

Vollard, a shrewd dealer, also appreciated them, but this picture never left the artist's studio during his lifetime.

I. C.

1. A kitchen table, still in the Les Lauves studio in Aix, or a similar one, figures in *Young Man with Skull*, 1894-96 (V. 679); *Still Life with Apples and Peaches*, c. 1905 (National Gallery of Art, Washington, D.C.; not in Venturi); a watercolor *Bed and Table*, dated 1885-87 (Philadelphia Museum of Art; R. 186); *Seated Man*, 1900-1902 (R. 542); *Apples, Carafe, and Sugar Bowl*, 1900-1906 (R. 552); and *Bottles, Pots, Spirit Stove, Apples*, 1900-1906 (R. 563).
2. While acknowledging that there is no direct connection between Cézanne's work and the art of East Asia, Brion-Guerry (in Musée Granet, 1982, pp. 143-55) makes a convincing case for an affinity between these two aesthetics, especially with regard to their respective approaches to space.
3. A knife and a rumpled tablecloth appear in several compositions by Chardin, notably *The Ray* (Musée du Louvre, Paris), which Cézanne copied (C. 958).
4. Sterling, 1959, p. 102.
5. Bernard, 1925, p. 32.
6. Pératé, November 1907, p. 388.

167 | *Madame Cézanne in a Yellow Chair*

1893-95
Oil on canvas; 45⁷/₈ × 35¹/₄ inches (116.5 × 89.5)
The Metropolitan Museum of Art, New York.
The Mr. and Mrs. Henry Ittleson, Jr., Purchase Fund, 1962
V. 570

PROVENANCE
Ambroise Vollard and the Galerie Bernheim-Jeune sold this painting to Auguste Pellerin by 1907. It remained in the family, passing to Jean Victor Pellerin, in whose collection it remained until 1962, when it was acquired for the Metropolitan Museum of Art by the Mr. and Mrs. Henry Ittleson, Jr., Purchase Fund.

EXHIBITIONS
After 1906: Paris, 1907 (b), no. 18; Paris, 1936, no. 76; Aix-en-Provence, 1956, no. 44; Tübingen, 1993, no. 41.

Cézanne painted four portraits of his wife wearing a distinctive carmine red dress with a shawl collar that falls in heavy folds down the bodice (cat. no. 167, V. 572, V. 573, and fig. 1). In three of these she sits in a high-backed chair of seventeenth-century design, covered with a richly patterned yellow fabric. The portrait now in the Metropolitan Museum of Art is the most spatially complex. It is, in fact, the largest and most ambitious portrait he ever did of his wife, Hortense Fiquet.

Hortense is shown head-on, her erect body leaning to the right, further exaggerating the slight tilt of the chair. The pitch of the entire room is even more radical, as indicated by the angle of the dark red band above the wainscoting. The only elements that conform to the conventional horizontal plane of the canvas are the mirror in the upper left corner and the mantelpiece supporting it. This penchant for precarious slants is a device Cézanne used to great effect in landscapes, still lifes, and figure paintings of the 1890s. This is often discussed in terms of a formal dialectic in which the artist creates unbalanced patterns (according to the terms of conventional illusionistic painting), which are then ingeniously rebalanced through the arrangement of other compositional elements (in this case, the drape of heavy material that frames the image on the right). This occurs in three dimensions as well as two, and is central to Cézanne's construction of pictorial space in a way the Cubists would develop into abstraction.

However, such analyses of Cézanne's complex spatial manipulations often leave the impression of the painter as a magician at work, and seldom address the expressive life of these pictures, which, much like the observed patterns of imbalance/balance, work through an equally engaging sequence of dislocation/relocation. Except in this more subjective realm, matters never quite right themselves. The poetic dynamics played out through an animation of wives-in-tilting-chairs are brought around, finally, to the chair that does not topple (or the apple that does not roll off the table). Although Cézanne's mighty abilities rein in the forces he has released, we are never completely rid of the disquieting quality pictures such as this convey.

By the 1890s Cézanne possessed enormous powers to describe the nature of forms in space; this he wrought through color with a complexity few before him had managed. But as he indicated in his own statements, he was, in fact, feeling his way very slowly to a final goal, and the characterizations in his portraits (particularly of people he knew well) are so disarmingly vital precisely because of their lack of resolution. As calmly as Madame Cézanne's gaze holds our (and the artist's) eyes—just as calmly as she holds the rose above her lap—we feel we know very little about her, and perceive an effect more of distance than intimacy. This quality pervades all four pictures in this series; perhaps it is most wrenching in the seemingly simpler painting in a private collection (fig. 1).

In three of these portraits, a red band marks the boundary between the wainscoting and the wallpaper. Both the band and the mirror extending beyond the mantelpiece also appear in other pictures known to have been painted in the apartment at 15, quai d'Anjou in Paris, which Cézanne rented for his family from 1888 to 1890. Accordingly, several have convincingly dated the entire series to that period.[1] Even so, others, including Venturi and Rewald, have placed these works some four or five years later, pointing to the similarity between the Metropolitan portrait and the *Woman with a Coffeepot* (cat. no. 168). Their view finds support in the handling of the crimson dress, in which the priming was left selectively exposed, producing an effect of luminous amplitude reminiscent of the figures in the first two *Cardplayers* of the early 1890s. Puzzling irresolutions seem to haunt these pictures.

J. R.

1. Adriani, 1993 (b), no. 41, pp. 144.

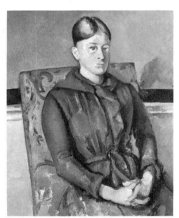

Fig. 1. Paul Cézanne,
Madame Cézanne in a Yellow Chair, 1893-95,
oil on canvas,
private collection (V. 571).

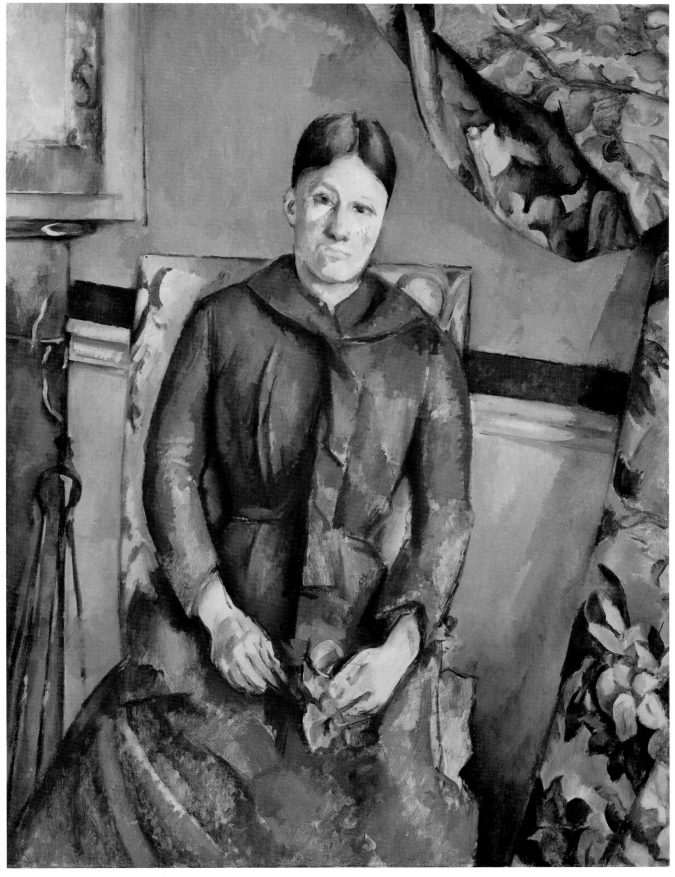

167

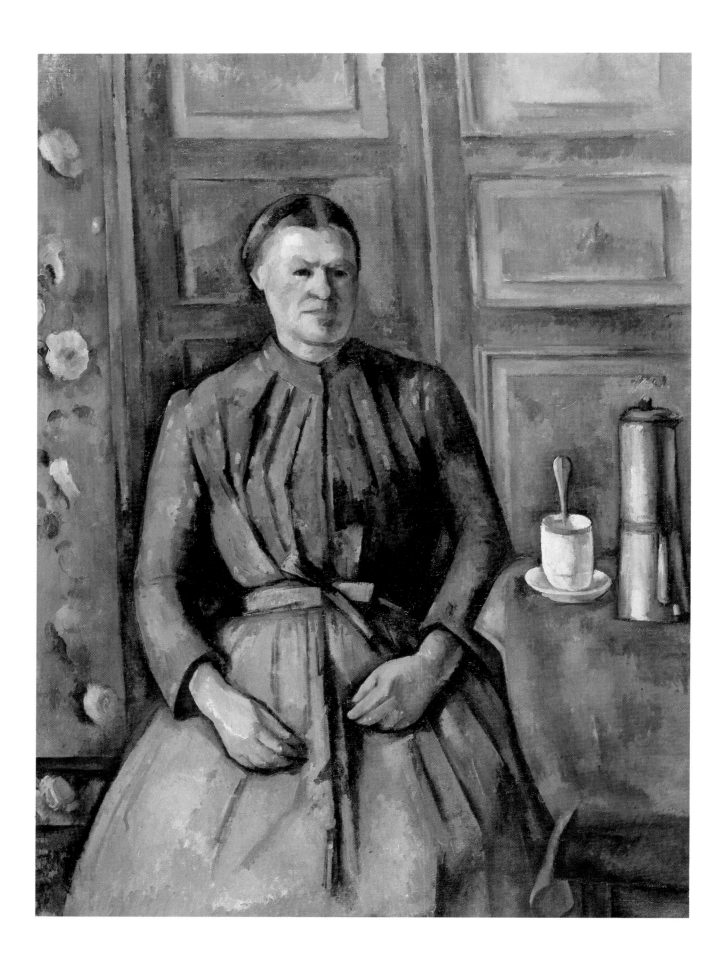

168 | *Woman with a Coffeepot*

c. 1895
Oil on canvas; 51³/₈ × 38 inches (130.5 × 96.5 cm)
Musée d'Orsay, Paris. Gift of Jean-Victor Pellerin (R.F. 1956-13)
V. 574

PROVENANCE
Acquired jointly by Ambroise Vollard and Bernheim-Jeune on April 16, 1904, this canvas was sold three months later to Auguste Pellerin. M. and Mme Jean-Victor Pellerin donated it to the Musées Nationaux in 1956, on the occasion of the fiftieth anniversary of Cézanne's death.

EXHIBITIONS
After 1906: Paris, 1936, no. 86; Aix-en-Provence, 1956, no. 44; Paris, 1974, no. 42.

Few paintings by Cézanne better illustrate his celebrated dictum that one should "treat nature by means of the cylinder, the sphere, the cone,"[1] for both the figure and the surrounding objects in this canvas are a magisterial demonstration of it. The woman is structured pyramidally and stands out against a geometric configuration of paneling, while beside her are the cylindrical forms of the coffee percolator and the cup, from which the handle of a spoon "exerts an erect upward thrust that belongs to the human will of Cézanne and of his model to remain rigidly upright in a world where all forms are tyrannized by the powerful pull of an imposed vertical order."[2]

The volumetric power of the woman and the objects on the table is countered by the soft, irregularly spaced flowers of the wallpaper and the red tablecloth. Cézanne scholars, long concerned almost exclusively with formal issues, have given short shrift to the sitter imbued with such monumentality in this picture, a domestic—probably a cook or a washerwoman—having coffee before or after her day's work. There is, of course, no sentimentality in this portrait, nor anything that might be dubbed "literary," but it is wrong to maintain that Cézanne treated his model purely as an object. Numerous details point to Cézanne's genuine interest in her as an individual: her hands, coarsened by hard work, her clothing and coiffure, quite fastidious, and her face, rough but dignified and full of humanity. The artist clearly set out to confer grandeur, without pathos, on the sitter by transforming her into a monumental icon of the simple life.

According to Venturi, she "gives the impression of a grandiose force of nature. She is firmly rooted like a powerful tower. . . . There's a unity and a strength of style here exceptional in the entire history of art."[3] Most scholars, for example, Bernard Dorival and Germain Bazin, have also sensed the classicism of this frontal image, evoking Piero della Francesca, or, in the case of Rosenblum, a "blue-robed Madonna."[4] Theodore Reff has compared the canvas with Italian Renaissance portrait busts, especially those by Benedetto da Maiano, in particular the ones depicting Pietro Mellini and Filippo Strozzi, which Cézanne drew in the Louvre (cat. nos. 82 and 83).[5]

The date, the identity of the model, and the place of execution are all uncertain, but the work's style suggests it was painted in the early 1890s. The composition, pose, and facture bring to mind *Madame Cézanne in a Yellow Chair* (cat. no. 167), and it is almost as if this composition were meant to picture a lower social stratum along similar lines—the curtain is replaced by the paneled doors of a kitchen armoire, and the rose held by Madame Cézanne gives way to a modest coffeepot—but in terms of their handling and the compelling presence of their subjects the two works are remarkably similar. For a time, *Woman with a Coffeepot* was itself considered a portrait of Hortense Fiquet, but this is clearly not his wife. The artist's son told Rewald that the model was the mother of the sitter pictured in *Young Man with Skull* (V. 679),[6] which is known to have been painted in Aix, at the Jas de Bouffan.

The Musée d'Orsay has recently received an interesting letter from an elderly person now living in Senlis, stating that family tradition maintains that the sitter was a great aunt, Mme Louis Girault. It asserts the latter was "displeased" with her employers for insisting that she sit for Cézanne, who was "visiting them" at the time, but the letter specifies neither who the employers were nor where they resided.[7] A photograph dated 1914 bears a certain resemblance to the woman in blue, but, oddly, the subject seems to be the same age there as in the painting. Was the canvas painted in the Île-de-France or in Normandy, where the artist visited Victor Chocquet in 1889? During a sojourn in Paris, or at Marlotte in 1892? In Melun or Giverny in 1894? These theories are all plausible, but it seems most likely that the sitter was an employee at the Jas de Bouffan. Whoever the model was, Cézanne depicted her more than once. He made a preparatory oil study of her face;[8] a watercolor (cat. no. 169) of a woman in a blue dress also appears to represent her.

F. C.

1. Cézanne to Bernard, April 15, 1904, in Cézanne, 1978, p. 300.
2. Rosenblum, 1989, p. 363; and Fry, 1927, p. 66.
3. Venturi, 1936, vol. 1, p. 60.
4. Dorival, 1948 (b), p. 58; Bazin, 1958, p. 228; and Rosenblum, 1989, p. 363.
5. Reff, in New York and Houston, 1977-78, p. 17.
6. Rewald to Germain Bazin, January 4, 1958, archives, Musées Nationaux, Paris.
7. Archives, Musée d'Orsay, Paris.
8. Formerly collections of Sir Kenneth Clark and of Edgar William and Bernice Chrysler Garbisch; sold at Sotheby Parke Bernet, New York, May 12, 1980 (lot 25). Not in Venturi.

169 | *Seated Woman*

c. 1895
Graphite and watercolor on paper; 18⁷/₈ × 14³/₁₆ inches (48 × 36 cm)
Collection of Jan and Marie-Anne Krugier-Poniatowski
R. 543

PROVENANCE
This sheet passed quickly from Ambroise Vollard to Adams Brothers, London dealers, to a private collector, to Paul Rosenberg, New York. It long figured in the celebrated Von Hirsch collection in Basel. It was sold at Sotheby's, London, on June 27, 1978 (lot 838), when it was acquired by its present owners.

EXHIBITIONS
After 1906: London, Leicester, and Sheffield, 1946, no. 25; Tübingen and Zurich, 1982, no. 101.

EXHIBITED IN PARIS ONLY

John Rewald dated this watercolor 1902-4,[1] which would preclude its being contemporary with *Woman with a Coffeepot* (cat. no. 168). Several factors could be cited to support this view: the touch, the character of the draftsmanship, its elliptical quality (notably in the hands and face), and also the little table, like the one now in the Chemin des Lauves studio, where he began to work in 1902—indeed, this sheet could show the model posing at Les Lauves.

But the style of this beautiful watercolor—selectively emphatic, rhythmically arresting—suggests an earlier date. The table, like all the furnishings that ended up in the Chemin des Lauves studio, almost certainly came from the Jas de Bouffan. Furthermore, Venturi dated it 1895-1900,[2] which brings it closer to the date usually assigned *Woman with a Coffeepot*. Resemblances between the two images—in each of them the woman wears a similarly pleated blue dress, has an assertive chin, and wears her hair in a tight chignon—suggest they may picture the same model.

An apparently unfinished painting (V. 1611) still in Vollard's possession in the 1930s repeats the composition of this watercolor.

F. C.

1. See Rewald, 1983, no. 543, p. 221.
2. See Venturi, 1936, vol. 1, no. 1093, p. 276.

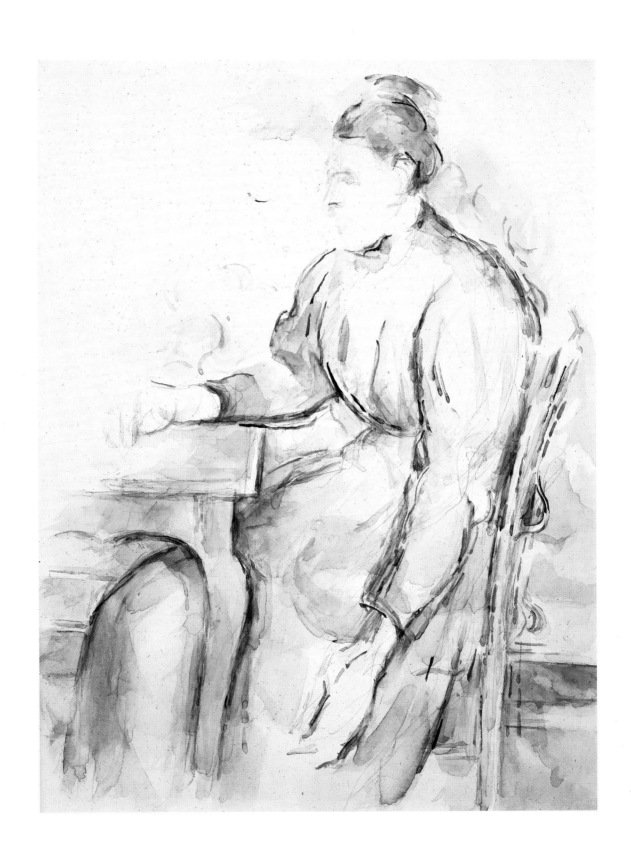

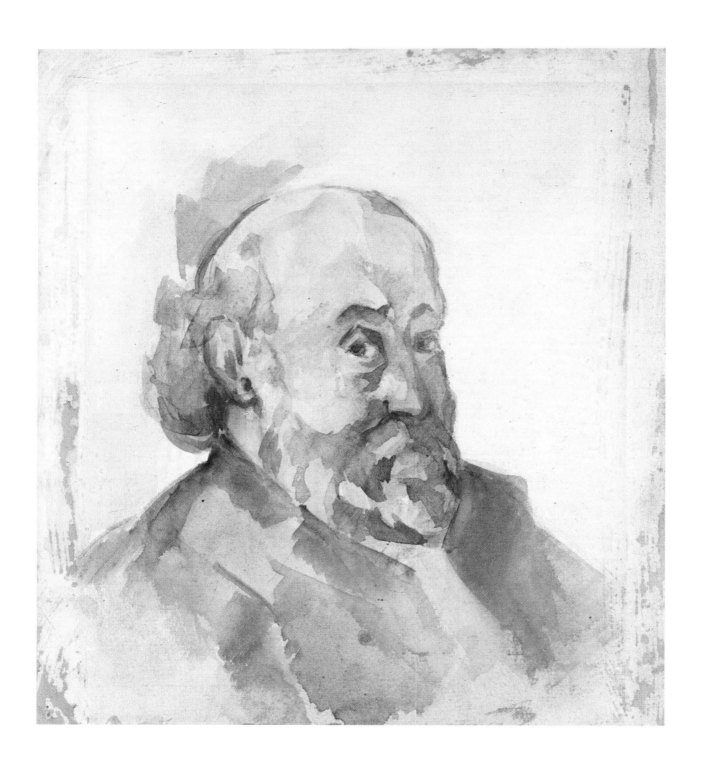

c. 1895
Graphite and watercolor on paper; 11¹/₈ × 10¹/₈ inches (28.2 × 25.7 cm)
Private collection
R. 486

PROVENANCE
This watercolor was sold by the Galerie Bernheim-Jeune to the collector Hans Mettler (1876-1945). In 1943 it was acquired by Walter Feilchenfeldt, Zurich. It is now in a private collection.

EXHIBITIONS
After 1906: Paris, 1926, no. 31; Chicago and New York, 1952, no. 69; Munich, 1956, no. 91; The Hague, 1956, no. 74; Zurich, 1956, no. 121; Cologne, 1956-57, no. 43; New York, 1963 (a), no. 28; Hamburg, 1963, no. 21; Tübingen and Zurich, 1982, no. 100; Tokyo, Kobe, and Nagoya, 1986, no. 54.

This moving watercolor is the only self-portrait by the artist in this medium, a fact that has led some to question its attribution.[1] It is now considered to be an authentic study for Cézanne's penultimate self-portrait in oil (fig. 1),[2] formerly in the Pellerin collection, which features a similar scrutinizing right eye beneath a curious S-shaped eyebrow. The profile of the head, hair, and beard is exactly the same. In the canvas Cézanne retained the positioning of the head but shifted the torso away from the viewer, thereby giving greater prominence to the beard and facial features. He seems to have reworked the oil, for the dark left shoulder and lapel can still be discerned beneath a thin layer of blue pigment, which shows that the painting was originally much closer to the watercolor. But he made no attempt to imitate the broad patches of blue wash in the earlier work.

These two self-portraits in different mediums were executed around the time Cézanne was introduced to a young American painter, Matilda Lewis, who was staying at the same hotel in Giverny, where he had come to spend some time with Monet (see Chronology, September 7-30, 1894). The young woman wrote to her family: "Monsieur Cézanne is from Provence, and is like the man from the Midi whom Daudet describes. When I first saw him I thought he looked like a cutthroat with large red eyeballs standing out from his head in a most ferocious manner, a rather fierce looking pointed beard, quite gray, and an excited way of talking that positively made the dishes rattle. I found later on that I had misjudged his appearance, for far from being fierce or a cutthroat, he has the gentlest nature possible, 'comme un enfant' as he would say."[3]

F. C.

Fig. 1. Paul Cézanne,
Self-Portrait, c. 1895,
oil on canvas,
private collection (V. 578).

1. According to Rewald (1983, no. 486, p. 205), both Chappuis and Léo Marschutz had doubts about this sheet, but Novotny, also skeptical initially, later became convinced of its authenticity. Rewald himself accepted it wholeheartedly.
2. The last self-portrait—more serene but less intimate—is now in the Museum of Fine Arts, Boston (V. 693).
3. [November 1894], typescript in object file 1955.29.1, Yale University Art Gallery, New Haven, Connecticut. Previously this letter was attributed to Mary Cassatt (Breeskin, 1948, p. 33; Rewald, 1948, p. 166). It is, in fact, by Matilda Lewis (see Gerdts, 1993, p. 118, p. 235 n. 6).

1895-96
Oil on canvas; 31³/₄ × 25³/₄ inches (80.6 × 65.5 cm)
The Trustees of the National Gallery, London
V. 702

PROVENANCE
Cézanne gave this work directly to Joachim Gasquet, who may have sold it to the fashionable playwright Henry Bernstein. It was with the Galeries Émile Druet, Paris, by February 1910. From 1917 it was in the possession of the couturier and collector Jacques Doucet; it remained the property of his widow at Neuilly until 1953, when César de Haucke purchased it on behalf of the National Gallery in London with the assistance of a grant-in-aid and the Florence, Temple-West, Clarke, Hornby-Lewis, and Champney Funds.

EXHIBITIONS
After 1906: Paris, 1907 (b), no. 47; London, 1910-11, no. 13; New York (no. 214), Chicago (no. 38), and Boston (no. 14), 1913; Paris, 1920 (b), no. 1; Paris, 1936, no. 105; Cincinnati, 1947, no. 11; Aix-en-Provence, Nice, and Grenoble, 1953, no. 23 (not exhibited in Grenoble); Edinburgh and London, 1954, no. 57; Liège and Aix-en-Provence, 1982, no. 22.

Joachim Gasquet (see cat. no. 173), to whom Cézanne supposedly gave this portrait, reported having seen him paint it the year he met the artist. He first wrote about it in an article published in July 1896, where he referred to it as a "pure masterpiece."[1] There is nothing surprising in the young poet's having been particularly drawn to this canvas, for he was a zealous Christian.

Cézanne, it would seem, worked long and hard on it, hence its lack of fluency—in comparison with many contemporary works by the artist—and the many obvious repaintings, which produced an especially crusty surface around the face: "Was Cézanne satisfied with it? He worked furiously on *Old Woman with a Rosary* at the Jas de Bouffan for eighteen months. The canvas completed, he tossed it into a corner. It accumulated dust and ended up on the floor, unrecognizable, carelessly trod upon. One day I spotted it; I found it leaning against the stove, under the coal scuttle, where moisture from a zinc pipe was dripping on it every five minutes or so. I don't know what miracle had preserved it intact. I cleaned it. She appeared before me. . . . There she was, the poor woman, all in a heap, stubborn, resigned, unbudging, her large peasant's hands, crumbly like old bricks, joined together and clinging to the rosary, her coarse blue cotton-cloth apron, her coarse black pious servant's shawl, her cap, her wrecked mystic's mug. However, a hopeful ray of light, a shadow of pity provided a note of solace on her vacant lowered forehead. Shriveled and spiteful as she was, a goodness enveloped her. Her wizened soul still trembled, having taken refuge in her hands.

"Cézanne told me her story. A nun who had lost her faith, at age seventy she jumped in an agonizing leap over the wall of her convent, with the aid of a ladder. [She was] decrepit, hallucinating, prowling about like an animal—he had taken her in and more or less made her his maid, in memory of Diderot[2] and out of natural goodness, then he

had her pose, and now the defrocked old woman stole from him shamelessly, reselling his own napkins and sheets to him as rags to dry his brushes after ripping them to shreds, mumbling litanies as she did so; but he closed his eyes and kept her on out of charity."[3]

Thus does Gasquet have Cézanne speaking about his own picture. It is widely known that the poet's "recollections" must be taken with a grain of salt, since, in the apt words of P. M. Doran, the dialogues in his book "combine the authentic and the speculative."[4] Despite some false stylistic notes, however, many of the remarks reported by Gasquet ring true. Cézanne is known to have venerated Baudelaire as much as Flaubert, and both can be sensed behind another passage about the painting that seems to echo the poet's *Correspondances:* "You know, Flaubert said that while writing *Salammbô* he saw purple. Well, myself, when I painted my *Old Woman with a Rosary*, I saw a Flaubert color, an atmosphere, something undefinable, a bluish and reddish-brown tone that's given off by *Madame Bovary,* or so it seems to me. I tried reading Apuleius to banish this obsession, which for a moment I thought dangerous, too literary. Nothing worked. This grand blue russet fell upon me, sang to me in my soul. I bathed in it completely. . . . I scrutinized all the details of the clothing, the cap, the folds in the apron; I deciphered the shifty face. It was only much later that I realized the face was reddish brown, the apron bluish, just as it was only after the picture was finished that I remembered the description of the old servant at the agricultural fair."[5] Here is the passage from *Madame Bovary:* "A frightened-looking little old woman who seemed to have shriveled inside her shabby clothes. On her feet were heavy wooden clogs, and she wore a long blue apron. Her thin face, framed in a simple coif, was more wrinkled than a withered russet, and out of the sleeves of her red blouse hung her large, gnarled hands. . . . A kind of monklike rigidity gave a certain dignity to her face, but her pale stare was softened by no hint of sadness or human kindness. Living among animals, she had taken on their muteness and placidity."[6]

While *Old Woman with a Rosary* is not, as Gasquet would have it, a portrait in the tragic mode of Rembrandt or Dostoyevsky, it would be absurd to deny it its human resonance.

It is more evocative of Courbet than of Rembrandt. The emphatically modeled face conveys both the concentration of prayer and a kind of bemused cunning, and one senses a complicity between the painter and his sitter. Solitude, old age, piety, and a tendency to eccentric behavior were traits they shared, but the painter's evocation of them in

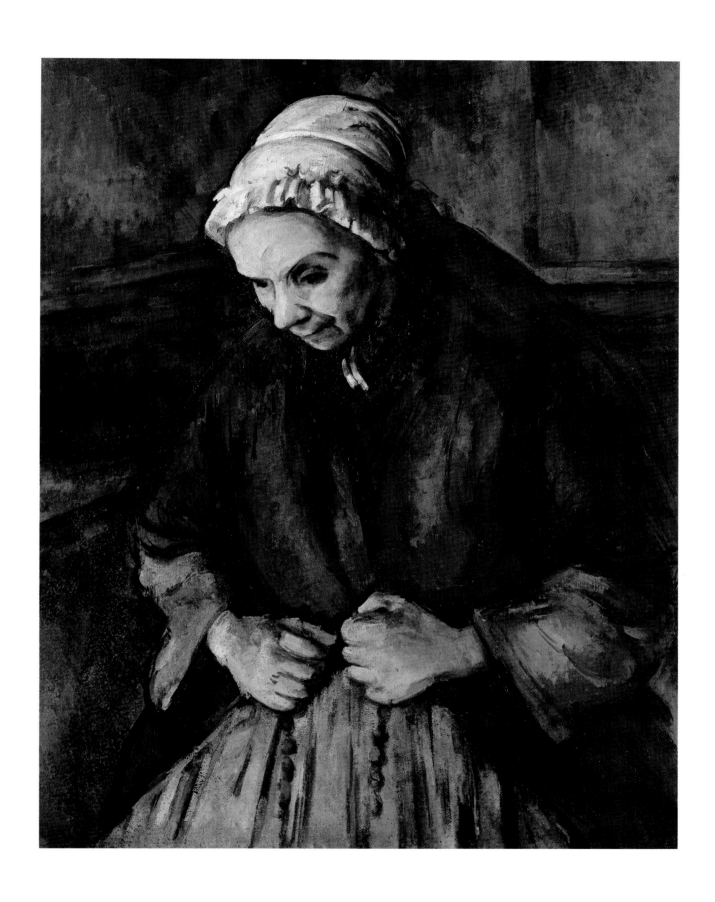

the painting is completely without sentimentality, like Flaubert's description in *Madame Bovary.*

The work's combination of an advanced style with edifying, readily identifiable subject matter made it one of Cézanne's most famous works in the early years of the twentieth century. It was included in both the *Manet and the Post-Impressionists* exhibition organized by Roger Fry in London in 1910[7] and, three years later, the famous Armory Show in New York. It was assigned the highest price of any of the Cézannes exhibited; the collector Henry Clay Frick almost purchased it, and it is reported that President Theodore Roosevelt contemplated it at length.[8]

The proximity of this canvas rendered the artist's other works in the show, deemed incomprehensible or unfinished by many, more palatable, and it partly exonerated him for the ravaging and revolutionary effects his paintings had on artists of the avant-garde—on Marcel Duchamp, for example, whose *Nude Descending a Staircase* was also exhibited in New York in 1913, not far from *Old Woman with a Rosary.*

F. C.

1. Gasquet, July 1896; cited in Rewald, 1959, p. 29.
2. A reference to Diderot's novel *La Religieuse* (The Nun), which, among other things, is an exposé of psychological and physical abuse in eighteenth-century French convents.
3. Gasquet, 1921, p. 67.
4. Doran, 1978, p. 106.
5. Gasquet, 1921.
6. Gustave Flaubert, *Madame Bovary*, translated by Francis Steegmuller (New York, 1957), pp. 169-70.
7. Rewald, 1989, p. 136.
8. Ibid., pp. 200-203.

172 | *Portrait of Gustave Geffroy*

1895-96
Oil on canvas; 43⁵/₁₆ × 35 inches (110 × 89 cm)
Musée d'Orsay, Paris. Gift, with retained life interest, 1969 (R.F. 1969-29)
V. 692

PROVENANCE
The critic sold his portrait to the Galerie Bernheim-Jeune shortly after Cézanne's death, on January 28, 1907; the gallery presumably acquired it expressly for Auguste Pellerin, for he was its owner the following day. It remained in the Pellerin family's collection, coming into the possession of the Lecomte family, until it was given by Mme Lecomte to the Musées Nationaux in 1969, with retained life interest.

EXHIBITIONS
After 1906: Paris, 1907 (b), no. 16; Paris, 1912, no. 19; Paris, 1924, unnumbered; Paris, 1936, no. 93; Paris, 1954, no. 60; Paris, 1974, no. 45; New York and Houston, 1977-78, no. 1; Paris, 1978, no. 1.

EXHIBITED IN PARIS ONLY

The critic Gustave Geffroy (1855-1936) had this to say about his portrait, begun by Cézanne in April 1895: "During this period Cézanne worked on a painting that is, despite its incompletion, one of his most beautiful works. The library, the papers on the table, the small plaster of a sculpture by Rodin, the artificial rose that he brought at the beginning of the sessions, everything is of the first rank, and of course there is also a person in this decor, which is painted with meticulous care and an incomparable tonal richness and harmony. He only sketched in the face, saying over and over: 'That will be for the end.' Alas, the end never arrived. One fine morning Cézanne sent for his easel, his brushes, and his paints, writing me that the undertaking was decidedly beyond his strength, that he had been mistaken to undertake it, and apologizing for his withdrawal. I was insistent. . . . He returned and, for eight days or so, he seemed to work, accumulating as only he knew how the thin films of color, always retaining the freshness and sparkle of his painting. But his heart was no longer in it. He left for Aix, once again sent for his painting materials a year later, on April 3, 1896, and never returned, leaving the portrait behind as he did with so many of his paintings."[1]

The story of this relatively brief friendship and of the portrait that was its by-product is well known.[2] Gustave Geffroy, after having written short but laudatory texts about the Cézannes in the Caillebotte bequest (three of which were refused by the State), wrote a long piece about the painter—doubtless at Monet's prompting—that was published in *Le Journal* on March 25, 1894. While a bit circumspect, it was the first article about Cézanne by a well-known critic to appear in a prestigious venue. Cézanne was deeply touched by it: "Yesterday I read the long study that you devoted to illuminating the attempts I've made in painting. I wanted to express my gratitude."[3]

The artist did not actually meet the critic until late November, at a luncheon arranged by Monet. "I hope Cézanne will still be here," Monet wrote to Geffroy, "and that he will attend, but he is so peculiar, so fearful of seeing new faces, that I'm afraid he'll be absent, despite his great desire to meet you."[4] The meeting took place; Monet had also invited Gustave Mirbeau, Georges Clemenceau, and Rodin. The following spring Cézanne offered to paint Geffroy's portrait. He worked on it almost daily from April to June, at the critic's home in the Belleville neighborhood

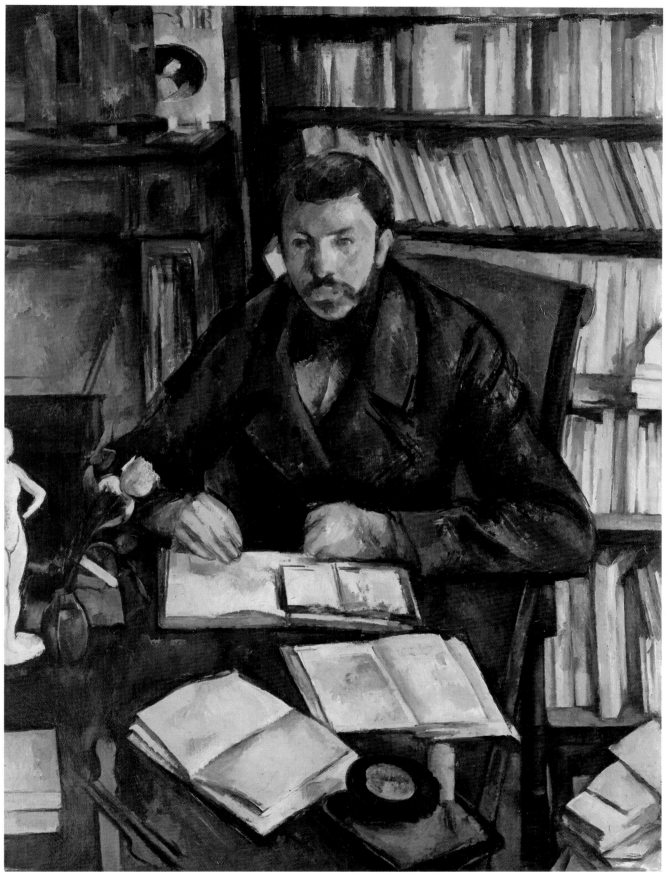

172

Fig. 1. Edgar Degas,
Portrait of Edmond Duranty, 1879,
oil on canvas,
Glasgow Museums,
The Burrell Collection.

of Paris, before giving up on it. "I had to abandon momentarily the study I had begun," he wrote to Monet on July 6, 1895, ". . . and I'm a bit confused by the meager result I've obtained, especially after so many sessions, and successive bursts of enthusiasm and discouragement. So here I am back in the Midi, which perhaps I never should have left, to throw myself into the chimerical pursuit of art."[5]

This famous portrait carries many reminiscences of earlier works; the critic posing for a painter whom he had praised was an established genre, especially since the portrait of Zola by Manet—which Cézanne, of course, knew quite well—and that of Edmond Duranty by Degas (fig. 1), which he could have seen at the fourth Impressionist exhibition in 1879. The comparison with this last work has often been made because of the prominence of books in the two paintings.[6] But in the Degas portrait they serve both as decor and as a psychological counterpoint to the image of a writer to whom the painter felt quite close, and whose intellectual vitality is conveyed through his gaze and posture as well as by the profusion of books and papers. Cézanne, by contrast, conceived his picture in terms that were more intellectual than affective, setting out to adapt a classic genre to suit his own preferences. Geffroy forms a powerful triangle in the center of the painting, a strategy that was unusual in such portraits in this period. The decor—shelved and open books, the inkwell, the rose, the Rodin figurine[7]—identifies the sitter's activities and tastes efficiently enough, but without any indications of complicity with the artist, as in Manet's portrait of Zola, for example. One senses quite clearly that the painter and the critic did not know one another well.

Furthermore, as the posing sessions proceeded, Cézanne's initial sympathy and gratitude gave way to irritation at remarks made by the sitter, whom he found overly eclectic in his tastes and disrespectful of religion.[8] This annoyance soon turned to outright hostility, if we are to believe Joachim Gasquet, who wrote of the "kind of inexplicable hatred that Cézanne felt for M. Gustave Geffroy, despite his articles and the prodigious portrait he'd painted of him, an abhorrence that he expressed often, in both letters and conversation."[9]

Cézanne put off completing the face and hands to the last moment, and in the end he never finished them. As a result the sitter comes across as an opaque and mysterious presence, powerful, even a bit menacing. In all likelihood this was indeed how the skittish Cézanne perceived Geffroy. The incompletion, however, adds a singular grandeur to the image, the product of an odd coupling of psychological indifference and formal intelligence.

This portrait was one of the most admired paintings in the retrospective exhibition at the 1907 Salon d'Automne (by which time Geffroy was no longer its owner). Clearly it held special interest for Cubists, notably Braque and Picasso, who would have been drawn to the geometric yet irregular forms of the books and the audacious downward tilt of the tabletop. According to Félix Vallotton, "the portrait of M. Geffroy . . . is a complete artistic education in itself; observe the expressiveness of the color, the stylishness of the *bibelots* on the table, the blue papers, and the beautiful drawing of the head."[10]

The English critic Roger Fry saw in this portrait a signal demonstration of the success of Cézanne's art: "The equilibrium so consummately achieved results from the counterpoise of a great number of directions. One has only to imagine what would happen if the books on the shelf behind the sitter's head were upright, like the others, to realize upon what delicate adjustments the solidity of the amazing structure depends. . . . The concordance which we find in Cézanne between an intellect rigorous, abstract and exacting to a degree, and a sensibility of extreme delicacy and quickness of response is seen here in masterly action. Such a concordance must be something of a miracle."[11]

F. C.

1. Geffroy, 1922, p. 197.
2. See Rewald, in New York and Houston, 1977-78, no. 1, pp. 385-86.
3. Cézanne to Geffroy, March 26, 1894, in Cézanne, 1978, p. 239.
4. Monet to Geffroy, November 23, 1894, in Geffroy, 1922, p. 196; and in Wildenstein, 1974-85, vol. 3, no. 1256, p. 278.
5. Cézanne, 1978, p. 246.
6. See Hoog, in Paris, 1974, no. 45, pp. 114-17; and Reff, in New York and Houston, 1977-78, pp. 14-15.
7. Reff (in New York and Houston, 1977-78, p. 20) has identified the figurine as a plaster now in the Musée Rodin, Paris, but this seems unlikely.
8. This hypothesis was advanced by Rewald, 1959, pp. 19-21.
9. Gasquet, 1921, p. 43. Geffroy (1922, pp. 199-202) contested this view.
10. Vallotton, Autumn 1907, p. 136.
11. Fry, 1927, pp. 69-70.

173 | *Portrait of Joachim Gasquet*

1896
Oil on canvas; 25³/₄ × 21¹/₂ inches (65.5 × 54.4 cm)
Národní Galerie, Prague
V. 694

PROVENANCE
It seems unlikely that the portrait of Gasquet would have been put up for sale by the Cézanne family before the author's death in 1921. In any case, it was with Ambroise Vollard in 1923; on December 10 of that year he sent it to Prague, where the Národní Galerie purchased it.

EXHIBITIONS
After 1906: Paris, 1920 (b), no. 13; Paris, 1936, no. 104; The Hague, 1956, no. 45; Aix-en-Provence, 1956, no. 53; Zurich, 1956, no. 75; Munich, 1956, no. 58; Vienna, 1961, no. 36; Paris, 1978, no. 2; Tübingen, 1993, no. 68.

EXHIBITED IN PARIS AND LONDON ONLY

Is it the incompletion of this portrait that makes it so moving, the artist's working method being unusually accessible here in all its paradoxical blend of hesitancy and certitude? The face is unfinished, but the features, though reduced to essentials, are all the more arresting for that: the gaze—or rather the single eye, for the left half of the sitter's face is ill defined—fixes us more intently than in most of the likenesses painted by Cézanne, with the exception of the self-portraits.

The model, Joachim Gasquet (1873-1921), appears to be older than his twenty-three years; contemporary descriptions of him speak of "his blond beard and hair, his light complexion (like a second Musset), his charming voice."[1]

Joachim, who in 1921 published a biography of Cézanne, was the son of one of the artist's childhood friends, Henri Gasquet, whose portrait Cézanne also painted about the same time (fig. 1). The father was a baker, the son a poet, "smitten with Symbolist literature and philosophy, an active royalist, a regionalist of the Félibrige stamp, and a devout Catholic."[2] The young man's enthusiasm for Cézanne's painting did the painter much good, for he was then quite isolated and already ill. "You have no idea how invigorating it is, for an abandoned old man like me, to find around him a youngster who's not yet ready to bury him,"[3] Cézanne wrote to Henri Gasquet in 1898.

They met in April 1896. Gasquet recounted the first week of their acquaintance as follows: "I saw him every day. He brought me to the Jas de Bouffan, showed me his canvases. We took long walks together. He came to fetch me in the morning, we didn't return until the evening, exhausted, dusty. . . . Cézanne seemed regenerated. It was as though he were drunk. A similar naïveté joined my youthful ignorance with his full, candid knowledge. All subjects suited us."[4] With a characteristic gesture of retreat—prompted by his legendary fear that people would "get their hooks into him," as he used to say, or perhaps having come to feel that the presence of the talkative and exuberant young man was an encumbrance—Cézanne sent him a note saying he was about to depart for Paris. A few days later Gasquet ran into him in Aix, understood the gambit, and took offense, but Cézanne then wrote him a touching letter in which he excused himself by invoking his need for solitude.[5] Gasquet recounted: "I ran to the Jas. As soon as he saw me he opened his arms to me. 'Let's say no more about it,' he said, 'I'm an old fool. Put yourself over there, I'm going to do your portrait.'"[6]

The work was begun in May of 1896.[7] Gasquet posed in the large salon at the Jas de Bouffan, in front of the folding screen Cézanne had painted in his youth, but the artist depicted him from a closer vantage than that of *Peasant in a Blue Smock* (cat. no. 137), also set before the screen; only the screen's decorative border, with its large floral motifs,

Fig. 1. Paul Cézanne,
Portrait of Henri Gasquet, 1896-97,
oil on canvas,
The McNay Art Institute,
San Antonio, Texas (V. 695).

is visible over the sitter's right shoulder. The pose is odd: the sitter leans toward the left, as if reacting to the deep and powerful blue on the right side of the canvas. His instability may be an unconscious reflection of the vertiginous disorientation that this young man, with his penchant for exalted, breathless speech, must have induced in Cézanne, who was more accustomed to models who remained calm and silent.

Gasquet doubtless took notes during the heyday of his friendship with Cézanne, a friendship lasting about five years, for Cézanne began to distance himself from the poet in 1901. In the winter of 1912-13,[8] Gasquet began to write a book about Cézanne that was published only in 1921, the year of his own death. This biography contains fascinating information about the painter, but it is marred by the author's flowery style and his obvious embellishments of Cézanne's remarks to bring them more into line with his own taste. "He imagined a lyrical and heroic Cézanne who is a Provençal superman—and who somewhat resembles Gasquet himself. The platonic dialogue between Cézanne and the poet is nothing other than a conversation between Gasquet and Gasquet and the many gods of his own Olympus," wrote Jacques-Émile Blanche when the book appeared.[9] The judgment is a bit harsh, for Cézanne is known to have indulged in lyrical digressions on occasion, and his intimacy with his young admirer can only have encouraged them. There can be no doubt that Gasquet often "rewrote" Cézanne to suit himself,[10] but he succeeded in conveying something of his presence as well as the essential content of his thought.[11]

F. C.

1. Aurenche, in Rewald, 1959, p. 59.
2. Rewald, 1959, p. 20.
3. Cézanne to Henri Gasquet, December 23, 1898, in Cézanne, 1978, pp. 266-67.
4. Gasquet, 1921, pp. 55.
5. Cézanne to Joachim Gasquet, April 15 and 30, 1896, in Cézanne, 1978, pp. 248-50; and in Rewald, 1959, pp. 22-23.
6. Gasquet, 1921, p. 56.
7. Cézanne to Joachim Gasquet, May 21, 1896, in Cézanne, 1978, p. 251. This letter sets an appointment for one of the posing sessions.
8. This is the date given by Marie Gasquet in Joaquim Gasquet, *Des chants de l'amour et des hymnes* (Paris, 1928), p. 56.
9. Blanche, May 13, 1921.
10. See Reff, 1960, pp. 155-56.
11. See Doran, 1978, pp. 106-7.

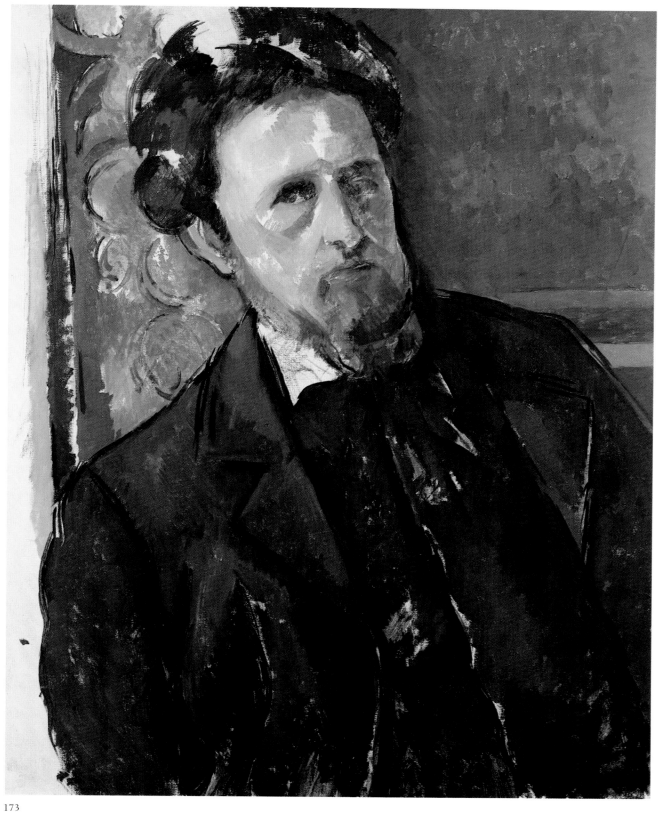

173

1896
Oil on canvas; 25⁹/₁₆ × 31⁷/₈ inches (65 × 81 cm)
The Courtauld Institute Galleries, London. Courtauld Bequest
V. 762

PROVENANCE
Ambroise Vollard purchased this canvas from the artist in 1897, and sold it to Cornelis Hoogendijk. It was put on the market by Paul Rosenberg, Paris, and was acquired by the Parisian collector Marcel Kapferer, who sold it to the Galerie Bernheim-Jeune on April 30, 1925. Percy Moore Turner bought it on January 22, 1926; later that same year he sold it to Samuel Courtauld, who gave it to the institute that he established in London in 1931.

EXHIBITIONS
After 1906: Amsterdam, 1911, no. 21; Paris, 1929, no. 7; Chicago and New York, 1952, no. 118; Edinburgh and London, 1954, no. 55.

EXHIBITED IN PARIS AND LONDON ONLY

"Here I am, away from our Provence for awhile," wrote Cézanne from Talloires on the Lac d'Annecy in July 1896 to his young friend Joachim Gasquet (see cat. no. 173). "After a lot of shuffling about, my family, in whose hands I presently find myself, has convinced me to settle down for the time being where I am. It's a temperate zone. The altitude of the surrounding hills is considerable. The lake, narrowed at this spot by two gorges, seems to lend itself to the linear exercises of the young English misses. It's still nature, assuredly, but a bit like we've learned to see it in the travel sketchbooks of young ladies. . . . The descriptive pen of Chateau[briand] would be needed to give you an idea of the old convent where I'm staying."[1] Two days later he wrote to Solari, another friend in Aix: "To relieve my boredom, I paint. It's not much fun, but the lake is very good, with large hills all around, it's not as good as our country."[2]

These remarks tell us much about this landscape, which, for all its beauty, is suffocating and skyless. The Château de Duingt is close to Talloires, and, more than the watercolors painted by travelers, this work brings to mind Courbet's landscapes with the Château de Chillon, on Lake Geneva. But in this canvas the building, engulfed by trees, has been emptied of all picturesque meaning; it functions as the central pivot for one of the cruciform constructions Cézanne loved so much, prompting the viewer's gaze upward to an absent sky and downward toward the lake, whose depths are evoked with intense blues.

Several historians have seen in this work a classic vision of a romantic site, evident in both the compositional scheme—the tree in the left foreground spreads across the entire upper edge, framing the landscape in a manner familiar from seventeenth-century paintings[3]—and in the austerity of the final effect, for the pictured site was, in fact, a bustling resort. "The elegant Lake of Annecy is transformed into a kind of bottomless Styx," Bernard Dorival

rightly observed.[4] Twelve years earlier, Lionello Venturi wrote: "A feeling of panic induced by the height of the mountain and the depth of the lake manifests itself in the blue, graduated to the deepest darks."[5]

In this picture—the only oil painted during his sojourn in Talloires—Cézanne selectively combined thicker handling with a fluid technique, seemingly related to the beautiful series of watercolors he also executed there (fig. 1, R. 466–79). It seems likely that the canvas was reworked after his return to Aix. The equilibrium of the massing is complemented by the subtle plays of color, which particularly struck the English aesthetician Adrian Stokes: "It is a commonplace of colour 'science' that adjacent colours, such as greens and blues, are difficult to 'manage.' It may be so, but many of Cézanne's pictures are characterized by the solution of this very juxtaposition, in none with more astonishing beauty than in the Annecy picture."[6]

F. C.

1. Cézanne to Gasquet, July 21, 1896, in Cézanne, 1978, pp. 252-53.
2. Cézanne to Philippe Solari, July 23, 1896, in Cézanne, 1978, p. 254.
3. See Reff, in New York and Houston, 1977-78, pp. 26-27; and Verdi, 1990, no. 36, p. 135.
4. Dorival, 1948 (b), p. 81.
5. Venturi, 1936, vol. 1, p. 64.
6. Stokes, 1950, p. 8.

Fig. 1. Paul Cézanne,
Reflections on the Water, c. 1896,
graphite and watercolor on paper,
private collection (R. 471).

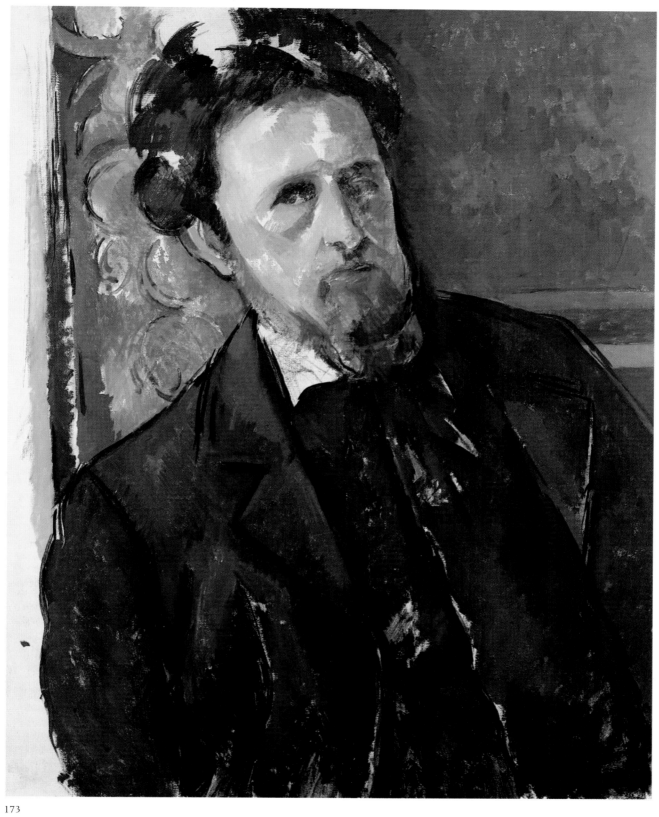

173

1896
Oil on canvas; 25⁹/₁₆ × 31⁷/₈ inches (65 × 81 cm)
The Courtauld Institute Galleries, London. Courtauld Bequest
V. 762

PROVENANCE
Ambroise Vollard purchased this canvas from the artist in 1897, and sold it to Cornelis Hoogendijk. It was put on the market by Paul Rosenberg, Paris, and was acquired by the Parisian collector Marcel Kapferer, who sold it to the Galerie Bernheim-Jeune on April 30, 1925. Percy Moore Turner bought it on January 22, 1926; later that same year he sold it to Samuel Courtauld, who gave it to the institute that he established in London in 1931.

EXHIBITIONS
After 1906: Amsterdam, 1911, no. 21; Paris, 1929, no. 7; Chicago and New York, 1952, no. 118; Edinburgh and London, 1954, no. 55.

EXHIBITED IN PARIS AND LONDON ONLY

"Here I am, away from our Provence for awhile," wrote Cézanne from Talloires on the Lac d'Annecy in July 1896 to his young friend Joachim Gasquet (see cat. no. 173). "After a lot of shuffling about, my family, in whose hands I presently find myself, has convinced me to settle down for the time being where I am. It's a temperate zone. The altitude of the surrounding hills is considerable. The lake, narrowed at this spot by two gorges, seems to lend itself to the linear exercises of the young English misses. It's still nature, assuredly, but a bit like we've learned to see it in the travel sketchbooks of young ladies. . . . The descriptive pen of Chateau[briand] would be needed to give you an idea of the old convent where I'm staying."[1] Two days later he wrote to Solari, another friend in Aix: "To relieve my boredom, I paint. It's not much fun, but the lake is very good, with large hills all around, it's not as good as our country."[2]

These remarks tell us much about this landscape, which, for all its beauty, is suffocating and skyless. The Château de Duingt is close to Talloires, and, more than the watercolors painted by travelers, this work brings to mind Courbet's landscapes with the Château de Chillon, on Lake Geneva. But in this canvas the building, engulfed by trees, has been emptied of all picturesque meaning; it functions as the central pivot for one of the cruciform constructions Cézanne loved so much, prompting the viewer's gaze upward to an absent sky and downward toward the lake, whose depths are evoked with intense blues.

Several historians have seen in this work a classic vision of a romantic site, evident in both the compositional scheme—the tree in the left foreground spreads across the entire upper edge, framing the landscape in a manner familiar from seventeenth-century paintings[3]—and in the austerity of the final effect, for the pictured site was, in fact, a bustling resort. "The elegant Lake of Annecy is transformed into a kind of bottomless Styx," Bernard Dorival

rightly observed.[4] Twelve years earlier, Lionello Venturi wrote: "A feeling of panic induced by the height of the mountain and the depth of the lake manifests itself in the blue, graduated to the deepest darks."[5]

In this picture—the only oil painted during his sojourn in Talloires—Cézanne selectively combined thicker handling with a fluid technique, seemingly related to the beautiful series of watercolors he also executed there (fig. 1, R. 466–79). It seems likely that the canvas was reworked after his return to Aix. The equilibrium of the massing is complemented by the subtle plays of color, which particularly struck the English aesthetician Adrian Stokes: "It is a commonplace of colour 'science' that adjacent colours, such as greens and blues, are difficult to 'manage.' It may be so, but many of Cézanne's pictures are characterized by the solution of this very juxtaposition, in none with more astonishing beauty than in the Annecy picture."[6]

F. C.

1. Cézanne to Gasquet, July 21, 1896, in Cézanne, 1978, pp. 252-53.
2. Cézanne to Philippe Solari, July 23, 1896, in Cézanne, 1978, p. 254.
3. See Reff, in New York and Houston, 1977-78, pp. 26-27; and Verdi, 1990, no. 36, p. 135.
4. Dorival, 1948 (b), p. 81.
5. Venturi, 1936, vol. 1, p. 64.
6. Stokes, 1950, p. 8.

Fig. 1. Paul Cézanne,
Reflections on the Water, c. 1896,
graphite and watercolor on paper,
private collection (R. 471).

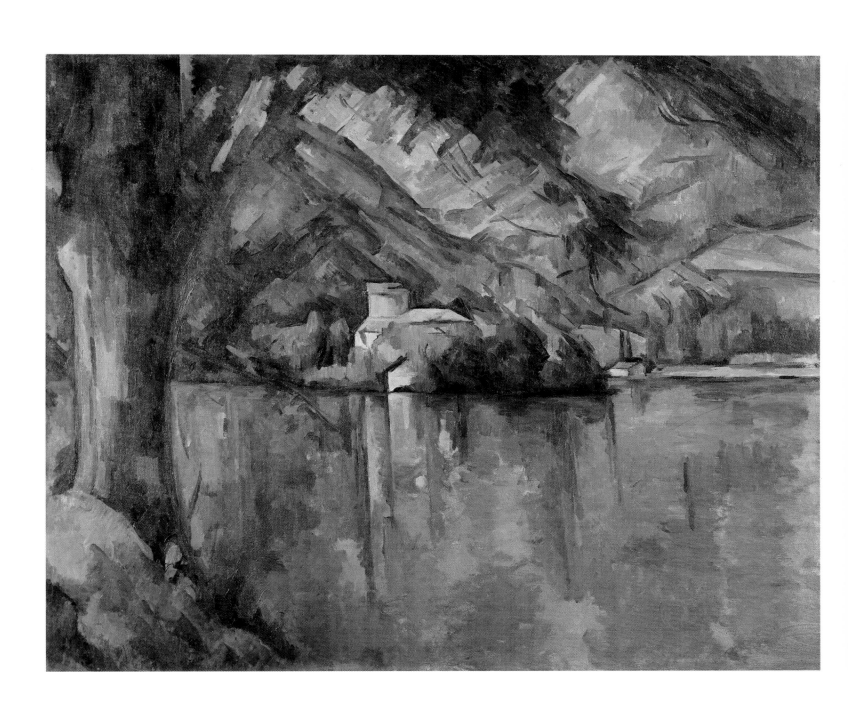

Mont Sainte-Victoire Seen from Bibémus

c. 1897
Oil on canvas; $25^{1}/_{8} \times 31^{1}/_{2}$ inches (63.8 × 80 cm)
The Baltimore Museum of Art. The Cone Collection,
formed by Dr. Claribel Cone and Miss Etta Cone of Baltimore, Maryland
V. 766

PROVENANCE
Ambroise Vollard owned this painting; then it belonged to Maurice Gang-nat. On his death, it was sold at the Hôtel Drouot, Paris, June 25, 1925 (lot 162), to the Galerie Bernheim-Jeune. Dr. Claribel Cone purchased it from them on the following day. It was bequeathed in 1949 to the Baltimore Museum of Art by Miss Etta and Dr. Claribel Cone.[1]

EXHIBITIONS
After 1906: Paris, 1907 (b), no. 39; Chicago and New York, 1952, no. 108; Paris, 1955, no. 4; New York, 1959 (b), no. 49; Washington, Chicago, and Boston, 1971, no. 27; New York and Houston, 1977-78, no. 12; Paris, 1978, no. 38.

This magnificent canvas was painted in the quarries of Bibémus, where Cézanne undertook a series of views in the 1890s (see cat. no. 149). Almost all of the pictures painted at Bibémus were made from a low vantage point, looking up or across at the quarry walls from a position below the rim. They all seem to have been painted in intense summer light, when the deep orange of the cliffs played off against the dark green pines and purple-blue sky. In the Baltimore picture, the most dramatic of the group, Cézanne placed himself in such a way that the profile of the mountain looms very large, like a sun rising over the east lip of the quarry. The mountain is painted with purple, blue, and pale pink strokes and a few dashes of reddish ocher that relate to the cliffs in front of it. Yet the barrier of rock is abrupt and precise, giving the mountain the quality of something both near and far. It raises a question not of spatial or expressive ambiguity, but rather of what Schapiro, writing about this picture, has called "a primitive emotional perspective" by which distant objects grow larger in focus.[2] Cézanne reinforced this effect by honing the jagged profile of the mountain with sharply struck, intense blue strokes, while the planes of the cliff face and the pines remain suggestive blurs.

Rarely are elements of nature placed in such brutal contrast to each other. The drama intensifies when one realizes, from the cropping of the three pines in the foreground, that the view is from a vantage high above the quarry floor, with the ground dropping abruptly away in the great fissure just before our feet. This canyon is another barrier between us and the mountain, thwarting even further any means of approach.

This painting addresses the same formal problem Cézanne set for himself in his view of Zola's house at Médan (cat. no. 69) almost a decade earlier. A set of vertical planes, each parallel to the picture plane, step back in three major intervals into a remarkably shallow space. But in the moist air and fertile landscape of the Île-de-France, the separation and unification of these carefully constructed planes occurs in a gentle, almost lyrical process. Here, in the Midi, where the landscape is vast and its elements roughly hewn, the strength it takes to unite part to part, particularly with three so absolutely defined barriers, is titanic. The result is a picture in which great forces are put in motion. The wonder, of course, is the high degree to which Cézanne brought them into alignment.

J. R.

1. For more information on the Cone gift, see "Baltimore Inherits the Cone Collection of Modern Art," *Art Digest*, vol. 24, no. 1 (October 1, 1949), p. 9; "The Baltimore Museum's Cone Collection: A Pointed Star," *Art Digest*, vol. 24, no. 8 (January 15, 1950), pp. 7-8; and Arnold L. Lehman, foreword to Brenda Richardson, *Dr. Claribel and Miss Etta: The Cone Collection of the Baltimore Museum of Art* (Baltimore, 1985), pp. 17-18.
2. Schapiro, 1952, p. 110.

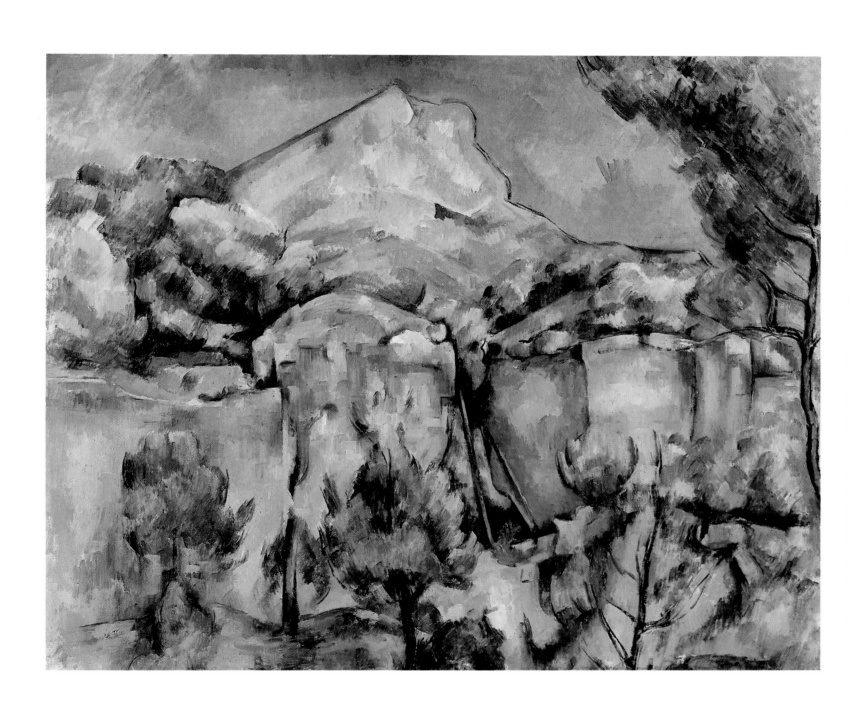

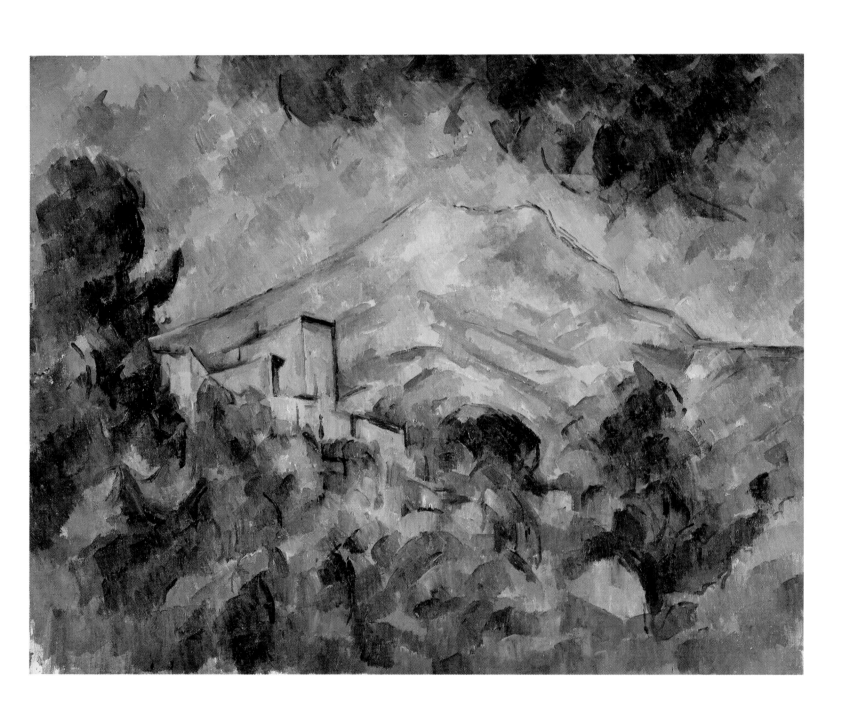

Mont Sainte-Victoire and the Château Noir

1904-6
Oil on canvas; 26^1/16 × 32^5/16 inches (66.2 × 82.1 cm)
The Bridgestone Museum of Art, Tokyo. Ishibashi Foundation
V. 765

Zenichiro Hara, Yokohama, acquired this canvas in 1923 from Ambroise Vollard. It subsequently came into the possession of Hitoshi Hasegawa (Nichido Gallery), before entering the Ishibashi collection in 1946. In 1962 it was given to the Ishibashi Foundation and is now in the Bridgestone Museum of Art.

EXHIBITIONS
After 1906: Tokyo, Kyoto, and Fukuoka, 1974, no. 59.

EXHIBITED IN PHILADELPHIA ONLY

This view of the isolated structure of the Château Noir, fully exposed in an open vista, could be deemed the redemption in contrast to the macabre *Château Noir* in the National Gallery of Art, Washington, D.C. (cat. no. 189). Built up laboriously over time, that densely worked and intense view compresses its elements to a nearly combustible moment, and evokes a feeling of apprehension, a descent into darkness.

Although the two paintings share similar palettes, the pigments in this work seem to take on the qualities of watercolor, fluid and quickly moving, staining every inch of the canvas. Scant pause was taken to record the details of the scene; a stroke or two of dark paint establishes the geometry of the château and the profile of the mountain. Cézanne seems to have rushed to his principal purpose, creating a wreath around the mountain with billowing shapes of dark green and purple so freely painted that it hardly seems to matter whether they represent trees or storm clouds. With wondrous effect, the image of the mountain emerges as a lustrous nucleus within this swirling vortex of energy. Of the visionary late landscapes incorporating the mountain, this one may be the most harmonious, the least intimidating. The house—projected onto the profile of the mountain and turning its face to the same splendid light that seems to break through a storm—is a noble (and hopeful) image in itself, but one sufficiently deferential not to detract from the overwhelming majesty of the mountain.

This canvas has had a different effect on each successive generation. For Walter Pach, it had the mystical quality of "the great Chinese painters of mountain scenery."[1] Denys Sutton found it "has an almost dreamlike character: the mood conjured up is akin to the music of Wagner or Debussy and the relationship underlines the artist's connexion with the world of the Symbolists."[2] Comparing this painting with a photograph of the site, Michel Hoog noted: "His pictures give the impression of nature at her beginnings, while the photographs of the same landscapes suggest the works of men, their conveniences, their impending presence."[3]

This is also a painting that makes idle the speculation about "finish" and "unfinish" in Cézanne's work. In comparison, for example, to even the most swiftly rendered views of Mont Sainte-Victoire from Les Lauves (see cat. nos. 200, 202, 203, and 205), this is but a series of dense stains on the canvas, truly more akin to a watercolor than a painting. Yet its impact, as a resolved and powerful image and a deeply moving work of art, is as grand and effective as any of those masterpieces.

J. R.

1. Pach, 1929, p. 107.
2. Sutton, August 1974, p. 107.
3. Hoog, 1989, p. 160.

Portraits of Ambroise Vollard

177 | *Portrait of Ambroise Vollard*

1899
Oil on canvas; 39³/₈ × 31⁷/₈ inches (100 × 81 cm)
Musée du Petit Palais de la Ville de Paris
V. 696

PROVENANCE
The portrait was commissioned from Cézanne by the dealer Ambroise Vollard and remained in his personal collection until his death in 1939, when it was bequeathed to the City of Paris for the Musée du Petit Palais.

EXHIBITIONS
After 1906: Paris, 1936, no. 101; New York, 1936, no. 22; Tokyo, Kyoto, and Fukuoka, 1974, no. 51; New York and Houston, 1977-78, no. 4; Paris, 1978, no. 3; Liège and Aix-en-Provence, 1982, no. 23.

178 | *Ambroise Vollard*

1899
Graphite on paper; 18¹/₁₆ × 15¹¹/₁₆ inches (45.8 × 39.8 cm)
Fogg Art Museum, Harvard University Art Museums, Cambridge, Massachusetts.
Gift of Mr. and Mrs. Frederick Deknatel
C. 1194

PROVENANCE
This drawing was sold by Ambroise Vollard to Mr. and Mrs. Frederick Deknatel, Cambridge, who subsequently gave it to the Fogg Art Museum.

EXHIBITED IN PHILADELPHIA ONLY

On October 21, 1899, Maurice Denis made the following entry in his journal: "Vollard has been posing every morning at Cézanne's for what seems like forever. As soon as he moves, Cézanne complains that he's made him lose the *line of concentration*. He also talks about his deficient optical qualities and his inability to *realize* like the old masters (Poussin, Veronese, Le Nain; he also loves Delacroix and Courbet), but he thinks he has *sensations*. In order to prepare himself for his morning painting sessions, he strolls through the Louvre or the Trocadéro in the afternoons and draws statues, antiquities, or the Pugets, or he makes watercolors *en plein air*; he maintains this predisposes him to *see* well the next day. If it's sunny, he complains and does little work: what he needs are *gray days*."[1] Joachim Gasquet provided another interesting account of how Cézanne proceeded in painting this portrait (cat. no. 177), as well as others: "During many sessions, Cézanne seemed to make only a few brushstrokes but never ceased to devour the sitter with his eyes. The next day, M. Vollard found that the canvas had been advanced by three or four hours of intense work. The portrait of my father [Henri Gasquet, p. 413, fig. 1] was painted in the same way. . . . His memory for colors and lines was perhaps without equal."[2]

Ambroise Vollard (1867-1939) was the first picture dealer to become interested in Cézanne. By his own ac-count, it was in 1892, when he was still a law student, that he discovered the artist's work at the only Parisian venue where it could then be seen: the legendary shop of père Tanguy, paintseller and protector of artists.[3] The next year Vollard opened his gallery at 6, rue Laffitte and later, after exhibiting drawings by Manet and Forain, acquired— doubtless on the advice of Pissarro and Renoir—an important lot of paintings and watercolors through Cézanne's son, who was then living in Paris. In December 1895 he organized the first exhibition of the artist's work, finally revealing to the Parisian public the production of one who was at the time both mythic and unknown. This was only the first masterstroke of the young dealer, who was to exhibit and sell the work of Gauguin, Van Gogh, and the Nabis before 1900, Picasso from 1901, Matisse from 1904, and Vlaminck and Derain from 1906. It was above all in his gallery that artists could see Cézanne's paintings and watercolors, even outside the context of formal exhibitions. In 1914 Vollard wrote a biography of the artist, an entire chapter of which recounts the protracted and difficult posing sessions for this portrait.[4]

Sittings were held in Cézanne's studio at 15, rue Hégésippe-Moreau in 1899. "The sessions began at eight in the morning and lasted until eleven-thirty."[5] He described Cézanne's nervousness, his concentration, his need

for absolute silence, and reported a few of the painter's remarks, some of which—for example "It's terrifying, this life!"[6]—seem to have been favorite sayings of his, for they recur in other sources.

"After a hundred and fifteen sessions, Cézanne abandoned my portrait to return to Aix. 'I'm not discontent with the front of the shirt'—such were his last words. He had me leave the shirt in which I'd posed at the studio, intending upon his return to Paris to stop up the two little white points in the hands [where the canvas is not covered], and then, of course, rework certain parts. 'I'll have made some progress along the way. Try to understand, Monsieur Vollard, the contour escapes me!'"[7]

Vollard's recollections of Cézanne should be regarded skeptically, for he liked to pose as the discoverer of an unknown genius, as a solitary hero who fended off a pack of philistines, despite the fact that among painters—to whom Vollard profitably paid heed—Cézanne had long been considered a great artist. Accordingly, when citing in his book reviews of the exhibitions he had organized he gave pride of place to those in which the artist is mocked or censured.[8]

Cézanne was distrustful by nature, but he was fond of Vollard, at least in his capacity as a dealer. "I believe absolutely in Vollard's honesty," he wrote to Charles Camoin in 1902, and, by way of commentary on his son's having sold works to other dealers, he added: "I remain faithful to Vollard, even regretting that my son has left the impression I could give my canvases to anyone else."[9] Vollard had Cézanne's complete confidence: "He showed such kindness toward me that one day I dared to ask him to do my portrait."[10]

Cézanne chose to depict Vollard as an attentive figure who seems to reflect or listen, holding a journal in his lap. As so often, the face and hands are not very worked up. Indeed, despite the countless posing sessions, the whole retains a somewhat sketchy character; in any case, there is no sign of the thick, reworked passages one might have expected. Like Picasso (fig. 1) a decade later,[11] the painter has emphasized the large forehead and the lowered gaze, but he did not insist on his large snub nose and his scowlish air,

as did other painters who were soon to paint Vollard's portrait (Vallotton, Renoir, Forain, and Picasso). He gave us a man who is young, reserved, and perhaps bored, for he himself told us he sometimes fell asleep, to the artist's dismay: "Wretch! You're changing the pose! I say to you, in all truth, you must remain still like an apple. Does an apple fidget?"[12]

This picture, one of the artist's most geometrically constructed portraits, is organized around another of the cross-like configurations to which Cézanne was so partial. The vertical axis descends from the top of the head, passing through the nose, the placket of the shirt, and the vest to rejoin the lower leg, after a brief interruption by the bent leg. The horizontal axis, which intercepts Vollard's figure precisely at the level of his mouth, is delineated by the bottom of the window of the studio. The colors of the painting make for a somber harmony of grays, russets, and browns; only the triangle of the shirt illuminates the center of the portrait, and its note of brightness renders the sitter's face that much more pensive and preoccupied.

Cézanne also drew Vollard on several occasions, at the time of their first meeting and/or during the posing sessions for this portrait (C. 1190-93). The sheet in the Fogg Art Museum (cat. no. 177) appears to be a study for the oil; according to Chappuis, Vollard attested that it was drawn in 1899.[13]

F. C.

1. Denis, journal entry for October 21, 1899, in Denis, 1957, vol. 1, p. 157.
2. Gasquet, 1921, p. 57.
3. See Vollard, 1914, pp. 51-52.
4. Ibid., chap. 6, pp. 91-107.
5. Ibid., p. 92.
6. Ibid., p. 100.
7. Ibid., p. 105.
8. Ibid., pp. 59-71.
9. Cézanne to Camoin, March 11, 1902, in Cézanne, 1978, p. 284.
10. Vollard, 1914, p. 91.
11. Vollard sold Picasso's portrait of him to the Russian collector Morosov in 1913.
12. Vollard, 1914, p. 92.
13. See Chappuis, 1973, vol. 1, no. 1194, p. 268.

Fig. 1. Pablo Picasso,
Portrait of Ambroise Vollard, 1910,
oil on canvas,
Pushkin State Museum of Fine Arts,
Moscow.

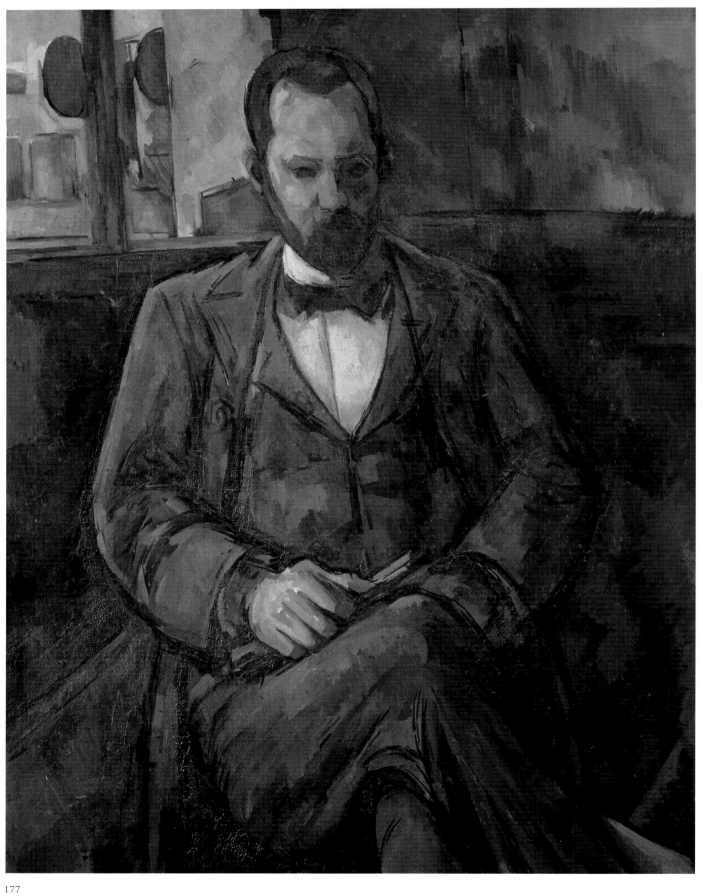

177

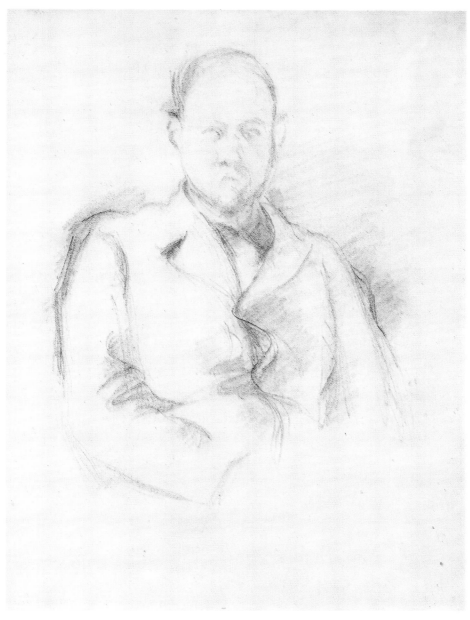

178

Man with Crossed Arms

c. 1899
Oil on canvas; 36¹/₄ × 28⁵/₈ (92 × 72.7 cm)
The Solomon R. Guggenheim Museum, New York
V. 689

PROVENANCE
In 1912 Ambroise Vollard sold this portrait to the German collector Gott-lieb Friedrich Reber; he ceded it to Martha Reuther, Heidelberg. In 1952 it was in the possession of the Galerie Durand-Matthiesen, Geneva, passing in 1953 to the Knoedler Gallery, New York, where it was acquired for $100,000 in 1954 for the collection of the Solomon R. Guggenheim Museum.

EXHIBITIONS
Before 1906: Paris, 1904, no. 10 (?).
After 1906: Darmstadt, 1913, no. 10; The Hague, 1956, no. 43; New York, 1963 (b), unnumbered; New York and Houston, 1977-78, no. 6.

Fig. 1. Paul Cézanne,
Man with Crossed Arms, c. 1899,
oil on canvas,
private collection (V. 685).

Cézanne did not set out to convey the social status and temperament of his models as a genre painter would have done, but such is the probity and truth of his observation that the sitters seem fully defined as human beings. This portrait depicts neither a peasant nor a writer but a complex individual who eludes ready classification but who possesses great psychological force, as well as a kind of uneasy elegance. Venturi, in his catalogue, provided the identification "Picture also known as 'The Clockmaker,'" information that doubtless derives, directly or indirectly, from Cézanne's son, Paul.[1]

In any case, the figure is full of tension and contrast. His face is rough and troubled, but he has taken some care with his dress—he wears a cravat and a vest—and his long hair is more suggestive of an artist or a bohemian than a worker. His hands are long and rather elegant, characteristics Cézanne emphasized to an even greater extent in another portrait of the same model (fig. 1).

There is nothing that definitively ties these two paintings to Aix; they may well have been painted in Paris in 1898 or 1899 in the rue Hégésippe-Moreau studio. The subject could be a Parisian artisan from the quarter—perhaps a clockmaker, as indicated by Paul *fils,* who was living in Paris at the time and saw his father and his models with some regularity. Although Rewald was often skeptical of the information provided by Cézanne's son, much of its content, aside from his often questionable datings, can be trusted.

The face is irregular, even skewed, either as the result of a physical trait—in which case it would border on hemiplegia—or because Cézanne depicted the two sides of the face in different moments. It is known that he made his models pose countless times—and under different lighting conditions, anticipating the experiments of the Cubists. But we should be wary of such retrospective ideas, favored by art historians whose hindsight has been clouded by the notion of Cézanne as the great precursor.

The other portrait (fig. 1) is characterized by the same deformation, perhaps in an even more exaggerated form, the left side of the face being partly in shadow, an effect that makes the figure seem even more sullen than in the present canvas. Erle Loran compared this deformation to the distorted figures of El Greco.[2] Liliane Brion-Guerry thought it resulted from a deliberate accentuation of actual physical appearance: "The real was distorted to better convey his characteristics."[3] She discerned something aggressive in the position of the crossed arms: "The character's violence is heightened by the brutality of the single gesture burdened with expressing it."[4] Although the model is sitting quietly in the artist's studio (as indicated by the palette and stretcher in the lower left corner), his facial expression and upward-cast gaze, averted from the painter (as in the other picture), indicate a melancholy and a controlled tension with which Cézanne would have had no difficulty identifying.

F. C.

1. Venturi, 1936, vol. I, no. 689, p. 213. Notation in the hand of Paul Cézanne *fils* on a photograph of the painting in the Vollard Archives, Musée d'Orsay, Paris.
2. See Loran, 1943, p. 90; and Rewald, in New York and Houston, 1977-78, no. 6, p. 388.
3. Brion-Guerry, 1966, p. 132.
4. Ibid.

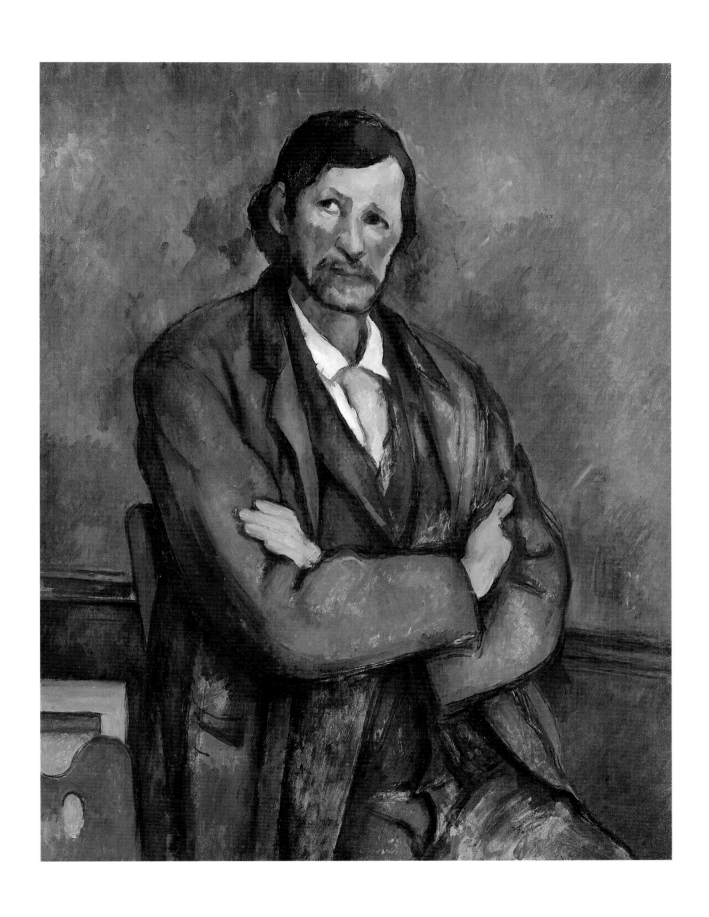

Still Life with Curtain and Flowered Pitcher

c. 1899
Oil on canvas; 21⁵/₈ × 29⁵/₁₆ inches (55 × 74.5 cm)
The Hermitage Museum, St. Petersburg
V. 731

PROVENANCE
The Moscow collector Ivan Morosov acquired this canvas from Ambroise Vollard in October of 1907,[1] for the sum of 17,000 francs.[2] It has been in the Hermitage since 1917.

EXHIBITIONS
After 1906: Moscow, 1926, no. 14; New York and Houston, 1977-78, no. 27; Paris, 1978, no. 23.

This still life belongs to a group of six compositions probably realized in Paris in the course of 1898-99,[3] all of which, minor variations aside, feature identical elements arrayed on a table: a curtain decorated with a pattern of leaf forms, a faience pitcher with flowered decoration, some fruit—apples and oranges—arranged on a plate or in a compotier, and some white napkins. Theodore Reff has proposed a chronology for these works in which the two earliest are the Musée d'Orsay picture, *Apples and Oranges* (cat. no. 181), and the canvas in the Barnes Foundation (fig. 1). *Still Life with Curtain and Flowered Pitcher* (cat. no. 180) comes next, followed by the very incomplete oil sketch also in the Barnes Foundation (V. 745), the picture in the Reinhart Foundation in Winterthur (fig. 2), and *Still Life with Apples and Peaches*, now in the National Gallery of Art in Washington, D.C.[4] All of these works have stable compositions, with the exception of *Apples and Oranges*, from which secure spatial reference points have been banished. This "passage from planar space to volumetric space"[5] was something toward which Cézanne strove, and this suggests—contrary to Reff's chronology—that the Musée d'Orsay canvas was probably the last in the series.

The Hermitage still life is constructed in accordance with a schema that is remarkable for its equilibration. The background is divided into two sections of almost equal size; one part is occupied by the curtain with the leaf pattern[6] and one part is empty. In the foreground, a clearly delineated wooden table—familiar from compositions dating from 1880 to 1890—serves as a support for the decorative arrangement. The still life proper is arrayed in a triangular configuration on this stable horizontal base, with the flowered faience pitcher forming a vertical axis around which the fruit is grouped symmetrically. Harmoniously placed white napkins shore up the composition and serve as a visual counterweight to the colored mass of the curtain. However, the balance of forms and colors does not preclude considerable freedom in both the rendering of objects and the representation of space. Note that the dishcloth added at a late stage on the right foreground was deliberately left unfinished, as was the lower portion of the curtain resting on the table.[7] Transitions from one object to another are effected by means of color gradations.

Cézanne sometimes made them coincide, as in the tubular fold of the white napkin and the curving edge of the white plate on which five pieces of fruit have been placed. The flowers on the pitcher, painted without being drawn, offer a blurry alternative to the full, clearly outlined, and assertive fruit that are the picture's principal focus. In order to display them to best advantage, the painter introduced a few striking spatial anomalies, such as the perilous tilt of the plate of fruit on the left and the upward extension of the tabletop's right rear corner.[8] These voluntary distortions manifest a desire to escape a unified vision of still life in which the objects are deployed within a clearly defined space. "He did not want to separate the stable things which we see and the shifting way in which they appear; he wanted to depict matter as it takes on form, the birth of order through spontaneous organization. . . . When the over-all composition of the picture is seen globally, perspectival distortions are no longer visible in their own right but rather contribute, as they do in natural vision, to the impression of an emerging order, of an object in the act of appearing, organizing itself before our eyes."[9]

Beyond his interest in matter, Cézanne set out to translate the infinity of relations that objects sustain with one another by means of line, form, and color. This project explains his having worked in series, with the same elements appearing in a sequence of canvases. "These glasses, these plates, they talk among themselves. Interminable disclosures," he confided to Joachim Gasquet.[10] These connections and tensions constitute a veritable pictorial rhetoric from which anecdotal discourse is excluded.

I. C.

Fig. 1. Paul Cézanne,
Compotier, Pitcher, and Fruit, 1898-99,
oil on canvas,
The Barnes Foundation, Merion,
Pennsylvania (V. 592).

Fig. 2. Paul Cézanne,
Still Life, c. 1899,
oil on canvas,
Oskar Reinhart Foundation, Winterthur,
Switzerland (V. 742).

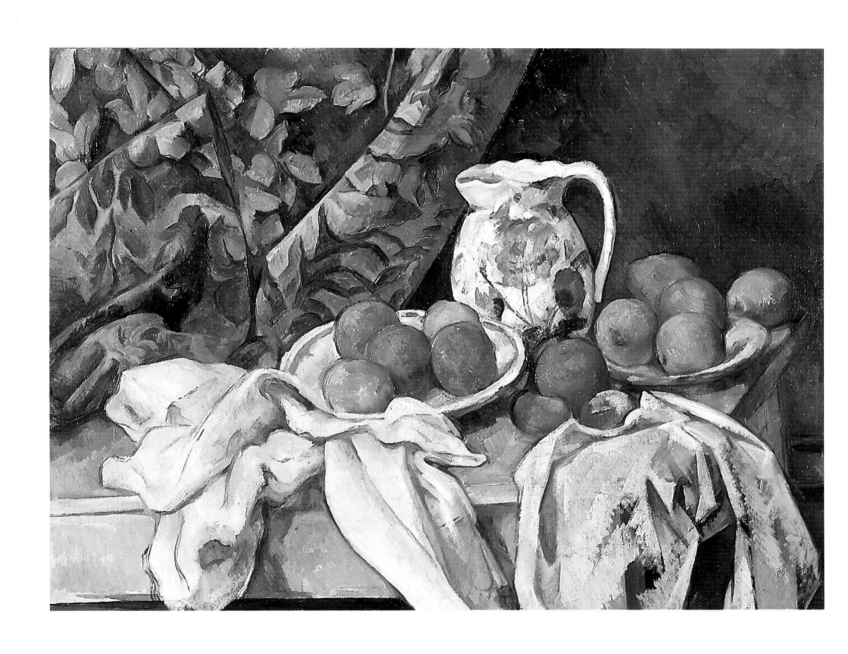

1. "Sur une table au milieu d'un [pli?] de nappe, et dominées d'un côté par une draperie bleu[e] deux assiettes de pommes au milieu un pichet 54 × 73 [cm]" (On a table in the middle of [folds?] of tablecloth, and dominated on one side by a blue drapery, a pitcher between two plates of apples 54 × 73 [cm]), or "Nature morte; assiette de pommes, cruchon et draperie 54 × 73 [cm]" (Still life; plate of apples, pitcher, and drapery 54 × 73 [cm]). Vollard record-book, no. 3687 [A] or no. 3564 [B], October 5, 1907, Vollard Archives, Musée du Louvre, Bibliothèque Centrale et Archives des Musées Nationaux, Paris.
2. See Barskaya and Kostenevich, 1991, p. 67.
3. See Rewald, in Paris, 1978, nos. 22, 23, pp. 106, 108.
4. See Reff, in New York and Houston, 1977-78, p. 29.
5. Brion-Guerry, 1966, p. 121.
6. This curtain or hanging is depicted in several pictures, including cat.

nos. 167, 181, 187; V. 562, V. 613, V. 679, V. 682, V. 736, V. 741; p. 276, figs. 1 and 2, and repro. p. 63.
7. Vollard (1914, pp. 95-96) bore witness to the difficulties Cézanne experienced in completing his canvases: "In my portrait, there are two small points on the hands where the canvas is not covered. I pointed this out to Cézanne: 'If my session at the Louvre this afternoon is good,' he answered me, 'perhaps tomorrow I'll find the right tone to stop up these whites. Try to understand, Monsieur Vollard, if I apply something haphazardly I'll be obliged to rework my whole picture beginning in this area!'"
8. See John Richardson and Eric Zafran, eds., *Master Paintings from the Hermitage and the State Russian Museum, Leningrad* (New York, 1975), p. 88.
9. Merleau-Ponty, 1964, pp. 13-14.
10. Gasquet, 1921, p. 122.

181 | *Apples and Oranges*

c. 1899[1]
Oil on canvas; 29^{1}/$_{8}$ × 36^{5}/$_{8}$ inches (74 × 93 cm)
Musée d'Orsay, Paris. Bequest of Comte Isaac de Camondo (R.F. 1972)
V. 732

PROVENANCE
This picture first belonged to the critic Gustave Geffroy. On January 28, 1907, Geffroy sold it and four other paintings by Cézanne to the Galerie Bernheim-Jeune.[2] Comte Isaac de Camondo acquired it on May 4 of the same year and in 1911 bequeathed it to the Louvre along with the rest of his collection.

EXHIBITIONS
After 1906: Paris, 1936, no. 96; Chicago and New York, 1952, no. 88; Paris, 1954, no. 62; Paris, 1974, no. 46; New York and Houston, 1977-78, no. 28; Paris, 1978, no. 22.

In executing this canvas Cézanne chose a vantage quite close to his still-life arrangement, and the result is a composition that tightly frames the picture's central motif—apples on a plate, oranges in a compotier, fruit arranged on a table, and a faience pitcher, all of which assertively encroach upon the surrounding space—"Apple colored space/ Compotier burning space."[3] By way of accompaniment for these very simple elements, which recur like leitmotifs in his work, the painter deployed sumptuous drapery around them, overflowing the confines of the visual field. These fabrics are not unfamiliar. The patterned carpet on the left, with its geometric repeats in brown, violet, green, and red, is also visible in *Woman in Blue* (cat. no. 188), *Italian Girl Leaning on Her Elbow* (V. 701), and *Three Skulls on a Patterned Carpet* (cat. no. 213). This carpet remained in the Chemin des Lauves studio for a time after the artist's death but disappeared prior to the outbreak of World War I. The drapery on the right, with its blue-green leaf motifs against a beige ground, was depicted by Cézanne many times. It appears in several still-lifes, portraits, and other works beginning in the late 1880s.[4] Here its folds evoke the geological configurations of Mont Sainte-Victoire. To counter the opulence of this decor, Cézanne arranged a white tablecloth—"white like a bed of new-fallen snow"[5]—across the

table's front edge. The immaculate surface of this material is rendered with white impastoes complemented by blue shadows, a mode of handling that recurs in the compotier, the plate, and the pitcher. Imprinted upon this white are numerous reflections indicated by touches of colored pigment. The deep folds in the fabric, which give it relief, are rendered by a combination of contours and dark hatching. The vigorous treatment of the tablecloth admirably conveys the stiffness of the starched linen. Against the foil provided by these light grounds—tablecloth, plate, compotier—the colored skins of the fruit stand out with a heightened brilliance and immediacy.

Snugly nestled within these folds, the still-life objects are disposed in a diagonal configuration that extends across the entire canvas, rising from the lower left to the upper right. This orientation is underscored—and a sense of depth created—by the edge of a sofa at the bottom of the composition, a visual extension of the top of the table, only the right leg of which is visible. The effect of upward dynamism is amplified by the elevated point of view, which encourages a perusal of the picture that proceeds from bottom to top. This tactic was favored by the great masters of still life—De Heem, Van Beyeren, and Chardin—and was used by Cézanne himself in many paintings of Mont Sainte-Victoire as well as in the *Large Bathers*. The fruit is stacked pyramidally in a way that accentuates its volume without resorting to overt illusionism. This skillful deployment of geometry weaves a skein of relations among the objects that visually locks them into place: "Objects interpenetrate. . . . They never stop living. . . . They spill over imperceptibly into their surroundings with intimate reflections, as we do with our looks and words. . . . It's Chardin who first grasped this, who nuanced the

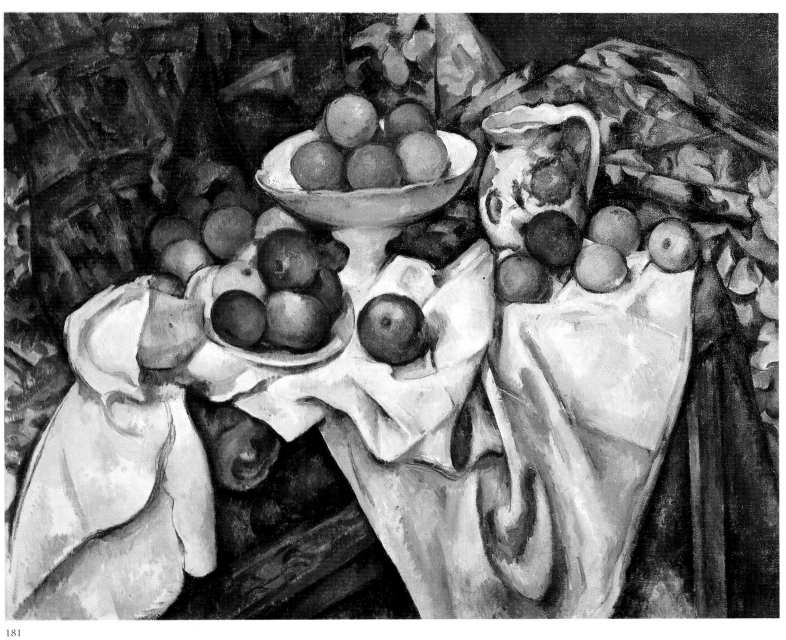

181

atmosphere of things."[6] Cézanne sought to convey the secret correspondence between objects, "this dust of emotion that envelops [them]."[7]

The translation of these mute existences into visual signs on canvas consumed considerable amounts of time.[8] It was for this reason, perhaps, that Cézanne chose to depict fruit, for his deliberate pace of execution precluded the use of materials that would spoil more quickly, such as meat, fish, and game. His preference was for hardy varieties like apples, oranges, and lemons, as opposed to figs and grapes. "Pieces of fruit are more faithful [than flowers]," he confided to Joachim Gasquet. "They like having their portraits painted. It's as though they sought your forgiveness for becoming discolored. Their essence is emitted with their perfume. They come to you in all their odors, speaking to you of the fields they've left behind, of the rain that's nourished them, of the dawns they've witnessed. In defining with fleshy touches the skin of a beautiful peach or the melancholy of an old apple, I [always] glimpse in the reflections that they exchange the same tepid shadow of renunciation, the same love of the sun, the same recollection of dew, a freshness."[9] Cézanne "staged" fruit in theatrical configurations set within bourgeois interiors, eschewing conventional realism, occasionally to such an extent that it becomes difficult to distinguish, for example, between a peach and an apple. The fruit asserts itself in elementary terms, as pure form and vibrant color, delicately modeled by small brushstrokes and heightened by vivid touches of brilliantly colored pigment. Whereas Chardin imbued the humble objects he depicted with a compassion that he projected onto them, Cézanne's still lifes communicate a jubilation that is essentially pictorial. Venturi explained: "Cézanne feels that his objects are beautiful, which inspires him with joy. And the fruit, the tablecloth, and the pitcher provide occasions for the expression of his joy: these are yellows, reds, and whites that sing with joy. . . . Something astonishing happens, something that critics still refuse to admit: the artist's very soul is captured within a painted apple. . . . In other words, the artist's life experience of joy and pain impresses itself upon his still lifes, and he elevates the simplest of apples to the level of humanity."[10]

Of the six related still lifes by Cézanne depicting the same pitcher, drapery, and fruit,[11] it is this one in the Musée d'Orsay, with its spatially invasive colored objects, its majestically arrayed fabric, and its imposing baroque diagonal, that is the most sumptuous.

I. C.

1. Rewald wrote that the brown background in the painting's upper right corner "seems related" to the wall in Cézanne's portrait of Ambroise Vollard (cat. no. 177), which would date the still life to the same time. See New York and Houston, 1977-78, no. 28, p. 395.
2. Bernheim-Jeune Archives, Paris, stock no. 15.604.
3. "Espace couleur de pomme / Espace brûlant compotier." René Char, "Contre une maison sèche," Le Nu perdu (Paris, 1971), p. 116.
4. See cat. no. 180, note 6.
5. Honoré de Balzac, La Peau de chagrin, cited in Gasquet, 1921, p. 123.
6. Gasquet, 1921, p. 122.
7. Ibid.
8. According to Bernard (1925, pp. 70-71), "Cézanne painted very slowly, and what's more he reflected deeply as he worked. . . . He needed time to bring something forth, and he found it in front of skulls, green fruit, and paper flowers. It is in this genre that he best said what he had to say."
9. Gasquet, 1921, p. 122.
10. Venturi, 1936, vol. 1, pp. 56-57.
11. Cat. no. 180, figs. 1 and 2 on p. 428, cat. no. 181, V. 745, and Still Life with Apples and Peaches, National Gallery of Art, Washington, D.C. (not in Venturi).

182 *The Balcony*

c. 1900 (possibly later)
Graphite and watercolor on paper; 24 × 17³/₄ inches (61 × 45.1 cm)
Philadelphia Museum of Art. The A. E. Gallatin Collection, 1943-75-1
R. 529

PROVENANCE
This watercolor was originally in the possession of the artist's son, Paul, in Paris. Thereafter it passed into the possession of the Galerie Bernheim-Jeune, who sold it in 1921 to A. E. Gallatin for his Museum of Living Art at New York University. In 1943 it entered the collection of the Philadelphia Museum of Art by bequest of A. E. Gallatin.

EXHIBITIONS
After 1906: Paris, 1909, no. 13; Chicago and New York, 1952, no. 124; New York, 1963 (a), no. 53; Washington, Chicago, and Boston, 1971, no. 53; Newcastle upon Tyne and London, 1973, no. 91; New York and Houston, 1977-78, no. 94; Paris, 1978, no. 28; Philadelphia, 1983, no. 33.

EXHIBITED IN PARIS AND LONDON ONLY

Many have noted the freedom and energy of the watercolors Cézanne painted near the end of his life, but even among these, the scale and robust confidence of this sheet are remarkable.[1] The pattern of the ornamental grille has the dynamism of Saint Catherine's wheel. Rapid strokes of intense blue and gray black alternate in great pulsating curves, while the rich strokes of color on the leaves of the trees beyond celebrate their vitality in the dazzling light. The loose and spontaneous pencil underdrawing leads a nearly independent life from the watercolor. Each medium, in its own way, catches the exuberant spirit of the moment.

182

Fig. 1. Detail of the facade of the Hôtel d'Albertas,
Aix-en-Provence.
From Léon Deshairs, *Aix-en-Provence:
Architecture et décoration aux XVIIᵉ et XVIIIᵉ siècles*
(Paris, 1909), pl. 6.

The seventeenth- and eighteenth-century architecture
of Aix, especially the buildings lining the cour Mirabeau, is
justly renowned. It is not known in which building
Cézanne sat to make this work—certainly not the rela-
tively modest spaces of his apartment on the rue Boule-
gon—but one can imagine a high-ceilinged room on the
principal floor, on a level with the treetops, with a window
opening onto a shallow balcony with a fine iron railing.
The shutter arrangement—one closed, one open, but with
the full lower section open—seems unusual until one
notes that in Aix, and in the Midi in general, it was custo-
mary to have shutters that closed only above the balcony,
leaving an area beneath that was constantly open for ven-
tilation (fig. 1).

J. R.

1. On the verso of this sheet is a study of foliage, 1895-1900, graphite
 and watercolor on paper.

183 | *Group of Bathers*

c. 1900
Graphite and watercolor on buff paper; 8 × 11 inches (20.3 × 27.9 cm)
The Pierpont Morgan Library, New York. The Thaw Collection
R. 495

PROVENANCE
This watercolor was originally in the possession of the artist's son, Paul.
Thereafter it passed to Maurice Renou, Paris. By 1982, it was in a private
collection. In December 1993 it entered the Thaw Collection at the Pier-
pont Morgan Library.

EXHIBITIONS
After 1906: Paris, 1935, unnumbered; Basel, 1936, no. 81; New York,
1937, no. 14 (?); London, 1939 (b), no. 65; Lyon, 1939, no. 54; Tübingen
and Zurich, 1982, no. 116; Basel, 1989, no. 87; New York, 1994-95, no. 83.

EXHIBITED IN PARIS AND LONDON ONLY

This marvelously fresh and energetic watercolor repeats,
with minor variations, a composition of male bathers
Cézanne had developed in the 1880s. The young men, of
whom several strike poses found in antique sculpture, are
arranged along a narrow stream, and two are actually in
the water. The vitality of the group stems, in part, from the
fact that nearly all the "drawing" is done with the brush in
swift, almost electric strokes of dark blue; the pencil lines
that set the forms are kept to a minimum. Two diving fig-
ures, shown half-length at the bottom of the page, can also
be found in other male Bather images, although never in
this closely related "stop-action" juxtaposition.

This work is closely related to a large oil sketch in a pri-
vate collection (V. 387).[1] Despite its tentative and unfin-
ished quality, the oil has often been cited as the source for
a color lithograph Cézanne made of this subject (fig. 1).[2]
As early as 1894 Ambroise Vollard began asking artists,

even those who had shown little interest in printmaking,
to create images that they, assisted by master printers,
would make into prints. Shortly after meeting Cézanne in
1896, Vollard encouraged him to make three lithographs: a
black-and-white self-portrait, a color print based on the
Barnes Foundation's *Bathers at Rest* (p. 279, fig. 1), and the
so-called *Small Bathers* (fig. 1). The *Small Bathers* seems to
be the only one Cézanne himself drew on the lithographic
stone (the others were transferred by craftsmen from his
drawings). It is possible that the Thaw drawing has a direct
relationship to that process, since all but two of the figures
share similar poses.

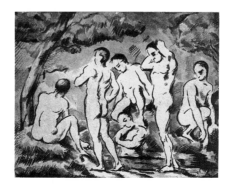

Fig. 1. Paul Cézanne,
Small Bathers, 1896-97,
color lithograph,
Öffentliche Kunstsammlung Basel,
Kupferstichkabinett.

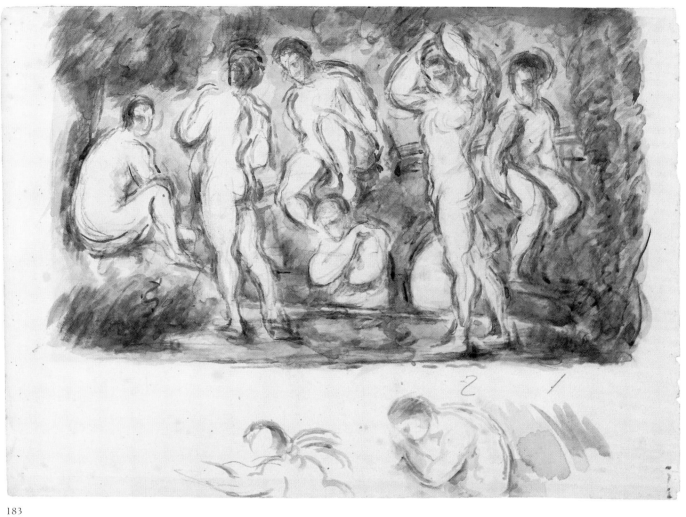

183

It is revealing that Cézanne would choose two male Bather subjects, one work from twenty-five years previous, to represent his art in this most public and broadly circulated form. One explanation may be found in the rejection by the French government, in 1894, of much of Gustave Caillebotte's collection of paintings by his fellow Impressionists. Among the much-debated paintings that were rejected were three by Cézanne, including, in all likelihood, the Barnes Foundation's *Bathers at Rest.* These Bather compositions seem to have been, for Cézanne, the imagery he most wanted to place before the public, the subjects he associated with the art of the museums to which he aspired so earnestly.

J. R.

1. See Krumrine, 1989, p. 187.
2. See Venturi, 1936, vol. 1, no. 1156, p. 287; and Druick, in New York and Houston, 1977-78, pp. 126-27.

184 | *The Pistachio Tree in the Courtyard of the Château Noir*

c. 1900
Graphite and watercolor on paper; 21$^{1}/_4$ × 16$^{15}/_{16}$ inches (54 × 43 cm)
The Art Institute of Chicago. Mr. and Mrs. M. A. Ryerson Collection
R. 516

PROVENANCE
This drawing was first owned by Georges Bernheim, Paris. By 1933 it was in the collection of Mr. and Mrs. M. A. Ryerson, Chicago,[1] who gave it to the Art Institute of Chicago in 1937.[2]

EXHIBITIONS
After 1906: Chicago and New York, 1952, no. 99; The Hague, 1956, no. 76; Zurich, 1956, no. 123; Munich, 1956, no. 95; Washington, Chicago, and Boston, 1971, no. 54; New York and Houston, 1977-78, no. 88; Paris, 1978, no. 57.

EXHIBITED IN PHILADELPHIA ONLY

The little room that Cézanne rented at the Château Noir opens onto a crudely defined courtyard, in the middle of which still stands a gnarled and venerable pistachio tree, its roots surrounded and contained by rough blocks of stone. An octagonal block, probably a wellhead, sits in one corner. The view opens to the east, toward Mont Sainte-Victoire, whose northern slope is barely suggested by long strokes of blue watercolor through the trees on the left. Around 1900 Cézanne made this site the subject of two watercolors (cat. no. 184 and R. 515), the present sheet standing as one of his most accomplished and masterful works.

In some of Cézanne's late watercolors, including this one, the union between his pencil and his brush—both of them "drawing" and "coloring" at the same time—attains an astonishing level of engagement. Any conventional pictorial language of "line" or "edge" becomes completely irrelevant when confronted with the way a stroke of color turns and then submerges under a dash of lead to form twisting branches or blocks of stone bathed in intense light. The piece is so beautifully wrought and so convincingly evocative of the place that the expressive associations such a subject invites—age, tenacity, struggle, survival—seem beside the point. Cézanne usually reserved this kind of emotional investment in his subjects for a different mode of handling, one in which color was given full ascendancy.

J. R.

1. See The Art Institute of Chicago, *Catalogue of a Century of Progress Exhibition of Paintings and Sculpture Lent from American Collections* (Chicago, 1933), no. 845, p. 89.
2. See Kate Lancaster Brewster, "The Ryerson Gift to the Art Institute of Chicago," *Magazine of Art,* vol. 31, no. 2 (February 1938), pp. 98-99.

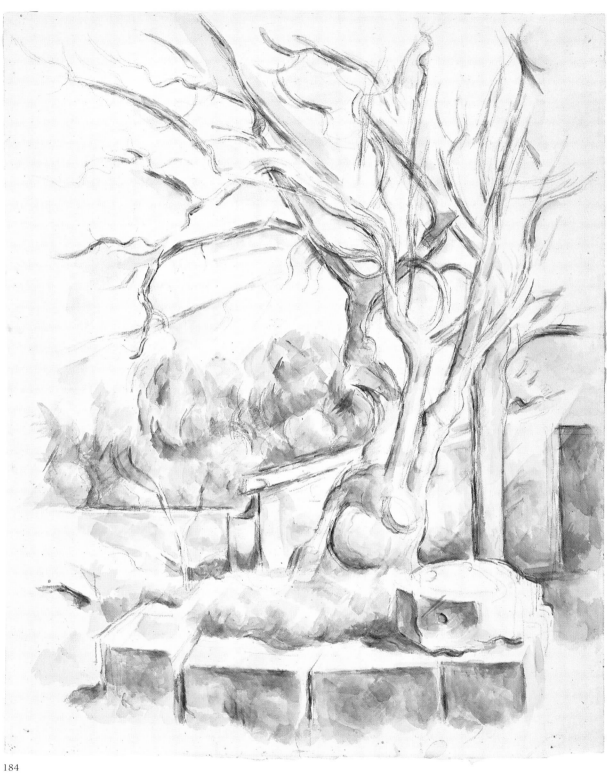

184

| *Dying Slave (after Michelangelo)*

c. 1900
Graphite on paper; 8¹/₂ × 5 inches (21.6 × 12.7 cm)
Philadelphia Museum of Art. Gift of Mr. and Mrs. Walter H. Annenberg, 1987-53-56a
C. 1208

PROVENANCE
This drawing was originally part of a sketchbook in the possession of the artist's son, Paul, in Paris. Subsequently this and several other sketchbooks were purchased from the artist's family by Renou and Poyet, Paris. Around 1950 this and four other Cézanne sketchbooks were purchased from the latter by the New York dealer Sam Salz. Shortly thereafter two of the sketchbooks were acquired by Mrs. Enid Annenberg Haupt, New York. At this point the pages were removed and mounted separately. Mrs. Haupt sold them to her brother, Walter Annenberg, and his wife, Leonore, who gave them to the Philadelphia Museum of Art in the winter of 1987.[1]

EXHIBITIONS
After 1906: Philadelphia, 1989, unnumbered.

EXHIBITED IN PARIS AND LONDON ONLY

Nearly one-fifth of the twelve hundred surviving drawings by Cézanne are after sculptures. The plaster putto attributed to Puget (see cat. nos. 161–65) and the small *écorché* then thought to be after Michelangelo (see cat. no. 111), which he had with him in Aix, were points of constant reference. When Cézanne was in Paris, he haunted the sculpture galleries of the Louvre as well as the collection of modern casts in the Musée de Sculpture Comparée at the Trocadéro. Many of the artist's sketches after sculptures have the quality of exercises, of Cézanne's literally "keeping his hand in" and sharpening the probity of his eye by rendering in two dimensions complex three-dimensional forms. It was a process begun in his early schooling, when he worked from the live model; he continued it with sculptures for the rest of his life. However, particularly when he was looking at a great work of art, there is also a sense that these drawings are part of another artistic search; Cézanne seems to have been seeking from the past those masters from whom he could learn the most and with whom he wished to align himself in the history of art.

The galleries of Italian Renaissance sculpture at the Louvre held a special attraction for Cézanne, not least because they housed the two colossal marbles Michelangelo carved for the tomb of Julius II: the so-called *Rebellious Slave* and *Dying Slave* (figs. 1 and 2). There are four sketchbook drawings of the former (C. 303, C. 589, C. 590, and C. 679) and three of the expiring figure, including the one shown here (as well as C. 473 and C. 678). Chappuis dated the earliest sheet to 1872-75, and this one toward 1900.

The Philadelphia page is, perhaps, the most complicated of the group, the one in which Cézanne employed the greatest variety of gestures with his pencil to set the figure in space and to study how it takes the light. "This immensely complex work . . . keenly analyzes contours and volumes with emphatic marks: convex and concave curves, straight and undulating lines, light hatching and strong black accents. All this is supple, lively, and perfectly articulated."[2]

This figure echoes through many of Cézanne's paintings of male nudes, where he stripped away much of Michelangelo's pathos but retained the sculpture's spiritual and sensuous languor. Cézanne was particularly taken with the gesture of the elbow raised in the air at an almost ninety-degree angle with the shoulder. He used this gesture to great effect in both his male and female bathing subjects.

J. R.

1. See Shoemaker, in Philadelphia, 1989, p. 15.
2. Jean-Pierre Cuzin and Marie-Anne Dupuy, in Réunion des Musées Nationaux, *Copier Créer de Turner à Picasso: 300 Oeuvres inspirées par les maîtres du Louvre* (Paris, 1993), no. 69, p. 126.

Fig. 1. Michelangelo, *The Rebellious Slave*, 1513-15, marble, Musée du Louvre, Paris.

Fig. 2. Michelangelo, *The Dying Slave*, 1513-15, marble, Musée du Louvre, Paris.

Lion and Serpent (after Barye)

c. 1900
Graphite on paper; 5 × 8¹/₂ inches (12.7 × 21.6 cm)
Philadelphia Museum of Art. Gift of Mr. and Mrs. Walter H. Annenberg, 1987-53-69b
C. 1210

EXHIBITED IN PARIS AND LONDON ONLY

Chappuis dated this drawing to about 1900 and grouped it with several others that Cézanne sketched from sculptures (see cat. no. 185). Cézanne's drawings after other works of art often have a quality of pensive exploration, as if he were pondering what use he might make of them later. However, in this group of late drawings, he concentrated with such force on the nature of converting three dimensions into two that they have a remarkable congruity with the observed object.

His subject is a sculpture by Antoine-Louis Barye (1796-1875) of a lion killing a snake, first shown in plaster in the Salon of 1833. The Romantic sculptor's most successful and most reproduced work, it was cast in numerous editions from desk-top scale to larger-than-life bronzes (fig. 1), one of which was in the Tuileries gardens in Cézanne's time (it was moved inside the Louvre in 1911). There was a plaster cast in the Musée de Sculpture Comparée at the Trocadéro, where Cézanne also made drawings. The version that he consulted must have been placed quite high, affording a dramatically low point of view.

With clusters of repeated strokes and a few very assured light lines, Cézanne distilled all the romantic intensity of this piece with powerful contrasts of light and dark. Clearly, there was something in the lion—violent, heroic, and virile—that held great appeal for him.

J. R.

1. See Shoemaker, in Philadelphia, 1989, p. 15.

Fig. 1. Antoine-Louis Barye,
Lion and Serpent, 1832-35, bronze,
Musée du Louvre, Paris.

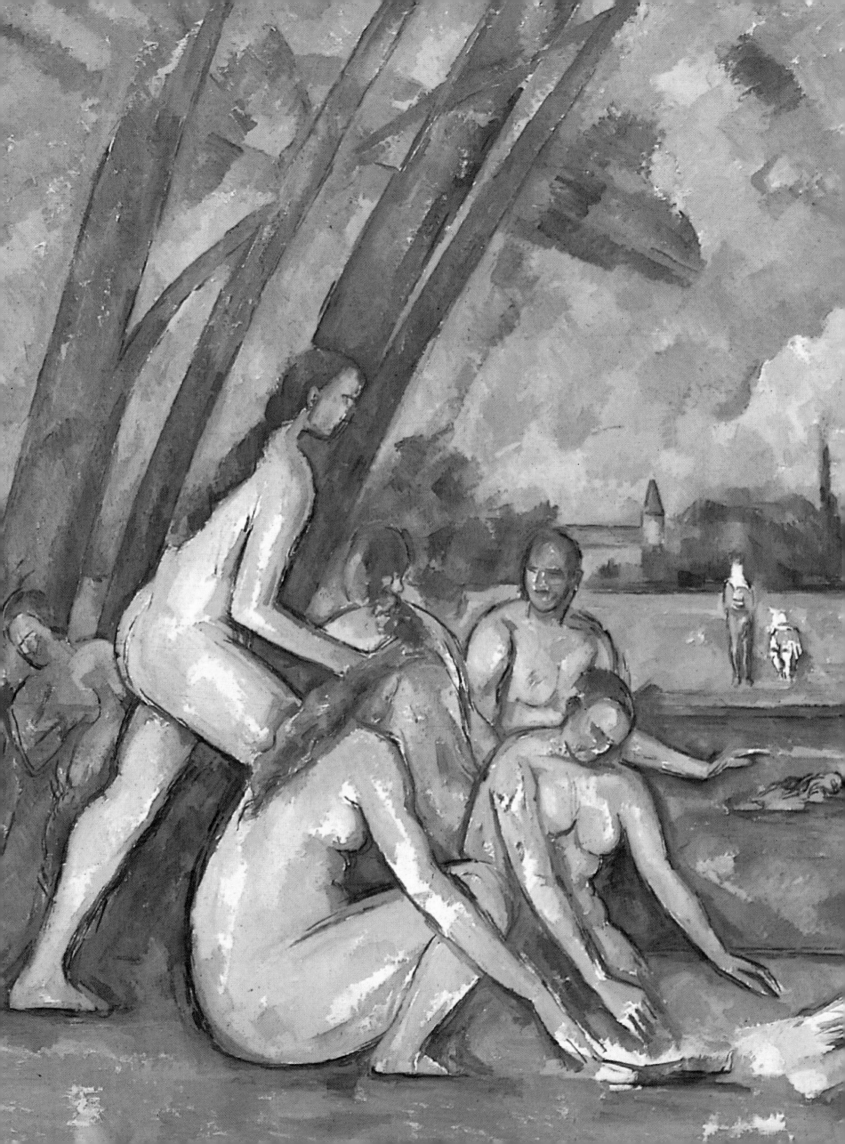

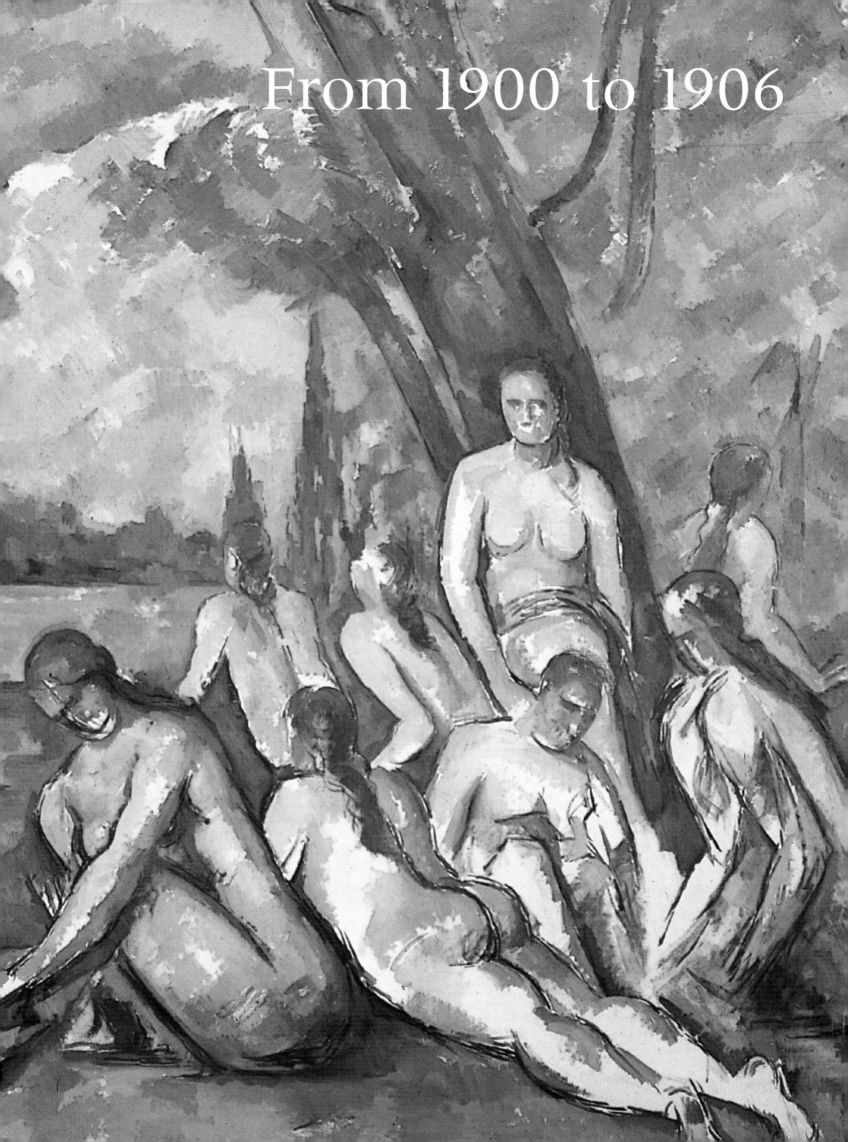

From 1900 to 1906

1898-1900
Oil on canvas; 40⁵/₁₆ × 29³/₄ inches (102.5 × 75.5 cm)
Nasjonalgalleriet, Oslo
V. 697

PROVENANCE
This picture's first owner was Odilon Redon, but both the date and the circumstances of his acquiring it are unknown. Doubtless the work is too late to have been shown at père Tanguy's shop; Paul Cézanne *fils* was probably the intermediary. Ambroise Vollard acquired it from Redon, probably in 1912. It then came into the possession of the collector Egisto Fabbri, Florence, and subsequently passed once more to Vollard, who included it in an exhibition of French art that traveled to Copenhagen and Oslo in 1914 and to Stockholm in 1917. In 1918 he sold the canvas to the Nasjonalgalleriet, Oslo.

EXHIBITIONS
After 1906: Berlin, 1909, no. 12; Cologne, 1912, no. 142; Copenhagen, 1914, no. 24; Oslo, 1914; Stockholm, 1917; Paris, 1936, no. 89; Chicago and New York, 1952, no. 121; The Hague, 1956, no. 46; Zurich, 1956, no. 77; Munich, 1956, no. 60.

EXHIBITED IN PARIS ONLY

In contrast to most of Cézanne's portraits from the late 1890s and early 1900s, the figure in this painting is neither a peasant nor a gardener. Was it executed at the Jas de Bouffan before 1899, when the property was sold, or (a more likely scenario) in the apartment on the rue Boulegon in Aix? Is the seated man a resident of the town—a tradesman, perhaps? A neighbor? A bailiff or other comparable official? Or perhaps a café-keeper? "I love above all things," said Cézanne, "the aspect of people who've grown old without changing their ways, abandoning themselves to the laws of time. I hate the efforts of those who resist these laws. Look at that old café-keeper sitting in front of his door under that spindle tree. What style!"[1]

The model with the drooping moustache may not be a cabaret-keeper, but his ruddy cheeks and ample belly indicate that he is indeed a bon vivant. He could be someone whom Cézanne knew from the public houses of Aix; perhaps he and the artist have just exchanged comments about some items in the newspaper resting on his leg. In any case, the face has a kind of spent melancholy that the painter has rendered sympathetically.

The composition is baffling. The model appears to sit on nothing at all, for there's not the slightest trace of a chair leg or back in sight. He is in front of a blond wood sideboard rendered in peculiar perspective—it seems about to float away—on which rest some objects that, aside from a black bottle, elude identification. The hanging drapery—the same as that depicted in *Young Man with Skull* in the Barnes Foundation (V. 679), as well as in several still lifes, including *Still Life with Curtain and Flowered Pitcher* and *Apples and Oranges* (cat. nos. 180 and 181)—is here suspended against a brick-red wall in the background. Some of its folds have been manipulated into a kind of aureole for the head, as if in answer to the arcs of the skull and the drooping moustache. And there are other intriguing features. What, for instance, is the meaning of the defect in the upper right corner? Was this triangular piece of canvas added to repair some damage? To effect some significant modification?

The juxtaposition of an unpretentious decor and an imposing figure of classical, even monumental aspect gives this portrait a singular quality, for the intermingling of the lofty and the rustic here has a remarkable piquancy. It should be recalled that this portrait was immediately appreciated by another great artist, though one whose sensibility was quite different from Cézanne's: Odilon Redon, who also figures in Maurice Denis's *Homage to Cézanne* (repro. pp. 22-23). Judging from a remark made by Cézanne in a letter to Émile Bernard, the admiration was mutual: "I've already told you that I like Redon's talent very much, and I share his deep feeling for and admiration of Delacroix."[2]

F. C.

1. Cited by Borély, July 1, 1926; reprinted in Doran, 1978, p. 21.
2. Cézanne to Bernard, May 12, 1904, in Cézanne, 1978, p. 301.

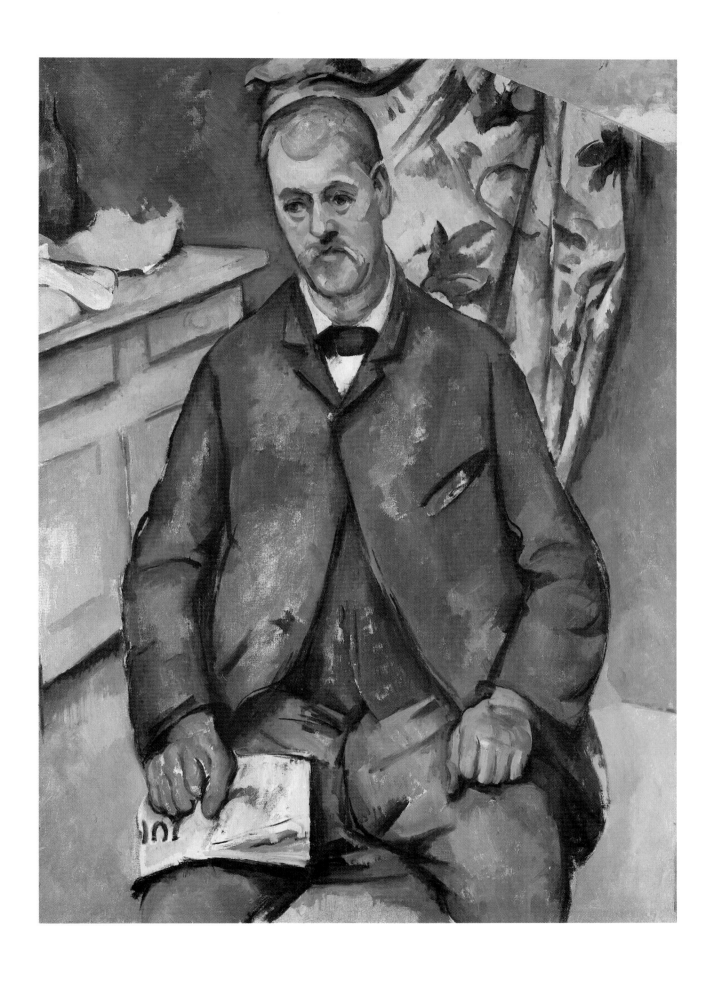

Woman in Blue

1900-1904
Oil on canvas; 35³/₈ × 28³/₄ inches (90 × 73 cm)
The Hermitage Museum, St. Petersburg
V. 705

PROVENANCE
Sergei Shchukin acquired this picture from Ambroise Vollard sometime between 1906 and 1912; it entered the collection of the Museum of Modern Western Art, Moscow, in 1918; it was transferred to the Hermitage Museum, Leningrad, in 1948.

EXHIBITIONS
After 1906: Moscow, 1926, no. 20; Leningrad, 1956, no. 21; New York and Houston, 1977-78, no. 54; Paris, 1978, no. 11; Tübingen, 1993, no. 77.

The formalist tradition of Cézanne criticism maintains that the artist's subjects were a matter of indifference to him, and in making their case its defenders point, above all, to his portraits. Lawrence Gowing, for instance, wrote about the present painting as follows: "Two little portraits of a lady in a tailored blue jacket with black lapels and a flowered black hat are like pendants to the 'great' still lifes; they may have been among the pictures painted in the rue Boulegon at Aix before the studio on the Chemin des Lauves was finished in 1902. The first [fig. 1] . . . is massively modeled in light and dark and sharply characterized. . . . In the second, although the chiaroscuro remains as deep, modulations of color take over the rendering of volume. The summits of the relief have patches of pink. From pink the progression passes to yellow-buff and emerald on the way to the local hue of cobalt blue, and thence to the surrounding black, loosely following the recession, but less as an exposition than as a descant. Far from systematic though the color is, its primacy and its codification involve a change in the role of the human subject. The lady's face appears transfixed, emptied of personal or expressive character. The features themselves and the red triangle of the cheek are isolated in the mask, like a pattern, as remote from any function or purpose as the red bouquet on the tablecloth."[1]

Douglas Cooper went still farther, writing that Cézanne was "quite indifferent to his sitter's face or character. . . . His portraits have great vitality, but because of their plastic organization not because of the sitter's personality."[2]

Nevertheless, the artist simplified and refined his pictorial means to create a powerful image of a singular individual. In the words of Cézanne himself: "It's necessary to see one's model clearly, to feel on pitch, and still express oneself with distinction and force. Taste is the best judge. It is rare."[3]

But who is this woman in blue who seems to pose so reluctantly, eager for the trial to end? Madame Cézanne has been proposed[4] (as with most of the artist's female portraits at one point or another), but it is certainly not she. The canvas was probably painted between 1900 and 1904—by which time Hortense Fiquet-Cézanne was no longer posing for her husband—a dating supported by the many features this work shares with others painted after the turn of the century, notably the colorful patterned carpet that can be seen in other works (*Italian Girl Leaning on Her Elbow*, V. 701) and several of the late still lifes (see cat. no. 197), including some of the *Skulls* (see cat. no. 213).

This was the period during which Cézanne painted many portraits of those in daily contact with him—in effect, the guardians of his old age. There is no reason, for example, why this could not be a likeness of the faithful Madame Brémond, Cézanne's housekeeper and cook, gotten up in her Sunday best.[5] The blue jacket with dark blue lapels, perhaps made of velvet, and the flowered hat also appear in a picture that seems to depict the same person reading a book, although there the face looks more square and somewhat older (fig. 1).

The image of this timid, dignified woman, whether a housekeeper or a female visitor, is anything but indifferent. Neither the gentleness of her face nor the slightly ridiculous effect of her elegant *bibi*, or forward-set hat—surely it is a mistake to presume that Cézanne never amused himself in his work—diminishes her impressive presence, conveyed by the assertive structure of bluish masses as well as by the powerful hands, which like the face are rendered in strong light.[6]

The background is difficult to construe. The dark, oblique form to the left of the sitter resists identification; it could be a structural beam in an attic room of the rue Boulegon apartment. But it is more likely that the picture was painted at the Chemin des Lauves studio after 1902, and this passage could evoke a painting resting on the floor

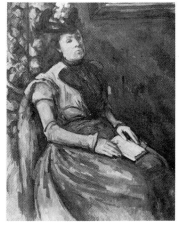

Fig. 1. Paul Cézanne,
Seated Woman in Blue, 1902-6,
oil on canvas,
The Phillips Collection, Washington, D.C. (V. 703).

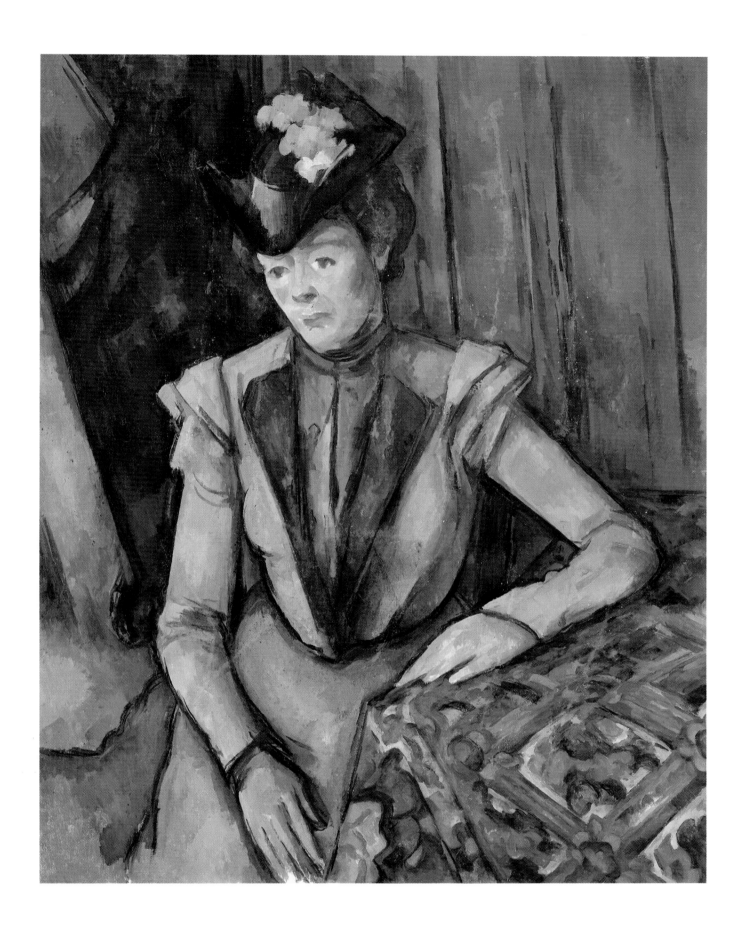

behind the model and to the left. This may be the upper right corner of one of the three *Large Bathers*—perhaps the version in the Barnes Foundation (repro. p. 39)—in which case we see a schematized depiction of the top portion of the tree trunk leaning to the left. If so, the contrast between the very proper sitter and the Dionysiac scene featuring several female nudes, cropped out of the picture on the left—but visible to Cézanne as he worked—adds a humorous overtone to the work.

F. C.

1. Gowing, in New York and Houston, 1977-78, p. 64.
2. Cooper, June 1938, p. 263.
3. Cézanne to Émile Bernard, May 12, 1904, in Cézanne, 1978, p. 301.
4. See Ministère d'État Affaires Culturelles, *Chefs-d'oeuvre de la peinture française dans les musées de Léningrad et de Moscou* (Paris, 1965), no. 49, p. 129.
5. See Rewald, in New York and Houston, 1977-78, no. 53, p. 402. Reff (in New York and Houston, 1977-78, p. 22) was inclined to think the painting represented one of Cézanne's sisters, which seems unlikely.
6. Reff (in New York and Houston, 1977-78, p. 22) discerned a traditional approach here: "Here, as in many seventeenth-century portraits, the head and hands alone are strongly lit and much of the figure remains in shadow. It is perhaps the most fully Baroque in style of Cézanne's late portraits."

189 | ## *The Château Noir*

1900-1904
Oil on canvas; 29 × 38 inches (73.7 × 96.6 cm)
National Gallery of Art, Washington, D.C. Gift of Eugene and Agnes E. Meyer, 1958
V. 796

PROVENANCE
Ambroise Vollard sold this canvas to Marius de Zayas, who opened his own gallery in New York and actively promoted the work of Cézanne and other modernists. De Zayas sold this painting to Eugene Meyer for $10,000.[1] The painting was given by Eugene Meyer and his wife Agnes to the National Gallery of Art in 1958.

EXHIBITIONS
After 1906: Paris, 1907 (b), no. 49 (?); London, 1912, no. 2; New York, 1921, no. 23; New York and Houston, 1977-78, no. 34; Paris, 1978, no. 51.

This is one of four oil paintings of the Château Noir that Cézanne made from this general viewpoint (with V. 794, V. 795, and V. 797). These works have been regarded as the darkest expressions he would make of the landscape east of Aix. The site itself, with its grotesque architecture secluded on a steep bluff amid dense pine woods, was always implicitly sinister, but it seems to have struck Cézanne in this way only near the end of his life. By contrasting the deep greens and purples of the shadowy trees with the brightly lit orange facade of the house, Cézanne has charged the site with a gothic emotionalism worthy of Delacroix.

The artist situated himself on the path that leads to the Château Noir, at a height that permitted him to depict its terrace and facade head-on against the distant cliffs of Le Cengle. The path disappears into the woods on the left. Beneath and beyond it rises a dense barrier of trees, their branches intermeshed, past which the house seems forbiddingly remote and impossible to reach. The charm of a hidden palace in the forest, such as one might find in the Chicago watercolor of the Château Noir (cat. no. 191), is here less childlike and more disturbing.

Though Cézanne constructed his space in contrasts of light and dark, placing the château in an eerie hot spot of intensity, the even saturation of the colors unifies them in a particularly dense, containing way. Any conventional means of escaping into space is thwarted, first by the menacing tangle of branches coming in on the right and then by the somber profile of Le Cengle beyond the building. In addition, the sky, playing through the branches of the tree in dashes of green and leaden blue, is weighty and compressed. The paint, very lean and built up in thick layers, creates a relief of overlapping patterns that attests to the painting's long and labored execution.

Cézanne rarely cast the landscape of Provence in this sad and desperate mood. The brutal image of *The Great Pine* (cat. no. 153), for example, which partook of similarly abrupt and angular forms, seems exalted and wondrously declarative in comparison to this airless, menacing, and desolate space. The château, with the blue of the sky reflected in its second-story windows, seems completely lifeless, a skull without eyes. This is not, of course, an incarnation of the romanticism of Delacroix or even Victor Hugo, as much as Cézanne may be rekindling those passions from his youth. The pervasive tension and fear evinced in this work, instead, suggest a sensibility that is quite modern, a profoundly unsettled quality, always held in restraint through his strong personal resolve.

J. R.

1. See Rewald, 1989, p. 305.

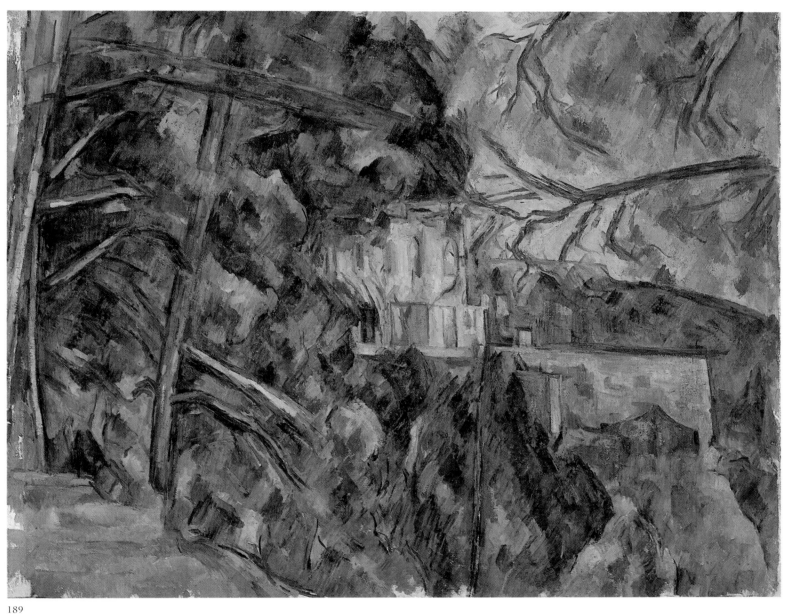

189

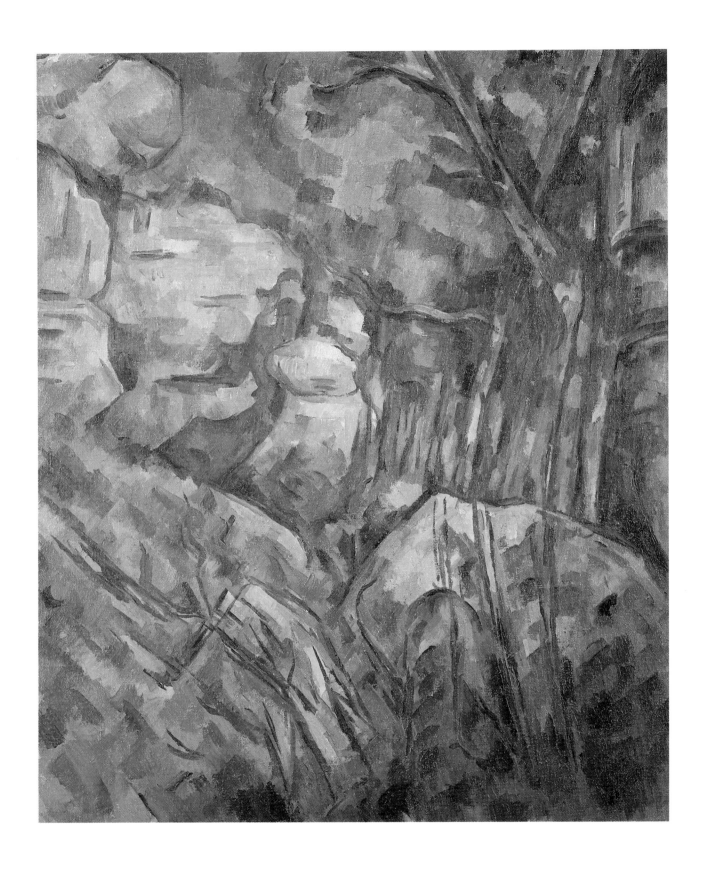

190 | *Rocks Near the Caves Above the Château Noir*

c. 1904
Oil on canvas; 25⁹/₁₆ × 21¹/₄ inches (65 × 54 cm)
Musée d'Orsay, Paris (R.F. 1978-32)
V. 786

PROVENANCE
It was in all likelihood the Galerie Bernheim-Jeune that sold this picture, at an unknown date, to Henri Matisse, its first owner; he subsequently left it to his son Jean Matisse. It was ceded by Mme Jean Matisse to the Jeu de Paume in lieu of taxes in 1978, and was transferred to the Musée d'Orsay in 1986.

EXHIBITIONS
After 1906: Paris, 1924, unnumbered; Paris, 1978, no. 54; Liège (no. 47) and Aix-en-Provence (no. 12), 1982; Aix-en-Provence, 1990, no. 34.

EXHIBITED IN PARIS ONLY

"Cézanne applied some blue to make his yellow sing, but he used it with the discernment that was characteristic of him on every occasion, him, and him alone," wrote Henri Matisse.[1] Perhaps he was thinking of this canvas, which he could contemplate at leisure because it was in his own collection. It is well known that Matisse, like almost all the great painters of his generation, was a passionate admirer of Cézanne's work. As early as 1899 he had acquired *Three Bathers* (cat. no. 60), to which he gradually added examples from each of the artist's other principal thematic groups: a still life (V. 613), two portraits (p. 293, fig. 1, and cat. no. 126), and this remarkable landscape, one of Cézanne's most inventive in its facture and one of his most simplified—in short, one of his most "modern" exercises in the genre.

The motif of trees amid rocks, whether in their natural state or shaped by the hand of man as in the nearby quarries (see cat. no. 149),[2] occurs almost as frequently in Cézanne's oeuvre as that of Mont Sainte-Victoire. From the 1890s until his death he loved to immerse his gaze in these fragments of nature, both tumultuous and still, lacking a horizon line and perspective. The resulting works depict primordial landscapes in which the struggle between the vegetal and the mineral has produced an uneasy equipoise of forces, powerfully translated by Cézanne into plastic terms. The painter built up his picture with broad strokes of pigment that weave the forms together pictorially. To cite Henri Matisse: "There are architectural laws in Cézanne's work that are quite useful for young painters. He had, among the greatest, the merit of endeavoring, giving to his task of painting its highest mission, to make his colors *forces* in a picture."[3]

There are many watercolors that, like this canvas, counter thin straight lines of trees with the rounded forms of rocks (see cat. nos. 150 and 151).[4] Furthermore, the lightness of touch here exemplifies the interaction between watercolor and oil techniques that was characteristic of Cézanne's late production.

"His method was singular," reported Émile Bernard (who had watched him paint), "totally outside conventional means, and of an excessive complication. He began on the shadows with a single patch, which he then overlapped with a second, and a third, until all these hues, making a screen, modeled the object by coloring it. I understood immediately that his work was guided by a law of harmony and that the direction of all his modulations was fixed in advance, in his reason. In short, he proceeded in the same way as the old tapestry-weavers must have done, making related colors succeed one another until they met up with their contrast in the opposition."[5]

F. C.

1. Matisse, "Notes d'un peintre," *La Grande Revue*, vol. 52, no. 24 (December 25, 1908); reprinted in Dominique Fourcade, ed., *Henri Matisse: Écrits et propos sur l'art* (Paris, 1972), p. 74.
2. See also cat. no. 227, V. 768, V. 773-88, and V. 792. All of these works were painted between 1895 and 1904 in the Bibémus quarry or in the pine forest around the Château Noir.
3. Matisse, cited in Jacques Guenne, "Entretien avec Henri Matisse," *L'Art Vivant*, no. 18 (September 15, 1925); reprinted in Fourcade (see note 1 above), p. 84.
4. See also the watercolors R. 336, R. 418, R. 420, R. 422, R. 423, R. 436, R. 442, R. 508, and others.
5. Bernard, October 1 and 15, 1907; reprinted in Doran, 1978, p. 59.

| *The Château Noir*

c. 1904
Graphite and watercolor on paper; 16 × 21 inches (40.6 × 53.3 cm)
Private collection, Chicago
R. 636

PROVENANCE
This watercolor originally belonged to the Galerie Bernheim-Jeune.
Thereafter it passed to the dealer Jacques Seligmann, Paris and New York.
It was subsequently acquired by Mrs. Potter Palmer, Jr., Chicago, and re-
mains in the family.

EXHIBITIONS
After 1906: Paris, 1907 (a), no. 1; Berlin, 1907, no. 1; New York, 1933 (b),
no. 2; Paris, 1936, no. 138; Chicago and New York, 1952, no. 116; Wash-
ington, Chicago, and Boston, 1971, no. 58; New York and Houston, 1977-
78, no. 111; Paris, 1978, no. 55.

EXHIBITED IN PHILADELPHIA ONLY

This view shows the facade of the Château Noir with the
red door and ogive windows, facing west, from a vantage
point along the path that leads to the Maison Maria (see
cat. no. 145). Any interest Cézanne may have had in an
objective description of the structure, such as was evi-
denced almost fifteen years earlier in the Rotterdam water-
color (cat. no. 119), was here set aside. His intent in this
work, depicting the trees and the stuccoed facade in
oblique afternoon sunlight, appears to be entirely expres-
sive. The rather shabby and half-built château has as-
sumed the qualities of a magical and forbidden palace, a
castle hidden by a romantic turn of fate. The walls, isolated
and withdrawn, are splendid gold in the even light; the
forest is aflame with shifting tones and tangled lines.
Cézanne, for whom the intense romanticism of Delacroix
and of his own youth was never far below the surface, here
merged his considerable powers of observation with his
equally formidable abilities to invent, and to dream.

All the elements were established on the page with a
nervous network of pencil lines that was often disregarded
when overwashed with complex layers of color, some of
which overlap and blend, still wet, into the paper. Only
the ocher tones of the house and terrace wall were brushed
in deliberate and even dashes. The colors of the foliage
have a darting, shifting rhythm. Cézanne was perhaps un-
satisfied with the dazzle of color he had placed before the
single planar form; with the point of a brush dipped in blue
and black pigment he reinforced the pencil marks of the
tree trunks and branches, creating sprays of radiating
lines that add yet another expressive level. The final ef-
fect is one of dazzling animation throughout the densely
worked sheet.

J. R.

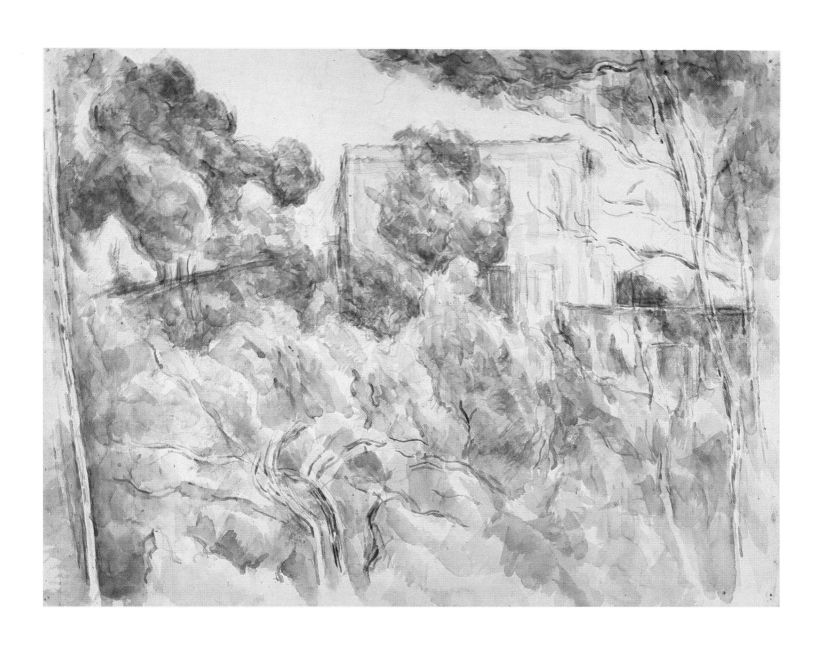

The Forest

1900-1904
Graphite and watercolor on paper; $22^{3}/_{8} \times 17^{1}/_{8}$ inches (56.8 × 43.5 cm)
The Newark Museum. Gift of Mrs. C. Suydam Cutting, 1950
R. 531

PROVENANCE
This watercolor was in the possession of the Moderne Galerie, Lucerne.
Thereafter it was with Justin K. Thannhauser, New York, who sold it to
Mrs. C. Suydam Cutting, New York. It is now in the Newark Museum,
given by Mrs. Cutting in 1950.

EXHIBITIONS
After 1906: Basel, 1936, no. 85; Chicago and New York, 1952, no. 104;
Newcastle upon Tyne and London, 1973, no. 93; New York and Houston,
1977-78, no. 98; Paris, 1978, no. 71.

EXHIBITED IN PARIS AND LONDON ONLY

Rewald identified the site depicted here as the place on the
crude road connecting the Château Noir with the Maison
Maria (see cat. no. 145) where it makes a sharp bend,
marked by an ancient cistern, visible in this watercolor at
the far right. The distinctive concentration of oak saplings
growing up amid the boulders shows that in the arid land-
scape this particular spot had accumulated a reserve of
groundwater. Just to the left and behind the viewer are
the rough-cut millstones from an abandoned olive press.

It was one of Cézanne's favorite haunts, offering the se-
clusion he deemed necessary for his work, particularly at
this stage in his career. It also must have been an agree-
ably cool and protected place, sheltered from the intense
Provençal sun. Cézanne did some of his most meditative
and serene landscapes at this site (fig. 1), and this is the
most complex and finished of the watercolors.

Characteristic of nearly all Cézanne's watercolors is the
interplay of line and color on the page. In his late works,
line and color merge in such a way that these elements—a
dash of color or an extended pencil line—not only set a
plane in space or define a tree trunk, but do both simulta-
neously, magically. In this watercolor the strokes of blue
accenting many of the contours situate the objects in picto-
rial depth just as much as the ocher and green patches of
color convey the volume of a boulder or a tree. Because
the steep hillside enclosed the view, the sheet has become
a tapestry of forest colors that continues to the top edge.
Perhaps to compensate for the absence of any release into
the sky at the top, Cézanne stepped back slightly from the
path in the foreground and let the paper, and the broad
wash of purple, open up the image, in reverse, as it were.
All of this is carried out in a spirit of lively but unhurried
ease, in keeping with the almost secret intimacy of this
place.

<div align="right">J. R.</div>

Fig. 1. Paul Cézanne,
The Cistern in the Park of the Château Noir, c. 1900,
oil on canvas,
The Art Museum, Princeton University, on loan from
the Henry and Rose Pearlman Foundation (V. 780).

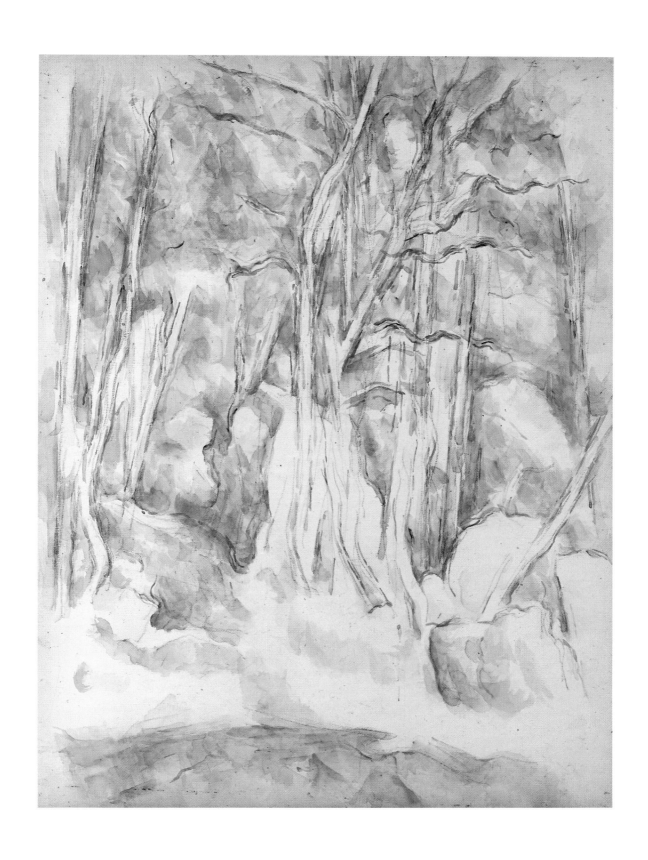

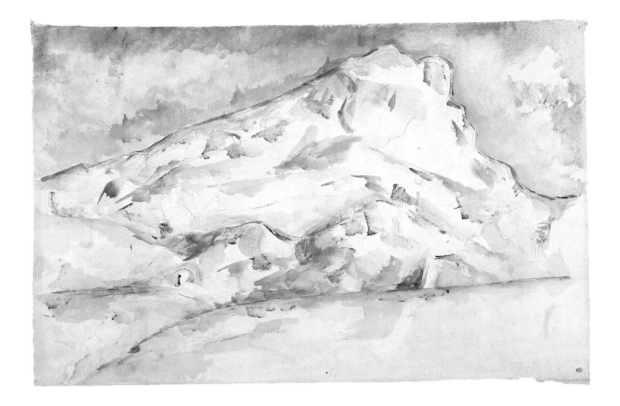

193 | *Mont Sainte-Victoire*

1900-1902
Graphite, gouache, and watercolor on paper; 12$^{1}/_{4}$ × 18$^{3}/_{4}$ inches (31.1 × 47.7 cm)
Musée du Louvre, Paris. Département des Arts Graphiques. Musée d'Orsay
R. 502

PROVENANCE
Ambroise Vollard sold this watercolor to Leo and Gertrude Stein, Paris, in the first decade of the twentieth century.[1] The watercolor passed solely to Gertrude Stein after her brother Leo's death. Thereafter it may have come into the possession of the dealer Paul Rosenberg, Paris. It was subsequently acquired by Baron Kojiro Matsukata, Kobe and Paris, who had begun his collection in 1916 with the intention of creating a public museum of Western art in Japan. Although much of his collection remained in France during World War II, the French government agreed to its return at the war's end. This collection formed the core of the National Museum of Western Art, Tokyo, which opened in June 1959.[2] In the same year this watercolor entered the collections of the Musée du Louvre in keeping with the peace treaty with Japan.[3]

EXHIBITIONS
After 1906: Aix-en-Provence, Nice, and Grenoble, 1953, no. 50; Aix-en-Provence, 1956, no. 87; Munich, 1956, no. 152; Cologne, 1956-57, no. 46; Paris, 1974, no. 64; New York and Houston, 1977-78, no. 96; Paris, 1978, no. 81.

EXHIBITED IN PHILADELPHIA ONLY

There is a moment in the late work of Cézanne when the watercolors and paintings became so similar that their points of view and means of investigating them were almost interchangeable. This ravishing sheet is one of several watercolor studies (see R. 498, R. 503, R. 504) of Mont Sainte-Victoire from behind the Château Noir. From this vantage the mountain seems very close, even though the valley leading to the village of Le Tholonet (and containing Zola's father's dam) lies over the first rise of ground.

This watercolor closely resembles a painting now in Michigan (p. 264, fig. 2). Both works convey the way in which, on a splendidly limpid day, Provence is bathed in a pervasive blue light. Even Cézanne's methods for the painting and the watercolor are not so different; the white tones are represented by exposed canvas or paper. Perhaps the most significant difference is the extra degree of freshness Cézanne could achieve with watercolor, a medium that retains the appearance of wetness.

Rewald has observed that this work was originally even more brilliant, before the touches of opaque lead white Cézanne used to define the contours of the mountain began to oxidize into dark spots. "These spots, added to the staccato execution, create a kind of unrest that obviously goes beyond Cézanne's intention."[4]

J. R.

1. Leo Stein was introduced to Cézanne's work by Bernard Berenson, who suggested to Stein in the spring of 1904 that he go and see the artist's work at the gallery of Ambroise Vollard. See Irene Gordon, "A World Beyond the World: The Discovery of Leo Stein," in The Museum of Modern Art, *Four Americans in Paris: The Collections of Gertrude Stein and Her Family* (New York, 1970), pp. 13-33.
2. See Soichi Tominaga, introduction to The National Museum of Western Art, *Masterpieces of the Ex-Matsukata Collection* (Tokyo, 1960), n.p.
3. See Michel Hoog, in Paris, 1974, no. 64, p. 154.
4. Rewald, 1983, no. 502, p. 210.

194 | *Group of Trees*

c. 1900
Graphite and watercolor on paper; 18 × 11³/₄ inches (45.7 × 29.8 cm)
The Pierpont Morgan Library, New York. The Thaw Collection
R. 538

PROVENANCE

This watercolor, probably one of the 187 watercolors by Cézanne owned jointly by Bernheim-Jeune and Vollard, was then purchased by Paul Vallotton, Lausanne, Bernheim-Jeune's Swiss branch. From him it went to a private collection in Switzerland and then to Wildenstein Galleries, New York, from whom it passed to Lazarus Phillips, Montreal. It was sold through Wildenstein Galleries to the Thaw Collection.

EXHIBITIONS
After 1906: New York, 1959 (b), no. 76; New York, 1963 (a), no. 62; Washington, Chicago, and Boston, 1971, no. 55; Tokyo, Kyoto, and Fukuoka, 1974, no. 80; New York and Houston, 1977-78, no. 101; New York, 1994-95, no. 99.

EXHIBITED IN PHILADELPHIA ONLY

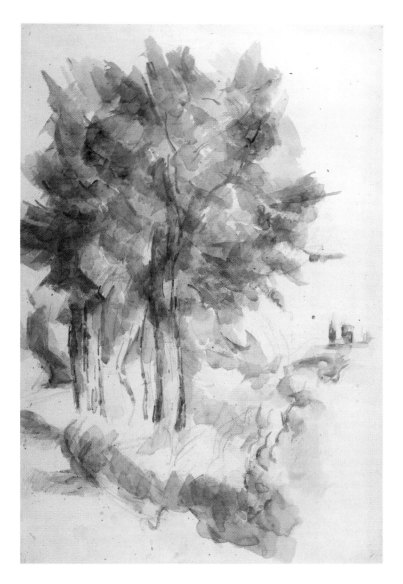

Some late Cézanne watercolors have a profusion of brushstrokes that suggests bursts of fireworks or pulsating kaleidoscopes of color. In part because of its remarkable freshness and fine state of preservation, this landscape stands out even from these remarkable works. Lively, overlapping washes of blue, green, yellow, and orange are loosely interspersed with sparkling passages of bare white paper to depict the full summer foliage of a group of trees growing out of a ravine at the edge of a bending road. The interplay of undulating curves of the three trees to the right introduces a still greater degree of energy and vitality. On the far left, the fourth and largest tree, upright and solid, would seem to be the one stabilizing element, but this role is betrayed by the riotous explosion of branches that fan out in abrupt folds from its crown.

A stretched accordion of overlapping lavenders, greens, and yellows describes the undergrowth at the edge of the road. A few soft pencil lines keep this rhythm in play through the rocks tumbling down the slopes just beyond. These are reinforced by quick commas of watercolor, painted with the tip of the brush, over the bushes on the ascending bank to the right.

The site has not been identified; as Reff has noted, this would appear to be its only appearance in Cézanne's oeuvre.[1] The way the road hugs the hill, as well as the sharp changes in elevation, suggests a point somewhere along the Tholonet road on the way to the Château Noir. However, nearly all of Cézanne's depictions of the area have a contained and rather mysterious quality, like the hidden and isolated nature of the place itself. This bend in the road, by contrast, is completely open and airy, pulsating with a verdancy and an animation perhaps foreign to the Aix landscape. Wherever this place was, it triggered in Cézanne a particularly forceful surge of creative energy.

J. R.

1. See Reff, March 1960, p. 118.

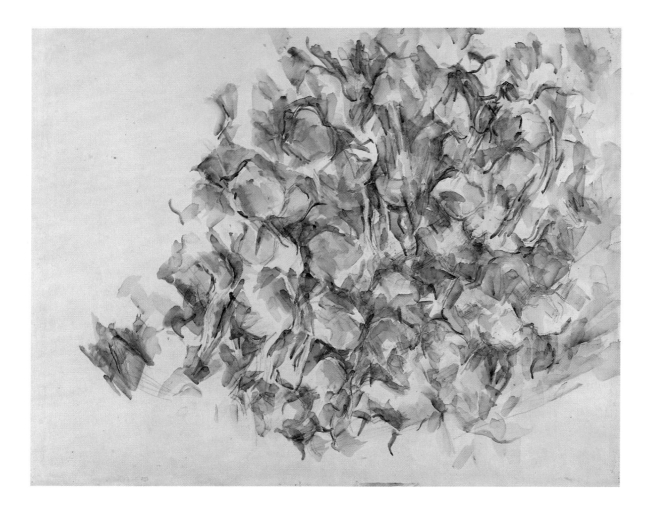

195 | *Study of Leaves*

1900-1904
Graphite and watercolor on paper; 17⁵/₈ × 22³/₈ inches (44.8 × 56.8 cm)
The Museum of Modern Art, New York. Lillie P. Bliss Collection, 1934
R. 551

PROVENANCE
This watercolor was originally in the possession of the artist's son, Paul, who sold it in 1907 to the Galerie Bernheim-Jeune. It was purchased by the Montross Gallery, New York, and Lillie P. Bliss acquired it in 1916 from their exhibition of Cézanne's work. She bequeathed it to the Museum of Modern Art, in 1931. It entered their collection in 1934.

EXHIBITIONS
After 1906: Paris, 1907 (a), no. 44; Berlin, 1907, no. 40; Paris, 1909, no. 3; New York, 1916, no. 35; New York, Andover, and Indianapolis, 1931-32, no. 21; Philadelphia, 1934, no. 50; Chicago and New York, 1952, no. 125; New York, 1963 (a), no. 42; Washington, Chicago, and Boston, 1971, no. 49; Newcastle upon Tyne and London, 1973, no. 90; New York and Houston, 1977-78, no. 69; Paris, 1978, no. 29.

As Chappuis noted, this is the type of Cézanne image that is often reproduced or even hung on the wall upside down,[1] and it is not difficult to see why. Leaves composed of alternating green and yellow strokes radiate from an indeterminate center in a wonderfully organic way. Through these thread blue and purple lines, clearly branches, interspersed with patches of pink (roses, according to Rewald; geraniums, according to Chappuis). From the right side of the page, this exuberant plant seems to grow with little concern for the laws of either gravity or phototropism. Like the close-up views of rocky ledges (cat. nos. 150 and 151) that present similar problems of orientation, these works, because of their alleged tendency toward incipient abstraction, are seen as stepping stones toward developments in art after Cézanne.

Yet our problem with Cézanne's "ambiguities" seem, in the end, always to be ours and not his. Cézanne, probably from a level slightly above his motif, looked down on this living thing that amused him sufficiently to record it, outlining its shapes quickly with pencil, and then, seemingly, to fly over the page with his brush. As Sarah Faunce has noted, "we do not know whether this is plant, bush, or tree. There is no certainty of location or security of human control; we are plunged directly into a mass of living growth, in which the only order is that of the artist's touch."[2]

J. R.

1. See Chappuis, July-September 1971, p. 22.
2. Faunce, in New York, 1963 (a), no. 42, p. 45.

196 | *Still Life with Carafe, Sugar Bowl, Bottle, Pomegranates, and Watermelon*

1900-1906
Graphite and watercolor on paper; 12³/₈ × 17 inches (31.5 × 43.1 cm)
Musée du Louvre, Paris. Département des Arts Graphiques. Musée d'Orsay (R.F. 38979)[1]
R. 562

PROVENANCE
After passing through the hands of several dealers—Ambroise Vollard, Gérard, Jacques Dubourg in 1944—this watercolor long remained unknown and was identified by Venturi only in 1952. It was ceded to the Musée d'Orsay in lieu of estate taxes in 1982.

EXHIBITIONS
After 1906: Paris, 1985-86, no. 130.

EXHIBITED IN PHILADELPHIA ONLY

Over a brief span of time Cézanne executed two watercolors representing different configurations of the same objects: a watermelon, some pomegranates, a sugar bowl, a carafe, and a bottle.[2] The elements were arranged in accordance with purely plastic criteria: the roundness of their forms, the contrast of their colors, and their transparency or opacity. After quickly sketching in the basic outlines of his design, the artist set about impetuously adding color with a heavily loaded brush. The pencil lines were only provisional indicators, and as often as not he ignored them, reworking the contours with agile strokes. These revisions are quite visible on the watermelon and the pomegranate in the center of the composition. The contours of the fruit and the carafe are indicated with discontinuous blue lines, whereas much of the faience sugar bowl is defined by areas of virginal white. Cézanne proceeded by covering the surface of the paper with patches of color but left empty spaces here and there that make the whole seem to exhale light. Extremely diluted touches, applied side by side, overlap where they meet to enhance the tones with rich nuances: a pinkish yellow for the pomegranates and a blue violet inflected with green and yellow for the watermelon, the sides of the sugar bowl, and the bottle. The multiple lines and brushstrokes, which sweep across the surface of the paper as if without any preconceived program, imbue this composition with that extraordinary sense of freedom and movement so characteristic of Cézanne's late watercolors.

I. C.

1. The verso of the sheet carries a watercolor of flowers and a landscape.
2. The other watercolor is *Still Life with Watermelon and Pomegranates*, 1900-1906, collection of Mr. and Mrs. Walter Annenberg, Palm Springs, California (R. 561).

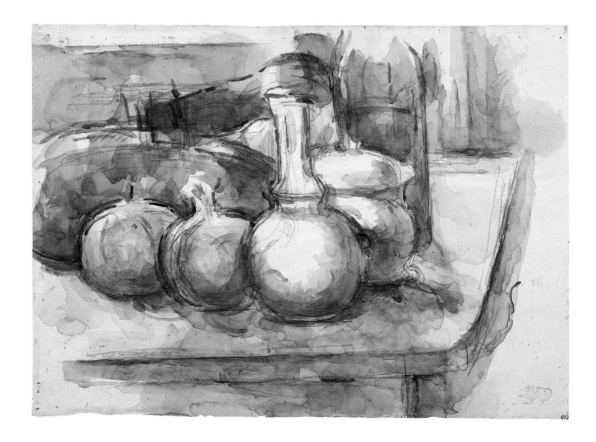

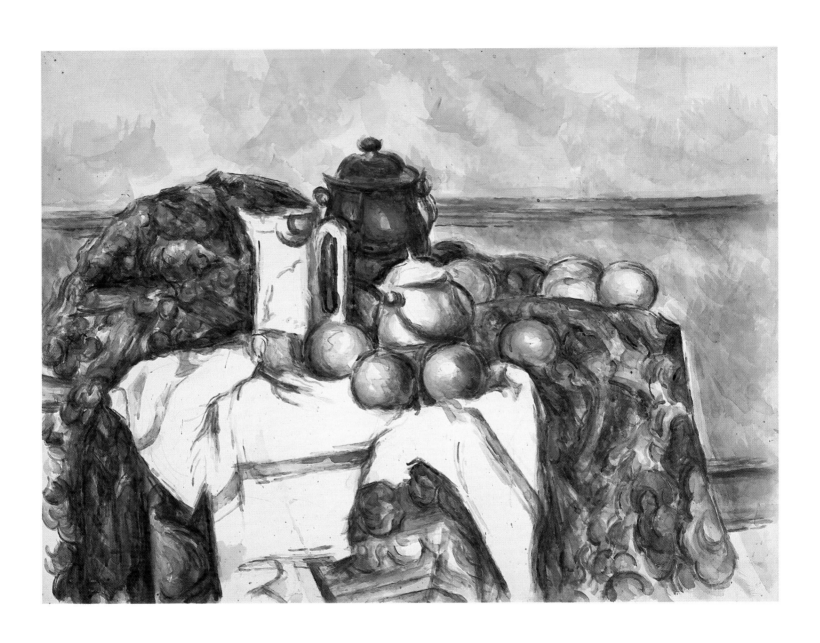

Still Life with Blue Pot

1900-1906
Graphite and watercolor on paper; 18¹/₄ × 24¹/₄ inches (46 × 61.5 cm)
Collection of the J. Paul Getty Museum, Malibu, California
R. 572

PROVENANCE
The Galerie Matthiesen, Berlin, sold this watercolor to Werner Feuz, Zurich; from there it passed to Gottfried Tanner, Zurich, and then to Jacques Seligmann, Paris and New York. It was next in the collection of Lord Sieff of Brimpton. It was sold at Sotheby's, London, on April 26, 1967 (lot 18), to Norton Simon, Los Angeles. It was sold at his sale at Parke-Bernet, New York, on May 2, 1973 (lot 9). It then passed to a collector in Switzerland. At a sale at Sotheby's in London on July 1, 1980 (lot 5), it was bought by Alain Delon, Geneva. It is now in the collection of the J. Paul Getty Museum.

EXHIBITIONS
After 1906: New York, 1933 (b), no. 1; Zurich, 1956, no. 210; Munich, 1956, no. 93.

EXHIBITED IN PHILADELPHIA ONLY

Near the end of his life Cézanne executed a small group of still-life watercolors noteworthy for their scale and brilliance, even when compared to his earlier achievements in this medium. They strike a balance between stability of composition and fluidity of execution that is more assured and accomplished than in any other set of works he executed. The Getty sheet is a particularly fresh example of this late watercolor style.

A loosely woven carpet (or tapestry) is mounded up atop a large table. The tapestry's red, green, and rusty brown pattern is familiar from Cézanne's use of it in other watercolors and oil paintings (see cat. nos. 181, 188, 213, 215, and 216). Over this he arranged a red-banded white kitchen towel, into which he nestled a faceted ceramic pitcher and a small, round metal pot with a wire handle. Just above them, near the center of the composition, is a deep blue enamel milk pot. Seven apples are judiciously grouped amid these elements. The table is placed before a wall with an ocher wainscoting parallel to the picture plane.

The design is set by sweeping pencil lines whose quickness and ease anticipate the application of color with the brush, which follows them in the most cursory way. The exposed white of the paper for the kitchen cloth creates a bright field in the center of the composition, around which

Cézanne arranged his other objects. His washes of pigment vary considerably in their density, although the white of the paper shines through as highlights even in areas such as the blue pot, where the pigment is nearly opaque.

He used the same elements for an equally large watercolor, now in Michigan (fig. 1), a work in which the artist's concerns were almost opposite those of the Getty sheet. The Michigan watercolor shows considerably more attention to outline and silhouette, with the white towel moved to the right to form the farthest edge of the still life, and with a watermelon viewed directly on end, forming a perfect circle in the center. Color is applied in thin glazes, with much of the pencil drawing still showing. The Getty work, by comparison, much more aggressively conveys the third dimension. Nearly all the edges are blurred in deference to the highlights. The apples and household objects seem contained within the folds of the colorful cloth, whereas in the Michigan watercolor they maintain a hard unity among themselves. It is a contrast of dry elegance versus wet sensuality.

J. R.

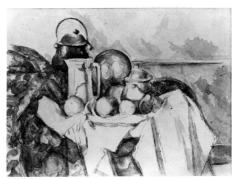

Fig. 1. Paul Cézanne,
Still Life with Milk Pot, Melon, and Sugar Bowl,
1900-1906, watercolor,
Edsel & Eleanor Ford House,
Grosse Pointe Shores, Michigan (R. 571).

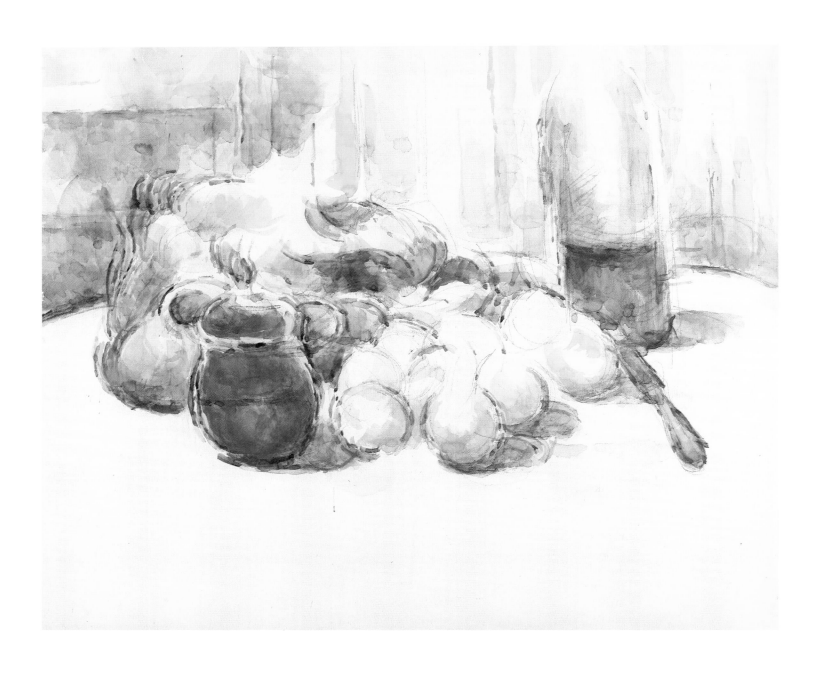

198 | *Blue Pot and Bottle of Wine*

1902-6
Graphite, crayon, and watercolor on yellowish paper; 18³/₄ × 24⁵/₁₆ inches (47.6 × 61.7 cm)
The Pierpont Morgan Library, New York. The Thaw Collection
R. 567

PROVENANCE
Ambroise Vollard sold this watercolor to Henri Manguin, Paris, who be-
queathed it to Lucile Manguin-Martinais, Paris. Subsequently it came into
the possession of the Galerie de Paris, Paris. By 1968, it was owned by
Norton Simon, Los Angeles. It is now in the Thaw Collection at the Pier-
pont Morgan Library.

EXHIBITIONS
After 1906: London, Leicester, and Sheffield, 1946, no. 43 (exhibited in
London only); New York, 1963 (a), no. 68; New York, 1994-95, no. 82.

EXHIBITED IN PARIS AND PHILADELPHIA ONLY

Cézanne's late still lifes, whether in oil or in watercolor, are some of the most resoundingly monumental works of his entire career. Their sense of rightness and profound stabil-ity is irrefutable. Yet, there is nothing static or abstracted about them; they truly pulsate with life. Even though they often share the same objects of study, each work retains, in its particular construction and mood, complete indepen-dence from the others, an achievement that can be claimed for few other artists, not even Chardin. This is nowhere more evident than in this extremely vivid sheet that enliv-ens and humanizes a group of kitchen items in a remark-able way.

The entry into space is made all the more dramatic by the large white void across nearly a third of the stage, which compresses all the objects into the middle ground. The cropped wine bottle gives a sense that the curtain of this theater is just going up. Variegated bands of wet color play across the back like an aurora borealis. The horizontal bands on the wall to the left suggest that these vertical stripes could be a curtained window; however, to judge from the strong pools of shadow, this observation is con-trary to the direction of the light, which comes from the upper left. What is clear, from the beautiful effect of light passing through the bottle and the white paper left ex-posed with such striking abundance in this sheet, is that Cézanne was exploring natural transparency in a very lively and satisfying way.

A blue jug (perhaps enameled, as Rewald thought) holds stage left—its counterpart, the half-empty bottle, stepped back on the right. Between these two poles, as it were, are arranged a handful of small, greenish apples and, on the left, a larger sphere, perhaps an onion. These clus-ter against the third pivot in the space, a lidded ceramic casserole or tureen sitting on a heavy plate (a vessel with a similarly knobbed lid still exists at the Chemin des Lauves studio). To the left of the lid there is a doughlike form that is difficult to read; it may be a cloth folded against and partly over the casserole. The conventional spatial device of a knife placed at a diagonal strikes a rather strong note in this work, where space is manipulated in an under-stated, rather melding fashion.

Swift swirls of pencil line describe the apples, the gen-eral shape of the table, the bottle, and critical points of transition throughout the sheet, or so it appears at first glance. In fact, nearly all of these lines are placed over the watercolor, which preceded them, as if Cézanne were using his pencil (and, in some cases, what appears to be crayon) both to animate and to set in order the forms he has already "drawn" in color with his brush. The outlines of certain objects, the apples for example, are carefully in-scribed in blue-black watercolor, probably after he de-picted the light falling across them with contrasting dashes of green and yellow. Over these, almost as if he were con-sidering a very different arrangement of apples, there is a second set quickly suggested in pencil, at times allying itself with the apples already worked up in color. This game, which is not one of ambiguity but of two things happening at once, plays over the casserole lid and comes to a climax in the ripple of the wet, black brush lines (one breaking off into space) that seem to define the back edge of the cloth. These are similar to the pulsating pencil lines that so en-liven Cézanne's late figure drawings. In this manner he represented the turn of an object in space without using the convention of the silhouetting edge, but his intention here seems not to have been to define form in space. Rather, it seems to be a curious and engaging sleight-of-hand maneuver (which in a lesser work of art would be passed off as *pentimenti*), by which the entire space of the still life is brought to a gently vibrating degree of anima-tion. None of this is overstated or obvious. The general tone of the sheet is, in fact, low-keyed and autumnal.

J. R.

199 | *Still Life with Green Melon*

1902-6
Graphite and watercolor on paper; 12 × 19 inches (30.5 × 48.3 cm)
Private collection
R. 610

PROVENANCE
This watercolor, part of Ambroise Vollard's estate, passed into the collection of Édouard Jonas in Paris. Paul Rosenberg, New York, sold it to Robert von Hirsch, Basel, in October 1949. At his sale at Sotheby's, London, on June 27, 1978 (lot 836), it was sold to the British Rail Pension Fund. It was bought by a private collector at Sotheby's, London, on April 4, 1989.

EXHIBITIONS
After 1906: Tübingen and Zurich, 1982, no. 94.

EXHIBITED IN PARIS AND LONDON ONLY

The audacity of Cézanne's late still-life watercolors is amazing. He literally flooded the paper with color, bringing them to a level of freshness and brilliance that exceeds anything done in oil. His freedom in the manipulation of this medium after about 1900 allowed him to explore a realm of ideas hardly touched in earlier works. As he said, and sometimes explained in his letters and conversations about the making of art, much of his life was devoted to understanding how form and space can be depicted through the use of color. As evidenced in the radiance of several of the late oil paintings, he was also reintroducing to his artistic pursuits what was most central to the Impressionists, and especially to Monet: light. Cézanne's observation of the reflections and transparencies within his still-life arrangements, and his translations of these effects through thin washes of watercolor on bright white paper, carry these concerns the farthest.

Various items are aligned near the back edge of a highly polished surface: a shallow basket holding a white cloth (perhaps there to be mended, as Rewald observed), a watermelon, an empty glass, a branch of leaves, and one apple. The corner of a white object intrudes from the lower left. The relationship of these things seems to have no meaning other than the formal service to which Cézanne has put them. His concern is not essentially with their weight and physical presence—even for something so bulky as the watermelon, whose mass is diminished by being turned nearly perpendicular to the front edge of the table—but rather with their surfaces, the way their local colors interact and pervade the appearance of other objects. The luxurious green sheen of the watermelon radiates through the bands of rippling colors across the background, alternating with the lavender-blue shade of the glass. The same green is reflected off the tabletop through the transparent bottom of the glass. In two quick strokes, it splashes over to the apple and is reflected off its underside. The local yellow of the apple is carried over to a pool of similar tones just before it. This and the red of its other half, mixing with the blue of the glass, dance over the entire surface of the polished tabletop. The white of the cloth, the projecting object, the amount of paper left showing through the leaves, and, most crucially, the white exposed patch at the near end of the watermelon establish a discreet dazzle that keeps everything gently in play.

Interestingly, even given the potential of the watermelon (which he would cut open in other late watercolors), the effect here is not so much obviously sensual as it is effectively visual. As clear as Cézanne is about the individual forms of each object, the real concern here is how they perform in light, and how light—through whiteness and color—dances among them.

J. R.

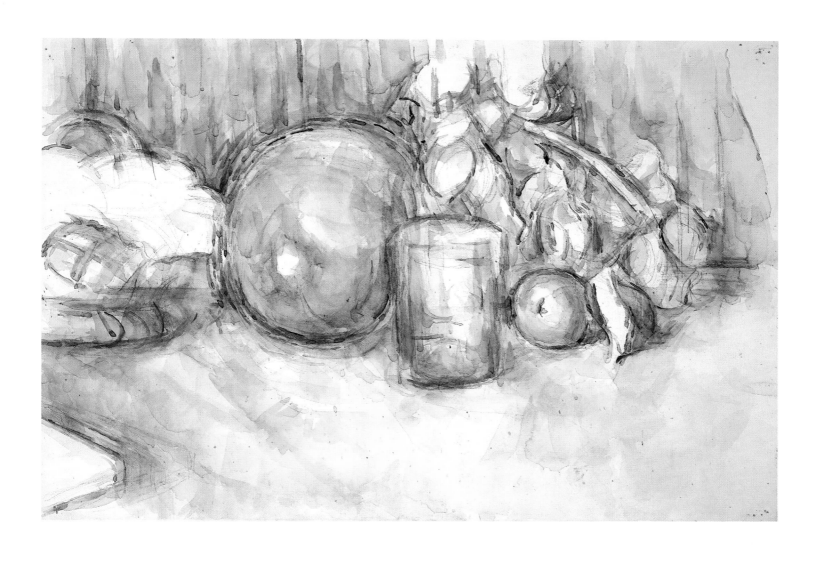

Second Series of Mont Sainte-Victoire

200 | *Mont Sainte-Victoire*

c. 1902
Oil on canvas; 33 × 25⁵/₈ inches (83.8 × 65.1 cm)
The Henry and Rose Pearlman Foundation, Inc.

PROVENANCE
Victor Schuster, London, purchased this canvas from Ambroise Vollard. It was put up for sale at Sotheby's, London, on July 26, 1939 (lot 75). By 1952, it was in the collection of Mr. and Mrs. Henry Pearlman, and is now on loan from the Henry and Rose Pearlman Foundation to the Art Museum, Princeton University.

EXHIBITIONS
After 1906: London, 1939 (b), no. 45; New York, 1959 (a), no. 4; Cambridge, 1959, unnumbered; New York and Houston, 1977-78, no. 57.

201 | *Mont Sainte-Victoire Seen from Les Lauves*

1902-6
Graphite and watercolor on paper; 18¹/₂ × 12³/₈ inches (47 × 31.4 cm)
Private collection, Philadelphia
R. 588

PROVENANCE
Ambroise Vollard sold this watercolor to the dealer Walter Feilchenfeldt, Zurich. It was acquired by Otto Wertheimer, Paris, before passing through the Wildenstein Galleries, New York. It subsequently came into the collection of Helen R. Tyson, Philadelphia, and passed into her estate at her death. It is now in a private collection in Philadelphia.

EXHIBITIONS
After 1906: London, Leicester, and Sheffield, 1946, no. 57; New York and Houston, 1977-78, no. 107; Paris, 1978, no. 88; Philadelphia, 1983, no. 36.

EXHIBITED IN PARIS AND LONDON ONLY

202 | *Mont Sainte-Victoire Seen from Les Lauves*

1902-6
Oil on canvas; 25¹/₈ × 32¹/₈ inches (63.8 × 81.5 cm)
The Nelson-Atkins Museum of Art, Kansas City, Missouri. Purchase: Nelson Trust, 38-6
V. 800

PROVENANCE
This canvas belonged to Ambroise Vollard until 1936. It was purchased in 1938 from the Wildenstein Galleries, New York, by the William Rockhill Nelson Gallery, now the Nelson-Atkins Museum of Art.

EXHIBITIONS
After 1906: New York, 1947, no. 67; New York, 1959 (b), no. 55; New York and Houston, 1977-78, no. 61; Liège and Aix-en-Provence, 1982, no. 26; Tübingen, 1993, no. 90.

203 | *Mont Sainte-Victoire*

1902-4
Oil on canvas; 27$^{1}/_{2}$ × 35$^{1}/_{4}$ inches (69.8 × 89.5 cm)
Philadelphia Museum of Art. The George W. Elkins Collection, E1936-1-1
V. 798

PROVENANCE
Ambroise Vollard sold this painting to the dealer Paul Rosenberg, Paris. In 1936 it was purchased by the Philadelphia Museum of Art, with funds from the George W. Elkins Collection.

EXHIBITIONS
After 1906: Chicago and New York, 1952, no. 109; Paris, 1955, no. 6; New York and Houston, 1977-78, no. 58; Paris, 1978, no. 82; Philadelphia, 1983, no. 20.

204 | *Mont Sainte-Victoire Seen from Les Lauves*

1901-6
Graphite and watercolor on paper; 18$^{11}/_{16}$ × 24$^{3}/_{16}$ inches (47.5 × 61.5 cm)
National Gallery of Ireland, Dublin
R. 585

PROVENANCE
Originally in the collection of Ambroise Vollard, this watercolor was, by 1937, in the possession of Reid and Lefevre, London. By 1947 it had been acquired by Mrs. Chester Beatty, who donated it to the National Gallery of Ireland.

EXHIBITIONS
After 1906: London, 1937, no. 17; London, Leicester, and Sheffield, 1946, no. 39; Newcastle upon Tyne and London, 1973, no. 96; New York and Houston, 1977-78, no. 104; Paris, 1978, no. 83; Tübingen and Zurich, 1982, no. 74.

EXHIBITED IN LONDON ONLY

205 | *Mont Sainte-Victoire*

1904-5
Oil on canvas; 23$^{5}/_{8}$ × 28$^{3}/_{4}$ inches (60 × 73 cm)
Pushkin State Museum of Fine Arts, Moscow
V. 803

PROVENANCE
Ambroise Vollard sold this canvas to Sergei Shchukin in 1911. When, at the end of his life, he had to emigrate from Russia with his family, his collection became (in 1918) the property of the State and entered the collection of the Museum of Modern Western Art, Moscow. During World War II, the works in the collection were distributed to the Pushkin Museum (where this canvas went) and the Hermitage Museum, St. Petersburg.

EXHIBITIONS
After 1906: Moscow, 1926, no. 25; Leningrad, 1956, no. 25; Paris, 1978, no. 91.

EXHIBITED IN PARIS AND LONDON ONLY

Mont Sainte-Victoire Seen from Les Lauves

1902-6
Graphite and watercolor on paper; $14^{1}/_{4} \times 21^{5}/_{8}$ inches (36.2×54.9 cm)
Tate Gallery, London. Bequest of Sir Hugh Walpole, 1941
R. 587

PROVENANCE
Ambroise Vollard apparently sold this watercolor, along with a number of other Cézanne works, to the Galerie Pierre [Loeb], Paris, around 1932. It was subsequently acquired by Charles Montag, Lausanne. By 1934 it was in the possession of the Pierre Matisse Gallery, New York, and by 1936 it had passed to the Dalzell Hatfield Gallery, Los Angeles. By 1937 it was in the collection of Sir Hugh Walpole, London, who bequeathed it to the Tate Gallery in 1941.

EXHIBITIONS
After 1906: London, Leicester, and Sheffield, 1946, no. 19; Newcastle upon Tyne and London, 1973, no. 99; Tokyo, Kyoto, and Fukuoka, 1974, no. 82; Paris, 1978, no. 94; Tübingen and Zurich, 1982, no. 77; Liège and Aix-en-Provence, 1982, no. 47 (exhibited in Aix-en-Provence only).

The road leading north from Cézanne's studio on the Chemin des Lauves divides as it descends the other side of the hill. The right fork, a lane called the Chemin des Marguerites, soon comes to a large sloping meadow that opens up on the right. It was here, on a knoll with views toward the east, that Cézanne undertook his last and most heroic paintings and watercolors of Mont Sainte-Victoire. Maurice Denis, who visited Cézanne with Ker-Xavier Roussel in 1906, made an oil sketch of the artist working at this site (repro. p. 44).

Seen from this vantage the mountain presents its most dramatic profile: the gentle contours of the northern slope (on the left in the pictures) crest in a stupendous peak of rock, then fall steeply away to spread over the broad slopes of Le Cengle. Before it lies the wide plain northeast of Aix, a patchwork of walled fields, farm buildings, and copses of trees.

Cézanne painted eleven canvases and numerous watercolors of this view. The works are similar in tone and share a sense of urgency and anticipation in the handling of their surfaces. None, however, repeats another. Each view shows the motif from a slightly different angle (sometimes just a mere turn of the artist's head), with the emphasis shifting among different elements in the landscape. Many of the works seem to have been made in direct response to changes in light and atmosphere sweeping over the broad plain, but never are these effects presented with the Impressionists' abiding attention to observed conditions and temporality. Cézanne has here attained so emotional and expressive a connection between the external world and his internal state of mind that one can truly speak of their temperaments as one. For many, this group of views are the culmination of Cézanne's efforts, his last titanic struggle to weld nature into art through profoundly complex, but finally extremely lucid, workings of color.

They have been discussed in the grandest terms. The late Mont Sainte-Victoires show the artist's transformation of the mountain into a realm of "cosmic" creation. For Lionello Venturi, "the structure is more and more implied, and less and less apparent."[1] It is most tempting to believe one of Joachim Gasquet's "remembered" conversations with Cézanne, in which he quoted the artist as saying:

"Look at Sainte-Victoire there. What élan, what imperious thirst for the sun, and what melancholy in the evening, when all that weight sinks back! . . . Those blocks were made of fire. There's still some fire in them. During the day, shadows seem to draw back with a shiver, to be afraid of them. Plato's cave is up there; note how, when large clouds pass overhead, their shadows quiver on the rocks as if burnt up, instantly consumed by a mouth of fire."[2]

Gasquet's Cézanne of the sacred fire bears resemblance to the one who wrote to Vollard on January 9, 1903: "I work obstinately, I glimpse the Promised Land. . . . I've made some progress. Why so late and so painfully? Is Art, then, a priesthood demanding pure beings who belong to it completely?"[3] The emotional intensity and romanticism of his early paintings of the 1860s and 1870s seem to have resurfaced, but now the artist is equal to his subjective ambitions.

One difficulty in discussing the late Mont Sainte-Victoire works individually is that they have, in Cézanne literature and criticism, usually been grouped as a unit (like Monet's series paintings), even though it has always been understood that they were executed over a period of at least four years. Such grouping is understandable given that the paintings are—albeit in strikingly different ways—about one thing: Cézanne's exaltation in depicting the vast expanse of space centered on the grand mountain. It was an experience he obviously enjoyed repeating.

The differences among the works are most obvious in their shape and size. Four are of a standard, pre-primed canvas size ($24^{3}/_{4}$ by $31^{7}/_{8}$ inches [63 by 81 cm]); two others are also a stock dimension ($23^{5}/_{8}$ by $28^{3}/_{4}$ inches [60 by 73 cm]). All the others deviate from the usual format, except one that Cézanne simply rotated in order to present the view vertically (cat. no. 200). In one case (fig. 1), he successively added four strips of canvas to a standard format to accommodate the evolving composition, and he repeated this procedure—one frequently used by Degas but rarely by Cézanne (however, see cat. no. 153)—in a watercolor (R. 594) closely related to this oil painting.[4] The sizes of the watercolors follow a similar pattern of experimentation with format.

The scale of these works seems not to correlate with the time Cézanne took to make them; in fact, the two smallest

Fig. 1. Paul Cézanne,
Mont Sainte-Victoire, 1902-6,
oil on canvas,
collection of Mr. and Mrs. Walter Annenberg,
Palm Springs, California (V. 804).

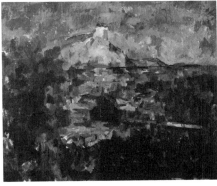

Fig. 2. Paul Cézanne,
Mont Sainte-Victoire from Les Lauves, 1904-6,
oil on canvas,
Öffentliche Kunstsammlung Basel (V. 1529).

(cat. no. 205 and fig. 2) are far and away the most heavily and intensely worked, while the one with the most exposed canvas and the loosest brushwork (cat. no. 200) is a mid-sized work.

While all these works depict the plain, the mountain, and the sky from the same basic vantage, there is a considerable variety of compositions. Most readily apparent are the different ways Cézanne introduced the vista from the foreground. Both the Pearlman and Kansas City paintings (cat. nos. 200 and 202) open with an ample band at the bottom—the downward slope of the meadow—and then break in a sharp transition to the plain far below. In all but two of the pictures (cat. no. 205 and fig. 2), the complex modulations of the plain then lead to the base of the mountain, where one enters a different realm. The others drop the viewer into the sweeping vista with no entry transition (fig. 1), or feature a roughly blurred explosion of brushwork at the bottom edge of the canvas that acts as a defensive apron to Cézanne's stage (cat. nos. 201, 203, fig. 1, and V. 802). Yet, in virtually all of these paintings, the division of the canvas into three horizonal bands (foreground, fields, and mountain) is Cézanne's working principle. This gives way only in the Moscow painting (cat. no. 205), in which the entire surface is united into a field of charged animation.

The mountain itself has a distinctive quality in each painting: in the Kansas City and Bürhle versions (cat. no. 202 and V. 802) it is sharply outlined with firm dashes of blue and black lines; in the Philadelphia canvases (cat. no. 204 and fig. 3), quicker, shorter brushstrokes integrate it with less contrast to the sky and fields; and in the Moscow and Basel works (cat. no. 205 and fig. 2) there is a nearly organic integration of its edges and surfaces with the surrounding atmosphere. One cannot help but feel Cézanne's careful attention to optical effect, the perception of the volume of the distant objects shifting with changes in light. To what degree these observed changes coincided with Cézanne's sense of the mountain's—and his own—temperamental variability, is the wonderful puzzle of each picture. The skies, which usually have a life of their own, are the most telling indication of these tremendous differences in expressive impact. They can be (depending greatly on the amount of white canvas showing through) luminous and radiant as if a storm just washed them clean. They can also be more sharply brilliant, when particularly bright greens and blues sit next to patches of purple, with lavender and pink opening up the space of the sky. In two versions, the heavens seem charged with static energy, producing an effect both ominous and exhilarating (cat. no. 205 and fig. 2).

It has been difficult to assess how useful are these formal and expressive differences (much more complicated than any pattern of theme and variation) in establishing the evolution of Cézanne's ideas and feelings about Mont Sainte-Victoire. There are very few facts to go on—not even the year Cézanne began painting this subject is certain, since it cannot be assumed that Cézanne waited until

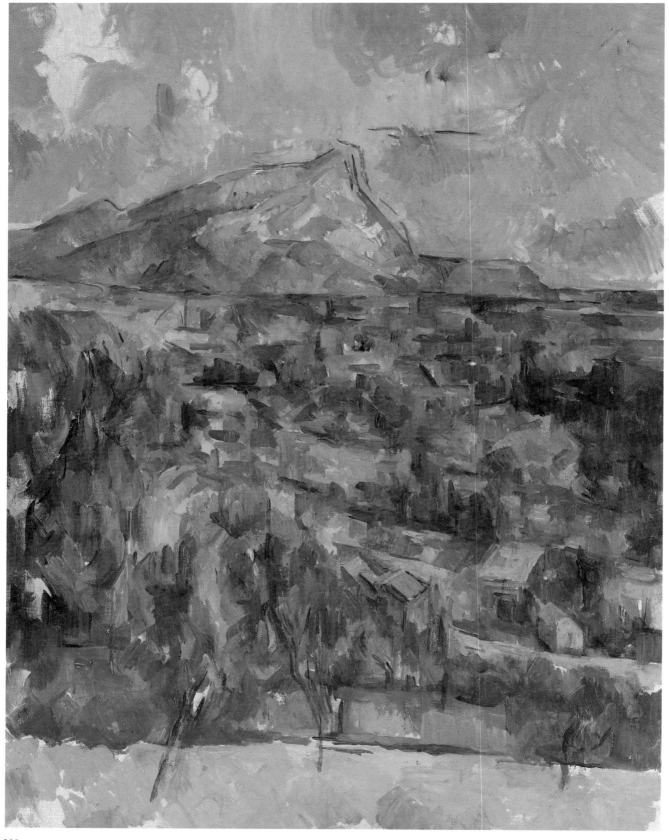

200

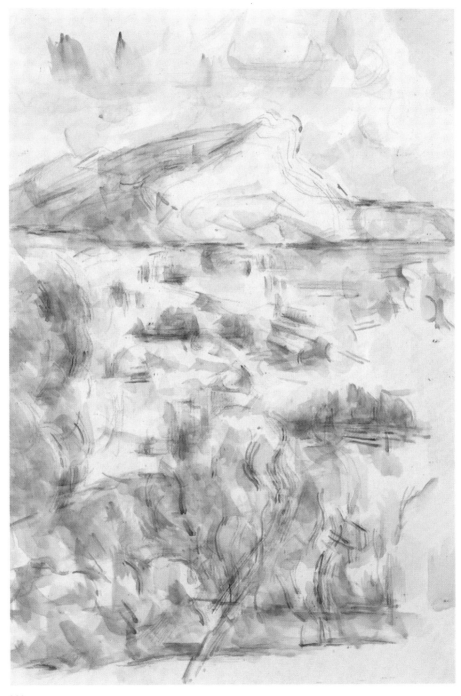

201

the nearby Chemin des Lauves studio was completed in the autumn of 1902 before commencing his exploration of this view of the mountain. Proximity was important for him, since, while not yet old, he was beginning to suffer severely from diabetes. However we do know, from Maurice Denis's account,[5] that Cézanne took a carriage to the vantage beside the Chemin des Marguerites in 1906 and could just as easily have done so before the fall of 1902, from the apartment in town on the rue Boulegon.

Venturi set a key in the lock by identifying the painting on the easel in Denis's oil sketch of Cézanne at work (repro. p. 44) as the Moscow canvas (cat. no. 205).[6] Consistent with the inclination of nearly all those who have considered the chronology of the late mountain paintings, this situates the Moscow picture near the end of the sequence. But the little painting on the easel in Denis's sketch shows too generic a Mont Sainte-Victoire to be certain of an absolute identification. Furthermore, a sticker on the stretcher of the Moscow painting clearly indicates that it was already in Paris, with Vollard, by 1905.[7] Thus the one point in this chronology that was previously considered secure is denied.

Fig. 3. Paul Cézanne,
Mont Sainte-Victoire, 1902-6,
oil on canvas,
private collection, Philadelphia,
partial gift to the Philadelphia
Museum of Art (V. 799).

Fig. 4. Paul Cézanne,
Mont Sainte-Victoire, 1904-6,
oil on canvas,
Kunsthaus Zurich (V. 801).

The approach to this problem put forward by Theodore Reff outlines what is perhaps the most seductive overview: "And as the variants succeed each other, they become more passionate in execution and more spiritual in content, the peak seeming to embody that striving upward from the darkness of the valley toward the luminous sky in which Cézanne's own religious aspiration can be felt, yet at the same time dissolving in the torrent of energetic brushstrokes, fusing with the air filled with similar strokes all around it."[8]

If one envisions the evolution of these canvases as progressing from specific to general, objective to subjective, then the vertical canvas in the Pearlman Foundation (cat. no. 200) seems a likely point of origin. There are only a handful of vertical landscapes in Cézanne's oeuvre, and they all have a quality of abruptness, as if Cézanne were varying his routine to jar himself into a new way of looking at his motif. While the distribution of elements—fields, mountain, sky—does not differ much from the horizontal pictures, the upright format seems to pitch the mountain very high in the space, giving great emphasis to the complex movements across the plain at its base. The increased visual weight of the foreground is immediately established by the ocher band of the meadow at the picture's bottom edge. The foreground trees initiate a rhythm of oblique angles, which then play throughout the plain. The decidedly sharp angle of the farmhouse on the far right clicks it all into place and plays over a cluster of three tile roofs, giving the space the particularly material quality discerned by Lawrence Gowing.[9] Approaching the base of the mountain, the zigzag pattern of parallel rhythms becomes tenuous, the brushwork looser. The mountain's right profile stands in stark silhouette; three broken blue lines explore the length of the sharp decline, whipped about like a pennant in a gale. The sky is rendered in curvaceous brushstrokes that lift, fall, and surge about like great currents of air. Their beautifully unhurried pace is much in keeping with what one takes to be the spirit of the entire picture: animated and lively but with a completely contained nobility and grace.

The only vertical watercolor of Mont Sainte-Victoire (cat. no. 201) has always been closely associated with the Pearlman painting (cat. no. 200), and for good reason. These two works present essentially the same "window" of space and share such details as the almond trees in the foreground as well as a partially cropped tree that functions as a repoussoir at the edge of the meadow. A half-dozen parallel, purple strokes give the watercolor the same obliquely angled rhythm throughout the middle ground that features so importantly in the painting. However (and this is often true in comparisons of Cézanne's paintings and watercolors) there is a true *joie de vivre* to this sheet that is absent in the more stately oil painting. The crest of the mountain is lightly stroked in blue, and the isolated touch of brilliant green gives unexpected panache to the sky.

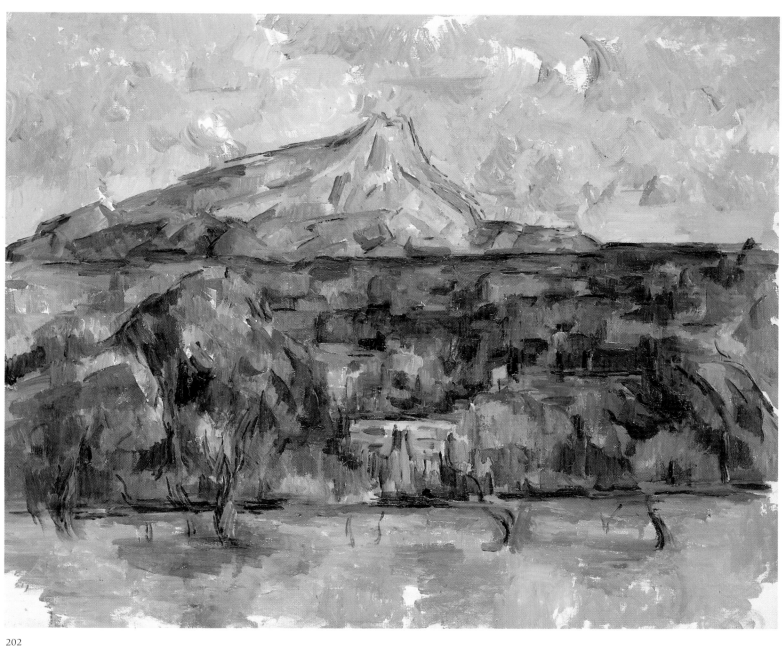

202

Like the vertical landscape in the Pearlman collection (cat. no. 200), the painting of Mont Sainte-Victoire now in Kansas City (cat. no. 202) introduces the foreground with the same meadow, now bright green and with more legible almond trees. It gives an extremely vivid sense of the place and what it is like to be there, but is lyrical and unaffected by the visionary forces that pervade other views. The same sequence of closely placed orange-roofed buildings is still discernible between the trees near the center. However, the elements of the middle ground have begun to merge into an emphatic band, with strokes of white, brighter orange, and pale green concentrated in its center, directly beneath the peak of the mountain. These colors play out into alternating patches of fuller and deeper tones of dark green and purple blue, laced with dashes of tan and pale orange. The full volume of the mountain, its sharply bending ridge of stone, is very apparent. The shadowy crevices and the valleys on Mont Sainte-Victoire's flanks are emphatically marked in a strong blue, as is its profile. The sky is freely brushed in pale blues and greens. This may be one of Cézanne's lustiest, most vigorously alert views of the mountain.

The geometry of the farmhouses in the Pearlman *Mont Sainte-Victoire* (cat. no. 200) is used quite differently in the canvas in Philadelphia (cat. no. 203). The buildings have been splayed like a fan. Their rooflines initiate oblique rhythms subtly reinforced by patterns playing across the intervening plain, which direct the viewer's gaze toward the center of the mountain's base. This thrust is countered by a long diagonal of green shooting in from the right. Before the buildings, a roughly applied expanse of greens and deep purples may be taken to represent the tops of the trees—so prominent in the Pearlman and Kansas City pictures—that mark the edge of the now-absent foreground meadow. It is as if the entire view has been pulled closer, the foreground now aligned with the plane of the canvas. Correlating with this rather harsh manipulation of space is the expressively abrupt contrast of the ocher and green strokes throughout the middle ground. There is a similar play of contrasting colors over the massiveness of the mountain, giving the three-dimensional dynamics of its form still greater force, while maintaining all the elegance of its profile. Perhaps to counterbalance the high contrast in the middle ground (and the relative monochrome of the foreground), Cézanne worked the sky with large, loosely formed panels of compatible tones of lavender and pale blue, while leaving enough exposed canvas to lend luminosity and even a suggestion of radiance that strikes a blurred highlight on the mountain's peak. The brushstrokes in this extremely complicated work are very evenly distributed over the surface and retain a fairly similar, smoothed-on, texture throughout. It is as if, during its making, the artist were working to hold together a picture in constant danger of blowing apart. The result, ironically, is a canvas that is perhaps the most formally constructed and least expressive of the sequence.

The single most resolved and classically beautiful watercolor of the views of Mont Sainte-Victoire from Les Lauves is the one in Dublin (cat. no. 204). Here Cézanne infused the balance and repose of the works on paper from the late 1880s (see cat. no. 119) with the sense of spiritual elevation he clearly experienced in this particular place. Soft pencil lines gently establish the space in bands in the foreground and sweetly play over the contours and of the mountain. Discrete washes of ocher, green, purple, and pink are thinly laid on within an elliptical area in the middle ground, expanding in breadth as they near the base of the mountain. From passage to passage delicate pencil marks or pale strokes of color alter the white of the paper just enough to evoke light or substance—sky, rock, or earth.

The Moscow *Mont Sainte-Victoire* (cat. no. 205) has a degree of urgency and compressed intensity unequaled in Cézanne's landscapes. Chaos seems imminent. The exaltation of the struggle for any vestige of stability is rapturous. One is strongly inclined to place this canvas last in Cézanne's eleven paintings of the view of Mont Sainte-Victoire from Les Lauves. It is difficult to imagine how he could have taken the theme to a formal or expressive end greater than this one.

The agitation and density of the brushstrokes and the ridges of layered paint are extraordinary even for Cézanne's late work. Intense dashes of orange, seeded with vivid strokes of red, dominate the plain; over which also play the sharp greens that gain the upper hand in the strip of meadow and trees in the foreground. Similar but less densely applied greens reappear in the sky amid purples and dark blues. There, against the white of the canvas showing through, the crisp strokes are more visible than they are in the foreground, where they seem smothered under thick pigment. In comparison to the cold, bright splendor of the sky and the foreboding darkness of the plain, the mountain seems extremely sensual. Opaque strokes of lavender, pink, and violet sit among more transparent blues and greens. For all this encrustation and dark compression, this painting is neither a despairing vision nor Cézanne's Götterdämmerung. He has given it too much energy, too much passion.

In connection with these late Mont Sainte-Victoires, Meyer Schapiro wrote: "Toward the end of his life, Cézanne's painting becomes passionately free, to the point of ecstatic release. The intensity of feeling that marked his early romantic pictures returns in a new form. It is no longer a painting of excited mental images of human violence and desire, but a stormy rhapsody in which earth, mountain, and sky are united in a common paean, an upsurge of color, of rich tones on a vast scale. . . . Under all this turbulence of brushwork and color lies the grand horizontal expanse of the earth."[10]

Ronald Alley, who catalogued the Tate Gallery's collection in 1959, seems to have been the first to relate the London watercolor (cat. no. 206) to the *Mont Sainte-Victoire*

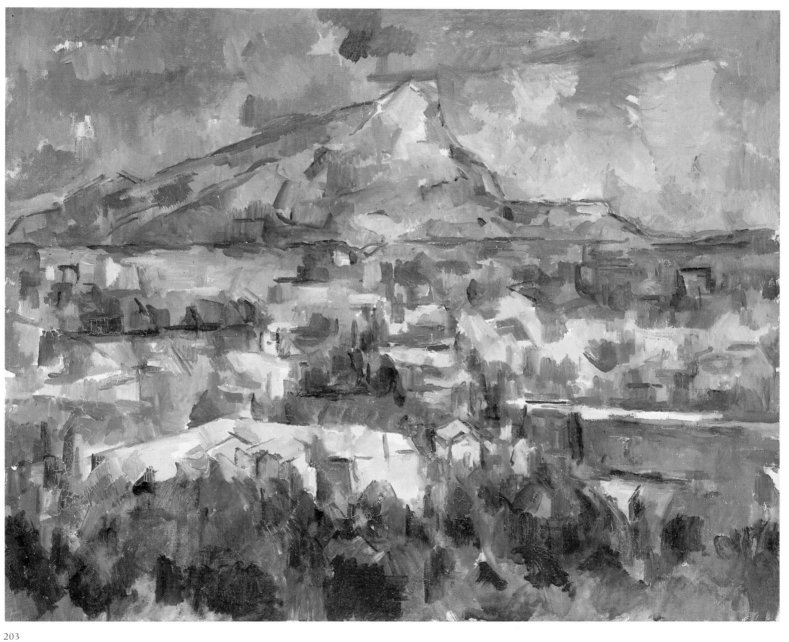

203

from the Pushkin Museum (cat. no. 205)—a connection that has been maintained ever since. The comparison is apt. Both works convey a similar urgency and exhilaration in their making; several compositional elements suggest as well that Cézanne probably made them from the same spot if not at the same time. They share several specific components: a tree that enters theatrically on the left (in the watercolor it is merely suggested by a few billowing washes of color); the three almond trees in the foreground, their branches nervously extending, like flames, into the middle ground; and the prominent use of ocher in the middle ground. The two works nevertheless produce quite different effects. As Richard Kendall has noted, the watercolor is "both simple and dramatic."[11] The swiftness with which the brush moved over the paper may be equated with the jabbing, belabored brushstrokes of the oil, but in the watercolor the tones quite literally sweep over the foreground and the sky, in waves that in some areas interplay and in others follow a light pencil line. Yet the high drama of the Pushkin painting is not present here and doubtless could never have been expressed in watercolor. The medium—particularly in this work, where Cézanne used swift, overlapping strokes—does not lend itself to rendering such weighty drama, but rather is destined to provide a more lyrical and fresh vision.

J. R.

1. Venturi, 1943, p. 37.
2. Gasquet, 1921, pp. 82-83.
3. Cézanne, 1978, p. 292.
4. See Rishel, in Philadelphia Museum of Art, *Masterpieces of Impressionism and Post-Impressionism: The Annenberg Collection* (Philadelphia, 1989), pp. 88-89, 181-83.
5. Denis to his wife, Marthe, [January 1906], in Denis, 1957, vol. 2, p. 30.
6. See Venturi, 1936, vol. 1, no. 803, p. 236.
7. See Marina Bessonova, in Museum Folkwang, Essen, *Morozov and Shchukin—The Russian Collectors: Monet to Picasso* (Cologne, 1993), no. 33, p. 386; and Barskaya, 1975, pp. 190-91. See also Gowing, in New York and Houston, 1977-78, p. 71 n. 52.
8. Reff, in New York and Houston, 1977-78, p. 27.
9. See Gowing, in New York and Houston, 1977-78, p. 69.
10. Schapiro, 1952, p. 124.
11. Kendall, 1989, p. 47.

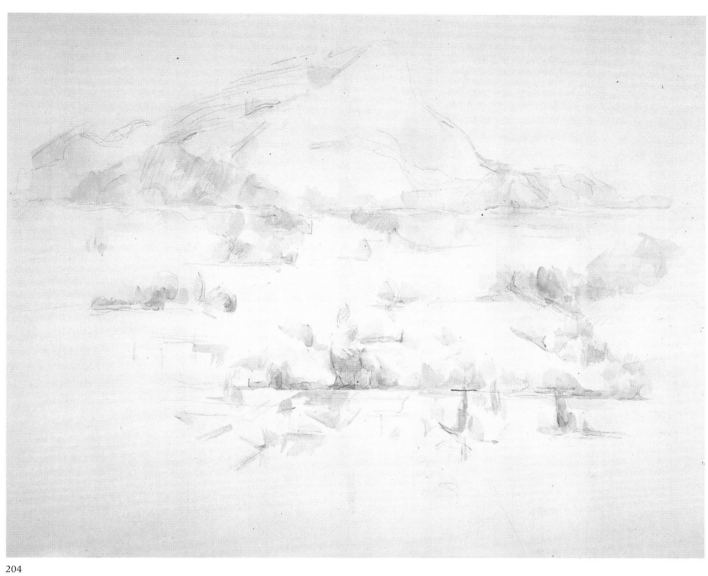

204

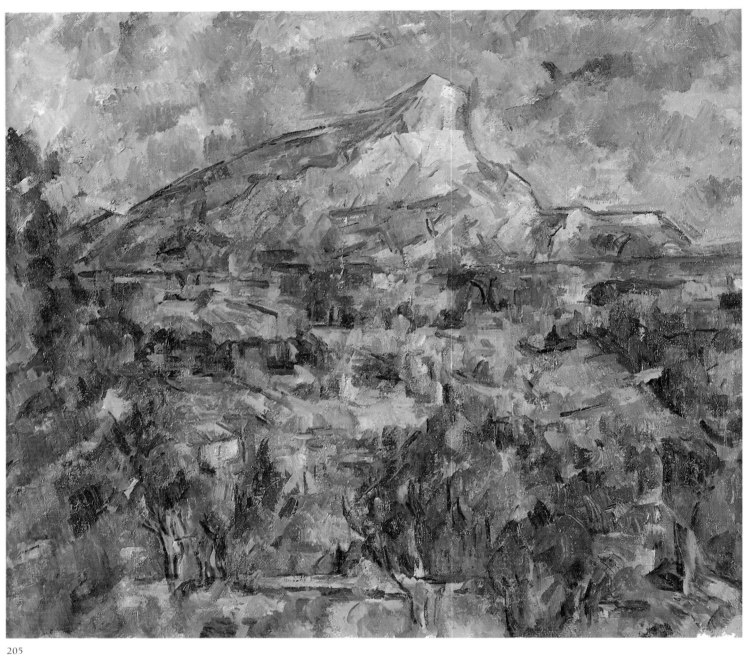

205

206

Views from the Terrace of the Studio at Les Lauves

207 | ## *The Garden Terrace at Les Lauves*

1902-6
Graphite and watercolor on paper; 17 × 21¹/₁₆ inches (43.2 × 53.4 cm)
The Pierpont Morgan Library, New York. The Thaw Collection
R. 621

PROVENANCE
This watercolor was originally owned by Ambroise Vollard. Thereafter it passed to George Bernheim, Paris, to the Knoedler Galleries, Paris and New York, and to Sam Salz in New York. By 1943, it was in the collection of Erich Maria Remarque, Ascona, author of *All Quiet on the Western Front.* From him, it came into the possession of Walter Feilchenfeldt, Zurich. Since 1977 it has been owned by the Thaw Collection at the Pierpont Morgan Library.

EXHIBITIONS
After 1906: New York, 1943, no. 33; New York, 1947, no. 86; Chicago and New York, 1952, no. 103; The Hague, 1956, no. 89; Zurich, 1956, no. 142; Munich, 1956, no. 110; New York, 1963 (a), no. 63; New York and Houston, 1977-78, no. 108; Paris, 1978, no. 74.

EXHIBITED IN PARIS AND PHILADELPHIA ONLY

208 | ## *Aix Cathedral Seen from Les Lauves*

1902-4
Graphite and watercolor on paper; 12¹/₂ × 18³/₄ inches (31.7 × 47.6 cm)
Philadelphia Museum of Art. The Louise and Walter Arensberg Collection, 1950-134-35
R. 581

PROVENANCE
This watercolor may have been in the possession of Marius de Zayas, New York. Subsequently it was purchased by Louise and Walter Arensberg, New York and Hollywood. In 1950 it entered the collection of the Philadelphia Museum of Art, as a gift of the Arensbergs.

EXHIBITIONS
After 1906: Philadelphia, 1983, no. 35; Edinburgh, 1990, no. 68.

EXHIBITED IN PARIS AND LONDON ONLY

209 | ## *The Garden at Les Lauves*

c. 1906
Oil on canvas; 25³/₄ × 31⁷/₈ inches (65.4 × 80.9 cm)
The Phillips Collection, Washington, D.C.
V. 1610

PROVENANCE
This painting originally belonged to Ambroise Vollard (through 1936).[1] Subsequently it passed into the possession of the Wildenstein Galleries, New York, from whom it was purchased in 1955 by Duncan Phillips for the Phillips Collection.

EXHIBITIONS
After 1906: New York and Houston, 1977-78, no. 55; Paris, 1978, no. 63.

On September 1, 1902, Cézanne wrote from Aix to his niece and godchild, Paule Conil, who was staying by the sea at L'Estaque. After railing against the "so-called progress" in the seaside resort that had led to the "invasion of bipeds, who increasingly have all but transformed everything into odious quays with gas-jets and—what's worse, still—electric lighting," Cézanne related that "little Marie has cleaned my studio, which is finished and where I am settling in bit by bit."[2] By January 9 of the following year, he could report to Vollard, "I have a large studio in the country. I'm working there, I'm better off there than in the city."[3]

The space Cézanne described is, of course, the building he had erected on the half acre of land he purchased on November 16, 1901 (fig. 1). Situated just below the crest of a hill called Les Lauves, north of Aix, it was within walking distance of his apartment at 23, rue Boulegon in the center of the city. The two-story stucco building has one large window facing north, and three smaller windows facing south, from which one could look down into the city and across to the range of mountains called La Chaîne de l'Étoile. A gravel terrace borders the south side of the building; the entrance leads directly up a staircase to a studio on the second floor. On the ground level are workroom/bedrooms; these are the spaces Cézanne allowed Émile Bernard to use during his visit in 1904, from which the young painter could hear Cézanne pacing restlessly in the studio above his head.

Rewald has speculated that one motivation for the new studio at Les Lauves, which had a slot in the back wall to accommodate the movement in and out of large, stretched canvases, was Cézanne's desire to proceed with ambitious projects such as the three *Large Bathers* (cat. nos. 218 and 219, and repro. p. 69), for which the rue Boulegon apartment provided insufficient space.[4] It was also at this time that he had tried, unsuccessfully, to buy the Château Noir and its grounds overlooking the Tholonet road east of Aix.

Fig. 1. Photograph
of Cézanne's studio at Les Lauves,
c. 1904,
collection of Sabine Rewald.

The years between 1899 and 1902, when he had only the rue Boulegon apartment as a base, must have been extremely trying for Cézanne, although it was then that he made more of an effort to see other people than he had in twenty years. Two young men who were stationed in Aix for military duty, the poet Léo Larguier and the painter Charles Camoin, became close friends. Both would write moving memoirs of their meetings with Cézanne.[5] He also saw Joachim Gasquet, the son of an old friend. However, the tone Cézanne took against Gasquet and his literary circle by January 1903—"unspeakable . . . clan of intellectuals, and of what a vintage, good God!"[6]—suggests just how eager Cézanne had become to retreat into the safe isolation and stable workplace the new Les Lauves studio provided.

Running down the south slope of the property was a small plot, maintained by his gardener Vallier (see cat. nos. 225 and 226), who would often pose for Cézanne, seated either in the sun-filled pockets of this space or in the studio. The low retaining wall bordering the gravel terrace and the potted plants Vallier placed there serve as the threshold in a watercolor view toward the little water channel that marks the southern extent of Cézanne's property (cat. no. 207). The effect of lifting one's eyes from the enclosed sanctuary of the garden to the airy prospect of the distant mountains, floating like a purple-blue mirage in the sky, must have been mesmerizing.

This kind of subject held special attraction for Cézanne toward the end of his life. The walls supporting the potted plants provided the strict, right-angled geometry he needed to establish the foreground of his vista. A sequence of receding panels (stages in the terracing down the hill) steps down from the right. Immediately beyond these rectangular confines rise the progressively looser and more organic shapes of the screen of foliage that dominates the middle ground. This containment is then released in the center of the sheet, opening into the vast distance. The leafless tree on the right reenacts this progress on the two-dimensional plane, as the regularity of the trunk transforms gradually into flamelike branches.

But if this description suggests a quality of staged calculation in the creation of this watercolor, its true genesis could not be more different. As dramatic as the vista may be, Cézanne has depicted it with a naturalness that seems spontaneous and unstudied. The colors that wash and overlap across the page give a sense of great transparency and freshness. The mountains are indicated in the most discreet, almost dreamlike, way, with a half dozen pale strokes. Provence, Aix, and this specific place suited Cézanne in a way that always seems remarkable. He was completely attuned to and at ease with it. And especially in works such as this one, the pleasure it gave him is evident.

Another watercolor (cat. no. 208) depicts the view from the south windows on the second story of Cézanne's studio at Les Lauves; there, one could see over the trees to the rooftops of Aix and the grand panorama ending at the

207

208

mountains. The double-tiered tower of the cathedral of Saint-Sauveur, which Cézanne passed every day, is visible on the left. The great sweep of the vista is laid across the paper with remarkable amplitude. Swift strokes of the pencil establish the essential forms, over which are spare washes of light green, blue, lavender, and yellow. These are applied in cursive licks with an even lightness from the bottom to the top of the sheet, giving an almost crystalline clarity to the view; the distant mountains are more precisely defined than anything in the foreground. The air itself seems charged.

The gentleness of the color here might be seen to indicate, as is sadly often the case with Cézanne's watercolors, that the pigments have faded and the paper has darkened. The white of the paper may have yellowed slightly, yet it is clear that the effect is essentially, as Cézanne intended, one of great delicacy.

Venturi was the first to identify the site in the painting from the Phillips Collection (cat. no. 209) as Les Lauves; the view into the garden from the walled terrace of the studio encompasses a vista to the mountains beyond Aix. This is one of a small group of surviving canvases made late in Cézanne's life that relate to subjects in the most elemental way; their meaning for the artist is far from clear. Are they skeletal records of abandoned projects and therefore to be considered "unfinished"? Vollard describes (perhaps apocryphally) that Cézanne would retrieve from a tree canvases he had thrown there in frustration, only to reconsider them:[7] Could this be one of those? Or, as Duncan Phillips proposed when he purchased this picture in 1955, is the question of finish irrelevant, since works such as this stand in their elemental rudimentary state as the beginnings of a type of pictorial distillation that would have far-reaching ramifications for the development of painting in the twentieth century.

Phillips wrote: "In his latest paintings Cézanne reveals that, after many years of research and discipline and after many accomplished masterpieces of pondered composition and execution, he had finally made himself so much the intuitive master of his unique method of color-construction and color-design that he could extemporize with his brush strokes, combining vertical, diagonal, horizontal and semicircular strokes on the same canvas in an impetuous

temperamental freedom. If not the subconscious mind at least the emotional instinct was predominant over the planning intellect. The classicist became at the close of his career as he had been at the beginning, an expressionist. What was expressed was not only his technic but his obsessive conception, his passionate aim to realize with pigments the vitality and organic unity he sensed in nature."[8]

According to Denis, Renoir had said of Cézanne: "How does he do it? He cannot put two touches of color on a canvas without it being very good."[9] The point is well taken in the case of pictures such as this one. The palette is as complicated as any in Cézanne's more finished pictures, the execution as stabbing and vigorous as it was in the late views of Mont Sainte-Victoire. The textures vary from thick impasto to thin washes of paint. And the expressive dynamics range from the exposed priming and blurred dashes of yellow green that he used to represent the sparse terrace, to the very workmanlike mosaic of color applied in hooked strokes across the central band of foliage, to the swirls of pink and lavender and deep purple in the sky. Cézanne wrote to Émile Bernard on October 23, 1905: "Now, being old, nearly seventy years, the sensations of color, which give the light, are for me the reason for the abstractions which do not allow me to cover my canvas entirely nor to pursue the delimitation of the objects where their points of contact are fine and delicate; from this it results that my image or picture is incomplete. On the other hand, the planes fall one on top of the other from whence neo-impressionism emerged, which circumscribes the contours with a black line, a fault which must be fought at all costs. But nature, if consulted, gives us the means of attaining this end."[10]

J. R.

1. See Venturi, 1936, vol. 1, no. 1610, p. 343.
2. Cézanne, 1978, p. 290.
3. Ibid., p. 292.
4. See Rewald, in New York and Houston, 1977-78, p. 95.
5. Larguier, 1925; and Camoin, January 1921.
6. Cézanne to Vollard, January 9, 1903, in Cézanne, 1978, p. 292.
7. See Vollard, 1914, p. 74.
8. Phillips, April 1956, p. 32.
9. Denis, September 1907; reprinted in Denis, 1912, p. 244.
10. Cézanne, 1978, p. 315.

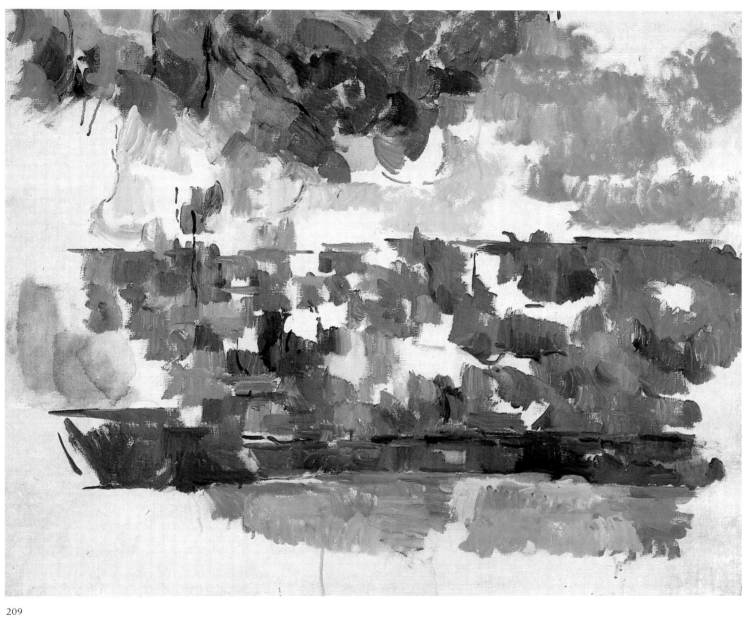

209

210 | *Mill on a River*

1904-5
Watercolor on paper; 12 × 19 inches (30.5 × 48.3 cm)
Hamburger Kunsthalle, Hamburg. Kupferstichkabinett
R. 630

PROVENANCE
This watercolor was originally owned by Ambroise Vollard (through 1936).[1] Thereafter it came into the possession of the Adams Brothers in London. It was subsequently acquired by H. Teltsch, London, and was sold at his sale at Sotheby's, London, on November 23, 1960 (lot 78). Thereafter it passed through Marlborough Galleries, London, to Walter Dudek, Hamburg (by 1977).[2] It is now in the collection of the Hamburger Kunsthalle.

EXHIBITIONS
After 1906: London, Leicester, and Sheffield, 1946, no. 32; Hamburg, 1963, no. 25.

EXHIBITED IN PARIS AND LONDON ONLY

This watercolor is altogether a mystery. The subject is unclear, the site unknown, the date a question of speculation. This suspended state suits it perfectly.

A simple structure with what might be a sluice hangs over the wooded bank of a river. A band in the center background must be a rudimentary bridge. Light dapples through the leaves and plays in shimmering panels on the placid water. This echo of Impressionism seems in stark contrast to the emphatic, simple geometry that defines the man-made objects. Although this general subject is found in Cézanne's paintings as early as 1880 (see cat. no. 57), the assurance and control with which the watercolor is washed on the paper, with no preparatory pencil lines to guide it, are most often found in the very late works. Rewald paired it with another watercolor of about the same size, executed solely with the brush in a very similar manner; that work (cat. no. 211) shows a willow leaning over a river, a simple mooring pounded into the tree's roots, and the corner of a building projecting into a meadow on the far right. The proposition that both watercolors may have been done in the forest of Fontainebleau has great appeal. It is a place that sometimes cast him (as it has other artists) into a melancholy mood (see cat. no. 158). The vaporous quality of these two watercolors, the sharpness of certain forms against the blurred atmosphere that surrounds them, and the pervasive green tonality are in keeping with what we think this place meant to Cézanne. He is known to have worked there in the summers of 1904 and 1905.

The quality of distillation in this watercolor is rare for Cézanne, its parallel in painting being the most generalized forest scenes after 1900. It is a quality not to be confused with simplification. Here Cézanne—and this alone might be good reason for dating the work quite late—seems able to do more with less, to give a stronger sense of the mood and space of one very specific location with fewer gestures than he had ever needed before.

J. R.

1. See Venturi, 1936, vol. 1, no. 1554, p. 337.
2. See New York and Houston, 1977-78, pl. 108.

211 | *Bare Trees by a River*

c. 1904
Watercolor on paper; 12³/₈ × 19¹/₄ inches (31.2 × 49 cm)
The Pierpont Morgan Library, New York. The Thaw Collection
R. 631

Long, wet strokes of watercolor are applied to the paper with an easy spareness. The pigments are restricted to black, blue, green, and yellow, all of them thinned to an unassertive paleness. The unity of these washes with the off-white of the paper gives the sheet a distinctive wholeness, as if it all came into being through one rather pensive campaign.

An old willow tree leans over the banks of a still river. At its base is a rudimentary dock, three stakes pounded in the mud with a couple of boards connecting them. The only other work of man is a vaguely suggested structure on the far right, its one visible opening filled with what might be a collapsed door or shutter. The reflections on the water and the few tree trunks beyond the structure are sufficient to give the sense of a contained and melancholy place, dank and rotting, with only filtered light finding its way onto the slow-moving surface of the water.

This manner and this mood have always led to a close comparison of this drawing with the watercolor now in Hamburg (cat. no. 210). The two works are almost identical in size, and the essential geometry of their crudely made structures is brought into play with the water, earth, and dark bark of the bare trees. All of these elements are solid and transparent at the same time, the least immaterial surface perhaps being the water.

J. R.

The Skulls

212 | *Pyramid of Skulls*

1898-1900
Oil on canvas; 15³/₈ × 18³/₈ inches (39 × 46.5 cm)
Private collection
V. 753

PROVENANCE
This work was acquired directly from Ambroise Vollard's heirs by Walter Feilchenfeldt, Zurich, in 1953. It is now in a private collection.

EXHIBITIONS
After 1906: Zurich, 1956, no. 79; Vienna, 1961, no. 38; Aix-en-Provence, 1961, no. 16; Tokyo, Kyoto, and Fukuoka, 1974, no. 50; New York and Houston, 1977-78, no. 30; Paris, 1978, no. 25; Tübingen, 1993, no. 87.

213 | *Three Skulls on a Patterned Carpet*

1898-1905
Oil on canvas; 21¹/₄ × 25³/₁₆ inches (54 × 64 cm)
Kunstmuseum Solothurn, Switzerland. Fondation Dübi-Müller
V. 759

PROVENANCE
This painting, initially in the collection of Gertrud Müller, Solothurn, passed after her death to the Fondation Dübi-Müller and was donated to the Kunstmuseum.

EXHIBITIONS
After 1906: Basel, 1921, no. 27 (?); Paris, 1936, no. 10; The Hague, 1956, no. 51; Zurich, 1956, no. 83; Tübingen, 1993, no. 86.

EXHIBITED IN PARIS ONLY

214 | *Two Skulls*

1890-1900
Graphite and watercolor on paper; 9¹/₂ × 12³/₈ inches (24.2 × 31.4 cm)
Private collection
R. 232

PROVENANCE
The writer Erich Maria Remarque, New York and Ascona, acquired this watercolor from the dealer Paul Cassirer, Amsterdam, who had purchased it from Ambroise Vollard in 1938. Upon Remarque's death it passed to his widow, Paulette Goddard, New York and Ascona, who sold it to its present owner.

EXHIBITIONS
After 1906: New York, 1943, no. 41; The Hague, 1956, no. 65; Zurich, 1956, no. 103; Munich, 1956, no. 80; New York, 1963 (a), no. 56; Tübingen and Zurich, 1982, no. 90.

EXHIBITED IN PARIS ONLY

215 | *Three Skulls*

1902-6
Graphite and watercolor on paper; 18³/₄ × 24⁷/₈ inches (47.7 × 63.2 cm)
The Art Institute of Chicago. Mr. and Mrs. Lewis L. Coburn Memorial Collection
R. 611

PROVENANCE
This work passed through the hands of several dealers after Ambroise Vollard (J. Seligmann, Paris and New York; Justin Thannhauser, Lucerne; Walter Feilchenfeldt, Zurich) before being acquired for the Art Institute of Chicago through the Mr. and Mrs. Lewis Coburn Memorial Fund.

EXHIBITION
After 1906: New York, 1933 (b), no. 3; Paris, 1955, no. 57; New York, 1963 (a), no. 55; Washington, Chicago, and Boston, 1971, no. 57; New York and Houston, 1977-78, no. 74; Paris, 1978, no. 26.

EXHIBITED IN PHILADELPHIA ONLY

216 | *Skull on a Drapery*

1902-6
Graphite and watercolor on paper; 12¹/₂ × 18³/₄ inches (31.7 × 47.6 cm)
Private collection
R. 612[1]

PROVENANCE
This watercolor, owned by Ambroise Vollard until his death, was subsequently sold by the estate to Walter Feilchenfeldt, Zurich. It was then purchased by Paul Rosenberg, New York, who sold it to Paul Mellon. It was sold in the Mellon sale at Christie's and purchased again by Walter Feilchenfeldt, Zurich, and sold to Ian Woodner, New York, whose heirs sold it to the present owners.

EXHIBITIONS
After 1906: New York, 1933 (b), no. 8; San Francisco, 1937, no. 50; Hamburg, 1963, no. 24; New York and Houston, 1977-78, no. 73; Paris, 1978, no. 27.

217 | *Study of a Skull*

1902-3
Graphite and watercolor on paper; 10 × 12¹/₂ inches (25.4 × 31.7 cm)
The Henry and Rose Pearlman Foundation, Inc.
R. 613

PROVENANCE
This watercolor passed directly from Paul Cézanne *fils* to the Galerie Bernheim-Jeune, then to Paul Cassirer, Berlin. In 1910 it figured in the collection of Georg Reinhart, Winterthur, who purchased Cézannes before his brother Oskar. It passed to the gallery of Fritz and Peter Nathan, Zurich, from which it was acquired by Mr. and Mrs. Henry Pearlman, New York.

EXHIBITIONS
After 1906: Paris, 1909, no. 5; Basel, 1936, no. 89; New York, 1959 (a), no. 25; Cambridge, 1959, unnumbered; New York, 1963 (a), no. 57; New York, 1963 (b), unnumbered; New York and Houston, 1977-78, no. 72.

For a span of almost thirty years all direct allusion to death in the form of the human skull vanished from Cézanne's work. The motif reappeared in force between 1898 and 1904, when it was treated not in the *vanitas* tradition but in a mode that was simultaneously subtler and more funereal.

It is, of course, possible to view the skull as a form ideally suited to the Cézannean expression of volume by means of modulation, for it is round like a piece of fruit or the handle of a jug. "How beautiful a skull is to paint!" Cézanne reportedly remarked,[2] providing some justification for those maintaining that the artist rendered faces and death's-heads like apples. Furthermore, skulls often figured in the interiors of devout Catholics—a group to which Cézanne certainly belonged—and, like plaster casts and wooden mannequins, had been stock accessories in artists' studios for centuries. Formal considerations were probably most important in Cézanne's decision to include one in the 1895-1900 *Still Life with Skull,* now in the Barnes Foundation (V. 758),[3] where, given its size and rigid rotundity, it easily dominates the perishable forms of the pears, the apples, and what appears to be a pomegranate. This juxtaposition may also reflect an intention to render death banal, to deprive the skull of its traditional *terribilità* by making it droll. In any case, we are very far removed from the youthful painting *Skull and Candlestick* (cat. no. 5)[4] which honors the conventions of the *vanitas* theme.

Nevertheless, the skull's sudden reappearance in the Cézannean universe—despite its offhand character, perhaps even a suggestion of an exorcism—was clearly not innocent. Cézanne was conversant with ancient Christian texts. If the central fruit in the Barnes picture is a pomegranate, in all likelihood it was included deliberately as a symbol of fecundity and divine perfection. If, on the other hand, it is an apple, a fruit that carried associations of mortal life and pleasure, then its juxtaposition with a death's-head is perhaps less allegorical but more immediately eloquent.

Indeed, the surviving evidence, including the artist's own correspondence,[5] bears witness to the fact that from the late 1870s Cézanne became obsessed with his own death. But the artist did not undertake to translate this preoccupation into pictorial terms, in the form of repeated *memento mori* images, until the end of the 1890s.

There are some obvious reasons for the timing of this development. There has been considerable discussion in this connection of the death of Cézanne's father in 1886 (twenty years to the day before that of the artist), which ended their intense conflicts, dating from the son's adolescence, that many scholars have seen as the root of Cézanne's youthful intransigence and self-destructive behavior.[6] But far too little attention has been paid to the death of his mother, on October 25, 1897, at the age of eighty-three, after an illness that had much affected the painter. She adored him; a protective mother, she had always been supportive of his artistic ambitions, and, in the final accounting, he spent more time with her in the

course of his adult life than with his own wife. It is known, however, that he chose to paint in the countryside instead of attending her funeral.[7] This decision doubtless reinforced his local reputation as an old crank, but it is not as shocking as it might first appear, for the ceremony would have been extremely difficult for him. It is quite natural, then, that pictorial meditations on death should have made their appearance precisely at the moment at which his final bulwark against annihilation—the presence of his mother—had been removed, making his own death seem that much more imminent. It is also worth pointing out that his own health began to decline seriously about the same time.

Before the sale of the family house, the three skulls were a fixture in Cézanne's large salon-studio there. According to one of his nieces, "After the death of old father Cézanne, Paul somewhat abandoned his [upstairs] studio in the Jas de Bouffan to paint in the large salon on the ground floor. An incomparable disorder reigned there: flowers, fruit, white tablecloths, on the mantelpiece three skulls, an ivory Christ on an ebony cross, grandmother's [Cézanne's mother] Christ."[8]

It seems significant that, in the family salon of the Jas de Bouffan, the skulls and crucifix—emblematic, respectively, of death and of the deepening piety of the artist in his final years—were placed in proximity to one another.

Gasquet recounted: "On his last mornings he clarified this idea of death into a heap of bony brainpans to which the eyeholes added a bluish notion. I can still hear him reciting to me, one evening along the Arc River, the quatrain by Verlaine:

Car dans ce monde léthargique
Toujours en proie au vieux remords
Le seul rire encore logique
Est celui des têtes de morts.
[For in this lethargic world
Perpetually prey to old remorse
The only laughter to still make sense
Is that of death's-heads.]

"I can still hear him in his rue Boulegon studio intoning Baudelaire's 'La Charogne' in a strange voice like a schoolboy's or a priest's, or asking me to read him 'Un Pouacre' from *Jadis et Naguère*.[9]

"One day he decided to bring together in a vertical canvas all these ideas that so haunted him, this 'motif' of the death's-head, and painted his *Young Man and Death*. Standing out against an opulent leaf-patterned drapery, the one he used in his still lifes, he sat a young man dressed in blue in front of a table of blond wood, a death's-head before him."[10]

In this painting[11] Cézanne reverted to the classical approach to both composition and subject matter (here, a young man meditating before a symbol of death) that had characterized his youthful *Mary Magdalen* (p. 87, fig. 1) and *Hamlet and Horatio (after Delacroix)*.[12] In the tra-

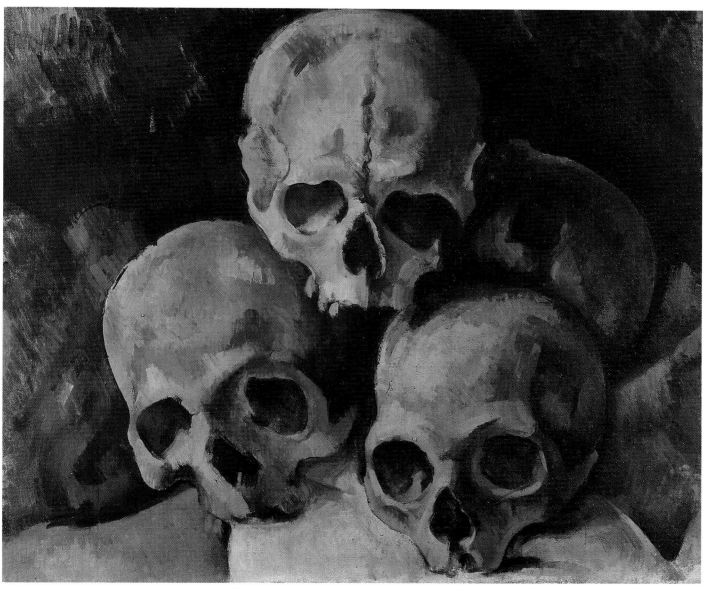

212

ditional conception, which Cézanne adopted in his *Young Man with Skull*, the meditative face-to-face involves only a single skull. By bringing several of them together in the still lifes—both oils and watercolors—painted around the turn of the century, Cézanne gave the imagery a new dimension.

First, the skulls confront the viewer straight-on in a manner reminiscent of the artist's portraits. They rivet the beholder with their gaping voids, and they are powerfully modeled. In all likelihood the series began with the picture in which three skulls are lined up prosaically across a tabletop (fig. 1). The dramatic intensity is increased in the *Pyramid of Skulls* (cat. no. 212), in which the three skulls stare out frontally while a fourth can be glimpsed behind them. This sort of trophy arrangement brings to mind the memorable severed Celtic heads of Entremont, found near Aix, which Cézanne knew well (and which can still be seen in the Musée des Beaux-Arts there). The objects are viewed

from very close up: unlike the famous apples, always judiciously arrayed for harmonic effects of form and color, these bony visages all but assault the viewer, displaying an assertiveness very much at odds with the usual reserve of domestic still-life tableaux.

This canvas was certainly painted in Aix, in the rue Boulegon studio, where Cézanne worked between the sale of the Jas de Bouffan (1899) in the wake of his mother's death and his move to the newly completed Les Lauves studio (September 1902). One person who visited him in July 1902 wrote: "I left Cézanne after having spent another half hour with him in his cold house. In his bedroom, on a narrow table in the middle, I noticed three human skulls facing one another, three beautiful polished ivories. He spoke of a very good painted study that was somewhere in the attic. I wanted to see it. He looked for the key to this garret, but in vain, for the maid had mislaid it."[13]

The other version of these same objects in a pile, *Three*

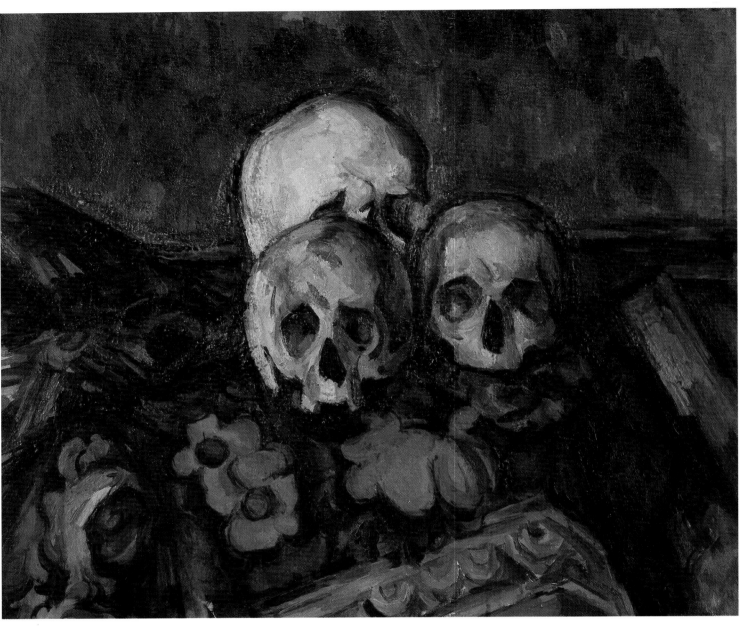

213

Skulls on a Patterned Carpet (cat. no. 213), which again pictures them with the whitest skull above darker ones, is probably later in date, for it is painted in a thickly impastoed technique characteristic of the artist's very last years. This surface may be the result of reworking, however, for the artist doubtless revisited an earlier work, begun about the same time as the previous canvas, as indicated by Vollard: "Visible on the easel was a still life begun several years earlier and representing some skulls on an oriental carpet."[14] Another witness, Émile Bernard, mentioned the same canvas in an account of a visit with Cézanne that took place in February 1904: "For a month he had been working every morning, from six to ten-thirty. . . . 'What I lack,' he said to me in front of his three death's-heads, 'is *réalisation*. Perhaps I'll manage it, but I'm old, and it could

be that I'll die without having attained this supreme point: To realize like the Venetians!' . . . That's the way I saw him, during the whole month I was in Aix: toiling over the picture of death's-heads that I consider to be his testament."[15]

In the few years separating the two paintings of three skulls, what was initially an impressive motif was transformed into a novel *vanitas,* one in which the fragility of life is shown not by a youthful face, a ripe piece of fruit, a butterfly, or fading flowers, as in the seventeenth century, but rather by the sensuous color of a richly patterned carpet.[16]

Cézanne's skulls are somewhat unusual in that they lack both their teeth and their lower jaws, features that would have evoked more vividly the mordant laughter that figures in Verlaine's poem. In these still lifes Cézanne emphasized instead the cranium just as he did in his self-

portraits, where he always articulated the profile of his own bald, round pate, and obscured his jaw or any possible smile behind his beard. In both the self-portraits and the paintings of skulls the focus of concentration is, in effect, the seat of thought and the locus of vision—long empty, in the case of these skulls, but rendered with an intensity that is all but unbearable.

It is difficult to date Cézanne's watercolors with precision, but surely it is reasonable to assume that he did this series at about the time he painted the same objects. *Two Skulls* (cat. no. 214) probably dates from the period of the first oils, for example the one in Detroit (fig. 1), or from shortly before *Pyramid of Skulls* (cat. no. 212), with which it shares fluid handling and a certain compositional resolution. This drawing with watercolor belonged to the German novelist Erich Maria Remarque, who was prompted by the horrors of the First World War to write *All Quiet on the Western Front,* which met with international success in 1929. He acquired it in the United States (where he resided from the late 1930s), apparently on the eve of the outbreak of World War II.[17] Would it be overbold to suggest that it caught his eye because its two death's-heads struck him as a metaphor of the two wars?

Study of a Skull (cat. no. 217) is clearly later, for the multiple lines circumscribing the skull and the forcefully structured masses of color around it are characteristic of the watercolors of the artist's last years. There is something serene and almost mirthful about this rotund white form.

The *Three Skulls* (cat. no. 215) in Chicago appears to be a study for the oil of the same subject (cat. no. 213), or perhaps a parallel work produced at the same time. But the lightness of the watercolor and the vivacity of the colors, as well as a tremulous quality in the drawing, impart a rare grace to these morbid objects. Note that two of the skulls are placed at a slight angle, setting this sheet somewhat apart from the more rigidly frontal compositions, such as *Skull on a Drapery* (cat. no. 216).

The "drapery" in question here is really a thick carpet, the same one visible in the oil (cat. no. 213); Cézanne placed the whitest of the skulls on it to maximize the effect of contrast. Here the patterns and colors of the carpet are rendered more vividly than in the preceding watercolor and the painting, where the greens seem to have darkened considerably. The geometric pattern has remarkable force, pitting the gently rounded contour of the skull against the crisp angles of the crumpled rug, on which the skull has been set like a precious stone. Form is evoked primarily by the white areas of the paper, and the overall impression of a rare, almost sacred object is reinforced by the four triangular areas left empty in the four corners of the sheet. As Rewald observed, it is probably this watercolor, and not a canvas that has since been lost, that was listed erroneously as a painting in Georges Rivière's first attempt at a catalogue raisonné of the oils.[18]

It must be the arrangement devised for this impressive sheet that Francis Jourdain described in his account of the visit to Aix in Camoin's company in 1904: "We entered a pavilion that Cézanne used only for work, where an indescribable disorder reigned, with the pipe of an old clyster-pump rising to a skull that, placed on an imitation oriental carpet, constituted the motif for a still life."[19]

Vollard must have been very attached to this watercolor, for he never sold it; it remained in his personal collection at his death.

F. C.

1. On the verso of this watercolor is a drawing (C. 1151).
2. Vollard, 1914, p. 148.
3. See Rishel in The Barnes Foundation, Merion, Pennsylvania, *Great French Paintings from The Barnes Foundation: From Cézanne to Matisse* (New York, 1995), p. 148.
4. See also V. 68.
5. Cézanne to Zola, December 19, 1878 ("I'll die before he does, for sure" [referring to his father]) and November 27 [1882] ("I have resolved to draft my will"), in Cézanne, 1978, pp. 177, 207.
6. See Badt, 1965, pp. 97-99; and Schapiro, 1968, p. 48. Reff (October 1983) has analyzed a strange text written by Cézanne in his youth, "La Mort règne en ces lieux," in which a father encourages his children to eat a severed head; this text was enclosed in a letter to Zola dated January 17, 1859 (in Cézanne, 1978, pp. 45-48).
7. See Bernard, 1925, p. 35.
8. M. C., November 1960, p. 300.
9. "Une Charogne" ("Carrion") is one of the most celebrated poems in Baudelaire's *Les Fleurs du Mal.* "Un Pouacre" (literally "A Lice-Infested Person") is a passage from *Jadis et Naguère* by the poet and critic Jean Royère (1871-1956), a disciple of Mallarmé.
10. Gasquet, 1921, pp. 19-20.
11. V. 679; The Barnes Foundation, Merion, Pennsylvania.
12. Now in a private collection; see Philadelphia, 1983, no. 1, p. 2.
13. Borély, July 1, 1926; reprinted in Doran, 1978, p. 22.
14. Vollard, 1914, p. 148.
15. Bernard, October 1 and 15, 1907; reprinted in Doran, 1978, pp. 57-58.
16. See Sterling, 1959, pp. 102-3.
17. This sheet was exhibited with his collection as early as 1943, at the Knoedler Galleries, New York, no. 41.
18. See Rivière, 1923, p. 224; and Rewald, in New York and Houston, 1977-78, no. 73, p. 408.
19. Jourdain, 1950, p. 9.

Fig. 1. Paul Cézanne, *Three Skulls,* 1898-1900, oil on canvas, The Detroit Institute of Arts, Tannahill Collection.

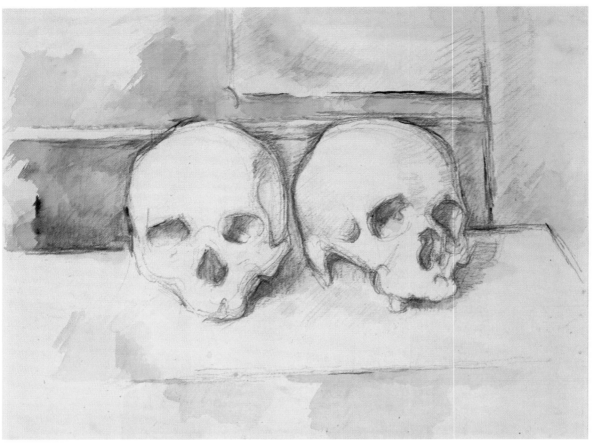

214

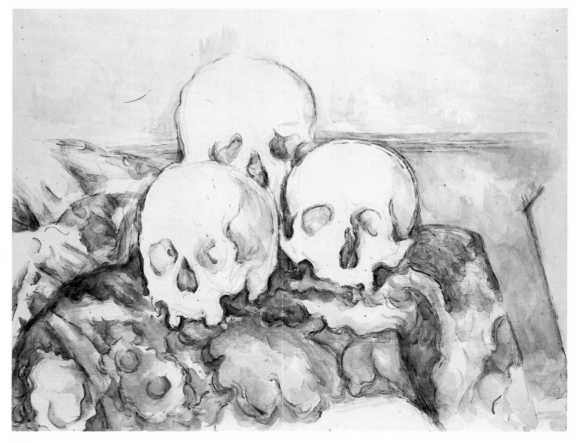

215

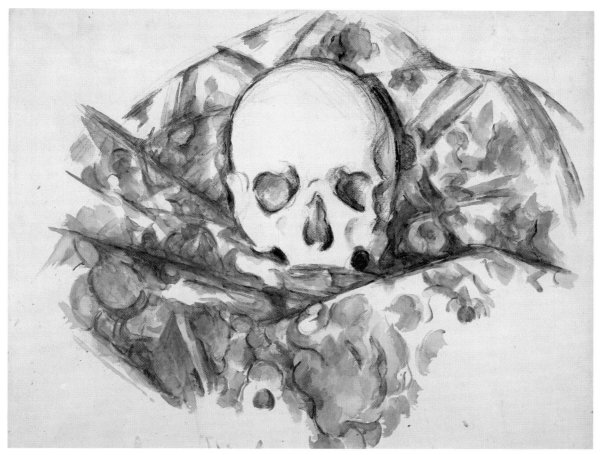

216

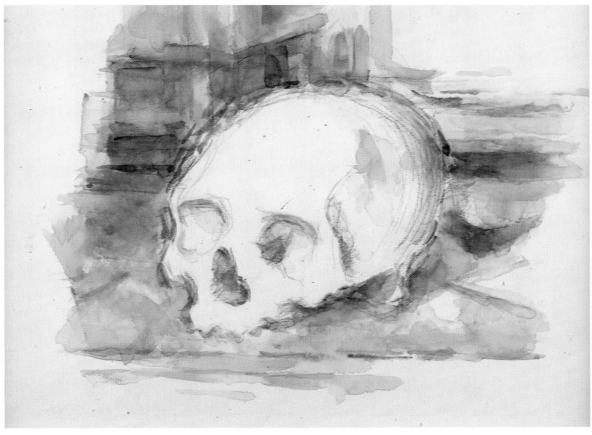

217

Bathers

218 | *The Large Bathers*

1894-1905
Oil on canvas; 50^1/$_{16}$ × 77^3/$_{16}$ inches (127.2 × 196.1 cm)
The Trustees of the National Gallery, London
V. 721

PROVENANCE
Auguste Pellerin owned this painting as early as 1907, when he lent it to
the Salon d'Automne; he probably purchased it from Bernheim-Jeune in
February 1907.[1] It remained in the Pellerin family, passing by descent to
his daughter, Mme René Lecomte, Paris, from whom it was purchased in
1964 for the National Gallery, London, with the aid of the Max Rayne
Foundation and a special grant.

EXHIBITIONS
After 1906: Paris, 1907 (b), no. 17; Paris, 1954, no. 63; Paris, 1978, no. 96;
Basel, 1989, no. 70.

219 | *The Large Bathers*

1906
Oil on canvas; 82 × 99 inches (208.3 × 251.5 cm)
Philadelphia Museum of Art.
Purchased with the W. P. Wilstach Fund, W1937-1-1
V. 719

PROVENANCE
Ambroise Vollard sold this painting to Auguste Pellerin. It remained in the
family, passing to Jean-Victor Pellerin, Paris, who sold a half share to Wil-
denstein Galleries, New York. In 1937 it was purchased by the Philadel-
phia Museum of Art, with the W. P. Wilstach Fund.

EXHIBITIONS
After 1906: Paris, 1907 (b), no. 19; Berlin, 1908, no. 40; Paris, 1926,
no. 107; Paris, 1936, no. 107; Chicago and New York, 1952, no. 95; Paris,
1955, no. 5.

220 | *Bathers*

1899-1904
Oil on canvas; $20^{3}/_{16} \times 24^{5}/_{16}$ inches (51.3×61.7 cm)
The Art Institute of Chicago. Amy McCormick Memorial Collection
V. 722

PROVENANCE
This painting was first in the collection of Jacques Zoubaloff, Paris, until its sale at the Galerie Georges Petit, Paris, on June 16-17, 1927 (lot 113). Thereafter it was in the possession of Jos Hessel, Paris. It subsequently passed through the dealer Paul Rosenberg to the Chester H. Johnson Gallery, Chicago. It was purchased before 1930 by Col. Robert R. McCormick, Chicago.[2] In 1942 it was acquired by the Art Institute of Chicago.

EXHIBITIONS
After 1906: Cincinnati, 1947, no. 12; Chicago and New York, 1952, no. 98; Edinburgh and London, 1954, no. 60; Washington, Chicago, and Boston, 1971, no. 29; New York and Houston, 1977-78, no. 38; Paris, 1978, no. 100; Liège and Aix-en-Provence, 1982, no. 28; Basel, 1989, no. 68.

221 | *Bathers*

1902-6
Oil on canvas; $28^{15}/_{16} \times 36^{7}/_{16}$ (73.5×92.5 cm)
Private collection
V. 725

PROVENANCE
On his death in 1939, Ambroise Vollard left this painting to Paul Cézanne *fils*. After World War II, the latter's widow sold it, through Maurice Renou, to Walter Feilchenfeldt, Zurich. It is now in a private collection.

EXHIBITIONS
After 1906: Paris, 1929, no. 43; Paris, 1936, no. 106; Aix-en-Provence, 1956, no. 63; The Hague, 1956, no. 47; Zurich, 1956, no. 82; Munich, 1956, no. 63; Cologne, 1956-57, no. 31; Aix-en-Provence, 1961, no. 19; Vienna, 1961, no. 42; Hamburg, 1963, no. 13; Tokyo, Kyoto, and Fukuoka, 1974, no. 55; New York and Houston, 1977-78, no. 41; Paris, 1978, no. 104; Basel, 1989, no. 72; Tübingen, 1993, no. 83.

With the *Large Bather* in the Museum of Modern Art, of about 1885 (cat. no. 104), and the *Bathers* in the Musée d'Orsay, of about 1890 (cat. no. 140), Cézanne brought his series of male bathers in a landscape to a scale and a compositional complexity beyond which he would never venture again. Thereafter his ambition to create a masterpiece in the Western figurative tradition was concentrated on the female nude. That Cézanne succeeded, though not without great effort, is evidenced in the three *Large Bathers*, which occupied him to the very end of his life. They are, with the Barnes Foundation's *Cardplayers* (repro. p. 56), the largest works he ever undertook. With the late paintings of Mont Sainte-Victoire, they are for many his greatest achievements.[3]

Two of these large canvases are included in the present exhibition (cat. nos. 218 and 219); the other is in the Barnes Foundation in Merion, Pennsylvania (repro. p. 39). Like the depictions of Mont Sainte-Victoire seen from Les Lauves, they are superficially very similar but quite different in pictorial arrangement and expressive effect. Even before Cézanne's death, their histories and meanings had become intertwined and confused. In light of this, it may be best to begin our discussion with a survey of the early sources.[4]

Ambroise Vollard, in his biography of Cézanne, published in 1914, wrote as follows: "In the same period as my portrait [cat. no. 177], Cézanne was also working on some *nudes*. . . .

"He began this canvas in 1895, and he worked on it until the end of 1905.

"For his nude compositions, Cézanne used drawings from nature [he had] made previously at the Atelier

Suisse, and, for the rest, he called upon his memories of the museums.

"His dream would have been to have nude models pose in the open air; but that was unfeasible for many reasons, the most important being that women, even when clothed, frightened him. He made an exception only for a female servant who had previously worked for him at the Jas de Bouffan, an old creature with a rough-hewn face of whom he remarked admiringly to Zola, 'Look, is that handsome? One would say she's a man!'

"Imagine my surprise, then, when he informed me one day that he wanted to have a woman pose for him in the nude. 'What's that, Monsieur Cézanne,' I couldn't help exclaiming, 'You're going to have a woman pose in the nude?'—'Oh! M. Vollard, I'll get some old crow *[une très vieille carne]*!' He indeed found one that suited him, and, after doing a nude study, he painted two portraits of the same model, now clothed, that bring to mind the poor relations encountered so frequently in Balzac's stories."[5]

The archaeologist Jules Borély, in an article published in *L'Art Vivant* in 1926, reported on a visit he paid Cézanne in 1902 at Les Lauves: "We went up to the studio, for I had expressed a desire to do so. I saw a high broad room with bare, lifeless walls and a window overlooking an olive grove. There, captive and sad, two easel paintings. A band of nude young women, their white bodies set against lunar blues."[6]

Émile Bernard photographed Cézanne sitting before a *Large Bathers* in the Aix studio in 1904 (repro. p. 563). Cézanne believed this photograph was taken at the request of Vollard.[7] In a letter to his mother, posted from Marseille and dated February 5, 1904, Bernard reported on this visit as follows: "I have seen some of his pictures, among others a large canvas of female nudes that is a magnificent thing, in its forms as much as in the power of the whole and of the human anatomy. It seems he's been working on it for

ten years."[8] Returning from a trip to Naples in March 1905, Bernard paid another brief visit to Cézanne, about which he subsequently wrote: "There was also, on a mechanical easel that he had just had installed, a large canvas of female nudes bathing that was in a state of total disorder. The drawing in it struck me as rather deformed. I asked Cézanne why he didn't use models for his nudes. He answered that at his age one had the obligation not to make a woman undress to paint her, that it would be permissible for him, if absolutely necessary, to call on a woman in her fifties, but that he was almost certain he would never find such a person in Aix. He went to his portfolios and showed me some drawings he had made in the Atelier Suisse in his youth. 'I've always used these drawings,' he said to me. 'It's scarcely sufficient, but I have to at my age.' I divined that he was the slave of an extreme sense of decorum, and that this slavery had two causes: the one, that he didn't trust himself with women; the other, that he had religious scruples and a genuine feeling that these things could not be done in a small provincial town without provoking scandal."[9]

R.-P. Rivière and Jacques-Félix-Simon Schnerb provided the following account of their visit to the painter, published as "L'Atelier de Cézanne" in 1907 in *La Grande Revue*: "The visit we are reporting took place in January 1905. Visible at that time in the studio on the Chemin de l'Aubassane [Chemin des Lauves] was a large picture of bathers with eight figures, almost life-size, on which Cézanne was still working. 'I scarcely dare admit it,' he said, 'I've been working on it since 1894. I wanted to lay on the paint, like Courbet.' Apparently he had returned to his first admiration for the master of the Franche-Comté, whom he qualified as a 'beautiful brute.'"[10]

One of the last visitors to be received by Cézanne was the Westphalian collector Karl Ernst Osthaus, who in April 1906 went to Aix with his wife specifically to see the artist. Of the studio at Les Lauves, Osthaus wrote: "It was here that he created in his last years most of his immortal works. On the easel were a still life, scarcely begun, and the capital work of his old age, *The Bathers*. The tall shafts of the trees bent down, already forming the cathedral vault beneath which unfolded the scene of bathers."[11]

Cézanne himself stated at least twice that he had commenced work on an ambitious painting of female bathers in the mid-1890s. Vollard's indication that he learned of such a project while posing for his 1899 portrait is thus credible, even though he made no mention of having seen any evidence of it in the Paris studio. Götz Adriani has suggested that the model in Vollard's anecdote is the one pictured in a watercolor and a painting of an older woman holding both arms over her head (figs. 1 and 2).[12] This figure is not repeated, however, in any of the late Bather compositions. Given Cézanne's own insistence to Bernard in 1904 that a large *Bathers* had been in progress since 1894, as well as the independent confirmation of a similar time frame from Rivière, Schnerb, and Gasquet, it seems likely that something ambitious was afoot by the late

Fig. 1. Paul Cézanne,
Standing Female Nude, 1898-99,
watercolor,
Musée du Louvre, Paris,
Département des Arts Graphiques,
Musée d'Orsay (R. 387).

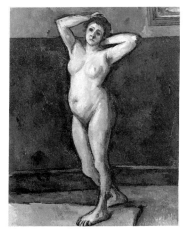

Fig. 2. Paul Cézanne,
Standing Female Nude, 1898-99,
oil on canvas,
private collection (V. 710).

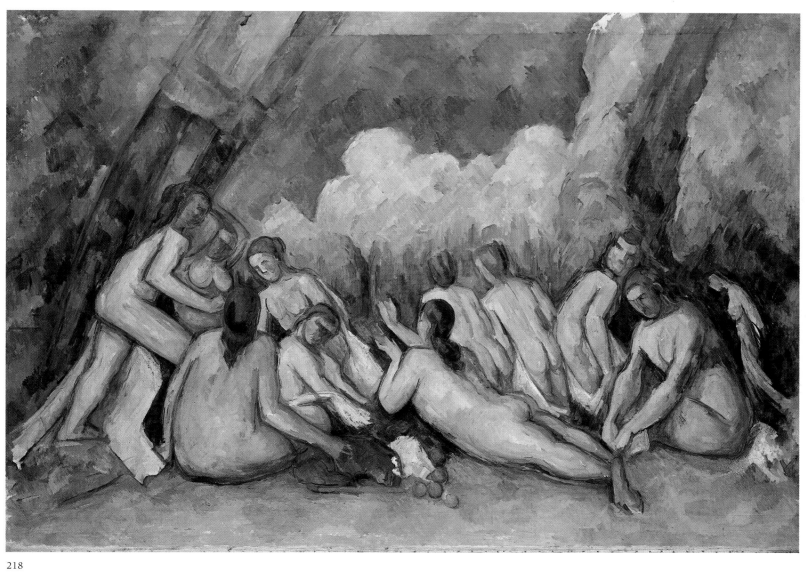

218

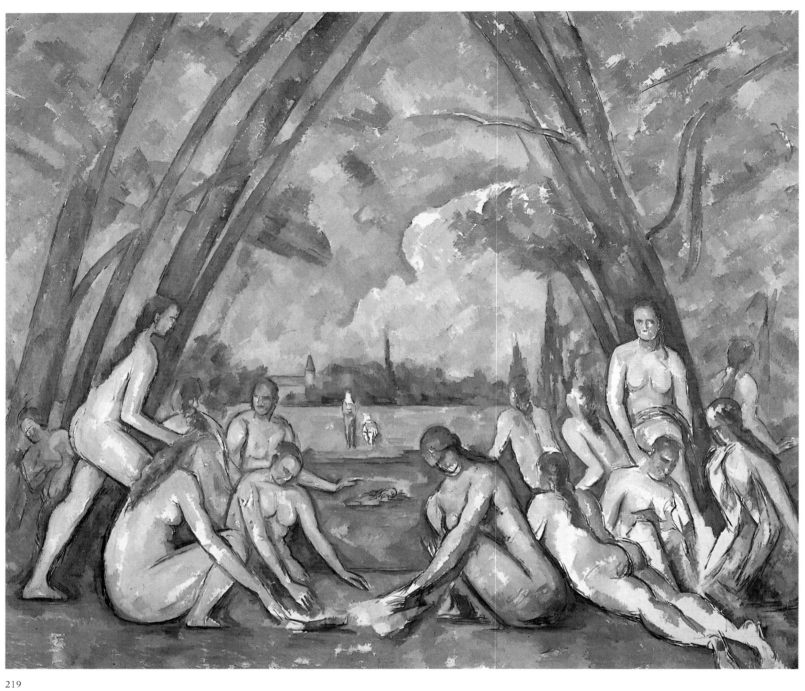

219

1890s. This idea is buttressed by Gasquet's account of having seen a *Large Bathers* in the Jas de Bouffan, the house Cézanne was forced to abandon in 1899.[13]

Gasquet reported having seen in the Jas de Bouffan, at an unspecified date, a version of the large "Pellerin *Bathers*": "I once saw a splendid replica of it, almost finished, at the top of the stairway of the Jas de Bouffan. It remained there for three months, then Cézanne turned it against the wall, then it disappeared. He didn't want anyone to talk to him about it, even when it shone in full sunlight and one had to pass in front of it to reach his studio, under the eaves. What became of it? The subject that so haunted him consisted of bathing women beneath some trees, in a meadow. He made at the very least some thirty small sketches of it, including two or three very fine, very finished canvases, a multitude of drawings, some watercolors, some sketchbooks that never left the chest of drawers in his bedroom or the table in his studio."[14] It becomes clear from a lengthy and emotional description immediately following this passage that Gasquet's "Pellerin *Bathers*" is the Philadelphia version, which was then in the collection of Auguste Pellerin. As Reff has indicated, this description is so detailed that Gasquet must have had a photograph in front of him as he wrote (there is some doubt as to exactly when Gasquet's text was written, but it was prior to 1921, when he died).[15]

Borély's description of "a band of nude young women, their white bodies set against lunar blues"[16] is consistent with the eerie "day for night" light that permeates both the Barnes and London paintings; the Philadelphia *Large Bathers*, by contrast, is awash in the bright light of midday.

The painting in the background in Bernard's photograph of 1904 is irrefutably the Barnes picture, as it existed before Cézanne reworked the giantess striding in from the left (the relief of her outline as she appears in the photograph is still apparent in the painting). Cézanne's assertion to Rivière and Schnerb in 1905 that he "wanted to lay on the paint, like Courbet"[17] is also most consistent with the thick and ruggedly worked surface of the Barnes painting, an association confirmed by the mention of eight figures. On the other hand, Osthaus's description of a great vault of trees can only be a reference to the Philadelphia painting.

Reviewing the situation in inverse chronological order, we know from Osthaus that the Philadelphia painting was definitely in the studio at Les Lauves in 1906, as was the Barnes painting from the autumn of 1904 through Rivière and Schnerb's visit in early 1905. Either the London or Barnes *Large Bathers* was seen by Borély in 1902, and each is a good candidate for the picture seen at the Jas de Bouffan by Gasquet, or the project mentioned by Vollard.

There is also some technical information that bears on the possible evolution of these works. Cecil Gould recorded that the London painting had been folded under the stretcher at the top, with the result that there is a paler strip, untouched by some later campaign of background painting, running across its upper edge (now intentionally hidden by the frame).[18] This adjustment pushed the figures three or four inches higher in the picture plane. There are also two folds along the bottom edge containing what might be two different rows of nail holes, painted over with ocher by Cézanne. Clearly the London picture was removed from its stretcher and remounted, once if not twice. If these alterations were not the result of Cézanne's ruthless self-editing while he painted, they may have occurred when the picture was stored during the three-year period between the sale of the Jas de Bouffan (when the artist returned to Aix from Paris) and the completion of the studio at Les Lauves. While the Barnes picture has not been examined for such technical details (and the density of paint is such that nearly any folds and nail holes would have been completely obliterated, perhaps in the course of the transformation that took place between Bernard's visits in 1904 and 1905), the 1904 photograph does show a large crease on the right side that is still visible in the painting. Hence the possibility that the Barnes picture was begun prior to 1899 cannot be discounted. There is no evidence in the Philadelphia canvas of any such adjustments or early restretching.

What conclusions are to be drawn from this fragmentary documentation? It seems clear that an ambitious painting of female bathers was in progress by the mid-1890s, and it is entirely plausible that two such canvases were underway prior to 1899, with Cézanne continuing to work on one or the other through 1905. A third painting, the Philadelphia canvas, is first documented in 1906. Most scholars believe that the Barnes painting preceded the one in London; Gould is the only firm dissenter, holding that this order should be reversed.[19] The most credible chronological sequence, then, moves from the Barnes painting, to the London canvas, to the work now in Philadelphia.

As trifling as these observations may seem initially, the implications they hold for our understanding of Cézanne are considerable. If this order is correct, the progression through the sequence then takes on the quality of a spiritual quest, a search for purification. With an increase in the dimensions of the canvases and the number of figures, the heavily worked, sexually charged drama of the Barnes painting evolves through a more pastoral and lyrical reading of the subject in the London version to the final, serene—some would say transcendent—nobility of the Philadelphia canvas. The destructive powers of Diana are gradually brought into balance by the calming influence of Venus;[20] Cézanne's psychic struggles with his father and sexuality in general are brought to a kind of "closure."[21]

The history of the three *Large Bathers* becomes a microcosm of Cézanne's career: a transformation from the reckless brutality of 1865-72 to a slowly achieved control and balance in the years 1872-85, culminating in a visionary force near the end of his life—Moses glimpsing the Promised Land, as he wrote to Vollard in 1903.[22]

These notions are best tested through a consideration of the individual paintings.

In the London *Large Bathers* (cat. no. 218), eleven nude women are gathered in a forest glade. Everything implies

that they are on a sandy beach near a river, but no water is visible. They seem completely at ease, with perhaps the exception of the large figure who aggressively strides in from the left. Her arrival, however, has not disturbed the leisure of others, who stretch, converse, and play with the black dog in the center foreground. A pair of evenly matched redheads with pearly skin move away from the viewer, presumably toward the water. The one strange note in this scene of contentment is the sketchy profile figure on the far right in the distance, who appears to be pacing restlessly in the underbrush.

The composition is very shallow, and it is difficult to imagine that the water beyond is more than a stream. The colors are generally muted and carefully balanced, so the assertive ochers of the foreground, echoed in a semicircle in the distance, are held in check by the pale greens, deep purples, and lavenders. All the whites are blued in varying degrees—dominated by the cobalts, ultramarines, and Prussian blues that Cézanne favored near the end of his life—with a milky quality that sets the tone of the entire picture.

The paint is applied with an even texture: undemonstrative in the figures, somewhat livelier in the landscape, but always with a sense that it has been melted slightly, or washed down, blurring the transition from stroke to stroke and giving the entire surface a nacreous sheen. Much of this is due to Cézanne's having applied opaque pale pigments over darker, more transparent layers. The result, while consistently fluid in its surface, gives the painting an aura of deep, slowly aroused sensuality. This quality is further enhanced by the filtered light that pervades the space evenly, producing the "lunar" effect noted by Borély.

The principal elements—the two trees on the left as well as the figures—are boldly outlined in deep blue. While this inscribes them with great weight along the narrow shelf of space—almost "as if they'd been sliced out of mountain rock," as Henry Moore noted when he first saw this picture in the Pellerin collection in 1921[23]—it also unifies them into one massive element. With little to define or characterize them as individuals—their hair colors are their most distinguishing features—these women revert to essential forms of a very primitive nature. This generic quality adds considerably to the blunt plainness and homogeneity of the picture.

The passions and conflicts that run through the Barnes picture with such a fervor seem entirely spent here, or at least deeply submerged under some slow-beating pulse. The tempestuous nature of the landscape and churning sky have been cleansed by the blue wash. A new kind of domestic serenity and ease has taken over. The London *Large Bathers* is, in a way, as close as Cézanne would ever come in the female theme to the less "loaded" spirit of his male bather compositions. It seems an unassertive, plain, and comfortable painting, not unlike certain Raphaels that remain very grounded for all their ethereal enchantment.

The cast of characters and their disposition in the *Large Bathers* in Philadelphia (cat. no. 219) are essentially those of the London painting, but the number of figures on the near riverbank has risen to fourteen, joined in the distance by a swimmer in midstream as well as two mysterious people on the opposite shore. The principal figurative innovation in the Philadelphia painting is the frontal nude leaning gracefully against the tree on the right (derived, as Krumrine has pointed out, from Cézanne's drawings after the Venus de Milo),[24] a becalmed variant of the highly charged woman stretching against the corresponding tree in the Barnes painting. While Cézanne seems content to have rearranged his stock figures in his Bather compositions,[25] there is a wonderfully engaging sense of invention in some of the poses in this final version. For example, Cézanne's addition—with only a few brushed lines—of a kneeling woman with her arms crossed (?), beneath the tree on the far left, was doubtless meant to counterbalance the similarly sketchy figure departing on the far right.

Despite this painting's unfinished state, it is clear that the attentions of the central group are still focused on the dog and the picnic paraphernalia, here indicated by summary blurs of pigment. The enchanting pair of women setting out for the water—reminiscent of a similar couple in Domenichino's *Diana with Nymphs at Play* (1616-17; Galleria Borghese, Rome)—are now more upright and alert. The self-absorbed figure pacing in the distance on the far right of the London version has been turned as if ready to move offstage. This spirit of dispersal, enlivening the drama, is also evident in another new figure just to the right of the striding woman; turned away from the viewer, as she is from her companions, she seems to be rising to leave.

The fact that such activity can take place among the figures is, of course, due to the space they have to explore. For the first time in this theme of female bathers, Cézanne has opened the barrier of hills and foliage that confined earlier groups to a narrow frieze of space. In the Philadelphia painting they participate freely in an immense and welcoming landscape, contained only by the vast sky that expands beyond the open vault of arched trees.

The colors are very harmonious and simple: greens, ochers, and blues, heightened with small touches of vermilion, all laid on with the discretion and transparency of watercolors. The sense of a great and even radiance permeating the picture is not the product of heavily built-up transparent layers as in the Barnes and London versions, but rather of the amount of white canvas allowed to show through, giving this painting an airy freshness.

The effect is both exalting and exhilarating. It is a wonder that such a monumental and gravely traditional subject, which Cézanne had explored in ponderous and ruminative ways earlier, was achieved so lightly and with such grace. The fact of this accomplishment has the second effect of liberation.

Two large oil sketches (cat. nos. 220 and 221) are closely related to the Philadelphia *Large Bathers*. They are quite different from one another, and stand as substantial works in their own right. Neither seems in any way to be a pre-

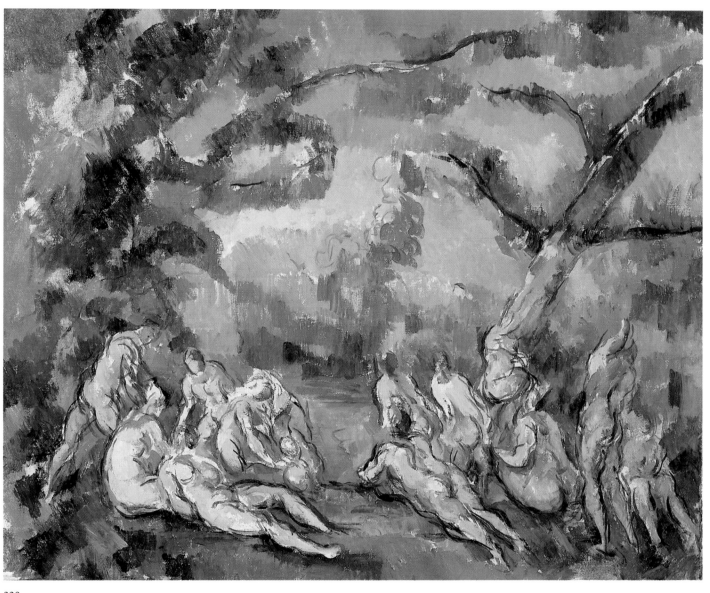

220

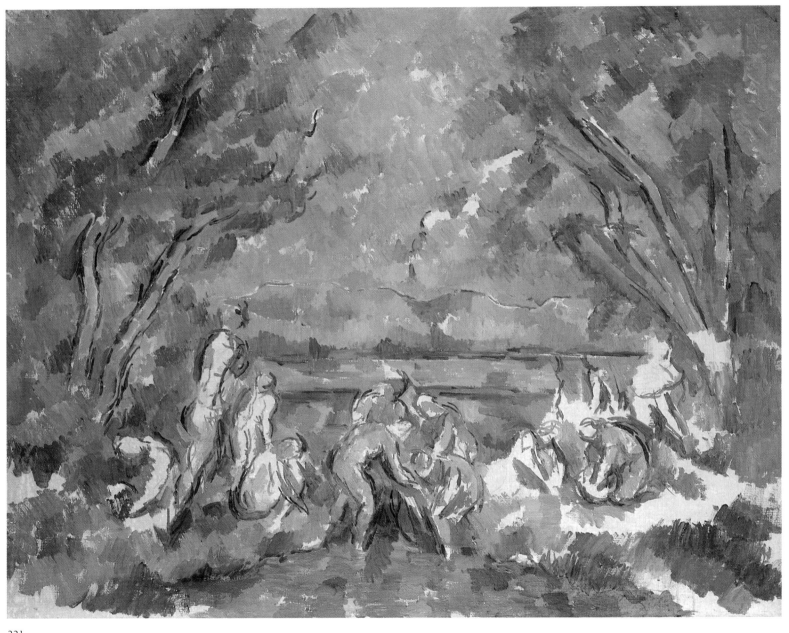

221

paratory study for the large compositions on the subject. If anything, their smaller scale and looser handling may have served Cézanne as a release from the solemn deliberations of the large canvases into something more amusing or more purely beautiful.

In many respects, the Chicago *Bathers* (cat. no. 220) is a comic variant of the large Philadelphia painting. It has a liveliness and gaiety that brings to mind the late watercolors of male bathers (see cat. no. 141), or one of the studies of female figures playing in the water under an arched bridge (fig. 3). A ripple of pending activity plays through the group, with the exception of the rather blowzy woman (an addition to Cézanne's bather repertory) sprawling contentedly on her back in the left foreground. She counters the parallel woman reclining on her stomach, who appeared as such a weighty and crucial element in the London and Philadelphia paintings. The two red-headed figures receding down the bank (also present in the London and Philadelphia versions) here seem about to plunge into the water, while the woman awkwardly stretching against the large tree in the Barnes painting has been replaced by a figure who quite vigorously bestrides its trunk. Coursing blue-black lines emphasize the more telling and curvaceous parts of the figures, uniting the party in rhythms of a rococo playfulness. A similarly sprightly sense of fun suffuses the lush and vernal landscape, made up of wet, dashed brushstrokes of myriad greens and blues intershot with touches of yellow.

The second important oil sketch to be considered here is now in a private collection (cat. no. 221). Venturi listed it as a "sketch *[ébauche]* for the *Large Bathers*," but this is potentially misleading. As in the Philadelphia *Bathers*, the figures gather about a river to commune and perhaps play, with an expansive landscape opening behind them through a proscenium of arching trees. It has all the grace, ease, and nobility of the Philadelphia canvas, but this is a stranger, more hauntingly beautiful image. The light, represented by exposed canvas, is concentrated not in the center but on the right, creating a kind of spotlight around a kneeling figure, perhaps clothed, who works a round object with her hands. The four central figures actually stand in the water; their attention is focused on the one of their number who bends lowest. Eerie flashes light the figures on the left, who seem to observe the goings-on to their right.

While the palette is quite varied, with strong purples, greens, deep reds, and ochers, the result has the almost monochromatic quality of a blue grisaille. Kurt Badt captured this quality nicely, observing that the work is "absolutely drenched in a mysteriously floating milky blue, the blue of a dove's wing, the blue of a parma violet, which very nearly swallows up all the local colours."[26] One might add that it envelops all the elements—trees, sky, water, figures—in a rapturously vibrating unity that is unique in Cézanne's oils, and perhaps allows us a glimpse of a new expressive manner on which he was yet to embark. The unity here between figures and landscape, humans and nature, approaches a pantheistic ecstasy, yet one imbued with great serenity and acceptance that borders on the devotional. In turn, blue is used in much the same way Matisse would use blue for the window in the chapel in Vence some fifty years later.

J. R.

1. "A label formerly on the back . . . reads 'Bernheim Jeune & Fils, 25, Boulevard de la Madeleine, No. 15662 Cézanne Baigneuses.'" Martin Davies and Cecil Gould, *National Gallery Catalogues, French School, Early 19th Century, Impressionists, Post-Impressionists* (London, 1970), p. 24.
2. See The Museum of Modern Art, *Summer Exhibition: Retrospective* (New York, 1930), no. 15.
3. The Bathers series and their history within Cézanne's work were the subject of an exhibition organized by Mary Louise Krumrine and Christian Geelhaar. See Krumrine, 1989; and Krumrine, September 1992.
4. This material has been outlined by Theodore Reff (October 1977 [b]; and in New York and Houston, 1977-78, pp. 38-44).
5. Vollard, 1914, p. 96.
6. Borély, July 1, 1926; reprinted in Doran, 1978, p. 19.
7. Cézanne to Bernard, May 12, 1904, in Cézanne, 1978, p. 302.
8. Doran, 1978, p. 24.
9. Bernard, October 1 and 15, 1907; reprinted in Doran, 1978, pp. 58-59.
10. Rivière and Schnerb, December 25, 1907; reprinted in Doran, 1978, p. 91.
11. Osthaus, 1920-21; reprinted in Doran, 1978, p. 99.
12. See Adriani, 1993 (b), no. 76, p. 226.
13. See Gasquet, 1921, p. 35.
14. Ibid.
15. Reff's objection (in New York and Houston, 1977-78, p. 38) that all three of the late *Bathers* were too large to fit into the attic studio at the Jas de Bouffan is logical, but Gasquet said only that one had to pass in front of it to reach the stairs leading to the attic. Cézanne could have worked on the painting elsewhere in the house, or it could have been brought to the Jas de Bouffan from Paris.
16. See note 6 above.
17. See note 10 above.
18. Davies and Gould (see note 1 above), pp. 22-24.
19. Ibid.
20. See Krumrine, 1989, p. 214.
21. See Geist, 1988.
22. Cézanne to Vollard, January 9, 1903, in Cézanne, 1978, p. 292.
23. Philip James, ed., *Henry Moore on Sculpture* (London, 1966), p. 190.
24. See Krumrine, 1989, p. 214.
25. See the glossary of figures in Krumrine, 1989, pp. 243-53.
26. Badt, 1985, p. 316.

Fig. 3. Paul Cézanne,
Bathers Under a Bridge, 1900-1906, graphite and watercolor on paper,
The Metropolitan Museum of Art, New York,
Maria de Witt Jesup Fund (R. 601).

Seated Peasants

222 | *Seated Peasant*

c. 1900-1904
Oil on canvas; 28³/₄ × 23⁵/₈ inches (73 × 60 cm)
Private collection
V. 713

PROVENANCE
Ambroise Vollard left this canvas to Madame de Galéa; it subsequently
passed from Robert de Galéa to a private collection.

EXHIBITIONS
After 1906: Paris, 1929, no. 40; Paris, 1945, unnumbered.

EXHIBITED IN PARIS ONLY

223 | *Seated Peasant*

c. 1900-1904
Watercolor on yellowish paper; 18¹/₁₆ × 12³/₁₆ inches (45.8 × 31 cm)
Kunsthaus Zurich
R. 491

PROVENANCE
Ambroise Vollard sold this watercolor to Paul Cassirer, Berlin, in the early
1920s. On his death, it passed to his daughter Suse Paret-Cassirer, Berlin.
In 1935 she consigned it to the firm of Paul Cassirer, Amsterdam, and it
was sold in the same year to the Kunsthaus Zurich.

EXHIBITIONS
After 1906: Paris, 1936, no. 132; Paris, 1939 (b), no. 52; Lyon, 1939,
no. 55; Aix-en-Provence, 1956, no. 80; The Hague, 1956, no. 83; Zurich,
1956, no. 134; Munich, 1956, no. 106; Vienna, 1961, no. 77; Newcastle
upon Tyne and London, 1973, no. 89; New York and Houston, 1977-78,
no. 119; Paris, 1978, no. 7; Tübingen and Zurich, 1982, no. 102.

EXHIBITED IN PARIS ONLY

Cézanne liked to paint his figures from a vantage directly
in front of them, prompting a silent dialogue in which the
models look calmly and squarely into the eyes of the artist,
but usually with a less penetrating gaze than we see in the
self-portraits.

His preference for frontal poses, with the figure central-
ly placed and inscribed in a regular geometric configura-
tion, became even more pronounced at the end of his life.
The scheme had previously been used in *Woman with a Cof-
feepot* (cat. no. 168) and the *Portrait of Ambroise Vollard* (cat.
no. 177) and would continue in some of the portraits of

Vallier (cat. no. 226), but never would it be so systematic as
in the painting *Seated Peasant* (cat. no. 222). Here the torso
and arms describe a perfect diamond, whose four corners
coincide with the hat, the elbows, and the gap between the
hands. This form is echoed in the patterned wallpaper;
only the cane disrupts the perfect symmetry. The charac-
ter of the old model is accentuated by the contrast between
his enormous hands (especially the left one) and his small
head, weary and shriveled beneath his cap but imbued
with a resolute dignity. This picture inevitably brings to
mind an oft-cited remark of Cézanne's: "I love above all

things the aspect of people who've grown old without changing their ways, abandoning themselves to the laws of time."[1]

Both the sitter's identity and the venue are unknown; thus it is difficult to date the picture with any precision. Sometimes it is possible to situate certain works in specific Parisian apartments by the wallpaper patterns (see cat. nos. 47 and 48); the one pictured here might have been found in the Jas de Bouffan or even the Chemin des Lauves studio, but its most likely location is the rue Boulegon apartment in Aix, where Cézanne resided from the autumn of 1899 until his death. He kept a small studio there, even though he worked every day at the Chemin des Lauves studio after 1902.

The painting has rarely been shown, but when it was exhibited in Paris in 1945, it made a strong impression on Louis Aragon, who had seen all the works before writing his preface to the show's small catalogue. The timing of this event, so soon after the Liberation, prompted him to view the canvases in a context that extolled the great tradition of "our country of painters," and he was especially alert to anything that touched upon the image of an eternal *France profonde* rooted in her peasant stock: "I was there, it was indeed five o'clock in winter, the light from the contrived illumination was harsh and cold like the season, the portrait of an unknown sitter by Cézanne glowed on the wall, with that blue-green hue in the background that ought to be called Cézanne blue but never is, the same one that's in the *Cardplayers*. On the floor was the other Cézanne, much smaller and still unframed, a peasant set against a yellow background and drawn in orange. I'm wary about deciding what I think of it, for what will it become when it has its frame? I saw what happened to the Picasso, a small harlequin from the rose period, once he'd been sprung into an old frame, gilded and regilded, that gave him broader shoulders: he lost his initial character of a study and became an object of great luxury. I'm afraid the same thing might happen to Cézanne's peasant, but this would be more serious. Harlequins can be up to anything, and then it's a Picasso! But if Cézanne's peasant were to be deprived of this atmosphere redolent of a cabaret in Provence or central France, this impoverished air, with the flowered wallpaper"[2]

Some years later, André Lhote, on the basis of notes taken at the same exhibition, reacted more like a painter-theoretician than a poet-patriot: "His entire figure is woven of blue and an orangish color . . . with an infinity of intermediate hues passing through yellow, green, pink, and violet. The intelligent line insinuates itself between these modulations to remind us that what's in question, still, is the decoration of a wall and the construction of an architecture in which geometry hides behind a thousand

smiles. One savors all the more the rhomboidal rhythm of this figure who appears as though enclosed within a diamond, or like a pyramid placed on a platform of robust thighs. Rhomboidal as well are the magnificently overscale hands, although the baroque spirit, on all sides, marries the slightest caprice with the rigor of regulating outlines."[3]

The watercolor (cat. no. 223), a study for the painting, represents the model in the same pose but without the wallpaper background. Its light handling, without the slightest trace of a pencil line, resembles that in *Seated Woman* (cat. no. 169). As has often been remarked, the model's central and symmetrical placement confers upon him a certain hieratic grandeur.[4] Note that Cézanne gave up on the sitter's right hand, devoting all his attention to its enormous mate, which holds the cane.

Lawrence Gowing—himself a painter—has examined how the watercolor was used as an aid in organizing the structure of the painting. In his analysis, aimed at elucidating Cézanne's working methods as well as what he termed his "logic of organized sensations," Gowing established that in the artist's practice, painting was a pursuit of the real, whereas watercolor "translated form into metaphoric sequences of color." About the differences between the present canvas and watercolor he wrote: "In the watercolor the key of blue modulating into yellow and pink formed a conventional system for the notation of the actual bulk. When the lumpy shapes of the model had been elucidated on paper Cézanne could proceed to the pyramidal formulations from which he built the structure on canvas—forms that taper upward from the elbows toward the head and downward to the hands, making a diamond shape, which was painted in the specific earthy colors of the subject (colors of which there is no sign in the watercolor) and reinforced by the pattern of the wallpaper behind. The painting, which appears more 'real,' with a more objective and material reference, is in fact more schematic. The drawing is straighter; the planes are flatter. It seems that the conventional coloration of the watercolor served a functional purpose. It was needed to grasp the actual volumes; it was a digestive system. Only when the complex solidity had been grasped were the schematic structure and indeed the naturalness within reach. In this case the imposing simplicity of the painting was evidently arrived at in two stages."[5]

F. C.

1. Reported by Borély, July 1, 1926; reprinted in Doran, 1978, p. 21.
2. Aragon, in Paris, 1945, p. 19.
3. Lhote, *Traité de la figure* (Paris, 1950), p. 229.
4. Neumeyer, 1958, no. 47, p. 49.
5. Gowing, in New York and Houston, 1977-78, p. 60.

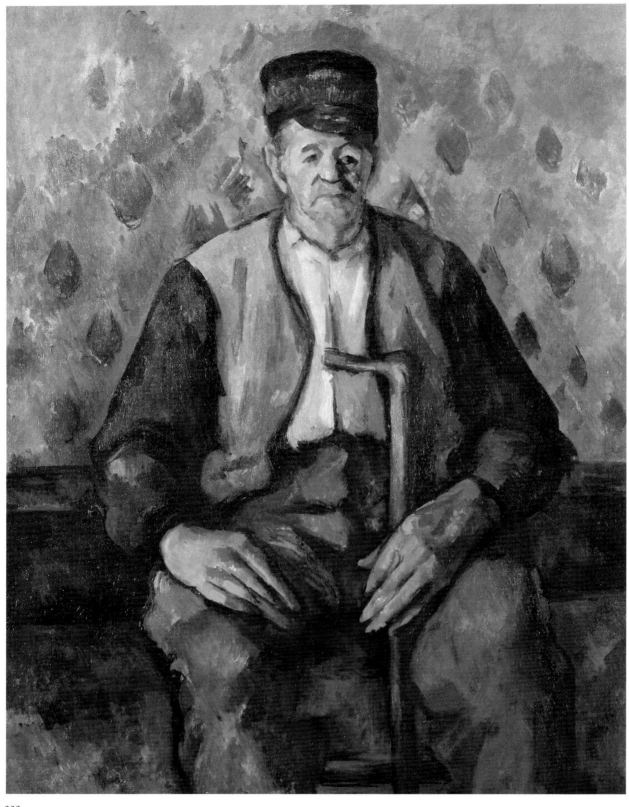

222

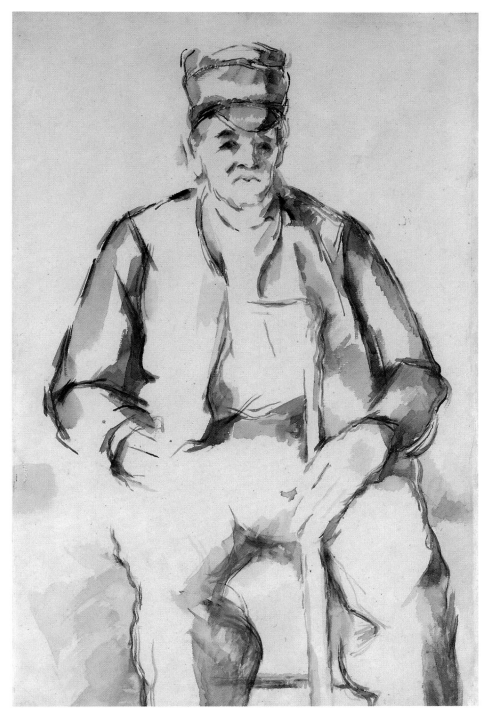

223

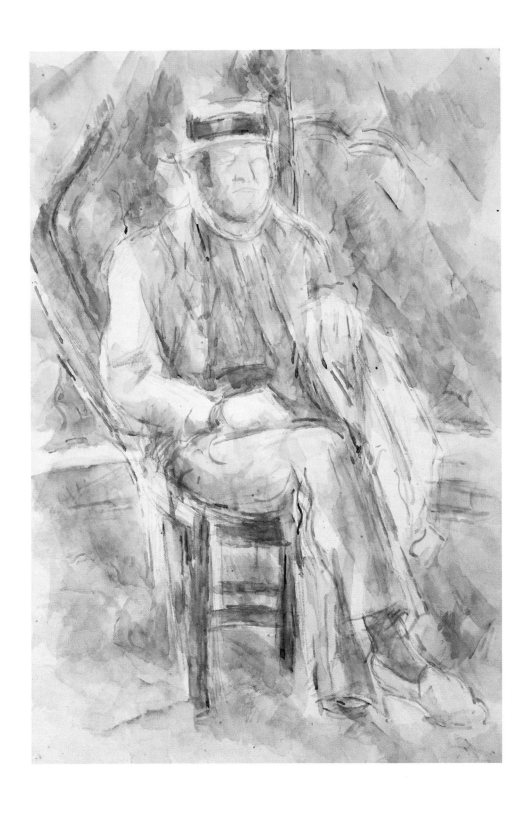

224 | *Peasant in a Straw Hat*

c. 1906
Graphite and watercolor on paper; 18¹¹/₁₆ × 12³/₈ inches (47.5 × 31.4 cm)
The Art Institute of Chicago. Gift of Janis H. Palmer
R. 638

PROVENANCE
This watercolor was purchased from the Vollard estate by Rosenberg and
Stiebel, in the United States. It entered the collection of Mrs. Pauline K.
Palmer, Chicago, then of Mrs. Gordon Palmer. It is now in the Art Insti-
tute of Chicago.

EXHIBITIONS
After 1906: Chicago and New York, 1952, no. 119; Washington, Chicago,
and Boston, 1971, no. 62; New York and Houston, 1977-78, no. 120; Paris,
1978, no. 9.

EXHIBITED IN PHILADELPHIA ONLY

At the end of his life, Cézanne seems to have strayed very
little from his Chemin des Lauves studio, where he worked
in both oils and watercolor, inside as well as outside on the
shaded terrace, which afforded him views of the distant
Mont Sainte-Victoire, the landscape nearby (see cat. nos.
208 and 209), and, close at hand, the flowerpots on the
balustrade (see cat. no. 207). When he found someone
willing to sit for him, it was here that he often had them
pose, as in the depictions of the gardener Vallier (see cat.
no. 226). The man with an oval head in the present water-
color wears a rather crabbed look beneath his hat. Stand-
ing out against the green foliage of the garden, he rests his
left arm, draped with his jacket, on an invisible cane. The
very similar oil painting of the same sitter (fig. 1) was prob-
ably executed about the same time. It seems that in his last
years Cézanne often made parallel watercolors and oils,
using the former either as a preliminary study or to work
out a form or a color after he had begun a painting. In the
case of the *Peasant in a Straw Hat*, the principal difference
between the canvas and the sheet is one of color: the yel-
low hat and sill of the low wall are left white in the water-
color. This may well be the painting that Vollard indicated
was the artist's last: "The next day he went down to the
garden, intending to 'give a push' to a study of a peasant
that was 'coming along well.' In the middle of the session
he fainted. The model called for help and [Cézanne] was
put to bed. He never got up again and died a few days
later."[1] Vollard's lack of precision, however, is well known,
and it seems more likely that Cézanne's final brushstrokes
were applied not to this portrait of a peasant, but to one of
the gardener Vallier (see cat. nos. 225 and 226).

As in the beautiful *Portrait of Vallier* in a private collec-
tion (fig. 2), the lines of blue watercolor—animated and
quivering—are here repeated with the restless, febrile pre-
cision characteristic of Cézanne's late watercolors.

F. C.

1. Vollard, 1914, p. 155.

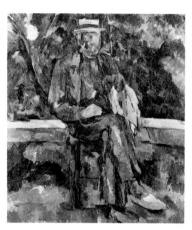

Fig. 1. Paul Cézanne,
Seated Peasant, c. 1906,
oil on canvas,
Collection Thyssen-Bornemisza, Madrid (V. 714).

Fig. 2. Paul Cézanne,
Portrait of Vallier, 1906,
graphite and watercolor on paper,
private collection, Chicago (R. 641).

Portraits of Vallier

225 | *Portrait of the Gardener Vallier*

1904-6
Oil on canvas; 39³/₈ × 31⁷/₈ inches
(100 × 81 cm)
Private collection
V. 717

PROVENANCE
This picture was owned jointly by Ambroise Vollard and Bernheim-Jeune
in 1907; it then passed to Jos Hessel, and thence into the collection of the
playwright Henry Bernstein, who auctioned it in the Bernstein sale (Hôtel
Drouot, Paris, June 8, 1911, lot 8), where it was acquired by Joseph
Müller, Solothurn. It is now in a private collection.

EXHIBITIONS
After 1906: Paris, 1907 (b), no. 51 *(Un vieillard);* Zurich, 1956, no. 85; New
York and Houston, 1977-78, no. 67; Paris, 1978, no. 13; Basel, 1983,
no. 30.

EXHIBITED IN PARIS ONLY

226 | *Portrait of the Gardener Vallier*

1906
Graphite and watercolor on paper;
18⁷/₈ × 12³/₈ inches (48 × 31.5 cm)
The Berggruen Collection,
on loan to the National Gallery, London
R. 640

PROVENANCE
Ambroise Vollard sold this watercolor to Victor Schuster, London. It then
passed to Edward Molyneux, Paris, whence it entered the collection of O.
Edler, London. It was acquired at public auction at Sotheby's, London, on
March 26, 1958 (lot 138), by Heinz Berggruen.

EXHIBITIONS
After 1906: London, 1939 (b), no. 71; Vienna, 1961, no. 82; Aix-en-
Provence, 1961, no. 39; New York, 1963 (a), no. 70; Paris, 1971, no. 21;
Newcastle upon Tyne and London, 1973, no. 97; Tokyo, Kyoto, and
Fukuoka, 1974, no. 87; Tübingen and Zurich, 1982, no. 103.

EXHIBITED IN PARIS AND LONDON ONLY

The last portraits painted by Cézanne carry a special emo-
tional charge. Vallier was an old man who worked for the
artist in his final years, keeping up the garden around the
Chemin des Lauves studio. He became a sort of factotum,
even serving on occasion as his nurse.[1] Like Uncle Domi-
nique in the artist's youth and Hortense in his maturity,
Vallier consented to pose for Cézanne on a regular basis. It
is a matter of record that toward the end of his life the
painter liked to represent his contemporaries: "I live in the
city of my childhood, and it's in the look of people my own
age that I see the past again."[2]

During the last two years of his life he painted five oil
portraits of Vallier: three during the summer—along with
three watercolors[3]—in which the sitter wears a shirt and a
straw hat, and two during the fall or winter, in which he
wears a jacket, an overcoat, and a cap[4] (hence the alter-
native title for these works, *The Sailor).*

The last visitors to Cézanne's studio—Émile Bernard,
R.-P. Rivière, and Jacques-Félix-Simon Schnerb—remem-
bered the various paintings of the gardener Vallier as vivid-
ly as the *Large Bathers* canvases: "Cézanne also painted a
portrait of a man in profile, wearing a cap, what's more he
said he had always conducted nature study and technical
work in parallel. He seemed to attach great importance to
this painting: 'If I màke a success of this fellow, then the
theory will be true.'"[5] He was still working on one of the
Vallier paintings when Charles Camoin and Francis Jour-
dain paid him a visit: "Camoin had anticipated that we
would find on the two easels the same two paintings that

he had seen there a year earlier, and he was not mistaken.
He noted only that the *Portrait of a Gardener* and the *Bathers*
seemed a bit less worked up than when he'd last visited."[6]

A few days before his death, Cézanne tried to complete
a portrait of Vallier, but we do not know which work in the
series this was. According to Gasquet, this would have
been Vallier in the cap (fig. 1) or nearly full-face (cat. no.
225). But can one believe the poet? He stated that Cé-
zanne sometimes posed for these likenesses himself. Clear-
ly, this portrait of an old man is metaphorically a
self-portrait, emblematic of the painter's identification
with his model. But Gasquet goes much further: "He had
the old man pose. Often the poor fellow was ill and did not
come. Then Cézanne posed himself. He dressed up in
dirty old rags in front of a mirror. And then by means of a
strange transference, a mystical and perhaps intentional
substitution, the features of the old beggar and those of the
artist were intermingled on the dark canvas, both their
lives [about to] issue into the same void and the same
immortality. One recognizes, under the tattered cap, a dis-
illusioned Cézanne. . . . The lugubrious greens, the flows
of pigment simultaneously warm and livid, the sordid
impastoes, the crusty clothes, the ravaged and feverish
face: the whole canvas exudes atrocious misery, the misery
of a robust body ruined by misfortune and hunger, the
misery of an immense soul whose dreams, whose art have
deceived him. . . . This *Old Man Wearing a Cap* is redolent of
the painter's twilight days, of his decline. It is more than a
work of art; it is something like a moral testament. It is

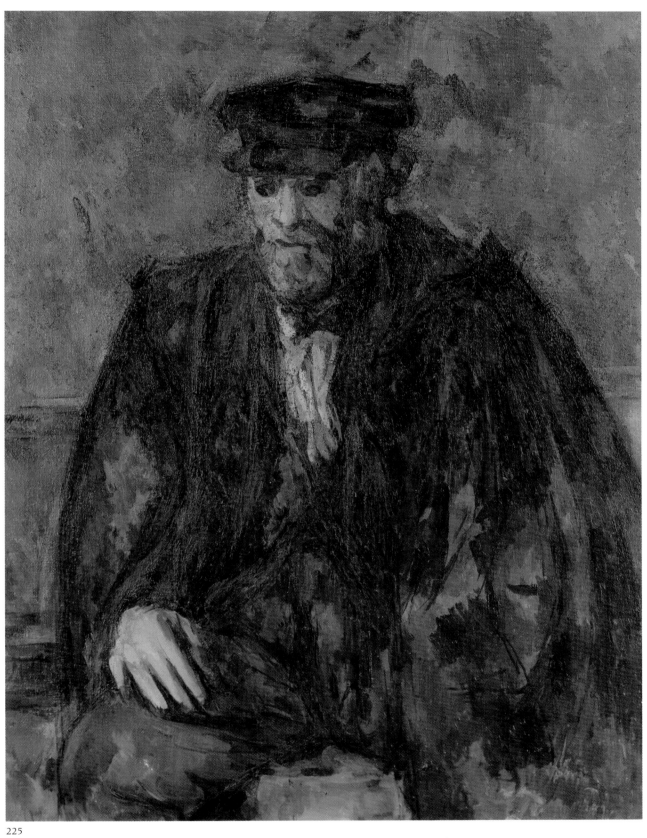

225

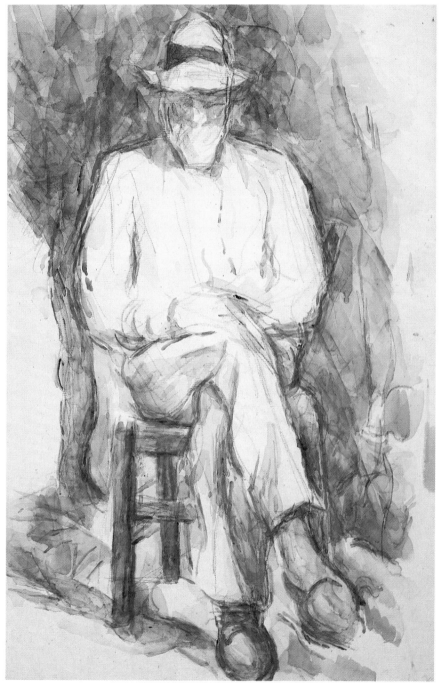

226

here, perhaps, that we must seek out and contemplate old Cézanne's last words about life and about himself. By infusing this body and this degraded face with his [own] soul, he extracted from them, like Shakespeare, a sort of king who remains unaware of his uncouth saintliness."[7]

Gasquet's brand of lyricism now appears sentimental, but here he touched on something significant. His evocation of the old gardener posing in the cold on the terrace at Les Lauves with a reflective air (his barely sketched hand on his knee making him resemble Ingres's *Monsieur Bertin*) transformed into a grandiose beggar, a King Lear, an old sailor whose seafaring days are over, is far from absurd. Venturi compared these portraits of Vallier with the last paintings by Titian, which, to cite Vasari, were "executed in broad brushstrokes applied coarsely and in patches," a mode of handling that he deemed "judicious, beautiful, and stupefying."[8]

Cézanne, too, painted with a broad and lively touch in the present series, as can be seen in the watercolors. But he then considerably reworked the handling bit by bit, especially around the face and shoulders, building up the pigment into something resembling a crust. At the very end of his life he favored a much thicker accumulation of pictorial matter, as earlier in his career.

His letters describe his work on a portrait of Vallier in September 1906, a month before his death: "I still see Vallier, but I'm so slow in my *réalisation* that it makes me very sad."[9] Previous consensus, based largely on Gasquet's descriptions, held that this work was the *Portrait of Vallier* in which the gardener is shown wearing a cap (fig. 1), but this is unlikely, for Gasquet did not frequent Cézanne's studio at the end of his life. It seems more probable that the picture on which Cézanne continued to work until a few days before his death—"I've sworn to die painting"[10]—was one of the two portraits on which he had been engaged since the warm weather of his final summer, and for which the gardener had posed in light clothing. It could be either the unfinished canvas in which Vallier is seen full-length, seated frontally in a chair with his legs crossed, wearing summer clothes (now in the Tate Gallery, London), or the splendid portrait of the gardener in profile in a private collection (fig. 2).

A letter written by the painter's sister to her nephew "after Cézanne's first collapse" removes all doubt about the matter: "The next day, he went early in the morning to the garden [at Les Lauves] to work on a portrait of Vallier under the linden tree; when he returned he was dying."[11] At 7:00 a.m. on October 23, 1906, at his home at 23, rue Boulegon, Cézanne died.

As in the last watercolors, these canvases are painted in broad patches of pigment complemented by outlines in darker tones. In 1936, when Venturi published his catalogue raisonné, the picture in the Tate Gallery was still in Vollard's personal collection, suggesting that he was particularly attached to it, perhaps because he knew it to be the artist's last painting, or one of the last.

The Tate *Vallier* is very close to two large watercolors (cat. no. 226 and R. 639). The one shown here is the most finished and impressive. The gardener, whose white clothing and beard are indicated by untouched areas of paper, is outlined against a network of overlapping strokes in mauve, pink, and green. Vallier's presence here has an apparitional quality, dignified and angelic, an image of tranquillity as well as an ethereal hymn to color.

F. C.

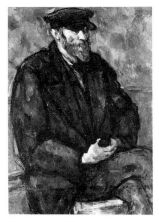

Fig. 1. Paul Cézanne,
Portrait of Vallier, 1905-6,
oil on canvas,
private collection (V. 716).

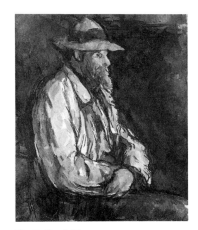

Fig. 2. Paul Cézanne,
Portrait of Vallier, 1905-6,
oil on canvas,
private collection (V. 718).

1. On July 25, 1906, Cézanne wrote to his son: "Vallier massages me, the kidneys are doing a bit better. . . . It's very hot. —From eight o'clock the weather is unbearable." (In Cézanne, 1978, p. 317). This affecting watercolor may date from about the same time.
2. Cited in Borély, July 1, 1926; reprinted in Doran, 1978, p. 21.
3. V. 715, V. 718, V. 1524, and R. 639-41.
4. V. 716 and V. 717.
5. Rivière and Schnerb, December 25, 1907; reprinted in Doran, 1978, p. 91.
6. Jourdain, 1950, p. 9. Doran (1978, p. 81) dated this visit to late 1904, but it must have taken place in September 1906, when Camoin's presence is documented; additional support for this thesis is provided by Jourdain, who used the phrase "two months before Cézanne's death."
7. Gasquet, 1921, pp. 67-68.
8. Vasari, cited in Venturi, 1936, vol. 1, p. 63.
9. Cézanne to his son, September 28, 1906, in Cézanne, 1978, p. 329.
10. Cézanne to Émile Bernard, September 21, 1906, in Cézanne, 1978, p. 327.
11. Marie Cézanne to Paul Cézanne *fils,* October 20, 1906, in Cézanne, 1978, p. 333.

227 | *Bend in the Forest Road*

1902-6
Oil on canvas; 32¹/₂ × 25¹/₂ inches (81.3 × 64.8 cm)
The Selch Family, New York
V. 789

PROVENANCE
Purchased directly from Ambroise Vollard in 1937 by Dr. and Mrs. Harry Bakwin, New York, the painting is owned by their grandchildren.

EXHIBITIONS
After 1906: Paris, 1934, unnumbered; New York, 1959 (b), no. 52; Vienna, 1961, no. 44; New York, 1963 (b), unnumbered; New York and Houston, 1977-78, no. 43.

The device of a gently curving road entering a composition was much favored by Cézanne (see cat. nos. 76 and 97), perhaps something he first learned in the 1870s from Pissarro. However, Cézanne would never take it to such expressive ends as he did in this opulently rich and fluid picture.

On one level, the compositional drama of the work is played out very near the surface of the canvas. The bands of horizontal planes that mark the slow progress of the dirt path back into the landscape stand nearly perpendicular to the fluidly interwoven vertical strokes defining the closely planted trees and the cliff just beyond. The dramatic descent of the crest of the hill toward the right adds a third directional element, the weight of its fall countered by the isolated tree trunk—the most clearly delineated form in the painting—and the more loosely suggested branch arching just above it. The blended ease with which the paint is applied—charmingly swift strokes of cobalt blue from the point of the brush, enlivening and detaching what otherwise might meld into a complete blur of color—makes little distinction between the physical properties of earth, stone, leaves, or sky. The overall effect is a steadily ascending scroll of color unrolled before us in a nearly hallucinatory fashion.

As Rewald has noted, there is very little paint build-up, despite the richness of the surface.[1] In this sense, the oil painting shares the same direct ease and seductive freshness of many of the late watercolors, the difference being that the distinctly drawn lines and panels of color are still more complexly merged and blended.

The site has never been precisely established. It could be a section above the Tholonet road near the Château Noir where the path draws very close to the shelf of rocks beyond, a place that held great attraction for Cézanne, particularly when he was interested in such emphatically closed and vertical compositions. However, the crenellated edge of the top of the cliffs recalls more the strangely geometric rock surfaces that drew Cézanne to the quarry of Bibémus farther up the slope. The most curious thing is the way the road, so ample and broad at the bottom of the canvas, is brought to such a resolved point just as it enters the forest. It is as if, in fact, it need not proceed any farther than what we can see, its form completely absorbed into the composition. There is no sense of movement into deeper space, nor for that matter, any relief or escape.

J. R.

1. See Rewald, in New York and Houston, 1977-78, no. 43, p. 400.

The Sketchbooks

The great majority of Cézanne's drawings, and nearly all the small watercolors (see cat. no. 141) were once part of sketchbooks that the artist carried with him, probably even during his trips between Paris and Provence, and used over long periods of time.[1] High-quality artist's goods (some still bear the stickers of major art-supply stores), they were sewn together at the short end and bound in cloth covers. They vary in size from 2⅝ by 4⅝ inches (6.7 by 11.7 cm) to 8¼ by 10¾ inches (21 by 27.3 cm).

Chappuis has speculated that at least eighteen sketchbooks survived in Cézanne's estate, although it is clear that the process of dispersal of individual sheets was begun by Cézanne himself, who would tear out pages either as gifts or, if we are to believe Vollard, out of petulance or pure whim. Dismantling was continued by Paul *fils* and his mother, who inherited all the sketchbooks. Well into the 1930s, pages were sold either individually or in lots, starting with the watercolor pages and the more complex pencil drawings, which were clearly of greater commercial value than the more intimate and casual records Cézanne made of his family and surroundings. At an early date, someone numbered the pages of many of the sketchbooks while they were intact, perhaps as a means of keeping a record as they were sent to exhibitions or photographed for publication. For example, some thirty drawings and watercolors are illustrated in Georges Rivière's 1923 *Le Maître Paul Cézanne;* these were probably removed from their bindings to make them flat enough to photograph.

From these page numbers (indicated in arabic or roman numerals), as well as the sheet sizes and other physical details (such as tack marks that line up through several drawings, or ghost images transferred to the backs of preceding pages), it has been possible to reconstruct all eighteen original sketchbooks with varying degrees of confidence.

Of the seven books that are still within their original covers, four are included in this exhibition. However, none can be considered completely intact: several sheets have been removed. For example, the pages of the book now in the Art Institute of Chicago (see also cat. no. 41) have been rebound in an order inconsistent with their numbering.

Cézanne, like many other artists, used these pocket-sized books as a convenient channel in the exercise of his eye and hand. About one-third of the surviving drawings are studies after old master paintings or sculptures that the artist saw in the Louvre or in the new plaster-cast galleries of the Musée de Sculpture Comparée at the Trocadéro, or after two of the plaster casts he kept in his studio, the *écorché* (see cat. no. 111) and the putto (see cat. nos. 161-65). A large number of the sketchbook drawings record details of Cézanne's domestic life: portraits of his wife and child (often asleep or caught unawares), of neighbors and friends, or of himself (see figs. 1, 2, and cat. no. 51). The long format of the sheets suited landscape vistas; many of these seem to have been studies for more ambitious projects, although some of the freshest have no consequence

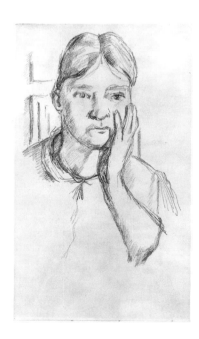

Fig. 1. Paul Cézanne,
Madame Cézanne,
Her Head Leaning on Her Hand,
1881-82,
graphite on paper,
page V verso,
The Pierpont Morgan Library,
New York,
The Thaw Collection (C. 828).

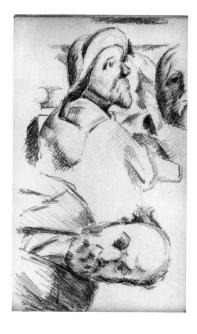

Fig. 2. Paul Cézanne,
Self-Portrait, Busts,
1882-85,
graphite on paper,
page XIV verso,
The Pierpont Morgan Library,
New York,
The Thaw Collection (C. 620).

Fig. 3. Paul Cézanne *fils*,
Copy of House with Trees, 1876-79,
graphite on paper, page IV verso,
The Art Institute of Chicago, Arthur Heun Fund.

Fig. 4. Paul Cézanne,
House with Trees, 1876-79,
graphite on paper, page V verso,
The Pierpont Morgan Library, New York, The Thaw Collection (C. 755).

beyond themselves. The disarming appearance of works by a young Paul *fils* (fig. 6) demonstrates that his father would occasionally turn a book over to his son as a means of distraction or, in some cases, instruction (as in two facing pages in the Chicago sketchbook where the son clearly set out to copy his father's view of a house and trees, with fading industry; figs. 3 and 4). There are also sketches of figures drawn from his imagination, including variations on the Bathers theme (fig. 5); these pages were often worked up with watercolor into very finished works, which therefore were the least likely to remain bound in the sketchbooks. Some pages bear lists of artist's supplies, addresses, and drafts of letters, indicating that he put the sketchbooks to practical use.

As an ensemble, the sketchbooks offer us an insider's view into the artist's life. They often have the intimacy and objective curiosity seen in the sketchbooks of Gabriel de Saint-Aubin; other passages recall the rigorous analysis one finds in the manuscripts of Leonardo da Vinci. Finally, if the sketchbooks better reveal this artist, making him more accessible than his works in other mediums, it is nevertheless striking how completely naturally these notebooks integrate into Cézanne's oeuvre. They touch on nearly all of his major artistic concerns and act, in their way, as a microcosm of his entire career.

J. R.

1. For sources on the sketchbooks and the complex problems they present in terms of their reconstruction and the artist's use of them over time, see Chappuis, 1973, vol. 1, pp. 20-23; Rewald, 1951; Rewald, 1982; New York, 1988; and Philadelphia, 1989.

Fig. 5. Paul Cézanne,
Woman Bather, 1876-79,
graphite on paper,
page L recto,
The Pierpont Morgan Library,
New York, The Thaw Collection
(C. 511).

Fig. 6. Paul Cézanne and Paul Cézanne *fils*,
Head of a Man in Profile and *Two Figures by the Artist's Son*,
graphite on paper, page XVI recto,
The Art Institute of Chicago, Arthur Heun Fund.

Sketchbook

1857-71
$5^7/_8 \times 9^1/_{16}$ inches (15 × 23 cm)
Musée du Louvre, Paris. Département des Arts Graphiques.
Musée d'Orsay (R.F. 29949)

PROVENANCE
The Musées Nationaux purchased this sketchbook from Pierre Bérès in 1953 and deposited it in the artist's studio at Les Lauves, Aix-en-Provence, which had just opened to the public. The sketchbook was later transferred to the Louvre.

Many, but not all, of the pages in this sketchbook have been numbered with arabic numerals; the last page is numbered 55. This probably provides a reasonable estimate of the total number of pages in the book when intact, although several sheets were certainly removed. Torn remnants bound into the book, pages cut in half, various stains, and overlapping images testify to the rough use made of this densely illustrated sketchbook, to which Chappuis has given dates for individual pages ranging from 1857 to 1871. This long period of use explains the diversity of the styles and levels of accomplishment represented in the book's pages. There are several drawings of such crudity and naïveté that it would be difficult to think of them as by Cézanne, were it not for their similarity to drawings he made in his early letters to Zola (Chappuis has even speculated that other hands may be present, including Cézanne's younger sister Rose). Other pages, nevertheless, have a complexity and a level of sophistication that conform perfectly well with the artist's early compositions in oil.

The overall effect of the book is one of charged intensity juxtaposed with lassitude; extremely dense and heavily worked images face copies after engravings in which the boredom of the exercise is hardly disguised. It is one of the

Man, Near a Woman Lying Asleep Outdoors, 1868-71, graphite and ink on paper, page 10 verso (C. 246).

Studies, Including a Man with a Gun, 1859-62, graphite on paper, page 11 recto (C. 23).

Fig. 1. Paul Cézanne,
Man with a Jacket, 1875-76,
oil on canvas,
The Barnes Foundation, Merion,
Pennsylvania (V. 248).

great surviving testaments to the rambling and restless nature of adolescence, even if many of the images can be dated well into Cézanne's twenties.

Chappuis dismissed the pencil sketch of a figure in profile as the work of a child.[1] The framed image, in dark ink bluntly applied with a reed pen, shows a nude woman asleep on the grass by the sea. A top-hatted man, apparently carrying his coat, strides jauntily in from the left; he has the same air as the inexplicable fellow standing by the sea in a little picture now in the Barnes Foundation (fig. 1). This scene presents the kind of comic sexual encounter (with heavy shades of satyrs surprising nymphs) that greatly amused Cézanne in his early narrative pictures.

This page offers a good example of the whimsical and rather distrait gathering of childlike images that fill much of this sketchbook: two sun or moon faces in nimbuses (which Cézanne would use in a bizarre little painting of Chinese men worshiping the sun [V. 13]); a caricature in profile, a squatting man, and a huntsman shooting birds. Chappuis speculated that the birds were added by another hand, underscoring the playful use these pages may have served for Cézanne and his sisters.

J. R.

1. Chappuis, 1973, vol. 1, no. 246, p. 104.

Sketchbook

1875-85
4^{15}/$_{16}$ × 8^{1}/$_{2}$ inches (12.6 × 21.6 cm)
The Pierpont Morgan Library, New York. The Thaw Collection

To judge from the roman numerals appearing in the corner of each sheet, this sketchbook of twenty-four pages is among the most intact to survive—it is missing only two leaves, which were undoubtedly blank. This observation is based on the following assumption, which seems to hold true for all the sketchbooks: a numbering system was established to inventory the leaves in each book before individual pages were removed by Madame Cézanne or, more likely, Paul *fils*. The numbering order here is not consistent throughout, in part because the pages were reassembled when the notebook was in Chicago, and several others were introduced out of sequence.[1]

The Thaw sketchbook is particularly rich in portraits and landscapes, whose identification allowed Rewald to date the volume to between 1875 and 1885. Moreover, a comparison of individual pages with known motifs clearly shows that Cézanne carried the book with him when traveling between Aix and the Île-de-France.

These two pages face each other in the current binding of the Thaw sketchbook; given their consecutive roman numerals, this was very likely the original order.[2]

Rewald speculated that both drawings were made at Médan, in Émile Zola's richly (by some descriptions, overly) furnished house on the Seine; Cézanne visited the novelist several times between 1879 and 1885 (see cat. nos. 69 and 70). Two portraits showing Zola at work at his writing table appear two pages later in the same sketchbook (fig. 1). As Chappuis noted, the sale of Zola's estate at the Hôtel Drouot in 1903 included three suits of occidental armor, as well as "fifty-seven vases, porcelain jars, and flower stands."[3] Rewald has associated a third page in the sketchbook—showing a vase and several porcelain pots atop an armoire—with the artist's visits to Médan (fig. 2).

Fig. 1. Paul Cézanne, *Portraits of Émile Zola*, 1882-85, graphite on paper, page XV recto, The Pierpont Morgan Library, New York, The Thaw Collection (C. 624).

Fig. 2. Paul Cézanne, *Piece of Furniture with Vase, and Head*, 1881-84, graphite on paper, page XVI recto, The Pierpont Morgan Library, New York, The Thaw Collection (C. 551).

Plants in a Flower Stand, 1882-85,
graphite on paper, page XII verso (C. 644).

Study of a Suit of Armor, 1881-84,
graphite on paper, page XIII recto (C. 550).

Subjects this overloaded occur nowhere else in Cézanne's oeuvre; however bourgeois the artist's domestic surroundings in Aix and in the various apartments he rented may have been, the drawings reflect Zola's much more *nouveau riche* taste. Vollard took great pleasure in describing the eclecticism and pretention of the decor of the writer's Parisian home, albeit at a later time, when he visited Zola in search of works by Cézanne.[4]

The metal jardiniere, elevated on a pole, seems almost full to bursting with palms and other exotic plants. Cézanne has emphasized the sense of horror vacui by letting the vegetation overrun the page. The armor—even with expert advice Chappuis was unable to determine whether it was a sixteenth-century suit or a nineteenth-century reproduction[5]—seems to be set up in a niche or on a landing. The blunt rendering of its bulbous forms, its reflective panels separated with quick parallel hatchings of a soft pencil, portrays it as a toylike object, rather amusing and not at all heroic.

J. R.

1. See Rewald, 1951, pp. 50-56; Rewald, 1982; and Chappuis, 1973, vol. 1, p. 22.
2. When the old binding was replaced, the leaves were bound in a different order and paged in arabic numerals. For identification purposes, we provide the old pagination as recorded by Rewald and Chappuis.
3. See Chappuis, 1973, vol. 1, nos. 550, 644, pp. 159, 178.
4. Vollard, 1923, pp. 154-60.
5. See Chappuis, 1973, vol. 1, p. 30 n. 52.

Sketchbook

c. 1875-86
$4^{7}/_{8} \times 8^{9}/_{16}$ inches (12.4 × 21.7 cm)
The Art Institute of Chicago. Arthur Heun Fund

PROVENANCE
This sketchbook is one of five that were in the possession of the artist's son, Paul. On consignment to Renou and Poyet, Paris, it was sold to the New York dealer Sam Salz. The Art Institute acquired it from him in 1951.

This sketchbook's binding is intact, and the fifty sheets bear an unbroken sequence of roman numerals ranging from *I* to *L*.

The pages feature a variety of subjects: fantastic narratives (see cat. no. 41), which preoccupied Cézanne until the mid-1870s; numerous studies of his son (born 1872) who, benefiting from an indulgent access to the book, also filled it with his own drawings; studies after the plaster *écorché*, which Cézanne had with him in Aix (see cat. no. 111) and, among the most beautiful images in the book, panoramic landscapes of L'Estaque and a view of Bellevue, the estate owned by his sister and brother-in-law. There

Fig. 1. Paul Cézanne,
Environs of Marseille, c. 1882-85,
oil on canvas,
private collection (V. 407).

are no images to suggest that he carried the book with him to Paris or northern France. Numerous spatters of oil paint and watercolor indicate, more than in any other of the surviving sketchbooks, how close at hand in the studio these books must have been when Cézanne was making more ambitious art.

The landscape extending over two pages of the sketchbook demonstrates the panoramic use Cézanne could make of an open book in this format. There are no paintings or watercolors that convey such an expanded sense of breadth. It allowed the artist to extend the vista that had been the dominant motif of a painting of about 1882-85 (fig. 1), from the mountains beyond Marseille to the island on the far right. In the middle of the bay Paul *fils* added his own structure in an attempt to copy (as he did elsewhere in this sketchbook; see p. 519, fig. 3) a feature depicted by his father to the left.

The figure of the crawling man has been compared with a much earlier work (dated by Venturi to 1870-72) called *The Strangled Woman* (p. 108, fig. 1), in which a man chokes a woman, holding her over the edge of a bed while a maid seems to assist.[1] A sort of inverse representation of Judith and Holofernes, the scene could just as well be Cézanne's copy after a painting by Delacroix that was reproduced in numerous engravings.

J. R.

1. Schniewind, 1951, vol. 1, p. 28.

View of the Bay of l'Estaque, 1881-84,
graphite on paper, page XIII verso (C. 811).

Continuation of *View of the Bay of L'Estaque* and *Man on All Fours*, c. 1877,
graphite on paper, page XIV recto (C. 811).

Sketchbook

c. 1888-92
$5^3/_8 \times 8^1/_2$ inches (13.7 × 21.6 cm)
Musée du Louvre, Paris. Département des Art Graphiques. Musée d'Orsay (R.F. 29933)

PROVENANCE
This sketchbook is one of five that were in the possession of the artist's son, Paul. On consignment to Renou and Poyet, Paris, it was sold to the New York dealer Sam Salz in 1951. Mr. Salz, in turn, presented it to the Louvre.

Although Chappuis stated that this sketchbook is intact,[1] it is a slim volume of sixteen unnumbered leaves, rather than the more customary twenty-five. It consists almost exclusively of studies after sculptures and paintings found in Paris, either in the Louvre or in the Musée de Sculpture Comparée at the Trocadéro. Rewald speculated that Cézanne used this sketchbook only briefly during the family's visit to Paris in 1880-81,[2] but Chappuis dated it more than a decade later. It is true that Cézanne's use of reproductive engravings and illustrated journals is a well-established fact, obscuring the dating of drawings after older works of art. Moreover, one of the drawings is a study of his son (born 1872), appearing closer to sixteen or seventeen years old than nine or ten; this external evidence would confirm Chappuis's assertion. A label inside the front cover perhaps clarifies these dating problems. It reads, "La Palette du Louvre/P. Briault/2 rue du Louvre, Paris." Not until 1887 did this artist's-supply shop appear in the Paris business directory *Annuaire du commerce Didot-Bottin*.[3]

The repertory of images in this sketchbook is familiar: a small group of studies after antique marbles in the Louvre, several sketches after French baroque sculpture in the École Française, Renaissance portrait busts, and individual figures copied from Rubens's *Apotheosis of Henri IV*. The volume's novelty rests in two sketches (fig. 1) after French Renaissance sculptures representing two female figures from Strasbourg cathedral, whose casts were displayed in the Trocadéro museum.

On these two facing pages, the juxtaposition of images presents a strangely beautiful effect: the severe and downcast female portrait, whose coif and face are rendered in hatched lines, opposes the august head of a Roman emperor, which is marked in strong curves of light and dark. This particular female figure, identified by Gertrude Berthold as a sculpture of Barbara von Hottenheim by Nicolaus Gerhaert van Leyden (fig. 2), was tremendously popular. Her portrait bust, placed on a window ledge at the Strasbourg chancellery, seemed to contemplate passersby coquettishly. The building was destroyed by the Prussians in 1870; a fragment of the figure, rediscovered in 1934, is now in Frankfurt. Cézanne, who may not have known the original context of the piece, made his drawing after a plaster cast in the Musée de Sculpture Comparée at the Trocadéro. This may, in part, explain the artist's expressive transformation of the figure from a jolly maiden into a stern and pensive matron.

Among Cézanne's drawings representing the emperor (see also C. 1062, and perhaps C. 1136 and C. 1137), this is the most fully achieved. The bust, seen in three-quarter view, is treated in a very conventional manner. The drawing, of tremendous vitality, seems to have been executed rapidly and with great ease.

J. R.

1. See Chappuis, 1973, vol. 1, p. 22.
2. See Rewald, 1951, p. 39.
3. This information has been supplied by Innis Howe Shoemaker, Philadelphia Museum of Art.

Fig. 1. Paul Cézanne,
Study after one of the "Foolish Virgins"
of Strasbourg Cathedral,
1895-98, graphite on paper,
page 32 verso,
Musée du Louvre, Paris,
Département des Arts Graphiques,
Musée d'Orsay (C. 1133).

Fig. 2. Nicolaus Gerhaert van Leyden,
Barbara von Hottenheim,
plaster cast after the 1464 bust.

Barbara von Hottenheim (after N. G. van Leyden), c. 1890,
page 29 recto (C. 1017).

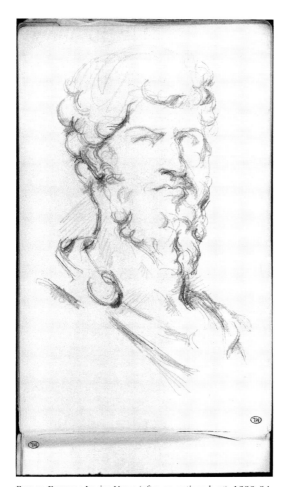

Roman Emperor Lucius Verus (after an antique bust), 1890-94,
page 28 verso (C. 1063).

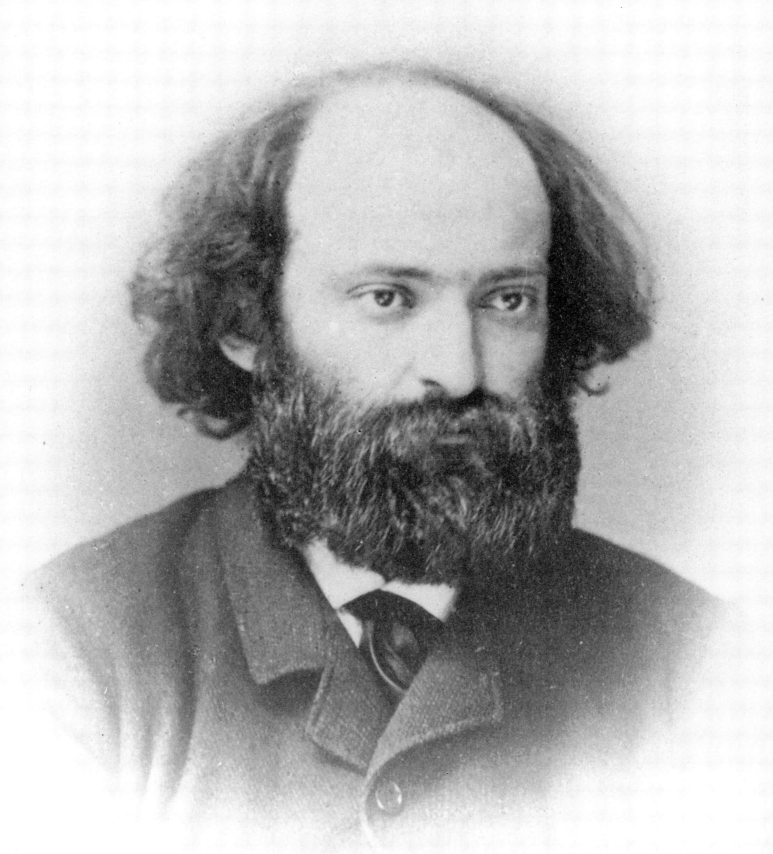

Chronology

by Isabelle Cahn

The rue de l'Opéra in Aix-en-Provence, postcard.

The cours Mirabeau in Aix-en-Provence, postcard.

1839

January 19

Paul Cézanne is born in Aix-en-Provence, at 28, rue de l'Opéra, the son of Louis-Auguste Cézanne, a hatter, aged forty, originally from Saint-Zacharie (Var), residing at 55, sur le Cours–known as the cours Mirabeau from 1876—and of Anne Élizabeth Honorine Aubert, aged twenty-four, a native of Aix. The child, born out of wedlock, is acknowledged by his father. The father's given address is the hattery of François Carbonnel (also spelled Carbonel) and his wife, Marie Aubert (presumably a relative of the child's mother), where Louis-Auguste Cézanne had worked and lived for several years.

Birth certificate, Archives, Hôtel de Ville, Aix-en-Provence; census, F1 ART.12, 1836, and F1 ART.14, 1845, Communal Archives, Aix-en-Provence.

February 20

Paul Cézanne is baptized at the church of Sainte-Marie-Madeleine. His godmother is his grandmother Rose Aubert; his godfather, his uncle Louis Aubert, a hatter.

Register, church of Sainte-Marie-Madeleine, Departmental Archives, Aix-en-Provence, 30 J 110, B 14.

1841

July 4

Birth of Marie Cézanne, the couple's second child, in Aix-en-Provence at 55, sur le Cours, the address of the hattery in which Louis-Auguste Cézanne is still employed. The child is baptized on July 7 in

the church of Sainte-Marie-Madeleine. Her godparents are the same as those for her brother, Paul.

Birth certificate, Archives, Hôtel de Ville, Aix-en-Provence; register, church of Sainte-Marie-Madeleine, Archdiocesan Archives, Aix-en-Provence.

1844

January 29

Marriage at the Hôtel de Ville, Aix-en-Provence, of Louis-Auguste Cézanne, man of property, residing at 14, rue de la Glacière, and Anne Élizabeth Honorine Aubert, without profession, who, according to the marriage certificate, resided with her mother at 23, rue des Suffrens. A marriage contract stipulating terms of separation of property was executed on January 10. Louis-Auguste Cézanne is described there as a former hatmaker, now a property owner without profession. The dowry of Anne Élizabeth Aubert, "the result of savings to date from her earnings as a hatmaker," consists of a trousseau valued at 500 francs, a sum of 1,000 francs cash, and an anticipated inheritance of 1,000 francs.

The religious service is performed at the church of Sainte-Marie-Madeleine on January 30. The couple's two children are legitimized by the marriage.

Marriage certificate, Archives, Hôtel de Ville, Aix-en-Provence; registration of the marriage certificate, notarial archives of the successor of Maître Béraud; register of the church of Sainte-Marie-Madeleine, Archdiocesan Archives, Aix-en-Provence.

1848

June 1

Opening of the Cézanne and Cabassol bank, listed in the *Cicérone marseillais* of 1849 as "MM. Césanne [sic] et Cabassol, rue des Cordeliers, 24." It replaces the establishment of Félix Alexis, who retains ownership of the premises. Joseph Cabassol, clerk and then banker, resides at the

same address. In 1856 the Cézanne and Cabassol bank moves to 13, rue Boulegon.

Mack, 1935, pp. 8-9; census, F1 ART.12, 1836, F1 ART.14, 1845, F1 ART.16, 1853, F1 ART.17, 1855, F1 ART.18, 1857, Communal Archives, Aix-en-Provence.

1849

The paintings in the Granet bequest enter the collection of the museum in Aix-en-Provence, later becoming accessible to Cézanne.

1850-52

After attending the public school in his neighborhood, where he meets Philippe Solari, Cézanne is registered for two years at the Catholic school of Saint-Joseph, where he befriends Henri Gasquet.

Provence, 1925, p. 823; Rewald, 1936, p. 8.

1852

Cézanne enters the sixth grade as a boarder at the Collège Bourbon (now Lycée Mignet). In conformity with its rules, he wears a uniform consisting of a blue tunic with red piping and gold palms on the collar, white or gray duck pants, and a blue *képi*, or military cap. An excellent student, he wins many prizes. He becomes a day student from 1857. He befriends Émile Zola, one year his junior, who en-

Louis-Auguste Cézanne (1798-1886), photograph, Musée d'Orsay, Paris, Service de documentation.

The Musée des Beaux-Arts in Aix-en-Provence, modern gallery, postcard, photograph by Bourrelly.

The Musée des Beaux-Arts in Aix-en-Provence, c. 1870, hall of antiquities, photograph by Claude Gondran, Bibliothèque Méjanes, Aix-en-Provence.

tered the school the same year as he; Jean-Baptistin Baille, future astronomer and professor at the École Polytechnique; and Louis Marguery, future attorney and writer for vaudeville; they are known collectively as "les trois inséparables."

Provence, 1925, pp. 823-26; Zola, 1978-, vol. 1, pp. 88, 543, 552; Gasquet, 1921, p. 16; Rewald, 1936, p. 7.

1854

June 1

Birth of Rose Honorine Cézanne, 14, rue Matheron in Aix-en-Provence, the third and last child of Louis-Auguste Cézanne, "a banker," and his wife. The family lives on the rue Matheron until about 1870. According to census data, Rose Cézanne does not reside with her parents for several years, until 1858. She is baptized on June 5 at the cathedral of Saint-Sauveur. Her godfather is her brother, Paul; her godmother, her sister Marie.

Birth certificate, Archives, Hôtel de Ville, Aix-en-Provence; register, cathedral of Saint-Sauveur, Archdiocesan Archives, Aix-en-Provence; census, F1 ART.17, 1855, F1 ART.18, 1857, F1 ART.19, 1860, F1 ART.22, 1868, and F1 ART.23, 1872, Communal Archives, Aix-en-Provence.

1857

Cézanne registers at the École Gratuite de Dessin [free drawing school] of Aix, in the Priory of Malte, which also houses the affiliated museum. Joseph Gibert, both director of the school and curator of the museum, is his teacher from 1858 to 1861. Cézanne takes classes in which he draws after the live model and ancient sculpture in the form of plaster casts as well as the marble originals in the museum collection.

Ély, 1984, pp. 142, 144, 149-51.

1858

February

Émile Zola, accompanied by his grandfather, leaves Aix and moves in with his mother at 63, rue Monsieur-le-Prince, in Paris, where Madame Zola settled in 1857, ten years after the death of her husband. He maintains a correspondence with his friends in the Midi. Cézanne's letters to Zola are filled with poems, rhymes, and songs. Zola returns to Aix for two consecutive summers.

Zola to Cézanne, June 14, 1858, in Zola, 1978-, vol. 1, no. 1, pp. 96-98, p. 250 n. 1; Cézanne, 1978, pp. 17-42.

September 2

Cézanne is smitten with an unknown woman he sometimes encounters on the way to school. He thanks Zola for his "morceau poétique" and sends him an original poem accompanied by a watercolor, *Cicero Striking Down Cataline after Having Discovered the Conspiracy of That Dishonorable Citizen.*

Cézanne to Zola, September 2, 1858 [incorrectly dated 29...1858 by Rewald], in Cézanne, 1976, pp. 21-22.

November 12

After having failed in his first attempt at qualifying for his General Certificate of Education on August 4, Cézanne passes with the mark "rather good."

Cézanne to Zola, July 26, 1858, in Cézanne, 1976, p. 30; Zola, 1978-, vol. 1, p. 99 n. 12; Cézanne to Zola, November 23, 1858, in Cézanne, 1978, p. 36.

December

His father obliges him to study law at the law school in Aix, where he registers on December 16. He asks Zola to obtain in-

The Lycée Mignet in Aix-en-Provence (formerly the Collège Bourbon) as it appears today.

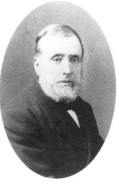

Joseph Gibert (1808-1884), photograph, Musée Granet, Aix-en-Provence.

The law school in Aix-en-Provence, postcard.

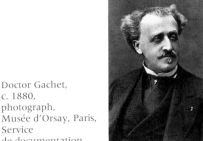

Doctor Gachet, c. 1880, photograph, Musée d'Orsay, Paris, Service de documentation.

1860

February

Cézanne does not register at the law school. He wants to go to Paris to learn to paint. This plan is thwarted by Gibert, his drawing teacher, who opposes his departure.

Zola to Baille, February 20, 1860, and to Cézanne, March 3, 1860, in Cézanne, 1978, pp. 66-67.

March

His departure is delayed by the illness of his sister Rose. He asks Zola to send him prints.

Zola to Baille, March 17, 1860, in Cézanne, 1978, p. 69; Zola to Cézanne, March 25, 1860, in Zola, 1978-, vol. 1, no. 14, p. 141.

April

He becomes discouraged. Zola tries to console him by describing his conception of artistic work: "There are two men inside the artist, the poet and the worker. One is born a poet, one becomes a worker. And you, who have the spark, who

formation about entry to the École des Beaux-Arts in Paris.

Registration records of the Aix law school, 1 T 1900, no. 113, Departmental Archives of the Bouches-du-Rhône, Marseille; Cézanne to Zola, December 7, 1858, in Cézanne, 1978, p. 40.

Doctor Gachet meets Louis-Auguste Cézanne in Aix.

Gachet, 1956, p. 28.

1859

January 19

Cézanne registers for his second session at the law school in Aix.

Registration records of the Aix law school, 1 T 1900, no. 83, Departmental Archives of the Bouches-du-Rhône, Marseille.

April 11

Third registration at the law school in Aix.

Registration records of the Aix law school, 1 T 1900, no. 95, Departmental Archives of the Bouches-du-Rhône, Marseille.

July 7

Fourth registration at the law school in Aix.

Registration records of the Aix law school, 1 T 1900, no. 53, Departmental Archives of the Bouches-du-Rhône, Marseille.

Certificate of the École Gratuite de Dessin of Aix, 1859, Musée d'Orsay, Paris, Service de documentation.

August 25

He is awarded the second prize for painting at the École Gratuite de Dessin of the city of Aix, in the form of a leather-bound drawing album. Students' works are exhibited in the "large classroom" for assessment by a jury. Cézanne submitted a "life-size study of a head after the live model painted in oil."

Minutes of the prize allocation on August 25, 1859, p. 4, Archives, Musée Granet, cited by Ély, 1984, pp. 139-40.

September 15

Louis-Auguste Cézanne acquires from Gabriel-Fernand Joursin a country property, known as the Jas de Bouffan, consisting of approximately 14 hectares and 97 ares for the sum of 85,000 francs. The sale, effected by Maître Béraud, is formally registered on September 20. He moves in about 1870.

List of purchasers and new owners, Aix office, 12 Q1/12/22, order no. 51, Departmental Archives of the Bouches-du-Rhône, Marseille; records of Cézanne/Joursin sale, notarial archives of the successor of Maître Béraud, Aix-en-Provence; electoral records, K1 1-2-3, 1872, 1874, 1885, Communal Archives, Aix-en-Provence.

November 19

Cézanne registers for his fifth session at the law school in Aix.

Registration records of the Aix law school, 1 T 1900, no. 143, Departmental Archives of the Bouches-du-Rhône, Marseille.

November 28

He passes his first examination for the *bachelier*: "The examination completed, the ballot results favored admission of the candidate with two red balls against one black." Another year and another examination are necessary to obtain a license, required by both the bar and the magistracy.

Register of examinations and public acts of the Aix law school, 1 T 1921, 3/38/10, p. 147 D, Departmental Archives of the Bouches-du-Rhône, Marseille; Cézanne to Zola, November 30, 1859, in Cézanne, 1978, p. 54; Zola, 1978-, vol. 1, p. 106 n. 5.

The Jas de Bouffan as it appears today: the rear façade, the entrance from the front, the pool.

Émile Zola
(1840-1902),
c. 1865,
photograph,
collection of
Dr. F. Émile Zola.

possess what cannot be acquired, you complain, when all you have to do to succeed is exercise your fingers, become a worker." He urges him to stop copying paintings by a master in Aix whom Cézanne admires, perhaps Joseph-François Villevieille.

Brief falling-out with Jean-Baptistin Baille.

Zola to Cézanne, April 16, 1860, in Zola, 1978-, vol. 1, no. 15, p. 146, and in Cézanne, 1978, p. 73; Zola to Baille, May 2, 1860, in Zola, 1978-, vol. 1, no. 17, pp. 157, 159 n. 13.

May

Cézanne's father stipulates that the trip to Paris will be contingent upon his continuing to study law.

Zola to Cézanne, May 5, 1860, in Zola, 1978-, vol. 1, no. 18, p. 161.

May 28

In the draft lottery on February 24, Cézanne comes up number 49; the medical examiners declare him "fit for service." On June 14, he receives a certificate declaring him exempt from service obligations. After the cantonal quota has been met, he is released of obligations on July 14, and receives a second certificate on July 26.

His height is 69 inches; his profession, law student.

Military archives, class of 1859, 1 R 229, Departmental Archives of the Bouches-du-Rhône, Marseille.

June

During a walk in the town of Vitry, near Paris, Zola discovers in a café some large wall paintings, "large panels like the ones you want to paint at your house, painted on canvas, representing village festivals."

Cézanne lets his beard grow.

Zola to Cézanne, June 13, 1860, in Zola, 1978-, vol. 1, no. 21, pp. 175, 178.

June-July

He once again becomes deeply discouraged. Zola chides him for his passivity. He encourages him to devote himself to painting.

Zola to Cézanne, June 25 and [July 1860], in Zola, 1978-, vol. 1, nos. 24, 28, pp. 191-92, 212-13.

October

Zola plans to establish an "artistic society" in Paris with Cézanne, Baille, and Georges Pajot, a fellow student at the Lycée Saint-Louis, in order "to form a powerful union for the future, to provide mutual support, whatever positions might await us."

Cézanne and Baille take it upon themselves to remove papers, furniture, and a painting belonging to the Zola family, left in their apartment on the cours Grillaud, to safeguard them from creditors following the failure of the Société du Canal Zola.

Zola to Baille, [late August-early September 1860] and October 2, 1860, in Zola, 1978-, vol. 1, nos. 31, 34, pp. 233, 242-43.

The census indicates that Cézanne is still living with his family at 14, rue Matheron in Aix-en-Provence. He is registered as a legal clerk.

Census, F1 ART.19, 1860, Communal Archives, Aix-en-Provence.

1861

The Granet wing of the museum in Aix is remodeled for exhibition of the bequest of 1849.

Ély, 1984, p. 142.

April 21?

Despite the continuing disapproval of Gibert, his professor at the drawing school, Cézanne leaves Aix for Paris, where he remains until September. Zola helps him to organize both his time and his budget: "Paris offers you, in addition, an advantage that you'll find nowhere else, that of the museums where you can study the old

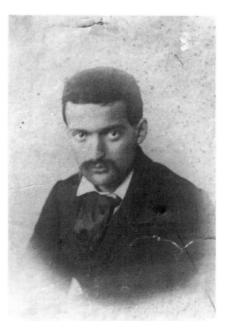

Cézanne, c. 1861, photograph,
Musée d'Orsay, Paris, Vollard Archives.

masters, from eleven until four o'clock. Here's how you could organize your time. From six to eleven you'll paint after the live model in a studio; you'll have lunch, then from noon to four you'll copy, at the Louvre or the Luxembourg, whatever masterpiece you like. Which will make nine hours of work. . . . It's a fact that 125 francs per month won't allow you much luxury. . . . A room for 20 francs a month, lunch 18 sous and dinner 22 sous And you'll have to pay your studio fee; the [Académie] Suisse, one of the cheapest, is, I believe, 10 francs [per month]."

Louis-Auguste Cézanne accompanies his son to Paris, where he remains for a time. Cézanne settles at 39, rue d'Enfer. Property records indicate several studios at this address, but Cézanne's name is not listed.

Zola to Cézanne, March 3 [1861], and to Baille, April 22 and [late June-early July] 1861, in Zola, 1978-, vol. 1, nos. 41, 43, 46, pp. 271, 272, 279-81, 284-85, 299, p. 118 n. 8; Cézanne to Joseph Huot, June 4, 1861, in Cézanne, 1978, pp. 96, 98; Vollard, 1914, p. 12; cadastral survey, D1P4, Archives de Paris.

May

Cézanne visits the Salon with Zola. He admires works by, among others, Meissonier and Doré. He begins the portrait of Zola.

In the mornings he works at the Académie Suisse and in the afternoons at the studio of Joseph-François Villevieille, a painter from Aix, a former student of François-Marius Granet, who had attended the École des Beaux-Arts in Paris. At the Académie Suisse, he befriends the Aixois painter Achille Emperaire and Francisco Oller, Antoine Guillemet, Armand Guillaumin, and Camille Pissarro. As Pissarro attested some years later: "Did I see things clearly myself when, in 1861, Oller and I went to see this curious Provençal at the Atelier Suisse, where he made nudes that prompted laughter from all the school's impotents" Cézanne probably intended to compete for a place at the École des Beaux-Arts.

Zola to Baille, [June] 1 and June 10, 1861, in Zola, 1978-, vol. 1, nos. 44, 45, pp. 288, 293; Cézanne to Huot, June 4, 1861, in Cézanne, 1978, pp. 97, 112 n. 1; Gasquet, 1926, p. 38; Pissarro to his son Lucien, December 4, 1895, in Pissarro, 1980-91, vol. 4, no. 1181, p. 128.

June-July

He stays in Marcoussis several times on the outskirts of Paris. After a slight cooling with Zola, the two friends resume warmer ties. Cézanne wants to leave Paris.

Zola to Baille, [late June-early July 1861], and July 18, 1861, in Zola, 1978-, vol. 1, nos. 46, 47, pp. 299-300, 309.

The environs of Aix-en-Provence with
the François Zola Dam, postcard.

September

Probably after having failed to qualify for
a place at the École des Beaux-Arts, he re-
turns to Aix, where he works in his fa-
ther's bank. Zola writes:

> Cézanne, le banquier, ne voit pas
> sans frémir
> Derrière son comptoir naître un
> peintre à venir.
> (Cézanne, the banker, can't see
> without a quake
> The birth of a future painter at the
> back of his bank.)

Zola to Baille, [late June-early July 1861], in Zola,
1978-, vol. 1, no. 46, p. 303; account ledger of the
Cézanne and Cabassol bank, Rewald, 1986, p. 34.

1862

Cézanne registers once more at the École
Gratuite de Dessin in Aix-en-Provence,
where he draws after the live model.

Ély, 1984, p. 161.

Summer

He works in the Aix countryside with
Numa Coste, who "accompanies [him]
every morning to the landscape and satu-
rates him with a thousand affronts of var-
ious kinds that he multiplies every
minute." He begins a painting depicting a
view of the dam built by Zola's father.

Zola informs him of the subject for the
Prix de Rome competition, "Coriolanus
Entreated by His Mother Veturia."

Zola to Pénot, late August [1862], sale, Hôtel des
Ventes, Avignon, April 19, 1980, lot 73; Zola to
Baille and Cézanne, September 18, 1862, and to
Cézanne, September 29, 1862, in Zola, 1978-,
vol. 1, nos. 50, 52, pp. 321, 324.

Early November

Cézanne returns to Paris. He registers at
the Académie Suisse, where he works
mornings from eight until one and eve-
nings from seven until ten. Joseph-Tho-
mas Chautard, a painter originally from
Avignon and a friend of Villevieille, cor-
rects his studies.

At the end of his life, Cézanne report-
ed he had made two unsuccessful at-
tempts to qualify for entry to the École des
Beaux-Arts.

Cézanne to Coste and Villevieille, January 5, 1863,
in Cézanne, 1978, pp. 107-8; Rivière and Schnerb,
December 25, 1907, pp. 811-17.

1863

January 13

Louis-Auguste Cézanne visits his son in
Paris. The latter is living on the cul-de-sac
Saint-Dominique d'Enfer (now Royer-
Collard), probably in the residence of Ma-
dame Zola. At this time Émile Zola is
living at 62, rue de la Pépinière (now rue
Daguerre), in Montrouge.

Cézanne to Coste and Villevieille, January 5, 1863,
in Cézanne, 1978, p. 108; Zola, 1978-, vol. 1,
p. 314.

The rue des Feuillantines in Paris,
photograph by Eugène Atget,
Bibliothèque Nationale, Paris,
Département des Estampes.

May 15

Opening of the Salon des Refusés. *Le Dé-
jeuner sur l'herbe (Le Bain)* by Édouard
Manet becomes a focus of scandal.

August 13

Death of Eugène Delacroix.

November 11

Official decree reorganizing the École Im-
périale et Spéciale des Beaux-Arts.

November 20

Cézanne is authorized to make copies in
the Louvre. He names Chesneau as his
teacher, probably the critic Ernest Ches-
neau, who is also an editor of *La Revue eu-
ropéenne*. His address is given as 7, rue des
Feuillantines.

Register of student authorizations, LL 10, card
no. 2097, Archives du Louvre, Paris.

End of December

He begins a copy of *Dante and Virgil Cros-
sing the Styx* by Delacroix; two months
later it is still unfinished.

Cézanne to Coste, February 27, 1864, in Cézanne,
1978, p. 111.

Bazille introduces Cézanne and Zola to
Renoir.

Robida, 1958, p. 127.

1864

April

Cézanne has cut his beard and "consecrat-
ed the tufts on the altar of Venus."

Zola to Antony Valabrègue, April 21, 1864, in Zola,
1978-, vol. 1, no. 76, p. 360.

April 19

He begins a copy of *The Arcadian Shepherds*
by Poussin.

Register of copyists of the French and Flemish
schools, 1851-71, LL22, card no. 3246, Archives du
Louvre, Paris.

July

Cézanne returns to Aix.

Cézanne to Coste, February 27, 1864, in Cézanne,
1978, p. 111; Zola to Valabrègue, July 6, 1864, in
Zola, 1978-, vol. 1, no. 82, p. 368.

August

Zola writes the famous letter known as
"L'Écran" (The Screen), a veritable artistic
manifesto: "Every work of art is like a
window open on creation; inserted in the
window embrasure is a kind of transpar-
ent Screen through which one perceives
objects that are more or less distorted,
subjected to more or less perceptible
changes in their lines and their color.
These changes follow from the nature of
the Screen. One no longer has a creation
that's precise and real but a creation mod-
ified by the medium through which the
image passes."

First mention of a sojourn in L'Estaque by Cézanne.

Zola to Valabrègue, August 18, 1864, in Zola, 1978-, vol. 1, no. 88, pp. 373-81; Cézanne to [S]aint-Martin, August 15, 1864, Bibliothèque d'Art et d'Archéologie, Paris, Doucet Collection.

1865

March 15
Cézanne is in Paris. He spends several days at Saint-Germain-en-Laye before returning to the capital to deliver canvases to the Salon, with Oller, "that will make the Institute blush from rage and despair."

Having been unable to go to Pissarro's house, he proposes that he meet him at the Atelier Suisse, where he works mornings, or at his own quarters in the evening, or wherever might be convenient for him.

Cézanne to Pissarro, March 15, 1865, in Cézanne, 1978, pp. 112-13.

June?
Guillemet asks Pissarro for news of the Salon and of his friends Cézanne and Oller. Cézanne's submission to the Salon is refused.

Guillemet to Pissarro, [1865], Pissarro Archives sale, Hôtel Drouot, Paris, November 21, 1975, lot 79.

October 15
Zola dedicates his novel *La Confession de Claude* to "my friends P. Cézanne and J.-B. Baille." On this occasion, Marius Roux publishes an article about the artists from Aix in Zola's circle, especially Baille and Cézanne: "M. Cézanne is one of the good students with which our school in Aix has provided Paris. . . . A great admirer of Ribera and Zurbarán, our painter goes his own way." Several of his works from the late 1860s are, indeed, inspired by the Spanish masters he had studied in *L'Histoire des peintres de toutes les écoles*, published in installments beginning in 1849; the one on the "Spanish School" was published in 1869. He also was influenced by reproductions in *L'Artiste*, the *Magasin pittoresque*, and the *Musée des familles*.

Roux, December 3, 1865; Rewald, 1936, pp. 45-46; Ballas, December 1981, pp. 223-31.

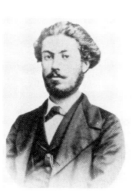

Fortuné Marion (1846-1900), c. 1866, photograph, Musée d'Orsay, Paris, Vollard Archives.

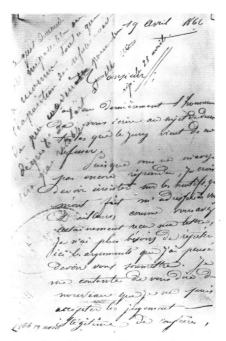

Letter from Cézanne to Nieuwerkerke, with Nieuwerkerke's response in the corner, April 19, 1866, Musée d'Orsay, Paris, Vollard Archives.

Winter
Cézanne is in Aix. In the postscript to a letter from Antoine-Fortuné Marion to Heinrich Morstatt, a musician passionately fond of Wagner, he invites Morstatt, who is in Marseille, to come to Aix and play Wagner over the Christmas holidays. Morstatt, born in 1844 near Stuttgart, was then pursuing a business career in Marseille.

Pissarro to Oller, December 14, 1865, in Pissarro, 1980-91, vol. 3, no. 1090, p. 533; Marion to Morstatt, December 23, 1865, in Cézanne, 1978, p. 113, and in Barr, 1938, no. 3, pp. 84, 288.

1866

Mid-February
Cézanne leaves Aix for Paris. He attends the Thursday evening gatherings organized by Zola, which are also frequented by Baille and Coste.

Zola to Valabrègue, January 8, 1866, and [February 1866], in Zola, 1978-, vol. 1, nos. 139, 145, pp. 435, 445.

April
Despite Daubigny's intervention with a member of the jury, Cézanne's *Portrait of a Man* (cat. no. 8) is refused by the Salon jury along with the submissions of Manet, Renoir, Guillemet, and Solari. Marion writes: "The whole realist school has been refused. . . . In reality we triumph and this mass refusal, this vast exile is in itself a victory. All we have to do is to plan an exhibition of our own and put up a deadly competition against those blear-eyed idiots."

The rue Beautreillis in Paris, photograph by Eugène Atget, Bibliothèque Nationale, Paris, Département des Estampes.

Marion to Morstatt, April 12, 1866, in Barr, 1938, no. 5, p. 220; Zola to Coste, June 14, 1866, in Zola, 1978-, vol. 1, no. 150, p. 451.

First half of April
Cézanne visits Manet, who has seen his still lifes at Guillemet's. "He found them powerfully treated. Cézanne is very happy about this, though he does not expatiate about his happiness and does not insist on it, as is his wont. Manet is going to call on him. Parallel temperaments, they will surely understand one another."

Passage in a letter from Valabrègue cited in another letter from Marion to Morstatt, April 12, 1866, in Barr, 1938, no. 5, p. 223.

April 19
Cézanne sends a second letter of protest—his first letter having met with no response—to Comte de Nieuwerkerke, Minister of Fine Arts, requesting reestablishment of the Salon des Refusés, a juryless exhibition "open to all serious workers." The following note was written in the margin: "What he requests is impossible, it has been acknowledged that the exhibition of the rejected works was prejudicial to the dignity of the art, and it will not be reestablished."

Cézanne resides at 22, rue Beautreillis. Jeanne Duval, Baudelaire's mistress, lived in this house in 1858-59, and the poet also resided there temporarily.

Cézanne to Nieuwerkerke, April 19, 1866, Archives du Louvre, Paris, X Salons; Cézanne, 1978, p. 114-15; Paris, 1993-94, p. 111.

April 26

The painter Oller, who is in Madrid, asks Cézanne and Pissarro to send paintings via Tanguy for exhibition in the Spanish capital.

Oller to Pissarro, April 26, 1866, Pissarro Archives sale, Hôtel Drouot, Paris, November 21, 1975, lot 137/4.

April 27–May 20

Zola, signing himself "Claude," publishes seven articles on the Salon in *L'Événement*, later collected in a book entitled *Mon Salon* and dedicated to Cézanne (May 20, 1866). Only one member of the jury, Daubigny, finds favor with him. The day of the last installment, Zola sends Cézanne a long, very warm dedication, which is published as a preface to the brochure.

Zola, dedication to Cézanne, May 20, 1866, in Cézanne, 1978, pp. 116-18.

May 7

Manet congratulates Zola on the article devoted to him in his series on the Salon ("M. Manet," *L'Événement*, May 7, 1866). Eager to meet him, Manet suggests that he come to the Café de Bade, boulevard des Italiens, where he can be found every day from 5:30 to 7:00.

Cézanne introduces Zola to Guillemet.

Manet to Zola, Monday, May 7 [1866], in Paris and New York, 1983, no. 1, p. 519; Brady, 1968, p. 77.

May–early August

Cézanne makes several visits to Bennecourt in the company of Zola, Jean-Baptiste Chaillan, Baille, and Valabrègue. It was probably Daubigny who had drawn his attention to this village, situated on the bank of the Seine opposite Bonnières. Cézanne settles in the local inn, which is operated by père Dumont. He undertakes canvases of large dimensions. Zola forwards him 60 francs on Baille's account.

Madame Zola to her son, May 10, 1866, in Walter, 1961, p. 34; Walter, February 1962, p. 104; Zola to Coste, June 14 and July 26, 1866, in Zola, 1978-, vol. 1, nos. 150, 151, pp. 450, 453; Cézanne to Zola, June 30, 1866, in Cézanne, 1978, pp. 119, 121.

Mid-August

Cézanne is back in Aix. He takes walks in the countryside with Marion and Valabrègue. A poem dedicated to Paul Cézanne appears in *L'Écho des Bouches-du-Rhône*, an Aix newspaper. During the month of August he works on the first version of a painting inspired by Wagner, *Young Girl at the Piano–Overture to Tannhäuser* (present location unknown; see cat. no. 17).

Marion to Morstatt, August 18 and 28, September 1 (?), 1866, in Barr, January 1937, nos. 6, 7, 8, pp. 44, 45, 53-54, 58.

September

The Café Guerbois, 11, Grande-Rue des Batignolles (now 9, avenue de Clichy), becomes a meeting place for Manet and his friends Zacharie Astruc, Émile Belot, Edmond Duranty, Léon Cladel, Philippe Burty, H. Vignaux, Antoine Guillemet, Whistler, Degas, Renoir, Fantin-Latour, and others. It is probably here that Cézanne, "consenting to take a seat there two or three times in his unsociable way," meets Monticelli.

Monet recounts that when Cézanne arrived at the Café Guerbois, he "pushed his jacket aside with a movement of the hips worthy of a zinc-worker, pulled up his pants, and openly readjusted the red belt to the side. After that he shook everyone's hand. But in Manet's presence he removed his hat and, smiling, said through his nose: 'I won't give you my hand, Monsieur Manet, I haven't washed for eight days.'"

Duret, 1902, pp. 63-64; Tabarant, 1947, p. 117; Garibaldi, 1991, p. 54; Elder, 1924, p. 48.

October 6

Marion and Cézanne plan a trip to Marseille to visit Morstatt.

Marion to Morstatt, October 6, 1866, in Barr, January 1937, no. 11, p. 58.

Mid-October

Guillemet arrives in Aix, where he stays with Cézanne for several days before renting an apartment at 43, cours Sainte-Anne. Cézanne works on a portrait of his sister Rose and, despite rainy weather, on some landscapes, although "all pictures done inside, in the studio, will never be as good as things done in the open air." He paints *Marion and Valabrègue Setting Out for the Motif*, the sketch that is complimented by Guillemet. He confides to Zola: "I don't know if you'll agree with me, and it wouldn't make me change my mind anyway, but I'm beginning to realize that art for art's sake is an awful joke."

On the invitation of his former teacher Gibert, he visits, along with Baille, Marion, and Valabrègue, the collection of old masters recently bequeathed to the museum in Aix by J.-B. de Bourguignon de Fabregoules and provisionally exhibited in

Adolphe Monticelli (1824-1886), photograph, Musée d'Orsay, Paris, Service de documentation.

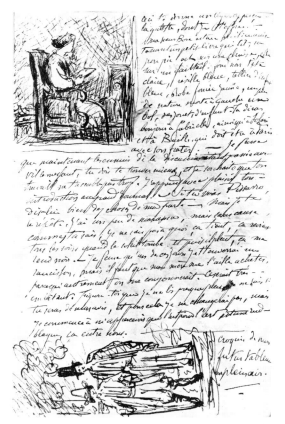

Illustrated letter from Cézanne to Zola, about October 19, 1866, Le Blond-Zola collection.

the chapel of the Pénitents Blancs. "I found everything bad. It's very reassuring," he wrote Zola.

Cézanne to Zola, [around October 19, 1866], in Cézanne, 1978, pp. 122-23.

October 23

He is in conflict with his family, "the most disgusting beings in the world, . . . crappier than anybody." He resolves not to send canvases to the Salon in Marseille.

Cézanne to Pissarro, [October 23, 1866], in Cézanne, 1978, pp. 124-25

November 2

Guillemet describes Cézanne in very positive terms: "His physique has become rather more handsome, his hair is long, his figure exudes health, and his very dress causes a sensation on the Cours [Mirabeau]." He expresses admiration for his most recent canvases, *Young Girl at the Piano–Overture to Tannhäuser* (cat. no. 17) and the *Portrait of the Artist's Father Reading "L'Événement"* (p. 84, fig. 1). The inhabitants of Aix begin to show interest in Cézanne's painting and Guillemet predicts a future "in which he'll be offered the directorship of the museum," which would be the only chance of "some fairly successful landscapes made with a palette knife . . . getting into any museum whatever."

Guillemet to Zola, November 2 [1866], in Cézanne, 1978, pp. 127-28.

December

Zola recommences his Thursday receptions, which are frequented by Pissarro, Baille, Solari, and Georges Pajot. Cézanne is still in Provence.

Zola to Valabrègue, December 10, 1866, in Zola, 1978-, vol. 1, no. 159, p. 464.

Late December

Guillemet returns to Paris after his sojourn in Aix.

Guillemet to Zola, November 2 [1866], in Cézanne, 1978, p. 128.

1867

January 1

Zola publishes "Une nouvelle manière en peinture: M. Édouard Manet" in *La Revue du XIXᵉ siècle*. Édouard Dentu reissues it as a brochure in June on the occasion of Manet's one-man exhibition.

February

Cézanne is in Paris and "dreams of immense paintings."

Zola to Valabrègue, February 19, 1867, in Zola, 1978-, vol. 1, no. 162, p. 473.

April

Two canvases by Cézanne, *The Wine Grog* and *Drunkenness*, are refused by the Salon jury, as are the submissions by Guillemet, Sisley, Bazille, and Renoir. Zola asserts that his articles probably had something to do with this: "The jury, irritated by my 'Salon,' has shown the door to all those who tread the new road." In conformity with a new regulation, a list of canvases specifying dimensions and subject matter had been proposed before December 15, 1866.

A petition protesting the jury's severity and demanding reestablishment of the Salon des Refusés is left with the picture dealer Latouche, on the rue Laffitte. It attracts about three hundred signatories.

Zola to Valabrègue, April 4, 1867, and to Francis Magnard, [around April 8, 1867], in Zola, 1978-, vol. 1, nos. 169, 172, pp. 486, 491-92, 492 n. 8.

April 1

Opening of the Exposition Universelle on the Champ-de-Mars.

April 8

A daily newspaper in Frankfurt attacks Cézanne's Salon submissions: "I have also been told of two refused pictures by M. Sésame (nothing to do with the *Thousand and One Nights*), the same who in 1863 prompted general hilarity at the Salon des Refusés–again!–with a canvas representing two pig's feet arranged like a cross. This time M. Sésame sent to the Exposition two compositions if not equally bizarre, then at least equally deserving of exclusion from the Salon. These composi-

tions are entitled *The Wine Grog* and represent, the one, a nude man to whom an elaborately dressed woman brings a wine grog, the other, a nude woman and a man dressed like a lazzarone. Here the grog has been overturned." Zola again defends Cézanne, "a young painter whose vigorous and personal talent I hold in singular esteem." Much of his letter is published in *Le Figaro* on April 12.

Mortier, April 8, 1867; Zola to Magnard, [around April 8, 1867], in Zola, 1978-, vol. 1, no. 172, pp. 490-91, 492 n. 3.

May 24

Opening of Manet's private exhibition, including fifty paintings, in a temporary structure built at his own expense at the corner of the avenues Montaigne and de l'Alma. Zola's brochure (see January 1, 1867), containing his article and two etchings, one by Manet and the other a portrait of the painter by Félix Bracquemond, is on sale there.

Monet to Bazille, [May 20, 1867], in Wildenstein, 1974-85, vol. 1, no. 32, p. 423; Manet to Zola, [between January and May 1867], in Paris and New York, 1983, no. 5, p. 520.

May 29

Opening of a private exhibition of works by Courbet in a pavilion erected on the avenue de l'Alma traffic circle.

Monet to Bazille, [May 20, 1867], in Wildenstein, 1974-85, vol. 1, no. 32, p. 423.

Early June

Cézanne, who has spent a portion of the winter and spring in Paris, returns to Aix with his mother, who had probably come to visit the Exposition Universelle. He works on "some truly beautiful portraits; no longer [executed] with the palette knife, but just as vigorous." He hopes to return to Paris for a week in mid-August to view once more the private Manet and Courbet exhibitions in the company of Marion. In the end, the plan does not work out and Marion goes to Paris alone.

Marion and Cézanne plan to send paintings to Morstatt in Marseille.

Cézanne works on some large canvases. He begins a second version of *Young Girl at the Piano—Overture to Tannhäuser* in a lighter palette (see cat. no. 17).

Zola to Valabrègue, May 29, 1867, and to Philippe Solari, June 6, 1867, in Zola, 1978-, vol. 1, nos. 180, 186, pp. 500, 507; Marion to Morstatt, June or July 1867, August 15, 1867, September 6, 1867, in Barr, January 1937, nos. 19, 20, 22, 23, pp. 40-41, 49-50, 54-55.

July 31

Guillemet invites Zola and Cézanne to spend some time in Brittany, at Plancoët.

Guillemet to Zola, [July] 31 [1867], in Baligand, 1978, p. 186.

1868

January 26

Cézanne attends the Concerts Pasdeloup, where he hears the overtures to *The Flying Dutchman* (January 26) and *Tannhäuser* (February 23) as well as the prelude to *Lohengrin* (April 19).

Postscript by Cézanne to a letter from Marion to Morstatt, May 24, 1868, in Barr, 1938, no. 31, p. 289, and in Cézanne, 1978, p. 130; Paris, 1983-84, p. 158.

February 13

He receives authorization to copy in the Louvre. He lists Chesneau as his teacher. It is not known what painting he copied. He is living at 22, rue Beautreillis.

Register of student authorizations, LL11, card no. 278, Archives du Louvre, Paris; Reff, 1964, p. 555.

April

His Salon submission is refused. "Realist painting of the moment . . . is . . . farther than ever from official success and it is quite certain that Cézanne won't be able to show his work in official, sanctioned exhibitions for a long time. His name is already too well known, and too many revolutionary ideas in art are connected with it, for the painters on the jury to weaken for a single instant. And I admire the tenacity and *sangfroid* with which Paul writes to me: 'Very well! We'll stick it to them like that in eternity with even more persistence.'"

Marion to Morstatt, April 27, 1868, in Barr, January 1937, no. 30, p. 48.

May 2-June 16

Seven articles by Zola on the Salon appear in *L'Événement*.

May 16

Cézanne leaves Paris for Aix.

Cézanne to Coste, May 13, 1868, in Cézanne, 1978, p. 129.

May 24

He plans to paint a composition representing his friends in a landscape listening to one of them talk, using earlier portraits and photographs. He intends to give this painting, "handsomely framed," to Morstatt for the museum in Marseille, "which will thus be obliged to exhibit realist painting and our glory."

Marion to Morstatt, May 24, 1868, in Barr, 1938, no. 31, p. 85.

June and early July

Paul Alexis pays him several visits. He lends him the *Revue de Paris* for 1840, edited by Balzac, which contains a long article on Stendhal's *Charterhouse of Parma*.

Cézanne takes an excursion to Saint-Antonin, a small village at the foot of Mont Sainte-Victoire. Otherwise he leads a solitary life with his family, occasionally venturing into a café and gleaning "insig-

The Pont de la Cible over the Arc River
near Aix-en-Provence, postcard.

nificant news" from *Le Siècle*. He visits
Villevieille.

Cézanne to Coste, early July [18]68 and late No-
vember [1868], in Cézanne, 1978, pp. 131-33.

July 17
Marion sends a painting to Morstatt; Cé-
zanne sends him a still life with other can-
vases to follow.

Marion to Morstatt, July 17, 1868, in Barr, 1938,
no. 32, p. 86.

November
He works on a landscape on the banks of
the Arc River for the next Salon. "Cé-
zanne is still working with a will, with all
his might to control his temperament, to
make it submit to the rules of a calm
science. If he succeeds, . . . we'll have
some strong and complete works to ad-
mire."

Cézanne to Coste, late November [1868], in Cé-
zanne, 1978, p. 134; Marion to Morstatt, [Autumn
1868], in Barr, 1937, no. 34 [not 36], p. 57.

Around December 15
He returns to Paris.

Cézanne to Coste, late November [1868], in Cé-
zanne, 1978, p. 132.

1869

At the beginning of the year, in Paris, Cé-

zanne meets Emélie Hortense Fiquet, who
becomes his companion. She was born on
April 22, 1850, in Saligney, in the Jura.

Rewald, 1936, p. 67; birth certificate, Hôtel de Ville,
Saligney.

April
Cézanne is in L'Estaque, where he paints
a watercolor, *Factories in L'Estaque*. This
sheet (R. 24), given to Alexandrine Meley,
Zola's companion (and later his wife), is
inscribed on the back: "Watercolor made
especially for a work table belonging to
Mme Alexandrine-Émile Zola, by Paul Cé-
zanne in April 1869. Certified by me.
Alex. Émile Zola." Cézanne then goes to
Paris to deliver his Salon submissions,
which are once more refused by the jury.

Marie Cézanne to her brother, April 5, 1869, in
Rewald, 1936, p. 74.

Summer
Cézanne experiences a period of groping
and uncertainty. He probably sojourns in
Bennecourt and Gloton, where Zola is
renting the Pernelle house on the banks of
the Seine.

Guillemet expresses confidence in the
artist's future success: "It is time for him
to produce in accordance with his ideas,
and I'm anxious to see him assume his
rightful place; intelligence [alone] is not

sufficient to do well. In the end, with
time, he'll succeed, I don't doubt it."

Zola, 1978-, vol. 2, p. 182; Guillemet to Zola, July
20, 1869, in Baligand, 1978, p. 193.

1870

March
Cézanne returns to Paris. He resides at 53,
rue Notre-Dame-des-Champs.

Zola to Solari, February 13, 1870, in Zola, 1978-,
vol. 2, no. 84, p. 212.

March 20
Despite a change in the admission proto-
col—the jury members are now elected by
previously accepted artists—the two paint-
ings submitted by Cézanne, the *Portrait of
the Painter Achille Emperaire* (cat. no. 19)
and a reclining nude, are refused. The
caricaturist Stock captions one of his car-
toons: "Artists and critics present at the
Palais de l'Industrie last March 20, the
deadline for submitting pictures, remem-
ber the ovation that greeted two paintings
in a new genre."

Cézanne to Justin Gabet, June 7, 1870, in Cézanne,
1978, pp. 135-36; Zola, 1978-, vol. 2, p. 216 n. 5;
Stock, March 20, 1870.

May 30
Théodore Duret writes a series of articles
on the Salon in *L'Électeur libre*. He wants
to meet Cézanne, but Zola refuses to give
him his address: "He keeps very much to
himself, he's in a period of groping, and in
my view he's right not to let anyone pen-
etrate his studio. Wait until he's found
himself."

Duret to Zola, May 30, 1870, and Zola to Duret,
May 30, 1870, in Zola, 1978-, vol. 2, p. 219 n. 1,
and no. 89, p. 219.

May 31
Marriage of Zola and Alexandrine Meley
at the municipal building of the XVIIᵉ ar-
rondissement in Paris. The witnesses are
Marius Roux, Paul Alexis, Philippe Solari,
and Paul Cézanne ("artiste-peintre").

Marriage certificate, Archives de Paris.

July 19
France declares war on Prussia.

September
Cézanne sojourns at L'Estaque in the
company of Hortense Fiquet. Zola, his
wife, and his mother join them at the be-
ginning of the month before settling in
Marseille.

"During the war, I worked a great deal
from the motif at L'Estaque. . . . I divided
my time between the landscape and the
studio."

Zola, 1978-, vol. 2, p. 225 n. 1; Vollard, 1914,
p. 37.

September 4
Proclamation of the Republic after the

View of Saint-Henri
and the Gulf of L'Estaque,
postcard,
Musée Cantini, Marseille.

defeat at Sedan (September 2) and the surrender of Napoleon III.

A new city council is elected in Aix, including, among others, Louis-Auguste Cézanne, Baille, and Valabrègue. The artist's father, placed in charge of the fisc, does not take part in council meetings.

Roux to Zola, September 18, 1870, in Zola, 1978-, vol. 2, p. 229 n. 4; Rewald, April 1939, p. 167.

September 17
Beginning of the siege of Paris by the Prussians.

November 18
Cézanne, still in L'Estaque, is elected to head the commission of the École Gratuite de Dessin in Aix. He does not attend its meetings, and the body is dissolved on April 19, 1871.

Zola to Valabrègue, November 21, 1870, in Zola, 1978-, vol. 2, no. 100, p. 229; Ély, 1984, pp. 200-201.

December
Madame Zola thinks that Cézanne and Hortense Fiquet (nicknamed "la Boule") are "hidden away" in Marseille. In fact, they are still in L'Estaque, and Cézanne visits his family in Aix from time to time.

Alexandrine Zola to her husband, December 17, 1870, and Marius Roux to Zola, January 4, 1871, in Zola, 1978-, vol. 2, pp. 253 n. 6, 274 n. 1.

1871

January
Cézanne is declared a draft dodger.

Roux to Zola, January 4, 1871, in Zola, 1978-, vol. 2, p. 274 n. 1.

February 26
The Treaty of Versailles brings the Franco-Prussian War to an end.

April 2
Beginning of confrontations between the Commune, declared on March 26, and the government based in Versailles.

May
The owner of the house rented by Cézanne at L'Estaque, M. Giraud, claims that the couple has left L'Estaque for Lyon until "Paris is no longer smoldering."

Zola fears that his last letter, containing "certain compromising details," has been forwarded to the Jas de Bouffan. Cézanne's father does not know of his son's liaison with Hortense Fiquet, but his mother is aware of it.

Alexis to Zola, June 19, 1871, in Bakker, 1971, no. 4, p. 43; Zola to Alexis, June 30, 1871, in Zola, 1978-, vol. 2, no. 131, p. 288.

May 21-28
"Bloody Week" in Paris. The Commune is crushed.

July
Cézanne, who probably has not left the Midi during these events, is at the Jas de Bouffan.

Zola to Cézanne, July 4, 1871, in Zola, 1978-, vol. 2, no. 134, pp. 293-94.

Summer/Fall
He settles for a few months in Paris with his friend the sculptor Philippe Solari at 5, rue de Chevreuse.

Solari to Zola, December 14, 1871, in Rewald, 1936, p. 78.

1872

January 4
Birth of Paul, the son of Cézanne and Hortense Fiquet, at 45, rue de Jussieu (second floor). The artist acknowledges his paternity. He asks his friend Achille Emperaire to deliver a letter to his mother that probably conveyed this news.

Birth certificate, Archives de Paris; Cézanne to Emperaire, [January 1872], in Cézanne, 1978, p. 139.

February 19
Emperaire arrives in Paris. Cézanne offers him hospitality but according to Emperaire he "is pretty badly set up.–What's more a hubbub that would wake the dead." After a few weeks he leaves the apartment, disappointed by the state of af-

fairs there: "I found him abandoned by everyone.–He no longer has a single intelligent or affectionate friend.–The Zolas, the Solaris, and others . . . are no longer mentioned."

Cézanne to Emperaire, January 26 and February 5, 1872, and Emperaire to friends in Aix, February 19, March 17 and 27, 1872, in Cézanne, 1978, pp. 140-42.

April
Cézanne's Salon submission is refused. He signs a petition addressed to the minister of public instruction, religion, and fine arts requesting that a room be opened in the middle of the exhibition in the Palais de l'Industrie for artists refused by the jury. Among the forty signatories are Manet, Jongkind, Fantin-Latour, Renoir, and Pissarro (by proxy). The request is denied.

Petition for a Salon des Refusés initiated by the painter Authié, April 25, 1872; Charles Blanc, Director of Fine Arts, to Authié, June 18, 1872, F21, 535, Dr 3, Archives Nationales, Paris.

April 9
Doctor Gachet acquires a property on the rue Rémy in Auvers.

Gachet, 1956, p. 53.

July 22
Zola signs a contract with Georges Charpentier, who becomes the publisher of the

The rue de Jussieu in Paris, seen from the place Jussieu, photograph, Bibliothèque Nationale, Paris, Département des Estampes.

Panoramic view of Auvers-sur-Oise, postcard, photograph by Godefroy, Bibliothèque Nationale, Paris, Département des Estampes.

Pissarro and Cézanne, photograph,
Musée d'Orsay, Paris, Service de documentation.

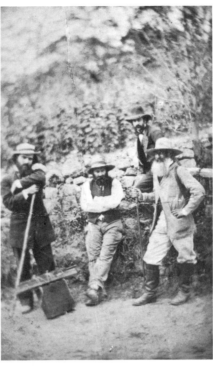

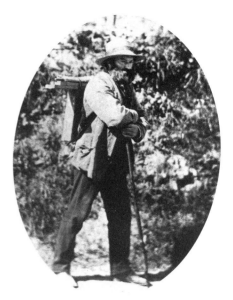

Cézanne setting out for the motif,
photograph,
Musée du Louvre, Paris,
Département des Arts Graphiques,
Musée d'Orsay.

Rougon-Macquart novels. He frequents
the salon of the Charpentiers, into which
he introduces Cézanne.

Zola, 1978-, vol. 2, p. 310; Robida, 1958, p. 127.

August

Pissarro settles in Pontoise, 16, rue Malle-
branche. Cézanne joins him there before
proceeding to Auvers. He settles at the
Hôtel du Grand Cerf, 59, rue Basse, in
Saint-Ouen-l'Aumône.

Pissarro, 1980-91, vol. 1, p. 32; Pissarro to Guille-
met, September 3, 1872, in Pissarro, 1980-91, vol.
1, no. 18, p. 77; Gachet, 1956, p. 51; Rewald, 1936,
p. 79.

December

He works in Pontoise.

Cézanne to Pissarro, [December 11, 1872], in Cé-
zanne, 1978, p. 142.

1873

Cézanne spends the entire year in Auvers
with Hortense and their son, Paul. Every
day he walks to Pontoise, where he works
at Pissarro's side.

In Auvers, Pissarro and Guillaumin
make etchings in Doctor Gachet's studio.

Gachet, 1956, pp. 53-55, 60; Pissarro to Gachet,
[October 28, 1873], in Pissarro, 1980-91, vol. 1,
no. 25, p. 83; Lucien Pissarro to Paul-Émile Pis-
sarro, [1912], in Thorold, 1980, no. 13, p. 8.

Early August

Doctor Gachet informs Cézanne's father of
the death of the doctor's nephew and the
birth of his son. He also administers the
painter's allowance.

Louis-Auguste Cézanne to Gachet, August 10,
1873, in Cézanne, 1978, p. 143; Gachet, 1956,
p. 29.

Cézanne (center) and Pissarro (right)
with two other artists in the vicinity of Auvers,
c. 1873, photograph,
Musée d'Orsay, Paris,
Service de documentation.

Paul Cézanne, *Pissarro Setting Out for the Motif*,
c. 1874-77, graphite on paper,
Musée du Louvre, Paris,
Département des Arts Graphiques,
Musée d'Orsay.

Paul Cézanne, *Cézanne Engraving with Doctor Gachet*,
c. 1873, graphite on paper,
Musée du Louvre, Paris,
Département des Arts Graphiques,
Musée d'Orsay.

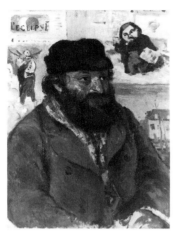

Camille Pissarro, *Portrait of Cézanne*,
c. 1874, oil on canvas,
private collection.

Cézanne, c. 1875,
photograph,
Musée Granet, Aix-en-Provence.

October
Pissarro moves into 26, rue de l'Hermitage in Pontoise.
Pissarro to Duret, October 31, 1873, in Pissarro, 1980-91, vol. 1, no. 27, p. 85.

December 8
Pissarro recommends Cézanne to Duret: "If you're looking for five-legged sheep, I think Cézanne might be to your liking, for he has studies that are quite strange and seen in a unique way."
Pissarro to Duret, December 8, 1873, in Pissarro, 1980-91, vol. 1, no. 29, p. 88.

December 27
Establishment of the Société Anonyme Coopérative des Artistes-Peintres, Sculpteurs, Graveurs, etc., an organization of artists.

1874

Early in the year
Cézanne leaves Auvers for Paris, where he settles at 120, rue de Vaugirard. According to Rewald, before departing he settles a debt to his grocer in Pontoise, M. Rondès, by giving him a painting. He asks his father to increase his allowance to 200 francs per month. Should the request be granted, he will consider returning to Aix, where he would derive "much pleasure from working in the Midi, which offers so many views suitable for my painting."
Cézanne to a collector in Pontoise, [early 1874], and to his parents, [around 1874], in Cézanne, 1978, pp. 144, 145; Paris, 1874.

March 5
Doctor Gachet asks Pissarro to organize a benefit sale for Daumier, then almost blind, with paintings by Manet, Monet, Sisley, Ludovic Piette, Gautier, Degas, Guillaumin, Cézanne, and "the whole cooperative."
Gachet to Pissarro, March 5, 1874, Pissarro Archives sale, Hôtel Drouot, Paris, November 21, 1975, lot 26.

April 15-May 15
Three paintings by Cézanne are presented at the first Impressionist exhibition: *The House of the Hanged Man, in Auvers-sur-Oise* (cat. no. 30); *A Modern Olympia* ("sketch, property of Doctor Gachet"; cat. no. 28); and *Study: Landscape in Auvers* (probably V. 157, Philadelphia Museum of Art).

The House of the Hanged Man is purchased by Comte Doria from the exhibition.
Paris, 1874, nos. 42-44; Lora, April 18, 1874; Zola, April 18, 1874; Prouvaire, April 20, 1874; Leroy, April 25, 1874; Castagnary, April 29, 1874; Montifaud, May 1, 1874; Polday, May 3, 1874, p. 188.

Late May
Cézanne returns to Aix, where he remains through the summer. Intrigued by press coverage of the Impressionist exhibition, the director of the museum in Aix visits the artist's studio. "I shall be able to appreciate much better the dangers now threatening painting after seeing your attempts on its life." Nonetheless, he encourages him to persevere.
Cézanne to Pissarro, June 24, 1874, in Cézanne, 1978, pp. 146-47.

September
Cézanne returns to Paris.
Cézanne to his mother, September 26, 1874, in Cézanne, 1978, p. 148.

December 17
He does not attend the general meeting of the Société Anonyme Coopérative, where a unanimous decision is taken to disband the organization.
Minutes of the meeting, Pissarro Archives sale, Hôtel Drouot, Paris, November 21, 1975, lot 82/1.

1875

January 3
Pissarro drafts a will naming Piette, Guillaumin, and Cézanne his executors.
Pissarro, 1980-91, vol. 1, no. 39, p. 97.

March 24
Cézanne does not participate in the auction of Impressionist paintings organized at the Hôtel Drouot.
Bodelsen, June 1968, pp. 333-36.

The rue de Vaugirard in Paris, view from the rue Madame, photograph, Bibliothèque Nationale, Paris, Département des Estampes.

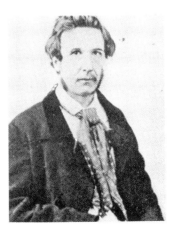

Victor Chocquet (1821-1891), photograph found in Cézanne's papers, Musée d'Orsay, Paris, Service de documentation.

Edgar Degas, drawing after *Bathers at Rest* (p. 279, fig. 1) by Cézanne, 1877, sketchbook no. 28, p. 3, Bibliothèque Nationale, Paris.

August 18

He joins the Union des Artistes, an artists' organization headed by Alfred Meyer that succeeded the Société Anonyme Coopérative.

Cézanne, 1978, p. 153 n. 8.

October 21, November 1, and December 30

Tanguy sells Victor Chocquet three canvases by Cézanne for 50 francs each. It was Renoir who brought Cézanne's paintings to the collector's attention. Like Cézanne, Chocquet is a great admirer of Delacroix.

Rewald, July-August 1969, p. 39; Vollard, 1920, chap. 8; Cézanne to Chocquet, May 11, 1886, in Cézanne, 1978, p. 226.

Cézanne meets Jean-Louis Forain in the Louvre.

Cézanne to his son, August 3, 1906, in Cézanne, 1978, p. 319.

1876

February 5

Monet, who wants to meet the collector, invites Chocquet and Cézanne to visit him in Argenteuil.

Monet to Chocquet, February 4, 1876, in Wildenstein, 1974-85, vol. 1, no. 86, p. 430.

April

Cézanne is in Aix. He does not take part in the second Impressionist exhibition but reads the reviews sent him by Chocquet. His name appears in a list of artists who decided not to exhibit inscribed by Degas in one of his notebooks.

His Salon submission is refused.

Cézanne to Pissarro, April 1876, in Cézanne, 1976, pp. 143-45; Degas notebook no. 26, p. 99, Bibliothèque Nationale, Paris, Dc 327d *réserve*, Carnet 7, in Reff, 1976, vol. 2, p. 124.

April 15-May 1

Manet, refused by the Salon, exhibits works in his studio.

Bazire, 1884, pp. 90-98; Cézanne to Pissarro, April 1876, in Rewald, 1976, p. 143.

June-late July

Cézanne is in L'Estaque, where he works on marines for Chocquet. He would like to remain there long enough to complete some large canvases. He resides at the maison Giraud on the place de l'Église and plans to return to Paris toward the end of July.

Cézanne to Pissarro, July 2, 1876, in Cézanne, 1978, pp. 152-54.

September 10

In a letter to his parents he describes the Impressionist exhibition in very positive terms and informs them that Monet had risen to his defense against Ludovic Napoléon Lepic, who opposed his participation in the exhibition planned for the following year. He often sees Guillaumin, with whom he works at Issy-les-Moulineaux, and continues to frequent Doctor Gachet.

Cézanne to his parents, September 10, 1876, and to Gachet, October 5 [1876], in Cézanne, 1978, pp. 155, 156.

1877

Late March

Cézanne attends a dinner organized by the Impressionists at the Café Riche. Zola is also invited.

Monet to Zola, [late March 1877], in Wildenstein, 1974-85, vol. 1, no. 105, p. 432.

April 4-30

Third Impressionist exhibition. Cézanne shows sixteen works, including three watercolors, some still lifes, and, above all, several landscapes, but also a painting of a tiger, probably inspired by Delacroix. Degas makes two quick sketches of his *Bathers at Rest* (V. 276).

His address is 67, rue de l'Ouest.

Paris, 1877; Rivière, April 6, 1877; Pothey, April 7, 1877; Sébillot, April 7, 1877; Lafenestre, April 8, 1877; Anonymous, April 10, 1877; Lora, April 10, 1877; Leroy, April 11, 1877; Jacques, April 12, 1877; Schop, April 13, 1877; Leroy, April 14, 1877, p. 83; Rivière, April 14, 1877, pp. 1-3; Zola, April 19, 1877; Ballu, April 23, 1877, p. 392; Burty, April 25, 1877; Bigot, April 28, 1877; cadastral survey, August 11, 1877, D1P4, Archives de la Seine, Paris; Degas notebook no. 28, p. 3, in Reff, 1976, vol. 1, p. 129.

May 27-October 27

Zola sojourns in L'Estaque.

Zola to Michel Stassioulevitch (editor of the *Messager de l'Europe*, a monthly published in St. Petersburg), May 27 and June 13, 1877, in Zola, 1978-, vol. 2, no. 353, p. 567, and vol. 3, no. 1, pp. 66-67, p. 67 n. 4.

May 28

Cézanne does not take part in the second auction organized by the Impressionists at the Hôtel Drouot.

Bodelsen, June 1968, pp. 336-39.

August

He is in Paris and works in the parc d'Issy.

For several years the artist's mother has rented a house in L'Estaque during the summer. Cézanne asks Zola to deliver a message requesting that she find him a two-room apartment in Marseille, not too expensive, beginning in December, so he can spend the winter there, but this plan is soon abandoned. He buys his painting supplies at père Tanguy's shop on the rue Clauzel.

Cézanne to Zola, August 24 and 28, 1877, in Cézanne, 1978, pp. 158-59.

He frequents the Nouvelle-Athènes: "Cézanne showed up not too long ago at the little café on the place Pigalle in one of his outfits from the past: blue overalls, white toile vest covered with brushstrokes and smears from other implements, old battered cap. He was a great success! But displays of this kind are dangerous."

Introduced by Cabaner or Paul Alexis, he attends soirées organized by Nina de Villard. Cézanne runs into Cabaner on the rue de La Rouchefoucauld on his way back from working in the open air at Saint-Nom-la-Bretèche. The musician asks to see the freshly painted canvas and admires it. Cézanne gives it to him. At dinners on the rue des Moines, Cézanne socializes with Léon Dierx, Frank Lamy, de Marrast, Ernest d'Hervilly, Comte Villiers de l'Isle-Adam, Alexis, Manet, Mallarmé, Verlaine, and Edmond de Goncourt.

Duranty to Zola, [1877], in Auriant, July 1946, p. 50; Cézanne to his son, August 3, 1906, in Renoir, 1981, pp. 128-29; Cézanne, 1978, p. 319; Vollard, 1914, pp. 148-49.

Over the winter he rereads plays by Molière.

Cézanne to Zola, September 14, 1878, in Cézanne, 1978, p. 172.

1878

March 4

Cézanne acknowledges a debt to Tanguy, for painting materials, in the amount of 2,174.80 francs.

Cézanne to Tanguy, March 4, 1878, in Cézanne, 1978, p. 160.

March 23

He is in the Midi: Aix, L'Estaque, and Marseille, where Hortense is living with their son. Intercepting a letter from Chocquet, Cézanne's father learns of the existence of Hortense and young Paul. He threatens to cut off his allowance. Cézanne considers working and asks Zola to find him a position.

His son falls ill with typhoid fever.

At this time Cézanne renews ties with Monticelli, whom he had met in Paris. The two artists paint together in the open.

Cézanne to Zola, March 23, 1878, in Cézanne, 1978, pp. 160-61; Garibaldi, 1991, p. 133.

March 28

He writes Zola requesting that, should there be an Impressionist exhibition, he lend *The Black Clock* (repro. p. 27), which he owns. He also asks Caillebotte to lend some of his pictures. But the Impressionist group cannot reach consensus and the exhibition does not take place. Cézanne decides to submit a work to the Salon jury.

Cézanne to Zola, March 28 [1878], in Cézanne, 1978, p. 162; Pissarro to Caillebotte, [1878], in Pissarro, 1980-91, vol. 1, no. 53, pp. 109-10.

April 4

He asks Zola to send 60 francs to Hortense Fiquet, at 183, rue de Rome in Marseille, as the 100-franc allowance paid by his father is insufficient to support both his own and his son's needs. He continues to lead

Zola's property at Médan, photograph, Bibliothèque Nationale, Paris, Département des Estampes.

Émile Zola in his study at Médan, photograph by Dornac, Larousse-Giraudon Archives, Paris.

a double life divided between Aix and Marseille. His son is on the road to recovery.

Cézanne to Zola, April 4, 1878, in Cézanne, 1978, p. 164.

April 14

He thanks Zola for his two dispatches of money. He remains on cordial terms with Joseph Gibert despite their differences over artistic matters: "And yet he is without any doubt the one who deals most and best with art in a town of 20,000 souls." He complains of the attitude of Villevieille's students, who insult him when he passes—perhaps, he surmises, because his hair is too long.

Cézanne to Zola, April 14, 1878, in Cézanne, 1978, pp. 164-65.

Late April

He thanks Zola for having sent his most recent novel, *Une page d'amour* (published by Charpentier on April 20), as well as for its dedication, and says complimentary things about it.

His mother is seriously ill.

Cézanne to Zola, March 28 [1878], and 1878, in Cézanne, 1978, pp. 162-63.

May 1-November 10

The Exposition Universelle is held in Paris.

May

Duret publishes a brochure entitled *Les Peintres impressionnistes*, in which Cézanne is mentioned in the postscript.

May 8

Cézanne thanks Zola for having sent the 60 francs to Hortense as requested. His mother is convalescing. His Salon submission is refused.

Cézanne to Zola, May and May 8, 1878, in Cézanne, 1978, pp. 165-66, 166 n. 6.

May 28

Zola acquires a property at Médan for 9,000 francs. Cézanne congratulates him and writes: "With your consent, I'll take advantage of it to get to know the country better; and if life is not impossible for me there, either at La Roche, or at Bennecourt, or a little here and a little there, I'll try to spend a year or two there as I did at Auvers."

Zola, 1978-, vol. 3, p. 152; Cézanne to Zola, July 29, 1878, in Cézanne, 1978, pp. 169-70.

June 1 and July

Cézanne asks Zola twice more to send 60 francs to Hortense Fiquet. In late June or early July she moves into 12, Vieux-Chemin-de-Rome in Marseille, where she remains until September 10. Cézanne purchases an illustrated edition of Zola's *L'Assommoir*, published on April 25 by Marpon and Flammarion.

Cézanne to Zola, June 1, July, August 27, 1878, in Cézanne, 1978, pp. 167, 170; Zola, 1978-, vol. 3, p. 152.

The rue de l'Ouest in Paris, photograph by C. M., Bibliothèque Nationale, Paris, Département des Estampes.

Around July 8

He settles in L'Estaque in a house rented to M. Isnard, close to the maison Giraud, where he usually stayed. He learns from his landlord in Paris, M. Laligaud, that the apartment he rents there at 67, rue de l'Ouest is occupied by strangers, probably friends of Antoine Guillaume, a cobbler residing at 105, rue de Vaugirard with whom Cézanne had left keys during his absence. His father, who is still reading his mail, concludes from this that he is keeping women in his rooms.

Cézanne to Zola, July 16 and 29, November 4, 1878, in Cézanne, 1978, pp. 168-69, 175 (Contrary to Rewald's note [Cézanne, 1978, p. 169 n. 9], the rent paid by Cézanne had not been specially reduced, rendering relations with his landlord more sensitive than usual; the difference between the assessed monthly amount, 270 francs, and the sum he paid, 230 francs, resulted from a "déduction des non-valeurs spéciales," or reduction due to previous overcharges, applicable to all the tenants.); cadastral survey, D1P4, 1877, Archives de Paris.

Summer

He entreats Zola to help out Emperaire, "a very courageous man who's been abused by everybody and abandoned by all the clever types." He asks that his mail be addressed to Monsieur A. Fiquet.

Cézanne to Zola, [Summer 1878], in Cézanne, 1978, p. 171.

August 27

Cézanne again asks Zola to send 60 francs to Hortense Fiquet. He looks for inexpensive lodgings in Marseille so that he can spend the winter there.

Cézanne to Zola, August 27, 1878, in Cézanne, 1978, p. 170.

September 14

Cézanne's father, still opening his son's mail, reads a letter from Hortense Fiquet's father addressed to "Madame Cézanne" at his son's address in Paris and forwarded by the concierge there to the Jas de Bouffan. Contrary to expectation, he does not discontinue the allowance and even gives Cézanne an extra 300 francs. The painter thinks this liberality a function of the old

man's attraction to a "charming little maid" at the Jas de Bouffan. Cézanne and his mother sojourn in L'Estaque. The painter thanks Zola for having sent a volume of his plays, published in September (*Théâtre*, comprising "Le Bouton de rose," "Thérèse Raquin," and "Les Héritiers Rabourdin").

Cézanne to Zola, September 14, 1878, in Cézanne, 1978, p. 172; Zola, 1978-, vol. 3, p. 152.

Around September 16
Cézanne's mother leaves L'Estaque for Aix, where the artist's parents rent an apartment at 20, rue Émeric-David. Cézanne works at L'Estaque, returning each night to Marseille.

Hortense settles at 32, rue Ferrari in Marseille.

Cézanne to Zola, September 24 and December 19, 1878, in Cézanne, 1978, pp. 173, 177; marriage certificate of Rose Cézanne, 1881, Hôtel de Ville, Aix-en-Provence; notarial archives of the successor of Maître Béraud.

Early November
Hortense Fiquet goes to Paris on urgent business and remains there until December 15. Cézanne, still in L'Estaque, asks Zola to send her 100 francs via Antoine Guillaume.

Cézanne to Zola, November 4, 1878, in Cézanne, 1978, p. 175.

November 13
Belatedly, due to his distance from Paris, Cézanne sends a letter of condolence to Caillebotte, whose mother had died on October 20.

Cézanne to Caillebotte, November 13, 1878, in Cézanne, 1978, p. 175.

November 20
He thanks Zola for the 100 francs sent to Hortense. He is still in L'Estaque with his son. He rereads *L'Histoire de la peinture en Italie* by Stendhal for the third time.

Cézanne to Zola, November 20, 1878, in Cézanne, 1978, p. 176.

December 15
Hortense Fiquet, who "had a little adventure in Paris," returns to Marseille. Cézanne, weary of conflict with his father, envisions leaving the Midi to find some

tranquility. "The author of my days is obsessed with the thought of liberating me.—There's really only one way to do that, it's to lay two or three thousand francs a year on me and not wait until after my death to make me his heir, since I'll die before he does, for sure."

Cézanne to Zola, December 19, 1878, in Cézanne, 1978, p. 177.

1878 ?
He commends his musician friend Cabaner to his youthful companion and compatriot Roux, now a journalist and novelist. He also recommends his own painting, "in case the day of the Salon should dawn for me" (Roux was also occasionally an art critic).

Cézanne to Roux (draft), [around 1878], in Cézanne, 1978, pp. 178-79.

1879

January
Cézanne is still in L'Estaque. He asks Chocquet to obtain information from one of his friends in the Midi, probably Monticelli, on the procedure for submitting paintings to the Salon jury without going to Paris.

Cézanne to Chocquet, [January] 28, 1879, in Cézanne, 1978, pp. 180-81; Garibaldi, 1991, p. 134.

Second half of February
He leaves L'Estaque for Paris by way of Aix. He congratulates Zola on the success of his play based on *L'Assommoir*.

Cézanne to Zola, February 1879, in Cézanne, 1978, p. 182.

April 1
Having decided to submit to the Salon jury, he chooses not to take part in the fourth Impressionist exhibition held from April 10 to May 11.

Cézanne to Pissarro, April 1, 1879, in Cézanne, 1978, p. 182.

Early April
He settles at Melun, 2, place de la Préfecture, in a second-floor apartment, but he makes regular trips to Paris. Despite the advocacy of Guillemet, a member of the Salon jury, his submission is refused.

Cézanne to Pissarro, April 1, 1879, and to Zola, June 3, 1879, in Cézanne, 1978, p. 183; census, 1-F-1, 1881, Municipal Archives, Melun.

April 20
Zola publishes "La République et la littérature" in *Le Figaro*. He sends the article to Cézanne, who forwards it to Guillaumin.

Cézanne to Zola, June 3, 1879, in Cézanne, 1978, p. 183.

June 9
Cézanne returns to Paris, proceeding the next day to Zola's house at Médan. He remains there for twelve days and then returns to Melun.

Cézanne to Zola, June 5 and 23, 1879, in Cézanne, 1978, p. 184.

June 23
He thanks Zola for his book *Mes Haines*, sent to him in Melun, and for his article on Jules Vallès published in *Le Voltaire*. He has read *L'Enfant*, the first volume of Vallès's *Jacques Vingtras*, published early in the year, which "aroused much sympathy in me for the author."

Cézanne to Zola, June 23, 1879, in Cézanne, 1978, pp. 184-85.

August-September
He suffers from bronchitis for a month.

Cézanne to Zola, September 24, 1879, in Cézanne, 1978, pp. 185-86.

September 24
He asks Zola for three tickets to *L'Assommoir* at the Théâtre de l'Ambigu. He alludes to the success of Alexis's play *Celle qu'on n'épouse pas*, which opened at the Gymnase on September 8.

He works on landscapes in the environs of Melun: "I'm still striving to find my way as a painter. Nature presents me with the greatest difficulties."

Cézanne to Zola, September 24, 1879, in Cézanne, 1978, p. 185.

View of Melun, postcard, photograph by E.L.D., Bibliothèque Nationale, Paris, Département des Estampes.

Scene from *L'Assommoir* at the Théâtre de l'Ambigu, 1879, photograph by Nadar, Bibliothèque Nationale, Paris, Département des Estampes.

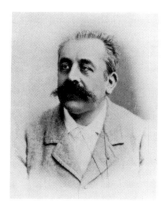

Paul Alexis, c. 1894,
photograph,
Musée d'Orsay, Paris,
Service de documentation.

Rose Cézanne, c. 1874,
photograph,
Musée d'Orsay, Paris,
Service de documentation.

Marie Cézanne, c. 1874,
photograph,
Musée d'Orsay, Paris,
Service de documentation.

October 6
He attends a performance of *L'Assommoir* in Paris and then writes to Zola, praising the play and the actors.

Cézanne to Zola, October 9, 1879, in Cézanne, 1978, pp. 186-87.

Winter
Over the winter, which is brutal, he paints landscapes in the snow. Unable to obtain coal, he thinks he might be forced to leave Melun for Paris on or about December 20.

Cézanne to Zola, December 18, 1879, in Cézanne, 1978, p. 187.

1880

February
Cézanne thanks Zola for sending his last novel, *Nana*, "a magnificent book." He is astonished—mistakenly—that it is receiving no attention in the press. Alexis also sends him his most recent publication, *La Fin de Lucie Pellegrin*. Cézanne, who does not have his address, asks Zola to convey his thanks. "This volume adds to the literary collection you've given me, and I have enough to entertain myself and occupy my winter evenings for a good while."

Cézanne to Zola, [February 1880], and February 25, 1880, in Cézanne, 1978, pp. 189-90.

April 1
He departs Melun and settles at 32, rue de l'Ouest in Paris. As in the preceding year, he opts not to exhibit with the Impressionists (fifth exhibition, April 1 to 30), preferring to submit works to the Salon jury, which again refuses him. He visits the Impressionist exhibition, where he encounters Paul Alexis and Doctor Gachet. He invites Zola to dine with the three of them on April 3.

Cézanne to Zola, April 1, 1880, in Cézanne, 1978, pp. 190-91.

May
He thanks Zola and his collaborators for *Les Soirées de Médan*, a collection of stories by Zola, de Maupassant, Alexis, Huysmans, and others, published on April 14 by Charpentier.

Cézanne to Zola, [18]80, in Cézanne, 1978, pp. 194-95.

May 8
Death of Flaubert.

May 10
Cézanne sends Zola a copy of a letter sent by Renoir and Monet to the minister of fine arts protesting the poor placement of their paintings at the Salon and requesting that an exhibition be organized the following year of works exclusively by the Impressionists. He asks that Zola publish it in *Le Voltaire*, accompanied by a few remarks about the group's previous activities.

Cézanne to Zola, May 10, 1880, in Cézanne, 1978, p. 191.

June 18-22
Zola publishes a series of articles entitled "Le Naturalisme au Salon." Of Cézanne, he writes: "M. Paul Cézanne, a great painter's temperament still floundering in a search for the right facture, remains closer to Courbet and Delacroix." The artist thanks him for his assistance with his previous request.

Zola, June 18-22, 1880; Cézanne to Zola, June 19, 1880, in Cézanne, 1978, p. 192.

August
He visits Zola at Médan. "If you're not alarmed by the long time I might stay there, I'll permit myself to bring along a small canvas and do up a motif there."

Cézanne to Zola, June 19 and July 4, 1880, in Cézanne, 1978, pp. 193-94; Zola to Guillemet, August 22, 1880, in Zola, 1978-, vol. 4, no. 15, p. 94.

October 17
Zola's mother dies at Médan. She is buried beside her husband on October 20, in Aix. Cézanne, who is in Paris, learns of her death through the press and sends Zola his condolences.

Zola, 1978-, vol. 3, p. 428; Cézanne to Zola, October 28, 1880, in Cézanne, 1978, p. 195.

1881

February 26
Marriage, in Aix-en-Provence, of the painter's sister, Rose Cézanne, and Paul-Antoine-Maximin [Maxime] Conil, a lawyer. A marriage contract is executed on February 10. Rose's possessions consist of a trousseau valued at 6,000 francs, a sum of 5,000 francs owed her by Madame Marie Antoinette Delphine de Rollaux de Villans, wife of the marquis de Castellane, in accordance with a debenture dated December 10, 1879, one-fifth of a 3,000-franc annuity, two shares in the Paris-Lyon-Mediterranean railway line, and a house in Aix on rue Émeric-David valued at 16,500 francs.

The wedding ceremony takes place in the church of Sainte-Marie-Madeleine on February 27. Cézanne attends and signs the register.

Marriage certificate, Hôtel de Ville, Aix-en-Provence; drafts of the marriage contract, notarial archives of the successor of Maître Béraud, Aix-en-Provence; register of the church of Sainte-Marie-Madeleine, Archdiocesan Archives, Aix-en-Provence.

April 2-May 1
Cézanne does not take part in the sixth Impressionist exhibition. Despite Guillemet's advocacy, he is refused by the Salon.

Zola to Guillemet, August 22, 1880, in Zola, 1978-, vol. 4, no. 15, pp. 94, 94 n. 9.

May 5
He settles in Pontoise at 31, quai du Pothuis (now quai Eugène-Turpin) with Hortense and Paul. He often sees Pissarro, who resides at 18 *bis*, rue de l'Hermitage, then, from July, at 85, quai du Pothuis. He reads the most recent publications by Zola, *Une belle journée* by Henry Céard, and *En ménage* by Huysmans (he had met these two authors at Zola's). He walks from Pontoise to Médan, a distance of nine miles.

Cézanne to Zola, May 7 and 20, 1881, and to Chocquet, May 16 [18]81, in Cézanne, 1978, pp. 198-200; Pissarro, 1980-91, vol. 1, p. 37.

The quai du Pothuis at Pontoise, postcard, photograph by N. D., Bibliothèque Nationale, Paris, Département des Estampes.

May 14

Benefit sale organized by Frank Lamy for the ailing musician Cabaner, who dies in destitution shortly afterward, on August 3. Manet, Degas, Pissarro, Guillemet, Cézanne, and others contribute works. Zola writes a preface for the sale catalogue at Cézanne's request.

Cézanne to Zola, April 12, 1881, in Cézanne, 1978, p. 196.

May 16

Tanguy has sold Chocquet a painting by Cézanne, unframed.

Cézanne to Chocquet, May 16, 1881, in Cézanne, 1978, p. 199.

Late May

Rose and Maxime Conil as well as Marie Cézanne spend several days in Paris. Cézanne accompanies them to Versailles to see the fountains in full operation. Rose falls ill and he puts them on a train back to Aix.

Cézanne to Zola, May 20 and June 1881, in Cézanne, 1978, pp. 200-201.

June

He thanks Zola for sending his last work, *Les Romanciers naturalistes*. He notes having received at his Parisian address *Palmyre Veulard* by Édouard Rod, a Swiss novelist who belonged to the Médan circle.

Cézanne to Zola, June 1881, in Cézanne, 1978, p. 201.

July

He goes to Auvers. There he learns that Paul Alexis was wounded on July 18 during a duel with the journalist Albert Delpit. He asks Zola for news of his compatriot.

Cézanne to Zola, July 25, 1881, in Bakker, 1971, p. 207 n. 11, and in Cézanne, 1978, p. 202; Zola, 1978-, vol. 4, p. 212 n. 5.

Gauguin quips about Cézanne: "Has M. Cézanne found the exact *formula* for a work acceptable to everyone? If he's found a recipe for compressing the exaggerated expression of all his sensations into a single and unique procedure, do please try to get him to talk in his sleep."

Gauguin to Pissarro, [July 1881], in Gauguin, 1984, no. 16, p. 21.

Late July

Cézanne visits Alexis during a brief trip to Paris.

Cézanne to Zola, August 5, 1881, in Cézanne, 1978, p. 202.

October 24 or 25

He spends a week at Médan with Zola before leaving for Aix.

Cézanne to Zola, October 15, 1881, in Cézanne, 1978, pp. 203, 203 n. 9; Zola to Coste, November 5, 1881, in Zola, 1978-, vol. 4, no. 171, p. 235.

From 1881 to 1885, Cézanne's father has a new roof of industrial tiles installed on the manor house at the Jas de Bouffan. He uses the opportunity to have a studio built for his son.

Oral communication of Doctor Corsy, former owner of the Jas de Bouffan; dates inscribed on the tiles.

1882

Second half of January

Renoir, returning from Italy, disembarks at Marseille. He spends several days at L'Estaque, where he visits Cézanne. The two artists work together. Renoir develops pneumonia in early February and is devotedly nursed by Cézanne and his mother.

Renoir to Paul Durand-Ruel, January 23, February 14 and 19, 1882, in Venturi, 1939, vol. 1, nos. 6-8, pp. 118-19; Cézanne to Chocquet, March 2, 1882, in Joëts, April 1935, pp. 121-22.

February

Cézanne sojourns in L'Estaque. He thanks Alexis for sending his book *Émile Zola: Notes d'un ami*, though it fell into the hands of his parents in Aix, who "tore it from its envelope, cut the pages, looked it over every which way" before telling him it had arrived.

Cézanne to Alexis, February 15, 1882, and to Zola, February 28, 1882, in Cézanne, 1978, pp. 204-5.

February 1

Doctor de Bellio, an admirer of the Impressionists, rejoices at Manet's having been awarded the Legion of Honor. He laments the fact that other artists in the group, Monet, Degas, Sisley, Renoir, Cézanne, and Pissarro, have not been so honored.

De Bellio to Pissarro, February 1, 1882, Pissarro Archives sale, Hôtel Drouot, Paris, November 21, 1975, lot 29.

February 28

Cézanne thanks Zola for sending a volume of his literary criticism, probably *Une campagne*.

Cézanne to Zola, February 28, 1882, in Cézanne, 1978, p. 205.

Early March

He returns to Paris. He does not take part in the seventh Impressionist exhibition (March 1-31), on the pretext that he has no works that would be suitable.

Renoir to Chocquet, March 2, 1882, in Drucker, 1944, p. 127; Pissarro to Monet, [around February 24, 1882], in Pissarro, 1980-91, vol. 1, no. 98, p. 155.

May

His *Portrait of M. L. A . . .* is accepted for the Salon. Cézanne identifies himself in the catalogue as a "student of Guillemet," a subterfuge that makes it possible to bypass the jury, for at their discretion each of its members can exhibit a work by one of their students. The rule was rescinded the following year, closing this "back-door" access route.

He still resides at 32, rue de l'Ouest.

Opening of the Musée de Sculpture Comparée at the Trocadéro.

Paris, 1882, no. 520.

Summer

He probably sojourns in Hattenville, in Normandy, with Chocquet (see cat. no. 86).

Rewald, July-August 1969, p. 61; see Venturi nos. 442-47.

September

He spends several weeks with Zola at Médan before going to Aix in early October.

Cézanne to Zola, September 2, 1882, in Cézanne, 1978, p. 205; Zola to Alexis, September 24, 1882, in Zola, 1978-, vol. 4, no. 248, p. 325.

October 3

Cézanne's sister Rose gives birth to a daughter, Marthe Anna Marie Louise, at 20, rue Émeric-David.

Birth certificate, Communal Archives, Aix-en-Provence; Cézanne to Zola, March 10, 1883, in Cézanne, 1978, p. 209.

November 14

Cézanne thanks Zola for sending his book, probably *Pot-Bouille*. He is at the Jas de Bouffan. He sees few people in town but visits Gibert.

Cézanne to Zola, November 14, 1882, in Cézanne, 1978, p. 206.

Late November

He decides to draft a will leaving his annuity income and property to his mother and his son, "for if I were to die in the near future, my sisters would be my heirs, and I think my mother would be cut out, and my little boy (having been *acknowledged* when I registered him at the *mairie*) would, I think, still be entitled to half my estate, but perhaps not without contest." He asks Zola to keep a duplicate of any holographic will he should draft.

Cézanne to Zola, November 27 [1882], in Cézanne, 1978, p. 207.

1883

January

Cézanne thanks Coste for sending him the periodical *L'Art libre*, which he had founded along with Zola, Alexis, and others.

Cézanne to Coste, January 6, 1883, in Cézanne, 1978, p. 208.

March

He spends several days at L'Estaque. Renoir asks him to send back two paintings left with him the previous year for inclusion in an exhibition at Durand-Ruel. After returning to Aix, Cézanne thanks Zola for sending his last novel, *Au bonheur*

des dames, published by Charpentier on March 2.

Cézanne to Zola, March 10, 1883, in Cézanne, 1978, pp. 208-9.

April 30
Death of Manet. Cézanne describes his decease as a "catastrophe." He probably does not attend the funeral, held on May 3 at the church of Saint-Louis-d'Antin.

Cézanne to Zola, May 19, 1883, in Cézanne, 1978, p. 210.

May
He is in L'Estaque, where he has rented a small house and garden in the Château-Bovis quarter, near the train station. Cézanne and his mother visit a notary in Marseille, with whom they draft a will naming her his universal heir. He entrusts her with a duplicate and sends the holograph to Zola, proposing that on his return to Paris they consult another notary together and draw up another will.

He and Monticelli take outings in the countryside around Marseille and Aix.

Cézanne to Zola, May 19 and 24, 1883, in Cézanne, 1978, pp. 210-11; Zola to Cézanne, May 20, 1883, in Zola, 1978-, vol. 4, no. 320, p. 393; Gasquet, 1926, pp. 77-78.

Huysmans publishes *L'Art moderne*. Pissarro is amazed that there is no mention of Cézanne: "How is it you say not a word about Cézanne, whom not one among us would fail to acknowledge as one of the most astounding and curious temperaments of our time and who has had a very great influence on modern art?" Huysmans tries to justify himself: "Yes, he has temperament, he's an artist, but in sum, aside from some still lifes that hold up, the rest in my view is not likely to live."

Pissarro to Huysmans, May 15, 1883, in Pissarro, 1980-91, vol. 1, no. 149, p. 208; Huysmans to Pissarro, [1883], Pissarro Archives sale, Hôtel Drouot, Paris, November 21, 1975, lot 81.

May 24
Cézanne has read Zola's most recent novel, *Au bonheur des dames*, which he liked very much.

Cézanne to Zola, May 24, 1883, in Cézanne, 1978, p. 211.

July
Gauguin buys two paintings by Cézanne at Tanguy's shop for 120 francs, a view of L'Estaque (cat. no. 56) and an allée of trees (Konstmuseet, Göteborg; not in Venturi).

Gauguin to Pissarro, [between July 25 and 29, 1883], in Gauguin, 1984, no. 38, pp. 50-51.

July 10
Cézanne congratulates Solari on his daughter's marriage.

Cézanne to Solari, July 10, 1883, in Cézanne, 1978, p. 212.

September 21
Birth of Auguste Mathieu Joseph Conil, the second child of Rose and Maxime Conil, at 20, rue Émeric-David. The child dies two months later, on November 20.

Birth and death certificates, Communal Archives, Aix-en-Provence; Cézanne to Zola, November 26, 1883, in Cézanne, 1978, p. 213.

November
Cézanne again sojourns in L'Estaque until February 22, 1884. He thanks Zola for his book, probably *Naïs Micoulin*, published by Charpentier on November 23.

Cézanne to Zola, November 26, 1883, in Cézanne, 1978, p. 212.

December 17
Monet and Renoir, traveling along the Mediterranean coast from Marseille to Genoa, visit Cézanne at the end of the month.

Monet to de Bellio, December 16 [1883], in Wildenstein, 1974-85, vol. 2, no. 386, p. 232; Renoir to Paul Durand-Ruel, [December 1883], in Venturi, 1939, vol. 1, no. 16, pp. 126-27; Cézanne to Zola, February 23, 1884, in Cézanne, 1978, p. 214.

1884

February 23
Cézanne thanks Zola for his book *La Joie de vivre*. He is still in L'Estaque but goes to Aix to see Valabrègue.

Cézanne to Zola, February 23, 1884, in Cézanne, 1978, p. 214.

Early March
Pissarro acquires four "studies" by Cézanne.

Pissarro to his son Lucien, [early March 1884], in Pissarro, 1980-91, vol. 1, no. 224, p. 294.

Émile Zola, c. 1883,
photograph by Mélandrie,
Le Blond-Zola collection.

March 29
Guillemet learns from Zola that the painting of "a head" Cézanne had asked him to recommend to the Salon jury was refused.

Guillemet to Zola, March 29, 1884, in Zola, 1978-, vol. 5, p. 90 n. 1.

June-October
Cholera epidemic in Marseille.

June 11
Establishment of the Société des Artistes Indépendants, whose agenda is the organization of juryless and prizeless exhibitions.

July
Paintings in the Eugène Murer collection—a Cézanne, nine Pissarros, four Sisleys, a Gauguin, and one or more Guillaumins—are exhibited in his residence in Rouen.

In Tanguy's shop, Gauguin notices "four heavily worked *Césanne [sic]* of *Pontoise*: here are marvels of an art that's essentially pure and that one never tires of looking at."

Alfred Isaacson to Lucien Pissarro, September 6, 1884, in Pissarro, 1980-91, vol. 1, p. 309 n. 2; Gauguin to Pissarro, [around July 10, 1884], in Gauguin, 1984, no. 49, p. 65, p. 396 n. 141.

November 27
Cézanne is still in Aix. He thanks Zola for sending two new books. He offers some reflections about painting: "Art is changing terribly in its outer appearance and affects too much of a small, very mean form, while at the same time ignorance of harmony becomes more and more apparent in discordant coloring and, what's even worse, in an aphony of tone."

Cézanne to Zola, November 27, 1884, in Cézanne, 1978, p. 215.

Late November/early December
Gauguin, who is studying graphology, asks Pissarro for one of Cézanne's letters.

Gauguin to Pissarro, [late November/early December] 1884, in Gauguin, 1984, no. 57, p. 77.

In Tanguy's shop, Paul Signac purchases a landscape, *The Oise Valley* (cat. no. 67), by Cézanne.

Ratcliffe, 1960, cited in Rewald, forthcoming, no. 414.

1885

January
Gauguin formulates an analysis of Cézanne's character on the basis of his handwriting. He sees in him "the essentially mystical nature of the Orient . . . he cherishes in forms a mystery and a heavy tranquillity like a man reclining to dream, his color is grave like the character of Orientals."

Gauguin to Émile Schuffenecker, January 14, 1885, in Gauguin, 1984, no. 65, p. 88.

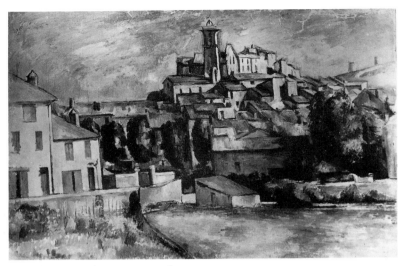

Paul Cézanne, *Gardanne*, 1885-86, oil on canvas,
The Barnes Foundation, Merion, Pennsylvania (V. 430).

March

Cézanne is again in L'Estaque. He suffers
from severe headaches. He thanks Zola
for sending his book *Germinal*.

Cézanne to Zola, March 11, 1885, in Cézanne,
1978, p. 216.

Spring

He is in love and asks Zola to receive let-
ters for him and to forward them to an ad-
dress to be provided subsequently.

Cézanne to an unknown woman (draft), Spring
1885, and to Zola, May 14, 1885, in Cézanne,
1978, pp. 216-17.

May 3

Birth of Marie Antoinette Paule Conil, the
painter's niece, at 20, rue Émeric-David.

Birth certificate, Communal Archives, Aix-en-
Provence.

June 14

Back from Aix, he spends an evening at
Zola's house in Paris.

Cézanne to Zola, June 15, 1885, in Cézanne, 1978,
p. 218.

June 15

He settles in La Roche-Guyon, in Renoir's
rooms on the Grande-Rue, and provides
Zola with an address *(poste restante)* for for-
warding his mail.

Cézanne to Zola, June 15 and 27, 1885, July 3 and
6, 1885, in Cézanne, 1978, pp. 218-20.

July 3

Due to "fortuitous circumstances," Cé-
zanne wants to visit Zola in Médan as
soon as possible.

Cézanne to Zola, July 3, 1885, in Cézanne, 1978,
p. 219.

July 11

Zola has many guests and cannot receive
him. Cézanne takes a room at the inn in

Villennes, close to Médan, and asks Zola
to lend him his skiff, the *Nana*, to paint.
Due to the July 14 holiday, all the hotels
in Villennes are full; he moves to the
Hôtel de Paris in Vernon.

Zola to Cézanne, July 2 and 4, 1885, in Zola, 1978-,
vol. 5, pp. 276-77; Cézanne to Zola, July 11, 13, 15,
and 19, 1885, in Cézanne, 1978, pp. 220-22.

July 15

He is in a state of great agitation and de-
cides to leave as soon as possible for Aix.
He asks Zola to return the papers he has
confided to him, probably his will.

Cézanne to Zola, July 15, 1885, in Cézanne, 1978,
pp. 221-22.

July 24

Cézanne arrives in Médan, where he re-
mains for several days.

Cézanne to Zola, July 19, 1885, in Cézanne, 1978,
p. 222; Zola, 1978-, vol. 5, p. 277 n. 2.

August

He is in Aix. From there he goes each day
to Gardanne, a village seven miles away,
returning to the Jas de Bouffan each
night. He is going through a difficult pe-
riod: "The most complete isolation. The
brothel in town, or something like, but
nothing more. I pay, the word is ugly, but
I need repose, and at that price I ought to
get it. . . . If only I had an indifferent fam-
ily, everything would have been for the
best."

Cézanne to Zola, August 20 and 25, 1885, in Cé-
zanne, 1978, pp. 222-23.

August 31

Tanguy asks Cézanne to send him an
IOU for 1,840.90 francs to pay his lease,
against his accumulated debt of 4,015.40
francs.

Tanguy to Cézanne, August 31, 1885, in Cézanne,
1978, p. 224.

October 27

Monet asks Pissarro for news of Cézanne.

Monet to Pissarro, October 27, 1885, in Wilden-
stein, 1974-85, vol. 2, no. 599, p. 263.

First half of December

Gauguin entreats his wife not to sell the
two Cézannes still in Denmark with the
rest of his collection: "They are rare in this
genre for he's made very few that are fin-
ished and one day they'll be quite
valuable."

Gauguin to his wife, [first half of December 1885],
in Gauguin, 1984, no. 90, p. 118.

December 22

The first installment of *L'Oeuvre* appears in
Gil Blas (issue dated the following day).

1886

In the Gardanne census, Cézanne is listed
along with Hortense and Paul as a person
of independent means *(rentier)* living in
the cours de Forbin. His son attends the
village school.

Census, May 30, 1886, Archives, Hôtel de Ville,
Gardanne; Cézanne to Chocquet, May 11, 1886, in
Cézanne, 1978, p. 227.

April 4

He thanks Zola for his last novel, *L'Oeuvre*,
published March 31: "I thank the author
of the *Rougon-Macquart* [novels] for this
kind token of remembrance, and I ask
that he permit me to clasp his hand while
dreaming of bygone years." This is proba-
bly the painter"s last letter to the writer,
for the novel precipitated a break between
them.

Monet also thanks Zola for his novel:
"I have just finished it and remain trou-
bled, uneasy, I admit to you. You have
been very careful to make sure that none
of your characters resembles any one of
us, but despite this I'm afraid our enemies
in the press and the public will pronounce
the names of Manet or at least ours, mak-
ing us out to be failures, which is not in
your spirit, I don't want to believe it." A
little later he asks Pissarro: "Have you read
Zola's book? I'm afraid he's doing us a
great wrong."

Cézanne to Zola, April 4, 1886, in Cézanne, 1978,
p. 225; Monet to Zola, April 5, 1886, and to Pis-
sarro, [around April 10, 1886], in Wildenstein,
1974-85, vol. 2, nos. 664, 667, pp. 273-74.

April 28

Cézanne, "artiste peintre," marries Hor-
tense Fiquet at the Hôtel de Ville in Aix-
en-Provence. By this act, he recognizes
and legitimizes their son. There is no mar-
riage contract. Maxime Conil is one of the
witnesses. The artist's parents attend the
marriage. A church ceremony takes place
the next day at the church of Saint-Jean-
Baptiste in the presence of Maxime Conil

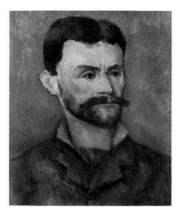

Paul Cézanne, *Portrait of Jules Peyron*,
1885-87, oil on canvas,
The Fogg Art Museum, Harvard University
Art Museums, Cambridge, Massachusetts,
gift of Mr. and Mrs. Joseph Pulitzer, Jr.
Peyron, a resident of Gardanne,
was a witness at Cézanne's marriage.

and Marie Cézanne, as well as two other
witnesses who sign the register.

Marriage certificate, Archives, Hôtel de Ville, Aix-
en-Provence; register of the church of Saint-Jean-
Baptiste, Archdiocesan Archives, Aix-en-Provence.

May 5
Paul Alexis publishes an article on his col-
lection of paintings, which includes a still
life by Cézanne titled *Three Apples*.

Alexis, May 5, 1886.

May 11
Responding to a letter from Victor Choc-
quet, Cézanne confesses that he envies his
serenity: "Chance has not endowed me
with such stability, that's the only regret I
have about things on this earth. Other-
wise I have no reason to complain. The
sky, the boundless things of nature always
attract me and offer me occasions to take
pleasure in looking."

Cézanne to Chocquet, May 11, 1886, in Cézanne,
1978, p. 226.

May 15-June 15
Cézanne does not take part in the eighth
and last Impressionist exhibition.

June 29
Death of Monticelli.

October
Van Gogh frequents père Tanguy's shop,
where he sees paintings by Cézanne.

Van Gogh to Charles Angrand, October 1887, in
Paris, 1988, p. 378.

October 23
Death of the artist's father at the Jas de
Bouffan. He is buried the next day at the
church of Saint-Jean-Baptiste.

Death certificate, Archives, Hôtel de Ville, Aix-
Provence; register of the church of Saint-Jean-
Baptiste, Archdiocesan Archives, Aix-en Provence.

December 2
Rose Conil acquires some property, proba-
bly Bellevue, for 38,000 francs.

Rewald, 1986 (a), p. 269.

December 17
The will of Louis-Auguste Cézanne is
read. His three children are heirs. Paul
Cézanne is described as "without profes-
sion." The estate consists of furniture val-
ued at 174 francs, 220 shares in the
Paris-Lyon-Mediterranean railway line,
worth 85,222.50 francs, 13 bonds from
the city of Aix for the Verdon canal, worth
6,630 francs, and the Jas de Bouffan pro-
perty, valued at 62,500 francs.

Probate filing, Aix, 1886; register of probate pro-
ceedings, XII Q1/16/22, no. 88, and XII Q1 7/73,
no. 465, Departmental Archives of the Bouches-du-
Rhône, Marseille.

1887

August 15
An article by Paul Alexis, "Trubl'–Auvers-
sur-Oise," appears in *Le Cri du peuple*; it
mentions Cézanne's painting *The House of
the Hanged Man, in Auvers-sur-Oise* (cat. no.
30).

October 15
Alexis publishes an article in *Le Cri du
peuple* about the collection of Eugène
Murer, which includes eight Cézannes:
"1. *Le Bataillon sacré*, pommes en batailles
sur une table [*The Sacred Battalion*, apples
in combat on a table]. 2. *La Tentation de
Saint-Antoine*, superbe étude [*The Tempta-
tion of Saint Anthony*, superb study]. 3. *Les
Harengs-saurs*, nature morte [*Red Herrings*,
still life]. 4. *Le Val-Fleury*, paysage [*The
Flowering Valley*, landscape]. 5. *Enlèvement
de femmes*, sous-bois fantastique, aquarelle
[*Abduction of Women*, fantastic composition
in a wood, watercolor]. 6. *Vagabond de
l'Estaque*, mettant sa veste [*Vagabond of
L'Estaque*, donning his jacket]. 7. *Plat de
pommes*, nature morte [*Plate of Apples*, still
life]. 8. *Desserts de table*, magistral morceau
peint [*Desserts*, masterly painted piece]."

Paul Alexis, "Trubl'–Auvers-sur-Oise," *Le Cri du
peuple*, October 15, 1887.

1888

January
Renoir stays at the Jas de Bouffan but
soon leaves "because of the black avarice
that reigns in the household." He settles
in the Hôtel Rouget in Martigues.

Renoir to Charles Durand-Ruel, [late January
1888], in Venturi, 1939, vol. 1, no. 34, pp. 138-39;
Renoir to Monet, [February 1888], in Baudot,
1949, pp. 53-54.

May-June
Van Gogh, living in Arles, mentions hav-
ing seen some landscapes by Cézanne.

They stick in his mind, and some time
later he adds: "Involuntarily the Cézannes
I saw come back into my memory, be-
cause he has so captured—as in the 'Har-
vest' we saw at Portier's—the harsh side
of Provence." He admires the coloristic
precision of his canvases, which he thinks
the result of his intimate familiarity with
his native region. He also suggests that, if
Cézanne's touch sometimes seems awk-
ward, this is because of the mistral, which
makes his canvases shake as he paints on
them.

Van Gogh to his brother Theo, [May-June 1888],
and to Émile Bernard, [late June 1888], in Van
Gogh, 1990, vol. 3, nos. 488, 497, B9, pp. 115, 139,
179.

June
Gauguin still refuses to sell a painting by
Cézanne in his collection, probably *Compo-
tier, Glass, and Apples* (repro. p. 31): "An
exceptional pearl and I've already refused
300 francs for it: it's the apple of my eye,
and except in case of dire necessity, I'll
keep it until my last shirt's gone. Besides,
who'd be crazy enough to pay that
much."

Gauguin to Schuffenecker, [early June 1888], in
Gauguin, 1984, no. 47, p. 182.

Summer?
According to the young Paul Cézanne, his
father lodged at the Hôtel Delacourt in
Chantilly for five months.

See Venturi nos. 626-28 and cat. no. 118.

Second half of July
Van Gogh sends some drawings to Ber-
nard: "Knowing how much you love
Cézanne, I thought these sketches of
Provence might please you; not that
there's any similarity between a drawing
of mine and one by Cézanne."

Van Gogh to Bernard, [second half of July 1888], in
Van Gogh, 1990, vol. 3, no. B11, p. 211.

Early August
After remarking on the virility of paintings
by Degas, Rubens, Courbet, and Delacroix,
Van Gogh writes about Cézanne: "Cé-

23 — Parc du Château de CHANTILLY. Les Trois Allées. ND Phot.

The route des Lions through the Chantilly Forest,
postcard, photograph by N. D.,
Bibliothèque Nationale, Paris,
Département des Estampes.

The rue du Val-de-Grâce in Paris, 1889,
Bibliothèque Nationale, Paris,
Département des Estampes.

zanne is precisely a man in a middle-class marriage just like the old Dutchmen; if he gets a hard-on in his work, it's because he hasn't wasted himself in debauchery *[s'il bande bien dans son oeuvre, c'est que ce n'est pas un trop évaporé par la noce]*."

Van Gogh to Bernard, [early August 1888], in Van Gogh, 1990, vol. 3, no. B14, pp. 236-40.

August 4
Huysmans publishes in *La Cravache* an article devoted to Cézanne, Tissot, and Wagner, which is included the following year in his collection *Certains*.

Huysmans, August 4, 1888.

October 18
Tanguy provides Cézanne with tubes of paint in exchange for 43 francs and acknowledges having received the 200 francs sent by the artist in the first days of October.

Institut Néerlandais, Fondation Custodia, Paris.

December 27
Birth of Marie Rose Amélie, the painter's niece, at 20, rue Émeric-David.

Birth certificate, Communal Archives, Aix-en-Provence.

Cézanne moves to 15, quai d'Anjou on the Île Saint-Louis in Paris and rents a studio on the rue Val-de-Grâce.

Perruchot, 1956, p. 361; Brussels, 1890.

1889

June
Cézanne stays in Hattenville (Normandy) with Chocquet. He then returns to Paris.

Rewald, July-August 1969, pp. 66-67; Cézanne, 1978, pp. 228-31.

June 30
Cézanne asks Comte Doria to send his painting *The House of the Hanged Man, in Auvers-sur-Oise* (cat. no. 30) to the Palais

des Beaux-Arts, where a centennial exhibition of French art organized to coincide with the Exposition Universelle is to be held from July to October. Cézanne thanks Roger Marx for his support and asks him to convey his thanks to Antonin Proust, who was in charge of the exhibition.

Paris, 1889, no. 124; Cézanne to Comte Doria, June 30, 1889, and to Roger Marx, July 7, 1889, in Cézanne, 1978, pp. 228-29.

July
Monet organizes a subscription for the purchase of Manet's *Olympia* for the Louvre. Cézanne does not appear on the list of contributors, nor does Zola.

Monet to Zola, July 22, 1889, and to Armand Fallières, Minister of Public Instruction, February 7, 1890, in Wildenstein, 1974-85, vol. 3, nos. 1000 and 1032, pp. 250, 254.

October 30-November 11
At the initiative of the critic Karl Madsen, the Association of Friends of Art (Kunstforeningen) organizes an exhibition of French and Scandinavian Impressionist painting in Copenhagen. It includes paintings by Cézanne from Gauguin's collection.

Bodelsen, September 1970, p. 602; Madsen, November 9 and 10, 1889.

November 27
He accepts an invitation from Octave Maus to participate in the exhibition of Les XX in Brussels. "Dreading criticism that would be all too justified, I resolved to work in silence until the day I feel capable of defending theoretically the results of my efforts. Before the pleasure of finding myself in such good company, I do not hesitate to modify my resolution." Durand-Ruel takes on the delivery and cataloguing responsibilities.

Cézanne to Octave Maus, November 27 and December 21, 1889, in Cézanne, 1978, pp. 229-31.

December 18
Cézanne asks Chocquet, to whom the painting now belongs, to lend *The House of the Hanged Man, in Auvers-sur-Oise* (cat. no. 30) to the exhibition of Les XX in Brussels. He also writes to Robert de Bonnières, asking him to lend a painting.

View of the Exposition Universelle in Paris, 1889, Musée d'Orsay, Paris, Service de documentation.

The quai d'Anjou in Paris,
photograph,
Musée d'Orsay, Paris, Service de documentation.

Cézanne to Chocquet, December 18, 1889, and to Maus, December 21, 1889, in Cézanne, 1978, pp. 230-31.

1890

January 18
Opening of the seventh annual exhibition of Les XX in the Palace of Fine Arts in Brussels. Three paintings by Cézanne are exhibited: "Landscape Study, property of M. R. de Bonnières"; "A Cottage in Auvers-sur-Oise [*The House of the Hanged Man, in Auvers-sur-Oise*, cat. no. 30], property of M. Chocquet"; and "Study of Bathers."

Cézanne does not go to Brussels. He thanks Maus for sending the exhibition catalogue, in which his address is given as 15, quai d'Anjou.

Brussels, 1890; Anonymous, January 19 and 27, 1890; Verdavainne, January 26, 1890; Arnoux, February 1890; Solvay, February 4, 1890; Cézanne to Maus, February 15, 1890, in Cézanne, 1978, p. 232.

March 22
Victor Chocquet acquires a house at 7, rue Monsigny in Paris. At his request, Cézanne paints two oblong decorative panels, probably overdoors (V. 583–84).

Rewald, July-August 1969, pp. 68-69.

July 28
Marie Cézanne buys a property in Aix, at 15, traverse Sainte-Anne (now rue Paul-Beltcaguy) for 17,500 francs.

Will of Marie Cézanne, December 16, 1921, vol. 2058, no. 47, land registry, Draguignan, communicated by Robert Tiers.

Summer
The painter stays in Émagny (Doubs) with Hortense, who is a native of the Jura, and their son. Despite bad weather that lasts until July 10, he works on landscapes. In early August he goes to Switzerland, where Hortense and young Paul have already spent ten days and visited Vevey. The family sojourn there lasts five

months. They go successively to Neuchâtel (Hôtel du Soleil), Bern, Fribourg, Vevey, Lausanne, and Geneva. According to Paul Alexis, Cézanne is very unhappy about the trip.

Hortense Cézanne alludes to a quarrel between the artist's mother and his sister Marie.

Hortense Cézanne to Madame Chocquet, August 1, 1890, in Cézanne, 1978, pp. 232-33; Alexis to Zola, February 13, 1891, in Bakker, 1971, no. 207, p. 400; Perruchot, 1956, pp. 370-71.

November
Back in France, Hortense returns to Paris, while Cézanne settles in Aix.

Guillaumin has told Murer that Cézanne had been committed to a madhouse. In fact, the artist has begun to suffer from diabetes, which makes him extremely irritable.

Alexis to Zola, February 13, 1891, in Bakker, 1971, no. 207, p. 400; Pissarro to his son Lucien, December 3, 1890, in Pissarro, 1980-91, vol. 2, no. 605, p. 371.

Paul Alexis publishes *Madame Meuriot*, which describes a soirée at the home of Nina de Villard with Manet (Édouard Thékel), Cabaner, and Cézanne (Poldex).

1891

February 12
Cézanne reduces the allowance to his wife and son so they will return to Aix. He sets them up in an apartment at 9, rue de la Monnaie, while he resides with his mother and sister at the Jas de Bouffan. Hortense is on bad terms with her in-laws.

Cézanne becomes a devout Catholic.

In Aix he frequents Alexis and Coste. The latter keeps Zola informed about him: "How to explain that a grasping and obdurate banker could give birth to a being like our poor Cézanne, whom I saw recently. He feels well and physically he's in no jeopardy. But he's become timid and primitive and younger than ever."

According to Signac, Cézanne gave four canvases to Alexis during his sojourn in the Midi.

Alexis to Zola, February 13, 1891, in Bakker, 1971, no. 207, pp. 400-401, 401 n. 6; Coste to Zola, March 5, 1891, in Cézanne, 1978, p. 235; voter registration records, K1, 1892, Communal Archives, Aix-en-Provence.

February
Renoir is briefly in Aix.

Renoir to Paul Bérard, March 5, 1891, in Bérard, December 1968, p. 7.

April 7
Death of Chocquet at Yvetot. Cézanne, who is in Aix, does not attend the funeral.

Early May
Publication of "Paul Cézanne" by Bernard in the series *Les Hommes d'aujourd'hui* (no. 387), with a portrait of Cézanne by Pissarro on the cover. Pissarro accuses Gauguin of having surreptitiously communicated to Bernard his own views about the influences on Cézanne.

Cézanne receives the brochure through Alexis, who obtains it from Signac.

Pissarro to his son Lucien, May 7, 1891, in Pissarro, 1980-91, vol. 3, no. 659, pp. 76-77; Bernard, 1925, p. 13.

May
The new generation begins to recognize Cézanne as a master. Félix Fénéon writes: "Long neglected, the Cézanne tradition is today being diligently cultivated, thanks to MM. Séruzier *[sic]*, Willumsen, Bernard, Schuffenecker, Laval, Ibels, Filliger, Denis, etc."

Fénéon, May 23, 1891, p. 2.

June
Tanguy moves from 14, rue Clauzel, to number 9. Among the canvases exhibited in his boutique are "an admirable portrait of the painter Empereire by Césanne *[sic]*, some still lifes and landscapes, by the same."

Aurier, June 1891, p. 374.

September 1
Republication of Huysmans's article, "Paul Cézanne," which had previously appeared in *La Cravache* (August 4, 1888) and *Certains* (1889).

Cézanne settles in Paris at 69, avenue d'Orléans, in an apartment consisting of an entry vestibule, a kitchen, a dining room with an alcove, a closet *(un cabinet-noir)*, and a bedroom with a fireplace.

Huysmans, September 1, 1891, p. 301; cadastral survey, D1P4, 1876, Archives de Paris. Theo van Gogh's address book gives Cézanne's address as 78, avenue d'Orléans; see Paris, 1988, p. 355.

Cover of the Paul Cézanne issue of *Les Hommes d'aujourd'hui*, Musée d'Orsay, Paris, Service de documentation.

The avenue d'Orléans in Paris, photograph, Bibliothèque Nationale, Paris, Département des Estampes.

1892

January 28
Alexis tries to persuade Cézanne to exhibit at the Salon des Artistes Indépendants.

Alexis to Zola, January 28, 1892, in Bakker, 1971, no. 210, p. 405.

February
In *L'Art moderne* (Brussels), Georges Lecomte publishes "L'Art contemporain: Le Salon des XX," in which Cézanne is singled out as a precursor: "It is above all M. Cézanne who was one of the first annunciators of the new tendencies and whose effort exercised a notable influence on the Impressionist evolution." In April the article reappears in *La Revue indépendante*. Lecomte gives a lecture on the same subject at a meeting of Les XX and the same year publishes a book titled *L'Art impressionniste d'après la collection privée de M. Durand-Ruel*, in which he devotes several lines to Cézanne: "His sober craft, his syntheses and his color simplifications, so surprising in a painter particularly smitten with reality and analysis, his luminous, delicately tinted shadows, his very soft values, whose skilled play creates subtle harmonies, were a valuable education for his contemporaries."

Lecomte, April 1892; Lecomte, "Paul Cézanne," in Blot, 1900, p. 26; Lecomte, 1892, p. 31.

April
An article by Cecilia Waern on the French Impressionists refers to the "laden canvases" of Cézanne in père Tanguy's shop, "painted as though with mud but with happy successes in figure interpretation."

Waern, April 1892, p. 541.

September 20
Birth of Louis Conil, the last child of Rose and Maxime Conil.

Young Paul Cézanne is listed in voter registration records of Aix-en-Provence as a student. His address is 9, rue de la Monnaie. His father never registered to vote, either in Aix or in Paris.

Birth certificate, Archives, Hôtel de Ville, Aix-en-Provence; voter registration records, K1, 1872, Communal Archives, Aix-en-Provence.

According to Rewald, Cézanne acquires a house in the town of Marlotte, but no

Cézanne, c. 1890, photograph,
Musée d'Orsay, Paris, Service de documentation.

mention of this purchase has been found in the archives of the Seine-et-Marne. According to Pierre Lagrange, he stayed, probably at some earlier date, in the Sabot Rouge inn in Bourron-Marlotte, where Zola, Renoir, and Forain are also known to have rented rooms briefly. According to Vollard, Cézanne is living in Avon and rents a studio in Fontainebleau.

Rewald, 1986, p. 269; private agreements, October 5, 1891-May 4, 1893, 141 Q 52, public agreements, January 8, 1892-April 15, 1893, 140 Q 183-86, and census of the Nemours district, 1896, 1901, 10 M 348 and 10 M 380, Archives of the Seine-et-Marne, Dammarie-les-Lys; Lagrange, n.d.; Vollard, 1914, pp. 12, 56-58.

Vollard first encounters works by Cézanne in Tanguy's shop.

Vollard, 1914, pp. 51-52.

1893

October
A Cézanne self-portrait–"a superb fiftyish figure with gray beard and conspiratorial cap"–is included in an exhibition of "Portraits du prochain siècle" at Le Barc de Boutteville gallery.

Anonymous (1), October 1893, p. 44; Anonymous (2), October 1893; Christophe, October 1893, pp. 415-16; Mauclair, October 1893, pp. 117-28.

November 28
Marie Cézanne acquires a lot adjoining her own on the traverse Sainte-Anne for 4,288 francs.

Will of Marie Cézanne, December 16, 1921, vol. 2058, no. 47, land registry, Draguignan, communicated by Robert Tiers.

December 15
Gustave Geffroy publishes an article on Impressionism with illustrations including Pissarro's portrait etching of Cézanne, (captioned *Portrait du peintre Cézanne, précurseur de l'impressionnisme*), and a

Cézanne still life (V. 213). The text is devoted primarily to Monet, Pissarro, Renoir, Manet, Degas, and Raffaëlli, but he adds: "To be absolutely complete, these six studies must be complemented by some words about Cézanne, who was a sort of precursor of another art."

Geffroy, December 15, 1893, pp. 1218-36, esp. p. 1223.

1894

January
Establishment of the Société des Amis des Arts d'Aix-en-Provence, 2 *bis*, avenue Victor Hugo.

February 6
Tanguy dies of stomach cancer. Mirbeau organizes a benefit auction for his widow at the Hôtel Drouot on June 2. Cézanne does not send any works, but the paintings left in Tanguy's shop are sold for ridiculously low prices: "Les Dunes" *(Dunes)*, 95 francs; "Coin de village" *(View of a Village)*, 215 francs; "Le Pont" *(The Bridge*; ripped), 102 francs; "Ferme" *(Farm)*, 145 francs; "Village" *(Village)*, 102 francs; "Village" *(Village)*, 175 francs. Four canvases are purchased by Vollard, "a picture dealer who's just opened on the rue Laffitte": *Dunes, Village, View of a Village*, and *The Bridge*. Murat buys *Farm*, and another dealer, Malcoud, the *Village* that went for 102 francs.

Bernard, December 16, 1908, pp. 600-616; sale records, D48 E3 ART.79, Archives de Paris; Madame Tanguy to André Bonger, June 12, 1894, in Bodelsen, June 1968, p. 346.

February 21
Death of Caillebotte. He leaves the French state sixty-five paintings from his collection; several are refused by the administration and revert to his heirs. The estate inventory of the initial bequest lists four Cézannes (*Bathers, Fishermen, Bouquet of Flowers*, and a landscape), but Geffroy's parallel inventory also includes a second landscape, making a total of five. A final revised list, drawn up after consultation with the curators at the Musée du Luxembourg, includes two Cézannes (the two landscapes, *Farmyard in Auvers* and *L'Estaque*), valued at 750 francs each. According to Vollard, three paintings were rejected (*Bathers, Bouquet of Flowers, Scène champêtre [Fishermen]*). This episode prompts Vollard to mount an exhibition devoted entirely to Cézanne.

Archives du Louvre, Paris, P8, 1895-96; Paris and Chicago, 1994-95, pp. 23-24, 323-24; Vollard, 1914, pp. 55-56.

The Galerie Durand-Ruel acquires its first paintings by Cézanne: two still lifes for Sarah Hallowell, a New York collector.

Durand-Ruel Archives, New York, stock nos. 1164, 1165.

March 19
Auction of the Théodore Duret collection at the Galerie Georges Petit; its forty paintings include three Cézannes: a still life, "Fruit," acquired by the abbé Gaugain for 600 francs; *Turn in the Road* (cat. no. 76), purchased by Paul-César Helleu for 800 francs; and *The Harvest* (V. 249), bought by E. Chabrier for 650 francs.

Julie Manet, the almost sixteen-year-old daughter of Berthe Morisot and Eugène Manet, visits the exhibition prior to the sale and is drawn to the Cézannes: "[There's] a painter I like very much, based on what I see of him in these canvases, it's Cézanne; it's above all his very well painted apples that I find pretty (I don't know anything by him except these three pictures)."

Sale records, D 48 ART.79, Archives de Paris; Bodelsen, June 1968, pp. 344-46; Mauclair, April 1894, p. 379; Natanson, April 1894, pp. 376-79; anonymous, April 15, 1894; Julie Manet, diary entry, March 17, 1894, in Manet, 1988, p. 52.

March 25
Gustave Geffroy publishes his article "Paul Cézanne." The artist, who is in Alfort (now Alfortville), expresses his gratitude.

Geffroy, March 25, 1894, pp. 214-20; Cézanne to Geffroy, March 26, 1894, in Geffroy, 1922, p. 200, and in Cézanne, 1978, p. 239.

Late summer ?
Cézanne moves to a Parisian apartment, consisting of an entry, a salon, a dining room, a bedroom, a room with fireplace, and a kitchen, on the third floor of 2, rue des Lions-Saint-Paul. He probably rents a studio, in the passage Dulac.

Cadastral survey, D1P4, 1876, Archives de Paris; Imbourg, January 20, 1939; Andersen, June 1965, pp. 313-14.

September
He works in Melun.

Cézanne to a painting materials merchant (draft), September 21, 1894, in Cézanne, 1978, pp. 239-40.

The rue des Lions-Saint-Paul in Paris, photograph, Bibliothèque Nationale, Paris, Département des Estampes.

Hôtel Baudy in Giverny, 1887-99, postcard.

September 7-30

He stays at the Hôtel Baudy in Giverny, where Mary Cassatt meets him. A young American painter, Matilda Lewis, writes a vivid description of him: "[He] is like the man from the Midi whom Daudet describes. When I first saw him I thought he looked like a cutthroat with large red eyeballs standing out from his head in a most ferocious manner, a rather fierce looking pointed beard, quite gray, and an excited way of talking that positively made the dishes rattle. I found later on that I had misjudged his appearance, for far from being fierce or a cutthroat, he has the gentlest nature possible, 'comme un enfant' as he would say."

Guest register of the Hôtel Baudy, Giverny, 1887-99, no. 410, Library of the Philadelphia Museum of Art; Matilda Lewis to her family, [November 1894], typescript in object file 1955.29.1 of the Yale University Art Gallery, New Haven. This letter has traditionally been ascribed to Mary Cassatt (see for example, Breeskin, 1948, p. 33, and Rewald, 1948, p. 166); the letter, of which the original is lost, was reattributed to Matilda Lewis in Gerdts, 1993, p. 118, p. 235 n. 6.

November 28

Monet organizes a reception in Cézanne's honor attended by Georges Clemenceau, Rodin, Mirbeau, and Geffroy, whom the artist meets for the first time on this occasion. Cézanne leaves Giverny abruptly without informing Monet, leaving at the inn several canvases, which Monet sends to him.

Monet to Geffroy, November 23, 1894, in Wildenstein, 1974-85, vol. 3, no. 1256, p. 278; Geffroy, 1922, pp. 196-97, 199.

Late December

Cézanne thanks Mirbeau for his appreciative comments in his article "Le Legs Caillebotte et l'État" (The Caillebotte bequest and the State), published in *Le Journal* on December 24.

Cézanne to Mirbeau (draft), [late December 1894], in Cézanne, 1978, pp. 241-42.

1895

January 5

Captain Dreyfus is dishonorably discharged from the French army after having been accused of betraying secrets to Germany.

January 31

Cézanne thanks Geffroy for both the dedication and the contents of his book *Le Cœur et l'esprit*, which contains passages inspired by his artistic ideas.

Cézanne to Geffroy, January 31, 1895, in Cézanne, 1978, pp. 243-44.

March 2

Death of Berthe Morisot. Renoir hears the news while painting with Cézanne in the countryside outside Aix and returns immediately to Paris.

Julie Manet, diary entry, December 3, 1895, in Manet, 1987, p. 81.

April 4

Cézanne wants to paint Geffroy's portrait. He works on it until the beginning of June, then abandons the picture, promising the sitter he will take it up again later.

Cézanne to Geffroy, April 4 and June 12, 1895, and to Monet, July 6, 1895, in Cézanne, 1978, pp. 244, 246; Geffroy, 1922, p. 197.

April 18

Vollard sells a landscape by Cézanne, *Dunes*, to Bauchy.

Vollard record-book, 1895, Vollard Archives, Musée du Louvre, Bibliothèque Centrale et Archives des Musées Nationaux, Paris.

May 25

He visits the exhibition of Monet's paintings of Rouen Cathedral at the Durand-Ruel gallery (May 10-31), where he encounters Pissarro; the two artists are "swept away" by them.

Pissarro to his son Lucien, May 26, 1895, in Pissarro, 1980-91, vol. 4, no. 1138, p. 75.

Late June

Cézanne departs for Aix, where he visits his mother, now old and infirm and living alone at 30, cours Mirabeau. His sister Marie is living at 8, rue de la Monnaie.

Responding to Cézanne's invitation, Francisco Oller plans to make the train trip from Paris to Aix with him. They miss one another at the station but Oller proceeds to Lyon alone, where he is robbed and asks for Cézanne's help. According to Pissarro, Cézanne responds with an "atrocious" letter consistent with what he describes as Cézanne's recent anger toward Renoir and "all of us." The facts, however, are somewhat different: Oller solicits the aid not of Cézanne but of his son, Paul, in Paris, who then informs him that his father is already in Aix, where the latter subsequently receives Oller warmly.

Vollard tries to meet Cézanne but fails to contact him before his departure for Aix. Young Paul receives the dealer's proposal to mount an exhibition of his father's works in his gallery and forwards it to Aix. Cézanne gives his consent.

Cézanne to Geffroy, June 12, 1895, and to Monet, July 6, 1895, in Cézanne, 1978, pp. 244, 246; cen-

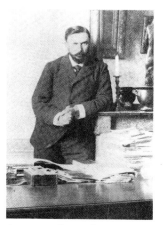

Gustave Geffroy in his study, c. 1894, photograph, Musée d'Orsay, Paris, Service de documentation.

sus, F1 ART.28, 1896, Communal Archives, Aix-en-Provence; Pissarro to his son Lucien, January 20, 1896, in Pissarro, 1980-91, vol. 4, no. 1203, p. 153; telegram from Paul Cézanne *fils* to Oller, Pissarro Archives sale, Hôtel Drouot, Paris, November 21, 1975, lot 137/4; Cézanne, 1978, p. 245 n. 7; Vollard, 1914, pp. 56-58.

July 5

Quarrel between Cézanne and Oller. Cézanne asks that he never return to the Jas de Bouffan.

Cézanne to Oller, July 5, 1895, in Cézanne, 1978, p. 245.

July 6

He informs Monet of his departure from Paris and tells him he has provisionally ceased work on the portrait of Geffroy. He thanks him for his moral support, which "stimulates him to paint."

Cézanne to Monet, July 6, 1895, in Cézanne, 1978, p. 246.

July 17

In a follow-up letter to Oller, Cézanne reminds him of bills he had settled at Tanguy's shop on his account but says he need not repay the money lent him directly. He asks Oller to reclaim a canvas left in his studio on the rue Bonaparte before January 15, 1896, when the lease expires.

The rue Bonaparte in Paris, photograph, Bibliothèque Nationale, Paris, Département des Estampes.

451. Environs d'Aix-en-Provence. – LE THOLONET. – Vue générale

View of Le Tholonet
outside Aix-en-Provence,
postcard, private collection.

The Tholonet road
(now the route Cézanne)
and Mont Sainte-Victoire, c. 1920,
photograph, private collection.

Cézanne to Oller, July 17, 1895, in Cézanne, 1978,
pp. 246-47.

September
Maxime Conil sells the Bellevue property.

Rewald, 1986, p. 269.

Fall
Renoir's first meeting with Vollard. The painter praises Cézanne highly. Renoir's son, Jean, later recalled: "Vollard knew Cézanne's painting. It is possible that it was Renoir who first made him appreciate it at its full value, 'unequaled since the end of Roman art.'"

Renoir, 1981, pp. 336-39.

November
In Aix, Coste sees Cézanne and Solari, but rarely.

53 Env. d'AIX-EN-PROVENCE. – Ancien Couvent des Camaldules. – Montagne Sainte-Victoire

The old convent of the Camaldules
at the summit of Mont Sainte-Victoire,
postcard, private collection.

Coste to Zola, November 19, 1895, in Zola, 1978-,
vol. 8, p. 278 n. 2.

November 8
Cézanne, Emperaire, Philippe Solari, and the latter's son Émile make an excursion to Bibémus. They have lunch at Saint-Marc and dine at Le Tholonet in the evening. Emperaire, drunk, falls and bruises himself badly.

That same autumn, Cézanne and the two Solaris climb Mont Sainte-Victoire. After reaching the summit, they have lunch in the ruins of the chapel of the Camaldules.

Notes by Émile Solari, in Mack, 1935, pp. 327-28.

Before November 13
Opening of an exhibition of paintings and drawings by Cézanne—about 50 according to the press, 150 according to the dealer—in Vollard's gallery on the rue Laffitte. (Rewald has suggested that the venue's limited space prompted several successive hangings.) Renoir, Degas, and Monet acquire works. Pissarro exchanges one of his Louveciennes paintings for two small *Bathers (Women Surprised at Their Bath [Don Quixote], Male and Female Nudes Fighting [Female Combatants?])* and a self-portrait. According to Vollard, Auguste Pellerin ac-

quires his first painting by Cézanne, but there is no evidence of this sale in the dealer's notes. On Camondo's recommendation, King Milan of Serbia buys some watercolors.

Degas acquires two still lifes, "Three Pears" and "Green, Yellow, and Red Apples," for 100 francs each. Julie Manet visits the exhibition with him and Renoir: "The still lifes appealed to me less than those I have seen so far; however there were some apples and a decorated pot in lovely colours. The nudes enveloped in blue are shielded by trees with light soft foliage. Monsieur Degas and M. Renoir drew lots for a magnificent still-life watercolour of pears [R. 298] and a small one

depicting an assassination in the Midi which isn't in the least bit horrifying—the figures stand out in exactly the right tones, red, blue, and violet in a landscape like that of Brittany and the Midi with rounded trees, areas of land drawn against a blue sea, and, in the background, some islands." Julie buys this watercolor (*The Murder*, R. 39), which is also admired by Renoir.

Pissarro seizes the occasion to analyze the influences on Cézanne: "They don't know that at first Cézanne was influenced by Delacroix, Courbet, Manet, and even Legros, like all of us; he was influenced by me at Pontoise and I by him." Pissarro recommends Cézanne to the London dealer Van Wisselingh.

During the exhibition Vollard makes several sales and duly records them.

Natanson, November 15, 1895, p. 473; Geffroy, November 16, 1895; Anonymous, November 23, 1895; Anonymous, November 25, 1895; Denoinville, December 1, 1895; Natanson, December 1, 1895, pp. 496-500; Alexandre, December 9, 1895; Thiébault-Sisson, December 22, 1895; Mellerio, January-February 1896, pp. 13-14; Saunier, February 1896, p. 40; Vollard, 1914, pp. 59-71; Rewald, 1959, p. 17; notes by Degas, cited in Paris, Ottawa, and New York, 1988-89, p. 491, purchase dated January 1896; Julie Manet, diary entry, November 29, 1895, in Manet, 1987, p. 76; Pissarro to Esther Pissarro, November 13, 1895, and to his son

Lucien, November 19, 22, 29, and December 4, 1895, in Pissarro, 1980-91, vol. 4, nos. 1169, 1171, 1175, 1180, 1181, pp. 113, 114-15 n. 2, 116, 121, 126, 128; Vollard record-book, 1895, Vollard Archives, Musée du Louvre, Bibliothèque Centrale et Archives des Musées Nationaux, Paris.

December

Cézanne takes part in the first exhibition organized by the Société des Amis des Arts de la Ville d'Aix-en-Provence, showing two landscapes: "The Arc Valley (landscape)" (*Mont Sainte-Victoire with Large Pine*, cat. no. 92) and "Landscape (study)."

Aix-en-Provence, 1895, nos. 23, 24; D'Arve, December 22, 1895; Gautier, 1895, with a quatrain accompanying an illustration of "The Arc Valley": "A travers les rameaux des pins géants on voit / Se profiler en bleu le Mont Ste-Victoire; / Si la nature était ce que la peintre croit / Ce sommaire tableau suffirait pour sa gloire" (Through the branches of giant pines one sees / The blue profile of Mont Sainte-Victoire; / If nature were as the painter thinks / This summary painting would secure his glory); Gasquet, 1926, p. 87.

December 26

Opening of the first Salon de l'Art Nouveau in the Siegfried Bing's gallery in Paris. Arsène Alexandre deplores the absence of several artists, among them Degas, Renoir, Monet, Cézanne, Redon, and Gauguin.

Alexandre, December 28, 1895.

1896

January

According to Pissarro, Doctor Aguiar—one of his friends who also knows Oller, Guillaumin, Doctor Gachet, and Cézanne—thinks Cézanne is ill. "This poor Cézanne is furious with all of us, even with Monet, who on balance has been quite kind to him." He reportedly said to Oller: "Pissarro is an old beast, Monet a slyboots, they have no guts. . . . I'm the only one who has any temperament, I'm the only one who knows how to do red!" Having learned about the episode with Oller from his father, Lucien Pissarro expresses surprise at Cézanne's behavior: "Do you remember that already old père Tanguy maintained, a long time ago, that he was crazy? At the time we racked this up to Tanguy's simplicity, maybe he was right! Now, is it avarice? Combined with excitability?"

Pissarro to his wife Julie, January 18, 1896, and to his son Lucien, January 20, 1896, in Pissarro, 1980-91, vol. 4, nos. 1201, 1203, pp. 151, 153; Lucien Pissarro to his father, January 22, 1896, in Pissarro, 1993, p. 458.

January 6

Degas acquires a Cézanne still life, *Glass and Apples* (V. 339), from Vollard for 400 francs.

Vollard record-book, 1896, Vollard Archives, Musée du Louvre, Bibliothèque Centrale et Archives des Musées Nationaux, Paris.

January 11

Egisto Fabbri buys three canvases by Cézanne from Vollard: "Standing Italian" (600 francs), "House Reflected in the Water" (500 francs), and a sketch (100 francs).

Vollard record-book, 1896, Vollard Archives, Musée du Louvre, Bibliothèque Centrale et Archives des Musées Nationaux, Paris.

Late January

Georges Lecomte writes Pissarro that Cézanne had criticized him in front of Geffroy.

Pissarro to his son Lucien, January 31, 1896, in Pissarro, 1980-91, vol. 4, no. 1207, p. 159.

March 7

Vollard sells Monsieur Mondain a Cézanne landscape for 600 francs and Halévy a still life ("Pomegranate and Pear in a Dish") for 250 francs.

Vollard record-book, 1896, Vollard Archives, Musée du Louvre, Bibliothèque Centrale et Archives des Musées Nationaux, Paris.

March 19

From Vollard Degas buys a "study" by Cézanne of "a pear, a lemon, 1/2 a plate" for 200 francs.

Vollard record-book, 1896, Vollard Archives, Musée du Louvre, Bibliothèque Centrale et Archives des Musées Nationaux, Paris.

March 26

Auction at the Hôtel Drouot of paintings, pastels, watercolors, drawings, etchings, and lithographs in the collection of Emmanuel Chabrier. Cézanne's *Harvest* (V. 249), a painting that Chabrier had acquired two years before at the Duret sale, sells for 500 francs.

Sale, Hôtel Drouot, Paris, March 26, 1896, lot 5.

March 31

Count Takora buys two Cézanne watercolors from Vollard for 100 francs and 50 francs.

Vollard record-book, 1896, Vollard Archives, Musée du Louvre, Bibliothèque Centrale et Archives des Musées Nationaux, Paris.

March or April

Beginning of Cézanne's relations with Joachim Gasquet, the son of his childhood friend. The painter, who cherishes peace and quiet, tries to minimize human contact: "I curse the Geffroys and other scoundrels who, to earn fifty francs for an article, drew me to the public's attention. . . . I thought one could make good paintings without drawing attention to one's private existence." In Aix he frequents Solari, Coste, and Henri Gasquet. Occasionally he goes to the Café Oriental on the cours Mirabeau, where he meets Alexis and Coste. He gives a landscape of Mont Sainte-Victoire exhibited the previous year at the Société des Amis des Arts d'Aix (cat. no. 92) to Joachim Gasquet.

Joachim Gasquet (1873-1921), photograph, Musée d'Orsay, Paris, Service de documentation.

Cézanne to Joachim Gasquet, April 15 and 30, 1896, in Cézanne, 1978, pp. 248-49; Gasquet, 1926, pp. 86-88.

Spring?

Vollard visits Cézanne in Aix. This is the first meeting between the painter and the dealer, who previously had dealt only with the artist's son. Vollard lists the prints and photographs he saw on the walls of Cézanne's studio: *The Arcadian Shepherds* by Poussin, *The Living Carrying the Dead* by Luca Signorelli, some by Delacroix, *A Burial at Ornans* by Courbet, *The Assumption* by Rubens, a *Cupid* then attributed to Puget, some Forains, *Psyche* by Prud'hon, *Romans in the Period of Decadence* by Couture. During his stay, Vollard buys paintings the painter had given to residents of Aix.

Vollard, 1914, pp. 73-83.

April 1

Monet asks Durand-Ruel to send to Giverny several paintings belonging to him, including three Cézannes.

Monet to Durand-Ruel, April 1 [1896], in Wildenstein, 1974-85, vol. 3, no. 1344, p. 291.

April 3

Cézanne has the painting materials previously left with Geffroy returned to him.

Geffroy, 1922, p. 197.

April 15, 16, 19, and 29

Vollard makes several Cézanne sales: to Geffroy, two "studies" for 50 francs each and a landscape, "Farm," for 400 francs; to Mary Cassatt, some apples, for 211 francs; to Maufra, four "studies."

Vollard record-book, 1896, Vollard Archives, Musée du Louvre, Bibliothèque Centrale et Archives des Musées Nationaux, Paris.

May

Cézanne begins a portrait of Joachim Gasquet (cat. no. 173).

Cézanne to Joachim Gasquet, May 21, 1896, in Cézanne, 1978, pp. 250-51; Gasquet, 1926, p. 91.

May 2

Zola publishes a Salon review in which he

writes: "Thirty years have passed [since *Mon Salon* of 1866] and my interest in painting has waned somewhat. I grew up virtually in the same cradle as my friend, my brother Paul Cézanne, in whom the touches of genius of a great [but] aborted painter are only now beginning to be discovered."

Zola, May 2, 1896.

May 4 and 6
Vollard makes two more Cézanne sales: to Félicien Roux, a landscape (300 francs); to Degas, a portrait of Chocquet (V. 375).

Vollard record-book, 1896, Vollard Archives, Musée du Louvre, Bibliothèque Centrale et Archives des Musées Nationaux, Paris.

June 4
Cézanne attends the first communion of his niece and goddaughter, Paule Conil, at the community of the Sisters of Zion in Marseille.

M. C., November 1960, pp. 300-301.

Early June
Cézanne takes a room in the Hôtel Molière in Vichy, where he remains for a month.

Cézanne to Joachim Gasquet, June 13, 1896, and to Solari, July 23, 1896, in Cézanne, 1978, pp. 251-52, 254.

June 15-July 20
An etching, six watercolors, and a drawing by Cézanne are included in an exhibition of works by painters and engravers at the Vollard gallery (nos. 41-48). None of them, however, figure in the *Album des peintres-graveurs* published by Vollard in a limited edition of 100 signed by the artists.

June 19
Vollard sells a Cézanne still life to Monsieur Murat for 150 francs.

Vollard record-book, 1896, Vollard Archives, Musée du Louvre, Bibliothèque Centrale et Archives des Musées Nationaux, Paris.

The Lac d'Annecy, photograph, Bibliothèque Nationale, Paris, Département des Estampes.

July
At the request of his wife and son, the painter goes to Talloires on the shore of the Lac d'Annecy. He passes through Chambéry (Hôtel de Verdun) and Annecy (Hôtel de la Paix). From Chambéry, he goes to Saint-Laurent-du-Pont to visit the large Carthusian monastery there. In Talloires he stays at the Hôtel de l'Abbaye, where he soon becomes bored: "Life begins to be as monotonous as the grave for me." During the trip he makes several excursions into the surrounding area (Thônes, the Château de Duingt on the shore across from Talloires, etc.). His route back to Aix takes him through Lyon and Rognac via Miramas. He thanks Joachim Gasquet for sending the second issue of a review he has founded, *Les Mois dorés*, which contains a few lines about him.

Cézanne to Joachim Gasquet, July 21, 1896, and to Solari, July 23, 1896, in Cézanne, 1978, pp. 252-54; Andersen, June 1965, pp. 313-17.

July 16
Vollard sells a Cézanne "study" of a "peasant at rest" for 150 francs.

Vollard record-book, 1896, Vollard Archives, Musée du Louvre, Bibliothèque Centrale et Archives des Musées Nationaux, Paris.

Late August
Cézanne goes to Paris, where he spends a long time looking for a studio. At 58, rue des Dames in the Batignolles quarter he rents a third-floor apartment consisting of an antechamber, a salon, a dining room, a kitchen, a hallway, a study, a bathroom, and two rooms with fireplaces. He rereads Flaubert.

Cézanne to Joachim Gasquet, September 29, 1896, in Cézanne, 1978, p. 255; cadastral survey, D1P4, 1876, Archives de Paris.

September 4
Pissarro informs his son that Vollard is going to install a lithographic press in his gallery.

Pissarro to his son Lucien, September 4, 1896, in Pissarro, 1980-91, vol. 4, no. 1288, pp. 245-46.

Late October-November
Zola spends several days in Aix at the home of Coste but does not encounter Cézanne.

Zola to Coste, n.d., in Rewald, 1936, pp. 141-42.

November 15
Renoir buys two Cézannes from Vollard: "Red rocks, lilac hills" and "a large old painting (Idyll)" for 2,000 francs each.

Vollard record-book, 1896, Vollard Archives, Musée du Louvre, Bibliothèque Centrale et Archives des Musées Nationaux, Paris.

December 1
Thadée Natanson encourages his readers to visit the Gauguin exhibition at Vollard's gallery and also to look at the admirable paintings by Cézanne in the same venue:

The rue des Dames in the Batignolles quarter in Paris, c. 1906, photograph by N. D., Bibliothèque Nationale, Paris, Département des Estampes.

"[Gauguin's] influence is less profound than Monsieur Cézanne's has been and will continue to be . . . , [but he] will nonetheless be numbered among those who had an effect on the youngest generation of contemporary painters."

Natanson, December 1, 1896, p. 517.

Late December
Émile Solari, the sculptor's son, visits Cézanne in Paris.

Cézanne to Philippe Solari, January 30, 1897, in Cézanne, 1978, p. 258.

Publication of *Le Mouvement idéaliste en peinture* by André Mellerio. To the four artists he cites as founders of the movement—Puvis de Chavannes, Gustave Moreau, Odilon Redon, and Paul Gauguin—he adds Van Gogh and Cézanne, "a fantastic personage. Still alive, he is spoken of as though he were dead."

Mellerio, 1896, p. 260.

The rue Saint-Lazare in Paris, c. 1900, photograph by N. D., Bibliothèque Nationale, Paris, Département des Estampes.

1897

January
Cézanne, bedridden with the flu the whole month, misses a visit by Guillemet to his studio. His son is busy moving to a new address, 73, rue Saint-Lazare. Joachim Gasquet intervenes with Dumesnil, a professor of philosophy in Aix, to make sure two canvases by Cézanne are "accepted." The painter asks Solari and Gasquet to have his sister Marie conduct them to the Jas de Bouffan, where the two paintings are to be found. He thanks Gasquet for sending the latest issue of his review.

Cézanne to Guillemet, January 13, 1897, to Solari, January 30, 1897, and to Joachim Gasquet, January 30, 1897, in Cézanne, 1978, pp. 257-59.

January 27
Vollard sells Charles Loeser three paintings by Cézanne: "Village" (400 francs), "Bathers" (400 francs), and "House/a lake" (700 francs).

Vollard record-book, 1897, Vollard Archives, Musée du Louvre, Bibliothèque Centrale et Archives des Musées Nationaux, Paris.

February 9
Opening of the annex to the Musée du Luxembourg housing the Caillebotte bequest. Pissarro objects to the way his works are displayed; visitors mock the Impressionists.

Pissarro to his son Lucien, February 18, 1897, in Pissarro, 1980-91, vol. 4, no. 1373, pp. 329, 329 n. 2; Thiébault-Sisson, March 9, 1897.

April 17 and May 1
Durand-Ruel buys two Cézanne paintings—"Apples" and a landscape—from Robert de Bonnières.

Durand-Ruel Archives, Paris, stock nos. 4176, 4193.

May
Cézanne works at Mennecy (Essonne), where he stays at the Hôtel de la Belle Étoile.

Cézanne to Solari, May 24, 1897, in Cézanne, 1978, p. 259.

May 31
He returns to Aix.

Cézanne to Solari, May 24, 1897, in Cézanne, 1978, p. 259.

June 25
Vollard sells Degas a Cézanne painting, "Nymph and cupid (?)," for 150 francs.

Vollard record-book, 1897, Vollard Archives, Musée du Louvre, Bibliothèque Centrale et Archives des Musées Nationaux, Paris.

June?-September
He rents a cottage in Le Tholonet, which he retains until the fall, working on landscapes and depictions of the Bibémus quarry. He is visited by his friends Gasquet, Philippe Solari, and Émile Solari. He

theorizes about painting, writing to Émile Solari: "Your father came and spent the day with me–poor fellow, I saturated him with theories about painting." After one of his workdays he goes to Aix for dinner with his mother.

Coste, who sees Philippe Solari and Cézanne rather frequently, conveys news about the latter to Zola: "Cézanne is very depressed and often beset by dark thoughts. He has had some validating satisfactions, however, and his works are having a degree of success at the sales to which he's not accustomed. But his wife must have made him do a lot of stupid things. . . . He rented a cabin at the quarry near the dam and he spends the bulk of his time there."

Gasquet, 1926, pp. 96-97; Cézanne to Philippe Solari, [late August 1897], to Émile Solari, September 2 and 8, 1897, and to Joachim Gasquet, September 26 [1897], in Cézanne, 1978, pp. 260-62; Coste to Zola, [1897, not 1896], in Cézanne, 1978, p. 236.

September 8
Cézanne thanks Émile Solari for sending a copy of his review L'Avenir artistique et littéraire.

Cézanne to Émile Solari, September 8, 1897, in Cézanne, 1978, p. 262.

October 25
Death of the painter's mother at age 83 in her house at 30, cours Mirabeau. The funeral takes place on October 27 at the church of Saint-Jean-de-Malte.

Émile Bernard reports that Cézanne chose not to accompany the burial procession but went to work at the motif.

The Aix death registry specifies that no effective date of inheritance was forthcoming. A certificate attesting that the deceased held no assets is dated June 24, 1899.

Death certificate, Archives, Hôtel de Ville, Aix-en-Provence; registry of interments in the parish of Saint-Jean-de-Malte, Archdiocesan Archives, Aix-en-Provence; Bernard, 1925, p. 35; death records, Aix, 1897, XII Q [1/16/24], Departmental Archives of the Bouches-du-Rhône, Marseille.

Hugo von Tschudi, the new director of the National Gallery in Berlin, acquires a Cézanne landscape from Durand-Ruel, *Mill on the Couleuvre at Pontoise* (cat. no. 75), for 1,500 francs. The museum archives indicate that the funds for the acquisition were given by Wilhelm Staudt. Thanks to Tschudi, several nineteenth-century French masters—Manet, Monet, Degas, Pissarro, Cézanne, Fantin-Latour, and Rodin—are exhibited in Berlin before being widely recognized by French museums.

The Church of Saint-Jean-de-Malte and the Musée des Beaux-Arts in Aix-en-Provence, postcard, private collection.

The French press, however, publicizes the purchase beginning in June: "The Berlin museum has just acquired an important landscape by M. Cézanne. The price was not high, but that's unimportant. Isn't the relevant point that in 1897 a foreign administration purchased a painting that none of this country's own museums would have had anything to do with, even as a gift, in this same year of 1897?" A similar tone was struck in *L'Écho de Paris:* "It is known that our own Musée du Luxembourg owns two canvases by this painter. They are exhibited in the same Caillebotte Gallery that provoked such shrieks from the MM. of the Académie des Beaux-Arts."

It is reported, however, that Tschudi decided to remove the Cézanne from view when the emperor visited the museum.

Meier-Graefe, November 26, 1898, p. 1015; Gronau, February 1, 1898, p. 132; Anonymous, 1898, p. xx; Duret, 1906, pp. 192-94; Natanson, June 1897, pp. 803-4; Anonymous, July 1, 1897.

December
Vollard publishes a second *Album des peintres-graveurs*, this time including a print by Cézanne—*The Bath*—with "nudes in the open air over which the light moves and plays marvelously" (Fontainas).

Anonymous, November 1897, p. 126; Fontainas, January 1898, p. 300.

Senator Victor Leydet, who went to school with Cézanne and Zola, tries to engineer an official decoration for the painter, in vain.

Cézanne, 1978, p. 311 n. 1.

1898

January 8
Death of Achille Emperaire.

January 13
Zola publishes his celebrated open letter to the president of the French Republic on the Dreyfus affair *(J'accuse)*. Following this article, Zola is sentenced to imprisonment on February 23.

Zola, January 13, 1898; Signed "La Revue blanche," March 1, 1898, p. 321.

The Villa des Arts, rue Hégésippe-Moreau, photograph, Musée d'Orsay, Paris, Service de documentation

Back in Paris, Cézanne rents a studio in the Villa des Arts, 15, rue Hégésippe-Moreau, fourth floor, which he retains until 1899. He hangs reproductions of works by Forain on the walls.

Cadastral survey, D1P4, 1876, Archives de Paris; Vollard, 1914, pp. 91-92.

March

Maurice Denis first envisages the painting that was to become *Homage to Cézanne*: "Make a painting of Redon in Vollard's shop, surrounded by Vuillard, Bonnard, etc."

Denis, journal entry, March 1898, in Denis, 1957, vol. 1, p. 143.

April 25

Opening of the Salon of the Société Nationale des Beaux-Arts, where Rodin's *Balzac* becomes the focus of scandal. After the statue is refused by the Société des Gens de Lettres, which commissioned it in 1892, Mathias Morhardt, editor of *Le Temps*, launches a subscription for its purchase. Many artists, men of letters, musicians, and critics contribute (including Geffroy, Arsène Alexandre, Lecomte, Forain, Monet, Pissarro, Toulouse-Lautrec, Besnard, Vuillard, Blanche, Signac, Luce, Carpeaux, Bourdelle, Maillol, and others). According to Vollard, Cézanne, who admired this work, indicated his intention to contribute.

Lecomte, July 1, 1939, pp. 335-36; Vollard, 1914, p. 115; Gasquet, 1926, p. 160.

May

Degas pays 200 francs for a Cézanne painting of green pears: "relined–doubtless a fragment of a [larger] painting."

Notes by Degas, cited in Paris, Ottawa, and New York, 1988-89, p. 494.

May 1

Signac publishes "De Delacroix au néo-impressionnisme" in three installments in *La Revue blanche*: "La Technique de Delacroix" on May 1, "Les Techniques impressionniste et néo-impressionniste" on May 15, and "L'Éducation de l'oeil" on July 1. It appears in book form the following year.

It contains a few short passages about Cézanne: "Cézanne, by juxtaposing in squared and distinct strokes, without concern for either imitation or resolution, the various elements of decomposed tints, was closer to the methodical *division* of the Neo-Impressionists. . . . Likewise, Cézanne's stroke is the connecting link between the modes of execution of the Impressionists and of the Neo-Impressionists. . . . Cézanne arrives at the motif knowing what he wants, in quest of volume. . . . In front of a tree trunk, Cézanne discovers elements of beauty that escape so many others. All these lines that intertwine, that caress and envelop one another, all these colored elements that overlap, that diminish or oppose one another, he takes hold of them and disposes of them."

Signac, May 15, 1898, pp. 128-29, in Signac, 1978, p. 186.

May 9-June 10

Exhibition of sixty paintings by Cézanne in the Vollard gallery, 6, rue Laffitte. The announcement consists of a card bearing a lithograph after his *Four Bathers* (V. 547) and, on the back, a list of exhibited works.

Exhibition announcement, Musée Granet; Anonymous, May 15, 1898; Fontainas, June 1898, p. 890; Natanson, June 1, 1898, p. 220; Mallarmé to Marie and Geneviève Mallarmé, [May 12 and 16, 1898], in Mallarmé, 1984, pp. 185, 193-94.

Summer ?

Cézanne paints in Montgeroult and Marines, both in the environs of Paris (Val-d'Oise). He sometimes works with the painter Louis Le Bail but quarrels with him.

While painting in the region he meets Baron Denys Cochin, an art lover who owns several canvases by him as well as some by Delacroix.

Cézanne to Louis Le Bail, [1898], in Cézanne, 1978, pp. 264-65, 264 n. 2; Vollard, 1914, pp. 110-12; Larguier, 1927, pp. 162-63.

June 22

He thanks Gasquet for remarks about his work in the review of a book about late medieval Provençal society by Charles de Ribbe, a historian and native of Aix, in the March-April issue of *Les Mois dorés*. Gasquet considers Cézanne's painting a testimonial to Provence "almost" equal to the work of the Provençal poet Frédéric Mistral. Cézanne seizes the occasion to express his annoyance with Geffroy. According to Vollard, his relations with the critic deteriorated after he asked the painter to paint a portrait of Clemenceau, a work he began and then abandoned: "One fine morning I flattened everything, the canvas, the easel, Clemenceau, Geffroy." Some years later Geffroy denied this story.

Cézanne to Joachim Gasquet, June 22, 1898, in Cézanne, 1978, pp. 265-66; Gasquet, 1926, p. 195; Vollard, 1914, p. 112; Geffroy, 1922, p. 197.

July 29

A certain Montfort tries to visit Cézanne, but he is away from Paris. He works in the countryside (Fontainebleau, Montigny-sur-Loing). A Fontainebleau address for Cézanne, at 11, rue Saint-Louis, is entered in Vollard's address book.

Paul Cézanne *fils* to Joachim Gasquet, July 29, 1898, Bibliothèque Méjanes, Aix-en-Provence; Vollard Archives, Musée du Louvre, Bibliothèque Centrale et Archives des Musées Nationaux, Paris.

September

Gauguin, running out of money and ill in Tahiti, has had Chaudet sell one of his Cézannes.

Gauguin to Daniel de Monfreid, October 1898, in Gauguin, 1918, p. 109.

Announcement of the *Cézanne* exhibition, 1898, at the Galerie Vollard, Musée d'Orsay, Paris, Service de documentation.

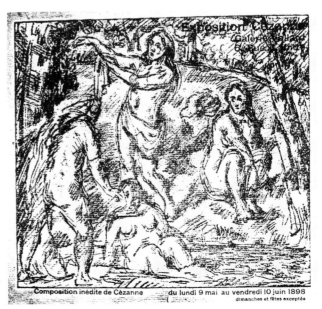

December 23

Cézanne renews his friendship with Henri Gasquet and his son Joachim, lending his support to the regionalist art movement initiated by the latter.

Vollard offers to buy Signac's Cézannes. He refuses to sell his largest canvas but exchanges a small still life for a woman's head by Renoir, two watercolors by Jongkind, and a Seurat.

Cézanne to Henri Gasquet, December 23, 1898, in Cézanne, 1978, pp. 266-67; Rewald, July-August 1953, p. 37.

December 25

Signac rebuffs another offer to purchase his Cézanne: "These are people who reacquire, for substantial sums, works of art purchased fifteen years earlier by real artlovers for nothing. In my house they look only at paintings by established names."

Rewald, July-August 1953, p. 37.

1899

For several months Cézanne works on the *Portrait of Ambroise Vollard* (cat. no. 177) in his studio on the rue Hégésippe-Moreau. He confides to Solari that the two daily posing sessions exhaust him. As always, in the afternoons he goes to the Louvre or to the Musée de Sculpture Comparée at the Trocadéro: "[He] draws statues, antiquities, or the Pugets, or he makes watercolors *en plein-air;* he maintains this predisposes him to *see* well the next day."

Vollard, 1914, pp. 91-107; Denis, journal entry, s.v. October 21, 1899, in Denis, 1957, vol. 1, p. 157; Cézanne to Solari, February 25 [1899?], in Cézanne, 1978, p. 268.

During a sojourn in Toulouse, Matisse decides to buy Cézanne's *Three Bathers* (cat. no. 60) from Vollard after returning to Paris.

Diehl, 1972, p. 134 n. 103; the purchase is recorded and dated December 7, 1899, in Vollard's "Entrées-Sorties" record-book, Vollard Archives, Musée du Louvre, Bibliothèque Centrale et Archives des Musées Nationaux, Paris.

January 29

Death of Sisley at Moret-sur-Loing. Monet resolves to organize a benefit auction for the painter's children at the Galerie Georges Petit, to be held on May 1. Cézanne contributes a painting that brings 2,300 francs. Jeanne Sisley, who does not know the painter's address, sends Georges Petit a letter of thanks for him.

Death certificate, Hôtel de Ville, Moret-sur-Loing; Monet to Geffroy, February 3, 1899, in Wildenstein, 1974-85, vol. 4, no. 1435, p. 337; Jeanne Sisley to Georges Petit, May 3, 1899, 1990-A.790, Institut Néerlandais, Fondation Custodia, Paris.

March

Denis writes in his journal of the "impression made . . . this spring by Cézanne."

Denis, journal entry, s.v. March 1899, in Denis, 1957, vol. 1, p. 151.

May 4 and 5

Sale of the collection of Comte Doria at the Galerie Georges Petit. Monet acquires a Cézanne, *Melting Snow at Fontainebleau* (V. 336), for 6,750 francs. Denis writes that Cézanne painted this landscape from photographs, adding that "he has painted flowers from magazine illustrations."

Sale, Galerie Georges Petit, Paris, May 4-5, 1899, lot 45; Monet to Petit, May 3, 1899, in Wildenstein, 1974-85, vol. 4, no. 1463, p. 338; Denis, journal entry, December 7-9, 1899, in Denis, 1957, vol. 1, p. 157.

May 16

Marthe Conil, one of the painter's nieces, invites him, Hortense, and young Paul to her first communion. Cézanne, "detained in Paris by some demanding work," probably Vollard's portrait, cannot go to Marseille for the occasion.

Cézanne to Marthe Conil, May 16, 1899, in Cézanne, 1978, pp. 268-69.

May 28

The collector Egisto Fabbri, who owns sixteen works by Cézanne, thinks they represent "the noblest that modern art has to offer." He wants to meet the painter. Cézanne gives him his address but tries to justify his desire for isolation: "Doubt about seeming inferior to what is expected of a person presumed equal to any situation is surely an excuse for the necessity to live in seclusion."

Fabbri to Cézanne, May 28, 1899, and Cézanne to Fabbri, May 31, 1899, in Cézanne, 1978, pp. 269 n. 2, 269-70.

June 3

Cézanne receives the May 7 issue of the *Mémorial d'Aix,* which includes an article by Joachim Gasquet.

Cézanne to Henri Gasquet, June 3, 1899, in Cézanne, 1978, pp. 270-71.

Ambroise Vollard (1867-1939), c. 1930, photograph,
Musée d'Orsay, Paris,
Service de documentation.

The children of Rose and Maxime Conil, photograph by Cézanne,
Musée du Louvre, Paris, Bibliothèque Centrale et Archives des Musées Nationaux.

Late June?

He travels to the Midi.

Cézanne to Marthe Conil, May 16, 1899, in Cézanne, 1978, p. 269.

July 1, 3, and 4

Sale of the collection of Chocquet's widow at the Galerie Georges Petit. The catalogue includes thirty-one paintings, three watercolors, and some pastels by Cézanne; additional works by him are not listed. The prices range from 145 francs for a small oil study to 4,000 francs for *Mardi Gras,* one of no fewer than seventeen paintings acquired by Durand-Ruel. Duret pays homage to Chocquet in the preface to the catalogue: "He was especially tireless on the subject of Cézanne, whom he placed in the very first rank. And seeing how Cézanne's painting, with its grandeur and tragedy, was precisely what then excited the most opposition, many were amused by M. Chocquet's enthusiasm, which seemed to them a kind of gentle folly." A private viewing of the paintings is held on June 29. Julie Manet attends and writes in her journal: "He owned some very pretty Cézannes; still lifes especially, I liked one of them." She observes that, thanks to Vollard, Cézanne's prices are rising. Monet reportedly advises Comte Isaac de Camondo to buy *The House of the Hanged Man, in Auvers-sur-Oise* (cat. no. 30; not listed in the sale catalogue).

Sale, Galerie Georges Petit, Paris, July 1, 3, and 4, 1899; Monet to Camondo, [June 1899], in Wildenstein, 1974-85, vol. 4, no. 1467, p. 338 (this letter is now lost); Durand-Ruel Archives, Paris, stock nos. 5333-47, 5388-89; Julie Manet, diary entries, June 29 and July 1, 1899, in Manet, 1988, pp. 173-74.

September

Opening of the Maison Moderne at 82, rue des Petits-Champs, "a new house for the production and sale of art objects for daily use" that also offers paintings by Manet, Monet, Degas, Cézanne, Renoir,

Denis, Van Rysselberghe, Vuillard, Bonnard, and others.

Anonymous, September 1899, p. 215; R., September 1899, p. 277.

September 18

The Jas de Bouffan is sold by Maître Mouravit, the Cézanne family notary.

In the fall Cézanne returns to Aix to remove his personal effects and painting materials from the Jas de Bouffan. He moves to the second floor of a house at 23, rue Boulegon, where he has a studio built under the eaves. While the work is in progress he stays for several months with Joachim Gasquet. It is at this time that he must have filled out the questionnaire "Mes Confidences."

Cézanne lives alone on the rue Boulegon with his housekeeper Madame Brémond, but Hortense and young Paul also give this venue as their address in the 1906 census.

His offer to purchase the Château Noir, where he rents a room, is rejected.

Land sale records, Archives, Tax Bureau, Aix-en-Provence; Larguier, 1927, p. 158; census, F1 ART.29, 1901, and F1 ART.30, 1906, Communal Archives, Aix-en-Provence; Gasquet, 1926, p. 106; Aurenche, in Rewald, 1959, pp. 59-60; Cézanne, "Mes Confidences," in Chappuis, 1973, pp. 25-28; Lebensztejn, August-September 1993, pp. 609-30; Rewald, 1936, p. 148.

October 15

Vollard asks the Dutch collector Cornelis Hoogendijk for 3,000 francs, owed for two Cézanne still lifes purchased and paid for in part some months earlier.

Vollard to Hoogendijk, [August 1899?] and October 15, 1899, Vollard Archives, Musée du Louvre, Bibliothèque Centrale et Archives des Musées Nationaux, Paris, 421 (4,1) 3-4, 421 (4,1) 10.

October 21-November 26

Cézanne exhibits two still lifes and a landscape at the Salon des Indépendants. His address in Paris is 31, rue Ballu, where he occupies an apartment on the third floor. Zola, whom Cézanne has not seen for many years, lives nearby. Despite their differences, he hopes they will run into

one another by chance.

Paris, 1899 (a), nos. 20-22; cadastral survey, D1P4, 1876, Archives de Paris; Vollard, 1914, pp. 134-36.

November

Some Cézanne landscapes are exhibited at the Durand-Ruel gallery.

Coquiot, November 22, 1899.

November 26

Vollard writes to Tschudi, director of the National Gallery in Berlin, offering to acquire the Cézanne in the museum collection, "having heard that the museum was not satisfied with the picture." Three days later, Tschudi denies this rumor: "On the contrary, it seems to me one of the master's most beautiful works and one of his most characteristic. I have no desire to give it up."

Vollard to Tschudi, November 26, 1899, and Tschudi to Vollard (draft) on the back of the preceding, Archives, Nationalgalerie, Berlin.

Late November-December

Exhibition of some forty paintings by Cézanne in Vollard's gallery.

Coquiot, November 27, 1899; Lecomte, December 9, 1899, pp. 81-87; Fagus, December 15, 1899, pp. 627-28.

December 7-9

Maurice Denis copies a Cézanne still life in the collection of Dr. Georges Viau (repro. p. 31, previously owned by Gauguin), which he places in the center of his painting *Homage to Cézanne* (repro. pp. 22-23).

Denis, journal entry, December 7-9, 1899, in Denis, 1957, vol. 1, p. 157.

December 18

Vollard acknowledges receipt of two Cézanne canvases sent by Maxime Conil for which he had paid 6,000 francs.

Vollard Archives, Musée du Louvre, Bibliothèque Centrale et Archives des Musées Nationaux, Paris, 421 (4,1) 24.

Late December

Vollard acquires everything then in Cézanne's studio. He writes to Gauguin: "I've already mounted three or four exhi-

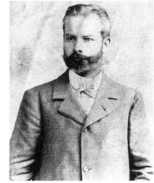

Eugène Blot (born 1857), photograph, Musée d'Orsay, Paris, Service de documentation.

bitions with them: they're beginning to take with the public."

Vollard to Gauguin, [January 1900], Loize Archives, Musée Gauguin, Papeari, Tahiti.

1900

February 8

Georges Feydeau buys a painting by Cézanne from Vollard.

Note acknowledging a debt owed by Feydeau to Vollard, February 8, 1900, Vollard Archives, Musée du Louvre, Bibliothèque Centrale et Archives des Musées Nationaux, Paris, 421 (4,1) 24.

May

In a letter to Vollard, Gauguin makes exaggerated claims about his collection of Impressionist paintings in the care of his brother-in-law Edvard Brandès in Denmark including "a dozen Cézannes."

Gauguin to Vollard [not to Emmanuel Bibesco], [May] 1900, in Gauguin, 1948, no. 173, p. 223.

May 9 and 10

Sale at the Hôtel Drouot of the collection of Eugène Blot (paintings, watercolors, pastels, and drawings), which includes five canvases by Cézanne. Georges Lecomte publishes an important article on the artist as a preface to the catalogue.

Blot, 1900, pp. 23-31.

May 26

Cézanne leaves on deposit with his notary in Aix, Maître Mouravit, the sum of 25,000 francs, his one-third share of the sale price of the Jas de Bouffan.

Declaration of title transfer on the death of Paul Cézanne, December 10, 1906, Archives, Tax Bureau, Aix-en-Provence.

July 10

Cézanne, in Aix, provides Roger Marx with biographical information for the Exposition Centennale de l'Art Français, which opened on May 1 and which included three paintings by him: *Compotier, Glass, and Apples* (repro. p. 31; "property of M. Viau"); "Landscape" ("property of M. Pellerin"); "My Garden" ("property of

The rue Ballu, in Paris, photograph, Bibliothèque Nationale, Paris, Département des Estampes.

M. Vollard"). Some months prior to the opening, André Fontainas, art columnist for the *Mercure de France*, had expressed concern about the case of Cézanne, Redon, and Gauguin.

Cézanne to Roger Marx, July 10, 1900, in Cézanne, 1978, p. 272; Paris, 1900, nos. 86-88; Alexandre, May 1, 1900, p. 4; Tschudi, November 1, 1900, pp. 59-73; Grosjean-Maupin, December 22, 1900, p. 1040; Coquiot, 1900, p. 334; Kahn, 1900, p. 510; Mellerio, 1900, p. 8; Geffroy, 1901, pp. 102-3; Fontainas, February 1900, p. 523.

Around October
Publication of the program of the Collège d'Esthétique Moderne. Cézanne is a member of the board of directors, which includes writers, philosophers, scholars, and painters.

Leblond, November 23, 1901, p. 1110.

Fall
Cézanne meets some young writers at the home of Joachim Gasquet: Louis Aurenche, the poet Léo Larguier (stationed in Aix for military service until September 1902), and Edmond Jaloux. He invites his young friends to the rue Boulegon and meets them at the Café Clément on the cours Mirabeau. Larguier visits him at the Château Noir, where Cézanne works during the day, returning to Aix in the evenings.

Rewald, 1959, pp. 40, 42; Larguier, 1927, pp. 150-66; Aurenche, in Rewald, 1959, p. 62.

November-early January 1901
For the first time, paintings by Cézanne—thirteen, including twelve sent on October 18 by Durand-Ruel and shipped back to Paris on January 9, 1901—are included in a group exhibition at the Bruno and Paul Cassirer gallery in Berlin. Rainer Maria Rilke has his first encounter with Cézanne's painting.

Berlin, 1900; Feilchenfeldt, 1993, pp. 296-99; Warncke, November 29, 1900, p. 105; Rosenhagen, January 9, 1901, p. 193; Rilke to his wife, October 10, 1907, in Rilke, 1991, p. 44.

Denis paints his *Homage to Cézanne* (repro. p. 22-23).

1901

January 20-February 20
Exhibition of "original prints" at the Vollard gallery, including works by Renoir, Cézanne, Raffaëlli, Lunois, Bonnard, Vuillard, Fantin-Latour, Denis, and others.

Thirty-six paintings by Cézanne are also exhibited at the Vollard gallery.

Anonymous, February 1901, p. 225; Marx, July 13, 1901, pp. 649-52; Beral, February 5, 1901, pp. 6-7.

March 1-31
Vollard sends a Cézanne painting, "Still Life," to the eighth exhibition of the Libre Esthétique group in Brussels, which also includes *Homage to Cézanne* by Denis.

Brussels, 1901, no. 103; Anonymous, March 1, 1901; G.V.Z., March 1, 1901; L. S., March 6, 1901; Ethèrel (?), March 9, 1901; Louis, March 10, 1901; O. L., March 10, 1901; Senne, March 16, 1901; G.V.Z., March 26, 1901; H. D., March 30, 1901; L. E., April 1, 1901.

April-May
A canvas by Cézanne, "Fruit," property of Gustave Fayet, is exhibited at the Salon of the Société des Beaux-Arts in Béziers. In the preface to the catalogue, Maurice Fabre praises the artist: "There is an element of Spanish excess in this temperament. He has rendered the harsh side of his country, and he has shown the importance of painting in itself. He has already had and will continue to have considerable influence on the destiny of French painting."

Béziers, 1901, no. 17.

April 17
Durand-Ruel acquires "A Meadow" by Cézanne from Egisto Fabbri.

Durand-Ruel Archives, Paris, stock no. 6289.

April 19
Odilon Redon reflects on the vicissitudes of the art market: "Everything changes, you see; you also know how prices have risen for paintings by Cézanne and Renoir. In sum, everything that's beautiful ultimately makes a place for itself."

Redon to Bonger, April 19, 1901, in Redon, 1923, p. 48.

April 20-May 21
Two paintings by Cézanne, "Still Life" and "Landscape," are included in the seventeenth Salon des Indépendants.

The painter still resides at 31, rue Ballu.

Paris, 1901 (a), nos. 154-55; Fontainas, May 15, 1901, pp. 352-55; Natanson, May 1, 1901, pp. 52-57; Alexandre, May 2, 1901.

April 22
Opening of the Salon of the Société Nationale des Beaux-Arts, which includes *Homage to Cézanne* by Denis. Cézanne thanks the painter and those who posed with him—Redon, Vuillard, Roussel, Vollard, Sérusier, Mellerio, Ranson, Bonnard, and Marthe Denis—for this manifestation of "artistic sympathy." Commenting on the many reactions to his canvas in the press, Denis writes him: "Perhaps you will now have some idea of the place you occupy in the painting of our time, of the admiration you inspire, and of the enlightened enthusiasm of a few young people, myself included, who can rightly call themselves your students." The painting is acquired by André Gide.

Paris, 1901 (b); Geffroy, 1903, pp. 374-80; Cézanne to Maurice Denis, June 5, 1901, and Maurice Denis to Cézanne, June 13, 1901, in Cézanne, 1978, pp. 274-75, and in Denis, 1957, vol. 1, p. 170; Gide to Maurice Denis, April 24, 1901, in Denis, 1957, vol. 1, p. 169.

May 8
Durand-Ruel buys a Cézanne still life at the abbé Gaugain sale.

Durand-Ruel Archives, Paris, stock no. 6346.

May 9-June 12
Four paintings by Cézanne—a self-portrait and three still lifes belonging to the Dutch collector Cornelis Hoogendijk—are shown at the Eerste Internationale Tentoonstelling (First International Exhibition) in The Hague.

The Hague, 1901, nos. 23-26.

June 17
Cézanne thanks Gasquet for sending his work *L'Ombre et les vents*. Henceforth relations between the two men become less cordial.

Cézanne to Joachim Gasquet, June 17, 1901, and to Aurenche, November 20, 1901, in Cézanne, 1978, pp. 275, 277; Rewald, 1959, p. 42.

June 25-July 14
Exhibition of work by Francisco Iturrino and Picasso at the Vollard gallery.

Paris, 1901 (c); Alexandre, June 26, 1901.

July 22
Cézanne sends some "canvases and pastels" to Vollard.

Cézanne to Vollard, July 22, 1901, in Venturi, January-March 1951, p. 48.

Early October
On the occasion of his departure from Aix due to his having been named tax collector for Pierrelatte (Drôme), Louis Aurenche invites his friends—including Cézanne—to a farewell dinner in a "wagoner's hotel," La Croix de Malte, just outside the city.

Aurenche, in Rewald, 1959, p. 66; Cézanne to Aurenche, [October 1901], in Cézanne, 1978, p. 276.

November
Gide tells Maurice Denis a colorful story about Cézanne. It seems the artist had consecrated a room in his apartment to his mother's memory. His wife, in a fit of jealousy, burned all the *bibelots*. On discovering this, Cézanne left and spent several days in the countryside.

Denis, journal entry, s.v. November 1901, in Denis, 1957, vol. 1, pp. 175-76.

Arrival in Aix of the painter Charles Camoin, stationed there during his stint in the military. He is soon introduced to Cézanne.

Camoin, January 1921, p. 25.

November 16
Cézanne acquires from Joseph Bourquier, for 2,000 francs cash, a small country property and a plot of cultivable land in the vicinity of Les Lauves, to the north of the city.

Land sale records, November 18, 1901, Mortgage Office, Aix-en-Provence.

November 19

Cézanne and Léo Larguier dine together. The painter has just met Pierre Leiris, a young student at the Aix law school.

Cézanne to Aurenche, November 20, 1901, in Cézanne, 1978, p. 277.

November 29

Durand-Ruel buys a Harlequin from Cassirer.

Durand-Ruel Archives, Paris, stock no. 6829.

1902

Early January

Vollard goes to Aix-en-Provence.

Cézanne to Camoin, January 28, 1902, in Cézanne, 1978, p. 280.

January 20

Paul Cézanne *fils* thanks Vollard for sending a case of wine. He tries to locate additional watercolors for an exhibition Vollard wants to organize in his Paris gallery. Apparently this show never took place.

The bouquet of flowers begun by his father (V. 757) is progressing well.

Paul Cézanne *fils* to Vollard, January 20, 1902, in Venturi, January-March 1951, p. 49.

January 23

Cézanne thanks Vollard for a watercolor by Delacroix, *Bouquet of Flowers*, purchased by the dealer at the 1899 Chocquet sale and recently sent to Cézanne. He hangs it in his bedroom. He continues to work on a bouquet of roses intended for the Salon.

Cézanne to Vollard, January 23, 1902, in Cézanne, 1978, pp. 278-79; Bernard, 1925, p. 40.

January 28

Responding to a letter from Camoin, Cézanne expresses reservations about abstract theorizing on painting: "One talks more, in fact, and perhaps better about painting when at the motif than when devising purely speculative theories, which often lead one astray."

He has received news from Monet (letter lost). The painter Louis Leydet, son of his friend the senator from Aix, sends him a postcard.

Cézanne to Camoin, January 28, 1902, in Cézanne, 1978, pp. 279-80.

February 2

Cézanne advises Camoin to make studies in the Louvre "after the great decorative masters, Veronese and Rubens, as you would after nature, something I've only managed to do inadequately." However, he stresses that the most important thing is direct study after nature.

Concerning Vollard, he writes that he "is a sincere man and serious at the same time."

Cézanne to Camoin, February 3, 1902, in Cézanne, 1978, pp. 280-81.

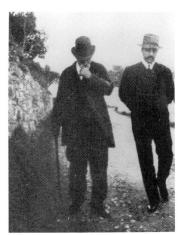

Cézanne and Josse Bernheim-Jeune in Aix-en-Provence, c. 1902, photograph, Bernheim-Jeune Archives.

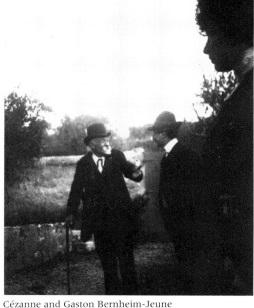

Cézanne and Gaston Bernheim-Jeune in Aix-en-Provence, c. 1902, photograph, Musée d'Orsay, Paris, Vollard Archives.

February 11

Durand-Ruel buys a Cézanne still life from Baron Cochin.

Durand-Ruel Archives, Paris, stock no. 6957.

February/March ?

Cézanne receives a visit from Josse and Gaston Bernheim-Jeune and another dealer with whom his son has done business. But the painter is determined to remain faithful to Vollard, "regretting that my son could have even suggested I might take my canvases to someone else." The Bernheims give some money to a friend of Cézanne's, instructing him to buy several watercolors. He succeeds in obtaining only one for them.

Cézanne to Camoin, March 11, 1902, in Cézanne, 1978, p. 284; Dauberville, 1967, pp. 229-30.

March 10

Cézanne alludes to "cerebral disturbances" *(troubles cérébraux)* that oblige him to work only after the model. He asks Louis Aurenche, in Pierrelatte, not to come to Aix until May, when his wife and son will have left for Paris.

Cézanne to Aurenche, March 10, 1902, in Cézanne, 1978, p. 283; Rewald, 1959, p. 66.

March 11

Construction continues on the studio begun the previous year on Cézanne's plot at Les Lauves.

Cézanne to Camoin, March 11, 1902, and to Vollard, April 2, 1902, in Cézanne, 1978, pp. 285-87.

March 17

At Denis's insistence, he agrees to exhibit at the Salon des Indépendants and asks Vollard to make his canvases available to

Denis. "It seems to me that it's difficult for me to distance myself from the young people who have shown themselves so much in sympathy with me, and I don't think that, by exhibiting, I'll compromise the course of my studies in any way."

Cézanne to Denis, March 17, 1902, and to Vollard, March 17, 1902, in Cézanne, 1978, p. 285.

March 29-May 5

Three paintings by Cézanne—two landscapes (one belonging to M.P.S.) and a still life—are exhibited at the Salon des Indépendants.

Paris, 1902, nos. 321-23; Alexandre, April 1, 1902; A. T., May 1902, p. 85; Klingsor, May 1, 1902, pp. 566-71; Dervaux, June 15, 1902, pp. 740-44; Garnier, 1902, pp. 282-84.

April 2

The bouquet of roses intended for the Salon is not ready.

Cézanne to Vollard, April 2, 1902, in Cézanne, 1978, pp. 286-87.

May 1

Félicien Fagus publishes an article on the Cézanne landscapes exhibited at Vollard's gallery.

Fagus, May 1, 1902, p. 546.

May 12

After having requested that Vollard send one of his paintings to the Société des Amis des Arts d'Aix-en-Provence for an exhibition, Cézanne asks Gasquet to lend *Old Woman with a Rosary* (cat. no. 171), but in the end it is not exhibited.

Cézanne to Vollard (draft), May 10, 1902, and to Joachim Gasquet, May 12, 1902, in Cézanne, 1978, p. 287.

May

Gauguin writes: "M. [Vollard] is crazy about Cézanne: he's right. But it's the same old story now that the pictures are expensive, now that it's considered good taste to understand Cézanne, now that Cézanne is a millionaire!"

Gauguin to Daniel de Monfreid, [May 1902], in Gauguin, 1950, no. 79, p. 192.

June

Two paintings by Cézanne are presented at the fourth exhibition of the Amis des Arts d'Aix-en-Provence: "The Meadow, at the Jas-de-Bouffan (environs of Aix)" and "Still Life." In the catalogue Cézanne identifies himself as a "student of Pissarro."

Aix-en-Provence, 1902, nos. 16 and 16 *bis*; Anonymous, June 22, 1902.

July 8

Cézanne justifies his having failed to visit Gasquet (now living about 10 kilometers from Aix on the Font Laure property in Éguilles), as anticipated in a letter of May 17, by invoking the tenacity with which he works: "I pursue success through work. I have contempt for all living painters except Monet and Renoir, and I want to succeed through work."

Cézanne to Joachim Gasquet, July 8, 1902, in Cézanne, 1978, pp. 288-89.

July 24-26

Louis Aurenche, passing through Aix, visits Cézanne and introduces his wife to him.

Cézanne to Aurenche, July 16, 1902, in Cézanne, 1978, p. 289; Rewald, 1959, pp. 66-67.

September 1

Construction of Cézanne's studio is complete. He settles into it "bit by bit." A few months later, in February 1904, Bernard sees on its walls reproductions of *Romans in the Period of Decadence* by Couture, *Hagar*

in the Desert by Delacroix, a drawing by Daumier, and a Forain. Rivière and Schnerb, who visit the studio early in 1905, also see a photograph of Poussin's *Arcadian Shepherds*.

Cézanne to Paule Conil, September 1, 1902, in Cézanne, 1978, p. 290; Bernard, 1925, p. 23; Rivière and Schnerb, December 25, 1907.

September 26

Cézanne drafts a holograph will, left with Maître Mouravit, naming his son as his sole heir. "Consequently my wife, should she survive me, will have no legal claim on the property that will constitute my estate on the day of my death."

Archives, Tax Bureau, Aix-en-Provence.

September 29

Death of Zola in Paris. Cézanne is very upset.

Vollard, 1914, p. 131.

September

Léo Larguier completes his military service in Aix. In the fall Cézanne visits him in Cévennes with his wife and son.

Mirbeau tries to convince Roujon, Minister of Fine Arts, that Cézanne should be awarded the Legion of Honor. He does not succeed.

Larguier, 1925, pp. 24-27; Vollard, 1914, pp. 139-40.

1903

January-February

Seven paintings by Cézanne are exhibited in the Impressionist exhibition at the Secession in Vienna.

Heilbut, February-March 1903, pp. 169-207; Anonymous, February-March 1903, p. 235, with a reproduction of a Cézanne landscape that was exhibited.

January 9

Cézanne abandons the flower painting in-

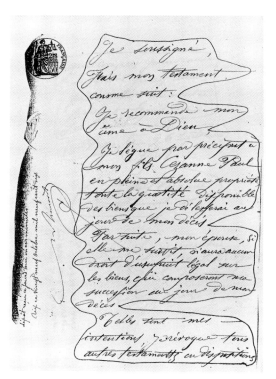

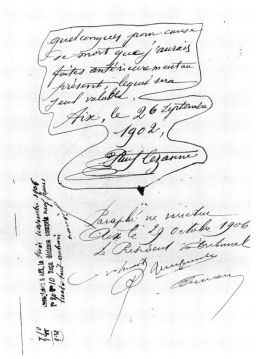

Cézanne's holograph will, 1902, Archives, Tax Bureau, Aix-en-Provence.

The Chemin des Lauves studio in Aix-en-Provence, photograph, collection of Sabine Rewald.

tended for Vollard (V. 757), with which he is dissatisfied.

He is content with his new studio, where he works better than in town. "I work obstinately, I glimpse the Promised Land. Will I be like the great leader of the Hebrews, or will I really penetrate it? . . . I've made some progress. Why so late and so painfully! Is Art, then, a priesthood demanding pure beings who belong to it completely?"

He leads a solitary life: "The Gasquets, the Desmolins are unspeakable, they're a clan of intellectuals, and of what a vintage, good God!"

In a passage from this letter not published by Rewald and withheld by Vollard, Cézanne writes about Geffroy's book *Le Coeur et l'esprit*: "How did such a distinguished critic reach such a point of complete castration of feeling? He's become a businessman." Another unpublished passage indicates that his wife and son are about to leave for Paris.

Cézanne to Vollard, January 9, 1903, in Cézanne, 1978, p. 292, and Vollard Archives, Musée d'Orsay, Paris.

February 22

After confiding his exhaustion to Camoin, Cézanne advises him to visit his son in Paris at 31, rue Ballu, describing Paul as a "great philosopher . . . rather skittish, or indifferent, but a good boy."

Refusing to provide extended theoretical analysis, saying he "must work," he sums up his thoughts in a few phrases: "Everything, especially in art, is theory developed and applied in contact with nature. . . . Nothing but the initial force, that is to say, temperament, can bring a person to the goal he ought to attain."

Cézanne to Camoin, February 22, 1903, in Cézanne, 1978, p. 293, and Vollard Archives, Musée d'Orsay, Paris.

March 9-13

Auction of works of art, furniture, musical instruments, and other items from the Émile Zola estate. Nine canvases by Cézanne are listed in the catalogue: "Nereids and Tritons" (*Nymph and Tritons*, V. 55), "L'Estaque," "Studio Corner" (*A Corner of the Studio*, V. 64), *Paul Alexis Reading to Émile Zola* (V. 118), "Still Life: The Shell" (*The Black Clock*, repro. p. 27), *The Abduction* (cat. no. 12), "Portrait" (*Self-Portrait*, V. 81), "Portrait of a Woman" (*Head of a Woman*, presumed to be Madame Zola, V. 22), and "Still Life" (*Sugar Bowl, Pears, and Blue Cup*, V. 62). Five of the listed works are bought by Auguste Pellerin. The prices range from 600 to 4,200 francs.

On this occasion, Henri Rochefort publishes an article harshly critical of Cézanne: "If M. Cézanne were still being nursed when he committed these garish daubs, we'd have nothing to say, but what are we to think of the leader of a school

who pretended to be the lord of Médan and who nurtured such pictorial insanities? . . . The love of physical and moral ugliness is a passion like any other."

Cézanne tells his son he need not send copies of the article, for several have already arrived.

Sale, Hôtel Drouot, Paris, March 9-13, 1903, nos. 110-18; *Le Diable boîteux*, March 7, 1903; Rochefort, March 9, 1903; *Le Diable boîteux*, March 12, 1903; Anonymous, April 7, 1903, p. 280; Cézanne to his son, [March 1903], in Cézanne, 1978, p. 294.

Spring

Three paintings by Cézanne—a portrait, two women in a garden, and a landscape—are exhibited at the seventh Secessionist exhibition in Berlin.

Berlin, 1903, nos. 35-37; Heilbut, May 1903, pp. 297-311.

May

Exhibition of Impressionist paintings at the Bernheim-Jeune gallery, including the *Portrait of Gustave Geffroy* (cat. no. 172), a landscape, and a still life.

Saunier, 1903, pp. 530-31; Schmidt, June 5, 1903, pp. 444-48.

May 8

Death of Gauguin in Hiva Oa (Marquesas Islands).

June 25

Cézanne thanks Joachim Gasquet for sending his most recent publication, *Chants séculaires*.

Cézanne to Joachim Gasquet, June 25, 1903, in Cézanne, 1978, pp. 294-95.

September

He works on a canvas intended for the exhibition of the Société des Artistes Français. He derisively signs a letter addressed to Gasquet: "P. Cézanne, Roujon's 'bête noire'" (Roujon, the Minister of Fine Arts, had thwarted Mirbeau's efforts to have Cézanne decorated with the Legion of Honor).

Cézanne to Joachim Gasquet, September 5, 1903, in Cézanne, 1978, p. 295.

September 13

He advises Camoin to study the masters in the Louvre but above all to work after nature: "After having seen the masters who repose there, you must hasten out to rejuvenate, through contact with nature, the instincts, the sensations of art that reside in us." He asks him to give his regards to Monet.

His wife and son are in Fontainebleau.

Cézanne to Camoin, September 13, 1903, in Cézanne, 1978, p. 296.

September 25

He congratulates Aurenche on the birth of his son: "You'll see what a stability he will make in your life."

Cézanne to Aurenche, September 25, 1903, in Cézanne, 1978, p. 297.

October 31-December 6

Although not listed in the catalogue, Cézanne exhibits at the Salon d'Automne.

Charles, October 17, 1903; Alexandre, October 31, 1903; Dayot, November 4, 1903; Schmidt, November 27, 1903, pp. 97-102; Fagus, December 1, 1903, pp. 602-6; Golberg, December 15, 1903, pp. 646-50.

November 13

Death of Pissarro in Paris.

1904

January 25

Cézanne confides to Aurenche the importance of an artist's mastering his means of expression: "For if a strong sensation of nature . . . is the necessary basis of every conception of art, one on which a work's future grandeur and beauty rest, knowledge of the means of expressing our emotion is no less essential and is acquired only through long experience."

His meetings with Joachim Gasquet become rare.

Cézanne to Aurenche, January 25, 1904, in Cézanne, 1978, p. 298.

February 4

Bernard, back from Egypt by way of Marseille, visits Cézanne for the first time in Aix, where he remains for a month. He accompanies him to the motifs—Mont Sainte-Victoire, the Château Noir—and works in a room on the ground floor of his studio.

Bernard, 1925, pp. 9-17, 29, 44, 47; Stevens, 1990, p. 103.

February 25-March 29

Nine paintings by Cézanne are exhibited at the Libre Esthétique exhibition in Brussels: "Still Life: Fruit (coll. G. Viau)," "The Bay of Marseille (coll. D. Cochin)," "Still Life (coll. P. Gallimard)," "Antique Idyll (coll. M. Fabre)," "The Fountain (coll. D. Cochin)," "Village Street (coll. P. Gallimard)," "Plate of Fruit (coll. M. Fabre)," "Valley of the Rhône (coll. D. Cochin)," and "Peaches (coll. Mlle Diéterle)."

Brussels, 1904, nos. 13-21; M. S., February 29, 1904; Sedeyn, May 1904, supplement.

March

Together, Cézanne and Bernard visit the museum in Aix-en-Provence. During his stay in the city Bernard takes notes on Cézanne. Twenty-one years later he publishes "Une conversation avec Cézanne," composed of remarks ostensibly made by the painter.

On the eve of Bernard's departure he takes two photographs of the master in his studio with the idea of painting his portrait.

Bernard, 1925, pp. 55, 79-110; Bernard, July 1904, p. 30.

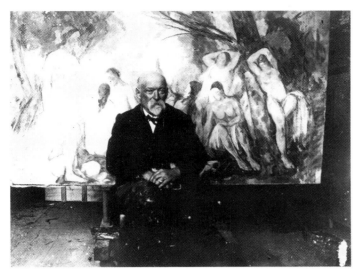

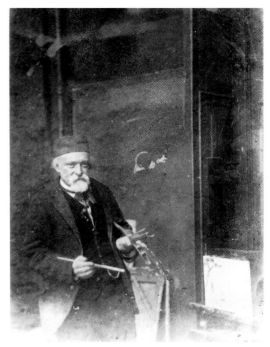

Cézanne in front of *The Large Bathers*
(version at the Barnes Foundation, Merion, Pennsylvania), 1904,
photograph by Émile Bernard, Musée d'Orsay, Paris, Vollard Archives.

Cézanne, c. 1904,
photograph by Émile Bernard,
Musée d'Orsay, Paris, Vollard Archives.

March 2
Vollard places on deposit at the Galerie Bernheim-Jeune thirteen pictures by Cézanne, of which one is not for sale.

Vollard Archives, Musée du Louvre, Bibliothèque Centrale et Archives des Musées Nationaux, Paris, 421 (4,1) 58.

March 11
Vollard places three Cézannes on consignment with Bernheim-Jeune: the still life "Flowers and Fruit" (6,000 francs) and two paintings of Mont Sainte-Victoire (6,000 and 5,000 francs).

Vollard Archives, Musée du Louvre, Bibliothèque Centrale et Archives des Musées Nationaux, Paris, 421 (4,1) 56.

April 15
Cézanne advises Bernard to "treat nature by means of the cylinder, the sphere, the cone, with everything put in perspective so that each side of an object or a plane is directed toward a central point. Lines parallel to the horizon convey the extent of a section of nature, or if you prefer, of the spectacle that the *Pater Omnipotens Aeterne Deus* spreads out before our eyes. Lines perpendicular to this horizon convey depth. Now nature, for us men, is more depth than surface, hence the need to introduce into our vibrations of light, represented by reds and yellows, a sufficient amount of blue, to make the air palpable."

Cézanne to Bernard, April 15, 1904, in Cézanne, 1978, p. 300.

April-June
Exhibition of works by Cézanne at the Galerie Paul Cassirer in Berlin.

Anonymous, April 29, 1904, p. 382; Heilbut, June 1904, p. 378; Meier-Graefe, June 1904, pp. 378-79; Rosenhagen, June 1, 1904, pp. 401-3.

Spring?
Roger Marx hopes to have a canvas by Cézanne accepted by the jury of the Univer-

Cézanne sitting among ferns, c. 1905,
photograph probably taken at Fontainebleau,
Musée d'Orsay, Paris.

sal Exposition in St. Louis, Missouri, and to have the painter decorated on this occasion with the Legion of Honor by the Ministry of Commerce and Industry. Vollard submits *My Garden*, which had been exhibited at the 1900 Exposition Centennale de l'Art Français, but the painting is refused.

Vollard, 1914, p. 146.

May 12
Cézanne writes Bernard that Redon's talent pleases him and that he shares his enthusiasm for Delacroix, whose apotheosis he still hopes to paint. He warns the young artist against "the literary cast of mind, which so often makes painters stray from the true path—the concrete study of nature—and waste too much time on in-

tangible speculations." He thanks Bernard for sending his book, *La Décadence du beau*, and authorizes him to forward Vollard a photograph of himself as requested.

Cézanne to Bernard, May 12, 1904, in Cézanne, 1978, pp. 301-2; Bernard, 1925, pp. 43-44, 58 n. 1.

May 26
In principle, he approves of the content of an article by Bernard to be published in *L'Occident*, but he remarks: "Chatter about art is almost useless."

Cézanne to Bernard (signed "*Pictor* P. Cézanne"), May 26, 1904, in Cézanne, 1978, p. 302.

May
Gabriel Mourey, director of *Arts de la vie*, launches a subscription for the purchase of Rodin's *Thinker* for donation to the French State, intending that it be installed in Paris. According to Vollard, Cézanne participates because Rodin, in an open letter, had expressed regret about there being no Dreyfusard subscribers. No trace of Cézanne's contribution has been located.

Vollard, 1914, p. 115; Cézanne to Geffroy, [1904], in Cézanne, 1978, p. 309; Anonymous, June-November, 1904; Mirbeau, 1988, p. 221 n. 5.

June 1-18
First Matisse exhibition at the Vollard gallery.

Paris, 1904 (a).

June 27
Cézanne again complains of "cerebral disturbances that prevent me from moving about freely." His son is in Paris at 16, rue

Duperré; he has attended a "soirée dans-ante" given by Vollard to which were invited "the entire young school . . . Maurice Denis, Vuillard, etc., . . . and Joachim Gasquet." Cézanne disapproves of such diversions. He advises Bernard to "work hard."

Young Paul Cézanne rents a house in Fontainebleau for two months.

Cézanne to Bernard, June 27, 1904, in Cézanne, 1978, pp. 303-4.

July

Bernard's article "Paul Cézanne" appears in *L'Occident*. Cézanne, who has received the issue, thanks him. He advises the young painter to look above all at the Venetians and the Spaniards, whom he considers the greatest artists.

Bernard, July 1904, pp. 17-30; Cézanne to Bernard, July 25, 1904, in Cézanne, 1978, p. 304.

July 27

Last letter from Cézanne to Joachim Gasquet.

Cézanne to Joachim Gasquet, July 27, 1904, in Cézanne, 1978, p. 305.

September 24

He offers to pose the following Sunday for a life-size clay bust of him being modeled by Philippe Solari.

Cézanne to Solari, September 24 [1904], in Cézanne, 1978, p. 306.

October 3

Vollard sends several Cézanne canvases to Cassirer in Berlin.

Vollard to Cassirer, October 3, 1904, Vollard Archives, Musée du Louvre, Bibliothèque Centrale et Archives des Musées Nationaux, Paris, 421 (4,1) 78.

October 11

Cézanne agrees to receive Gaston Bernheim-Jeune (de Villers) of the Galerie Bernheim-Jeune, "if all I have to do is explicate my theories for you and explain the aim I've pursued constantly my whole

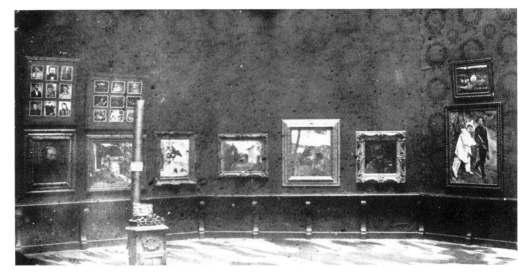

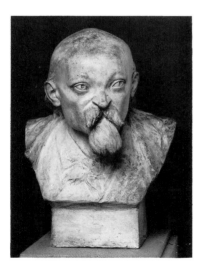

Philippe Solari, *Bust of Cézanne*, 1904-5, plaster, Musée d'Orsay, Paris.

life." He refuses to be unfaithful to Vollard.

Cézanne to Gaston Bernheim-Jeune (de Villers), October 11, 1904, in Cézanne, 1978, pp. 306-7.

October 15-November 15

At the second Salon d'Automne in Paris, an entire room is devoted to his work: thirty-one paintings and two drawings. The artist is listed in the catalogue as one of the Salon's founding members.

Paris, 1904 (b), nos. 1-33; Vauxcelles, September 15, 1904; Anonymous, October 1904; Desies, October 2, 1904; Alexandre, October 14, 1904; Babin, October 14, 1904; Bettex, October 14, 1904; Fourcaud, October 14, 1904; Fouquier, October 14, 1904; Valensol, October 14, 1904; Vauxcelles, October 14, 1904; A. M., October 15, 1904; Anonymous, October 15, 1904; Ponsonailhe, October 15, 1904; Vauxcelles, October 15, 1904; C.I.B., October 17, 1904; Le Senne, October 18, 1904; Boissard, October 22, 1904; Péladan, October 22, 1904, pp. 446-56; Benedict, October 25, 1904, p. 135; Hamel, November 1904, pp. 33-34; Horus, November 1904; Sarradin, November 4, 1904; Schmidt, November 4, 1904, pp. 54-58; Bouyer, November 5, 1904, pp. 601-5; Brahm, November 5-20, 1904, pp. 76-79; Norval, November 13, 1904; Le Say, November 14, 1904; Guérin, December 1904, pp. 309-14; Holzamer, December 1904, pp. 177-78; Marx, December 1904, pp. 458-74; Mauclair, December

1904, pp. 222-30; Solrac, December 6, 1904, pp. 303-11; Vauxcelles, December 21, 1904; Vauxcelles, March 18, 1905.

October-November

Exhibition of Impressionist works at the Emil Richter gallery in Dresden, including at least one Cézanne.

Rewald, 1986, p. 270.

November 11

Paul Cézanne *fils* thanks Vollard for sending a 2,000-franc money order. He adds: "My father is enchanted with his success at the Salon d'Automne and owes you heartfelt thanks for the care you took with his exhibition." He asks Vollard to send his father photographs of all four walls of the room of his works. Vollard is also going to send Paul *fils* some photographs of his father's paintings and asks that he specify their dates, sites, and "nature." He expects to return to Paris early in December with "the results of this little project."

Cézanne works on a canvas of Bathers, a portrait of an old poacher, and some landscapes. He also paints some watercolors.

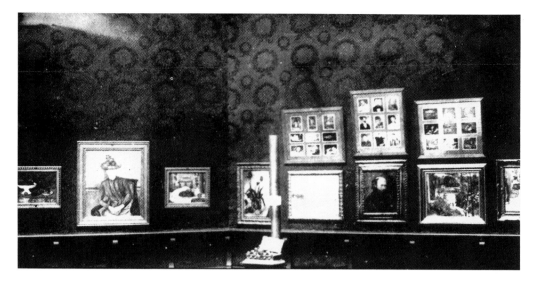

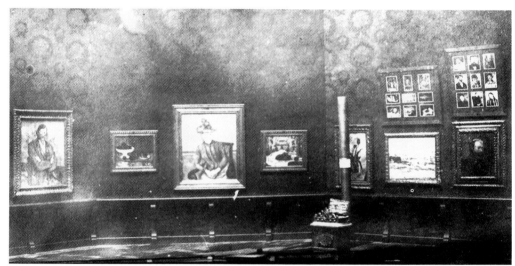

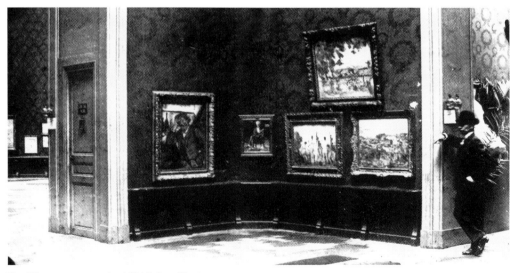

The Cézanne room at the 1904 Salon d'Automne,
photographs by Ambroise Vollard,
Musée d'Orsay, Paris, Vollard Archives.

Paul Cézanne *fils* to Vollard, November 11, 1904, in
Venturi, January-March 1951, p. 49.

November 30
Mary Cassatt is delighted by Cézanne's
success at the Salon d'Automne.

Mary Cassatt to Duret, November 30 [1904], in
Mathews, 1984, p. 295.

December 5
Responding to Julie Pissarro, who has re-
quested information about prices for
contemporary pictures, Monet writes:
"Another thing I've noticed is the general
enthusiasm for Cézannes, which you
should surrender only for good prices."

Monet to Julie Pissarro, December 5, 1904, in Wil-
denstein, 1974-85, vol. 4, no. 1749, p. 367.

December 9
Cézanne invites Camoin, in Martigues, to
work at the motif with him. He says he
should come directly to his studio, where,
since the summer, he has had lunch
brought at 11 o'clock prior to departing
for the motif, weather permitting, until
5:00 p.m. He encourages him to be wary
of the influence of other painters. Francis
Jourdain accompanies Camoin to Aix.

Cézanne to Camoin, December 9, 1904, in Cé-
zanne, 1978, p. 307; Bernard, 1925, p. 20; Jour-
dain, 1950, pp. 8-11.

December 15
Cézanne is mentioned and one of his
landscapes reproduced in an article by
Adolf Hölzel, "Über künstlerische Aus-
drucksmittel und deren Verhältnis zu
Natur und Bild" (The Means of Artistic
Expression and Their Relation to Nature
and Image).

Hölzel, December 15, 1904, pp. 121-42.

December 23
Cézanne writes to Bernard in Naples and
endorses his admiration for Tintoretto,
"the most valiant of the Venetians."
 His wife and son are in Paris.

Cézanne to Bernard, December 23, 1904, in Cé-
zanne, 1978, pp. 308-9.

He thanks Jean Royère for his *Poèmes
eurythmiques.*

Cézanne to Royère, [1904], in Cézanne, 1978,
p. 309.

Publication in Paris of Camille Mauclair's
book *L'Impressionnisme: Son histoire, son es-
thétique, ses maîtres*; in Stuttgart of Julius
Meier-Graefe's *Entwicklungsgeschichte der
modernen Kunst* (History of the Develop-
ment of Modern Art), which includes a
chapter on Cézanne; and in London of
Wynford Dewhurst's *Impressionist Painting:
Its Genesis and Development*, whose second
chapter is entitled "'The Forerunners':
Jongkind, Boudin, and Cézanne."

1905

January
The painters Rivière and Schnerb visit Cézanne in Aix. Two years later they publish an account of their meeting in the studio.

Rivière and Schnerb, December 25, 1907.

January 5
Camoin wants to go to Aix; Cézanne conveys information about rooms to let.

Cézanne to Camoin, January 5, 1905, in Cézanne, 1978, p. 310.

January 10
Despite the success of his paintings, he "works all the time, and without worrying about criticism and critics, which is what a true artist should do. Work must prove me right."

Cézanne to Aurenche, January 10, 1905, in Cézanne, 1978, p. 310.

January 17
He thanks Louis Leydet, the son of his friend the senator, for his greeting and expresses his hope to "manage to formulate sufficiently the sensations we experience in contact with this beautiful nature, man, woman, still life."

Cézanne to Leydet, January 17, 1905, in Cézanne, 1978, p. 311.

January 23
He thanks Roger Marx for his articles in the *Gazette des Beaux-Arts*. "My age and my health will never allow me to realize the dream of art I've pursued my whole life. But I will always be grateful to the public of intelligent art-lovers who—through my hesitations—have had an intuition of what I wanted to attempt to renew my art. In my thought one doesn't replace the past, one only adds a new link to it. Along with a painter's temperament and an artistic ideal, in other words a conception of nature, sufficient means of expression are necessary to be intelligible to the average public and occupy a suitable rank in the history of art."

Cézanne to Marx, January 23, 1905, in Cézanne, 1978, pp. 311-12.

January-February
Ten paintings by Cézanne are presented at a group exhibition (Boudin, Cézanne, Degas, Manet, Monet, Morisot, Pissarro, Renoir, Sisley) organized by Durand-Ruel at the Grafton Galleries in London.

London, 1905, nos. 39-48.

March 18
Louis Vauxcelles publishes an important article on Cézanne.

Vauxcelles, March 18, 1905.

Hortense Fiquet Cézanne, c. 1905, photograph, Musée d'Orsay, Paris, Service de documentation.

Late March
Bernard, back from Naples, visits Cézanne in Aix. He meets his wife and son. Cézanne travels with him to Marseille, where Bernard takes the train to Paris. They never see one another again.

Bernard, 1925, pp. 62-64.

April 20
Paul Cézanne *fils* has received five albums of photographs from Vollard, probably of works by his father. The dealer has purchased some Cézanne watercolors and drawings that were at the framer's and plans to organize an exhibition. The artist's son instructs him not to sell the still lifes on consignment, as his father has not yet decided to give them up. He sends him the list "of a collection of good pictures, more or less authentic, that can be had cheaply."

Paul Cézanne *fils* to Vollard, April 20, 1905, in Venturi, January-March 1951, p. 50.

May 12
Durand-Ruel acquires *Village by the Sea* from Baron Cochin.

Durand-Ruel Archives, Paris, stock no. 7906.

June
A Cézanne still life is shown at a group exhibition at the Galerie Paul Cassirer in Berlin.

Rosenhagen, June 15, 1905, pp. 436-38.

Vollard mounts an exhibition of Cézanne watercolors in his gallery.

Morice, July 1, 1905; Denis, November 15, 1905, pp. 309-19.

Summer
Cézanne works at Fontainebleau, where he is staying at 8, rue de la Coudre. He asks his paint dealer to send him materials.

Cézanne to a paint dealer, July 6, 1905, in Cézanne, 1978, p. 313; Cézanne to a paint dealer, July 14, 1905, Chevassu collection sale, Hôtel Drouot, Paris, October 23-24, 1980, lot 51.

August 1 and 15, September 1
Charles Morice publishes "Enquête sur les tendances actuelles des arts plastiques" (Investigation of Current Trends in the Plastic Arts) in which artists are asked to answer the question: "What do you think of Cézanne?"

Morice, August 1 and 15, and September 1, 1905, pp. 346-59, 538-55, 61-85.

September 10
Madame Cézanne authorizes Bernard to publish photographs of works by her husband in a book on the Midi. She lets him select six (?) drawings by Cézanne to augment others he already owns. She complains of the work involved in organizing exhibitions of her husband's work.

Hortense Cézanne to Bernard, September 10, 1905, Vollard Archives, Musée d'Orsay, Paris.

October 1 and 16
Bernard publishes "Souvenirs sur Paul Cézanne."

Bernard, October 1 and 16, 1905, pp. 385-404, 606-27.

October 18-November 25
Ten paintings by Cézanne are exhibited at the Salon d'Automne in Paris.

Paris, 1905, nos. 314-23; Sarradin, October 5, 1905; Alexandre, October 17, 1905; Anonymous, October 17, 1905; Babin, October 17, 1905; Bettex, October 17, 1905; Charles, October 17, 1905; Ferry, October 17, 1905; Geffroy, October 17, 1905; Vauxcelles, October 17, 1905; Veber, October 17, 1905, p. 7; Anonymous (1), October 18, 1905; Anonymous (2), October 18, 1905; d'Anner, October 18, 1905; Vauxcelles, October 18, 1905; Anonymous, October 19, 1905; Mauclair, October 21, 1905, pp. 521-25; Bernard, October 25, 1905; Asselin, October 26, 1905; Anonymous, October 28, 1905; Péladan, October 28, 1905, pp. 455-73; Lestrange, November 5, 1905; Saint-Hilaire, November 11, 1905; Mauclair, December 1905, pp. 198-210; Saunier, December 1905, pp. 625-29; Morice, December 1, 1905, pp. 376-93; Mauclair, December 15, 1905, pp. 506-23.

October 23
In a letter to Bernard, Cézanne discusses some of his ideas about art and declares to him: "I owe you the truth in painting and I will tell it to you."

Cézanne to Bernard, October 23, 1905, in Cézanne, 1978, pp. 314-15.

December
A painting of apples by Cézanne is included in an exhibition of still lifes at the Keller and Reiner gallery in Berlin.

Anonymous, December 15, 1905, p. 140.

As a follow-up to Morice's questionnaires for his investigation of current trends, Pierre Hepp publishes an article discussing the new generation's admiration for Cézanne.

Hepp, December 1905, pp. 263-65.

In an article entitled "Un après-midi chez Claude Monet," Vauxcelles reports that Monet "admires him greatly, takes him for

a contemporary master." According to Monet, Cézanne cannot bear to hear Gauguin's name mentioned: "That Gauguin, I'll wring his neck."

Several Cézannes are hanging in the painter's bedroom: *The Negro Scipion* (cat. no. 11), a still life with apples, and a landscape of L'Estaque. According to Geffroy, Monet owns no fewer than a dozen Cézannes: V. 100, V. 102, V. 295, V. 329, V. 336. V. 581, V. 599, V. 680, V. 733, V. 735, V. 756, and V. 794.

Vauxcelles, December 1905, pp. 88-89; Geffroy, 1922, p. 331.

Hermann-Paul paints Cézanne's portrait (Musée Granet, Aix-en-Provence). At the end of the year Vollard goes to Aix.

Vollard, 1914, pp. 147-48.

1906

In the course of the year Vollard sells many paintings by Cézanne.

Vollard record-book, 1906, Vollard Archives, Musée du Louvre, Bibliothèque Centrale et Archives des Musées Nationaux, Paris.

Late January

Maurice Denis travels to Provence with Ker-Xavier Roussel. They pass through Aix, visit the Jas de Bouffan, and find Cézanne after Mass at the cathedral of Saint-Sauveur. They then visit his studio and accompany him to the motif (Mont Sainte-Victoire). Cézanne confides to them: "I have no doctrine like Bernard, but theories are necessary. Nature, I wanted to copy it, I didn't succeed."

Denis, journal entry, s.v. January 26, 1906, and Denis to Marthe Denis, January 28, 1906, in Denis, 1957, vol. 2, pp. 28-30.

January 22

Schnerb goes to Druet's gallery with Moreau-Nélaton to see paintings by Cézanne.

Adhémar, April 1982, pp. 148-49.

Mid-February-mid-April

Two landscapes by Cézanne—including the one in the collection of the Nationalgalerie, Berlin—are exhibited at the Kunstverein in Bremen.

Bremen, 1906, nos. 34, 35; Anonymous, January 15, 1906, p. 192.

February 19

The Prince de Wagram buys a Cézanne painting from Vollard, a copy of *Hagar in the Desert* after Delacroix.

Vollard to the Prince de Wagram, January 4, 1907, Vollard Archives, Musée du Louvre, Bibliothèque Centrale et Archives des Musées Nationaux, Paris, 421 (4,1) 104.

February 20-March 14

Paul Cassirer includes a Cézanne landscape, *Village by the Sea*, in a group exhibition in his gallery.

Berlin, 1906, no. 10; Anonymous, April 1, 1906, pp. 306-8.

February 22

Cézanne thanks Roussel for sending Delacroix's *Journal*: "I accept it with the greatest pleasure, for reading it will provide further confirmation, I hope, of my feelings about the truth of some of my researches into nature."

Cézanne to Roussel, February 22, 1906, in Rewald, 1989, p. 108, ill. 61.

March

Bernard, signing himself Francis Lepeseur, writes an article in response to the article by Hepp, "Sur le choix d'un maître," denigrating Cézanne.

Bernard, March 1906, pp. 253-59.

Vollard exhibits a dozen paintings by Cézanne in his gallery, according to Rewald.

Rewald, 1986 (a), p. 270.

March 7

Paul Cézanne *fils* asks Vollard to send a painting by his father to an exhibition of modern art sponsored by an organization of Provençal artists in Marseille.

Paul Cézanne *fils* to Vollard, March 7, 1906, in Venturi, January-March 1951, p. 50.

March 9

Death of Henri Gasquet.

March 16

Paul Cézanne *fils* writes Vollard acknowledging receipt of 6,000 francs in payment for two still lifes by his father in his gallery since March 2, 1905. His father is not doing too badly, but "he's lost a good month's work, bothered by snow and wind and then by an onset of the flu."

Paul Cézanne *fils* to Vollard, March 16, 1906, in Venturi, January-March 1951, p. 50.

April 13

The German collector Karl Ernst Osthaus visits Cézanne in Aix. He then buys two paintings, *The House at Bellevue and the Dovecote* (V. 651) and *Bibémus Quarry* (cat. no. 149), for the Folkwang Museum.

Osthaus, 1920-21, pp. 81-85.

May

"Exhibition of French Impressionist Paintings" at the Kaiser Friedrich Museum in Posen (Poznań), consisting of thirty paintings by Cézanne, Courbet, Van Gogh, Monet, Pissarro, Renoir, and Sisley.

Anonymous, May 25, 1906, p. 411; Anonymous, July 1, 1906, pp. 454-55.

May 27

Cézanne attends the dedication of a bust of Zola by Solari at the Bibliothèque Méjanes in Aix-en-Provence.

Baligand, 1978, p. 184 n. 1.

May 30

The Prince de Wagram buys eleven Cézanne paintings from Vollard. The latter

invites him to come and see "new Cézannes" in his gallery.

Vollard to the Prince de Wagram, June 11, 1906, Vollard Archives, Musée du Louvre, Bibliothèque Centrale et Archives des Musées Nationaux, Paris, 421 (4,1) 95.

Summer ?

Cézanne exhibits a "Château du Diable" at the fifth exhibition of the Société des Amis des Arts d'Aix-en-Provence. He is listed in the supplement to the catalogue as "student of Pissarro" and "hors concours."

Aix-en-Provence, 1906, no. 310.

June 13

Monet asks Durand-Ruel to send Vollard 2,500 francs for a Cézanne he has bought from him.

Monet to Durand-Ruel, June 13, 1906, in Wildenstein, 1974-85, vol. 4, no. 1805, p. 370.

June 25

The Prince de Wagram buys five more Cézannes from Vollard.

Vollard to the Prince de Wagram, August 2, 1906, Vollard Archives, Musée du Louvre, Bibliothèque Centrale et Archives des Musées Nationaux, Paris, 421 (4,1) 97.

July

The summer is very hot. Cézanne works at the motif beginning at dawn. After eight o'clock "the heat becomes stupefying and so affects my mind that I don't even think about painting any more."

His wife and son are in Paris.

Cézanne to his son, July [20], and August 3, 1906, in Cézanne, 1978, pp. 316, 318-19.

July 24

Having been disturbed by the abbé Roux while painting, he announces that he has no intention of keeping his promise to visit him at the Catholic college.

Cézanne to his son, July 24 and 25, 1906, in Cézanne, 1978, p. 317.

July 25

Hortense Cézanne is ill. Cézanne asks his son to take good care of her and to seek "the well-being, coolness, and diversions appropriate to the circumstances." He himself is ill from his diabetes. His gardener, Vallier, massages him. He is undergoing an "atrocious" regimen of treatment.

Cézanne to his son, July 25, 1906, in Cézanne, 1978, p. 317.

August 3

Ill with bronchitis, he decides to abandon homeopathic treatment and consult Dr. Guillaumont.

His son is actively promoting his work: "I am happy to learn about the good relations between you and the artistic intermediaries with the public, whom I wish to see continue in these good intentions toward me."

Forain and Léon Dierx send him their regards. Cézanne responds by evoking the dinners at Nina de Villard's they all attended in the late 1870s.

Cézanne to his son, August 3, 1906, in Cézanne, 1978, pp. 318-19.

August 12

Overcome and exasperated by pain, he lives in isolation. He stops going to Mass at Saint-Sauveur because he does not like the way the new abbé plays the organ. He criticizes the Catholic Church. After describing the abbé Roux as a "blackfrock" and "poisonous" (twice), he declares: "I think that to be Catholic you have to be without any feeling for what's right ['sentiment de justesse,' a punning reference to mistakes on the organ] but have an eye out for your own interests."

Cézanne to his son, July 24 and 25, August 12, 1906, in Cézanne, 1978, pp. 317, 320.

August-September

He works every late afternoon on the banks of the Arc, at the Trois Sautets bridge and the spot known as the Gour de Martelly, where he watches the cows and sheep that come to drink there in the evening. He also works on landscapes: "The same subject seen from a different angle offers a subject for study of the most compelling interest, and so varied that I think I could keep myself busy for months without changing my position, moving now more to the right, now more to the left." On these excursions he leaves his materials with a man named Bossy.

Cézanne to his son, August 14, September 2, 8, and 26, 1906, in Cézanne, 1978, pp. 321, 323-24, 329.

August 26 ?

The heat, which is still oppressive, weakens him: "I live a bit as if in a void. Painting is what matters most to me."

Cézanne to his son, August [26], 1906, in Cézanne, 1978, p. 322.

September 13

Cézanne assesses Baudelaire as an art critic: "One who's strong is Baudelaire, his *Art romantique* is amazing, and he's not mistaken about the artists he likes." Cézanne pays particular attention to the poet's writing about Delacroix.

Cézanne to his son, September 13 and 28, 1906, in Cézanne, 1978, pp. 326, 329.

September 21

He sends a last letter to Bernard: "Will I reach the goal so long sought-after, so long pursued? . . . having realized something more developed than in the past, and thereby proving the theories." He continues his work and his quest, having sworn to die painting.

Cézanne to Bernard, September 21, 1906, in Cézanne, 1978, pp. 326-27.

The banks of the Arc River, c. 1870, photograph by Claude Gondran, Bibliothèque Méjanes, Aix-en-Provence.

The Pont des Trois Sautets over the Arc River, photograph by Claude Gondran, c. 1870, Bibliothèque Méjanes, Aix-en-Provence.

First purchase by Gaston and Josse Bernheim-Jeune of a painting by Cézanne, "The Little Smoker" (probably *Man with a Pipe*, V. 563), from Vollard.

Bernheim-Jeune Archives, Paris, stock no. 15.116.

September 22

He still suffers from "troubles cérébraux," or headaches, and relies on his son to look after his affairs.

Cézanne to his son, September 22, 1906, in Cézanne, 1978, pp. 327-28.

September 25

Camoin, who spends a few days in Aix, visits him and shows him his work. Cézanne criticizes Bernard's painting, which he finds overly intellectual and "congested" by memories of the museums.

Cézanne to his son, September 26, 1906, in Cézanne, 1978, p. 328.

September 26

He has just learned that eight of his canvases are to be exhibited at the Salon d'Automne. In fact, ten will be shown.

Cézanne to his son, September 26, 1906, in Cézanne, 1978, p. 328.

September 28

He remains wary of the world around him: "I should remain alone, people's cunning is such that I can't get away from it, it's theft, conceit, infatuation, rape, seizure of your production, and yet nature is very beautiful."

Cézanne to his son, September 28, 1906, in Cézanne, 1978, p. 329.

October 6-November 15

Ten paintings by Cézanne are exhibited at the Salon d'Automne.

Paris, 1906, nos. 317-26; Alexandre, October 5, 1906; Bettex, October 5, 1906; Vauxcelles, October 5, 1906; Veber, October 5, 1906; Dauzats, October 6, 1906; Charles, October 7, 1906; Bernard, November 1906, pp. 26-29; Guillemot, November 1906, pp. 296-308; Mauclair, November 1906, pp. 141-52; Rambosson, November 1906, pp. 161-76; Morice, November 1, 1906, pp. 34-48; Kahn, November 15, 1906, pp. 368-71; Leclère, November 15, 1906, pp. 371-74; Royère, November 15, 1906, pp. 375-82; Vauxcelles, November 22, 1906; Jamot, December 1906, pp. 456-84.

October 7

He spends his late afternoons in the Café des Deux Garçons with friends from Aix: Capdeville, the painter Niollon, Fernand Bouteille, and others.

Cézanne to his son, October 8, 1906, in Cézanne, 1978, p. 330.

Mid-October

The weather has turned cool and stormy, and he abandons the banks of the Arc to work in the Beauregard quarter, where he paints some watercolors. He is looking for a place nearby to keep the heavier painting materials he needs to work in oil.

Cézanne to his son, October 13, 1906, in Cézanne, 1978, p. 331.

October 15

He orders two dozen brushes through his son.

He reflects on young painters: "I think the young painters are much more intelligent than the others, the old ones see in me only a disastrous rival."

Cézanne to his son, October 15, 1906, in Cézanne, 1978, p. 332.

He collapses and remains in the rain for several hours. He is brought home in a laundry cart. The next day he goes to his studio to work on the portrait of Vallier, then returns home seriously ill. He settles down to work in his wife's dressing room.

Marie Cézanne to Paul Cézanne *fils*, October 20, 1906, in Cézanne, 1978, pp. 333-34.

October 17

Cézanne complains to his paint dealer about not having received what he had ordered eight days earlier. This is Cézanne's last known letter.

Cézanne to a paint dealer, October 17, 1906, in Cézanne, 1978, p. 333.

October 18

Schnerb goes to Vollard's gallery, where he sees the dealer's portrait by Cézanne: "very complete, very solid . . . *What modern painting can be hung at its side?*"

Adhémar, April 1982, p. 149.

October 19

Gaston and Josse Bernheim-Jeune buy a Cézanne landscape from Cassirer.

Bernheim-Jeune Archives, Paris, stock no. 15.152.

October 20

Marie Cézanne asks her nephew to come

to his father's side as quickly as possible.

Marie Cézanne to Paul Cézanne *fils*, October 20, 1906, in Cézanne, 1978, pp. 333-34.

October 22

Cézanne's housekeeper, Madame Brémond, telegraphs the painter's son that his father is seriously ill. Madame Cézanne and Paul arrive too late.

Cézanne is given last rites.

Cézanne, 1978, p. 334; Andersen, June 1965, p. 313.

October 23

Cézanne dies at 7:00 a.m. at his home, 23, rue Boulegon. The funeral is held the next day in the cathedral of Saint-Sauveur.

Death certificate, Archives, Hôtel de Ville, Aix-en-Provence; register of the cathedral of Saint-Sauveur, Archdiocesan Archives, Aix-en-Provence, no. 98 (Cézanne is erroneously identified as "husband Aubert," his mother's family name).

October 25

Vollard announces Cézanne's death to Louis Vauxcelles.

Telegram, sale, Hôtel Drouot, Paris, June 10, 1974, lot 9.

Many obituaries are published.

Anonymous, October 24, 1906; Alexandre, October 25, 1906; Anonymous (1), October 25, 1906; Anonymous (2), October 25, 1906; Ferry, October 25, 1906; Thiébault-Sisson, October 25, 1906; Vauxcelles, October 25, 1906; Anonymous, October 30, 1906; Evelyne, October 30, 1906; Guillemot, November 1906; Mauclair, November 1906; Anonymous, November 2, 1906, p. 54; Anonymous, November 3, 1906, p. 268; J.-F.-S., November 3, 1906, pp. 293-94; Fagus, November 11, 1906; Anonymous, December 1, 1906, p. 128.

October 27

Gaston and Josse Bernheim-Jeune buy a watercolor, "Landscape," from Vollard.

Bernheim-Jeune Archives, Paris, stock no. 15.178.

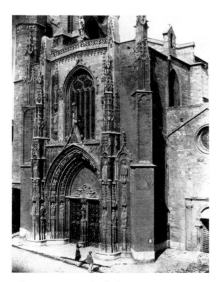

Saint-Sauveur Cathedral in Aix-en-Provence, photograph by Claude Gondran, c. 1870, Bibliothèque Méjanes, Aix-en-Provence.

Cézanne's tomb in the cemetery of Aix-en-Provence.

October 29

Unsealing of the painter's will, left with Maître Mouravit on September 26, 1902.

Minutes, Clerk's Office, Lower Civil Court, Aix-en-Provence.

November 3

Gaston and Josse Bernheim-Jeune buy a Cézanne watercolor of flowers from Auguste Pellerin.

Bernheim-Jeune Archives, Paris, stock no. 15.185.

November 9 and 12

The Prince de Wagram buys several Cézanne paintings and a watercolor from Vollard.

Vollard to the Prince de Wagram, November 22, 1906, Vollard Archives, Musée du Louvre, Bibliothèque Centrale et Archives des Musées Nationaux, Paris, 421 (4,1) 101-2 and 105-6.

November 20

Paul Cézanne *fils* is his father's sole heir. Hortense Cézanne surrenders her life interest in the rural property (the Les Lauves studio), owned by the couple in common.

Minutes of sale by auction, no. 525, Archives, Lower Civil Court, Aix-en-Provence.

November 27

At the request of Bernard, a mass is celebrated "for the repose of the soul of the master painter Paul Cézanne" at Notre-Dame-de-Lorette in Paris.

Paris, 1980-81, document no. 73.

November 28

An estate inventory is drawn up at the painter's domicile by Maître Mouravit. Lucien Exel, Aix assessor, with the assistance of Henri Poitier, director of the museum in the city, estimates the total value of the paintings at 5,800 francs. As an indicator of their valuation scale, the *Large Bathers* (cat. no. 219) is assigned a value of 300 francs. Other paintings sold during the painter's lifetime and after his death

are assigned an aggregate value of 24,500 francs.

Registry of public civil actions and inventory minutes, no. 542, Archives, Lower Civil Court, Aix-en-Provence.

December 10

Distribution, to his son's sole benefit, of Cézanne's estate, which consists of furnishings valued on January 30, 1902, at 12,000 francs, the works described in the inventory of Maître Mouravit and valued at 5,800 francs, a sum of 24,500 francs resulting from the sale of other works, a 2,600-franc annuity, a sum of 650 francs representing a disbursement from said annuity for the trimester ending October 1, 1906, a certificate for 118 shares in the Paris-Lyon-Mediterranean railroad "emprunt Victor Emmanuel 1862" worth 51,280 francs, a certificate for 199 shares in the P.L.M. railroad "emprunt Victor Emmanuel 1862" worth 85,172 francs, a certificate for 74 shares in the P.L.M. railroad worth 32,042 francs, a certificate for 150 shares in the P.L.M. railroad, worth 493.75 francs each, and for 149 others worth 64,889.50 francs (435.50 francs each), a certificate for 200 P.L.M. shares worth 87,100 francs and a certificate for 60 shares in the Northern Railway worth 27,240 francs, a small rural property (the Les Lauves studio) worth 5,000 francs, and the sum of 25,000 francs deposited with Maître Mouravit and representing one-third of the sale price of the Jas de Bouffan. The aggregate value of the estate is 248,001.31 francs.

Declaration of title transfer on the death of Paul Cézanne, December 10, 1906, Archives, Tax Bureau, Aix-en-Provence.

Théodore Duret publishes *L'Histoire des peintres impressionnistes*, which includes a chapter devoted to Cézanne. A German translation of this chapter appears in the magazine *Kunst und Künstler*, followed by a corrigendum.

Anonymous, December 1906, pp. 93-104; Anonymous, February 1907, p. 212.

Cézanne's Collectors

From Zola to Annenberg

by Walter Feilchenfeldt

Dedicated to Jayne Warman,
John Rewald's longtime assistant,
without whom his life's work, the catalogue raisonné of
Cézanne's paintings, could never have reached completion.

This text is divided into three sections during Cézanne's lifetime (1860-74, 1874-93, and 1893-1906) and three sections after his death (1906-14, 1914-39, 1939-95). Within these sections, the collectors of paintings, including several dealers with private collections, are listed chronologically, according to when they began acquiring Cézanne's work.

This work is based on information from the forthcoming publication *The Paintings of Paul Cézanne: A Catalogue Raisonné,* by John Rewald, and his previous books and articles, particularly *Studies in Impressionism* (New York, 1985), *Studies in Post-Impressionism* (New York, 1986), *Cézanne and America: Dealers, Collectors, Artists, and Critics, 1891-1921* (Princeton, N.J., and London, 1989), and last but not least *The History of Impressionism* (4th ed., rev., New York, 1973), and *Post-Impressionism: From Van Gogh to Gauguin* (3rd ed., rev., New York, 1978). Of equal importance are the French publications by Sophie Monneret, *Dictionnaire international illustré: L'Impressionnisme et son époque* (Paris, 1978); Sylvie Patin, "Amateurs et collectionneurs des œuvres de jeunesse de Cézanne," in the exhibition catalogue Musée d'Orsay, Paris, *Cézanne: Les Années de jeunesse, 1859-1872* (Paris, 1988); and Anne Distel, *Les Collectionneurs des impressionnistes: Amateurs et marchands* (Düdingen, Switzerland, 1989) and her entries in *Petit Larousse de la peinture* (Paris, 1979), as well as her essay "Dr. Barnes in Paris" in the exhibition catalogue The Barnes Foundation, *Great French Paintings from The Barnes Foundation: From Cézanne to Matisse* (New York, 1993).

For the individual collectors, see the respective museum and collection catalogues. For Cornelis Hoogendijk, see Herbert Henkels, "Cézanne en Van Gogh in het Rijksmuseum voor Moderne Kunst in Amsterdam: de collectie van Cornelis Hoogendijk (1866-1911)," *Bulletin van het Rijksmuseum,* vol. 41, nos. 3/4 (1993), pp. 155-287.

The titles of works by Cézanne mentioned here are, for the most part, translated from the French titles of the forthcoming catalogue raisonné by John Rewald. For those works that are catalogued in Lionello Venturi, *Cézanne, son art—son œuvre,* 2 vols.(Paris, 1936), the Venturi catalogue numbers (V., or non-V. if not in Venturi) follow the titles. A concordance of Venturi numbers and forthcoming Rewald painting numbers is provided in the back matter. Watercolors are identified by catalogue numbers (R.) published in *Paul Cézanne: The Watercolors, A Catalogue Raisonné,* by John Rewald (Boston, 1983). Works in the present exhibition that are mentioned are identified by catalogue numbers (cat. no.).

I thank Maria Feilchenfeldt for correcting my manuscript, Roland Dorn and Marina Thouin for reading my text, and especially my two editors, Céline Julhiet-Charvet (French) and Jane Watkins (English edition) for their involvement and interest.

1860-1874

The first owners of works by Paul Cézanne were his family and childhood friends from Aix. After 1871, during his stay in Pontoise with Pissarro, his colleagues as well as a few art lovers acquainted with him began collecting his pictures.

Émile Zola (1840-1902)

A close childhood friend of the artist, Émile Zola was a confidant and source of inspiration from the earliest days. Their friendship lasted until 1886, when Cézanne, deeply hurt by Zola's novel *L'Oeuvre,* broke away from him. Zola owned twelve paintings by Cézanne, given to him by the artist, among them such important works as *Self-Portrait* (V. 81), *The Abduction* (cat. no. 12), *The Black Clock* (repro. p. 27), and *Paul Alexis Reading to Émile Zola* (repro. p. 25). Zola's collection was auctioned in Paris at the Hôtel Drouot, March 9-13, 1903.

Camille Pissarro (1830-1903)

Pissarro, who after 1871 spent some time with the artist in Pontoise, possessed twenty paintings by Cézanne, including *Still Life with a Soup Tureen* (cat. no. 32) and *The Battle of Love, I* (cat. no. 64) as well as several major landscapes: *The Wine Depot, Seen from the Rue de Jussieu* (cat. no. 26), *Entrance to a Farm, Rue Rémy, in Auvers-sur-Oise* (V. 139), *Turning Road in a Wood* (V. 140), *The Path to the Ravine, Seen from the Hermitage, Pontoise* (V. 170), and *The Hermitage in Pontoise* (V. 176). His pictures were subsequently acquired by Octave Mirbeau and Auguste Pellerin.

Dr. Paul-Ferdinand Gachet (1828-1909)

Doctor Gachet, whom Cézanne visited when working in Pontoise and Auvers, owned several paintings executed on the premises: *Bouquet in a Small Delft Vase* (V. 183), *The House of Doctor Gachet at Auvers-sur-Oise* (V. 145), and *A Modern Olympia* (cat. no. 28), all left by his son Paul to the Musée du Louvre in 1951. Doctor Gachet also owned *Stoneware Pitcher, Glass, Fruit, and Knife* (V. 185) and *View of Louveciennes, after Pissarro* (V. 153), two paintings Paul Gachet sold to Bernheim-Jeune in 1912, three years after his father's death.

Eugène Murer (1846-1909)

Murer, a *pâtissier* from Auvers, was an art lover, like Doctor Gachet, who supported various local artists. What little is known about him comes from the book *Deux amis des impressionnistes, le*

docteur Gachet et Murer, by Gachet's son, Paul, published in Paris in 1956. Murer possessed several small-size Cézannes, including a version of *The Temptation of Saint Anthony* (V. 240). After the artist's death he sold several paintings to Bernheim-Jeune.

Claude Monet (1840-1926)

Monet, during the 1880s one of the most affluent of his colleagues, greatly appreciated Cézanne's work and owned fourteen of his paintings, including *Turn in the Road* (cat. no. 76) and two important early works: *Portrait of a Man* (V. 102) and *The Negro Scipion* (cat. no. 11). In 1899 he hit the headlines upon acquiring, for a record price, *Melting Snow at Fontainebleau* (V. 336). He also owned three major late works of different subjects: *Pot of Primroses and Fruit on a Table* (V. 599), *Boy in a Red Vest* (repro. p. 49), and *The Château Noir* (V. 794), eventually leaving them all to his son Michel.

Julien Tanguy (1825-1894)

Pissarro introduced Cézanne to Julien Tanguy in 1873, and from then on Cézanne's canvases could always be seen at his premises, some of them hidden away from the occasionally destructive inclinations of Cézanne toward his own work. It was at père Tanguy's shop that the wealthy Belgian painter Eugène Boch acquired the *Portrait of Achille Emperaire* (cat. no. 19) and the American Sarah Hallowell bought two still lifes (V. 338 and V. 337), which she then sold in 1895 to Durand-Ruel's New York branch. Degas, Gauguin, and Paul Signac also bought paintings by Cézanne at Tanguy's. His death was a huge loss to his artist clients; an estate auction was organized and held at the Hôtel Drouot on June 2, 1894, and six Cézannes were sold, ranging from 75 to 215 francs.

1874-1893

In 1874 Cézanne exhibited his work for the first time at the initial Impressionists' exhibition, held by the Société Anonyme des Artistes at Nadar's atelier, where he sold his first picture to a collector he did not know. Another collector, Victor Chocquet, became his friend and a regular buyer, improving Cézanne's financial situation considerably. His works were always to be seen at Tanguy's and occasionally found buyers, usually his colleagues. In 1886 Cézanne's father died, leaving him a fortune that freed him from financial worry and allowed him to concentrate completely on his work.

Comte Armand Doria (1824-1896)

Comte Doria was the first buyer of a work by Cézanne personally unknown to the artist. In 1874 he purchased *The House of the Hanged Man, in Auvers-sur-Oise* (cat. no. 30) in the Impressionists' first group exhibition for 100 or 200 francs. In 1889 he exchanged it with Victor Chocquet for *Melting Snow at Fontainebleau* (V. 336). On May 4-5, 1899, the Doria collection was sold in Paris at the Galerie Georges Petit. As noted, the snow landscape went to Monet for a record price of 6,750 francs.

Auguste Renoir (1841-1919)

Renoir came into possession of four Cézannes, from the artist himself, from Tanguy, or from Vollard, the most important being *Houses in a Wood* (V. 308) and *A Turn in the Road at La Roche-Guyon* (V. 441).

Victor Chocquet (1821-1891)

A customs official, Victor Chocquet is considered one of the most important personalities in the field of nineteenth-century collecting. He was a passionate art lover, equally friendly with Renoir and Cézanne. He bought his first painting by Cézanne, *Three Bathers* (V. 266) at Tanguy's on Renoir's recommendation in 1875. Shortly afterward, he met Cézanne himself and, based on a mutual admiration of Delacroix, a friendship developed, ultimately manifesting itself in six portraits of the collector (cat. nos. 45 and 46, V. 375, V. 532, V. 562, and non-V.). Chocquet also commissioned paintings: a landscape of L'Estaque (V. 168) and, later, four landscapes painted on Chocquet's estate near Hattenville (cat. no. 86, V. 442, V. 445, and V. 447). Although Chocquet died childless, no provisions were made to leave his collection to the State. After Madame Chocquet's death, it was put up for auction on July 1-4, 1899, at the Galerie Georges Petit. Of the thirty-three paintings by Cézanne, Comte de Camondo bought *The House of the Hanged Man, in Auvers-sur-Oise* (cat. no. 30), which Chocquet had received in exchange from Comte Doria. Eugène Blot, Thadée Natanson, Auguste Pellerin, and Georges Viau acquired one painting each. The remaining twenty-eight paintings went to the three leading Paris art dealers: seventeen to Durand-Ruel, eight to Bernheim-Jeune, and three to Vollard. It was at this sale that many collectors became aware of Cézanne for the first time.

Théodore Duret (1838-1927)

Duret, a collector and an art historian, wrote a book about his artist friends, *Histoire des peintres impressionnistes*, first published in 1878, adding a chapter on Cézanne in the 1906 edition. Under financial pressure, he auctioned his collection of Impressionist paintings on March 19, 1894, at the Galerie Georges Petit. Three Cézannes were sold: "Nr. 3—Route dans un village *[Turn in the Road]*, 800 francs" (cat. no. 76); "Nr. 4—Nature morte *[Still Life]*, 600 francs" (V. 346); and "Nr. 5—La Moisson *[The Harvest]*, 650 francs" (V. 249), formerly owned by Gauguin. Duret later owned two other masterpieces by Cézanne: *Madame Cézanne in a Yellow Chair* (V. 572) and *The Bellevue Plain* (V. 450). In 1910 he sold the first to Paul Rosenberg and the second to Paul Cassirer.

Gustave Caillebotte (1848-1894)

Caillebotte, an artist and a collector, had belonged to the Impressionist group since 1876. His financial independence allowed him to support his friends and colleagues. He owned five Cézannes (V. 232, V. 276, V. 222, V. 326, and V. 428), which he left to the French State. The government accepted, however, only two of them: *Farmyard* (V. 326) and *The Gulf of Marseille Seen from L'Estaque* (V. 428). The remaining three were sold by the family.

Paul Gauguin (1848-1903)

Gauguin was a great admirer of Cézanne's work. He owned five paintings, which he probably got from Tanguy before becoming an artist, plus the above-mentioned *Harvest* (V. 249). Among them were the lost painting *Female Nude* (non-V.), *Mountains in Provence (Near L'Estaque?)* (cat. no. 56), *The Allée* (non-V.), *The Château de Médan* (cat. no. 69), and (immortalized by Maurice Denis's painting *Homage to Cézanne*, repro. pp. 22-23) *Compotier, Glass, and Apples* (repro. p. 31). He took these five paintings with him when he left Paris for Copenhagen in 1884.

1893-1906

After Julien Tanguy's death in 1894, Ambroise Vollard took it upon himself to become Cézanne's dealer. The 1895 exhibition of Cézanne's work at Vollard's won him general recognition among artists and important critics.

Ambroise Vollard (1867-1939)

Vollard saw his first Cézanne painting at père Tanguy's shop on the rue Clauzel in 1892. Upon Tanguy's death, Vollard became his successor in dealing with contemporary artists, and when Tanguy's estate was subsequently auctioned, Vollard acquired four paintings, of which three are easily identifiable (V. 151, V. 356, and V. 316). Encouraged by this transaction, he contacted Cézanne and his son, who were willing to do business with him. They sent him nearly 150 paintings for an exhibition, which was mounted in 1895 in his gallery on the rue Laffitte. Commercial success, however, was reached only after 1897, with purchases made by the foreign collectors Egisto Fabbri, Charles Loeser, and Cornelis Hoogendijk. After the turn of the century, the French industrialist Auguste Pellerin, the Russians Sergei Shchukin and Ivan Morosov, as well as the German dealer Paul Cassirer became his regular clients. Later, the Paris dealer Étienne Bignou, buying Cézannes for English and American collectors, was one of his most regular visitors. In the summer of 1939, Vollard died in a car accident. His executor and long-time assistant, Martin Fabiani, handled part of the estate, and the rest was divided between Mme Robert de Galéa and Vollard's relatives. During World War II some of the paintings were stored at the National Gallery of Canada in Ottawa but were later returned to Paris, where they were gradually sold.

Joachim Gasquet (1873-1921)

The poet and writer Joachim Gasquet, with his father, Henri, was friendly with the artist and both had portraits painted by him (see cat. no. 173). Gasquet owned five paintings, all gifts of the artist, among them the major work *Mont Sainte-Victoire with Large Pine* (cat. no. 92). He sold his paintings to the writer and collector Henry Bernstein and to the Paris art market.

Edgar Degas (1834-1917)

Degas possessed seven paintings by Cézanne, including *Apples* (cat. no. 49), all of which he acquired from Vollard between 1895 and 1897. After his death, all seven were sold as part of his collection at auction on March 26, 1918, at the Galerie Georges Petit.

Octave Mirbeau (1884-1917)

Friendly with contemporary artists and a huge admirer of Cézanne, Octave Mirbeau owned twelve paintings, six of which had come from Pissarro. Three were sold to Bernheim-Jeune; the other nine were put up for sale at the Mirbeau auction, held at Durand-Ruel on February 24, 1919.

Gustave Geffroy (1855-1926)

Geffroy was a personal friend of the artist, who painted his portrait in 1895-96 (cat. no. 172). He owned seven Cézannes, including *Apples and Oranges* (cat. no. 181), which, via the Isaac Comte de Camondo collection, came to the Musée d'Orsay. Vollard wrote in his *Souvenirs d'un marchand de tableaux* that shortly after the artist's death, when Geffroy offered his paintings for sale in 1907, he lost the deal to the collector the Prince de Wagram, who then immediately passed them on to Bernheim-Jeune.

Charles A. Loeser (1864-1928)

Like Egisto Fabbri and Bernard Berenson, Charles Loeser lived in Florence. He apparently discovered Cézanne independently at Vollard's and purchased his paintings between 1896 and 1899. Altogether he owned fifteen works, eight of which he left in his will to the presidents of the United States of America. These paintings, *Landscape with a Tower* (non-V.), *Boathouse on a River* (non-V.), *Still Life with Skull* (V. 751), *Gardanne (Afternoon)* (V. 431), *House on the Banks of the Marne* (non-V.), *Still Life with Quince, Apples, and Pears* (non-V.), *The Forest* (V. 645), and *House on a Hill* (non-V.), are now part of The White House collection, Washington, D.C., as the bequest of Charles A. Loeser.

Cornelis Hoogendijk (1866-1911)

This eccentric collector of old masters and contemporary art, who between 1897 and 1899 acquired thirty-one paintings by Cézanne from Vollard, was committed to an asylum in 1900 and died in 1911, at age forty-five. Although Vollard only briefly mentions this key figure, not using a name, the transactions between Vollard and Hoogendijk were the dealer's first commercial successes with Cézanne. Only after these sales did Vollard enter Cézanne's work into his record-books. Hoogendijk's selection consisted of the figure painting *Self-Portrait* (cat. no. 34), eight landscapes, including *The Gulf of Marseille Seen from L'Estaque* (cat. no. 114), and *The Lac d'Annecy* (cat. no. 174), and as many as twenty-two still lifes. In 1906-7 most of these pictures were moved to the Rijksmuseum in Amsterdam and later shown there on permanent loan. After Hoogendijk's death, negotiations regarding a bequest were opened, resulting in a legacy of fifty-three old master paintings. Several Hoogendijk sales took place at F. Muller's in Amsterdam in May 1912. Two small Cézannes were auctioned: *Factories Near Le Cengle* (p. 89, fig. 2) was bought by Auguste Pellerin, and *Vase of Flowers* (V. 752) was sold to Gottlieb Friedrich Reber and Justin Thannhauser. The Cézanne collection remained at the Rijksmuseum, its future still undecided. The Amsterdam art dealer Douwe Komter, agent for the German collector Karl Ernst Osthaus, endeavored to purchase twenty-five Cézannes, but was challenged by his opponent J. H. de Bois, who represented the Hoogendijk family. During World War I the paintings remained at the Rijksmuseum, where hopes for a Cézanne donation were still high. However, in May 1920 the paintings were returned to the family and a month later the twenty-five Cézannes were sold to Paul Rosenberg, who purchased them with the support of his colleagues Bernheim-Jeune and Durand-Ruel. Two remaining paintings, *Mont Sainte-Victoire* (V. 456) and *Bottles and Peaches* (V. 604), stayed in the family and are today in the possession of the Stedelijk Museum, Amsterdam.

Gustave Fayet (1865-1925)

The artist and collector Gustave Fayet wrote to Gauguin in 1901 that he owned "three first-rate Cézannes." They were *The Bay of L'Estaque* (V. 489), *Petunias* (V. 198), and *Six Bathers* (V. 538), acquired from Vollard or from the artist's immediate circle.

Egisto Fabbri (1866-1933)

Egisto Fabbri, an American painter living in Florence, was one of Vollard's first Cézanne clients. He supposedly possessed sixteen Cézannes as early as 1899. However, in the years to come he sold them all, the last group including such masterpieces as *Madame Cézanne in a Red Armchair* (cat. no. 47), *Boy in a Red Vest* (V. 682), *Self-Portrait in a Beret* (V. 693), *Five Bathers* (cat. no. 62), *Houses in Provence* (cat. no. 71), *Seated Man* (cat. no. 187), *The Banks of the Marne* (V. 629), and *The Farm at the Jas de Bouffan* (V. 461), in 1928, to Paul Rosenberg and his partners.

Hugo von Tschudi (1851-1911)

In 1897 the museum director Hugo von Tschudi, of Swiss origin, bought with the assistance of Durand-Ruel and in the presence of his mentor, the Berlin painter and collector Max Liebermann, a major work by Cézanne, *Mill on the Couleuvre at Pontoise* (cat. no. 75), for the Nationalgalerie of Berlin. Funds for the acquisition were provided by Wilhelm Staudt. This was the first picture by Cézanne to be purchased by a public collection. In 1904 and 1906 two still lifes followed: *Flowers and Fruit* (V. 610) and *Jars, Bottle, Cup, and Fruit* (V. 71). In 1909 Tschudi resigned in Berlin and became director of the Königliche Bayerische Staatsgemäldesammlungen in Munich, and within two years he purchased three more paintings by Cézanne: *The Railroad Cut with Mont Sainte-Victoire* (V. 50), *Self-Portrait in a White Cap* (cat. no. 77), and *Still Life with Chest of Drawers* (V. 496). These three pictures, purchased by him privately between 1908 and 1910, were given to the Munich museum by his friends in his memory.

Isaac Comte de Camondo (1851-1911)

In 1899 the banker bought *The House of the Hanged Man, in Auvers-sur-Oise* (cat. no. 30) at the Chocquet sale. In 1908 he bequeathed this painting and four others by Cézanne—*Dahlias in a Large Delft Vase* (V. 179), *The Blue Vase* (V. 130), *The Cardplayers* (cat. no. 134), and *Apples and Oranges* (cat. no. 181)—to the French State. Upon his death in 1911, the donation was accepted and the paintings have been on view since 1914.

Louis Granel (1861-1917)

In 1899 the Cézanne family sold their estate, the Jas de Bouffan, to Louis Granel, thereby making him the owner of important early works, several of very large dimensions, created by Cézanne for the decoration of the house. They were *The Four Seasons* (p. 89, fig. 1), *Portrait of Louis-Auguste Cézanne* (V. 25), *Christ in Limbo* (p. 99, fig. 1), *Mary Magdalen* (p. 87, fig. 1), and *Bather and Rocks* (cat. no. 10), sold by Granel in 1907 to Jos Hessel, cousin of the Bernheim-Jeune brothers. The eight remaining sections of the large fresco *Bather and Rocks* as well as *Romantic Landscape with Fishermen* (non-V.) were auctioned by Granel's son-in-law, Dr. Frédéric Corsy, in 1960 at the Galerie Charpentier.

Auguste Pellerin (1852-1929)

Auguste Pellerin is said to have bought his first Cézanne painting, *Farm in Normandy, Summer (Hattenville)* (cat. no. 86), at the Chocquet sale in 1899. In fact, he purchased his first Cézannes from Vollard six months earlier, in December 1898. In the Zola sale of 1903, he bought six of the nine Cézannes offered for purchase. In 1904 he acquired seven important Cézannes from Bernheim-Jeune, and from 1907 to 1912, through Bernheim-Jeune alone, he purchased another twenty-nine paintings. When he started to sell his Manets, the identity of the Cézannes he acquired becomes more difficult to ascertain because of the frequent exchanges that took place. His last recorded purchase was *Large Pine and Red Earth* (p. 371, fig. 1) at the Gangnat sale on June 25, 1925, at the Hôtel Drouot. Upon his death in 1929, he left ninety-two pictures by Cézanne: forty-five to his son, Jean-Victor, and forty-seven to his daughter, Renée Lecomte. In the major Cézanne exhibition at the Musée de l'Orangerie in 1936 these two collections, with eighteen and sixteen paintings represented, comprised the largest Cézanne collections excluding that of Dr. Albert Barnes. Today, nine paintings by Cézanne from the former Auguste Pellerin collection are either exhibited as donations at the Musée d'Orsay or are recorded as promised gifts.

Denys Cochin (1851-1922)

Denys Cochin, a politician, started collecting Cézanne paintings at the turn of the century. Vollard complained about him, as he constantly returned his purchases, apparently unable to make up his mind. However, according to John Rewald, twenty-one paintings by Cézanne passed through his hands, most of which were sold by Bernheim-Jeune before World War I.

Paul Durand-Ruel (1831-1922)

The great dealer of the Impressionists only reluctantly came to terms with the work of Cézanne. Finally, in 1899 at the Chocquet sale, encouraged by Monet, he appeared as a buyer and purchased seventeen works by the artist. A year later, he sent some of these paintings to Bruno and Paul Cassirer for the first exhibition of Cézanne's work to be held in Germany. In 1903, through his New York gallery, he arranged the sale of *The Abduction* (cat. no. 12) and *Still Life with Eggplants* (V. 597) to the Havemeyers for Vollard. In 1920 Durand-Ruel was instrumental in Dr. Albert Barnes's purchase of the Cézannes owned by Cornelis Hoogendijk, but the dealer was less involved in being supportive of Cézanne than Vollard, Bernheim-Jeune, and, later, Paul Rosenberg.

Andries Bonger (1861-1934)

Theo van Gogh's brother-in-law and a close friend of Émile Bernard, Andries Bonger was very familiar with the art scene in Paris, where he lived on and off in the 1880s. According to a written report, dated June 5, 1899, he acquired four paintings by Cézanne from Vollard: "une toile pommes tasse et verre" (a canvas: apples, cup, and glass) (V. 187), "une toile poire et pommes" (a canvas: pear and apples) (V. 354), "une toile bouquet de fleurs sur fond gris" (a canvas: bouquet of flowers against gray background" (V. 511), and "une toile assiette de pommes et poire, 53.40 cm" (a canvas: plate of apples and pear, 53.40 cm) (non-V., whereabouts unknown). He also owned *Small Town in the Île-de-France* (V. 307), *Road Leading to a Pond* (V. 327), and *Flowers in a Red Vase* (V. 358), which he probably purchased from Tanguy at an earlier date.

Georges Viau (1855-1939)

Seven Cézannes belonged to the dentist Georges Viau. He was a buyer at the 1899 Chocquet sale, where he acquired *Farm in Normandy* (V. 447), and he owned *Compotier, Glass, and Apples* (repro.

p. 31), formerly in Gauguin's collection. These two, as well as *Les Mathurins, Pontoise* (V. 172) and *Portrait of the Artist's Son* (non-V.), were sold in the first Viau sale on March 4, 1907, at Durand-Ruel.

Henri Matisse (1869-1954)

It was apparently Pissarro who brought Cézanne to Matisse's attention, and he became one of his greatest admirers. In 1899 he bought *Three Bathers* (cat. no. 60) at Vollard's. Four purchases followed: *Portrait of Madame Cézanne* (p. 293, fig. 1), *Portrait of Madame Cézanne* (cat. no. 126), *Fruit and Foliage* (V. 613), and *Rocks Near the Caves Above Château Noir* (cat. no. 190).

Henry O. Havemeyer (1847-1907) and Louisine Elder Havemeyer (1858-1929)

Sugar baron and industry tycoon Harry and his wife, Louisine, a close friend of Mary Cassatt, were the most ambitious and powerful American art collectors at the turn of the century. Friendly with Paul Durand-Ruel, who had sold them a Manet still life as early as 1886, they first encountered Cézanne's works at the Chocquet sale in 1899. They were introduced to Vollard and in 1901 Havemeyer advanced him a considerable sum of money, which, as recorded by Mary Cassatt, saved him from financial ruin. Two major Cézanne paintings, *Mont Sainte-Victoire Seen from Bellevue* (cat. no. 89) and *Still Life with Eggplants* (V. 597), may have entered the Havemeyer collection due to this financial transaction. Both these paintings are today at the Metropolitan Museum of Art in New York. At the time of H. O. Havemeyer's death in 1907, Louisine owned thirteen paintings by Cézanne. Influenced by Mary Cassatt, who personally owned three still lifes by the artist (*Apples and Cloth* [V. 203], *Compotier, Apples, and a Loaf of Bread* [V. 344], and *Bottle of Liqueur* [V. 606]), she decided to part with *Self-Portrait in a Visored Cap* (V. 289) and *Banks of the Marne* (V. 630). Durand-Ruel sold both pictures to the Russian collector Ivan Morosov. After Louisine's death the Metropolitan Museum of Art received five Cézannes through the Havemeyer Bequest, including the earlier-mentioned *Mont Sainte-Victoire*, as well as *Portrait of Gustave Boyer* (V. 131), *Pot, Cup, and Fruit on a White Cloth* (V. 213), *The Gulf of Marseille* (V. 429), and *Rocks at Fontainebleau* (cat. no. 158). *The Abduction* (cat. no. 12) was sold in 1930 at the sale of the Havemeyer estate. The remaining Cézannes left to their son Horace are no longer in the family's possession.

Eugène Blot (born 1857)

Eugène Blot bought small paintings from the Paris art market. He owned eleven Cézannes, the most important being *The Blue Vase* (cat. no. 130), of which he is listed as the first owner. He sold his collection at auction in 1900 and 1906. In 1907 he became an art dealer and in 1933 and 1937 again sold paintings from his collection at auction.

Henry Bernstein (1876-1953)

The writer and collector possessed six Cézannes, two of which, *Chestnut Trees at the Jas de Bouffan* (V. 478) and *Old Woman with a Rosary* (cat. no. 171) he had purchased from Cézanne's personal friend Joachim Gasquet. Another painting, *Chestnut Trees and Farm at the Jas de Bouffan* (cat. no. 97), came from the critic Gustave Geffroy and the remaining three from Vollard. Four of the six paintings were sold at auction in 1911, and fetched between 15,000 and 24,000 francs.

Harry Graf Kessler (1868-1937)

Count Harry Kessler was one of the most prominent supporters of French art in Germany. Co-editor of the art review *Pan*, he was friendly with Julius Meier-Graefe and Max Liebermann and knew the European art scene perfectly. According to his diary entries, he purchased his three paintings by Cézanne from Vollard on February 14, 1902; however, Vollard noted the date as November 11, 1904. They were among the earliest acquisitions of this distinguished collector, who also owned Seurat's large version of *Models* and Van Gogh's *Portrait of Doctor Gachet*.

Michael Stein (1865-1938), Leo Stein (1872-1947), and Gertrude Stein (1874-1946)

On Bernard Berenson's recommendation, the Steins visited Vollard's gallery in 1904, where Leo purchased a landscape by Cézanne. Shortly afterward they acquired *Madame Cézanne with a Fan* (V. 369), which had been exhibited at the Salon d'Automne of 1904. The Steins maintained a salon in Paris where the Russians Sergei Shchukin and Ivan Morosov, as well as Roger Fry and Dr. Albert Barnes, saw paintings by Cézanne and Matisse for the first time.

1906-1914

About a year before Cézanne's death in 1906, the international art market expanded into a boom, with Germany playing a leading role. It reached a peak in 1912 with the Sonderbund Exhibition in Cologne, followed a year later by the Armory Show in New York. Both exhibitions displayed numerous works by Cézanne. New bourgeois collectors emerged and collecting flourished, until abruptly ending with the outbreak of World War I.

Josse Bernheim-Jeune (1870-1941) and Gaston Bernheim de Villers (1870-1953)

Around the turn of the century, the brothers Josse and Gaston, owners of the Galerie Bernheim-Jeune, began more actively purchasing and exhibiting Post-Impressionist art. With the engagement of the well-known art critic Félix Fénéon (1861-1944) as managing director, they soon became the leading dealers of modern art in Paris. For this reason, Vollard approached them, when, immediately after the artist's death, Madame Cézanne and her son Paul offered him Cézanne's entire estate for sale. The offer consisted of twenty-seven paintings and one hundred eighty-seven watercolors, which Vollard and Bernheim-Jeune divided between them. The Bernheim brothers were collectors of the work they dealt in. A two-volume book of their collection, titled *L'Art moderne*, was published in 1919, and includes thirty-four reproductions of paintings by Cézanne, some of which were put into safekeeping during World War II and have since disappeared.

Alexandre Berthier, Prince de Wagram (1883-1918)

The Prince de Wagram began collecting in 1905. He is said to have purchased entire groups of paintings by Gauguin and Cézanne from Vollard. He apparently owned twenty-eight Cézannes. However, although René Gimpel quoted this exact figure in his book *Journal d'un collectionneur marchand de tableaux*, John Rewald was unable to trace more than seven paintings back to his possession. When Vollard and Bernheim-Jeune took over Cézanne's estate, the Prince de Wagram was engaged in a partnership with the

Bernheim brothers and their cousin Jos Hessel, which shortly afterward dissolved and ended in a legal case. It is said that the Prince de Wagram disliked paying his bills and only did so with great delay. After 1910 he sold his paintings through Galerie Druet and Galerie Barbazanges, Paris.

Sergei Shchukin (1851-1936)

From a family of influential Russian textile manufacturers with an interest in the arts, Sergei Shchukin owned eight paintings by Cézanne, acquired between 1904 and 1911, before turning his attention to collecting Matisse. In addition to two landscapes and two still lifes, he owned four figure paintings: *Self-Portrait* (V. 368), *Smoker* (p. 342, fig. 2), *Woman in Blue* (cat. no. 188), and, most important, *Mardi-Gras* (repro. p. 63), formerly in the Chocquet collection, which he purchased in 1904 from Durand-Ruel.

Ivan Morosov (1871-1921)

Morosov's motivation to embark upon collecting contemporary French art stemmed from the desire to counterbalance his brother Michail's Russian collection with an equally worthy parallel. Bringing together his eighteen Cézanne paintings between 1907 and 1913, he began with *Mont Sainte-Victoire, View of the Valcros Road* (V. 423), *Mont Sainte-Victoire, Above the Tholonet Road* (V. 663), and *Still Life with Curtain and Flowered Pitcher* (cat. no. 180). The painting *Madame Cézanne in the Conservatory* (p. 272, fig. 2), once in the collection of Auguste Pellerin, which he bought from Vollard in 1911, was sold by the Russian government in 1933, via Knoedler's, to Stephen C. Clark, and is now in the Metropolitan Museum of Art in New York.

Paul Cassirer (1871-1926)
and Bruno Cassirer (1872-1941)

In 1898 the two cousins opened an art gallery in Berlin. In collaboration with Paul Durand-Ruel and the agent Emil Heilbut, in 1900 they exhibited fourteen paintings by Cézanne. Previously they had each purchased, probably from Vollard, a Cézanne painting. Bruno bought *House under the Trees* (V. 633), which he kept all his life, and Paul, *Large Apples* (V. 502), kept by his first wife after their divorce in 1902. She later married a Mr. Ceconi and sold her pictures to Bernheim-Jeune. Paul Cassirer, sole owner of the gallery after 1901, maintained close business ties with French dealers and bought paintings by Cézanne regularly from Vollard and his colleagues until their relationship was severed by the outbreak of World War I. At the time of his death, four paintings—*Head of a Man* (V. 110), *Roofs in Paris* (V. 175), *The Château Noir Seen Through Trees* (V. 667), and *Man with Crossed Arms* (p. 426, fig. 1)—were listed as the property of his second wife, the actress Tilla Durieux, who sold them through Paul Cassirer, Amsterdam, before the outbreak of World War II.

Hugo Cassirer (1869-1920)

As early as 1903 or 1904, the Berlin industrialist Hugo Cassirer acquired works by Cézanne through his brother Paul. He owned seven paintings, which he left to his wife and his sons, Stephan and Reinhold. After his death, his widow, Lotte Cassirer-Jacoby, married a Mr. Fürstenberg. After 1933 the collection was brought via Switzerland to Holland, from where, with the help of Justin Thannhauser, it was sent first to Montevideo, Uruguay, and then to New York. There, just after the war, Thannhauser sold *Bread and Eggs* (cat. no. 3) to the Cincinnati Art Museum and *Allée at Chantilly* (cat. no. 118) to an American collector. The latter is now in the Toledo Museum of Art, Ohio.

Oskar Schmitz (1861-1933)

Oskar Schmitz's first Cézanne, *Milk Can and Apples* (V. 338), bought in 1904, came from Durand-Ruel. Five more paintings were purchased from Paul Cassirer, Berlin, between 1911 and 1916. In 1931 he moved to Switzerland, depositing his paintings at the Kunsthalle in Basel. In 1936 his collection was exhibited at Wildenstein's in New York. The paintings were subsequently sold, mostly to American collectors.

Marczell de Nêmes (1866-1930)

Marczell de Nêmes, an important Hungarian collector of old master paintings, owned six Cézannes, purchased between 1904 and 1911. He was a client of Vollard and managed to buy *Boy in a Red Vest* (p. 322, fig. 2) from him. He sold all his Cézannes with the rest of his collection at auction in Paris on June 18, 1913, at the Galerie Manzi-Joyant.

Karl Ernst Osthaus (1874-1921)

The German art collector and founder of the Folkwang Museum in Hagen visited Cézanne in 1906 in Aix. He was graciously received by the artist and subsequently bought *House at Bellevue and Pigeon House* (V. 651) and *Bibémus Quarry* (cat. no. 149) from Vollard. Today, both paintings are in the collection of the Folkwang Museum in Essen. The second was deaccessioned in 1937 as "degenerate art" and bought back by the museum in 1964.

Gottlieb Friedrich Reber (1880-1959)

The German industrialist bought his first Cézanne in 1906. His collection, which had eleven Cézannes, was shown in 1912 in Barmen, Wuppertal, and Mannheim and in 1913 in Darmstadt and Berlin at Paul Cassirer's. He did business with Justin Thannhauser and Paul Rosenberg, and it is often unclear who owned what picture. His most important purchase was *Boy in a Red Vest* (p. 322, fig. 2) at the Nêmes sale in 1913, which he sold in 1948. Reber left Germany in 1919 for Switzerland. He lived in Lucerne, Ascona, Lugano, and finally Lausanne. In the 1920s he sold his Cézannes in order to buy Cubist paintings, assembling a remarkable collection of works by Picasso and his circle.

Alphonse Kann (1868-1948)

Like Gottlieb Friedrich Reber, Alphonse Kann was a *marchand-amateur* (a collector who also sold works), handling a number of major Cézanne paintings. Living in St. Germain-en-Laye and in London, he dealt primarily with Paul Rosenberg and Gottlieb Friedrich Reber, but also with Alfred Flechtheim and Justin Thannhauser. Little is known about him and his collection was dispersed.

Bernhard Koehler (1849-1927)

At the outbreak of World War I, this Berlin art collector possessed one of the most complete collections of contemporary German art. It was later enlarged by his son Bernhard Koehler (1882-1964) and the greater part was donated in 1965 to the Lenbachhaus in Munich. Koehler was friendly with the German artist August Macke, who accompanied him to Paris, where they visited Vollard. There, between 1907 and 1913, he purchased four paintings by Cézanne. Two were sold by his son before World War II. The other two, *Peaches, Pears, and Grapes* (V. 345) and *Mont Sainte-Victoire* (V. 664), were thought to have been lost in World War II, but they recently have surfaced at the Hermitage Museum, in St. Petersburg.

Sidney Brown (1865-1941)

The industrialist Sidney Brown, from Baden, Switzerland, and his wife, Jenny, went to Paris in 1908. While going for a walk, they discovere Vollard's gallery on the rue Laffitte, where they found the owner showing paintings by Cézanne to Sergei Shchukin. On the recommendation of the Russian collector, they purchased the unusual *Peaches, Carafe, and Figure* (V. 739). In 1910 they bought twelve paintings from Georges Viau, among them *Fruit and Box of Powder* (V. 1606). Four more Cézannes were added between 1913 and 1917 and another three in 1933. In 1987 the collection, including nine Cézannes, was turned into the Stiftung Langmatt, and was opened to the public in the couple's former home near the Brown-Boveri factory.

Henri Rouart (1833-1912)

The industrialist and painter Henri Rouart was a friend of Degas and the Impressionists. He owned five small paintings by Cézanne, which were all sold in Paris at the Rouart auction, held on December 9, 1912, at the Galerie Manzi-Joyant.

Maurice Gangnat (1856-1924)

A friend of Renoir, possessing one hundred eighty paintings by him, Maurice Gangnat also owned eight Cézannes, three of which he sold to Paul Rosenberg in 1913. Four appeared in the sale of his estate at the Hôtel Drouot on June 25, 1925.

Eugene Meyer (1875-1959)

The New York banker Eugene Meyer and his wife, Agnes, were friends of the photographer Edward Steichen, who introduced them to the Steins in Paris. In 1912 they bought *Still Life with Apples and Peaches* (non-V.) and *The Sailor* (non-V.) from Vollard, and four years later, two more late works, *Bouquet of Flowers* (V. 757) and *The Château Noir* (cat. no. 189), from the New York dealer Marius de Zayas, who had acquired them from Vollard for his gallery. Today, all four outstanding paintings are at the National Gallery of Art in Washington, D.C., exhibited as the gift of Mr. and Mrs. Eugene Meyer.

John Quinn (1870-1925)

John Quinn, a lawyer, was one of the first American buyers of contemporary European art. He was also one of the key figures in organizing the Armory Show in 1913 and personally owned a remarkable group of Post-Impressionist works, up to Matisse and Picasso. He purchased his first Cézanne, *Madame Cézanne in a Striped Skirt* (V. 229), in 1912 from Vollard, followed in 1921 by a late *Mont Sainte-Victoire* (V. 801) and in 1923 by the early work *Portrait of the Artist's Father* (V. 25). The collection was dispersed after his death.

Dr. Albert C. Barnes (1872-1951)

Dr. Albert Barnes, from Philadelphia, who made a fortune in the pharmaceutical business, left to posterity the largest collection of Cézanne's work. He began collecting on his first trip to Paris in 1912, where he purchased two small Cézanne paintings at the sale of Henri Rouart's estate on December 9. On the same day he also purchased a "Madame Cézanne" from Vollard, followed on December 11 by *Plate of Fruit on a Chair* (V. 352) and *Three Bathers* (V. 270). In 1915 he made another purchase from Vollard, *Madame Cézanne in a Green Hat* (V. 704). By this time he already owned fifteen Cézannes. He regularly reappeared in Paris buying one painting after another, so it hardly seemed surprising that he and Durand-Ruel, the dealer he most liked to buy from, should negotiate for the Cézannes that had been owned by Cornelis Hoogendijk when they were offered by Paul Rosenberg in 1920. Without having set eyes on them, he arranged for thirteen paintings to be shipped to his home in Merion, Pennsylvania. Those three landscapes and ten still lifes form the most important single group of works by Cézanne ever assembled that has not been dispersed since. In 1922 Barnes transformed his collection into a foundation and continued buying, unaffected by the ups and downs of the European art market. His favorite suppliers at that time were the Paris dealers Paul Guillaume, Georges Keller, and Étienne Bignou, who, in return, treated him as their best client. Some of his most important purchases took place in the 1930s, when most collectors were hit by the Depression. Two acquisitions from that period are *Bathers at Rest* (p. 279, fig. 1), formerly in the Caillebotte collection and rejected by the Musée du Louvre, and *Young Man with a Skull* (V. 679), from the Gottlieb Friedrich Reber collection. The two great masterpieces of the Barnes Foundation collection, *The Cardplayers* (repro. p. 56), formerly in the Auguste Pellerin collection, and *The Large Bathers* (repro. p. 39), were purchased from Vollard.

Margarete Oppenheim (died 1934)

Margarete Oppenheim, from Berlin, became an important client of Paul Cassirer's. She began buying in 1913 and owned nine important paintings by Cézanne, among them *Environs of Gardanne* (V. 436), *House with Red Roof* (cat. no. 117), and *On the Bellevue Plain* (V. 448). After her death the collection was dispersed, some works sold privately by Paul Cassirer in Berlin, and the remainder in her posthumous sale of May 22, 1936, by Julius Böhler in Munich.

1914-1939

During and after World War I, collecting almost came to a standstill. About 1920 the outstanding Cézannes of the Cornelis Hoogendijk and Egisto Fabbri collections were offered for sale. Dr. Albert Barnes had become the most active buyer in the art market. After the years of inflation, at the end of the 1920s, Germany enjoyed a few years of economic upswing, and many new galleries opened, particularly in Berlin. With renewed world depression and the rise of German National Socialism, followed by World War II, international collecting was largely halted.

Justin K. Thannhauser (1892-1976)

In 1904 Heinrich Thannhauser (1859-1934) and Joseph Brakl had founded the Moderne Galerie in Munich. Heinrich Thannhauser separated from his partner in 1908, renaming his business Moderne Galerie [Heinrich Thannhauser], with his son Justin joining the firm in 1911. Justin sought the work of the Post-Impressionists and also contemporary art such as Picasso and the Cubists. A number of Cézannes are illustrated in his 1916 stock catalogue. However, the artist's name only appears for the first time in 1921 in the stock books of the Munich and Lucerne branches of the firm. The Lucerne branch opened in 1920 and was run by Justin's cousin Siegfried Rosengart (1894-1985). In 1927 another branch opened in Berlin, initiating transactions involving all three branches. In 1937 Thannhauser and Rosengart split. Thannhauser moved to New York, taking along most of the firm's Cézanne paintings. He successfully began to expand his private collection, eventually leaving five paintings by Cézanne in the Thannhauser Bequest to the Guggenheim Museum in New York. One landscape, *The Château de Marines* (V. 636), is on permanent loan from the Hilde Thannhauser estate at the Kunstmuseum in Bern.

Sally Falk (1888-1962)

Sally Falk, a businessman from Mannheim, was a great patron and collector of contemporary art. During the war years of 1916 and 1917, he bought five Cézannes—*The Murder* (cat. no. 16), *The Twisted Tree* (V. 420), *Village Seen Through Trees* (V. 438), *Portrait of Madame Cézanne* (V. 522), and *Vase of Tulips* (V. 618)—at the Julius Stern sale, one of the first of many sales held at Paul Cassirer's in Berlin. However, in April 1918, he sold his collection back to Paul Cassirer, who was able to sell most of it before the war ended.

Jean Laroche (1866-1935)

The French industrialist Jean Laroche owned seven paintings by Cézanne. Appearing as a buyer for the first time in 1919 at the Mirbeau sale, he purchased several paintings from Paul Rosenberg in 1920, among them *Self-Portrait* (cat. no. 34) from the Hoogendijk collection, which, together with five paintings by other artists, was later presented by his son Jacques Laroche (1904-1976) to the French State.

Paul Guillaume (1891-1934)

A friend of Guillaume Apollinaire, Paul Guillaume opened a gallery for contemporary art in Paris in 1914. He became friendly with Dr. Albert Barnes, to whom he sold not only works by Henri Rousseau, Modigliani, and his contemporaries but also African art. In 1941 his widow, Juliette, a collector in her own right, married the architect, industrialist, and art lover Jean Walter. On May 14, 1952, at the Cognacq sale, she acquired the Cézanne painting *Apples and Biscuits* (cat. no. 78), drawing attention to her collection, which today can be admired as a mainstay of the Musée de l'Orangerie in Paris. Of the fourteen Cézannes on view, five were assembled by Paul Guillaume: *Madame Cézanne in the Garden* (V. 370), *The Artist's Son in a Red Chair* (cat. no. 85), *Still Life, Rose and Fruit* (V. 359), *Portrait of Madame Cézanne* (V. 523), and *Ginger Jar, Sugar Bowl, and Apples* (V. 616); seven by Juliette Guillaume-Walter: *Provençale Landscape with Red Roof* (V. 163), *Le Dejeuner sur l'herbe* (V. 238), *Apples and Biscuits* (V. 78), *The Dark Blue Vase* (V. 362), *Trees and House on the Tholonet Road* (V. 480), *Boat and Bathers* (V. 583), and *In the Park at the Château Noir* (V. 779); and two came from Domenico and Jean Walter: *Apples, Napkin, and Milk Can* (V. 356) and *The Red Rock* (V. 776).

Baron Kojiro Matsukata (1865-1950)

The Japanese collector lived in Paris between 1920 and 1928. He owned seven Cézannes, most acquired from the German art market, three of which, *Houses at Valhermeil* (V. 318), *Fruit on a Cloth* (V. 603), and *The House with Cracked Walls* (V. 657), came from the Adolph Rothermundt collection in Dresden. His collection was dispersed.

Arthur Hahnloser (1870-1965)
and Hedy Hahnloser Bühler (1873-1952)

Arthur Hahnloser, an oculist, and his wife, Hedy, from Winterthur, Switzerland, were friends and supporters of the Swiss artist Félix Vallotton, who lived in Paris and was married to a sister of the Bernheim-Jeunes. Through him they met the Paris artists and dealers. They owned six Cézannes, which they left to their children, Hans R. Hahnloser and Lisa Jäggli-Hahnloser.

Oskar Reinhart (1885-1965)

The paintings by Cézanne assembled by the Swiss collector between 1921 and 1938 are open to the public in Winterthur at the Sammlung Oskar Reinhart. In 1915 Oskar's brother Werner purchased *Still Life* (V. 750) at Vollard's. He left it to Oskar in his will, who bought his own first Cézanne, *Compotier, Apples, and Loaf of Bread* (V. 344) in 1921 at Paul Rosenberg's gallery in Paris. When, in 1922, the Danish businessman Wilhelm Hansen, founder of the Oordrupgaard-Samlingen, had to sell part of his collection, Oskar Reinhart was able to acquire, among other paintings, the two Cézannes: *Self-Portrait* (V. 367) and *The Pilon du Roi* (V. 658). In 1923 he added *Plate of Peaches* (V. 607) from the Galerie Barbazanges; in 1925, *Still Life* (V. 742) from Paul Rosenberg; in 1926, *The Château Noir Seen Through Trees* (V. 667) from Paul Cassirer, Amsterdam; and finally, in 1938, *Portrait of a Man* (V. 102) from Wildenstein Galleries.

Lillie P. Bliss (1864-1931)

Lillie Bliss began collecting at the time of the Armory Show in 1913. Her advisors were the painter Arthur B. Davies and, later, the New York dealer Marius de Zayas, who in 1916 sold her the *Large Bather* (cat. no. 104). She left all of her eleven Cézannes to the Museum of Modern Art in New York, only four of which are still there today. These are the *Large Bather, Still Life* (V. 736), *Pine Trees and Rocks (Fontainebleau?)* (V. 774), and *Ginger Jar, Sugar Bowl, and Oranges* (V. 738).

Gwendoline E. Davies (1882-1951)

Granddaughter of a Welsh coal and railway magnate, Gwendoline Davies received an unusual and, at that time, exceptional Francophile education. She and her sister were known to the London art market as buyers of French art even before 1914. Gwendoline Davies was the first person in England to own a painting by Cézanne. Her three pictures by Cézanne—*Mountains in Provence (Near L'Estaque?)* (cat. no. 56), *The Forest* (V. 446), and *Still Life with Teapot* (V. 734)—were purchased between 1917 and 1919 from Bernheim-Jeune. In 1922 the three paintings were shown at the Burlington Fine Arts Club in London in the exhibition "Pictures, Drawings, and Sculpture of the French School of the Last 100 Years." A year later, *Mountains in Provence (Near L'Estaque?)*

was the first painting by Cézanne to be seen in an English museum, when it was lent to the Tate Gallery. Since 1952 the three paintings have been in Cardiff at the National Museum of Wales as the Gwendoline E. Davies Bequest.

Samuel Courtauld (1876-1947)

In 1923 Alex Reid, the leading dealer of French art in London and Glasgow, held an exhibition in London at Agnew's called "Twenty Masterpieces of French Art of the 19th Century." Samuel Courtauld purchased his first two Cézannes from this exhibition: *Étang des Soeurs, Osny* (V. 174) and *Still Life with Plaster Cupid* (cat. no. 162). He also made available to the Tate Gallery a donation of £50,000 for acquisitions, known as the Courtauld Fund. From this fund, *Self-Portrait* (V. 365) was purchased in 1925 and is today at the National Gallery in London. Until 1929 Samuel Courtauld purchased a Cézanne a year, owning ten paintings altogether: six landscapes, two still lifes, and two figure paintings of the Cardplayers series. Eight Cézanne paintings are permanently exhibited at the Courtauld Institute Galleries in Somerset House, London, as part of the Samuel Courtauld Trust.

Otto Krebs (1873-1941)

The German collector Otto Krebs, who lived in Holzdorf, near Weimar, bought his paintings in the late 1920s in Berlin, mainly from Justin Thannhauser and Hugo Perls. His collection, including five paintings by Cézanne, was considered lost since World War II. The paintings have recently come to light again at the Hermitage Museum in St. Petersburg, undamaged and in perfect condition. They are *The Pool at the Jas de Bouffan* (V. 167), *Portrait of Cézanne, after Renoir* (V. 372), *Houses along a Road, I* (V. 330), *Bottle and Fruit* (V. 1518), and *Bathers in the Open Air* (V. 582).

Duncan Phillips (1886-1966)

It was Duncan Phillips's wish to collect and to share his collection, which he opened to the public in Washington, D.C., in 1921. He purchased his first and most important Cézanne, *Mont Sainte-Victoire with Large Pine* (cat. no. 93), in 1925, and acquired five more prior to 1955. They are all on view at the Phillips Collection in Washington, D.C.

Carroll S. Tyson, Jr. (1878-1956)

Having come into his inheritance in 1925, Carroll Tyson, a painter, was finally able to collect the paintings he had already admired in the Armory Show. He owned eight Cézannes, of which six (V. 197, V. 218, V. 411, V. 489, V. 768, and V. 799) are today in the Philadelphia Museum of Art.

Averell Harriman (1891-1986)

Marie Harriman, wife of the politician, owned and managed a gallery of French art in New York from 1930 to 1942. They kept five Cézannes in their private collection, now bequeathed to the National Gallery of Art in Washington, D.C., by Averell Harriman, in memory of his wife Marie.

Chester Dale (1881-1962)

Chester Dale purchased five of his six Cézannes in 1927-28. In 1941 his collection was exhibited at the National Gallery of Art in Washington, D.C., and in 1962 it became part of the museum.

1939-1995

Once World War II was over, Americans emerged as the most visible collectors. Privileged by favorable tax laws encouraging donations, they enabled their museums to benefit from their private art collecting. It would be impossible to mention here each single donor of every Cézanne to the many American institutes and museums, but a few private collections were formed at that time for perpetuity. Some Europeans, generally of multinational origin, also began to collect Cézannes, and in recent years Japanese collectors have been particularly assertive. Nearly everyone today, however, prefers to remain anonymous, with very few collectors buying under their own names.

Emil Georg Bührle (1890-1956)

After the war, when many collectors were forced to sell their pictures, the Swiss industrialist Emil Bührle became the most prolific buyer on the international art market. His first Cézanne, *Mont Sainte-Victoire* (V. 802), was purchased in 1937. From 1947 until his death in 1956, he acquired seven additional paintings. The three large portraits *Madame Cézanne with a Fan* (V. 369), *Boy in a Red Vest* (p. 322, fig. 2), and *Self-Portrait with a Palette* (repro. p. 72) form the most important group of Cézanne paintings assembled by one person since Dr. Barnes. These three paintings, together with four others—*The Temptation of Saint Anthony* (V. 103), *Landscape* (V. 306), *Le Cengle* (V. 483), and *The Gardener* (V. 1524)—are on view at the Stiftung Sammlung E. G. Bührle in Zurich, open to the public.

Henry Pearlman (1896-1974)

Henry Pearlman bought his first Cézanne watercolor in 1950. Today, the Rose and Henry Pearlman Collection, housed in the Art Museum at Princeton University, consists of nine watercolors and six paintings by Cézanne. Pearlman did not hesitate to acquire unknown and unpublished works. Four of his paintings—*Portrait of the Artist's Son, Houses in Provence*, as well as the large-size *Mont Sainte-Victoire* (cat. no. 200), and *View Toward the Tholonet Road*—are not recorded by Venturi.

Paul Mellon (born 1907)

Paul Mellon's collecting activities are closely connected with the National Gallery of Art in Washington, D.C., which possesses the greatest number of Cézannes in an American museum, six of them presented by Paul Mellon. Two small paintings were also given by him to the Yale University Art Gallery, New Haven, and two to the Virginia Museum of Fine Arts, Richmond. In 1995 he presented his most important work by Cézanne to the National Gallery of Art: *Boy in a Red Vest* (V. 682), a key painting in the history of art collecting since World War II. Originally owned by Egisto Fabbri, it was one of the eight paintings belonging to the Berlin banker Jakob Goldschmidt that were sold at auction on October 15, 1958, at Sotheby's in London. This sale created a new price level for Impressionist and Post-Impressionist art.

David Rockefeller (born 1915)

In 1955 David Rockefeller purchased the *Boy in a Red Vest* that had been in Claude Monet's collection and, in 1978, the famous *Compotier, Glass, and Apples*, once owned by Paul Gauguin.

Chateaubriand Bandeira de Mello (1891-1968)

In the short span of five years, between 1947 and 1952, the Brazilian newspaper magnate assembled the collection that is today on view in his museum in São Paulo. He purchased five major works by the artist: *The Negro Scipion* (cat. no. 11), *Paul Alexis Reading to Émile Zola* (repro. p. 25), and *Rocks at L'Estaque* (cat. no. 55) from Wildenstein; and *Large Pine* (cat. no. 153) and *Portrait of Madame Cézanne in Red* (V. 573) from Knoedler's.

Norton Simon (1907-1993)

The California industrialist who started buying art in the 1960s left his large collection, covering many fields, to the public, in the Norton Simon Museum in Pasadena. There are four paintings by Cézanne, among them the most important "rediscovery" in John Rewald's catalogue raisonné: *Chestnut Trees and Farm at the Jas de Bouffan* (non-V.), which had been given by the artist in 1884 to Fanny, a young servant at the family estate who kept it all her life unknown to everybody, until it was sold after her death in 1943.

Heinz Berggruen (born 1914)

Heinz Berggruen, originally from Berlin, came to Europe as an American soldier. He settled in Paris after World War II, opened a gallery, and became the most successful dealer of Picasso and his contemporaries, especially in handling their prints. In 1958 he purchased the Cézanne watercolor *Portrait of the Gardener Vallier* (cat. no. 226) at Sotheby's in London. This was the beginning of his Cézanne collection, consisting today of seven paintings. He owns four figure paintings, two landscapes, and one still life, now exhibited on loan at the National Gallery in London.

Walter Annenberg (born 1908)

Ambassador Walter Annenberg's two Cézanne paintings, *Dish of Apples* (V. 207) and *Mont Sainte-Victoire* (V. 804), together with the three works he inherited from his sister Mrs. Enid Haupt in 1983, are the five paintings that are promised to the Metropolitan Museum of Art in New York as part of the Walter and Leonore Annenberg Collection. In a period when collectors of important works of art prefer to remain anonymous, Annenberg has, under his name, recently purchased several masterpieces.

List of Sources Cited

The following alphabetical list of sources corresponds to the abbreviations cited in this catalogue. When an author has published several articles in the same year, the date is followed by the letters (a), (b), or (c). Anonymous articles published in the same year are distinguished by (1) or (2).

Adhémar, April 1982
Adhémar, Jean. "Schnerb, Cézanne, Renoir." *Gazette des Beaux-Arts*, 6th ser., vol. 99, no. 1359 (April 1982), pp. 147-52.

Adriani, 1983
Adriani, Götz. *Cézanne Watercolors*, trans. Russell M. Stockman. New York, 1983.

Adriani, 1993 (a)
Adriani, Götz, with Walter Feilchenfeldt. *Cézanne—Gemälde*. Cologne, 1993.

Adriani, 1993 (b)
Adriani, Götz, with Walter Feilchenfeldt. *Cézanne Paintings*, trans. Russell Stockman. Cologne, 1993.

Alexandre, December 9, 1895
Alexandre, Arsène. "L'Art nouveau." *Le Figaro*, December 9, 1895.

Alexandre, December 28, 1895
Alexandre, Arsène. "L'Art nouveau." *Le Figaro*, December 28, 1895.

Alexandre, May 1, 1900
Alexandre, Arsène. "Les Beaux-Arts à l'Exposition Universelle de 1900: La Centennale de l'Art Français." *Le Figaro*, May 1, 1900.

Alexandre, May 2, 1901
Alexandre, Arsène. "La Vie artistique II: Les Indépendants." *Le Figaro*, May 2, 1901.

Alexandre, June 26, 1901
Alexandre, Arsène. "Petites expositions." *Le Figaro*, June 26, 1901.

Alexandre, April 1, 1902
Alexandre, Arsène. "Les Indépendants." *Le Figaro*, April 1, 1902.

Alexandre, October 31, 1903
Alexandre, Arsène. "Le Salon d'Automne." *Le Figaro*, October 31, 1903.

Alexandre, October 14, 1904
Alexandre, Arsène. "Le Salon d'Automne." *Le Figaro*, October 14, 1904.

Alexandre, October 17, 1905
Alexandre, Arsène. "Le Salon d'Automne." *Le Figaro*, October 17, 1905.

Alexandre, October 5, 1906
Alexandre, Arsène. "Le Salon d'Automne." *Le Figaro*, October 5, 1906.

Alexandre, October 25, 1906
Alexandre, Arsène. "Paul Cézanne." *Le Figaro*, October 25, 1906.

Alexis, May 5, 1886
Trublot [Paul Alexis]. "Mon Vernissage." *Le Cri du peuple*, May 5, 1886.

A. M., October 15, 1904
A. M. "Le Salon d'Automne." *La Lanterne*, October 15, 1904.

Andersen, June 1965
Andersen, Wayne V. "Cézanne's *Carnet violet-moiré.*" *The Burlington Magazine*, vol. 107, no. 747 (June 1965), pp. 313-18.

Andersen, June 1967
Andersen, Wayne V. "Cézanne, Tanguy, Chocquet." *The Art Bulletin*, vol. 49, no. 2 (June 1967), pp. 137-39.

Andersen, December 1990
Andersen, Wayne V. "Cézanne's *L'Éternel Féminin* and the Miracle of Her Restored Vision." *The Journal of Art*, vol. 3, no. 3 (December 1990), pp. 43-44.

Anonymous, April 6, 1877
Anonymous. "L'Exposition des impressionnalistes." *L'Événement*, April 6, 1877.

Anonymous, April 9, 1877
Anonymous, "Les Impressionnistes." *La Petite Presse*, April 9, 1877.

Anonymous, April 10, 1877
Anonymous. "Exposition des impressionnistes: 6, rue le Peletier, 6." *La Petite République française*, April 10, 1877.

Anonymous, January 19 and 27, 1890
Anonymous. "L'Exposition des XX." *Le Soir* (Brussels), January 19 and 27, 1890.

Anonymous (1), October 1893
Anonymous. "Choses d'art." *L'Art littéraire*, October 1893, p. 44.

Anonymous (2), October 1893
Anonymous. "Exposition des portraits du prochain siècle." *Le Coeur*, no. 7 (October 1893).

Anonymous, April 15, 1894
Anonymous. "Vom Kunstmarkt." *Die Kunst für Alle*, vol. 9, no. 14 (April 15, 1894), p. 222.

Anonymous, November 23, 1895
Anonymous. "Les Expositions: Oeuvres de M. Césanne." *L'Art français*, November 23, 1895.

Anonymous, November 25, 1895
Anonymous. In *L'Art international*, November 25, 1895.

Anonymous, July 1, 1897
Anonymous. In *L'Écho de Paris*, July 1, 1897.

Anonymous, November 1897
Anonymous. "Studio Talk." *The Studio*, vol. 12, no. 56 (November 1897).

Anonymous, 1898
Anonymous. "Amtliche Berichte II, National-Galerie". *Jahrbuch der Königlichen preussischen Kunstsammlungen*, vol. 19 (1898).

Anonymous, May 15, 1898
Anonymous. "Au jour le jour." *Le Journal*, May 15, 1898.

Anonymous, September 1899
Anonymous. "Korrespondenzen." *Dekorative Kunst*, September 1899.

Anonymous, February 1901
Anonymous. "Expositions ouvertes ou prochaines." *L'Art décoratif*, no. 29 (February 1901).

Anonymous, March 1, 1901
Anonymous. "L'Exposition de la Libre Esthétique, I." *L'Étoile belge*, March 1, 1901.

Anonymous, June 22, 1902
Anonymous. In *La Provence nouvelle*, June 22, 1902.

Anonymous, February-March 1903
Anonymous. "Chronik." *Kunst und Künstler*, no. 6 (February-March 1903).

Anonymous, April 1903
Anonymous. "Chronik: Paris." *Kunst und Künstler*, no. 7 (April 1903).

Anonymous, April 29, 1904
Anonymous. "Ausstellungen." *Kunstchronik*, April 29, 1904.

Anonymous, June-November 1904
Anonymous. In *Les Arts de la vie*, nos. 6-11 (June-November 1904).

Anonymous, October 1904
Anonymous. In *La Petite Gironde*, October 1904.

Anonymous, October 15, 1904
Anonymous. "Petites expositions." *L'Éclair*, October 15, 1904.

Anonymous, October 17, 1905
Anonymous. In *Le Matin*, October 17, 1905.

Anonymous (1), October 18, 1905
Anonymous. In *La Petite Gironde*, October 18, 1905.

Anonymous (2), October 18, 1905
Anonymous. In *Le XIXᵉ siècle*, October 18, 1905.

Anonymous, October 19, 1905
Anonymous. In *La Lanterne*, October 19, 1905.

Anonymous, October 28, 1905
Anonymous. In *La Dépêche*, October 28, 1905.

Anonymous, December 15, 1905
Anonymous. "Von Ausstellungen und Sammlungen." *Die Kunst für Alle*, vol. 21, no. 6 (December 15, 1905), p. 140.

Anonymous, January 15, 1906
Anonymous. In *Die Kunst für Alle*, vol. 21, no. 8 (January 15, 1906).

Anonymous, April 1, 1906
Anonymous [Hans Rosenhagen]. "Von Ausstellungen und Sammlungen." *Die Kunst für Alle*, vol. 21, no. 13 (April 1, 1906), pp. 307-308.

Anonymous, May 25, 1906
Anonymous. In *Kunstchronik*, May 25, 1906.

Anonymous, July 1, 1906
Anonymous. "Von Ausstellungen und Sammlungen." *Die Kunst für Alle*, vol. 21, no. 19 (July 1, 1906), p. 454.

Anonymous, October 24, 1906
Anonymous. "Échos." *Le Figaro*, October 24, 1906.

Anonymous (1), October 25, 1906
Anonymous. In *Le Gaulois*, October 25, 1906.

Anonymous (2), October 25, 1906
Anonymous. In *Le Soleil*, October 25, 1906.

Anonymous, October 30, 1906
Anonymous. In *Le Journal de Monaco*, October 30, 1906.

Anonymous, November 2, 1906
Anonymous. "Nekrologie." *Kunstchronik*, November 2, 1906.

Anonymous, November 3, 1906
Anonymous. "Nécrologie." *Le Bulletin de l'art ancien et moderne*, November 3, 1906.

Anonymous, December 1906
Anonymous. In *Kunst und Künstler*, vol. 5, no. 3 (December 1906).

Anonymous, December 1, 1906
Anonymous. "Personal- und Atelier-Nachrichten: Gestorben." *Die Kunst für Alle*, vol. 22, no. 5 (December 1, 1906), p. 128.

Anonymous, February 1907
Anonymous. "Chronik." *Kunst und Künstler*, vol. 5, no. 5 (February 1907).

Arnoux, February 1890
Arnoux, Jacques. "Chronique artistique: Le Salon des XX de 1890." *La Jeune Belgique*, vol. 9, no. 2 (February 1890), p. 124.

Arrouye, 1982
Arrouye, Jean. *La Provence de Cézanne*. Aix-en-Provence, 1982.

Asselin, October 26, 1905
Asselin, Henry. In *Le Chroniqueur mondain*, October 26, 1905.

A. T., May 1902
A. T. "Expositions du mois." *L'Art décoratif*, no. 44 (May 1902).

Athanassoglou-Kallmyer, September 1990
Athanassoglou-Kallmyer, Nina. "An Artistic and Political Manifesto for Cézanne." *The Art Bulletin*, vol. 72, no. 3 (September 1990), pp. 482-92.

Auriant, July 1946
Auriant. "Duranty et Zola". *La Nef*, no. 20 (July 1946).

Aurier, June 1891
Aurier, Georges-Albert. "Choses d'art." *Mercure de France*, June 1891, p. 374.

Babin, October 14, 1904
Babin, Gustave. "Le Salon d'Automne." *L'Écho de Paris*, October 14, 1904.

Babin, October 17, 1905
Babin, Gustave. "Le Salon d'Automne." *L'Écho de Paris*, October 17, 1905.

Badt, 1956
Badt, Kurt. *Die Kunst Cézannes*. Munich, 1956.

Badt, 1965
Badt, Kurt. *The Art of Cézanne*, trans. Sheila Ann Ogilvie. London and Berkeley, California, 1965.

Badt, 1985
Badt, Kurt. *The Art of Cézanne*, trans. Sheila Ann Ogilvie. New York, 1985.

Bakker, 1971
Bakker, B. H. *Naturalisme pas mort: Lettres inédites de Paul Alexis à Émile Zola 1871-1900*. Toronto, 1971.

Baligand, 1978
Baligand, Renée. "Lettres inédites d'Antoine Guillemet à Émile Zola." *Les Cahiers naturalistes (1866-1870)*, no. 52 (1978).

Ballas, 1975
Ballas, Guila. "Daumier, Corot, Papety et Delacroix, inspirateurs de Cézanne." *Bulletin de la Société de l'Histoire de l'Art Français, . . . Année 1974* (1975), pp. 193-99.

Ballas, December 1981
Ballas, Guila. "Paul Cézanne et la revue 'L'Artiste.'" *Gazette des Beaux-Arts*, 6th ser., vol. 98, no. 1355 (December 1981), pp. 223-32.

Ballu, April 23, 1877
Ballu, Roger. "L'Exposition des peintres impressionnistes." *Les Beaux-Arts illustrés*, April 23, 1877, p. 392.

Barnes and de Mazia, 1939
Barnes, Albert C., and Violette de Mazia. *The Art of Cézanne*. New York, 1939.

Barr, January 1937
Barr, Alfred. "Cézanne, d'après les lettres de Marion à Morstatt, 1865-1868." *Gazette des Beaux-Arts*, 6th ser., vol. 17 (January 1937), pp. 37-58.

Barr, 1938
Barr, Alfred. "Cézanne: In the Letters of Marion to Morstatt, 1865-1868," trans. Margaret Scolari.

Parts 1-3. *Magazine of Art*, vol. 31, no. 2 (February 1938), pp. 84-89; no. 4 (April 1938), pp. 220-25; no. 5 (May 1938), pp. 288-91.

Barr, 1954
Barr, Alfred, ed. *Masters of Modern Art*. New York, 1954.

Barskaya, 1975
Barskaya, Anna G. *Paul Cézanne*, trans. N. Johnstone. Leningrad, 1975.

Barskaya and Kostenevich, 1991
Barskaya, Anna G., and Albert G. Kostenevich. *The Hermitage, Catalogue of Western European Painting: French Painting, Mid-Nineteenth to Twentieth Centuries*. Moscow and Florence, 1991.

Baudelaire, 1857
Baudelaire, Charles. *Les Fleurs du Mal*. Paris, 1857.

Baudelaire, 1975-76
Baudelaire, Charles. *Oeuvres complètes*, ed. Claude Pichois. 2 vols. Paris, 1975-76.

Baudot, 1949
Baudot, Jeanne. *Renoir, ses amis, ses modèles*. Paris, 1949.

Bazin, 1958
Bazin, Germain. *French Impressionnists in the Louvre*, trans. S. Cunliffe-Owen. New York, 1958.

Bazire, 1884
Bazire, Edmond. *Manet*. Paris, 1884.

Bell, 1922
Bell, Clive. *Since Cézanne*. New York and London, 1922.

Benedict, October 25, 1904
Benedict, Lélia. "Chronique des beaux-arts: Le Salon d'Automne." *L'Encyclopédie contemporaine*, October 25, 1904, p. 135.

Beral, February 5, 1901
Beral, J. "Cézanne." *Art et littérature*, no. 1 (February 5, 1901), pp. 6-7.

Bérard, December, 1968
Bérard, Maurice. "Lettres de Renoir à Paul Bérard." *La Revue de Paris*, December 1968, p. 7.

Bernard, 1891
Bernard, Émile. "Paul Cézanne." *Les Hommes d'aujourd'hui*, vol. 8, no. 387 [1891], n.p.

Bernard, December 1903
Bernard, Émile. "Notes sur l'École dite 'de Pont-Aven.'" *Mercure de France*, December 1903, pp. 675-82.

Bernard, July 1904
Bernard, Émile. "Paul Cézanne." *L'Occident*, vol. 6 (July 1904), pp. 17-30.

Bernard, October 1 and 16, 1905
Bernard, Émile. "Souvenirs sur Paul Cézanne." *Mercure de France*, October 1 and 16, 1905.

Bernard, October 25, 1905
Bernard, Émile. In *Le Petit Dauphinois*, October 25, 1905.

Bernard, March 1906
Lepeseur, Francis [Émile Bernard]. "De Michel-Ange à Paul Cézanne." *La Rénovation esthétique*, vol. 2 (March 1906), pp. 254-60.

Bernard, November 1906
Lepeseur, Francis [Émile Bernard]. "Le Salon d'Automne." *La Rénovation esthétique*, vol. 4 (November 1906), p. 28.

Bernard, October 1 and 15, 1907
Bernard, Émile. "Souvenirs sur Paul Cézanne et lettres inédites." Parts 1 and 2. *Mercure de France*, October 1, 1907, pp. 385-404; and October 15, 1907, pp. 606-27. Reprinted in Doran, 1978, pp. 49-80.

Bernard, December 16, 1908
Bernard, Émile. "Julien Tanguy, dit le 'Père Tanguy.'" *Mercure de France*, December 16, 1908, pp. 600-16.

Bernard, 1912
Bernard, Émile. *Souvenirs sur Paul Cézanne*. Paris, 1912.

Bernard, 1917
Bernard, Émile. *Erinnerungen an Paul Cézanne*. Basel, 1917.

Bernard, March 1, 1920
Bernard, Émile. "La Méthode de Paul Cézanne." *Mercure de France*, March 1, 1920, pp. 289-318.

Bernard, December 1920
Bernard, Émile. "La Technique de Paul Cézanne." *L'Amour de l'art*, no. 8 (December 1920), pp. 271-78.

Bernard, 1921
Bernard, Émile. *Souvenirs sur Paul Cézanne et lettres*. Paris, 1921.

Bernard, June 1, 1921
Bernard, Émile. "Une conversation avec Cézanne." *Mercure de France*, June 1, 1921, pp. 372-97.

Bernard, February 1924
Bernard, Émile. "Les Aquarelles de Cézanne." *L'Amour de l'art*, vol. 5, no. 2 (February 1924), pp. 32-36.

Bernard, 1925
Bernard, Émile. *Sur Paul Cézanne*. Paris, 1925.

Bernard, 1926
Bernard, Émile. *Souvenirs sur Paul Cézanne, une conversation avec Cézanne*. Paris, 1926.

Bernard, May 1, 1926
Bernard, Émile. "L'Erreur de Cézanne." *Mercure de France*, May 1, 1926, pp. 513-28.

Berthold, 1958
Berthold, Gertrude. *Cézanne und die alten Meister: Die Bedeutung der Zeichnungen Cézannes nach Werken anderer Künstler*. Stuttgart, 1958.

Bettendorf, January 1982
Bettendorf, M. Virginia B. "Cézanne's Early Realism: 'Still Life with Bread and Eggs' Reexamined." *Arts Magazine*, vol. 56, no. 5 (January 1982), pp. 138-41.

Bettex, October 14, 1904
Bettex. "Le Salon d'Automne." *La République française*, October 14, 1904.

Bettex, October 17, 1905
Bettex. In *La République française*, October 17, 1905.

Bettex, October 5, 1906
Bettex. In *La République française*, October 5, 1906.

Bigot, April 28, 1877
Bigot, Charles. "Causerie artistique: L'Exposition des 'impressionnistes.'" *La Revue politique et littéraire*, April 28, 1877, pp. 1045-48.

Blanche, May 13, 1921
Blanche, Jacques-Émile. "Gasquet l'animateur." *Comedia*, May 13, 1921.

Blot, 1900
Hôtel Drouot, Paris. *Catalogue de tableaux, aquarelles, pastels et dessins . . . composant la collection de M. E. Blot*. May 9-10, 1900.

Bodelsen, May 1962
Bodelsen, Merete. "Gauguin's Cézannes." *The Burlington Magazine*, vol. 104, no. 710 (May 1962), pp. 204-11.

Bodelsen, June 1968
Bodelsen, Merete. "Early Impressionist Sales 1874-1894 in the Light of Some Unpublished 'Procès-Verbaux.'" *The Burlington Magazine*, vol. 110, no. 783 (June 1968), pp. 331-49.

Bodelsen, September 1970
Bodelsen, Merete. "Gauguin, the Collector." *The Burlington Magazine*, vol. 112, no. 810 (September 1970), pp. 590-615.

Boissard, October 22, 1904
Boissard. "Le Salon d'Automne." *Le Monde illustré*, October 22, 1904.

Borély, July 1, 1926
Borély, Jules. "Cézanne à Aix." *L'Art Vivant*, no. 37 (July 1, 1926), pp. 491-94. Reprinted in Doran, 1978, pp. 18-22.

Bouyer, November 5, 1904
Bouyer, Raymond. "Le Procès de l'art moderne au Salon d'Automne." *La Revue bleue*, November 5, 1904, pp. 601-5.

Brady, 1968
Brady, Patrick. "*L'Oeuvre*" d'Émile Zola. Geneva, 1968.

Brahm, November 5-20, 1904
Brahm, Alcanter de. "Art, Salon d'Automne." *La Critique*, no. 220 (November 5-20, 1904).

Breeskin, 1948
Breeskin, Adelyn D. *The Graphic Work of Mary Cassatt*. New York, 1948.

Musée Granet, 1982
Musée Granet, Aix-en-Provence. *Cézanne ou la peinture en jeu*. Limoges, 1982.

Brion-Guerry, 1966
Brion-Guerry, Liliane. *Cézanne et l'expression de l'espace*. Paris, 1966.

Burty, April 25, 1877
Ph. B. [Philippe Burty]. "Exposition des impressionnistes." *La République française*, April 25, 1877.

Cabanne, 1963
Cabanne, Pierre. *The Great Collectors*. New York, 1963.

Cachin, 1964
Cachin, Françoise. "Cézanne et Delacroix." *Art de France*, vol 4 (1964), pp. 341-43.

Callen, 1983
Callen, Anthea. *Les Peintres impressionnistes et leur technique*. Paris, 1983.

Callias, 1861
Callias, Hector de. "Salon de 1861." *L'Artiste*, vol. 12 (1861).

Camoin, January 1921
Camoin, Charles. "Souvenirs sur Paul Cézanne." *L'Amour de l'art*, vol. 2, no. 1 (January 1921), pp. 25-26.

Castagnary, April 29, 1874
Castagnary, Jules-Antoine. "Exposition du boulevard des Capucines: Les Impressionnistes." *Le Siècle*, April 29, 1874.

Cézanne, 1973
Cézanne, Paul. *Mes Confidences*. In Chappuis, 1973, vol. 1, pp. 25-28.

Cézanne, 1976
Cézanne, Paul. *Letters*, ed. John Rewald, trans. Marguerite Kay. 1941. 4th ed., rev., New York, 1976.

Cézanne, 1978
Cézanne, Paul. *Correspondance*, ed. John Rewald. 1937. Rev. ed., Paris, 1978.

Chappuis, July-September 1971
Chappuis, Adrien. Note in "La Chronique des arts." *Gazette des Beaux-Arts*, 6th ser., vol. 78, nos. 1230-32 (July-September 1971), supplement, p. 22.

Chappius, 1973
Chappuis, Adrien. *The Drawings of Paul Cézanne: A Catalogue Raisonné*. 2 vols. Greenwich, Connecticut, 1973.

Charles, October 17, 1903
Charles, Étienne. "Le Salon d'Automne." *La Liberté*, October 17, 1903.

Charles, October 17, 1905
Charles, Étienne. "Le Salon d'Automne." *La Liberté*, October 17, 1905.

Charles, October 7, 1906
Charles, Étienne. In *La Liberté*, October 7, 1906.

Christophe, October 1893
Christophe, Jules. "Les Expositions: Les Portraits du prochain siècle." *La Plume*, October 1893.

C.I.B., October 17, 1904
C.I.B. "Topics in Paris: The Special Features of the Autumn Salon." *New York Tribune*, October 17, 1904.

Clark, 1949
Clark, Kenneth. *Landscape into Art*. London, 1949.

Clark, July 1974
Clark, Kenneth. "The Enigma of Cézanne." *Apollo*, vol. 100, no. 149 (July 1974), pp. 78-81.

Cooper, June 1938
Lord, Douglas [Douglas Cooper]. "Nineteenth-Century French Portraiture." *The Burlington Magazine*, vol. 72, no. 423 (June 1938), pp. 253-63.

Cooper, November-December 1954
Cooper, Douglas. "Two Cézanne Exhibitions." Parts 1 and 2. *The Burlington Magazine*, vol. 96, no. 620 (November 1954), pp. 344-49; no. 621 (December 1954), pp. 378-83.

Cooper, February 15, 1955
Cooper, Douglas. "Au Jas de Bouffan." *L'Oeil*, no. 2 (February 15, 1955), pp. 13-16, 46.

Cooper, December 1956
Cooper, Douglas. "Cézanne's Chronology." *The Burlington Magazine*, vol. 98, no. 645 (December 1956), p. 449.

Coquiot, November 22, 1899
Coquiot, Gustave. "La Vie artistique: Petits salons." *Gil Blas*, November 22, 1899.

Coquiot, November 27, 1899
Coquiot, Gustave. "La Vie artistique: Exposition Paul Cézanne." *Gil Blas*, November 27, 1899.

Coquiot, 1900
Coquiot, Gustave. "Les Beaux-Arts à l'Exposition." *La Plume*, 1900, p. 344.

Coquiot, 1919
Coquiot, Gustave. *Paul Cézanne*. Paris, 1919.

Dagen, 1986
Dagen, Philippe. *La Peinture en 1905: "L'Enquête sur les tendances actuelles des arts plastiques" de Charles Morice*. Paris, 1986.

d'Anner, October 18, 1905.
d'Anner. In *L'Intransigeant*, October 18, 1905.

D'Arve, December 22, 1895
D'Arve. In *La Provence nouvelle*, December 22, 1895.

Dauberville, 1967
Dauberville, Henri. *La Bataille de l'impressionnisme*. Paris, 1967.

Dauzats, October 6, 1906
Dauzats, Charles. "Le Vernissage du Salon d'Automne." *Le Figaro*, October 6, 1906.

Dayot, November 4, 1903
Dayot, Armand. "La Vie artistique: Le Salon d'Automne (suite et fin)." *Gil Blas*, November 4, 1903.

Denis, November 15, 1905
Denis, Maurice. "La Peinture." *L'Ermitage*, November 15, 1905, pp. 309-19. Reprinted as "De Gauguin, de Whistler et de l'excès des théories" in Denis, 1912, pp. 192-202.

Denis, September 1907
Denis, Maurice. "Cézanne." *L'Occident*, vol. 12 (September 1907), pp. 118-33. Reprinted in Denis, 1912, pp. 237-53. Translated as Denis, January-February 1910.

Denis, January-February 1910
Denis, Maurice. "Cézanne," trans. Roger Fry. Parts 1 and 2. *The Burlington Magazine*, vol. 16, no. 82 (January 1910), pp. 207-19; no. 83 (February 1910), pp. 275-80. Translation of Denis, September 1907.

Denis, December 1920
Denis, Maurice. "L'Influence de Cézanne." *L'Amour de l'art*, no. 8 (December 1920), pp. 279-84.

Denis, 1912
Denis, Maurice. *Théories, 1890-1910: Du symbolisme et de Gauguin vers un nouvel ordre classique*. Paris, 1912.

Denis, 1957
Denis, Maurice. *Journal*. 2 vols. Paris, 1957.

Denoinville, December 1, 1895
Denoinville. "Un comble." *Le Journal des artistes*, December 1, 1895.

Dervaux, June 15, 1902
Dervaux, Adolphe. "Notes rapides sur la peinture sympathique." *La Plume*, June 15, 1902.

Desies, October 2, 1904
Desies, Eugène. "Au Salon d'Automne." *Gil Blas*, October 2, 1904.

Dewhurst, 1904
Dewhurst, Wynford. *Impressionist Painting: Its Genesis and Development*. London and New York, 1904.

Diehl, 1972.
Diehl, Gaston. *Henri Matisse*. Paris, 1954. Reprinted in Dominique Fourcade, ed., *Henri Matisse: Écrits et propos sur l'art*. Paris, 1972.

Distel, 1989
Distel, Anne. *Les Collectionneurs des impressionnistes: Amateurs et marchands*. Düdingen-Guin, Switzerland, 1989.

Doran, 1978
Doran, P. M., ed. *Conversations avec Cézanne*. Paris, 1978.

Dorival, 1948 (a)
Dorival, Bernard. *Cézanne*. Paris, 1948.

Dorival, 1948 (b)
Dorival, Bernard. *Cézanne*, trans. H.H.A. Thackthwaite. New York and Boston, 1948.

Drucker, 1944
Drucker, Michel. *Renoir*. Paris, 1944.

Duret, 1902
Duret, Théodore. *Histoire d'Édouard Manet et son oeuvre*. Paris, 1902.

Duret, 1906
Duret, Théodore. *Histoire des peintres impressionnistes: Pissarro, Claude Monet, Sisley, Renoir, Berthe Morisot, Cézanne, Guillaumin*. Paris, 1906.

Elder, 1924
Elder, Marc. *À Giverny, chez Claude Monet*. Paris, 1924.

Ély, 1984.
Ély, Bruno. In Aix-en-Provence, 1984.

Ethèrel, March 9, 1901
Ethèrel (?). "Les Expositions: La Libre Esthétique.—Au cercle artistique, etc." *Le Messager de Bruxelles*, March 9, 1901.

Evelyne, October 30, 1906
Evelyne, Charles. "Un hommage à Cézanne." *Gil Blas*, October 30, 1906.

Fagus, December 15, 1899
Fagus, Félicien. "Quarante tableaux de Cézanne." *La Revue blanche*, December 15, 1899, pp. 627-28.

Fagus, May 1, 1902
Fagus, Félicien. "Paysages de Cézanne." *La Revue blanche*, May 1, 1902.

Fagus, December 1, 1903
Fagus, Félicien. "Art et critique, I—Le Salon d'Automne." *La Plume*, December 1, 1903.

Fagus, November 11, 1906
Fagus, Félicien. In *La Revue des Beaux-Arts*, November 11, 1906.

Faure, 1913
Faure, Élie. *Cézanne*, trans. Walter Pach. New York, 1913.

Feilchenfeldt, 1993
Feilchenfeldt, Walter. "Zur Rezeptionsgeschichte Cézannes in Deutschland." In Adriani, 1993 (a), pp. 293-312.

Fénéon, May 23, 1891
Fénéon, Félix. "M. Gauguin.—M. Dujardin." *Le Chat noir*, May 23, 1891.

Ferry, October 17, 1905
Ferry, René-Marc. "Salon d'Automne." *L'Éclair*, October 17, 1905.

Ferry, October 25, 1906
Ferry, René-Marc. "Paul Cézanne." *L'Éclair*, October 25, 1906.

Florisoone, August 10, 1936
Florisoone, Michel. "Paul Cézanne, la secrète et dramatique montée sur le Divin." *Le Correspondant*, August 10, 1936.

Fontainas, January 1898
Fontainas, André. "Art moderne." *Mercure de France*, January 1898.

Fontainas, June 1898
Fontainas, André. "Art moderne." *Mercure de France*, June 1898, p. 890.

Fontainas, February 1900
Fontainas, André. "Art moderne." *Mercure de France*, February 1900, pp. 522-27.

Fontainas, May 15, 1901
Fontainas, André. "Les Artistes indépendants." *La Plume*, May 15, 1901.

Fontainas, July 1, 1905
Fontainas, André. In *Mercure de France*, July 1, 1905.

Fourcaud, October 14, 1904
Fourcaud, M. L. de. "Le Salon d'Automne." *Le Gaulois*, October 14, 1904.

Fouquier, October 14, 1904
Fouquier, Marcel. "Le Salon d'Automne." *Le Journal*, October 14, 1904.

Fry, August 1917
Fry, Roger. "'Paul Cézanne' by Ambroise Vollard: Paris, 1915." *The Burlington Magazine*, vol. 31, no. 173 (August 1917), pp. 52-61.

Fry, May 1921
[Fry, Roger]. "Cézanne and the Nation." *The Burlington Magazine*, vol. 38, no. 218 (May 1921), p. 209.

Fry, May 27, 1922
Fry, Roger. "The Burlington Fine Arts Club: Cézanne Once More." *The New Statesman*, May 27, 1922, pp. 210-211.

Fry, 1927
Fry, Roger. *Cézanne: A Study of His Development*. London, 1927.

Fry, February 1928
Fry, Roger. "In Praise of Cézanne." *The Burlington Magazine*, vol. 52, no. 299 (February 1928), pp. 98-99.

Gache-Patin, 1984
Gache-Patin, Sylvie. "Douze oeuvres de Cézanne de l'ancienne collection Pellerin." *La Revue du Louvre et des musées de France*, vol. 34, no. 2 (1984), pp. 128-46.

Gachet, 1956
Gachet, Paul. *Deux amis des impressionnistes, le docteur Gachet et Murer*. Paris, 1956.

Garibaldi, 1991
Garibaldi, Charles and Mario. *Monticelli*. Geneva, 1991.

Garnier, 1902
Garnier, Paul-Louis. "Les Indépendants." *Revue universelle*, no. 63 (1902).

Gasquet, July 1896
Gasquet, Joachim. "Juillet." *Les Mois dorés*, July 1896.

Gasquet, March-April 1898
Gasquet, Joachim. "Le Sang provençal." *Les Mois dorés*, March-April 1898.

Gasquet, 1921
Gasquet, Joachim. *Cézanne*. Paris, 1921.

Gasquet, 1926
Gasquet, Joachim. *Cézanne*. New ed., Paris, 1926.

Gasquet, 1991
Gasquet, Joachim. *Joachim Gasquet's Cézanne: A Memoir with Conversations*, trans. Christopher Pemberton. London and New York, 1991.

Gauguin, 1918
Gauguin, Paul. *Lettres de Paul Gauguin à Georges-Daniel de Monfreid*, ed. Victor Segalen. Paris, 1918.

Gauguin, 1948
Gauguin, Paul. *Letters to His Wife and Friends*, ed. Maurice Malingue, trans. Henry J. Stenning. London, 1948.

Gauguin, 1950
Gauguin, Paul. *Lettres de Paul Gauguin à Georges-Daniel de Monfreid*, ed. Anne Joly-Segalen. Rev. ed., Paris, 1950.

Gauguin, 1984
Gauguin, Paul. *Correspondance de Paul Gauguin, documents, témoignages*, ed. Victor Merlhès. Paris, 1984.

Gautier, 1895
Gautier, Théophile. *Revue illustrée du Salon aixois*. 1895.

Geffroy, December 15, 1893
Geffroy, Gustave. "L'Impressionnisme." *La Revue encyclopédique*, no. 73 (December 15, 1893), p. 1223.

Geffroy, 1894
Geffroy, Gustave. *La Vie artistique*. Vol. 3. Paris, 1894.

Geffroy, March 25, 1894
Geffroy, Gustave. "Paul Cézanne." *Le Journal*, March 25, 1894. Reprinted in Geffroy, 1894, pp. 249-60.

Geffroy, November 16, 1895
Geffroy, Gustave. "Paul Cézanne." *Le Journal*, November 16, 1895. Reprinted in Geffroy, 1900, pp. 214-20.

Geffroy, 1900
Geffroy, Gustave. *La Vie artistique*. Vol. 6. Paris, 1900.

Geffroy, 1901
Geffroy, Gustave. "L'Exposition Centennale de la peinture française." *La Vie artistique*. Vol. 7. Paris, 1901, pp. 81-104.

Geffroy, 1903
Geffroy, Gustave. "Salon de 1901, I: Société Nationale des Beaux-Arts." *La Vie artistique*. Vol. 8. Paris, 1903, pp. 353-413.

Geffroy, October 17, 1905
Geffroy, Gustave. "Le Salon d'Automne." *Le Journal*, October 17, 1905.

Geffroy, 1922
Geffroy, Gustave. *Claude Monet, sa vie, son temps, son oeuvre*. Paris, 1922.

Geist, 1988
Geist, Sidney. *Interpreting Cézanne*. Cambridge, Massachusetts, and London, 1988.

Gerdts, 1993
Gerdts, William H. *Monet's Giverny: An Impressionist Colony*. New York, London, and Paris, 1993.

Gerlötei, May-June 1966
Gerlötei, Eugène. "L'Ancienne Collection François de Hatvany." *Gazette des Beaux-Arts*, 6th ser., vol. 67, nos. 1168-69 (May-June 1966), pp. 357-74.

Gimpel, 1963
Gimpel, René. *Journal d'un collectionneur marchand de tableaux*. Paris, 1963.

Gimpel, 1966
Gimpel, René. *Diary of an Art Dealer*, trans. John Rosenberg. New York, 1966.

Golberg, December 15, 1903
Golberg, Mecislas. "Les Peintres du Salon d'Automne." *La Plume*, December 15, 1903.

Goncourt, December 1, 1863
Goncourt, Edmond and Jules de. "Chardin." *Gazette des Beaux-Arts*, 1st ser., vol. 15, no. 6 (December 1, 1863), pp. 514-33.

Gosebruch, 1961
Gosebruch, Martin, ed. *Festschrift Kurt Badt zum siebzigsten Geburtstage: Beiträge aus Kunst- und Geistesgeschichte*. Berlin, 1961.

Gosebruch and Dittmann, 1970
Gosebruch, Martin, and Lorenz Dittmann, eds. *Argo: Festschrift für Kurt Badt zu seinem 80. Geburtstag am 3. März 1970*. Cologne, 1970.

Gottlieb, Winter 1959
Gottlieb, Carla. "*The Joy of Life*: Matisse, Picasso and Cézanne." *College Art Journal*, vol. 18, no. 2 (Winter 1959), pp. 106-16.

Gowing, June 1956
Gowing, Lawrence. "Notes on the Development of Cézanne." *The Burlington Magazine*, vol. 98, no. 639 (June 1956), pp. 185-92.

Gowing, April 1991
Gowing, Lawrence. "The True Nature of Cézanne's Bathers." *The Journal of Art*, vol. 4, no. 4 (April 1991), pp. 58-59.

Gowing and Rewald, September 1990
Gowing, Lawrence, and John Rewald. "'Les Maisons provençales': Cézanne and Puget." *The Burlington Magazine*, vol. 132, no. 1050 (September 1990), pp. 637-39.

Greenberg, May-June 1951
Greenberg, Clement. "Cézanne and the Unity of Modern Art." *Partisan Review*, vol. 18, no. 3 (May-June 1951), pp. 323-30.

Gronau, February 1, 1898
Gronau, Georg. "Die Neuegehaltung der National Galerie in Berlin." *Die Kunst für Alle*, vol. 13, no. 9 (February 1, 1898).

Grosjean-Maupin, December 22, 1900
Grosjean-Maupin, E. "L'Art français (Exposition Centennale de 1900)." *La Revue encyclopédique*, no. 381 (December 22, 1900).

Guérin, December 1904
Guérin, Joseph. "Le Salon d'Automne." *L'Ermitage*, December 1904, pp. 309-14.

Guillemot, November 1906
Guillemot, M. "Le Mois artistique: Le Salon d'Automne." *L'Art et les artistes*, no. 20 (November 1906).

G.V.Z., March 1, 1901
G.V.Z. "À la Libre-Esthétique, I." *La Gazette*, March 1, 1901.

G.V.Z., March 26, 1901
G.V.Z. "La Libre Esthétique, III." *La Gazette*, March 26, 1901.

Heilbut, February-March, 1903
H. [Emil Heilbut]. "Die impressionisten Ausstellung der Wiener Secession." *Kunst und Künstler*, vol. 1 (February-March 1903).

Heilbut, May 1903
H. [Emil Heilbut]. "Die Ausstellung der Wiener Secession." *Kunst und Künstler*, vol. 1 (May 1903).

Heilbut, June 1904
H. [Emil Heilbut]. "Chronik." *Kunst und Künstler*, vol. 2, no. 9 (June 1904), p. 378.

Hamel, November 1904
Hamel, Maurice. "Le Salon d'Automne." *Les Arts*, no. 35 (November 1904), p. 32.

H. D., March 30, 1901
H. D. "Correspondance de Bruxelles: Le Salon de la Libre-Esthétique." *Le Bulletin de l'art ancien et moderne*, March 30, 1901.

Hepp, December 1905
Hepp, Pierre. "Sur le choix des maîtres." *L'Occident*, vol. 8 (December 1905), pp. 263-65.

Herding, 1970
Herding, Klaus. *Pierre Puget: Das bildnerische Werk*. Berlin, 1970.

Holzamer, December 1904
Holzamer, Wilhelm. "Der Herbstsalon 1904." *Kunst und Künstler*, vol. 3, no. 3 (December 1904).

Hölzel, December 15, 1904
Hölzel, Adolf. "Über künstlerische Ausdrucksmittel und deren Verlhältnis zu Natur und Bild, III." *Die Kunst für Alle*, vol. 20, no. 6 (December 15, 1904), pp. 121-42.

Hoog, 1984
Hoog, Michel. *Catalogue de la collection Jean Walter et Paul Guillaume*. Paris, 1984.

Hoog, 1989
Hoog, Michel. *Cézanne "Puissant et Solitaire."* Paris, 1989.

Horus, November 1904
Horus. In *La Revue libre*, November 1904.

Huysmans, August 4, 1888
Huysmans, Joris-Karl. "Trois peintres: Cézanne, Tissot, Wagner." *La Cravache*, August 4, 1888.

Huysmans, September 1, 1891
Huysmans, Joris-Karl. "Paul Cézanne." *La Plume*, September 1, 1891.

Imbourg, January 20, 1939
Imbourg, Pierre. "Cézanne et ses logis à Paris." *Beaux-Arts*, January 20, 1939.

Isaacson, September 1994.
Isaacson, Joel. "Constable, Duranty, Mallarmé, Impressionism, Plein Air, and Forgetting." *The Art Bulletin*, vol. 76, no. 3 (September 1994), pp. 427-50.

Jacques, April 12, 1877
Jacques. "Menus propos: Exposition impressionniste." *L'Homme libre*, April 12, 1877.

Jamot, December 1906
Jamot, Paul. "Le Salon d'Automne (premler article)." *Gazette des Beaux-Arts*, 3rd ser., vol. 36, no. 594 (December 1906), pp. 456-84.

Jamot, July 1914
Jamot, Paul. "La Collection Camondo au Musée du Louvre: Les Peintures et les dessins." *Gazette des Beaux-Arts*, 4th ser., vol. 12, no. 685 (July 1914), pp. 53-66.

J.-F.-S., November 3, 1906
J.-F.-S. "Nécrologie: Paul Cézanne." *La Chronique des arts et de la curiosité*, no. 33 (November 3, 1906).

Joëts, April 1935
Joëts, Jules. "Les Impressionnistes et Chocquet." *L'Amour de l'art*, vol. 16, no. 4 (April 1935), pp. 120-25.

Jourdain, 1950
Jourdain, Francis. *Cézanne*. Paris and New York, 1950.

Kahn, 1900
Kahn, Gustave. "L'Art à l'Exposition." *La Plume*, 1900, p. 510.

Kahn, November 15, 1906
Kahn, Gustave. "Lettre à un exposant du Salon d'Automne." *La Phalange*, November 15, 1906.

Kendall, 1989
Kendall, Richard. *Cézanne: The History and Techniques of the Great Masters*. Secaucus, New Jersey, 1989.

Kendall, 1993
Kendall, Richard, ed. *Cézanne and Poussin: A Symposium*. Sheffield, England, 1993.

Kimball and Venturi, 1948
Kimball, Fiske, and Lionello Venturi. *Great Paintings in America*. New York, 1948.

Klingsor, May 1, 1902
Klingsor, Tristan. "Les Salons de 1902." *La Plume*, May 1, 1902.

Kropmanns, 1993
Kropmanns, Peter. "Cézanne, Delacroix et Hercule. Réflexions sur *L'Enlèvement*, 1867, oeuvre de jeunesse de Paul Cézanne," trans. Nathalie Sevestre. *Revue de l'art*, no. 100 (1993), pp. 74-83.

Krumrine, May 1980
Krumrine, Mary Louise. "Cézanne's Bathers: Form and Content." *Arts Magazine*, vol. 54, no. 9 (May 1980), pp. 115-23.

Krumrine, 1989
Krumrine, Mary Louise, with Gottfried Boehm and Christian Geelhaar. *Paul Cézanne: The Bathers*. Basel, 1989.

Krumrine, September 1992
Krumrine, Mary Louise. "Cézanne's 'Restricted Power': Further Reflections on the 'Bathers.'" *The Burlington Magazine*, vol. 134, no. 1074 (September 1992), pp. 586-95.

Lafenestre, April 8, 1877
[Lafenestre, Georges]. "Le Jour et la nuit." *Le Moniteur universel*, April 8, 1877.

Lagrange, n.d.
Lagrange, Pierre. *Les Artistes de Bourron-Marlotte et les maisons où ils vécurent*. Archives de Seine-et-Marne, Az 6174, n.d.

Larguier, 1925
Larguier, Léo. *Le Dimanche avec Paul Cézanne (Souvenirs)*. Paris, 1925.

Larguier, 1927
Larguier, Léo. *En compagnie des vieux peintres*. Paris, 1927.

Lawrence, 1929
Lawrence, David Herbert. *The Paintings of D. H. Lawrence*. London, 1929.

L. E., April 1, 1901
L. E. "Salon de la Libre Esthétique." *Le Thyrse*, April 1, 1901.

Lebensztejn, December 1988
Lebensztejn, Jean-Claude. "Les Couilles de Cézanne." *Critique*, vol. 44, no. 499 (December 1988), pp. 1031-47.

Lebensztejn, August-September 1993
Lebensztejn, Jean-Claude. "Persistance de la mémoire." *Critique*, nos. 555-56 (August-September 1993), pp. 609-30.

Leblond, November 23, 1901
Leblond, Marius-Ary. "Collège d'esthétique moderne." *Revue universelle*, no. 47 (November 23, 1901).

Leclère, November 15, 1906
Leclère, T. "Au Salon d'Automne." *La Phalange*, November 15, 1906.

Lecomte, 1892
Lecomte, Georges. *L'Art impressionniste d'après la collection privée de M. Durand-Ruel*. Paris, 1892.

Lecomte, April 1892
Lecomte, Georges. "L'Art contemporain." *La Revue indépendante*, April 1892, pp. 1-29.

Lecomte, December 9, 1899
Lecomte, Georges. "Paul Cézanne." *La Revue de l'art*, December 9, 1899, pp. 81-87.

Lecomte, July 1, 1939
Lecomte, Georges. "Le Triomphe du *Balzac* de Rodin." *L'Illustration*, July 1, 1939.

Le Diable boîteux, March 7, 1903
Le Diable boîteux. "Échos: Les Bibelots de Zola." *Gil Blas*, March 7, 1903.

Le Diable boîteux, March 12, 1903
Le Diable boîteux. "Échos: Paul Cézanne." *Gil Blas*, March 12, 1903.

Leroy, April 25, 1874
Leroy, Louis. "L'Exposition des impressionnistes." *Le Charivari*, April 25, 1874, pp. 2-3.

Leroy, April 11, 1877
Leroy, Louis. "Exposition des impressionnistes." *Le Charivari*, April 11, 1877, p. 2.

Leroy, April 14, 1877
Leroy, Louis. "Le Public à l'exposition des impressionnistes." *Le Charivari*, April 14, 1877.

Le Say, November 14, 1904
Le Say. In *L'Univers*, November 14, 1904.

Le Senne, October 18, 1904
Le Senne, Camille. "Salon d'Automne." *L'Événement*, October 18, 1904.

Lestrange, November 5, 1905
Lestrange, Robert. "Prenez garde à la peinture, s. v. p. Salon d'Automne." *Le Tintamarre*, November 5, 1905.

Lhander, September 25-October 1, 1958
Lhander, Louis. "Le Grand Peintre et le petit pont." *Les Lettres françaises*, September 25-October 1, 1958.

584

Lichtenstein, March 1964
Lichtenstein, Sara. "Cézanne and Delacroix." *The Art Bulletin*, vol. 46, no. 1 (March 1964), pp. 55-67.

Lichtenstein, June 1966
Lichtenstein, Sara. "An Unpublished Portrait of Delacroix, and Some Figure Sketches, by Cézanne." *Master Drawings*, vol. 4, no. 1 (June 1966), pp. 39-45.

Lichtenstein, February 1975
Lichtenstein, Sara. "Cézanne's Copies and Variants after Delacroix." *Apollo*, vol. 101, no. 156 (February 1975), pp. 116-27.

Lindsay, 1969
Lindsay, Jack. *Cézanne: His Life and Art*. London, 1969.

Lora, April 18, 1874
Lora, Léon de. "Petites nouvelles artistiques: Exposition libre des peintures." *Le Gaulois*, April 18, 1874.

Lora, April 10, 1877
Lora, Léon de. "L'Exposition des impressionnistes." *Le Gaulois*, April 10, 1877.

Loran, April 1930
Johnson, Erle Loran. "Cézanne's Country." *The Arts*, vol. 16, no. 8 (April 1930), pp. 521-51.

Loran, 1943
Loran, Erle. *Cézanne's Composition: Analysis of His Form with Diagrams and Photographs of His Motifs*. Berkeley, California, and Los Angeles, 1943.

Losch, 1990
Losch, Michael Lee. "The Sacred and the Profane: Mont Saint-Victoire and Other Notions of Duality in the Paintings of Paul Cézanne." Ph.D. diss., Pennsylvania State University, 1990.

Louis, March 10, 1901
Louis, Edmond. "Salon de la Libre Esthétique." *La Fédération artistique*, March 10, 1901.

L. S., March 6, 1901
L. S. "La Libre Esthétique." *Le Soir* (Bruxelles), March 6, 1901.

Mack, 1935
Mack, Gerstle. *Paul Cézanne*. New York and London, 1935.

Madsen, November 9 and 10, 1889
Madsen, Karl. "Kunst: Impressionisterne i Kunstforeningen." *Politiken*, November 9 and 10, 1889.

Mallarmé, 1984
Mallarmé, Stéphane. *Correspondance*. Vol. 10. Paris, 1984.

Manet, 1979
Manet, Julie. *Journal de Julie Manet*. Paris, 1979.

Manet, 1987
Manet, Julie. *Growing Up with the Impressionists: The Diary of Julie Manet*, trans. and ed. Rosalind de Boland Roberts and Jane Roberts. London, 1987.

Manet, 1988
Manet, Julie. *Journal (Extraits), 1893-1899*. 2nd ed., Paris, 1988.

Marx, July 13, 1901
Marx, Roger. "La Saison d'art (de janvier à juillet 1901)." *Revue universelle*, no. 28 (July 13, 1901).

Marx, December 1904
Marx, Roger. "Le Salon d'Automne." *Gazette des Beaux-Arts*, 3rd ser. vol. 32, no. 570 (December 1904), pp. 458-74.

Mathews, 1984
Mathews, Nancy Mowll, ed. *Cassatt and Her Circle: Selected Letters*. New York, 1984.

Mauclair, October 1893
Mauclair, Camille. "Beaux-Arts." *Essais d'art libre*, vol. 4 (October 1893).

Mauclair, April 1894
Mauclair, Camille. "Choses d'art." *Mercure de France*, April 1894.

Mauclair, 1904
Mauclair, Camille. *L'Impressionnisme: Son histoire, son esthétique, ses maîtres*. Paris, 1904.

Mauclair, December 1904
Mauclair, Camille. "La Peinture et la sculpture au Salon d'Automne." *L'Art décoratif*, no. 75 (December 1904).

Mauclair, October 21, 1905
Mauclair, Camille. "Le Salon d'Automne." *La Revue bleue*, October 21, 1905, pp. 521-25.

Mauclair, December 15, 1905
Mauclair, Camille. "La Jeune Peinture française et ses critiques." *La Revue*, December 15, 1905.

Mauclair, December 1905
Mauclair, Camille. "La Peinture et la sculpture au Salon d'Automne." *L'Art décoratif*, no. 87 (December 1905).

Mauclair, November 1906
Mauclair, Camille. "Le Salon d'Automne." *Art et décoration*, vol. 20 (November 1906), pp. 141-52.

M. C., November 1960
M. C. "Quelques souvenirs sur Paul Cézanne, par une de ses nièces." *Gazette des Beaux-Arts*, 6th ser., vol. 56, no. 1102 (November 1960), pp. 299-302.

Meier-Graefe, November 26, 1898
Meier-Graefe, Julius. "L'Art en Allemagne et en Autriche." *La Revue encyclopédique*, no. 263 (November 26, 1898).

Meier-Graefe, 1904
Meier-Graefe, Julius. *Die Entwicklungsgeschichte der modernen Kunst: Ein Beitrag zur modernen Ästhetik*. 3 vols. Stuttgart, 1904.

Meier-Graefe, June 1904
Meier-Graefe, Julius. "Pariser Ausstellungen." *Kunst und Künstler*, vol. 2, no. 9 (June 1904).

Meier-Graefe, 1908
Meier-Graefe, Julius. *Modern Art: Being a Contribution to a New System of Aesthetics*, trans. Florence Simmonds and George W. Chrystal. 2 vols. London and New York, 1908.

Meier-Graefe, 1910
Meier-Graefe, Julius. *Paul Cézanne*. Munich, 1910. 5th edition translated and revised as Meier-Graefe, 1927.

Meier-Graefe, 1918
Meier-Graefe, Julius. *Cézanne und sein Kreis: Ein Beitrag zur Entwicklungsgeschichte*. Munich, 1918.

Meier-Graefe, 1920
Meier-Graefe, Julius. *Cézanne und sein Kreis: Ein Beitrag zur Entwicklungsgeschichte*. 2nd ed., Munich, 1920.

Meier-Graefe, 1927
Meier-Graefe, Julius. *Cézanne*, trans. J. Holroyd-Reece. London and New York, 1927. Translation and revision of 5th edition of Meier-Graefe, 1910.

Mellerio, 1896
Mellerio, André. *Le Mouvement idéaliste en peinture*. Paris, 1896.

Mellerio, January-February 1896.
Mellerio, André. "L'Art moderne, exposition de Paul Cézanne." *La Revue artistique*, January-February 1896.

Mellerio, 1900
Mellerio, André. *L'Exposition de 1900 et l'impressionnisme*. Paris, 1900.

Merleau-Ponty, December 1945
Merleau-Ponty, Maurice. "Le Doute de Cézanne." *Fontaine*, no. 47 (December 1945).

Merleau-Ponty, 1964
Merleau-Ponty, Maurice. *Sense and Non-Sense*, trans. Hubert L. Dreyfus and Patricia Allen Dreyfus. Evanston, Illinois, 1964.

Mirbeau, 1988
Mirbeau, Octave. *Correspondance avec Auguste Renoir*, ed. Pierre Michel and Jean-François Nivet. Tusson, France, 1988.

Moffett, 1973
Moffett, Kenworth. *Meier-Graefe as Art Critic*. Munich, 1973.

Monod, December 1905
Monod, François. "Le Salon d'Automne." *Art et décoration*, vol. 18 (December 1905), pp. 198-210.

Montifaud, May 1, 1874
Montifaud, Marc de [Marie-Émilie Chartroule]. "Exposition du boulevard des Capucines." *L'Artiste*, May 1, 1874, pp. 307-13.

Morice, July 1, 1905
Morice, Charles. "Art moderne: Les Aquarelles de Cézanne." *Mercure de France*, July 1, 1905, pp. 133-34.

Morice, August 1 and 15, and September 1, 1905
Morice, Charles, ed. "Enquête sur les tendances actuelles des arts plastiques." Parts 1-3. *Mercure de France*, August 1, 1905, pp. 346-59; August 15, 1905, pp. 538-55; September 1, 1905, pp. 61-85.

Morice, December 1, 1905
Morice, Charles. "Le Salon d'Automne." *Mercure de France*, December 1, 1905.

Morice, November 1, 1906
Morice, Charles. "La IVᵉ Exposition du Salon d'Automne." *Mercure de France*, November 1, 1906, pp. 34-48.

Morice, February 15, 1907
Morice, Charles. "Paul Cézanne." *Mercure de France*, February 15, 1907, pp. 577-79.

Mortier, April 8, 1867
Mortier, Alexandre. *L'Europe politique, scientifique, commerciale, industrielle et littéraire*. Cited by F. Magnard in *Le Figaro*, April 8, 1867.

M. S., February 29, 1904
M. S. "À la Libre Esthétique." *L'Étoile belge*, February 29, 1904.

Natanson, April 1894
Natanson, Thadée. "Expositions, Théodore Duret." *La Revue blanche*, April 1894.

Natanson, November 15, 1895
Natanson, Thadée. "En passant. . . ." *La Revue blanche*, November 15, 1895.

Natanson, December 1, 1895
Natanson, Thadée. "Paul Cézanne." *La Revue blanche*, December 1, 1895, pp. 496-500.

Natanson, December 1, 1896
Natanson, Thadée. "Peinture." *La Revue blanche*, December 1, 1896.

Natanson, June 1897
Natanson, Thadée. "Petite gazette d'art." *La Revue blanche*, June 1897.

Natanson, June 1, 1898
Natanson, Thadée. "Notes sur l'art des salons." *La Revue blanche*, June 1, 1898.

Natanson, May 1, 1901
Natanson, Thadée. "Les Artistes indépendants." *La Revue blanche*, May 1, 1901.

Neumeyer, 1958
Neumeyer, Alfred. *Cézanne Drawings*. New York and London, 1958.

Norval, November 13, 1904
Norval. In *Le Clairon*, November 13, 1904.

Novotny, 1929
Novotny, Fritz. "Paul Cézanne." *Belvedere: Monatsschrift für Sammler und Kunstfreunde*, vol. 8, no. 12 (1929), pp. 440-50.

Novotny, 1937
Novotny, Fritz. *Cézanne*. Vienna and New York, 1937.

Novotny, 1938
Novotny, Fritz. *Cézanne und das Ende der wissenschaftlichen Perspektive*. Vienna, 1938.

O. L., March 10, 1901
O. L. "La Libre Esthétique." *La Verveine*, March 10, 1901.

Osthaus, 1920-21
Osthaus, Karl Ernst. "Cézanne." *Das Feuer*, 1920-1921, pp. 81-88. French translation in Doran, 1978, pp. 96-100.

Pach, 1929
Pach, Walter. *The Masters of Modern Art*. New York, 1929.

Péladan, October 22, 1904
Péladan, Joseph. "Le Salon d'Automne." *La Revue hebdomadaire*, October 22, 1904.

Péladan, October 28, 1905
Péladan, Joseph. "Le Salon d'Automne." *La Revue hebdomadaire*, October 28, 1905.

Pératé, November 1907
Pératé, André. "Le Salon d'Automne." *Gazette des Beaux-Arts*, 3rd ser., vol. 38, no. 605 (November 1907), pp. 385-407.

Perruchot, 1956
Perruchot, Henri. *La Vie de Cézanne*. Paris, 1956.

Phillips, 1931
Phillips, Duncan. *The Artist Sees Differently: Essays Based upon the Philosophy of a Collection in the Making*. New York and Washington, D.C., 1931.

Phillips, April 1956
Phillips, Duncan. Commentaries in "The Phillips Gallery." *Arts*, vol. 30, no. 7 (April 1956), pp. 30-37.

Pissarro, 1980-91
Pissarro, Camille. *Correspondance de Camille Pissarro*, ed. Janine Bailly-Herzberg. 5 vols. Paris, 1980-91.

Pissarro, 1993
Pissarro, Lucien. *The Letters of Lucien to Camille Pissarro, 1883-1903*, ed. Anne Thorold. Cambridge, England, 1993.

Pissarro and Venturi, 1939
Pissarro, Ludovic-Rodo, and Lionello Venturi. *Camille Pissarro, son art—son oeuvre*. 2 vols. Paris, 1939.

Polday, May 3, 1874
Polday, Henri. "Les Intransigeants." *La Renaissance artistique*, no. 16 (May 3, 1874).

Ponsonailhe, October 15, 1904
Ponsonailhe, Charles de. "Le Salon d'Automne." *La Revue illustrée*, vol. 19, no. 21 (October 15, 1904).

Pothey, April 7, 1877
A. P. [Alexandre Pothey]. "Beaux-Arts." *Le Petit Parisien*, April 7, 1877.

Prouvaire, April 20, 1874
Prouvaire, Jean. "L'Exposition du boulevard des Capucines." *Le Rappel*, April 20, 1874.

Provence, February 1 and August 1, 1925
Provence, Marcel. "Cézanne collégien." Parts 1 and 2. *Mercure de France*, February 1, 1925, pp. 823-27; August 1, 1925, pp. 820-22.

R., September 1899
R. "Chronique de l'art décoratif." *L'Art décoratif*, no. 12 (September 1899).

Rambosson, November 1906
Rambosson, Yvanhoé. "La Peinture et la sculpture au Salon d'Automne." *L'Art décoratif*, no. 98 (November 1906).

Ratcliffe, 1960
Ratcliffe, Robert William. "Cezanne's Working Methods and Their Theoretical Background." Ph.D. diss., University of London, 1960.

Redon, 1923
Redon, Odilon. *Lettres d'Odilon Redon, 1878-1916*. Paris and Brussels, 1923.

Reff, May 1959
Reff, Theodore. "Cezanne's Drawings, 1875-85." *The Burlington Magazine*, vol. 101, no. 674 (May 1959), pp. 171-76.

Reff, 1960
Reff, Theodore. "Cézanne and Poussin." *Journal of the Warburg and Courtauld Institutes*, vol. 23 (1960), pp. 150-74.

Reff, March 1960
Reff, Theodore. "A New Exhibition of Cézanne." *The Burlington Magazine*, vol. 102, no. 684 (March 1960), pp. 114-18.

Reff, November 1960
Reff, Theodore. "Reproductions and Books in Cézanne's Studio." *Gazette des Beaux-Arts*, 6th ser., vol. 56, no. 1102 (November 1960), pp. 303-9.

Reff, March 1962
Reff, Theodore. "Cézanne's Bather with Outstretched Arms." *Gazette des Beaux-Arts*, 6th ser., vol. 59, no. 1118 (March 1962), pp. 173-90.

Reff, June 1962
Reff, Theodore. "Cézanne, Flaubert, St. Anthony, and the Queen of Sheba." *The Art Bulletin*, vol. 44, no. 2 (June 1962), pp. 113-25.

Reff, Autumn 1962
Reff, Theodore. "Cézanne's Constructive Stroke." *The Art Quarterly*, vol. 25, no. 3 (Autumn 1962), pp. 214-26.

Reff, 1963
Reff, Theodore. "Cézanne et Poussin." *Arts de France*, vol. 3 (1963).

Reff, April 1963
Reff, Theodore. "Cézanne: The Logical Mystery." *Art News*, vol. 62, no. 2 (April 1963), pp. 28-31.

Reff, June 1963
Reff, Theodore. "Cézanne's *Dream of Hannibal*." *The Art Bulletin*, vol. 45, no. 2 (June 1963), pp. 148-52.

Reff, 1964
Reff, Theodore. "Copyists in the Louvre, 1850-1870." *The Art Bulletin*, vol. 46, no. 4 (December 1964), pp. 552-59.

Reff, March 1966
Reff, Theodore. "Cézanne and Hercules." *The Art Bulletin*, vol. 48, no. 1 (March 1966), pp. 35-44.

Reff, July 1975
Reff, Theodore. "Cézanne's Drawings." *The Burlington Magazine*, vol. 117, no. 868 (July 1975), pp. 489-91.

Reff, 1976
Reff, Theodore. *The Notebooks of Edgar Degas: A Catalogue of the Thirty-Eight Notebooks in the Bibliothèque Nationale and Other Collections*. 2 vols. Oxford, 1976.

Reff, October 1977 (a)
Reff, Theodore. "Cézanne on Solids and Spaces." *Artforum*, vol. 16, no. 2 (October 1977), pp. 34-37.

Reff, October 1977 (b)
Reff, Theodore. "Cézanne's Late Bather Paintings." *Arts Magazine*, vol. 52, no. 2 (October 1977), pp. 116-19.

Reff, June 1979
Reff, Theodore. "The Pictures Within Cézanne's Pictures." *Arts Magazine*, vol. 53, no. 10 (June 1979), pp. 90-104.

Reff, November 1980
Reff, Theodore. "Cézanne's 'Cardplayers' and Their Sources." *Arts Magazine*, vol. 55, no. 3 (November 1980), pp. 104-17.

Reff, October 1983
Reff, Theodore. "Cézanne: The Severed Head and the Skull." *Arts Magazine*, vol. 58, no. 2 (October 1983), pp. 84-100.

Renoir, 1962
Renoir, Jean. *Renoir, My Father*. Boston and Toronto, 1962.

Renoir, 1981
Renoir, Jean. *Pierre-Auguste Renoir, mon père*. Paris, 1981.

Rewald, January 1935
Rewald, John, with Léo Marschutz. "Plastique et réalité: Cézanne au Château Noir." *L'Amour de l'art*, vol. 16, no. 1 (January 1935), pp. 15-21.

Rewald, 1936
Rewald, John. *Cézanne et Zola*. Paris, 1936.

Rewald, March-April 1937
Rewald, John. "À propos du catalogue raisonné de l'oeuvre de Paul Cézanne et de la chronologie de cette oeuvre." *La Renaissance* (Paris), vol. 20 (March-April 1937), pp. 53-56.

Rewald, May 3, 1938
Rewald, John. "Achille Emperaire, ami de Paul Cézanne." *L'Amour de l'art*, vol. 19, no. 4 (May 3, 1938), pp. 151-58.

Rewald, 1939
Rewald, John. *Cézanne, sa vie, son oeuvre, son amitié pour Zola*. Paris, 1939.

Rewald, April 1939
Rewald, John. "Paul Cézanne: New Documents for the Years 1870-1871." *The Burlington Magazine*, vol. 74, no. 433 (April 1939), pp. 163-71.

Rewald, February 15-29, 1944
Rewald, John. "As Cézanne Recreated Nature." *Art News*, vol. 43, no. 1 (February 15-29, 1944), pp. 9-13.

Rewald, 1948
Rewald, John. *Paul Cézanne—A Biography*. New York, 1948.

Rewald, November 1948
Rewald, John. "Cézanne's Theories about Art." *Art News*, vol. 47, no. 7 (November 1948), pp. 31-34, 53.

Rewald, 1950
Rewald, John. *The Ordeal of Paul Cézanne*. London, 1950.

Rewald, 1951
Rewald, John. *Paul Cézanne—Carnets de dessins—Préface et catalogue raisonné*. 2 vols. Paris, 1951.

Rewald, July-August 1953
Rewald, John. "Extraits du journal inédit de Paul Signac, III, 1898-1899." *Gazette des Beaux-Arts*, 6th ser., vol. 42 (July-August 1953), pp. 27-57.

Rewald, July 21-27, 1954
Rewald, John. "Un article inédit sur Paul Cézanne en 1870." *Arts* (Paris), July 21-27, 1954, p. 8.

Rewald, 1958
Rewald, John. *Cézanne Landscapes*. New York, 1958.

Rewald, 1959
Rewald, John. *Cézanne, Geffroy et Gasquet, suivi de souvenirs sur Cézanne de Louis Aurenche et de lettres inédites*. Paris, 1959.

Rewald, 1968
Rewald, John. *Paul Cézanne—A Biography*. New York, 1968.

Rewald, July-August 1969
Rewald, John. "Chocquet and Cézanne." *Gazette des Beaux-Arts*, 6th ser., vol. 74, nos. 1206-7 (July-August 1969), pp. 33-96.

Rewald, 1971-72
Rewald, John. "Cézanne and His Father." In National Gallery of Art, *Studies in the History of Art*. Washington D.C., 1971-72, pp. 38-62.

Rewald, 1975
Rewald, John. "Cézanne et Guillaumin." In Albert Châtelet and Nicole Reynaud, eds., *Études d'art français offertes à Charles Sterling*. Paris, 1975, pp. 343-53.

Rewald, November 1975
Rewald, John. "Some Entries for a New Catalogue Raisonné of Cézanne's Paintings." *Gazette des Beaux-Arts*, 6th ser., vol. 86, no. 1282 (November 1975), pp. 157-68.

Rewald, 1982
Rewald, John. *Paul Cézanne Sketchbook, 1875-1885*. New York, 1982.

Rewald, 1983
Rewald, John. *Paul Cézanne: The Watercolors, A Catalogue Raisonné*. Boston, 1983.

Rewald, 1985
Rewald, John. *Studies in Impressionism*, ed. Irene Gordon and Frances Weitzenhoffer. New York, 1985.

Rewald, 1986 (a)
Rewald, John. *Cézanne: A Biography*. New York, 1986.

Rewald, 1986 (b)
Rewald, John. *Studies in Post-Impressionism*, ed. Irene Gordon and Frances Weitzenhoffer. New York, 1986.

Rewald, 1986 (c)
Rewald John. "Paintings by Paul Cézanne in the Mellon Collection." In John Wilmerding, ed., *Essays in Honor of Paul Mellon, Collector and Benefactor*. Washington, D.C., 1986, pp. 289-319.

Rewald, 1989
Rewald, John, with Frances Weitzenhoffer. *Cézanne and America: Dealers, Collectors, Artists and Critics, 1891-1921*. Princeton, New Jersey, and London, 1989.

Rewald, 1990
Rewald, John. *Cézanne: A Biography*. New York, 1990.

Rewald, forthcoming
Rewald, John, with Walter Feilchenfeldt and Jayne Warman. *The Paintings of Paul Cézanne: A Catalogue Raisonné*. New York, forthcoming.

Rey, December 1929
Rey, Robert. "Trois tableaux de Cézanne." *Bulletin des musées de France*, n.s., vol. 1, no. 12 (December 1929), pp. 271-75.

Richardson, 1991
Richardson, John, with Marilyn McCully. *A Life of Picasso*. Vol. 1, *1881-1906*. New York, 1991.

Rilke, 1952
Rilke, Rainer Maria. *Briefe über Cézanne*, ed. Clara Rilke. Frankfurt, 1952.

Rilke, 1985
Rilke, Rainer Maria. *Letters on Cézanne*, ed. Clara Rilke, trans. Joel Agee. New York, 1985.

Rivière, April 6, 1877
G. R. [Georges Rivière], "À. M. le Rédacteur du 'Figaro.'" *L'Impressionniste*, no. 1 (April 6, 1877), pp. 1-2.

Rivière, April 14, 1877
Rivière, Georges. "L'Exposition des impressionnistes." *L'Impressionniste*, no. 2 (April 14, 1877), pp. 1-7.

Rivière, 1921
Rivière, Georges. *Renoir et ses amis*. Paris, 1921.

Rivière, 1923
Rivière, Georges. *Le Maître Paul Cézanne*. Paris, 1923.

Rivière, December 15, 1926
Rivière, Georges. "Les Impressionnistes chez eux." *L'Art Vivant*, no. 48 (December 15, 1926).

Rivière, 1933
Rivière, Georges. *Cézanne, le peintre solitaire*. Paris, 1933.

Rivière and Schnerb, December 25, 1907
Rivière, R.-P., and J.-F. Schnerb. "L'Atelier de Cézanne." *La Grande Revue*, December 25, 1907, pp. 811-17. Reprinted in Doran, 1978, pp. 85-91.

Robida, 1958
Robida, Michel. *Le Salon Charpentier et les impressionnistes*. Paris, 1958.

Rochefort, March 9, 1903
Rochefort, Henri. "L'Amour du laid." *L'Intransigeant*, March 9, 1903.

Roger-Marx, March-April 1936
Roger-Marx, Claude. "Les Tentations de saint Antoine." *La Renaissance* (Paris), vol. 19 (March-April 1936).

Rosenblum, 1989
Rosenblum, Robert. *Paintings in the Musée d'Orsay*. New York, 1989.

Rosenhagen, January 9, 1901
H. R. [Hans Rosenhagen]. "Aus Berliner Kunstsalons." *Die Kunst für Alle*, vol. 16, no. 7 (January 9, 1901).

Rosenhagen, June 1, 1904
Rosenhagen, Hans. "Von Ausstellungen und Sammlungen." *Die Kunst für Alle*, vol. 19, no. 17 (June 1, 1904), pp. 401-3.

Rosenhagen, June 15, 1905
Rosenhagen, Hans. "Von Ausstellungen und Sammlungen." *Die Kunst für Alle*, vol. 20, no. 18 (June 15, 1905), pp. 436-38.

Roux, December 3, 1865
Roux, Marius. "La Confession de Claude par Émile Zola." *Mémorial d'Aix*, December 3, 1865.

Royère, November 15, 1906
Royère, Jean. "Sur Paul Cézanne." *La Phalange*, November 15, 1906.

Saint-Hilaire, November 11, 1905
Saint-Hilaire, J. de. "Le Salon d'Automne." *Le Journal des arts*, November 11, 1905.

Sarradin, November 4, 1904
Sarradin. In *Les Débats*, November 4, 1904.

Sarradin, October 5, 1905
Sarradin. "Le Salon d'Automne." *Les Débats*, October 5, 1905.

Saunier, February 1896
Saunier, Charles. "Les Expositions." *La Revue encyclopédique*, no. 124 (February 1896).

Saunier, 1903
Saunier, Charles. "Petites expositions." *Revue universelle*, no. 96 (1903).

Saunier, December 1905
Saunier, Charles. "Le Salon d'Automne." *Revue universelle*, no. 147 (December 1905).

Schapiro, 1952
Schapiro, Meyer. *Paul Cézanne*. New York, 1952.

Schapiro, 1968
Schapiro, Meyer. "The Apples of Cézanne: An Essay on the Meaning of Still-Life." In Thomas B. Hess and John Ashbery, eds., *Art News Annual*. Vol. 34, *The Avant-Garde*. New York, 1968, pp. 34-53.

Schmidt, 1953
Schmidt, Georg. *Water-Colours by Paul Cézanne*. New York, 1953.

Schmidt, June 5, 1903
Schmidt, Karl Eugen. "Pariser Brief." *Kunstchronik*, June 5, 1903.

Schmidt, November 27, 1903
Schmidt, Karl Eugen. "Der Pariser Herbstsalon." *Kunstchronik*, November 27, 1903.

Schmidt, November 4, 1904
Schmidt, Karl Eugen. "Der Pariser Herbstsalon." *Kunstchronik*, November 4, 1904.

Schniewind, 1951
Schniewind, Carl, ed. *Paul Cézanne: Sketchbook Owned by the Art Institute of Chicago*. 2 vols. New York, 1951.

Schop, April 13, 1877
Schop, Baron. "La Semaine parisienne." *Le National*, April 13, 1877.

Sébillot, April 7, 1877
Sébillot, Paul. "Exposition des impressionnistes." *Le Bien public*, April 7, 1877.

Sedeyn, May 1904
Sedeyn, Émile. "Expositions." *L'Art décoratif*, no. 68 (May 1904).

Sedlmayr, 1948
Sedlmayr, Hans. *Verlust der Mitte—Die bildende Kunst des 19. und 20. Jahrhunderts als Symptom und Symbol der Zeit*. Salzburg, 1948.

Sedlmayr, 1957
Sedlmayr, Hans. *Art in Crisis: The Lost Centre*. London, 1957.

Senne, March 16, 1901
Senne, Jean de la. "Les Expositions: À la Libre Esthétique." *La Ligue artistique*, March 16, 1901.

Seznec, March 1947
Seznec, Jean. "The Temptation of St. Anthony in Art." *Magazine of Art*, vol. 40, no. 3 (March 1947), pp. 87-93.

Shiff, 1984
Shiff, Richard. *Cézanne and the End of Impressionism: A Study of the Theory, Technique, and Critical Evaluation of Modern Art*. Chicago and London, 1984.

Signac, May 1, 1898
Signac, Paul. "La Technique de Delacroix." *La Revue blanche*, May 1, 1898, pp. 13-35.

Signac, May 15, 1898
Signac, Paul. "Les Techniques impressionniste et néo-impressionniste." *La Revue blanche*, May 15, 1898, pp. 115-33.

Signac, July 1, 1898
Signac, Paul. "L'Education de l'oeil." *La Revue blanche*, July 1, 1898, pp. 357-69.

Signac, 1978
Signac, Paul. *D'Eugène Delacroix au néo-impressionnisme*, ed. Françoise Cachin. Paris, 1978.

Signed "La Revue blanche," March 1, 1898
Signed "La Revue blanche." "Hommage." *La Revue blanche*, March 1, 1898.

Simon, May 1991
Simon, Robert. "Cézanne and the Subject of Violence." *Art in America*, vol. 79, no. 5 (May 1991), pp. 120-35, 185-86.

Solrac, December 6, 1904
Solrac. "Réflexions sur le Salon d'Automne." *L'Occident*, vol. 6 (December 6, 1904), pp. 303-11.

Solvay, February 4, 1890
Solvay, Lucien. "Les XX." *Le Soir*, February 4, 1890.

Sterling, 1952
Sterling, Charles. *La Nature morte de l'Antiquité au XXᵉ siècle*. Paris, 1952.

Sterling, December 1955
Sterling, Charles. "Le Pont de Mennecy, par Cézanne." *La Revue des arts*, vol. 5, no. 4 (December 1955), pp. 195-98.

Sterling, 1959
Sterling, Charles. *Still Life Painting from Antiquity to the Present Time*, trans. James Emmons. Rev. ed., New York and Paris, 1959.

Stevens, 1990
Stevens, Mary Anne, et al. *Émile Bernard, 1868-1941: A Pioneer of Modern Art*. Zwolle, Netherlands, 1990.

Stock, March 20, 1870
Stock. "'Le Salon' par Stock." *Album Stock*, March 20, 1870.

Stokes, 1950
Stokes, Adrian. *Cézanne*. New York and London, 1950.

Sutton, August 1974
[Sutton, Denys]. "The Paradoxes of Cézanne." *Apollo*, vol. 100, no. 150 (August 1974), pp. 98-107.

Tabarant, 1947
Tabarant, Adolphe. *Manet et ses oeuvres*. Paris, 1947.

Thiébault-Sisson, December 22, 1895
Thiébault-Sisson, François. "Petites expositions." *Le Temps*, December 22, 1895.

Thiébault-Sisson, March 9, 1897
Thiébault-Sisson, François. In *Le Temps*, March 9, 1897.

Thiébault-Sisson, October 25, 1906
Thiébault-Sisson, François. "Nécrologie." *Le Temps*, October 25, 1906.

Thorold, 1980
Thorold, Anne, ed. *Artists, Writers, Politics: Camille Pissarro and His Friends, An Archival Exhibition Held at the Ashmolean Museum from 1 November 1980 to 4 January 1981*. Oxford, 1980.

Tolnay, 1974
Tolnay, Charles de. "Les Écrits de Lapos Fülep sur Cézanne." *Acta Historia Artium*, vol. 20 (1974).

Tompkins Lewis, 1989
Tompkins Lewis, Mary. *Cézanne's Early Imagery*. Berkeley, California, and London, 1989.

Tschudi, November 1, 1900
Tschudi, Hugo von. "Die Jahrhundert-Ausstellung der Französischen Kunst." *Die Kunst für Alle*, vol. 16, no. 3 (November 1, 1900).

Twitchell, 1987
Twitchell, Beverly H. *Cézanne and Formalism in Bloomsbury*. Ann Arbor, Michigan, 1987.

Valensol, October 14, 1904
Valensol. "Le Salon d'Automne." *Le Petit Parisien*, October 14, 1904.

Vallotton, October 25, 1907
Vallotton, Félix. "Le Salon d'Automne." *La Grande Revue*, October 25, 1907.

Van Buren, 1966
Van Buren, Anne H. "Madame Cézanne's Fashions and the Date of Her Portraits." *The Art Quarterly*, vol. 29, no. 2 (1966), pp. 111-27.

Van Gogh, 1959
van Gogh, Vincent. *The Complete Letters of Vincent van Gogh*, trans. Johanna van Gogh-Bonger and C. de Dood. 3 vols. 2nd ed., Greenwich, Connecticut, 1959.

Van Gogh, 1990
van Gogh, Vincent. *Correspondance générale*, trans. Maurice Beerblock and Louis Roëlandt. 3 vols. Paris, 1990.

Vassy, April 6, 1877
[Vassy, Gaston]. "La Journée à Paris: L'Exposition des impressionnalistes." *L'Événement*, April 6, 1877.

Vauxcelles, September 15, 1904
Vauxcelles, Louis. "Le Problème du Salon d'Automne." *Gil Blas*, September 15, 1904.

Vauxcelles, October 14, 1904
Vauxcelles, Louis. "Le Salon d'Automne." *Gil Blas*, October 14, 1904.

Vauxcelles, October 15, 1904
Vauxcelles, Louis. "Le Salon d'Automne: Le Vernissage." *Gil Blas*, October 15, 1904.

Vauxcelles, December 21, 1904
Vauxcelles, Louis. "Le Schisme au Salon d'Automne." *Gil Blas*, December 21, 1904.

Vauxcelles, March 18, 1905
Vauxcelles, Louis. "Cézanne." *Gil Blas*, March 18, 1905.

Vauxcelles, October 17, 1905
Vauxcelles, Louis. "Le Salon d'Automne." *Gil Blas*, October 17, 1905, supplement.

Vauxcelles, October 18, 1905
Vauxcelles, Louis. "Impressions de vernissage." *Gil Blas*, October 18, 1905.

Vauxcelles, December 1905
Vauxcelles Louis. "Un après-midi chez Claude Monet." *L'Art et les artistes*, no. 9 (December 1905).

Vauxcelles, October 5, 1906
Vauxcelles Louis. "Le Salon d'Automne." *Gil Blas*, October 5, 1906, supplement.

Vauxcelles, October 25, 1906
Vauxcelles, Louis. "La Mort de Paul Cézanne." *Gil Blas*, October 25, 1906.

Vauxcelles, November 22, 1906
Vauxcelles, Louis. "La Vie artistique: La Clôture du Salon d'Automne." *Gil Blas*, November 22, 1906.

Veber, October 17, 1905
Veber, Pierre. "The Autumn Salon at Paris." *New York Tribune*, October 17, 1905.

Veber, October 5, 1906
Veber, Pierre. "Call Autumn Salon Disappointing." *New York Tribune*, October 5, 1906.

Venturi, 1936
Venturi, Lionello. *Cézanne, son art—son oeuvre*. Paris, 1936.

Venturi, 1939
Venturi, Lionello. *Les Archives de l'impressionnisme: Lettres de Renoir, Monet, Pissarro, Sisley et autres, mémoires de Paul Durand-Ruel, documents*. 2 vols. Paris and New York, 1939.

Venturi, 1943
Venturi, Lionello. *Paul Cézanne: Water Colours*. Oxford, 1943.

Venturi, 1945
Venturi, Lionello. *Painting and Painters: How to Look at a Picture, from Giotto to Chagall*. New York, 1945.

Venturi, January-March 1951
Venturi, Lionello. "Giunte a Cézanne." *Commentari*, vol. 2, no. 1 (January-March 1951).

Venturi, 1956
Venturi, Lionello. *Four Steps Toward Modern Art: Giorgione, Caravaggio, Manet, Cézanne*. New York, 1956.

Venturi, 1978
Venturi, Lionello. *Cézanne*. Geneva, 1978.

Verdavainne, January 26, 1890
Verdavainne, Georges. "L'Exposition des XX." *La Fédération artistique*, January 26, 1890.

Verdi, 1990
Verdi, Richard. *Cézanne and Poussin: The Classical Vision of Landscape*. London, 1990.

Verdi, 1992
Verdi, Richard. *Cézanne*. London and New York, 1992.

Vollard, 1914
Vollard, Ambroise. *Paul Cézanne*. Paris, 1914.

Vollard, 1920
Vollard, Ambroise. *La Vie et l'oeuvre de Pierre-Auguste Renoir*. Rev. ed., Paris, 1920.

Vollard, 1923
Vollard, Ambroise. *Paul Cézanne: His Life and Art*, trans. Harold L. Van Doren. New York, 1923.

Vollard, 1936
Vollard, Ambroise. *Recollections of a Picture Dealer*, trans. Violet M. MacDonald. Boston, 1936.

Waern, April 1892
Waern, Cecilia. "Some Notes on French Impressionism." *The Atlantic Monthly*, vol. 69, no. 414 (April 1892), pp. 535-41.

Waldfogel, 1961
Waldfogel, Melvin. "The Bathers of Paul Cézanne." Ph.D. diss., Harvard University, 1961.

Walter, 1961
Walter, Rodolphe. "Zola et ses amis à Bennecourt." *Les Cahiers naturalistes*, 1961.

Walter, February 1962
Walter, Rodolphe. "Cézanne à Bennecourt en 1866." *Gazette des Beaux-Arts*, 6th ser., vol. 59, no. 1117 (February 1962), pp. 103-18.

Warncke, November 29, 1900
P. W. [Paul Warncke]. "Sammlungen und Ausstellungen." *Kunstchronik*, November 29, 1900.

Wechsler, 1972
Wechsler, Judith. *The Interpretation of Cézanne*. Ann Arbor, Michigan, 1972.

Weitzenhoffer, 1986
Weitzenhoffer, Frances. *The Havemeyers: Impressionism Comes to America*. New York, 1986.

Wildenstein, 1974-85
Wildenstein, Daniel. *Claude Monet: Biographie et catalogue raisonné*. 4 vols. Lausanne and Paris, 1974-85.

Wright, February 1916
Wright, Willard Huntington. "Paul Cézanne." *The International Studio*, vol. 57, no. 228 (February 1916), pp. cxxix-cxxxi.

Zola, 1866
Zola, Émile. *Mon Salon, augmenté d'une dédicace et d'un appendice*. Paris, 1866.

Zola, 1867
Zola, Émile. *Éd. Manet.* Paris, 1867.

Zola, April 12, 1867
Zola, Émile. In *Le Figaro*, April 12, 1867.

Zola, April 18, 1874
[Zola, Émile]. "Lettre de Paris." *Le Sémaphore de Marseille*, April 18, 1874.

Zola, April 19, 1877
[Zola, Émile]. "Notes parisiennes: Une exposition,

les peintres impressionnistes." *Le Sémaphore de Marseille*, April 19, 1877.

Zola, June 18-22, 1880
Zola, Émile. "Le Naturalisme au Salon." *Le Voltaire*, June 18-22, 1880.

Zola, May 2, 1896
Zola, Émile. "Peinture." *Le Figaro*, May 2, 1896.

Zola, January 13, 1898
Zola, Émile. "J'accuse." *L'Aurore*, January 13, 1898.

Zola, 1974
Zola, Émile. *Le Bon Combat de Courbet aux impressionnistes: Anthologie d'écrits sur l'art*, ed. Gaëton Picon and Jean-Paul Bouillon. Paris, 1974.

Zola, 1978-
Zola, Émile. *Correspondance*, ed. B. H. Bakker. Montreal and Paris, 1978-.

Zola, 1991
Zola, Émile. *Écrits sur l'art*, ed. Jean-Pierre Leduc-Adine. Paris, 1991.

List of Exhibitions Cited

The following list of exhibitions corresponds to the abbreviations cited in this catalogue and is divided into two groups: exhibitions featuring only works by Cézanne and those presenting the works of other artists. Within each of these groups, the exhibitions are listed in chronological order. When more than one exhibition was held in the same city in the same year, the abbreviations are distinguished by the designations (a), (b), or (c).

Monographic Exhibitions of Cézanne's Works

Paris, 1895
Paul Cézanne. Paris, Galerie Ambroise Vollard, November-December 1895.

Paris, 1898
Exposition Cézanne. Paris, Galerie Ambroise Vollard, May 9-June 10, 1898.

Paris, 1899 (b)
Paul Cézanne. Paris, Galerie Ambroise Vollard, late November-December 1899.

Paris, 1907 (a)
Les Aquarelles de Cézanne. Paris, Galerie Bernheim-Jeune, June 17-29, 1907.

Berlin, 1907
Cézanne Aquarelle. Berlin, Galerie Paul Cassirer, September-October 1907.

Paris, 1907 (b)
Rétrospective d'oeuvres de Cézanne. Paris, Grand Palais, Salon d'Automne, October 1-22, 1907.

Paris, 1910
Exposition Cézanne. Paris, Galerie Bernheim-Jeune, January 10-22, 1910.

New York, 1911
An Exhibition of Water-colors by Cézanne. New York, Gallery of the Photo-Secession, March 1-25, 1911.

Paris, 1913
Aquarelles de Cézanne. Paris, Galerie Blot, November-December 1913.

Paris, 1914
Cézanne. Paris, Galerie Bernheim-Jeune, January 6-17, 1914.

New York, 1916
Cézanne Exhibition. New York, Montross Gallery, January 1916.

New York, 1917
Cézanne. New York, Arden Gallery, 1917.

Venice, 1920
Mostra individuale di P. Cézanne. Venice, XIIa Esposizione internazionale d'arte, 1920.

Paris, 1920 (b)
Exposition Cézanne. Paris, Galerie Bernheim-Jeune, December 1-18, 1920.

Basel, 1921
Cézanne. Basel, Kunsthalle, February 6-March 6, 1921.

Berlin, 1921
Cézannes Werke in deutschem Privatbesitz. Berlin, Galerie Paul Cassirer, November-December 1921.

Paris, 1924
Paul Cézanne. Paris, Galerie Bernheim-Jeune, March 3-22, 1924.

London, 1925
Paintings and Drawings by Paul Cézanne. London, Leicester Galleries, June-July 1925.

Paris, 1926
Rétrospective Paul Cézanne. Paris, Galerie Bernheim-Jeune, June 1-30, 1926.

New York, 1928
Loan Exhibition of Paintings by Paul Cezanne, 1839-1906. New York, Wildenstein Galleries, January 1928.

Paris, 1929
Exposition Cézanne, 1839-1906. Paris, Galerie Pigalle, December 1929.

New York, 1931
Cézanne. New York, The Metropolitan Museum of Art, 1931.

Paris, 1931
Cézanne. Paris, Galerie Bernheim-Jeune, 1931.

New York, 1933 (b)
Water Colors by Cézanne. New York, Jacques Seligmann Gallery, November 16-December 7, 1933.

Philadelphia, 1934
Cézanne. Philadelphia, Pennsylvania Museum of Art, November 10-December 10, 1934.

Paris, 1935
Aquarelles et Baignades de Cézanne. Paris, Galerie Renou et Colle, June 3-17, 1935.

London, 1935
Cézanne. London, Reid and Lefevre, July 1935.

Paris, 1936
Cézanne. Paris, Musée de l'Orangerie, May-October 1936.

Basel, 1936
Paul Cézanne. Basel, Kunsthalle, August 30-October 12, 1936.

New York, 1936
Paul Cézanne (1839-1906). New York, Bignou Gallery, November-December 1936.

London, 1937
Cézanne. London, Reid and Lefevre, June 1937.

San Francisco, 1937
Paul Cézanne: Exhibition of Paintings, Water-colors, Drawings and Prints. San Francisco, San Francisco Museum of Art, September 1-October 4, 1937.

Paris, 1939 (a)
Exposition Cézanne (1839-1906), organisée à l'occasion de son centenaire. Paris, Galerie Paul Rosenberg, February 21-April 1, 1939.

Paris, 1939 (b)
Centenaire du peintre indépendant Paul Cézanne, 1839-1906. Paris, Grand Palais, Société des Artistes Indépendants, March 17-April 10, 1939.

London, 1939 (a)
Exhibition Cézanne (1839-1906), to Celebrate His Centenary. London, Rosenberg and Helft, April 19-May 20, 1939.

London, 1939 (b)
Homage to Paul Cézanne. London, Wildenstein Galleries, July 1939.

Lyon, 1939
Centenaire de Paul Cézanne. Lyon, Musée de Lyon, 1939.

New York, 1942
Loan Exhibition of Paintings by Cézanne (1839-1906). New York, Paul Rosenberg Galleries, November 19-December 19, 1942.

London, Leicester, and Sheffield, 1946
Paul Cézanne: An Exhibition of Watercolours. London, Tate Gallery, March-April 1946; Leicester, Museum and Art Gallery, May-June 1946; Sheffield, Graves Art Gallery, July 1946.

Cincinnati, 1947
Paintings by Paul Cézanne. Cincinnati, Cincinnati Art Museum, February 5-March 9, 1947.

New York, 1947
A Loan Exhibition of Cézanne. New York, Wildenstein Galleries, March 27-April 26, 1947.

Chicago and New York, 1952
Cézanne: Paintings, Watercolors and Drawings. Chicago, The Art Institute of Chicago, February 7-March 16, 1952; New York, The Metropolitan Museum of Art, April 1-May 16, 1952.

Aix-en-Provence, Nice, and Grenoble, 1953
Cézanne: Peintures, Aquarelles, Dessins. Aix-en-Provence, Musée Granet, June 30-August 5, 1953; Nice, Musée Masséna, August 8-September 12, 1953; Grenoble, Musée des Beaux-Arts, September 15-October 18, 1953.

Paris, 1954
Hommage à Paul Cézanne. Paris, Orangerie des Tuileries, July 2-October 17, 1954.

Edinburgh and London, 1954
An Exhibition of Paintings by Cézanne. Edinburgh, Royal Scottish Academy, August 20-September 18, 1954; London, Tate Gallery, September 29-October 30, 1954.

The Hague, 1956
Paul Cézanne, 1839-1906. The Hague, Gemeentemuseum, June-July 1956.

Aix-en-Provence, 1956
Exposition pour commémorer le cinquantenaire de la mort de Cézanne. Aix-en-Provence, Pavillon de Vendôme, July 21-August 15, 1956.

Zurich, 1956
Paul Cézanne. Zurich, Kunsthaus, August 22-October 7, 1956.

Munich, 1956
Paul Cézanne, 1839-1906. Munich, Haus der Kunst, October-November 1956.

Leningrad, 1956
Paul Cézanne: 50 Years Since His Death. Leningrad, The Hermitage Museum, 1956.

Paris, 1956
Aquarelles de Cézanne. Paris, Galerie Bernheim-Jeune, 1956.

Cologne, 1956-57
Cézanne, Ausstellung zum Gedenken an sein 50. Todesjahr. Cologne, Kunsthaus Lempertz, Wallraf-Richartz-Museum, December 1956-January 1957.

Cambridge, 1959
Drawings, Watercolors, and Oils by Paul Cézanne Lent by an Anonymous Collector. Cambridge, Massachusetts, Fogg Art Museum, Summer 1959.

New York, 1959 (b)
Loan Exhibition Cézanne. New York, Wildenstein Galleries, November 5-December 5, 1959.

Paris, 1960
Cézanne—Aquarelliste et Peintre. Paris, Galerie Bernheim-Jeune, May-July 1960.

Vienna, 1961
Paul Cézanne, 1839-1906. Vienna, Österreichische Galerie, Oberes Belvedere, April 14-June 18, 1961.

Aix-en-Provence, 1961
Exposition Cézanne: Tableaux, Aquarelles, Dessins. Aix-en-Provence, Pavillon de Vendôme, July 15-August 15, 1961.

Tokyo and Kyoto, 1962
Cézanne. Tokyo, National Museum of Art; Kyoto, Municipal Museum, 1962.

New York, 1963 (a)
Cézanne Watercolors. New York, Knoedler Galleries, April 2-20, 1963.

Paris, 1971
Aquarelles de Cézanne. Paris, Galerie Bernheim-Jeune, January 12-March 13, 1971.

Washington, Chicago, and Boston, 1971
Cézanne: An Exhibition in Honor of the Fiftieth Anniversary of The Phillips Collection. Washington, D.C., The Phillips Collection, February 27-March 28, 1971; Chicago, The Art Institute of Chicago, April 17-May 16, 1971; Boston, Museum of Fine Arts, June 1-July 3, 1971.

Newcastle upon Tyne and London, 1973
Watercolour and Pencil Drawings by Cézanne. Newcastle upon Tyne, Laing Art Gallery, September 19-November 4, 1973; London, Hayward Gallery, November 13-December 30, 1973.

Tokyo, Kyoto, and Fukuoka, 1974
Cézanne. Tokyo, National Museum of Western Art, March 30-May 19, 1974; Kyoto, Municipal Museum, June 1-July 17, 1974; Fukuoka, Cultural Center, July 24-August 18, 1974.

Paris, 1974
Cézanne dans les musées nationaux. Paris, Orangerie des Tuileries, July 19-October 14, 1974.

New York and Houston, 1977-78
Cézanne: The Late Work. New York, The Museum of Modern Art, October 7, 1977-January 3, 1978; Houston, The Museum of Fine Arts, January 26-March 19, 1978.

Paris, 1978
Cézanne, les dernières années (1895-1906). Paris, Grand Palais, April 20-July 23, 1978.

Tübingen, 1978
Paul Cézanne—Das zeichnerische Werk. Tübingen, Kunsthalle, October 21-December 31, 1978.

Tübingen and Zurich, 1982
Paul Cézanne Aquarelle, 1866-1906. Tübingen, Kunsthalle, January 16-March 21, 1982; Zurich, Kunsthaus, April 2-May 31, 1982.

Liège and Aix-en-Provence, 1982
Cézanne. Liège, Musée Saint-Georges, March 12-May 9, 1982; Aix-en-Provence, Musée Granet, June 12-August 31, 1982.

Philadelphia, 1983
Cézanne in Philadelphia Collections. Philadelphia, Philadelphia Museum of Art, June 19-August 21, 1983.

Basel, 1983
Paul Cézanne: Peintures, Aquarelles, Dessins. Basel, Galerie Beyeler, June-September 1983.

Madrid, 1984
Paul Cézanne. Madrid, Museo Español de Arte Contemporáneo, March-April 1984.

Aix-en-Provence, 1984
Cézanne au musée d'Aix. Aix-en-Provence, Musée Granet, 1984.

Tokyo, Kobe, and Nagoya, 1986
Cézanne. Tokyo, Isetan Museum of Art, September-October 1986; Kobe, The Hyogo Prefectural Museum of Modern Art, October-November 1986; Nagoya, The Aichi Prefectural Art Gallery, November-December 1986.

New York, 1988
Paul Cézanne: The Basel Sketchbooks. New York, The Museum of Modern Art, March 10-June 5, 1988.

London, Paris, and Washington, 1988-89
Cézanne: The Early Years 1859-1872. London, Royal Academy of Arts, April 22-August 21, 1988; Washington, D.C., National Gallery of Art, January 29-April 30, 1989. *Cézanne: Les Années de jeunesse, 1859-1872.* Paris, Musée d'Orsay, September 20-December 31, 1988.

Philadelphia, 1989
Paul Cézanne: Two Sketchbooks. Philadelphia, Philadelphia Museum of Art, May 21-September 17, 1989.

Basel, 1989
Paul Cézanne: Die Badenden. Basel, Kunstmuseum, September 10-December 10, 1989.

Aix-en-Provence, 1990
Sainte-Victoire-Cézanne 1990. Aix-en-Provence, Musée Granet, June 16-September 2, 1990.

Tübingen, 1993
Cézanne—Gemälde. Tübingen, Kunsthalle, January 16-May 2, 1993.

Other Exhibitions

Paris, 1874
Première exposition (First Impressionist Exhibition). Paris, 35, boulevard des Capucines, Société Anonyme des Artistes Peintres, Sculpteurs, Graveurs, etc., April 15-May 15, 1874.

Paris, 1877
Troisième exposition de peinture (Third Impressionist Exhibition) Paris, 6, rue Le Peletier, April 1877.

Paris, 1882
Salon. Paris, 1882.

Paris, 1889
Exposition Centennale de l'Art Français (1789-1889). Paris, Exposition Universelle Internationale de 1889, July-October 1889.

Copenhagen, 1889
Scandinavian and French Impressionists. Copenhagen, Copenhagen Art Society, October 30-November 11, 1889.

Brussels, 1890
VIIᵉ exposition annuelle. Brussels, Les XX, January 18-February 1890.

Aix-en-Provence, 1895
Première exposition. Aix-en-Provence, Société des Amis des Arts, December 1895.

Paris, 1899 (a)
Salon des Indépendants. Paris, Société des Artistes Indépendants, October 21-November 26, 1899.

Paris, 1900
Exposition Centennale de l'Art Français de 1800 à 1889. Paris, Exposition Universelle de 1900, Summer 1900.

Berlin, 1900
III. Jahrgang der Kunst-Ausstellungen. Berlin, Galerie Bruno und Paul Cassirer, November 1900-early January 1901.

Brussels, 1901
Huitième exposition. Brussels, La Libre Esthétique, March 1-31, 1901.

Béziers, 1901
Salon. Béziers, Société des Beaux-Arts, April-May 1901.

Paris, 1901 (a)
Salon des Indépendants. Paris, Grandes Serres, April 20-May 21, 1901.

Paris, 1901 (b)
Salon. Paris, Grand Palais, April 22-June 30, 1901.

The Hague, 1901
Eerste Internationale Tentoonstelling. The Hague, May 9-June 12, 1901.

Paris, 1901 (c)
Exposition de tableaux de F. Iturrino et de P.-R. Picasso. Paris, Galerie Vollard, June 25-July 14, 1901.

Paris, 1902
Salon des Indépendants. Paris, Grandes Serres, March 29-May 5, 1902.

Aix-en-Provence, 1902
Quatrième exposition. Aix-en-Provence, Société des Amis des Arts, June 1902.

Vienna, 1903
Entwicklung des Impressionismus in Malerei und Plastik. Vienna, Secession, January-February 1903.

Berlin, 1903
Siebente Kunstausstellung der Berliner Secession. Berlin, Secession Ausstellungshaus, Spring 1903.

Brussels, 1904
Exposition des peintres impressionnistes. Brussels, La Libre Esthétique, February 25-March 29, 1904.

Berlin, 1904
Ausstellung. Berlin, Galerie Paul Cassirer, April-June 1904.

Paris, 1904 (a)
Exposition des oeuvres du peintre Henri Matisse. Paris, Galerie Vollard, June 1-18, 1904.

Paris, 1904 (b)
Salon d'Automne. Paris, Petit Palais, October 15-
November 15, 1904.

London, 1905
*Pictures by Boudin, Cézanne, Degas, Manet, Monet,
Morisot, Pissarro, Renoir, Sisley, Exhibited by Messrs.
Durand-Ruel & Sons, from Paris*. London, Grafton
Galleries, January-February 1905.

Paris, 1905
Salon d'Automne. Paris, Grand Palais, October 18-
November 25, 1905.

Bremen, 1906
Internationale Kunstausstellung. Bremen, Kunst-
verein, mid-February–mid-April 1906.

Berlin, 1906
VIII. Jahrgang, . . . V. Ausstellung. Berlin, Galerie
Paul Cassirer, February 20-March 14, 1906.

Posen, 1906
Ausstellung französischer Impressionisten. Posen, Kai-
ser Friedrich Museum, May 1906.

Aix-en-Provence, 1906
Cinquième exposition. Aix-en-Provence, Société des
Amis des Arts, Summer (?) 1906.

Paris, 1906
Salon d'Automne. Paris, Grand Palais, October 6-
November 15, 1906.

London, 1906
Exhibition of the International Society. London, New
Gallery, 1906.

Budapest, 1907
Gauguin, Cézanne Stb. Müvei. Budapest, Nemzeti
Szalon, May 1907.

Prague, 1907
Francouzšti Impressionisté. Prague, Manes Society,
October-November 1907.

Berlin, 1908
XV. Ausstellung der Berliner Secession. Berlin, Seces-
sion Ausstellungshaus, Spring 1908.

Paris, 1909
*Aquarelles et pastels de Cézanne, H.-E. Cross, Degas,
Jongkind, Camille Pissarro, K.-X. Roussel, Paul Signac,
Vuillard*. Paris, Galerie Bernheim-Jeune, May 3-15,
1909.

Berlin, 1909
XII. Jahrgang, . . . III. Ausstellung. Berlin, Galerie
Paul Cassirer, November 27-December 10, 1909.

London, 1910-11
Manet and the Post-Impressionists. London, Grafton
Galleries, November 8, 1910-January 15, 1911.

Berlin, 1911
XIII Jahrgang, . . . VIII. Austellung. Berlin, Galerie
Paul Cassirer, March 1911.

Amsterdam, 1911
*Internationale Tentoonstelling van Moderne Kunst—
Moderne Kunst Kring*. Amsterdam, Stedelijk
Museum, October 6-November 5, 1911.

Paris, 1912 (a)
Exposition d'art moderne. Paris, Galerie Manzi-
Joyant, 1912.

Paris, 1912 (b)
Exposition d'art moderne. Paris, Hôtel de la Revue
des Arts, 1912.

Saint Petersburg, 1912
Exposition centennale. Saint Petersburg, Institut
Français, early 1912.

Berlin, 1912
XIV. Jahrgang, . . . VIII. Ausstellung. Berlin, Galerie
Paul Cassirer, April 1912.

Cologne, 1912
Sonderbund Internationale Kunstausstellung. Cologne,
Städtische Ausstellungshalle, May 25-September
30, 1912.

Paris, 1912 (c)
Exposition de portraits du XIXᵉ siècle. Paris, Grand Palais,
Salon d'Automne, October 1-November 8, 1912.

London, 1912
Second Post-Impressionist Exhibition. London, Grafton
Galleries, October 5-December 31, 1912.

New York, Chicago, and Boston, 1913
International Exhibition of Modern Art (Armory
Show). New York, Armory of the Sixty-Ninth
Infantry, February 17-March 15, 1913; Chicago,
The Art Institute of Chicago, March 24-April 16,
1913; Boston, Copley Hall, Copley Society of Bos-
ton, April 28-May 19, 1913.

Berlin, 1913
XXVI. Ausstellung der Berliner Secession. Berlin,
Secession Ausstellungshaus, Spring 1913.

Stuttgart, 1913
Grosse Kunstausstellung. Stuttgart, Königliches
Kunstgebäude, May-October 1913.

Cologne, 1913
Eröffnungs-Ausstellung. Cologne, Kunstverein
Gemäldegalerie, October-November 1913.

Darmstadt, 1913
Sammlung G. F. Reber. Darmstadt, 1913.

Copenhagen, 1914
Fransk Malerkunst. Copenhagen, Statens Museum
for Kunst, May 14-June 30, 1914.

Oslo, 1914
Fransk Kunst. Oslo, Nasjonalgalleriet, 1914.

Stockholm, 1917
French Art. Stockholm, Nationalmuseum, 1917.

Zurich, 1917
Französische Kunst des XIX. und XX. Jahrhunderts.
Zurich, Kunsthaus, 1917.

Paris, 1920 (a)
Paysages impressionnistes. Paris, Galerie Bernheim-
Jeune, February-March 1920.

Tokyo, 1920
France Kindai Kaiga Choso. Tokyo, 1920.

New York, 1921
*Loan Exhibition of Impressionist and Post-Impressionist
Paintings*. New York, The Metropolitan Museum of
Art, May 3-September 15, 1921.

London, 1922
*Pictures, Drawings, and Sculpture of the French School of
the Last 100 Years*. London, Burlington Fine Arts
Club, 1922.

Moscow, 1926
Paul Cézanne—Vincent van Gogh. Moscow, Museum
of Modern Western Art, 1926.

Berlin, 1927 (a)
Erste Sonderausstellung. Berlin, Galerie Thannhauser
(shown at the Berliner Künstlerhaus), January 9-
mid-February 1927.

Berlin, 1927 (b)
*Cézanne Aquarelle und Zeichnungen, Bronzen von
Edgar Degas*. Berlin, Galerie Alfred Flechtheim, May
10-June 16, 1927.

New York, 1929
*First Loan Exhibition: Cézanne, Gauguin, Seurat, Van
Gogh*. New York, The Museum of Modern Art,
November 8-December 7, 1929.

New York, 1930
The H. O. Havemeyer Collection. New York, The
Metropolitan Museum of Art, March 10-November
2, 1930.

Paris, 1931
Exposition coloniale internationale de Paris. Paris,
1931.

New York, Andover, and Indianapolis, 1931-32
*Memorial Exhibition: The Collection of the Late Miss Liz-
zie P. Bliss*. New York, The Museum of Modern Art,
May 17-September 27, 1931; Andover Massachu-
setts, Addison Gallery of American Art, Phillips
Academy, October 17-December 15, 1931; Indi-
anapolis, John Herron Art Institute, January 1932.

Paris, 1933
*20ᵉ Salon de la Société des Peintres-Graveurs Français:
Rétrospective Bracquemond, Cézanne et Renoir*. Paris,
Bibliothèque Nationale, March 1933.

New York, 1933 (a)
Paintings from the Ambroise Vollard Collection.
New York, Knoedler Galleries, 1933.

Rotterdam, 1933-34
Teekeningen van Ingres tot Seurat. Rotterdam,
Museum Boymans, December 20, 1933-January
21, 1934.

Paris, 1934
Impressionnistes. Paris, Galerie Bernheim-Jeune,
1934.

Basel, 1935
*Meisterzeichnungen französischer Künstler von Ingres bis
Cézanne*. Basel, Kunsthalle, June 29-August 18,
1935.

Brussels, 1935
L'Impressionnisme. Brussels, Palais des Beaux-Arts,
1935.

New York, 1937
Cézanne Watercolors, Renoir Drawings. New York,
Valentine [Dudensing] Gallery, January 4-30,
1937.

New York, 1943
*Loan Exhibition of the Collection of Pictures of Erich
Maria Remarque*. New York, Knoedler Galleries,
October 18-November 13, 1943.

Paris, 1945
*Quelques toiles, de Corot à Matisse, exposées au profit de
la Stage Door Canteen*. Paris, Galerie Fabiani, 1945.

Amsterdam, 1946
Fransche Meesters 1800-1900. Amsterdam, Stedelijk
Museum, February-March 1946.

London, 1948
Samuel Courtauld Memorial Exhibition. London, Tate
Gallery, 1948.

Aix-en-Provence, 1949
Cézanne et ses amis. Aix-en-Provence, Musée Gra-
net, 1949.

Kamakura, 1951
Cézanne and Renoir. Kamakura, Museum of Modern
Art, November 18-30, 1951.

Paris, 1953
Monticelli et le baroque provençal. Paris, Musée de
l'Orangerie, 1953.

Paris, 1955
*De David à Toulouse-Lautrec: Chefs-d'oeuvre des collec-
tions américaines*. Paris, Musée de l'Orangerie, 1955.

New York, 1959 (a)
*A Loan Exhibition of Paintings, Watercolors and Sculp-
ture from the Collection of Mr. and Mrs. Henry
Pearlman*. New York, Knoedler Galleries, January
27-February 21, 1959.

Hamburg, 1963
*Wegbereiter der modernen Malerei: Cézanne, Gauguin,
Van Gogh, Seurat*. Hamburg, Kunstverein, May 4-
July 14, 1963.

New York, 1963 (b)
Cézanne and Structure in Modern Painting. New York,

Solomon R. Guggenheim Museum, June-August 1963.

Paris, 1966
Collection Jean Walter-Paul Guillaume. Paris, Musée de l'Orangerie, 1966.

Paris and New York, 1974
Centenaire de l'Impressionnisme. Paris, Grand Palais, September 21-November 24, 1974. *Impressionism: A Centenary Exhibition*. New York, The Metropolitan Museum of Art, December 12, 1974-February 10, 1975.

Paris, 1980-81
Donations Claude Roger-Marx. Paris, Musée du Louvre, November 27, 1980-April 19, 1981.

Paris and New York, 1983
Manet, 1832-1883. Paris, Grand Palais, April 22-August 8, 1983; New York, The Metropolitan Museum of Art, September 10-November 27, 1983.

Paris, 1983-84
Wagner et la France. Paris, Théâtre National de l'Opéra de Paris, October 26, 1983-January 26, 1984.

Los Angeles and Chicago, 1984-85
A Day in the Country: Impressionism and the French Landscape. Los Angeles, Los Angeles County Museum of Art, June 28-September 16, 1984; Chicago, The Art Institute of Chicago, October 23, 1984-January 6, 1985.

Paris, 1985
L'Impressionnisme et le paysage français. Paris, Grand Palais, February 4-April 22, 1985.

Paris, 1985-86
Anciens et nouveaux: Choix d'oeuvres acquises par l'État ou avec sa participation de 1981 à1985. Paris, Grand Palais, November 5, 1985-February 3, 1986.

Washington and San Francisco, 1986
The New Painting: Impressionism 1874-1886. Washington, D.C., National Gallery of Art, January 17-April 6, 1986; San Francisco, M. H. de Young Memorial Museum, April 19-July 6, 1986.

Brooklyn and Dallas, 1986
From Courbet to Cézanne: A New 19th Century (Preview of the Musée d'Orsay). Brooklyn, The Brooklyn Museum, March 13-May 5, 1986; Dallas, The Dallas Museum of Art, June 1-August 3, 1986.

Washington, 1986
Gifts to the Nation: Selected Acquisitions from the Collections of Mr. and Mrs. Paul Mellon. Washington, D.C., National Gallery of Art, July 20-October 19, 1986.

Paris, 1988
Van Gogh à Paris. Paris, Musée d'Orsay, February 2-May 15, 1988.

Paris, Ottawa, and New York, 1988-89
Degas. Paris, Grand Palais, February 9-May 16, 1988; Ottawa, National Gallery of Canada, June 16, 1988-August 28, 1988; New York, The Metropolitan Museum of Art, September 27, 1988-January 8, 1989.

Edinburgh, 1990
Cézanne and Poussin: The Classical Vision of Landscape. Edinburgh, National Gallery of Scotland, August 9-October 21, 1990.

New York, 1993
Splendid Legacy: The Havemeyer Collection. New York, The Metropolitan Museum of Art, March 27-June 20, 1993.

Paris, 1993-94
Baudelaire, Paris. Paris, Bibliothèque Historique de la Ville de Paris, November 16, 1993-February 15, 1994.

Marseille, 1994
L'Estaque: Naissance du paysage moderne, 1870/1910. Marseille, Musée Cantini, June 25-September 25, 1994.

London, 1994
Impressionism for England: Samuel Courtauld as Patron and Collector. London, Courtauld Institute Galleries, 1994.

Paris and New York, 1994-95
Impressionnisme: Les Origines 1859-1869. Paris, Grand Palais, April 19-August 8, 1994. *Origins of Impressionism*. New York, The Metropolitan Museum of Art, September 27, 1994-January 8, 1995.

Paris and Chicago, 1994-95
Gustave Caillebotte. Paris, Grand Palais, September 12, 1994-January 9, 1995; Chicago, The Art Institute of Chicago, February 15-May 28, 1995.

New York, 1994-95
The Thaw Collection: Master Drawings and New Acquisitions. New York, The Pierpont Morgan Library, September 21, 1994-January 22, 1995.

Index of Names

Index of Illustrated Works by Cézanne

Concordance

Cat. no. 1, C. 76
Cat. no. 2, C. 99
Cat. no. 3, V. 59, N.R. 82
Cat. no. 4, V. 62, N.R. 93
Cat. no. 5, V. 61, N.R. 83
Cat. no. 6, V. 74, N.R. 106
Cat. no. 7, V. 73, N.R. 107
Cat. no. 8, V. 127, N.R. 147
Cat. no. 9, V. 109, N.R. 135
Cat. no. 10, V. 83, N.R. 29
Cat. no. 11, V. 100, N.R. 120
Cat. no. 12, V. 101, N.R. 121
Cat. no. 13, R. 29
Cat. no. 14, V. 92, N.R. 128
Cat. no. 15, R. 23
Cat. no. 16, V. 121, N.R. 165
Cat. no. 17, V. 90, N.R. 149
Cat. no. 18, V. 70, N.R. 137
Cat. no. 19, V. 88, N.R. 139
Cat. no. 20, C. 229
Cat. no. 21, C. 230
Cat. no. 22, C. 155
Cat. no. 23, V. 104, N.R. 166
Cat. no. 24, V. 47, N.R. 158
Cat. no. 25, C. 121
Cat. no. 26, V. 56, N.R. 179
Cat. no. 27, V. 106, N.R. 171
Cat. no. 28, V. 225, N.R. 225
Cat. no. 29, R. 135
Cat. no. 30, V. 133, N.R. 202
Cat. no. 31, V. 150; N.R. 221
Cat. no. 32, V. 494, N.R. 302
Cat. no. 33, C. 273
Cat. no. 34, V. 288, N.R. 182
Cat. no. 35, V. 286, N.R. 274
Cat. no. 36, V. 290, N.R. 383
Cat. no. 37, V. 265, N.R. 256
Cat. no. 38, V. 267, N.R. 361
Cat. no. 39, V. 224, N.R. 291
Cat. no. 40, V. 241, N.R. 300
Cat. no. 41, C. 453
Cat. no. 42, V. 247, N.R. 299
Cat. no. 43, V. 251, N.R. 282
Cat. no. 44, V. 168, N.R. 279
Cat. no. 45, V. 283, N.R. 292
Cat. no. 46, V. 373, N.R. 296
Cat. no. 47, V. 292, N.R. 324
Cat. no. 48, V. 209, N.R. 325
Cat. no. 49, V. 190, N.R. 346
Cat. no. 50, V. 385, N.R. 365
Cat. no. 51, C. 713
Cat. no. 52, C. 536
Cat. no. 53, V. 164, N.R. 350
Cat. no. 54, V. 408, N.R. 394
Cat. no. 55, V. 404, N.R. 442
Cat. no. 56, V. 490, N.R. 391
Cat. no. 57, V. 396, N.R. 436

Cat. no. 58, V. 335, N.R. 407
Cat. no. 59, R. 113
Cat. no. 60, V. 381, N.R. 360
Cat. no. 61, C. 514
Cat. no. 62, V. 542, N.R. 554
Cat. no. 63, C. 517
Cat. no. 64, V. 379, N.R. 455
Cat. no. 65, R. 60
Cat. no. 66, V. 366, N.R. 415
Cat. no. 67, V. 311, N.R. 434
Cat. no. 68, R. 88
Cat. no. 69, V. 325, N.R. 437
Cat. no. 70, R. 89
Cat. no. 71, V. 397, N.R. 438
Cat. no. 72, V. 425, N.R. 395
Cat. no. 73, R. 116
Cat. no. 74, R. 159
Cat. no. 75, V. 324, N.R. 483
Cat. no. 76, V. 329, N.R. 490
Cat. no. 77, V. 284, N.R. 510
Cat. no. 78, V. 343, N.R. 431
Cat. no. 79, C. 363
Cat. no. 80, R. 145
Cat. no. 81, C. 504
Cat. no. 82, C. 555
Cat. no. 83, C. 556
Cat. no. 84, C. 608
Cat. no. 85, V. 535, N.R. 465
Cat. no. 86, V. 443, N.R. 508
Cat. no. 87, C. 878
Cat. no. 88, C. 792
Cat. no. 89, V. 452, N.R. 511
Cat. no. 90, C. 896
Cat. no. 91, C. 239
Cat. no. 92, V. 454, N.R. 599
Cat. no. 93, V. 455, N.R. 598
Cat. no. 94, R. 241
Cat. no. 95, V. 488, N.R. 698
Cat. no. 96, R. 281
Cat. no. 97, V. 467, N.R. 538
Cat. no. 98, C. 916
Cat. no. 99, C. 917
Cat. no. 100, R. 194
Cat. no. 101, R. 209
Cat. no. 102, R. 193
Cat. no. 103, V. 549, N.R. 370
Cat. no. 104, V. 548, N.R. 555
Cat. no. 105, C. 850
Cat. no. 106, C. 951
Cat. no. 107, R. 289
Cat. no. 108, R. 192
Cat. no. 109, C. 957
Cat. no. 110, C. 489
Cat. no. 111, C. 980
Cat. no. 112, C. 1065
Cat. no. 113, V. 476, N.R. 551
Cat. no. 114, V. 493, N.R. 626

Cat. no. 115, V. 431, N.R. 571
Cat. no. 116, V. 433, N.R. 573
Cat. no. 117, V. 468, N.R. 603
Cat. no. 118, V. 627, N.R. 616
Cat. no. 119, R. 313
Cat. no. 120, R. 325
Cat. no. 121, V. 650, N.R. 692
Cat. no. 122, C. 938
Cat. no. 123, C. 941
Cat. no. 124, V. 554, N.R. 620
Cat. no. 125, V. 529, N.R. 650
Cat. no. 126, V. 530, N.R. 581
Cat. no. 127, R. 375
Cat. no. 128, V. 594, N.R. 636
Cat. no. 129, N.R. 672
Cat. no. 130, V. 512, N.R. 675
Cat. no. 131, V. 391, N.R. 682
Cat. no. 132, R. 379
Cat. no. 133, R. 377
Cat. no. 134, V. 558, N.R. 714
Cat. no. 135, C. 1093
Cat. no. 136, V. 684, N.R. 756
Cat. no. 137, V. 687, N.R. 826
Cat. no. 138, V. 527, N.R. 685
Cat. no. 139, V. 726, N.R. 667
Cat. no. 140, V. 580, N.R. 665
Cat. no. 141, R. 134
Cat. no. 142, C. 973
Cat. no. 143, C. 1027
Cat. no. 144, R. 382
Cat. no. 145, V. 761, N.R. 792
Cat. no. 146, R. 392
Cat. no. 147, R. 389
Cat. no. 148, R. 327
Cat. no. 149, V. 767, N.R. 797
Cat. no. 150, R. 432
Cat. no. 151, R. 435
Cat. no. 152, R. 407
Cat. no. 153, V. 669, N.R. 601
Cat. no. 154, V. 458, N.R. 761
Cat. no. 155, R. 286
Cat. no. 156, R. 287
Cat. no. 157, V. 419, N.R. 815
Cat. no. 158, V. 673, N.R. 775
Cat. no. 159, V. 601, N.R. 739
Cat. no. 160, V. 598, N.R. 770
Cat. no. 161, V. 707, N.R. 782
Cat. no. 162, V. 706, N.R. 786
Cat. no. 163, C. 988
Cat. no. 164, R. 560
Cat. no. 165, R. 558
Cat. no. 166, V. 730, N.R. 803
Cat. no. 167, V. 570, N.R. 655
Cat. no. 168, V. 574, N.R. 781
Cat. no. 169, R. 543
Cat. no. 170, R. 486
Cat. no. 171, V. 702, N.R. 808

Cat. no. 172, V. 692, N.R. 791
Cat. no. 173, V. 694, N.R. 809
Cat. no. 174, V. 762, N.R. 805
Cat. no. 175, V. 766, N.R. 837
Cat. no. 176, V. 765, N.R. 939
Cat. no. 177, V. 696, N.R. 811
Cat. no. 178, C. 1194
Cat. no. 179, V. 689, N.R. 851
Cat. no. 180, V. 731, N.R. 846
Cat. no. 181, V. 732, N.R. 847
Cat. no. 182, R. 529
Cat. no. 183, R. 495
Cat. no. 184, R. 516
Cat. no. 185, C. 1208
Cat. no. 186, C. 1210
Cat. no. 187, V. 697, N.R. 789
Cat. no. 188, V. 705, N.R. 944
Cat. no. 189, V. 796, N.R. 937
Cat. no. 190, V. 786, N.R. 909
Cat. no. 191, R. 636
Cat. no. 192, R. 531
Cat. no. 193, R. 502
Cat. no. 194, R. 538
Cat. no. 195, R. 551
Cat. no. 196, R. 562
Cat. no. 197, R. 572
Cat. no. 198, R. 567
Cat. no. 199, R. 610
Cat. no. 200, N.R. 910
Cat. no. 201, R. 588
Cat. no. 202, V. 800, N.R. 913
Cat. no. 203, V. 798, N.R. 912
Cat. no. 204, R. 585
Cat. no. 205, V. 803, N.R. 932
Cat. no. 206, R. 587
Cat. no. 207, R. 621
Cat. no. 208, R. 581
Cat. no. 209, V. 1610, N.R. 926
Cat. no. 210, R. 630
Cat. no. 211, R. 631
Cat. no. 212, V. 753, N.R. 822
Cat. no. 213, V. 759, N.R. 824
Cat. no. 214, R. 232
Cat. no. 215, R. 611
Cat. no. 216, R. 612
Cat. no. 217, R. 613
Cat. no. 218, V. 721, N.R. 855
Cat. no. 219, V. 719, N.R. 857
Cat. no. 220, V. 722, N.R. 859
Cat. no. 221, V. 725, N.R. 877
Cat. no. 222, V. 713, N.R. 852
Cat. no. 223, R. 491
Cat. no. 224, R. 638
Cat. no. 225, V. 717, N.R. 951
Cat. no. 226, R. 640
Cat. no. 227, V. 789, N.R. 889

V. Lionello Venturi, *Cézanne, son art—son oeuvre*, 2 vols. (Paris, 1936).

R. John Rewald, *Paul Cézanne: The Watercolors, A Catalogue Raisonné* (Boston, 1983).

C. Adrien Chappuis, *The Drawings of Paul Cézanne: A Catalogue Raisonné* (Greenwich, Connecticut, 1973).

N.R. John Rewald, *The Paintings of Paul Cézanne: A Catalogue Raisonné* (New York, forthcoming).

Photography Credits

Aix-en-Provence
Bibliothèque Méjanes, photo Bernard Terlay (pp. 529, 568 [2 ills.], 569) — Centre des impôts (p. 561) — Musée Granet, photo Bernard Terlay (cat. nos. 1, 4; pp. 527-28 [2 ills.], 529) — Bernard Terlay (pp. 528-30, 532, 536, 552 [3 ills.], 555)
Avignon
Musée Calvet (cat. no. 22)
Baltimore
The Baltimore Museum of Art (cat. no. 175)
Basel
Öffentliche Kunstsammlung Basel, photo Martin Bühler (cat. nos. 20, 62, 82, 111, 143; p. 29, fig. 2; p. 217, fig. 2; p. 313, fig. 1; p. 434, fig. 1; p. 469, fig. 2)
Berlin
Nationalgalerie, Staatliche Museen Preussischer Kulturbesitz, photo Klaus Göken (cat. no. 75)
Bern
Kunstmuseum Bern (cat. no. 66)
Boston
Little, Brown and Company, © 1973 by Adrien Chappuis (p. 216, fig. 1; p. 242, fig. 1; p. 245, fig. 1; p. 281, fig. 1; p. 352, fig. 1 [R. W. Ratcliffe]; p. 440, fig. 1; p. 524, fig. 1) — Museum of Fine Arts (cat. nos. 47, 76; p. 186, fig. 1 [© 1995]) — New York Graphic Society Books/Little, Brown and Company, © 1984, John Rewald (p. 238, fig. 1)
Bremen
Kunsthalle Bremen (cat. no. 81)
Cambridge
Fitzwilliam Museum, University of Cambridge (cat. nos. 2, 49)
Cambridge, Massachusetts
Fogg Art Museum (cat. nos. 52, 155, 178, p. 547 [© President and Fellows Harvard College, Harvard University Art Museums]; cat. no. 96 [photo Bob Kolbrener]; p. 167, fig. 1)
Canberra
Australian National Gallery (cat. no. 39)
Cardiff
National Museum of Wales (cat. nos. 13, 56)
Chicago
© 1994, The Art Institute of Chicago (cat. nos. 25, 31, 41, 94, 114, 123, 133, 184, 215, 220, 224, p. 523; p. 186, figs. 3, 4; p. 281, fig. 2; p. 519, figs. 3, 6)
Cincinnati
Cincinnati Art Museum (cat. no. 3)
Cleveland
The Cleveland Museum of Art (cat. no. 121)
Columbus
Columbus Museum of Art (cat. no. 46)
Copenhagen
Ny Carlsberg Glyptotek (cat. no. 139 [Ole Haupt Atelier Sorte Hest]; p. 189, fig. 1; p. 234, fig. 1)
Detroit
The Detroit Institute of Arts (p. 493, fig. 1)
Dublin
The National Gallery of Ireland (cat. no. 204)
Essen
Museum Folkwang (cat. no. 149; p. 310, fig. 1)
Florence
Casa Buonarroti (p. 393, fig. 2)
Fort Worth, Texas
The Kimbell Art Museum, photo Michael Bodycomb (cat. nos. 137, 145)
Frankfurt-am-Main
Städelsches Kunstinstitut, © Ursula Edelmann (cat. no. 59)
Geneva
Patrick Goetelen (cat. nos. 9, 225)
Glasgow
Glasgow Museums (cat. no. 69; p. 412, fig. 1)
Grosse Pointe Shores, Michigan
Edsel & Eleanor Ford House (p. 264, fig. 2; p. 461, fig. 1)
Hamburg
Hamburger Kunsthalle, photo Elke Walford Fotowerkstatt (cat. no. 210)
Hertfordshire
© The Henry Moore Foundation (p. 153, fig. 1)
Houston
Museum of Fine Arts, photo A. Mewbourn (cat. no. 125; p. 186, fig. 2)
Indianapolis
Indianapolis Museum of Art (cat. no. 116)

Kansas City
The Nelson–Atkins Museum, © 1994, The Nelson Gallery Foundation (cat. no. 202)
Liverpool
Walker Art Gallery, Board of Trustees of the National Museums and Galleries on Merseyside (cat. no. 16)
London
The British Museum (cat. nos. 99, 163) — Christie's (p. 522, fig. 1) — A. C. Cooper Ltd (cat. no. 107) — The Courtauld Institute Galleries (cat. nos. 86, 92, 162, 174, pp. 208-9 [photo Gordon H. Roberton, A. C. Cooper Ltd.]; p. 338, fig. 3; p. 372, fig. 3; p. 380, fig. 2) — Gate Studio (cat. no. 150) — The National Gallery (cat. nos. 171, 218, 226) — Sotheby's (p. 163, figs. 1, 2) — Tate Gallery Publications (cat. no. 24; cat. no. 206 [photo John Webb])
Los Angeles
Armand Hammer Collection, Armand Hammer Museum of Art and Cultural Center (cat. no. 131) — © 1995, Los Angeles County Museum of Art (cat. no. 157; p. 126, fig. 1)
Madrid
Museo del Prado (p. 205, fig. 2)
Malibu, California
The J. Paul Getty Museum (cat. nos. 8, 42)
Mannheim
Städtische Kunsthalle (cat. no. 136)
Marseille
Musée Cantini (p. 188, fig. 5)
Merion, Pennsylvania
The Barnes Foundation (pp. 39, 56 [©1992], 546; p. 200, fig. 1; p. 279, fig. 1; p. 298, fig. 1; p. 305, fig. 1; p. 310, fig. 3; p. 322, fig. 1; p. 329, fig. 1; p. 342, fig. 3; p. 348, fig. 1; p. 428, fig. 1; p. 520, fig. 1)
Minneapolis
The Minneapolis Institute of Arts (cat. no. 113)
Montreal
Canadian Center for Architecture (cat. no. 148)
Moscow
The Pushkin State Museum of Fine Arts (cat. no. 205; p. 63; p. 342, fig. 2)
Munich
Neue Pinakothek, photo Joachim Blauel, Artothek (cat. no. 77)
New York
Alex Hillman Family Foundation (cat. no. 105) — Schecter Lee (cat. no. 45) — The Metropolitan Museum of Art (cat. nos. 7, 37, 68, 89, 97, 158, 167; p. 100, fig. 3; p. 225, fig. 1; p. 272, fig. 1; p. 505, fig. 3) — The Museum of Modern Art (cat. no. 104 [© 1994]; p. 329, fig. 2; p. 348, fig. 2 [© 1995]) — The Pierpont Morgan Library (cat. nos. 135, 165, 183, 198, 207, pp. 520-21; p. 518, figs. 1, 2; p. 519, figs. 4, 5; p. 521, figs. 1, 2, p. 522) — Eric Pollitzer (cat. no. 159) — © Sabine Rewald (p. 561; p. 310, fig. 2; p. 481, fig. 1) — The Selch Family (cat. no. 227) — © The Solomon R. Guggenheim Museum Foundation, photo David Heald (cat. no. 179) — © Malcom Varon (pp. 31, 49)
Newark
The Newark Museum, photo Armen (cat. no. 192)
Norfolk
The Chrysler Museum (cat. no. 10)
Northampton
Smith College Museum of Art (cat. no. 74)
Oslo
Nasjonalgalleriet, J. Lathion, 1993 (cat. no. 187)
Paris
Agence Novosti (Bureau soviétique d'information) (p. 423, fig. 1) — Archives Larousse-Giraudon (p. 541) — Martine Beck Coppola (cat. no. 35) — Bernheim-Jeune (p. 560) — Bibliothèque Nationale de France (pp. 532, 533, 537 [2 ills.], 539, 540, 541 [2 ills.], 542 [2 ills.], 543, 547-51, 554 [3 ills.], 558) — Bulloz (p. 100, fig. 5) — Laboratoire de Recherche des Musées de France (p. 139, fig. 1) — Olivier Morel (p. 530 [3 ills.], 569) — Musée de l'Armée (p. 120. fig. 1; p. 120, fig. 2) — Musée d'Orsay (pp. 76-77, 520 [2 ills.], 528, 530 [2 ills.], 531, 532, 533 [2 ills.], 534, 538 [2 ills.], 539 [2 ills.], 540, 543 [3 ills.], 548 [2 ills.], 549, 550, 551, 553, 556 [2 ills.], 557 [2 ills.], 558, 560, 563 [3 ills.], 564 [2 ills.], 565 [3 ills.], 566; p. 87, fig. 1; p. 100, fig. 2; p. 390, fig. 1; p. 397, fig. 1) — Musée du Petit Palais, Musées de la Ville de Paris, © by SPADEM (cat. nos. 60, 177; p. 89, fig. 1) — Réunion des Musées Nationaux [Frédérique Kar-

touby; photos Hervé Lewandowski, Daniel Arnaudet, Gérard Blot, Gilles Berizzi] (cat. nos. 6, 18, 19, 21, 23, 28, 30, 32, 34, 40, 50, 57, 58, 72, 78, 85, 95, 100, 102, 108, 122, 126, 128, 130, 134, 140, 146, 166, 168, 172, 181, 190, 193, 196, p. 525; pp. 21-23, 538 [3 ills.], 564; p. 96, fig. 2; p. 108, fig. 1; p. 232, fig. 1; p. 237, fig. 1; p. 243, fig. 1; p. 280, figs. 3, 4; p. 291, fig. 1; p. 330, fig. 1; p. 338, fig. 1; p. 354, fig. 1; p. 438, figs. 1, 2; p. 498, fig. 1; p. 524, fig. 1) — Paul Rosenberg, ©1936 (p. 96, fig. 1) — Galerie Paul Rosenberg (p. 170, fig. 1; p. 426, fig. 1) — Vizzavona (p. 146, fig. 1)
Philadelphia
Courtesy Pennsylvania Academy of the Fine Arts (p. 372, fig. 2) — Philadelphia Museum of Art (cat. nos. 29, 33, 43, 83, 106, 138, 182, 185, 186, 201, 203, 208, 219; pp. 442-43; p. 591 [photo Lynn Rosenthal], p. 188, fig. 6; p. 280, fig. 5; p. 293, fig. 1; p. 434, fig. 1; p. 469, fig. 1 [photo Graydon Wood]; p. 472, fig. 3)
Prague
Národní Galerie, photo Milan Posselt (cat. no. 173)
Princeton, New Jersey
Princeton University, The Art Museum (cat. nos. 200; 147, 217; p. 454, fig. 1 [photo Bruce White])
Providence
Museum of Art, Rhode Island School of Design (cat. no. 132)
Riggisberg
Abegg-Stiftung (p. 276, fig. 2)
Rochester
Memorial Art Gallery of the University of Rochester (cat. no. 54)
Rotterdam
Musée Boymans—van Beuningen (cat. nos. 73, 79) [photo Frequin]; cat. no. 112 [photo Jannes Linders]; cat. nos. 61, 84, 87, 90, 98, 119 [© Tom Kroeze]; p. 245, fig. 2; p. 341, fig. 4)
St. Louis, Missouri
The Saint Louis Art Museum (p. 352 fig. 2)
St. Petersburg
The Hermitage Museum (cat. nos. 17, 154, 180; pp. 332-33; p. 183, fig. 1; p. 342, fig. 1)
San Antonio, Texas
The McNay Art Institute (p. 413, fig. 1)
São Paulo
Museu de Arte de São Paulo, Chateaubriand Collection, photo Luiz Hossaka (cat. nos. 11, 55, 153; pp. 25, 124-25)
Schönaich
Volker Naumann, Fotodesign (cat. no. 15)
Solothurn
Kunstmuseum, photo Mario and Béatrix Schenker, Günsberg (cat. no. 213)
Stockholm
Nationalmuseum (cat. no. 161)
Tokyo
Bridgestone Museum of Art (cat. no. 141)
Toledo
The Toledo Museum of Art (cat. no. 118)
Upperville, Virginia
Mr. and Mrs. Paul Mellon Collection (p. 272, fig. 1; p. 374, fig. 4)
Vienna
Graphische Sammlung Albertina (cat. nos. 51, 91)
Washington, D.C.
National Gallery of Art (cat. nos. 71, 124, 189; p. 84, fig. 1; p. 92, fig. 1; p. 113, fig. 1; p. 204, fig. 1; p. 235, fig. 2; p. 285, fig. 1) — The Phillips Collection (cat. nos. 36, 93, 209; p. 100, fig. 4; p. 287, fig. 2; p. 446, fig. 1) — © The White House Historical Association (p. 301, fig. 1)
Winterthur
Fondation Oskar Reinhart (p. 183, fig. 2; p. 428, fig. 2)
Zurich
Dräyer (p. 72) — E. G. Bührle Foundation (p. 156, fig. 1; p. 322, fig. 2) — Foto-Studio H. Humm (cat. nos. 144, 212, 221) — Kunsthaus Zurich, © 1995 (cat. nos. 70, 80, 156, 160, 223; p. 472, fig. 4) — Peter Schälchli Fotoatelier (cat. no. 44)